Origins of Impressionism

Gary Tinterow and Henri Loyrette

THE METROPOLITAN MUSEUM OF ART

Distributed by Harry N. Abrams, Inc., New York

This publication is issued in conjunction with the exhibition *Origins of Impressionism*, held at the Galeries Nationales du Grand Palais, Paris, April 19–August 8, 1994, and at The Metropolitan Museum of Art, New York, September 27, 1994–January 8, 1995.

The exhibition is sponsored by Philip Morris Companies Inc.

Additional assistance has been provided by the National Endowment for the Arts and the Janet Traeger Salz Foundation.

The exhibition was organized by The Metropolitan Museum of Art and the Réunion des musées nationaux/Musée d'Orsay.

The publication of this catalogue has been made possible in part by a gift from Janice H. Levin.

Published by The Metropolitan Museum of Art
John P. O'Neill, Editor in Chief
Margaret Aspinwall and Kathleen Howard, Editors, with the assistance of Carol Fuerstein and Cynthia Clark
Bruce Campbell, Designer, after the French edition by Jean-Pierre Rosier
Peter Antony, Production Manager

Photography of Metropolitan Museum paintings by the Photograph Studio, The Metropolitan Museum of Art

Type set by U.S. Lithograph, typographers, New York
Printed by Julio Soto Impresor, S.A., Madrid
Bound by Encuadernación Ramos, S.A., Madrid

The translations from the French were done by Chantal Combes ("The Salon of 1859," "History Painting," "The Nude," "Still Life," and "Chronology"), Georgette Felix ("Chronology"), Mary E. D. Laing (catalogue texts for Manet), and Joachim Neugroschel ("Foreword," "Introduction," "Portraits and Figures," "Modern Life," and Henri Loyrette's catalogue texts except for those on Manet).

Jacket/cover: Detail of cat. 130. Claude Monet, *Femmes au jardin*. Musée d'Orsay, Paris

Library of Congress Cataloging-in-Publication Data

Loyrette, Henri.
 [Impressionnisme. English]
 Origins of impressionism / by Gary Tinterow and Henri Loyrette. p. cm.
 Catalog of an exhibition held at the Grand Palais, Paris, France, and the
Metropolitan Museum of Art, New York.
 Loyrette's contributions translated from French.
 Includes bibliographical references (p.) and index.
 ISBN 0-87099-717-3.—ISBN 0-87099-718-1 (pbk.).—ISBN 0-8109-6485-6 (Abrams)
 1. Impressionism (Art)—France—Exhibitions. 2. Painting, French—
Exhibitions. 3. Painting—19th century—France—Exhibitions.
I. Tinterow, Gary. II. Metropolitan Museum of Art (New York, N.Y.)
III. Grand Palais (Paris, France) IV. Title.
ND547.5.I4L6913 1994
759.4'09'034074747I—dc20 94-19380
D. L.: M-26065-1994 CIP

Contents

Curators of the Exhibition

Gary Tinterow
*Engelhard Curator of European Paintings at The Metropolitan Museum of Art,
with the assistance of Anne M. P. Norton, Research Associate*

Henri Loyrette
*Conservateur en chef at the Musée d'Orsay, with the assistance of Marina
Ferretti-Bocquillon*

Sponsor's Statement

Impressionism was both an artistic movement and a new way of looking at the world. In *Origins of Impressionism*, we witness the birth of Impressionism during an extraordinary decade of development in the 1860s. These artists celebrated, as though for the first time, the marvels of perception and the everyday circumstances of urban—and suburban—life. In the process, they forged a new way of painting.

This exhibition reminds us of the crucial roles of risk and innovation. The artists featured in this exhibition were driven by a creative dissatisfaction with the status quo—the force behind most progress, whether in industry or the arts. We at Philip Morris know the importance of creative thought and intelligent risk, and we applaud The Metropolitan Museum of Art and the Réunion des musées nationaux for their collaborative efforts to offer a new vision of the origins of Impressionism.

William Murray
Chairman of the Board
Philip Morris Companies Inc.

Lenders to the Exhibition

Public Institutions

ALGERIA
Algiers Musée National des Beaux-Arts d'Alger, 60

ARGENTINA
Buenos Aires Museo Nacional de Bellas Artes, 84

AUSTRALIA
Melbourne National Gallery of Victoria, 83

BELGIUM
Brussels Musées Royaux des Beaux-Arts de Belgique, 38

BRAZIL
São Paulo Museu de Arte de São Paulo Assis Chateaubriand 30, 171, 180

CZECH REPUBLIC
Prague Národni Galeri v Praze, 160

DENMARK
Copenhagen Ordrupgaardsamlingen, 119

FRANCE
Aix-les-Bains Musée Faure, 23
Alençon Musée des Beaux-Arts et de la Dentelle, 82
Avignon Musée Calvet, 85
Bordeaux Musée des Beaux-Arts, 19, 49
Bourg-en-Bresse Musée de Brou, 113
Douai Musée de Douai, La Chartreuse, 76
Grenoble Musée de Grenoble, 73, 188
Lille Musée des Beaux-Arts, 36
Marseilles Musée des Beaux-Arts, 166
Montpellier Musée Fabre, 5, 8, 9, 13, 14, 187
Nantes Musée des Beaux-Arts, 1
Paris Musée d'Orsay, 12, 20, 21, 24, 27, 34, 35, 54, 55, 56, 59, 68, 74, 79, 87, 93, 95, 97, 101, 102, 108, 109, 110, 114, 122, 123, 130, 142, 144, 172, 175, 189, 190A
 Musée du Louvre, 37, 183, 190
 Musée du Petit Palais, 186
 Musée Gustave Moreau, 152
 Musée Marmottan, 151
Rouen Musée des Beaux-Arts et de la Céramique, 53
Villeneuve-sur-Lot Musée Gaston-Rapin, 78

GERMANY
Berlin Staatliche Museen zu Berlin, National-galerie, 132, 174
Cologne Wallraf-Richartz-Museum, 159
Hamburg Kunsthalle, 168
Mannheim Städtische Kunsthalle, 125
Munich Neue Pinakothek, 65

GREAT BRITAIN
Edinburgh National Gallery of Scotland, 128, 155
Glasgow Art Gallery and Museum, Kelvingrove, 154
London The Courtauld Institute Galleries, 94
 Tate Gallery, 191
 The Trustees of the National Gallery, 69, 88, 146, 164

HUNGARY
Budapest Szépmüvészeti Múzeum, 92

JAPAN
Tokyo Murauchi Art Museum, 42

THE NETHERLANDS
Otterlo Rijksmuseum Kröller-Müller, 173
The Hague Gemeentemuseum, 134

NORWAY
Oslo Nasjonalgalleriet, 107

PUERTO RICO
Ponce Museo de Arte de Ponce, 77

Foreword

The exhibition *Origins of Impressionism* renews the excellent and longstanding cooperation between the Réunion des musées nationaux and the Musée d'Orsay in Paris and The Metropolitan Museum of Art in New York. Previous collaborations have included the retrospective exhibitions *Manet* in 1983, *Degas* in 1988, and *Seurat* in 1991.

Over the past fifteen years, retrospective exhibitions have been devoted to the work of other masters of Impressionism. Among these were *Monet* in 1980, *Pissarro* in 1980, *Renoir* in 1985, *Cézanne: The Early Years* in 1988, and *Sisley* in 1992. The immense popularity throughout the world of the art created by the Impressionists—indeed it ranks among the best ambassadors of French culture—often makes us lose sight of the complexity and richness of a movement certainly more diverse than it would seem.

We tend to forget that Impressionism was not born in a day. Instead, it is the result of a slow evolution precipitated by certain singular personalities and exceptional circumstances. In this process the 1860s were a crucial time. In 1862, Monet, Renoir, and Bazille met at Gleyre's studio in Paris. In 1863, the Salon des Refusés was organized by artists whose works were rejected by the Salon jury. And in 1867 Manet had a one-man exhibition in a pavilion near the Pont de l'Alma in Paris.

Thus it seems appropriate for us to recognize that in that period the Impressionists did not occupy an isolated and besieged fortress but were connected by innumerable ties to the main artistic currents of the nineteenth century. Similarly, we are now more disposed to understand that this group was neither uniform nor univocal and that its art cannot be reduced to simply a new approach to landscape painting, even though this aspect was of prime importance to the movement.

The present exhibition aims to illuminate through a remarkable gathering of works—some famous, others too little known—the overlapping destinies of the painters who paved the way for and gave life to one of the most brilliant periods in the history of painting. It was organized under the vigilant stewardship of Gary Tinterow and Henri Loyrette with the assistance of their colleagues Anne M. P. Norton and Marina Ferretti-Bocquillon.

In the United States, we thank the National Endowment for the Arts and the Janet Traeger Salz Foundation for assistance toward the exhibition and Janice H. Levin for a gift toward publication of the English edition of the catalogue.

An exhibition of this magnitude cannot be undertaken without major financial support. This sponsorship is provided by Philip Morris Companies Inc., whose generosity we gratefully acknowledge.

Philippe de Montebello
Director, The Metropolitan
Museum of Art

Irène Bizot
Administrateur Général de la
Réunion des musées nationaux

Acknowledgments

In preparing the New York presentation of the exhibition and this English version of the catalogue, a number of individuals made contributions beyond the call of duty, and we would like to acknowledge our gratitude here: Kathleen Howard, Margaret Aspinwall, Andrew Shelton, Roberta Wue, Susan A. Stein.

We owe thanks to many who have given time and expertise to the project, particularly: Alexander Apsis, Juliette Armand, Janine Bailly-Herzberg, Claire Barbillon, Clémence Berg, Louis Béthuleau, Irène Bizot, Robert Boardingham, Jean Sutherland Boggs, Béatrice de Boisséson, Bénédicte Boissonnas, Jeanne Bouniort, Alexis Brandt, Myriam Bru, Bernadette Buiret, Françoise Cachin, Bruce Campbell, Yveline Cantarel-Besson, Jean-Luc Chanonat, Michael Clarke, Ute Collinet, Jean Coudane, Pierre Curie, Alain Daguerre de Hureaux, François Daulte, Evelyne David, Marianne Delafond, France Dijoud, Françoise Dios, Anne Distel, M. and Mme Roland Diziain, Shin Doi, comte de Dreuille-Sennecterre, Douglas Druick, Françoise Dubois, Annick Dubosc, Manou Dufour, Walter Feilchenfeldt, Jean-Louis Ferrarri, Martine Ferretti, Claire Filhos-Petit, Michael Findlay, Françoise Fur, Bernard Giraud, Frank Giraud, Gilles Gratté, Sophie Grêlé, Renée Haas, David Harvey, Sybille Heftler, Françoise Heilbrun, Ay-Whang Hsia, Kimberley Jones, Martine Kahane, Sue Koch, Isabelle de La Bruyère, Geneviève Lacambre, Marie-Agnès Languette, Caroline Larroche, Annick Lautraite, Gaïta Leboissetier, John Leighton, Florence Le Moing, Aggy Lerolle, Dominique Lobstein, Domitille Loyrette, Neil McGregor, Alain Madeleine-Perdrillat, Anne de Margerie, James H. Maroney, Jr., Nina S. Maruca, Caroline Mathieu, Melissa de Medeiros, Rudi Meyer, Charles Moffett, Philippe de Montebello, Serge Morozov, Herbert M. Moskowitz, Jean Munisardi, David Nash, Jean Naudin, Philippe Néagu, Monique Nonne, John P. O'Neill, Robert McDonald Parker, Sylvie Patin, Richard Peduzzi, Claude Perchenet, Jérôme Picon, Anne Pingeot, Jean-Paul Pinon, Joachim Pissarro, Emily Rafferty, Joseph Rishel, Francine Robinson, Anne Roquebert, Jean-Pierre Rosier, Mme Denis Rouart, Annie Roux-Dessarps, Élisabeth Salvan, Polly J. Sartori, Patrice Schmidt, Manuel Schmit, Barbara Shapiro, Daniel Shulman, Cosima Spender, M. and Mme Jacques Stevens, Charles F. Stuckey, Margret Stuffmann, Linda M. Sylling, Mahrukh Tarapor, Antoine Tasso, Hélène Toussaint, Cécile Vignot, Diana Widmaier-Picasso, Gretchen Wold, Eric Zafran, Zack Zanolli, Henri Zerner.

G.T. H.L.

Introduction

During the last fifteen years most of the major Impressionist artists have been given large retrospectives. Exhibitions devoted to the movement itself, however, have been relatively infrequent, focusing either on the group's activities between 1874 and 1886 (*Impressionism: A Centenary Exhibition*, Paris, New York 1974–75; *The New Painting*, San Francisco, Washington 1986) or on landscape painting (*Naissance de l'impressionnisme*, Bordeaux 1974; *Impressionism and the French Landscape*, Los Angeles, Chicago, Paris 1984–85; *The Rise of Landscape Painting in France*, Manchester, New York, Dallas, Atlanta 1991–92). New Painting—the term used by the critic Edmond Duranty in 1876, and which is far more telling than the reductive label "Impressionism"—called for work in all genres, not only landscape but also the portrait, still life, scenes of contemporary life, nude, and even history painting, which seemed to be dying of old age. Monographic exhibitions allow us to grasp an artist's entire oeuvre, but their nature demands that comparisons and correspondences among artists be omitted and that little mention be made of the tenacious common effort to create "a great movement of artistic renewal."[1] All the Impressionists stressed the qualities that united them, despite their disparate origins and educations, long before the first "Impressionist exhibition" of 1874. Degas pointed out his earlier closeness to Fantin-Latour and Whistler;[2] Cézanne proclaimed his debt to Courbet and Manet;[3] Monet remembered the "inexhaustible kindness" of his teacher Boudin;[4] and Renoir recalled with pleasure the camaraderie of Gleyre's studio, where he encountered Monet, Bazille, and Sisley.[5]

In fact, critics were quick to perceive the kinship between these artists, despite their diverse styles. In 1868 Zola listed those who, as "naturalists [and] actualists . . . were traveling the great road of truth and power" and proposed that after Courbet and Manet there would be "a new way of painting"—that of Pissarro, Monet, Renoir, and Bazille.[6] At the Salon of 1868 Renoir's *Lise* (fig. 176) was regarded as the younger sister of Monet's *Camille* (fig. 236), exhibited two years before. Manet's *Jeune Dame en 1866* (fig. 243) was a response to Courbet's *La Femme au perroquet* (fig. 148), which was itself, observers noted, a reply to Manet's *Olympia* (fig. 146). Before 1870 critics had defined a "School of Batignolles," led by the "tremendous realist" Manet. Fantin-Latour's *Atelier aux Batignolles* (fig. 232), a brilliant manifesto, was exhibited at the Salon of 1870; in it, Manet was shown with his artistic comrades Renoir, Monet, Bazille, Astruc, Zola, and others. And in the contemporaneous *Atelier de la rue La Condamine* (fig. 355), in which Bazille depicts his studio hung with his canvases and with those by his friend Renoir, Manet appears as an almost princely visitor.

As we investigated the origins of Impressionism, we had to decide which artists were relevant and what time span was appropriate. During the 1860s the enthusiasts of the New Painting were not a closely knit group but rather a fellowship, loose and mutable. On a number of occasions, however, these artists did close ranks: the establishment of the Salon des Refusés in 1863; the circulation of Bazille's petition in March 1867, demanding a new Salon des Refusés and signed by Pissarro, Monet,

Renoir, Sisley, and others; the organization of a committee, in which Manet was active, by Jules de La Rochenoire in March 1870 to transform the Salon jury. The critics Duranty (1876), Théodore Duret (1878), Diego Martelli (1880), Félix Fénéon (1886), Gustave Geffroy (1894), Paul Signac (1898), and André Mellério (1900) consistently described certain artists as "Impressionists" (among them were Bazille, Cézanne, Degas, Manet, Monet, Morisot, Pissarro, Renoir, and Sisley).[7] A few, such as Fantin-Latour and Whistler, played essential roles in founding the new school (the current retrospective of Whistler's oeuvre allows only three of his works to be shown here). Others went only part of the way: Tissot (fig. 278) was close to Degas for several years and experimented with similar portrait compositions; Carolus-Duran (fig. 230) was a sometime disciple of Manet's; and Legros (fig. 166) was important in what Henri Focillon called "the group of 1863."[8] Many of the immediate forerunners had a lesser or a greater influence: Monet was trained to some extent by Boudin and Jongkind; the landscape painters Monet, Pissarro, Sisley, and Cézanne were indebted to Daubigny; and all of these artists, including Degas and Manet, were taught by the lessons of "Papa" Corot.

Pride of place must, however, go to Courbet. He was a model for all the masters of the New Painting, even those who, like Degas or Fantin-Latour, seemed the most removed from him. They all coveted his sound pictorial sense, his ability to tackle the most diverse subjects, and his fine pugnacity. His belligerence, as well as his one-man exhibitions (1855 and 1867), vituperations, and polemic stances, made Courbet a pioneer in the struggle against academic institutions. He did jeer at Manet's *Anges au tombeau du Christ* (fig. 68), but he was usually sympathetic to his young colleagues; he advised Whistler, whom he proudly called "my pupil," and Monet, whom he helped in hard times. Throughout the 1860s Courbet was omnipresent, and some critics regarded Manet, Monet, and Renoir as his epigones. Thus, the origins of New Painting can be found in the subtle passage from Realism to Impressionism, from Courbet to Manet, and then in the rather more quick movement to Monet and Degas. Manet came to play the role Courbet had acted a decade earlier. He did not, however, hold the stage for long; by 1867 he was outstripped and, in turn, influenced by the "young ones." Monet, whose *Déjeuner sur l'herbe* (fig. 169) pointed Manet toward pleinairism, urged him to paint more brightly and to abandon his magnificent "prune juice" hues; Degas encouraged exploration of all aspects of modern life.

The evolution of the New Painting was gradual. The year 1863, long cited as the birth date of modern art, was simply a milestone—albeit a major one—in the lively history of the official Salon. Manet's *Déjeuner sur l'herbe* (fig. 143), which made a scandalous appearance at the Salon des Refusés, had neither more nor less impact on the younger generation than the painter's earlier or later entries. The year 1859 may have been more pertinent. It marked the first Salon for Degas, who returned from Italy after three years' absence, for Monet, newly arrived from Le Havre and discovering Paris after a childhood in Normandy, and for Pissarro who showed a modest landscape. Manet, Fantin-Latour, and Whistler endured the jury's harshness. The Salon of 1859 provided a survey of French painting, showing the painters our artists admired, if only temporarily (among them Daubigny,

Troyon, Corot, Delacroix, Puvis de Chavannes, Fromentin, and Ricard), and those they neglected or disliked (Flandrin, Baudry, Bouguereau, and Gérôme). A Manichaean critic would interpret the birth of Impressionism as a brutal reaction to academicism and would regard the new movement pure as a sharp break "with the tradition of painting."[9] A more balanced view holds that the New Painting contemplated Courbet and the lessons of Realism more than it opposed Bouguereau or Gérôme; it profited from the favorable environment created by the collapse of the restrictive old categories of genre and the ensuing triumph of landscape and genre painting.

Ten years later, in 1869, the movement that would be called Impressionism was already in existence. Its characteristics were numerous and not restricted to the luminous painting and agitated brushstrokes that were found only in Monet and Renoir. All of these artists refused to "stage" a composition, excluded metaphor, and called things by their proper names. They were all marked by the "pantheism," evident early in Manet, that emphasized the "small fact as strongly as the large" and that called for a figure and an accessory to be painted in the same fashion. Above all they wanted to present the "modern sentiment."[10] In 1867, in a perceptive but little-known text, Castagnary wrote what could be the credo of our painters:

> Nature and man, country and city—the country with the depth of its skies, the verdure of its trees, the transparency of its water, the mist of its changing horizons, all the attractive charms of plant life illuminated by the whims of seasons and days; the city with man, woman, family, the forms conditioned by functions and characteristics, the diversity of the social spectacle freely displayed in the sunlight of the public square or discreetly imprisoned within the precincts of the home, all the reborn surprises of individual or collective life illuminated by the light of passions and customs. . . . What need is there to go back through history, to seek refuge in legend, to examine the registers of the imagination? Beauty is in front of the eyes, not inside the brain; in the present, not in the past; in truth, not in dreams; in life, not in death. The universe we have here, before us, is the very one that painting ought to translate.[11]

It took ten years to reach this point, and it is this decade's history—the beginning of a great adventure—that we are retracing. We are dealing with "painting for the long haul," as Duranty wrote in 1876, remarking that along with a few "solid ships" there were frail skiffs, good only for the "coastal trade"; he invited all the pilots to be "attentive, resolute, and patient," as he wished them a gentle wind and tranquil sea for their perilous crossing.[12]

1. "un grand mouvement de rénovation artistique." Washington, San Francisco 1986, p. 484.
2. Degas 1945, p. 256.
3. Gasquet 1926, pp. 181–85.
4. "inépuisable bonté . . . entreprit [son] éducation." Thiébault-Sisson 1900, p. 3.
5. Ambroise Vollant, "La jeunesse de Renoir," *La Renaissance de l'art français et des industries du luxe*, May 1918, pp. 16–24.

6. "actualistes"; "naturalistes"; "suivent la grande voie de la vérité et de la puissance"; "nouvelle manière en peinture." Zola 1991, pp. 201–11.
7. Edmund Duranty, *La Nouvelle Peinture. A propos du groupe d'artistes qui expose dans les galeries Durand-Ruel* (Paris, 1876); Théodore Duret, *Les Peintres impressionnistes* (Paris, 1878); Diego Martelli, *Gli Impressionnisti. Lettura data al Circolo filologico di Livorno* (Florence,

1980); Félix Fénéon, *Les Impressionnistes en 1886* (Paris, 1886); Gustave Geffroy, *Histoire de l'impressionnisme*, La Vie artistique, ser. 3 (Paris, 1894); Paul Signac, *D'Eugène Delacroix au néo-impressionnisme* (Paris, 1899); André Mellério, *L'Exposition de 1900 et l'impressionnisme* (Paris, 1900).

8. "le groupe de 1863." Henri Focillon, *La Peinture au XIXe siècle*, vol. 2, *Du réalisme à nos jours* (1927; facsimile, Paris, 1991), pp. 164–65.

9. "avec toute la tradition de la peinture." See "L'Impressionnisme, une révision," editorial in *Revue de l'art*, no. 25 (1974), and Henri Loyrette, "L'Impressionnisme, quinze ans après," *Revue de l'art*, no. 86 (1989), pp. 4–7.

10. "panthéisme"; "petit fait aussi puissamment que le grand"; "sentiment moderne." Gustave Flaubert, *Correspondance* (Paris, 1980), vol. 2, p. 30.

11. "La nature et l'homme, la campagne et la cité;—la campagne avec la profondeur de ses ciels, la verdure de ses arbres, la transparence de ses eaux, la brume de ses horizons changeants, tous les charmes attirants de la vie végétative éclairée au gré des saisons et des jours;—la cité avec l'homme, la femme, la famille, les formes conditionnées par les fonctions et les caractères, la diversité du spectacle social librement étalé au soleil de la place publique ou discrètement enfermé dans l'enciente de la maison, toutes les surprises renaissantes de la vie individuelle ou collective éclairée au jour des passions et des moeurs. . . . Qu'est-il besoin de remonter dans l'histoire, de se réfugier dans la légende, de compulser les registres de l'imagination? La beauté est sous les yeux, non dans la cervelle; dans le présent, non dans le passé; dans la vérité, non dans le rêve; dans la vie, non dans la mort. L'univers que nour avons là, devant nous, est celui-là même que le peintre doit traduire." Castagnary 1892, pp. 241–42.

12. "peinture au long cours"; "solides navires"; "peinture de cabotage"; "attentifs, résolus et patients." Washington, San Francisco 1986, p. 484.

Origins of Impressionism

I

The Salon of 1859

HENRI LOYRETTE

On April 5, 1859, at the age of twenty-four, Edgar Degas came back to Paris after a two-and-a-half-year absence. He had lived in Italy since July 1856, staying at his grandfather's home in Naples, in Rome, or with his aunt Bellelli in Florence. On his return Degas was an undecided young man who knew only that he wanted to paint and who missed the encouragement of his mentor, the painter Gustave Moreau. The two had met in Rome during the winter of 1858 and immediately became fast friends. Moreau, eight years older, had already begun his painting career. Degas found him better educated and more immersed in the arts than "the young men almost all without interest . . . and without great talent" whom he met at the French Academy at the Villa Medici.[1] Moreau had been Théodore Chassériau's pupil, he knew Eugène Delacroix, and he was friendly with Eugène Fromentin. Joseph Tourny, an engraver and friend of Degas's, wrote that Moreau was "full of talent, full of illusions, of enthusiasm, and knows how to communicate these great qualities."[2] Moreau was an excellent teacher, and in the 1890s, near the end of his life, Matisse and Rouault studied with him. Though his severity made "the trade of painting too difficult," he had "inexhaustible zest" and "encouraged his students in moments of despair and depression."[3] Degas was then working under the influence of Ingres, following Hippolyte Flandrin and Louis Lamothe. Moreau introduced him not only to the art of the Venetians and Rubens but also to that of Delacroix and Chassériau. Being in Italy, Degas had not seen the work of his French contemporaries that was so admired by Moreau. The 1859 Salon gave the young artist his first opportunity to observe the evolution of French painting since the 1855 Exposition Universelle and to discover the artists Moreau had talked about at length.

In 1859 the Salon was held in the Palais de l'Industrie, which had been built for the 1855 Exposition. This vast building, whose metal skeleton was sheathed in masonry, was strongly criticized when the Salon was first held there in 1857. As a result, its interior had been

1. "jeunes gens presque tous très insignifiants . . . et sans grand talent." Letter from Gustave Moreau to his parents, January 20, 1858, quoted in Loyrette 1991, p. 118.
2. "beaucoup de talent, beaucoup d'illusions, d'enthousiasme et sait communiquer ces grandes qualités." Letter from Gabriel-Joseph Tourny to Degas, December 31, 1859, quoted in Loyrette 1991, p. 114.
3. "le métier d'artiste trop difficile." Letter from Eugène Lacheurié to Gustave Moreau, August 12, 1859, quoted in Loyrette 1991, p. 115. "inépuisable verve" and "*coeur au ventre* dans [les] moments de découragement ou d'affaisement." Letter from Émile Lévy to Gustave Moreau, July 1, 1859, quoted in Loyrette 1991, p. 116.

Eugène Delacroix, *Ovide en exil chez les Scythes*, detail of fig. 12

EXPLICATION
DES OUVRAGES
DE PEINTURE, SCULPTURE,
GRAVURE, LITHOGRAPHIE
ET ARCHITECTURE
DES ARTISTES VIVANTS
EXPOSÉS
AU PALAIS DES CHAMPS-ÉLYSÉES
LE 15 AVRIL 1859.

Prix : 1 Fr. 50 c.

PARIS
CHARLES DE MOURGUES FRÈRES, SUCCESSEURS DE VINCHON,
IMPRIMEURS DES MUSÉES IMPÉRIAUX
rue J.-J. Rousseau, 8.

1859

Fig. 1. Cover of the booklet of the Salon of 1859

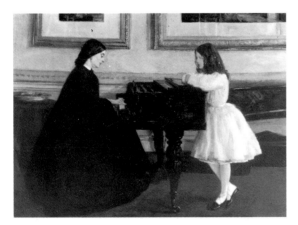

Fig. 2. Jean-François Millet, *La Mort et le Bûcheron* (*Death and the Woodcutter*), 1858–59. Oil on canvas, 30½ x 38¾ in. (77.5 x 98.5 cm). Ny Carlsberg Glyptotek, Copenhagen

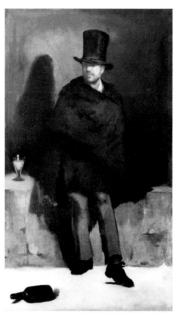

Fig. 3. James McNeill Whistler, *At the Piano*, 1858–59. Oil on canvas, 26⅜ x 35⅝ in. (67 x 90.5 cm). The Taft Museum, Cincinnati

significantly modified: the uniform succession of rooms was replaced by "four parallel galleries, preceded and followed by a salon"; in the middle, facing the peristyle of a great staircase, was the usual *salon d'honneur*.[4] But these better-designed and more majestic galleries still seemed to float inside an "enormous glass cage."[5] Many visitors missed the earlier Salon installation at the Louvre: there they could easily compare the works of the old masters and those of the new school; artists had to be aware of their predecessors, be part of a tradition, and address elevated topics. In contrast, the Palais de l'Industrie was designed for industrial shows, not for art exhibitions. The harsh lighting, which could not be adjusted, emphasized the trend toward commercialization characteristic of that time.[6] The merchants were in the temple: "ham and pâté were sold" and sculptures were lined up like potted plants for the "leisurely passerby" who came to "smoke a cigar" or "enjoy a delicious sherbet."[7]

These criticisms were repeated throughout the 1860s. Almost all reports on the Salon make the same complaints about the inappropriate exhibition space, the incoherent route through the galleries, and the shabby temporary walls on which the paintings were hung. In fact, the perennial problem at the Salon—and the situation of 1859 was repeated during the next decade—was the great number of works both accepted and rejected. Two obstacles stood in the artist's way: he could be rejected, and if admitted, he could be relegated to a bad spot where his work was almost impossible to view. A total of 3,894 catalogue numbers were listed in the thick booklet

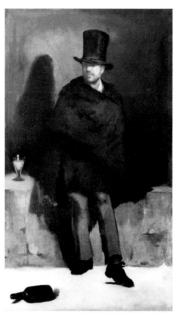

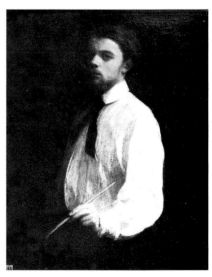

Fig. 4. Édouard Manet, *Le Buveur d'absinthe* (*The Absinthe Drinker*), 1858–59. Oil on canvas, 71¼ x 41¾ in. (181 x 106 cm). Ny Carlsberg Glyptotek, Copenhagen

Fig. 5. Henri Fantin-Latour, *Auto-portrait* (*Self-Portrait*), 1859. Oil on canvas, 39¾ x 32⅜ in. (101 x 82 cm). Musée de Grenoble

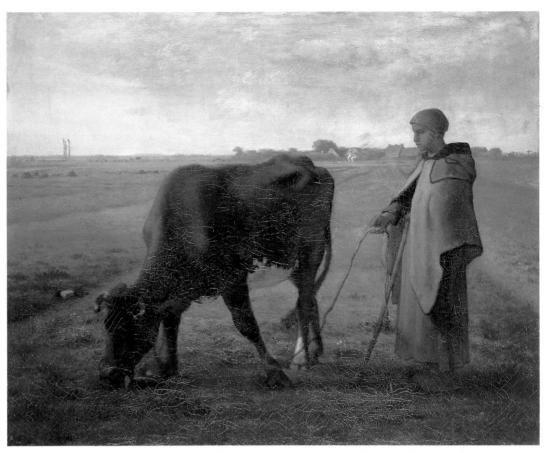

Fig. 6 (cat. 113). Jean-François Millet, *Femme faisant paître sa vache* (*Woman Pasturing Her Cow*), 1858. Oil on canvas, 28¾ x 36⅝ in. (73 x 93 cm). Musée de Brou, Bourg-en-Bresse

accompanying the Salon of 1859 (fig. 1) (3,045 were assigned to paintings). In his detailed description Maurice Aubert remarked that he was "almost frightened" by the huge numbers. The exhibitors totaled 1,700, including "81 misses, 59 ladies, and 1,560 individuals of the less fair sex.... There were 1,278 painters (including 250 landscape painters), 225 sculptors, 101 etchers, 42 lithographers, 54 architects or architectural engravers and draftsmen. There were 1,439 Frenchmen and 261 foreigners or individuals born abroad to French parents."[8] The critics assailed the jury's "unconscionable leniency," not its severity.[9] A few omissions—such as the rejection, on the grounds of immorality, of *Ève endormie sous le regard de Satan* (*Eve Asleep under the Gaze of Satan*) by Mme O'Connell and of *Étoile du matin* (*Morning Star*) by Charles Chaplin—were widely noted. To a lesser extent there was criticism of the rejection of *La Mort et le Bûcheron* (fig. 2), one of Millet's great masterpieces (only one painting by Millet was accepted, *Femme faisant paître sa vache*, fig. 6). The absence of Manet (*Le Buveur d'absinthe*, fig. 4), Fantin-Latour (three rejected paintings, including an *auto-portrait*, fig. 5), and Whistler (*At the Piano*, fig. 3) went unnoticed.

Nonetheless, the Salon's rejections sparked a protest at the Institute, directly under the windows of the comte de Nieuwerkerke, directeur général des Musées impériaux and chairman of the jury.

4. "quatre galeries parallèles, précédées et suivies d'un salon." Houssaye 1859, p. 123.
5. "immense cage de verre." Léo Lespés, "Ouverture du Salon. Réflexions d'un homme qui n'y connaît rien," *La Vérité*, April 21, 1859, p. 2.
6. On this topic, see Maurice Aubert, *Souvenirs du Salon de 1859* (Paris, 1859), p. 6; Anatole de Montaiglon, "La Peinture au Salon de 1859," *Revue universelle des arts* 9 (April–September 1859), p. 436. On the criticism of the Palais de l'Industrie during the 1857 Salon, see Mainardi 1987, p. 115.
7. "du jambon et de la galantine." Lespés, "Ouverture du Salon," p. 2. "promeneur désoeuvré," "fumer un cigare," "savourer un excellent sorbet." Perrier 1859, p. 290.
8. "presque effrayé"; "81 demoiselles, 59 dames et 1560 individus appartenant à la moins belle moitié du genre humain"; "parmi les 1700 exposants, on compte 1278 peintres (dont 250 paysagistes), 225 sculpteurs, 101 graveurs, 42 lithographes, 54 architectes ou graveurs et dessinateurs de travaux d'architecture. Sur ce nombre, 1439 sont français et 261 étrangers ou nés à l'étranger de parents français." Aubert, *Souvenirs*, pp. 8, 17.
9. "complaisance impardonnable." Perrier 1859, p. 288.

Alexandre Dumas père attacked a jury that "granted itself a right to censorship that we do not recognize," that accepted "fifteen hundred completely worthless paintings," and that "denied entry to canvases by Mme O'Connell, Chaplin, and Millet."[10] However, the wave of protest which lasted throughout the following decade died out over that year. The jury cited Mme O'Connell for "the improper character of her composition"; although "deeply wounded in her inmost being by this allegation, as an artist and a woman," she successfully exhibited *Ève* in the gallery of M. Détrimont, 33 rue Laffitte.[11] Chaplin organized a private showing of his work on the rue de Boulogne. Manet more quietly exhibited *Le Buveur d'absinthe* (fig. 4) in the studio on the rue Lavoisier that he shared with Balleroy; there the work was greeted with sarcasm by Thomas Couture, his teacher, and the usual compliments by his fellow painters.[12] François Bonvin opened his *atelier flamand* (Flemish studio), 189 rue Saint-Jacques, to those of his friends who, unlike himself, had been rejected. Among them were Théodule Ribot, Alphonse Legros (partially rejected), Fantin-Latour, and Whistler.[13]

Other artists in vogue who chose not to be represented at the Salon were Paul-Joseph Chenavard, Couture, Octave Tassaert, Jacques-Raymond Brascassat, Jules Dupré, Rosa Bonheur, Alexandre-Gabriel Decamps, and Ernest Meissonier. In fact, as several critics remarked, the presence of the last was felt high up on the Salon walls in the works of numerous undistinguished disciples, such as Jean-Baptiste Fauvelet, Antoine-Émile Plassan, Victor-Joseph Chavet, Benjamin-Eugène Fichel, Monjalet. These "children of Papa Meissonier" produced an ever greater number of smooth and precise little canvases.[14] Ingres and Courbet were not represented. Ingres had avoided the Salon since 1834, when his *Martyre de Saint Symphorien* (*Martyrdom of Saint Symphorien*; Cathédrale of Saint-Lazare, Autun) had been rejected. His admirers lamented his absence from the field at a time when landscape painting was triumphant, when realism seemed to have won, and when Delacroix, his rival, sent eight paintings to the Salon. Charles Perrier stated, "What we missed most at the Salon of 1859 was not a painting of M. Ingres's vigorous old age but his beliefs—we do not lack skilled workmen but we do lack principles."[15] Courbet had failed to complete the two large canvases he intended for the Salon but was nevertheless omnipresent. He had become the standard against which his contemporaries were judged, including those who refuted him, those who imitated him, and those who appealed to public taste by serving up yesterday's boldness. He was said to be responsible not only for artistic decadence, trivial subject matter, and contempt for great painting, but also for the liveliness of the modern school and the efforts to rid the Salon of what Zola in *L'Oeuvre* called the

10. "s'arroge un droit de censure que nous ne lui concédons pas"; "quinze cents tableaux sans valeur aucune"; "laisse à la porte des toiles de Mme O'Connell, de Chaplin et de Millet." Alexandre Dumas, *L'Art et les artistes contemporains au Salon de 1859*, Paris, 1859, p. 6.
11. "en raison de l'inconvenance de sa composition"; "cruellement atteinte par cette allégation dans ce qu'un artiste et surtout une femme, doit avoir de plus cher." Albert de la Fizelière, "La Peinture hors du Salon," *L'Artiste*, May 1, 1859, pp. 6–7.
12. Proust 1897, p. 23, reports that Couture remarked, "Mon ami, il n'y a ici qu'un buveur d'absinthe, c'est le peintre qui a produit cette insanité" (My friend, there is only one absinthe drinker here, the painter who made this insane painting).
13. The little information we have regarding the hanging in Bonvin's studio comes from Pennell 1908, vol. 1, p. 75.
14. "progéniture de papa Meissonier." Chaud-de-Ton, "Salon de 1859," *La Vérité contemporaine*, May 25, 1859, p. 3.
15. "Ce que nous regrettons de n'avoir pas trouvé au Salon de 1859, c'est moins telle oeuvre de la forte vieillesse de M. Ingres que ses convictions, car nous ne manquons pas d'ouvriers habiles, mais nous manquons beaucoup trop de principes." Perrier 1859, p. 291.

cambouis (dirty lubricating oil) of convention. After experiencing a "Stations of the Cross" in the Palais de l'Industrie, Zacharie Astruc wrote, in *Les 14 Stations du Salon*, a thirty-page hymn to Courbet, "the first champion of a new art that may well arouse interest for centuries to come."[16]

In the abundant literature on the Salon of 1859 the critics were in agreement on several points: the Salon of 1859 marked the end of an era without announcing the birth of a new one; never had technical skill been so common and grand ambition so lacking; everywhere confusion between the genres was erasing once-clear distinctions and turning the old order upside down—landscape and genre painting were triumphant, while history painting was declining, if not dying.

Unlike most of the grumblers, Baudelaire knew that the Salon included some remarkable works—for him those of Delacroix, Octave Penguilly L'Haridon, and Fromentin. But he summed up the dull atmosphere: "No explosion; no unknown genius."[17] "Art is repeating itself," Astruc declared.[18] Maxime Du Camp, who saw no change from the Salon of 1857, remarked that the most recent artistic revolution had been that of the Romantics of 1830. Indeed the critics were disappointed more by the lack of new talent than by the overwhelming mediocrity. Some great painters still remained, though at the end of their careers, but new artists, who had shown merit during previous exhibitions, did not fulfill their promise. The neo-Greeks, particularly Jean-Louis Hamon (fig. 7), had lost themselves in antique affectation. A more alarming example for some critics was Paul Baudry (fig. 8). Paul Mantz remarked that "the paintings exhibited by Baudry today betray in their manner a moment of hesitation and crisis"; Arsène Houssaye commented, "I was expecting a history painter and I find only a bewildered seeker"; and Paul de Saint-Victor stated, "His talent is softening, his drawing becoming effeminate."[19] Ernest Hébert (fig. 9), William Bouguereau, and Jean-Léon Gérôme were criticized as Baudry was.[20] Artists such as Jules Breton (fig. 10), who confirmed their early potential, were the exception. Perrier wrote bluntly: "Most of the young artists . . . have not properly justified the confidence their first attempts inspired."[21]

More than a century later, it is difficult to agree that the 1859 Salon witnessed "a total eclipse of first-rank stars."[22] In fact, Delacroix, Corot, Millet, and Théodore Rousseau each exhibited masterpieces. But contemporary critics did not recognize the originality of their new works, reproaching Millet with reiterating old mistakes, Rousseau with repeating himself, and Corot (fig. 11), who was rarely admired without reservations, with "a manual inability that has become proverbial."[23] Some criticism is more understandable—Narcisse Diaz was described as a "Spaniard who stayed too long in

Fig. 7. Jean-Louis Hamon, *L'Amour en visite (Cupid Visiting)*, after the painting exhibited at the Salon of 1859. Charcoal, 40⅝ x 33⅛ in. (103 x 84 cm). Musée des Beaux-Arts, Lille

16. "le premier champion de cet art nouveau qui sera peut-être la curiosité des siècles futurs." Astruc 1859, p. 375.
17. "Nulle explosion: pas de génie inconnu." Baudelaire 1985–87, vol. 2, p. 608.
18. "L'art radote." Astruc 1859, p. 368.
19. "Les tableaux qu'il expose aujourd'hui trahissent dans sa manière un instant d'hésitation et de crise." Mantz 1859, p. 207. "J'avais compté sur un peintre d'histoire, et je ne trouve plus qu'un chercheur dépaysé." Houssaye 1859, p. 263. "Son talent s'amollit, son dessin s'efférmine." Paul de Saint-Victor, "Salon de 1859," *La Presse*, April 30, 1859.
20. Hébert: Saint-Victor, "Salon de 1859," *La Presse*, April 30, 1859; Bouguereau: Perrier 1859, p. 303; Gérôme: Saint-Victor, "Salon de 1859," *La Presse*, April 30, 1859.
21. "La plupart des jeunes artistes . . . n'ont justifié que bien faiblement la confiance que leurs premiers essais nous avaient inspirés." Perrier 1859, p. 291.
22. "une éclipse totale des astres de première grandeur." Chaud-de-Ton, "Salon de 1859," *La Vérité contemporaine*, May 4, 1859.
23. Millet and Rousseau: Ernest Chesnau, "Libre étude sur l'art contemporain, Salon de 1859," *Revue des races latines*, 1859, XIV, p. 163. Corot: "une inhabileté de mains devenue proverbiale." Gautier 1859, p. 412.

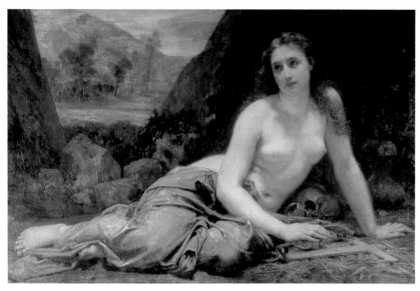

Fig. 8 (cat. 1). Paul Baudry, *La Madeleine pénitente* (*The Penitent Magdalen*), 1858. Oil on canvas, 37 x 57⅞ in. (94 x 147 cm). Musée des Beaux-Arts de Nantes

Fig. 9 (cat. 79). Ernest Hébert, *Les Cervarolles (États romains)* (*The Cervarolles*), 1858. Oil on canvas, 113⅜ x 69¼ in. (288 x 176 cm). Musée d'Orsay, Paris

Fig. 10 (cat. 20). Jules Breton, *Le Rappel des glaneuses (Artois)* (*The Calling of the Gleaners*), 1859. Oil on canvas, 35⅜ x 69¼ in. (90 x 176 cm). Musée d'Orsay, Paris

Fig. 11 (cat. 36). Camille Corot, *Idylle*, 1859. Oil on canvas, 64 x 51⅛ in. (162.5 x 130 cm).
Musée des Beaux-Arts, Lille, Gift of the artist

Venice" and an artist who had "broken his kaleidoscope."[24] The puzzlement over Delacroix's entry (fig. 12) remains surprising. Known for his large-scale decorative works and immense canvases, he was represented by only eight small paintings and thus seemed as absent as Ingres or Courbet. Saint-Victor and Perrier, both faithful supporters, were confused: "It is painful to reproach this renowned master for the first time," wrote the former; "The small paintings by M. Delacroix are completely unintelligible if you do not remember the large ones," said the latter.[25] In *Le Moniteur des arts* Ferdinand

24. "un espagnol [qui s'est] attardé à Venise." Houssaye 1859, p. 246. "cassé son kaléidoscope." Paul de Saint-Victor, "Salon de 1859," *La Presse*, June 5, 1859.
25. "Il nous en coûte d'avoir à blâmer pour la première fois le maître illustre." Paul de Saint-Victor, "Salon de 1859," *La Presse*, April 23, 1859. "Les petits tableaux de M. Delacroix sont absolument inintelligibles si on ne les voit pas avec le souvenir des grands." Perrier 1859, p. 293.

Fig. 11a (cat. 36a). Camille Corot, *Dante et Virgile;
paysage (Dante and Virgil, Landscape)*, 1859.
Oil on canvas, 102½ x 67⅛ in. (260.5 x 170.5 cm).
Museum of Fine Arts, Boston, Gift of Quincy A. Shaw

26. "harmonie sourde et monotone"; "fautes de lèse-anatomie"; "tous ces sophismes de forme et de couleur que ressemblent aux hallucinations sorties d'un cerveau malade." Ferdinand Gabriélis, "Salon de 1859," *Le Moniteur des arts*, June 25, 1859.
27. "spécialité"; "excellent dessinateur, prodigieux coloriste, compositeur ardent et fécond"; "sensation de nouveauté"; "imagination créatrice." Baudelaire 1985–87, vol. 2, p. 636.
28. "dernier grand peintre"; "dernier classique." Castagnary 1892, p. 69.
29. "intelligences viriles"; "entraves, des bâillons et des corsets de force"; "rumeurs de la lutte." Astruc 1859, p. 25.

Gabriélis remarked on the great colorist's "dull and monotonous harmony," the "anatomical errors" committed by the member of the Institute, and "all the illogical forms and colors that resemble the hallucinations of a sick brain."[26] Only Baudelaire, recalling earlier struggles, mocked the oft-spoken criticisms and praised Delacroix's established "originality"— "excellent draftsman, amazing colorist, lively and rich composer"—and his *envoi*'s "new feeling," which was created by his rich imagination; but Baudelaire did not find any such "creative imagination" in a prosaic Salon where commercial interests ensured the tyranny of labored painting and vulgar subject matter.[27] Despite his influence on Fromentin, Delacroix stood alone. For Jules Castagnary, he was the "last great painter" just as Hugo was the "last classical writer," the final representative of an era that had passed.[28] A radical change was expected; something had to happen and every critic was looking for any sign of regeneration. Praising Fromentin's work and Gérôme's earlier *envois*, Théophile Gautier looked for this renewal among the Orientalist painters. Astruc turned to the "virile intellects" who, following the example of Delacroix, Corot, and Courbet, would free painting from its "shackles, muzzles, and straitjackets"; he sensed the "clamor of battle," although other critics heard nothing.[29]

Fig. 12 (cat. 69). Eugène Delacroix, *Ovide en exil chez les Scythes* (*Ovid among the Scythians*), 1859. Oil on canvas, 34½ x 51¼ in. (87.6 x 130.2 cm). The Trustees of the National Gallery, London

Most painters had technical mastery: "Everyone knows how to paint"; "everyone has talent"; "throughout the profession there is unquestioned craftsmanship"; "painters' skill has improved greatly in the last years."[30] But critics deplored the use of such expertise to produce mediocre paintings. The "arts that belong to the decorative realm" were triumphant, as were the fashionable artists who painted "the pretty, the elegant, the small."[31] Landscape painting was triumphant, and history painting seemed to be in an inexorable decline. In fact, this movement toward the less serious was pervasive, evident not only in painting but also in the success of light opera, one-act plays, and simple entertainments. As Perrier observed, the "pretty" had become the "heir apparent of the beautiful."[32] A number of causes were put forward to explain and ward off this evil. Lithography "enhanced the color of a bad painting, giving it a certain charm," and bestowed a "kind of popularization" on "often talentless artists."[33] With its growing popularity photography had become the "refuge of all would-be painters," not serving the arts

30. "tout le monde sait peindre." Astruc 1859, p. 366. "tout le monde a du talent." Perrier 1859, p. 290. "partout . . . le métier est d'une supériorité incontestable." Faucheux, "Aperçu sur l'exposition des arts à Paris," *Revue Universelle des arts*, April–September 1859, p. 266. "l'habileté pratique a beaucoup augmenté dans ces derniers temps." Chesneau, "Libre étude," p. 21.
31. "arts qui font partie de l'ameublement." Perrier 1859, p. 289. "le joli, l'élégant, le petit." Astruc 1859, p. 367.
32. "l'héritier présomptif du beau." Perrier 1859, p. 291.
33. "Il n'est pas un mauvais tableau qui n'acquière pas son secours du relief de la couleur, un certain charme"; "sorte de popularisation [qu'elle accorde] à des artistes souvent sans talent." Astruc 1859, pp. 280–81.

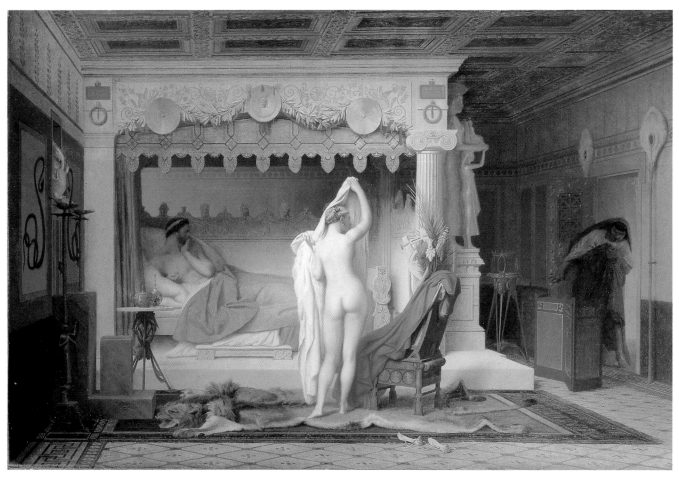

Fig. 13 (cat. 77). Jean-Léon Gérôme, *Le Roi Candaule* (*King Candaules*), 1859. Oil on canvas, 26¼ x 39½ in. (66 x 100.3 cm). Museo de Arte de Ponce, Puerto Rico

34. "refuge de tous les peintres manqués." Baudelaire 1985–87, vol. 2, p. 618. In 1855 Claude Vignon wrote about the beneficial role of photography (*Critique* 1990, p. 42).
35. On the Salon as market, see Astruc 1859, p. 367, and Faucheux, "Aperçu sur l'exposition," p. 266. "discrédit de l'imagination"; "le mépris du grand"; "pratique exclusive du métier." Baudelaire 1985–87, vol. 2, p. 661.
36. "Les genres empiètent les uns sur les autres." Augustin-Joseph Du Pays, "Salon de 1859," *L'Illustration*, July 16, 1859.
37. "une petite peinture de genre transportée dans un grand cadre." Astruc 1859, p. 187. "poésie naturelle." Baudelaire 1985–87, vol. 2, p. 661.
38. Gautier 1859, pp. 175, 197.

but corrupting them, according to Baudelaire.[34] The increasing impact of commerce had helped make the Salon into a marketplace and artworks into goods to be consumed. Baudelaire and Delacroix singled out the "discrediting of the imagination," the "contempt for the great," and the "concentration on craftsmanship."[35] The old hierarchy was fading and the well-defined categories of the past were collapsing. Critics complained that "genres were encroaching on each other."[36] For Astruc, Gérôme's *Roi Candaule* (fig. 13) was nothing more than a "small genre painting in a large frame"; Baudelaire thought Millet (fig. 6) guilty of damaging the "natural poetry" of his subject with ambitions proper to religious painting.[37] Gautier found fault with both Constant Troyon and Louis Français (fig. 14) for painting genre scenes or landscapes on the scale reserved for history painting.[38]

Indeed, the decline of history painting was the great event of the Salon of 1859. Whether bemoaned or welcomed, this decline was observed by almost all, although some critics discerned a renewed interest in a few artists or declared that history painting was certainly alive on the walls of churches and palaces. Far more typical

were remarks such as Mantz's: "Today, like yesterday, many grand frames, few grand paintings"; Mathilde Stevens observed "mediocrity" in the "gallery of church paintings," and Augustin-Joseph Du Pays an "almost always deserted gallery" where a few stray visitors "glided past all those Christian subjects."[39] In fact, history painting still attracted many painters, and many large canvases presented the usual mythological scenes, subjects from ancient, medieval, and modern history, and military feats glorifying the empire. But the old formulas had been exhausted; history paintings were now *"grandes machines"* in which a painter's ambition was reduced to the largeness of the format and his talent was measured by the number of classical quotations. New solutions were not successful; critics looked askance at the "archaic singularity of young 'Jacobus' [James] Tissot [fig. 15] who believed in the decadence of all painting after Memling, Lucas Cranach and Albrecht Dürer," and at Baudry's method of reviving old subject matter and giving it a contemporary 'chic' that "made [his paintings; fig. 8] look like copies of the old masters executed in a modern fashion."[40] But neither the "gothic toys" (later abandoned) of Tissot nor Baudry's affected elegance provoked as much heated discussion as Gérôme's archaeological reconstructions (fig. 13).[41] His three entries at the Salon, inspired by ancient history, had great public success; *Ave, Caesar imperator, morituri te salutant* (fig. 16) was especially popular with visitors. All three were, however, strongly challenged by the critics. Théophile Gautier, once a supporter of Gérôme, questioned the "emphasis on scholarly details and archaic accuracy." So much knowledge and so much attention to secondary elements threatened to suffocate painting. Gautier observed that "because of [Gérôme's] artifice, his painting was fading, evaporating, and disappearing"; Mantz shared this opinion—"[Gérôme's] brush already so cold is growing more and more numb"—as did Saint-Victor—"his drawing is overly simplified and as concise as an elegant synopsis; his color covers the canvas no more than ink penetrates paper."[42] All three critics condemned Gérôme for "desert[ing] painting for archaeology" and joining the camp of literary artists.[43] After acknowledging that "it is impossible not to recognize M. Gérôme's noble qualities," Baudelaire lashed out: "His originality (if it truly exists) is often laborious and hardly visible. He coldly warms up his subject matter with inconsequential elements and childish devices.... In our opinion at least, he has occupied until now and will continue to occupy the first place only among narrow-minded men. No doubt these Roman games are precisely rendered and their local color scrupulously observed.... However, to build one's success on such details is like playing a game that, if not unfair, is at least dangerous. It can arouse suspicious resistance in many viewers who will shake their heads after

Fig. 14. Louis Français, *Les Hêtres de la côte de Grâce, près d'Honfleur; effet d'automne* (*The Beech Trees on the Coast of Grâce, near Honfleur; Autumn Effect*), 1859. Oil on canvas, 117 x 94½ in. (300 x 240 cm). Musée des Beaux-Arts, Bordeaux

Fig. 15. James Tissot, *Promenade dans la neige* (*A Walk in the Snow*), 1858. Oil on canvas, 9 x 6⅞ in. (23 x 17.5 cm). Private collection

39. "aujourd'hui comme hier beaucoup de grands cadres, peu de grandes oeuvres." Paul Mantz, "Salon de 1859," *Gazette des Beaux-Arts*, May 1, 1859, pp. 139–40. "pauvreté [régnant dans la] Galerie des peintures d'église." Mathilde Stevens, *Impressions d'une femme au Salon de*

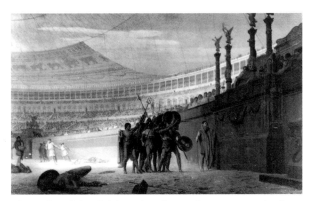

Fig. 16. Jean-Léon Gérôme. *Ave, Caesar imperator, morituri te salutant*, 1859. Oil on canvas, 36⅜ x 57⅛ in. (92.5 x 145 cm). Yale University Art Gallery, New Haven

1859, Paris, 1859, p. 108. "presque toujours déserte [où quelques égarés] effleurent du regard tous ces sujets chrétiens." Augustin-Joseph Du Pays, "Salon de 1859," *L'Illustration*, May 7, 1859, p. 299.

40. "bizarreries archaïques du jeune 'Jacobus' Tissot pour qui la peinture depuis Memmeling, Lucas Cranach et Albert Dürer est en pleine décadence." Gautier 1859, p. 153. "les faisant ressembler à des copies de maîtres exécutées dans un sentiment moderne." Astruc 1859, p. 163.

41. "joujoux gothique." Paul de Saint-Victor, "Salon de 1859," *La Presse*, June 5, 1859.

42. "l'emprise de l'érudition du détail et [de] l'exactitude archaïque"; "à force de finesse, sa peinture s'atténue, s'évapore et disparaît." Gautier 1859, p. 10. "son pinceau déjà si froid s'engourdit de plus en plus." Paul Mantz, "Salon de 1859," *Gazette des Beaux-Arts*, May 15, 1859, p. 196. "Son dessin s'abrège et prend la concision d'un élégant résumé; sa couleur ne recouvre guère plus la toile que l'encre n'entame le papier." Paul de Saint-Victor, "Salon de 1859," *La Presse*, April 30, 1859.

43. "désert[ant] la peinture pour l'archéologie." Chaud-de-Ton, "Salon de 1859," *La Vérité contemporaine*, May 25, 1859, p. 2.

44. "Il est impossible de méconnaître chez M. Gérôme de nobles qualités"; "son originalité (si toutefois il y a originalité) est souvent d'une nature laborieuse et à peine visible. Froidement il réchauffe les sujets par de petits ingrédients et par des expédients puérils.... Il n'a été jusqu'à présent, et ne sera, ou du moins cela est fort à craindre, que le premier des esprits pointus. Que ces jeux romains soient exactement représentés, que la couleur locale soit scrupuleusement observée, je n'en veux point douter... mais baser un succès sur de pareils éléments, n'est-ce pas jouer un jeu, sinon déloyal, du moins dangereux, et susciter une résistance méfiante chez beaucoup de gens que s'en iront hochant la tête et se demandant s'il est bien certain que les choses se passassent absolument ainsi? En supposant même qu'une pareille critique soit injuste...elle est la punition mérité d'un artiste qui substitue l'amusement d'une page érudite aux jouissances de la pure peinture." Baudelaire 1985–87, pp. 639–41.

45. "peinture de demi-caractère, sérieux quant au fond mais familier pour la forme"; "peinture de haut style." Étienne-Jean Delécluze, "Exposition de 1859," *Journal des débats*, April 27, 1859, p. 1.

seeing the painting and ask themselves if indeed things were exactly like that. And if such a criticism is unjust . . . , it is a well-deserved punishment for an artist who prefers the amusement of a scholarly page to the delight of pure painting."[44] Moreau's friends, who included Degas, agreed with Baudelaire: history painting was moribund, and Gérôme's painstaking reconstructions served only to weaken it further rather than offering any reviving force. It was necessary to look for something new, to abandon the temptation of archaeology and to avoid dry literalness when painting scenes of ancient history.

Landscape and genre scenes were flourishing in the ruins of history painting. For Étienne-Jean Delécluze, genre scenes were "between two categories, serious in subject but homely in form" and were a particular threat to "painting of elevated style."[45] He who had long championed the classical school saw this evolution as inevitable because it paralleled that of society at large. Everywhere modest country homes were replacing great châteaux. Delécluze wrote: "While viewing the exhibition, we may sometimes be tempted to think that a *small art* has emerged in the last few years, just as *small houses* have. Many middling artists, . . . who exist in such great numbers nowadays, practice it."[46] Since the 1855 Exposition Universelle, genre painting had been in vogue. The Germans, Belgians, and English had taken it up, and in France a whole "contingent of microscopic artists almost invisible to the naked eye" were growing in Meissonier's dwarf shadow.[47] Their paintings, which had to be viewed through a magnifying glass, had become exercises in precision; their images were appreciated only for their exact details and praised for their meticulousness. Viewers pointed out the strength, charm, and picturesque qualities of the paintings; missteps in taste and historical errors were noted; there was chatter about the authenticity of various types. Genre painting was swarming with activity. It was not only gaining ground on history painting but was also subverting it by diffusing a taste for anecdote, a liking for fabrics and bibelots, an upholsterer's craftsmanship, a designer's elegance. Genre painters—and their smallish, uniformly smooth, and painstaking works—were said to despise or, more accurately, to ignore style and to promulgate a dry and conventional manner. Faced with so many similar products, more philosophical viewers accepted the situation, enjoying the charm of an image, the elegance of a figure, the precise rendering of a fabric, the flawless resurrection of the past. At times, however, some critics threw up their hands; about Auguste Toulmouche's delicate work Astruc wrote, "It's pretty—charming—gracious—full of color—nice—and it's dreadful."[48]

Landscape painting was perceived very differently. The names Corot, Charles-François Daubigny, and Théodore Rousseau showed

that "the true strength of the French school" was found there.[49] Castagnary saw the supremacy of landscape painting as the sign of a "new revolution"—like that sparked in literature by George Sand's "rustic epics"—which would end the era of Delacroix and the Romantics. He wrote: "And then the works of Th. Rousseau, Corot, Daubigny, Troyon, Millet appeared. These strong works, imbued with melancholy, elegance, and a gloomy grandeur, transformed landscape painting into the most important branch of contemporary art. And thus today roles are reversed: Landscape, once the lowest genre, now holds first place, and history painting, once at the top, exists in name only."[50] But this success was contested. Some could not accept the recent dominance of pure landscape and mourned the death of historical landscape painting; others had lively discussions about the choice of settings, and they applauded the artist's efforts to paint nature in a simple manner and criticized his banal motifs. Gautier, always equitable, described the situation: "The landscape painters are divided into two camps: on one side, those who seek style and beauty, on the other, those who paint nature as it is."[51] In the first group Paul Flandrin and Théodore Caruelle d'Aligny were the last partisans of the historical landscape, whose imminent death was universally expected. This genre would die a natural death, of old age, to a chorus of conventional regrets. Comments about d'Aligny's *envois* at the Salon had a condolence-like tone. Critics paid homage to a courageous fighter, whose fierce stubbornness sometimes misled. They pointed out a dryness of manner—seen in the metallic ponds, the arid rocks, the stillness of the great trees—and remarked on the conventionality that transformed Mortefontaine (fig. 17) into an ancient site. They pitied nature which appeared to fade as the painter did, being represented as "skin and bones" and as hoary, literate trees that knew "Greek and Latin."[52]

Once artists such as Paul Huet, "the Romantic landscapist par excellence," were gone, the imaginary landscape with its medieval ruins, cathedrals, and sunsets gave way to an "objective" rendering of nature.[53] Some critics welcomed the defeat of the "assassins" of nature, in Astruc's words.[54] Daubigny (fig. 18) was highly regarded —"He does not choose, he does not compose, he neither adds nor subtracts, he does not mix his personal feelings with the reproduction of the site . . . ; his paintings are like pieces of nature cut out and set into a golden frame."[55] Théodore Rousseau was also much praised—"simple, calm, permeated with naturalism, he respects the accurate relation of trees, animals, man, and sky." The sincerity of both Corot and Troyon was suspect, given their taste for the theatrical. It was remarked that there was "no truth in [Corot's] creation."[56] Troyon was said to have "an ungiving, bad-tempered, and cold nature, very exaggerated, black and white, expressing itself

46. "en parcourant l'Exposition on serait parfois tenté de penser qu'à l'instar de la *petite propriété*, il s'est établi depuis plusieurs années un *petit art*, dont l'exercice est devenu plus à portée de cette foule d'esprits, je ne dirai pas médiocres, mais mitoyens, si communs en ce monde." Étienne-Jean Delécluze, "Exposition de 1859," *Journal des débats*, May 18, 1859, p. 1.

47. See Mainardi 1987, pp. 119, 163ff., 190, and Mainardi in Bouillon 1989, pp. 59–60. "phalange d'artistes microscopiques presque invisibles à l'oeil nu." Gautier 1859, p. 154. Regarding the importance of "Papa Meissonier's children," see Chaud-de-Ton, "Salon de 1859," *La Vérité contemporaine*, May 25, 1859, p. 3; Paul de Saint-Victor, "Salon de 1859," *La Presse*, June 5, 1859; Houssaye 1859.

48. "c'est joli,—charmant,—gracieux,—coloré,—fin,—et c'est affreux." Astruc 1859, p. 168.

49. "la vraie force de l'école française." Du Camp 1859, p. 16.

50. "Alors se sont produites les oeuvres de Th. Rousseau, Corot, Daubigny, Troyon, Millet, oeuvres de force, de mélancolie, de grâce ou de morne grandeur, qui ont fait du paysage la branche la plus importante de l'art de notre temps. Et voilà comment les rôles sont aujourd'hui intervertis, comment ce qui était infime autrefois occupe le premier rang, comment ce qui était au faîte n'existe plus guère que de nom." Castagnary 1892, pp. 71–72.

51. "Les paysagistes se divisent en deux camps: l'un contient ceux qui cherchent le style et la beauté; l'autre ceux qui prennent la nature telle qu'elle est." Gautier 1859, p. 184.

52. "la peau sur les os." Marquis de Belloy, "Salon de 1859," *L'Artiste*, May 8, 1859, p. 19. "le grec et le latin." Gautier 1859, p. 190.

53. "le paysagiste romantique par excellence"; "objective." Gautier 1859, pp. 198, 192.

54. "les meurtriers." Astruc 1859, p. 12.

55. "Il ne choisit pas, il ne compose pas, il n'ajoute ni n'élague, il ne mêle pas son sentiment personnel à la reproduction du site . . . ; ses tableaux sont des morceaux de nature coupés et entourés d'un cadre d'or." Gautier, "Salon de 1859," reprinted in Drost and Henninges 1992, p. 192.

56. "simple, calme, tout imprégné de naturalisme, il respecte la relation exacte des arbres, des animaux, de l'homme et du ciel"; "nulle vérité dans son invention." Castagnary 1892, pp. 96, 88.

Fig. 17. Théodore Caruelle d'Aligny, *Vue prise dans le parc de Mortefontaine* (*View of the Park of Mortefontaine*), 1859. Oil on canvas, 23⅝ x 36¼ in. (60 x 92 cm). Musée des Beaux-Arts, Lyon

57. "Nature sourde, criarde, froide, très exagérée, blanche et noire, qui s'exprime avec fracas." Astruc 1859, p. 250.
58. "Liber veritatis." Paul de Saint-Victor, "Salon de 1859," *La Presse*, July 2, 1859. "culte niais de la nature, non épurée, non expliquée par l'imagination." Baudelaire 1985–87, vol. 2, p. 660.
59. "Après le *paysage champêtre*, on a cherché le *paysage naïf*. C'est très bien encore! Mais on se laisse aller sur cette pente . . . et de naïveté en naïveté, on pourrait bien arriver au *paysage bête*." Augustin-Joseph Du Pays, "Salon de 1859," *L'Illustration*, July 23, 1859, p. 76.
60. "pâturages normands"; "cours de ferme"; "gardeuses de dindons"; "motifs de rencontre qui n'ont d'autre objet, d'autre signification, d'autre charme que la production littérale de la réalité"; "campagnes héroïques, les temples et les dryades." Delaborde 1859, p. 518.
61. "Le paysage doit être autre chose que la vérité positive." Dumas, *L'Art et les artistes*, p. 7. "toute la nature n'est pas circonscrite dans la banlieue." Gautier 1859, p. 188. "des horizons plats, des sites sans caractère." Étienne-Jean Delécluze, "Exposition de 1859," *Journal des débats*, May 24, 1859, p. 2. "animaux beaucoup trop herbivores." Baudelaire 1985–87, vol. 2, p. 667.
62. "d'un côté le corps des *néo* de toutes sortes, imitateurs des écoles passées . . . de l'autre côté, le corps des *indépendants*, des chercheurs"; "vaste champ de bataille." Émile Cantrel, "Salon de 1859," *L'Artiste*, July 17, 1859.
63. "chaque artiste a ses idées, ses fantaisies, sa manière et tout son système." Étienne-Jean Delécluze, "Exposition de 1859," *Journal des débats*, May 18, 1859, p. 1.
64. Houssaye 1859, p. 246. Delacroix 1980, p. 631.
65. "Les uns se gaspillent en futiles réminiscences du dernier siècle, les autres s'immobilisent dans une prétentieuse imitation de la naïveté; d'autres encore cherchent à conquérir leur part de notoriété soit en exagérant les laideurs et les misères de la réalité, soit en enjolivant outre mesure les élégances de la vie actuelle." Delaborde 1859, p. 531.
66. See Delacroix 1980, p. 807.

with great noise."[57] Apart from the accounts of Castagnary and of Astruc and the praise showered on Daubigny for his *Liber veritatis*, much critical writing, including that of Baudelaire, condemned the "naive cult of nature unpurified and uninterpreted by imagination."[58] Du Pays warned against gradual degradation: "After the *country landscape*, artists searched for the *naive landscape*. That's all to the good, but if we keep going in this direction, from naïveté to naïveté we could get to the *stupid landscape*."[59] Soon bored with the "Normandy meadows," "farmyards," "turkey keepers," and all the "randomly selected motifs whose only purpose, meaning, and charm rested in a literal reproduction of reality," some critics bemoaned "the heroic campaigns, the temples, and the dryads" of the past.[60] Alexandre Dumas stated that "landscape had to be something other than positive truth"; Gautier observed that "nature does not confine itself to the suburbs"; Delécluze and Baudelaire, who usually disagreed, took a similar sardonic stance: Delécluze mocked the already old-fashioned "flat horizons and commonplace sites"; Baudelaire described the landscapists as "animals that were too herbivorous" for him.[61]

The confusion of genres was made worse by the confusion (or collapse, according to some) of established styles. Sculpture had split into only two major movements—"on one side, all the *Neos* who imitated previous schools . . . ; on the other, the *independents*, the seekers"—while painting had become the "vast battlefield."[62] The elderly Delécluze, who was used to binary antagonisms, was faced with a maddening myriad of tendencies: "Each artist has his ideas, his imagination, his manner—his own system."[63] Houssaye was overwhelmed by the neo-Greeks, the neo-Italians, and the neo-Flemish and sought in vain the French character he could not find in Ingres or Courbet. He did recognize this essence in Delacroix, Couture, and Chaplin, but these men were the last of their kind, and the critic was becoming isolated. Delacroix himself counted up the damages done by eclectic artists who wanted to borrow the best from each school but instead simplified and vulgarized art, making it worthless.[64]

According to Henry Delaborde, "Some [painters] wasted their time in futile recollections of the last century; others were paralyzed by pretentious imitation of the Primitives' naïveté; others sought glory by exaggerating the ugly misery of reality or by outrageously embellishing the elegance of contemporary life."[65] A negative account of the 1859 Salon was indeed justified. There was no history painting and no religious painting. Nothing pointed toward a coming revival; a taste for the "pretty" and the "coquettish"[66] reigned everywhere. There was a general lassitude; no one stood out. Painters could be said to paint well in the same way authors are said to

Fig. 18 (cat. 49). Charles-François Daubigny, *Les Bords de l'Oise* (*The Banks of the Oise*), 1859. Oil on canvas, 35⅜ x 71⅝ in. (90 x 182 cm). Musée des Beaux-Arts, Bordeaux

write well-written books. Fortunately, there were genre and land-scape painting; a few critics recognized in them the vitality of the French school, even in the absence of more noble ambitions. Castagnary was the most optimistic: "a few admirable landscapes, remarkable paintings of genre scenes, several good portraits, a hundred works all together."[67] He did not mention, however, the Salon's two great successes: *Les Soeurs de charité* (fig. 19) by Henriette Browne, a sentimental representation of two nuns at the side of a dying child—"It was the painting that was most looked at, that pleased the greatest number of visitors"[68]—and the severe *Portrait de Mlle M[aison]* by Hippolyte Flandrin (fig. 20). Against a dark background, Flandrin had set the melancholy profile of a woman who was soon called *la jeune fille à l'oeillet* (the young girl with a carnation). Her appealing face had "something peculiar, mysterious, and disturbing"; the work had "admirable drawing and volume"; a "great simplicity of execution," but Degas saw it as a survivor from a past era.[69]

For Du Camp, this portrait was paradoxically "the only history painting in the entire Salon." In his *Salon de 1859* the seven-page chapter on history painting was entirely devoted to Flandrin's three portraits. This approach emphasized the decline of "great painting," the rejection of "the ideal," "honesty," and "respect for art," the quest for "easy and brilliant execution," and the contempt for

67. "Quelques admirables paysages, des tableaux de genre remarquables, plusieurs bons portraits, en tout une centaine de toiles." Castagnary 1892, p. 69.
68. "c'est le tableau qui a été le plus regardé, c'est le tableau qui a fait le plus de plaisir au plus grand nombre de visiteurs." Anatole de Montaiglon, "La peinture au Salon de 1859," *Revue universelle des arts*, April–September 1859, p. 484.
69. "quelque chose de singulier, de mystérieux, d'inquiétant." Gautier 1859, p. 129. "l'admirable expression du dessin du modelé." Astruc 1859, p. 214. "grande sobriété dans les moyens d'exécution." Augustin-Joseph Du Pays, "Salon de 1859," *L'Illustration*, July 30, 1859, p. 94.

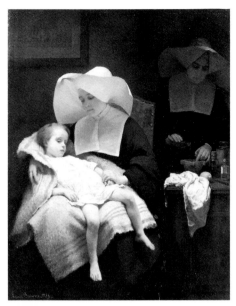

Fig. 19. Henriette Browne, *Les Soeurs de charité*
(*The Sisters of Charity*), 1859.
Oil on canvas, 65¾ x 51⅛ in. (167 x 130 cm).
Kunsthalle Hamburg

70. "la seule *peinture d'histoire* que contiene le Salon";
 "grande peinture"; "idéal," "probité," "respect de l'art,"
 "exécution facile et brilliante," "chic." Du Camp 1859,
 pp. 19–20.
71. "quelques plaintes sur la mort de la peinture d'histoire."
 Letter from Moreau to Degas, May 18, 1859, published in
 Loyrette 1991, pp. 162–63.
72. "bien peinte." Astruc 1859, pp. 286–87. Pissarro's name
 is only mentioned in the table of contents, p. 405.
73. The two paintings exhibited at Bonvin's studio were *Por-
 trait of Mlle Marie Fantin* (Fantin-Latour 1911, no. 112)
 and *Auto-portrait* (*Self-portrait*) (Musée des Beaux-Arts,
 Grenoble; Fantin-Latour 1911, no. 113). According to
 Alphonse Julien, *Les Deux Soeurs* (fig. 234), which was
 very large, was not shown because of lack of space.
 Colleen Denney rejects this hypothesis and believes that
 it was exhibited in the *atelier flamand* on the rue
 Saint-Jacques.
74. Pennell 1908, vol. 1, p. 75.
75. "Le 10 mars / Monsieur le comte,
 J'ai l'honneur de solliciter de votre bienveillance de pro-
 longer de trois jours c'est-à-dire jusqu'au quinze le délai
 que vous aviez bien voulu m'accorder déjà et qui expire
 le 12.
 Recevez Monsieur le directeur l'assurance de ma parfaite
 considération.
 Edouard Manet / 52 rue de la Victoire [en haut au crayon:
 Vu]
 [March 10, / Monsieur le conte, / Dear Count,
 I respectfully ask you to extend the delay that you
 have already granted me by three days, that is to say, to
 give me to the 15 instead of the 12.
 Sincerely yours, / Edouard Manet / 52 rue de la Victoire"
 (above in pencil: *seen*)]
 Paris, Archives of the Louvre x, Salon de 1859.

tradition and the search for the "elegant."[70] Du Camp was writing an obituary for history painting, like those Moreau received in Rome from his Parisian friends who wrote detailed accounts of the 1859 Salon. Moreau, however, did not take these "few complaints on the death of history painting" seriously.[71] Because of his letter to Moreau, Degas's opinions of contemporary painters are known. Two letters that Monet, newly arrived in Paris, had sent to Eugène Boudin, his first teacher, complement these observations by commenting on artists not mentioned by Degas and his friends. Although somewhat sparse, these sources indicate how the early Impressionists judged contemporary painting.

For Manet, Degas, Pissarro, Fantin-Latour, and Whistler the Salon of 1859 was in effect their first salon. Except for Fantin and Whistler, who had been friends for a few months, those young men did not know one another. They worked by themselves and studied with different teachers. They were all between the ages of twenty-three and twenty-nine and were starting their careers with the ambition of succeeding at the Salon. Only Pissarro, who introduced himself as a "student of Anton Melbye," was accepted with his *Paysage à Montmorency* (*Montmorency Landscape*); Astruc praised this little work, judging it "well painted," but forgot to mention the name of the artist.[72] Three paintings by Fantin-Latour and Whistler's single entry, *At the Piano* (fig. 3), were rejected, while two etchings by Whistler were accepted. However, both painters exhibited the rejected paintings in Bonvin's *atelier flamand* on the rue Saint-Jacques.[73] At this rather unpretentious event Whistler was congratulated by Courbet.[74] Manet was also absent; however, it is not certain that his *Buveur d'absinthe* (fig. 4), one of his lifesize Parisian characters, was indeed *refusé*, as has always been thought. Perhaps it was unfinished—in an unpublished letter of March 10, 1859, addressed to Nieuwerkerke, Manet asked for a second delay that would have allowed him to retouch the painting before it was sent to the jury.[75] Degas too was unable to complete his entry in time; the *Famille Bellelli* (fig. 253), which was begun in Florence in fall 1858, was ultimately sent to the Salon of 1867.

Degas first visited the Palais de l'Industrie on April 24. He went with two of Moreau's friends: Antoine Koenigswarter, whom he had met in Tuscany a few months earlier, and Eugène Lacheurié, with whom he soon became friends. The next day, in the first letter to his mentor since his return to France, Degas wrote: "In my opinion Fromentin almost deserves the honors of the exhibition. Unfortunately, whenever he wants to strengthen his composition a little, it becomes too heavy. There are two masterpieces: *Bateleurs nègres dans les tribus* [fig. 24] and *Lisière d'oasis pendant le sirocco* [*The Edge of an Oasis during the Sirocco*]. Compared to

Fig. 20 (cat. 75). Hippolyte Flandrin, *Portrait de Mlle M[aison] (La Jeune Fille à l'oeillet) (Portrait of Mlle M[aison] [Young Girl with a Carnation])*, 1858. Oil on canvas, 31⅛ x 25¼ in. (79 x 64 cm). Private collection

these, everything else seems insignificant."[76] Two letters to Moreau from Degas's companions at the Salon fill out these comments. Koenigswarter, a second-generation banker and a reasonably cultivated man, noted laconically that the exhibition was "pitiful," remarking that "in the artists' eyes, only Fromentin has had genuine success; he has shown five truly charming paintings and his progress is quite apparent."[77] Lacheurié, a composer and landscape painter who knew Moreau's taste and ideas, wrote more extensively. He began by praising the works of Fromentin, also one of Moreau's friends: "He [has] sent a wonderful simoon to the Salon [no. 1174: *Lisière d'oasis pendant le sirocco*], two figurative subjects showing great progress over his best accomplishments in that genre [no. 1172: *Bateleurs nègres dans les tribus*; no. 1173: *Une rue à El-Aghouat*

76. "Fromentin a presque les honneurs de l'exposition, à mon avis. Malheureusement quand il veut serrer un peu son exécution, il l'alourdit. Il y a une *Danse de bateleurs nègres dans les tribus* et une *Lisière d'oasis pendant le sirocco* qui sont deux chefs d'oeuvre. Tout y paraît sauce rousse à côté." Letter from Degas to Gustave Moreau, April 26, 1859, published by Theodore Reff, "More Unpublished Letters of Degas," *The Art Bulletin* 51 (1969), p. 284. The two paintings by Fromentin that Degas noticed are no. 1172, *Bateleurs nègres dans les tribus* (private coll.; reproduced in Thompson and Wright 1987, p. 173) and no. 1174, *Lisière d'oasis pendant le sirocco* (present location unknown; see Thompson and Wright 1987, p. 168). About Degas and the friends of Gustave Moreau at the 1859 Salon, see Loyrette 1989, pp. 16–17.

77. "pitoyable"; "aux yeux des artistes, Fromentin a le succès de meilleur aloi; il a vraiment exposé cinq charmantes toiles et il y a un progrès très marqués." Letter from Antoine Koenigswarter to Gustave Moreau, May 25–28, 1859, quoted in Loyrette 1989, p. 16.

Fig. 21 (cat. 76). Eugène Fromentin, *Une rue à El-Aghouat* (*A Street in El-Aghouat*), 1859. Oil on canvas, 55⅞ x 40½ in. (142 x 103 cm). Musée de la Chartreuse, Douai

Fig. 22 (cat. 182). Gustave Ricard, *Portrait de M. Paul de D...* (*Portrait du prince Paul Demidoff*) (*Portrait of Prince Paul Demidoff*), 1859. Oil on canvas, 82⅝ x 50⅜ in. (210 x 128 cm). H.R.H. Prince Alexander of Yugoslavia

(fig. 21)], and two or three delightful, light works with all his usual qualities that I prefer to all the rest." Lacheurié emphasized the Salon's mediocrity: "Ah! my poor fellow, if you could see all the works that are on view for twenty sous at the Salon of 1859, you certainly would not want to leave Rome to try to fight alone, or almost alone, against this crowd of vulgar artists." He praised Flandrin's dignified, dull talent (carefully, because Moreau did not admire painting of this type): "To begin with, I must confess that I was struck by a female portrait by Flandrin [*Portrait de Mlle M*(aison), called *La Jeune Fille à l'oeillet* (fig. 20)]; it is very successful, but that doesn't make it good. I don't know whether you would like this painting much; I doubt it; but it seems to me that you would acknowledge the distinguished qualities that I believe I recognized in it." Degas passed over work he had adored previously. At the 1855 Exposition he admired only Ingres and Flandrin, but at the Salon of 1859 he turned away from the portraits by Flandrin that he had

Fig. 23 (cat. 166). Pierre Puvis de Chavannes, *Un retour de chasse* (*Return from the Hunt*), 1859. Oil on canvas, 155½ x 116⅛ in. (395 x 295 cm). Musée des Beaux-Arts, Marseille

so carefully studied in the past. Lacheurié wrote: "I think this [*Mlle M(aison)*] is much better than those of Ricard that your friend M. de Gas pointed out to me and that he seems to prefer. Despite my lack of expertise, I can see that it is better painted; some of the clothing is remarkable in its coloring and rendering, the composition is more *picturesque*, but the treatment of the human figure has less simplicity and the characters are less elevated." Degas's admiration for Ricard was fleeting; in 1859 Ricard's sfumato and "picturesque" elements (fig. 22) were a powerful antidote against Flandrin's severity—he reflected on this lesson and went on. Degas's passion for Delacroix, central to his discussions with Moreau in Italy, was more consistent and grew warmer during the Salon of 1859. Lacheurié wrote that when he and Degas visited the Salon, they "almost always" agreed about their "impressions," but they had "fairly serious differences" over some of Delacroix's paintings. He noted: "I confess I was unable to share his opinion on this point; *Ovide chez*

Fig. 24. Eugène Fromentin, *Bateleurs nègres dans les tribus* (*Jugglers among the Tribesmen*), 1859. Oil on canvas, 39 x 55½ in. (99 x 141 cm). Private collection

les Scythes [fig. 12] is a very remarkable painting, but otherwise I thought the work [Delacroix] showed this year was mediocre. The shepherds in the painting *Herminie et les bergers* [fig. 25] inspire only pity for the weaknesses of this greatly talented man.... To be fair, one must say that Erminia is ravishing. Talked about all of this with Fromentin, who agreed with me. We concluded that Delacroix, having sent the Salon only a placard inscribed 'Ovid chez les Scythes,' deserved to be hung one row up." Lacheurié ended with the "colossal success" of Gérôme's entry: "There is nothing to say, one can only shudder. It did allow Th. Gautier, P. de Saint-Victor, and *tutti quanti* to show off their style and their knowledge of Etruscan civilization, to call ancient chamber pots by their proper names—and they didn't let this delightful opportunity pass."[78]

Another friend who wrote to Moreau about the Salon was the painter Émile Lévy. Upon his return from Rome, where he had been a pensionnaire at the French Academy, he was commissioned to execute an important decoration for the Hôtel Furtado. Lévy was a brilliant man of many talents, somewhat thin-skinned and arrogant. In a letter to Moreau of May 27, 1859, he observed: "Your friend Fromentin has had a success: all of his paintings are good; they make a strong impression. Their execution is less impressive. It seems to me he was wrong to adopt a certain freedom of execution

Fig. 25. Eugène Delacroix, *Herminie et les Bergers* (*Erminia and the Shepherds*), 1859. Oil on canvas, 32¼ x 41 in. (82 x 104 cm). Nationalmuseum, Stockholm

78. "La vérité est qu'il a envoyé au salon un simoun merveilleux, deux sujets à figure très en progrès sur ce qu'il a fait de mieux dans ce genre-là et deux ou trois petites toiles ravissantes, légèrement traitées avec toutes ses qualités et que je préfère au reste"; "Ah! mon pauvre cher, si tu pouvais te faire une idée de ce que l'on vous fait voir pour vingt sous au Salon de 1859, tu ne voudrais certainement pas quitter Rome pour essayer de lutter seul, ou presque seul, dans cette mêlée d'art vulgaire"; "Je t'avouerai en commençant que j'ai été très frappé d'un portrait de femme par Flandrin; il a beaucoup de succès mais ce n'est pas une raison pour le croire bon. Je ne sais pas si tu aimerais beaucoup cette *peinture*-là, j'en doute; cependant il me semble que tu rendrais justice à des qualités vraiment distinguées que j'ai cru reconnaître"; "Pour te dire je trouve ce portrait-là fort supérieur à ceux de Ricard que ton ami, Monsieur de Gas, m'a fait remarquer et qu'il me paraît estimer davantage. Je vois bien malgré que je m'y connaisse bien peu, que c'est mieux peint; il y a des vêtements d'une couleur et d'une facture incomparable. C'est composé d'une façon plus *pittoresque*, mais la figure humaine y est traduite avec beaucoup moins de simplicité et d'élévation"; "presque toujours avec [Degas] dans [ses] impressions"; "un peu sérieusement divisés que sur certains Delacroix"; "Mais je t'avoue qu'il m'a été vraiment impossible de partager son sentiment là-dessus; à la réserve d'un Ovide chez les Scythes, qui est tout à fait remarquable, son exposition de cette année m'a paru déplorable. Jamais, non jamais ses bergers, dans son tableau d' 'Herminie chez les Bergers,' ne m'inspireront qu'une grande pitié pour les faiblesses d'un homme de grand talent.... Pour être juste il faut dire que l'Herminie est ravissante. Causant de tout cela avec Fromentin, qui était de mon avis, nous convînmes que Delacroix n'ayant envoyé au Salon qu'une pancarte avec annoté 'Ovide chez les Scythes' mériterait encore un rang supérieur"; "un succès colossal"; "il n'y a rien à en dire, il n'y a qu'à en frémir: qu'il te suffise de savoir qu'il a fourni à Th. Gautier, P. de Saint-Victor et *tutti quanti* une occasion de placer leurs phrases et leur érudition étrusque, de nommer par leur nom les pots de chambre antiques, qu'ils n'y ont pas manqué et qu'ils sont ravis." Letter from Eugène Lacheurié to Gustave Moreau, June 9, 1859, quoted in Loyrette 1989, pp. 16–17.

because the work becomes somewhat loose. His view of an Algerian street [*Une rue à El-Aghouat* (fig. 21)] is perfect. One could rest in its shadows. I'd like to have a painting like that. I won't speak of Delacroix—I don't understand him. I find his work horribly ugly. . . . there are one or two scenes arranged in a picturesque manner, but one has to renounce much to simply be able to look at them, leaving beauty aside. Troyon and others have some very well-painted canvases, very sophisticated values and a strong manner, but I wonder whether the French school of Poussin and Lesueur is now reduced to artists who paint goats, donkeys, and cows; why not paint birds—they are as beautiful and at least as poetic. . . . Among the disasters is Hamon [fig. 7]; he shows a quintessence of spirit which has nothing to do with painting and very little to do with spirit, that is, a sane or fine spirit. The same goes for Bouguereau [fig. 26], who is flat, dry, without color, and for Baudry [fig. 8] whose softness is pleasant, but pretentious and who shows a sketchy portrait of a child, almost a study. Worthwhile men such as *père* Jean de Montauban [Ingres] occupy a very high position compared to these shabby beings."[79]

These accounts of the Salon of 1859 record the thoughts on contemporary painting in Moreau's circle. Delacroix, even if he disappointed or confused, was still the focus of attention; Fromentin was regarded as a master of the contemporary school; history painting, which Moreau wanted to save, was dying, slowly smothered by a tight archaeological corset.

The young Monet saw things differently. He wrote to Boudin on May 19, after his first visit to the Salon, and on June 3, after "seeing it again several times."[80] Monet said that Hamon had made "horrible things without color or drawing. Affected and pretentious, with no idea about nature." About Delacroix, for whom he had a lukewarm admiration, he remarked that the artist "has painted better works than those he is showing this year. They are only indications, *ébauches*; but as always, he has verve, he has movement." Otherwise Monet mentioned only landscape artists and still-life painters, most of whom were friends of Boudin's (and to whom Boudin had written letters of introduction for Monet). Among them were Amand Gautier, Charles-Marie Lhuillier, and above all Troyon who gave Monet a friendly welcome, telling him to "make serious art," to enroll in a studio where figure drawing was taught (he recommended Couture's), to paint after nature, and to copy the masterpieces in the Louvre. In his letter to Boudin, Monet wrote: "M. Gautier's [*Les Soeurs de charité* (*The Sisters of Charity*)] is very pretty; it is calm and painted in a very sad gray tonality." In spite of this artist's affability, Monet was not interested. He criticized the obscure Lhuillier with Diaz and Morel-Fatio, noting that his "seascapes" were "lacking in common sense."[80] Monet had reservations about many artists,

79. "Ton ami Fromentin a du succès: tous ses tableaux sont bien; particulièrement bien d'impression; comme exécution, c'est moins bien, il me semble avoir tort de chercher une certaine liberté de facture de second ordre qui donne l'apparence lâchée à ses tableaux. Sa vue d'une rue à Alger je crois [*Une rue à El-Aghouat*] est parfaite; on s'y repose à l'ombre. On aimerait à avoir ce tableau-là. Je ne me permets pas de parler de Delacroix, je n'y comprends rien; je trouve cela horriblement laid; . . . il y a bien une ou deux de ses scènes pittoresquement disposées, mais qu'il faut faire de sacrifices, pour trouver cela, je ne dis pas beau, mais simplement regardable. Troyon et autres ont des tableaux fort bien peints des valeurs très savantes une peinture corsée mais l'École française qui a produit Poussin et Lesueur est-elle donc définitivement réservée à faire une école de peintres de chèvres, d'ânes, de boeufs; pourquoi pas des oiseaux c'est bien aussi beau et pour le moins aussi poétique. . . . Parmi les sombrages mentionnons Hamon avec sa quintessence d'esprit cela n'a plus absolument aucun rapport avec la peinture et bien peu, bien peu même avec l'esprit, l'esprit sain ou l'esprit fin. Bouguereau, la même chose, plat, sec décoloré. Baudry, mou quoique fort agréable mais prétentieux, expose une pochade de portrait d'enfant, un bout d'étude. Comme les hommes de la valeur, de la conscience du père Jean de Montauban [Ingres] sont juchés haut, à côté de ces mesquineries." Letter from Émile Lévy to Gustave Moreau, started on March 12–13, 1859 and finished on March 27, 1859, quoted in Loyrette 1989, p. 17.

80. Monet wrote two letters to Eugène Boudin; they were published in Cahen 1900, pp. 19–22, 24–27, and in Wildenstein 1974, letters 1 and 2, p. 419. The following quotations from them appear in the present text: "retourné plusieurs fois"; "d'horribles choses sans couleur, sans dessin. C'est grimacier, prétentieux: en un mot ça n'a aucune idée de la nature"; "Delacroix a fait de plus belle toiles que ce qu'il a mis cette année. Ce ne sont que des indications, des ébauches; mais comme toujours, il a de la verve, du mouvement"; "faire de l'art sérieux"; "Le tableau de M. Gautier est très joli; il est calme et dans une gamme grise d'une tristesse profonde"; "marines qui n'ont pas le sens commun"; "trop grand"; "un peu confus"; "horrible machine"; "de simples merveilles"; "de très beaux paysages"; "masse de tableaux d'Orient"; "Il y a dans tous ces tableaux de la grandeur, une lumière chaude, et ensuite c'est très beau comme détail et comme mouvement"; "merveilleux, il y a un ciel magnifique, . . . les vaches, les chiens sont de toute beauté"; "C'est superbe: c'est surtout très lumineux"; "étendue étonnante"; "pleine campagne"; "Les Daubigny sont pour moi quelque chose de bien beau. Il y en a surtout un d'Honfleur qui est sublime"; "Daubigny, en voilà un gaillard dont je vous ai parlé, c'est quelque chose de merveilleux. Ce serait bien malheureux si vous ne voyiez pas ça"; "les peintres de marines manquent totalement"; "Il n'y a pas une marine un peu passable"; "chemin qui [le] mènerait loin."

81. "Un hasard malencontreux a laissé ouverte la porte du chenil et, attiré par le fumet d'un déjeuner succulent, toute la meute s'est ruée dans la salle à manger avant l'arrivée des maîtres." Gautier 1859, p. 158.

such as the animal painter Joseph Stevens, who, he said, lacked finesse, and Philippe Rousseau whose ridiculous painting *Jour de Gala*—"By chance, the kennel door has been left open, and a pack of dogs, lured by the smell of a delicious meal, has rushed into the dining room before the return of their masters"—was extremely popular at the Salon.[81] Monet thought it "too large" and "a bit confused." The only value of the *"horrible machine"* painted by Eugène Isabey (fig. 28) was in its pretty details. He gave conventional praise to Corot and Théodore Rousseau. The work of the former was full of "simple wonders" and that of the latter of "very beautiful landscapes." He did not linger over them but passed on to the "great number of oriental paintings" exhibited by Théodore Frère:[82] "All these paintings have a grandeur, a warm light; their

82. Théodore Frère sent fourteen paintings to the 1859 Salon, none of which have been located. See Gautier 1859, pp. 259–60.

Fig. 26 (cat. 19). William Bouguereau, *Le Jour des morts* (*All Soul's Day*), 1859.
Oil on canvas, 57⅞ x 47¼ in. (147 x 120 cm). Musée des Beaux-Arts, Bordeaux

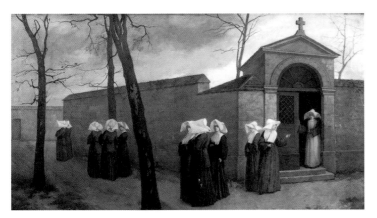

Fig. 27. Amand Gautier, *Les Soeurs de charité* (*The Sisters of Charity*), 1859. Oil on canvas, 41¾ x 73⅝ in. (106 x 187 cm). Musée des Beaux-Arts, Lille

Fig. 28. Eugène Isabey, *Incendie du steamer l'"Austria," le 13 septembre 1858* (*Burning of the Steamer "Austria," September 13, 1858*), 1858. Oil on canvas, 95¼ x 169⅜ in. (242 x 430 cm). Musée des Beaux-Arts, Bordeaux

details and movement are very beautiful." Troyon and Daubigny attracted Monet's warm attention. He praised Troyon's *Retour à la ferme* (*Return to the Farm*; Musée d'Orsay, Paris): "wonderful, there is a magnificent sky... the cows and dogs are extremely beautiful." Troyon's *Départ pour le marché* (*Departure for the Market*) "is superb and above all full of light," and his *Vue prise des hauteurs de Suresnes* (fig. 29) had an "incredible width" and a feeling of "deep country." Daubigny, even more than Troyon, was a revelation for Monet. On May 19 he wrote: "Daubigny's paintings are really beautiful in my opinion. One of Honfleur in particular is sublime." Two weeks later he again commented on the landscapist: "Daubigny, the man I told you about, is a wonderful artist. It would be very unfortunate if you were not able to see his work." Monet's enthusiasm was understandable. Daubigny's *Les Graves au bord de la mer, à Villerville (Calvados)* (fig. 30) is in some ways the prototype of many of Monet's seascapes of the 1860s.[83] In this quiet depiction of the Normandy countryside, the format, composition, and soft curve toward the sea are similar to those Monet would paint. Other shared features were the large size, the emphasis on season and climate, and the discreet presence of small figures. Finally, Monet observed that "seascape painters [were] completely absent" from the Salon. Stating "there [were] no seascape painters any better than passable," he advised Boudin to "follow this path, for it could take him far." Monet's admiration for Daubigny's canvas was a clear indication that he himself would take that path.

And so, in sum, what can be said about the Salon of 1859? While the debt some of the New Painting artists owed their elders is often discussed, it is less frequently remarked that, in spite of the still-considerable influence of the institutions, all artists benefited from

83. Daubigny's seascape was ruined when it was stolen from the Musée des Beaux-Arts, Marseille, in 1978.

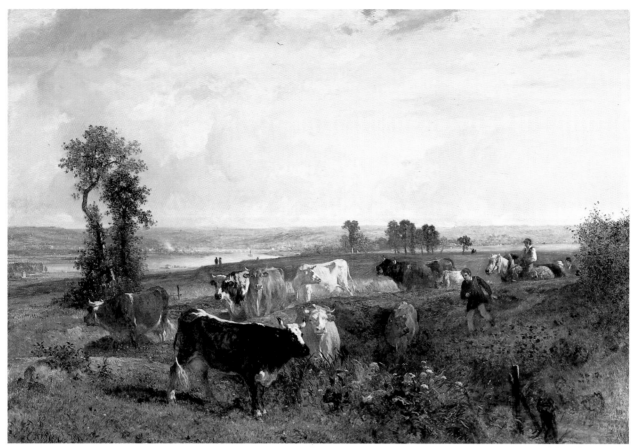

Fig. 29 (cat. 190). Constant Troyon, *Vue prise des hauteurs de Suresnes (Seine-et-Oise)* (*View from the Heights of Suresnes [Seine-et-Oise]*), 1856. Oil on canvas, 71⅝ x 104⅜ in. (182 x 265 cm). Musée du Louvre, Paris, Bequest of Thomy Thiéry, 1902

Fig. 30. Charles-François Daubigny, *Les Graves au bord de la mer, à Villerville (Calvados)* (*Seascape at Villerville*), 1859. Oil on canvas, 35⅜ x 75¼ in. (90 x 191 cm). Musée des Beaux-Arts, Marseille

84. "lieux les plus insignifiants"; "les peignent en manière d'esquisse et parfois même en font de véritables *tartouillades*." Étienne-Jean Delécluze, "Salon de 1859," *Journal des débats*, May 26, 1859, p. 2.

a situation that was favorable to them. They were not the first to criticize the way the Salon worked, the domination of the Institute, and the irrationality of the hanging; they were not the first to rebel against official rejection by organizing private exhibitions. But, as the Salon of 1859 showed, these artists were beginning their careers at a time when the old categories were disintegrating and when landscape painting and genre scenes were triumphant. The foundations of Impressionism, with its emphasis on landscapes and images of modern life, were laid on an already prepared ground. In 1859, as we have seen, some of the elements that were singled out for admiration or blame were to become characteristics of Impressionism. These included a predilection for a simple everyday nature—banal for some—without any touch of the picturesque and a particular affection for the environs of Paris and the Normandy countryside, two areas later favored by the Impressionists. In 1859 critics were startled to see simple studies, executed with large and rapid brushstrokes, presented as true paintings. Delécluze, taking aim at Huet, Félix Ziem, and Corot, railed against those who not only were satisfied to paint "the most insignificant places" but also "painted them in a sketchy manner, at times making only paint smears."[84] Baudelaire reproached Théodore Rousseau for using brushstrokes "with the famous modern defect, born from a blind

love of nature and nothing but nature; he takes a simple study for a composition."[85] Du Pays told the visitor to the Exposition how to view the paintings: "Do not get too close. Step back, step back again; and when you are far enough, you will grasp the harmony of landscapes that, seen close up, dissolve into flat and monotonous brushstrokes, of almost identical tones placed next to each other, without forms, perceptible but not at all precise."[86] In 1859 the large format was no longer reserved for history painting; the cows and sheep painted by Troyon in the large scale traditionally used for mythological figures prepared the way for Monet's picnic scenes and women in a garden. In 1859 the success of genre scenes expressed a taste for painting representing modern life. Anatole de Montaiglon stressed that "modern costumes" should be accepted and that artists should "paint...the subjects of our time. Women in a garden, an intimate chat by the fireside, a visit, a ball, a farewell, a return, in a word all the scenes of life." The "plaints over the death of history painting" discouraged neither Manet nor Degas—both artists attempted to revive the genre in the 1860s.[87] Manet began the huge *Moïse sauvé des eaux* (*Moses Saved from Drowning*); Degas admired Delacroix passionately and copied *Ovide chez les Scythes* either at the Galerie d'Apollon or at Saint-Denis-du-Saint-Sacrement; once he had found a studio, Degas put aside the studies for *La Famille Bellelli* (1858–67; fig. 253) and set to work on large historical compositions with the hope of gaining success at the Salon.[88]

85. "dans le fameux défaut moderne, qui naît d'un amour aveugle de la nature, de rien que la nature; il prend une simple étude pour une composition." Baudelaire 1985–87, vol. 2, p. 662.

86. "Ne vous approchez pas trop. Reculez, reculez encore; et quand vous serez assez éloigné, vous saisirez dans leur aspect harmonieux ces paysages qui, vus de près, se dissolvent à l'oeil dans une juxtaposition de touches plates et monotones, de tons à peu près identiques à côté les uns des autres, sans formes, non point précises mais seulement appréciables." Augustin-Joseph Du Pays, "Salon de 1859," *L'Illustration*, April 30, 1859, p. 278.

87. "accepter franchement le costume moderne et...peindre...les sujets de notre temps. Des femmes dans un jardin, une causerie intime au coin du feu, une visite, un bal, un adieu, un retour, en un mot toutes les scènes de la vie"; "quelques plaintes sur la mort de la peinture d'histoire." Anatole de Montaiglon, "La Peinture au Salon de 1859," *Revue universelle des arts*, April–September 1859, pp. 481–82.

88. For Manet, see Proust 1897, p. 168. For Degas, see Reff 1985, notebook 18, p. 127; notebook 14, pp. 59, 63–65, 70, 72–74; notebook 16, p. 35.

II
History Painting

HENRI LOYRETTE

On January 1, 1867, at the age of eighty-seven, Ingres did a portrait of his goddaughter, the widow of his student Hippolyte Flandrin. In the next days he returned to a variation of *Stratonice* and touched up some old drawings. He ordered a string quartet for the evening of Tuesday, January 8, and after he and some friends dined, they listened to Mozart, Cherubini, Haydn, and Beethoven. During the night Ingres got out of bed to pick up a burning coal that had rolled from the fireplace. He caught a chill after opening a window and died a few days later on Monday, January 14. On January 17, "a cold and gloomy day," M. Ingres, "history painter" as the announcement called him, was buried. An immense crowd made the funeral procession from the Quai Voltaire to Saint-Thomas d'Aquin, through the Place Vendôme and the boulevards, and to Père Lachaise.[1]

This "irreparable loss," this "great sorrow [striking] the French school," the sudden death of this "silent champion of the principles of Beauty"[2] sounded the knell for history painting more effectively than the jeremiads of Salon reviews. Léon Lagrange wrote: "His death breaks the last bond of decency which was holding back anarchy."[3] Many shared this opinion, and seeing the ebb of all that Ingres symbolized—"probity of art," "high principles," "the search for and attainment of beauty"—they laid down their arms, resigned to a barbarian invasion.[4] Olivier Merson, in an article published the day after Ingres's death, and Charles Blanc, in eight issues of the *Gazette des Beaux-Arts*, from June 1867 to August 1868, began the process of beatification, emphasizing both the position attained by the master "through the sweat of his genius" and the value of his example to younger generations.[5] But this campaign changed nothing. In 1868 Marius Chaumelin repeated the "mournful words" which "for the past twenty some years" had greeted each Salon: "Fine art is dying, fine art is dead."[6] In 1872 an elated Jules Castagnary observed that all that remained of history painting was "detritus from two decomposing schools: the classical and the romantic" and that the artistic scene was well rid of it—"We are left with portraits,

1. "par une journée sinistre et glacée"; "peintre d'histoire." Charles Blanc, "Ingres, sa vie et ses ouvrages," *Gazette des Beaux-Arts*, September 1, 1868, pp. 239–41.
2. "perte irréparable"; "grand deuil [frappant] l'école français"; "champion muet des principes du Beau." Léon Lagrange, "Bulletin mensuel, janvier 1867," *Gazette des Beaux-Arts*, February 1, 1867, p. 206.
3. "Sa mort brise le dernier lien de pudeur qui retenait l'anarchie." Ibid.
4. "probité de l'art"; "principes élevés." Ibid., p. 248. "recherche et rencontre de la beauté." Blanc, "Ingres," p. 248.
5. Olivier Merson, *Ingres, sa vie et ses oeuvres*, Paris, 1867. "à la sueur de son génie." Blanc, "Ingres," p. 248.
6. "mots lugubres"; "depuis une vingtaine d'années"; "La grande peinture se meurt, la grande peinture est morte." Marius Chaumelin, "Salon de 1868," *La Presse*, June 29, 1868, p. 2.

Édouard Manet, *Les Anges au tombeau du Christ*, detail of fig. 68

Fig. 31. Alexandre Cabanel, *Le Paradis perdu* (*Paradise Lost*). This painting, formerly at the Maximilianeum, was burned during World War II.

7. "détritus de deux écoles en décomposition, l'école classique et l'école romantique"; "nous n'avons plus devant nous que les portraits, les paysages, les natures mortes, les scènes de la vie humaine." Jules Castagnary, "Salon de 1872," *Le Siècle*, May 25, 1872, p. 1.

8. "morte, avec ce qui est mort." See Bouillon 1989, p. 51, n. 26.

9. "images copiées sur d'autres images, où l'on ne rencontre rien de divin et même rien d'humain"; "au détachement des choses du ciel." Edmond About, *Salon de 1864* (Paris, 1864), p. 61. See also Hector de Callias, "Salon de 1864," *L'Artiste*, May 1, 1864, p. 199: "Il y a encore des tableaux religieux, mais il n'y a plus de peintres religieux, surtout depuis qu'est mort Flandrin." (There are still some religious paintings, but there are no more religious painters, especially since Flandrin's death). On plagiarism in religious art, see Marius Chaumelin, "Salon de 1868," *La Presse*, June 3, 1868, p. 3.

10. "s'étiole"; "l'atmosphère morale est malsaine." Abbé Hurel, *L'Art religieux contemporain* (Paris, 1868), p. 219.

11. "a trop réussi"; "prétexte à études académiques sur le nu, disposées avec un pittoresque de convention et une dramatisation vulgaire"; "un berger d'Arcadie"; "un baigneur en disponibilité qui occupe ses loisirs." Ibid., pp. 410, 421.

landscapes, still lifes, scenes from daily life."[7] Religious painting, "sincere and contemplative as a prayer," had been declared "dead" in 1852 by the Goncourts, "dead with that which has died [i.e., faith]."[8] Some twelve years later Edmond About observed that "detachment from heavenly things" led to a dismal repetition of pieties—"images copied from other images where nothing is divine and nothing is human."[9] In 1868 Abbé Hurel, a friend of Manet's, said that Christian art was "fading" because of an "unhealthy moral atmosphere."[10] Giving a list of paintings shown at the 1867 Exposition Universelle, he pointed out that those that had religious subject matter did not express devotion. Claude-Marie Dubufe's *Le Fils prodigue* (The Prodigal Son) was as propagandist as Thomas Couture's *Les Romains de la Décadence* (*Romans of the Decadence*); William Bouguereau's *Sainte Famille* (*Holy Family*) had "succeeded only too well" in depicting an ordinary family; Alexandre Cabanel's *Paradis perdu* (fig. 31) was a "pretext for nude academic studies conventionally displayed and vulgarly dramatized," and in Alphonse Legros's *Martyre de Saint Étienne* (*Martyrdom of Saint Stephen*) the torturers were "a shepherd from Arcadia" and "an idle bather occupying his free time."[11]

Despite these laments, throughout France commissions were being completed for the walls of churches, town halls, and prefectures. And the Salons continued to exhibit large canvases of battle scenes celebrating imperial victories, with sword-wielding officers, heroic foot soldiers being mowed down by a hail of bullets, and cruel enemies (in turn, Russians, Arabs, and Mexicans). And there was the array of mythic and religious themes: Leda, Phryne, Danaë, Cleopatra; a few Zenobias agonizing on the banks of the Araxes River, some Brunhilds tied to horses' tails, all the Magdalens a sinful age could want, clouds of virgins smiling under torture, ecstatic saints, and adolescent martyrs; scenes of the Visitation, the Nativity, the Assumption, the Immaculate Conception, and the Mater Dolorosa; and Christ, always illuminated by a ray of light, walking on water, entering Jerusalem, raising Lazarus or Jairus's daughter or the widow's son of Nain, calming the storm, praying in the olive grove, being crucified, being laid in his tomb. The photographs from the Michelez albums (figs. 32–35) show, through a succession of Salons, the hodgepodge caused by strange juxtapositions—the blessed paying a great price for paradise could be hung next to bacchantes being tickled by satyrs. And the imp of history painting affected even the most resistant. Marie-Émilie Chartroule, who, writing as Marc de Montifaud, praised the worthy talents of Cabanel and Ernest Hébert, intoned a joyous Te Deum when Manet announced his *Mort de Maximilien*, a subject she thought "worthy of the brush of Paul Delaroche or Eugène Delacroix."[12]

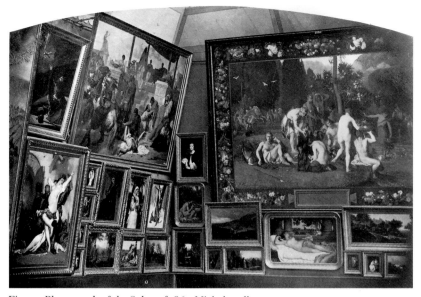

Fig. 32. Photograph of the Salon of 1861, Michelez album

Fig. 35. Photograph of the Salon of 1865, Michelez album

Fig. 33. Photograph of the Salon of 1861, Michelez album

Fig. 34. Photograph of the Salon of 1864, Michelez album

Fig. 32, far lower left, Jaroslav Cermak, *Razzia de bachibouzoucks dans un village chrétien de l'Herzégovine (Turquie)* (*Turkish Mercenaries Raiding a Christian Village in Herzegovina*); top right, Pierre Puvis de Chavannes, *Concordia*

Fig. 33, Alexandre Cabanel, *Nymphe enlevée par un faune* (*Nymph Raped by a Faun*), between two other works by him, *Poète florentin* (*Florentine Poet*) at lower left, and *Marie-Madeleine* (*Mary Magdalen*) at lower right

Fig. 34, from left to right: Jean-Baptiste Prudent Carbillet, *Jésus marchant sur les eaux* (*Jesus Walking on the Water*); Adrien Dauzats, *Une fontaine, près de la mosquée du sultan Hassan au Caire* (*A Fountain near the Mosque of Sultan Hasan in Cairo*), above; Guillaume-Alphonse Cabasson, *Captivité de saint Louis, après la bataille de Mansourah* (*The Imprisonment of Saint Louis after the Battle of Al Mansurah*), below; Auguste Loyer, *Saint François de Sales pendant sa mission dans le Chablais (Savoie)* (*Saint Francis de Sales during His Mission to Chablais*); Henri Coroenne, *Le Christ en croix* (*Christ on the Cross*)

Fig. 35, clockwise from upper right: Louis-Frédéric Schutzenberger, *Europe enlevée par Jupiter* (*Rape of Europa*); Antony Régnier, *La Bénédiction des semailles* (*Blessing of the Sowing*); Adrien Dauzats, *La Porte Saint-Martin et le boulevard Saint-Denis*; Louis Lamothe, *L'Origine du dessin* (*The Birth of Drawing*)

Fig. 36. Albert Lambron, *La Vierge et l'enfant Jésus* (*The Virgin and Child*), 1865. Oil on canvas, 57⅞ x 96½ in. (147 x 245 cm). Musée des Beaux-Arts, Angers

Fig. 37. Charles Sellier, *L'Âme perdue* (*The Lost Soul*), Salon of 1868. Oil on canvas. Whereabouts unknown

Fig. 38. Théodule Ribot, *Saint Sébastien, martyr*, 1865. Oil on canvas, 38¼ x 51⅛ in. (97 x 130 cm). Musée d'Orsay, Paris

Fig. 39. Gustave Doré, *Dante et Virgile dans le neuvième cercle de l'Enfer* (*Dante and Virgil in the Ninth Circle of Hell*), 1861. Oil on canvas, 122⅜ x 168½ in. (311 x 428 cm). Musée de Brou, Bourg-en-Bresse

In 1876 Edmond Duranty, in his booklet *La Nouvelle Peinture* (*The New Painting*), among the first discussions of what would be called Impressionism, cited the revival of history painting as one of the movement's objectives. Throughout this period there was felt to be a great need for an ambitious, "epic" painting style, which would give life to great myths and great historical events. The rapid success of Puvis de Chavannes, who became established in the successive Salons of 1861 and 1863, shows the strength of this desire. Although Puvis was criticized for the oddness of his compositions, for his subdued, frescolike colors, and for his large "synthetic" figures, he was praised—by Castagnary, Étienne-Jean Delécluze, Théophile Thoré, and Théophile Gautier—for "a return to artistic integrity" and for "an effort toward what is usually termed fine art."[13]

In retrospect it is apparent that a certain idea of history painting was slowly fading during this decade. This was the style—with its "precise but weak" drawing, its "copied, labored, and unoriginal composition," "innate sobriety of color," and "respect for the academic tradition"—that was practiced by the wretched Garnotelle in the novel *Manette Salomon* (1866) by the Goncourts.[14] Such an approach, rigid with the "obsession for beauty" denounced by Delacroix, led to the mechanical reiteration of the great masters.[15]

However, not everyone did the same thing in the same way, and it would be wrong to maintain, as is sometimes done, that this elevated genre was given over to the drivelings of a few old bores. New solutions were everywhere. There were intriguing and ephemeral variations like the *Vierge et l'enfant Jésus* (fig. 36) by Albert Lambron des Piltières, who made the intimacy of the divine and the human into a stylized country outing on a white background dotted with large birds. There was the dogged research of Charles Sellier (fig.

37), who used astonishing light effects to create his visions. Théodule Ribot (fig. 38) combined the lessons of seventeenth-century Spain with recent realism. Gustave Doré (fig. 39) illustrated the Bible and *The Divine Comedy*, "roaming with ease among nightmares and apotheoses."[16] Henri Regnault found in biblical and medieval stories pretexts for oriental scenes and made *Salomé* (fig. 40) into a charming girl in Turkish slippers from Tangier.

Those from whom nothing was hoped—who reproduced popular formulas with greater or lesser success—regenerated themselves. Ernest Meissonier, putting aside musketeers and little marquises for the moment, turned his miniaturist talent to Napoleonic legend and contemporary history. Gérôme, while maintaining a steady production of harems and gynaeceums, made forays into the events of his century and into the gospel. With *L'Empereur à la bataille de Solférino* (1864 Salon; fig. 41), Meissonier grappled with "things of substance" but in his usual small format. By contrast, at the 1861 Salon Adolphe Yvon exhibited the huge sixteen-by-twenty-four-foot *Bataille de Solférino* (*Battle of Solferino*; Musée National du Château, Versailles) which had been commissioned by the state. Forgoing the grandiloquence so identified with the genre, Meissonier gave a calm, meticulous vision of modern warfare. The emperor is hardly differentiated from his staff officers; the uniforms are carefully detailed; the horses are portrayed with an anatomical accuracy that Degas admired (see fig. 351); the smoke seems just as it should be, and three bodies mark this as a bloody battle rather than a military exercise: the painting is an unsettling image of an unsettled battle.[17] On the other hand, Meissonier's *1814, la Campagne de France* (fig. 42), shown at the same Salon of 1864 and the prototype for a series of Napoleonic paintings, returns to the artificiality of a stage set.

Fig. 40. Henri Regnault, *Salomé*, 1870. Oil on canvas, 63 x 40⅛ in. (160 x 102 cm). The Metropolitan Museum of Art, New York, Gift of George F. Baker, 1916

12. "digne du pinceau de Paul Delaroche ou d'Eugène Delacroix." Marc de Montifaud, "Salon de 1868." *L'Artiste*, May 1, 1868, p. 253.
13. "retour vers la probité artistique"; "effort vers ce qu'on est accoutumé d'appeler la grande peinture." Maxime Du Camp, *Salon de 1861* (Paris, 1861), pp. 74–80.
14. "exact et pauvre"; "contour copié, peiné et servile"; "sagesse native de coloris"; "respect de la tradition de l'école." Goncourt 1867, p. 175.
15. "manie de la beauté." In his notes "L'Idéal et le Réalisme" published posthumously in 1868, Delacroix wrote: "Les élèves de certains écoles n'ont fait autre chose que de répéter sans fin les mêmes formes, non pas imitées, mais calquées sur l'antique…! d'autres écoles ont élevé le même préjugé en faveur de Raphaël: un peu en deça et au-delà de la manière de ce maître est une infraction abominable. Ils imitent stupidement jusqu'à ses écarts et ses fautes de dessin avec la piété d'un homme qui

Fig. 41. Ernest Meissonier, *L'Empereur à la bataille de Solférino* (*The Emperor at the Battle of Solferino*), 1863. Oil on canvas, 17⅛ x 29⅞ in. (43.5 x 76 cm). Musée National du Château, Compiègne

Fig. 42. Ernest Meissonier, *1814, la Campagne de France* (*1814, the Campaign of France*), 1864. Oil on canvas, 20¼ x 30⅛ in. (51.5 x 76.5 cm). Musée d'Orsay, Paris

Fig. 43. Jean-Léon Gérôme, *Louis XIV et Molière*, 1862.
Oil on canvas, 16½ x 29½ in. (42 x 75 cm).
Malden Public Library, Malden, Massachusetts

baise les vieilles pantoufles de son père" (The students
of some schools have constantly used the same forms,
not so much through imitation but by copying the
antique . . . ! Other schools have had a similar prejudice,
but in favor of Raphael: a little to this side or the other
of this master's manner was an abominable transgres-
sion. They mindlessly imitated all his faults and his short-
comings in drawing with the filial devotion of a man
who kisses his father's old slippers). Delacroix 1868,
pp. 334–35.

16. "vagabond[ant] à l'aise dans les cauchemars et les
apothéoses." Zola 1991, p. 58.
17. On Solferino, see the notable discussion by Constance
Cain Hungerford in Meissonier 1993, pp. 166–71.
18. "restitution archéologique des moeurs et des choses."
Delaborde 1859, p. 502.
19. On this subject, see Ackerman 1986, pp. 82–83.
20. "droit d'écrire l'histoire avec [son] pinceau." Ibid., p.
82.

Napoléon, with all his conventional mannerisms— his bicorne and
gray frock coat, his right hand in his coat, and his pensive look
—leads the endless column of lieutenants and soldiers. The stormy
sky, the muddy, half-frozen road, the upturned shako foreshadow
the inevitable defeat.

Similarly, the power and novelty of Gérôme's images gave origi-
nality to some of his compositions. Gérôme continued in a neo-
Greek vein, presenting Diogenes, Phryne, and Alcibiades in paintings
that received the same criticism and the same praise as his *Roi
Candaule* (fig. 13). But he also expanded the "pictorial chronicle"
to eras other than Greek and Roman antiquity; his characteristic
thoroughness was evident in the "archaeological re-creation of cus-
toms and objects" in his *Louis XIV et Molière* (Salon of 1863; fig. 43).[18]
This painting continued the troubadour tradition—Gérôme merely
changed the costumes. However, his determined innovation was clear
in his entries at the Salon of 1868—*L'Exécution du maréchal Ney*
(fig. 44) and *Jérusalem* (fig. 45)—whose unsettling images were not
traditional. Ney's son, the prince de La Moskowa, would try unsuc-
cessfully to have this painting of his father's death barred from the
Salon. In *L'Univers*, Louis Veuillot's Catholic newspaper, Claudius
Lavergne harshly attacked Gérôme's religious painting *Jérusalem*.[19]
The artist, however, asserted his "right to paint history with [his]
brush," that is, to present, as all historians do, a version of events
which he regarded as true and which he supported with extensive
research.[20] Gérôme presented the raw facts without interpretation
or "historic" orchestration. His title for the death of Ney was *Le 7
décembre 1815; neuf heures du matin* (fig. 44). The man who died
early on a cold, cloudy day was not the hero of the imperial wars
but a bourgeois clad in black, lying in the mud by a long bare

Fig. 44. Jean-Léon Gérôme, *7 décembre 1815; neuf heures du matin
(L'Exécution du maréchal Ney) (December 7, 1815; 9 A.M.
[The Execution of Maréchal Ney]),* 1867. Oil on canvas, 25¼ x 51⅜ in.
(64 x 130.5 cm). City Art Galleries, Sheffield

Fig. 45. Jean-Léon Gérôme, *Jérusalem,* 1867. Oil on canvas, 32 x 57½ in.
(81.3 x 146 cm). Musée d'Orsay, Paris

wall. The man who died at three in the afternoon on a Jerusalem hill was simply a self-proclaimed king of the Jews, crucified between two thieves. Once more the title explains the painting. This Crucifixion does not have the conventional elements of eyes looking upward, tortured bodies, dejected disciples, and mournful women. Rather, it is Jerusalem seen by a curious onlooker captivated by the awesome shadows of three crosses, cast by a sunbeam in the dark sky. By searching for innate truth and rejecting conventions, Gérôme risked the criticism that by catering to contemporary taste for the literal, he was reducing history to anecdote. Many saw the return to essentials as a flattening out, always futile and sometimes sacrilegious, of great historical moments. Castagnary, who was still a proponent of naturalism, should perhaps have appreciated the dreadful exactness of Ney's execution scene, but he saw only the woeful end of a "drunk whom the morning patrol forgot to pick up."[21]

Gérôme believed that to be an informed and accurate historian, one must be meticulous and objective; one must present details evenhandedly; one must compete with the photographic illusion of unmediated reality. This approach, regarded as dull and narrow by the New Painting artists, was at least as responsible for the gulf between them and Gérôme as were their contrary conceptions of history painting. Bouguereau's silly porcelainlike images were laughed at, but Gérôme was more harshly attacked; more talented, he came to embody everything that Impressionism rejected. A comparison of paintings of approximately the same date shows the abyss that separated Gérôme and Manet. In Gérôme's work (fig. 46) the image is cold and distant, precise and oddly silent despite the size of the crowd and the drama of the moment; Manet's painting (fig. 47) is open and lively, a "fluttering" image where the artist wanted to put down a "fleeting view of this motley assembly."[22] And Degas never missed an opportunity to poke fun at members of the Institute. As Gérôme stood dumbfounded before Degas's *Petites Filles spartiates provoquant des garçons* (fig. 70), the artist bantered: "I guess this isn't Turkish enough for you, Gérôme."[23] When the composer Ernest Reyer asked him about Gérôme's *Phryné devant l'Aréopage* (fig. 49), Degas questioned the plausibility of the scene, saying dryly: "Listen, I'm going to talk to you about thought, not painting but thought. Phryne was one of the glories of her age because of her beautiful body. She was honored in Greece—people there knew to honor beauty. The philosophers were proud to know her. What can one say of a painter who makes Phryne a poor shameful creature who tries to conceal herself? Phryne did not conceal herself, could not conceal herself since her nudity was the source of her glory. Gérôme did not understand and thus made this painting a pornographic

Fig. 46. Jean-Léon Gérôme, *Taureau et Picador (Bull and Picador)*, 1867–68. Oil on canvas. Whereabouts unknown

Fig. 47. Édouard Manet, *Combat de taureaux (Bullfight)*, 1866. Oil on canvas, 35⅜ x 43¼ in. (90 x 110 cm). Musée d'Orsay, Paris

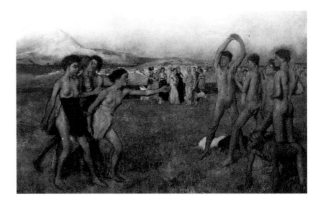

Fig. 48. Edgar Degas, *Petites Filles spartiates provoquant des garçons (Young Spartans)*, ca. 1860–62, retouched in 1880. Oil on canvas, 42⅞ x 61 in. (109 x 155 cm). The Trustees of the National Gallery, London

21. Castagnary 1892, pp. 261–62.
22. "l'aspect rapide de cet assemblage de monde tout bariolé." Letter from Manet to Astruc, cited in Paris, New York 1983, p. 237.
23. "Je suppose que ce n'est pas assez turc pour vous, Gérôme?" Cited by George Moore, *Impressions and Opinions* (New York, 1891), p. 306.

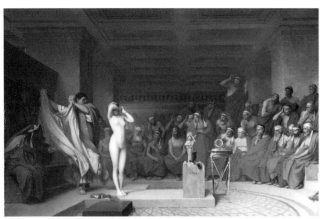

Fig. 49. Jean-Léon Gérôme, *Phryné devant le tribunal (Phryné devant l'Aréopage) (Phryne before the Areopagus)*, 1861. Oil on canvas, 31¾ x 50⅜ in. (80.5 x 128 cm). Kunsthalle Hamburg

Fig. 50. Paul Delaroche, *Les Enfants d'Édouard (The Children of Edward IV)*, 1830. Oil on canvas, 71¼ x 84⅝ in. (181 x 215 cm). Musée du Louvre, Paris

Fig. 51. Paul Baudry, *Charlotte Corday*, 1860. Oil on canvas, 79⅞ x 60⅝ in. (203 x 154 cm). Musée des Beaux-Arts, Nantes

24. "Écoutez, je vais vous parler pensée, pas peinture, pensée. Phryné était une des gloires de son temps à cause de la beauté de son corps. On l'honorait en Grèce, comme ces gens-là savaient honorer la beauté. Tous les philosophes se faisaient gloire de la connaître. Que dire du peintre qui a fait de *Phryné devant l'Aréopage* une pauvre honteuse qui se cache? Phryné ne se cachait pas, ne pouvait pas se cacher, puisque sa nudité était précisément la cause de sa gloire. Gérôme n'a pas compris, et a fait de ce tableau, par cela même, un tableau pornographique." Georges Jeanniot, "Souvenirs sur Degas," *La Revue universelle* 55 (October 15, 1933), p. 172.

25. "Ce qui me fait plaisir, c'est qu'il y a contre nous une vraie animosité. C'est M. Gérôme qui a fait tout le mal, il nous a traité de bandes de fous, et déclaré qu'il croyait de son devoir de tout faire pour empêcher nos peintures de paraître." Bazille 1992, p. 172.

image."[24] Gérôme returned Degas's animosity. A pillar of the establishment, Gérôme became a teacher at the École des Beaux-Arts in 1864, a member of the Institute in 1865, and an officer of the Légion d'Honneur in 1867; he was an influential member of the Salon jury, and he worked to keep the artists of the New Painting out. In 1869 Bazille was told of the jury deliberations by Alfred Stevens; when all his works except *Vue de village* (fig. 182) were rejected, he wrote to his father: "The strong animosity toward us gives me pleasure. M. Gérôme has caused it all—he called us a pack of lunatics and said it was his duty to do everything possible to prevent our paintings from being shown."[25]

In the 1860s the contamination of history painting by genre painting was a cause célèbre. Gérôme was regarded as a leader, but the painter-writer Eugène Fromentin had earlier singled out Paul Delaroche for blame. The latter had, since the Bourbon restoration, presented tragic events of French and British history. In his notes for *Une année dans le Sahel (A Year in the Sahel*, 1858) Fromentin denounced Delaroche more explicitly than in the published version, curiously mentioning Delacroix, his own master and friend, in the reproving aphorisms:

It is not difficult to prove that even in his large so-called history paintings Delacroix is only a genre painter.

What can be said of Delaroche whose great success is his *Duc de Guise*; what can be said of his *Jeanne Grey* [The Execution of Lady Jane Grey], of his *Enfants d'Édouard* [fig. 50]?

Would they have suffered if they had been smaller?

How do they differ from genre painting other than in dimension? The difference is in size rather than in concept.

What is genre painting if not anecdote introduced into art, whatever genre it happens to be?

The fact rather than the plastic concept.

The story if there is a story; the scenery.

The authenticity of the costume, the plausibility of the effect, in other words, the truth be it picturesque or historical.

All the things alien to fine art.[26]

Ten years later Castagnary described with delight the widespread havoc in history painting, which could not be stemmed by the rewards, titles, and commissions that the comte de Nieuwerkerke, the intendant of the Beaux-Arts, gave to his favorites, the supporters of "church art" and "palace art." He observed, "*History* [painting] was going through a transformation into *genre*—that is, the representation of the practices, the clothing, the figures, the characters, the customs, all the visible realities of the world—*genre*, disparaged, damned, persecuted, and yet developing, growing, outrunning its old boundaries, rising to the height of *history*." Paul Baudry's *Charlotte Corday* (fig. 51) triggered a controversy at the Salon of 1861. There was so much debate about the scene's authenticity that the "artistic aspect was forgotten or misunderstood."[27] In the *Gazette des Beaux-Arts* Lagrange recounted the questions that art critics and visitors asked about Corday's clothing, the time of the murder, the light (too bright for such a lowly abode), Marat's flesh (too white for a common man), and the murderer's demeanor (not that of someone who had just committed a crime) and expression (not proud as it should have been but stupefied).[28] History painting had become an inquest; the art of painting was hardly an issue.

The perversion of history by genre painting has been, for good reason, much discussed, but less has been said of the inverse movement—from history to genre—which was important in the genesis of Impressionism. The second process carried the solidity, permanence, and solemnity of history painting into genre painting which was inherently ephemeral and subject to the influence of fashion. The often-prescient Castagnary saw this movement in the Salon of 1857: "The artist has finally understood, as the poet before him, that a work's value is not at all found in the importance of the characters depicted, be they gods or heroes, but rather in the magnitude of passion, the depth of sentiment, the vividness of line. He has become convinced that a beggar standing in the sun has more elements of true beauty than a king on his throne; that a team of horses working in the clear, cold morning light has a religious solemnity equal to that of Jesus preaching on the mount; that three peasant women bent over, gleaning a harvested field, while on the horizon the owner's carts creak under the weight of the sheaves,

Fig. 52. Jean-François Millet, *Les Glaneuses* (*The Gleaners*), 1857. Oil on canvas, 32⅞ x 43¾ in. (83.5 x 111 cm). Musée d'Orsay, Paris

26. "Il n'est pas difficile de prouver que même dans ses grands tableau dits d'histoire, Delacroix n'est qu'un peintre de genre.

Que dire de Delaroche, dont le triomphe est le *duc de Guise*, que dire de la *Jeanne Grey*, des *Enfants d'Édouard*?

Souffriraient-ils à être faits petits?

En quoi diffèrent-ils du genre, sinon par la dimension? La différence est donc dans la mesure et non dans l'idée.

Qu'est-ce [que le] genre, sinon l'anecdote introduite dans l'art, de quelque genre qu'elle soit?

Le fait, au lieu de l'idée plastique.

Le récit quand il y a récit, la scène.

L'exactitude du costume, la vraisemblance de l'effet, en un mot la vérité, soit pittoresque soit historique.

Toutes choses étrangères au grand art." "Notes sur le genre dans la peinture" in Fromentin 1984, p. 921; see also a corresponding passage in *Une année dans le Sahel*, ibid. pp. 315–16. On the contamination of history painting by genre and the example of Delaroche, see Mainardi 1987, pp. 154ff. See also, on Pils's *Rouget de l'Isle*, Geneviève Lacambre in *L'Art du XIXᵉ siècle*, 1990, p. 24.

27. "*L'histoire* achevait le mouvement de conversion par lequel elle s'achemine au *genre*, c'est-à-dire les usages, les costumes, les personnages, les caractères, les moeurs, toutes les réalités visibles du monde présent, le *genre* si décrié, si maudit, si persécuté, se développait, grandissait, sortait de ses anciennes limites, montait à la hauteur de l'*histoire*"; "question d'art s'est trouvée oubliée ou méconnue." Léon Lagrange, "Salon de 1861," *Gazette des Beaux-Arts*, June 1, 1861, p. 279.

28. Ibid., pp. 279–80. On Baudry's *Charlotte Corday*, the main source is Edmond About, "Salon de 1861," *L'Opinion nationale*, May 22, 1861, p. 2; Claude Vignon, "Une visite au Salon de 1861," *Le Correspondant*, May 25, 1861, pp. 151–52; Henry Fouquier, "Le Salon de 1861," *Revue du mois*, July 1861, pp. 350–51; Armand Maillard, "Salon de 1861," *La Mode de Paris*, June 16, 1861, p. 155. At the Salon of 1859 there was an intense debate regarding the *Dernière séance* by Henry-Guillaume Schlesinger on similar grounds, especially on the color of Charlotte Corday's hair; see E. J. Delécluze, "Exposition of 1859," *Journal des débats*, May 13, 1859, p. 2; May 26, 1859, pp. 1–2.

Fig. 53. Jean-François Millet, *Un paysan greffant un arbre* (*A Peasant Grafting a Tree*), 1855. Oil on canvas, 31⅞ x 39⅜ in. (81 x 100 cm). Bayerische Staatsgemäldesammlungen, Munich

Fig. 54. Jean-François Millet, *Le Repas des moissonneurs* (*The Harvesters' Meal*), 1853. Oil on canvas, 26½ x 47⅛ in. (67.4 x 119.8 cm). Museum of Fine Arts, Boston

Fig. 55. Jean-François Millet, *Un paysan se reposant sur sa houe* (*L'Homme à la houe*) (*Man with a Hoe*), 1860–62. Oil on canvas, 31½ x 39 in. (80 x 99 cm). Collection of the J. Paul Getty Museum, Malibu, California

29. "L'artiste comprend à la fin, comme le poète l'a compris avant lui, que ce qui fait la valeur d'une oeuvre, n'est point l'importance des personnages qui y figurent, dieux ou héros, mais la grandeur de la passion, la profondeur du sentiment, le pittoresque de la ligne. Il a acquis cette conviction qu'un mendiant sous un rayon de soleil est dans des conditions de beauté plus vraies qu'un roi sur son trône; qu'un attelage marchant au labour sous un ciel clair et froid du matin, vaut, comme solennité religieuse, Jésus prêchant sur la montagne; que trois paysannes courbées, glanant dans un champ moissonné, tandis qu'à l'horizon les charettes du maître gémissent sous le poids des gerbes, étreignent le coeur plus douloureusement que tout l'appareil des tortures s'acharnant sur un martyr." Castagnary 1892, pp. 13–14.

30. "une oeuvre d'art très belle, et très simple, franche de toute déclamation . . . une de ces pages de la nature vraies et grandes, comme en trouvaient Homère et Virgile." Ibid., p. 24.

31. The best recent analyses of the works of Millet are those by Robert L. Herbert (in Millet 1975) and by André Fermigier (Fermigier 1977).

touch the heart more painfully than all the paraphernalia of torture that besets a martyr."[29] The "three peasant women" Castagnary cited were those in Jean-François Millet's *Glaneuses* (fig. 52), which was exhibited in the Salon of 1857. Castagnary went on: "A very beautiful and very simple work, free of any moralizing . . . a true and noble page from nature like those found in Homer and Virgil."[30] Since 1850, in what was in fact a response to Delaroche, Millet had been bringing something of history's epic greatness to his peasant subjects and had turned an often wretched everyday life into an authentic saga.[31] The *Repas des moissonneurs* (fig. 54) is a modern version of the biblical story of Ruth and Boaz. In *Un paysan greffant un arbre* (fig. 53) Millet gave his three figures—a man, a woman, and a child—the serenity, gravity, and prayerfulness of a Holy Family. Millet's supporters and critics praised or condemned him for this manner. Some laughed at the "enormous pretensions" of these gleaners, posed like the "three Fates of pauperism";[32] others found the *Femme faisant paître sa vache* (fig. 6) "philosophic, melancholy, and Raphaelesque" and were touched by *L'Homme à la houe* (fig. 55), a "pitiful Christ of eternal labor."[33] Unlike Jules Breton (fig. 10), who treated figures similar to Millet's in an agitated, overly decorative, and anecdotal manner, Millet was sparing with lines and movement, always simplifying and stylizing forms; "rarefying" them in the words of a critic who feared "he would stop being a painter and would become someone who isolates essences."[34] Millet's example would not be lost on Puvis de Chavannes.

Thus, rather than announce the death of history painting, it is more accurate to emphasize its dissolution into genre painting. Instead of dying, history painting took on other forms, profiting from the erosion of old categories and appearing where it had never been before. This evolution can be seen in the relationship that Manet

Fig. 56. Auguste Renoir, *Diane chasseresse (Diana the Huntress)*, 1867. Oil on canvas, 77½ x 52 in. (197 x 132 cm). National Gallery of Art, Washington

Fig. 57. Frédéric Bazille, *Ruth et Booz (Ruth and Boaz)*, 1870. Oil on canvas, 54⅜ x 79½ in. (138 x 202 cm). Private collection

and especially Degas had with history painting. In 1859 Paul de Saint-Victor stiffly remarked about Millet's entry (fig. 6): "Why take on Etruscan airs when one has merely returned from Poissy?"[35] Ten years later the critic had his answer.

In the 1860s the artists of the New Painting explored some of history painting's heavenly mansions: biblical history, antiquity, religious painting, contemporary history, allegories, fanciful subjects, and variations on literary and musical themes. Manet was the most versatile; Fantin-Latour stayed with one note. And there were varying degrees of perseverance. Renoir stopped after two attempts on the borders of history painting. In 1864 he sent his *Esméralda*, based on Victor Hugo's *Notre-Dame de Paris*, to the Salon and in 1867 his *Diane chasseresse* (fig. 56). The latter, despite its thin mythological disguise, was Renoir's tribute to Courbet, with stately bathers and game from the forest of Ornans side by side on the canvas. In the summer of 1870, a few months before his death, Bazille made a sally into history painting with his large *Ruth et Booz* (fig. 57), which owes more to Victor Hugo than to the Bible. Following Puvis's star, Bazille created a legendary and exotic nocturnal variation of figures in a landscape, a dominant theme of his work.

Some painters were more persistent. After 1862 Fantin-Latour, a realist painter, specialized in imaginary subjects, fantasies on Wagnerian and Schumannian themes, and mythological variations, with an occasional attempt at religious painting.[36] Unlike his stern portraits, painted in a somber, narrow palette, and his tranquil still lifes where flowers and fruits only murmur, the invented subjects are lively, passionate, and busy. Fantin made extensive use of theatrical devices, clouds, mist, and artificial light, as though he were becoming profligate after making pious sacrifices in his devotional

32. "prétentions gigantesques"; "comme les trois Parques du paupérisme." Paul de Saint-Victor, cited in Paris, London 1975–76, p. 100.
33. "philosophique, mélancolique et raphaëlesque." Baudelaire 1985–87, vol. 2, p. 661. "lamentable Christ du labour éternel." Castagnary 1892, p. 152.
34. "raréfie"; "cess[er] d'être peintre pour devenir abstracteur de quintessence." A. J. Du Pays, "Salon de 1859," *L'Illustration*, May 21, 1859, p. 342.
35. "Pourquoi prendre des airs étrusques quand on revient de Poissy?" Paul de Saint-Victor, "Salon de 1859," *La Presse*, May 25, 1859, p. 1.
36. In 1862 he sent four drawings (Fantin-Latour 1911, nos. 197–200) and in 1865 *Le Jugement de Pâris (The Judgment of Paris)* (Fantin-Latour 1911, no. 276). In 1867 he sent *Une Vierge et deux saintes (A Virgin and Two Saints)* (Fantin-Latour 1911, no. 298).

Fig. 58 (cat. 71). Henri Fantin-Latour, *Scène du Tannhäuser* (*Tannhäuser on the Venusberg*), 1864. Oil on canvas, 38⁷⁄₁₆ x 51⁵⁄₁₆ in. (97.5 x 130.2 cm). The Los Angeles County Museum of Art, Gift of Mr. and Mrs. Charles Boyer

exercises. The influence of the Venetians, whom he often copied, and of Delacroix, whom he venerated, are apparent in these works. At the Salon of 1864 Fantin paid Delacroix a double tribute. The official one, *Hommage à Delacroix* (fig. 233), is as austere as a funerary monument; the other, unacknowledged but more appropriate and affectionate, is *Scène du Tannhäuser* (fig. 58) whose ardor and palette recall those of the master.

Except for *Madeleine* (fig. 66) and *Christ aux limbes* (fig. 67), two details from the same canvas, paintings of imaginary subjects also dominated Cézanne's oeuvre. These often-violent scenes would later be ascribed to the artist's youthful wildness, a sort of romantic fever that maturity would calm. Citing Cézanne's enthusiasm for Decamps's *Bataille des Cimbres* (*Battle against the Cimbri*; Musée du Louvre, Paris) and Delacroix's *Entrée des Croisés à Constantinople* (*The Crusaders' Entrance into Constantinople*; Musée du Louvre,

Fig. 59 (cat. 33). Paul Cézanne, *Le Festin* (*The Banquet*), ca. 1870. Oil on canvas, 50¾ x 31½ in. (129 x 80 cm). Private collection

Paris), Joachim Gasquet pointed out his "taste for vibrant renderings which always needed a sort of sanctity to oppress."[37] The ascetic Cézanne, sworn to the classicism of apples and Mont Sainte-Victoire, struggled to thrust aside the tempting visions, sometimes erotic or brutal but always passionate, which came to him. He did so with the faith of a Saint Anthony (one of his favorite figures), putting to flight apparitions as, fearful of women, he had banished nude models from his studio.[38] Studies of the young Cézanne's pictorial and literary sources, affiliations, and influences (particularly Delacroix

37. "goût des vibrantes évocations qu'il mit toujours une sorte de sainteté à étouffer." Gasquet 1926, pp. 12–13.
38. On this subject, see the complete analysis of Krumrine 1989.

and the generation of 1830) place his early paintings firmly within his oeuvre and emphasize the originality of his grand, harsh, passionate, dense manner, unequaled in the painting of the time.[39]

Antonin Proust reported that Manet thought that being called a "history painter" was "the most wounding insult that can be made to an artist."[40] However, Manet, as well as Degas, was obsessed with this genre. While the landscape artists—Monet, Pissarro, Sisley—remained uninterested, Manet executed, mostly in the 1860s, religious and contemporary history paintings. He pursued this work through the heyday of Impressionism (for example, the two versions of *L'Évasion de Rochefort* [*Rochefort's Escape*], 1880–81) and was always thinking about a Crucifixion.[41] From 1859 to 1865 Degas spent most of his time on history painting, making numerous drawings and sketches for ambitious compositions, most of which were unrealized. His activities at this time owed nothing to the early Impressionists but were influenced by Moreau (fig. 69) and Puvis de Chavannes (figs. 23, 60), with whom he shared a disdain for archaeological re-creation, a taste for allegory, and a predilection for

39. The following should be added to the recent bibliography cited in Cézanne 1988 and Krumrine 1989: Robert Simon, "Cézanne And the Subject of Violence," *Art in America*, May 1991, pp. 120–35, 185–86, Peter Kropmanns, "Cézanne, Delacroix et Hercule: Réflexions sur *L'Enlèvement*, 1867, oeuvre de jeunesse de Paul Cézanne," *Revue de l'art* 100 (1993), pp. 74–83.
40. "peintre d'histoire [était] la plus sanglante injure que l'on pût adresser à un artiste." Proust 1897, p. 21.
41. Ibid., p. 64.

LA GUERRE

Fig. 60 (cat. 167). Pierre Puvis de Chavannes, *La Guerre* (*War*), 1867 (reduced version of the painting shown at the Salon of 1861). Oil on canvas, 43⅛ x 58¾ in. (109.5 x 149.2 cm). The John G. Johnson Collection, Philadelphia Museum of Art

Fig. 61 (cat. 55). Edgar Degas, *Scène de guerre au Moyen Âge (Scene of War in the Middle Ages)*, 1865. Essence on paper mounted on canvas, 31⅞ x 57⅝ in. (81 x 147 cm). Musée d'Orsay, Paris

large synthetic drawings and for the muted tonalities of frescoes. The reasons for Manet's and Degas's abandonment of history painting remain unknown, but in both cases the failure of their history paintings must have played a role. In 1865 Degas was finally accepted by the Salon, but his *Scène de guerre au Moyen Âge* (fig. 61) was ignored. Manet's *Exécution de Maximilien* (fig. 63), laboriously rendered in three large consecutive versions (1867–69), was censored by Louis-Napoléon's government. These two artists may also have had strategic reasons for their choices.

Scorned as a history painter, Degas undoubtedly thought that he would gain greater recognition with the portraits and contemporary scenes that he later sent to the Salon. Most important, he had come to believe that daily events could be rendered with the amplitude and ambition of history painting. Not disavowing any themes, he claimed that there were no low subjects: everything then became a matter of art. In 1866 *Scène de steeple-chase* (fig. 350), which followed *Scène de guerre au Moyen Âge*, shows two marvelous riderless horses that fly over a fallen jockey, passing across the canvas like medieval angels of death. Still later, *Intérieur* (fig. 344) completed this remarkable change: the everyday and the commonplace

Fig. 62. (cat. 99) Édouard Manet, *Le Combat des navires américains "Kearsarge" et "Alabama"* (*Battle of the "Kearsarge" and the "Alabama"*), 1864. Oil on canvas, 54¼ x 50¾ in. (137.8 x 128.9 cm). The John G. Johnson Collection, Philadelphia Museum of Art

have been raised to the order of history painting. Degas claimed that if he had lived in another century, he would have painted Susanna at her bath instead of his women at their tubs.[42] Indeed, had he lived in other times, he would not have painted *Intérieur* at all, but rather Tarquin and Lucretia. But for Degas the modest iron bed, the oil lamp, the flowered wallpaper, the middle-class fireplace had replaced columns, pilasters, tapestries, and candelabra; the camisole and the corset had replaced the peplum; and the top hat, the plumed helmet. A contemporary wish was fulfilled: "Ah! Giotto! Let me see Paris. Paris, let me *see* Giotto!"[43]

Always unsatisfied, Degas returned to his works over and over again; he sank into long torturous musings and was burdened

42. Halévy 1960, pp. 59–60.
43. "Ah! Giotto! laisse-moi voir Paris, et toi, Paris, laisse-moi *voir* Giotto!" Reff 1985, notebook 22 (BN, no. 8, p. 5).

with doubt and depression about his art and his career. Manet, however, was intuitive, spontaneous, and spirited (*Le Combat des navires américains "Kearsage" et "Alabama,"* fig. 62) or indignant (*L'Exécution de Maximilien,* fig. 63). In some ways they corresponded to the categories of painter and man of letters described by the Goncourts: one was remarkable for "the skillful use of hand and eye," the other for endless "mental anguish."[44] In fact, Degas recognized that Manet was very much a painter, that is—and this should not be taken the wrong way—he was more interested in the physical art of painting than in its intellectual underpinnings. Between *L'Exécution de Maximilien* and *L'Évasion de Rochefort,* Manet may not have found contemporary events that interested him, although in 1871, a supporter of the Commune, he may have considered a large composition on the siege by the troops of the Versailles government.[45] Manet must have been shaken by Zola's pronouncing the subject insignificant and by the increasing public dissatisfaction with this genre. With *Le Combat des navires américains "Kearsage" et "Alabama"* and *Le "Kearsage" à Boulogne* (fig. 289), two frames from the same film, Manet had himself played with the fine border between genres: history painting—the combat scene, the swirls of smoke as the Confederate ship sinks—and marine painting—the winners' corvette on a calm sea with curious sailboats fluttering around it. Painting history, for Manet, Degas, Cézanne, and Fantin-Latour, meant placing oneself within a continuity, announcing one's allegiance to the old masters, to the endurance of great themes, to the art of museums. Those who view Impressionism only as a rupture with the past and a prefiguration of modern art have neglected history paintings by these artists. These critics limit themselves to listing sources and searching for past analogies, emphasizing the bondage of a type of painting that descended from established models and lacked the courage to abandon an oppressive past.

Degas's numerous formal borrowings in *La Fille de Jephté* (fig. 64) and *Sémiramis construisant Babylone* (fig. 65) have long been regarded as proof of his ineptness as a history painter: archaeological finds and the Italian Renaissance came to the aid of young artists who could not conceive original compositions. However, to enumerate what *La Fille de Jephté* borrowed from Girolamo Genga, Cesare da Sesto, and Mantegna and what *Sémiramis construisant Babylone* owed to recent Assyrian discoveries, Greek sculpture, Luca Signorelli, Piero della Francesca, and François Clouet is to overlook the uniqueness of these paintings. The *Fille* is an ambitious emulation of Delacroix's large, colorful, and animated works; *Sémiramis* is a chilly frieze that rejects the artist's earlier energy.

Of course, it is often impossible to determine exact sources. Thus,

Fig. 63. Édouard Manet, *L'Exécution de Maximilien* (*The Execution of Maximilian*), 1868–69. Oil on canvas, 99¼ x 120 in. (252 x 305 cm). Städtische Kunsthalle, Mannheim

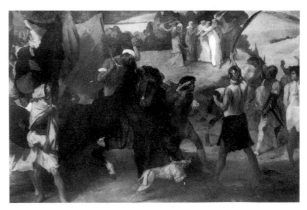

Fig. 64. Edgar Degas, *La Fille de Jephté* (*Jephthah's Daughter*), ca. 1859–61. Oil on canvas, 77 x 115½ in. (195.5 x 293.5 cm). Smith College Museum of Art, Northampton, Massachusetts

Fig. 65. Edgar Degas, *Sémiramis construisant Babylone* (*Semiramis Building Babylon*), ca. 1860–62. Oil on canvas, 59 x 101⅝ in. (150 x 258 cm). Musée d'Orsay, Paris

44. "une fonction heureuse de la main et de l'oeil"; "supplice du cerveau." Goncourt 1956, vol. 8, p. 200.
45. Paris, New York 1983, pp. 323–28.

Fig. 66 (cat. 27). Paul Cézanne, *La Madeleine (Mary Magdalen)*, ca. 1867. Oil on canvas, 65 x 49⅜ in. (165 x 125.5 cm). Musée d'Orsay, Paris

Fig. 67. Paul Cézanne, *Le Christ aux limbes et la Madeleine (Christ in Limbo and the Magdalen*, before the canvas was cut), ca. 1867. Oil on canvas, 66⅞ x 38¼ in. (170 x 97 cm). Private collection

Manet's *Les Anges au tombeau du Christ* (fig. 68) was vaguely accused of being a pastiche of El Greco by the well-meaning Thoré, was defended by Baudelaire, and was said to derive from Francisco Ribalta, Veronese, or Tintoretto—who executed similar compositions, as did many others—and also from David or Gericault.[46] Cézanne's *Madeleine* (fig. 66) was declared to have been inspired by Domenico Feti's *Melancholy* (Musée du Louvre, Paris), by a Magdalen once attributed to Pierre Subleyras (Musée Granet, Aix-en-Provence), and by a figure in the Avignon Pietà.[47]

Portraiture is dependent on fashionable whims, and landscape painting attempts to fix a constantly evolving nature; but in taking up eternal themes, history painting, like the nude (see pp. 94–123), forced the artist to confront the old masters. In the 1860s, when history painting was so vehemently discussed and challenged, it

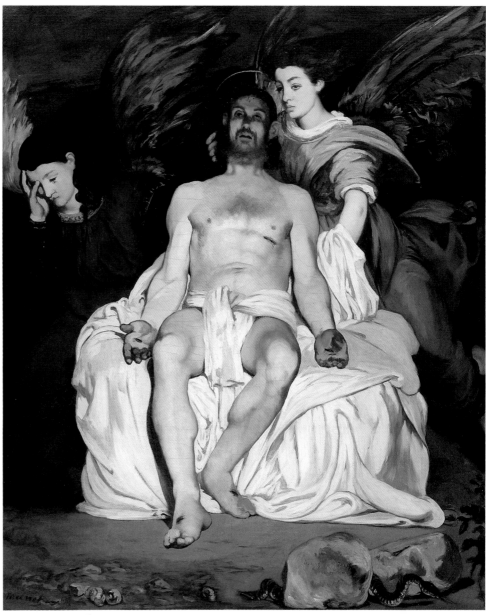

Fig. 68 (cat. 96). Édouard Manet, *Les Anges au tombeau du Christ (Le Christ mort aux anges)*
(*The Dead Christ and the Angels*), 1864. Oil on canvas, 70⅝ x 59 in. (179.4 x 149.9 cm). The Metropolitan
Museum of Art, New York, H. O. Havemeyer Collection, Bequest of Mrs. H. O. Havemeyer, 1929

was also polemical. When the "realist" Manet painted *Les Anges au tombeau du Christ* in 1864, he was rebelling against Courbet's statements of three years earlier: "Art in painting consists only of representations of objects visible and tangible to the artist"; "Painting is essentially a *concrete* art and consists only of representations of *real* and *existing* things"; "An *abstract* object, not visible, not existing, is not within the realm of painting." Manet answered this stream of nonsense with *Les Anges*, an admirable utilization of "convention" (Courbet would write that "beauty in nature is superior to all the conventions of artists").[48] Courbet's reaction to these winged beings was immediate; according to Renoir, he upbraided Manet: "So you have seen angels then and know that they have backsides?"[49]

With his *Petites Filles spartiates provoquant des garçons* (fig. 70), Degas addressed Gérôme. On the arid Spartan plain, the young

46. El Greco: Baudelaire 1983, vol. 2, p. 386; William Bürger (Théophile Thoré), "Salon de 1864" in Thoré-Bürger 1870, vol. 2, pp. 99–100.

Ribalta, Veronese, or Tintoretto: see Charles S. Moffett in Paris, New York 1983, p. 201; Michel Florisoone, "Manet inspiré par Venise," *L'Amour de l'art*, January 1937, pp. 26–27.

David or Géricault: Michael Fried, "Manet's Sources: Aspects of His Art, 1859–65," *Art Forum*, March 1969. See refutations of Fried in Theodore Reff, "Manet's Sources: A Critical Evaluation," *Art Forum*, September 1969.

47. Feti: Albert Châtelet in exh. cat., Orangerie des Tuileries, Paris, 1954, p. 5. Subleyras: Carol Salomon Kiefer, "Cézanne's 'Magdalen': A New Source in the Musée Granet, Aix-en-Provence," *Gazette des Beaux-Arts*, February 1984, pp. 91–94. Avignon Pietà: Paris Orangerie des Tuileries, 1974, *Cézanne dans les musées nationaux*, July 20–October 14, 1974, no. 1, p. 25.

48. "L'art en peinture ne saurait consister que dans la représentation des objets visibles et tangibles pour

Fig. 69 (cat. 152). Gustave Moreau, *Hésiode et les Muses* (*Hesiod and the Muses*), ca. 1860. Oil on canvas, 52⅜ x 52⅜ in. (133 x 133 cm). Musée Gustave Moreau, Paris

l'artiste"; "la peinture est un art essentiellement *concret et ne peut consister que dans la représentation des choses réelles et existantes*"; "Un objet *abstrait*, non visible, non existant, n'est pas du domaine de la peinture." "Lettre de M. Courbet," *Le Courrier du dimanche*, December 29, 1861, p. 4.

49. "Tu as vu des anges, toi, pour savoir s'ils ont un cul?" Ambroise Vollard, *Renoir* (Paris, 1920), p. 44.

50. "l'expert en mignonnes archéologies." Gautier 1859, p. 49.

51. *La Fille*: Loyrette 1991, pp. 166–67; *Sémiramis*: Paris, Ottawa, New York 1988–89, p. 92.

52. Hélène Adhémar, "Edgar Degas et la Scène de guerre au Moyen Age," *Gazette des Beaux-Arts*, November 1967, pp. 295–98.

Lacedaemonian girls aroused "the expert on pretty archaeologies"[50] more than the indifferent ephebes. Like Moreau, who evoked a similar Greece of graceful youths in his *Hésiode* (fig. 69), Degas made few concessions to historical detail or local color. Instead he created a dream of antiquity based on slender documentation—his reading of a passage in Plutarch or in Abbé Jean Jacques Barthélemy.

Like the old masters to whom he so often referred, Degas concealed contemporary meanings in historical settings. Thus, *La Fille de Jephté* (fig. 64) can be seen as a critique of Napoléon III's foreign policy in Italy, while *Sémiramis construisant Babylone* (fig. 65) implicitly deplores Baron Haussmann's rebuilding of Paris.[51] *Scène de guerre au Moyen Âge* (fig. 61) is an allegorical treatment of the American Civil War and the Northern soldiers' cruelty toward the women of New Orleans.[52] Manet's *Les Anges au tombeau du Christ* (fig. 68) and *L'Exécution de Maximilien* (fig. 63) present contemporary themes in a similar veiled manner. The first work is most likely based on Ernest Renan's *Vie de Jésus* (Life of Jesus; 1863), which took a historical rather than theological view. *L'Exécution de*

Fig. 70 (cat. 51). Edgar Degas, *Petites Filles spartiates provoquant des garçons* (*Young Spartan Girls Provoking Boys*), 1860.
Oil on canvas, 37¾ x 50⅜ in. (96 x 128 cm). The Art Institute of Chicago, Charles H. and Mary F. S. Worcester Collection

Maximilien is not a journalistic report of the sad events in Querétaro but rather a damaging indictment of French foreign policy in Mexico.[53] Degas's belief that Napoléon III had sacrificed Italy to Austria in the Villafranca peace agreement of 1859 was presented graphically as the biblical king Jephthah's sacrifice of his daughter after his victory over the Ammonites. By subtly modifying the available data, Manet demonstrated that French negligence and cowardice had killed Maximilian. Fantin-Latour had similar polemical intentions but without a political end. In 1864, when he painted *Scène du Tannhäuser* (fig. 58), he chose the scene of carnal love at the Venusberg that had shocked the audience and caused the failure of this Wagnerian opera three years earlier.

In 1876, at the second Impressionist exhibition, Duranty again asserted that the revival of history painting was a primary ambition of the New Painting. Inspired by Degas, he wrote *La Nouvelle Peinture, à propos du groupe d'artistes qui expose dans les galeries Durand-Ruel* (New Painting as regards the group of artists showing at the

53. For an analysis of this painting, see my review of "Manet, The Execution of Maximilien," a 1992 exhibition, at the National Gallery, London, in *Burlington Magazine*, September 1992, pp. 612–14.

Fig. 71. Gustave Moreau, *Orphée* (*Orpheus*), 1865. Oil on panel, 59½ x 39⅛ in. (151 x 99.5 cm). Musée d'Orsay, Paris

Fig. 72. Eugène Fromentin, *Centaures* (*Centaurs*), 1868. Oil on canvas, 80¾ x 51⅝ in. (205 x 131 cm). Musée du Petit Palais, Paris

54. On Degas's role in the writing of this tract, see Crouzet 1964, pp. 334–38.
55. Eugène Fromentin, "Les Maîtres d'autrefois," *La Revue des Deux Mondes*, February 15, 1876, pp. 777–78, 796–97.
56. "Tous deux sont parvenus à inspirer aux nouveaux groupes de ces jeunes gens qu'on élève au biberon de l'art officiel et traditionnel, un étrange système de peinture, borné au sud par l'Algérie, à l'est par la mythologie, à l'ouest par l'histoire ancienne, au nord par l'archéologie: la vraie peinture trouble d'une époque de critique, de bibelotage, et de pasticheries." For the sake

Durand-Ruel galleries).[54] In it Duranty responded to a section of Fromentin's *Maîtres d'autrefois* (Masters of the past) which had appeared in the *Revue des Deux-Mondes*.[55] Opening with a scathing attack on Fromentin and Moreau, he wrote that, in their attempt to take painting from its academic rut, "both of them succeeded in inspiring new groups of young people weaned on official and traditional art with an odd painting system bounded to the south by Algeria, to the east by mythology, to the west by ancient history, to the north by archaeology: a truly confused painting for an age of criticism, bibelot-collecting, and pastiche."[56] A few pages later, after Legros, Whistler, Félix Bracquemond, and Giuseppe de Nittis had been beatified, Degas was hailed as a hero of the New Painting (a much more satisfactory term than "Impressionism"). Before anyone else and better than anyone else, he abolished "the partition between the studio and daily life"; he made the artist emerge from "his snuffbox, his cloister, where he was in touch only with the heavens" and placed him "among men, in the world."[57] In a way Duranty's *Nouvelle Peinture* retraced Degas's steps after he returned to Paris from Italy and left behind the undecided young man who swore only by Moreau. At the second Impressionist exhibition Duranty had gleefully condemned Degas's mentor and named Degas leader of the New Painting. Indeed in 1876 Duranty subtly but not very elegantly disavowed a significant part of Degas's past. Moreau and his friend Fromentin were censured; Delacroix, whom Moreau discovered and who was surprisingly not counted a founder of the New Painting, was eclipsed by an odd trinity of Courbet, Ingres, and Millet. Duranty's opening diatribe took aim at the compositions that earned Moreau his greatest success at the Salons of 1864 and 1866: *Oedipe et le sphinx* (*Oedipus and the Sphinx*), purchased by Prince Napoléon, and *Orphée* (fig. 71), purchased by the state for the Musée du Luxembourg. (Degas would accuse Moreau of having an inordinate taste for bijouterie.) Duranty then assailed Fromentin's wearisome Saharan variations and his strange 1868 foray into high art: the depiction of a charming herd of male and female centaurs— "busts of Parisian grisettes on purebred horses"—in a patently local landscape (fig. 72).[58]

However, neither upbraiding the Moreau-Fromentin twosome nor praising the painters of modern life put an end to history painting. Duranty cudgeled those who reduced it to an easy recipe—a dusting of Carpaccio, a pinch of Veronese, a dash of Rubens and of Signol—and those who thought success lay in references to sacrosanct archaeological knowledge. He remarked that "they are unaware that for great artists and discerning minds the fire of contemporary life illuminates the classical world." He observed that Veronese's *Wedding at Cana* would have been "pitiable were it not

for those Venetian gentlemen"; he admired the daring metaphors of Renan, who went so far as to "compare Pontius Pilate to a Brittany prefect"; and he suggested that "the strength of the English in art" came from the fact that "in their minds, Ophelia was always *a Lady.*" There followed a condemnation of the teaching at the École des Beaux-Arts and then a return to the main theme. "The strength of Renaissance and earlier Italian artists came from the fact that under the veil of the antique, or even a classical label, they presented the customs, clothing, and decor of their own times. They depicted their personal lives; they recorded their era." After strewing the battlefield of history painting with fresh bodies, notably those of Gérôme and Mariano Fortuny, Duranty searched for signs of renewal. He cited Legros, who in his *Ex-voto* (fig. 73) of 1860 combined the "ingenuity and grandeur of fifteenth-century works with a modern sensibility" and Fantin-Latour and Manet. Duranty mentioned only the portraits and still lifes of Fantin-Latour and hailed Manet only for being the precursor of "plein air" painting and for having introduced "true sunlight" in his art.[59] He did not acknowledge that Fantin-Latour, inspired by the Venetians, had revived fables in art and that Manet had used "the fire of contemporary life" to illuminate the Gospels.

Duranty's blindness—largely strategic, with the intent of minimizing past successes in order to emphasize those of the revolution in progress—presaged the disdain and misunderstanding which greeted the Impressionists' many history paintings over the next century. Thus, until recently, Degas's history paintings were regarded as interesting, though unsuccessful, efforts by a painter who had not yet found himself, by a Degas before Degas, still waiting for the revelations of his friendships with Manet and Duranty. Manet was more tenacious, and after completing those symbols of modernity, *Le Déjeuner sur l'herbe* and *Olympia*, he painted Christ supported by angels and Christ insulted by soldiers (fig. 74). Then the subject was quietly abandoned. In 1867 Zola refused to be drawn into the controversy about religious orthodoxy that greeted Manet's *Anges au tombeau du Christ* (fig. 68)—"Some said this Christ was not a Christ, and I admit that that may be so"—and praised the painting as "a corpse painted in full light with candor and energy."[60] Degas belatedly challenged Courbet's remark to Vollard: "Yes, I know that Courbet said that never having seen angels, he did not know whether they had backsides and that, given their size, the wings Manet gave them could not have carried them. But I don't give a d . . . about any of this. In this *Christ aux anges*, there is line! And the paint's transparency! Ah, the *cochon!*"[61] In 1911 Hourticq began his discussion of this work: "Few painters are less suited to religious painting than Manet."[62] He then quoted from Lagrange's "Salon de 1864," which

Fig. 73. Alphonse Legros, *L'Ex-voto*, 1860. Oil on canvas, 68½ x 77½ in. (174 x 197 cm). Musée des Beaux-Arts, Dijon

Fig. 74. Édouard Manet, *Jésus insulté par les soldats* (*Jesus Mocked by the Soldiers*), 1865. Oil on canvas, 75⅜ x 58⅜ in. (191.5 x 148.3 cm). The Art Institute of Chicago

of convenience I have used the recent reprint of Edmond Duranty, "La Nouvelle Peinture," in Washington, San Francisco 1986, p. 477.

57. "la cloison qui sépare l'atelier de la vie commune"; "de sa tabatière, de son cloître où il n'est en relation qu'avec le ciel"; "parmi les hommes, dans le monde." Ibid., p. 482.

58. "bustes de grisettes parisiennes sur des chevaux pur sang." Jean Rousseau, "Eugène Fromentin," *L'Art* 8 (1877), p. 25; Thompson and Wright 1987, p. 230.

59. "ils ignorent que c'est au feu de la vie contemporaine que les grands artistes, les esprits sagaces éclairent ces choses antiques"; "piteuses sans ces gentilhommes de Venise"; "comparer Ponce Pilate à un préfet en Basse-

Bretagne"; "force des anglais dans l'art"; "vient de ce qu'Ophélie est toujours *une Lady* dans leur esprit"; "ce qui a fait la force des hommes de la Renaissance et des primitifs, c'est que, sous le voile antique, et il ne faut même pas dire le voile, mais simplement l'étiquette antique, ils ont exprimé les moeurs, les costumes et les décors de leur temps, rendu leur vie personnelle, enregistré une´ époque"; "l'ingénuité et la grandeur des oeuvres du xv^e siècle au sentiment moderne"; "plein air"; "vrai soleil." Washington, San Francisco 1986, pp. 477–80.

60. "on a dit que ce Christ n'était pas un Christ, et j'avoue que cela peut être"; "un cadavre peint en pleine lumière, avec franchise et vigueur." Zola 1991, p. 159.

61. "Oui, je sais, Courbet disait que n'ayant jamais vu d'anges il ne pouvait savoir s'ils avaient un derrière et au surplus qu'étant donné leur taille, ce n'étaient pas les ailes que leur avait mises Manet qui pouvaient les porter. Mais je me f... de tout ça; il y a dans ce *Christ aux Anges* un dessin! Et cette transparence de pâte. Ah! le cochon!" Ambroise Vollard, *Degas 1834–1917* (Paris, 1924), pp. 65–66.

62. "Peu de peintres étaient moins indiqués que Manet pour la peinture religieuse." Hourticq 1911, p. 37.

63. Zola 1991, p. 162; Hourticq 1911, p. 63.

64. Bazin: "Le sujet n'est pour lui qu'un prétexte à peindre. Le choix lui en est indifférent sauf dans la mesure où il est le moins chargé d'intentions morales et sert ses désirs de peintre"; Colin: "On peut être certain que la tragédie de Queretaro ne lui parut pas plus émouvante que la veste en velours noir du Déjeuner à l'atelier"; Florisoone: "*L'Exécution de Maximilien*, malgré la vérité des attitudes, est un autre chef d'oeuvre d'irréalisme; elle se place à l'opposé des *Scènes du 3 mai 1808* de Goya où la passion et la haine s'expriment par des gesticulations forcenées. Manet, lui, reste suprêmement indifférent." Cited by Sandblad 1954, p. 119.

65. "C'est le Trois Mai de Goya, moins ce que ce tableau signifie"; "Manet peignit la mort du condamné avec la même indifférence que s'il avait élu pour objet de son travail une fleur, ou un poisson"; "Restent les taches de différentes couleurs et l'impression égarante qu'un sentiment aurait dû naître du sujet: c'est l'étrange impression d'une absence." Bataille 1983, pp. 45–48.

66. On this evolution, see Françoise Cachin in Bataille 1983, pp. 5–13.

67. "manifeste laïc." Philip North, "Manet And Radical Politics", *Journal of Interdisciplinary History* 19 (winter 1989), pp. 457–59; "*Ululer.*" Sidney Geist, *Interpreting Cézanne* (Cambridge, Mass.), 1988, p. 15.

reproached Manet for ignoring his subject for mere color studies. By 1911, however, this criticism from half a century earlier had become high praise. This phenomenon—once-attacked qualities coming to be regarded as praiseworthy—is evident in responses to *Le Combat des navires américains "Kearsage" et "Alabama"* (fig. 62), which Zola, like Hourticq, saw as only a "marine" painting.[63] It is even more marked in comments about *L'Exécution de Maximilien* (fig. 63). In 1954 N. G. Sandblad surveyed critical reactions to *L'Exécution*. Germain Bazin (1932) stated: "For him, the subject is only a pretext for the act of painting. The choice is unimportant except to the extent that it is uncharged by moral content and that it serves his desires as a painter." Paul Colin (1932) observed: "The tragedy at Querétaro was certainly no more moving to him than the black vest in the Déjeuner à l'atelier." Michel Florisoone (1947) wrote: "*L'Exécution de Maximilien*, despite its realistic poses, is another masterpiece of unreality. It is radically opposed to Goya's *May 3, 1808*, where passion and hatred are expressed through frantic gesticulation. Manet remains supremely indifferent."[64] Georges Bataille analyzed *L'Exécution* at length in 1955 (it was the only history painting by Manet that he ever discussed). He began by quoting Malraux: "It is Goya's *May 3*, minus that painting's significance." He concluded: "Manet painted the death of the condemned man with the same indifference he would have shown if a flower or a fish had been his subject" and "What remains are spots of varying colors and the bewildering impression that some emotion should have been excited by the subject: it is the odd impression of an absence."[65]

Times have changed.[66] The standard speeches on pure painting and the tiresome perorations on the origins of modern art have been followed by serried ranks of dissertations that have succumbed to psychoanalytic vertigo or sociological delights. Manet, Degas, and Cézanne have become purveyors of images, like Gérôme and Meissonier before them. Now one can read that in *Les Anges au tombeau du Christ* (fig. 68), Manet painted a "secular manifesto" and that "the folds of the Magdalen's blouse (fig. 66) create the clearly visible letters ULU, the beginning of *ululer*, [French for] to wail or lament loudly."[67] Fortunately a few extraordinary voices put forward analyses that strike a balance between the scrutiny of the subject itself and a description of its physical rendering, between content and form. Take, for example, Bruno Foucart: "A painting by Manet—and this is what makes him as irritating and as pleasing as the bitterness of a lemon—follows two parallel melodic lines: that of pure painting and that of meaningful painting. The two lines are not exactly congruent but accompany each other, glance off each other, requiring the viewer to turn somersaults."[68]

In short, the wishes Duranty expressed in 1876 did not come true—Impressionism would neglect history painting. However, in about 1880 Degas returned to his *Petites filles* (fig. 48) intending to show it at the fifth Impressionist exhibition. There, among Degas's recent works (which were portraits and dance scenes), among the paintings of Cassatt, Gauguin, Morisot, and Pissarro, this work would have been a "historic" painting in every sense of the word, standing out from the rest but proving, as Degas must have intended, that the New Painting included not only landscapes, portraits, and genre scenes but also history painting. In this "definitive" version, Degas brought to bear the conceptions he had developed in the 1860s. A comparison to the earlier version of *Petites Filles* (fig. 70) shows that he eliminated all traces of Hellenism, did away with the central architecture, cut out the trees, and replaced the conventional Greek-style figures with the everyday features of Paris urchins. As Duranty had hoped, "the flesh-and-blood French woman, with her upturned nose" had replaced "the marble Greek woman with her straight nose and heavy chin," an image deeply "embedded in our minds."[69] It had taken twenty years to gain a victory that would prove to be hollow. For unknown reasons, *Petites Filles* was not shown. It may not have been ready; Degas may have, as was his custom, reserved the right to make further modifications; or he may have decided that the hour was past, that it was already too late. Impressionism had turned everything upside down. Sparta, angels, chimeras were forgotten. The artist no longer looked across vast fields of history but rather toward "today's little garden," abundantly flowering and enclosed, where "an art, completely modern from top to bottom," would appear, "imbued with our environs, with our feelings, with the stuff of our times."[70]

68. "Un tableau de Manet, ce qui le rend aussi agaçant et plaisant que l'amertume du citron, suit parallèlement deux lignes mélodiques, celle de la peinture pure, celle de la peinture qui signifié. Les deux lignes n'adhèrent pas exactement mais s'accompagnent, se frôlent, nécessitant du spectateur, de véritables sauts carpés." Foucart 1991, p. 15.
69. "la femme française vivante, au nez retroussé"; "la femme grecque en marbre, au nez droit, au menton épais"; "encastrée dans nos cervelles." Washington, San Francisco 1986, p. 479.
70. "dans le jardinet de ceux d'ici"; "de pied en cap, un art tout moderne, tout imprégné de nos alentours, de nos sentiments, des choses de notre époque." Ibid.

III
The Realist Landscape

GARY TINTEROW

History painting is dead. Long live landscape! Such was the general consensus of the copious criticism of the 1859 Salon. Although many critics were not pleased with the prospect—Zacharie Astruc complained that "there are too many landscapists" and believed that the genre would remain inferior unless it accommodated figure painting[1]—the preponderance and resilience of landscape painting was an irrefutable fact. This fact, nevertheless, was greeted with surprise and incredulity. No matter how skeptical or independent the critic, each had assimilated the hierarchy of subjects ordained by the state's art establishment, which gave preeminence to the depiction of noble subjects in a noble—that is, classical—style. The hierarchy was of course a holdover from the seventeenth century, revitalized from time to time by various circumstances, but it had always been subject to attack, whether by great critics such as Diderot or no less great artists such as Greuze and Chardin. By the mid-nineteenth century, France had changed so thoroughly that it had become impossible to maintain a link with the classicism of the past, a classicism rooted in stable social structures.[2] Yet the goal of an elevated genre remained unchallenged regardless of whether a critic considered contemporary history painting, the work of Hippolyte Flandrin, or Alexandre Cabanel, or Pierre Puvis de Chavannes, good or bad. That ambitious artists should consider lowly landscape, "an inferior genre," to quote Baudelaire,[3] an appropriate vehicle for expression continued to surprise. Perhaps even more surprising to the critics, many of whom wrote for state publications or submitted to state censorship, was that the majority of artists, those outside the academy, did not heed them. Despite the state's extensive control of both patronage and press, artists continued to misbehave.

"What is surprising is that the influence of a criticism so narrow does not universally dominate studio practice," wrote Théophile Thoré, a committed socialist, in an article on the consolidation of

1. "il y a trop de paysagistes." Astruc 1859, p. 366.
2. Meyer Schapiro demonstrated that mid-nineteenth-century classicism had very little in common with previous classical revivals in his review of *French Painting between the Past and the Present* by Joseph C. Sloane, in *Art Bulletin*, 1954, pp. 163–65.
3. "un genre inférieur." "Salon de 1859," in Baudelaire 1975–76, vol. 2, p. 660.

Frédéric Bazille, *Paysage aux bord du Lez*, detail of fig. 100

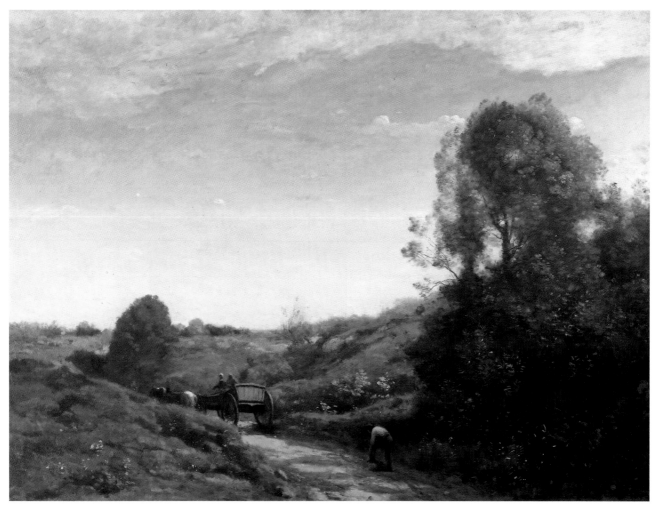

Fig. 75 (cat. 35). Camille Corot, *Souvenir de Marcoussis, près Montlhéry* (*Memory of Marcoussis, near Montlhéry*), ca. 1855. Oil on canvas, 38¼ x 51⅛ in. (97 x 130 cm). Musée d'Orsay, Paris

the art bureaucracy under the reactionary comte de Nieuwerkerke after the embarrassment of the 1863 Salon des Refusés.

Since we no longer have the same ideas, the same mores, the same aspirations as ancient Greece or the Italian Renaissance, Phidias or Raphael are not the criteria to judge contemporary artists. Beauty, the ideal, style, are not all the same for the man of the nineteenth century as for the pagan or the Catholic. French criticism, in general, seems to be neither of its time nor of its country when it advocates the ideal and the style that belonged to Greece or Italy. Yet the critics who control all French journalism, from *Le Moniteur, La Revue des Deux Mondes*, the *Gazette des Beaux-Arts, La Presse, Le Journal des débats*, to the *Temps*, to the *Constitutionnel*, to *L'Opinion nationale*, etc., are in agreement. All are imprisoned in the same theory, and never with greater unanimity.[4]

Despite a reigning theory that devalued landscape, despite critics who called for noble, classicizing compositions, despite a powerful

4. "Ce qu'il y a d'étonnant, c'est que l'influence d'une critique si compacte ne domine pas universellement la pratique des ateliers. Puisque nous n'avons plus les mêmes idées, ni les mêmes moeurs, ni les mêmes aspirations que la Grèce antique et que l'Italie de la Renaissance, Phidias ou Raphaël ne sont pas un critérium pour juger les artistes contemporains. La beauté, l'idéal, et le style, si l'on veut, ne sont point du tout les mêmes pour l'homme du dix-neuvième siècle que pour le païen ou le catholique. La critique française, en général, ne semble être ni de son temps ni de son pays, lorsqu'elle prône l'idéal et le style qui appartenaient jadis à la Grèce ou à l'Italie. Et là-dessus pourtant, les critiques qui tiennent tout le journalisme français, depuis *Le Moniteur, La Revue des Deux Mondes*, la *Gazette des Beaux-Arts, La Presse, Le Journal des débats*, jusqu'au *Temps*, au *Constitutionnel*, à *L'Opinion nationale*, etc., s'accordent. Tous sont emprisonnés dans la même théorie, et jamais on n'avait vu plus complète unanimitié." "Salon de 1864," in Thoré-Bürger 1870, vol. 2, p. 20.

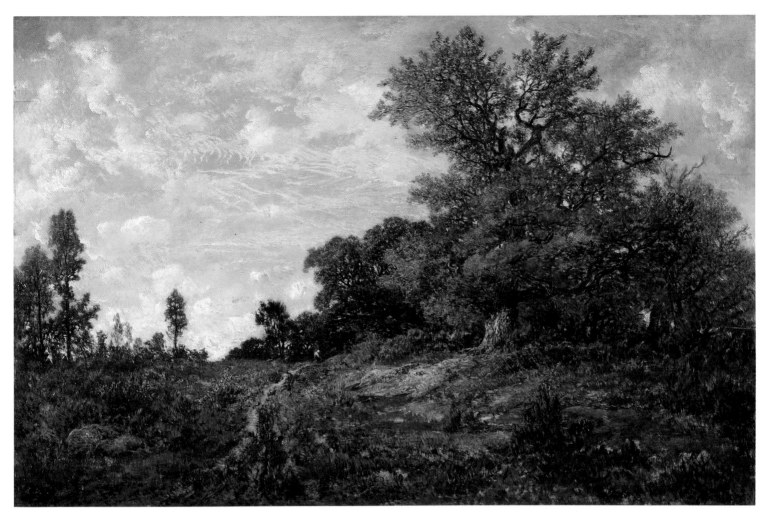

Fig. 76 (cat. 184). Théodore Rousseau, *Lisière des Monts-Girard, forêt de Fontainebleau* (*The Edge of the Woods at Monts-Girard, Fontainebleau Forest*), 1854. Oil on panel, 31½ x 48 in. (80 x 121.9 cm). The Metropolitan Museum of Art, New York, Catharine Lorillard Wolfe Collection, Wolfe Fund, 1896

art administration determined to crush naturalism, realist landscape flourished. What was evident at the 1859 Salon had already been perceived at the 1855 Exposition Universelle, when Edmond About wrote, "The only genre in which the French painters seem to gather in a school is landscape painting. It is different from the other genres because its only recognized master is nature, the country, and because the only studio it requires is nature." But About saw a disturbing similarity in landscape style.

No one is sacrificing his originality, no one is imitating others. Fifty to sixty artists, equally talented, or very close, spread out in the fields with all their equipment. They come back to Paris, compare their paintings at the next exhibition, and observe that the results are almost identical. They did not agree on anything before they started; they did not say to each other: "We shall copy literally all objects that chance puts before us; we shall abstain from all composition; we shall not move a tree or a mountain; we shall make an intelligent and tinted photograph of nature." And yet, they paint as if they had made an arrangement.[5]

5. "Le seul genre où les peintres français semblent réunis en école, est le paysage. Elle diffère des autres en ce qu'elle ne reconnaît pour maître que la nature, la campagne, et qu'elle n'adopte qu'un seul atelier, la nature." "Personne n'y sacrifie son originalité, personne n'y copie le voisin. Cinquante ou soixante artistes, de même force ou peu s'en faut, se dispersent dans les champs avec armes et bagages. Ils rentrent à Paris, ils comparent leurs tableaux à plus prochaine exposition, et ils reconnaissent qu'ils ont fait à peu près la même chose. Ils n'étaient convenus de rien au départ; ils ne s'étaient pas dit les un aux autres: 'Nous copierons textuellement les objets que le hasard mettra sous nos yeux; nous nous abstiendrons de toute composition; nous nous garderons de déranger un arbre ou une montagne; nous ferons une photographie intelligente et colorée de la nature.' Et cependant ils se rencontrent comme s'ils s'étaient entendus." About 1855, pp. 215–16.

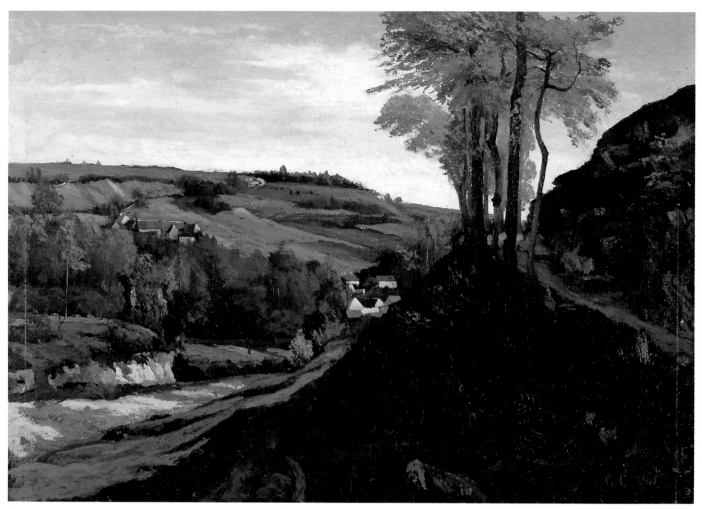

Fig. 77 (cat. 39). Gustave Courbet, *La Vallée d'Ornans* (*The Ornans Valley*), 1858. Oil on canvas, 23¾ x 33½ in. (60.2 x 85.2 cm). The Saint Louis Art Museum, Museum Purchase

Thus in 1855 About touched on the issues that would continue to define debate through the 1860s: whether to be faithful to appearances or to be faithful to the feeling received from nature; whether to delineate or to paint atmospherically; whether to compose according to tonal relationships or to paint as a colorist; whether to finish paintings in the studio or to work exclusively *en plein air*. What About looked for and found lacking in the "intelligent and tinted photograph of nature" was the human contribution to the perception of nature, art. Baudelaire placed the matter at the forefront in his review of landscape at the 1859 Salon.

If the combination of trees, mountains, water and houses that we call a landscape is beautiful, its beauty does not come from itself but from me, by my own grace, from the idea or feeling I associate with it.... The artists who want to express nature apart from the feelings it inspires are engaged in a strange process that consists of killing the thinking and feeling man in themselves, and that, unfortunately, is neither bizarre nor painful. Such a school prevails today and has done so for a long time.[6]

6. "Si tel assemblage d'arbres, de montagnes, d'eaux et de maisons, que nous appelons un paysage, est beau, ce n'est pas par lui-même, mais par moi, par ma grâce propre, par l'idée ou le sentiment que j'y attache.... Les artistes qui veulent exprimer la nature, moins les sentiments qu'elle inspire, se soumettent à une opération qui consiste à tuer en eux l'homme pensant et sentant, et, malheureusement, n'a rien de bizarre ni de douloureux. Telle est l'école qui, aujourd'hui et depuis longtemps, a prévalu." "Salon de 1859," in Baudelaire 1975–76, vol. 2, p. 660.

All critics did not see the unified school that Baudelaire and About did, since landscapists continued to be classified in the well-worn polarity of idealist and realist.[7] Some, such as Théophile Gautier, held Hippolyte Flandrin and Théodore Caruelle d'Aligny as venerable but moribund practitioners of an old craft, *paysage héroïque*, considered by many to be a dodo on the verge of extinction. But most critics focused on the so-called modern school of landscape, "the true strength of the French school,"[8] that was traced back to the School of 1830, and there they saw a polarity that could be defined by the work of Camille Corot and Théodore Rousseau, a polarity that was also frequently defined as classicist versus realist.

Little had changed in the critical discourse between the Salon of 1845, when Baudelaire made his debut as a critic, and the Salon of 1859, when he wrote his last comprehensive Salon review. "Heading the modern landscape school," Baudelaire wrote in 1845, "is M. Corot.—if M. Théodore Rousseau wanted to exhibit his work, the supremacy would be doubtful."[9] In 1859 he wrote, "The two men who have always been considered by public opinion as the most preeminent representatives of landscape painting are MM. Rousseau and Corot."[10] To be sure, in 1845 *paysage héroïque* still seemed viable, and Corot's grand biblical figures or sporting nymphs and satyrs were happy inhabitants of his world, whereas by 1859 their viability had been sorely questioned by Courbet's aggressive prose-lytizing for his brand of realism. Yet Corot's dreamy, imaginary landscapes were perceived as poetic, and therefore artful; Rousseau's art lay in making the mute forms of nature speak in terms of human emotions. Beneath the exalted rank of Corot and Rousseau, the Baudelaire of 1859 added Charles-François Daubigny, whose landscapes "convey immediately to the viewer's soul the original feeling that pervaded them"; Jean-François Millet, whose "beautiful qualities first attract the gaze" but are undermined by the "philosophic, melancholic and Raphaelesque pretension" of his work; and Constant Troyon, "the most beautiful example of skill without soul."[11] Not everyone agreed with Baudelaire, however. The archconservative Charles Blanc, countering Baudelaire's criteria for an expressive art, wrote, "To make a painted object impress the viewer in the exact same way as the seen object: those are the terms in which some artists pose the problem. . . . But such an understanding of art may well lead to only vague depictions, half-finished execution and a devaluation of the painter's currency, for the mind is not all and the craft has its own requirements."[12] Critics more conservative than Baudelaire but more liberal than Blanc often perceived some sort of achievement in the work of these artists but found that quality mitigated by inadequate technique. Corot, Rousseau, Millet, Daubigny,

7. For a more detailed discussion of landscape criticism in 1859, see, in this catalogue, Henri Loyrette, "The Salon of 1859."

8. "la vraie force de l'école française." Du Camp 1859, p. 16.

9. "À la tête de l'école moderne du paysage, se place M. Corot.—Si M. Théodore Rousseau voulait exposer, la suprématie serait douteuse." "Salon de 1845," in Baudelaire 1975–76, vol. 2, p. 389.

10. "Les deux hommes que l'opinion publique a toujours marqués comme les plus importants dans la spécialité du paysage sont MM. Rousseau et Corot." "Salon de 1859," in Baudelaire 1975–76, vol. 2, p. 662.

11. "transmettent tout de suite à l'âme du spectateur le sentiment originel dont ils sont pénétrés"; "belles qualités qui attirent tout d'abord le regard vers lui"; "prétension philosophique, mélancolique et raphaélesque"; "le plus bel example de l'habileté sans âme." "Salon de 1859," in Baudelaire 1975–76, vol. 2, pp. 661–62.

12. "Faire que la chose peinte vous procure la même impression que vous aurait procurée la chose vue: voilà dans quels termes certains artistes se posent le problème. . . . Mais avec une telle manière de comprendre l'art, on risque fort d'en rester aux à peu près, de sous-entendre l'exécution et d'altérer la monnaie du peintre, car enfin l'esprit n'est pas tout, non plus; le métier a ses rigueurs." Charles Blanc, "Salons de 1866," *Gazette des Beaux-Arts* 21 (1866), p. 41.

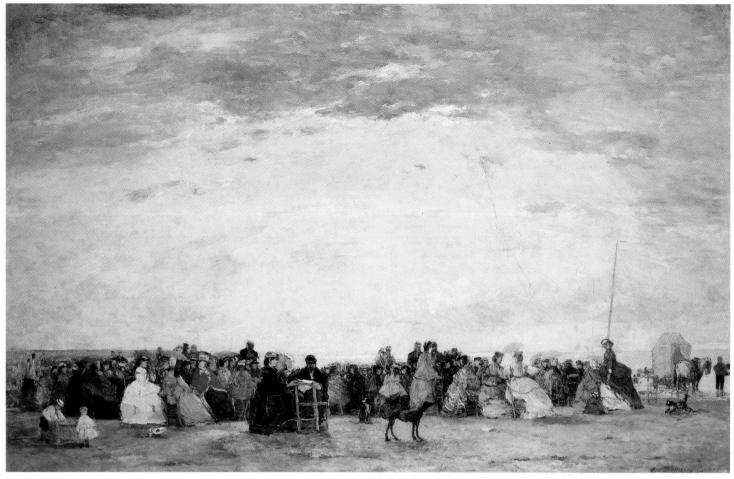

Fig. 78 (cat. 18). Eugène Boudin, *La Plage de Trouville* (*Beach at Trouville*), ca. 1865. Oil on canvas, 26½ x 41 in. (67.3 x 104.1 cm). The Minneapolis Institute of Arts, The William Hood Dunwoody Fund

and Troyon were all criticized in their turn for awkward compositions, bad drawing, poor brushwork, somber or dull palettes, and, worst of all, for having the gall to exhibit plein air studies as if they were paintings. Even Baudelaire thought that to confuse a beautiful study with a finished painting was a grave mistake.

This was the climate in the early 1860s, when the new generation of plein air landscape painters came of age. Classical landscape, *paysage héroïque*, was out of the question. Naturalism was de rigueur. Courbet's realism was a dangerous but seductive art. Corot was a great old master. Rousseau was respected like a venerable oak of the Fontainebleau forest. At worst, one would make "tinted photographs"; at best, one would make pictures that conveyed the experience of immersion in nature. One can see in the present exhibition that the early landscapes of Frédéric Bazille, Alfred Sisley, Auguste Renoir, and Berthe Morisot all grapple in one way or another with the example of Corot and of Rousseau, and in some instances the generalizations of Corot's manner are conjoined with the specificity of Rousseau's style. For Camille Pissarro, a self-styled "student of Corot," it was the precepts of *père* Corot and not the appearance of his

Fig. 79 (cat. 117). Claude Monet, *Le Phare de l'hospice* (*The Lighthouse*), 1864. Oil on canvas, 21¼ x 31⅞ in. (54 x 81 cm). Kunsthaus Zurich, Gift of the heirs of Dr. Adolf Jöhr

paintings that was essential to the younger artist, whose pictures follow more closely the art of Daubigny. For Claude Monet, it was Eugène Boudin and Johan Barthold Jongkind who provided the key formative examples until about 1865, when Monet's range widened to embrace the art of the true avant-garde—Courbet, Manet, Whistler—while still working within the tradition of Barbizon painting. But for each of the artists of the new generation of landscapists, the authority of the plein air picture, conveying an authentic experience of nature, was preeminent.

"If I have become a painter, I owe it to Eugène Boudin."[13] Boudin, patient, kind, and plodding, saw talent in the eighteen-year-old Monet and taught him how to sketch out-of-doors. The next year, when Boudin's *Pardon de Sainte-Anne-Palud au fond de la baie de Douarnenez (Finistère)* was exhibited at the 1859 Salon, it was not this ambitious but banal figure painting that truly impressed Baudelaire, but rather the sight of a multitude of cloud and sky studies that Baudelaire, accompanied by Courbet, saw in Boudin's studio. "But M. Boudin, who could be proud of his devotion to his art, shows his curious collection with great modesty. He knows that

13. "Si je suis devenu un peintre c'est à Eugène Boudin que je le dois." Jean-Aubry 1922, p. 35.

Fig. 80 (cat. 2). Frédéric Bazille, *Plage à Sainte-Adresse* (*Beach at Sainte-Adresse*), 1865. Oil on canvas, 23 x 55⅛ in. (58.4 x 140 cm). High Museum of Art, Atlanta, Gift of the Forward Arts Foundation in honor of Frances Floyd Cocke

Fig. 81 (cat. 116). Claude Monet, *Bord de la mer à Sainte-Adresse* (*Seaside at Sainte-Adresse*), 1864. Oil on canvas, 15¾ x 28¾ in. (40.1 x 73.3 cm). The Minneapolis Institute of Arts, Gift of Mr. and Mrs. Theodore W. Bennett

Fig. 82 (cat. 80). Johan Barthold Jongkind, *Sur la plage de Sainte-Adresse* (*On the Beach at Sainte-Adresse*), 1862. Oil on canvas, 10¹¹⁄₁₆ x 16³⁄₁₆ in. (27 x 41 cm). Phoenix Art Museum, Mrs. Oliver B. James Bequest

Fig. 83 (cat. 118). Claude Monet, *La Pointe de la Hève à marée basse* (*Pointe de la Hève at Low Tide*), 1865. Oil on canvas, 35½ x 59¼ in. (90.2 x 150.5 cm). Kimbell Art Museum, Fort Worth

all of this has to be transformed into painting by means of a poetic impression recalled at will; and he does not pretend to present his notes as finished paintings. Later, he will no doubt show us the prodigious magic of air and water in completed paintings." After extolling the meteorological exactitude of these studies, Baudelaire remarked that they were so beautiful and fulfilling in themselves that he did not regret the absence of human figures, but, he quickly added, he feared that was a dangerous notion and "if he wants to gain a little popularity, he must keep from believing that the public shares the same enthusiasm for solitude."[14] No doubt both Boudin and Monet took Baudelaire's words very seriously. Boudin's grand *Plage de Trouville* (fig. 78) provides the immediacy of the artist's cloud studies within the context of "finished painting," and the lively depiction of fashionable vacationers on the beach corresponded precisely to Baudelaire's call for scenes of modern life. It was surely painted in Boudin's studio, a synthesis of multiple studies he had

14. "Mais M. Boudin, qui pourrait s'enorgueillir de son dévouement à son art, montre très modestement sa curieuse collection. Il sait bien qu'il faut que tout cela devienne tableau par le moyen de l'impression poétique rappelée à volonté; et il n'a pas la prétention de donner ses notes pour des tableaux. Plus tard, sans aucun doute, il nous étalera dans des peintures achevées les prodigieuses magies de l'air et de l'eau." "S'il veut gagner un peu de popularité, qu'il se garde bien de croire que le public soit arrivé à un égal enthousiasme pour la solitude." "Salon de 1859," in Baudelaire 1975–76, vol. 2, pp. 665–66.

Fig. 84 (cat. 81). Johan Barthold Jongkind, *Le Port de Honfleur*, 1865. Oil on canvas, 20½ x 32⅛ in. (52.1 x 81.6 cm). The Metropolitan Museum of Art, New York, Catharine Lorillard Wolfe Collection, Wolfe Fund, 1916

made of the sky, the beach, and the seekers of salubrious air. Monet's first Salon painting, *La Pointe de la Hève à marée basse* (fig. 83), was made in the same fashion. It was painted in his studio, enlarged from a study (see cat. 118) that he probably had begun out-of-doors. The study captured the composition and the colors that Monet observed and was fairly finished for such a study—an ébauche rather than an esquisse. (Two similar and contemporary pictures are included in this exhibition [cats. 116, 117].) In the large painting Monet carefully retained not only the composition and harmony of gray and brown, but also the sketchy brushwork of the pochade. Neither highly polished nor carelessly slapdash, the brushwork revealed the artist's hand and conveyed a sense of immediacy—both were characteristic of contemporary naturalist landscape. But for this, his Salon debut, Monet did not choose to render one of Boudin's typical scenes of subtle harmony and little contrast in either composition or hue. He chose instead a view with a deep recession to the horizon and a dramatic, diagonal repoussoir, and therefore

Fig. 85 (cat. 83). Édouard Manet, *Le Pont d'un bateau* (*The Deck of a Ship*), ca. 1860.
Oil on canvas, 22¼ x 18½ in. (56.4 x 47 cm). National Gallery of Victoria, Melbourne,
Felton Bequest, 1926

Fig. 86 (cat. 126). Claude Monet, *Le Port de Honfleur*, 1866. Oil on canvas, 19¼ x 25⅝ in. (48.8 x 65.1 cm).
Private collection

followed the more constructive example of Jongkind. Critics saw Courbet rather than Jongkind, but no matter, the picture was a success: Astruc said of it, "The most original and supple, solidly and harmoniously executed seascape that has been exhibited in a long time. It has the same muted tonalities as works by Courbet; but it is so rich and so simple."[15]

Recalling his meeting with the Dutch painter in 1862, Monet said, "From this moment on, he was my true master, and it is to him that I owe the final education of my eye."[16] Contemporary works by Jongkind (fig. 82) show that Monet did use a similar palette and compositional strategies for *La Pointe de la Hève*. Monet's harbor scenes of 1866, with their attentive descriptive detail (fig. 86), seem to be an attempt to update Jongkind's contemporaneous efforts (fig. 84) with a new fluid handling of paint borrowed from Manet, and the two versions of the beach at Sainte-Adresse in 1867 (figs. 87, 88) reflect Jongkind's practice of painting the same composition at different times of day or under different weather conditions—albeit Monet's palette is already more audacious than that of any painting by Jongkind. A year later, however, when Monet sought a sure bet for Salon admission, having seen his figure painting refused in 1867, he returned to a subject and treatment reminiscent of Boudin. *Navires sortent des jetées du Havre* (see figs. 418, 419) was accepted; *La Jetée du Havre par mauvais temps* (fig. 421), for which there is a study in this exhibition (fig. 89), was rejected, but both can be seen as a kind of homage to his first master. Boudin would not have dared a two-meter canvas, as Monet did. "Although less ambitious, I would like to undertake something bigger than my little canvases," wrote Boudin about this time.[17] But when he saw Monet's painting, he immediately perceived how it extended his own precepts. "At the Salon, I met Monet who sets for us all the example of an artist faithful to his principles. One of his works has been accepted, to the great dismay of some people who are wrong because this painting shows an always commendable search for true tonality that everybody is beginning to appreciate."[18] That these jetty scenes were bound to his own initiatives Boudin also recognized: "These gentlemen congratulate me precisely because I dared to represent in painting the things and people of our time, because I found the means to paint the gentleman in a top coat and the lady in a waterproof thanks to the mixture of paint and the composition."[19] It is worth recalling that in 1868, despite the variety and ambition of his output, Monet was still regarded, above all, as a painter of marines: "There is a first-rank seascape painter in him. . . . He loves the water like a mistress, he knows each part of the hull of a boat, he could name the smallest parts of the rigging."[20]

15. "La marine la plus originale et la plus souple, la plus solidement et la plus harmonieusement peinte qu'on ait exposée depuis longtemps. Une tonalité un peu sourde. comme dans les Courbet; mais quelle richesse et quelle simplicité d'aspect." Quoted in Geffroy 1922, p. 28.

16. "Il fut à partir de ce moment mon vrai maître, et c'est à lui que je dus l'éducation définitive de mon oeil." Thiébault-Sisson 1900, p. 3.

17. "Je voudrais bien, moins ambitieux, entreprendre quelque chose de plus étendu que mes petites toilettes." Letter from Boudin to his brother, December 20, 1865, Jean-Aubry 1922, p. 6.

18. "Au Salon, j'ai rencontré Monet qui nous donne à tous l'exemple de la ténacité à ses principes. On lui a admis un de ses tableaux au grand scandale de certaines gens qui ont tort car il y a toujours dans cette peinture une louable recherche du *ton vrai* qui commence à être estimée par tous." Letter of May 4, 1868, Jean-Aubry 1968, p. 66.

19. "Ces messieurs me félicitent précisément d'avoir osé mettre en tableau des choses et des gens de notre temps, d'avoir trouvé le moyen de faire le monsieur en paletot et la dame en waterproof grâce à la sauce et l'accommodement." Letter of September 3, 1868, Jean-Aubry 1968, p. 72.

20. "Il y a en lui un peintre de marines de premier ordre. . . . Il aime l'eau comme une amante, il connaît chaque pièce de la coque d'une navire, il nommerait les moindres cordages de la mâture." "Mon Salon: Les actualistes," 1868, in Zola 1991, p. 208.

Fig. 90 (cat. 171). Auguste Renoir, *Jules Le Coeur et ses chiens se promenant en forêt de Fontainebleau* (*Jules Le Coeur and His Dogs Walking in the Forest of Fontainebleau*), 1866. Oil on canvas, 41¾ x 31½ in. (106 x 80 cm). Museu de Arte de São Paulo Assis Chateaubriand

who published guidebooks, paved paths, and placed hundreds of signs throughout the region to facilitate tourism, much to the dismay of the resident artists, who hoped the region might retain its primitive state. Any naturalist painter worth his salt was obliged to paint at Barbizon and partake of the conviviality at the Auberge Ganne, the inn that the Goncourts parodied in *Manette Salomon*: "This inn at Barbizon was indeed a picturesque and lively place, a true siphon of Art."[21] The forest had been a hunting preserve, a sport to which Renoir alluded in his portrait of Jules Le Coeur walking with his dogs (fig. 90). But by the 1860s, tourism and art making had become the principal activities. The Goncourts provide a description of what the experience of the forest, the most varied and undomesticated landscape in the vicinity of Paris, meant to a young painter.

21. "Pittoresque et riante auberge que cette auberge de Barbizon, vrai vide-bouteille de l'Art." Goncourt 1867, p. 33.

An emotion, an almost religious emotion seized him each time, when, after a quarter of an hour, he [Coriolis] reached the avenue of Bas-Bréau: he felt he was before one of the great majesties of nature. And, for a few minutes, he always stood in a sort of respectful rapture and emotional silence of the soul, in front of this allée entrance, this triumphal gate, where trees carried on the arch of their superb columns an immense greenery filled with the joy of the day. From the end of the curving allée, he looked at these magnificent and stern oak trees, as old as gods and as solemn as monuments, invested with the sacred beauty of the centuries, leaving the fern forests like a dwarf grass crushed by their height; the morning light reflected on their rough bark, their centenary skin, and made their wooden veins resemble white polished stone.[22]

The Goncourts' description of the forest quite naturally resembles the contemporary descriptions of the work of the Barbizon painters, who attempted to capture the preternatural magic of a sacred place. One could imagine their protagonist, the artist Coriolis, mak-

22. "Une émotion, une émotion presque religieuse le prenait chaque fois, quand, au bout d'un quart d'heure, il arrivait à l'avenue de Bas-Bréau: il se sentait devant une des grandes majestés de la nature. Et il demeurait toujours quelques minutes dans une sorte de ravissement respectueux et de silence ému de l'âme, en face de cette entrée d'allée, de cette porte triomphale, où les arbres portaient sur l'arc de leurs colonnes superbes l'immense verdure pleine de la joie du jour. Du bout de l'allée tournante, il regardait ces chênes magnifiques et sévères, ayant un âge de dieux, et une solemnité de monuments, beaux de la beauté sacrée des siècles, sortant, comme une herbe naine, des forêts de fougères écrasées de leur hauteur; le matin jouait sur leur rude écorce, leur peau centenaire, et passait sur leurs veines de bois les blancheurs polies de la pierre." Goncourt 1867, p. 39.

Fig. 91 (cat. 53). Edgar Degas, *Le Renard mort* (*The Dead Fox*), ca. 1861–64. Oil on canvas, 36¼ x 28¾ in. (92 x 73 cm). Musée des Beaux-Arts, Rouen

Fig. 92 (cat. 183). Théodore Rousseau, *Groupe de chênes dans les gorges d'Apremont* (*Oak trees in the Gorge of Apremont*), ca. 1850–52. Oil on canvas, 25 x 39⅛ in. (63.5 x 99.5 cm). Musée du Louvre, Paris, département des Peintures, Bequest of Thomy Thiéry, 1902

Fig. 93 (cat. 42). Gustave Courbet, *Le Chêne de Flagey appelé chêne de Vercingétorix* (*Oak Tree in Flagey, Called the Oak of Vercingétorix*), 1864. Oil on canvas, 35 x 44 in. (90 x 111.7 cm). Murauchi Art Museum, Tokyo

ing in a state of rapture a pastiche of Rousseau's *Groupe de chênes dans les gorges d'Apremont* (fig. 92) or Courbet's *Chêne de Flagey* (fig. 93). And when Monet and his friends painted in the region, they could not help but be conscious of their predecessors, members of the School of 1830, who were then at the apogee of their careers. But a painting like Monet's *Chêne de Bodmer,* which only recently came to light (fig. 96), shows the important shift in attitude that differentiates the old school from the new. The young generation attempted to elaborate a much more objective vision, and they eschewed the latent sentimentality and anthropomorphism characteristic of the Barbizon school. One could not say of the Monet, as Sensier did of Rousseau's *Lisière des Monts-Girard* (fig. 76), that the fatherly old oak was "irritated to see a young tree daring to grow again after the slaughter of its contemporaries."[23] And rather than painting the tree as he understood it, which is what Courbet did, Monet seemed to be preoccupied with understanding not the tree but how light fell on it and revealed its forms to him. A similar process can be detected in the larger Barbizon landscapes of Monet, *Le Pavé de Chailly* (fig. 99), of Bazille, *Paysage à Chailly* (fig. 97), or in Sisley's contemporaneous *Allée de châtaigniers à La Celle-Saint-Cloud* (fig. 98). Although comparison is complicated because the Monet and the Bazille are ébauches while the Sisley is a finished "tableau," conceived for exhibition, the fact is that there is much greater emphasis on light, color, and texture than there is on projected human feelings. Nevertheless these pictures do evoke "the great majesties of nature," but they do so in a way that is similar to the approach of photography. Monet, Bazille, and Sisley seem to wish to convey how the forest looked when they painted there as well as how it felt to be observing the forest, but they did not go so far as to project feelings onto the inanimate objects of nature, as the romantic Rousseau and Millet did. None of the younger artists hark back to the Dutch masters, as Rousseau did, or the Italians, as Millet did. They seem determined instead to see the forest with fresh eyes.

Their eyes, however, were already conditioned by photography. It is remarkable how similar the calotypes of Gustave Le Gray, Charles Marville, and Henri Le Secq are to the work of the young landscape painters. Of course much of the similarity can be explained by the style of the period, which affected photographers and painters alike. Camera lenses were designed to reproduce a field equivalent to that of human sight, and cameras were typically set up at the same height as a human head, and so it is no surprise that there is a common point of view. Le Gray, like most of the gifted early photographers, had been trained as an artist—he worked in Delaroche's

23. "irrité de voir devant lui un jeune bois qui ose reverdir après le massacre de ses contemporains." Sensier 1872, p. 213.

Fig. 94. Claude Monet, *Un chêne au Bas-Bréau*
(*An Oak at Bas-Bréau*), 1865. Oil on canvas,
21⅜ x 16⅛ in. (54.4 x 41 cm). Private collection,
New York

Fig. 95. Gustave Le Gray, *Forêt de Fontainebleau* (*Fontainebleau Forest*), ca. 1851.
Calotype, 10⅛ x 14⅞ in. (25.6 x 37.7 cm). Private collection

studio—and he had learned perspective and composition in much the same manner as the students at the Atelier Gleyre. Le Gray knew Corot's and Rousseau's paintings, as did, for example, Monet, and so when they both went to the Fontainebleau forest, it is natural that they should emerge with similar results (figs. 75, 94, 95, 96). What is surprising, though, is that Le Gray's picture was made with a camera, which records all that it sees with impartiality, whereas Monet's vision was highly prejudicial. While Le Gray could carefully select his position, choose a lens, experiment with exposure, and wait for a desired effect of light, he could not delete a branch or move a rock as easily as a painter could. Yet both artists were equally true to nature, and both were equally determined to extract from nature the extraordinary pattern of branches etched against sky or rocks and forest floor dappled with light filtered through the leaves. Le Gray gave his print a painterly air through his developing process and choice of printing paper, while Monet gave his picture a photographic air by avoiding references to traditional landscape conventions, all the while painting in a very fluid and free manner. It is not known whether Monet actually saw this particular photograph, although he was certainly aware of the landscape photography that began to flood artists' studios in the late 1840s.[24] Even though Rousseau's comparatively meticulous technique is closer to the realism of photography than is the free painting and daring palette of Monet, Rousseau's pictures seem much closer in spirit to Ruysdael,

24. For further discussion of photography and landscape painting, see Margret Stuffmann, "Between the Barbizon School and the Beginnings of Impressionism," in *Pioniere der Landschaftsphotographie* (Frankfurt, 1993).

Fig. 96 (cat. 120). Claude Monet, *Le Chêne de Bodmer. La Route de Chailly* (*The Bodmer Oak, Fontainebleau Forest, the Chailly Road*), 1865. Oil on canvas, 37⅞ x 50⅞ in. (96.2 x 129.2 cm). The Metropolitan Museum of Art, New York, Gift of Sam Salz and Bequest of Julia W. Emmons, by exchange, 1964

and Monet's closer to photography. It was the difference between the old realism and the new.

Le Gray's technique was based on the "theory of sacrifices," the sacrifice of detail for effect.[25] Delacroix observed in 1859 that "photography would be unbearable if our eyes were as accurate as a magnifying glass." He believed that "the most striking photographs are those in which certain gaps are left, owing to the failure of the process itself to give a complete rendering. . . . Even when we look at nature, our imagination constructs the picture; we do not see blades of grass in a landscape."[26] Le Gray concurred: "The artistic beauty of a photographic print consists nearly always in the sacrifice of certain details; by varying the focus, the exposure time, the artist

25. See Eugenia Janis's pathbreaking study on early photography in André Jammes and Eugenia Parry Janis, *The Art of the French Calotype* (Princeton, 1983).
26. *The Journal of Eugène Delacroix*, September 1, 1859, quoted in Jammes and Janis, *Art of the French Calotype*, p. 98.

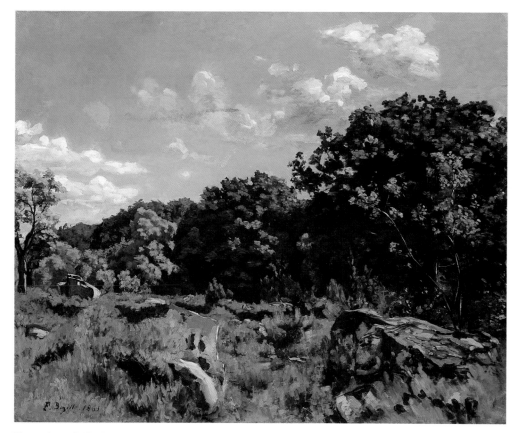

Fig. 97 (cat. 3). Frédéric Bazille, *Paysage à Chailly* (*Landscape at Chailly*), 1865. Oil on canvas, 31⅞ x 39½ in. (81 x 100.3 cm). The Art Institute of Chicago, Charles H. and Mary F. S. Worcester Collection

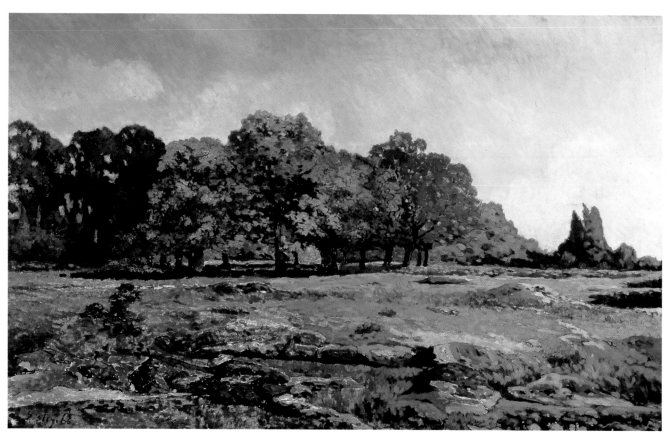

Fig. 98 (cat. 186). Alfred Sisley, *Allée de châtaigniers à La Celle-Saint-Cloud* (*Avenue of Chestnut Trees in La Celle-Saint-Cloud*), ca. 1866–67 (?). Oil on canvas, 51 x 81⅞ in. (129.5 x 208 cm). Musée du Petit Palais, Paris

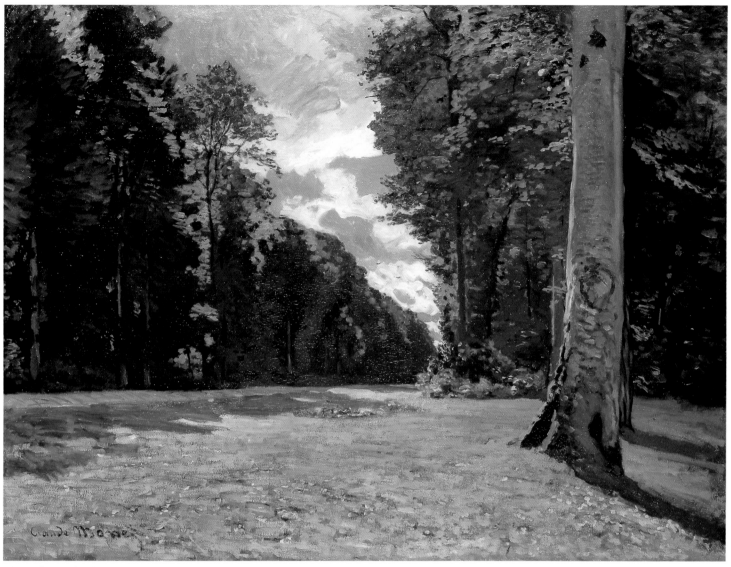

Fig. 99 (cat. 119). Claude Monet, *Le Pavé de Chailly dans la forêt de Fontainebleau* (*Pavé de Chailly in the Fontainebleau Forest*), 1865. Oil on canvas, 38¼ x 51⅜ in. (97 x 130.5 cm). Ordrupgaardsamlingen, Charlottenlund

can make the most of one part or sacrifice another to produce powerful effects of light and shadow, or he can work for extreme softness or suavity, copying the same model or site, depending on how he feels."[27] While the "pencil of nature," as an inventor of photography called it, might normally be thought to produce linear images, artists immediately recognized that monotone calotypes—as opposed to the magnifying-glass precision of daguerreotypes—were essentially coloristic. The infinite variety of grays or browns—Le Gray also printed in greens—represented not lines but tones of color. Hence the aims and interests of the new generation of landscapists were closely allied to those of the calotypists.

Of the older artists who influenced the young generation, Daubigny came closest to Le Gray's aesthetic. He "sacrificed details"

27. Quoted in Jammes and Janis, *Art of the French Calotype*, p. 202.

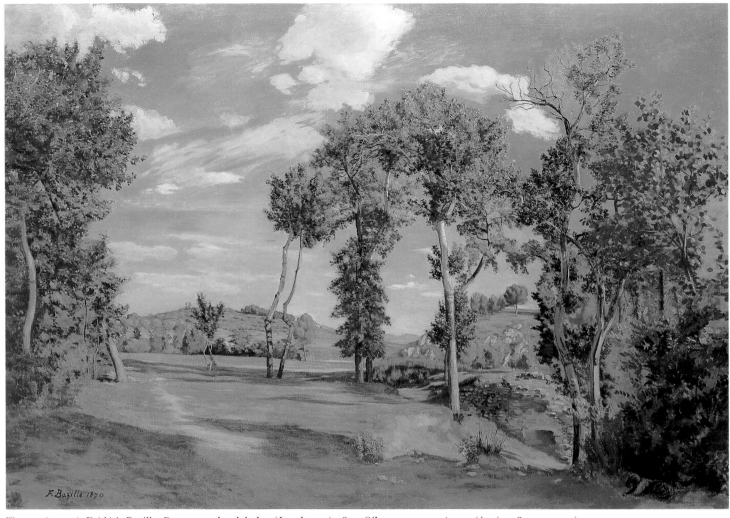

Fig. 100 (cat. 15). Frédéric Bazille, *Paysage au bord du Lez* (*Landscape*), 1870. Oil on canvas, 54¼ x 79¾ in. (137.8 x 202.5 cm).
The Minneapolis Institute of Arts, Special Arts Reserve Fund

Fig. 101 (cat. 165). Camille Pissarro, *La Forêt* (*The Forest*), 1870. Oil on canvas, 31 x 38½ in. (78.8 x 97.9 cm).
Johannesburg Art Gallery

Fig. 102 (cat. 48). Charles-François Daubigny, *Le Hameau d'Optevoz* (?) (*The Hamlet of Optevoz* [?]), ca. 1857. Oil on canvas, 22¾ x 36½ in. (57.8 x 92.7 cm). The Metropolitan Museum of Art, New York, Bequest of Robert Graham Dun, 1911

according to how he "felt." It so happens that Le Gray's approach conformed to Baudelaire's ideal. Baudelaire said of Daubigny in 1859 that his poetic quality, his ability to transmit "immediately to the viewer's soul the original feeling that pervaded" his landscapes, came at the expense of the "finish and perfection of detail."[28] In other words, the theory of sacrifices. One can see this operation in effect in a group of works selected for this exhibition. Like Daubigny's *Hameau de Optevoz* (fig. 102), Sisley's *Rue à Marlotte* and *Vue de Montmartre* (figs. 103, 104) are on one level a straightforward description of things seen; yet on another level the restricted palette and indeterminate detail lend a somber aspect that defines the experience—or at least suggests an experience—for the spectator, even if it is not the "soul" that Baudelaire so sought. In his *Vue de Bonnières* (fig. 105), Cézanne seems to explore the expressive potential of Daubigny's dark palette, but with the fluid touch of Manet. By contrast, Corot's *Cour d'une maison de paysans* (fig. 107), a delicious morsel of painting, does not presume to set a mood. Corot

28. "tout de suite à l'âme du spectateur le sentiment originel dont ils sont pénétrés"; "fini et de la perfection dans le détail." "Salon de 1859," in Baudelaire 1975–76, vol. 2, p. 661.

Fig. 103 (cat. 185). Alfred Sisley, *Une rue à Marlotte; environs de Fontainebleau (A Street in Marlotte, near Fontainebleau)*, 1866.
Oil on canvas, 25½ x 36 in. (64.8 x 91.4 cm). Albright-Knox Art Gallery, Buffalo, New York, General Purchase Funds, 1956

does not privilege one aspect of the scene over another, and so we are left to make of it what we will. Monet's two versions of the *Rue de la Bavolle, Honfleur* (figs. 108, 109) make a different effect. The shadows do not convey mood or mystery, they make patterns; the wedge of sky is reflected in the shape of the receding street, and one side of the street is mirrored in the other, so we are struck first and foremost by the interesting shapes and brilliant contrasts of light and dark. The eye is dazzled by these Monets, but the soul is unmoved.

Underlying these various approaches to village scenes was the desire, conscious or unconscious, to capture a world that was quickly disappearing. Implicit in Rousseau's pictures of the Fontainebleau forest was criticism directed at those who would exploit it for commercial activity. Frédéric and Rosalie, Flaubert's characters in *L'Éducation sentimentale*, escaped the tumult of Paris after the revolution of 1848 for the quiet asylum of Fontainebleau only to find the forest threatened by loggers and stone breakers. A corollary of

Fig. 104 (cat. 188). Alfred Sisley, *Vue de Montmartre prise de la cité des Fleurs aux Batignolles* (*View of Montmartre from the Cité des Fleurs, Les Batignolles*), 1869. Oil on canvas, 27½ x 46⅛ in. (70 x 117 cm). Musée de Grenoble

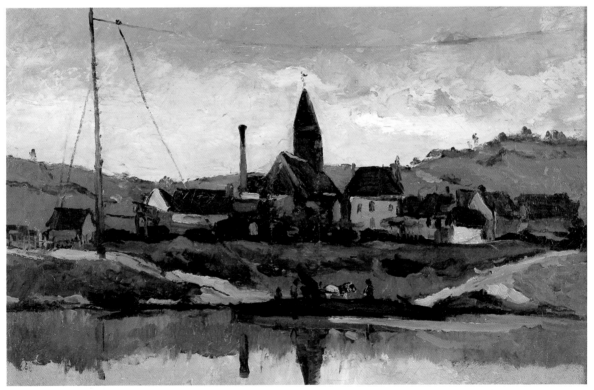

Fig. 105 (cat. 23). Paul Cézanne, *Vue de Bonnières* (*View of Bonnières*), 1866. Oil on canvas, 15 x 23⅝ in. (38 x 60 cm). Musée Faure, Aix-les-Bains

the constant modernization of France was the chronic fear that the past was slipping away. So while Paris was rebuilt by successive regimes, Baron Taylor recorded what was left of the provinces in his monumental *Voyages pittoresques et romantiques dans l'ancienne France*, a twenty-volume compendium of lithographs conceived in 1810 and published from 1820 to 1878. Daubigny made his own "voyage pittoresque" and published the result as an album of etchings, *Voyage en bateau*. As Baron Haussmann's demolition of vast tracts of old Paris reached a fever pitch in the 1850s and 1860s, the ministry of the interior commissioned photographers to make "heliographic missions" to record the streets of Paris in addition to the monuments of France that were faced with deterioration or, worse, renovation. In doing so, the photographers naturally were drawn to informal domestic architecture as well as grand ruins. P.-F. Mathieu's views of Rouen (fig. 106) have something in common with the village views of the young landscapists, although the sentiment in the photographs may be stronger. Bazille's three views of the walls at Aigues-Mortes (figs. 110, 112, 113) are very similar in effect to Baldus's view of the ramparts of Avignon during the flood of 1856 (fig. 111) or, perhaps more apt, Charles Nègre's series *Midi de la France*. Nègre confided of his method that "being a painter myself . . . whenever I

Fig. 106. P.-F. Mathieu, *Maisons à Rouen* (*Houses in Rouen*), 1850. Calotype, 6¾ x 9¾ in. (17.3 x 24.9 cm). Bibliothèque Nationale, Paris

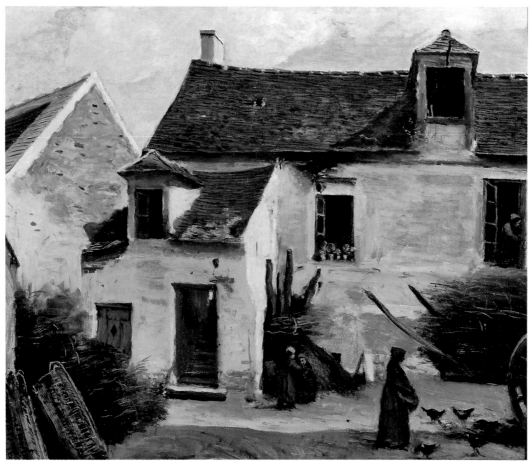

Fig. 107 (cat. 37). Camille Corot, *Cour d'une maison de paysans aux environs de Paris* (*Courtyard of a Farmhouse, in the Vicinity of Paris*), ca. 1865–70. Oil on canvas, 18¼ x 22 in. (46.5 x 56 cm). Musée du Louvre, Paris, département des Peintures, on deposit at the Musée d'Orsay

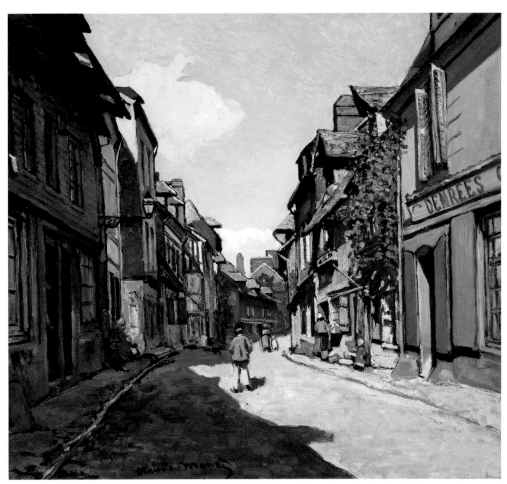

Fig. 108 (cat. 124). Claude Monet, *Rue de la Bavolle, Honfleur,* 1866. Oil on canvas, 22 x 24 in. (55.9 x 61 cm). Museum of Fine Arts, Boston, Bequest of John T. Spaulding

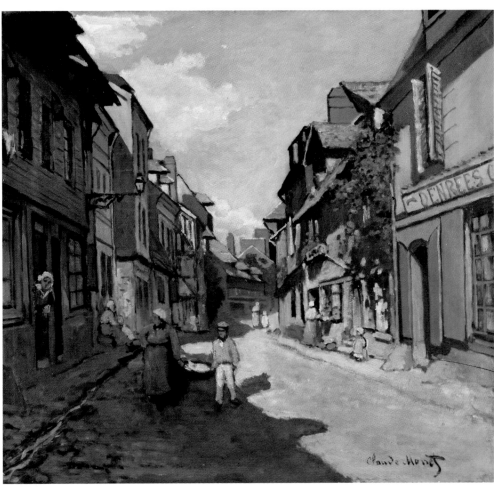

Fig. 109 (cat. 125). Claude Monet, *Rue de la Bavolle, Honfleur,* 1866. Oil on canvas, 22⅞ x 24¾ in. (58 x 63 cm). Städtische Kunsthalle, Mannheim

Fig. 110 (cat. 5). Frédéric Bazille, *Aigues-Mortes*, 1867. Oil on canvas, 18⅛ x 21⅝ in. (46 x 55 cm). Musée Fabre, Montpellier

Fig. 111. Édouard Baldus, *Les Remparts d'Avignon pendant les inondations de 1856* (*The Ramparts at Avignon during the Flood of 1856*), 1856. Calotype, 13¼ x 17¼ in. (33.5 x 43.8 cm). Private collection

Fig. 112 (cat. 6). Frédéric Bazille, *Remparts d'Aigues-Mortes* (*The Ramparts at Aigues-Mortes*), 1867. Oil on canvas, 24⅜ x 43¼ in. (62 x 110 cm).
National Gallery of Art, Washington, Collection of Mr. and Mrs. Paul Mellon

Fig. 113 (cat. 7). Frédéric Bazille, *Porte de la Reine à Aigues-Mortes* (*Porte de la Reine at Aigues-Mortes*), 1867. Oil on canvas,
31¾ x 39¼ in. (80.7 x 99.7 cm). The Metropolitan Museum of Art, New York, Purchase, Gift of Raymonde Paul, in memory
of her brother, C. Michael Paul, by exchange, 1988

could dispense with architectural precision, I indulged in the picturesque, in which case I sacrificed a few details when necessary, in favor of an imposing effect that would give a monument its real character and also preserve the poetic charm that surrounds it."[29] Bazille's aim was absolutely consonant, and it could well have been coupled with a desire to preserve for himself the appearance of the local landmark before the likes of Viollet-le-Duc were commissioned to "renovate" them.

If Daubigny, of the older generation, came closest to practicing in paint Le Gray's theory of sacrifices, then Pissarro, of the younger generation, was his greatest exponent. Reading contemporary criticism, one learns that Daubigny was the perfect realist landscapist, realism being slander from the pens of conservatives and the highest compliment awarded by Zola. Daubigny's paintings were called "pieces of nature cut out and set into a golden frame,"[30] a nature that instilled sentiments in the spectator through the selective sacrifice of details in order to improve the overall effect. So convincing was *Les Bords de l'Oise* (fig. 18) at the 1859 Salon that Nadar published a cartoon of a gallery goer removing his clothes to jump into the limpid water (fig. 403). Daubigny's method involved the selection of unconventional, nonpicturesque sites, a practice picked up by the young generation. Astruc felt that "this common nature charms you with its quiet sweetness like the kindness of a plain woman."[31] Yet when *Un Village près de Bonnières* (fig. 114) was shown in 1861, Théophile Thoré complained, "But is this village made of cardboard or of tin?"[32] Théophile Gautier thought that "a motif so vulgar, so unpicturesque in itself, needed to be enhanced by the execution to become interesting."[33]

The sustained development of Daubigny's precepts, "enhanced by the execution," can be found in Pissarro's works of the 1860s. Although he called himself a student of Melbye and Corot in the *livret* of the 1864 Salon, the painting he showed, *Bords de la Marne* (fig. 116), was an homage to Daubigny. The subject was inextricably bound to Daubigny's paintings of the rivers and canals of France, and the nondescript site is typical of Daubigny as well. Pissarro's Salon *envoi* of the following year, *Chennevières au bord de la Marne* (fig. 115), was once again a large, handsome river landscape in Daubigny's manner, with a pretty color scheme that ensured acceptance. The next year, however, he eschewed the picturesque and pretty for a somber picture (fig. 117) that required for acceptance the intervention of Daubigny, who was serving on the Salon jury for the first time. The critic Jean Rousseau understood immediately what Pissarro was doing:

> Surely, nothing is more vulgar than this site, and yet I challenge you to walk in front of it without noticing it. It becomes original

29. *Le Midi de la France photographié* (Paris, 1853–54), quoted in Jammes and Janis, *Art of the French Calotype*, p. 62.
30. "des morceaux de nature coupés et entourés d'un cadre d'or." Gautier 1859, p. 192.
31. "cette nature commune vous charme par sa tranquille douceur, comme la bonté d'une femme laide." Astruc 1859, pp. 303–6.
32. "encore ce village, est-il en carton ou en fer-blanc?" Thoré-Bürger 1870, vol. 1, p. 53.
33. "un motif si vulgaire, si peu pittoresque en lui-même, avait besoin d'être relevé par l'exécution pour être intéressant." Gautier 1861, p. 121.

Fig. 114 (cat. 50). Charles-François Daubigny, *Un village près de Bonnières* (*A Village near Bonnières*), 1861. Oil on canvas, 32½ x 57½ in. (82.5 x 146 cm). Private collection

Fig. 115 (cat. 155). Camille Pissarro, *Chennevières au bord de la Marne* (*Chennevières on the Banks of the Marne*), ca. 1864–65. Oil on canvas, 36 x 57¼ in. (91.5 x 145.5 cm). National Galleries of Scotland, Edinburgh

Fig. 116 (cat. 154). Camille Pissarro, *Bords de la Marne* (?) (*The Banks of the Marne* [?]), 1864. Oil on canvas, 32¼ x 42½ in. (81.9 x 107.9 cm). Glasgow Museums, Art Gallery and Museum, Kelvingrove

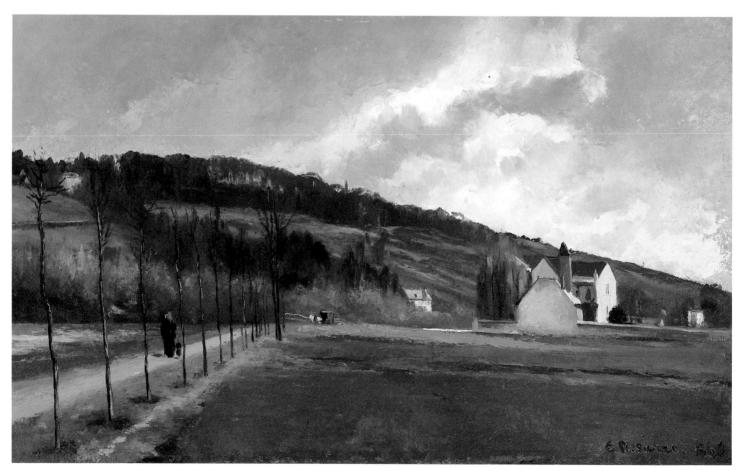

Fig. 117 (cat. 156). Camille Pissarro, *Bords de la Marne en hiver* (*The Banks of the Marne in Winter*), 1866. Oil on canvas, 36⅛ x 59⅛ in. (91.8 x 150.2 cm). The Art Institute of Chicago, Gift of Mr. and Mrs. Lewis L. Coburn Fund, 1957

Fig. 118 (cat. 29). Paul Cézanne, *Usines près du mont de Cengle (Factories near Mont de Cengle)*, ca. 1869–70. Oil on canvas, 16⅛ x 21⅝ in. (41 x 55 cm). Private collection

by the brusque energy of the execution, in some way underlining ugliness rather than attempting to conceal it. One can see that M. Pissarro is not banal because he is lacking in the picturesque. On the contrary, he uses his strong and exuberant talent to emphasize the crudeness of the contemporary world, in the manner of a satirical poet, all the more eloquent as he is telling the raw and unaltered truth.[34]

Not all of Pissarro's "crudeness" and "brusque energy of the execution" came from Daubigny. About 1866 he began to use the palette knife—or properly speaking, the paint knife—a tool associated with Courbet. Pissarro's use of the tool was closer to Cézanne than to Courbet, since both Pissarro and Cézanne used it to lay thick slabs of paint of the same color, while Courbet used it to blend several colors into earthy agglomerates, but the knife was nevertheless a signature instrument of Courbet. "Courbet uses it constantly and achieves extraordinary effects with it. . . . This broad execution and beauty of color everyone recognizes in his work are partially due to this process. Examine this ground, this running water, this

34. "Rien de plus vulgaire assurément que ce site, et pourtant je vous défie de passer devant sans le remarquer. C'est qu'il devient original par l'énergie abrupte de l'exécution qui souligne, en quelque sorte, ces laideurs, au lieu de chercher à les dissimuler. On voit que M. Pissarro n'est pas banal par impuissance d'être pittoresque. Il emploie au contraire un talent robuste et exubérant à faire ressortir les vulgarités du monde contemporain, à la façon du poète satirique, d'autant plus éloquent qu'il est d'une vérité plus brutale et moins arrangée." Rousseau 1866, p. 447.

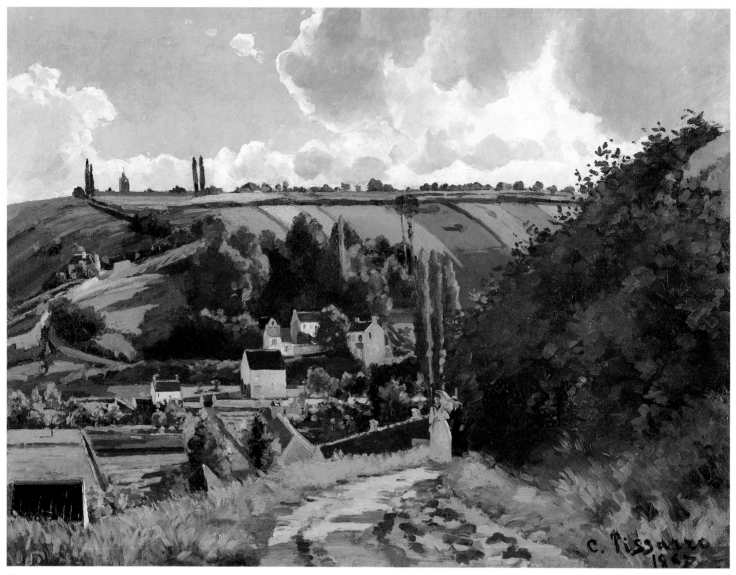

Fig. 119 (cat. 158). Camille Pissarro, *La Côte de Jallais* (*Jallais Hill*), 1867. Oil on canvas, 34¼ x 45¼ in. (87 x 114.9 cm). The Metropolitan Museum of Art, New York, Bequest of William Church Osborn, 1951

underwood so clear and so light, this profound and true harmony, all come from using a knife."[35] Pissarro's great canvases of the hamlet of l'Hermitage, adjacent to Pontoise (figs. 120–22), all refer to the example of Courbet, whether in the use of hills in the middle ground to block the horizon and thus to create a pictorial amphitheater, whether in the use of dark browns and sharp greens, or whether in the inclusion of peasant figures to provide a human presence. Most important, though, was Pissarro's use of the knife and the concomitant new insistence on the materiality of the paint. Courbet had equated thick paint, roughly applied, with realism in order to distinguish his art from the illusionism and slickly polished surfaces of the painters of the academy: Flandrin, Cabanel, Bouguereau. The association of the palette knife with a radical new style is nowhere better explained than in a remark made by Antoine Guillemet to the painter Francisco Oller in 1866: "Courbet is be-

35. "Courbet en fait un usage constant, et qu'il en tire des effets extraordinaires. . . . Cette largeur d'exécution et cette beauté de coloris que tout le monde lui reconnaît viennent en partie de là. Examinez ces terrains, ces eaux courantes, ce dessous de bois si clair et si léger, cette harmonie profonde et juste, tout cela est dû à l'emploi du couteau." "Salon de 1868," in Castagnary 1892, p. 272.

90

coming classical. He has done superb things, but next to Manet he is traditional and Manet next to Cézanne will become traditional in turn.... The gods of today will not be those of tomorrow; let's take up arms, let's seize with a febrile hand the knife of insurrection, let's demolish and reconstruct...paint with heavy impasto and dance on the belly of the terrified bourgeois."[36] Critics like Zola were quick to seize upon this feature of Pissarro's art as an element of modernity: "What a clumsy fellow you are, sir—you are one artist I like."[37]

Pissarro's *Côte de Jallais* (fig. 119) was one of the great successes of the Salon of 1868. The neophyte art critic Odilon Redon noted how the lack of detail, the subdued palette—Le Gray's theory of sacrifices—and the blocky application of paint contributed to its modern appeal: "His peculiar talent seems to brutalize nature. He paints it in an apparently very rudimentary manner, but this indicates above all sincerity...the sacrifices he makes in his coloring only express the general impression more vividly, and this expression is always strong because it is simple."[38] Zola found in Pissarro

36. "Courbet devient classique. Il a fait des choses superbes, à côté les Manet c'est de la tradition et Manet à côté de Cézanne le deviendra à son tour.... Les dieux d'aujourd'hui ne seront pas ceux du lendemain, aux armes, saisissons d'une main fébrile le couteau de l'insurrection, démolissons et construisons...peindre en pleine pâte et danser sur le ventre des bourgeois terrifiés." Letter from Antoine Guillemet to Francisco Oller, March 12, 1866, quoted in Puerto Rico, Museo de Arte de Ponce, 1983, *Francisco Oller: A Realist Impressionist*, pp. 226–27; reprinted in Christopher B. Campbell, "Pissarro and the Palette Knife," *Apollo* 136 (November 1992), p. 314, n. 18.

37. "Vous êtes un grand maladroit, monsieur—vous êtes un artiste que j'aime." "Mon Salon: Adieux d'un critique d'art," 1866, in Zola 1991, p. 133.

38. "Singulier talent qui semble brutaliser la nature. Il traite dans une facture en apparence très rudimentaire, mais cela dénote surtout de la sincérité...il a, dans la couleur, ces sacrifices qui n'expriment que plus vivement l'impression générale, toujours forte parce qu'elle est simple." "Le Salon de 1868," in Redon 1987, p. 57.

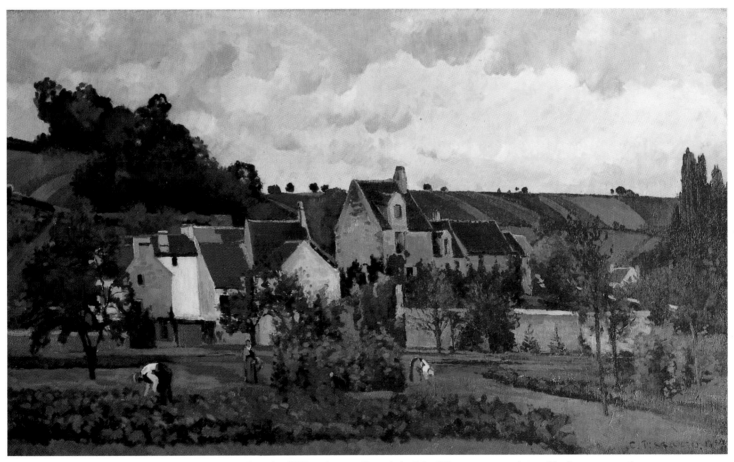

Fig. 120 (cat. 159). Camille Pissarro, *L'Hermitage à Pontoise* (*L'Hermitage at Pontoise*), 1867. Oil on canvas, 35⅞ x 59¼ in. (91 x 150.5 cm). Wallraf-Richartz-Museum, Cologne

the hero of landscape that he had been looking for: "one of the most profound and serious talents of our time." And he attributed to Pissarro the qualities of the artist that Baudelaire demanded in 1859, a painter who could find in banal, everyday scenes the poetry of modern life. Of the *Côte de Jallais* Zola wrote, "This is the modern country. One feels that man has been here, digging the ground, dividing it, and creating a dejected landscape. This small valley, this little hill possess a heroic simplicity and candor. If it were not so great, nothing would be more banal. The temperament of the painter has drawn a precious poem of life and force out of ordinary truth."[39]

The Salon of 1868 was thus the site of the triumph of realist landscape. "Never more obvious proof followed so closely a more contested affirmation...the point of view had changed, the old schools, whatever their names, classic or romantic, had ceased to exist." In a final desperate statement, the comte de Nieuwerkerke

39. "un des talents les plus profonds et les plus graves de l'époque"; "c'est là la campagne moderne. On sent que l'homme est passé, fouillant le sol, le découpant, attristant les horizons. Et ce vallon, ce coteau sont d'une simplicité, d'une franchise héroïque. Rien ne serait plus banal si rien n'était plus grand. Le tempérament du peintre a tiré de la vérité ordinaire un rare poème de vie et de force." "Mon Salon: Les naturalistes," 1868, in Zola 1991, pp. 201, 205.

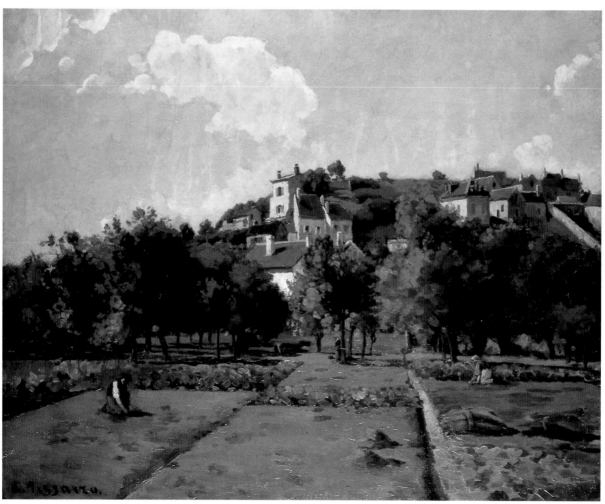

Fig. 121 (cat. 160). Camille Pissarro, *L'Hermitage*, ca. 1868. Oil on canvas, 32⅛ x 39⅜ in. (81.5 x 100 cm). Národni Galeri, Prague

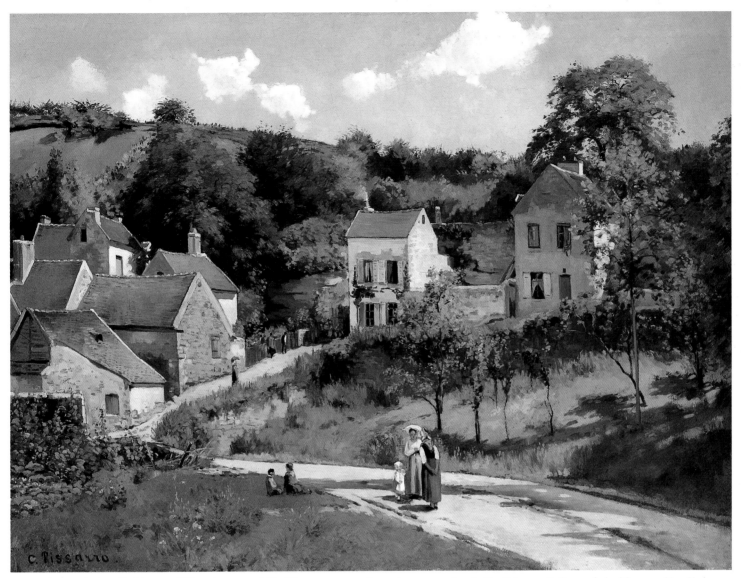

Fig. 122 (cat. 161). Camille Pissarro, *L'Hermitage*, ca. 1868. Oil on canvas, 59⅝ x 79 (151.4 x 200.6 cm). The Solomon R. Guggenheim Museum, New York, Justin K. Thannhauser Collection

had declared, "the mission of the State is to discourage the false vocations and false talents blocking all the avenues," but, as Castagnary observed, Nieuwerkerke had "fallen in the struggle he had conducted for a long time on behalf of authority." Thanks to the presence of Daubigny on the jury, Castagnary could proclaim, "The Salon of 1868 will be the Salon of the young."[40] In fact, Bazille, Degas, Manet, Monet, Morisot, Pissarro, Renoir, Sisley—in short, everyone except Cézanne—exhibited in 1868. Soon "the young" would become Impressionists.

40. "Jamais démonstration plus évidente n'aura suivi de plus près affirmation plus contestée...que le point de vue était changé, que les anciennes écoles, de quelque nom qu'on les nommât, classique ou romantique, avaient pris fin"; "la mission de l'État est de décourager les fausses vocations et les faux talents qui obstruent toutes avenues"; "succombé dans la lutte que depuis longtemps il avait entreprise au nom de l'autorité." "Le Salon de 1868 sera le Salon des jeunes." "Salon de 1868," in Castagnary 1892, pp. 252, 257.

IV
The Nude

HENRI LOYRETTE

One Sunday in Argenteuil, in the early 1860s: stretched out on the riverbank, Manet and his friend Antonin Proust were watching the "white yawls streak along the Seine, their brightness carried over the blue of the deep water. Women were bathing." Gazing at the "flesh of the women emerging from the water," Manet had a revelation of his major works to come: "It seems that I must produce a nude. Well then, I will paint them one."[1] Thus the golden legend of Impressionism explains the genesis of *Déjeuner sur l'herbe* (figs. 143, 145): preoccupied with plein air painting and captivated by the reflections playing on the bathers' wet bodies, Manet in turn gave himself to the nude, because of necessity, but also to revolutionize it. One needs only to look at the magnificent studio painting that is the *Déjeuner sur l'herbe*, full of the lessons of the old masters, to prove the inanity of Proust's text, which judged all by the standard of Impressionism. Manet did not resign himself to painting the nude and was not a pioneer of plein air painting; between 1859 and 1865, the nude was central to his thought, as history painting was for Degas during the same period. Manet's ambition was to paint "modern beauty," as Baudelaire had entreated and as Courbet had already done.[2] Following Manet's example, Bazille, Renoir, and Cézanne would try their hands at the nude, "a subject so dear to artists" but equally "a necessary feature of success."[3] When Bazille painted, in 1870, his *Atelier de la rue de La Condamine* (fig. 355), among the paintings covering the high walls, nudes took up the most space. There was a male nude, *Le Pêcheur à l'épervier* (fig. 153), and, behind the rose sofa, *La Toilette* (fig. 154), still unfinished; right in the center was a vast composition by Renoir (soon partially destroyed) juxtaposing a woman dressed in white and a female bather viewed from the back. In contrast to history painting, which barely survived among the Impressionists after the 1860s, the nude would remain a favorite subject for Degas, Renoir, and Cézanne throughout their careers.

Because it was then regarded as the highest expression of art and because it easily aroused suspicions of indecency, the nude was a frequent and preferred cause for scandal. The nudes that embellished

1. "yoles blanches sillonner la Seine et enlever leur note claire sur le bleu de l'eau foncée. Des femmes se baignaient"; "chair des femmes qui sortaient de l'eau"; "Il paraît qu'il faut que je fasse un nu. Eh bien je vais leur faire un nu." Proust 1897, p. 30.
2. "beauté moderne." Baudelaire, 1985–87, vol. 2, "Salon de 1856," p. 952.
3. "cette chose si chère aux artistes"; "cet élément nécessaire de succès." Ibid.

Édouard Manet, *Nymphe surprise*, detail of fig. 123

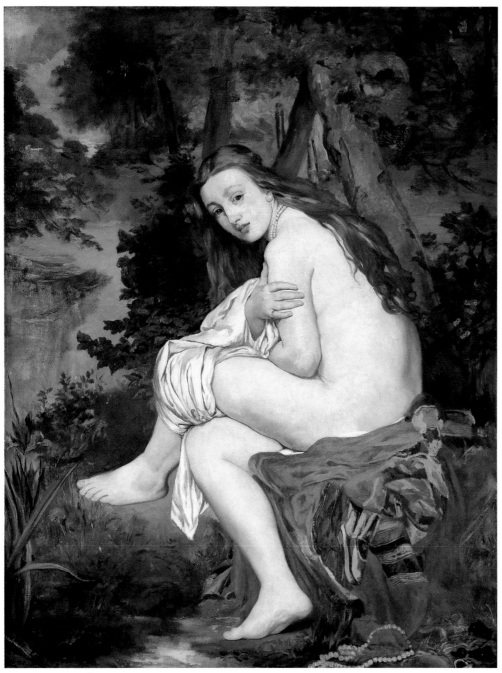

Fig. 123 (cat. 84). Édouard Manet, *Nymphe surprise* (*The Surprised Nymph*), 1861. Oil on canvas, 56⅞ x 44¼ in. (144.5 x 112.5 cm). Museo Nacional de Bellas Artes, Buenos Aires

the 1860s—the presentations in 1863 and 1865 of Manet's *Déjeuner sur l'herbe* (fig. 143) and *Olympia* (fig. 146)—produced commotions similar to those of earlier decades, notably the exhibition of William Haussoulier's *Fontaine de Jouvence* (fig. 125) at the Salon of 1845 or that of Courbet's *Baigneuses* (fig. 124) at the Salon of 1853. Manet was not alone in earning the crown of martyrdom. Moreover, the situation during the decade of the 1860s cannot be summarized in terms of the opposition, convenient in its didactic, albeit reductive, Manichaeism, between the defenders of idealized beauty who vulgarized the Ingres-like nude to the point of insipidity and the champions of modern beauty who, emulating Courbet, boldly showed the truth of the model—the conflict between Cabanel's *Venus* (fig. 127) and Manet's *Olympia*. The common explanation of the

origins of Impressionism, used regularly to condemn academic art, does not account for Manet, who triumphed too easily over an honorable "rival"—Cabanel—represented here by one of his worst paintings; above all, it conveys a false idea of figure painting at that time; in fact, like history painting, figure painting was complex and rich in new solutions. Most certainly, next to Cabanel one must rank Baudry (*La Perle et la Vague*, fig. 128) and Giacomotti (*L'Enlèvement d'Amymoné*, fig. 129), who have no reason to envy him in terms of flaccidity. Worse yet is Schutzenberger, laboriously hoisting a fat Europa onto Jupiter as a bull with a calf's head (fig. 126). But one

Fig. 124. Gustave Courbet, *Les Baigneuses* (*The Bathers*), 1853. Oil on canvas, 89⅜ x 76 in. (227 x 193 cm). Musée Fabre, Montpellier

Fig. 125. Guillaume, called William Haussoulier, *Fontaine de Jouvence* (*The Fountain of Youth*), 1843. Oil on canvas, 53⅛ x 73¼ in. (135 x 186 cm). Graham Reynolds Collection, London

Fig. 126. Louis-Frédéric Schutzenberger, *L'Enlèvement d'Europe* (*The Rape of Europa*), 1865. Oil on canvas, 57½ x 87¾ in. (146 x 223 cm). Musée des Beaux-Arts, Arras

Fig. 127. Alexandre Cabanel, *La Naissance de Vénus* (*The Birth of Venus*), 1863. Oil on canvas, 51⅛ x 88⅝ in. (130 x 225 cm). Musée d'Orsay, Paris

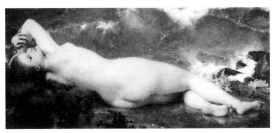

Fig. 128. Paul Baudry, *La Perle et la Vague* (*The Pearl and the Wave*), 1862. Oil on canvas, 32⅝ x 68⅞ in. (83 x 175 cm). Museo del Prado, Madrid

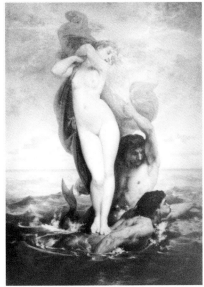

Fig. 129. Félix-Henri Giacomotti, *L'Enlèvement d'Amymoné* (*The Rape of Amymone*), 1865. 18⅛ x 14⅛ in. (46 x 36 cm). Musée Raymond Lafage, Lisle-sur-Tarn

Fig. 130. Charles Gleyre, *Le Bain* (*The Bath*), 1868. Oil on canvas, 32 x 21 in. (81.4 x 53.3 cm). The Chrysler Museum, Norfolk, Virginia

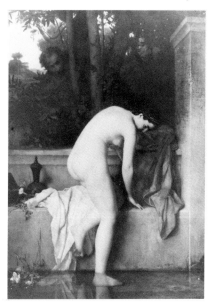

Fig. 131. Jean-Jacques Henner, *La Chaste Suzanne (Suzanne au bain) (Susanna Bathing)*, 1865. Oil on canvas, 72⅞ x 51⅛ in. (185 x 130 cm). Musée d'Orsay, Paris

Fig. 132. James Tissot, *Japonaise au bain (Japanese Woman Bathing)*, 1864. Oil on canvas, 81⅞ x 48⅞ in. (208 x 124 cm). Musée des Beaux-Arts, Dijon

Fig. 133. Gustave Moreau, *Jason*, 1865. Oil on canvas, 80¼ x 45½ in. (204 x 115.5 cm). Musée d'Orsay, Paris

Fig. 134. Jules-Joseph Lefebvre, *Femme couchée (Reclining Woman)*, 1868. Oil on canvas. Whereabouts unknown

must also make room for the excellent Gleyre (fig. 130)—recognized today only as the tolerant master of Whistler, Monet, Bazille, and Renoir—who scattered a legendary Greece with impeccable bodies of goddesses, nymphs, and bacchantes. On the side of Courbet, Manet, and Renoir, the ambiguous Jules Lefebvre denied his *Femme couchée* (fig. 134) of the Salon of 1868 any mythological disguise, giving her a "boldly modern" character, while borrowing from the academy the easy seduction of "conventional coloring, entirely white and pink."[4] Nevertheless, the borders between the two camps were not clearly drawn; for his *Femme au perroquet* (fig. 148) Courbet appropriated a reclining nude from one of Gleyre's best-known compositions, *La Danse des bacchantes* (fig. 149). Further, many artists did not fall within any of these simplistic categories. Henner renewed, in 1865, the exhausted motif of *Suzanne au bain* (fig. 131), drawing his inspiration from the Flemish and Dutch, and no longer painting a mediocre biblical Venus but rather a "commoner Susanna, the bourgeois of Babylon";[5] Tissot, always fashionable, depicted a solid model from the Batignolles as a blossoming and provocative geisha (fig. 132); and the odd Lambron, eager for iconographic novelties, sent to the Salon of 1863 a *Vénus aux rats blancs (Venus with White Rats)*—"some of those fellows are walking on her arms, on her breast, on her legs. A lot of talent and extravagance"—which was rejected.[6]

We must not forget the very lively movement—as in history painting—uniting Gustave Moreau, Degas, and Puvis de Chavannes. For all three artists, historical or allegorical compositions were primarily opportunities to paint the nude. Moreau established a canon that would vary little: thin and androgynous youngsters, as in *Jason* (fig. 133), their sex discreetly concealed, but subtly differentiated by

4. "franchement moderne"; "coloris de convention, tout fait de blanc et rose." Marius Chaumelin, "Salon de 1868," *La Presse*, May 27, 1868, p. 3; Castagnary 1892, p. 312.

5. "Suzanne roturière, la bourgeoise de Babylone." Paul de Saint-Victor, "Salon de 1865," *La Presse*, May 14, 1865, p. 3.

6. "quelques-uns de ces messieurs se promènent sur ses bras, sur son sein, sur ses jambes. Beaucoup de talent et d'extravagance." Émile Cantrel, "Salon de 1863," *L'Artiste*, May 1, 1863, p. 195.

Fig. 135. Edgar Degas, *Baigneuse allongée sur le sol (Female Bather Lying on the Ground)*, 1886–88. Pastel, 18⅞ x 34¼ in. (48 x 87 cm). Musée d'Orsay, Paris

Fig. 136. Edgar Degas, *Scène de guerre au Moyen Âge*, detail of fig. 61

Fig. 137. Pierre Puvis de Chavannes, *L'Automne (Autumn)*, 1864. Oil on canvas, 112¼ x 89 in. (285 x 226 cm). Musée des Beaux-Arts, Lyon

7. "traditions du grand art"; "beauté pure, chaste, élevée." Edmond About, *Salon de 1864* (Paris, 1864), p. 90.
8. "simplicité trop grande et trop voulue"; "C'est fort beau de peindre le nu, mais il ne faut pas le dépouiller." Ibid.
9. "avec leurs poses élancées et leurs yeux de poupées étonnées"; "si bizarres, si vagues, au milieu de ce troupeau de femelles échappées des ateliers." Quoted in Paris 1976, p. 80.
10. "malgré la prédominance du genre et la rareté des tableaux d'histoire." Théophile Gautier, "Salon de 1864," *Le Moniteur universel*, May 21, 1864, p. 1; Paul de Saint-Victor, "Salon de 1864," *La Presse*, May 7, 1864.

the means used to do so—a knot of fabric for Jason, a flower garland for Medea. These are the same adolescent bodies that Degas depicts provoking each other in the plane trees' shadow (fig. 70). But in *Scène de guerre au Moyen Âge* (fig. 61) the aberrant cruelty of the subject—soldiers shooting arrows that cause no apparent injury—is a pretext for conducting a quasi-clinical observation of women: naked bodies writhing, hair falling free, inanimate women, women taking flight, crawling on the ground, or riveted to a tree as if crucified, surprising anticipations of all Degas's female nudes. These women who appear to be posing, studio models scattered in a desolate countryside, have the same immodest attitudes as those women Degas will show bathing, combing their hair, drying off, dozing, revealing themselves—here their disregard for modesty pertains to being hunted down, raped, or dead; later, it will relate to performing, unobserved, their intimate toilets (figs. 135, 136).

Concerning the numerous nudes populating the compositions by Puvis de Chavannes, critics often underlined the influence of Greek statuary reformed by the synthetic spirit of the Italian fresco painters; always they saluted the fidelity to the "traditions of high art" in these tireless reprises of "pure, chaste, elevated beauty," even if they voiced reservations about the "simplicity too great and too intentional" that was the mark, even the genius, of Puvis (fig. 137).[7] "'It is fine to paint the nude,' warned Edmond About, a zealous admirer of all academic nudes, 'but do not strip it.'"[8] A quarter of a century later, the admirable figures of *L'Automne* "with their slender poses and their eyes of astonished dolls" would still seem to Huysmans "so bizarre, so vague, amid this herd of females escaped from the studios" of Puvis's colleagues.[9]

In contrast to the apparent anemia of history painting, the vitality of the nude struck contemporary critics. The year of the Salon des Refusés and the scandal of *Le Déjeuner sur l'herbe*, 1863, was also the year of the Salon of the "Three Venuses," which saw Cabanel, Baudry, and Amaury-Duval fight for the public's favors with blows of lascivious looks, flattering curves, and an entire array of putti and shells (figs. 127, 128, 141). This cleverly mounted dispute created a wave of nudes the following year, which, for Théophile Gautier and Paul de Saint-Victor, signified, "notwithstanding the predominance of the genre and the rarity of history paintings," a favorable leap.[10] "Female bathers abound," wrote a contemporary, and by 1868 enthusiasm had not yet subsided.[11] As Marius Chaumelin lamented, "The classicists should be happy: since the famous Salon of 1863 where *La Perle* by M. Baudry vied for the palm of beauty with *La Vénus anadyomène* by M. Cabanel, we have seen nude studies grow and multiply; I mean those images of nude men and women—particularly women—copied after a model more or less well con-

structed and by means of some small mythological accessories transformed into Olympian divinities or allegories."[12]

Daumier would enjoy such a display of flesh (fig. 138); Proudhon would not interpret it as a fleeting trend but as an epiphenomenon related to the advanced corruption of the empire: "The renewed cult of Astarte, Aphrodite, or Venus; orgiastic, Dionysian, or Bacchanalian parties; lamentations over the death of Adonis, floral games, sacred prostitution, universal priapism, erotic poetry, and trite and omnigamous love, these are its monuments." Recalling a visit to the Salon of 1863 where he had been enticed by a callipygian Venus (fig. 128), Proudhon suggested that the only way to "make this painting moral" and to protect youths from the dangers of such evil company would be to paint a "chancre on her anus."[13] Proudhon saw in his friend Courbet's *Vénus persécute Psyché* (fig. 139) a "satire of the abominations of his time," in which the artist exposed the faults of imperial society: "You are a troop of libertines and hypocrites; I know you, I know what you want and what your pimps ask of you: it is not painting the nude that you care about; it is not the beauty of nature that you are hungry for; it is filth. See, here is how one paints the nude, and I defy you to do the same. And here is what you all are searching for, you sodomites and lesbians."[14] No doubt Proudhon would have drawn some virtuous lesson from *La Femme au perroquet* (fig. 148); but most of his contemporaries saw it only as a "concession" to the fashion of the day: they congratulated "M. Courbet for having given up vulgar and worn-out forms for a more elegant nature," but there were some disdainful smiles in ascertaining that he was not exactly "in his realm."[15] The very people Proudhon flogged the day before now claimed the moral of the story: what is bred in the bone will out in the flesh. Courbet was like an upstart eager to reach the top but always betrayed by a vulgar attitude or an improper word.

Because the nude was "the very essence of art . . . , its principle and its force, the mysterious armature that prevents its decomposition and dissolution,"[16] it could only be conquered after lengthy study. With the collapse of history painting, the nude became, for those attached to tradition, the last bastion of style. Saluting its return to grace after the Salon of 1863, Théophile Gautier affirmed that "the nude is to painting what counterpoint is to music, the foundation of true science. The study of human form, unrestricted and free of all apparel and of all transitory fashion, is alone capable of producing complete artists. It is truth, beauty, and eternity. The imagination in quest of an ideal would know to go no further. Man cannot give his dream a more perfect form than his own. Thus it is toward expressing this form, modeled after the creator's own image, that the efforts and ambitions of serious art must strive."[17] Adrien

Fig. 138. Honoré Daumier, "Des Vénus, toujours des Vénus . . ." ("Venuses and more Venuses . . ."), 1863. Caricature published in *Le Charivari*

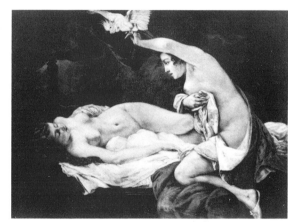

Fig. 139. Gustave Courbet, *Le Réveil. Vénus persécute Psyché avec son perroquet (The Awakening. Venus Persecutes Psyche with Her Parrot)*, 1864. Oil on canvas, 57⅞ x 75⅝ in. (147 x 192 cm). Destroyed

11. "Les baigneuses pullulent." Jean Rousseau quoted in Tabarant 1963, p. 334.
12. "Les classiques doivent être contents: depuis le fameux Salon de 1863 où la Perle de M. Baudry disputa la palme de beauté à la *Vénus anadyomène* de M. Cabanel, nous avons vu les *académies* croître et multiplier; j'entends ces figures d'hommes ou de femmes nus—de femmes surtout—copiés d'après un modèle plus ou moins bien construit et que moyennant quelques petits accessoires mythologiques on transforme en divinité de l'Olympe ou en personnifications allégoriques." Marius Chaumelin, "Salon de 1868." *La Presse*, May 27, 1868, p. 3.
13. "Le culte multiplié d'Astarté, Aphrodite ou Vénus; les fêtes orgiaques, dionysiaques ou bacchanales; les lamentations sur la mort d'Adonis, les jeux floraux, les prostitutions sacrées, le priapisme universel, les poésies érotiques, l'amour vulgivague, omnigame, en sont les monuments"; "rendre cette peinture morale"; "chancre à l'anus." Proudhon 1939, p. 207.

Fig. 140. Jean-Auguste-Dominique Ingres, *Vénus anadyomène* (*Venus Anadyomene*), 1808–48. Oil on canvas, 64⅛ x 36¼ in. (163 x 92 cm). Musée Condé, Chantilly

14. "satire des abominations de son temps"; "Vous êtes un ramassis de rufiens et de tartufes; je vous connais, je sais ce que vous voulez et que vos souteneurs vous demandent: ce n'est pas de peindre le nu que vous vous souciez; ce n'est pas de la belle nature que vous avez faim; c'est de saleté. Tenez, voilà comme on peint le nu, et je vous défie d'en faire autant. Et voilà ce que vous cherchez tous, race de pédérastes et de tribades." Ibid., p. 210.

15. "concession"; "M. Courbet d'avoir quitté les formes vulgaires, avachies pour une nature plus élégante"; "dans sa sphère." Hector de Callias, "Les Revenants de mai," *L'Artiste*, May 30, 1866, p. 208; Louis Auvray, *Salon de 1866* (Paris, 1866), p. 54.

16. "l'essence même de l'art..., son principe et sa force, l'armature mystérieuse qui l'empêche de se décomposer et de se dissoudre." Paul de Saint-Victor, "Salon de 1864," *La Presse*, May 7, 1864. For a different opinion, see Léon Lagrange, "Le Salon de 1864," *Gazette des Beaux-Arts*, June 1, 1864, pp. 508–10.

17. "le nu est pour la peinture ce que le contre-point est pour la musique, le fondement de la vraie science. L'étude de la forme humaine, absolue et dégagée de tout costume et de toute mode transitoires, est seule capable de produire des artistes complets. Là est le vrai, le beau, l'éternel. L'imagination en quête d'idéal ne saurait aller plus loin. L'homme ne peut donner à son rêve une forme plus parfaite que la sienne. Aussi c'est à rendre cette forme modelée à son image par le créateur que doivent tendre les efforts et les ambitions de l'art sérieux." Théophile Gautier, "Salon de 1864," *Le Moniteur universel*, May 21, 1864, p. 1.

18. "Le nu en peinture, c'est la forme épique, c'est l'ode en poésie. Proscrire le nu serait supprimer l'art." Adrien Paul, "Salon de 1863," *Le Siècle*, July 19, 1863, p. 1.

Paul was less verbose: "The nude in painting, it is the epic form, it is the ode in poetry. To proscribe the nude would be to suppress art."[18] Paul de Saint-Victor, enlivened by the numerous examples he reviewed at the Salon of 1864, saw the emergence of a new balance after the decline of history painting, the repeated successes of genre and landscape painting: "The honorable reinstatement of the study of the nude will put the sovereignty of human form back in its proper place.... Genre painting, practiced by so many artists, will remain the painting of private life; landscape painting has conquered a space that will no longer be contended. But between landscape and genre painting, the historical or mythological nude must rule, as from a pedestal, the picturesque vicissitudes of imagination and taste."[19] Proudhon alone raised a discordant voice, intoning fiercely against this vain "adoration of form" that sacrificed idea to beauty; once again, his diatribe had a moral purpose, "the emancipation of art from all the ill effects of prostitution."[20]

Art education contributed largely to this supremacy of the nude. Charles Blanc, in his *Grammaire des arts du dessin* of 1867, the Bible of Ingres's followers, maintained that the nude was the touchstone of the draftsman and developed an original idea about creation, according to which nature "increasingly brightens the colors of its palette ... as one descends the ladder of beings." But, "to the degree to which created things ascend, nature lessens the importance of color in favor of drawing. Finally, with the appearance of man, and with him, intelligence, drawing is triumphant, and color, which had passed from violence to harmony, then passes from harmony to unity, or at least tends to merge in unity."[21] To the colorist leave the portrayal of inanimate objects, animals, and landscapes and to the draftsman give that of the human figure and primarily of the nude. Of course, Blanc admitted further that many had lost themselves in the "search for sculptural beauty." Citing the example of *Oedipe et le Sphinx* (*Oedipus and the Sphinx*), Blanc praised Ingres, who understood "that one must give renewed force to style from the vitality of nature."[22] But for Blanc the nude remained only a question of drawing; color added little or nothing to it: "Since hair, eyebrows, eyelashes, and beards are predominantly effects of chiaroscuro rather than contrasts of color, it is clear that the human body is the work of a supreme draftsman and not that of a colorist."[23] This theory, of course, was in support of the "sculptors of the body" who all cited Ingres as their authority (fig. 140) and neglected those whom Zola, defending Courbet, called "the family of flesh-makers."[24] For champions of the ideal, the nude was form to which color must be added, light pink and milky pearl tones for the bodies of the women, darker flesh tones for men (fig. 160); for champions of realism, the body was above all flesh, throbbing and alive. Supporters of Baudry and

Cabanel reproached Courbet and his disciples for perpetually melancholy flesh; Baudry and Cabanel's adversaries, in turn, sneered at their "bloated sausage casings" with neither "muscles, nerves, nor blood."[25]

Nevertheless, the nude was foremost an attentive study of the model and therefore an essential feature of art education. Even if their exercises were not always preserved, all the Impressionists devoted themselves to the discipline of drawing from the nude model. Degas, brought up under the influence of Ingres, certainly did so more than others during his years of apprenticeship; in the studio of Lamothe, at the École des Beaux-Arts, and later at the Villa Medici he executed numerous studies from the nude that became sources for his first compositions. A gesture, a movement, an attitude progressively and almost inevitably induce a subject; tricks of the trade become routine, a path gliding toward stereotype and, in the real sense, toward academic art. In his history paintings, particularly *Sémiramis construisant Babylone* (fig. 65), Degas would remain faithful to the method of Ingres, drawing nude figures one by one with black lead before clothing them on the final canvas.

For a young painter, the ability to pay for a model permitted him to undertake ambitious figurative compositions and to no longer be compelled to produce landscapes or still lifes exclusively (see p. 156); sharing a studio, as did Bazille and Renoir, allowed for shared expenses and more frequent visits by the model. A good model was rare and expensive: in Rome during the late 1850s, models were almost not to be found, while in Paris they were increasingly hard to get. An article titled "Modèle" in the *Grand Dictionnaire universel du XIXème siècle*, published in 1874, underlined the hardships of the profession and the tenacious prejudices attached to it: "Most of the girls who work as models are Jewish. Their physical perfection and a certain disdain for what people say naturally predispose them to play a multitude of goddesses, mythological and scantily clad.... They adapt themselves fully to whatever role is dictated by their costume and allow themselves to be hired away with such ease that the artist is never sure of keeping—until the completion of his painting—the Venus he hired when he started. The truth is that female models are becoming more and more rare.... Some of them pose only for the masters; others, to the contrary, work in the studios of students or at academies, posing before forty or so art students. These are the most brazen ones; they are not afraid between poses to join in the malicious tricks the Raphaels of the future play among themselves."[26]
In *Manette Salomon*, a novel of 1867 telling the story of one of these studio girls, the Goncourts recorded the characteristics of various models: "the slender, vigorous body of Marie Poitou, elegant in its leanness . . . the androgynous body of Caroline, the German girl . . . the

19. "L'étude du nu remis en l'honneur replacera sur sa base la souveraineté de la forme humaine. . . . Le *genre* exercé par tant de talents restera la peinture de la vie privée; le paysage a conquis un espace qui ne lui sera plus disputé. Mais entre le Paysage et le Genre, il est nécessaire que le nu historique ou mythologique domine, comme d'un piédestal, les vicissitudes pittoresques de la fantaisie et du goût." Paul de Saint-Victor, "Salon de 1864," *La Presse*, May 7, 1864.

20. "adoration de la forme"; "l'affranchissement de l'art de toutes les atteintes de la prostitution." Proudhon 1939, p. 205.

21. "resplendir de plus en plus les tons de sa palette"; "en descendant l'échelle des êtres à mesure que la création s'élève, elle diminue l'importance de la couleur pour s'attacher au dessin. Enfin, quand l'homme arrive, et avec lui l'intelligence, c'est le dessin qui triomphe, et la couleur, qui était passée de la violence à l'harmonie, passe de l'harmonie à l'unité, ou du moins tend à se fondre dans l'unité." Blanc 1867, pp. 30–31.

22. "chercher le beau sculptural"; "qu'il fallait retremper le style dans les sources vives de la nature." Ibid., p. 539.

23. "La chevelure, les sourcils, les cils de la paupière et la barbe, étant plutôt des effets de clair-obscur que des oppositions de couleur, il est évident que le corps humain est l'oeuvre d'un dessinateur suprême et non celle d'un coloriste." Ibid., p. 51.

24. "sculpteurs de corps"; "la famille des faiseurs de chair." Zola 1991, p. 128.

25. "baudruches mal gonflées"; "ni muscles, ni nerfs, ni sang." Joris-Karl Huysmans, "Salon de 1879," *L'Art moderne* (Paris, 1975), p. 37.

26. "La plupart des filles qui servent de *modèles* sont juives. Leurs perfections physiques et un certain dédain du qu'en-dira-t-on les prédestinent tout naturellement à figurer une foule de déesses aussi mythologiques que peu vêtues. . . . Elles vont partout selon leur toilette et se laissent enlever avec une facilité telle que l'artiste n'est jamais sûr de garder jusqu'à l'achèvement de son tableau la Vénus de louage qui lui a servi à le commencer. La vérité est que les modèles féminins deviennent de plus en plus rares. . . . Certains *modèles* de femme ne posent que chez les maîtres; d'autres, au contraire, posent dans les ateliers d'élèves ou académies devant une quarantaine de rapins; ce sont les plus délurées; elles ne craignent point de se mêler entre deux poses aux malins tours que se jouent entre eux les Raphaëls de l'avenir."

27. "le corps mince nerveux distingué dans la maigreur de Marie Poitou"; "le corps androgyne de Caroline l'Allemande"; "le corps de Georgette, à la taille d'anguille, aux reins serpentins"; "le corps à la Rubens, la poitrine exubérante, les jambes magnifiques de Juliette"; "le corps fluet, maigriot, élancé et charmant de Caelina Cerf." Goncourt 1867, pp. 45–46.

28. "doit être correcte et prise sur la nature"; "gagner une largeur plus gracieuse et plus féminine"; "trichât"; "le côté rentrant, pour ôter au contour saillant ce qu'il semble avoir de brusque et d'exagéré." Théophile Gautier, "Salon de 1863," *Le Moniteur universel*, June 13, 1863, p. 1. See also Castagnary 1892, p. 115.

Fig. 141. Amaury-Duval, *Naissance de Vénus* (*The Birth of Vénus*), 1862. Oil on canvas, 77½ x 42⅞ in. (197 x 109 cm). Musée des Beaux-Arts, Lille

Fig. 142. Gustave Courbet, *L'Origine du monde* (*The Origin of the World*), 1866. Oil on canvas, 18⅛ x 21⅝ in. (46 x 55 cm). Private collection

29. "Je trouve que le nu cesse d'être honnête, lorsqu'il est traité de façon à exagérer intentionnellement certaines formes aux dépens de certaines autres." Maxime Du Camp, quoted in Clark 1985, p. 295, n. 131.
30. "les cordons de sa robe dénoués"; "Elle a un nom propre, comme qui dirait Paméla ou Thérésa, et ses charmes bien réels se peuvent au besoin vérifier." Charles Blanc, "Salon de 1866," *Gazette des Beaux-Arts*, June 1, 1866, p. 510.
31. See Françoise Cachin in Paris, New York 1983, p. 84.
32. "ce que peut signifier ce logogriphe peu séant." L. Etienne, *Le Jury et les exposants* (Paris, 1963), pp. 29–30.
33. "mythologiades incongrues"; "ces tristes images ne représentent point la femme"; signifient." Thoré-Bürger, 1870, vol. 2, "Salon de 1864," pp. 68, 206.

body of Georgette, with her slim waist and serpentine back ... the Rubenesque body, exuberant bosom, magnificent legs of Juliette ... the thin, spare body, lanky and charming, of Caelina Cerf."[27] These characteristics led to different specialties: for one, the attributes of an antique goddess; for another, the odalisque's turban and Turkish slippers; for a third, the martyr's palms.

But this transformation from the Parisienne for hire to Venus Anadyomene or Diana the Huntress could only be achieved, according to academic doctrine, by eliminating all individual details and idealizing an inevitably imperfect body. Amaury-Duval's *Vénus* (fig. 141) was heavily criticized in 1863 because of an extreme protrusion of the hip. Théophile Gautier conceded that this excessive line "must be correct and copied from nature," although he would have preferred—in order that the pelvis could achieve "a more gracious and more feminine dimension"—that the artist "cheat" with the model's features and support "the inward side, to remove the brusque and exaggerated line of the protruding contour."[28] When a woman was transferred onto the canvas with her own characteristics, qualities, and flaws, she was no longer a goddess or a nymph but a model who could be named; the conventional image became woman again, naturally indecent: "I find that the nude is no longer honest," claimed Maxime Du Camp, "when it is handled in a way that accentuates certain forms to the detriment of certain others."[29] Indeed, for Manet, no hesitation is possible, and the nude figure of *Le Déjeuner sur l'herbe* (fig. 143) is not a nymph as in the Renaissance example but a studio model, one of those, to repeat the Larousse's formula, who "are not afraid between poses to mingle" with the "Raphaels of the future." More ambiguous is Courbet's *Femme au perroquet* (fig. 148), toying with mythological references, halfway between the smooth-bodied goddesses of Baudry and Cabanel and Courbet's own lower-class female bathers of the 1850s. *Femme au perroquet* did not deceive the viewer for long. It took, in effect, only a very small detail—"the loose ribbons of her dress"—for the virtuous Charles Blanc to expose the creature forthwith: "She has a proper name, perhaps Pamela or Theresa, and her entirely real charms could be verified if necessary."[30]

Following Courbet, the effort of an entire generation of painters—those who would become the Impressionists—would be in essence to reject metaphors and paraphrases, to express things simply and calmly, to call them by name and to show that there was no shame in doing so. Although painted to be carefully hidden away, Courbet's *L'Origine du monde* (fig. 142), an anatomical description of a woman's genitals, is the most striking example of this new simplicity of language. Manet mastered this simplicity, as Françoise Cachin has demonstrated, in the course of two paintings: from the *Nymphe*

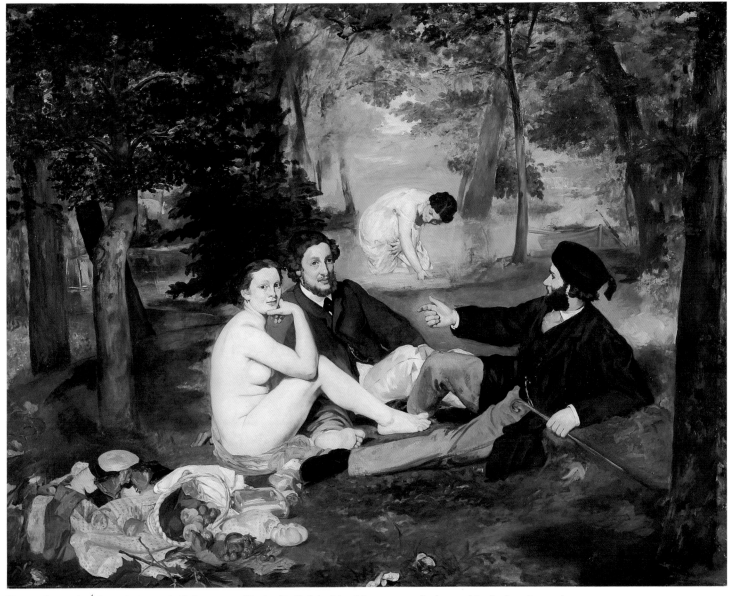

Fig. 143 (cat. 93). Édouard Manet, *Le Déjeuner sur l'herbe (Le Bain)*, 1863. Oil on canvas, 81⅞ x 104⅛ in. (208 x 264.5 cm). Musée d'Orsay, Paris, Moreau-Nélaton Gift, 1906

surprise (fig. 123) to *Le Déjeuner sur l'herbe*; from the disguised mythological scene to the realist nude; from the nymph wife, Suzanne Leenhoff, to the model muse, Victorine Meurent; from the body concealed to the body exposed.[31] Some people protested—"An Olympia? Which Olympia?"—and pretended not to understand; some asked of *Le Déjeuner sur l'herbe*—"What could this unseemly puzzle signify?"[32] Thoré commented that the supporters of the academic nude had tolerated all those "incongruous mythological subjects" because "those sad images did not represent woman at all"[33] and, based on obsolete conventions, literally no longer "signified" anything.

The scandal created by the work of Courbet and then of Manet—Bazille and Renoir benefited quietly from their victories—did not stem solely from their "immorality." Painters of a "school of decadence," they violently jostled the established order and dared to impose, by displaying the "vulgarities of the model," a "denial of

Fig. 144. Marcantonio Raimondi, *The Judgment of Paris*, after Raphael. Engraving

Fig. 145 (cat. 94). Édouard Manet, *Le Déjeuner sur l'herbe*, ca. 1863–67 (?). Oil on canvas, 35 x 45⅝ in. (89 x 116 cm). The Courtauld Institute Galleries, London

34. "immoralité"; "école de décadence"; "vulgarités du modèle"; "démenti aux lois éternelles"; "des exemplaires divins." Blanc 1867, p. 544.

35. "rajeunir"; "usé"; "Bethsabée, comme la chaste Suzanne, comme les Vierges, comme les Vénus, n'est pas dans l'ordre des sujets, mais des motifs, ce qui est bien différent." Hector de Callias, "Salon de 1861." *L'Artiste* 12 (1861), p. 8.

36. "mythologiades"; "roulées au caprice de la vague"; "s'enfle, bouillonne et crève." Théophile Gautier, "Salon de 1863," *Le Moniteur universel*, June 13, 1863, p. 1.

37. "Son corps divin semble pétri avec l'écume neigeuse des vagues. Les pointes des seins, la bouche et les joues sont seuls teintés d'une imperceptible nuance rose; une goutte de la pourpre ambroisienne se répand dans cette substance argentée et vaporeuse." Ibid.

38. "d'une immoralité tout à fait spéciale." Quoted in Loyrette 1991, pp. 277–78.

39. "chair nacrée"; "imperceptible nuance rose"; "des teintes de noyée"; "crasse tutélaire." Paul de Saint-Victor, "Salon de 1866," *La Presse*, June 10, 1866, p. 3; Bertall, caricature of *La Baigneuse au griffon*, *Le Journal amusant*, June 18, 1870; concerning *Olympia*, see the comments recorded by Clark 1985, pp. 79–146.

the eternal laws" and to corrupt "the divine examples."[34] As a last resort, some critics took refuge in subtleties that had never been accepted: It is useless to strive to "revive" a subject as "worn out" as that of the chaste Susanna, claimed Hector de Callias, considering that "Bathsheba, like the chaste Susanna, the Virgins, and the Venuses, was not really a subject but rather a motif, which is very different."[35] As a matter of fact, the hostility of many critics toward the nudes of Courbet and Manet stemmed from the impoverishment of their stock of critical ideas before these works. For years, the recurrent "mythological subjects" had produced conventional speeches, double entendres, and lecherous verses. From one Salon to another and from one nude to the next, Théophile Gautier purred gently lascivious niceties, multiplying lewd winks and erotic allusions. He surpassed himself at the Salon of 1863, unfurling around both Cabanel's and Baudry's *Venus* an unprecedented exuberance of aquatic metaphors, detailing piece by piece the bodies of these youthful beauties, "rocked at the whim of a wave," an enveloping, amorous, caressing wave, so deeply moved that it "swells, foams, and bursts."[36] If, for Gautier, such works were all order and beauty— "Her divine body seems kneaded by the snowy froth of the waves.

Édouard Manet, *Le Déjeuner sur l'herbe*, detail of fig. 143

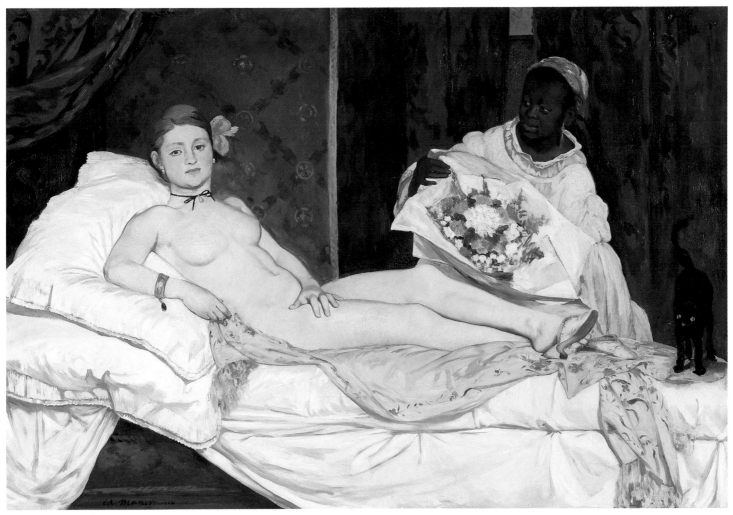

Fig. 146 (cat. 95). Édouard Manet, *Olympia*, 1863. Oil on canvas, 51⅜ x 73¾ in. (130.5 x 190 cm). Musée d'Orsay, Paris

The nipples, the mouth, and the cheeks alone are tinted with a subtle shade of pink; a drop of ambrosian purple flows over this silvery, vaporous substance"—the works of Courbet and Manet, as seen by their numerous detractors, were nothing but disorder and ugliness.[37] Not only was the realist nude immoral—"a very special immorality," noted Ludovic Halévy, who was no prude, regarding the *Déjeuner sur l'herbe*—but its immorality showed.[38] Here was neither the "pearly skin" nor a "subtle shade of pink" but rather "the complexion of a drowned woman" (as Saint-Victor proclaimed about *La Femme au perroquet*, fig. 148) or a "tutelary filth" (so Bertall stated of *La Baigneuse au griffon*, fig. 151); Olympia appeared so encrusted with dirt that many advised her to take a bath.[39] Whereas the academic body was perceived as united and harmonious, the figures painted by Courbet, the "marquis de Sade of Painting," and his followers seemed dissonant, constantly incorrect, often incoherent, piles of badly connected parts.[40] The limbs of *La Femme au perroquet* were "thrown right and left like the arms of an octopus."[41] "Misshapen," the pitiful body of the lascivious Olympia was "a sort of female gorilla, a grotesque in rubber outlined in

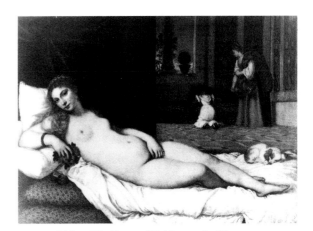

Fig. 147. Titian, *The Venus of Urbino*, 1538. Oil on canvas, 46⅞ x 65 in. (119 x 165 cm). Galleria degli Uffizi, Florence

40. "marquis de Sade de la Peinture." P. Gille in *L'Internationale*, June 1, 1865, quoted in Clark 1985, p. 286.
41. "jetés à droite et à gauche comme les membranes d'une pieuvre." L. Auvray, *Salon de 1866* (Paris, 1866), p. 54.

Édouard Manet, *Olympia*, detail of fig. 146

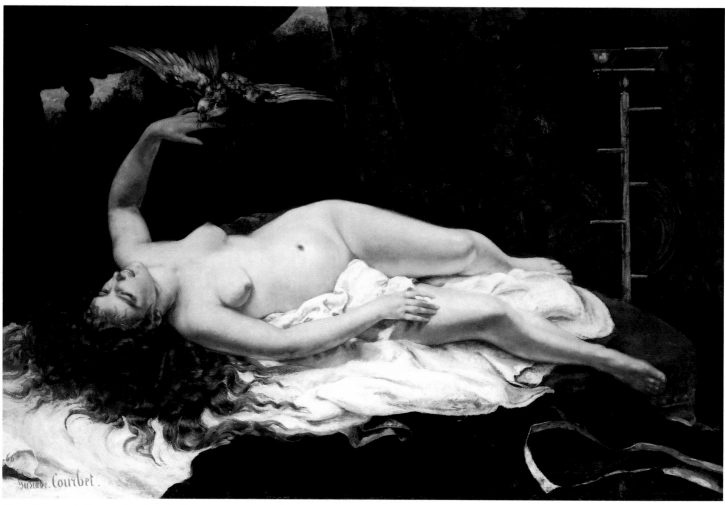

Fig. 148 (cat. 45). Gustave Courbet, *La Femme au perroquet* (*Woman with a Parrot*), 1866. Oil on canvas, 51 x 77 in. (129.5 x 195.6 cm). The Metropolitan Museum of Art, New York, H. O. Havemeyer Collection, Bequest of Mrs. H. O. Havemeyer, 1929

Fig. 149. Charles Gleyre, *Femme couchée* (*Reclining Woman*), study for *La Danse des bacchantes* (*The Dance of the Bacchantes*), 1844–45. Black chalk, 10⅝ x 17½ in. (27.1 x 44.4 cm). Musée Cantonal des Beaux-Arts, Lausanne

Fig. 150. Gustave Courbet, *Les Demoiselles des bords de Seine* (*Young Women on the Banks of the Seine*), 1856. Oil on canvas, 68½ x 81⅛ in. (174 x 206 cm). Musée du Petit Palais, Paris

Fig. 151 (cat. 180). Auguste Renoir, *Baigneuse (La Baigneuse au griffon)* (*Bather with a Terrier*), 1870. Oil on canvas, 72½ x 45¼ in. (184 x 115 cm). Museu de Arte de São Paulo Assis Chateaubriand

black, an ape on a bed.["]42 The crudity of the subject was matched by the austerity and strangeness of the style. T. J. Clark has clearly shown that besides the endlessly repeated accusations of moral and physical filth, one of the leitmotifs of *Olympia*'s detractors was that the painting had nothing in common with art; in their opinion, it belonged either to caricature, the *images d'Épinal* (cheap images printed on cards), commercial signs, or street-fair paintings. Even Courbet—flattered the following year by compliments he received for his *Femme au perroquet* from the academic trio of Cabanel, Pils,

42. "informe"; "lubrique"; "sorte de gorille femelle, de grotesque en caoutchouc cerné de noir, singe sur un lit." See Francis Aubert in *Le Pays*, May 15, 1865, quoted in Clark 1985, p.287; Théophile Gautier, "Salon de 1865," *Le Moniteur universel*, June 24, 1865; and Amédée Cantaloube in *Le Grand Journal*, May 21, 1865, quoted in Clark 1985, p. 287.

Fig. 152. Gustave Courbet, *Les Lutteurs*
(*The Wrestlers*), 1853. Oil on canvas,
99¼ x 78 in. (252 x 198 cm). Szépművészeti
Múzeum, Budapest

and Baudry—regarded Manet's figure as "a queen of spades" getting out of her bath.[43]

How can one explain so much artistic and moral ugliness except by a desire to shock, a need to attract attention? Courbet gave vogue to this subtle strategy of the rebel artist, sometimes defiant and rejected, at other times accommodating and warmly accepted. Of *Le Retour de la conférence* (*Return from the Conference*), a large anticlerical painting rejected by the jury in 1863 as well as prohibited from exhibition at the Salon des Refusés, Courbet wrote, "I made the painting so that it would be rejected and therefore bring me money."[44] With his *Femme au perroquet* (fig. 148), however, Courbet insinuated that he had momentarily made a deal with the enemy to have his painting accepted at the Salon: "If *they* are not happy this year, *they* will be hard to please.... *They* will have two *clean* paintings the way *they* like them, a landscape and a study from the nude."[45] Manet, in turn, would have envied this blaze of glory and sent to the Salon provocative paintings that quickly brought him what Degas called a "Garibaldi-like" celebrity. To aggravate the scandal, Manet arranged preposterous pairings: in 1865, along with the prostitute *Olympia*, he sent *Jésus insulté par les soldats* (*Jesus Mocked by the Soldiers*; fig. 74), a baffling image of an exhausted subject matter "treated with an amazing vulgarity."[46]

Curiously, the obvious references to the old masters never disarmed the critics. When such references were noted, rarely—in 1865 only two journalists linked *Olympia* with Titian's *Venus of Urbino* (fig. 147)—they simply amplified the furor; not content to display his own depravities, Manet soiled what artists held most dear.[47] Even today these references are perceived in different ways: as a desire, simple and shared, to place himself within the tradition of the masters; as an incapacity to find new formulas; as a wish to subvert tradition to better break away from it; and, more prosaically, as a propensity to make "jokes." Indeed, we see in these "jokes"— these "corrupting" jokes, which, according to the Goncourts, were a "new form of French spirit...a great leveler...a killer of respect...the *vis comica* of our decadence"—the reason for the repeated citations of Marcantonio Raimondi (fig. 144) and Titian in the work of Manet: the allusion to the old masters was parodic, as was Offenbach's vision of antiquity.[48] We can object that if Manet had really wanted to "play a joke," he would have made it more obvious, for absolutely no one noticed such an intention; further, he always showed deep respect for the artistic tradition, and these two paintings are obviously more than an art student's prank. A similar intention was never attributed to Renoir, Bazille, or Cézanne. Yet, there are so many sources for each of the nudes executed by Renoir, Bazille, and Cézanne in the 1860s that their paintings would appear

43. "dame de pique." Riat 1906, p. 237; Reff 1976, p. 30.
44. "J'avais fait le tableau pour qu'il soit refusé c'est comme cela qu'il me rapportera de l'argent." Paris, London 1977–78, p. 38.
45. "S'*ils* ne sont pas contents cette année, *ils* seront difficiles.... *Ils* auront deux tableaux *propres* comme *ils* les aiment, un paysage et une académie." Henry d'Ideville, *Gustave Courbet: Notes et documents sur sa vie et son oeuvre*, in Courthion 1948, p. 212.
46. "à la Garibaldi"; "parti-pris de vulgarité inconcevable." See T. J. Clark, "Un réalisme du corps: Olympia et ses critiques en 1865," *Histoire et Critique des arts* 4–5 (May 1978), p. 141; Chesneau quoted in Paris, New York 1983, p. 226.
47. Clark 1985, p. 94.
48. "blague"; "corruptrice"; "forme nouvelle de l'esprit français...grande démolisseuse...tueuse de respect... *Vis comica* de nos décadences." Goncourt 1867, pp. 42–43. See Linda Nochlin, "The Invention of the Avant-Garde," *Art News Annual* 34 (1968), p. 16. Nochlin's arguments are refuted in Rosen and Zerner 1986, p. 186. See also Georgel 1975, p. 67, and Paris, New York 1983, p. 170, which depend in part on ideas from Nochlin. For a parallel—overdrawn, in my opinion—between Offenbach and Manet, see Herbert 1988, pp. 60–61.

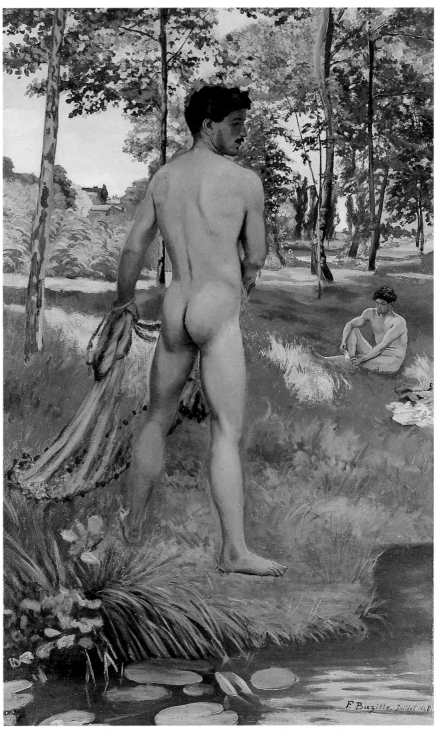

Fig. 153 (cat. 10). Frédéric Bazille, *Le Pêcheur à l'épervier* (*Fisherman with a Net*), 1868.
Oil on canvas, 54¼ x 34⅛ in. (137.8 x 86.8 cm). Fondation Rau pour le Tiers-Monde, Zurich

more anthological than original: Renoir's *La Baigneuse au griffon*
(fig. 151) drew inspiration from the Aphrodite of Cnidus and from
the "nude model" at the center of Courbet's *Atelier* (*The Studio*);[49]
Bazille's *Scène d'été* (fig. 337) may derive from Jacopo Bassano,
Laurent de La Hyre, and, loosely, from Renaissance art, but from
Courbet (fig. 152) comes the group of wrestlers painted in the
background.[50]

The nude of the early Impressionists always looked to the Courbet
model. Renoir's *La Baigneuse au griffon* (fig. 151) undressed

49. "modèle de femme nue." See London, Paris, Boston
 1985–86, p. 94.
50. Montpellier, Brooklyn, Memphis 1992–93, p. 119.

Courbet's *Demoiselles des bords de la Seine* (fig. 150). Bazille, as we mentioned, studied the example of the *Lutteurs* (fig. 152) in a work he himself called "[his] naked men" (figs. 153, 337).[51] Cézanne, toward the end of his life, delightfully evoked the "dense" flesh of Courbet—"One has a mouthful of colors. One drools about it."[52] Manet himself—although he apparently later disavowed "this ox Courbet"—owed to the painter of Ornans the desire to paint a contemporary nude as well as the technique of outlining figures against the background to render them impermeable to all that surrounds them.[53]

Indeed, neither Courbet's opulent female bathers (fig. 124) nor the nude woman of the *Déjeuner sur l'herbe* reverberate with the condensed shadows of large trees and shafts of sunlight; instead, they receive the raw, uniform light of a studio skylight, models posing in a conventional manner, figures flattened against a stage set. Today Manet is blamed for this ambiguity, and the *Déjeuner sur l'herbe* often seems a partial success, a rough draft prior to the final accomplishment of *Olympia*.[54] Manet, in 1863, did not know how to paint the nude in plein air; in 1879, according to Huysmans, when the Salon crumbled under scantily dressed ladies leaping about in greenery, no progress had been made: most painters "stand or recline a woman under the trees or in the sun, and they color her skin as if she were stretched out in a snug room on a white sheet, or standing, detached, near curtains or wallpapered walls."[55] But academic deficiency or negligence, as Huysmans saw it, cannot be attributed to Manet. When examined from an Impressionist point of view—a customary practice for the work of Manet—the *Déjeuner sur l'herbe*, unconcerned with "conveying the impression" of the surrounding air or the reverberation of the landscape on the naked body, can be interpreted only as a pioneering and worthy attempt, though unsuccessful. By contrast, if one places this painting in the tradition of the realist nude, viewing it from Courbet's perspective, it is an insolent novelty, so simple yet difficult to grasp, peacefully offered like the body of the yielding model, yet stealing away at the first request for explanation.

If one hundred thirty years later this painting is still somewhat unaccepted, it is for the most part because of its intrinsic power, its troubling authority, which prove so unsettling. Furthermore—and perhaps most important—Manet's position as a painter was itself very ambivalent. In 1863 he was incontestably within the realist tradition, a disciple, although rebellious and sometimes disrespectful, of Courbet. In 1867 Manet became, thanks to Zola, the promoter and guide of a revolution in progress. *Le Bain* (*The Bath*) of the 1863 Salon des Refusés, which by its very title was a discreet reference to Courbet's *Baigneuses* (fig. 124), became, in 1867 at the pont

51. "[ses] hommes nus." Bazille 1992, p. 176.
52. "on a la bouche pleine de couleurs. On en bave"; "épaisses." Gasquet 1926, p. 183.
53. "ce boeuf de Courbet." Ambroise Vollard, *Souvenirs d'un marchand de tableaux* (Paris, 1937; 1959 ed.), p. 163.
54. See Françoise Cachin in Paris, New York 1983, pp. 166–67.
55. "dressent ou couchent une femme sous des arbres, au soleil, et ils lui teignent la peau comme si elle était étendue dans une chambre calfeutrée, sur un drap blanc, ou debout et se détachant sur une tenture ou sur un papier de muraille." Joris-Karl Huysmans, "Le Salon de 1879," *L'art moderne* (Paris 1975), p. 35.

de l'Alma, the *Déjeuner sur l'herbe* (fig. 143), referring henceforth to Monet's large canvas completed the year before (fig. 169). For Manet, always eager to claim his pioneering role, this was a way of saying that he had painted figures in a landscape on a large scale before Monet. Although the paintings had obviously not changed, Manet's evolution in four years was considerable: since 1863, when Baudelaire called him "the first in the decrepitude of his art," Manet had become the precursor of a new art form; from being an outcast confined to a pictorial Kamchatka, to paraphrase Sainte-Beuve, Manet was at the frontier of a newly discovered continent. He had gone, with the same works but viewed differently, from Courbet to Monet, from Baudelaire to Zola. Unlike Francis Haskell, I do not believe that Manet, in 1867, invented with Zola the justification for his work, based on a simple argument, that had such considerable impact on posterity: "Look at this painting as if it were an abstract composition, a combination of color, light, and shadow and a pure pretext for painting flesh and costumes."[56] The reasoning was entirely Zola's, although Manet evidently approved—perhaps it was a revelation of what he had always wanted to do—this speech for the defense that elevated him from the last realist to the first Impressionist.

If we leave aside for a moment Zola's explanation and its later elaboration by his followers, if we do not read *Le Déjeuner sur l'herbe* in the light of the homonymous work by Monet, if we do not exclusively consider *Olympia* (fig. 146) as "the first nude of the new painting, . . . the first portrait of a naked woman," Manet's original intentions appear more clearly.[57] Stripped of Impressionist ambitions, the *Déjeuner sur l'herbe* is not a way station en route to *Olympia* but an intermediate work executed around the same date that same year, 1863, forming with the painting of the nude courtesan an obvious diptych, or, to quote the too often neglected words of Théodore Duret, "a kind of complement": a nude in a landscape and a nude in an interior, and, as George Mauner pointed out, a day painting and a night painting.[58] Might we add that *Olympia* concludes a trilogy begun a little earlier with the *Nymphe surprise* (fig. 123), Manet's own *Tales of Hoffmann*, portraits in succession of woman in her diverse nature, as wife, as model or muse, as courtesan?

In 1865, at the time Manet exhibited *Olympia*, the benevolent Théophile Thoré displayed some irritation at Manet's tenacity in drawing inspiration from ancient subjects: "It does not seem that Manet wishes to be taken for a routine worker in thoughtful art; nevertheless, having had the unfortunate idea of painting Christ in the praetorium, fine!, behold how this original artist even copies the celebrated composition by Van Dyck! Another year, he painted a Spanish subject he had never seen, fine!, behold how he copied a Velázquez from the Galerie Pourtalès!"[59] If he did not mention,

56. "Regardez ce tableau comme si c'était une composition abstraite, une combinaison de couleurs, de lumières et d'ombre, un pur prétexte pour peindre des chairs et des costumes." Haskell 1989, p. 315.
57. "premier nu de la nouvelle peinture, . . . le premier portrait d'une femme nue." Francis Carco, *Le Nu dans la peinture moderne (1863–1920)* (Paris, 1924), p. 4.
58. "une sorte de complément." Duret 1926, p. 35; Mauner 1975, p. 97.
59. "Il ne paraît pas que Manet veuille être pris pour un routinier de l'art pensif; néanmoins ayant eu la malheureuse idée de peindre un Christ dans le prétoire, bon! voilà que cet original copie jusque la célèbre composition de Van Dyck! L'autre année, faisant un sujet espagnol qu'il n'avait jamais vu, bon! voilà qu'il copiait le Vélasquez de la Galerie Pourtalès!" Thoré-Bürger 1870, vol. 2, p. 193.

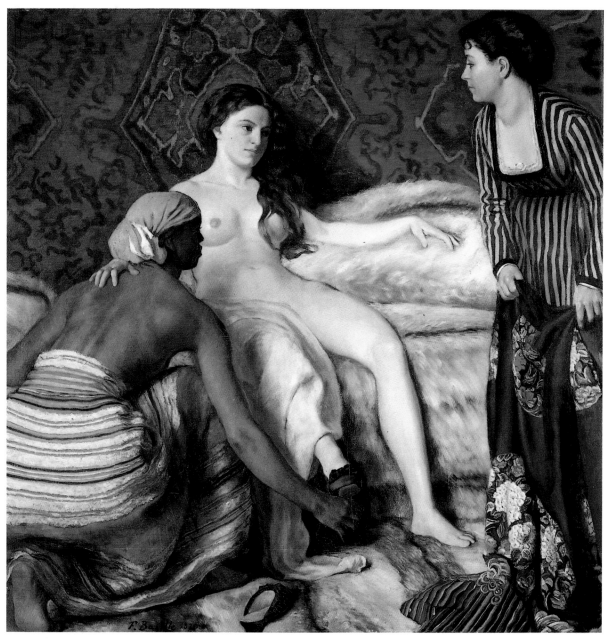

Fig. 154 (cat. 13). Frédéric Bazille, *La Toilette*, 1869–70. Oil on canvas, 52 x 50 in. (132 x 127 cm). Musée Fabre, Montpellier

apropos of *Olympia*, the reference to the *Venus of Urbino* (fig. 147), it is without doubt that, like many others, he did not recognize her under the contemporary disguise. Manet's three great nudes from the 1860s are, indeed, indebted to the masters but in different ways. In the *Nymphe surprise* (fig. 123), we can see, alternately or all at once, the influence of the Venetians, of Jules Romain, Boucher, Rembrandt, but the references are diffuse, with neither whim, nor parody, nor rivalry, in the manner most history painters embellish their compositions with citations, from an inability to conclude or from an anxiety to establish their genealogy. *Le Déjeuner sur l'herbe* and *Olympia* present other problems. We know beyond doubt that *Le Déjeuner sur l'herbe* borrowed formally—and so faithfully that

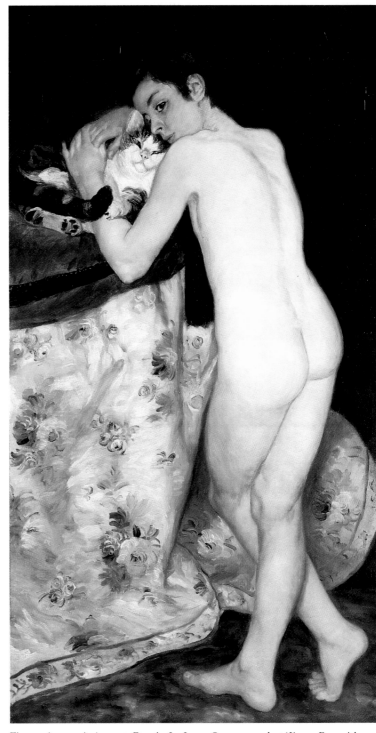

Fig. 155 (cat. 175). Auguste Renoir, *Le Jeune Garçon au chat* (*Young Boy with a Cat*), 1868–69. Oil on canvas, 43¾ x 26¼ in. (124 x 67 cm). Musée d'Orsay, Paris

some even talked of pastiche—from the right side of Marcantonio Raimondi's engraving after Raphael's *Judgment of Paris* (fig. 144), a source one might have considered obscure were it not familiar to the initiated: in the elegant atelier of Garnotelle—one of the heroes of the Goncourts' *Manette Salomon*, a mediocre history painter who has become an artist "of standing, fashionable"—prominently displayed on the walls, next to drawings by Ingres, are "some gilt-framed engravings by Marcantonio [Raimondi]," which take the

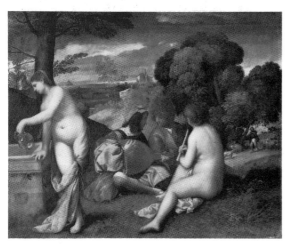

Fig. 156. Titian, *A Concert in the Country,* 1538.
Oil on canvas, 41⅜ x 53½ in. (105 x 136 cm).
Musée du Louvre, Paris

place of ancestral portraits.[60] But in the *Déjeuner sur l'herbe,* Manet refers initially, albeit implicitly, to Giorgione's *A Concert in the Country* (fig. 156; now attributed to Titian), one of the prototypes of that Venetian invention, painting the figure in a landscape.

By contrast, although various sources are often mentioned—Goya as well as Jean Jalabert and Jean-Achille Benouville—*Olympia* is above all a modern transposition of the *Venus of Urbino,* a free and perhaps impertinent variation on a theme by Titian.[61] The correspondences between these two paintings are so obvious that they could not be accidental or insignificant.

To begin with, we must underline that in the nineteenth century the paintings of Giorgione (let us allow this attribution to Giorgione since it was scarcely contested during Manet's time) and of Titian were not perceived as they are today, as a musical reverie, distant and melancholy, or as a nude tender and amorous, neither provocative nor lascivious. Both *A Concert in the Country* and the *Venus of Urbino* were viewed as naturalistic paintings. Giorgione's work, as Francis Haskell has demonstrated, was regarded as a "slice of life" from the Renaissance, in which young gentlemen of fashion amused themselves, during the course of a party in the country, with easy young girls; Titian's painting was seen as an immodest portrait of a courtesan who could well have been the artist's mistress—paintings of dubious morality, not the fruits of the gentle dreams of poetic painters.[62] A century earlier, Crozat, in his *Recueil d'estampes* of 1742, saw *A Concert in the Country* with the same reproachful eye as the censors of the *Déjeuner sur l'herbe*: "This great painter [Giorgione] depicted, in a pleasant countryside, people playing music, but, sacrificing the rules of decency to Art, he ventured to introduce, without much reason, naked women accompanying two young men dressed in the Italian fashion of the early sixteenth century."[63] Manet would do the same, sacrificing "the rules of decency to Art," accompanying his nude women with two young men dressed in the French fashion of the mid-nineteenth century.

Accordingly, Manet entered himself in the realist tradition and saluted in Giorgione and Titian auspicious precursors; three hundred years before him, great masters had sought to mix the nude with figures in contemporary costume and to present the portrait, undressed, of a courtesan. Here time becomes the issue. It is time—the distance in time, the patina of time—that transforms a pleasure-seeking mixed foursome in the Venetian countryside into *A Concert in the Country* and a Renaissance hetaera into the *Venus of Urbino.* This meditation on the effects of time revealed to Manet that he was not wasting himself on transitory and lewd genre scenes but that he too could aspire, with his modern subjects, to the format and grand manner of history painters. The examples of Titian and Giorgione

60. "posé, lancé"; "des cadres dorés, des gravures de Marc Antoine." Goncourt 1867, p. 155.
61. See Françoise Cachin in Paris, New York 1983, pp. 178–80.
62. "tranche de vie." Haskell 1989, p. 310.
63. "Ce grand peintre [Giorgione] y a représenté dans une campagne agréable, des gens qui forment un concert mais sacrifiant à l'Art les règles de la bienséance, il a hazardé d'y introduire, sans trop de raison, des femmes nues qui accompagnent deux jeunes homme vêtus suivant la mode qui était en usage en Italie dans le commencement du xvi⁼ siècle." Quoted by Alessandro Ballarin in *Le Siècle de Titien* (Paris, 1993), exh. cat., p. 341.

did not function as "diverted objects"; *Olympia* is not a "mimicry of Titian" in the same way that two contemporaneous critics who understood the reference considered it, but it was an *aggiornamento*, an adaptation to Manet's era.[64] For Manet, the most efficient way to disown the academic nude and to "break away from the codes of normal painting," as T. J. Clark put it, was to work toward it from within.[65] Titian's courtesan was long and supple, constructed along one melodic line from the tip of her toes to the angle of her resting elbow; her hand fell by chance across her genitals, concealing them; a small dog, curled up, slept. Manet's courtesan forms three broken lines: her head, separated from the rest of her body by a thin black ribbon, is held erect and scrutinizes; her hand is clenched on her genitals, in emphasis; a cat, fur bristled, arches its back. As a result, in 1865 *Olympia* "shocked and caused a sacred horror,"[66] the perfect adequation between the new rhythm, jolting and barbaric, on which she rises and the image of a prostitute with neither languor nor feelings, displaying alongside herself, as so many attributes, the obscure forces of a modern capital—venal love, the propitious night, all that prowls, all that hides. "She is scandal, idol," wrote Paul Valéry, who, better than anyone, would emphasize all that the perennial strength of *Olympia* owed to this truly unheard of tempo, this "power and public presence of a sorry secret of society. Her head is empty: a line of black velvet isolates her from the essence of her being. The purity of a perfect line encloses the impure par excellence, the woman whose function requires a calm and candid ignorance of decency. Bestial vestal, devoted to the absolute nude, she inspires dreams of all that lurks and remains of the primitive barbarity and ritual animality in the customs and labors of prostitution in the large cities."[67] To the flat, monotonous chants and salon romances of Baudry and Cabanel, Manet juxtaposes his primitive accents, his syncopated rhythm. Manet recaptured Titian's heritage, not as a legitimate heir—contrary to many of his academic colleagues, proud of the purity of their lineage yet exhausted by a succession of intermarriages—but as an offshoot of a younger line, degenerated through misalliances and lost in obscure kinship. To the art of Titian, Manet added a Spanish manner, the lessons of Courbet, the crudity of erotic photographs, the naïveté of popular images, and the flatness of *Japonisme*. He was not the eldest son, sure of his rights and entrenched in paternal respect, but rather the prodigal son who had been around a lot, lived a lot. He was not one who followed, but one who revived; he was neither iconoclast nor revolutionary, but redeemer.

With regard to the *Venus of Urbino*, Manet evinced both a scandalous liberty and a deep respect. To Werner Hofmann's very pertinent question, which *Olympia* inevitably arouses—"Is she a contempo-

64. "objets détournés"; "singerie du Titien." For reasons for this lack of awareness, see T. J. Clark, "Un réalisme du corps: Olympia et ses critiques en 1865," *Histoire et critique des Arts*, 4–5 (May 1978), pp. 142–43.
65. "rompre avec les codes de la peinture normale." Ibid., p. 144.
66. "choque et dégage une horreur sacrée." Paul Valéry, "Triomphe de Manet," *Oeuvres* (Paris, 1960), vol. 2, p. 1329.
67. "Elle est scandale, idole"; "puissance et présence publique d'un misérable arcane de la société. Sa tête est vide: un fil de velours noir l'isole de l'essentiel de son être. La pureté d'un trait parfait enferme l'Impure par excellence, celle de qui la fonction exige l'ignorance paisible et candide de toute pudeur. Vestale bestiale, vouée au nu absolu, elle donne à rêver à tout ce qui se cache et se conserve de la barbarie primitive et d'animalité rituelle dans les coutumes et les travaux de la prostitution des grandes villes." Ibid.

Fig. 157. Édouard Manet, *La Pêche* (Fishing), 1861–63.
Oil on canvas, 30⅜ x 48⅜ in. (77 x 123 cm).
The Metropolitan Museum of Art, New York,
Purchase, Mr. and Mrs. Richard J. Bernhard Gift, 1957

Fig. 158. Paul Cézanne, *La Tentation de saint Antoine*
(*The Temptation of Saint Anthony*), 1870. Oil on canvas,
21¼ x 28¾ in. (54 x 73 cm). Bührle Stiftung, Zurich

Fig. 159. Paul Cézanne, *L'Enlèvement* (*The Rape*), 1867.
Oil on canvas, 35⅝ x 46⅛ in. (90.5 x 117 cm).
On deposit at the Fitzwilliam Museum, Cambridge

Fig. 160. Alexandre Cabanel,
Nymphe enlevée par un faune
(*Nymph and Faun*), 1860. Oil on
canvas, 96½ x 57⅞ in. (245 x 147 cm).
Musée des Beaux-Arts, Lille

rary equivalent to Titian's Venus or her complete antithesis, the goddess of love in a new aspect or an ironic profanation of everything she stood for?"—I do not hesitate to answer with the first option: *Olympia* is a modern *Venus of Urbino* in the same way that the *Déjeuner sur l'herbe* is an 1860 version of *A Concert in the Country*.[68] The reference to Giorgione and the desire to update the Renaissance example seem to me more important than the ambition to place the figure in a landscape, which results, as I have said, from an "Impressionist" reading of Manet's oeuvre. In the early 1860s, Manet cared next to nothing about working in the open air: executed at almost the same time, *La Pêche* (fig. 157), a variation on a theme by Rubens, may have been based on sketches made at Gennevilliers, but it does not integrate the two costumed figures with the landscape, which they merely skirt. And when, in 1867, Degas heard a reading of the *Souvenirs* of Antonin Proust, who was driven by the desire to erect Manet as the founder of Impressionism, he violently reacted at the passage describing the *Déjeuner sur l'herbe* as the first plein air painting: "It is wrong. He confuses everything. Manet was not thinking about plein air when he painted the *Déjeuner sur l'herbe*. He never thought about it until he saw Monet's first paintings. He only imitated. Proust confuses everything."[69]

Even if his pronouncement reflected an old and friendly antagonism—"he only imitated"—Degas was right. Why be astonished, then, with the hasty manner in which the landscape was painted, since it is only a basic feature, a background like the canvas stage sets in the

Fig. 161 (cat. 34). Paul Cézanne, *Pastorale (Idylle)*, ca. 1870. Oil on canvas, 25⅝ x 31⅞ in. (65 x 81 cm). Musée d'Orsay, Paris

theater against which the protagonists of the drama stand out clearly? Manet's landscape is a suburban version of Giorgione's wonderful countryside; it is not an enveloping and primordial nature—supporting a great spectacle of lights, of rustling, of diverse matters—but the ordinary image, nearly ridiculous, of a modern Arcadia.

The last word belongs to Cézanne. For him, the nude was a school, an obsession, and, if one can believe his friends, always a difficult challenge. He was a member of the family of "flesh-makers," flesh abundant but firm, all curves and roundness, partially covered by long blond, red, and brown hair, more welcoming than comely, but which, when he approached, made him feel "dizzy."[70] Sometimes Cézanne's women quietly offer their charms (fig. 158) and bring to life Eve, the temptress; often they are pursued, abducted (fig. 159), tortured, strangled, stabbed; they can only seduce or submit, entice or receive a deserved punishment. They are similar sometimes to the women of Delacroix, as in *Le Festin* (fig. 59), a work reminiscent, with its pile of naked bodies, of Delacroix's *Mort de Sardanapale*

68. Werner Hofmann, *Nana: Mythos und Wirklichkeit* (Cologne, 1973), pp. 27–28.
69. "C'est faux. Il confond tout. Manet ne pensait pas au *plein air* quand il a fait *Le Déjeuner sur l'herbe*. Il n'y a jamais pensé qu'après avoir vu les premiers tableaux de Monet. Il n'a jamais pu qu'imiter. Proust confond tout." Halévy 1960, pp. 110–11.
70. "faiseurs de chair"; "vertiges." For a new approach to the Cézanne nudes and the artist's relations with women, see Gasquet 1926, p. 54; Krumrine 1989.

Fig. 162 (cat. 32). Paul Cézanne, *Une moderne Olympia* (*A Modern Olympia*), ca. 1869–70.
Oil on canvas, 22½ x 21⅝ in. (57 x 55 cm). Private collection

71. Peter Kropmans, "Cézanne, Delacroix et Hercule, Réflexions sur *L'Enlèvement*, 1867, oeuvre de jeunesse de Paul Cézanne," *Revue de l'art*, no. 100 (1993), pp. 74–83.

72. "la nymphe blanche comme le lait"; "les bras bruns du ravisseurs." Hector de Callias, "Salon de 1861," *L'Artiste*, 12 (1861), p. 244.

(*Death of Sardanapalus*; Musée du Louvre, Paris); sometimes to the women of Courbet (fig. 124), bathers become courtesans; and sometimes to those of Cabanel. While obviously inspired by Delacroix, the strange *Enlèvement* (fig. 159) was also a response to Cabanel's *Nymphe enlevée par un faune* (fig. 160), one of the great successes of the Salon of 1861, where Cézanne saw it.[71] Indeed, Cézanne was most likely struck by the staged violence of the scene and the brutal contrast of the two complexions, "the nymph white as milk" against "the brown arms of the abductor."[72]

At the end of the decade, Cézanne painted three works directly related to Manet's great nudes: on the one hand, *Le Déjeuner sur l'herbe* and *Pastorale* (fig. 161), on the other hand, *Une moderne*

Olympia (fig. 162). The last, titled by Cézanne himself, is a commentary on the painting shown at the Salon of 1865, but a difficult one to read, no doubt encumbered by references and winks that escape us. The two other paintings, titled posthumously, appear to be even more enigmatic and refer, of course, to Manet but also to Watteau or Giorgione. Although his praise was not exempt from reproach, Cézanne late in life commented upon Manet's work and acknowledged its supreme importance: "'One must always keep it in mind,' said he about *Olympia*. 'It is a new mode of painting. Our Renaissance dates from it.'"[73] Of course there is in *Olympia* a "pictorial truth of things," but in some way the painting like the woman leaves us with our hunger: for the "thin, delicate, cerebral" Olympia there is a corresponding "sharp quality," making us nostalgic for Courbet's abundant nudes, treated in a manner "thick, healthy, lively."[74] And if we compare the *Déjeuner sur l'herbe* (fig. 143) with *A Concert in the Country* (fig. 156), we will recognize that Manet lacks "a frisson of that nobility" that in the work of the Venetian Giorgione "offers a paradise for all senses."[75] Manet is "sharp," "intellectual," restrained, when the subject would want some of the truculence of a ferocious appetite; he is a realist, in other words prosaic, when we crave, in imitation of the ancient models, a whiff of the empyrean. If the paintings of Cézanne acknowledge their debt to Manet, they equally insist upon his deficiencies. Thus would Cézanne's paintings be abundant and eloquent when their prototype was frugal and could appear austere. To Manet's mediocre copse embellished with an improbable puddle of water, Cézanne responded with "primordial" nature: Arcadia or Venusberg; tall trees; rich meadows; a deep lake.[76] To Manet's suburban mixed foursome, an embarkation for Cythera; to the survey of contemporary manners, an autobiographical reverie. For Cézanne is staging himself; it is he who meditates, outstretched, in the middle of that "supernatural eclogue" of the *Pastorale* (fig. 161); it is he who details the charms of the *Moderne Olympia* (fig. 162).[77] Cézanne's Olympia, bent over herself, both timid and seductive, astray in the dearly paid for luxury of a rococo decor, has lost the self-confidence of Manet's courtesan. It is unclear whether the black woman behind her is a servant, "refreshing her brow with palm fronds," or a torchère of painted wood, as inanimate as the Atlas-like support of the small round table. The painter examines Olympia, pink on the white sheet, quietly, as he would some pieces of fruit on a tablecloth. She is a model, she is a subject, and Cézanne pays homage to her. It is the homage—translated by Manet as a bouquet of flowers—of the customer to his supplier, that is to say, the homage of the artist to everything he chose to represent, the homage of a painter to painting.

73. "Il faut toujours avoir ça sous les yeux. C'est un état nouveau de la peinture. Notre renaissance date de là." Gasquet 1926, p. 48.
74. "vérité picturale des choses"; "maigre, gracile, cérébrale"; "facture aiguë"; "épaisse, saine, vivante." Ibid.; p. 183.
75. "un frisson de cette noblesse"; "emparadise tous les sens." Ibid., p. 173.
76. "aigu"; "cérébral"; "primordiale." Schapiro 1968, p. 76.
77. "églogue surnaturelle." Gasquet 1926, p. 173.

V
Figures in a Landscape

GARY TINTEROW

The dream of all painters:
to place lifesize figures in a landscape.
Émile Zola[1]

He has tried to do what we have so often attempted—
a figure in the outdoor light.
Berthe Morisot[2]

Claude Lantier, the fictional painter Zola assembled from an amalgam of Manet, Monet, and Cézanne to typify the Batignolles artists of the 1860s, had worked hard all morning.

Backing away from his easel, Claude leaned up against the wall, relaxed. Sandoz, tired of posing, got up from the divan and went across to him. Without a word they both stood looking at the picture. The man in the black velvet jacket was now completely brushed in; his hand, which was farther advanced than the rest, showed up well against the grass, while the dark patch of his back stood out with such force that the two little shapes in the background, the two women tumbling each other in the sunshine, looked as if they had withdrawn far away into the shimmering light of the forest clearing; the big reclining female figure, however, was still only faintly sketched in, still little more than a shape desired in a dream, Eve rising from the earth smiling but sightless, her eyes still unopened.

"Tell me," said Sandoz, "what are you going to call it?"

"'Plein-air' [Open air]," was the curt reply.

Such a title sounded over-technical to Sandoz who, being a writer, often found himself being tempted to introduce literature into painting.

"'Plein-air!' But it doesn't mean anything!"

"It doesn't need to mean anything. A man and a couple of women resting in the woods, in the sunshine. What more do you want? Seems to me there's enough there to make a masterpiece."[3]

1. "Le rêve que font tous les peintres: mettre des figures de grandeur naturelle dans un paysage." Émile Zola, "Édouard Manet, étude biographique et critique," 1867, in Zola 1991, p. 158.
2. "Il cherche ce que nous avons si souvent cherché: mettre une figure en plein air." Berthe Morisot to Edma Pontillon, May 5, 1869, Morisot 1950, p. 28. Translation by Betty W. Hubbard, *The Correspondence of Berthe Morisot* (New York, 1957), p. 32.
3. Émile Zola, *The Masterpiece*, trans. by Thomas Walton (Oxford, 1993), p. 45.

Claude Monet, *Femmes au jardin*, detail of fig. 175

Fig. 163. Gustave Courbet, Study for *Demoiselles de village faisant l'aumône à une gardeuse de vaches, dans une vallée près d'Ornans* (*Study for Young Women from the Village*), 1851. Oil on canvas, 21¼ x 26 in. (54 x 66 cm). City Art Gallery, Leeds

Fig. 164. Gustave Courbet, *Demoiselles de village faisant l'aumône à une gardeuse de vaches, dans une vallée près d'Ornans* (*Young Women from the Village*), 1851–52. Oil on canvas, 76¾ x 102¾ in. (195 x 261 cm). The Metropolitan Museum of Art, New York, Gift of Harry Payne Bingham, 1940

For the practitioners of the New Painting, the definition of a masterpiece in the 1860s was a large canvas of figures relaxing out-of-doors. Zola and Morisot were thinking of different paintings—Manet's sensational *Déjeuner sur l'herbe* of 1863 (fig. 143) and Bazille's beautiful *Vue du village* of 1868 (fig. 182)—but they were both referring to one of the central goals of the painters of the Café Guerbois circle: to integrate figure painting with landscape painting within the context of modern life. To be sure, landscapes throughout history had always been peopled, whether with contemporary peasants, arcadian shepherds, royal hunters, sporting gods, or bourgeois pleasure-seekers. But until the mid-nineteenth century, painters had almost always subordinated landscape to figure or figure to landscape. One had invariably been an accessory to the other, until Courbet began to create paintings in which the figures and the landscape made equal, and often competing, claims for the viewer's attention.

Such was the case, for example, with Courbet's *Demoiselles de village* of 1851. Courbet's compositional sketch (fig. 163) has a traditional relationship of figure to ground, as one might find in Corot or Rousseau, where the landscape typically predominates. But in the final large canvas (fig. 164) the landscape, while not as highly finished as the figures, still accounts for much of the picture's interest, even though the figures have been greatly enlarged and brought to the foreground. Contemporary critics and modern historians are just as likely to comment on the identity of the landscape—the valley of the Communal beneath the Roche de Dix Heures—as on the identity of the women—Courbet's three sisters. The balance was deli-

Fig. 165. Gustave Courbet, *Un enterrement à Ornans* (*A Burial in Ornans*), 1850–51. Oil on canvas, 124 x 263 in. (315 x 668 cm). Musée d'Orsay, Paris

Fig. 166 (cat. 82). Alphonse Legros, *Femme dans un paysage* (*Woman and Dog in a Landscape*), 1860. Oil on canvas, 51⅝ x 64⅛ in. (131 x 163 cm). Musée des Beaux-Arts et de la Dentelle, Alençon

cate. When it was shown at the 1852 Salon the unusual scale of the figures and bizarre perspective were criticized, and the women were thought "to lack in charm,"[4] but compared with his *Enterrement à Ornans* (fig. 165), shown at the Salon the year before, the balance tipped in favor of the conventional. Courbet himself said, "I have done something gracious."[5] The potentially subversive illustration of the caste system of a French village, an issue of great significance to many modern art historians, evidently passed largely unnoticed,[6] since the canvas was purchased from the 1852 Salon by the comte de Morny, half brother and confidant of Napoléon III. By 1867, when Courbet exhibited it again at his pavilion at the Pont de l'Alma, it was considered a masterpiece, one that dealt with the immediate concerns of the new generation of artists. Cézanne's friend Fortuné Marion described seeing it in Courbet's exhibition, and his remarks can be taken as an accurate reflection of what it meant to a young painter:

> Among his early paintings is a canvas I consider to be the best achievement ever accomplished in painting until now. I am speak-

4. Quoted in Brooklyn, Minneapolis 1988–89, p. 107.
5. Quoted in Mainardi 1979, p. 96.
6. When the painting was reexhibited in 1855, reactionary critics objected to the representation not of the peasant, but of the young women of the rural bourgeoisie—"a race of pretentious upstarts," according to Augustin-Joseph Du Pays. "The bourgeoisie, which grew up under the monarchy, which overthrew it, which has had in its turn an ephemeral reign, occupies an important place in history. But in art the bourgeois are only peasants. Art is aristocratic: accustomed to consorting with Gods and Heroes, it doesn't thrive in bad company." A.-J. Du Pays, "Beaux-Arts: Exposition Universelle," *L'Illustration*, July 28, 1855, p. 71, quoted in Mainardi 1987, p. 94.

ing of his *Demoiselles de village*. In a luminous mountain landscape, a sort of amphitheater surrounded by beds of bright rocks, a young girl is tending her cattle which stride along the edge, a dog is rolling on the grass, and three young ladies who spent the afternoon in the country with some refreshments in baskets are offering their leftovers to the young girl, as shy as all the peasants of any country. This painting produces an astonishing effect, my dear fellow; the figures are rather tall, at least ten centimeters high, and the landscape is painted in a blond light that is affective. I consider this work superior to the paintings by Veronese in the Louvre, although I think those, along with ones by Delacroix, are the best paintings ever produced.[7]

Several years after painting the *Demoiselles de village*, which, despite the criticism, was a practical success, Courbet embarked on an even larger depiction of a country outing, *Le Repas de chasse* (fig. 167). It was painted in Frankfurt in 1858, one of the happiest years of Courbet's life. Here there is nothing subversive. Aristocrats, or wealthy bourgeois at the least, pause after a morning hunt to reward themselves with a rich lunch. They display their spoils in a heap jealously guarded by handsome dogs just as they parade their expensive and fashionable clothes. The landscape, with limestone cliffs typical of Courbet's native Jura, is reassuringly French in appearance, and the figures, waited upon by a servant, are reassuringly integrated within the landscape. Courbet reconfirms established social order and validates the prerogatives of an elite class through an accepted genre, hunting scenes, invoked by eliciting comparison

7. "Parmi ses premiers tableaux il y a une toile que je considère comme ce qui a été fait de plus fort jusqu'à ce jour en peinture. Je veux parler de ses *Demoiselles de village*. Dans un paysage de montagne tout en lumière, une espèce de cirque couronné par des bancs de rochers lumineux, une petite fille surveille des boeufs, qui passent sur la côte, une chien se roule sur l'herbe, et trois jeunes demoiselles qui sont allées dans la campagne passer l'après-midi avec leurs goûters dans des paniers donnent leurs restes à la petite fille, timide comme tous les paysans de tous les pays. Cette toile est d'un effet étonnant, mon cher; les personnages sont assez grands, un décimètre au moins, et tout le paysage est d'un blond lumineux qui attache. Je considère cela comme supérieur aux Véronèses du Louvre qui, à mon avis, sont pourtant avec les Delacroix les meilleures toiles produites." Letter from Fortuné Marion to Heinrich Morstatt, September 6, 1867, Barr 1937, p. 49.

Fig. 167. Gustave Courbet, *Le Repas de chasse* (*The Hunt Meal*), 1858. Oil on canvas, 81½ x 128 in. (207 x 325 cm). Wallraf-Richartz-Museum, Cologne

Fig. 168. Carle van Loo, *Halte de chasse* (*A Halt in the Hunt*), 1737. Oil on canvas, 86⅝ x 98⅜ in. (220 x 250 cm). Musée du Louvre, Paris

to Carle van Loo's huge *Halte de chasse* (fig. 168). But he does do two things to challenge conventional taste: his execution is deliberately unpolished, and the scale of the painting, at more than three meters wide, is one traditionally reserved for the depiction only of great episodes of human history. For Courbet, such episodes could now be found in the personal experiences of the artist, whether in *Un enterrement à Ornans* (fig. 165), *L'Atelier du peintre* (Louvre, Paris), or *L'Hallali du cerf* (fig. 402). The elevation of personal experience to huge canvases and the use of summary execution to express it—elements of Courbet's "déjeuner sur l'herbe"—were strategies later adopted by Manet and Monet in their essays in the genre.

Manet may well have made reference to Courbet's *Repas de chasse* (fig. 167) in his notorious *Déjeuner sur l'herbe* of 1863 (fig. 143), in which the luscious still life in the foreground seems like nothing more than the basket of fruit in Courbet's painting overturned,[8] a still life in *déshabillé*, like Manet's nude, undressed. Manet's *Déjeuner sur l'herbe* was in many respects Courbet's picture overturned. Wealthy hunters became bohemian students. Well-behaved women became an impudent model, an exhibitionist smiling at the observer who discovers her nudity. Manet wanted to shock, and he borrowed his tactics from Courbet himself, who in the previous decade showed a naked woman, not an idealized nude, emerging from a stream in *Les Baigneuses* (fig. 124), and two tarts out for some fresh air in *Les Demoiselles des bords de la Seine* (fig. 150). It was the salacious nature of Courbet's *Demoiselles* that Manet called on to electrify his canvas, and he left the landscape, plainly artificial, firmly in the background. As Théophile Thoré wrote at the time Manet's *Déjeuner sur l'herbe*, then called *Le Bain*, was shown at the 1863 Salon des Refusés, "The *Bain* is of a very risky taste. The nude woman does not have a beautiful figure, unfortunately...and you cannot imagine anything uglier than the man lying down next to her....I cannot guess why an intelligent and distinguished artist chose to paint such a preposterous composition. But there are qualities of color and light in the landscape, and even very truthful passages of modeling in the woman's torso."[9]

Writing at the end of the nineteenth century, Manet's friend Antonin Proust asserted—apocryphally—that Manet was inspired to paint his *Déjeuner* by the sight of a woman bathing in the Seine at Argenteuil. "When we were at the studio, I copied the women of Giorgione, the ones with the musicians. This painting is black. The background has thickened. I want to remake it but place it in a transparent atmosphere, with figures similar to those we see over there."[10] Thus Proust would have Manet setting out to make the painting memorialized in Zola's *L'OEuvre*, a great picnic, realized

8. That Manet's still life may also refer to the one in Titian's *Virgin with a Rabbit* (Louvre, Paris) does not exclude a simultaneous reference to Courbet. The early whereabouts of Courbet's *Repas de chasse* is not well known, but if Manet did not see the canvas he might have seen a photograph.

9. "*Le bain* est d'un goût bien risqué. La personne nue n'est pas de belle forme malheureusement...et on n'imaginerait rien de plus laid que le monsieur étendu près d'elle....Je ne devine pas ce qui a pu faire choisir à un artiste intelligent et distingué une composition si absurde. Mais il y a des qualités de couleur et de lumière dans le paysage, et même des morceaux très réels de modelé dans le torse de la femme." "Salon de 1863," in Thoré-Bürger 1870, vol. I, p. 425.

10. "Quand nous étions à l'atelier, j'ai copié les femmes de Giorgione, les femmes avec les musiciens. Il est noir ce tableau. Les fonds ont repoussé. Je veux refaire cela et le faire dans la transparence de l'atmosphère, avec des personnages comme ceux que nous voyons là-bas." Proust 1913, p. 43.

out-of-doors, with a nude in broad daylight. But that was not Manet's aim, at least not at the start. From the beginning he called his picture *Le Bain*, a title which explains the subject much more satisfactorily than *Déjeuner sur l'herbe*, since even models with loose morals dress to eat. And Manet's picture is patently a studio production, not a work *en plein air*. Upon hearing Proust's account of the genesis of the painting, Degas cried out: "That's not true. He [Proust] confuses everything. Manet wasn't thinking about *plein air* when he painted the *Déjeuner sur l'herbe*. He didn't think about it until he saw Monet's first paintings."[11] What is interesting is that indeed after hearing about or seeing Monet's enormous *Déjeuner sur l'herbe*, destined for the Salon of 1866 but never submitted, Manet changed the title of his painting from *Le Bain* to *Déjeuner sur l'herbe*, the title used at Manet's 1867 exhibition in the Pont de l'Alma. In Degas's negative view, Manet "could never do anything but imitate." No doubt Manet wanted to capitalize on the new vogue for painting plein air picnics, as Tissot did, for example.[12] More important, Manet probably wished to remind that he, and not the young upstart from Le Havre, was the preeminent painter of modern life.

Manet was annoyed when Monet's two marines (figs. 79, 83) were hung on either side of his great *Olympia* (fig. 146) at the alphabetically arranged Salon of 1865. Monet recalled "that because of the similarity in the names, Manet was thought to have painted this work and was congratulated from all sides for this superb painting. He bent to look at the signature and read the unknown name of Claude Monet. All of a sudden, white with rage, he turned back and muttered: 'Who is this rascal who pastiches my painting so shamelessly?'"[13] Although both seascapes were closer to Johan Barthold Jongkind and Eugène Boudin than Manet, Manet had good reason to feel challenged. While the 1865 Salon was on view, Monet had left Paris for Chailly where he had begun a picture of modern life that would out-Manet Manet, a genuine "déjeuner sur l'herbe," executed on a scale that would out-Courbet Courbet, with eleven figures *en plein air*.

One cannot overestimate the audacity of Monet's enterprise. Like Gericault at a similar age, Monet at twenty-five ordered a canvas nearly seven meters wide—three times larger than Manet's *Déjeuner*, twice as wide as Courbet's *Repas de chasse*. An elder Boudin was jealous. "I have seen Courbet and others daring to paint large canvases, the happy men. Young Monet has twenty feet to cover."[14] Consulting the same source that Courbet did, Carle van Loo's *Halte de chasse* (fig. 168), Monet conceived a picnic that would respond much more directly to the mounting chorus of critics who demanded modernity. Baudelaire's essay "The Painter of Modern Life," which

11. "C'est faux. Il confond tout. Manet ne pensait pas au *plein air* quand il a fait le *Déjeuner sur l'herbe*. Il n'y a jamais pensé qu'après avoir vu les premiers tableaux de Monet." Manet "n'a jamais pu qu'imiter." As recorded by Degas's young friend Daniel Halévy, in Halévy 1960, pp. 110–11. Translation by Mina Curtiss, *My Friend Degas* (Middletown, Conn., 1964), p. 92.

12. Tissot's gallant "déjeuner sur l'herbe," with horses and a château in the distance, is usually dated 1865–68. See Wentworth 1984, no. 43.

13. "que la similitude de noms avait fait passer pour l'auteur du tableau Manet, qu'on félicitait de tous côtés pour cette superbe toile, se penchait vers la signature et lisait le nom inconnu de Claude Monet. Il se retourna tout d'un coup, vert de rage, en grommelant: 'Qu'est-ce que c'est que ce polisson qui pastiche si indignement ma peinture?'" François Thiébault-Sisson, "Claude Monet," *Le Temps*, December 27, 1926.

14. "J'ai vu Courbet et d'autres qui osent les grandes toiles, les heureux. Le jeune Monet en a vingt pieds de long à couvrir." Letter from Boudin to his brother, December 20, 1865, Wildenstein 1974, pièce justificatif 9, p. 444.

Édouard Manet, *Le Déjeuner sur l'herbe*, detail of fig. 143

15. "Le beau n'est que la promesse du bonheur." "Pour le croquis de moeurs, la représentation de la vie bourgeoise et les spectacles de la mode, le moyen le plus expéditif et le moins coûteux est évidement le meilleur.... il y a dans la vie triviale, dans la métamorphose journalière des choses extérieures, un mouvement rapide qui commande à l'artiste une égale vélocité d'exécution." "Le Peintre de la vie moderne," in Baudelaire 1975–76, vol. 2, p. 686. The translations given here are by Jonathan Mayne, from Charles Baudelaire, *The Painter of Modern Life and Other Essays* (London, 1964), pp. 3, 5.

appeared in late 1863, contained the germ of the New Painting. Quoting Stendhal, he said, "Beauty is nothing else but a promise of happiness"; on the method of how to render modern beauty, he ordained, "For the sketch of manners, the depiction of bourgeois life and the pageant of fashion, the most expeditious [means] will obviously be the best.... in trivial life, in the daily metamorphosis of external things, there is a rapidity of movement which calls for an equal speed of execution from the artist."[15] Baudelaire was writing of inexpensive prints of modern manners, but his comments reveal an expectation that was very much of the moment. The Goncourts concurred: in their *Journal* entry for November 12, 1861, they wondered, "The future of modern art, will it not lie in a combination of Gavarni and Rembrandt, the reality of man and his costume transfigured by the magic of shadows and light, by the sun, a poetry of the colors which fall from the hand of the painter?"[16] Manet attempted to be that painter, witness his *Musique aux Tuileries* (fig. 332), but Monet's response was at once more honest and earnest.

Fig. 169 (cats. 122, 123). Claude Monet, *Le Déjeuner sur l'herbe*, 1865–66. Oil on canvas; left part, 164⅝ x 59 in. (418 x 150 cm), center part, 97⅝ x 85⅜ in. (248 x 217 cm). Musée d'Orsay, Paris

Claude Monet, *Le Déjeuner sur l'herbe* (left part), detail of fig. 169

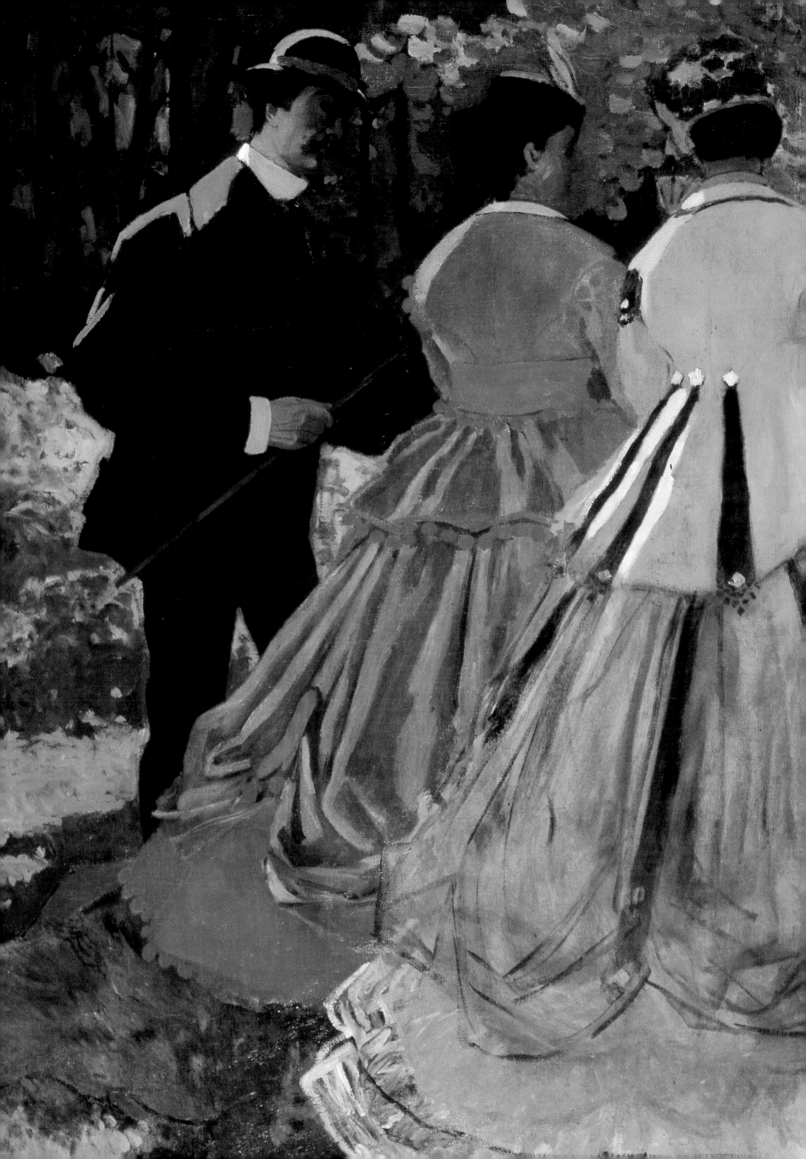

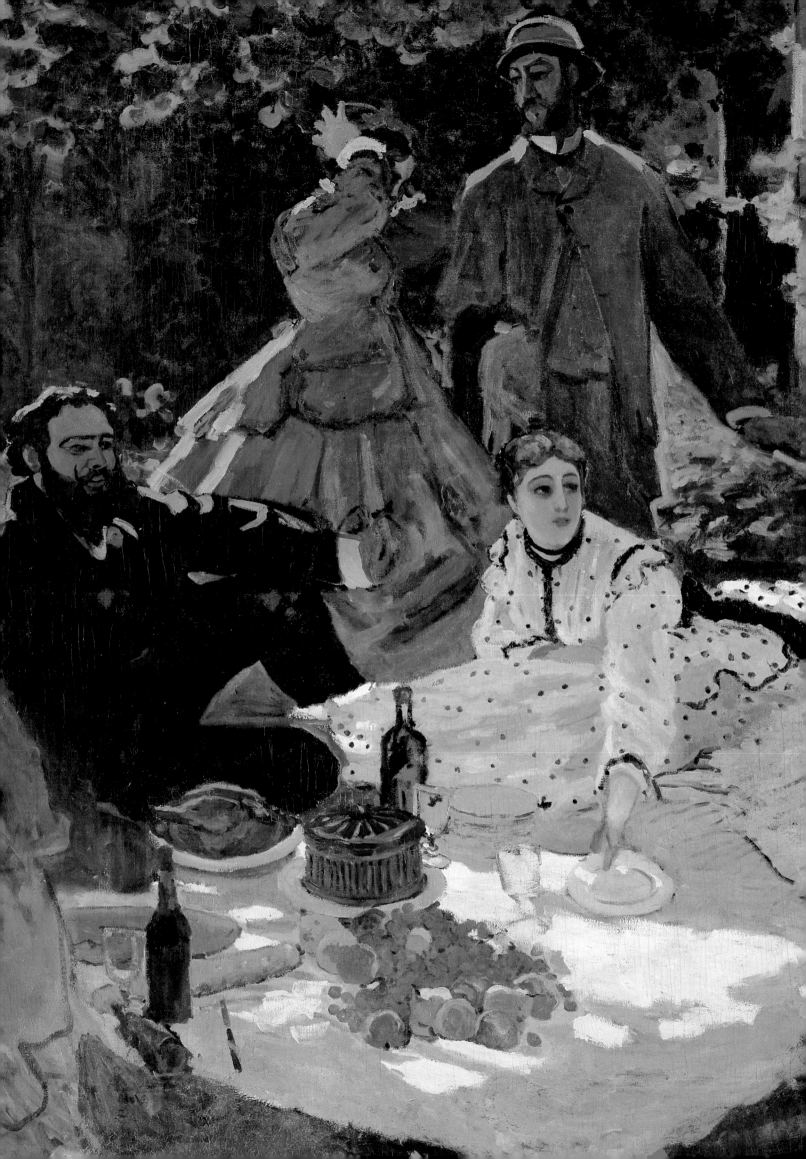

Fig. 170. Claude Monet, *Le Déjeuner sur l'herbe*, 1865.
Oil on canvas, 51⅛ x 71¼ in. (130 x 181 cm).
Pushkin State Museum of Fine Arts, Moscow

Fig. 171. Jean-Antoine Watteau, *L'Embarquement pour Cythère*
(*Embarkation for the Island of Cythera*), 1717. Oil on canvas,
50¾ x 76⅜ in. (129 x 194 cm). Musée du Louvre, Paris

Waiting several months at Chailly for his model Frédéric Bazille
to arrive, Monet executed a number of landscape studies for his
Déjeuner sur l'herbe, from small sketches to large ébauches. They
were acutely observed and painted on the spot, but in a manner
that was broad and free, with a contrast of value and tone that
neither Courbet nor Manet had achieved to date. Monet had a ready
model in his new companion, Camille Doncieux, who posed for most
of the female figures, but it was not until Bazille arrived in August
1865 that he began to paint the figure studies, of which only one
survives (fig. 172). Man, woman, and their costumes are indeed, to
use the words of the Goncourts, "transfigured by the magic of shadows
and light." While still at Chailly, Monet painted a large and very
complete sketch (fig. 170) that is by modern standards an absolute
masterpiece, an extraordinary composition held together with the
lilting rhythm of tilting heads, acknowledging glances, and out-
stretched arms, an homage to Watteau's elegant *Embarquement pour
Cythère* (fig. 171), the painting that Monet later said was his favorite
in the Louvre.[17] Once he had returned to Paris, Monet transferred
this composition onto his gargantuan canvas, intensifying the fresh
and free brushwork and the harsh contrasts of light and shade from
the sketch, creating an effect not dissimilar from painted scenery
for the stage, and very far indeed from the polished work of the
academy, far even from the broadly painted canvases of Monet's
predecessors Manet and Courbet.

Everyone who saw Monet's canvas had high hopes. Bazille bragged
to his brother that "Master Courbet... paid us a visit to look at
Monet's painting, and he was delighted by it. Further, more than

16. "L'avenir de l'art moderne, ne serait-ce point du Gavarni
brouillé avec du Rembrandt, la réalité de l'homme et de
l'habit transfigurée par la magie des ombres et des
lumières, par ce soleil, poésie des couleurs qui tombe de
la main du peintre?" Goncourt 1956, vol. 1, p. 985. The
translation given here is from *Paris and the Arts,
1851–1896: From the Goncourt* Journal, ed. and trans. by
George J. Becker and Edith Philips (Ithaca, N.Y., 1971),
p. 62.
17. Clemenceau 1965, pp. 92–93, cited in Spate 1993, p. 34.

Claude Monet, *Le Déjeuner sur l'herbe* (center part), detail of fig. 169

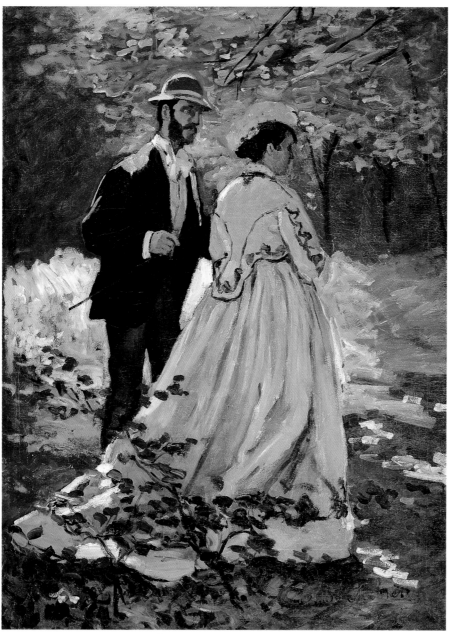

Fig. 172 (cat. 121). Claude Monet, *Étude pour le Déjeuner sur l'herbe (Les Promeneurs)* (*Study for the Déjeuner sur l'herbe [The Strollers]*), 1865. Oil on canvas, 36⅞ x 27⅜ in. (93.5 x 69.5 cm). National Gallery of Art, Washington, Ailsa Mellon Bruce Collection

18. "maître Courbet...est venu nous faire une visite pour voir le tableau de Monet, dont il a été enchanté. Du reste plus de vingt peintres sont venus le voir et tous l'admirent beaucoup, quoiqu'il soit loin d'être fini.... Ce tableau fera énormément de bruit à l'Exposition." Bazille in a letter to his brother, December 1865, Bazille 1992, no. 74, p. 116.

twenty painters came to see it and all admired it greatly, though it is not yet finished.... This painting would create a big impression at the Exposition."[18] But it was not to be. Monet did not complete the picture in time to submit it to the jury, and it was never exhibited during his lifetime. It has been said that he did not wish to risk rejection, but his strategy was mistaken: the jury of the 1866 Salon was liberal—after all, it admitted Monet's *Camille* (fig. 236), painted in only four days, as well as a landscape (see cat. 119)—and the jury for the 1867 Salon would be notoriously restrictive, rejecting Monet's *envoi* soundly. Had it been shown in 1866, it surely would have been attacked by most critics, but it also would have been seen as the new manifesto of pleinairism, with all of the ambition of Courbet

and Manet but without the sexual innuendo or political and social lessons of their work.

Emboldened by the success of *Camille*, Monet began work on a painting for the next Salon, a work that would summarize what he had learned in making *Le Déjeuner sur l'herbe* without the attendant problems. He gave up the huge scale, which would have been difficult for the Salon jury to swallow, and he gave up his strident contrasts, but he retained his commitment to plein air. He no longer used the traditional method of transferring outdoor sketches onto the final canvas indoors, instead painting all of *Femmes au jardin* (fig. 175) outside. "I really painted this work on the spot and after nature, an unusual process at the time. I had dug a hole in the ground, a sort of ditch, to gradually lower my canvas."[19] With a knowing nod to Winterhalter, Monet chose an ingratiating composition and finished the painting quite carefully, but the touch was still too broad, the palette too bright, for the severe jury of 1867. The comte de Nieuwerkerke personally ensured that the painting was rejected.[20] Yet Monet's Salon rejections, like those of Ingres and Rousseau before him, began to work to his advantage. They pushed him unhappily and unwittingly into notoriety, but they raised him in the esteem of his companions. Zola, sensing perhaps that Monet had a misunderstood talent as great as that of Manet, rallied to his defense. In his review of the Salon of 1868, Zola eulogized "painters who love their era with all the artist's mind and heart.... They try above all to penetrate the exact meaning of things.... Their works are neither banal and unintelligent fashion pictures nor journalistic drawings such as those published in the illustrated press. Their works are alive, because painters... have feelings for modern subjects. Among those artists, in the first rank, I will mention Claude Monet."[21]

Zola took pains to describe *Femmes au jardin*, which of course the public never saw.

> I saw original works by Claude Monet that are truly his flesh and blood. Last year, a figurative painting by him was rejected, representing women in light summer dresses picking flowers in the allées of a garden; the sun was aiming directly at the strikingly white skirts; the lukewarm shadow of a tree created a large area of gray on the allées and sunlit dresses. A very strange effect was thus produced. One must love his epoch very dearly to dare such a tour de force, fabrics divided in two by shade and sun, well-dressed women in a bed of flowers carefully groomed by a gardener's rake.[22]

But Zola was only informing the public of what Monet's colleagues already knew. Some, such as Courbet and Manet, were cynical at

19. "Ce tableau, je l'ai vraiment peint sur place et d'après nature, ce qui ne se faisait pas alors. J'avais creusé un trou dans la terre, une sorte de fossé, pour enfouir progressivement ma toile." Trévise 1927, p. 122.
20. Mainardi 1987, p. 189.
21. "les peintres qui aiment leur temps du fond de leur esprit et de leur coeur d'artistes.... Ils tâchent avant tout de pénétrer le sens exact des choses.... Leurs oeuvres ne sont pas de gravures de mode banales et inintelligentes, des dessins d'actualité pareils à ceux que les journaux illustrés publient. Leurs oeuvres sont vivantes, parce qu'ils... éprouvent pour les sujets modernes. Parmi ces peintres, au premier rang, je citerai Claude Monet." "Mon Salon: Les actualistes," 1868, in Zola 1991, p. 207.
22. "J'ai vu de Claude Monet des toiles originales qui sont bien sa chair et son sang. L'année dernière, on lui a refusé un tableau de figures, des femmes en toilettes claires d'été, cueillant des fleurs dans les allées d'un jardin; le soleil tombait droit sur les jupes d'une blancheur éclatante; l'ombre tiède d'un arbre découpait sur les allées, sur les robes ensoleillées, une grande nappe grise. Rien de plus étrange comme effet. Il faut aimer singulièrement son temps pour oser un pareil tour de force, des étoffes coupées en deux par l'ombre et le soleil, des dames bien mises dans un parterre que le râteau d'un jardinier a soigneusement peigné." "Mon Salon: Les actualistes," 1868, in Zola 1991, p. 209.

Fig. 173. Frédéric Bazille, *La Terrasse de Méric (The Terrace at Méric)*, 1867. Oil on canvas, 38¼ x 50⅜ in. (97 x 128 cm). Musée du Petit Palais, Geneva

Fig. 174. Frédéric Bazille, *Portrait de la famille *** (Réunion de famille) (The Family Reunion)*, 1867. Oil on canvas, 59⅞ x 89⅜ in. (152 x 227 cm). Musée d'Orsay, Paris

23. "Comment, petit, tu ne travailles donc pas?" "Vous voyez bien qu'il n'y a pas de soleil!" "Ça ne fait rien, tu n'as qu'à travailler le paysage." Trévise 1927, p. 122.

24. "Je viens de voir un tableau de Monet qui s'appelle: *Femmes en plein air.*" Trévise 1927, p. 122. Monet recalled the incident somewhat differently to his interviewer Thiébault-Sisson (1900), but the slight amounted to the same thing.

25. "Mais, vois-tu, tous les tableaux faits à l'intérieur, dans l'atelier, ne vaudront jamais les choses faites en plein air. En représent des scènes du dehors, les oppositions des figures sur les terrains sont étonnantes, et le paysage est magnifique. Je vois des choses superbes, et il faut que je me résous à ne faire que des choses en plein air." Letter from Cézanne to Zola, October 1866(?), Cézanne 1937, pp. 98–99. Translation by Marguerite Kay, *Paul Cézanne: Letters* (London, 1941), pp. 74–75.

26. Daulte 1952, no. 11; Daulte 1992, no. 14. This painting is not by Bazille. See Montpellier, Brooklyn, Memphis 1992–93, p. 149.

first. When Courbet visited Monet at Ville-d'Avray during the campaign of *Femmes au jardin*, he asked, "Say, my young man, you are not working?" Monet responded, "As you can see, there is no sun!" Courbet: "It doesn't matter, you can work on the landscape."[23] For his part, Manet made little of Monet's method by going to Tortoni's, his usual restaurant, and announcing, "I just saw a painting by Monet titled: *Femmes en plein air.*"[24] Nevertheless, the example of the *Déjeuner sur l'herbe* and *Femmes au jardin*, which Bazille bought and which Manet later acquired, was catalytic for the young painters around Monet. It set the immediate agenda for Bazille and Renoir, and even Cézanne, who was not in the close circle, resolved to paint compositions with figures out-of-doors: "But you know all pictures painted inside, in the studio, will never be as good as the things done outside. When out-of-door scenes are represented, the contrasts between the figures and the ground is astounding and the landscape is magnificent. I see some superb things and I shall have to make up my mind only to do things out-of-doors."[25]

While posing for Monet's *Déjeuner* at Chailly, Bazille did not, contrary to what has been written, paint a small picnic scene of his own, for which Monet, Camille Doncieux, and Sisley reputedly posed.[26] More to the point, Bazille planned for the Salons of 1867 and 1868 large figure paintings painted outdoors on the terrace of his family house, Méric, in Montpellier. The first (fig. 173), a casual scene not nearly as contrived nor as artful as Monet's pictures, was rejected by the strict jury of 1867, but the second (fig. 174), twice as large as his first, was accepted by the liberal jury of 1868. In it Bazille's entire extended family, with the exception of the resolute paterfamilias, Gaston Bazille, turns to stare at the intruder, like a pride of lions interrupted in their midday nap. Despite the stiff formality, it is an extraordinary work, with the same number of figures—eleven—as Monet's *Déjeuner*. But unlike Monet, Bazille did not dare disrupt his composition with strong light. Reverting to his habitual formula, he placed the figures in the foreground in a suffused half shadow, behind which extends a brilliantly illuminated landscape. Bazille worked hard to create a unified atmosphere, repeating, for example, the robin's-egg blue of the meridional sky in the chiffon overskirt of the young woman at center, Thérèse Hours-Farel. But there is a provincial quality to the painting, an aspect *trop dessiné* reminiscent of Léopold Robert's *Paysanne de la campagne de Rome (Peasant Woman in the Roman Countryside*, 1824; Louvre, Paris) that is very different in feeling from the fashion-print primitivism of Monet. Yet perhaps because it was a group portrait and therefore, unlike Monet's overscaled genre scenes, conformed to an acknowledged tradition, it was hung in the Salon.

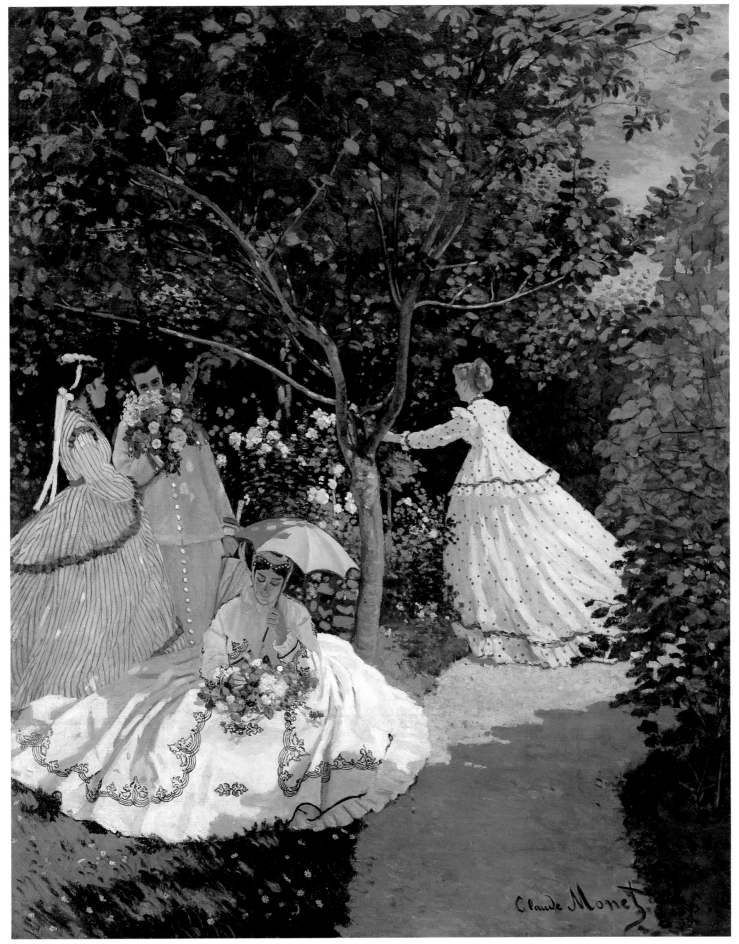

Fig. 175 (cat. 130). Claude Monet, *Femmes au jardin* (*Women in the Garden*), 1866–67. Oil on canvas, 100⅜ x 80¾ in. (255 x 205 cm). Musée d'Orsay, Paris

Fig. 176. Auguste Renoir, *Lise (Lise à l'ombrelle) (Lise with a Parasol)*, 1867. Oil on canvas, 72½ x 45¼ in. (184 x 115 cm). Museum Folkwang, Essen

Fig. 177. Gill, *Lise au parasol (Lise with a Parasol)*. Caricature published in *Le Salon pour rire*

Zola admired it as "showing a vivid love for the truth," and he rationalized the awkward drawing as conscientiousness: "Each physiognomy is carefully studied, each figure looks like itself."

In the same review, Zola remarked on Renoir's *envoi* to the 1868 Salon, *Lise* (fig. 176). "To me, this *Lise* looks like the sister of Claude Monet's *Camille* [fig. 236]. She is shown frontally, emerging from an allée, balancing her lithe body, warmed by the strong afternoon heat. She is one of our women, or rather one of our mistresses, painted with a great truth and a successful investigation of modernity."[27] Zola of course knew that Monet, Renoir, and Sisley were all in and out of Bazille's Paris studio at this period, sharing ideas, models, and the coal stove, so it was easy for him to connect *Lise* to Monet. But this time he missed the mark, for *Lise* was not the sister of *Camille*; she was one of the "femmes au jardin." Even if Renoir largely worked on the painting in the studio—we do not know enough about his practice in the 1860s—he presented his subject as plein air painting. He did not take the compromise Bazille developed and place his figure in an even shadow; he took a more adventurous position and cast Lise's face in darkness while allowing the sun to bounce brightly off the white summer dress. This dramatic contrast was the salient feature of the painting, the point that was caught by the caricaturists (fig. 177). Renoir's earlier essays in Salon figure painting, *Femmes au bain (Women Bathing*; now lost)[28] and *Diane chasseresse* (fig. 56), submitted to and rejected by the Salons of

27. "témoigne d'un vif amour de la vérité." "Chaque physionomie est étudiée avec un soin extrême, chaque figure a l'allure qui lui est propre." "Cette *Lise* me paraît être la soeur de la *Camille* de Claude Monet. Elle se présente de face, débouchant d'une allée, balançant son corps souple, attiédi par l'après-midi brûlante. C'est une de nos femmes, une de nos maîtresses plutôt, peinte avec une grande vérité et une recherche heureuse du côté moderne." "Mon Salon: Les actualistes," 1868, in Zola 1991, pp. 210–11.

28. As Anne Distel has cleverly surmised, the painting, which included a nude and a clothed figure, was probably cut up by Renoir, and the bust of the clothed figure that remains is the work she illustrated as figure c in London, Paris, Boston 1985–86, p. 179.

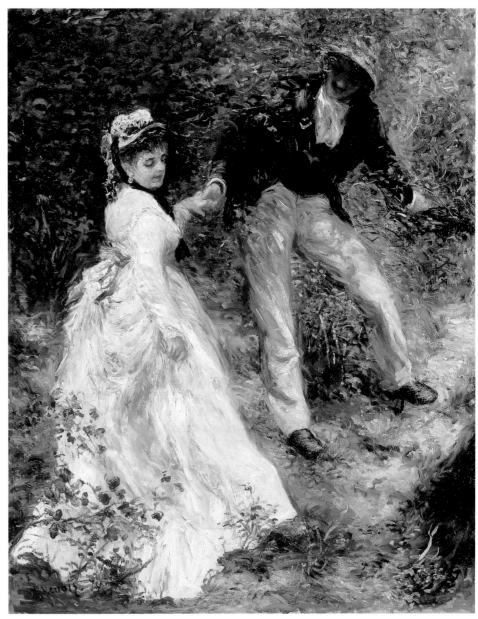

Fig. 178 (cat. 181). Auguste Renoir, *La Promenade* (*The Walk*), 1870. Oil on canvas, 32 x 25½ in. (81.3 x 65 cm). Collection of the J. Paul Getty Museum, Malibu, California

1866 and 1867, were essentially essays in Courbet's figural style. But the presence of Monet is unmistakable in *Lise*. Even Renoir's painting method had changed. Bazille's friend Edmond Maître saw Renoir in summer 1867, when he was working on *Lise*, and reported, "The painter Renoir is in Chantilly at the moment. Last time I saw him in Paris, he was painting strange canvases, having traded turpentine for an infamous sulfate and using, instead of a knife, the little syringe that you know."[29] This new fluid painting style became the vehicle for Renoir's genre paintings over the next few years. In *En été; étude* of 1868 (fig. 246), in *Les Fiancés* of about 1868 (fig. 247), and finally in *La Promenade* (fig. 178), he used ever more fluent brushwork and carefully calibrated palettes to integrate figures with landscape. These first two may have been studio productions—

29. "Le peintre Renoir est en ce moment à Chantilly. Il faisait la dernière fois que je l'ai vu à Paris d'étrange peinture, ayant changé la térébenthine contre un sulfate infâme et quitté son couteau pour la petite seringue que vous savez." Letter from Maître to Bazille, August 23, 1867, Daulte 1992, p. 61.

30. Cooper 1959, p. 167.

31. "Comme un vrai Parisien, il emmène Paris à la campagne, il ne peut peindre un paysage sans y mettre des messieurs et des dames de toilette. La nature paraît perdre de son intérêt pour lui, dès qu'elle ne porte pas l'empreinte de nos moeurs." "Mon Salon: Les actualistes," 1868, in Zola 1991, pp. 207–8.

Douglas Cooper wrote that they smacked of the photographer's studio[30]—but the last is decidedly not. It brings to fruition many of the implications of Monet's *Déjeuner sur l'herbe* and *Femmes au jardin*: the authenticity of quickly notated depictions of modern bourgeois life seen in the light of day, the attraction of beauty in the form of a promise of happiness.

Monet pursued these implications as well. Although in one vein he continued to explore pure landscape, witness his cliffs at Étretat (fig. 323), in another he examined the domesticated landscape, staffed with surrogate observers. As Zola remarked in 1868, "As a true Parisian [which, being an Havrais, he was not], he takes Paris to the country, and he cannot paint a landscape without placing well-dressed gentlemen and ladies within it. Nature seems to lose all interest for him when it does not bear the mark of our ways of life."[31] The manners he depicted were of course those of the bourgeoisie who

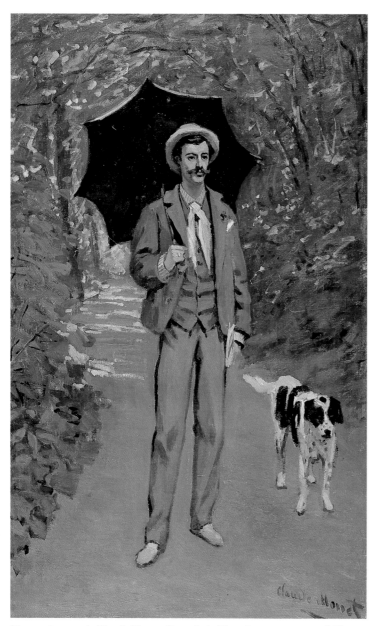

Fig. 179 (cat. 140). Claude Monet. *Portrait de Victor Jacquemont*, ca. 1868. Oil on canvas. 39 x 24 in. (99 x 61 cm). Kunsthaus Zurich

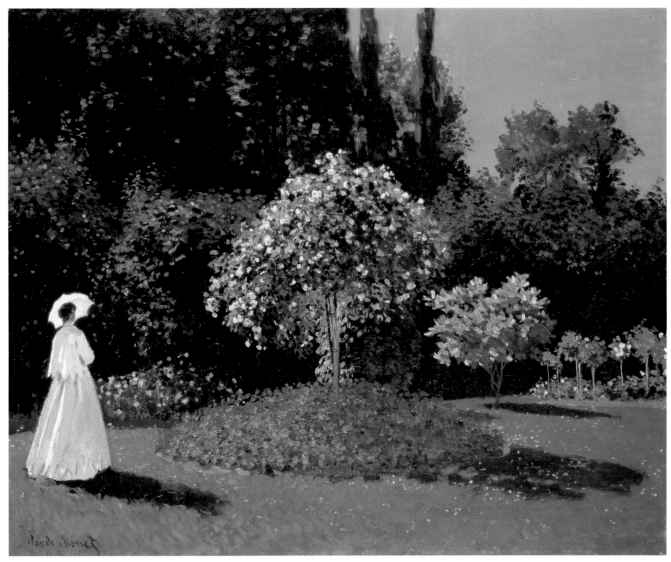

Fig. 180 (cat. 138). Claude Monet, *Jeanne Marguerite Lecadre au jardin* (*Jeanne Marguerite Lecadre in the Garden*), 1867. Oil on canvas, 31½ x 39 in. (80 x 99 cm). Hermitage Museum, Saint Petersburg

increasingly found pleasure in escape from Paris, a privilege formerly of the landed gentry but one now distributed more democratically by the availability of cheap railroad service. But Monet does not seem to have been concerned, as Zola was in his own writing, with the changing social habits of the French. His concerns were largely pictorial. He viewed the domesticated landscape as if he were a foreigner: not with the critical detachment of observers such as the Goncourts, a detachment that brought searing insight into the thoughts and habits of the people around them. Rather he looked at his cousin Jeanne Marguerite Lecadre in the garden of his aunt (fig. 180) or his family in his father's own garden (fig. 310) as a Yokohama woodblock designer might have looked at a gang of Yankees disembarking from their clipper. The appeal of Japanese

woodblock prints to Monet rested precisely in their convenient suggestions for seeing and organizing in a novel and unexpected manner the world which he knew all too well.[32] It cannot have been the village architecture of Gloton that interested Monet in his *Au bord de l'eau, Bennecourt* (fig. 181). It was the extraordinary reflections in the water, his joy in perceiving them, and his satisfaction in transposing them to paint. To the extent that Monet may have been expressing feelings about his companion, Camille, or their son, illegible in her lap, he was lying, for his feelings could only have been concern and anxiety: they could ill afford the peace, calm, or leisure that the painting projects. Penniless, Monet was dodging creditors and relentlessly dunning his friends for money. Renoir was poorer, but his pictures, in contrast to those of Monet, promise not only happiness, but also love.

Bazille's position remained equivocal. His views of landscape were not detached or objective. He was obviously deeply interested in his

32. This suggestion was made to me by Virginia Spate in conversation.

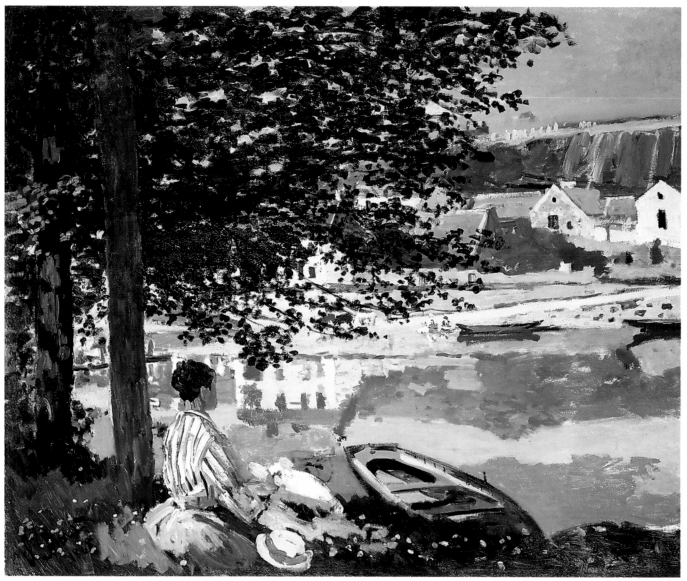

Fig. 181 (cat. 141). Claude Monet, *Au bord de l'eau, Bennecourt* (*The River at Bennecourt*), 1868. Oil on canvas, 32⅛ x 39⅝ in. (81.5 x 100.7 cm). The Art Institute of Chicago, Potter Palmer Collection

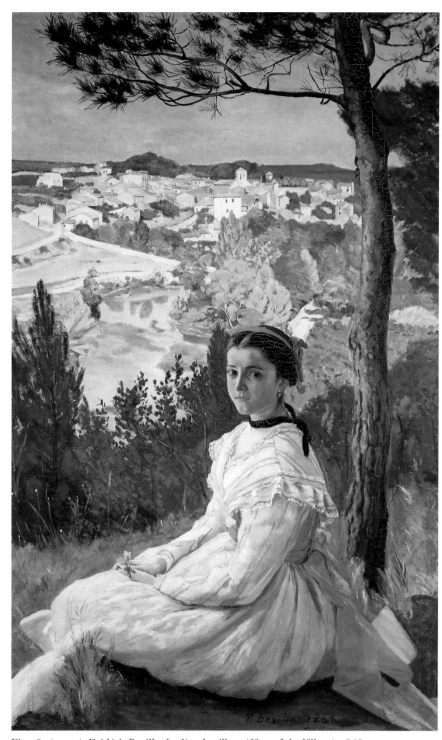

Fig. 182 (cat. 9). Frédéric Bazille, *La Vue du village* (*View of the Village*), 1868.
Oil on canvas, 51⅛ x 35 in. (130 x 89 cm). Musée Fabre, Montpellier

neighboring village of Castelnau, rendered so carefully in *La Vue du village* (fig. 182), and just as excited by the challenge of successfully depicting a figure *en plein air*. By giving equal emphasis to both he created a tension that animates his picture. In Berthe Morisot's eyes, he succeeded at placing "a figure in the outdoor light." But he was more committed to figure painting than Monet was, and so his plein air compositions of the late 1860s are at once more daring than Monet's and, paradoxically, more traditional. He placed nudes

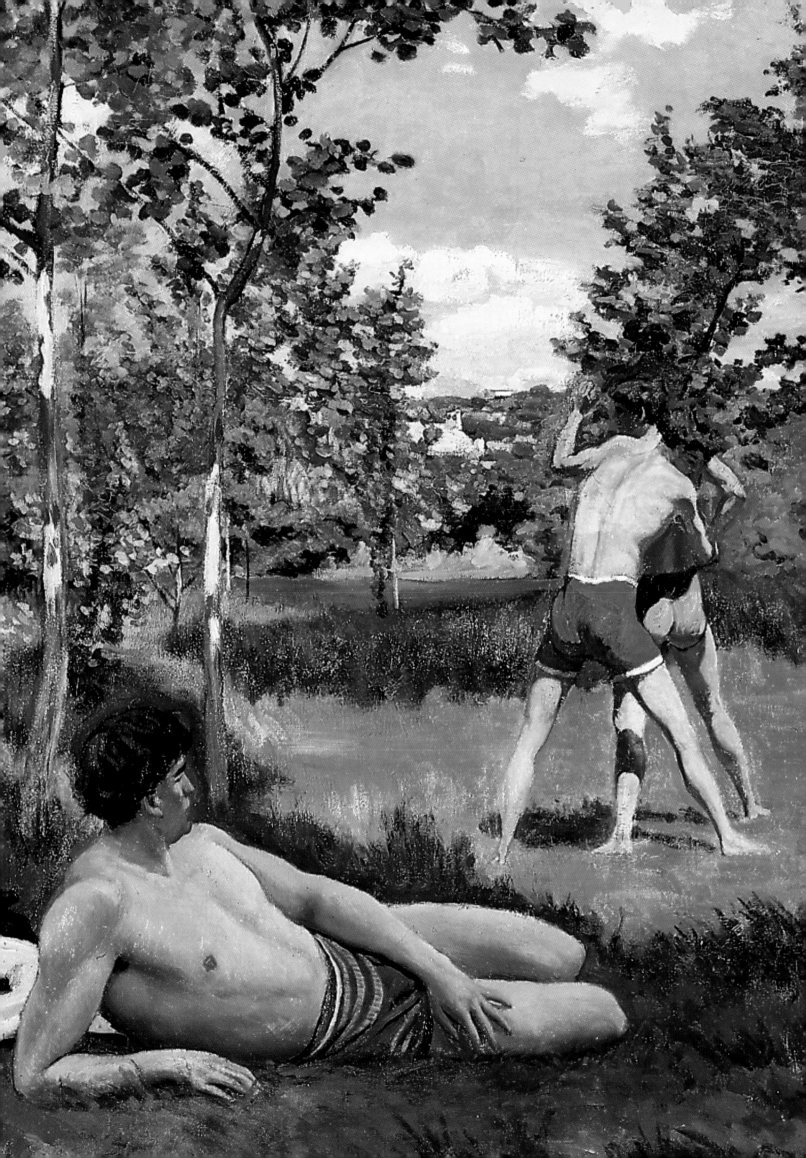

in landscapes (fig. 153). Taking his cues from the same sources as Monet—Courbet and Manet—he sought modern-day pretexts for arranging nudes out-of-doors. And just as Courbet and Manet borrowed poses from the old masters—especially through the engravings of Marcantonio Raimondi—to enter into a dialogue with rich currents of the past, so did Bazille evoke a Bassano Saint Sebastian at the left of his *Scène d'été* (fig. 337), a recumbent shepherd from de la Hire at center,[33] and wrestlers à la Courbet in the mid-distance. In painting the flesh, he looked to Renoir, not Monet, for effects of delicate translucency. In painting the landscape, he rejected Monet's rapidly notated observations in favor of elaborate drawings, squared up for transfer to the carefully worked canvas. It seems less mysterious, then, that Bazille's plein air paintings were accepted at the Salons of 1869 and 1870, while Monet's, like Claude Lantier's oeuvre *Plein-air*, were rejected. Bazille accommodated something of the novelty of Monet's method to the grand tradition of French painting. When war brought him death in 1870, he still aspired to be a *peintre d'histoire*. No wonder, then, that he could write, after he was accepted at the 1869 Salon, "Except for Manet whom they no longer dare reject, I am among the least badly treated. Monet was entirely rejected.... I was supported, to my astonishment, by Cabanel."[34]

33. Identified by Dianne Pitman in Montpellier, Brooklyn, Memphis 1992–93, p. 119 (English ed.).

34. "À part Manet qu'on n'ose plus refuser, je suis des moins maltraités. Monet est entièrement refusé.... J'ai été défendu, à mon grand étonnement, par Cabanel." Bazille to his father, April 9, 1869, Bazille 1992, no. 119, p. 172. Translation by Paula Prokopoff-Giannini in Chicago 1978, p. 179.

Frédéric Bazille, *Scène d'été*, detail of fig. 337

VI
Still Life

HENRI LOYRETTE

In 1873, before he wrote *Le Ventre de Paris*, Émile Zola would explore the central market of Paris at great length: "With a pencil in his hand," wrote his friend Paul Alexis sometime later, "[he] came in all weather, rain, sun, fog, snow, and at all hours, morning, afternoon, evening, in order to record all its diverse aspects. Once he spent the entire night there, to witness the great arrival of the food of Paris."[1] Zola's notes, reassembled and recently published, detail the streets of the quarter, Victor Baltard's new architecture, and the delivery and sale of merchandise, conveying some picturesque profiles and lingering on the metamorphoses created by changes of weather and the variations of light between night and day. These preparatory papers also bring together a number of still lifes, arranged according to the expertise of the merchants, who, for the author, revealed a true art: "hampers" of fish in which sprawled "conger eels, in twos or threes, in a circle, pearly gray blue," "pikes golden and grayish," "mackerel with backs striped in burnished green and gold, with bellies of shimmering pink mother-of-pearl," "baskets" of flowers tied in bunches, "tables mounted on trestles, trimmed mostly in black cloth" where "mountains of cabbages" tumble down, where "full endives, displaying their white hearts within the light green of their large leaves" rise like pyramids along with "red carrots," and "white turnips with their tufts of green leaves."[2] In Zola's novel this detailed enumeration would become a well-orchestrated description; the trivial spectacle of "the day rising over the vegetables" is seen through the eyes of Claude, the painter, who, standing on a bench, contemplates this edible "sea" with the same "enthusiasm" as a romantic poet before the ocean: "these foaming heaps like pressing waves, this river of greenery that seemed to flow into the street embankment, like the downpour of autumn rain, ranged from delicate and pearly shadows, to soft violets, to pinks tinted with milk, to greens drowned in yellows, all the pale and silky nuances of a sky at dawn." Claude Lantier, with his southern loquacity, laid out, for Florent, newly arrived from Cayenne, a sumptuous composition regardless of the ordinary character of the

1. "Un crayon à la main, [il] venait par tous les temps, par la pluie, le soleil, le brouillard, la neige et à toutes les heures, le matin, l'après-midi, le soir, afin de noter les différents aspects. Puis, une fois, il y passa la nuit entière, pour assister au grand arrivage de la nourriture de Paris." Zola had already explored the market three years earlier, when he published an article in *La Tribune*, October 17, 1869. Paul Alexis quoted in Émile Zola, *Carnets d'enquête* (Paris, 1986), p. 344.
2. "mannes"; "anguilles de mer, par deux ou trois, en rond, gris perle bleuâtre"; "brochets dorés et grisâtres"; "maquereaux à dos strié de brunissure verdâtre et dorée, à ventre aux reflets de nacre rose"; "paniers"; "tables posées sur des tréteaux, garnies la plupart d'étoffes noires"; "montagnes de choux"; "chicorées épanouies, montrant leur coeur blanc dans le vert tendre de leurs grosses feuilles"; "carottes rouges"; "navets blancs avec leur panache de feuilles vertes." Paul Alexis quoted in Zola, *Carnets d'enquête*, pp. 389, 391, 393.

149

Fig. 183. Paul Cézanne, *L'Automne* (*Autumn*), ca. 1860–62. Oil on canvas, 123⅝ x 41 in. (314 x 104 cm). Musée du Petit Palais, Paris

3. "le jour se levant sur les légumes"; "mer"; "enthousiasme"; "Ces tas moutonnants comme des flots pressés, ce fleuve de verdure qui semblait couler dans l'encaissement de la chaussée, pareil à la débâcle des pluies d'automne, prenaient des ombres délicates et perlées, des violets attendris, des roses teintés de lait, des verts noyés dans des jaunes, toutes les pâleurs qui font du ciel une soie changeante au lever du soleil"; "l'incendie du matin"; "les paquets d'épinards, les paquets d'oseille, les bouquets d'artichauts, les entassements de haricots et de pois, les empilements de romaines." Émile Zola, *Le Ventre de Paris*, in *Les Rougon-Macquart* (Paris, 1960), vol. I, pp. 626–27.
4. "tout le grand Cézanne des natures mortes [perçant] sous les fleurs, les gerbes de blé et les fruits des paniers." Gasquet 1926, p. 44.

material, arranging, in the "fire of the morning," "bundles of spinach, bundles of sorrel, bunches of artichokes, piles of beans and peas, stacks of romaine."[3] *Le Ventre de Paris* abounds in such descriptions, making the central market an "Eden" of all imaginable eatables; in this book, Zola indulges his own taste for still life, always exuberant, sometimes indigestible, closer to the lavish compositions of a Phillipe Rousseau than to those sober and quiet, of his friends Manet and Cézanne. When reading Zola, one is always surprised by the noise inanimate things can make. Yet despite the profusion of complex sentences and the abundance of metaphors, the still lifes created by Zola are not affected by the general theme of the novel, the struggle between rich and poor, profiteers of the empire and survivors of the coup; rather, they are the work of a painter, pieces of pure painting, mediated only by the science of composition, the play of light, the vivacity of brushstroke, the thickness of the impasto. Zola preached by example and transcribed all his writing on art dating to the 1860s into a parable: painting is concerned neither with ideas nor with feelings; the subject is of little import, for it is only a pretext for drawing, color, texture. The lowliness of the motif—accentuated by Zola, who, describing the bulk merchandise of the market and not the refinements of the retail shops, showed off industrial quantities of vegetables and meats—made the still life a particularly convincing model. *Le Ventre de Paris* thus consecrated the new importance of the still life, which, scorned for a long time, would henceforth be treated equal to any other genre.

During the 1860s all the artists of the New Painting executed still lifes. With variable frequency, however; although still life was already an essential element in the oeuvre of Fantin-Latour, the genre appeared more sporadically in the work of Courbet, Manet, Monet, Renoir, and Cézanne. In 1861, during his second visit to England, Fantin produced numerous rough sketches that were immediate successes with his hosts, the Hadens and the Edwardses. Upon his return to Paris, disregarding the self-portraits that until then had dominated his career, Fantin repeatedly painted still lifes and, especially, floral compositions, sources of both endless experiment and, very quickly, a not insubstantial profit. Nonetheless, he was the only artist who specialized in still life at that time; for Cézanne, who later would divide his time equally among figure paintings, still lifes, and landscapes, still life was then just a limited part of his oeuvre, even if some want to see in the mediocre *Saisons* (fig. 183) that began his career "all the great Cézanne of the still lifes [showing] under the flowers, the sheaves of wheat, and the baskets of fruit."[4] It was during his stay in Saintonge, in 1862, that Courbet, drawing his inspiration from Dutch models, vowed to paintings of flowers "a fugitive passion," resulting in some admirable bouquets (fig. 220)

Fig. 184 (cat. 114). Claude Monet, *Trophée de chasse* (*Trophy of the Hunt*), 1862.
Oil on canvas, 41 x 29½ in. (104 x 75 cm). Musée d'Orsay, Paris

and the complex arrangement of *Le Treillis* (fig. 280); he then aban-
doned the still life, devoting himself to it anew, after the Commune,
behind the bars at Sainte-Pélagie: the few apples that he painted
from his cell no doubt gave him the illusion that he still held the
world in his hands.

In contrast Manet and Monet, even if it was not the essence of their
activity, regularly executed still lifes, so much so that by lining up
all the still lifes painted by both artists throughout the decade one
gets a fair idea of the evolution of their styles. Thus by 1867 Monet
had arrived at realist subjects à la Bonvin (fig. 204) and had tried his

Fig. 185. Édouard Manet, *Fruits sur une table* (*Fruit on a Table*), 1864. Oil on canvas, 17¾ x 28⅞ in. (45 x 73.5 cm). Musée d'Orsay, Paris, Moreau-Nélaton Gift

Fig. 186. Édouard Manet, *Le Déjeuner* (*The Luncheon*), 1868. Oil on canvas, 46⅝ x 60⅝ in. (118.3 x 153.9 cm). Neue Pinakothek, Munich

Fig. 187. Claude Monet, *Nature morte, poires et raisins* (*Still Life with Pears and Grapes*), 1867. Oil on canvas, 18⅛ x 22 in. (46 x 56 cm). Private collection

hand, with commercial aspirations, at some ambitious compositions in which—following Troyon—he updated those paragons of eighteenth-century French painting Oudry and Desportes (fig. 184). Now following Manet, he placed some broadly painted fruit on the thick folds of a plain white tablecloth (figs. 185, 187). Two years later, in 1869, Monet—like Renoir, to whom he would never be closer—was already an Impressionist, translating the fullness of a bouquet and the flesh of fruit with lively brushstrokes, numerous and agitated (fig. 215).

As for Manet, the few still lifes that he exhibited throughout the decade—at Martinet's and Cadart's in 1865 and at the Pavillion de l'Alma in 1867—were the best-received pieces of his oeuvre: "the most vocal enemies of Edouard Manet's talent," Émile Zola wrote in 1867, "grant him that he paints inanimate objects well."[5] The following year Marius Chaumelin reduced to two still lifes the ambitious compositions Manet showed at the Salon, *Le Balcon* (fig. 266) and *Le Déjeuner* (fig. 186)—"M. Manet made a portrait of a *Balcony* and that of a *Luncheon*," wrote Chaumelin, congenially mocking the *Balcon* with its green balustrade freshly repainted "to pose for the portrait painter" and mentioning only the inanimate objects surrounding the central figure of the *Déjeuner:* "Lunch is served on a damask tablecloth of immaculate white: there are oysters, a lemon, a glass half filled with white wine, a bottle, a small blue pot, and white porcelain cups. Next to the table, on a seat covered in red velvet, I can see a helmet, a yataghan, a large pistol whose handle is inlaid in ivory. All this is painted in a master's hand with an exactness of tonalities and a boldness of brushstroke com-

5. "Les ennemis les plus déclarés du talent d'Édouard Manet lui accordent qu'il peint bien les objets inanimés." Zola 1991, p. 162.

Fig. 188 (cat. 104). Édouard Manet, *Fruits (Nature morte avec melon et pêches)* (*Fruit [Still Life with Melon and Peaches]*), 1866 (?). Oil on canvas, 27⅛ x 36¼ in. (69 x 92.2 cm). National Gallery of Art, Washington, Gift of Eugene and Agnes Meyer

Fig. 189 (cat. 16). François Bonvin, *Nature morte aux huîtres* (*Still Life with Lemon and Oysters*), 1858. Oil on canvas, 29½ x 33 in. (75 x 83.8 cm). Joey and Toby Tanenbaum, Toronto

Fig. 190 (cat. 31). Paul Cézanne, *La Pendule noire* (*The Black Clock*), ca. 1870. Oil on canvas, 21¾ x 29¼ in. (55.2 x 74.3 cm). Private collection

pletely extraordinary."[6] In 1868 young Odilon Redon equally criticized Manet's *Portrait d'Émile Zola* (fig. 270) for its lack of "moral life" and "interior life" because the painter had sacrificed "the man and his thought, for good composition, for the success of an accessory" and concluded that Manet's work was "rather a still life than the expression of a human character."[7] Later on, even those who most disliked Manet's work would often isolate and praise a few details, such as the sewing basket in the portrait of his parents (fig. 192), the overturned basket in the *Déjeuner sur l'herbe* (fig. 143), the bouquet in *Olympia* (fig. 146), the books and lemon accompanying *Zacharie Astruc* (fig. 193).

Throughout the decade, in these works as elsewhere, Manet reflected on the great examples of the past, those of the Spaniards and their bodegones—clearly apparent in *Guitare et chapeau* (fig. 191), Manet's "last sacrifice to the Spanish manner" so strong in his work of 1862—as well as those of the Dutch (fig. 188) and that of Chardin (fig. 211).[8] Like Bonvin, who cleared the way (fig. 189) yet always remained smooth, dull, and contrite, Manet played with sharp oppositions of black and white, the dark wood of a table against a burst of tablecloth or napkins on which he placed his accents of

6. "M. Manet a fait le portrait d'un *Balcon*, et celui d'un *Déjeuner*"; "poser devant le portraitiste"; "Le déjeuner est servi avec une nappe damassée d'une blancheur immaculée: il y a des huîtres, il y a un citron, il y a un verre à moitié plein de vin blanc, il y a une bouteille, un petit pot bleu et des tasses de porcelaine blanche. À côté de la table, sur un siège garni de velours rouge, j'aperçois un casque, un yatagan, un grand pistolet dont la crosse est incrustée d'ivoire. Tout cela est peint de main de maître avec une justesse de tons et une largeur de touche tout à fait extraordinaires." Marius Chaumelin, "Salon de 1868," *La Presse*, June 22, 1868, pp. 1–2.

7. "vie morale"; "vie intérieure"; "l'homme et sa pensée, à la bonne facture, à la réussite d'un accessoire"; "plutôt une nature morte que l'expression d'un caractère humain." Quoted in Paris, New York 1983, p. 285.

8. "dernier sacrifice à cet espagnolisme." Tabarant 1947, p. 56.

Fig. 191 (cat. 85). Édouard Manet, *Guitare et chapeau* (*Guitar and Hat*), 1862. Oil on canvas, 30⅜ x 47⅝ in. (77 x 121 cm). Musée Calvet, Avignon

Fig. 192. Édouard Manet, *Portrait de monsieur et madame Auguste Manet, parents de l'artiste* (*M. and Mme Auguste Manet, the Artist's Parents*), 1860. Oil on canvas, 43¼ x 35⅜ in. (110 x 90 cm). Musée d'Orsay, Paris

Fig. 193. Édouard Manet, *Portrait de Zacharie Astruc*, 1864. Oil on canvas, 35⅜ x 45⅝ in. (90 x 116 cm). Kunsthalle Bremen

Fig. 194. Edgar Degas, *Portrait d'homme* (*Portrait of a Man*), ca. 1866. Oil on canvas, 33½ x 25⅝ in. (85 x 65 cm). The Brooklyn Museum

Fig. 195. Henri Fantin-Latour, *Nature morte avec une tasse et un verre* (*Still Life with a Cup and a Glass*), 1861. Oil on canvas, 13¾ x 18½ in. (35 x 47 cm). Collection of Lord Astor of Hever, London

9. "blanche comme une couche de neige fraîchement tombée"; "nappe de neige fraîche." Gasquet 1926, pp. 204–5.
10. See Castagnary's observations regarding this artist, p. 168.
11. "route de Hollande"; "une petite table de toilette"; "Nous aurions pu la signer Whistler et moi." The "small dressing table" may have been *Nature morte avec une tasse et un verre* (fig. 195), no. 68 at the *Exposition de l'oeuvre de Fantin-Latour* Paris, École des Beaux-Arts, 1906. Degas 1945, p. 256.
12. "dernière pièce de quarante sous"; "quelques fruits et légumes pour les peindre." Regarding Boudin and the butcher, see Jean-Aubry 1922, p. 27; Boudin's "Notebooks," quoted ibid., p. 31.
13. "Ne me condamnez pas à la nature morte perpétuelle." Letter from Bazille to his mother, first half of December 1866, in Bazille 1992, p. 132.
14. "rapporter quelque profit"; "tableaux de salle à manger." Jean-Aubry 1922, p. 28.

color. Like Cézanne (fig. 190) and Monet (fig. 187), whom he would later influence, Manet found in the still life, obedient and available, a laboratory for his experimentation with color, the results of which were immediately reflected in other compositions; like Cézanne and Monet, Manet exhibited the curious obsession with bright white that was one of the characteristics of the 1860s, and he, too, wanted to paint one of those tables set with its cloth "white as a bed of newly fallen snow." At the end of his life, Cézanne, citing *La Peau de chagrin*, recalled sadly this noble obsession of his youth, to paint a "tablecloth of fresh snow."[9] Indeed, Manet's *Fruits* (fig. 188) and Cézanne's *La Pendule noire* (fig. 190), with their immaculate tablecloths, starched and heavy, are in effect handsome, snow-covered landscapes equal to *La Pie* (fig. 315). Later, reflecting like a mirror all the colors of the objects they bore, fragmented by the juxtaposed brushstrokes of Impressionism, tablecloths and napkins would never again show this bright and implacable white.

In our rapid evocation of the still life, it would be wrong to emphasize the single examples that we have bequeathed to Sisley (fig. 216) and Pissarro (fig. 205) and to neglect the contribution of Degas, who, while never painting a true still life nevertheless placed them prominently within most of his portraits, as attributes intended to specify the circumstances of the sitter. Thus Degas associated his friend Mme Valpinçon (fig. 281), in imitation of Courbet (fig. 280), with the bouquet of flowers she had just picked, representing her as the lady of the house, a hospitable countrywoman; or again, about 1866, Degas painted one of his comrades (fig. 194), a painter of still lifes—possibly the Englishman Robert Grahame, who specialized in bloody subjects—dressed as a bourgeois and seated tranquilly in the midst of the cuts of meat that served as his models.[10] Curiously, in 1906 Degas described himself as a painter of still lifes, evoking the common path, the "Dutch road" that he followed for a time with Whistler and Fantin-Latour. While visiting a retrospective exhibition at the École des Beaux-Arts dedicated to Fantin-Latour, who had just died, Degas declared in front of "a small dressing table" (fig. 195): "We could have signed it, Whistler and I."[11]

The reasons are many for this attachment to the still life: commercial, artistic, and, above all, practical. Next to the self-portrait, still life was both the cheapest and least demanding of models, disposable, malleable, subject only to the laws of decomposition—fruit that rots, flowers that wither. Boudin had an agreement with a neighboring butcher from whom he rented game for forty-eight hours; in 1856, with his last "forty-sous coin," Boudin bought "some fruit and vegetables to paint."[12] Bazille, although he received a regular income, enumerated the monetary needs brought on by his new living arrangements, his frequent outings to concerts, and the neces-

sity of finding a model in order to paint the nude, ending his appeal to his mother with this clinching argument: "Do not condemn me to paint still lifes forever."[13]

Nonetheless still-life painting was appreciated by members of the upper and middle bourgeoisie who were captivated by its decorative charm and modest dimensions; like the portrait, it thus was an easy source of income for a painter. Monet's *Trophée de chasse* (fig. 184), reminiscent of Oudry and Desportes, was clearly painted for a well-off clientele or those who had ambition to be. Bazille as well (fig. 196) did not escape this temptation of the Golden Age, certainly profitable, which brought him suddenly closer to a Jean Benner (fig. 197) than to his fellow Impressionists. When he moved to Le Havre, Boudin, totally broke, repeatedly produced all types of work that could "bring in some profit," watercolors, landscapes, and what he called "dining-room paintings."[14] Like Claude Lantier, Zola's emblematic painter who, in poverty, knocked out a lot of "work" doing "little paintings of flowers for England," Fantin-Latour executed numerous bouquets for his British clients.[15] Thanks to Whistler, Fantin in fact obtained some commissions from the considerable Greek community in London and then from a few local collectors. By 1867, however, the repetition of the same subjects and the weariness of the restricted circle of his patrons drove him, with the help of Edwards and the untiring Whistler, to seek a new clientele. But these patrons proved more limited and recalcitrant, driving Fantin, after his great success at the Salon of 1870, to neglect his English prospects and to wager all on a career in France.[16]

Most important, still-life painting was now fashionable and no longer suffered from the discriminations of the past. It built its new distinction on the collapse of the old hierarchy—from which it benefited as much as landscape and genre painting—as well as on the rediscovery of certain aspects of the eighteenth century, the very recent glory of Chardin, and the perseverance of a few painters, Bonvin in particular (fig. 189), who had made still life a specialty. Naturally, the resistance was plentiful, as illustrated by the abundance of still lifes at the Salon des Refusés in 1863. The champions of the ancient order condemned still life for the simplicity of its motifs; Baudelaire could not "repress a fit of bad temper" when he heard people speak "of a painter of animals or a painter of flowers with the same enthusiasm with which one would praise a universal painter (that is, a true painter) such as Rubens, Veronese, Velázquez, or Delacroix."[17] Many conceded to still-life painting a merely ornamental interest—"it constitutes the essential decoration of all noble and splendid architecture"—and mocked it as a genre entrusted predominantly to feminine talents.[18] According to a long-standing prejudice, women painters could only be good at still lifes. "Flock

Fig. 196. Frédéric Bazille, *Fleurs (Study of flowers)*, 1868. Oil on canvas, 51⅛ x 37⅜ in. (130 x 95 cm). Musée de Grenoble

Fig. 197. Jean Benner, *Vase de fleurs (Vase of Flowers)*, 1866. Oil on canvas, 78¾ x 56¾ in. (200 x 144 cm). Musée de l'Impression sur Étoffes, Mulhouse

15. "besogne"; "des petits tableaux de fleurs pour l'Angleterre." Émile Zola, *L'Oeuvre*, in *Les Rougon-Macquart* (Paris, 1966), vol. 4, p. 308.
16. For Fantin-Latour's British clients, see Douglas Druick's thorough study in Paris 1982, pp. 112–16.
17. "défendre d'une vive mauvaise humeur"; "d'un peintre d'animaux ou d'un peintre de fleurs, avec la même emphase qu'on mettrait à louer un peintre universel (c'est-à-dire un vrai peintre), tel que Rubens, Véronèse, Vélasquez ou Delacroix." Charles Baudelaire, "Réflexions sur quelques-uns de mes contemporains—Victor Hugo," in Baudelaire 1985–87, vol. 2, p. 134.
18. "elle constitue la décoration essentielle de toute noble et splendide architecture." Charles Coligny, "Salon de 1864," *L'Artiste*, May 15, 1864, p. 245.

Fig. 198 (cat. 97). Édouard Manet, *Un vase de fleurs (Pivoines dans un vase)* (*Vase of Flowers [Vase of Peonies on Small Pedestal]*), 1864. Oil on canvas, 36⅝ x 27½ in. (93 x 70 cm). Musée d'Orsay, Paris, Moreau-Nélaton Gift

Fig. 199. Édouard Manet, *Portrait d'Eva Gonzalès*, 1869–70. Oil on canvas, 75¼ x 52⅜ in. (191 x 133 cm). National Gallery, London

19. "S'assemble qui se ressemble"; "toute l'armée des peintres de fleurs et de fruits"; "douces compagnes"; "fleurs de la vie"; "les légumes et les fleurs de Mme Euphémie Maraton, les raisins et les fruits de Mme Adèle Piot, les fruits et les oranges de Mme Esther Laverpillère, les pêches et les raisins de Mme Marie Brosset, les fleurs et les fruits de Mme Emma Desportes et de Mme Céline de Saint-Albin." Georges Barral, *Salon de 1864: Vingt-sept pages d'arrêt!!!* (Paris, 1864), p. 23; for the list of still lifes by women artists, see Charles Coligny, "Salon de 1864," *L'Artiste*, May 15, 1864, p. 245.

together, birds of a feather," a critic amiably cried, counting "the entire army of painters of flowers and fruits" and listing them, "these gentle companions" who are the "flowers of life": "the vegetables and flowers of Mme Euphémie Maraton, the grapes and fruit of Mme Adèle Piot, the fruit and oranges of Mme Esther Laverpillère, the peaches and grapes of Mme Marie Brosset, the flowers and fruit of Mme Emma Desportes and Mme Céline de Saint-Albin."[19] Nothing demonstrates this stubborn bias better than Manet's portrait of his young pupil, Eva Gonzalès (fig. 199): Manet shows a woman of the world, elegant and studious, trying her hand at painting, adding the final touches to a bunch of peonies already sumptuously framed. Here Eva Gonzalès is presented as having painted a bouquet comparable to one executed by her teacher five years earlier (fig. 198), but hers is brighter and more fluent, less compact,

Fig. 200 (cat. 98). Édouard Manet, *Bouquet de pivoines* (*Peonies*), 1864. Oil on canvas, 23⅜ x 13⅞ in. (59.4 x 35.2 cm). The Metropolitan Museum of Art, New York, Bequest of Joan Whitney Payson, 1975

Fig. 201. Jules Desfosse, after Édouard Muller called Rosenmuller, *Le Jardin d'Armide* (*The Garden of Armida*), 1854. Painted paper, 153⅛ x 132¾ in. (389 x 337 cm). Musée d'Orsay, Paris

the voluted stems, heavy with flowers in full bloom, strewn across the entire canvas; in a word, more feminine. However, we must add, to confound Manet, that at the time of her portrait, 1869–70, Eva Gonzalès, then a painter of figures (fig. 260), had in fact never produced a still life.

The new popularity of still-life painting rested above all on a carefully administered instruction that mitigated the institutional deficiencies; the academic education, essentially preoccupied with the figure, neglected the still life. But the prominence of inanimate motifs in the industrial arts (including painted porcelain such as that executed by Renoir at the beginning of his career, decorated textiles, and wallpaper [fig. 201]) explains the multiplication, during the Second Empire, of pedagogical albums, among them photographic collections "intended to furnish elements for designers,"

Fig. 202. Chabal-Dussurgey, *Pivoines (Peonies)*.
Lithograph published in *Études et
Compositions de fleurs et fruits. Cours gradué
pour l'enseignement (Studies and Compositions
of Flowers and Fruits. Graduated Course of
Instruction)* (Paris, [1867])

20. "devant servir d'éléments pour dessinateurs." For the col-
lections and manuals, see Hardoin-Fugier and Grafe 1992,
pp. 209–10.
21. "des sériés de formes, de silhouettes, d'effets qui les
conduisent, sans efforts apparents des difficultés premières
aux combinaisons les plus libres"; "ton égal"; "tissu
épais"; "la plus opulente et la plus nacrée des fleurs
d'ornement"; "une couronne de roses-thé mêlées aux zin-
nias, dont la masse est allégée par des épis qui débordent";
"sur une étude consciencieuse et intelligente de la na-
ture"; "traduire une simple fleur de capucine"; "Mais
lorsque, s'asseyant à notre place, M. Chabal nous eut fait
remarquer que les pétales s'inséraient aussi strictement
que s'attachent les membres humains; qu'il y avait tels
raccourcis aussi hardis et difficiles à rendre que ceux du
bras et de la jambe vus en perspective; que les masses
d'ombres formaient de larges oppositions aux masses de
lumière, noyant les détails sans cependant les supprimer;
que le modelé faisait saillir ou fuir la forme circonscrite par
la silhouette; qu'enfin une fleur avait sa tournure, sa grâce,
sa force, sa personnalité tout comme un être animé; alors,
nous comprîmes que l'art ne consiste pas seulement dans
un vulgaire exercice de l'oeil et de la main, mais dans
l'éveil des qualités les plus subtiles de l'attention et du
jugement." Phillipe Burty, "Études et compositions de
fleurs et fruits, cours gradué pour l'enseignement par M.
Chabal-Dussurgey," *Gazette des Beaux-Arts*, January 1,
1868, pp. 102–4.
22. "traduire." Victor-Marie Ruprich-Robert, *Flore orne-
mentale; Essai sur la composition de l'ornement. Eléments
tirés de la nature et principes de leur application.* On
Pierre-Victor Galland, see Marie-Noël de Gary, *Botanique
et ornement, dessins de P.-V. Galland 1872–1892* (Paris,
1992).
23. For Chardin's critical reception and influence, see in par-
ticular McCoubrey 1964; Pierre Rosenberg in Paris 1979,
pp. 85–88; Gabriel P. Weisberg in Cleveland 1979, pp.
31–47.

published by Braun as early as 1848, and manuals like those by
Chabal-Dussurgey, painter at the imperial factory of the Gobelins
in Beauvais, which had a great celebrity.[20] His *Études et composi-
tions de fleurs et de fruits* of 1867 (fig. 202) offered to students a
"series of forms, of silhouettes, of effects that will lead them with no
apparent effort from basic problems to more complex combina-
tions." Thus the young painter went from easy magnolias, with their
"uniform color" and "thick texture," to camellias, to the supple
convolvulus, then later to fruit—peaches, then oranges and lemon
trees—followed by tulips, the peonies so dear to Manet—"the most
opulent and pearly ornamental flowers"—to end with, properly
speaking, a bouquet, "a crown of tea roses mixed with zinnias,
whose bulk was offset by projecting ears of wheat." The teaching of
Chabal-Dussurgey, according to Philippe Burty, who was his student
for three years at the Gobelins, was based on a "careful and intelli-
gent study of nature." Chabal demonstrated the complexity of a
flower, transforming it into a model as worthy of study as the human
body. His students were offended at first to have to "transcribe a
simple nasturtium," which seemed to them a beginner's exercise.
"But when, seating himself among us, M. Chabal made us see that
the petals were inserted as precisely as the limbs of a human body;
that there was foreshortening as daring and difficult to paint as
those of the arm and leg seen in perspective; that masses of shad-
ows were opposed to masses of light, attenuating details without
suppressing them; that the density emphasized or reduced the form
defined by the silhouette; that, lastly, a flower had its figure, grace,
strength, and personality just as a living being; we understood then
that art did not consist only in a vulgar exercise of the eye and the
hand, but in an awakening of the more subtle qualities of attention
and judgment."[21] While Chabal demonstrated that nature provided
a source of infinite observations and presented to the painter who
wished to "translate" it as many difficulties as the body of an aca-
demic model, the painter Pierre-Victor Galland and the architect
Ruprich-Robert, a disciple of Viollet-le-Duc, analyzed and stripped
down the flora to derive an entire ornamental repertoire.[22]

The work of Chardin, rediscovered in the late years of the July
Monarchy after a long period of oblivion, demonstrated the numer-
ous possibilities the arrangement of a few inanimate motifs offered
to the painter, be they variations on a silver cup, a hare, a game
bag, some peaches, insignificant objects.[23] The dual efforts of art
historians (Champfleury, Charles Blanc, Thoré, the Goncourts) and
collectors (Laperlier, La Caze, the Marcilles) rapidly exalted Chardin
as exemplary. In 1860, Thoré, reviewing the renowned exhibition of
eighteenth-century paintings at the Galerie Martinet, was more at-
tentive to painters of genre scenes than to painters of still lifes: "Con-

cerning these bits of still life," he wrote hastily at the end of his article, "one can say that almost all those by Chardin stand up honorably next to similar paintings by the Flemish and Dutch masters; several, like the *Bocal d'olives* (*The Olive Jar*) and the *Lièvre* (*The Hare*), would be remarked as first rate."[24]

But three years later, the Goncourts, enumerating all the qualities that transported Chardin above the Dutch painters, celebrated him primarily as a still-life painter: "Still life, there indeed is the specialty of Chardin's genius. He has elevated this secondary genre to the highest and most wonderful artistic rank. Perhaps never was the enchantment of the material painting, depicting insignificant objects, transfiguring them by the magic of the execution, pushed further than in his work."[25] Chardin, beatified by the two brothers, became the "bourgeois painter of the bourgeoisie," not the narrow-minded and greedy bourgeoisie of their century but the bourgeoisie of the Enlightenment, "the strong mother of the Third Estate," with her virtues of wisdom, order, and thrift; like her, Chardin knew his proper place—"He does not seek anything outside of himself, nor higher than his own vision"—like her, he was attentive to all that surrounded him, knew the cost of things, frequented the kitchen and the cellar.[26] "Nothing humiliates his brushes," confessed the Goncourts admirably, just as henceforth, contemplating this lesson, nothing humiliated the brushes of Bonvin (fig. 203) and Monet (fig. 204) painting cuts of meat, or of Pissarro (fig. 205) and Cézanne (fig. 206) laying out menus neither rich nor meager, but the ordinary rations of an art student.[27] Chardin's very style had the same favorable bourgeois appearance as the objects he painted, and the Goncourts savored "his beautiful buttery brushstrokes, the curves of his fat brush in the full impasto, the charm of his blond harmonies, the warmth of his backgrounds, the brightness of his whites, gleaming from the sun."[28] His work had an authentic flavor, one would say today, in contrast to the adulterated products of some of his contemporaries, an Oudry, for example, devoted to "clever decoration."[29] For Chardin always offers pertinent moral lessons; just as "everyone did not have, in the midst of the mad licentiousness of the eighteenth century, the placid temperament and the solid good nature of Chardin," not everyone had, in these years of imperial merry-making, the humility of a Ribot or a Bonvin.[30] And in the exaltation of the "good-natured" Chardin there was always, in abeyance, a condemnation of the eighteenth century revived by the court of the Tuileries, the artifice of the rococo garlands, the travesty of Pompadour and of the imperial Louis XVI.

The "Oudrys" of the day were called Monginot or Desgoffe; with the petty talent of window dressers, they arranged storefront displays or robbed pantries and exerted themselves with emphatic but

Fig. 203. François Bonvin, *Nature morte au quartier de viande* (*Still Life with a Piece of Meat*), 1858. Oil on canvas, 39 x 31⅝ in. (99.1 x 80.3 cm). Wadsworth Atheneum, Hartford, The Ella Gallup Sumner and Mary Catlin Sumner Collection Fund

Fig. 204. Claude Monet, *Nature morte, le quartier de viande* (*Still Life, the Piece of Meat*), ca. 1864. Oil on canvas, 9½ x 13 in. (24 x 33 cm). Musée d'Orsay, Paris, Moreau-Nélaton Gift

24. "Pour ce qui est des morceaux de *nature morte*, on peut dire que presque tous ceux de Chardin se tiendraient honorablement à côté des tableaux analogues peints par les maîtres flamands et hollandais; plusieurs comme le *Bocal d'olives* et le *Lièvre*, y marqueraient au premier rang." William Bürger [Théophile Thoré]. "Exposition de tableaux de l'École française ancienne tirés de collections d'amateurs," *Gazette des Beaux-Arts*, September 15, 1860, p. 339.

25. "La nature morte, là en effet est pour ainsi dire la spécialité du génie de Chardin. Il a élevé ce genre secondaire aux plus hautes comme aux plus merveilleuses conditions de l'art. Et jamais peut-être l'enchantement de la peinture matérielle, touchant aux choses sans intérêt, les transfigurant par la magie du rendu, ne fut poussé plus loin que chez lui." Goncourt 1863–64, p. 520.

26. "peintre bourgeois de la bourgeoisie"; "la forte mère du Tiers État"; "Il ne cherche point au-delà de lui-même, ni plus haut que son regard." Ibid., p. 145.

Fig. 205 (cat. 157). Camille Pissarro, *Nature morte* (*Still Life*), 1867. Oil on canvas, 31⅞ x 39¼ in. (81 x 99.6 cm). The Toledo Museum of Art, Purchased with funds from the Libbey Endowment, Gift of Edward Drummond Libbey, 1949

27. "Rien n'humilie ses pinceaux." Ibid., p. 521.
28. "sa belle touche beurrée, les tournants de son pinceau gras dans la pleine pâte, l'agrément de ses harmonies blondes, la chaleur de ses fonds, l'éclat de ses blancs, glacés de soleil." Ibid., p. 148.
29. "l'habile décoration." William Bürger [Théophile Thoré], "Exposition de tableaux de l'École française ancienne tirés de collections des amateurs," *Gazette des Beaux-Arts*, September 15, 1860, p. 339.
30. "tout le monde n'avait pas, au milieu de la folle dissolution du XVIIIᵉ siècle, l'humeur placide et la solide bonhommie de Chardin." Ibid.
31. "Si M. Monginot est le Meyerbeer des natures mortes, M. Philippe Rousseau est le Verdi des bêtes vivantes." (If M. Monginot is the Meyerbeer of still-life painting, M. Philippe Rousseau is the Verdi of living animals.) Émile Cantrel, "Salon de 1863," *L'Artiste*, May 1, 1863, p. 203. "M. Blaise Desgoffe est toujours le premier bijoutier de l'École." (M. Blaise Desgoffe is still the first jeweler of the École,) Paul de Saint-Victor, "Salon de 1865," *La Presse*, June 25, 1865, p. 2.
32. "cuisine pittoresque"; "en langue culinaire"; "liaison"; "rien ne ressort et rien ne s'accorde: cela roule et carambole au hasard." Paul de Saint-Victor, "Salon de 1861," *La Presse*, May 26, 1861, p. 2.

empty compositions, more thunderous than harmonious. Indeed, the "Meyerbeer of still lifes" and the "first jeweler of the École" lacked qualities that would be immediately recognizable in the work of Manet; not skill of composition (however gaudy their efforts might be) but the science that finds the harmonies and resonances between objects, melting them in an ambient light.[31] The "picturesque cuisine" of Monginot was missing what one would call "in cooking terms" the "sauce thickener"—"nothing hung together and nothing agreed: it tumbled and cannoned at random."[32] Blaise Desgoffe was skilled at rendering stones and fabrics, mineralized flowers and fruit, juxtaposing "agate grapes," "glass cranberries," "metallic peaches," and "marble cherries," each petrified and isolated in a corner of the canvas.[33] Chardin's lesson had to be learned: "If he did not mix his colors," wrote the Goncourts, "he bound them, assembled them, corrected them, and enriched them with a systematic study of reflected light, which allowed him to preserve the boldness of his layered tones while appearing to envelop each object with the color and light of all that bordered it. On any given

Fig. 206 (cat. 22). Paul Cézanne, *Pain et Oeufs* (*Still Life with Bread and Eggs*), 1865. Oil on canvas, 23¼ x 30 in. (59.1 x 76.3 cm). Cincinnati Art Museum, Gift of Mary E. Johnston

object, he always applied another tint, some bright glimmer e surrounding elements. A close look would reveal some red in that glass of water, some red in that blue apron, some blue in that white linen. It is from this, from these reminders, these continuous echoes, that the pervasive harmony of all that he paints arises, not a paltry harmony miserably derived from the blending of colors, but this grand harmony of consonances, which flows only from the hand of the masters."[34]

In 1907 Rainer-Maria Rilke would use similar terms to evoke Cézanne's *La Pendule noire* (fig. 190), in which Cézanne "responded with all his colors" to the solicitations of the objects he painted: "His still lifes are miraculously absorbed in themselves. First the white napkin, so often used, which is strangely imbued with the locally dominant shade; next the objects placed upon it, each of which manifests itself and expresses its essence with all its heart"; Rilke would also emphasize the skill with which Cézanne reconciled or contrasted forms and resonances.[35] Chardin's lesson, passed on by those who commented on or collected his work, was, during

33. "raisins d'agathe"; "groseilles de verre"; "pêches métalliques"; "cerises de marbre." Paul de Saint-Victor, "Salon de 1864," *La Presse*, June 26, 1864, p. 3.

34. "S'il ne mêle pas ses couleurs, il les lie, les assemble, les corrige, les caresse avec un travail systématique de reflets, qui, tout en laissant la franchise à ses tons posés, semble envelopper chaque chose de la teinte et de la lumière de tout ce qui l'avoisine. Sur un objet peint de n'importe quelle couleur il met toujours quelque ton, quelque lueur vive des objets environnants. À bien regarder, il y a du rouge dans ce verre d'eau, du rouge dans ce tablier bleu, du bleu dans ce linge blanc. C'est de là, de ces rappels, de ces échos continus, que se lève à distance l'harmonie de tout ce qu'il peint, non la pauvre harmonie, misérablement tirée de la fonte des tons, mais cette grande harmonie des consonnances, qui ne coule que de la main des maîtres." Goncourt 1863–64, pp. 166–67.

35. "répond sur tous les tons"; "Ses natures mortes sont miraculeusement absorbées en elles-mêmes. D'abord la serviette blanche, si souvent utilisée, qui s'imprègne étrangement du ton local dominant; puis les choses qui y sont posées, dont chacune se manifeste et s'extériorise de tout son coeur." Rainer Maria Rilke, *Lettres sur Cézanne* (Paris, 1991), pp. 76–77.

Fig. 207. Jean-Baptiste Siméon Chardin, *Lapin de garenne mort avec une gibecière et une poire à poudre* (*Dead Rabbit with a Game Bag and a Powder Flask*), ca. 1727–28. Oil on canvas, 31⅞ x 25⅝ in. (81 x 65 cm). Musée du Louvre, Paris

Fig. 208. Philippe Rousseau, *Hommage à Chardin* (*Homage to Chardin*), 1867. Oil on canvas, 69⅞ x 89 in. (177.5 x 226 cm). Musée d'Orsay, Paris

Fig. 209. Édouard Manet, *Un lapin (nature morte)* (*A Rabbit [Still Life]*), 1866. Oil on canvas, 24⅜ x 18⅞ in. (62 x 48 cm). Private collection

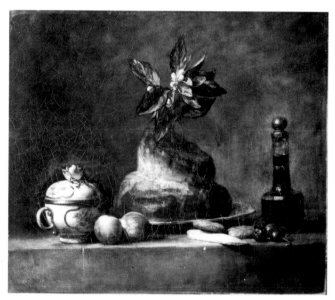

Fig. 210. Jean-Baptiste Siméon Chardin, *La Brioche* (*The Brioche*), 1763. Oil on canvas, 18½ x 22 in. (47 x 56 cm). Musée du Louvre, Paris

36. Even in the 1860s the constant mention of Chardin's name when speaking of Bonvin's still lifes or genre scenes was becoming tiresome: "Peintre de genre, M. Bonvin nous a fait croire un jour que Chardin était revenu parmi nous; mais Chardin s'est ennuyé et est reparti" (M. Bonvin, a genre painter, made us believe one day that Chardin had come back among us; but Chardin got bored and went back where he came from). Émile Cantrel, "Salon de 1863," *L'Artiste*, May 1, 1863, p. 197.

37. "roublard"; "poussière d'émotion." Gasquet 1926, p. 203; Émile Bernard, *Souvenirs sur Paul Cézanne et lettres*, (Paris, n.d.), p. 45. Regarding the Cézanne-Chardin relationship, see Sterling 1985, pp. 96–99.

the 1860s, broadly understood. A popular artist, Philippe Rousseau, paid homage to the man he claimed as his ancestor in a virtuoso painting in which one finds very few of the elder's precepts (fig. 208). The realists, with Bonvin in the lead (fig. 189), so attentively studied by Gabriel Weisberg, found in Chardin—painter of a vanished era—not only a model but also a shield.[36] Cézanne demonstrated a constant admiration for this "crafty" man and the way in which he covered all objects with a "dust of emotion."[37] Boudin, in 1856, sent to the exposition at Rouen a still life "largely treated

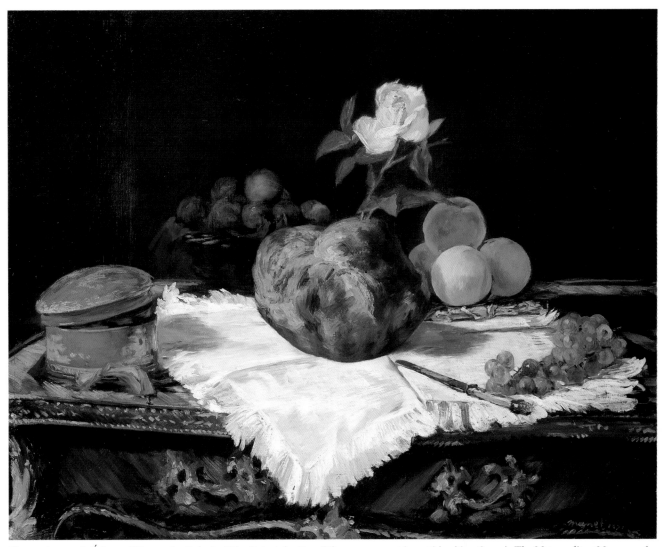

Fig. 211 (cat. 112). Édouard Manet, *La Brioche* (*The Brioche*), 1870. Oil on canvas, 25⅝ x 31⅞ in. (65 x 81 cm). The Metropolitan Museum of Art, New York, Partial and Promised Gift of Mr. and Mrs. David Rockefeller, 1991

à la Chardin," according to a city newspaper.[38] Two works by Manet were directly inspired by Chardin: *Un lapin* (fig. 209) revived, in a reduced format and a more condensed composition, the *Lapin de garenne* (fig. 207), the only example of Chardin's austere still lifes then on display at the Louvre; a little later, Manet's *Brioche* (fig. 211), with its rococo arrangement, saluted Chardin's simple brioche, topped with an orange blossom (fig. 210), when it entered the Louvre as part of the La Caze bequest in 1869.[39]

Even more than landscape painting, the still life was a painter's affair; in declaring its "triumph" at the Salon of 1872, Jean Aicard attributed such success primarily to the painters' desire to prove their excellence and to demonstrate not the "superiority of [their] ideal" but that of their execution. For trickery was impossible: "Neither gesture, nor vitality, nor sentiment can make us forget that the issue above all is to demand of painters good paintings."[40] Five years earlier, in his *Grammaire des arts du dessin*, Charles Blanc affirmed that "inorganic nature" had "only one language, that of color"—

38. "largement traitée à la Chardin." Cahen 1900, p. 12. See also Charles C. Cunningham, "Some Still-lifes by Eugène Boudin," *Studies in the History of Art Dedicated to William E. Suida* (London, 1959), pp. 382–92.

39. For the success of the *Lapin de garenne*, see Paris 1979, pp. 139–41; on painters and Chardin, see McCoubrey 1964 and Cleveland 1979.

40. "triomphe"; "supériorité de [leur] idéal"; "Ni le mouvement, ni la vie, ni l'âme ne peuvent nous faire oublier qu'il s'agit avant toute chose de demander aux peintres de la bonne peinture." J. Aicard, "Salon de 1872," *La Renaissance littéraire et artistique*, June 1, 1872, p. 42.

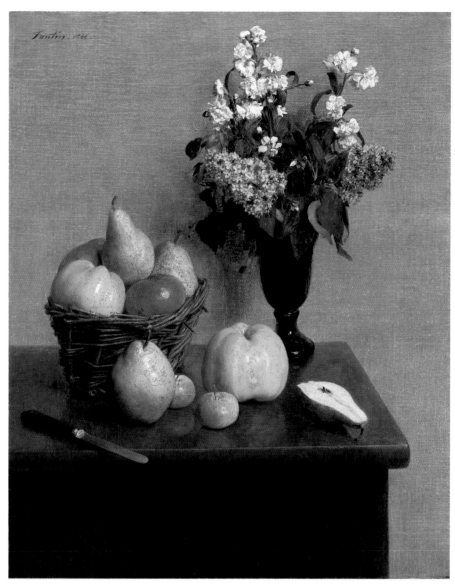

Fig. 212 (cat. 72). Henri Fantin-Latour, *Fleurs de printemps, pommes et poires* (*Still Life with Flowers and Fruit*), 1866. Oil on canvas, 28¾ x 23⅝ in. (73 x 60 cm). The Metropolitan Museum of Art, New York, Purchase, Mr. and Mrs. Richard J. Bernhard Gift, by exchange, 1980

"It is only by its color that such and such stone tells us: I am a sapphire, I am an emerald"—concluding: "Color is thus that which particularly characterizes lower nature, whereas drawing becomes the increasingly dominant means of expression as we ascend the ladder of living creatures."[41] Whoever dedicated himself to the still life could therefore dispense with being an excellent draftsman but had to prove himself to be a colorist and, most notably, a painter; the failure of Monginot or Desgoffe depended on the fact that while impeccable in sketching the contours of objects, they were inept at giving them texture, odor, or flavor through color. Thus the still life became the domaine par excellence of what we would call pure painting; and probably, it was for this reason that such works became the most common gifts from painter to painter—*Prunes* given by Manet to Degas, *Violettes* painted by Manet for Berthe Morisot, and a small spring bouquet accompanied by some fruit and a glass

41. "nature inorganique"; "pour tout langage, celui des couleurs"; "C'est uniquement par sa couleur que telle pierre nous dit: je suis un saphir, je suis une émeraude. La couleur est donc ce qui caractérise tout particulièrement la nature inférieure, tandis que le dessin devient le moyen d'expression de plus en plus dominant, à mesure que nous nous élevons dans l'échelle des êtres." Blanc 1867, p. 482.

of wine (fig. 213) selected by Victoria Dubourg, a painter of flowers herself, at the time of her engagement to Fantin-Latour: a gift that he alone could appreciate and understand, proof that like him, she was "in the business." The choice of motif had little importance, and the subject itself could be modest; in 1869, Ernest Feydeau, rebelling against the overly elaborate compositions at the Salon, reminded the public that "the most splendid innovation in the world will always be to represent a pebble that truly looks like a pebble, that sums up so well all the ideas that could arise from the character of the pebble."[42] Poussin supposedly collected pebbles and plants along the Tiber River, which in his studio became mountains and large trees; henceforth, in the simple disposition of a few objects, one can read a whole world, as rich in lessons, complex, and, finally, lively as the most grandiose spectacles on earth.

From the revival of the still life one might quickly infer the advent of pure painting; from the predilection for humble motifs, one

42. "la plus splendide nouveauté du monde sera toujours de représenter un caillou qui ait véritablement l'air d'un caillou, qui résume si bien toutes les idées qui peuvent naître dans l'aspect du sujet d'un caillou." Ernest Feydeau in *Revue Internationale de l'art et de la curiosité* 1 (1869), pp. 7–8, quoted in Schapiro 1978, pp. 82–83.

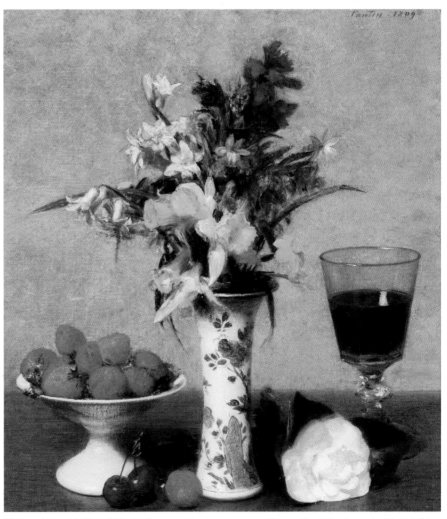

Fig. 213 (cat. 73). Henri Fantin-Latour, *Nature morte aux fiançailles* (*The Betrothal Still Life*), 1869. Oil on canvas, 12⅝ x 11⅜ in. (32 x 29 cm). Musée de Grenoble

Fig. 214 (cat. 176). Auguste Renoir, *Fleurs dans un vase* (*Flowers in a Vase*), 1869. Oil on canvas, 25½ x 21⅜ in. (64.9 x 54.2 cm). Museum of Fine Arts, Boston, Bequest of John T. Spaulding

might deduce a disdain for subject matter. The world of the still life reproduced in its midst the battles that were being fought elsewhere. The old hierarchy, those who hoped for "noble and elevated still lifes," such as "oranges, grapes, cherries, and other dessert fruit," and for "bourgeois [still lifes], still considered parvenu in an aristocratic salon, venison, fresh fish," was collapsing. In 1863 Castagnary hastened to celebrate the two rejected paintings by Robert Grahame, a student of Couture, whose titles, *Oeufs et fromages* (*Eggs and Cheeses*), and particularly *Pied de cochon* (*Pigs' Feet*) sounded like provocations.[43] Later, Cézanne's hagiographers would glorify him for painting without selection all that was immediately available.[44] And Meyer Schapiro has admirably demonstrated the path that leads from Zola's refusal to invest objects painted in a still life with any

43. "natures mortes nobles et élevées"; "les oranges, les raisins, les cerises et autres fruits de dessert"; "bourgeoises, qu'on accepte encore comme des parvenus dans un aristocratique salon, la venaison, la marée." Castagnary 1892, p. 169.
44. Gasquet 1926, p. 46.

Fig. 215 (cat. 145). Claude Monet, *Fleurs et Fruits* (*Flowers and Fruit*), 1869. Oil on canvas, 39⅜ x 31¾ in. (100 x 80.6 cm). The J. Paul Getty Museum, Malibu

significance other than that of providing a gamut of colors to Lionello Venturi's formalist readings: "Why have so many apples been painted in modern times?" Venturi demanded, and responded sanctimoniously, "Because the simplified motif gave the painter an opportunity for concentrating on problems of form."[45]

Venturi—and his innumerable followers, subscribers to the monotonous redundancies concerning pure painting—dated this mutation to 1860. However, a quick look at the still lifes exhibited that year reveals immediately the disparity of the motifs and of their combinations. For the choice of objects for a still life, as Giacometti claimed, is not a "pretext for form" but an "essential value"—"It would be difficult to imagine Cézanne," Schapiro commented, "painting the salmon, oysters, or the asparagus of Manet, the pleasure-

45. Lionello Venturi, *Art Criticism Now* (Baltimore, 1941), p. 47, quoted in Schapiro 1978, p. 16.

Fig. 216 (cat. 187). Alfred Sisley, *Le Héron* (*The Heron*), 1867. Oil on canvas, 31⅞ x 39⅜ in. (81 x 100 cm).
Musée Fabre, Montpellier

46. Giacometti quoted in Schapiro 1978, p. 37 n. 65. State-
 ment about Cezanne and Manet from Schapiro 1978,
 p. 27. Schapiro 1968, p. 84.
47. "J'ai tellement à travailler à mes études de dehors
 que je n'ose pas me mettre à faire des fleurs." Wildenstein
 1974, vol. 1, p. 421.

Fig. 217 (cat. 8). Frédéric Bazille, *Le Héron* (*The Heron*), 1867. Oil on canvas,
39⅜ x 27⅛ in. (100 x 70 cm). Musée Fabre, Montpellier

Fig. 218 (cat. 172). Auguste Renoir, *Frédéric Bazille peignant "Le Héron"* (*Frédéric Bazille Painting "The Heron"*), 1867. Oil on canvas, 41⅜ x 29 in. (105 x 73.5 cm). Musée d'Orsay, Paris

seeker"—and their disposition, far from being fortuitous, proved to be the result of successive attempts to reconcile colors, volumes, and textures.⁴⁶ This was work to be done in the studio, and, for the open-air painter, was an exercise for days of bad weather—"I have so much work to do on my studies of the outdoors," explained Monet, "that I dare not undertake any flowers."⁴⁷ The still life was also a social game allowing variations on an identical subject: Monet and Renoir painted, in 1869, the same bouquet (figs. 214, 215); Bazille

Page 172: Gustave Courbet, *La Fille aux mouettes*. detail of fig. 279

Page 173: Auguste Renoir, *Frédéric Bazille peignant "Le Héron"*, detail of fig. 218

Fig. 219 (cat. 17). Eugène Boudin, *Gerbe de fleurs* (*Hollyhocks*), ca. 1858–62. Oil on canvas, 23½ x 18¼ in. (59.7 x 46.4 cm). Mrs. John Hay Whitney

and Sisley executed, under Renoir's supervision (fig. 218), the same *Héron* (The Heron) (figs. 216, 217).

The painter of still lifes was a demiurge who created an entire world with whatever he had at hand. Sometimes he settled on a unique motif and painted it against a neutral background, eliminating anything likely to suggest a precise setting and, beyond the limit of the frame, any other objects or human presence. The bouquets of Courbet (fig. 220) and Boudin (fig. 219), for example, bloom nowhere else but in the space of the canvas. At other times, the still-life painter shows us only a fragment of a seemingly vaster continent, a parlor or a dining room, as in the "table corners" by Fantin-Latour (fig. 212) or Manet (fig. 211) and the top of a mantelpiece by Cézanne (fig. 190), even if the arbitrary character of the

Fig. 220 (cat. 40). Gustave Courbet, *Fleurs (Flowers in a Vase)*, 1862. Oil on canvas, 39½ x 28¾ in. (100.3 x 73 cm).
Collection of the J. Paul Getty Museum, Malibu, California

Fig. 221 (cat. 4). Frédéric Bazille, *Étude de fleurs* (*Study of Flowers*), 1866. Oil on canvas, 38¼ x 34⅝ in. (97.2 x 87.9 cm). Mrs. John Hay Whitney

Fig. 222 (cat. 115). Claude Monet, *Fleurs de printemps* (*Spring Flowers*), 1864. Oil on canvas, 46 x 35⅞ in. (116.8 x 91.1 cm). The Cleveland Museum of Art, Gift of the Hanna Fund

Fig. 223 (cat. 168). Auguste Renoir, *Fleurs de printemps* (*Spring Flowers*), 1864. Oil on canvas, 51⅛ x 38⅝ in. (130 x 98 cm).
Kunsthalle, Hamburg

assembled motifs primarily serves to emphasize the conventions of the studio. For unlike portraits that capture the model in familiar poses, as do those of Degas, for example, still lifes are never instantaneous, a table set or empty, never the happenstance of an impromptu conference of a few objects suddenly becoming subject matter for the painter: always the objects are posed, always they reaffirm, through their extraordinary assembly and the will of their placement, the omnipotence of the painter. On the narrow edge of a marble mantelpiece Cézanne juxtaposed a shell, a cup, a vase, a lemon, a clock, and an ink bottle (fig. 190); to a sampling of late summer fruit Manet nonchalantly added a rose (fig. 188). I read in Manet's still lifes, contrary to the view of Anne Coffin Hanson, no scenes of modern life, as evident in certain portraits or urban images; the painter did not display, on a pure white, heavily creased napkin, the remains of a festive meal "to give an impression of people who had just finished eating without clearing the table," but instead yielded with an evident pleasure to the conventions of the still life, which always evoked a distant and silent world.[48] This world possesses a singular geography: the flowery jungles of Renoir (fig. 223), Monet (fig. 222), and Bazille (fig. 221), despite a basket, clay pots, and florists' paper, recall primordial Eden; the peaceful landscapes of Manet, always broad and deep, in which, dominated by a towering bottle and glass, the domes of a melon and fruit basket coexist (fig. 188); the more rugged nature of Cézanne, in which a rococo conch shell and the severe and monumental facade of a clock perch on the dazzling cliffs of a white cloth (fig. 190).

This universe, a miniature version of the painter's world, was also a social microcosm. The elegant bouquets of Courbet (fig. 220) and Manet (fig. 198) found their counterparts in the domestic and bourgeois flowers of Monet (fig. 215); the abundant tables of Manet (fig. 188) had not the austerity of those of Cézanne (fig. 206) and Pissarro (fig. 205), on which a customarily meager menu conveyed daily difficulties. Everything in Fantin-Latour's work (fig. 212) was in good taste and fashionable, a subtle mix of Dutch quietude and Victorian comfort.

Sometimes in the work of Manet, often in that of Cézanne, a reminder of the vanity of this world disturbed the tranquillity of the motionless. Manet, when painting his peonies, showed the three ages of the flower or, as the poet André Fraigneau said, its "curve of agony": the tight buds of youth, the full bloom of maturity, and the collapse of old age with the rotting of the fading flower.[49] Cézanne painted vanitas motifs in the style of earlier centuries, with their usual apparatus (fig. 224) of a skull, cut flowers, an open book, and a burnt candle. It is largely this awareness of the vanity of all things, including painting itself, that later pushed Cézanne toward the still life.

48. Hanson 1977, pp. 69–70.
49. "courbe d'agonie"; "vanités." Quoted in Paris, New York 1983, p. 208.

After 1870, Manet would rapidly abandon composite still lifes to isolate, on small canvases, a fruit, a vegetable, a few flowers; Pissarro and Sisley would paint landscapes exclusively; Monet and Renoir would continue to paint inanimate objects periodically. Cézanne alone would make the still life a motif of preference, confirming his wonderful concern with the order and stability of the world. Late in his career, Cézanne explained the reasons for his attachment: to be a painter was not to endlessly repeat the example of the old masters but primarily to "confront the objects directly," to be "moved" by them; "a sugar bowl can tell us more about ourselves and our art than a Chardin or a Monticelli. It has more color. It is our paintings that become still lifes [in French "still life" is "nature morte," literally "dead nature"]." Thus painting is vanity for it provides only pale and deceptive reflections of the world; only the stupid birds picking at Zeuxis's grapes allowed themselves to be fooled by it. The still life is a metaphor for painting itself, since all that falls under the artist's brush tends irremediably toward it. In this sense, the still life is the last word of art. "Our pictures, they are like the night that prowls, like the night that gropes.... Museums are the caves of Plato. On their doors I will inscribe: " 'Painters are forbidden to enter. The sun is shining outside.' "50

50. "colleter directement avec les objets"; " 'soulevé' par eux: un sucrier nous en apprend autant sur nous et sur notre art qu'un Chardin ou un Monticelli. Il est plus coloré. Ce sont nos tableaux qui deviennent des natures mortes"; "Nos tableaux, c'est de la nuit qui rôde, de la nuit qui tâtonne.... Les musées sont des cavernes de Platon. Sur la porte je ferai graver: 'Défense aux peintres d'entrer. Il y a le soleil dehors.' " Gasquet 1926, p. 206.

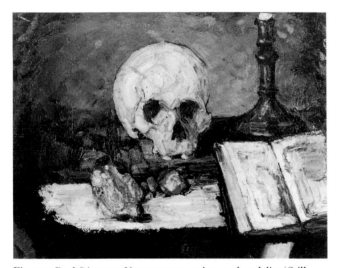

Fig. 224. Paul Cézanne, *Nature morte, crâne et chandelier* (*Still Life, Skull and Candlestick*), ca. 1866. Oil on canvas, 18½ x 24⅜ in. (47 x 62 cm). Private collection, on loan to the Kunsthaus Zurich

Paul Cézanne, *La Pendule noire*, detail of fig. 190

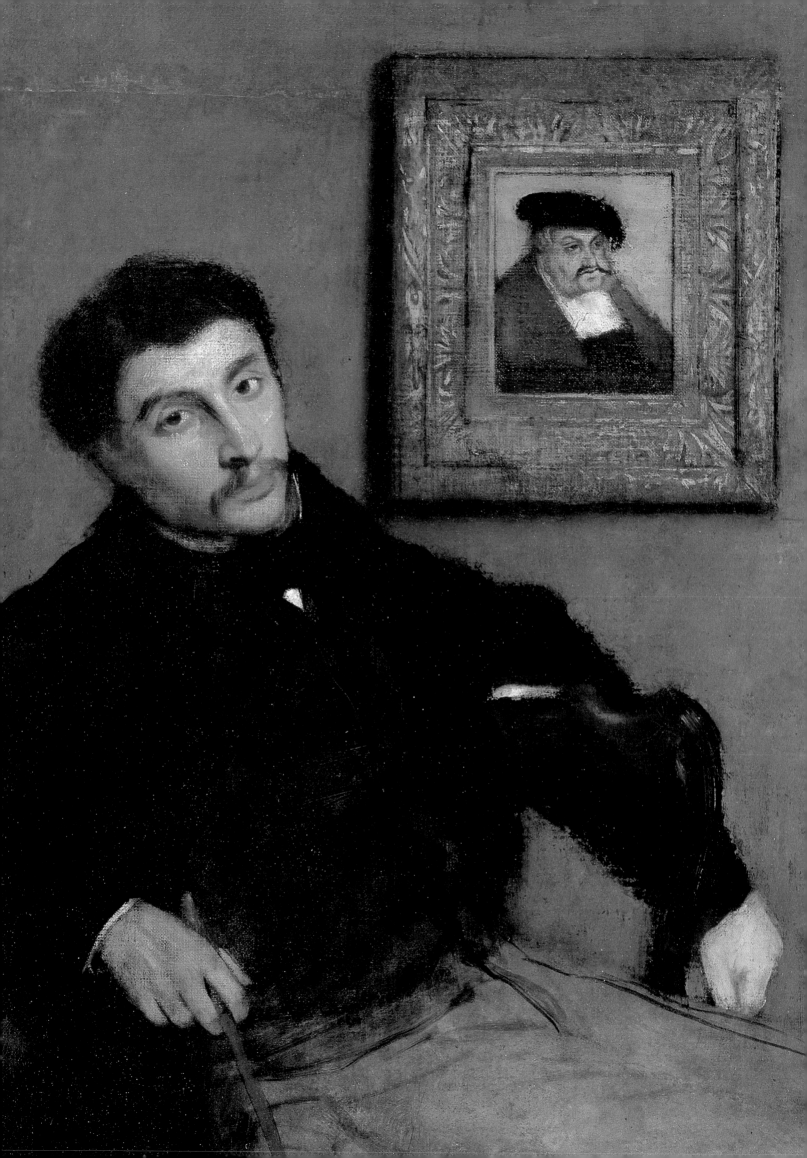

VII
Portraits and Figures

HENRI LOYRETTE

All that remained of the ancient estate were the coach houses and the stables hidden behind a stand of trees; the château itself was modern, "in the Italian style." They had simply transplanted the ancestors, who were now aligned against a dark wainscoting, in "large gilded frames [that] bore names in black letters at their bottom edges." To reach the salon, Madame Bovary sidles past these forebears, seeing two of them distinctly and able to read their biographies on the cartouches. Everything else is shadowy, and as she focuses on the "great gilded frames," all she can detect of these people, whom she guesses are numerous, is a mosaic of details: "a pale forehead, two staring eyes, powdered wigs cascading onto red-coated shoulders, a garter buckle high up on a fleshy calf."[1] The portrait gallery that Emma Bovary crosses before entering the splendor of the festivities is the musical overture to the ball in La Vaubyessard: a few grave and mysterious chords leading into a different world—*lento* and *cupo* (slow and dark), as a musical score would indicate. Here, solemnized by the dates on the plaques, by the majesty of poses and the historicity of costumes, is all the evanescence of this party, which will leave an indelible impact on the country doctor's wife, an impression summed up in a few stances, a few words, the physical peculiarities of an unknown breed, much gloom and much gold.

The tremendous proliferation of portraits during the nineteenth century is often attributed to the parvenu's desire to ape the aristocrat, to establish a dynastic collection that would eventually transform the perfumer or lawyer into a figure as glorious as the descendant of several knightly lineages. Tracing the "social conditions" of French painting under the July monarchy, Léon Rosenthal saw it as "one of the most striking products of middle-class patronage"; he quoted a journalist who in *Le Musée pour rire* (1839) poked fun at this tiresome emulation: "The bourgeois who has his oil likeness despises his neighbor who has a watercolor likeness; and he refuses to return the greeting of the man who has his image in a lithograph."[2]

1. "à l'italienne"; "de grands cadres dorés [qui] portaient, au bas de leur bordure, des noms écrits en lettres noires"; "grands carrés noirs bordés d'or"; "un front pâle, deux yeux qui vous regardaient, des perruques se déroulant sur l'épaule poudrée des habits rouges, ou bien la boucle d'une jarretière en haut d'un mollet rebondi." Gustave Flaubert, *Oeuvres: Madame Bovary* (Paris, 1962), vol. 1, p. 368. (Gustave Flaubert, *Madame Bovary*, trans. by Francis Steegmuller, New York, 1957, p. 53.)
2. "conditions sociales"; "une des conséquences les plus saillantes du mécénat bourgeois"; "Le bourgeois qui a son portrait à l'huile, méprise son voisin qui a son portrait à l'aquarelle; il ne rend pas le salut à celui qui a son image en lithographie." Rosenthal 1914, p. 23.

183

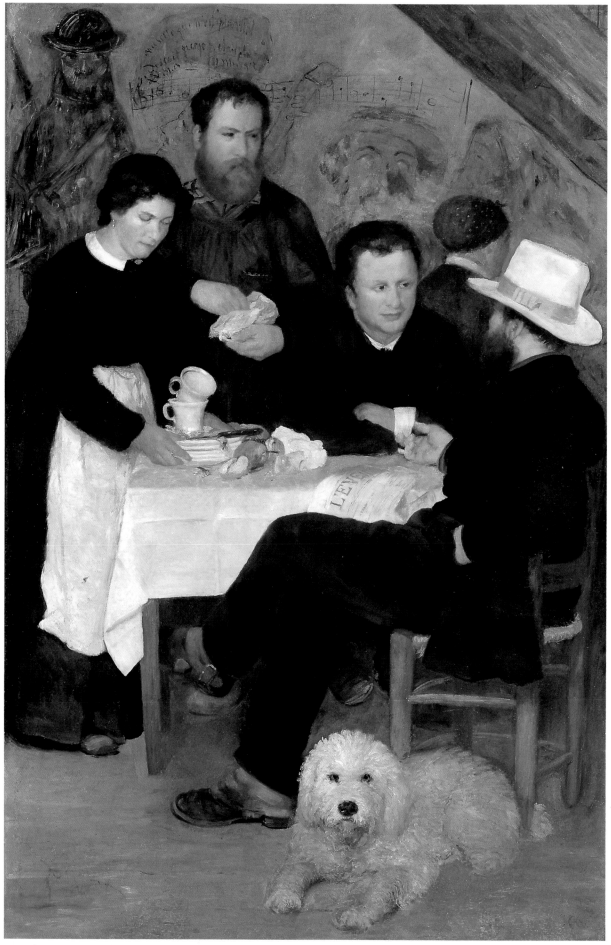

Fig. 225 (cat. 170). Auguste Renoir, *Le Cabaret de la mère Antony* (*The Cabaret of Mère Antony*), 1866.
Oil on canvas, 76¾ x 51⅝ in. (195 x 131 cm). Nationalmuseum, Stockholm

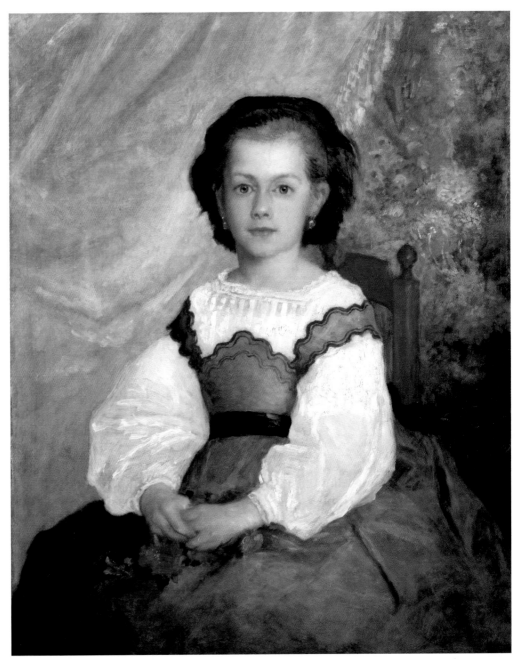

Fig. 226 (cat. 169). Auguste Renoir, *Portrait de Romaine Lacaux*, 1864. Oil on canvas, 31⅞ x 25½ in. (81 x 64.8 cm). The Cleveland Museum of Art, Gift of the Hanna Fund

In 1834 the Salon had 650 portraits; in 1841 portraits accounted for 500 of the 2,000 works exhibited; in 1844 there were 673; and in 1859, 866 out of a total of 3,045 items. "Hail and deluge," a critic grumbled.[3] In 1868 Zola noted that "the flood of portraits rises year by year, threatening to inundate the entire Salon." For him the cause of this unstemmable tide was obvious: "The only people still buying paintings are those who want portraits of themselves."[4]

A painter's career was now based on a redoubtable bottom line: he had to make money and therefore he had to do portraits. This equation is underscored by the Goncourt brothers in their novel *Manette Salomon*: Anatole Bazoche, deeply upset by his failure to win the Prix de Rome, modestly downsizes his ambitions; all he yearns for now is "a studio that would give him an artist's home

3. "la grêle et le déluge." Augustin-Joseph Du Pays, "Salon de 1859," *L'Illustration*, July 30, 1859, p. 94.
4. "le flot des portraits monte chaque année et menace d'envahir le Salon tout entier"; "Il n'y a plus guère que les personnes voulant avoir leur portrait, qui achètent encore de la peinture." Zola 1991, p. 192.

base, the possibility of doing portraits, of earning money—in short: the chance to *establish himself* as a painter."[5] Auguste De Gas tried to drum this into his insouciant son. In 1858, annoyed by the young man's "boredom" at the thought of doing portraits of members of Florentine society, the father stated that this would be "the loveliest blossom in his wreath.... And since in this world the problem of earning one's bread [is] so serious, so pressing, even crushing...only a fool [would] lose sight of it or disdain it."[6]

Such monetary considerations were not absent in 1865 when Courbet, who was staying at Deauville, boasted that, having painted the likenesses of several prominent people, he had "a reputation as a peerless portraitist."[7] While Manet and Degas, both well off, rarely sacrificed themselves to commissions, such jobs were manna for Monet and Renoir. In 1868 Monet was paid 130 francs for the full-length portrait of Mme Gaudibert, the wife of his Maecenas in Le Havre (fig. 231). Nor did Renoir turn up his nose at painting the daughter of a porcelain manufacturer (fig. 226) or—when hired by the owner of a neighboring café—the clown James Bollinger Mazurtreek (fig. 245), who was the great attraction of the Cirque d'Hiver. Beyond the anticipated triumph of their ambitious compositions at the Salon, most artists hoped that such a success would translate into lucrative portrait commissions.

These commercial motives often required a commercial approach. The disgust of most painters at the display at the Salon of "silly grimacing faces"[8] was provoked by the dreary rehashing of a few catchy formulas, the standardizing of tones and poses, the "outrageous idealization" that so flagrantly disregarded the model's true appearance and turned a "Strasbourg sausage" into a "field marshal's daughter."[9] At the start of the 1860s the road to fame and fortune looked extraordinarily narrow; on one side were the descendants of Ingres, on the other the imitators of Winterhalter, and in the middle the mob of synthesizers.

Baudelaire was stern with Ingres, reproaching him for his powerlessness to paint a portrait both "grand and true" and for his idealization and mechanical addition of a dose of "style"—that is, an "alien, generally bygone poetry" which undercut the initial goal of faithfully reproducing the sitter's features and of seeking truth.[10] Nevertheless, even Ingres's most ferocious adversaries conceded that he had an unequaled talent for portraiture. In 1857 Castagnary savaged most of Ingres's oeuvre—"All his paintings, dry, sparse, cramped, will pass away"—but saluted him as the only portraitist of the century.[11] In 1867, when visiting the Ingres retrospective at the École des Beaux-Arts, Bazille commented: "Almost all his portraits are masterpieces, but his [other] paintings are quite boring."[12] Ingres's disciples did not receive universal praise. Henri Delaborde, who

5. "un atelier qui lui donnerait le chez lui de l'artiste, la possibilité de faire des portraits, de gagner de l'argent; en un mot, *s'établir* peintre." Goncourt 1867, p. 79.

6. "le plus beau fleuron de sa couronne"; "la question du pot-au-feu dans ce monde [étant] tellement grave, impérieuse, écrasante même,...les fous seuls [pouvaient] la perdre de vue ou la dédaigner." Loyrette 1989, p. 20.

7. "une réputation de portraitiste sans pareil." "Lettres inédites de Courbet," *Bulletin des amis de Gustave Courbet* 23 (1959), p. 10.

8. "faces niaises et grimaçantes." Zola 1991, p. 192.

9. "idéalisme enragé." Valéry Vernier, "À travers les portraits," *L'Artiste*, May 15, 1861, p. 224. "saucisse de Strasbourg [en] fille d'un feld-maréchal." Alfred Delvau, "Salon de 1861," *Revue des Beaux-Arts*, 1861, p. 223.

10. "impuissance"; "à la fois grand et vrai"; "poésie étrangère empruntée généralement au passé." Baudelaire 1985–87, vol. 2, p. 657.

11. "Toute sa peinture, sèche, maigre, étriquée, passera." Castagnary 1892, p. 43.

12. "Presque tous les portraits sont des chefs d'oeuvre, mais ses tableaux sont bien ennuyeux." Bazille 1992, letter 93, p. 140.

wrote a biography of Ingres in 1870, admitted that they lacked "the stamp of boldness...the touch of pride that gives definitive meaning to intentions."[13] Delaborde desired a more dazzling and aggressive affirmation of sound principles.

In 1859, when Hippolyte Flandrin triumphed at the Salon with *La Jeune Fille à l'oeillet* (fig. 20), Baudelaire, ever hostile, railed against the "painful mark" that Ingres's instruction had left on his epigones, who "believe or pretend to believe that they are painting." According to Baudelaire, Amaury-Duval "courageously intensified the asceticism of the school," while Flandrin neglected both light and color, which Chenavard, "franker and more courageous," utterly "repudiated."[14] All these followers seemed to have turned the master's precepts into inflexible dogma: in the name of a hypothetical artistic morality, they condemned the freedom of the brushstroke as extravagance and the éclat of color as bad taste. Hence the denunciation of a "cramped," *comme il faut* painting that "freezes the human face in rigid graphic lines like a blueprint diagram, reducing the flesh hue to the dead tones of an old tinted daguerreotype that once sold for ten francs."[15] People expected this art to die of consumption, nobly and discreetly, and, in fact, it did not survive the death of Flandrin in 1864. With admirable integrity he had battled to the bitter end, decorating churches and depicting his contemporaries in severe but seldom dry or boring portraits, some of which, like that of Prince Napoléon (fig. 227), have the power of its Ingresque model (fig. 228).

13. "l'empreinte de la hardiesse...cet accent de fierté qui donne aux intentions une signification définitive." Henri Delaborde, "Le Salon de 1861," *La Revue des Deux Mondes* 3 (1861), p. 887.
14. "trace douloureuse"; "croient ou feignent de croire qu'ils font de la peinture"; "outra[nt] courageusement l'ascétisme de l'école"; "plus courageux et plus franc"; "répudié." Baudelaire 1985–87, vol. 2, pp. 656–57.
15. "étriquée"; "arrêtant le visage humain avec des lignes graphiques rigides comme le tracé d'une épure, réduisant le coloris de la chair aux teintes mortes d'un vieux daguerréotype colorié, dans le temps, pour dix francs." Goncourt 1867, p. 165.

Fig. 227. Hippolyte Flandrin, *Portrait de S. A. I. le prince Napoléon* (Portrait of Prince Napoléon), 1860. Oil on canvas, 46⅛ x 35 in. (117 x 89 cm). Musée d'Orsay, Paris

Fig. 228. Jean-Auguste-Dominique Ingres, *Monsieur Bertin*, 1832. Oil on canvas, 45⅝ x 37¾ in. (116 x 96 cm). Musée du Louvre, Paris

Fig. 229. Paul Baudry, *Portrait de Madeleine Brohan*, 1860. Oil on canvas, 41⅞ x 33⅛ in. (106.5 x 84 cm). Musée d'Orsay, Paris

Fig. 230 (cat. 21). Carolus-Duran, *Portrait de Mme X∗∗∗ (La Dame au gant)* (*Portrait of Mme X∗∗∗ [Woman with a Glove]*), 1869. Oil on canvas, 89¾ x 64⅝ in. (228 x 164 cm). Musée d'Orsay, Paris

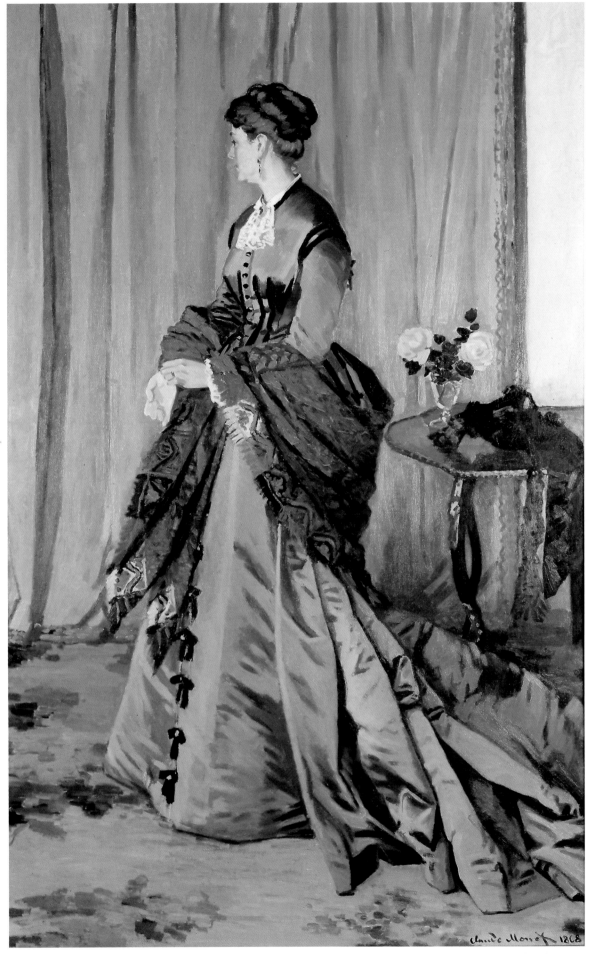

Fig. 231 (cat. 142). Claude Monet, *Portrait de madame Louis Joachim Gaudibert*, 1868. Oil on canvas, 85⅜ x 54½ in. (217 x 138.5 cm). Musée d'Orsay, Paris

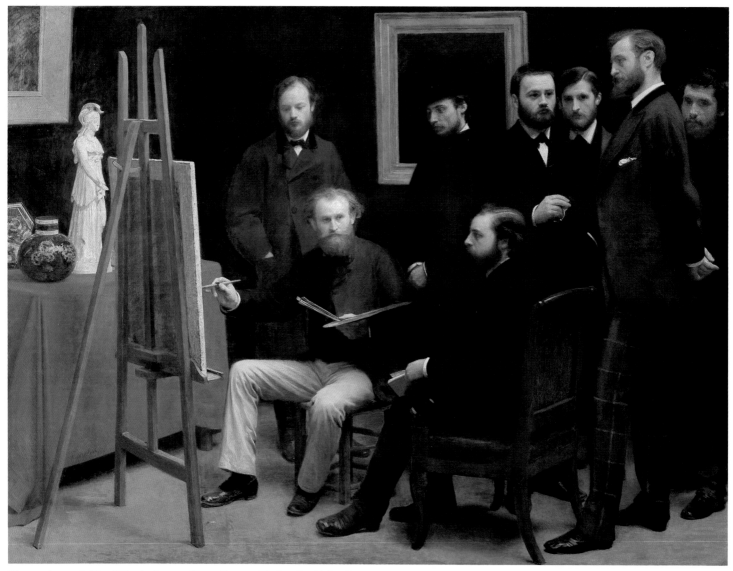

Fig. 232 (cat. 74). Henri Fantin-Latour, *Un atelier aux Batignolles* (*A Studio at Les Batignolles*), 1870. Oil on canvas, 80⅜ x 107⅝ in. (204 x 273.5 cm). Musée d'Orsay, Paris, Moreau-Nélaton Gift

Fig. 233. Henri Fantin-Latour, *Hommage à Delacroix* (*Homage to Delacroix*), 1864. Oil on canvas, 63 x 98⅜ in. (160 x 250 cm). Musée d'Orsay, Paris, Moreau-Nélaton Gift

There was a huge gap between Ingres's and Winterhalter's pupils: the latter seemed led only by the desire to do pretty things, to parade their skills. In works by "the painter of the European courts," the amiable Édouard Dubufe, and by the vague Charles Chaplin, the women, with their ravishing jewels, clothes, and coiffures, lean against studio balustrades or pose in front of a conventionalized nature; yet they are nothing but agreeable mannequins devoid "of flesh, nature, and bones."[16] Winterhalter's great successes at the court of Napoléon III came in the 1850s; during the following decade he seemed passé, overexposed, overimitated. The hour of his soft, remote noblewomen was past; now was the time of the up-to-date, sharp-minded Parisienne. Thus Baudry painted the witty Madeleine Brohan (fig. 229) as Mme Moitessier of the boulevard, a Paris edition of Ingres's Juno, while Carolus-Duran (fig. 230) presented his Madame X "with a slender waist, a graceful nonchalance, an elegant

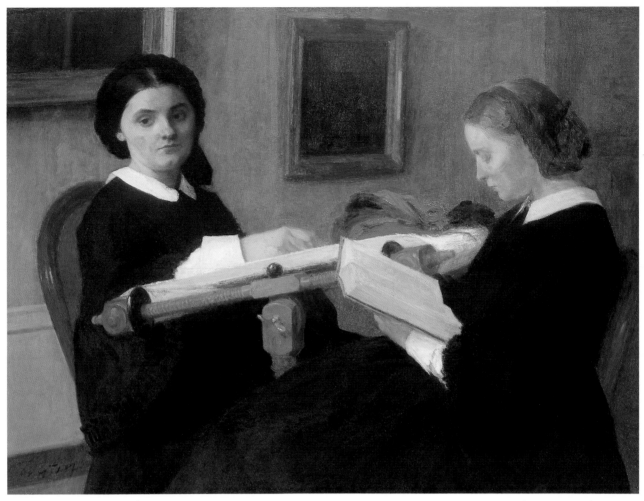

Fig. 234 (cat. 70). Henri Fantin-Latour, *Les Deux Soeurs* (*The Two Sisters*), 1859. Oil on canvas, 38⁹⁄₁₆ x 51³⁄₁₆ in. (100.3 x 130 cm). The Saint Louis Art Museum, Museum Purchase

costume—a woman entering her home and seeming to move across the painting."[17]

In 1872 Castagnary would reproach Carolus-Duran for turning the givens of the portrait upside down: once "an interior, private, intimate thing," it now seemed "made for the outdoors, for the street"—and that was the artist's fault: "Never has the human creature, never has the physiognomy been sacrificed more unceremoniously to accouterments."[18] The diatribe was obviously unjust; a legion of society portraitists had always sacrificed the sitter's true appearance to an effusion of jewelry and clothing. And Castagnary forgot that during the 1860s several artists in his own camp had turned the portrait into anything but a domestic affair. Manet's *Portrait d'Émile Zola* (fig. 270), shown at the Salon of 1868, was obviously meant for public viewing, as were Fantin-Latour's *Portrait de Manet* and the huge compositions *Hommage à Delacroix* (fig. 233) and *Un Atelier*

16. "peintre des cours d'Europe"; "de chair, de nature, de charpente." Vernier, "À travers les portraits," p. 224.
17. "d'une taille très élancée, d'une désinvolture gracieuse, d'une mise élégante qui rentre chez elle et semble traverser le tableau." Marius Chaumelin, "Salon de 1869," *La Presse*, June 22, 1869, p. 1.
18. "chose d'intérieur, d'intimité privée"; "fait pour le dehors, pour la rue. Jamais la créature humaine, jamais la physionomie n'ont été sacrifiés avec plus de sans-gêne à l'accoutrement." Jules-Antoine Castagnary, "Salon de 1872 (3ᵉ article)," *Le Siècle*, May 25, 1872, p. 1.

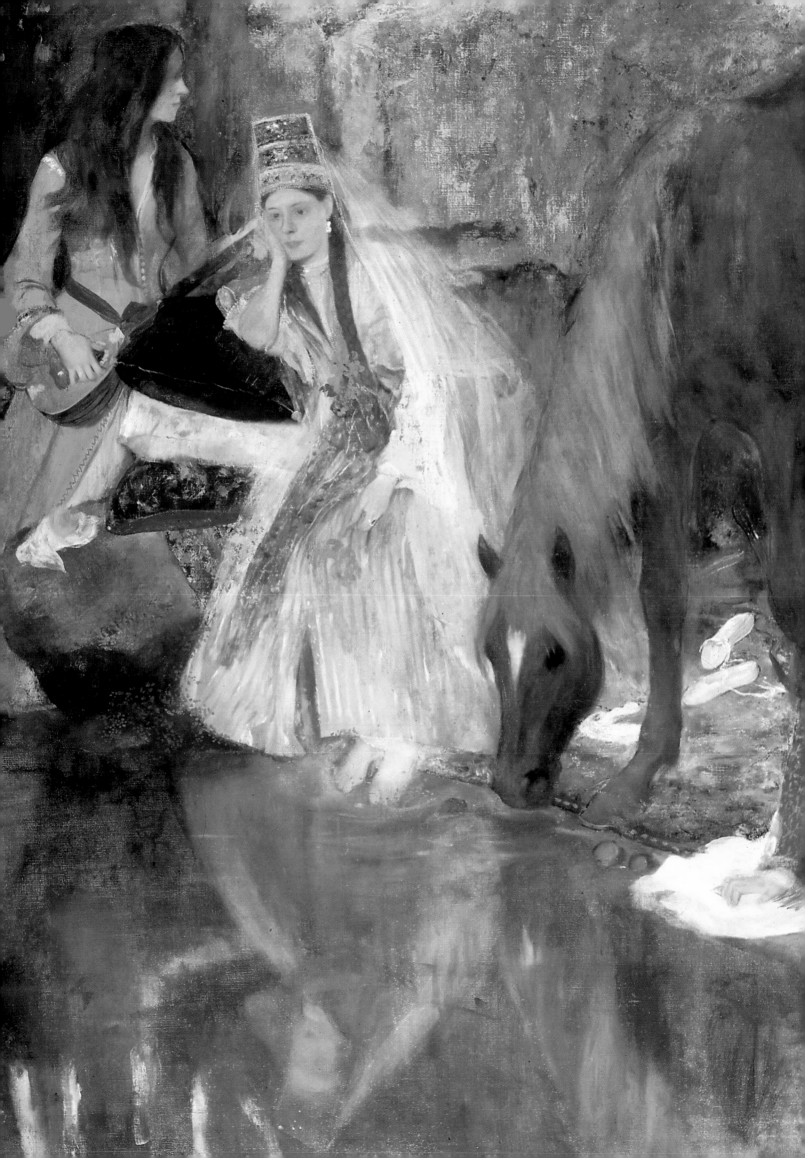

aux Batignolles (fig. 232). When Degas painted the beautiful and celebrated Eugénie Fiocre (fig. 343) for the Salon, he chose his sitter with an eye toward Parisian society, hoping, albeit vainly, to become "the painter of the high life" (according to Duranty as reported by Manet).[19]

Indeed, at the start of their careers, portraits and figures played a major role for most of the artists of the New Painting. From 1855 to 1876 these sorts of pictures constituted about 45 percent of Degas's output and from 1859 to 1870 about 25 percent of Manet's. It was with *Camille* (fig. 236), at the Salon of 1866, that Monet, a landscape artist, scored his first big hit. "Manifesto" portraits were aimed at declaring the painter's artistic ties, thereby stressing the cohesion of a movement. Some of these portraits were inspired by friendship, "private, intimate things" such as Manet's portrait of Théodore Duret (fig. 235) and Degas's of Manet and his wife (fig. 237). These artists, especially Degas, were engrossed in trying out new solutions, aspiring, as they did, to produce "a composition that paints our time."[20] Hence there was a diversity of approaches—portraits, figures, studies, interiors—and with this often came the difficulty of placing a work within a category. The painters themselves were confused about the exact terminology. When Fantin-Latour sent three portraits to the Salon of 1861, he titled them "studies after nature," emphasizing what he would eventually proclaim: the portraitist is akin to the painter of still lifes, he takes what is at hand, "painting people like flowerpots."[21] As for Degas, he made a subtle distinction between "portrait" and "painting." A "portrait," he felt, was limited to the simple reproduction of the sitter's features—an exercise he practiced regularly but without great enthusiasm to oblige his friends. A

Fig. 235. Édouard Manet, *Portrait de Théodore Duret*, 1868. Oil on canvas, 18¼ x 14 in. (46.5 x 35.5 cm). Musée du Petit Palais, Paris

19. "le peintre du high-life." Manet's letters to Fantin-Latour, August 26, 1868, quoted in Moreau-Nélaton 1926a, vol. 1, p. 103.
20. "choses d'intimité privée"; "une composition qui peigne notre temps." Reff 1985, notebook 16, p. 6.
21. "étude d'après nature"; "peint les gens comme des pots de fleur." Quoted in Paris 1982, p. 86.

Fig. 236. Claude Monet, *Camille (La Femme à la robe verte)* (*Camille [The Woman in the Green Dress]*), 1866. Oil on canvas, 91 x 59½ in. (231 x 151 cm). Kunsthalle Bremen

Fig. 237. Edgar Degas, *Portrait de monsieur et madame Édouard Manet*, ca. 1868. Oil on canvas, 25⅝ x 28 in. (65 x 71 cm). Kitakyushu Municipal Museum of Art

Edgar Degas, *Portrait de Mlle E[ugénie] F[iocre]*, detail of fig. 343

Fig. 238. Henri Fantin-Latour, *La Lecture* (*Reading*), 1863. Oil on canvas, 39⅜ x 31½ in. (100 x 80 cm). Musée des Beaux-Arts, Tournai

Fig. 239. Claude Monet, *Le Déjeuner* (*The Luncheon*), 1868. Oil on canvas, 90½ x 59 in. (230 x 150 cm). Städelsches Kunstinstitut, Frankfurt

22. "sa fortune, sa classe, son métier." Duranty in Washington, San Francisco 1986, p. 482; Loyrette 1989, p. 20.
23. "Il ne s'agit pas seulement de faire un portrait, il faut faire un tableau." Hector de Callias, "Salon de 1864," *L'Artiste*, June 1, 1864, p. 243.
24. "C'est bien Mme Monet, ma première femme, qui m'a servi de modèle et, bien que je n'aie pas eu l'intention d'en faire absolument un portrait mais seulement une figure parisienne de l'époque, la ressemblance on est complète." Quoted in Philadelphia, Detroit, Paris 1978–79, p. 392.

"painting," however, was a complex work, often showing several persons, in which the expressive morphology of the sitter was joined to complementary information about "his fortune, his class, his profession."[22] Hector de Callias, moaning that portraitists lacked ambition, made a similar statement: "You should not do just a portrait, you should do a painting."[23]

What differentiates the portrait from the figure painting, the figure painting from the genre scene? The lines are often hazy. When writing to the director of the museum in Bremen, who had purchased his *Camille* (fig. 236) at the beginning of this century, Monet explained: "Mme Monet, my first wife, did indeed serve as my model, and though I absolutely did not want to make a portrait but simply a Parisian figure of the era, the resemblance is total."[24] In 1861 Fantin-Latour sent the Salon a canvas he called *La Lecture* (fig. 238), the title signifying his intention to do a genre scene. Thoré, however, marked it off from the worthless likenesses in the Salon, describing it as "the most charming, the most intimate, the most naturally distinguished of all the female portraits."[25] About 1865 Manet painted his cherished Suzanne—a veritable harmony in white à la Whistler (fig. 240); several years later, according to Françoise Cachin's convincing interpretation, he added the profile of Léon Koëlla reading behind her. The *Portrait de Mme Manet* became *La Lecture* and was exhibited under that title in 1880. Countless other examples could be listed, including Fantin-Latour's *Les Deux Soeurs* (fig. 234), Monet's *Le Déjeuner* (fig. 239), and Cézanne's *L'Ouverture de Tannhäuser* (fig. 345). They all illustrate the same premise: the portrait was not just the replication of physiognomy and the analysis of character, it was also a snapshot of a person in a familiar context, surrounded by the things and people that the subject loved and that contributed to defining him or her. Sitters were no longer frozen in an eternity of convention, they were out in the world.

This opening toward the exterior caused both the decline of the self-portrait—that reclusive, introspective representation in which, according to Degas, the "hateful" self "has nothing but itself in front of itself, sees nothing but itself, and thinks about nothing but itself"—and a new abundance of figure paintings which gave models an infinity of possible lives.[26]

Beginning in 1854, Fantin-Latour made numerous self-portraits, but in 1861 he suddenly ceased. In 1865 Degas, who had depicted himself in every possible garb, painted himself one last time together with his friend Valernes (fig. 276). Fantin-Latour later claimed that his self-portraits had been a matter of convenience (he never lacked for a model), but this does not explain why he stopped.[27] Both he and Degas may have been tired of repeating the same motif; perhaps they realized that they were finally on the right track (why

Fig. 240 (cat. 101). Édouard Manet, *La Lecture* (*Reading*), 1865; retouched ca. 1873–75. Oil on canvas, 23⅞ x 29 in. (60.5 x 73.5 cm). Musée d'Orsay, Paris

195

Fig. 241 (cat. 109). Édouard Manet, *Madame Manet au piano* (*Mme Manet at the Piano*), 1868. Oil on canvas, 15 x 18¼ in. (38 x 46.5 cm). Musée d'Orsay, Paris

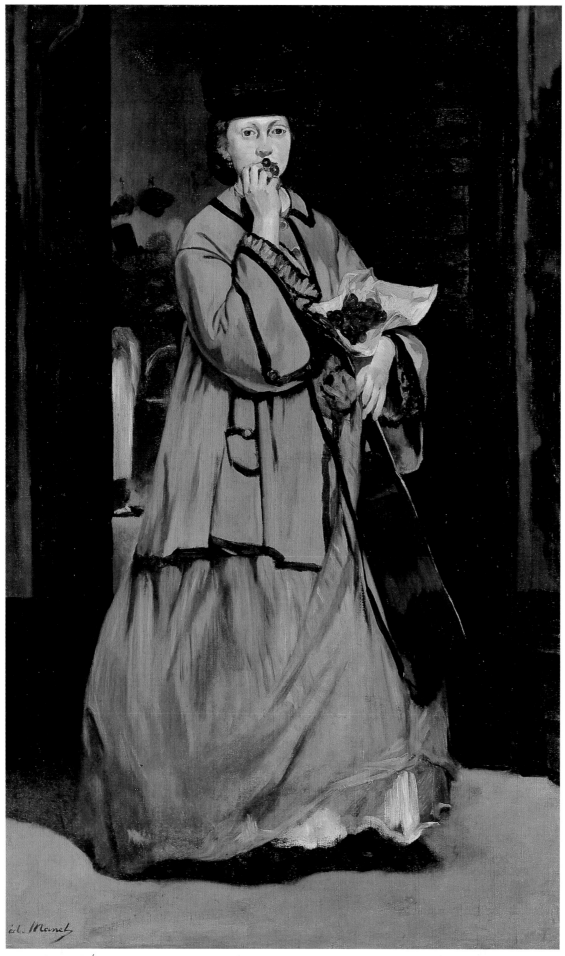

Fig. 242 (cat. 89). Édouard Manet, *La Chanteuse des rues* (*The Street Singer*), 1862. Oil on canvas, 67½ x 41⅝ in. (171.3 x 105.8 cm). Museum of Fine Arts, Boston, Bequest of Sarah Choate Sears, in memory of her husband, Joshua Montgomery Sears

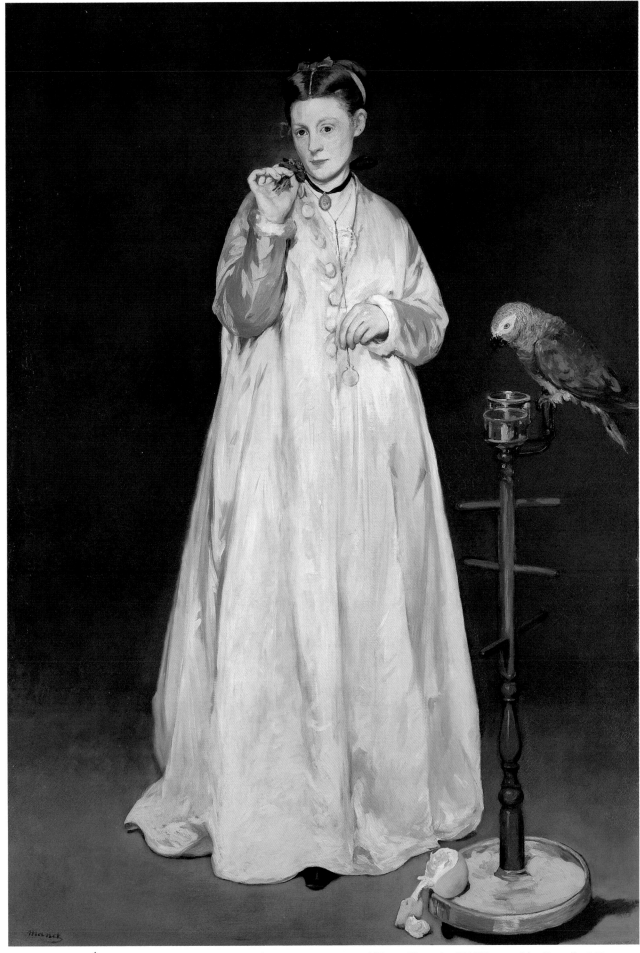

Fig. 243 (cat. 103). Édouard Manet, *Jeune dame en 1866 (La Femme au perroquet)* (*Young Woman in 1866 [Woman with a Parrot]*), 1866. Oil on canvas, 72⅞ x 50⅝ in. (185.1 x 128.6 cm). The Metropolitan Museum of Art, New York, Gift of Erwin Davis, 1889

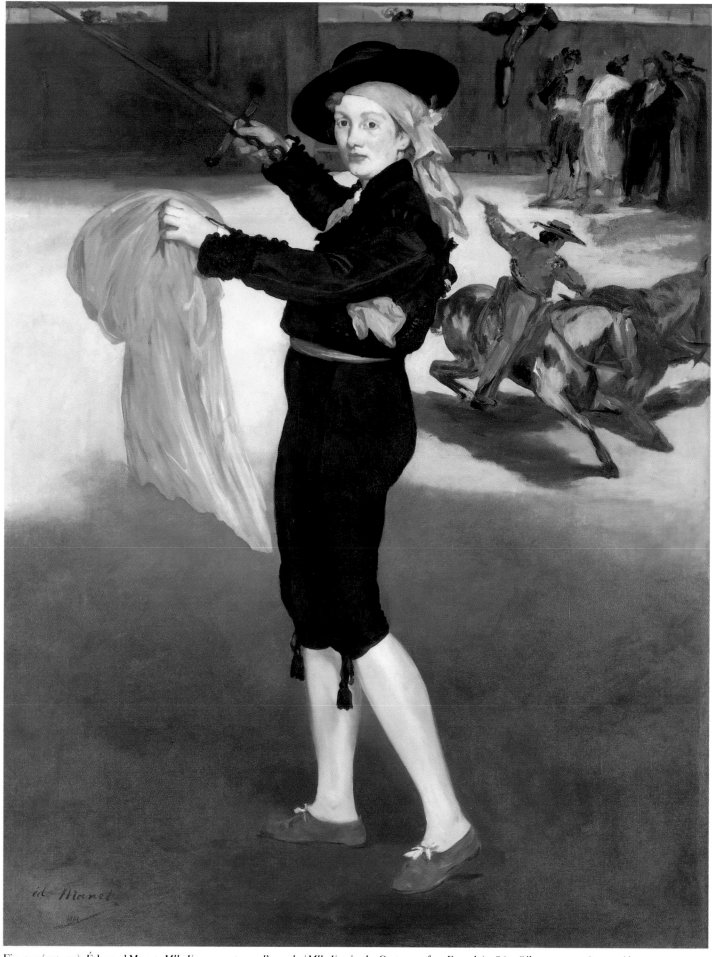

Fig. 244 (cat. 90). Édouard Manet, *Mlle V. . . en costume d'espada* (*Mlle V. . . in the Costume of an Espada*), 1862. Oil on canvas, 65 x 50¼ in. (165.1 x 127.6 cm). The Metropolitan Museum of Art, New York, H. O. Havemeyer Collection, Bequest of Mrs. H. O. Havemeyer, 1929

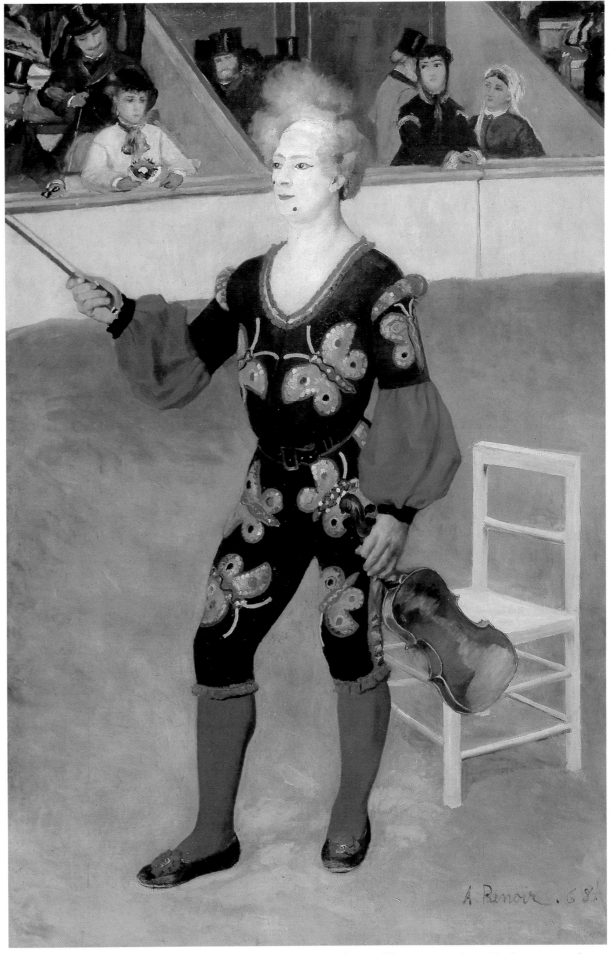

Fig. 245 (cat. 173). Auguste Renoir, *Clown au cirque* (*Clown at the Circus*), 1868. Oil on canvas, 76⅛ x 51⅛ in. (193.5 x 130 cm). Rijksmuseum Kröller-Müller, Otterlo

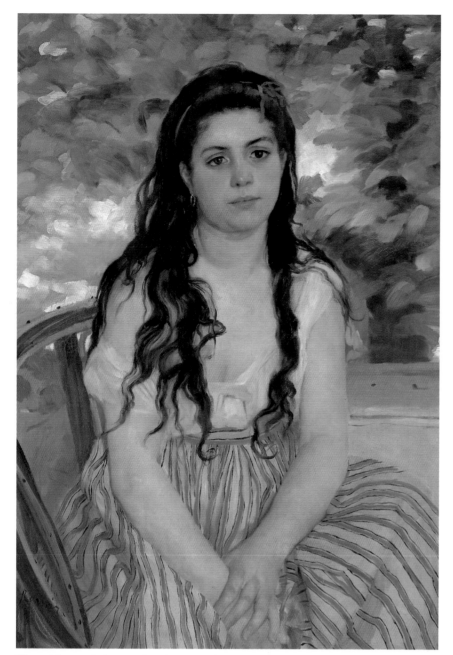

Fig. 246 (cat. 174). Auguste Renoir, *En été; étude* (*Summertime, Study*), 1868.
Oil on canvas, 33½ x 23¼ in. (85 x 59 cm). Staatliche Museen zu Berlin, Nationalgalerie

Fig. 247. Auguste Renoir, *Les Fiancés*
(*The Betrothed*), ca. 1868. Oil on canvas,
41¾ x 29⅛ in. (106 x 74 cm).
Wallraf-Richartz-Museum, Cologne

Fig. 248. Auguste Renoir, *Femme dans un
jardin (La Femme à la mouette)*
(*Woman in a Garden [Woman with a
Seagull Feather]*), ca. 1868. Oil on canvas,
41¾ x 28¾ in. (106 x 73 cm).
Kunstmuseum Basel

keep looking for yourself if you've found yourself?); or perhaps they
wanted to abandon a disturbing face-to-face confrontation, turning
instead toward other people and other vistas. By the mid-1860s,
egocentric analysis was a thing of the past; Impressionism was to be
an altruistic, available art, sharp, vivid, and alive to the random-
ness of encounters, the ephemerality of weather and of one's atti-
tudes, disclosing permanence in the instant and eternalizing on canvas
what had only been a pleasant moment.

Figure painting allowed a rapid exploration of the surrounding
world; by casting the same model in diverse roles, the painter, as
Courbet did in *L'Atelier du peintre* (1854–55, Musée d'Orsay, Paris),
summoned up a universe and conjured up a human comedy. It took
only a rented frock to transform the tender Camille Doncieux into
the dazzling and tempestuous *Femme à la robe verte* (fig. 236).

Fig. 249. James McNeill
Whistler, *The White Girl
(Symphony in White, No. 1)*,
1862. Oil on canvas, 85 x 43 in.
(216 x 109.2 cm). National
Gallery of Art, Washington,
Harris Whittemore Collection

Fig. 250 (cat. 191). James McNeill Whistler, *The Little White Girl: Symphony in White, No. 2*, 1864. Oil on canvas, 30⅛ x 20⅛ in. (76.5 x 51.1 cm). Tate Gallery, London, Bequeathed by Arthur Studd, 1919

Victorine Meurent was by turns a street singer (fig. 242), an improbable *espada* (fig. 244), a studio model (fig. 143), a prostitute (fig. 146), and an elegant Parisian (fig. 243). For Renoir, Lise Tréhaut metamorphosed into a placid, slightly cranky country lass (fig. 246), a pensive bourgeoise (fig. 248), and a comely girl clinging to her fiancé's arm (fig. 247). Contrary to what some have said, these are neither *figures de fantaisie* à la Fragonard, nor products of a vagabond imagination, nor dressed-up people like Nattier's duchesses, who, in mythological *déshabillé*, keep the powdered wigs of their rank. These are *truly* petty bourgeoises and great ladies, proper maidens and courtesans—characters from a novel, to be sure, but who, we are asked to believe, do exist. This is emphasized in accounts of the Salon, which speculate about the heroine's existence. For Castagnary, Whistler's *Young Girl in White* (fig. 249) is a young

25. "le plus charmant, le plus intime, le plus naturellement distingué de tous les portraits de femme." "Salon de 1863," in Thoré-Bürger 1870, vol. I, p. 384.

26. "haïssable"; "n'a que lui devant lui, ne voit que lui et ne pense qu'à lui." Letter from Degas to Gustave Moreau, in Theodore Reff, "More Unpublished Letters of Degas," *Art Bulletin,* September 1969, p. 281.

27. Paris 1982, p. 69.

Fig. 251 (cat. 24). Paul Cézanne, *L'Oncle Dominique (L'Avocat)* (*Uncle Dominique[The Lawyer]*), ca. 1866. Oil on canvas, 24⅜ x 20½ in. (62 x 52 cm). Musée d'Orsay, Paris

Fig. 252 (cat. 25). Paul Cézanne, *L'Oncle Dominique (Uncle Dominique)*, ca. 1866. Oil on canvas, 31⅜ x 25¼ in. (79.7 x 64.1 cm). The Metropolitan Museum of Art, New York, Wolfe Fund, 1951; acquired from The Museum of Modern Art, Lillie P. Bliss Collection

wife on the morning after her wedding night: "Standing on a white carpet with a faint blue tinge; dressed in a long white gown that pinches her frail waist and shows it off; looming against the white curtains of a closed alcove, where *the other* is probably still slumbering; holding a white flower that has lost most of its petals, her nostrils flaring, her eyes widened, her hair falling, she stands surprised and frightened, peering ahead and no doubt thinking how little it takes to turn a girl into a wife, a mother."[28] For Charles Blanc, *Camille* (fig. 236) is a dubious creature, "a prototype of those women who, already painted with several layers of pearl white and carmine and adorned with their vices and their elegance, strut by haughtily, inflicting their fashions on virtue, their wit on chroniclers, and their neologisms on slang."[29]

Around 1850 an important change occurred in the realist revolution: instead of rendering the sitter's features as objectively as possible, the painter's aim became the imposition of his own subjective vision.[30] In this spirit Manet's *Portrait d'Émile Zola* (fig. 270) has been called a self-portrait;[31] the model, as available and vacant as the inanimate objects in a still life, becomes the occasion for the

28. "Debout les pieds posés sur un tapis blanc à peine nuancé de bleu; vêtue d'une longue robe blanche qui resserre et dessine sa frêle taille; se détachant sur les rideaux blancs d'une alcôve fermée, derrière lesquels *l'autre* sommeille encore sans doute, tenant à la main une fleur blanche effeuillée,—la narine émue, l'oeil dilaté, les cheveux tombants,—elle se dresse surprise et effarouchée, regardant devant elle, et songeant sans doute combien peu de chose il faut pour d'une jeune fille faire une femme, une mère." Castagnary 1892, p. 179.

29. "un type de ces femmes, qui déjà peintes à plusieurs couches avec du blanc de perle et du carmin, passent fièrement, parées de leurs vices et de leur élégance, imposant leurs modes à la vertu, leur esprit aux chroniqueurs et leurs néologismes à la langue verte." Charles Blanc, "Salon de 1866," *Gazette des Beaux-Arts*, June 1, 1866, p. 519.

30. Chu 1974, pp. 49–50.

31. Richard Schiff remarks that the portrait of Zola "becomes Manet's self-expression, his own vision and his own portrait," in *New Literary History* 15 (1984), p. 351.

artist's introspection or presentation of his ideas. This hypothesis, in tandem with slightly precipitate conclusions on the decline of the subject and the emergence of pure painting, neglects the factors— love or friendship, physiognomic considerations, erotic fantasies, or what John Rewald called "pictogenic qualities"—that influence the artist's choice of a sitter.[32] These pictogenic qualities, along with goodwill and availability, explain Cézanne's frequent use of his uncle Dominique (figs. 251, 252), who endured disguises as a professional model would.

The same may be said about Degas's reprises of his sister Thérèse, whom he painted regularly from his earliest efforts in 1853 until about 1869 (fig. 258). Degas loved her perfectly oval face with its thick nose, fleshy lips, large, brown, slightly protuberant eyes, her shy, placid, attentive look, her air of being forever at sea. Above all, he loved the Ingresque character of her face, so like those of Mlle Rivière and Mme Devaucey, just as he loved Edmondo Morbilli's (fig. 256) look, so akin to that of a sixteenth-century lord, or his aunt Bellelli's appearance of a queen-regent in deep mourning (fig. 253).

Degas demanded that a woman have "that touch of ugliness without which there is no salvation"[33] and that all his models pay particular heed to their own depiction. André Gide would write: "I remember Degas saying he only liked people who attitudinized, and he added: 'How can you expect me to delineate a man who can't delineate himself?'"[34]

32. Rewald 1971–72, p. 45.
33. "cette pointe de laideur sans laquelle point de salut." Degas 1945, p. 28.
34. "Je me souviens du mot de Degas qui disait qu'il n'aimait que les poseurs, ajoutant: 'Comment voulez-vous que je dessine un homme qui ne sait pas se dessiner lui-même?'" André Gide. *Journal 1889–1939*, Paris, Gallimard, La Pléiade, p. 876 (dated March 10, 1928).

Fig. 253. Edgar Degas, *Portrait de famille (La Famille Bellelli) (Family Portrait [The Bellelli Family])*, 1858–67. Oil on canvas, 78¾ x 98⅜ in. (200 x 250 cm). Musée d'Orsay, Paris

Fig. 254. Edgar Degas, *Victoria Dubourg*, ca. 1868–69. Oil on canvas, 32 x 25½ in. (81.3 x 64.8 cm). The Toledo Museum of Art, Gift of Mr. and Mrs. William E. Levis

Attitudinize? Manet (fig. 237) and Victoria Dubourg (fig. 254) and Tissot (fig. 277) certainly did, and during the 1860s this trait aroused Degas's deep interest in portraits of artists—he may even have envisaged whole series of painters or musicians. Degas was a passionate student of human physiognomy. His notebooks mention Johann Kaspar Lavater twice, quoting Goethe, for whom the Swiss physiognomist was "a realist," and confess Degas's own ambition "to turn the *expressive head* (*académie* style) into a study of modern feeling. . . . In a sense, that is a more relative Lavater."[35]

Degas's preoccupations resemble those of Castagnary and Duranty. In his "Salon of 1857," Castagnary discussed the characteristics of a good model. He rejected women as too malleable and imprecise: "That unfixed being, with her soft, floating individuality, has none of the qualities necessary for a good portrait." He also rejected young men, whose features are still "in flux." However, he maintained that by forty "life experience" has finally molded a head and, "harmonizing it with the inner being that it is called upon to render," gives a "true physiognomy": "It is indeed logical that by stirring and heaving within us, the storms of the heart and the tumults of the mind reach our surfaces, taking hold of them and modifying them; and by hardening our lines, solidifying our planes, they leave their own imprints in all the creases in our faces and stamp upon us the true and definitive mask of our passions. Thus it is only after forty . . . that a man is responsible for and answerable to his own portrait."[36]

35. "un réaliste"; "faire de la *tête d'expression* (style d'académie) une étude du sentiment moderne. . . . c'est du Lavater plus relatif, en quelque sorte." Reff 1985, notebook 21, p. 4, notebook 23, p. 44. Regarding Degas and Lavater, see Reff 1985, pp. 26–28, and McCauley 1985, pp. 167–72.

36. "être infixe, d'une individualité molle et flottante, ne réunit aucune des conditions exigées pour le portrait"; "fluides"; "*vie vécue*"; "l'harmonisant avec l'être intérieur qu'elle est appelée à rendre"; "physionomie véritable"; "Il est logique en effet, qu'à force de remuer et de s'agiter en nous, les orages du coeur et les tumultes de la pensée arrivent jusqu'à notre surface, s'en emparent, la modifient; et, durcissant les lignes, solidifiant les plans, se moulent dans tous les plis de notre face, et nous impriment le masque définitif et vrai de nos passions. Aussi est-ce seulement à la quarantaine . . . que l'homme relève du portrait et en devient justiciable." Castagnary 1892, pp. 39–41.

Fig. 255. Edgar Degas, *Portrait d'Edmondo et Thérèse Morbilli*, 1863–64. Oil on canvas, 46⅛ x 35⅜ in. (117 x 89.9 cm). National Gallery of Art, Washington, Chester Dale Collection

Fig. 256. Edgar Degas, *Portrait d'Edmondo et Thérèse Morbilli*, 1865. Oil on canvas, 45⅝ x 35¼ in. (116 x 89.5 cm). Museum of Fine Arts, Boston, Gift of Robert Treat Paine

Fig. 257. Edgar Degas, *Portrait de Thérèse Morbilli*, ca. 1869. Pastel, 20⅛ x 13⅜ in. (51 x 34 cm). Private collection, New York

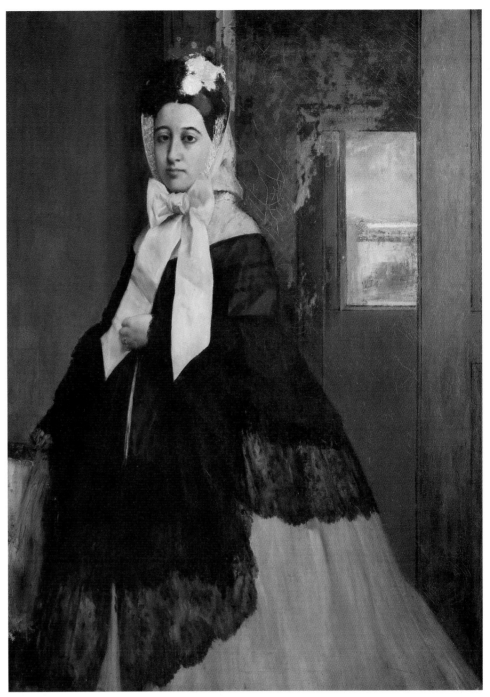

Fig. 258 (cat. 54). Edgar Degas, *Portrait de Thérèse De Gas*, 1863. Oil on canvas, 35 x 26⅜ in. (89 x 67 cm). Musée d'Orsay, Paris

Ten years later, in "On Physiognomy," Duranty challenged both the phrenology of Franz Joseph Gall and Lavater's theories of physiognomy. Tracking the "life experience" of a face, he concentrated on what a person's features owe to his métier: "The habits of every profession stamp a distinct bearing and physiognomy on those who exercise that calling."[37] Duranty laid the "foundations for the study of physiognomy"; some ten years later, in *La Nouvelle Peinture* (1876), he stated his goal: "to examine the people one knows well, to establish the features of their faces and see whether the people who resemble them think the same thoughts, have the same tastes, and do the same things."[38]

37. "vie vécue"; "chaque profession, par ses habitudes, imprime à ceux qui l'exercent une allure et une physionomie distinctes." Duranty 1867, p. 500.
38. "bases de l'étude de la physionomie." Ibid. "Examiner les gens qu'on connait bien, établir comment sont les traits de leur visage et voir si les personnes qui leur ressemblent, pensent de même, ont leur goûts, agissent comme eux." Crouzet 1964, pp. 248–49.

Fig. 259. Edgar Degas, *Portrait de Madame C[amus]* (*Mme Camus in Red*), 1870. Oil on canvas, 28⅝ x 36¼ in. (72.7 x 92.1 cm). National Gallery of Art, Washington, Chester Dale Collection

Like Duranty, Degas wanted to show all that his sitters and their usual postures owed to the lengthy practice of a métier, to the milieu in which they were immersed, and to the changes caused by joys and sorrows. We see Désiré Dihau (fig. 284) blowing into his bassoon among his orchestral colleagues at the Opéra and the very Parisian Mme Camus among the "statues and the slightly rosy figurines" collected by her husband: "a pale, porcelain woman, who, svelte and aristocratically bloodless, looks like the goddess of the world of [her husband's] shelves."[39]

Degas's portraits of his sister Thérèse in the 1860s make up a veritable naturalistic novel—the hopes and disappointments of a virtuous and rather ignorant girl overwhelmed by the course of events. Chapter one, spring 1863, the engagement portrait: with an always astonished face, the girl is dressed to go out or, more precisely, to depart (fig. 258); she timidly shows her engagement ring, and through the window is seen Naples, where she will settle after marrying her cousin Edmondo Morbilli—a serene image, an absolutely blue sky, a happy portent. Chapter two, several months later, Thérèse is at Edmondo's side, tranquilly exhibiting the signs of imminent motherhood (fig. 255). Chapter three, spring 1865, Thérèse has lost the child she was expecting the previous year. Once in the foreground, she is now literally nothing but her husband's shadow. Then, in the late 1860s, a final depiction of Thérèse (fig. 257), alone at her father's home, leaning against the fireplace, her posture recalling that of Ingres's famous *Portrait de la comtesse d'Haussonville*, but here severe, distant, and straitlaced. A bourgeois Judith, she holds with her fingertips a curious hat, which looks like an oval bearded face.

In the development of a thoroughly modern art, which was the ambition of the New Painting, the portrait was an essential element. Necessarily contemporary, it boldly adopted the costumes and customs of the time, proclaiming friendships and disclosing common interests, linking sitters to attributes that defined them or placed them in familiar and significant frameworks. By 1870 the portrait had moved away from the ideas expressed by Baudelaire and Castagnary ten years earlier. For Castagnary the portrait had to be a synthesis, an expression of quintessence, as opposed to the landscape, which showed "a diffuse and scattered life": "In order to be understood and made manifest, man imperatively demands a strict and severe unification of his essence and his potentiality. Unity is the law of the portrait." The painter would therefore have to pry into his sitter to present individuality and to bring out character traits in the facial features. But according to Castagnary, if the portrait dissects an individual, it evokes his passions and records his qualities and vices while haughtily ignoring the surrounding world.

39. "statuettes et les figurines pâlement rosées"; "pâle femme porcelainée, qui semble, dans sa sveltesse et son aristocratique exsanguinité, la divinité du monde de ses étagères." Goncourt 1956, vol. 10, p. 156.

"The portrait," he stated moralistically, "especially the historical portrait, is more than an artwork, it is a judgment."[40] And in 1857 he indeed considered it timeless and definitive rather than subject to an ambient, changing milieu as in the Goncourts, Flaubert, and Zola.

In 1846 Baudelaire stated that there were two ways of understanding the portrait: as "history and [as] novel." History, the domain of draftsmen, has the job of "rendering the outline and the bulk of the model faithfully, severely, and scrupulously," of being unhesitatingly idealizing—a device used by David and Ingres. The novel, the preserve of the colorists, of Rembrandt, Reynolds, and Lawrence, has the job of "turning the portrait into a painting, a poem with its ornaments, full of space and reverie"; here observation combines with imagination.[41] In 1859 Baudelaire would again urge fusing these two qualities to create a good portrait. Here observation is also called "obedience" and imagination "divination"; the painter is both a "historian," recording what he sees, and an "actor, dutifully [putting on] all characters and costumes."[42] Romance comes into whatever surrounds the sitter and gives the portrait coloration. "Ornaments" do not replicate a scruffy reality; instead they give wings to the commonplace, they concur with the moral portrait of the individual, they are an allegory of his or her character: a stormy sky for a tormented soul, a dense forest or melancholy lake for a dreamy woman.

But while describing his ideal portrait, Baudelaire could not find champions of this style: all the names he cites belong to the past. Nor were his ideas taken up by younger artists. In 1878, while talking with Arsène Houssaye, Manet regretted that no one had succeeded in painting that "prototype of an era...the woman of the Second Empire." He was, however, unjustly neglecting two works: his own *Jeune Dame en 1866* (fig. 243) and Monet's *Camille* (fig. 236). Manet was referring not so much to a portrait à la Baudelaire as to the earlier success of Ingres, who with *Monsieur Bertin* (fig. 228), among many others, had depicted "the prototype of the bourgeoisie of 1825 to 1850."[43]

In 1876, when Duranty included Ingres among the predecessors of the New Painting, he saluted the portraitist and the forebear of Degas, who always admired Ingres, even during the 1860s when it was fashionable to scorn him. Nevertheless it is improper to see Ingres's style in Degas's portraits (as is frequently done). Degas contemplates the example of his "god," retaining certain elements but tapping other sources that Ingres would have condemned. These sources include: Van Dyck, who informs the haughty figure of Laura Bellelli (fig. 253); Courbet, whose dense trees and rocks are quoted in Degas's portrait of Eugénie Fiocre (fig. 343); and an occasional recourse to photographic calling cards.[44]

40. "la vie éparpillée et diffuse"; "l'homme, pour être compris et exprimé, exige impérativement l'unification étroite et sévère de son être et ses virtualités. L'unité c'est la loi du portrait"; "Le portrait, surtout le portrait d'histoire, est plus qu'une oeuvre d'art: c'est un jugement." Castagnary 1892, pp. 33–39.
41. "l'histoire et le roman"; "rendre fidèlement, sévèrement, minutieusement, le contour et le modelé du modèle"; "faire du portrait un tableau, un poème avec ses accessoires, plein d'espace et de rêverie." Baudelaire 1985–87, vol. 2, p. 464.
42. "obéissance"; "divination"; "historien"; "comédien"; "par devoir...tous les caractères et tous les costumes." Ibid., p. 655.
43. " le type de la bourgeoisie de 1825 à 1850." Proust 1897, pp. 50–51.
44. McCauley 1985, pp. 152–55.

Fig. 260 (cat. 78). Eva Gonzalès, *Enfant de troupe* (*Soldier Boy*), 1870. Oil on canvas,
51⅛ x 38⅜ in. (130 x 97.5 cm). Musée Gaston Rapin, Villeneuve-sur-Lot

This crossbreeding—to use a word dear to that period—can also be found in Manet's oeuvre, where it is an essential element of a dazzling and venomous modernity. Paul de Saint-Victor had good reason to view *Mlle V... en costume d'espada* (fig. 244) as the work of a "Goya gone to Mexico, turning savage in the midst of pampas and smearing his canvases with cochineal,"[45] vituperating against things that we revere today, deriving strength from a burst of color and deliberate rigidity. To this Spanish strain, Manet added allusions to the Renaissance Italians, notably Marcantonio Raimondi and Andrea del Sarto.[46] As in *Le Déjeuner sur l'herbe* and *Olympia* (see pp. 116–20), the startling modernity of the painting comes from its incessant confrontation with older models.

In executing the large figures that were characteristic of the 1860s, Manet, Renoir, and Cézanne understood the power of combining

45. "Goya passé au Mexique, devenu sauvage au milieu des pampas et barbouillant ses toiles avec de la cochenille." Paul de Saint-Victor, *La Presse*, April 27, 1863, quoted in Leiris 1978, p. 112.
46. See the convincing associations in Farwell 1969 and Leiris 1978.

Fig. 261 (cat. 102). Édouard Manet, *Le Fifre* (*The Fifer*), 1866. Oil on canvas, 63⅜ x 38¼ in. (161 x 97 cm). Musée d'Orsay, Paris

authoritative archetypes with low, derisory elements. In *La Chanteuse des rues* (fig. 242) Manet, using the dimensions of an official full-length portrait, paints a girl munching cherries as she emerges from a tavern. By making the figure in *Le Fifre* (fig. 261) lifesize, Manet transforms the popular image of a fifer of the guard infantry —with "red trousers and fatigue cap"—into a "modern icon."[47] Renoir's *Clown* (fig. 245), brandishing a stick in one hand and clutching a pocket violin in the other, looks like a condottiere with a naked sword and his fist on his dagger. Cézanne turns the dwarf Empéraire into a majestic Napoléon (figs. 262, 263), while his father, whom Zola called "facetious, republican, bourgeois, cold, meticulous, miserly," "looks like a pope on his throne [fig. 264]."[48]

Many contemporaries were struck by the kinship of these figures and recognized in them the distinctive mark of a new school. In 1868 Zacharie Astruc saw Renoir's *Lise* (fig. 176) as the last figure in a "bizarre trinity, begun by the highly curious and powerfully expressive *Olympia* of tempestuous memory. Some time later, in Manet's wake, Monet created his *Camille* [fig. 236], the beauty wearing a green dress and slipping on her gloves. . . . And now, here is *Lise*, the most restrained of all."[49]

For Zola, *Lise* was truly a sister to *Camille*.[50] For Henry Fouquier, she was a late echo of Whistler's girl in white, exhibited at the Refusés of 1863.[51] Marius Chaumelin, praising "the strangeness of the effect, . . . the exactness of the tones, . . . and what the language of the realists traditionally calls a lovely splotch of color," stressed the closeness of this symphony in white to Manet's symphony in

47. "pantalon rouge et bonnet de police." Zola 1991, p. 117. "icône moderne." Françoise Cachin in Paris, New York 1983, p. 246.

48. "goguenard, républicain, bourgeois, froid, méticuleux, avare." Quoted in Rewald 1936, p. 73. "l'air d'un pape sur son trône." Antoine Guillemet's letter to Émile Zola, November 2, 1866 in Rewald 1971–72, p. 47.

49. "Trinité bizarre, intronisée par la très curieuse et puissamment expressive *Olympia*, d'orageuse mémoire. À la suite de Manet, Monet créait quelque temps après sa *Camille*, la belle à la robe verte qui met ses gants. . . . Voici maintenant *Lise* la plus retenue de toutes." Zacharie Astruc, "Salon de 1868," *L'Étendard*, June 27, 1868.

50. Zola 1991, p. 211.

51. Henry Fouquier, "Salon de 1868," *L'Avenir national*, May 23, 1868.

Fig. 262. Paul Cézanne, *Portrait d'Achille Emperaire*, ca. 1868. Oil on canvas, 78¾ x 47¼ in. (200 x 120 cm). Musée d'Orsay, Paris

Fig. 263. Jean-Auguste-Dominique Ingres, *Napoléon Ier sur le trône impérial* (*Napoléon I on the Imperial Throne*), 1806. Oil on canvas, 102⅜ x 64⅛ in. (260 x 163 cm). Musêe de l'Armée, Paris

Fig. 264 (cat. 26). Paul Cézanne, *Portrait de Louis-Auguste Cézanne*, 1866. Oil on canvas, 78¾ x 47¼ in. (200 x 120 cm). National Gallery of Art, Washington, Collection of Mr. and Mrs. Paul Mellon

Fig. 265 (cat. 30). Paul Cézanne, *Paul Alexis lisant à Émile Zola* (*Paul Alexis Reading to Émile Zola*), ca. 1869–70. Oil on canvas, 51⅛ x 63 in. (130 x 160 cm). Museu de Arte de São Paulo Assis Chateaubriand

Fig. 266. Édouard Manet, *Le Balcon* (*The Balcony*), 1868–69. Oil on canvas, 66⅞ x 49 in. (170 x 124.5 cm). Musée d'Orsay, Paris

pink (fig. 243).[52] And when Manet exhibited his *Jeune Dame en 1866*, the presence of the enigmatic parrot made this painting seem like a response to Courbet's *Femme au perroquet* (fig. 148). "Every marquis wants his pages, every realist wants his parrot."[53] That was the final quip in the Manet–Courbet dialogue that had been set off by *Olympia*.[54]

Most of the time those correspondences were readable, even by contemporaries who had only a limited view of these artists' works. Take Cézanne's *Émile Zola lisant à Paul Alexis* (fig. 265). Had it been exhibited, it would have promptly invited comparison with Manet because of its composition and its colors, the blacks and greens it owed to *Le Balcon* (fig. 266). At the Salon of 1870 Eva Gonzalès's *Enfant de troupe* (fig. 260) appeared to echo Manet's *Fifre* (fig. 261), which had been shown at his pavilion at the pont de l'Alma in 1867. However, the pupil gave body to the master's cut-off figure, thickening the flesh tones and the nuances, mellowing the bright colors, and softening the boldness to serve it up gently and more palatably. But how can the striking resemblance between

Fig. 267 (cat. 92). Édouard Manet, *La Maîtresse de Baudelaire couchée* (*Baudelaire's Mistress Reclining*), ca. 1862–63. Oil on canvas, 35 x 44½ in. (90 x 113 cm). Szépművészeti Múzeum, Budapest

Courbet's *Adela Guerrero* (fig. 268) and Manet's *Lola de Valence* (fig. 269) be explained, since Manet most likely never saw the Courbet canvas? Was it brought about by the sitters' similar appearances, by Manet's attentiveness to the older artist's works, or by sources in Goya and popular pictures that both artists drew upon?[55] The resemblance between the two vigorous Spanish women must have been even more thrilling when Lola de Valence loomed against a monochrome background; but after his one-man show in 1867, Manet, perhaps under Degas's influence, introduced the stage-set framework and beyond it a narrow sliver of the stage and the auditorium. Despite these additions, Manet's portrait is a descendant of Courbet's *Gueymard* (Metropolitan Museum of Art), where neither the theatrical elements nor the opera costume can eradicate the studio atmosphere. It was Degas—with his portraits of Eugénie Fiocre (fig. 343) and especially Désiré Dihau (fig. 284)—who perfected the formula for a portrait of an individual practicing his or her profession, surrounded by bit players who may steal the limelight and transform the intended portrait into a genre scene.

52. "l'étrangeté de l'effet"; "justesse des tons"; "ce que, dans la langue des réalistes, on est convenu d'appeler une belle tache de couleur." Marius Chaumelin, "Salon de 1868," *La Presse*, June 23, 1868; Moreau-Nélaton 1926a, vol. 1, pp. 101–2.
53. "Tout marquis veut avoir des pages, tout réaliste veut son perroquet." Quoted in Moreau-Nélaton 1926a, vol. 1, p. 97.
54. See Theodore Reff's excellent study (Reff 1980).
55. Hanson 1972, pp. 152–53; Brooklyn, Minneapolis 1988–89, p. 110.

Fig. 268 (cat. 38). Gustave Courbet, *La Signora Adela Guerrero*, 1851. Oil on canvas, 62¼ x 62¼ in. (158 x 158 cm).
Musées Royaux des Beaux-Arts de Belgique, Brussels

Fig. 269 (cat. 87). Édouard Manet, *Lola de Valence*, 1862. Oil on canvas, 48⅜ x 36¼ in. (123 x 92 cm). Musée d'Orsay, Paris

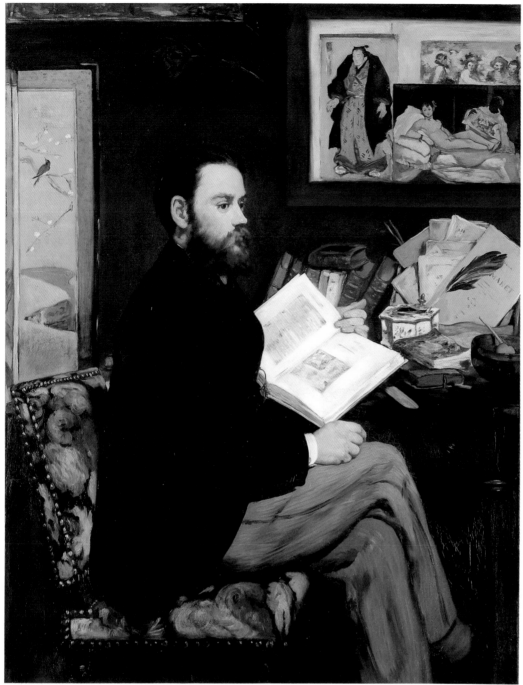

Fig. 270 (cat. 108). Édouard Manet, *Portrait d'Émile Zola*, 1868. Oil on canvas, 57⅝ x 44⅞ in. (146.5 x 114 cm). Musée d'Orsay, Paris

Degas was intent on expressing the sitter's state by way of all his or her surroundings; as a result his portraits were soon faulted for their "systematic preoccupation with strange things" and for their extreme sophistication, which "seeks out the bizarre" and therefore neglects the "strength of what is simple, precise, and true."[56] Manet's portraits were attacked for rendering inanimate objects as painstakingly as the sitter's features (see pp. 152, 154).[57] Although his remarks were meant to be negative, Thoré acutely noted Manet's "pantheism" ("He does not value a head more than a slipper") and his "current vice" of placing everything on the same level.[58] Zola, describing his own sessions as a sitter, acclaimed Manet for the same

56. "préoccupation d'étrangeté systématique"; "recherche bizarre"; "force du simple, du juste et du vrai." Edmond Duranty, "Le Salon de 1870," *Paris-Journal*, May 18, 1870.
57. Adrien Paul, "Salon de 1863—Les Refusés," *Le Siècle*, July 9, 1863, p. 2.
58. "panthéisme"; "il n'estime pas plus une tête qu'une pantoufle"; "vice actuel." Thoré-Bürger 1870, vol. 2, p. 532.

216

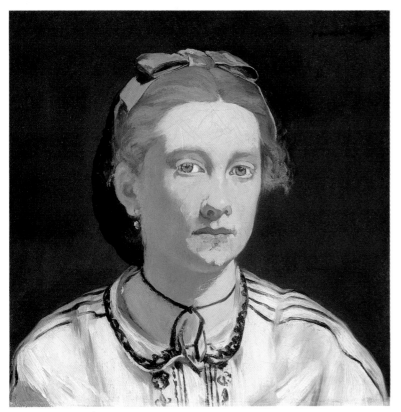

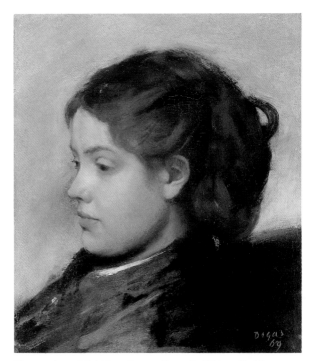

Fig. 271 (cat. 91). Édouard Manet, *Portrait de Victorine Meurent*, 1862. Oil on canvas, 16⅞ x 17¼ in. (42.9 x 43.7 cm). Museum of Fine Arts, Boston, Gift of Richard C. Paine, in memory of his father, Robert Treat Paine, 2nd

Fig. 272 (cat. 64). Edgar Degas, *Portrait d'Emma Dobigny*, 1869. Oil on canvas, 12 x 10⅜ in. (30.5 x 26.5 cm). Private collection, Switzerland

reasons: "He copied me as if he were copying any kind of human animal."[59] Odilon Redon considered this portrait a still life.[60] Other critics have offered numerous interpretations, which all head in the same direction: Manet is supposed to have used the Zola portrait as an occasion to present his choices and his taste, painting his own portrait through that of his defender.[61] In my opinion, however, this is not a shrewd and arrogant self-portrait so much as Manet's tribute to the writer's reading of the painter's oeuvre. Before being reproduced as a photograph or an engraving, the tutelary image of *Olympia* was already a reduction—in the musical sense—of a painting in which Zola initially discerned only the violent opposition of whites and blacks: "Olympia, lying on white sheets, forms a large pale splotch against the black background."[62]

The Japanese quotations in the portrait of Zola (fig. 270) refer to a passage in the writer's "biographical and critical study" of Manet, which had come out the previous year: "It would be far more interesting to compare this simplified painting with the Japanese engravings that resemble it in their strange elegance and magnificent splotches."[63] In depicting his ardent defender, Manet hewed as closely as possible to his vision of his sitter: he did a Zola portrait à la Zola, which was both a token of friendship and the expression of a common agenda. In 1867, when Zola had protested against the relationship between Manet and Baudelaire, he was speaking as an interested

59. "Il me copiait, comme il aurait copié une bête humaine quelconque." Zola 1991, p. 199.
60. Paris, New York 1983, p. 285.
61. See Françoise Cachin's discussion in Paris, New York 1983, pp. 280–85.
62. "Olympia, couchée sur des linges blancs, fait une grande tache pâle sur le fond noir." Zola 1991, p. 160.
63. "étude biographique et critique"; "Il serait beaucoup plus intéressant de comparer cette peinture simplifiée avec les gravures japonaises qui lui ressemblent par leur élégance étrange et leurs taches magnifiques." Ibid., p. 152.

party, since he was to a large extent responsible for their estrangement. As of that date, the writer and the painter joined forces; in defending Manet, Zola was articulating a defense for himself. Commenting (with Manet's blessing) on the artist's earlier works, Zola insists that Baudelaire has misunderstood the painter's meaning. Spelling out his own theory, he states that that is what Manet has always meant.

Like the landscape for Monet, the portrait for Degas was a source of constant experiment and innovation. At times he emulated Manet by doing a bust-length portrait in a small format (figs. 271, 272), but his essential preoccupation remained the placement of the figure against the background. The dark monochrome background in his self-portrait of 1855 (fig. 273) was succeeded by more complex arrangements—especially after the Salon of 1859, where he admired Ricard's layouts (see p. 22). In September of 1859, when visiting the museum at Montpellier, Degas had been struck by the vivid and sonorous backgrounds in certain Renaissance portraits.[64] A little later, in his notebook for 1858–59, he wrote: "I have to think of *figures* before anything else, or at least I have to study them by *thinking* only of the backgrounds."[65]

For more than a decade he tested the most diverse solutions: detaching the isolated figure from a neutral background; adding some accessories; placing the figure in an artificial but meaningful decor;

64. Reff 1985, notebook 4, p. 99.
65. "il faut que je pense aux *figures* avant tout, ou au moins que je les étudie en *pensant* seulement aux fonds." Ibid., notebook II, p. 60.

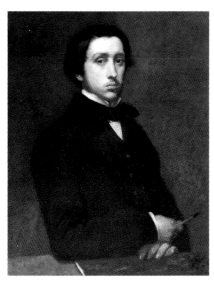

Fig. 273. Edgar Degas, *Autoportrait* (*Self-Portrait*), 1855. Oil on canvas, 31⅞ x 25⅜ in. (81 x 64.5 cm). Musée d'Orsay, Paris

Fig. 274. Edgar Degas, *Portrait de Giulia et Giovanna Bellelli*, 1865–66. Oil on canvas, 36¼ x 28¾ in. (92 x 73 cm). The Los Angeles County Museum of Art

Fig. 275. Henri Fantin-Latour, *Portrait d'Édouard Manet*, 1867. Oil on canvas, 46¼ x 35⅜ in. (117.5 x 90 cm). The Art Institute of Chicago, The Stickney Fund

Fig. 276 (cat. 56). Edgar Degas, *Portrait de l'artiste avec Évariste de Valernes* (*Portrait of the Artist with Évariste de Valernes*), 1865. Oil on canvas, 45⅝ x 35 in. (116 x 89 cm). Musée d'Orsay, Paris

trying, without success, to immerse the figure in nature; or arbitrarily comparing several faces. In 1865 Degas, renewing a sixteenth-century formula, did three double portraits, the first two of which revealed a troubling twinhood (fig. 274) and a couple's mute and painful rift (fig. 256). The third painting celebrated the friendship of two men united by a "long-term artistic relationship" and obvious social affinities, but forever separated by the inequality of their talents (fig. 276).[66] Disdaining painterly accouterments, the two men wear black suits, whose appropriateness has been questioned; here, however, these suits are worn without self-consciousness—they are the uniform of the era. According to Théophile Gautier, this uni-

66. "longs rapports d'art." Degas 1945, p. 178.

Fig. 277 (cat. 62). Edgar Degas, *Portrait de James Tissot*, 1867–68. Oil on canvas, 59⅝ x 44 in. (151.4 x 112 cm).
The Metropolitan Museum of Art, New York, Rogers Fund, 1939

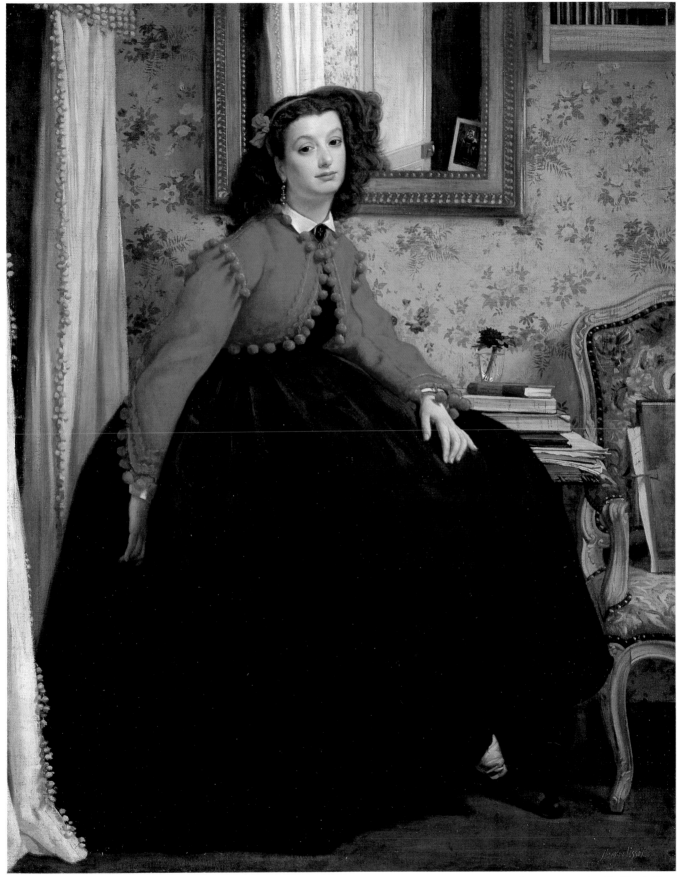

Fig. 278 (cat. 189). James Tissot, *Portrait de Mlle L. L . . . (Jeune Femme en veste rouge)* (*Portrait of Mlle L. L . . . [Young Woman in a Red Jacket]*), 1864. Oil on canvas, 48⅞ x 39⅛ in. (124 x 99.5 cm). Musée d'Orsay, Paris

Fig. 279 (cat. 43). Gustave Courbet, *La Fille aux mouettes* (*Girl with Seagulls*), 1865.
Oil on canvas, 31⅞ x 25⅝ in. (81 x 65 cm). Private collection, United States

form, "by its simple cut and neutral tone," spotlights the head "as the seat of the intelligence" and the hands "as the tools of thought or the sign of breeding."[67] In Degas, as in Fantin-Latour, the black suit sometimes has a deeper meaning. When Fantin portrayed his friend Manet (fig. 275), he deliberately presented the artist who had provoked the *Olympia* scandal as an elegant clubman, a reassuring image. Degas presented an unconcerned James Tissot (fig. 277) in a studio where he is merely passing through, more dandy than painter. Degas puts him in an artificial setting—as artificial as that surrounding Zola (fig. 270), as artificial as the plein-air backdrop in Renoir's *En été* (fig. 246) or Monet's *Victor Jacquemont* (fig. 179). The imaginary studio, where Tissot sits for a moment, is neither his

67. "par sa coupe simple et sa teinte neûtre"; "siège de l'intelligence"; "outil de la pensée ou signe de la race." Théophile Gautier, *De la mode*, new edition of the text of 1858 (Arles, 1993).

Fig. 280 (cat. 41). Gustave Courbet, *La Femme aux fleurs (Le Treillis)* (*Woman with Flowers [The Trellis]*), 1862. Oil on canvas, 43¼ x 53¼ in. (109.8 x 135.2 cm). The Toledo Museum of Art, Purchased with funds from the Libbey Endowment, Gift of Edward Drummond Libbey

nor that of any artist. This unreality underscores Tissot's situation: no longer the innovator of the early 1860s (fig. 278), who was close to Degas, he had slid into a facile production, both trendy and commercial. The decor exposes his eclectic—too eclectic—tastes: sixteenth-century German painting straying into historical scenes à la Henri Leys; Japanese art quickly digested into marketable *japonaiserie*. The setting is also a virtual catalogue for the smart clientele that was now Tissot's—a sample case of the genres he practiced so successfully: portrait, exotica, outdoor scene, historical motif. And the severe face of Cranach's Frederick the Wise, juxtaposed with the face of an elegant Parisian, not only alludes to his preferences but is also a warning.

Fig. 281 (cat. 57). Edgar Degas, *Femme accoudée près d'un vase de fleurs (Portrait de Mme Paul Valpinçon)* (*A Woman Seated beside a Vase of Flowers [Mme Paul Valpinçon?]*), 1865. Oil on canvas, 29 x 36½ in. (73.7 x 92.7 cm). The Metropolitan Museum of Art, New York, H. O. Havemeyer Collection, Bequest of Mrs. H. O. Havemeyer, 1929

As a portraitist, Degas, like the Renaissance painters, took obvious delight in significant minutiae that are sometimes hard to decipher. Among many examples are the view of Naples behind Thérèse De Gas (fig. 258) and the empty chair that, next to Victoria Dubourg, indicates the ghostly presence of the man who is already her fiancé, Henri Fantin-Latour (fig. 254). The sitter is accompanied not by decorative and telltale accessories but by attributes that pinpoint his or her condition: hence the intrusive bouquet next to Mme Valpinçon (fig. 281). Unlike Bazille's African woman (fig. 282), who has been turned into a figure, Mme Valpinçon, the wife of Degas's friend Paul, is the principal motif of the painting, even though she does not occupy the foreground. The flowers reaching toward her neck and her sleeve, her morning costume, the millefleurs of the painted wallpaper, the decorative tablecloth—all emphasize calmness, femininity, ease, efflorescence, maturity, breeding. Mme

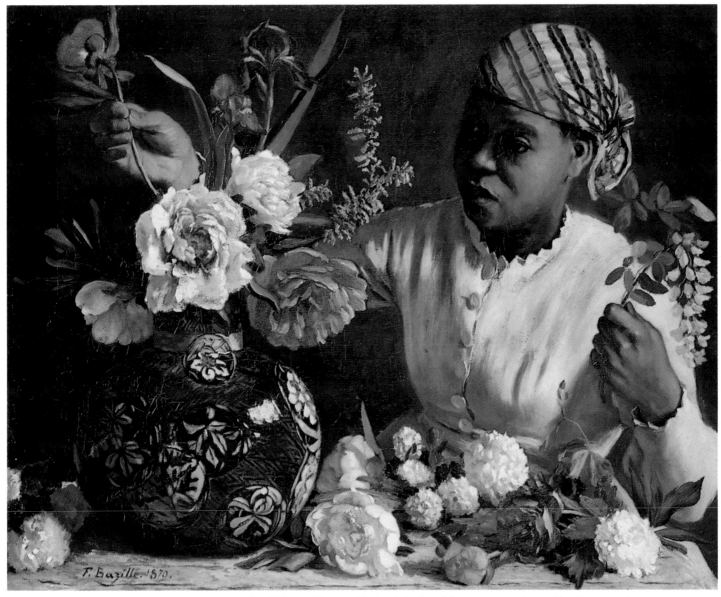

Fig. 282 (cat. 14). Frédéric Bazille, *Négresse aux pivoines* (*African Woman with Peonies*), 1870. Oil on canvas, 23⅝ x 29½ in. (60 x 75 cm). Musée Fabre, Montpellier

Valpinçon's bouquet is her work and her prerogative; she has engaged in the bucolic bourgeois ritual of cutting late-summer flowers and arranging them in a vase. The bouquet painted by Courbet three years earlier (fig. 280) is improbable in being culled from different seasons and is traditional in being imbued with floral symbolism; it gives an entirely different sense to a similar composition, allowing viewers to gauge the novelty of Degas's picture. The flowers in front of Courbet's young woman are not her attribute nor do they determine her status; they are a symbolic presentation of her existence and foreshadow the events awaiting her from her spring to her autumn: "the love and life of a woman, a wife."[68]

Shortly before the Franco-Prussian War (1870), Degas finished the portrait commissioned by Désiré Dihau (fig. 284); still unsatisfied, he thought of modifying it, but the bassoonist snatched it to exhibit it in Lille. The Degas family was effusively grateful to Dihau: "It is

68. "l'amour et la vie d'une femme." See Hélène Toussaint's analysis in Paris, London 1977–78, pp. 161–62.

Fig. 283 (cat. 58). Edgar Degas, *L'Amateur d'estampes* (The Collector of Prints), 1866.
Oil on canvas, 20⅞ x 15¾ in. (53 x 40 cm). The Metropolitan Museum of Art, New York,
H. O. Havemeyer Collection, Bequest of Mrs. H. O. Havemeyer, 1929

69. "C'est grâce à vous qu'il a enfin produit une oeuvre finie, un vrai tableau!" Lemoisne 1946–49, vol. 2, no. 186.
70. "Notre Raphaël travaille toujours mais n'a encore rien produit d'achevé, cependant les années passent." Ibid., vol. 1, p. 41.
71. "faire des portraits des gens dans des attitudes familières et typiques, surtout donner à leur figure les mêmes choix d'expression qu'on donne à leur corps." Reff 1985, notebook 23, pp. 46–47.

thanks to you that he has finally produced a work, a real painting!"⁶⁹ This was a belated (and unwarranted) rejoinder to Auguste De Gas's comment in November 1861: "Our Raphael is still working but has completed nothing so far, yet the years march on."⁷⁰ The Degas family had reasons to be satisfied: *L'Orchestre de l'Opéra* was the work that expressed most faithfully and in the most complex manner Degas's portraiture ambitions in the late 1860s: "To do portraits of people in familiar and typical attitudes—above all, to give their countenances the same range of expression as their bodies."⁷¹

Despite the presence of other individualized players, this is no group portrait like the various tributes produced by Fantin-Latour. Instead it is the portrait of an individual in a group. The deliberate

Fig. 284 (cat. 68). Edgar Degas, *L'Orchestre de l'Opéra (Portrait de Désiré Dihau)* (The Orchestra of the Opéra [*Portrait of Désiré Dihau*]), ca. 1870. Oil on canvas, 22¼ x 18¼ in. (56.5 x 46.2 cm). Musée d'Orsay, Paris

realism actually takes a few liberties, transforming the orchestra of the Opéra into a fantasy orchestra: in order to focus on the sitter, Degas turned the traditional arrangement around by moving the bassoon to the front (it is usually concealed behind a wall of cellos and contrabasses).

Once this formula was perfected, it allowed for variations: the portrait of Désiré Dihau is the prototype of numerous works in which Degas makes stage and orchestra pit confront each other. Begun shortly after this work but not completed until four or five years later, *Musiciens à l'orchestre* (fig. 285), with an identical composition, shows what separates a portrait from a scene of modern life. Here Degas, in the front row of the audience, uses a narrow view-

Fig. 285. Edgar Degas, *Musiciens à l'orchestre* (Orchestra Musicians), 1870; retouched ca. 1875. Oil on canvas, 27⅛ x 19¼ in. (69 x 49 cm). Städelsches Kunstinstitut, Frankfurt

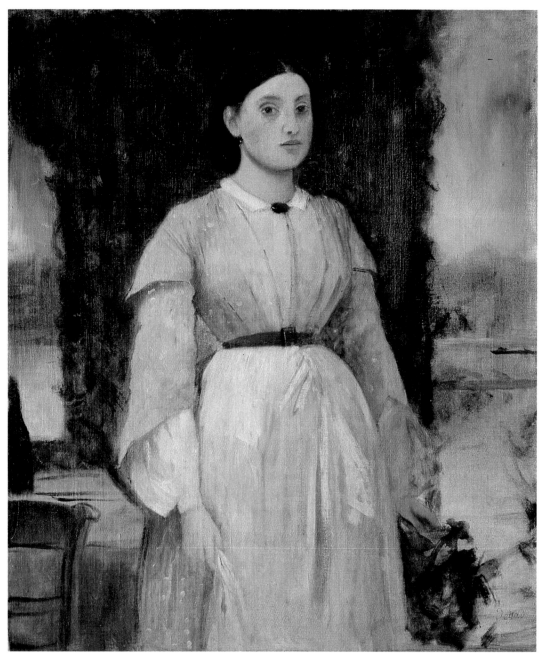

Fig. 286 (cat. 60). Edgar Degas, *Jeune Femme debout près d'une table* (*Young Woman Standing near a Table*), ca. 1867–68. Oil on canvas, 22½ x 19¼ in. (57 x 49 cm). Musée National des Beaux-Arts, Algiers

point, concentrating on the bizarre effects and oppositions that result. There are differences in scale (three men in half-length, seven ballerinas in full-length); differences in illumination (the pinpoint lights of the musicians' desks, the diffuse light of the stage); and differences in technique (the smooth, precise treatment of the instrumentalists, the lighter, swifter, more vibrant handling of the dancers). As in some medieval paintings, two worlds are juxtaposed and compartmentalized—barely linked by bassoon, bows, and heads: black-clad musicians in the somber river Acheron and women twisting and turning like angels in an Eden of painted canvases.

By the end of the 1860s Degas, constantly reflecting on the portrait, became "the philanthropist of art" (as Duranty would hail him in

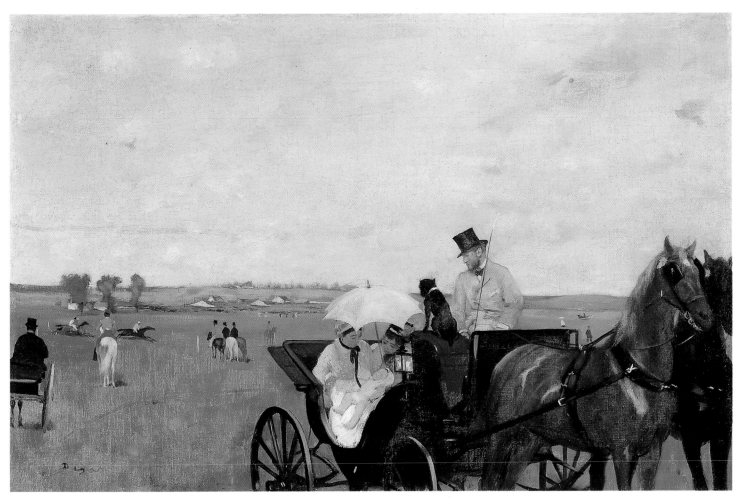

Fig. 287 (cat. 66). Edgar Degas, *Aux courses en province* (*At the Races in the Countryside*), 1869. Oil on canvas, 14⅜ x 22 in. (36.5 x 55.9 cm). Museum of Fine Arts, Boston, 1931, Purchase Fund

1876 at the time of the second Impressionist exhibition)—the source of most new ideas, the man who first thought of "removing the wall between the studio and everyday life, [of] getting the painter away from his cell, out of his monastery, where he relates only to the sky, and taking him among people, into the world." By 1870 Degas had presented, in his portraiture, the entire program of the New Painting: "We want a back to reveal a temperament, an age, a social standing; a pair of hands to express a magistrate or a businessman; a gesture to disclose a whole set of feelings. The physiognomy will tell us that this man must be cold, orderly, and meticulous, while that man is the epitome of disorder and carelessness. Their attitude will teach us that one person is off to a business meeting while another is about to go to an assignation."[72]

Degas went to unexpected lengths; in 1867–68, in an escapade in the Impressionist style, he painted a serving girl on a riverside restaurant terrace on the outskirts of Paris (fig. 286). However, the

72. "philanthrope de l'art"; "d'enlever la cloison qui sépare l'atelier de la vie commune, [de] faire sortir le peintre de sa tabatière, de son cloître où il n'est en relation qu'avec le ciel, et le ramener parmi les hommes, dans le monde"; "Avec un dos, nous voulons que se révèle un tempérament, un âge, un état social; par une paire de mains, nous devons exprimer un magistrat ou un commerçant; par un geste, toute une suite de sentiments. La physionomie nous dira qu'à coup sûr celui-ci est un homme rangé, sec et méticuleux, et que celui-là est l'insouciance et le désordre même. L'attitude nous apprendra que ce personnage va à un rendez-vous d'affaires, et que cet autre revient d'un rendez-vous d'amour." Duranty in Washington, San Francisco 1986, pp. 481–82.

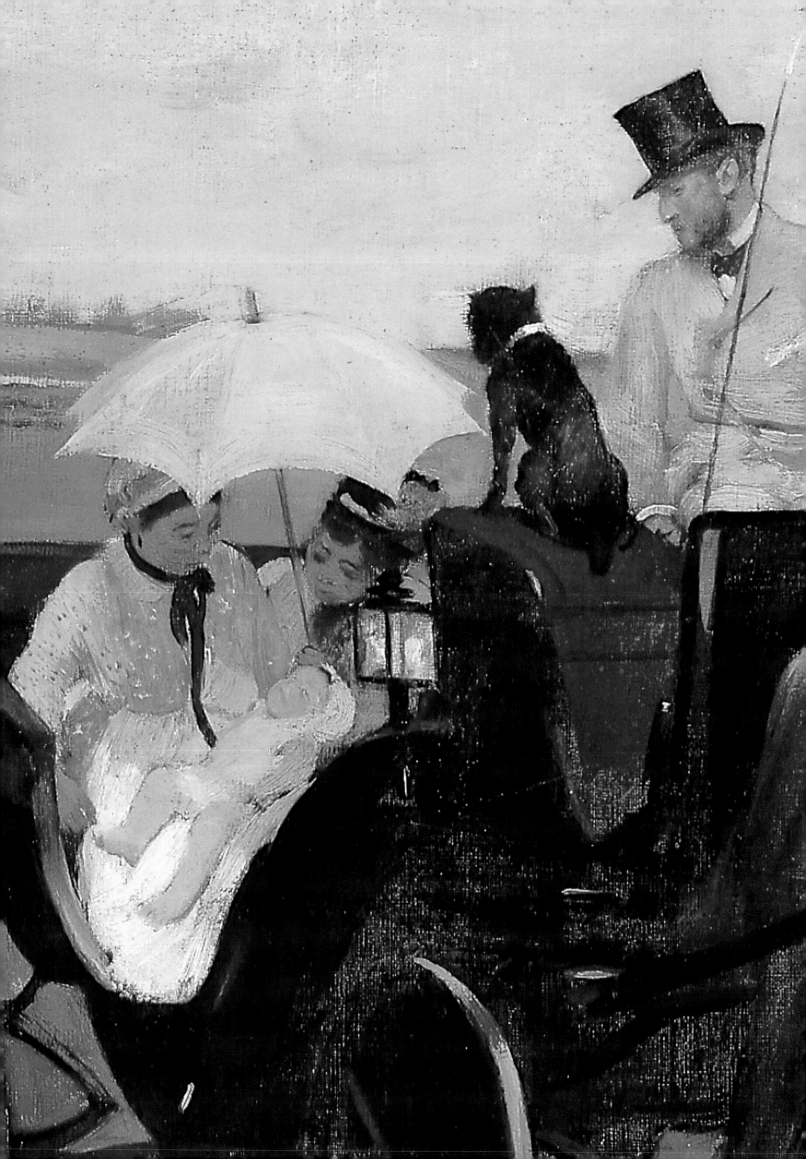

plein air picture, so unusual for him, concentrates on two things: the dark, compact background of a verdant bower and through the arches, which are like the narrow windows of an early Renaissance painting, a thin stretch of landscape, wooded riverbanks, and still water on which two yawls lie spellbound. Degas never completed this amazing portrait—perhaps because he was baffled by the Renoiresque subject, perhaps because he was unaccustomed to the changing light effects, perhaps because he was dissatisfied with the overly rigid pose.

A year or two later, after spending several weeks on the Normandy coast during the summer of 1869, Degas stayed with his friends the Valpinçons at their estate in Orne. During this happy visit he did a small painting (fig. 287) of their outing to the nearby racecourse in Argentan. This family portrait, like an informal vacation photo, is far livelier and ultimately more moving than any posed figures. With *Aux courses en province* Degas pulled off something that he had missed in his *Jeune femme debout près d'une table* (fig. 286). The distance between these two paintings is comparable to that between Renoir's *Les Fiancés* (fig. 247) and *La Promenade* (fig. 178), between a portrait staged in an artifical plein air setting and the snapshot of a country excursion. Then one remembers: Paul had brought out the victoria, which he drove himself; his wife sat in back, her parasol shading the wetnurse and the baby. Close to the racetrack, they stopped to feed the infant. In front of a clump of trees and some low houses, three horses were galloping for a scattered audience—squires from the surrounding area and a soldier in vermilion trousers. The day was beautiful, not too hot, the sky was blue and light, thickening here and there with a few clouds.

Edgar Degas, *Aux courses en province*, detail of fig. 287

VIII
The Impressionist Landscape

GARY TINTEROW

"In the same way as there were avalanches of *pifferaro* in painting in 1820, a torrent of Greeks and Turks in 1828, enough Bretons to inhabit all of Britanny around 1840, so many young chess players from 1840 to 1850 that they could fight against the battalions of Zouaves appearing in the Salons at the same time, today, in painting, we are threatened by a Japanese invasion."[1] By the end of 1868, Champfleury considered himself witness to an agreeable siege of aesthetic influence. The realist landscape (or naturalist—the terms had become virtually interchangeable) had evolved in the hands of the young generation, the successors to the Barbizon school. The palette was lightening, compositions were becoming more distinctive and unexpected, and subjects were inexorably unremarkable— ordinary scenes witnessed by ordinary people. Pictorial interest was shifting decisively from the subject depicted on a canvas to the means of representation.[2] Comparing the landscapes by Manet, Monet, Renoir, Sisley, Bazille, and Pissarro (Cézanne is the exception) made at the end of the 1860s to those made by them in the first years of the decade, one finds two features that were concomitant with these changes: the assimilation of *Japonisme* and the commitment to plein air painting. At first glance, it would seem that these factors would exclude one another. To paint out-of-doors means to paint precisely what you see in front of you, and to paint in a Japanese manner means to paint in a decidedly foreign, antinaturalist style, with new colors, without shadows, without single-point perspective. Oddly enough, the incorporation of lessons from Japanese color woodblock prints and the practice of painting out-of-doors brought about similar results: the new palettes, the new compositions, in short, the New Painting.

In February 1867, Manet's great friend Zacharie Astruc had already announced that the art of Japan had changed the face of painting. The color prints by Hokusai and Hiroshige, the illustrated albums by myriad artists great and small, the ceramics, bronzes, and

1. "De même qu'il y a eu en 1820 des avalanches de *pifferaro* en peinture, des déluges de Grecs et de Turcs en 1828, des Bretons en assez grande quantité vers 1840 pour peupler la Bretagne, de jeunes joueurs d'échecs si nombreux, de 1840 à 1850, qu'ils pouvaient lutter avec les bataillons de zouaves qui firent irruption aux Salons de la même époque, aujourd'hui nous sommes menacés d'une invasion japonaise en peinture." C.Y. [Champfleury], "La mode des japonaiseries," *La Vie parisienne*, November 21, 1868, p. 863.
2. Rosen and Zerner 1984, pp. 133–79, esp. pp. 149–50.

Fig. 288. Théodore Rousseau, *Village de Becquigny* (*Village of Becquigny*), Salon of 1864. Oil on panel, 25 x 39⅜ in. (63.5 x 100 cm). The Frick Collection, New York

3. "L'impression la plus profonde s'est traduite à Paris, dans les arts. N'est-ce pas, en définitive, un grand bonheur que les nouvelles inspirations demandées à ce peuple si éloigné, à cet Orient si différent de nous. Un lien tendait cependant à nous rapprocher: l'amour commun de la nature par lequel les modernes féconderont leurs travaux; l'inspiration demandée à la vérité, la nouveauté d'impressions si neuves, toujours intéressantes, pleines d'attraits et de sentiment. Quelques peintres se sont fortifiés de cette contemplation étendaient aussitôt leurs recherches.... Les paysagistes, bornés à quelques formules, à des types généraux qui sont comme des timbres usés peu intéressants, y trouvaient un champ plein de nuances." Zacharie Astruc, "Beaux-arts. L'empire du Soleil Levant," *L'Étendard*, February 27, 1867, p. 1.

lacquer boxes that had begun to trickle into Paris via the shops of Mme Desoye and La Porte Chinoise, where collectors like Whistler and Astruc would fight over the right of an acquisition, had begun to cast their spell.

The deepest impact was felt in Paris, in the arts. In the end, is it not a great good fortune that these new inspirations come from a people so far away and an Orient so different from us? A link, however, tended to bring us together: a common love for nature that will enrich the works of the moderns, an inspiration drawn from the truth and novelty of such new impressions, always interesting, full of attraction and sentiment. A few painters grew stronger from this contemplation and extended their research at once.... The landscape painters, limited to a few formulas, to general types resembling used and uninteresting stamps, found an entire field of nuances in it.[3]

Paradoxically, it was the realist painters who responded so enthusiastically to this enticing new art, and age was not the issue. The elders of Barbizon were as fascinated as the artists in their twenties.

A new event in the history of art gave [Théodore] Rousseau's excitement a new direction: the discovery of Japanese art, whose arrival moved the French artists like the vision of a meteor. The art of Japan, stemming from the islands of the Vermilion Sea like a volcanic eruption, presented itself to Rousseau in its most perfect individuality; a logical and sincere product from the land of light, not like the impersonal oeuvre of many artists, but like a fruit from the land of magic, spirits and supernatural generations. In it, Rousseau found the exact configuration of the drawing, a summary of horizons and planes, splendor in the color, the phosphorescence of the atmosphere, the simplicity of manner, the unexpected, the novelty and audacity of the compositions. He had before his eyes a telling formula summarizing in a thousand ways his own research on the modeling of light that Japanese art applied even to popular images.

This remembrance of the impact of Japanese prints on Rousseau was written only five years after his death by the artist's biographer Alfred Sensier; in 1872 the first wave of *Japonisme* was still riding high. Sensier left a valuable description of the specific changes that Japanese art brought to Rousseau in 1863:

He changed the entire harmony of his *Village* [fig. 288]; from soft and southern, he imagined a sky as blue as the colored sapphires of the Orient, like the intense flames of aurorae boreales. He repainted the sky, he polished its reflections, its lights, he left only

the outlines of his former village. Everything except the remaining form of the original shapes became Japanese through the mode of coloration. He patiently polished and successively applied a light and fair modeling, almost immaterial, allowing him to delicately grasp the substantial form of the invisible life in the air; then, he reworked his painting to give body and shadowy vigor to this world of vegetation; he always kept in mind the implacable light of Japan and its celestial intensities; its deep blues, its rosy dawns like a corrosive sublimity; this work interested him so much that he was forgetting his most pressing affairs.[4]

Rousseau's Barbizon compatriot Jean-François Millet was equally fascinated with the novelty of Japanese art, but the true transformation occurred in the paintings of Manet and Whistler around 1864 and 1865. In their seascapes one finds the "implacable light of Japan and its celestial intensities." Although some modern writers choose not to see it,[5] Manet's marines of 1864 show him grappling with Japanese art. True, he took pains in *Le Combat des navires américains "Kearsarge" et "Alabama"* (fig. 62) to accurately portray the vessels, their rigging, their flags, which he saw only after he had begun the painting. But the high horizon, asymmetrical composition, and bright color—especially the strange turquoise of the water—betray Manet's interest in Japanese art. The difference is all the more remarkable in the context of the dark palettes of his contemporary paintings— for example, *Olympia, Les Anges au tombeau du Christ, Fruits* (figs. 146, 68, 188), which maintain a dialogue with the art of Italian, Spanish, and French old masters. The brilliant *Combat des navires* has nothing to do with monochrome marines of the Dutch Golden Age, and *Le "Kearsarge" à Boulogne* (fig. 289) and *Vue de mer, temps calme* (fig. 291) come even closer to the style of Japanese prints. In *Vue de mer*, painted in the studio, from memory, the abbreviated drawing of the sailboats and, above all, the uniform treatment of the water, without the distinctions of foreground and background that Manet made in the *Combat des navires*, are unmistakably *japonisant*. Knowledgeable observers like Théodore Duret and other painters, such as Monet, recognized the origin of these new features and appreciated their potential. "Among living artists, no one contributed more than Manet in inspiring a taste for light painting."[6] But even less knowledgeable commentators understood that these new elements posed a threat to traditional Western conventions of representation. The caricaturist Stop made this clear when he wrote, upon seeing the *Combat des navires* at the Salon of 1872: "Untroubled by the vulgar bourgeois laws of perspective, M. Manet conceives the clever idea of giving us a vertical section of the Ocean, so that we may read the physiognomy of the fishes for their impressions of the conflict taking place above their heads."[7]

4. "Un événement nouveau dans l'histoire de l'art vint donner aux agitations de Rousseau une nouvelle carrière: ce fut la découverte de l'art japonais, dont les artistes français furent émus comme l'apparition d'un météore. L'art japonais, sorti comme une éruption volcanique des îles de la mer Vermeille, se présenta à Rousseau dans sa plus parfaite individualité; un produit logique et franc des contrées de la lumière, comme une émanation impersonnelle d'artistes, mais comme un fruit du pays des enchantements, des génies et des fabuleuses générations. Rousseau y trouvait la configuration exacte du dessin, le résumé des horizons et des plans, la splendeur des couleurs, la phosphorescence de l'atmosphère, la simplicité du procédé, l'imprévu, la nouveauté et l'audace des compositions. Il avait sous les yeux une formule parlante, qui resumait, en mille aspects, ses recherches sur le modelé de la lumière appliqué jusqu'aux images populaires en pays japonais." "Il changea toute l'harmonie de son *Village*; de doux et septentrional qu'il était, il rêva un ciel bleu comme les saphirs colorés de l'Orient, comme les flammes ardentes des aurores boréales. Il refit ce ciel, il repeignit ses reflets, ses lumières, il ne laissa de son ancien village que les silhouettes. Tout excepté la forme arrêtée des configurations mères, devint japonais par le mode des colorations. Il repeignait patiemment et faisait passer successivement par le modelé clair, blond, presque immatériel, voulant saisir avec délicatesse la forme substantielle au milieu de la vie invisible des airs; puis revenant après par un autre travail pour donner un corps, une vigueur ombreuse à ce monde des végétations; ayant toujours en vue la lumière implacable du Japon, ses intensités célestes; ses bleus profonds, ses aurores rosées comme un sublime corrosif; ce travail le passionnait au point d'oublier ses affaires les plus inquiétantes." Sensier 1872, pp. 271–72, 276–77.
5. Paris, New York 1983, pp. 218–19.
6. "Parmi les vivants, personne n'aura plus contribué qu'Édouard Manet donner le goût de la peinture claire." Théodore Duret, introduction to *Le peintre Claude Monet*, catalogue of an exhibition at *La Vie moderne*, Paris, June 7– , 1880, pp. 7–9 (reprinted in Paris, Tokyo 1988, p. 132).

Fig. 289 (cat. 100). Édouard Manet, *Bateau de pêche arrivant vent arriere (Le "Kearsarge" à Boulogne) (Fishing Boat Coming in before the Wind [The "Kearsarge" at Boulogne])*, 1864. Oil on canvas, 31⅞ x 39⅛ in. (81 x 99.4 cm). Private collection

7. "Sans se préoccuper des lois vulgaires et bourgeoises de la perspective, M. Manet a eu l'ingénieuse idée de nous donner une coupe verticale de l'Océan, de sorte que nous pouvons lire sur la physionomie des poissons leurs impressions pendant le combat qui a lieu sur leurs têtes." Stop, *Le Journal amusant*, May 23, 1872, quoted in Paris, New York 1983, no. 83, p. 219.

8. "L'Américain avait son atelier à Londres, on le voyait chez 'la Japonaise' aussi souvent que s'il eût demeuré à Neuilly; meubles et cabinets, il les expédiait en Angleterre avec la même facilité que s'il les eût confiés aux crochets d'un commissionnaire du coin de la rue. Les prêches du poète, les achats du peintre furent résumés en des peintures franco-américaines si bizarres qu'elles troublèrent les yeux des gens assez naïfs pour rechercher les fonctions de jurés aux expositions de peinture: comme ces colorations étaient distinguées et nouvelles, on leur ferma les portes au nez. Peut-être quelques-uns les ont-ils remarquées dans les salles des Refusés. Le résultat fut celui-ci: le Japon contesté fit école." Champfleury, "La mode des japonaiseries" (see note 1 above), p. 863.

Manet exhibited all three of these 1864 marines in his private exhibition of 1867, where Monet, among others, saw them. The *Combat des navires* was briefly shown at Cadart's in 1865. Manet evidently intended to exhibit *Le "Kearsarge" à Boulogne* and *Vue de mer* at Martinet's that same year, but it appears that he did not. Nevertheless when Whistler worked at Trouville in summer 1865, his marines exploited effects very similar to those of Manet.

Whistler, a friend of Manet's friends Félix Bracquemond and Henri Fantin-Latour, was much more caught up in "japanomania" than Manet ever was. Champfleury described his fever thus:

The American had his studio in London but he could be seen in the shop of "the Japanese woman" [Mme Desoye] as often as if he had lived in Neuilly; he shipped furniture and cabinets to England as easily as if he had entrusted them to a local commission agent. The poet's [Astruc] sermons and the painter's purchases were summarized in Franco-American paintings so bizarre that they confused the eyes of people naive enough to want to serve on the jury of painting exhibitions: since these colorings were distinct and new, the door was shut in their face. Perhaps some peo-

Fig. 290 (cat. 192). James McNeill Whistler, *Trouville (Grey and Green, the Silver Sea)*, 1865. Oil on canvas, 20¼ x 30⅜ in. (51.1 x 76.9 cm). The Art Institute of Chicago, Potter Palmer Collection, 1922

ple noticed them in the galleries of the [Salon des] Refusés. The result was as follows: Japan, contested, became a school.[8]

Champfleury may have remembered Whistler's *Young Girl in White* (fig. 249) at the Salon des Refusés, but that work was an essay in Rossettian Pre-Raphaelitism compared to his major figure paintings of 1864, all of which included explicit references to oriental art. *The Lange Leizen of the Six Marks, The Little White Girl, La Princesse du pays de la porcelaine, The Golden Screen* all conspicuously display Whistler's collection of Chinese and Japanese porcelains, screens, lacquer ware, rugs, and woodblock prints. But with the partial exception of *The Golden Screen*, the figure paintings were not made according to the principles of Oriental—or, more to the point, Japanese—art. Rather they are packed with an assortment, a very heteroclite assortment, of oriental art objects—"the painter's purchases." At Trouville, however, Whistler applied what he had observed from the landscapes of Hiroshige (figs. 299–301) and Hokusai to the making of pictures of the English Channel. Some, such as *Trouville* (fig. 290), have summarily painted boats skiting over a flat sheet of water in a manner very similar to Manet's *Vue de mer*. Oth-

Fig. 291. Édouard Manet, *Le Steam-Boat, marine (Vue de mer, temps calme) (Steamboat, Seascape [Sea View, Calm Weather])*, 1864–65. Oil on canvas, 29⅛ x 36⅝ in. (74 x 93 cm). The Art Institute of Chicago

Fig. 292 (cat. 193). James McNeill Whistler, *Sea and Rain*, 1865. Oil on canvas, 20⅛ x 28⅞ in. (51 x 73.4 cm).
The University of Michigan Museum of Art, Ann Arbor, Bequest of Margaret Watson Parker, 1955

Fig. 295. Gustave Courbet, *Les Bords de la mer à Palavas* (*The Shore at Palavas*), 1854. Oil on canvas, 10⅝ x 18⅛ in. (27 x 46 cm). Musée Fabre, Montpellier

9. Courbet 1992, letter 65-16, pp. 268–69.
10. Courbet 1992, letter 77-9, p. 601.

ers, such as *Sea and Rain* (fig. 292), are painted in horizontal bands of subtly modulated hues which look as if they had been printed with a color woodblock. But *Sea and Rain* and *Harmony in Blue and Silver* (Isabella Stewart Gardner Museum, Boston) have traditionally been discussed in comparison to Courbet's marines rather than *Japonisme*, and there are interesting distinctions to be made between the two operative influences on Whistler at this time.

There can be no doubt that *Harmony in Blue and Silver* and perhaps even *Sea and Rain* were intended as homages to Courbet, and they may have even been painted in his presence. Courbet arrived in Trouville in August 1865: "As usual I went to Trouville for three days and stayed for three months." In a letter to his parents he bragged that he had received over two thousand ladies in his studio, cured his constipation, and painted thirty-five canvases, "which has astonished everyone." He mentioned that he was there "with the painter Whistler... an Englishman who is my student."9 "Do you remember Trouville," Courbet wrote Whistler in 1877, "and Jo who clowned around to amuse us? In the evenings she used to sing Irish songs so beautifully, she had a feeling and talent for art."10 (Jo Hiffernan, an Irish painter who was Whistler's model and companion, began to have an affair with Courbet at Trouville.) As many historians have noted, there is a similarity between Courbet's 1854

Fig. 293 (cat. 44). Gustave Courbet, *La Trombe* (*Marine*), 1865. Oil on canvas mounted on cardboard. 17 x 25⅞ in. (43.2 x 65.7 cm). The John G. Johnson Collection, Philadelphia Museum of Art

Fig. 294 (cat. 47). Gustave Courbet, *Mer calme* (*The Calm Sea*), 1869. Oil on canvas, 23½ x 28¾ in. (59.7 x 73 cm). The Metropolitan Museum of Art, New York, H. O. Havemeyer Collection, Bequest of Mrs. H. O. Havemeyer, 1929

Fig. 296. James McNeill Whistler, *Blue and Silver: The Blue Wave, Biarritz*, 1862. Oil on canvas, 24 x 34½ in. (61 x 87.6 cm). Hill-Stead Museum, Farmington

Fig. 297. Amedée, comte de Noé, called Cham, "Gustave Courbet proves that the sea is made of the same material as the ships." Caricature published in *Le Monde illustré*, 1870, p. 365

Fig. 298. Stock, "The Wave by Courbet. May I offer you a slice of this light painting...." Caricature published in *Stock Album*, 1870

11. Cham (fig. 297): "Gustave Courbet prouve que la mer est faite de la même matière que les bateaux," *Le Monde illustré*, 1870, p. 365. Stock (fig. 298): "La Vague par Courbet. Permettez-moi de vous offrir une tranche de cette peinture légère...," *Stock Album*, 1870. Reproduced in Klaus Herding, *Courbet: To Venture Independence* (New Haven and London, 1991), p. 162, figs. 72, 73.
12. Cited in House 1986, p. 147.

Bords de la mer à Palavas (fig. 295) and Whistler's Trouville marines, a similarity that cannot be coincidental. But Courbet's *Bords de la mer* is exceptional in his oeuvre. Typical works, such as *La Trombe* (fig. 293), painted in 1865, or *Mer calme* (fig. 294) of 1869, with their careful attention to details such as cloud formations and wave patterns, have a meteorological specificity that is close in spirit to Gustave Le Gray's marine photographs. Whistler's 1865 marines resemble Courbet's in their common structure: horizontal bands of shore, sea, and sky in which the illusion of recession to the horizon is minimized. The crucial difference resides in the application of paint. Courbet's is muscular, applied thickly with either a knife or a stiff brush, whereas Whistler used gossamer thin glazes that suggest veils of atmosphere. Whistler's 1862 *Blue Wave, Biarritz* (fig. 296) is an exercise in a Courbet-like marine, and its earthy palette, frothy waves, and changing sky stand in marked contrast to his *japonisant* marines of 1864. That the materiality of paint was the essential feature of Courbet's marines is borne out by caricatures published in 1870 (figs. 297, 298).[11] Courbet's art was material, while Whistler's, inspired by the Japanese art he collected, sought immateriality.

After Jo Hiffernan left Whistler for Courbet, Whistler left Europe for a long voyage to Chile, ostensibly to aid in the uprising there. At Valparaiso in 1866 he painted his first nocturnes—he called them moonlights—and they are intimately bound up with his *Japonisme*. (Unfortunately, none could be obtained for the present exhibition.) Extending the near monochromy of the daylight marines, his veils of color turned inky and mysterious, evocative of the experience of an effect of nature without the tediousness of descriptive detail. That same year Monet painted a nocturne, *Marine: effet de nuit* (fig. 304), a natural corollary to his daylight harbor views. The *Effet de nuit* is one of only three paintings that Monet executed with a palette knife—the others are *La Vague verte* and *Marine: orage* (figs. 303, 302). Like Whistler's 1865 marines, these three paintings all display *japonisant* compositions and moods (see, for comparison Hiroshige's *Fireworks, Ryogoku* and *Whirlpool*, figs. 299, 300) while simultaneously referring to Courbet's works. According to Roger Marx, Monet painted marines with a palette knife in the presence of Zacharie Astruc at Ville-d'Avray. This probably occurred in 1866, and since only three palette-knife paintings are known, there can be little doubt about which they are. Roger Marx quoted a letter by Monet in which he referred to these paintings and said, "It was like a conversation painted in obedience to memories of my youth spent in Le Havre, as they rose before me."[12] As John House noted, such bravado was typical of Courbet, and Monet was as close to Courbet at this time as he would ever be—so close in fact that he felt free to

write the Master of Ornans in June 1866 to beg for money: "You who know, my dear friend, what it is to be a painter, you can understand my predicament better than anyone."[13] It is a curious paradox that Courbet the realist was associated with painting from memory, but he had no commitment to plein air painting. Indeed, upon visiting Monet one day and finding that due to a gray sky he was not at work on his enormous *Femmes au jardin* (fig. 175), Courbet said, "It doesn't matter, you can work on the landscape."[14] For Courbet, realism was the visualization of the real world rather than a slavish copy of nature.[15]

"I greatly admire moonlights and from time to time have made studies of them," Monet told an interviewer in 1899, "but I have never finished any of these studies because I found it so difficult to paint nature at night."[16] Monet painted only one other nocturne, a harbor scene of 1874 (private collection). However he continued to draw inspiration from Japanese art, especially when he broadened his repertory of motifs in the 1880s and again in the first years of the twentieth century when he began to concentrate on his pool of water lilies. Monet bragged that he was a precocious collector of woodblock prints—"I was sixteen years old"[17]—but it is unlikely that he could have obtained them so soon after 1854, the year Japan began trading with the West. What is true is that his understanding of the possibilities that Japanese art held for invigorating the Western pictorial conventions was as profound as any artist—as much as that of Whistler or Van Gogh—and more sustained in his oeuvre than in that of any other.

Fig. 299. Ando Hiroshige, *Fireworks, Ryogoku*, from the series *One Hundred Views of Famous Places at Edo*, 1858. Color woodcut, 14⅜ x 9⅜ in. (36.5 x 23.8 cm). The Metropolitan Museum of Art, New York, Purchase, Joseph Pulitzer Bequest, 1913

13. "Vous qui savez, mon cher ami, ce que c'est que de faire de la peinture, vous êtes plus que personne à même de comprendre mes ennuis." Wildenstein 1991, letter 2682, p. 188.
14. "Ça ne fait rien, tu n'as qu'à travailler le paysage." Trévise 1927, p. 122.
15. Rosen and Zerner 1984, pp. 151–52.
16. Fuller 1899, p. 24.
17. "J'avais seize ans." Elder 1924, p. 64.

Fig. 300. Ando Hiroshige, *The Great Whirlpool of Naruto at Awa*, from the series *Famous Places in Sixty and Other Provinces*, 1853–56. Color woodcut, 12⅞ x 8¾ in. (32.7 x 22.1 cm). The Metropolitan Museum of Art, New York, Rogers Fund, 1919

Fig. 301. Ando Hiroshige, *Arai, Boats on the Sea*, from the series *Fifty-Three Views Along the Road to Tokaido*, 1841–42. Color woodcut, 7⅞ x 12⅝ in. (20 x 32 cm). The Metropolitan Museum of Art, New York, Purchase, Joseph Pulitzer Bequest, 1918

Fig. 302 (cat. 129). Claude Monet, *Marine: orage* (*Seascape: Storm*), 1866–67. Oil on canvas, 19⅜ x 25½ in. (48.9 x 64.8 cm). Sterling and Francine Clark Art Institute, Williamstown, Massachusetts

Fig. 303 (cat. 127). Claude Monet, *La Vague verte* (*The Green Wave*), 1866–67. Oil on canvas, 19⅛ x 25½ in. (48.6 x 64.8 cm). The Metropolitan Museum of Art, New York, H. O. Havemeyer Collection, Bequest of Mrs. H. O. Havemeyer, 1929

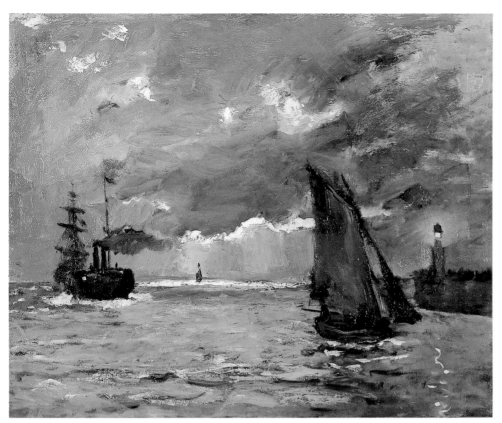

Fig. 304 (cat. 128). Claude Monet, *Marine: effet de nuit* (*Seascape, Shipping by Moonlight*), 1866–67. Oil on canvas, 23⅝ x 29 in. (60 x 73.8 cm). National Galleries of Scotland, Edinburgh

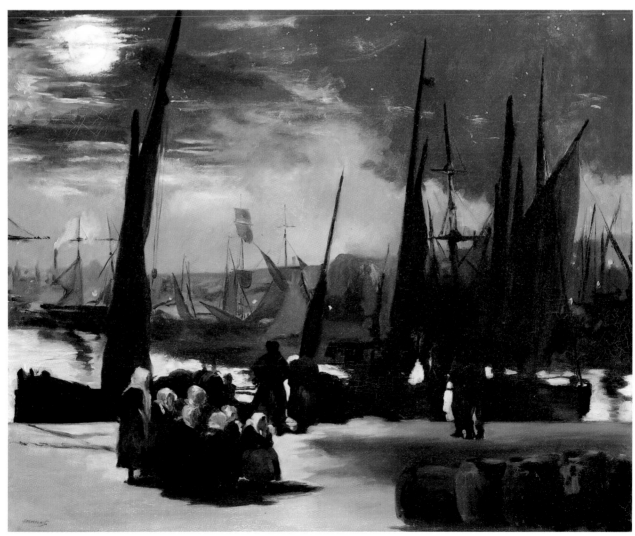

Fig. 305 (cat. 110). Édouard Manet, *Clair de lune* (*Moonlight in Boulogne*), 1868. Oil on canvas, 32¼ x 39¾ in. (82 x 101 cm). Musée d'Orsay, Paris

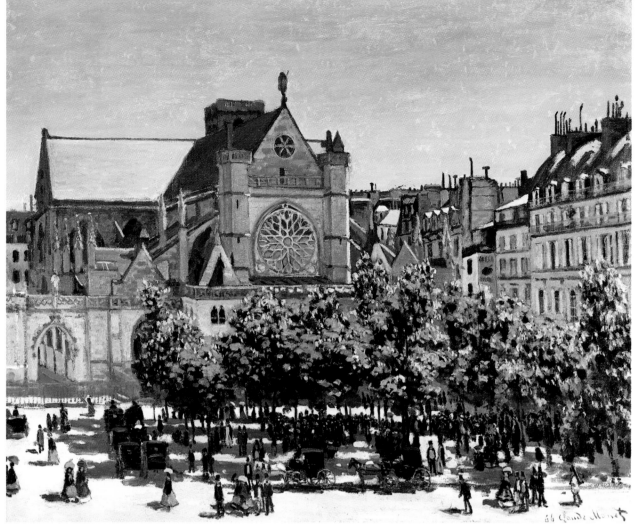

Fig. 306 (cat. 132). Claude Monet, *Saint-Germain-l'Auxerrois*, 1867. Oil on canvas, 31⅛ x 38⅝ in. (79 x 98 cm). Staatliche Museen zu Berlin, Nationalgalerie

Fig. 307. Auguste Renoir, *Le Pont des Arts*, 1867.
Oil on canvas, 24¼ x 40½ in. (61.6 x 102.9 cm).
The Norton Simon Foundation, Pasadena

18. "Je les dénichai au Havre, dans une boutique comme il
 y en avait jadis, où l'on brocantait les curiosités rapportées
 par les long-courriers." Elder 1924, p. 64.

Some sixty years after the fact, Monet remembered the pleasure of obtaining his first prints. "I found them at Le Havre, in a shop like the ones where, in the past, they used to sell curious objects brought back by the clippers."[18] But the most vivid description of the fascination that these works held for a young French painter is found in the Goncourts' *Manette Salomon*.

And a day from a magical country, a day without shadows and made entirely of light, arose for him [Coriolis] from these albums of Japanese drawings. His gaze penetrated the depth of the yellow skies, bathing the silhouettes of the creatures and countryside in a golden fluid; he lost himself in this sky where the pink blossoms of trees were drowning, in this blue enamel in which snowy flowers from the peach and almond trees were set, in these great crimson sunsets where the rays of a wheel of blood pro-

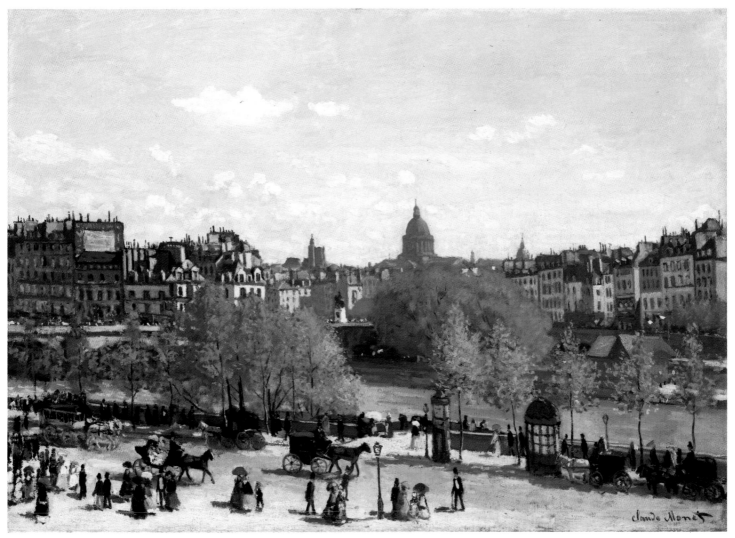

Fig. 308 (cat. 134). Claude Monet, *Le Quai du Louvre*, 1867. Oil on canvas, 25⅝ x 36⅝ in. (65 x 93 cm). Collection Haags Gemeentemuseum, The Hague

jected into the splendor of the stars, curtailed by the flight of traveling cranes.[19]

Théodore Duret, an admirer of Monet and Japanese art, saw color as the primary gift of Japanese art to France. "The arrival among us of Japanese albums and images completed the transformation by initiating us to an absolutely new system of coloring. Without the methods revealed by the Japanese, a whole array of [pictorial] means would have remained unknown to us."[20] One sees the new, high-pitched color in Monet's three city views of 1867 (figs. 306, 308, 309) in addition to a bird's-eye view and a plunging perspective that stand in marked contrast to the more conventional perspective of Renoir's contemporary city scene (fig. 307). The reduction of the figures to summary abbreviations, little silhouettes, in Monet's three urban views may also be a feature he took from Japanese prints.

19. "Et un jour de pays féerique, un jour sans ombre et qui n'était que lumière, se levait pour lui de ces albums de dessins japonais. Son regard entrait dans la profondeur de ces firmaments paille, baignant d'un fluide d'or la silhouette des êtres et des campagnes; il se perdait dans cet azur où se noyaient les floraisons roses des arbres, dans cet émail bleu sertissant les fleurs de neige des pêchers et des amandiers, dans ces grands couchers de soleil cramoisis et d'où partent les rayons d'une roue de sang dans la splendeur de ces astres écornés par le vol des grues voyageuses." Goncourt 1867, p. 175.
20. "L'apparition au milieu de nous des albums et des images japonais a achevé la transformation, en nous initiant à un système de coloration absolument nouveau. Sans les procédés qui nous ont été divulgués par les Japonais, tout un ensemble de moyens nous fût resté inconnu." Duret, introduction to *Le peintre Claude Monet* (see note 6 above).

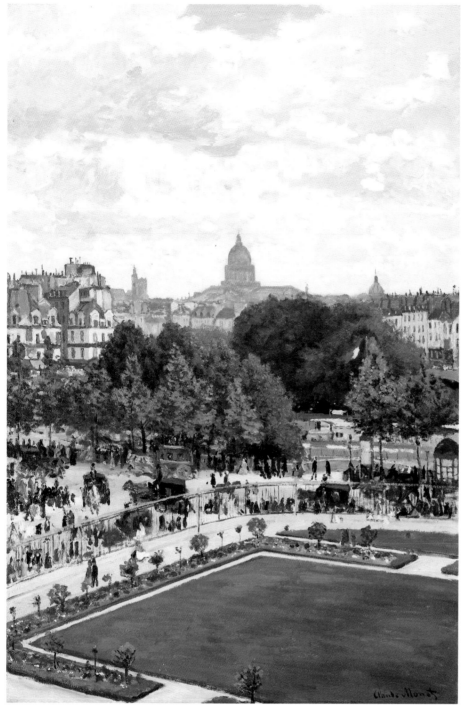

Fig. 309 (cat. 133). Claude Monet, *Le Jardin de l'Infante (Garden of the Princess, Louvre)*, 1867. Oil on canvas, 36⅛ x 24⅜ in. (91.8 x 61.9 cm). Collection of the Allen Art Museum, Oberlin College, Ohio, R. T. Miller, Jr., Fund, 1948

But the great demonstration piece of Monet's *Japonisme* was made in the summer of 1867, soon after he had had the opportunity to see the large exhibit of Japanese art at the Exposition Universelle, which opened in April.

Monet himself called *Jardin à Sainte-Adresse* (fig. 310) "the Chinese painting in which there are flags."[21] (The adjectives "Chinese" and "Japanese" were interchangeable then.) Although the painting does not seem to have been destined for the Salon (the paintings he planned for public exhibition were three to five times larger), it nev-

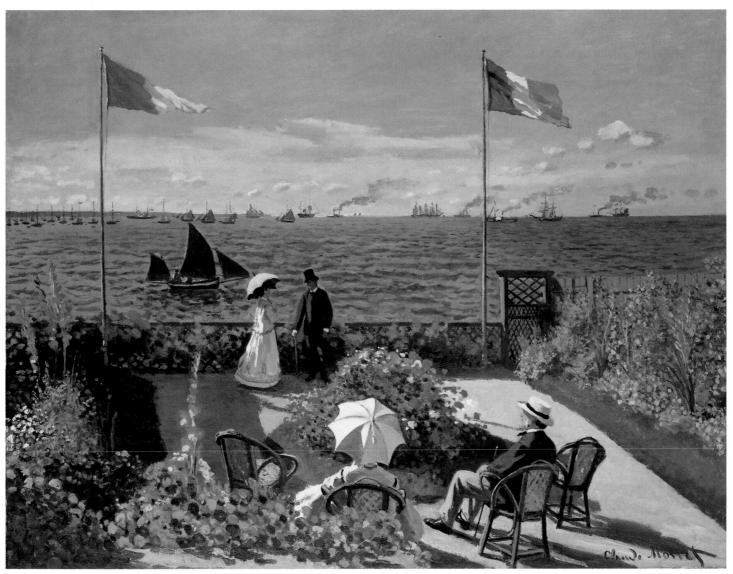

Fig. 310 (cat. 137). Claude Monet, *Jardin à Sainte-Adresse* (*Garden at Sainte-Adresse*), 1867. Oil on canvas, 38⅝ x 51⅛ in. (98.1 x 129.9 cm).
The Metropolitan Museum of Art, New York, Purchase, special contributions and funds given or bequeathed by friends of the Museum, 1967

ertheless has the appearance of a programmatic picture, designed
to assert his authority as a proponent of *Japonisme*. "At the time,"
Monet said, "this composition was considered very daring."[22] And
daring it was, with its bird's-eye point of view (Monet probably set
his easel next to a second-floor window of his father's house), its
split perspective (one vanishing point is behind the couple at the
fence, the other at the horizon), its division into three horizontal
zones stacked vertically (terrace, sea, and sky), its bright color and
brilliant contrasts (of yellow sunlight against blue-gray shadow, of

21. "Le tableau chinois où il y a des drapeaux." Monet to
Bazille, December 1868, Wildenstein 1974, letter 45,
p. 426.
22. "À l'époque, cette composition fut considérée comme
très osée." Gimpel 1963, p. 178. Translation from Gimpel
1966, p. 152.

vermilion gladiolus and orange nasturtiums against cool shadows or green foliage). Very likely, as John House has proposed,[23] Monet borrowed his composition from a Hokusai print which he owned, one that is still hanging in the dining room at Giverny: *The Sazaido of the Gohyaku Rakan-ji Temple* (fig. 311). But Monet's palette is even more audacious than Hokusai's, and his tilted perspective more unusual and antinatural. The *Jardin à Sainte-Adresse* was in every respect an extraordinary picture.

"In 1867, the Exposition put the finishing touch on the popularization of Japan."[24] On display was Hokusai's fourteen-volume *Manga*, a veritable catalogue of every possible human activity and animal movement, in addition to a dazzling assortment of screens, porcelains, and metalwork. Simultaneously Manet and Courbet mounted exhibitions of their own, and each would have important ramifications for the group of young painters in Monet's circle. Among many other works, Manet's *japonisant* marines (figs. 62, 289) were on view, confirming one avenue of exploration on which Monet had already embarked and indicating other possibilities. He wrote Bazille to say, "When I left [Paris], Manet's box office was becoming more successful, which will have done him a world of good, and also there are good things I did not know." Courbet's pavilion, to the contrary, was widely regarded as a disappointment. Even Monet, who was proud of his friendship with Courbet, said, "God, Courbet has shown us bad paintings. He really harmed himself, for he had enough beautiful works and did not need to show them all."[25] But among the novelties was a staggering five-meter canvas, *L'Hallali*

23. House 1986, p. 147.
24. "En 1867, l'Exposition acheva de mettre le Japon à la mode." Ernest Chesneau, "Le Japon à Paris," *Gazette des Beaux-Arts*, September 1, 1878, p. 387.
25. "Quand je suis parti, les recettes de Manet commençaient à devenir plus sérieuses, à lui cela aura fait un grand bien, et puis il y a des choses bien que je ne connaissais pas." "Dieu, que Courbet nous a sorti de mauvaises choses! Il s'est fait beaucoup de tort, car il avait assez des belles choses pour ne pas tout mettre." Wildenstein 1974, letter 33, p. 424.

Fig. 311. Katsushika Hokusai, *The Sazaido of the Gohyaku Rakan-ji Temple*, from the series *The Thirty-six Views of Mount Fuji*, 1829–33. Color woodcut, 9⅜ x 13½ in. (23.9 x 34.3 cm). Musée Claude Monet, Giverny

Fig. 312. Katsushika Hokusai, *Reconstruction of the Ponto de Sano in the Province of Kozuke*, from the series *The Astonishing Views of Famous Bridges in All the Provinces*, 1831–32. Color woodcut, 9⅝ x 14⅝ in. (24.5 x 37 cm). Musée Claude Monet, Giverny

Fig. 313 (cat. 46). Gustave Courbet, *La Pauvresse de village* (*The Poor Woman of the Village*), 1867. Oil on canvas, 34 x 50⅛ in. (86.3 x 127.4 cm). Private collection, Switzerland, courtesy of Galerie Schmit, Paris

du cerf (see cat. 46), a symphony, to borrow Whistler's terminology, in turquoise, brown, and white. There had been a great snowfall in the Ornans region over the winter of 1866–67, and Courbet celebrated it with some twenty "paysages de neige."[26] Under this new rubric (*L'Hallali du cerf*, on account of its importance, was called a "tableau"), he exhibited in his pavilion eleven works, including *La Pauvresse de village* (fig. 313), remarkable not only for the extraordinary treatment of the snow but also for the way the figures are silhouetted against the bright background.

Monet himself prepared five "paysages de neige" that same winter (see fig. 314). They seem to combine all the distinctive features of the emerging new aesthetic in that they refer simultaneously to Courbet's experiments in monochromy and heavy *empâtement*, to Japanese prints, and to pleinairism. Indeed it was Monet's dogged attachment to painting out-of-doors that made up an important part of his reputation in the 1860s. A writer from a newspaper in

26. Courbet 1992, letter 67-9, p. 309.

Honfleur described an encounter, probably in the winter of 1866–67: "It was cold enough to split rocks. We perceived a foot warmer, then an easel, then a gentleman bundled up in three overcoats, gloves on his hands, his face half-frozen; it was Monet studying an effect of snow."[27] Monet would carefully cultivate this reputation for the rest of his life. For centuries artists had painted oil sketches out-of-doors, and in the early nineteenth century Constable, for example, often painted a full-scale study (the equivalent in French would be an ébauche) in which he sought to capture his immediate sensation of nature before it was transformed into a painting for exhibition. But the attempt to bring exhibition paintings to completion out-of-doors was an entirely new phenomenon. Daubigny, as House has noted, completely painted out-of-doors his two-meter-wide canvas *Villerville-sur-Mer* (Rijksmuseum Hendrik Willem Mesdag, The Hague), which he exhibited at the Salon of 1864.[28] Monet countered with *Femmes au jardin* (fig. 175), which, with its multiple figures and huge scale, became a very difficult undertaking that he never again repeated. Nevertheless, Monet became indissolubly linked to the *appearance* of pleinairism. It is unlikely that the masterful *La Pie* (fig. 315) was painted entirely out-of-doors, but it was no doubt

27. "Il faisait un froid à fendre les cailloux. Nous apercevons une chaufferette, puis un chevalet, puis un monsieur emmailloté dans trois paletots, les mains gantées, la figure à moitié gelée: c'était M. Monet, étudiant un effet de neige." Léon Billot, "Exposition des Beaux-arts," *Journal du Havre*, October 9, 1868, reprinted in Charles Stuckey, *Monet a Retrospective* (New York, 1985), p. 40.
28. House 1986, p. 136.

Fig. 314 (cat. 139). Claude Monet. *La Route de la ferme Saint-Siméon, l'hiver* (*The Road from the Ferme Saint-Siméon, Winter*), 1867. Oil on canvas, 19 x 24⅞ in. (48.3 x 63.2 cm). Mrs. Alex Lewyt

Fig. 315 (cat. 144). Claude Monet, *La Pie* (*The Magpie*), 1869. Oil on canvas, 35 x 51⅛ in. (89 x 130 cm). Musée d'Orsay, Paris

begun outside, and the essential aspect of the picture was to repro-
duce, as faithfully as possible, the experience of being outdoors and
watching the play of cool shadows on the snow warmed by the rak-
ing sun. The fact that Monet brought the surface to a consistent
finish, while retaining the sense of fluid and informal brushwork,
indicates that he wanted to make this work a proper "tableau."[29]

This is the aesthetic that Monet brought to his colleagues Renoir,
Sisley, and Pissarro as he began to work more closely with them at
the end of the decade. At Louveciennes, Marly, and Bougival in
1868 and 1869, Monet and Pissarro, Renoir and Sisley, and later,
Monet and Renoir all worked out-of-doors together, attempting to
render their experiences, to capture on canvas their *impressions* of
effects of nature (figs. 316–22). As early as 1864, Monet described a
painting to Bazille as a "simple study... executed entirely after na-
ture" that had "a certain relationship to Corot, but without imitat-
ing him in any way. The motif and above all the quiet and vaporous

29. In her recent book on Impressionism, Norma Broude
rightly stresses the point that while the landscape paint-
ers increasingly exploited the aesthetic of pochades and
ébauches, they nevertheless continued to aspire, at least
during the 1860s, to the finished "tableau" worthy of
exhibition. See "Effect and Finish: The Evolution of the
Impressionist Style," in Broude 1991, pp. 69–110.

Fig. 316 (cat. 149). Claude Monet, *Route à Louveciennes, effet de neige* (*Road to Louveciennes, Effect of Snow*), 1869–70. Oil on canvas, 22 x 25¾ in. (55.9 x 65.4 cm). Private collection.

effect are the reasons for this. I executed it as conscientiously as possible without thinking of any other painting. Anyway, you know that that is not my habit."[30] Already then the motif, the subject depicted—the beach, the sea, the mountain, the field, the village road—was inferior to the "quiet and vaporous effect." By the end of the decade, the "effect" became the predominant subject.

It appears that the example of Japanese prints enabled the young landscapists to capture more successfully the effects that they experienced. Pissarro, for one, associated his snow scenes with *Japonisme*. In 1893, after seeing an exhibition of Japanese art in the company of Monet and Rodin, he wrote to his son to say: "Good God, this decides in our favor. There are some gray sunsets that are extraordinarily impressionist." The following day he wrote, "Hiroshige is a wonderful impressionist. Myself, Monet and Rodin are in raptures over him. I am glad to have made my effects of snow and flood; the Japanese artists give me confirmation of our visual choice."[31] Hence it is not only bright color and novel perspectives that came from Japanese prints, but also effects of subtle grays or monochromy.

The extraordinary paintings executed by Monet and Renoir at the bathing station La Grenouillère at Bougival exhibit qualities that

30. "simple étude . . . entièrement faite sur nature"; "un certain rapport avec Corot, mais c'est bien sans imitation aucune qu'il en est ainsi. Le motif et surtout l'effet calme et vaporeux en est seul la cause. Je l'ai faite aussi consciencieusement que possible sans penser à aucune peinture. Du reste vous savez que ce n'est pas mon système." Wildenstein 1974, letter 11, p. 421.

31. "Sapristi, c'est cela qui nous donne raison. Il y a des soleils couchants gris qui sont d'un impressionisme épatant." "Hiroshige est un impressionist merveilleux. Moi, Monet et Rodin en sommes enthousiastes. Je suis content d'avoir fait mes effets de neige et d'inondations; ces artistes japonais me confirment dans notre parti pris visuel." Pissarro 1988, letters 869, 870, pp. 308–9.

Fig. 317 (cat. 162). Camille Pissarro, *La Route de Versailles à Louveciennes (effet de neige)* (*The Versailles Road at Louveciennes [Snow]*), 1869. Oil on canvas, 15⅛ x 18¼ in. (38.4 x 46.3 cm). Courtesy of the Walters Art Gallery, Baltimore, Lent by the George A. Lucas Collection of the Maryland Institute, College of Art

Fig. 318 (cat. 163). Camille Pissarro, *La Route de Versailles à Louveciennes* (*The Versailles Road at Louveciennes*), 1870. Oil on canvas, 12⅞ x 16³⁄₁₆ in. (32.7 x 41.1 cm). Sterling and Francine Clark Art Institute, Williamstown (Massachusetts)

253

Fig. 319 (cat. 177). Auguste Renoir, *La Grenouillère*, 1869. Oil on canvas, 23¼ x 31½ in. (59 x 80 cm).
Pushkin State Museum of Fine Arts, Moscow

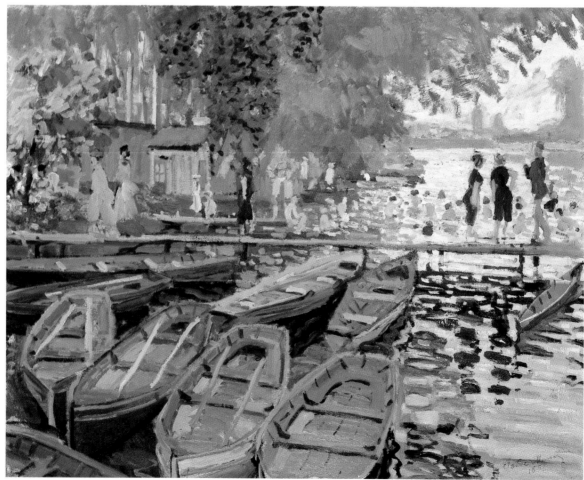

Fig. 320 (cat. 146). Claude Monet, *Les Bains de la Grenouillère*, 1869. Oil on canvas, 28¾ x 36¼ in. (73 x 92 cm).
The Trustees of the National Gallery, London

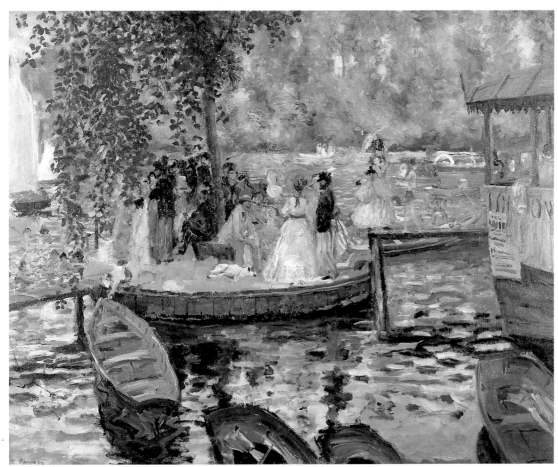

Fig. 321 (cat. 178). Auguste Renoir, *La Grenouillère*, 1869. Oil on canvas, 26⅛ x 31⅞ in. (66.5 x 81 cm).
Nationalmuseum, Stockholm

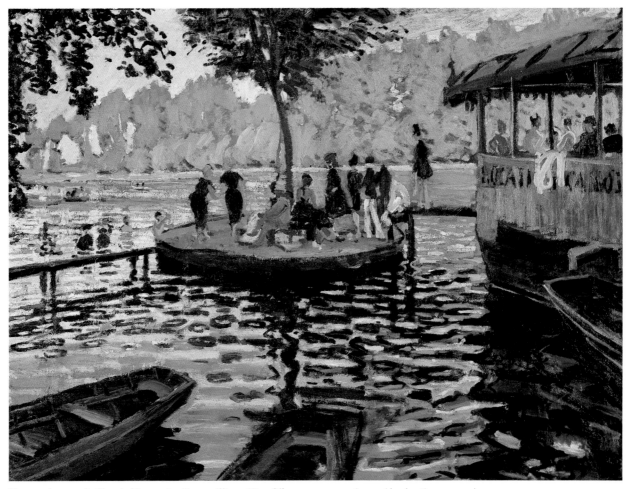

Fig. 322 (cat. 147). Claude Monet, *La Grenouillère*, 1869. Oil on canvas, 29⅜ x 39¼ in. (74.6 x 99.7 cm).
The Metropolitan Museum of Art, New York, H. O. Havemeyer Collection, Bequest of Mrs. H. O. Havemeyer, 1929

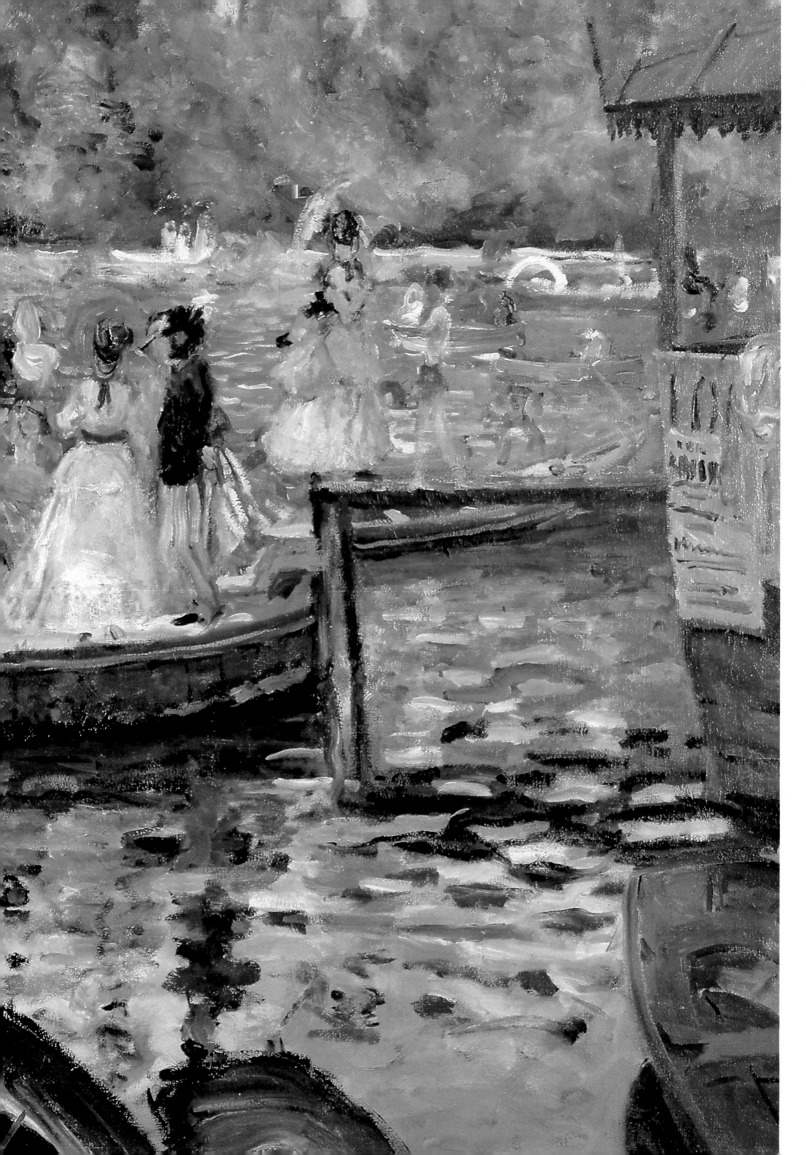

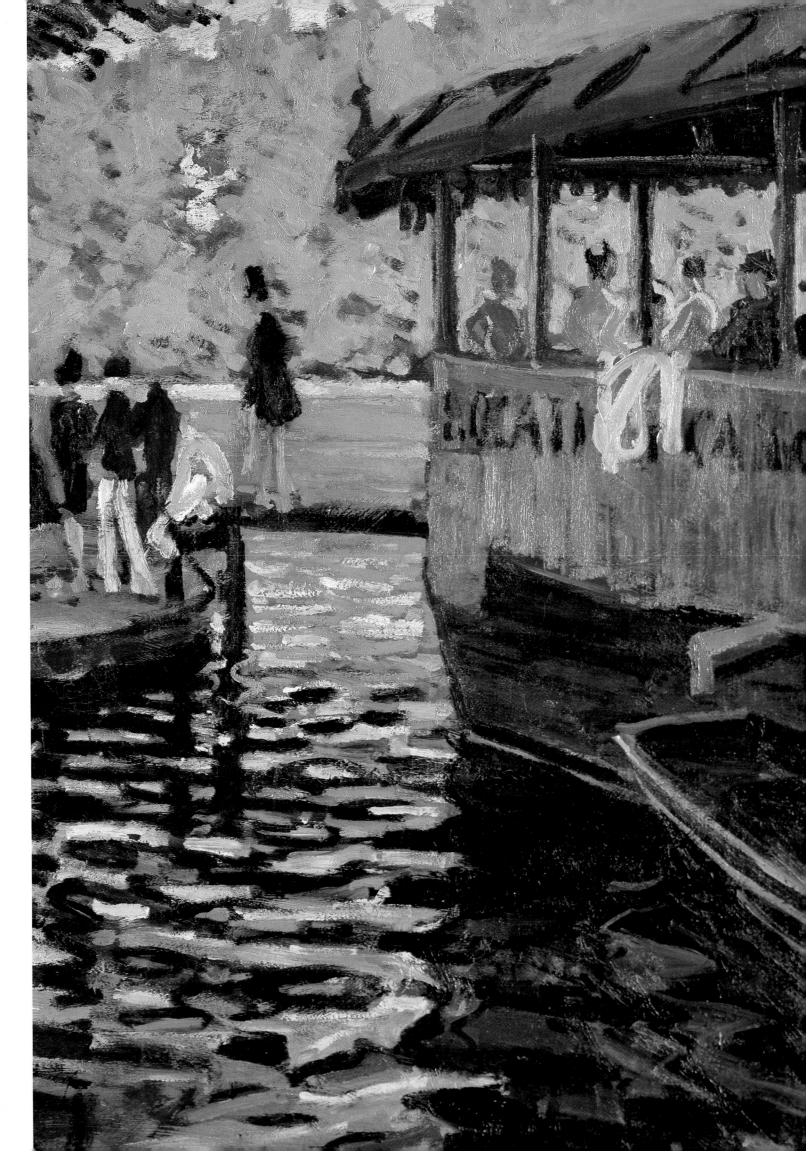

were perceived at the time to be Japanese (figs. 319–22). The subject, bathing scenes, was popular among ukiyo-e artists, and the colors seem artificially bright. But their most distinctive aspect, the depiction of myriad reflections in the water with broad, independent brushstrokes, may also derive in part from Japanese prints. In an essay of 1873, Armand Sylvestre, while actually speaking of different paintings, described very similar effects.

He [Monet] likes to juxtapose the multicolored reflections of the sunset, the colorful boats, the changing clouds onto slightly moving water. Metallic tonalities describing the polished surface of the water rippling in small uniform areas glitter on his canvases, and the image of the bank is quivering, with houses standing out clearly as in the children's game in which objects are reconstituted piece by piece. This effect, filled with an absolute truth and possibly borrowed from Japanese images, is so captivating for those of the young school that they repeat it constantly.

He then went on to mention Pissarro's contemporaneous work:

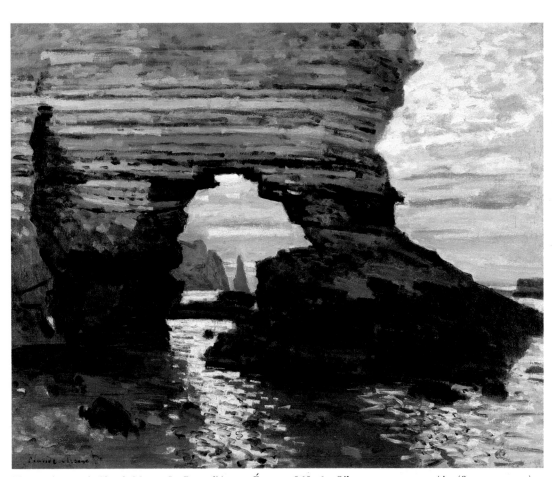

Page 256: Auguste Renoir,
La Grenouillère,
detail of fig. 321

Page 257: Claude Monet,
La Grenouillère,
detail of fig. 322

Fig. 323 (cat. 143). Claude Monet, *La Porte d'Amont, Étretat*, 1868–69. Oil on canvas, 32 x 39½ in. (81.3 x 100.3 cm). Fogg Art Museum, Harvard University Art Museums, Cambridge, Massachusetts, Gift of Mr. and Mrs. Joseph Pulitzer, Jr.

Claude Monet, *La Porte d'Amont, Étretat*, detail of fig. 323

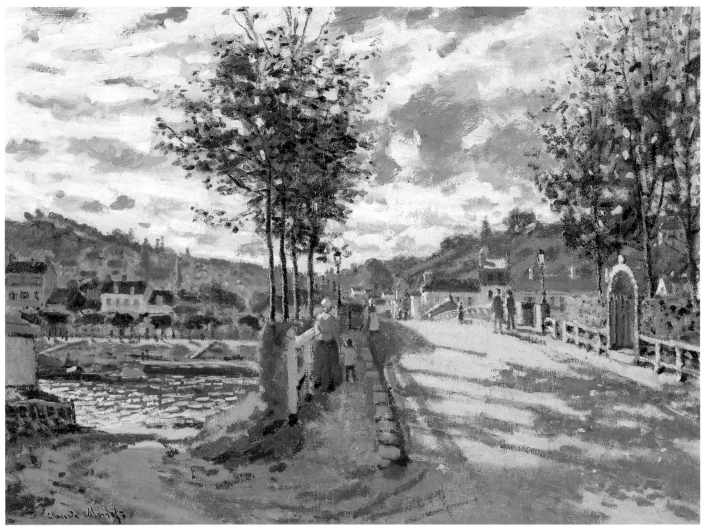

Fig. 324 (cat. 148). Claude Monet, *La Seine à Bougival* (*The Seine at Bougival*), 1869. Oil on canvas, 25 x 36 in. (63.5 x 91.4 cm). The Currier Gallery of Art, Manchester, New Hampshire, Currier Funds

32. "Il aime, sur une eau légèrement remuée, à juxtaposer les reflets multicolores du soleil couchant, des bateaux bariolés, de la nue changeante. Des tons métalliques dus au poli du flot qui clapote par petites surfaces unies miroitent sur ses toiles, et l'image de la rive y tremble, les maisons s'y découpant comme dans ce jeu d'enfants où les objets se reconstituent par morceaux. Cet effet, d'une vérité absolue et qui a pu être emprunté aux images japonaises, charme si fort la jeune école qu'elle y revient à tout propos." "Mais l'élément nouveau qu'elle rapporte vaut mieux que cet enfantillage. Les intérieurs de village de M. Pissarro sont un exemple bien plus compliqué des résultats qu'on en peut attendre. . . . Ce qui paraît devoir hâter le succès de ces derniers venus, c'est que leur tableaux sont peints dans une gamme singulièrement riante. Une lumière blonde les inonde, et tout y est gaieté, clarté, fête printanière, soirs d'or ou pommiers en fleurs.— Encore une inspiration du Japon." Armand Sylvestre, preface to Paris, London, Brussels, Galerie Durand-Ruel, 1873, *Receuil d'estampes gravées à l'eau-forte*, p. 23.

But the new element it brings forth is more valuable than this children's play. The interiors of villages painted by M. Pissarro are a far more complicated example of the results that may be expected from it. . . . The apparent reason behind the quick success of these latecomers is the fact that their works are executed in a particularly vivid range of colors. A blond light is flooding them, and everything is joy, brightness, spring feast, golden evenings or apple trees in bloom.—Again an inspiration from Japan.[32]

This blond light, and the concomitant broad touch, the aesthetic of the pochade, informed the work of all of the young avant-garde painters on the eve of the 1870 war. One finds it with Monet, on the cliffs at Étretat (fig. 323), on the bridge at Bougival (fig. 324), and on the beach of Trouville (figs. 327, 329); with Bazille, on the banks of the Lez (fig. 100); with Pissarro and Renoir, on the route de

Fig. 325 (cat. 179). Auguste Renoir, *Chemin à Louveciennes* (*Road at Louveciennes*), 1869 (?).
Oil on canvas, 15 x 18¼ in. (38.1 x 46.4 cm). The Metropolitan Museum of Art, New York,
The Lesley and Emma Sheafer Collection, Bequest of Emma A. Sheafer, 1973

Fig. 326 (cat. 164). Camille Pissarro, *Printemps à Louveciennes* (*Springtime in Louveciennes*), ca. 1870. Oil on canvas, 20¾ x 32¼ in. (52.7 x 81.9 cm).
The Trustees of the National Gallery, London, Lane Bequest

Fig. 327 (cat. 150). Claude Monet, *La Plage à Trouville* (*Beach at Trouville*), 1870. Oil on canvas, 21⅛ x 25⅝ in. (53.5 x 65 cm). Wadsworth Atheneum, Hartford, The Ella Gallup Sumner and Mary Catlin Sumner Collection Fund

Fig. 328 (cat. 153). Berthe Morisot, *Marine (Le Port de Lorient)* (*The Harbor at Lorient*), 1869. Oil on canvas, 17⅛ x 28¾ in. (43.5 x 73 cm). National Gallery of Art, Washington, Ailsa Mellon Bruce Collection

Versailles at Louveciennes (figs. 317, 318, 325). In the next decade, this new style would constitute Impressionism. And, to listen to the words of contemporaries, the catalyst for the Impressionist landscape came from Japan. The seeds of Impressionism were of course already present in Romanticism and Realism and were reflected in contemporary photographic practice, but the example of Japanese art gave the young painters license to explore more freely, to push more boldly in the direction that they were already traveling. Ernest Chesneau had already summed it up by 1878:

No one among the painters that I have named, all of whom developed a passion for Japan, remained untouched by its influence, at least for a time, not only as collectors, but also, I say it, as painters. Their surprise, their admiration, their rapture had been too vivid and too deeply felt for them to be able to elude it. They did not even try to resist. With intelligence, they knew how to direct the impact it would have on their talent without fail. Each of them assimilated from Japanese art the qualities demonstrating the closest affinities with their own talent.... And all of them found in it a confirmation of rather than an inspiration to their personal way of seeing, feeling, understanding and interpreting nature. A renewed individual originality rather than a notorious submission to Japanese art sprang from it.[33]

33. "Il n'est pas un des peintres que j'ai nommés plus haut et qui se passionnèrent pour le Japon, qui n'ait pendant un temps au moins, subi son influence non seulement comme amateur, je dis aussi comme peintre. Leur étonnement, leur admiration, leur enchantement, avaient été trop vifs et trop profondément ressentis pour qu'ils pussent s'y soustraire. Ils ne tentèrent même pas d'y résister. Avec intelligence ils surent diriger l'action qu'il devait infailliblement exercer sur leur talent. Chacun d'eux s'assimila de l'art japonais les qualités qui recélait les affinités les plus voisines avec ses propres dons.... Et tous y trouvèrent une confirmation plutôt qu'une inspiration à leurs façons personnelles de voir, de sentir, de comprendre et d'interpréter la nature. De là le redoublement d'originalité individuelle au lieu d'une lâche soumission à l'art japonais." Chesneau, "Le Japon à Paris" (see note 24 above), pp. 386–87.

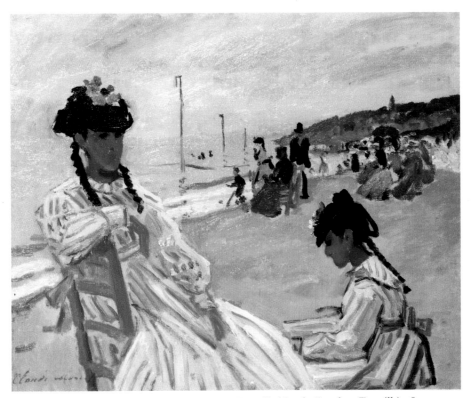

Fig. 329 (cat. 151). Claude Monet, *Sur la plage à Trouville* (*On the Beach at Trouville*), 1870. Oil on canvas, 15 x 18⅛ in. (38 x 46 cm). Musée Marmottan, Paris

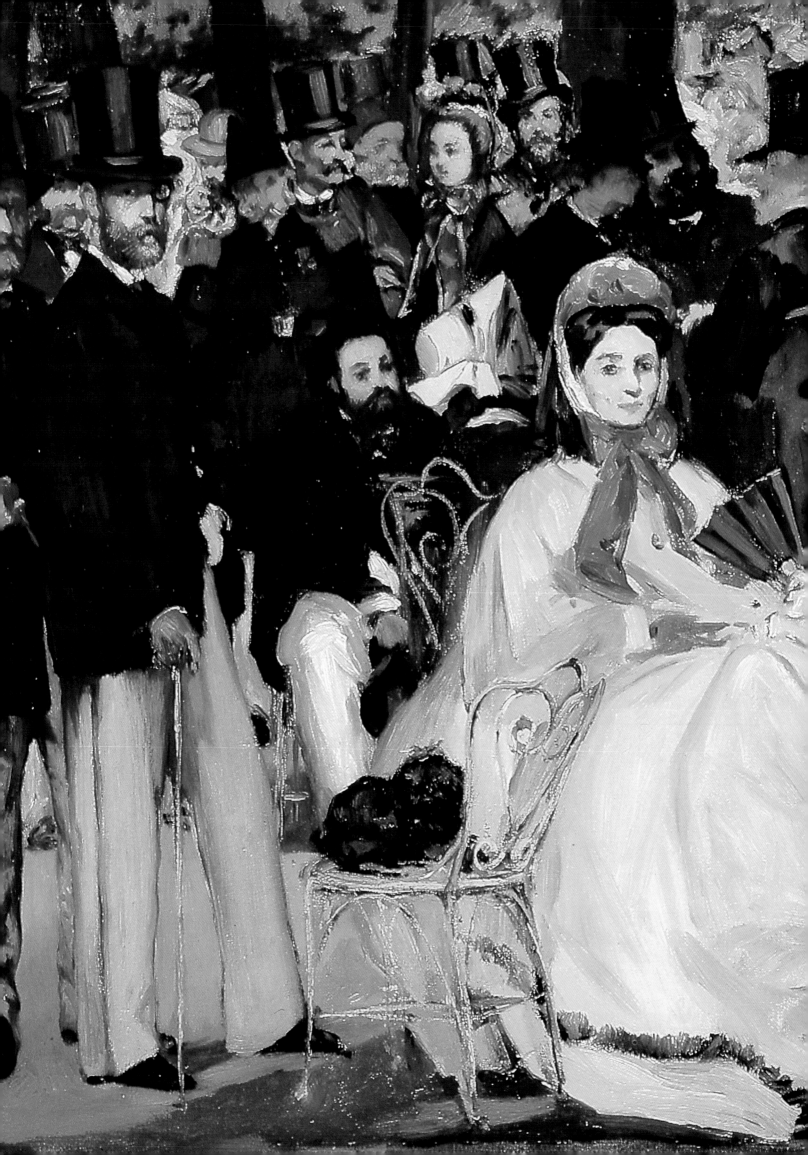

IX
Modern Life

HENRI LOYRETTE

During the Second Empire the garden of the Tuileries became passé; now the elite drove in carriages along the Champs-Élysées and through the Bois de Boulogne. The current fashion rejected Lenôtre's "didactic poem" with its regularly planted trees and geometric flowerbeds, while Nature in the English style, meticulously unexpected, abounded in "rosebushes and eternally green clumps of trees."[1] Nevertheless, on two lovely afternoons a week in spring and summer, an ephemeral social life reemerged in the Tuileries when a military band with brasses and percussions played transcriptions of well-known pieces. The musicians formed a circle around the leader; the public crowded behind them, standing or sitting on the new curlicued iron chairs, so graceful and so uncomfortable. A mixed cosmopolitan world, including elegant figures more at home on the boulevard than in high society, marriageable girls, strolling infantrymen, ministry clerks, and "enterprising men" trying to pick up some minor stage actress (fig. 330).[2] With his "little court," says Antonin Proust, Manet "went to the Tuileries almost every afternoon from two to four o'clock, under the trees, doing plein air studies of the children playing and the groups of nannies settled in chairs. Charles Baudelaire was his usual companion. People squinted curiously at this elegantly dressed painter as he set up his easel, armed himself with his palette, and painted."[3]

Though Manet did "plein air studies," it was in his studio, during the summer of 1862, that he executed *La Musique aux Tuileries* (fig. 332), a seminal work since it is rightly considered "the earliest true example of modern painting, in both subject matter and technique."[4] Manet gathered a dense cluster of men in black suits and women in light-colored summer frocks under airy foliage. This was not the disparate audience of outdoor concerts but the far more reduced company that was Manet's circle: his brother Eugène, a few relatives, some artist friends who were more dandies than painters, a gaggle of critics with divergent ideas (Zacharie Astruc, Théophile Gautier, Baudelaire), two famous boulevard faces (the composer Jacques Offenbach and the flaneur Aurélien Scholl)—all of whom

Fig. 330. Crafty [Victor Gerusez], *La Musique au jardin des Tuileries* (*Music in the Tuileries Gardens*). Caricature published in *La Vie parisienne*, May 28, 1864, p. 304

1. "poème didactique"; "massifs toujours verts et de buissons de roses." Arsène Houssaye in *Paris-Guide* (Paris, 1867), vol. 1, p. 603.
2. "gens entreprenants." Crafty [Victor Gerusez], "La musique au jardin des Tuileries," *La Vie parisienne*, May 28, 1864, p. 304.
3. "petite cour"; "[Manet] allait presque chaque jour aux Tuileries de deux à quatre heures, faisant des études en plein air, sous les arbres, d'après les enfants qui jouaient et les groupes de nourrices qui s'affalaient sur les chaises. Baudelaire était là son compagnon habituel. On regardait curieusement ce peintre élégamment vêtu qui disposait sa toile, s'armait de sa palette et peignait." Proust 1897, p. 29.
4. Françoise Cachin in Paris, New York 1983, p. 126.

Édouard Manet, *La Musique aux Tuileries*, detail of fig. 332

made the painting Parisian. To the far left is Manet himself, preceded, indeed virtually doubled, by his friend Albert de Balleroy, with whom he seems to form a musical duo. There are also military men, children making sand pies, a jumble of parasols, fans, knotted ribbons, top hats, and a small, quiet dog placed like a bibelot on a chair.

Manet gives the dimensions of a history painting to what used to be the domain of vignettes; the futile is flaunted, accessories triumph, the faces count as much as the abandoned hoop and balloon or the chairs' rigid arabesques. The painter presents his world in an informal and good-natured review: the rather listless participants, who are not overly concerned about posing, pay little heed to art—whether music or painting. This is no tribute à la Fantin-Latour, in which the figures' names constitute a coterie's roll call, backing each other up and swearing to fight the good fight. There is nothing solemn or deliberate here, but rather the deafening chatter of Parisians assembling for pleasure, a jumble of faces in the confusion of chairs noisily moved, and chitchat without end. Manet's genius lies in his having translated this amiable disorder in a new way, flitting, "fluttering" (to use one of his words): under the rapidly brushed shade of the alternate rows of trees, we find a juxtaposition of colored spots, some light, some dark, giving the picture its special cheerful and dancing rhythm. When the painting was shown at the Galerie Martinet in 1863, a stupefied Paul de Saint-Victor wrote: "His [*Musique*] *aux Tuileries* hurts the eye as carnival music assaults the ear."[5] That pronouncement was meant to kill; but today it has become the best of plaudits and the most appropriate of comments. Manet truly paints his New World Symphony, introducing unheard-of sonorities, the hubbub of a crowd, the thrust of brasses against a syncopated rhythm, and enjoying both the inevitable stridence and the continuo of the bass drum. Four years later in Offenbach's *La Vie parisienne*, we hear, "Tout tourne, tourne, tourne.... Tout danse, danse, danse" (Everything turns, turns, turns.... Everything dances, dances, dances).

With *La Musique aux Tuileries* the modern world made its grand entrance. Paul Mantz, fearing such recklessness, believed that a talented artist had gone astray for good: "With his instinctive courage, M. Manet has stepped into the realm of the impossible."[6] The astonishment of this well-meaning if timorous critic is understandable, but Baudelaire's reserve is more surprising. According to Tabarant, the painting "failed to seduce the friends to whom Manet showed it, with Baudelaire in the lead."[7] Yet Manet, as has often been pointed out, seemed to be fulfilling a wish that the poet formulated in his study *Le Peintre de la vie moderne* (*The Painter of Modern Life*). After passing through many versions, Baudelaire's exaltation of

Fig. 331. Constantin Guys, *Groupe d'hommes et de femmes* (*Men and Women*). Gray wash and brown ink, 8⅛ x 12⅞ in. (20.5 x 32.7 cm). Musée du Louvre, département des Arts Graphiques, Paris

5. "*Concert aux Tuileries* écorche les yeux comme la musique des foires fait saigner l'oreille." Quoted by Françoise Cachin, ibid.
6. "M. Manet est entré avec sa vaillance instinctive dans le domaine de l'impossible." Paul Mantz, "Exposition du boulevard des Italiens," *Gazette des Beaux-Arts*, April 1, 1863, p. 383. About Paul Mantz, see *Critique*, 1990, p. 19.
7. "séduisit peu les amis à qui Manet la montra, Baudelaire tout le premier." Tabarant 1947, p. 38.

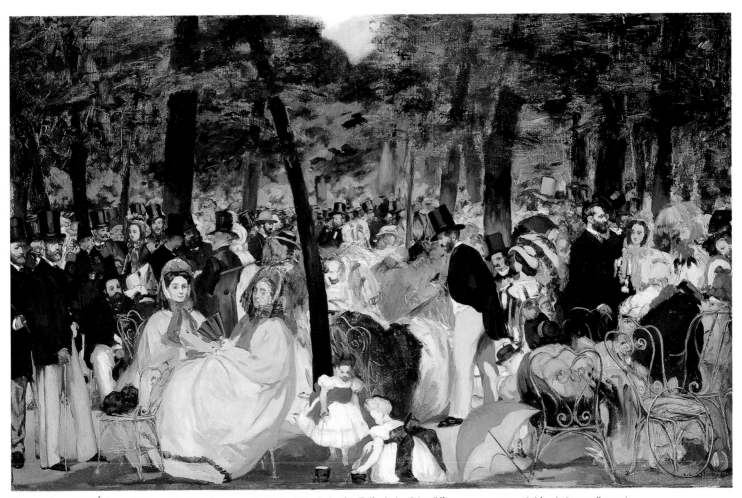

Fig. 332 (cat. 88). Édouard Manet, *La Musique aux Tuileries* (*Music in the Tuileries*), 1862. Oil on canvas, 30 x 46½ in. (76.2 x 118.1 cm). The Trustees of the National Gallery, London

Constantin Guys (fig. 331) was finally published in *Le Figaro* in November and December 1863. Baudelaire had originally written it in late 1859 and early 1860, and Manet, friendly with him since that period, certainly knew the tenor of the piece: ever since his *Salon de 1846*, the poet had been intent on bringing out "the heroism of modern life" by "drawing the eternal from the transitory" and on "archiving" an era's ephemera, the things that make it up yet are normally neglected—the manners and mores, the contingent, the fleeting, the trifles.[8] Baudelaire had his standard, Constantin Guys (even if he was still one of a kind), and a number of touchstones— eighteenth-century illustrators (Debucourt, Moreau, Saint-Aubin) and minor nineteenth-century masters (Lami, Devéria, Gavarni)— "all those exquisite artists who, though having painted only pretty and familiar things, are nevertheless serious historians in their own way."[9]

8. "l'héroïsme de la vie moderne." Baudelaire 1985–87, vol. 2, "Salon de 1846," p. 493. "tir[ant] l'éternel du transitoire"; "archiver." Baudelaire 1985–87, vol. 2, *Le Peintre de la vie Moderne*, pp. 694, 724.
9. "tous ces artistes exquis qui, pour n'avoir peint que le familier et le joli, n'en sont pas moins, à leur manière, de sérieux historiens." Ibid, p. 724.

Baudelaire, so attentive to the separation of genres and the continual life of ancient categories, was disconcerted by Manet's action of using a large canvas for an image from the realm of the vignette and vigorously painting that which is normally treated in drawings or engravings. For the poet there is a precise form for every subject: a large format and dense painting belong to history, while the frailty of paper and the delicacy of wash or watercolor are appropriate for modern life. Manet, forgetting to be "exquisite," had given his composition clothes that were too large, that were tailored for the epic or capriccio.

Despite this lack of understanding between poet and artist, which was also expressed on other occasions, Baudelaire's essay and Manet's painting testify to the irrepressible and often diffuse longing for the contemporary, a desire that in the 1860s gradually cracked the old molds. This yearning for the new was manifested everywhere, in music and in literature, in the most diverse imaginations. In 1912 Apollinaire, citing the Eiffel Tower, the "grace" of an "industrial street," and the "beautiful stenotypists," would proclaim his boredom with the "ancient world," his disgust at "living in Greek and Roman antiquity."[10] This same spirit was evident in 1866 when Jules Vallès expressed his "ennui" at "prowling the flotsam and jetsam of the ancient world."[11] Why keep turning to bygone civilizations, why keep chewing the same old cud when Paris was growing a new skin, the railroad was shrinking distances, and scientific discoveries were mounting up? Maxime Du Camp rebelled against the indestructibility of old chestnuts: "Everything is on the move, everything is growing, everything is increasing around us. . . . Science is working wonders, industry is making miracles, yet we remain impassive, unaware, contemptible, plucking at the strings of our out-of-tune lyres, closing our eyes to keep from seeing, or obstinately looking back to a past that nothing should make us regret. Scientists harness steam, and we celebrate Venus, the daughter of the bitter wave; scientists discover electricity, and we celebrate Bacchus, the lover of the vermilion grape. It is absurd."[12]

Manet announced, "A man must be of his time," and Zola stated, "I am at ease in our generation."[13] The modern galvanized Courbet as it did Coriolis, the protagonist of the Goncourts' *Manette Salomon*. Courbet, who dreamed of establishing a monumental art of painting consistent with the new society, was echoed in 1862 by Sainte-Beuve: "Courbet has the idea of erecting vast railroad stations, new churches for painting, and covering those huge walls with a thousand perfectly suitable subjects, the anticipated views of the great sites we are to cross; the portraits of the great men whose names are linked to the cities we will travel through; subjects that are picturesque, moral, industrial, metallurgic; in short, the saints and mira-

10. "grâce"; "rue industrielle"; "belles sténo-dactylographes"; "monde ancien"; "vivre dans l'antiquité grecque et romaine." Guillaume Apollinaire, "Zone," *Alcools* in *Oeuvres poétiques* (Paris, 1965), pp. 39–40.

11. "ennui"; "à travers les épaves du monde antique." Jules Vallès, "Le Salon: Les actualistes," *Le Courrier français*, June 17, 1866, p. 3.

12. "tout marche, tout grandit, tout s'augmente autour de nous. . . . La science fait des prodiges, l'industrie accomplit des miracles, et nous restons impassibles, insensibles, méprisables, grattant les cordes faussées de nos lyres, fermant les yeux pour ne pas voir, ou nous obstinant à regarder vers un passé que rien ne doit nous faire regretter. On découvre la vapeur, nous chantons Vénus, fille de l'onde amère; on découvre l'électricité, nous chantons Bacchus, ami de la grappe vermeille. C'est absurde!" Maxime Du Camp, preface to *Chants modernes*, quoted by Herbert 1988, p. 3.

13. "Il faut être de son temps." Proust 1897, p. 2. "Je suis à l'aise parmi notre génération." Zola 1991, p. 39.

cles of modern society."[14] Suddenly plagued by the contemporary, the Goncourts' Coriolis buckled down and did two large paintings for the Exposition Universelle of 1855: *Un Conseil de révision (Army Medical Board)* and *Un Mariage à l'église (Church Wedding)*, which he executed with the impasto and "the solid and severe harmonies" of the Spanish manner.[15]

In his rich and regular correspondence with his brother Alfred, the Belgian art dealer Arthur Stevens incessantly exhorted him to "get modern." The painter Alfred Stevens excelled in the subjects of the day, in which he had pioneered: "You are *the first* [artist] who has truly dared to tackle your time and your contemporaries.... You are *the only one* who has produced a complete new art that is completely of our time." But more important, as his brother pointed out, no other way was possible: "Woe to the artist who is not in the modern mood.... He can no longer interest anyone."[16]

At the Salon of 1868 Zola picked up on "a certain tendency toward modern subjects" and refused to plead their cause, which had been "won long ago" thanks to Courbet and Manet: "We find ourselves faced with the only reality—despite ourselves we encourage our painters to reproduce us on their canvases, just as we are, with our costumes and customs."[17]

Success was not automatic, however, for those whom Zola called the "up-to-date" (*actualiste*, a neologism coined two years earlier by Jules Vallès). In 1863, on the death of Horace Vernet, who had "dared to paint the first modern battle," Théophile Gautier remarked that although many artists treated "current subjects" to cater to the taste of the day, they often did so "reluctantly and in order to burlesque them."[18] Used to painting elaborate draperies, they were baffled by contemporary costume.[19] Suddenly eager to be faithful to the world around them, "they wanted to show everything," unaware that art was made of omissions.[20] Hence there was a "stiffness," an abrupt awkwardness in subjects they were tackling for the first time.[21] And there was an inevitable backlash—people who reviled the modern world and deplored seeing the disturbances in society and the city's fabric reverberate in the sacred territory of painting. They were also disturbed by the success of genre scenes and operettas, of one-act plays and light novels: "*Le Figaro* and Offenbach's pieces—that's the spirit that governs the world today."[22] These things seemed so futile, so lightweight, so contrary to the principles of Beauty and Greatness. The triumph of "minor taste," the stigma of a decadent epoch, was paralleled by Haussmann's upheavals and by the growing popularity of photography and metal architecture.[23] How, asked the antiprogressives, can we exalt a modernity that translates into systematic destruction, that proves to be incapable of offering a contemporary style for the new buildings and is content to pastiche

14. "inaugurer une peinture monumentale qui soit en accord avec la société nouvelle;" "Courbet a l'idée de faire des vastes gares de chemin de fer, des églises nouvelles pour la peinture, de couvrir ces grandes parois de mille sujets d'une parfaite convenance, les vues mêmes anticipées des grands sites qu'on va parcourir; les portraits des grands hommes dont le nom se rattache aux cités du parcours; des sujets pittoresques, moraux, industriels, métallurgiques; en un mot les saints et les miracles de la société moderne!" Saint-Beuve, letter to Charles Duveyrier, April 22, 1862, quoted in Paris, London 1977–78, p. 37.
15. "les harmonies solides et sévères." Goncourt 1867, pp. 320–22.
16. "faire moderne"; "C'est toi *le premier* qui a réellement osé aborder ton temps et tes contemporains.... Tu es *le seul* ayant fait un art complètement nouveau, complètement de notre temps"; "Malheur à l'artiste qui n'est pas dans le sentiment moderne...il ne peut plus intéresser personne." Arthur Stevens, unpublished letters to his brother Alfred, undated, private collection.
17. "une tendance certaine vers les sujets modernes"; "gagnée depuis longtemps"; "nous nous trouvons en face de la seule réalité, nous encourageons malgré nous nos peintres à nous reproduire sur leurs toiles, tels que nous sommes avec nos costumes et nos moeurs." Zola 1991, p. 206.
18. "osé peindre le premier la bataille moderne"; "sujets actuels"; "à regret et pour les travestir." Théophile Gautier, "Horace Vernet," *Le Moniteur*, January 23, 1863, reprinted in *Critique*, 1990, pp. 118–19.
19. Regarding the "eternity" of the drapery and the arbitrariness of contemporary costume, see Blanc 1867, p. 609.
20. "ils veulent tout montrer." Delacroix 1980, p. 615.
21. "Froideur." Anatole de Montaiglon, "La Peinture au Salon de 1859," *Revue universelle de l'art*, 1859, p. 481.
22. "*Le Figaro* et les pièces d'Offenbach", voilà l'esprit qui gouverne aujourd'hui le monde." Arthur Stevens's unpublished letter to his brother Alfred, undated, private collection. See Hippolyte Taine, "L'Art en France," in *Paris-Guide* (Paris, 1867), p. 849.
23. "petit goût." Hippolyte Taine, ibid.

all styles? The uniform gray of clothes and facades fed regrets for an earlier disorder, the murky, twisting alleys, and, emanating from those scabrous houses, a teeming and picturesque populace. Victor Hugo's *Les Misérables* (1862) was the funeral oration of this bygone Paris. Until 1862 Manet depicted popular types (fig. 242) so threatened by Haussmann's urban renewal; his paintings exalted the victims before their probable disappearance. The strict alignment of standardized apartment houses triggered a highly colored baroque reaction. Thus Théophile Gautier piled Nineveh on Ecbatana, imagining palaces made of marble and porphyry and encrusted with precious stones.[24] Charles Garnier, regretfully inserting his new opera house among Haussmann's "failures," proclaimed that it had nothing to do with what was being built in Paris: he rejected straight lines for curves, austerity for ornamental exuberance, and gray for polychrome. And Degas, in his *Sémiramis* (fig. 65) built a dreamlike Babylon, a tangle of domes, columns, stairways, terraces, and ramparts.

The genre scene, which had had success since the Exposition Universelle of 1855, was an important factor in the choice of increasingly modern subjects made by the artists of the New Painting.[25] There were potential buyers, both in France and abroad, for these small and medium-size pictures which dealt with everyday life. In the area of landscapes Monet benefited from Daubigny's advances, while Manet and Degas profited from the vogue of Meissonier and Alfred Stevens. For those who worried about it, the progress of genre and the concomitant decline of historical painting were ascribed to purely commercial factors: granted, "certain painters," said Castagnary in 1863, "are addressing an audience enamored of art," but most of them, "with one eye on the art dealers, are churning out countless works like the loaves of bread during Jesus' sermon."[26] Five years later Émile Zola remarked that he could count on the fingers of one hand "the up-to-date"—the *actualistes* Monet, Bazille, Renoir—"who approach reality out of a fervent love of reality." The novelist then sharply attacked the legion of "tailors whose sole concern is to satisfy their clients": "Our artists are women who wish to please. They flirt with the crowd. It has dawned on them that classic painting makes the public yawn, and so they have quickly dropped classic painting. A few have risked donning a black suit; but most of them have stuck to the rich garb of middle-class and high-born ladies. They have no desire whatsoever for truth, no longing whatsoever to renew art and make it greater by studying the present day. One senses that these people would paint decanter stoppers if it were fashionable to paint decanter stoppers. They cut their canvases to fit the modern taste, and that is all."[27]

Without giving in to such facile solutions, Degas and Manet nev-

24. Quoted by Gérard Lameyre, *"Haussmann, préfet de Paris* (Paris, 1958), p. 280.
25. See Mainardi 1987, pp. 119, 163ff., 190.
26. "quelques peintres s'adressent au public amoureux de l'art"; "qui les poussent à multiplier leurs oeuvres comme les pains sous la parole de Jésus." Castagnary 1892, p. 137.
27. "actualistes"; "qui vont à la réalité par amour fervent pour la réalité"; "tailleurs qui ont l'unique souci de satisfaire leurs clients"; "Nos artistes sont des femmes qui veulent plaire. Ils coquettent avec la foule. Ils se sont aperçus que la peinture classique faisait bâiller le public, et ils ont vite lâché la peinture classique. Quelques-uns ont risqué l'habit noir; la plupart s'en sont tenus aux toilettes riches des petites et grandes dames. Pas le moindre désir d'être vrai dans tout cela, pas la plus mince envie de renouveler l'art et de l'agrandir en étudiant le temps présent. On sent que ces gens-là peindraient des bouchons de carafe, si la mode était de peindre des bouchons de carafe. Ils coupent leurs toiles à la moderne, voilà tout." Zola 1991, p. 207.

ertheless developed what was in fact a commercial strategy in the late 1860s. They knew that contemporary subjects would easily find purchasers. They therefore probably thought of multiplying what Degas called "articles" or "products"—small to medium-size canvases that would sell regularly, allowing the artist to make ends meet. In 1869 Arthur Stevens, who was a great lover of genre scenes and who had negotiated the sale of one of Degas's works to Jules Van Praet, an important Brussels collector, offered the painter a contract for twelve thousand francs. For unknown reasons the deal fell through, but it inspired the artist to go to Brussels, where he sold two other paintings.[28] In 1868 Manet had visited England to "test the waters" and, as he wrote to Degas, to see "if there is an outlet for our products."[29] Degas most likely intended to heed Manet's advice and cross the English Channel, for he wrote down Whistler's London address on the back of an envelope; but it was not until fall 1871 that he reached the British capital, where he did indeed find "outlets." (Manet had caught him off guard, and then the Franco-Prussian War had prevented him from traveling.)

It would be a mistake, however, to tie the increase in genre works to mercantile goals. First of all, this expansion was a phenomenon of the history of taste, evident in reactions to contemporary painting and to older art. To a large degree, it explained why both art lovers and historians were interested in the Dutch and the Flemish painters of the golden age. In 1867 Théophile Thoré mounted a panoramic overview of Parisian collections, hanging pieces by Cuyp, Pieter de Hooch, Wouwermans, Jan Steen, Gerard Dou, Teniers, Ostade, and Snyders; he absolved himself for including so many Northern European artists: "It is not my fault that the Dutch take the lead in all the collections."[30] More and more critics extolled this art in which "the woods are tranquil, the roads safe; the boats glide to and fro along the canals; the rustic festivities still abound."[31] Such paintings were glorified by Théophile Gautier, Charles Blanc, and especially Thoré, who, forcing a comparison between Raphael and Rembrandt, labeled them the "Januses of Art": "Raphael looks back, Rembrandt looks forward. The former saw an abstract humanity under the symbols of Venus and the Virgin, Apollo and Christ; the latter artist saw a real and living humanity directly and with his own eyes. Raphael is the past, Rembrandt the future."[32]

If Italian art was an art of courts and churches, an art laden with mythological clichés and pious rehashings, Dutch art was "republican and rationalist, not having to bother with gods or grandees, with pontiffs or monks, and compelled to fall back on secular life...on modestly painting modest persons, simple mortals, depicting them offhandedly as they appeared at home, in a tavern, or on the public square, and that's all."[33]

28. About the negotiations with Arthur Stevens and the Van Praet collection, see Loyrette 1991, pp. 216–17.
29. "tâter un peu le terrain de ce côté, s'il y aurait un débouché pour nos produits." Manet's letter to Degas, July 29, 1868, published in Loyrette 1991, p. 222.
30. "ce n'est pas ma faute si, dans toutes les collections, les Hollandais priment tout." William Bürger [Théophile Thoré], "Les collections particulières" in *Paris-Guide*, (Paris, 1867), p. 541.
31. "les bois sont tranquilles, les routes sûres; les bateaux vont et viennent au cours des canaux; les fêtes champêtres n'ont pas cessé." Eugène Fromentin, *Les Maîtres d'autrefois*, introduced and annotated by Jacques Foucart (Paris, 1965), p. 201.
32. See Chu 1974, pp. 9–17. "Janus de l'Art"; "Raphaël regarde en arrière; Rembrandt regarde en avant. L'un a vu l'humanité abstraite, sous les symboles de Vénus et de la Vierge, d'Apollon et du Christ; l'autre a vu directement et de ses propres yeux, une humanité réelle et vivante. L'un est le passé, l'autre l'avenir." William Bürger [Théophile Thoré], *Musées de la Hollande* (Paris, 1860), vol. 2, p. x. This comparison was taken up again by Proudhon who quoted Thoré-Bürger extensively (Proudhon 1939, pp. 94–95).
33. "républicain et rationaliste, n'ayant à s'occuper ni des dieux, ni des grands, ni des pontifes, ni des moines, forcé de se replier sur la vie séculière"; "modestement de modestes personnages, de simples mortels, tels qu'il se montraient chez eux, sans façon, à la brasserie ou sur la place publique, voilà tout." Proudhon 1939, p. 98.

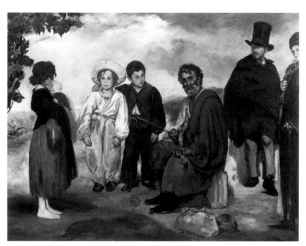

Fig. 333. Édouard Manet, *Le Vieux Musicien* (*The Old Musician*), 1862. Oil on canvas, 73¾ x 97¾ in. (187.4 x 248.3 cm). National Gallery of Art, Washington

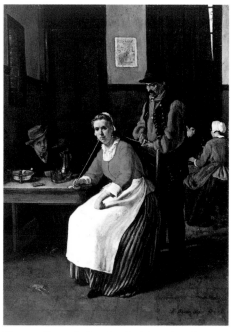

Fig. 334. François Bonvin, *Intérieur de cabaret* (*Interior of a Tavern*), 1867. Oil on canvas, 19¾ x 14⅝ in. (50.2 x 37.2 cm). The Walters Art Gallery, Baltimore

Fig. 335. Gavarni, *Les Lettres de l'ancienne* (*The Letters of the Old Woman*). Lithograph from *Les Étudiants de Paris* (*The Students of Paris*), 1839–40.

Proudhon reported that Thoré felt a new, democratic art should emerge, based on the Dutch model, "both inspired by and inspiring the people in turn," neglecting "symbols, idols, nobility, and silliness" and focusing solely on "industrious, knowledgeable, positive humankind."[34]

This attention to the humble, this glorification of an often miserable but busy and honest everyday life can be found in the Le Nain brothers, who, as "painters of the reality under Louis XIII," were invented by Champfleury in 1850. Manet took notice of them: his *Vieux musicien* (fig. 333) was inspired by an engraving of the Le Nain *Vieux joueur de flageolet* (*Old Flageolet Player*). But after 1862, after *La Musique aux Tuileries* (fig. 332), Impressionist modernity took up themes very different from those of Courbet and Bonvin (fig. 334), neglecting the works and days of the laboring classes. In contrast, the artists of the New Painting showed a society characterized by or seeking leisure and elegance, a society occupied with doing nothing instead of arduously earning enough to scrape by on. The old sources had been the placid scenes of Netherlandish painting as endlessly reiterated by Meissonier; now artists looked to eighteenth-century France, the world of Watteau and Chardin, of *fêtes galantes* and bourgeois intimacy, and the more anecdotal milieu of Debucourt, Saint-Aubin, Moreau Le Jeune, Trinquesse, and Baudouin, who were studied and collected by the Goncourt brothers.[35] The "rediscovery" of the eighteenth century, fostered by the compilation of numerous documents about life in that period, encouraged the adoption of contemporary subjects by painters in the 1860s. Attachment to the ephemeral and sensitivity to fashions, far from

34. "inspiré par le peuple et l'inspirant à son tour." Chu 1974, p. 14. "symboles"; "idoles"; "noblesse"; "niaiserie"; "l'humanité industrieuse, savante, positive." Proudhon 1939, p. 94.

35. See Elisabeth Launay, *Les frères Goncourt collectionneurs de dessins* (Paris, 1991).

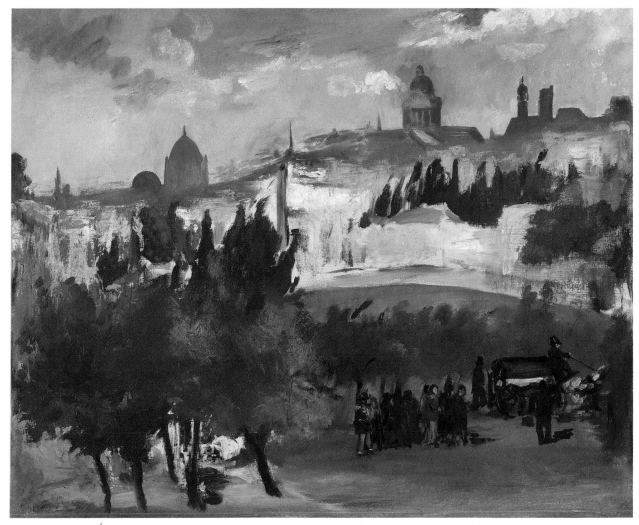

Fig. 336 (cat. 105). Édouard Manet, *L'Enterrement* (*The Burial*), ca. 1867. Oil on canvas, 28⅝ x 35⅝ in. (72.7 x 90.5 cm). Metropolitan Museum of Art, New York, Catharine Lorillard Wolfe Collection, Wolfe Fund, 1909

condemning them to oblivion, enabled them to escape it. Eternity was gained not by blurring any too visible traces of the fashionable but by gathering on canvas or paper all the evidence, even the most fleeting, of an era—indeed, Constantin Guys did so for Baudelaire and Gavarni (fig. 335) for the Goncourts.

However, people still had to agree on what was modern and what was not. For Baudelaire and Duranty, modernity was an essentially urban phenomenon. Baudelaire spoke of "the elegant life and the thousands of floating existences that secretly circulate in a large city."[36] Duranty pinpointed the "full human throng" of the Parisian scene. Both men regarded their country-loving contemporaries as too "herbivorous." In 1868 Duranty, irritated by the growing success of plein air scenes, wrote a brief article with an eloquent title: "What Does the Countryside Want of Us?" He bemoaned the ennui he felt when confronted by nature—the very slow days, the "cruel, fierce, bleak" sun, the men living bestial lives. People should live in the city, in the multitude; that was the only place where the artist could find his inspiration: "There I feel my flexibility renewed daily, the

36. "de la vie élégante et des milliers d'existences flottantes qui circulent dans les souterrains d'une grande ville." Baudelaire, 1985–87, vol. 2, "Salon de 1846," p. 495.

strength I lose is instantly restored, like a ball lobbed by a thousand rackets. Yes, houses, houses, nothing but houses, through which we barely glimpse the sky; cobblestones with carriages thundering over them; shops where the textiles clash with one another, where everything teems and swarms; posters, words, lampposts, horsemen, mobs of pedestrians, soldiers, magistrates, priests, workers, burghers, noblemen, thieves, courtesans, fashions, labels, prejudices, books, speeches, funerals, fights, bands, mistakes, betrayals, triumphs, masters, butlers, geniuses, idiots, a numberless enumeration!"[37]

Around the same time Zola, hailing Claude Monet as the first of the "up-to-date," emphasized that modernity was not limited by the topographical. Granted, the modern spirit was evident in the city, in streets, racetracks, and aristocratic promenades, but it also existed wherever human beings lived. Monet understood this; he "grew up worshiping everything around him" and he enjoyed "finding human traces everywhere." He preferred cultivated flowering gardens to "a forest nook," inhabited shorelines to wild coasts.[38]

However, Monet was not always the sort of person praised by Zola in 1868. Earlier, in 1864 and 1865, the landscapes he did in the Forest of Fontainebleau, revealing lessons learned from the Barbizon painters, presented an immutable nature—huge trees lauded for their size (fig. 96) and glades full of majesty but empty of human presence (fig. 99). Contemporary views of the Normandy coastline remained tenaciously antimodern. The sea was dotted with small craft and sailboats and the beaches were not always deserted; the villages were ancient, massive behind a guardian lighthouse, and the silhouettes those of fisherfolk engrossed in ancestral activities (figs. 79, 83).

Everything changed after 1866 with the great achievement of Monet's *Déjeuner sur l'herbe* (fig. 169). Next to fishermen there were now idle tourists, men in straw hats and gray suits and women in light-hued dresses; the crowded ranks of gray houses were replaced by the disorder of seaside architecture; the weather, which used to be gloomy, improved; the sea was less choppy, and the boats glissaded across the surface. Monet's landscapes, which, like those of Courbet (fig. 93) and Daubigny (fig. 114), had once aimed at being timeless, became scenes of modern life. This evolution is also evident in Sisley. In the imposing *Allée de châtaigniers à La Celle-Saint-Cloud* of about 1866–67 (fig. 98), stands of huge trees grow wildly on a rocky terrain in the Barbizon style; about two years later *Vue de Montmartre* (fig. 104) depicts a shabby industrial area with a few houses standing haphazardly behind a screen of gaunt tree trunks. Indeed, this same sort of change separates Manet's *Nymphe surprise* (fig. 123) from his *Olympia* (see p. 104). And there is a similar distance between Bazille's *Le Pêcheur à l'épervier* (fig. 153), a male nude in a landscape,

37. "pleine foule humaine"; "Que nous veut la campagne?"; "ennui"; "cruel, farouche et morne"; "Là je sens mon élasticité se renouveler toujours, la force que je perds m'est à l'instant rendue, comme à une balle lancée par mille raquettes. Oui, des maisons, des maisons, toujours des maisons, à travers lesquelles on n'aperçoive que peu de ciel; des pavés où roule le tonnerre des voitures; des boutiques où les étoffes s'entrechoquent, où toutes choses fourmillent; des affiches, des mots, des bec de gaz, des cavaliers, des cohues de piétons, des soldats, des magistrats, des prêtres, des ouvriers, des bourgeois, des nobles, des voleurs, des courtisanes, des modes, des étiquettes, des préjugés, des livres, des discours, des enterrements, des combats, des musiques, des erreurs, des trahisons, des triomphes, des maîtres, des valets, des génies, des idiots, innombrable dénombrement!" Edmond Duranty, "Que nous veut la campagne?" *Almanach parisien pour 1868* (Paris, 1868), p. 29; Crouzet 1964, pp. 249–50.
38. "a grandi dans l'adoration de tout ce qui l'entoure"; "à retrouver partout la trace de l'homme"; "un coin de forêt." Zola 1991, p. 207.

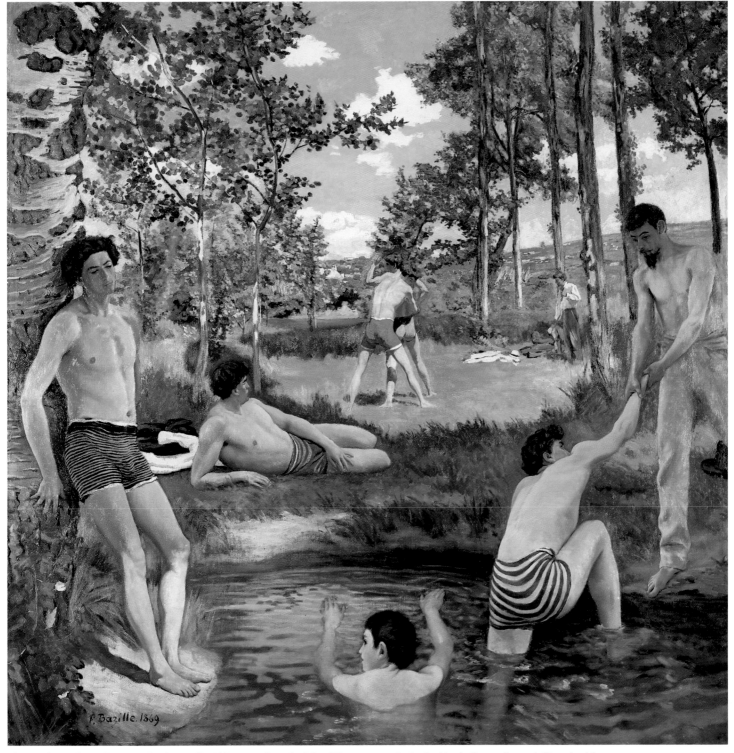

Fig. 337 (cat. 11). Frédéric Bazille, *Scène d'été* (*Summer Scene*), 1869. Oil on canvas, 62¼ x 62½ in. (158.1 x 158.9 cm). Fogg Art Museum, Harvard University Art Museums, Cambridge, Massachusetts, Gift of Mr. and Mrs. F. Meynier de Salinelles

and *Scène d'été* (fig. 337), in which young men of 1869 frolic in bathing suits.

By the end of the 1860s the modern subjects treated by the artists of the New Painting had little to do with those of their predecessors. Manet, Degas, Monet, and Renoir renewed typologically and topographically something that could no longer be called a genre scene. In 1869, Degas followed the realist tradition by depicting a proletar-

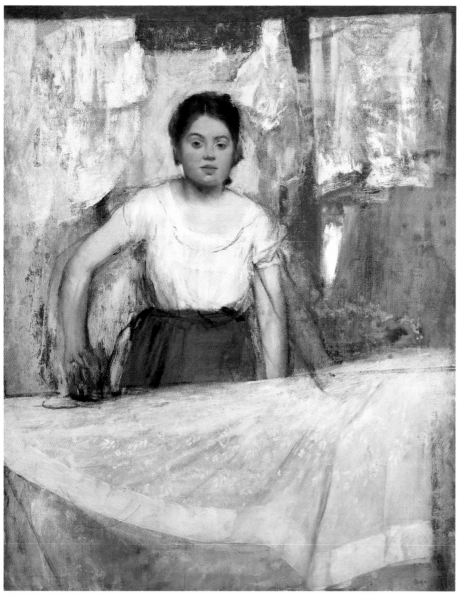

Fig. 338 (cat. 65). Edgar Degas, *La Repasseuse* (A Woman Ironing), 1869.
Oil on canvas, 36¼ x 29⅛ in. (92 x 74 cm). Neue Pinakothek, Munich

Fig. 339. François Bonvin, *La Repasseuse*
(*A Woman Ironing*), 1858. Oil on canvas,
20 x 14¼ in. (50.8 x 36.2 cm). Philadelphia
Museum of Art, The John G. Johnson
Collection

Fig. 340. Auguste Toulmouche, *La Fiancée
hésitante* (*The Hesitant Betrothed*), 1866.
Oil on canvas, 23½ x 19 in. (59.7 x 48.4 cm).
Private collection

Fig. 341. Alfred Stevens, *La Lettre de faire-
part* (*The Announcement*), before 1863 (?).
Oil on canvas, 39⅜ x 27⅛ in. (100 x 69 cm).
Private collection

Fig. 342 (cat. 67). Edgar Degas, *Bouderie* (*Sulking*), ca. 1869–70. Oil on canvas, 12¾ x 18¼ in. (32.4 x 46.4 cm). The Metropolitan Museum of Art, New York. H. O. Havemeyer Collection, Bequest of Mrs. H. O. Havemeyer, 1929

ian figure, the first time that this had occurred since Manet's works of 1862. This work, *La Repasseuse* (fig. 338), became the prototype for a series of pastels and canvases. Compared, however, with Bonvin's working-class figure done ten years earlier in tranquil and virtuous intimacy (fig. 339), Degas's active and brutalized subject, enveloped in hanging laundry, is already the woman in Zola's *L'Assommoir*: with her naked arms wielding the iron, her unfastened camisole, her hair caught up in an untidy topknot amid the strong odor of laundry and the damp heat of a steam bath. This sexually accessible creature, exposed in the wide, bright window of a neighborhood laundry, has nothing in common with Bonvin's placid worker devoted to the lover who has given her flowers.

When writing *L'Assommoir*, Zola confessed to Degas: "In several places I quite simply described a few of your paintings."[39] Turnabout is fair play—Zola's *Thérèse Raquin* (1867) and *Madeleine*

39. "J'ai tout bonnement décrit, en plus d'un endroit, dans mes pages, quelques-uns de vos tableaux." Jules Claretie, "Le mouvement parisien: L'exposition des impressionnistes," *L'Indépendence belge*, April 15, 1877, p.1. On the relationship between *L'Assommoir* and Degas's paintings, see Theodore Reff, *Degas: The Artist's Mind* (New York, 1976), pp. 166–68, and Loyrette 1991, pp. 367–69.

Férat (1868), as well as, to a lesser extent, some fiction by Duranty, allowed Degas to renew the usual stock-in-trade of the genre scene. In Auguste Toulmouche (fig. 340) or Alfred Stevens (fig. 341), the genre scene was always anecdotal and narrow, focusing on elegance and sentimental little tales. But in Degas (figs. 342, 344) it became tense and enigmatic, abruptly underscoring the mystery of relations between men and women.

Since it first became known in the early twentieth century, *Intérieur* (fig. 344) has elicited multiple readings, provoked in part by the title *Le Viol* (*The Rape*), which it is frequently given. Degas himself never commented on it; around 1897, showing it "on the floor, against the wall" to Paul Poujaud, he simply said: "You know my genre pic-

Fig. 343 (cat. 61). Edgar Degas, *Portrait de Mlle E[ugénie] F[iocre]: à propos du ballet de "La Source"* (*Mlle Fiocre in the Ballet "La Source"*), 1867–68. Oil on canvas, 51⅛ x 57⅛ in. (130 x 145 cm). The Brooklyn Museum, Gift of James H. Post, John T. Underwood, and A. Augustus Healy

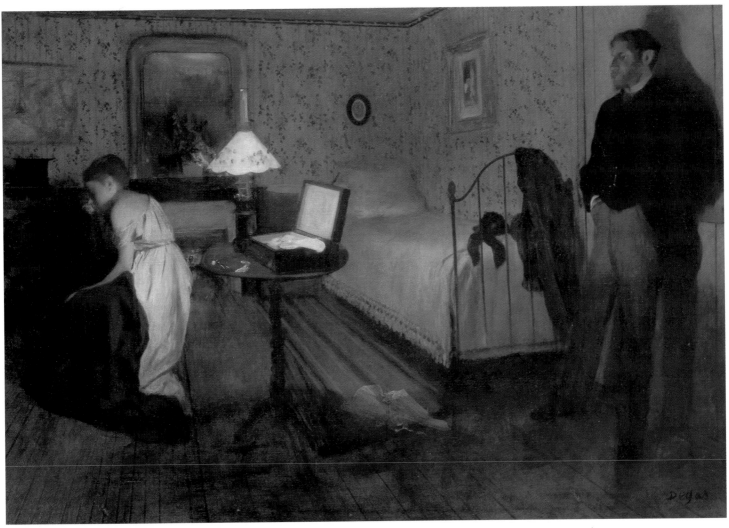

Fig. 344 (cat. 63). Edgar Degas, *Intérieur (Le Viol)* (*Interior [The Rape]*), ca. 1868–69. Oil on canvas, 32 x 45 in. (81.28 x 114.3 cm).
Philadelphia Museum of Art, The Henry P. McIlhenny Collection, in memory of Frances P. McIlhenny

ture, don't you?"[40] Critics have tried to elucidate it through passages in *Madeleine Férat* and *Thérèse Raquin*, but these efforts were unsuccessful. Degas was evidently not illustrating Zola even if he thought of him when painting his *tableau de genre*.

In 1868 Zola criticized Degas's *Portrait de Mademoiselle E[ugénie] F[iocre]* (fig. 343), accusing him of creating a "bizarre elegance" and a "slight" and "exquisite" result.[41] The artist decided to respond by creating a dense and somber painting that had little to do with the gallant and fashionable Paris. He depicted the violation of a young lower-class woman by a man who appears to be a young bourgeois. The picture's meaning lies neither in its title nor in its details, as it would in Victorian paintings and in similar works by Tissot or Stevens. Instead, enlightenment can be found in the open box on the pedestal table. Aside from the obvious signs of disdainfully treated intimacy—the corset on the floor, the man's garments

40. "à terre, contre le mur"; "vous connaissez mon tableau de genre, quoi!" Degas 1945, p. 255.
41. "élégances étranges"; "mince"; "exquis." Zola 1991, pp. 220–21.

tossed between the bureau and the bed—there is no more significant symbol of a violated virginity than this gaping casket, its rosy interior harshly exposed by the lamp.

As we have said (see pp. 44–45), Degas turns his genre scene into a history painting. Cézanne did the same in *L'Ouverture de Tannhäuser* (fig. 345). Its title suggests what the composition—resembling those of Fantin-Latour (fig. 234), Whistler (fig. 3), and Manet (fig. 241)—suppresses. In fact, *L'Ouverture de Tannhäuser* is a domestic transcription of Wagner's drama. There is the woman who embroiders and the woman who makes music, the woman who seems devoted to a peaceful life and the woman who dreams of being an artist: Martha and Mary rather than Elisabeth and Venus, each in her own world, so close together and yet so far apart, developing her talents within the suffocating framework of a bourgeois interior.

Despite these exceptions the genre scene was transformed chiefly by the adoption of new subjects. By 1870 Degas had already painted the first of his women ironing (fig. 338), *L'Orchestre de l'Opéra* (fig. 284), and several racing pictures. Manet, after *La Musique aux Tuileries* (fig. 332), had likewise done some horse races (fig. 353)

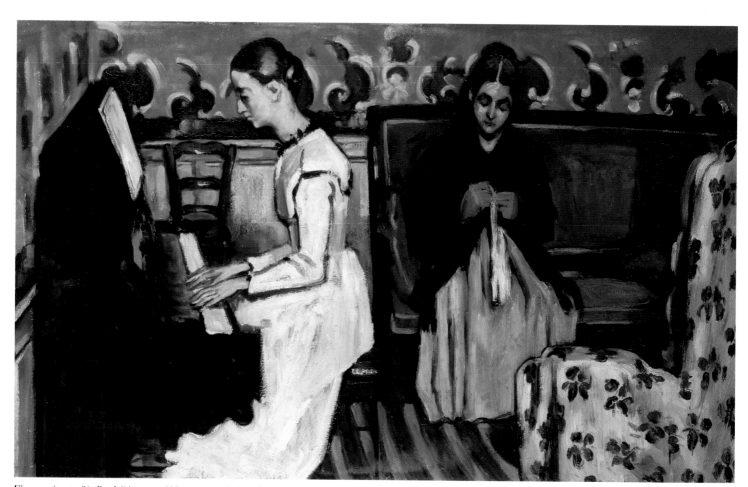

Fig. 345 (cat. 28). Paul Cézanne, *L'Ouverture de Tannhäuser* (*The Overture to "Tannhäuser"*), ca. 1869–70. Oil on canvas, 22¾ x 36⅜ in. (57.8 x 92.5 cm). Hermitage Museum, Saint Petersburg

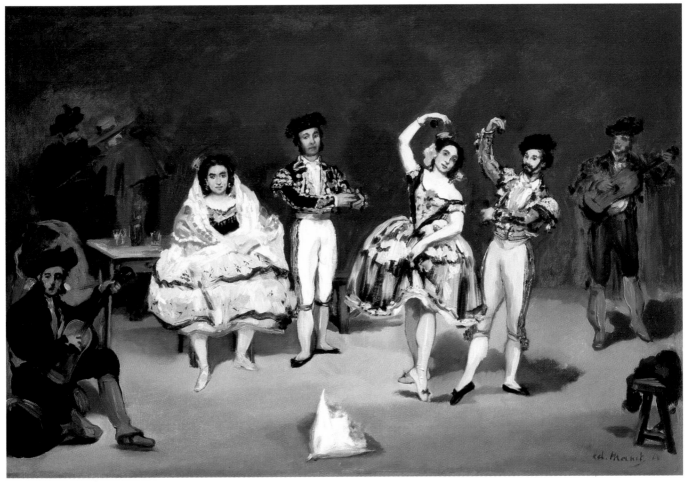

Fig. 346 (cat. 86). Édouard Manet, *Le Ballet espagnol* (*The Spanish Ballet*), 1862. Oil on canvas, 24 x 35⅝ in. (60.9 x 90.5 cm). The Phillips Collection, Washington

and gingerly approached the theater (fig. 269). In 1869 both artists, profiting from a holiday on the Normandy coast, painted the beach and the bathers scattered across the sand, facing a slack sea spangled with boats (figs. 358, 359). During the next ten years Degas developed this still small group of themes, adding the brasserie and the café-concert, the brothel and the backstage areas of the opera house. Ever intent on affirming his role as an initiator, Manet tardily maintained that Degas had followed him down this path, that Degas had still been plugging away at historical motifs while Manet was focusing on contemporary subjects: "Degas was painting Sémiramis while I was painting modern Paris."[42]

The truth was quite different. Although they may have met by 1862, Manet and Degas did not become close friends until about 1865–66. By then Manet was a famous artist, while Degas, still obscure, was known by a small coterie—more for his conversational gifts, his polemical talents, and the pungency of his bon mots than for his art. It was this Degas, the one he called "the great aesthetician," whom Manet admired, rather than the painter, one of whose canvases he mutilated.[43] For his part, Degas may have subsequently proclaimed his admiration for the Manet of the 1860s

42. "Degas peignait Sémiramis quand je peignais le Paris moderne." George Moore, *Confessions of a Young Man*, French translation (Paris, 1986), pp. 110–11.
43. "le grand esthéticien." Moreau-Nélaton, vol. 1, p. 102. About 1868–69 Degas did a portrait of M. and Mme Édouard Manet, which he gave them (fig. 237). However, Manet, dissatisfied with the face of his "dear Suzanne," cut the offending portion away. See Henri Loyrette in Paris, New York 1988, pp. 140–42.

Fig. 347. Edgar Degas, *Course de gentlemen. Avant le départ* (*Gentlemen's Race, before the Start*), 1862, retouched ca. 1882. Oil on canvas, 18⅞ x 24 in. (48 x 61 cm). Musée d'Orsay, Paris

Fig. 348. Édouard Manet, *Course à Longchamp* (*Race at Longchamp*), 1864. Watercolor over pencil sketch, 8⅞ x 22¼ in. (22.5 x 56.5 cm). The Fogg Art Museum, Harvard University Art Museums, Cambridge, Massachusetts

and his "magnificent prune juice"; but at the time he scarcely knew the older artist's paintings.[44] *Le Déjeuner sur l'herbe* did not make the same impact on him as on a number of other artists of his generation, and until 1865 Degas remained aloof from the trend that became the New Painting.

By 1861, however, during his earliest sojourn with his friends the Valpinçons in Orne, Degas had painted the first of his racecourses (fig. 349): a small, somber incunabulum, in which a few vivid touches—the women's hair, the caps and jackets of jockeys—stand out against the emerald meadows. Degas returned to this theme in a series of paintings, antedating the most remarkable one of 1862 (fig. 347).[45] He wanted to show his friend Manet that when the latter was doing *La Musique aux Tuileries* (fig. 332), he himself was not just working on "*grandes machines*" (huge canvases). Degas's first race pictures were sparked in a general sense by his stay with the Valpinçon family in early autumn 1861, his visit to the Pin stud farm, his probable outing to the nearby racing field of Argentan, and his interest in British painting. This obvious influence of British scenes and landscapes was strengthened by his hope of attracting French and perhaps British clients by making "products" with commercial subjects. And the influence (often ignored) of two artists who had previously failed to hold Degas's attention must be mentioned: Gericault, whom he copied at the Louvre after his return from Italy, and Alfred De Dreux, whose lithographs he studied.[46] A more proximate impetus—which critics generally fail to point out—was the example of Gustave Moreau, who, because of his contact with De Dreux, grew interested in racing motifs during the 1850s and then did a few drawings of jockeys about 1860.[47] Thus, curiously enough, it was the master of the Helens and Salomes who propelled Degas toward this modern subject, which claimed his interest throughout his life.

Manet did not tackle the world of horses until 1864 with a large canvas (approximately 30 x 80 in. [80 x 200 cm]), *Aspect d'une course au Bois de Boulogne* (*View of a Race in the Bois de Boulogne*), which he cut up after exhibiting it at the Galerie Martinet in 1865 (a watercolor of this composition survives [fig. 348]).[48] In 1867 he probably did a variant (fig. 353), which omitted the left side of the earlier composition (an elegant carriage and two horsemen), concentrating instead on the jockeys galloping between rows of spectators. While Degas certainly treated this theme before Manet, it cannot be asserted, as Moreau-Nélaton does, that Manet's racing themes were influenced by his confrère. In fact, nothing except the subject ties their paintings together. While Manet's teeming crowd (fig. 348) is an indistinct black-and-gray mass pressed against the wooden barrier, the throng in Degas's *Le Défilé* (fig. 351) is calmer and thinner,

44. "magnifique jus de pruneaux." Ambroise Vollard, *Degas* (Paris, 1924), p. 65.
45. Lemoisne 1946–49, vol. 2, cats. 75–78.
46. Reff 1985, notebook 13.
47. See Henri Loyrette in *Degas e l'Italia*, exh. cat., Rome, Villa Medici, 1984–85, p. 34, repr.
48. Harris 1966, pp. 78–82; Reff 1982, pp. 128–33; Charles S. Moffett in Paris, New York 1983, pp. 262–64.
49. "tourbillon des plus vives couleurs, du chaos des nuances les plus éclatantes"; "une prairie vivante sur laquelle on dirait que Diaz a versé sa palette." Amédée Achard in *Paris-Guide* (Paris, 1867), vol. 2, p. 1236.

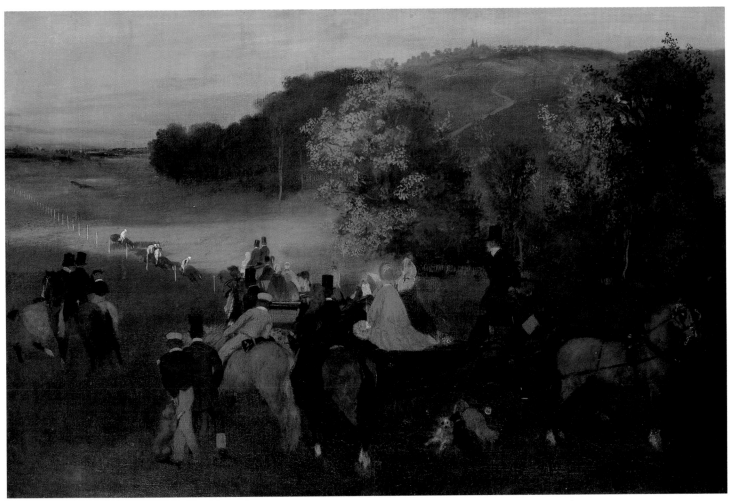

Fig. 349 (cat. 52). Edgar Degas, *Sur le champ de course* (*At the Racetrack*), 1861. Oil on canvas, 16⅞ x 25¾ in. (43 x 65.5 cm). Oeffentliche Kunstsammlung Basel, Kunstmuseum

with the dark touches of men's suits ranging up through the stands and white and bluish spots of parasols that shelter women in light-colored frocks. Separated from the spectators by a slender wooden barrier, seven horsemen, whose long shadows indicate that it is late in the afternoon, ride by in the uniform light of a hot spring or summer day. In this extraordinarily peaceful scene, which is barely ruffled by a horse rearing before an indifferent audience, there is nothing of the traditional racing scenes descended from Gericault's turbulent compositions. Nor is there the lively animation of Zola's celebrated passage in *Nana*, much less the kaleidoscope of elegant dresses, the "whirlwind of the most vivid colors, the chaos of the most dazzling nuances," which, as the contemporary *Paris-Guide* points out, turn every hippodrome into "a living meadow on which Diaz seems to have poured his palette."[49]

Degas's horses never gallop, except perhaps in a few of his back-grounds. But then he risks showing a galloping steed in his monumental *Scène de steeple-chase* (fig. 350), painted for the Salon of 1866. With its four hooves in the air, the horse, passing across the canvas like a medieval angel of death, soars over its unseated rider.

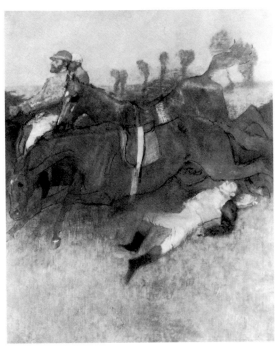

Fig. 350. Edgar Degas, *Scène de steeple-chase* (*Le Jockey blessé*) (*Steeplechase Scene [The Injured Jockey]*), 1866. Oil on canvas, 70⅞ x 59⅞ in. (180 x 152 cm). Paul Mellon Collection

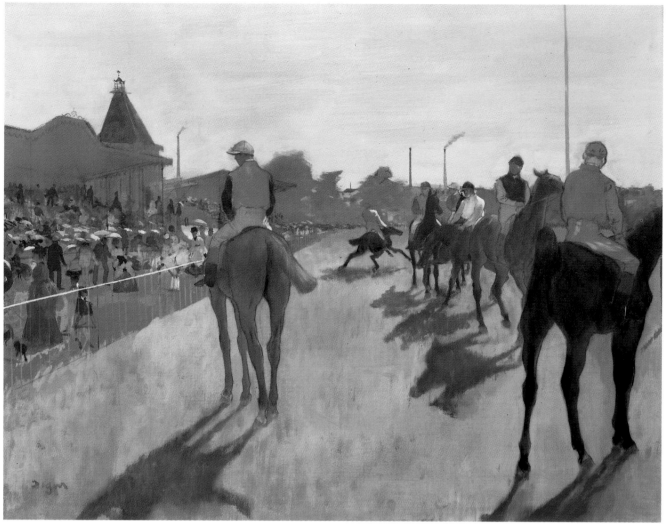

Fig. 351 (cat. 59). Edgar Degas, *Le Défilé (Chevaux de course devant les tribunes)* (*Horses before the Stands*), ca. 1866–68. Essence on paper mounted on canvas, 18⅛ x 24 in. (46 x 61 cm). Musée d'Orsay, Paris

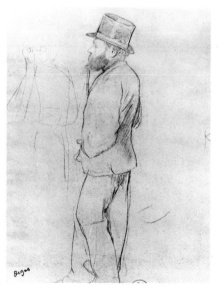

Fig. 352. Edgar Degas, *Manet sur le champ de courses (Manet at the Racetrack)*, ca. 1866–68. Graphite, 12¾ x 9¾ in. (32.4 x 24.8 cm). The Metropolitan Museum of Art, New York, Rogers Fund

One of the few contemporary critics who mentioned the canvas faulted the artist for not doing his homework: "Like this jockey, the painter does not yet know his mount perfectly."[50] Because of this review, Degas was discouraged from repeating the exercise.

On the other hand, Manet, focusing on the very moment of the race, adopts an original viewpoint: contrary to the examples available to him, especially tinted English engravings, he painted the horses not from the side but from the front, within a dense cluster that kicks up a flurry of dust. His galloping horses recall Turner's "human beast"—the locomotive charging full-throttle on the parallel tracks of a bridge—rather than Degas's tranquil creatures, endlessly waiting. Here as often elsewhere, Manet's modernity is bustling, deafening, rapid, even frantic—the viewer senses the speed, hears the clamor. Degas's modernity is acute, posed, distant; the crowd is not a confused aggregate but a gathering of individuals that can be counted one by one; in the light luminous air, each noise is heard distinctly.

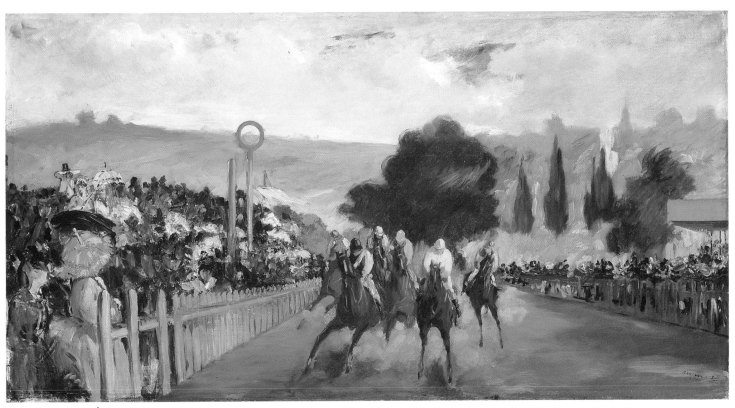

Fig. 353 (cat. 106). Édouard Manet, *Courses à Longchamp* (*Races at Longchamp*), 1867 (?). Oil on canvas, 17¼ x 33¼ in. (43.9 x 84.5 cm).
The Art Institute of Chicago, Potter Palmer Collection

One hand in his jacket pocket, the other holding a riding crop, his top hat lightly pushed back—this is how Degas shows Manet at the races (fig. 352), stressing, as portraitists and chroniclers will, his unaffected elegance and subtle blend of dandyism and banter. In 1870 Degas visited Bazille's studio as a sovereign would. This space on rue de la Condamine had a huge window opening on a facade characteristic of Haussmann's Paris. It was bright, without the flowerpots, chinoiseries, or animal skins that decorated the work space of many successful artists. Edmond Maître may have been playing Schumann on the piano, a passion he shared with Bazille and Manet. These were well-bred, well-dressed men, wearing as a matter of course the modern apparel "so victimized," quite remote from the realist studios and the meetings of bohemian art students (fig. 354).[51] Manet created the prototype of the modern painter, a Parisian, devoted to the spectacles of the street—his chief source of inspiration—dividing his time between working in the studio, strolling, talking with artists in cafés, attending musical soirées. This model was contradicted

50. "comme ce jockey, le peintre ne connaît pas encore parfaitement son cheval." Quoted by Henri Loyrette in Paris, New York 1988, p. 123.
51. "tant victimé." Baudelaire 1985–87, vol. 2, "Salon de 1846," p. 494.

Fig. 354. Amand Gautier, *À la brasserie Andler* (*At the Andler Brasserie*), 1857. Oil on canvas. Private collection

by the unkempt, untidy Cézanne, overdoing his meridional accent in order to taunt the painter of *Olympia*: "I won't shake hands with you, Monsieur Manet, I haven't washed for a whole week."[52] It was also refuted by Pissarro, who, always emanating a whiff of cow dung, obstinately focused on pastures and farmlands, while his colleagues had their fun at La Grenouillère or took off for the Normandy coast.

Manet and Degas were flaneurs—a new type of Parisian—who, benefiting from idlers' desire to "have an audience," enriched their "albums with sketches, [their] notebooks with jottings, and [their] mental cartoons with observations."[53] Degas's abundant notebooks testify to this hunger for catching people at a café, a race, a theater, for detailing a house, for seizing a gesture, an expression, the trivia of everyday life.[54] The setting is usually Paris but can also be the city's surroundings, the banks of the Seine, and, in fair weather, the Normandy coast. Sometimes they headed south, to Bazille's Midi with its skinny trees in denuded soil (fig. 100), to Cézanne's Midi with its small factories with smoking chimneys at the bottom of bare hills (fig. 118). In the 1860s, however, nature seldom had such rugged features. Fontainebleau's thick shade, into which hardworking miniature figures vanished, was replaced by closed gardens, grassy and flowering, crossed by narrow sandy paths; nymphs and satyrs were banned, but in their stead appeared young Parisian women who strolled and gossiped. Nature was not a sublime and often terrifying primordial force but a domesticated setting made by and for human beings—the idea of nature moved from Théodore Rousseau to Claude Monet, from George Sand to Michelet. "I want a garden, not a park," wrote Michelet, "a small garden. Man does not grow easily outside a garden's harmonious vegetation. That is where life begins in all Oriental legends. The nation of strong men, pure men, Persia, lets the world commence in a garden of light."[55]

And then there was Paris. The new Paris of twenty arrondissements, unified on paper even if, when walking toward Vaugirard or Bercy, or climbing to Passy or Montmartre, the observer could sense the industrial suburbs that were awkwardly grafted onto the capital's center. There were the parks and public squares with gardens, the broad straight avenues lined with still-demure trees and overgrown with benches, lampposts, kiosks, and pissoirs. There was Haussmann's unending and very controversial construction: old neighborhoods removed from the map; churches and old mansions sacrificed to linear uniformity. There were the fences and empty lots, the scaffolds and the streets being macadamized. There was the native Parisian, withdrawn or downright hostile; there was the mass of rustics and provincials who had rolled in, hoping to profit from the windfall; and there were the foreigners, every kind of for-

52. "Je ne vous donne pas la maing, Monsieur Manet, je ne me suis pas lavé depuis huit jours." See Darragon 1989, pp. I–XII, for descriptions of Manet by his contemporaries.

53. "avoir un public"; "croquis [leur] album, de notes [leur] calepin, et d'observations [leurs] cartons cérébraux." Alfred Delvau in *Les Plaisirs de Paris* (Paris, 1867), quoted by Herbert 1988, p. 33.

54. See Reff 1985.

55. "Je veux un jardin, non un parc; un petit jardin. L'homme ne croît pas aisément hors de ses harmonies végétales. Toutes les légendes d'Orient commencent la vie dans un jardin. Le peuple des forts, des purs, la Perse, met le monde d'abord dans un jardin de lumière." Jules Michelet, *La Femme* (Paris, 1981), p. 92. Michelet's book was first published in 1859.

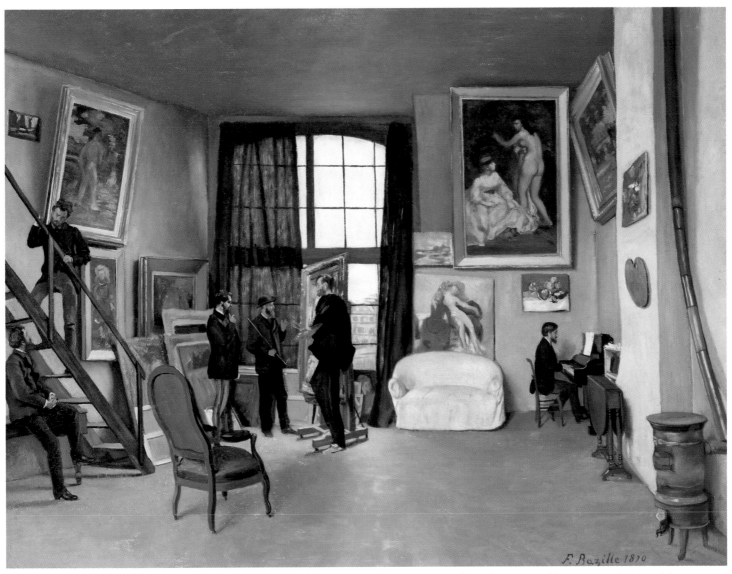

Fig. 355 (cat. 12). Frédéric Bazille, *L'Atelier de la rue La Condamine* (*The Studio in the rue La Condamine*), 1869–70. Oil on canvas, 38⅝ x 50⅝ in. (98 x 128.5 cm). Musée d'Orsay, Paris

eigner, turning the city into a Tower of Babel—the German, the Italian, the Pole, all making their way.

In his *Maison neuve* (*New House*), first staged at the Vaudeville in 1866, Victorien Sardou presented an old Parisian who both rages against the urban renewal and puts up with it, who mourns for the vanished city but does not excoriate the new one that is emerging. When his nephew impatiently asks him: "What do you have against this new Paris?" he soberly replies: "Ah, my dear boy! We're losing the old Paris, the true Paris, that Paris! A narrow, unhealthy, inadequate city, yet picturesque, varied, charming, full of memories, and so well suited to us! So comfortable in its very narrowness! We had our promenades just a few steps away, our habitual sights grouped into baskets. We had our own little revolutions entre nous: How nice it was! Doing errands didn't wear us out, they were fun. They produced that totally Parisian compromise between laziness and activity: the flaneur! Today you have to walk for miles and

miles to run even the simplest errand.... An eternal sidewalk, long, endlessly long—a tree, a bench, a kiosk—a tree, a bench, a kiosk—a tree, a bench...! And sun, dust, a mess of cleanliness! A motley, cosmopolitan crowd, jabbering away in any and all languages, sporting every imaginable color. There is nothing left of what we had, a little world, a world apart, self-appointed, amateurish, thumbing its nose at authority—the elite of mind and taste!" And when the younger man retorts by citing "the greatness, convenience, and *hygiene* of the new urbanism," the uncle explains: "Still, I tell you, I admire it! We have no choice: it had to be done and it *was* done. And in the end, the best won out! My hat's off and I applaud heartily—but I am so pleased that the good Lord did not know about this marvelous urban system and that he did not put all of nature's trees in a straight line, with all the stars in two rows."[56]

The Impressionists are often credited with using Haussmann's Paris as an artistic motif. It has been said that the New Painting celebrated the new Paris, making a common cause with it. In fact, this is true in the 1870s. In 1873 Monet painted *Boulevard des Capucines* (Pushkin Museum, Moscow) and in 1877 his multiple renderings of the Gare Saint-Lazare. Manet did *Le Chemin de fer* (*The Railroad*; National Gallery of Art, Washington) in 1873 and the pictures of rue Mosnier in 1878. In 1875 Caillebotte began exalting the series of identical apartment houses, the streets meeting at sharp angles, and the industrial bridges. In the 1860s, however, the artists who painted urban views were attached to the eternal Paris, the city of quais along the Seine and ancient monuments. Robert Herbert correctly emphasizes that Monet and especially Renoir turned what used to be topographical views into real paintings; on the other hand, it is difficult to agree with his statement that in *Le Pont des Arts* (fig. 307) "Renoir shows the extent to which he favored the new city over the old."[57] The only recent constructions in that picture, which captures the very heart of the city, are the twin roofs of the theaters on place du Châtelet, and they are so remote that they do not appear contemporary. That same year, 1867, Monet, standing in a window in the Louvre, painted *Saint-Germain-l'Auxerrois* (fig. 306), *Le Quai du Louvre* (fig. 308), and *Le Jardin de l'Infante* (fig. 309). It is evident that he was still attached to the traditional capital, the parish of the French kings, the ancient houses on Île de la Cité and the quai Conti, the bell tower of Saint-Étienne-du-Mont, the domes of the Panthéon and the Val-de-Grâce. By elevating the Gothic facade of Saint-Germain-l'Auxerrois against the blue sky, Monet adopts a vantage point that allows him to omit two important Haussmann projects, which were savaged by the critics: the belfry by Ballu (1861) and the first-arrondissement town hall by Hittorf (1859). He was, however, forced to include the high, flat

56. "Qu'est-ce que vous lui reprochez à ce nouveau Paris?"; "Ah! cher enfant! On y perd le vieux Paris, le vrai, celui-là! Une ville étroite, malsaine, insuffisante, mais pittoresque, variée, charmante, pleine de souvenirs, et si bien faite à nos tailles! si commode par son exiguïté même! Nous avions là nos promenades à deux pas, nos spectacles habituels groupés en corbeille; nous faisions là nos petites révolutions entre nous: c'était gentil. La course à pied n'était pas une fatigue, c'était une joie. Elle avait enfanté ce compromis si parisien, entre la paresse et l'activité, la flânerie! Aujourd'hui pour la moindre course des lieues à faire, une chaussée boueuse que les femmes traversent sans grâce, n'ayant plus pour rebondir l'élasticité du pavé! un trottoir éternel, tout le long, le long de l'aune! un arbre, un banc, un kiosque! un arbre, un banc, un kiosque! un arbre, un banc.... Et là-dessus, un soleil, une poussière, un gâchis de propreté! Une foule bigarrée, cosmopolite, baragouinant toutes les langues, bariolée de toutes les couleurs. Plus rien de ce qui nous constituait un petit monde à part, jugeur, amateur, frondeur, l'élite de l'esprit et du goût!"; "ce qu'il y a de grand, de commode, d'*hygiénique*"; "Mais puisque je te dis que je l'admire! C'est forcé: on devait le faire, on l'a fait! On a bien fait! et somme toute, c'est le mieux qui l'emporte! Vivat et j'applaudis des deux mains, en me félicitant que le bon Dieu n'ait pas connu ce merveilleux système municipal, et qu'il n'ait pas fait tous les arbres de la nature sur une seule ligne, avec toutes les étoiles sur deux rangs." Victorien Sardou, *Maison neuve* (1866), act I, scene 12, quoted by Gérard Lameyre, *Haussmann, préfet de Paris* (Paris, 1958), pp. 281–82.

57. Herbert 1988, p. 6.

Claude Monet, *Le Quai du Louvre*, detail of fig. 308

Fig. 356. Edgar Degas, *Maisons au bord de la mer (Houses beside the Sea)*, ca. 1869. Pastel, 12¼ x 18¼ in. (31 x 46.5 cm). Musée d'Orsay, Paris

Fig. 357. Edgar Degas, *Falaises au bord de la mer (Cliffs at the Edge of the Sea)*, 1869. Pastel, 12¾ x 18½ in. (32.4 x 46.9 cm). Musée d'Orsay, Paris

58. "Nous montions ce jour-là ce qui a été depuis le boule-vard Malesherbes, au milieu des démolitions coupées par les ouvertures béantes des terrains déjà nivelés. Le quartier Monceau n'était pas encore dessiné. À chaque pas Manet m'arrêtait. À un certain endroit un cèdre se dressait isolé au milieu d'un jardin défoncé. . . . Plus loin des démo-lisseurs se détachaient blancs sur la muraille moins blanche qui s'effondrait sous leurs coups, les enveloppant d'un nuage de poussière. Manet demeura absorbé dans une longue admiration devant ce spectacle." Proust 1897, p. 27.

59. "longue admiration"; "spectacle"; "insens absolu de l'art." J. K. Huysmans, *Certains* (Paris, 1976), p. 405. "dentelle gothique en fer." Quoted in *La Tour Eiffel présentée par Armand Lanoux* (Paris, 1980), p. 55.

60. Meyer Schapiro, "Seurat and La Grande Jatte." *Columbia Review*, November 1935, p. 15.

facade of a new apartment house on the right of his composition.

Whether springing from disdain or indifference, this reticence of the New Painting about the metamorphoses of the capital and its tardiness in capturing the Paris of twenty arrondissements are surprising. In 1862, in describing a Manet eager to take in every innovation and always discovering new motifs, Antonin Proust showed him to be passionate about Haussmann's vast reconstruction: "That day we walked up from what was to be the boulevard Malesherbes, amid demolitions interspersed with the yawning gaps of leveled lots. The Monceau district was not yet laid out. Manet kept stopping me. At a certain point, an isolated cedar loomed from a devastated garden. . . . Farther on, men working as wreckers stood out, white against a less white wall that crumbled under their blows, swathed in a cloud of dust. Manet lingered, lost in a long admiration of the spectacle."[58]

But this "long admiration" did not inspire a painting. Manet and his young confrères must have not known how to tackle the "spectacle," how to translate their city's new configuration, which most critics deemed unaesthetic. In a similar manner a quarter of a century later, the erection of the Eiffel Tower—"an absolute artistic absurdity of art," according to the novelist Huysmans—never held the attention of Pissarro, who painted numerous townscapes, or Gauguin, who lauded "the Gothic iron lacework," or Luce, Raffaëlli, and so many other artists who, fleeing conventional depictions of the historical center, focused on industrial innovations and industrial suburbs.[59] Seurat tackled the tower in progress, but that was because, as Meyer Schapiro has pointed out, there was a formal analogy between Seurat's juxtaposed brushstrokes and the bold crisscross of the metallic trusses.[60] During the 1860s French artists were not ready for the new Paris. It was not until the following decade that Monet dissolved house fronts in quivering sunbeams and drowned huge windows and iron bridges in trails of smoke and that Caillebotte developed a style so consistent with Haussmann's architecture—dry, cold, implacable, and fascinating because of its mineral accents and compositional rigor.

The summer of 1869 was beautiful. Manet spent the entire season in Boulogne-sur-Mer; Bazille was as usual in southern France. Renoir was at Ville d'Avray, and Monet, not far from there, in Saint-Michel, starving and too broke to buy pigments. Degas, unable to stay put in any one place, traveled to Étretat, Villiers-sur-Mer, and Boulogne-sur-Mer, where he visited Manet; on the way back Degas stopped at his friends the Valpinçons in Orne—by now a summer habit for him. There he painted *Aux courses en province* (fig. 287). Then, upon returning to his studio, he reconstructed a few Normandy sites, though disdaining topographic exactitude and climatic accuracy.

Fig. 358 (cat. III). Édouard Manet, *Sur la plage de Boulogne* (*On the Beach at Boulogne*), 1868. Oil on canvas, 12¾ x 26 in. (32.4 x 66 cm).
Virginia Museum of Fine Arts, Richmond, Collection of Mr. and Mrs. Paul Mellon

Instead he re-created everything from memory: bleak cliffs with fishermen's shanties clinging to them like seashells, beaches at low tide with sand and sea blurring into each other, stranded boats with no human presence (fig. 356), a long plume of smoke from a steamer (fig. 357), and the four black dots of sailboats on the horizon that separated the different blues of sky and sea.

After we study this series of pastels by Degas and his small portrait of the Valpinçon family, Manet's admirable nocturne (fig. 305) and *Sur la plage de Boulogne* (fig. 358), Bazille's *Scène d'été* (fig. 337), Monet's and Renoir's depictions of La Grenouillère (figs. 319–22), we have to admit that what is known as Impressionism and is said to have begun in 1874 was already in existence.

We can already see the fractured, quivering touch that—in Monet, in Renoir—translates the reflection of the sun, the sparkling of the water, the continuous wavering of nature, the disorder and agitation of human beings. We can already see the acute, instantaneous, almost arbitrarily cut compositions that—in Manet, in Degas—get to the very heart of the world. During the late 1860s, on a beach along the English Channel, we watch scattered figures (fig. 358). There are two little boys in their mother's skirts; others making sand pies; a horse-drawn cabana; women gossiping in a stiff wind; a nursemaid combing a little girl's hair; shivering bathers swaddled in white sheets; and an imposing woman and a man twirling his hat

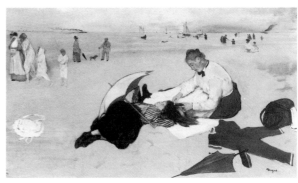

Fig. 359. Edgar Degas, *Petite Fille peignée par sa bonne* (*Combing the Hair*), 1869. Essence on paper mounted on canvas, 18½ x 32½ in. (47 x 82.6 cm). National Gallery, London

61. "dos de sardine." Reff 1985, notebook 38, p. 56.
62. "la plus belle époque d'art." Astruc 1859, pp. 368–69.
63. "Edgar travaille toujours énormément sans en avoir l'air. Ce qui fermente dans cette tête est effrayant." Paris, Ottawa, New York 1988–89, p. 55.
64. "Je découvre tous les jours des choses toujours plus belles. C'est à en devenir fou, tellement j'ai envie de tout faire, la tête m'en pète." Wildenstein 1974, p. 520.

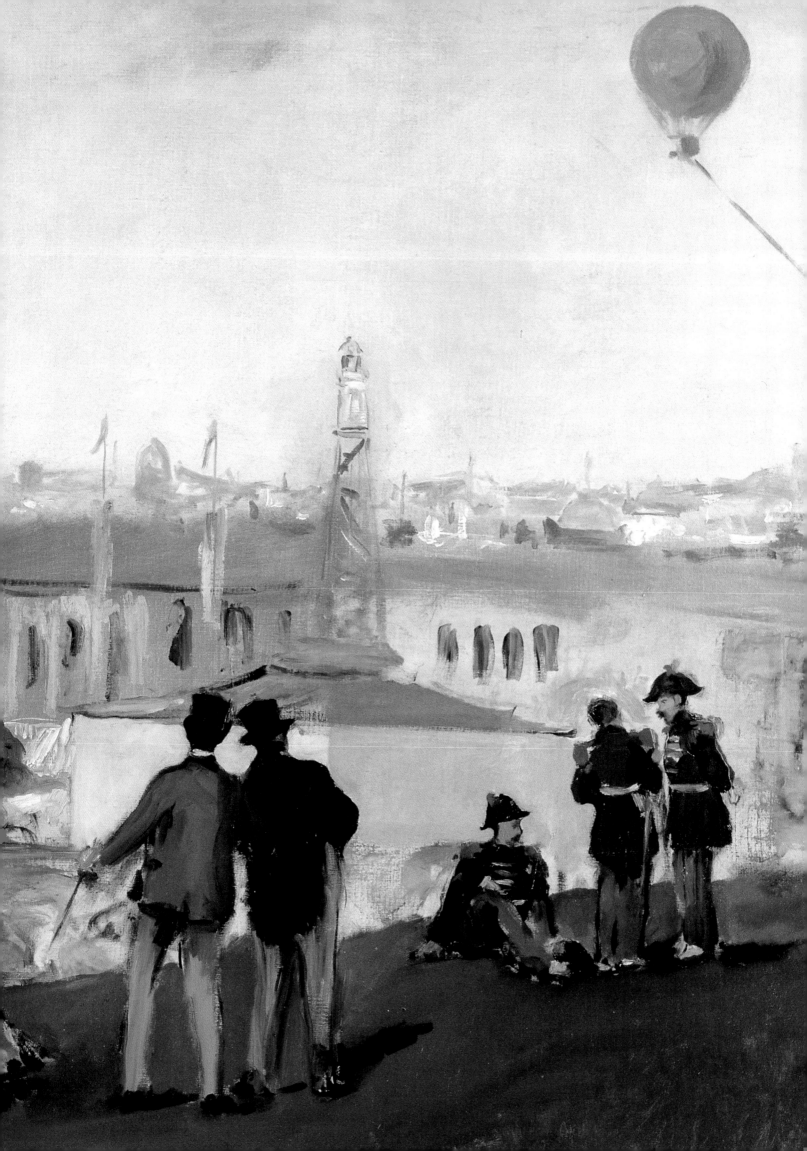

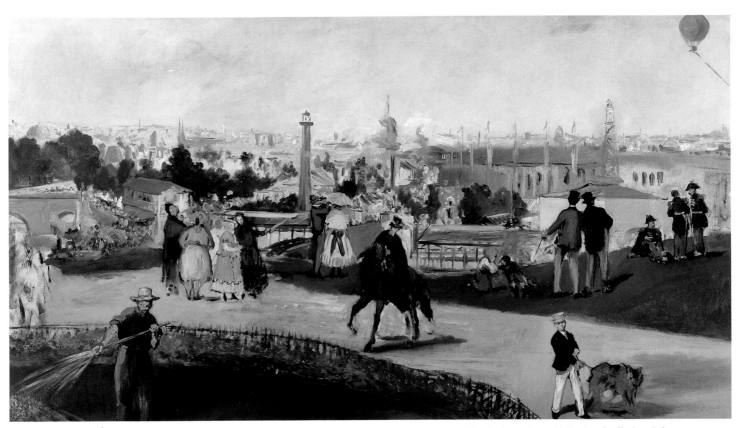

Fig. 360 (cat. 107). Édouard Manet, *L'Exposition universelle de 1867*, 1867. Oil on canvas, 42½ x 77⅜ in. (108 x 196.5 cm). Nasjonalgalleriet, Oslo

in his fingers, who are separated by a dog. Sailboats and steamboats ply the channel, which is the color of a "sardine back" (fig. 359).[61] The revamping of themes had led to a new way of painting. Within a span of ten years, several artists of different backgrounds and origins, forming not a constituted movement but a disparate and moving power, had extended and metamorphosed the teachings of Courbet and the realists. They spread the modern sentiment and organized what Zacharie Astruc had demanded in 1859—"the finest era of art."[62]

In 1867 Manet, from the heights of Chaillot, gazed down at the Exposition Universelle (fig. 360), the circular Palais de l'Industrie with all its flags, the scattered pavilions of the French quadrant, the rival beacons of France and England, one in solid brickwork, the other exposing a metallic skeleton, and in the distance, the domes and clock towers of old Paris, abolished by the modern, ephemeral city. In the empty sky, Nadar's balloon was keeping watch. And God, having gone back to gardening, was watering a minuscule Eden of grass and flowers. It was morning.

Édouard Manet, *L'Exposition universelle de 1867*, detail of fig. 360

Chronology of Works in the Catalogue

ÉDOUARD MANET
Bateau de pêche arrivant vent arrière (Le "Kearsarge" à Boulogne) (cat. 100, fig. 289)

CLAUDE MONET
Fleurs de printemps (cat. 115, fig. 222)

CLAUDE MONET
Bord de la mer à Sainte-Adresse (cat. 116, fig. 81)

CLAUDE MONET
Le Phare de l'hospice (cat. 117, fig. 79)

CAMILLE PISSARRO
Bords de la Marne (?) (cat. 154, fig. 116)

CAMILLE PISSARRO
Chennevières au bord de la Marne, ca. 1864–65 (cat. 155, fig. 115)

AUGUSTE RENOIR
Fleurs de printemps (cat. 168, fig. 223)

AUGUSTE RENOIR
Portrait de Romaine Lacaux (cat. 169, fig. 226)

JAMES TISSOT
Portrait de Mlle L. L . . . (Jeune Femme en veste rouge) (cat. 189, fig. 278)

JAMES MCNEILL WHISTLER
The Little White Girl: Symphony in White, No. 2 (cat. 191, fig. 250)

1865

FRÉDÉRIC BAZILLE
Plage à Sainte-Adresse (cat. 2, fig. 80)

FRÉDÉRIC BAZILLE
Paysage à Chailly (cat. 3, fig. 97)

EUGÈNE BOUDIN
La Plage de Trouville, ca. 1865 (cat. 18, fig. 78)

PAUL CÉZANNE
Pain et Oeufs (cat. 22, fig. 206)

CAMILLE COROT
Cour d'une maison de paysans aux environs de Paris, ca. 1865–70 (cat. 37, fig. 107)

GUSTAVE COURBET
La Fille aux mouettes (cat. 43, fig. 279)

GUSTAVE COURBET
La Trombe (Marine) (cat. 44, fig. 293)

EDGAR DEGAS
Scène de guerre au Moyen Âge (cat. 55, fig. 61)

EDGAR DEGAS
Portrait de l'artiste avec Évariste de Valernes (cat. 56, fig. 276)

EDGAR DEGAS
Femme accoudée près d'un vase de fleurs (Portrait de Mme Paul Valpinçon) (cat. 57, fig. 281)

JOHAN BARTHOLD JONGKIND
Le Port de Honfleur (cat. 81, fig. 84)

ÉDOUARD MANET
La Lecture, 1865, retouched ca. 1873–75 (cat. 101, fig. 240)

CLAUDE MONET
La Pointe de la Hève à marée basse (cat. 118, fig. 83)

CLAUDE MONET
Le Pavé de Chailly dans la forêt de Fontainebleau (cat. 119, fig. 99)

CLAUDE MONET
Le Chêne de Bodmer. La Route de Chailly (cat. 120, fig. 96)

CLAUDE MONET
Étude pour le Déjeuner sur l'herbe (Les Promeneurs) (cat. 121, fig. 172)

CLAUDE MONET
Le Déjeuner sur l'herbe, 1865–66 (cats. 122 and 123, fig. 169)

JAMES MCNEILL WHISTLER
Trouville (Grey and Green, the Silver Sea) (cat. 192, fig. 290)

JAMES MCNEILL WHISTLER
Sea and Rain (cat. 193, fig. 292)

1866

FRÉDÉRIC BAZILLE
Étude de fleurs (cat. 4, fig. 221)

PAUL CÉZANNE
Vue de Bonnières (cat. 23, fig. 105)

PAUL CÉZANNE
L'Oncle Dominique (L'Avocat), ca. 1866 (cat. 24, fig. 251)

PAUL CÉZANNE
L'Oncle Dominique, ca. 1866 (cat. 25, fig. 252)

PAUL CÉZANNE
Portrait de Louis-Auguste Cézanne (cat. 26, fig. 264)

GUSTAVE COURBET
La Femme au perroquet (cat. 45, fig. 148)

EDGAR DEGAS
L'Amateur d'estampes (cat. 58, fig. 283)

EDGAR DEGAS
Le Défilé (Chevaux de course devant les tribunes), ca. 1866–68 (cat. 59, fig. 351)

HENRI FANTIN-LATOUR
Fleurs de printemps, pommes et poires (cat. 72, fig. 212)

ÉDOUARD MANET
Le Fifre (cat. 102, fig. 261)

ÉDOUARD MANET
Jeune Dame en 1866 (La Femme au perroquet) (cat. 103, fig. 243)

ÉDOUARD MANET
Fruits (Nature morte avec melon et pêches), 1866 (?) (cat. 104, fig. 188)

CLAUDE MONET
Rue de la Bavolle, Honfleur (cat. 124, fig. 108)

CLAUDE MONET
Rue de la Bavolle, Honfleur (cat. 125, fig. 109)

CLAUDE MONET
Le Port de Honfleur (cat. 126, fig. 86)

CLAUDE MONET
La Vague verte, 1866–67 (cat. 127, fig. 303)

CLAUDE MONET
Marine: effet de nuit, 1866–67 (cat. 128, fig. 304)

CLAUDE MONET
Marine: orage, 1866–67 (cat. 129, fig. 302)

CLAUDE MONET
Femmes au jardin, 1866–67 (cat. 130, fig. 175)

CAMILLE PISSARRO
Bords de la Marne en hiver (cat. 156, fig. 117)

AUGUSTE RENOIR
Le Cabaret de la mère Antony (cat. 170, fig. 225)

AUGUSTE RENOIR
Jules Le Coeur et ses chiens se promenant en forêt de Fontainebleau (cat. 171, fig. 90)

ALFRED SISLEY
Une rue à Marlotte; environs de Fontainebleau (cat. 185, fig. 103)

ALFRED SISLEY
Allée de châtaigniers à La Celle-Saint-Cloud, ca. 1866–67 (?) (cat. 186, fig. 98)

1867

FRÉDÉRIC BAZILLE
Aigues-Mortes (cat. 5, fig. 110)

FRÉDÉRIC BAZILLE
Remparts d'Aigues-Mortes (cat. 6, fig. 112)

FRÉDÉRIC BAZILLE
Porte de la Reine à Aigues-Mortes (cat. 7, fig. 113)

FRÉDÉRIC BAZILLE
Le Héron (cat. 8, fig. 217)

PAUL CÉZANNE
La Madeleine, ca. 1867 (cat. 27, fig. 66)

GUSTAVE COURBET
La Pauvresse de village (cat. 46, fig. 313)

EDGAR DEGAS
Jeune Femme debout près d'une table, ca. 1867–68 (cat. 60, fig. 286)

EDGAR DEGAS
Portrait de Mlle E[ugénie] F[iocre]; à propos du ballet de "La Source," 1867–68 (cat. 61, fig. 343)

EDGAR DEGAS
Portrait de James Tissot, 1867–68 (cat. 62, fig. 277)

ÉDOUARD MANET
L'Enterrement, ca. 1867 (cat. 105, fig. 336)

ÉDOUARD MANET
Courses à Longchamp, 1867 (?) (cat. 106, fig. 353)

ÉDOUARD MANET
L'Exposition universelle de 1867 (cat. 107, fig. 360)

CLAUDE MONET
La Jetée du Havre par mauvais temps, 1867–68 (cat. 131, fig. 89)

CLAUDE MONET
Saint-Germain-l'Auxerrois (cat. 132, fig. 306)

CLAUDE MONET
Le Jardin de l'Infante (cat. 133, fig. 309)

CLAUDE MONET
Le Quai du Louvre (cat. 134, fig. 308)

CLAUDE MONET
Les Régates à Sainte-Adresse (cat. 135, fig. 87)

CLAUDE MONET
La Plage de Sainte-Adresse (cat. 136, fig. 88)

CLAUDE MONET
Jardin à Sainte-Adresse (cat. 137, fig. 310)

CLAUDE MONET
Jeanne Marguerite Lecadre au jardin (cat. 138, fig. 180)

CLAUDE MONET
La Route de la ferme Saint-Siméon, l'hiver (cat. 139, fig. 314)

CAMILLE PISSARRO
Nature morte (cat. 157, fig. 205)

CAMILLE PISSARRO
La Côte de Jallais (cat. 158, fig. 119)

CAMILLE PISSARRO
L'Hermitage à Pontoise (cat. 159, fig. 120)

PIERRE PUVIS DE CHAVANNES
La Guerre (reduced version of the painting shown at the Salon of 1861) (cat. 167, fig. 60)

AUGUSTE RENOIR
Frédéric Bazille peignant "Le Héron" (cat. 172, fig. 218)

ALFRED SISLEY
Le Héron (cat. 187, fig. 216)

1868

FRÉDÉRIC BAZILLE
La Vue du village (cat. 9, fig. 182)

FRÉDÉRIC BAZILLE
Le Pêcheur à l'épervier (cat. 10, fig. 153)

EDGAR DEGAS
Intérieur (Le Viol), ca. 1868–69 (cat. 63, fig. 344)

ÉDOUARD MANET
Portrait d'Émile Zola (cat. 108, fig. 270)

ÉDOUARD MANET
Madame Manet au piano (cat. 109, fig. 241)

ÉDOUARD MANET
Clair de lune (cat. 110, fig. 305)

ÉDOUARD MANET
Sur la plage de Boulogne (cat. 111, fig. 358)

CLAUDE MONET
Portrait de Victor Jacquemont, ca. 1868 (cat. 140, fig. 179)

CLAUDE MONET
Au bord de l'eau, Bennecourt (cat. 141, fig. 181)

CLAUDE MONET
Portrait de madame Louis-Joachim Gaudibert (cat. 142, fig. 231)

CLAUDE MONET
La Porte d'Amont, Étretat, 1868–69 (cat. 143, fig. 323)

CAMILLE PISSARRO
L'Hermitage, ca. 1868 (cat. 160, fig. 121)

CAMILLE PISSARRO
L'Hermitage, ca. 1868 (cat. 161, fig. 122)

AUGUSTE RENOIR
Clown au cirque (cat. 173, fig. 245)

AUGUSTE RENOIR
En été; étude (cat. 174, fig. 246)

AUGUSTE RENOIR
Le Jeune Garçon au chat, 1868–69 (cat. 175, fig. 155)

1869

FRÉDÉRIC BAZILLE
Scène d'été (cat. 11, fig. 337)

FRÉDÉRIC BAZILLE
L'Atelier de la rue La Condamine, 1869–70 (cat. 12, fig. 355)

FRÉDÉRIC BAZILLE
La Toilette, 1869–70 (cat. 13, fig. 154)

CAROLUS-DURAN
*Portrait de Mme X*** (La Dame au gant)* (cat. 21, fig. 230)

PAUL CÉZANNE
L'Ouverture de Tannhäuser, ca. 1869–70 (cat. 28, fig. 345)

PAUL CÉZANNE
Usines près du mont de Cengle, ca. 1869–70 (cat. 29, fig. 118)

PAUL CÉZANNE
Paul Alexis lisant à Émile Zola, ca. 1869–70 (cat. 30, fig. 265)

PAUL CÉZANNE
Une moderne Olympia, ca. 1869–70 (cat. 32, fig. 162)

GUSTAVE COURBET
Mer calme (cat. 47, fig. 294)

EDGAR DEGAS
Portrait d'Emma Dobigny (cat. 64, fig. 272)

EDGAR DEGAS
La Repasseuse (cat. 65, fig. 338)

EDGAR DEGAS
Aux courses en province (cat. 66, fig. 287)

EDGAR DEGAS
Bouderie, ca. 1869–70 (cat. 67, fig. 342)

HENRI FANTIN-LATOUR
Nature morte aux fiançailles (cat. 73, fig. 213)

CLAUDE MONET
La Pie (cat. 144, fig. 315)

CLAUDE MONET
Fleurs et Fruits (cat. 145, fig. 215)

CLAUDE MONET
Les Bains de la Grenouillère (cat. 146, fig. 320)

CLAUDE MONET
La Grenouillère (cat. 147, fig. 322)

CLAUDE MONET
La Seine à Bougival (cat. 148, fig. 324)

CLAUDE MONET
Route à Louveciennes, effet de neige, 1869–70 (cat. 149, fig. 316)

BERTHE MORISOT
Marine (Le Port de Lorient) (cat. 153, fig. 328)

CAMILLE PISSARRO
La Route de Versailles à Louveciennes (effet de neige) (cat. 162, fig. 317)

CAMILLE PISSARRO
Printemps à Louveciennes, ca. 1869–70 (cat. 164, fig. 326)

AUGUSTE RENOIR
Fleurs dans un vase (cat. 176, fig. 214)

AUGUSTE RENOIR
La Grenouillère (cat. 177, fig. 319)

AUGUSTE RENOIR
La Grenouillère (cat. 178, fig. 321)

AUGUSTE RENOIR
Chemin à Louveciennes, 1869 (?) (cat. 179, fig. 325)

ALFRED SISLEY
Vue de Montmartre prise de la cité des Fleurs aux Batignolles (cat. 188, fig. 104)

1870

FRÉDÉRIC BAZILLE
Négresse aux pivoines (cat. 14, fig. 282)

FRÉDÉRIC BAZILLE
Paysage au bord du Lez (cat. 15, fig. 100)

PAUL CÉZANNE
La Pendule noire, ca. 1870 (cat. 31, fig. 190)

PAUL CÉZANNE
Le Festin, ca. 1870 (cat. 33, fig. 59)

PAUL CÉZANNE
Pastorale (Idylle), ca. 1870 (cat. 34, fig. 161)

EDGAR DEGAS
L'Orchestre de l'Opéra (Portrait de Désiré Dihau), ca. 1870 (cat. 68, fig. 284)

HENRI FANTIN-LATOUR
Un atelier aux Batignolles (cat. 74, fig. 232)

EVA GONZALÈS
Enfant de troupe (cat. 78, fig. 260)

ÉDOUARD MANET
La Brioche (cat. 112, fig. 211)

CLAUDE MONET
La Plage de Trouville (cat. 150, fig. 327)

CLAUDE MONET
Sur la Plage à Trouville (cat. 151, fig. 329)

CAMILLE PISSARRO
La Route de Versailles à Louveciennes (cat. 163, fig. 318)

CAMILLE PISSARRO
La Forêt (cat. 165, fig. 101)

AUGUSTE RENOIR
Baigneuse (La Baigneuse au griffon) (cat. 180, fig. 151)

AUGUSTE RENOIR
La Promenade (cat. 181, fig. 178)

LA PREFACE DE L'EXPOSITION, par Cham.

— Tu envoies un canard à l'Exposition ?—Oui, mon cher; c'est un boursier qui me l'a commandé. C'est un hommage de reconnaissance qu'il doit à ces bêtes-là : elles l'ont aidé à faire fortune.

Le plus bel éloge que l'on puisse faire du tableau envoyé cette année à l'Exposition par M. Jadin.

— Monsieur, c'est une horreur ! Je veux que vous finissiez mon portrait avant de l'envoyer ! Il me manque un bras; mettez-le. — Madame, je n'aurai jamais le temps de l'ajouter; vous me feriez manquer l'Exposition.

— Auriez-vous l'extrême bonté de vouloir bien présenter mon tableau au jury ? Croyez bien que si j'étais assez heureux... et que votre portrait, celui de madame, ou de n'importe qui de votre famille... Ah! monsieur, ma reconnaissance serait éternelle !

— Vous n'allez pas à la Bourse aujourd'hui, mon cher monsieur Prudhomme ? — Je viens de peindre un tableau de bataille que je vais soumettre au jury. Je reviens ensuite jouer à la hausse ou à la baisse, suivant que mon sujet aura été refusé ou accepté.

— Commissionnaire, vous apportez au jury les tableaux de M. Meissonnier ? — Fouchtra! che les avais mis dans la poche de mon gilet! Che m'aperchois que j'avais un trou dans la doublure.

La vogue du docteur Noir exerçant une influence déplorable sur les portraits présentés à l'Exposition de 1859.

INDISCRÉTION.
Paysage italien. Ils se ressemblent tous cette année.

Le singe envoyé par le sculpteur Fremiet au jury de peinture, faisant croire à l'arrivée de Soulouque à Paris.

— Ils ont refusé ton tableau ? Il péchait peut-être un peu par l'exécution. Il est bien maintenant. Le voilà *exécuté!*

— Mon cher ami, si tu aimes ta femme, tu vas te battre en duel avec tout le jury de peinture : il a refusé mon portrait ! Et le peintre m'a assuré que cela ne pouvait être à cause de sa peinture; que cela devait tenir à un motif qui m'était tout personnel.

— Monsieur et madame, faites bien attention dans les escaliers; il y a dans la maison un peintre qui a eu tous ses tableaux refusés à l'Exposition.

Fig. 361. Amédée, comte de Noé, called Cham, *La Préface de l'exposition* (*The Preface to the Exhibition*), 1859. Caricature published in *L'Illustration*, April 2, 1859, p. 220

Chronology

1859

Courbet dates *Bouquet d'asters* (fig. 362) to 1859; on the frame, it used to read "To my friend Baudelaire."

Pissarro irregularly attends a free art school on the rue Cadet and the Académie Suisse on the quai des Orfèvres, where he meets **Monet.** London, Paris, Boston 1980–81, p. 58.

Renoir works at M. Gilbert's, a "Manufacturer of all kinds of blinds and shades," at 63, rue du Bac. London, Paris, Boston 1985–86, p. 370.

Les Amis de la nature by Champfleury is published by Poulet-Malassis. A drawing by **Courbet**, engraved by Bracquemond, is the frontispiece; Duranty writes an appreciative preface.

Michelet publishes *La Femme* (see p. 286).

Restoration of the paintings in the Louvre, "begun under the direction of M. Villot." In the Goncourt brothers' *Journal* one reads: "In my opinion, for Le Sueur's works, it is no great loss. But the Rubenses! It is like music without the half-tones: everything screams and yells, it is like mismatched crockery." On September 28, 1858, the engraver Tourny had written his own account of what was going on to **Degas**, then staying in Florence: "I have found that removing the varnish is very beneficial to some pictures and harmful to others;

anyhow, it teaches a good lesson to modern painters who darken their pictures with too much varnish in an attempt to imitate the old masters." Goncourt 1956, vol. 1, p. 578. Letter from Tourny to Degas, private collection.

JANUARY I First issue of the *Gazette des Beaux-Arts* (fig. 363); Charles Blanc, editor-in-chief, publishes "*Louis XIV et Molière*, an original painting by Ingres" (fig. 364): "For us, it is a great honor to launch the *Gazette des Beaux-Arts* under the auspices of M. Ingres and to have such a master agree to sign our birth certificate" (p. 16).

FEBRUARY The writer Zacharie Astruc (1835–1905) and some friends found *Le Quart d'heure, Gazette des gens demi-sérieux*; after four issues, the magazine ceases publication in August.

LATE MARCH–EARLY APRIL **Degas** leaves Florence, where he had been staying with his uncle Bellelli since the previous summer; he returns to Paris after a three-year absence. On his way back he stops in Genoa, where he admires works by Van Dyck at the Palazzo Rosso. Paris, Ottawa, New York 1988–89, p. 52.

APRIL 15 Opening of the Salon, which has been held since 1857 in the Palais de l'Industrie on the Champs-Élysées. **Manet, Fantin-Latour,** and **Whistler** are rejected. **Pissarro,** a "pupil of Anton Melbye," is accepted with his *Paysage à Montmorency.*" Photography is recognized as a fine art for the first time and is exhibited at the Palais de l'Industrie, but not as part of the official Salon.

APRIL 24 **Degas,** with Koenigswarter and Lacheurié, two friends of Gustave Moreau, visits the Salon for the first time (see pp. 20–23).

APRIL Bonvin holds an exhibition in his *atelier flamand* at 189, rue Saint-Jacques. It included eight works by himself, **Fantin-Latour, Whistler,** Legros, and Ribot, which had been rejected by the Salon jury (see cat. 70). Denny 1993 has a full discussion of this event.

END OF APRIL The work of Ary Scheffer is exhibited at 26, boulevard des Italiens, "in three rooms improvised in the garden of M. le marquis d'Hertford"; *Gazette des Beaux-Arts*, April 15, 1859, p. 126; July 1, 1859, pp. 40ff.

MAY 6 **Whistler,** who had been in Paris since mid-January, leaves for London, where he stays with the engraver Seymour Haden; he begins the *Thames Set* series of engravings. **Fantin** pays him a visit. Whistler will be back in Paris on October 6. Young et al. 1980, p. 59.

MAY 19 AND JUNE 3 **Monet** writes to Boudin and comments on the Salon's paintings; he tells

Fig. 362. Gustave Courbet, *Bouquet d'asters* (*Bouquet of Asters*), 1859. Oil on canvas, 18⅛ x 24 in. (46 x 61 cm). Kunstmuseum, Basel

Fig. 363. Frontispiece of the first issue of the *Gazette des Beaux-Arts,* January 1, 1859

Fig. 364. Léopold Flameng, *Louis XIV et Molière,* after the painting by Ingres. Engraving published in the *Gazette des Beaux-Arts,* January 1, 1859, p. 18

Boudin that he visited Troyon and Amand Gautier (see p. 25).

JUNE Achille Fould, minister of state, commissions Meissonier to paint "either the main characters of the great military drama unfolding in the Piedmont or some scenes relating to Italian independence; the choice of subject matter is up to him." *L'Artiste*, June 12, 1859, quoted in Tabarant 1963, p. 266 (see p. 33).

JULY Around July, **Manet** leaves the studio that he shared with Albert de Balleroy on the rue Lavoisier; he settles at 58, rue de la Victoire. Proust 1897, p. 25.

JULY 1 Following the peace and friendship treaty and the trade agreement signed by France and Japan on October 9, 1858, the harbors of Yokohama, Nagasaki, and Hakodate are opened to French ships. Paris, Tokyo 1988, p. 70.

JULY 1 **Manet** registers as a copyist at the Louvre; it is probably at this time that he executes his copies of *L'Infante Marguerite* by Velázquez (Rouart and Wildenstein, 1975, vol. 2, no. 69), and of *Les Petits cavaliers (Réunion de treize personnages)*, then attributed to Velázquez (Rouart and Wildenstein 21). Theodore Reff, "Copyists in the Louvre, 1850–1870," *Burlington Magazine*, July 1970, p. 556.

END OF JULY **Degas** finally finds a studio at 13, rue de Laval. Paris, Ottawa, New York 1988–89, p. 43.

SUMMER **Courbet** stays in Le Havre and in Honfleur, where he meets Baudelaire, Boudin, Schanne, and **Monet**. Riat 1906, p. 179. Laurent Manoeuvre, *Boudin et la Normandie* (Paris: Herscher, 1991), p. 119.

AUGUST 25 **Cézanne** is awarded a second prize for a figure study in the painting section, second division, of the École Spéciale et Gratuite de Dessin de la Ville d'Aix in Provence. Bruno Ély, "Cézanne, l'école de dessin et le Musée d'Aix," in *Cézanne au Musée d'Aix* (Aix-en-Provence, 1984), p. 139.

SEPTEMBER **Bazille** enrolls in the Montpellier medical school; at the same time, he is studying drawing with Joseph and August Baussan, sculptors in Montpellier. Bazille 1992, p. 152.

SEPTEMBER 1 Adolphe Guéroult starts the daily opposition newspaper *L'Opinion nationale*. One of the contributors is Jules-Antoine Castagnary (1830–1888), a solicitor's clerk who began a distinguished career as a critic with "La Philosophie du Salon de 1857" (1857). The newspaper will cease publication on October 16, 1876, and will resume from March 6, 1882, until July 1914.

OCTOBER Théophile Thoré [William Bürger, 1807–1869] returns from exile. At the end of 1849 the lawyer and political journalist had been sentenced in absentia to lifelong banishment for his actions during the 1848 revolution. During his exile he became a renowned critic of Dutch and Flemish painting and became known as the man

who rediscovered Vermeer. Frances S. Jowell in Bouillon 1989, pp. 25–41.

OCTOBER 1 **Courbet** gives a great Realist party in his studio, which he calls "the last party of the summer...given by the leader of the independent critics." Shortly thereafter the painter leaves for Ornans, where he will spend the fall. Riat 1906, p. 176; "Une soirée chez Courbet," *Les Amis de Gustave Courbet*, 1975, no. 54.

OCTOBER 14 Closing of the Divan. Located at 5, rue Le Peletier, this café, founded in 1837, was the meeting place of Balzac, Musset, Nerval, Berlioz, Gautier, Chenavard, Préault, Clésinger, Daumier, Couture, Troyon, Diaz, Rousseau, and **Courbet**. Tabarant 1963, p. 268.

NOVEMBER 1859–AUGUST 1860 While still attending law school, **Cézanne** enrolls for another year of classes at the École Spéciale et Gratuite de Dessin de la Ville d'Aix in Provence. Bruno Ély, "Cézanne, l'école de dessin et le Musée d'Aix," in *Cézanne au Musée d'Aix* (Aix-en-Provence, 1984), pp. 149ff.

NOVEMBER 1 In an article in the *Gazette des Beaux-Arts*, Léon Lagrange emphasizes the strength of the École de Marseille: "The School of Marseille lives with a constant sunburn. It sees only one thing in nature, the sun." Léon Lagrange, "Exposition de Marseille," *Gazette des Beaux-Arts*, November 1, 1859, p. 186.

DECEMBER 31 A letter from the engraver Tourny tells us that **Degas** has broken with his former teacher Louis Lamothe, a follower of Hippolyte Flandrin, and that he is preparing for "the forthcoming exhibition." Paris, Ottawa, New York 1988–89, p. 53.

DECEMBER 1859–60 Cadart publishes *Paris qui s'en va et Paris qui vient. Publication artistique dessinée et gravée par Léopold Flameng* (Paris coming and going: artistic publication with drawings and engravings by Léopold Flameng), with texts by Arsène Houssaye, Théophile Gautier, Marc Trapadoux, Duranty, and others. Bailly-Herzberg 1972, p. 17.

1860

Pissarro meets Chintreuil, probably through Corot. Julie Vellay, the daughter of wine growers from Burgundy, is hired by the Pissarro household and becomes Pissarro's companion and later his wife.

Cézanne begins work on the panels for the "grand salon" at Jas de Bouffan (fig. 183), a seventeenth-century estate, about a mile (two kilometers) west of Aix, bought by his father the previous year (see cat. 27).

Renoir registers as a copyist at the Louvre for the first time; his card will be renewed regularly until 1864. London, Paris, Boston 1985–86, p. 370.

Poulet-Malassis reprints an illustrated edition of Champfleury's works (1860–61). Amand Gautier illustrates *Monsieur de Boisdhyver*.

M. Jame organizes the Salon des Arts-Unis (the Salon of the United Arts) in a town house on the rue de Provence. The "main goal" of the society "is to open a permanent Salon for artists." In addition to galleries devoted to temporary exhibitions, the town house consists of "parlors for informal conversation," a library, and a print room. Some of the subscribers are Couture, Théodore Rousseau, Dupré, Barye, Delacroix, Hippolyte Flandrin, Joseph Stevens, Alfred Stevens, Troyon, Gérôme. Charles Blanc, "La Société des Arts-Unis," *Gazette des Beaux-Arts*, June 1, 1860, pp. 257–65.

WINTER An exhibition of *Tableaux de l'école moderne tirés des collections d'amateurs et exposés au profit de la caisse de secours des artistes* is held at 26, boulevard des Italiens. Théophile Gautier notes that "the canvases of the Exhibition of modern paintings are, for the most part, the work of painters trying (as did the poets in 1830) to revive the cold palette of the French school; they were: Bonington, Delacroix, Decamps, Jules Dupré, Théodore Rousseau, Boulanger, Isabey, Robert Fleury, Camille Roqueplan, Diaz, Riesener." However, Meissonier, Troyon, and Millet are also exhibiting, as well as Corot and Ingres. Delacroix's representation is particularly significant; in his notebooks, **Degas** makes a sketch from *Le Christ sur le lac de Génésareth* (fig. 365) and from *Mirabeau et Dreux-Brézé* (Ny Carlsberg Glyptotek, Copenhagen). In a letter to Boudin, **Monet** confesses his admiration for Delacroix, Decamps, Rousseau, Dupré, Corot, **Courbet**, and Millet, but he judges Troyon and above all Rosa Bonheur with severity. *Catalogue des tableaux tirés de collections d'amateurs et exposés...*, 26, boulevard des Italiens, Paris, 1860; Théophile Gautier, "Exposition de tableaux modernes...," *Gazette des Beaux-Arts*, February 15, pp. 193–205, March 1, pp. 283–96, March 15, 1860, pp. 321–31; A.-J. Du Pays, "Exposition de tableaux modernes," *L'Illustration*, February 11, 1860, pp. 87–89; Reff 1985, notebook 16, p. 20 A, notebook 18, p. 53; Cahen 1900, pp. 16–18; Wildenstein 1974, pp. 8, letter 3, pp. 419–20.

JANUARY 25, FEBRUARY 1 AND 8 Wagner gives three concerts at the Théâtre Italien, with pieces from *The Flying Dutchman, Tannhäuser*, and *Lohengrin*. On February 17, Baudelaire writes to Wagner: "I owe you the greatest musical pleasure I have ever felt." Wagner extends his thanks to Baudelaire through Champfleury. Baudelaire 1973, vol. 1, pp. 672–81.

FEBRUARY **Monet** settles at 18, rue Pigalle; he studies at the Académie Suisse, located at 4, quai des Orfèvres, and is a regular at the Brasserie des Martyrs. Wildenstein 1974, pp. 8–11.

BETWEEN FEBRUARY 23 AND MAY 19 Castagnary (1830–1888) meets **Courbet** and will write, among other works, Jules-Antoine Castagnary,

"Fragments d'un livre sur Courbet," *Gazette des Beaux-Arts*, January, December 1911, January 1912 (the manuscript is in the département des Estampes et de la Photographie de la Bibliothèque Nationale); Henri Dorra in Bouillon 1989, p. 72.

MARCH 2 In Le Havre, **Monet**'s number is drawn at the military service lottery; he joins the first regiment of the African Chasseurs on March 29 and arrives in Algiers on June 10. Wildenstein 1974, pp. 12–13.

MARCH 5 Death of Alfred De Dreux. "He had especially studied what we can call the sports world. His paintings of horses, hunting dogs, horsemen, and amazons had won him a special reputation, not only in France but also in England and Holland" (see p. 282). *Revue Universelle des Arts* 11 (1860), p. 56.

MARCH 21–APRIL **Degas** stays with his Italian relatives in Naples and Florence. In Florence, living with his uncle Bellelli, he makes additional sketches for the *Portrait de famille (La Famille Bellelli)* (fig. 253). Reff 1985, notebooks 18 and 19.

SPRING Exhibition of modern paintings in the new quarters of the Galerie Goupil on the rue Chaptal. Among the exhibitors are Curzon, Hébert, Gleyre, Gérôme, and Tissot *(Marguerite à l'office*, fig. 366). E. Saglio, "Exposition de tableaux modernes dans la Galerie Goupil," *Gazette des Beaux-Arts*, July 1, 1860, pp. 46–52; A.-J. Du Pays, "Galerie de tableaux de la Maison Goupil et Comp. éditeur d'estampes," *L'Illustration*, March 10, 1860, pp. 155–56.

APRIL Founding of the magazine *Les Beaux-Arts*; it will be published until August 1865.

APRIL 27 Jongkind leaves Rotterdam and goes to Paris, accompanied by the painter Cals. Jongkind rents a room at 69, rue Saint-Nicolas. Hefting 1975, p. 344.

MAY *At the Piano* (fig. 3) is **Whistler**'s first painting to be exhibited at the Royal Academy, London.

SUMMER A "fifteen-year-old art student named Alexandre," who was **Manet**'s model for *L'Enfant aux cerises* (Rouart and Wildenstein 18), and who "washed his brushes and cleaned his palette," hangs himself in Manet's studio on the rue de la Victoire. Manet is "very affected by the tragic death of his little companion whom he loved very much," and takes a studio on the rue de Douai for the summer. He moves to the rue de l'Hôtel-de-Ville (which becomes rue des Batignolles in 1868) with Suzanne Leenhoff and Léon Koëlla. Alexandre's suicide inspires Baudelaire to write the poem "La Corde" (in *Le Spleen de Paris*). Baudelaire dedicates his poem to Manet. Proust 1897, pp. 25–26; Tabarant 1947, p. 25.

JUNE Corot is in Auvers-sur-Oise, where he paints with Oudinot and Daubigny.

JUNE 24 **Courbet** exhibits fourteen pictures at the Exposition des Beaux-Arts, organized as a part of the Exposition Universelle de Besançon. Fernier 1977–78, vol. 1, p. 113.

JULY *Le Malheur d'Henriette Gérard*, a novel by the journalist and art critic Edmond [Louis-Émile] Duranty, is published by Poulet-Malassis with four etchings by Legros. This novel, already published as a serial in *Le Pays* from August 24 to September 25, 1858, is called "very remarkable" by Baudelaire. Crouzet 1964, pp. 79, 110–27.

AUGUST 22 Death of Alexandre-Gabriel Decamps. A.-J. Du Pays, "Decamps," *L'Illustration*, September 1, 1860, pp. 143–44.

SEPTEMBER Philippe Burty (1830–1890), an art critic who was one of the founders of the *Gazette des Beaux-Arts*, organizes the first major exhibition devoted to the French eighteenth century at Francis Petit's Galerie Martinet, located at 26, boulevard des Italiens. William Bürger (Théophile Thoré), "Exposition de tableaux de l'école fran-çaise tirés de collections d'amateurs." *Gazette des Beaux-Arts*, September 1, 1860, pp. 258–77. September 15, 1860, pp. 333–58; Haskell 1976, p. 102.

SEPTEMBER Millet spends three weeks in Franche-Comté with Théodore Rousseau. Paris, London 1975–76, p. 27.

1861

During a trip to Belgium, **Courbet** paints the portrait of Alfred Stevens (Musées Royaux des Beaux-Arts de Belgique, Brussels; Fernier 290).

Sisley stays in Barbizon, at the Auberge Ganne. London, Paris, Baltimore 1992–93, 268.

Manet settles in a new studio at 81, rue Guyot; he will stay there until 1870. Moreau-Nélaton 1926, vol. 1, p. 33.

Cadart publishes the first series devoted to original etching, including works by Legros, Bonvin, Jeanron. Bailly-Herzberg 1972, vol. 1, p. 18.

For the first time, the business directory Didot-Bottin gives addresses where one can find Japanese lacquers in Paris; all the stores are located in the vicinity of the Stock Exchange: À la porte chinoise, 36, rue Vivienne; Au Céleste Empire, 20, rue Saint-Marc; L'Empire céleste, 55, rue Vivienne. Paris 1988, p. 72.

Arsène Houssaye takes over the editorship of the newspaper *La Presse* from Solar.

Charles Blanc publishes *Histoire des peintres: École hollandaise*, 2 vols. (Paris: J. Renouard).

Edmond and Jules de Goncourt publish their study on *Prud'hon*, illustrated with four etched drawings.

JANUARY Poulet-Malassis opens a bookstore on the ground floor of the Hôtel des Princes, 97, rue

Fig. 365. Edgar Degas, copy after *Le Christ sur le lac de Génésareth (Christ on the Sea of Galilee)* by Delacroix, 1860. Graphite, 5¾ x 3¾ in. (14.6 x 9.4 cm). Bibliothèque Nationale, Paris

Fig. 366. James Tissot, *Marguerite à l'office (Marguerite at Prayer)*, 1860. Oil on wood, 26½ x 36 in. (67.3 x 91.4 cm). Private collection

de Richelieu. This bookstore is decorated with portrait medallions representing the authors published by Poulet-Malassis (Hugo, Gautier, Baudelaire, Banville, Champfleury, Asselineau, Babou). The medallions are painted by Legros, Bonvin, Soupplet, and Alexandre Lafond. Pichois and Ziegler 1987, pp. 409–10.

JANUARY 15 The *Gazette des Beaux-Arts* publishes an article by Claudet, "La Photographie dans ses relations avec les Beaux-Arts" (pp. 101–4). The author maintains that "photography was invented as an aid to the Fine Arts." In his introduction, Charles Blanc justifies the publication of the article by stating that "it is of the utmost importance to determine with precision where *mechanization* ends, and where art begins."

JANUARY 25 The Salon des Arts-Unis, on the rue de Provence, opens with an exhibition of one hundred drawings by Ingres. Charles Blanc, "Le Salon des Arts-Unis," *Gazette des Beaux-Arts*, February 1, 1861, pp. 189–92; Henri Delaborde, "Les desins de M. Ingres au Salon des Arts-Unis," *Gazette des Beaux-Arts*, March 1, 1861, pp. 257–69; Émile Galichon, "Description des dessins de M. Ingres exposés au Salon des Arts-Unis," *Gazette des Beaux-Arts*, March 15, 1861, pp. 343–62.

JANUARY 28 Henry Murger, author of *La Vie de Bohème*, dies destitute. His funeral is the occasion of great official demonstrations. Goncourt 1956, vol. 1, pp. 876–77; Tabarant 1963, p. 275; Seigel 1991, pp. 146–53.

FEBRUARY 1 Artists circulate two petitions against a regulation limiting to four the number of works an artist can exhibit at the Salon; one of the petitions is signed by Gérôme, Baudry, Cabanel, Hébert, Meissonier, Bouguereau, Dubufe, Heilbuth, and others; the second by Corot, Ar-

mand and Adolphe Leleux, Daubigny, Français, and others. Paris, Archives du Louvre, X, Salon of 1861.

MARCH 13 Premiere at the Opéra of Wagner's *Tannhäuser*. Gounod, who admires the work, says that it caused a "tumult" and was not a "flop"; Paul Landormy, *Gounod* (Paris, 1942), p. 110; Archives Nationales, AJ13502.

SPRING **Delacroix** writes to the comte de Nieuwerkerke, president of the jury for the Salon, to inform him that he refuses to participate in the deliberations: "I could not possibly find the necessary time to serve on the jury; the works that I am involved with at the moment require my total attention." Paris, Archives du Louvre, X, Salon of 1861.

APRIL **Pissarro** registers as a copyist at the Louvre. He meets Guillaumin and **Cézanne** at the Académie Suisse.

APRIL–SEPTEMBER **Cézanne**, who has just dropped out of law school, comes to Paris for the first time. In a letter to Joseph Huot, dated June 4, he recounts the working sessions at the Académie Suisse—where he meets **Pissarro**—"from six o'clock in the morning to eleven" and his first visit to the Salon. He admits to his admiration for Meissonier ("some magnificent works by Meissonier") and for Gustave Doré, who exhibits a "fabulous picture." By September, feeling discouraged, he goes back to Aix-en-Provence and works at his father's bank; from November 1861 to August 1862, he studies again at the École Municipale Libre de Dessin in Aix. Cézanne 1937, pp. 79–81; London, Paris, Washington 1988–89, p. 200.

APRIL 13 E. Delannoy, "artist-painter," intervenes in favor of "Monsieur **Wistler** [*sic*] from Boston" who is attempting to exhibit his etchings at the Salon. The administration refuses because it is "too late." Paris, Archives du Louvre, X, Salon of 1861.

APRIL 29–30 Auction of Decamp's studio at the Hôtel Drouet. "The auction has been carried on in an atmosphere of true fanaticism. . . . It brought over Fr 250,000." Philippe Burty, "Mouvement des Arts et de la Curiosité," *Gazette des Beaux-Arts*, May 15, 1861, p. 50; Tabarant 1963, p. 276.

BETWEEN MAY AND SEPTEMBER **Degas** meets **Manet** in the Louvre. Manet interrupts Degas while he is copying *La Infanta* by Velázquez directly onto a copper plate. Moreau-Nélaton 1926, vol. 1, p. 36; Loyrette 1991, pp. 184–85.

MAY 1 Opening of the Salon. For the first time, works are hung alphabetically by the artist's last name. Tabarant 1963, p. 277.

Courbet exhibits five pictures including *Le Rut du printemps (Combat de cerfs)* (fig. 367); Daubigny, five pictures including *Un village près de Bonnières* (cat. 50, fig. 114); Millet, three pictures; Puvis de Chavannes, *Concordia* and *Bellum* (fig. 32; cat. 167, fig. 60); Tissot, six pictures including *Rencontre de Faust et Marguerite* (Musée d'Orsay, Paris) and *Voie des fleurs, Voie des pleurs*, quickly sketched by **Degas** (Reff 1985, notebook 18, p. 109). For the first time (Rewald 1986b, French ed., p. 45) **Manet** and **Fantin-Latour** are allowed to exhibit. The latter exhibits three *Études d'après nature* and Manet shows *Espagnol jouant*

Fig. 367. Gustave Courbet, *Le Rut du printemps (Combat de cerfs)* (*Mating at Springtime [The Fight of the Stags]*), 1861. Oil on canvas, 11 ft. 6½ in. x 16 ft. 6 in. (355 x 507 cm). Musée d'Orsay, Paris

Fig. 368. Édouard Manet, *Espagnol jouant de la guitare (Le Chanteur espagnol)* (*The Spanish Singer*), 1860. Oil on canvas, 58 x 45 in. (147.3 x 114.3 cm). The Metropolitan Museum of Art, New York, Gift of William Church Osborn, 1949

de la guitare and *Portrait de monsieur et madame Manet* (fig. 192). *Espagnol jouant de la guitare* (fig. 368), which will be called *Le Chanteur espagnol* after 1867, earns Manet his first Salon success and an honorable mention, this possibly obtained through Delacroix's intervention. The painting is admired by a group of young painters who meet Manet on this occasion: "MM. Legros, Fantin, Karolus Durand [*sic*], and the others, looked at each other with surprise, searching their memory and asking themselves, as if at a magic show with trap doors, where did M. Manet spring from? The Spanish musician was painted in a certain *strange* and new fashion, whose secret the amazed young painters thought they were the only ones to possess; this painting belonged to the middle ground between Realism and Romanticism.... They decided on the spot that they would all go to M. Manet's studio. This striking demonstration of approval then took place." Desnoyers 1863, pp. 40–41.

The "paysage" submitted by **Pissarro** is not accepted; neither were two paintings by Jongkind and etchings by **Whistler**. For other works exhibited, see Baudry, *Charlotte Corday* (fig. 51); Flandrin, *Portrait de S.A.I. le prince Napoléon* (fig. 227); and Gérôme, *Phryné devant le tribunal* (fig. 49).

MAY 7 Because of serious financial problems, Théodore Rousseau organizes an auction of his paintings, as he had done in 1850. The twenty-five pictures are sold for Fr 37,000 at the Hôtel Drouot. Rousseau "insisted that the Hôtel Drouot provide him with a room where he could exhibit,

on a special day, a complete series of paintings whose impressions would be organized around either the choice of site, the time of the day, or the conditions of nature." Philippe Burty, "Mouvement des arts et de la curiosité," *Gazette des Beaux-Arts*, June 1, 1861, p. 311.

MAY 19 First representation of Duranty's Puppet Theater, in the Tuileries gardens. Besides friends such as Baudelaire and Champfleury, also present were Banville, Théophile Gautier, Jules Janin, and Saint-Victor. Crouzet 1964, pp. 144–45.

JUNE **Monet**, now a soldier, arrives in Algeria. Wildenstein 1974, p. 14.

JUNE 3 Realist banquet at the "barrière Clichy" to celebrate **Courbet**'s success at the Salon.

JUNE 15 Jongkind moves into the second floor of 9, rue de Chevreuse, on the corner of boulevard Montparnasse (in 1864, number 9 becomes number 5). He will live in an apartment in this building until his death. Hefting 1975, p. 346.

JUNE 15 Louis Martinet, the founder of the Société Nationale des Beaux-Arts, which organizes exhibitions at 26, boulevard des Italiens, founds *Le Courrier artistique*; this bimonthly four-page circular is sold for twenty centimes. Jean-Paul Bouillon, "Société d'artistes et institutions officielles dans la seconde moitie du XIXe siècle," *Romantisme*, December 1983, pp. 88–113; Lorne Huston, "Le Salon et les expositions d'art: Réflexions à partir de l'expérience de Louis Martinet (1861–1865)," *Gazette des Beaux-Arts* 116 (1990), pp. 45–50.

SUMMER **Fantin-Latour** visits **Whistler** in London. When Whistler is back in Paris, he probably meets **Manet**.

SUMMER Exhibition and celebrations in Antwerp; Daubigny, Millet, Courbet, and Troyon exhibit along with the contemporary Belgian painters Braekeleer, de Groux, and Leys. At the conference held during the exhibition, **Courbet** develops his theories during an improvised speech published in *Le Précurseur d'Anvers* on August 22, 1861. Paul Mantz, "L'Exposition et les fêtes d'Anvers," *Gazette des Beaux-Arts*, September 1, 1861, pp. 279–84; Riat 1906, p. 191.

JULY 21–AUGUST 3 On invitation, one can see "the great artistic event in Paris,... the chapel that M. Eugène Delacroix just finished in the church of Saint-Sulpice" (fig. 369). "Faits divers," *Gazette des Beaux-Arts*, September 1, 1861, p. 295; Tabarant 1963, p. 287.

AUGUST 15–31 **Manet** puts *Le Liseur* (Rouart and Wildenstein 35) up for sale at the Galerie Martinet, 26, boulevard des Italiens. From September 1 to 30, this painting will be replaced by *L'Enfant aux cerises* (Rouart and Wildenstein 18). *Le Courrier artistique*, September 1, 1861, p. 22; October 1, 1861, p. 30; Paris, New York 1983, p. 507.

AUGUST 20 Nomination of the Imperial Commission for the London World's Fair presided over by Mérimée. On September 17, Louis Martinet and the artists Dauzats, Gérôme, Cavelier, Barye are elected.

END OF AUGUST **Fantin-Latour** comes back from England; his first outing is to see Delacroix's chapel of Saints-Anges at Saint-Sulpice (fig. 369).

AUGUST 31 **Whistler**, on the advice of his doctor, leaves for Brittany. He stays there for three months and paints his first important seascape. *The Coast of Brittany* (Wadsworth Atheneum, Hartford). Young et al. 1980, p. 16.

SEPTEMBER The Goncourt brothers "embark on a short trip along the Rhine and in Holland." They admire Rembrandt and Vermeer (*Vue de Delft*, p. 238), and they meet Henri Leys in Antwerp. Goncourt 1956, vol. 1, pp. 954–67.

SEPTEMBER 3 "De Gas Edgar 26 years old 4 rue Mondovi" registers as a copyist at the Louvre. Paris, Archives du Louvre LL10: 1220.

SEPTEMBER 18 **Manet**'s *Nymphe Surprise* (cat. 84, fig. 123) is exhibited at the Imperial Academy in Saint Petersburg.

LATE SEPTEMBER–EARLY OCTOBER **Degas** stays at Ménil-Hubert, the estate of his friends the Valpinçons in Orne, Normandy (cat. 52, fig. 349). Lemoisne (1946–49), vol. 1, pp. 30–40; Reff 1985, notebook 18, p. 161; Paris, Ottawa, New York 1988–89, p. 54.

OCTOBER 1–15 **Manet** exhibits—without putting it up for sale—his Salon success, the *Espagnol jouant de la guitare* (fig. 368) at the Galerie

Fig. 369. Eugène Delacroix, decoration for the Chapel of the Saints-Anges (*La Lutte de Jacob et de l'Ange* [*The Fight of Jacob and the Angel*] and *Héliodore chassé du temple* [*Heliodorus Chased from the Temple*]). Oil and wax, each 24 ft. 4⅞ in. x 15 ft. 9⅛ in. (751 x 485 cm). Église Saint-Sulpice, Paris

Martinet. *Le Courrier artistique*, October 15, 1861, p. 34; Paris, New York 1983, p. 507.

NOVEMBER 1 Paul Mantz publishes an important article on Corot in the *Gazette des Beaux-Arts* (November 1, 1861, pp. 416–32): "Despite the different transformations his talent went through, M. Corot is one of the last 'lovers' of the ideal" (p. 417).

NOVEMBER 8 **Renoir** studies at the Gleyre studio (fig. 370) and, thanks to his teacher, is allowed to work in the Cabinet des Estampes in the Bibliothèque Impériale. Gleyre's studio is at 69, rue de Vaugirard. London, Paris, Boston 1985–86, p. 370; William Hauptman, "Delaroche's and Gleyre's Teaching Ateliers and Their Group Portraits," *Studies in the History of Art* 18 [1985], pp. 82, 111, n. 45). **Sisley** is also a Gleyre student; according to his recollections, he had already spent a year there and would stay until 1862 (Sisley letter to Adolphe Tavernier, January 19, 1892; Shone 1992, p. 216); according to other historians, he was not enrolled before October 1862 (Gustave Geoffroy, *Sisley* [Paris, 1927], pp. 9–10; Daulte 1959, p. 27).

DECEMBER 9 At the request of young artists, **Courbet** accepts to teach at the studio they have opened on the rue Notre-Dame-des-Champs; **Fantin-Latour** is among his students. In *Le Courrier du dimanche* dated December 25, 1861, Courbet publishes the letter written to his young colleagues for this occasion. On February 2, 1862, the owner of the studio will give notice to his young tenants: the experiment barely lasts two months. Riat 1906, pp. 194–96; Paris, London 1977–78, p. 36.

DECEMBER 13 Auction of Apollonie Sabatier's collection at the Hôtel Drouot, after the "Présidente" broke up with the rich Hippolyte Mosselman. "Mme Sabatier is getting rid of everything the regulars of the rue Frochot used to admire: antique furniture, Louis XIV candelabra, light fixtures, mantelpiece ornaments, clocks. Two biscuit figurines by Falconet; a terracotta by Clodion, *Bachante et Amours*. Besides a *Monsieur Polichinelle* painted on Mme Sabatier's parlor door by Meissonier, there are also three oil sketches and two minuscule watercolors by the master. Finally, there is a marble bust of the hostess, which Clésinger made to pay his debt to his beautiful model." The bust will be bought for the Musée du Luxembourg. Tabarant 1963, pp. 293–94.

1862

E. Desoye opens a shop of Japanese curios at 220, rue de Rivoli; it is often visited by **Fantin-Latour**. Paris, Tokyo 1988, p. 74.

Fantin-Latour exhibits at the Royal Academy in London for the first time. He visits Méryon's studio with Seymour Haden and makes his first lithographs. Paris, Ottawa, San Francisco 1982–83, p. 50.

In *Les Peintres de la réalité sous Louis XIII. Les Frères Le Nain*, Champfleury gathers in one volume most of the pieces written on these artists in the past twelve years. This book, a landmark in the history of art, has a tremendous impact that is particularly due to Sainte-Beuve, who devotes one of his *Lundis* to it (January 5, 1863). Paris, Grand Palais, 1978–79, *Les Frères Le Nain*, catalogue by Jacques Thuillier, pp. 65–66.

Ernest Chesneau publishes *La Peinture française au XIXe siècle. Les chefs d'école: L. David, Gros, Géricault, Decamps, Meissonier, Ingres, H. Flandrin, E. Delacroix* (Paris: Didier, 1862). In this book, Chesneau reviews eighty years of French painting and expresses his concern about the present situation: "growing uncertainty" on the part of the public and the artists due to the "confusion of the genres"; great technical skills that "are scattered and exhaust themselves producing works that are too often weak, insignificant, deprived of ideas and moral values"; isolation of the artists because "everyone is locked in his own studio, and produces for himself, without any concern for his neighbor's efforts." Further, he emphasizes that "the French school has not reached this troubled and scattered state in one moment. There has been no sudden revolution, the changes have been slow and hardly noticeable.... It will then be necessary to stake the terrain for recognition, classification, as much as possible, and to delimit types and groups. The only method available to us for defining these types and groups consists in going back to the very sources of the anarchy that we have observed; to see how it originated and how it spread, and to present, in brief, a concise summary of the fluctuations of the French school in the 19th century" (pp. VIII–X).

Alfred Delvau publishes *Histoire anecdotique des cafés et cabarets de Paris, avec dessins et eaux-fortes de Gustave Courbet, Léopold Flameng et Félicien Rops* (Paris: E. Dentu, 1862).

JANUARY **Whistler** exhibits his engravings of the Thames (see fig. 371) at the Galerie Martinet; Baudelaire admires them: "A wonderful jumble of rigging sails, and ropes; a chaos of haze, furnaces and swirling smoke, deep and complicated poetry of a vast capital." "Peintres et aquafortistes," in Baudelaire 1975–76, vol. 2, p. 740.

JANUARY 5 Carjat founds *Le Boulevard*. Baudelaire, Catulle-Mendès, Banville, Aurélien Scholl, Jules Vallès, and Daumier will contribute to the magazine; it will be published until June 1863. Tabarant 1963, p. 294.

SPRING 1862 **Manet** meets Victorine Meurent (cat. 91, fig. 271).

SPRING Ingres exhibits his picture, *Jésus au milieu des docteurs* (fig. 372). The work inspires a long article by Henri Delaborde. This same year, Ingres becomes a senator. Émile Galichon, "Le nouveau tableau de M. Ingres," *Gazette des Beaux-Arts*, May 1, 1862, pp. 487–88; Henri Delaborde, "De quelques traditions de l'art français. À propos du tableau de M. Ingres, Jésus au milieu des docteurs," *Gazette des Beaux-Arts*, November 1, 1862, pp. 385–400.

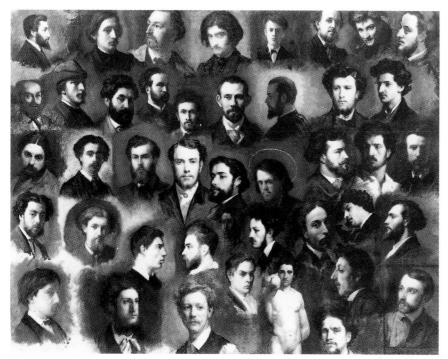

Fig. 370. Artist unknown, *Quarante-trois portraits de l'atelier Gleyre (Forty-three Portraits of the Gleyre Studio)*. Oil on canvas, 46⅛ x 57⅛ in. (117 x 145 cm). Musée du Petit Palais, Paris

SPRING Gérôme exhibits *Alcibiade chez Aspasie* at the Goupil Gallery. Works by Meissonier, Toulmouche, Hamman, Édouard Dubufe, Achenbach, and Knaus are also on view. *Gazette des Beaux-Arts*, May 1, 1862, pp. 485–87.

SPRING Exhibition of the Cercle de l'Union Artistique, on the rue de Choiseul: paintings by Meissonier, Fromentin, Ricard, Delacroix, Leys, Théodore Rousseau, Corot, Troyon, Jules Dupré, Diaz, Ziem, Millet, as well as watercolors by Lami and Isabey. R.V., *Gazette des Beaux-Arts*, July 1, 1862, pp. 95–96.

APRIL Exhibition of engravings by **Manet** at Cadart's, 66, rue de Richelieu. Baudelaire mentions them briefly in the *Revue anecdotique* (2nd half of April 1862; Baudelaire 1975–76, vol. 2, p. 736). He will discuss Manet's engravings at length in "Peintres et aquafortistes," published in *Le Boulevard*, September 14, 1862; Baudelaire identifies Manet, but also Legros and "Yonkind," as the pioneers of the etching revival; Baudelaire 1975–76, vol. 2, pp. 737–39.

APRIL 1 **Renoir** is admitted to the École des Beaux-Arts. He lives with Émile Laporte, a fellow student at Gleyre's studio and the École des Beaux-Arts, at 29, place Dauphine. London, Paris, Boston 1985–86, p. 370.

APRIL 22 Sainte-Beuve writes to Charles Duveyrier asking him to help **Courbet**, who is thinking of undertaking a large decoration project: "The other day, I was talking with Courbet; this painter is not only strong and solid but also has

ideas; and I think that one of his ideas is actually great: to undertake a monumental painting in tune with the new society. . . . Courbet has the idea of erecting vast railroad stations, new churches for painting, and covering those huge walls with a thousand perfectly suitable subjects, the anticipated views of the great sites we are to cross; the portraits of the great men whose names are linked to the cities we will travel through; subjects that are picturesque, moral, industrial, metallurgic; in short, the saints and miracles of modern society." Paris, London 1977–78, p. 37 (see p. 268).

MAY The Campana collection is exhibited at the Palais de l'Industrie:

MAY 1 Opening of the World's Fair in London. "France was assigned a relatively small space to display its painting. . . . Many complained, and, frankly, they were wrong, because we might not have done better with more room, given that the exhibition we put together was already not one of the best. Some of the selected works seem somewhat peculiar to me and do not adequately represent the elite of our modern French school. Thus, M. Ingres is represented by only one canvas, *La Source*, and M. E. Delacroix by one single drawing, *L'Évêque de Liège*. As for M. Meissonier, following his usual pattern, he does not occupy the place he had reserved for himself and announces works that he does not exhibit. Then, in truth, the placement of the pictures did not seem to contribute much to highlight their qualities. The paintings look like they were hung rather haphazardly, without any overall plan, and since

unity is the least of the strengths of our modern school, the faulty layout seemed to accentuate even more the ambitious individualism of each of our painters." The French selection, including mainly works from the Musée du Luxembourg and canvases exhibited at recent Salons, was not very daring. According to Alfred Darcel, its best features were the portraits, especially Hippolyte Flandrin's *La Jeune Fille à l'oeillet* (cat. 75, fig. 20). Alfred Darcel, "Les galeries de la peinture française à l'exposition de Londres," *L'Illustration*, August 9, 1862, p. 92.

MAY 31 Founding of the Société des Aquafortistes by Alfred Cadart and Félix Chevalier. The purpose of the society consists in "the extension and improvement of etching." **Manet**, **Fantin**, Bracquemond, Jongkind, Legros, and Ribot are among the founding members. Bailly-Herzberg 1972.

MAY–SEPTEMBER Viollet-le-Duc publishes "L'enseignement des Arts. Il y a quelque chose à faire," in the *Gazette des Beaux-Arts*, in four installments (May 1, pp. 393–402; June 1, pp. 525–34; July 1, pp. 71–82; September 1, pp. 249–55). Deploring the extreme specialization of the arts, the perversion of the public's taste, which favors the "knickknack," Viollet-le-Duc introduces some proposals to be investigated by the commission nominated on March 22 by the Ministry of State:
1) What to purchase and commision from the artists
2) Which publications dealing with the arts to subscribe to

Fig. 371. James McNeill Whistler, *Rotherhite*, from the *Thames Set*, 1860. Engraving, 10⅝ x 7¾ in. (27 x 19.7 cm). Hunterian Art Gallery, University of Glasgow, McCallum Collection

Fig. 372. J.-A. Dominique Ingres, *Jésus au milieu des docteurs* (*Jesus among the Doctors*), 1862. Oil on canvas, 104⅜ in. x 124¾ in. (265 x 320 cm). Musée Ingres, Montauban

3) What awards to grant to artists
4) How fine art institutions can be improved. Viollet-le-Duc harshly criticizes the courses taught at the École des Beaux-Arts for entirely neglecting the progress of archaeological and historical knowledge and failing to teach the students either to paint or to draw, but only preparing them for competitions. Viollet-le-Duc advocates the method of drawing from memory and the study of the figure in the out-of-doors, as practiced by Lecoq de Boisbaudran at the École Impériale de Dessin. "Instead of the efforts of one single class using a model, corrected indifferently by several professors," he recommends "opening as many academies as there are professors."

MAY 31–SEPTEMBER Invited by Étienne Baudry, whom he met through Castagnary, **Courbet** stays at the château de Rochemont near Saintes (cat. 40, fig. 220; cat. 41, fig. 280).

JUNE Duranty publishes *La Cause du Beau Guillaume*.

SUMMER **Renoir** works in Fontainebleau forest with his friends from Gleyre's studio: "There, in 1862, Renoir met old Diaz, who struck a friendship with the beginner and taught him the rules of the 1830 landscapists and, maybe even more importantly, secured his credit at the art supplies store." Meier-Grafe 1912, p. 16 (see cat. 171, fig. 90).

SUMMER Back from Algeria, **Monet** meets Jongkind near Le Havre thanks to a "British citizen." According to his aunt Lecadre, writing to Amand Gautier, Jongkind becomes Monet's true master. Wildenstein 1974, pp. 14–19.

JULY 28 **Whistler** meets D.G. Rossetti and Algernon Swinburne. Young et al. 1980, p. 60.

Fig. 373. Édouard Manet, *Les Gitanos* (*The Gypsies*), 1862. Etching (2nd state), 11¼ x 8⅛ in. (28.5 x 20.6 cm). Bibliothèque Nationale, Paris

AUGUST–SEPTEMBER Exhibition of the Société des Aquafortistes at Cadart's; Baudelaire publishes "Peintres et aqua-fortistes," in *Le Boulevard*, September 14.

AUGUST 12–NOVEMBER 2 The Spanish dance company of the Royal Theater of Madrid performs a ballet, *La Flor de Sevilla* (The Flower of Seville), at the Hippodrome at the Rond-Point de Saint-Cloud (now place Victor Hugo). The principal dancers Mariano Camprubi and Lolá Melea, known as Lola de Valence, pose for **Manet** (cat. 86, fig. 346; cat. 87, fig. 269).

AUGUST 31 Théophile Gautier gives a party for his birthday at 32, rue de Longchamp; "in the bedroom of Gautier's daughters, transformed into a theater," the Gautier family performed a slapstick comedy: "The curtain rises on the stage, decorated by history painter Puvis de Chavannes with rather funny sets.... After that, the guests went into the small garden, where they shot fireworks and lit Japanese lanterns.... Doré was making a superb caricature of **Courbet**—one buffoon painted by another—and was singing his song whose air, music, and lyrics are by Courbet: 'L'Institut / C'est des trous du cul.' [The Institut / They're assholes]." Goncourt 1956, vol. 1, pp. 1127–29.

AUGUST TO SEPTEMBER Baudelaire's *Petits poèmes en prose* is published in *La Presse*. These works had already been published in the *Revue fantaisiste* in November 1861, and this edition leads to a falling out between Baudelaire and Arsène Houssaye, co-owner of *La Presse*. Pichois and Ziegler 1987, p. 437.

SEPTEMBER Tissot visits Venice and Florence and describes both cities in a letter to **Degas**. Tissot is primarily impressed by Carpaccio, Mantegna, and Bellini. Letter from James Tissot in Venice to Edgar Degas in Paris, September 18, 1862, private collection.

SEPTEMBER 1 The Société des Aquafortistes publishes *Les Gitanos* by **Manet** (fig. 373) in the first installment of its collection of *Eaux-fortes modernes*, next to plates by Bracquemond, Daubigny, Legros, and Ribot.

SEPTEMBER 25 Auguste Manet, the artist's father, dies.

END OF SEPTEMBER Jongkind meets Boudin. Laurent Manoeuvre, *Boudin et la Normandie* (Paris; Herscher, 1991), p. 183.

NOVEMBER **Cézanne** has left his father's bank and returns to Paris; he fails the entrance examination for the École des Beaux-Arts. London, Paris, Washington 1988–89, p. 200.

NOVEMBER Paul Chenay publishes an album of engravings after drawings by Victor Hugo. This publication is highly praised by Philippe Burty. Georgel 1973, p. 17; Goncourt 1956, vol. 1, p. 1193.

NOVEMBER 1 **Bazille** leaves Montpellier to go to Paris. He makes a stopover in Lyon on November 2. In Paris, he enrolls in the École de Médecine

and is introduced to the Gleyre studio by Henri Bouchet-Doumecq, a friend of the painter Eugène Castelnau, who is his cousin. Bazille 1992, p. 28.

LATE FALL **Monet** settles in Paris with the painter Auguste Toulmouche as his artistic tutor. In order to prove himself to him, Monet paints *La Côtelette* (Wildenstein 9) and, upon Toulmouche's recommendation, joins Gleyre's studio. Wildenstein 1974, pp. 21–22.

DECEMBER The Goncourts publish *La Femme au XVIIIe siècle*.

1863

Baudelaire shows Zacharie Astruc a "superb set of Japanese prints, colored with remarkable dexterity." Paris, Tokyo 1988, p. 74.

Michel Lévy *frères* publishes Ernest Feydau's *Un début à l'Opéra*, "étude." The long introduction is a manifesto for realism: "Realism is a system consisting of painting nature (or humanity) as one sees it. And I can add: yes, I am a realist" (p. 44).

Marcelin Planat founds *La Vie parisienne*.

Charles Blanc publishes his *Histoire des peintres de toutes les écoles: École Française*, 3 vols. (Paris: Jules Renouard).

Manet makes a sketch of Adèle, the elusive mistress of Baudelaire (cat. 92, fig. 267). Tabarant 1963, p. 325.

Pissarro becomes a member of the Société des Aquafortistes and makes his first engravings. Through **Cézanne**, he meets Zola.

Eugène Fromentin publishes his novel *Dominique* in three installments in *La Revue des Deux Mondes* (April 15, May 1, and 15). The work will be published in book form by Hachette in January 1864.

Cézanne works at the Académie Suisse; he makes the acquaintance of Guillaumin, Guillemet, and Oller.

Fantin-Latour meets **Renoir**.

Legros settles finally in London.

JANUARY 5 In a letter to his friends Numa Coste and Villevieille, **Cézanne** writes that he is still working at the Académie Suisse, from eight in the morning to one in the afternoon and then from seven to ten in the evening: "I work, eat, and sleep peacefully." Cézanne 1937, pp. 84–87.

JANUARY 15 **Courbet** is staying in Saintes with Corot, who came to work in the area, and he takes part in an exhibition ("Explication des ouvrages de peinture et de sculpture exposés dans les salles de la mairie aux profits des pauvres. 160 tableaux signés Corot, Courbet, Aupuin, Pradelles") organized by two local disciples, the painters Auguin and Pradelles (cat. 40, fig. 220),

"to benefit the poor." The show takes place in the salons of the City Hall (see cats. 40, 41). Courbet is working on the *Retour de la conférence* (fig. 374). Bonniot 1986, pp. 209–14.

JANUARY 17 Death of Horace Vernet. In an article on Vernet, Théophile Gautier emphasizes his "tremendous predisposition" to paint contemporary events: "The greatness of Horace Vernet is to have been the first to dare painting the modern battle.... He understood that the hero of today is this collective Achilles called a regiment." Théophile Gautier, "Horace Vernet," *Le Moniteur*, January 23, 1863 (reprinted in *Portraits Contemporains* [Paris: Charpentier, 1898], pp. 312–18).

JANUARY 23 The students of Gleyre's studio perform *La Tour de Nesle* before many artists, including Gérôme, who is a neighbor. **Bazille** plays a small part. Wildenstein 1974, p. 23.

FEBRUARY The first installment of the *Littré* (a dictionary) is published; a controversy arises with Msgr. Dupanloup. Goncourt 1956, vol. 1, p. 1265.

FEBRUARY 23 Birth of Lucien Pissarro (1863–1944), son of the painter, in Paris. In 1865, **Pissarro** will have a daughter, Jeanne-Rachel (1865–1874), whose godfather will be Antoine Guillemet.

FEBRUARY 27 Champfleury tells Baudelaire that Mrs. O'Connell, a painter, wishes to invite him to her home to discuss "Poe's philosophical ideas." Baudelaire refuses. This leads to a breakup with Champfleury that lasts until May 1865. Baudelaire 1973, vol. 2, pp. 294, 806–7.

MARCH In a letter to his father, **Bazille** mentions meeting Ludovic Lepic in Gleyre's studio: "This young man and another from Le Havre called **Monet** ... are my best friends among my fellow students. I finished my first daub a few days ago; it is a copy after one of the Rubenses in the Louvre." Bazille 1992, p. 48.

MARCH 1 Exhibition at the Galerie Martinet, 26, boulevard des Italiens, of works by David (a replica of the *Sacre de Napoléon I*), **Courbet** (*La Curée*; Fernier 1977–78, vol. 1, no. 188; Museum of Fine Arts, Boston), Théodore Rousseau, Diaz, Corot (*Saint Sébastien*), Amaury-Duval, Baudry, Stevens, and others at the Galerie Martinet, on the boulevard des Italiens; **Manet** is represented by fourteen pictures, including *La Chanteuse des rues* (cat. 89, fig. 242), *Lola de Valence* (cat. 87, fig. 269), *Le Ballet espagnol* (cat. 86, fig. 346), *La Musique aux Tuileries* (cat. 88, fig. 332). Paul Mantz, "Exposition du boulevard des Italiens," *Gazette des Beaux-Arts*, April 1, 1863, pp. 381–83.

MARCH 6 Auguste De Gas writes to his brother-in-law Michel Musson to give him news of his son: What can I say about Edgar? We are waiting impatiently for the opening of the exhibition. I have good reason to believe he will not finish in time; he will scarcely have tackled what needs to be done." But René, the artist's brother, writes: "He works furiously, and thinks of only one thing, his painting. He works so hard that he does not take out time to enjoy himself." Paris, Ottawa, New York 1988–89, p. 55.

MARCH 7 Zacharie Astruc's "serenade." *Lola de Valence* is published, with his poetry and music and a lithograph by **Manet** (see cat. 87, fig. 269).

MARCH 20 In a letter to Amand Gautier, Marie-Jeanne Lecadre writes how happy she is to see her nephew **Monet** "transformed" and "ready to work." Wildenstein 1974, p. 24.

SPRING **Whistler** introduces the poet Algernon Swinburne to **Manet** and **Fantin-Latour**. Baudelaire 1973, vol. 2, p. 845, n. 4.

SPRING Second Exposition de Tableaux modernes du Cercle de l'Union Artistique, organized by Francis Petit on the rue de Choiseul. Next to works by Ingres, Ziem, Meissonier, Delacroix, Decamps, Corot, Troyon, Couture, and Diaz, small retrospective exhibitions of Théodore Rousseau and Jules Dupré are on view. Philippe Burty writes in praise of Rousseau: "M. Rousseau has produced without interruption an incredible number of paintings of all dimensions, provoking a well-deserved response in the last few years." But Burty is rather hostile toward Dupré, who "seems mostly to see nature through its fiery and excessive side." *Gazette des Beaux-Arts*, May 1, 1863, pp. 475–80.

EARLY APRIL **Monet** and **Bazille** are in Chailly, "in the middle of the forest [of Fontainebleau], near the most picturesque sites, and live at *père* Paillard's Auberge du Cheval Blanc; "I will try to do some sketches of trees," writes Bazille to his parents. Back in Paris, Bazille is pleased to have benefitted from the advice of Monet, who is "rather good at landscapes." Monet extends his stay in Chailly, despite Toulmouche and his aunt Lecadre's concern. He writes to Amand Gautier on May 23: "I have not abandoned the studio, and besides, I have discovered here a thousand charms that I was unable to resist. I worked a lot and, as you will see, I think I did more research than usual. Also, now, I shall go back to drawing." Wildenstein 1974, pp. 24, 420; Bazille 1992, pp. 50–51.

APRIL According to Arsène Alexandre, **Renoir**, when rejected from the Salon while still attending the École des Beaux-Arts, probably destroyed the picture he had sent, *Une nymphe avec un faune*. Paris, Durand-Ruel, 1892, *Exposition A. Renoir*, catalogue by Arsène Alexandre.

APRIL 13 Courmont, head of the Beaux-Arts section, writes to the comte de Nieuwerkerke to inform him of a complaint by the bishop of Arras, asking that **Courbet's** *Retour de la conférence* (fig. 374) not be exhibited at the Salon. Courmont adds that the comte Walewski also wishes to see the work withdrawn. Nieuwerkerke comments on the letter: "I answered that I did not wait for this suggestion to decide to reject this painting." The picture will not even been shown at the Salon des Refusés. Nevertheless, Courbet will exhibit it in his studio for several weeks. Paris, Archives du Louvre, X, Salon of 1863.

APRIL 16 In the church of the Madeleine in Paris, Thérèse De Gas, the painter's sister, marries her first cousin Edmondo Morbilli. Degas had painted his sister's engagement portrait (cat. 54, fig. 258).

APRIL 24 *Le Moniteur* publishes the emperor's authorization to open a Salon des Refusés at the Palais de l'Industrie, next to the official Salon: "Many complaints have reached the emperor regarding works of art rejected by the exhibition's jury. His Majesty wants to let the public be its own judge. He decided that works of art formerly

Fig. 374. Gustave Courbet, *Le Retour de la conférence* (*The Return from the Conference*), 1863. Oil on canvas, 90¼ in. x 128¾ in. (229 x 330 cm). Destroyed

rejected could be exhibited in another part of the Palais de l'Industrie. This exhibition will not be mandatory, and artists wishing not to participate will inform the administration and have their works promptly returned to them. This exhibition will open on May 15. Artists have until May 7 to pick up their works. After that date, their paintings will be considered part of the exhibition and hung in the galleries."

MAY 1 *La Revue française* publishes the first sonnets of José María de Heredia. Heredia will become one of **Degas**'s favorite poets and Degas will actually put himself under Heredia's patronage when writing his own sonnets in 1889. Loyrette 1991, pp. 547–50.

MAY 1 Zacharie Astruc founds *Le Salon*; this "daily paper will be available every evening during the two months that the exhibition is open," Cadart is the publisher. After much criticism of Hippolyte Flandrin's *Portrait de S. M. l'Empereur*, the paper, which had defended **Manet**'s picture at the Salon des Refusés, ceases publication on May 20. Flescher 1978, pp. 21–22.

MAY 15 Opening of the Salon and the Salon des Refusés.
 At the official Salon, see Amaury-Duval, *Naissance de Vénus* (fig. 141); Baudry, *La Perle et la Vague* (fig. 128); Cabanel, *Naissance de Vénus* (fig. 127); **Fantin-Latour**, *La Lecture* (fig. 238); Gérôme, *Louis XIV et Molière* (fig. 43); Millet, *Un paysan se reposant sur sa houe* (fig. 55).

Fig. 375. Édouard Manet, *Jeune Homme en costume de Majo* (*Young Man in the Costume of a Majo*), 1862. Oil on canvas, 74 x 49⅛ in. (188 x 124.8 cm). The Metropolitan Museum of Art, New York, The H. O. Havemeyer Collection, Bequest of Mrs. H. O. Havemeyer, 1929

At the Salon des Refusés, **Fantin-Latour** exhibits two paintings while Jongkind and **Pissarro** show three each. **Manet** is represented by *Le Déjeuner sur l'herbe (Le Bain)* (cat. 93, fig. 143), *Jeune Homme en costume de Majo* (fig. 375), and *Mademoiselle V ... en costume d'espada* (cat. 90, fig. 244); **Whistler**, *The White Girl: Symphony in White, No. 1* (fig. 249). Cézanne is also represented, but neither the number of works nor their titles is known.
 Fernand Desnoyers publishes *Salon des Refusés. Le Peinture en 1863*, in which he defends the exhibiting artists: "The paintings accepted [at the official Salon] may be less good, but they are certainly more common and more mediocre than those at the Salon des Refusés" (p. 6). On Desnoyers, see *Critique* 1990, p. 130.

MAY 16 Aurélien Scholl founds *Le Nain jaune*. The newspaper, taken over by Théophile Silvestre in 1864 and by Castagnary in 1866, will be published until 1913; Hippolyte Babou, Barbey d'Aurevilly, and E. and J. Goncourt are among its contributors.

MAY 18 Below a note written by a municipal police officer to inform the comte de Nieuwerkerke of the number of visitors at the Salon on that day, we read: "At 4:40, His Majesty the Emperor came to visit the exhibition. His Majesty examined the rejected works with great attention." Paris, Archives du Louvre, X, Salon of 1863.

JUNE–JULY Philippe Burty publishes a long study on Charles Méryon in the *Gazette des Beaux-Arts*, June 1, pp. 519–33, July 1, pp. 75–88.

JUNE 3 **Bazille** writes to his father: "I have visited the exhibition of paintings more than twenty times so that I now know it by heart, my overall opinion is that there are very few living painters truly in love with their art, most of them are only interested in making money by flattering the public taste, which is wrong most of the time." Bazille 1992, no. 23, p. 53.

SUMMER **Courbet** sees Proudhon on a regular basis, and works with him on a "book about art." The result will be *Du Principe de l'art et de sa destination sociale*, published with other works by Proudhon after his death (see pp. 101, 271). Riat 1906, p. 208; Courbet 1977–78, p. 29.

SUMMER **Pissarro** spends the summer with his family at La Varenne–Saint-Hilaire, on the Marne, near Chennevières and Champigny, not far from Paris.

SUMMER After June 23 **Bazille** goes to Montpellier, where he stays until the end of September.

JUNE 24 A decree, published in *Le Moniteur*, specifies that the Salon will be held every year from 1864 on and announces a restructuring of the jury. Billault assumes Walewski's post as minister of state. The ministère de la Maison de l'Empereur becomes the ministère de la Maison de l'Empereur et des Beaux-Arts.

JUNE 29 A decree places the division of Beaux-Arts as it existed within the ministry of state under the responsibility of the director of the Musées Impériaux, who takes the title of surintendant général des Beaux-Arts. Courmont becomes director of Beaux-Arts.

JULY 12 The critic Étienne-Jean Delécluze dies. Tabarant 1963, p. 318.

AUGUST 13 Eugène Delacroix dies. The funeral takes place on Monday, August 17, in Saint-Germain-des-Prés. **Manet** and Baudelaire attend, but Arsène Houssaye laments the absence of the younger generation: "They have left the honor of the greatest contemporary painter's funeral to the members of the Institute. Where was France on that day?" Tabarant 1963, pp. 319–20.

AUGUST 14 The new regulation of the Salon is promulgated: the Salon is to be held on an annual basis and artists can only send two works; three-quarters of the jury shall include members elected by exhibiting artists who have received an award, one-quarter shall include members of the administration. Works considered too weak by the jury might be exhibited in special galleries. This new regulation thus corroborates the end of the Institut's control over the Salon.

AUGUST 25 Jongkind arrives in Honfleur and lives at Blaue Dupuits.

SEPTEMBER 2 Baudelaire publishes "Au rédacteur. À propos de Delacroix," in *L'Opinion nationale*, in which he reprints texts previously published.

SEPTEMBER 25 Pierre-Auguste Fajon writes to **Courbet** from Montpellier: "Monsieur Frédéric **Bazille**, a friend of mine and of Baussan's, is going to Paris. I am asking him to give you my regards. He really wants to meet you and he deserves to do so." Daulte 1952, p. 37.

SEPTEMBER 30 Production of *Les Pêcheurs de perles* by Bizet at the Théâtre-Lyrique. On October 16, **Bazille** writes to his father: "The poem is absurd but some of the musical pieces are delightful, and I believe that we can count on one more composer, such a rare thing in itself." Bazille 1992, no. 30, p. 62.

OCTOBER 1 The Société des Aquafortistes publishes **Manet**'s etching *Lola de Valence*. Bailly-Herzberg 1972, vol. 1, pp. 93, 109.

OCTOBER 4 Nadar's hot-air balloon takes off from the Champ-de-Mars for the first time (see cat. 107, fig. 360). Bazille 1992, p. 59.

OCTOBER 6 In a letter to Étienne Carjat, Baudelaire writes: "[**Manet**] leaves tonight for Holland, whence he will bring back his *wife*. However, he is to be excused; I have heard that she is very beautiful, very nice, and a great artist." Baudelaire 1973, vol. 2, pp. 322–23.

OCTOBER 10 Baudelaire writes to **Whistler** on behalf of Nadar, who is going to London. Baudelaire Letters 1973, vol. 2, p. 326.

OCTOBER 28 **Manet** marries Suzanne Leenhoff at Zalt-Bommel in Holland, where they will stay for a month. Tabarant 1947, p. 80.

NOVEMBER 4 Production of *Les Troyens à Carthage* by Berlioz at the Théâtre-Lyrique. **Bazille** proclaims his enthusiasm for this work, which he sees over and over again. Bazille Letters 1992, pp. 68–69, 78.

NOVEMBER 13 Publication of the decree reforming the teaching of the École Impériale et Spéciale des Beaux-Arts and the Prix de Rome competition. The report is written by Nieuwerkerke and is addressed to the maréchal Vaillant, minister of the Maison de l'Empereur et des Beaux-Arts. It stipulates that professors shall be "appointed only by the minister." In this report Nieuwerkerke plans the restructuring of the studies and the opening of new classes. He is very critical of the curriculum sanctioning an "honest mediocrity" and designed to help "the student who makes the fewest mistakes" win the Prix de Rome, as opposed to "the student with the greatest qualities." Finally, he proposes changes that the French Academy in Rome raise the stipend awarded to students and limit their stay in Rome to two years, possibly extended by two additional years to "visit the main museums of Europe and to take other trips useful for their education." The Institute, losing its control over the École des Beaux-Arts, will be highly critical of such measures (see January 6, 1864). *Gazette des Beaux-Arts*, December 1, 1863, pp. 563–72.

NOVEMBER 20 **Cézanne**, a student of Chesnau's, seeks permission to make copies in the Louvre. London, Paris, Washington 1988–89, p. 215.

NOVEMBER 21 Auguste De Gas writes to his family in New Orleans with news of his son Edgar: "Our Raphael is still working but has not finished anything yet, meanwhile time goes by." Lemoisne 1946–49, vol. I, p. 41 and n. 2.

NOVEMBER 26–DECEMBER 3 Baudelaire's essay on Constantin Guys, "Le Peintre de la vie moderne," is published in *Le Figaro*, in three installments (see p. 266).

DECEMBER 1863–FEBRUARY 1864 Edmond and Jules de Goncourt publish their essay on Chardin in the *Gazette des Beaux-Arts* (see p. 161). At the same time, their novel, *Renée Mauperin*, appears in *L'Opinion nationale*. Goncourt 1956, vol. I, p. 1363.

EARLY DECEMBER **Bazille** writes to his mother: "Villa and **Monet** are the only students from the [Gleyre] studio whom I see on a regular basis; they like me and I like them too, for they are really charming young men. Monet invited me to spend a few days with his family in Le Havre next spring." Bazille also tells his mother that he has made the acquaintance of Théodore Pelloquet, "a good art critic of pictures whose name is probably not familiar to you but whose advice is very useful to me." But he has not yet met **Courbet**, who is in Ornans. Bazille 1992, pp. 68–69.

LATE DECEMBER **Degas** is in Bourg-en-Bresse, where he stays with his aunt and Musson cousins;

he makes several drawings of them. Paris, New York, Ottawa 1988–89, p. 55.

LATE 1863–EARLY 1864 **Courbet** works on his "epic picture," *La Source d'Hippocrène*. Riat 1906, p. 215.

1864

Degas visits Ingres when the latter "organizes a small exhibition in the manner of the old masters in his studio." He sees Homer leaning "on I do not know which companion," the *Portrait de Mme Moitessier*, and a "tondo variation of the turkish bath." Étienne Moreau-Nélaton, "Deux heures avec Degas. Interview posthume," *L'Amour de l'art*, July 1931, p. 270.

Renoir paints a picture of Alfred Sisley's father, *Portrait of William Sisley* (Musée d'Orsay, Paris), which he will show in the Salon of 1865 as *Portrait of M.W.S.*

Taine is named professor of aesthetics at the École des Beaux-Arts.

JANUARY 6 The Académie des Beaux-Arts publishes a protest in *Le Moniteur* after being deprived of its prerogatives in awarding the Prix de Rome (see November 13, 1863): "The judging of competitions will be taken away from the Académie;—the top awards will cease to be called *prix de l'académie*, they will become the École des Beaux-Arts awards and will be the responsibility of the administration;—the rules of the École de Rome, a volume written by the greatest masters and validated by half a century of triumphs, will become obsolete;—the École de Rome itself will be irreversibly isolated;—the works of its residents will no longer be submitted to the Académie, which used to encourage them with praise and straighten them out by giving advice;—finally the Académie's formal meeting will lose its usefulness and its prestige...." Maréchal Vaillant, minister of the Maison de l'Empereur et des Beaux-Arts, tries to dismiss these claims: "The decree of November 13 shatters the control [of the Académie] over teaching methods and the distribution of awards. For too long, this power has been in the hands of a group hiring only its own members, taking no responsibility and thinking it did not have to report to anybody about the orientation of the curriculum or the deterioration of the studies. It is no surprise that the Académie des Beaux-Arts demands to keep its monopoly, but the interest of the arts must supersede the established privileges of a group."

JANUARY 15 **Bazille** moves in with Louis-Émile Villa, a painter from Montpellier, in a studio at 117, rue de Vaugirard. About January 20, he writes to his father to inform him of the trouble Gleyre's studio is in: Gleyre is gradually losing his sight and the studio "is lacking in resources." Bazille 1992, no. 38, p. 75.

JANUARY 30 Founding of *L'Union des arts*, periodical of the Société des Aquafortistes. Bailly-Herzberg 1972, vol. I, pp. 48, 125ff.

FEBRUARY 9 **Whistler** asks to have until April 5 to send his works to the Salon; the extension is denied. About the same time, **Manet** asks for the same favor, "an additional eight or ten days"; it is also denied. Paris, Archives du Louvre, X, Salon of 1864; Paris, New York 1983, p. 508.

FEBRUARY 16–29 Delacroix's estate sale (Pillet and Lainné, auctioneers) at the Hôtel Drouot. Philippe Burty writes the preface to the catalogue, which includes 858 lots. Ten auctions will bring a total of Fr 368,000. On February 21, Jules de Goncourt visits the exhibition of drawings: "Every scrap of study, all the leftovers of his portfolio, the cleaning rags, the bits and pieces, the microscopic embryos and the miscarriages of the painter are here, religiously exhibited with ceremony." The next day **Bazille** also attends. On March 11, the furniture of the studio is sold on the premises. Goncourt 1956, vol. 6, pp. 180–81; Bazille 1992, p. 80.

FEBRUARY 29 **Bazille** meets Jongkind through Mme Lejosne. Bazille 1992, no. 41, p. 79.

MARCH Exhibition of the Cercle de la rue de Choiseul and the Société Nationale des Beaux-Arts; works by Delacroix, Meissonier, Millet, Théodore Rousseau, Corot (*L'Étoile du soir*; fig. 376) are on view. Philippe Burty, *Gazette des Beaux-Arts*, April 1, 1864, pp. 366–72.

MARCH Baudelaire writes to Chennevières recommending the works **Manet** (cat. 96, fig. 68) and **Fantin-Latour** (cat. 71, fig. 58) are sending to the Salon of 1864. On March 22, Baudelaire writes to Fantin-Latour to ask him for the address of Swinburne, who is in Paris and has left "a book and his calling card." Baudelaire 1973, vol. 2, pp. 350–51.

MARCH 12 Pierre Larousse publishes the first installment of his *Grand Dictionnaire universel*.

MARCH 21 Death of Hippolyte Flandrin (cat. 75, fig. 20) in Rome; the funeral takes place in Paris at Saint-Germain-des-Prés on April 28. In 1865, Henri Delaborde publishes *Lettres et pensées d'Hippolyte Flandrin*, with the first catalogue of his works.

SPRING Exhibition of the Société des Amis des Arts de Bordeaux. Several works by Delacroix and paintings by Bouguereau, Belly, Diaz, Troyon, Daubigny, Vollon, Ribot, Jongkind, Ziem, and **Courbet** (*Les Sources de la Loue*) are exhibited.

EARLY APRIL Baudelaire writes to **Manet** about *Les Anges au tombeau du Christ* (cat. 96, fig. 68): "Indeed, it seems that Christ was speared on the right side." Baudelaire 1973, vol. 2, p. 352.

APRIL 22 René De Gas writes to his relatives in New Orleans about his brother: "Even if he does not appear to do so, Edgar [**Degas**] always works very hard. What brews in his head is frightening. I believe and am even convinced that he

not only has talent but also genius, but will he be able to express what he feels? That is the question [last sentence is in English in the French text and alludes to *Hamlet*]." Paris, New York 1988, p. 55

MAY 1 Opening of the Salon.

Boudin has sent *Plage aux environs de Trouville*; Jongkind, two canvases and one engraving; and Berthe Morisot, a "student of MM. Guichard and Oudinot," exhibiting for the first time, two landscapes. **Fantin-Latour** shows *Hommage à Delacroix* (fig. 233) and *Scène du Tannhäuser* (cat. 71, fig. 58); **Manet**, *Les Anges au tombeau du Christ* (cat. 96, fig. 68) and *Épisode d'une course de Taureaux*; **Pissarro**, *Bords de la Marne* (cat. 154, fig. 116) and *Route de Cachalas, à la Roche-Guyon*; and **Renoir**, *La Esméralda* (a painting he will eventually destroy). **Cézanne** is rejected. See Meissonier, *L'Empereur à la bataille de Solférino* (fig. 41), Puvis de Chavannes, *L'Automne* (fig. 137), and Tissot, *Portrait de Mlle L. L...* (cat. 189, fig. 278).

MAY 2 "Reading" by Baudelaire on Delacroix at the Cercle Artistique et Littéraire de Bruxelles. Baudelaire 1973, vol. 2, p. 361; Tabarant 1963, p. 342.

LAST HALF OF MAY **Monet**, who has spent part of the spring in Chailly, leaves for Honfleur with **Bazille**. In Rouen, they admire the *Justice de Trajan* by Delacroix. In Honfleur, they rent rooms "at a baker's" and spend their days at the Ferme Saint-Siméon. Bazille will go back to Paris to study medicine in late June or early July. Monet remains in Normandy until the winter. Bazille 1992, no. 52, pp. 91–92.

JUNE 19 Two American ships, the *Kearsarge* (Federal) and *Alabama* (Confederate), battle off

Cherbourg. **Manet** may have witnessed the event; his painting (cat. 99, fig. 62) inspired by that incident is exhibited at Cadart's, 79, rue de Richelieu, barely a month later.

ABOUT JUNE 20 From Brussels, Baudelaire writes to Théophile Thoré to object to the term "pastiche" of the Spanish painters that Thoré used to describe the works that **Manet** sent to the Salon (cat. 96, fig. 68). Baudelaire 1973, vol. 2, p. 386.

SUMMER **Pissarro** is in La Varenne-Saint-Maur; he visits Ludovic Piette in Montfoucault (Mayenne).

SUMMER **Cézanne** goes back to Aix. He spends the month of August in L'Estaque.

JUNE 26 Théophile Thoré (William Bürger) publishes "Charles Baudelaire et les coïncidences mystérieuses" as a serial in *L'Independance belge*. He acknowledges that Baudelaire was right and admits that **Manet** pastiches neither Goya nor El Greco, for he never saw their work. Tabarant 1963, p. 345.

JULY–OCTOBER **Fantin-Latour** goes to England for the third time. **Whistler** tries to help him build a clientele. Paris, Ottawa, San Francisco 1982–83, pp. 50–51.

JULY 15 From Honfleur, **Monet** writes to **Bazille** in Paris. Bazille, who is struggling with a "life size study of a woman" in Paris (this work will be "nearly finished" in August): "Every day, I discover more beautiful things. I feel like I am losing my mind because I want to paint everything; my head is bursting." However, when looking at his own work, Monet admits only a feeling of mixed satisfaction: "When I look at nature, it seems to me that I am going to do everything, to write it all, but then it is totally different... when one starts the work on the canvas...." Wildenstein 1974, no. 8, p. 420; Bazille 1992, pp. 92–96.

AUGUST 13 During the distribution of the 1864 Salon awards, maréchal Vaillant announces that the emperor has decided to create a special award in the amount of Fr 100,000, drawn on the emperor's civil list, to reward "the author of a great work every five years." The first award will be given in 1869. Tabarant 1963, p. 340.

AUGUST 13–DECEMBER 11 Retrospective exhibition of Delacroix's works, boulevard des Italiens. On December 3, during the exhibition, the annual banquet of the Société Nationale des Beaux-Arts is held; Corot, Daubigny, Stevens, Dumas, Burty, Puvis de Chavannes, and Théodore de Banville are among the participants. Tabarant 1963, pp. 340–41.

AUGUST 16–OCTOBER 7 Jongkind is in Honfleur; he oftens sees **Monet** and works with him.

AUGUST 26 **Monet** writes to **Bazille** from Honfleur: "Ribot will probably come; he wants to paint a fishing boat with figures *en plein air*. I am curious to see how he will proceed." Many painters are staying in Honfleur, notably Boudin and Jongkind. Wildenstein 1974, no. 9, p. 421.

SEPTEMBER Boudin stays in Trouville until December 1. Laurent Manoeuvre, *Boudin et la Normandie* (Paris: Herscher, 1991), p. 184.

SEPTEMBER–OCTOBER Philippe Burty publishes a long article on "L'oeuvre de M. Francis Seymour-Haden" in the *Gazette des Beaux-Arts* (September 1, pp. 271–87; October 1, 1864, pp. 356–66, with reproductions and a catalogue). This artist, **Whistler**'s brother-in-law, was the instigator of England's etching revival.

SEPTEMBER 16 Jongkind dates to this day a watercolor representing *La Chapelle Notre-Dame-de-Grâce à Honfleur* (Hefting 1975, no. 311); at the same time, **Monet** paints *Notre-Dame-de-Grâce* (Wildenstein 35) from an identical vantage point. Hefting 1975, p. 354.

OCTOBER 14 From Sainte-Adresse, **Monet** sends **Bazille**, who is in Montpellier, two paintings to show to Alfred Bruyas, Courbet's friend as well as a collector of his works. Wildenstein 1974, p. 421.

OCTOBER 16 **Monet** is in Rouen with his friend Barry. Together they visit the *20eme exposition municipale des Beaux-Arts*. Monet is disappointed that his "Flowers" (possibly cat. 115) are badly hung and at the mediocrity of the other artists: "There are disgraceful things, apart from three truly outstanding canvases by Ribot, whose pictures are admirably painted." Wildenstein 1974, no. 12, p. 421.

LATE OCTOBER–EARLY NOVEMBER After Jongkind's departure three weeks earlier, **Monet** is alone in Honfleur. He writes to Boudin to ask him if he can also work for Louis-Joachim Gaudibert, Boudin's patron from Le Havre (cat. 142, fig. 231). Wildenstein 1974, p. 421.

NOVEMBER **Manet** moves to a new apartment at 34, rue des Batignolles. Paris, New York 1983, p. 508.

Fig. 376. Camille Corot, *L'Étoile du soir* (*Evening Star*), 1864. Oil on canvas, 50⅞ x 63 in. (129 x 160 cm). Musée des Augustins, Toulouse

NOVEMBER OR DECEMBER **Bazille** writes to his father: "At the moment, I am working every day on life size studies at **Monet**'s.... The Parisian collectors have been more generous [to Monet] than those in Montpellier; he has been commissioned to do three paintings for Fr 400 each." Bazille 1992, no. 57, p. 97

NOVEMBER 11 **Courbet** writes to Victor Hugo offering to paint his portrait the following spring. Hugo replies favorably, but the project will fall through. Roger Bonniot, "Victor Hugo et Gustave Courbet. Un projet de portrait abandonné," *Gazette des Beaux-Arts*, October 1972, pp. 241–48.

DECEMBER **Bazille** has a new address, 6, rue de Fürstenberg (fig. 377), a studio he rents along with **Monet**, who is just back from Normandy. Wildenstein 1974, p. 28; Bazille 1992, no. 61, pp. 100–101.

DECEMBER 1 Boudin leaves Honfleur and returns to Paris. On December 15 he moves to 31, rue Fontaine-Saint-Georges. Manoeuvre, *Boudin et la Normandie*, p. 184.

DECEMBER 10 During Delacroix's retrospective exhibition on the boulevard des Italiens, Alexandre Dumas gives an "informal talk" on the artist. The manuscript is in the Département des manuscrits of the Bibliothèque Nationale.

DECEMBER 17 Production of *La Belle Hélène* by Offenbach (libretto by Meilhac and Halévy) at the Théatre des Variétés.

LATE DECEMBER **Fantin-Latour** takes Dante Gabriel Rossetti on a tour of the studios of Parisian artists. Paris, Ottawa, San Francisco 1982–83, p. 51.

Fig. 377. Frédéric Bazille, *L'Atelier de la rue de Furstenberg* (*The Studio on the rue de Furstenberg*), ca. 1865. Oil on canvas, 31½ x 25⅝ in. (80 x 65 cm). Musée Fabre, Montpellier

1865

First attempts at chromo lithography with the publication of *Chefs-d'oeuvre des grands maîtres, reproduits en couleur par F. Kellerhoven d'après de nouveaux procédés*, text by Alfred Michiels (Paris: Didot et Cie.).

1865–66 Prince Paul Demidoff commissions Ricard, Corot, Fromentin, and Chaplin (see cat. 182) to decorate his town house on rue Jean-Goujon.

WINTER **Fantin-Latour** is working on his large painting *Le Toast! (Hommage à la Vérité)* in which he includes portraits of **Whistler**, Vollon, **Manet**, Bracquemond, Cordier, Duranty, Astruc, and Cazin. After the Salon, Fantin will destroy this canvas. Douglas Druick in Paris, Ottawa, San Francisco 1982–83, pp. 179–90.

JANUARY Publication of *Germinie Lacerteux* by Edmond and Jules de Goncourt.

JANUARY "**Manet** is discouraged and tore up his best studies." Letter from Mme Paul Meurice to Baudelaire, in *Lettres à Baudelaire* (Neuchâtel, 1973), p. 263.

JANUARY 6 **Degas** goes back to Bourg-en-Bresse, where he makes a watercolor portrait of his aunt, *Mme Musson et ses filles*(The Art Institute of Chicago).

JANUARY 20 Death of Pierre-Joseph Proudhon; **Courbet**, who witnessed his last moments, draws him on his deathbed. *Du Principe de l'art et de sa destination sociale* is published in July. Riat 1906, p. 220 (repr.); Léon Lagrange, "Bulletin mensuel, juillet 1865," *Gazette des Beaux-Arts*, August 1, 1865, pp. 187ff.

FEBRUARY Exhibition of the Cercle de l'union des arts, on the rue de Choiseul: next to works by Delacroix, Decamps, Diaz, Troyon, Daubigny, Millet, Fromentin, Meissonier, and Gérôme, the "younger generation" is represented by Schreyer, Heilbuth, Ribot, and Belly. Léon Lagrange, "Bulletin mensuel, février 1865," *Gazette des Beaux-Arts*, March 1, 1865, pp. 291–96.

FEBRUARY 15–APRIL 1 Exhibition of works by Hippolyte Flandrin at the École dex Beaux-Arts.

FEBRUARY 19 Opening of an exhibition of the Société Nationale des Beaux-Arts at the Galerie Martinet. **Manet**, who initially planned to send nine paintings, then six, only sends two; he then decides to leave the Société. Most Société members do not send any paintings; Louis Martinet resigns: it is the end of the Société Nationale. Moreau-Nélaton 1926, vol. 1, p. 62; *Lettres à Baudelaire*, Neuchâtel, 1973, pp. 215, 230–32; Lorne Huston, "Le Salon et les expositions d'art: réflexions à partir de l'expérience de Louis Martinet (1861–1865)," *Gazette des Beaux-Arts* 116 (1990), pp. 45–50.

MARCH 10 Death of the duc de Morny, the emperor's half brother. The funeral is held on March 13 at the church of the Madeleine with numerous delegations from the studios, including Picot, Couture, Gleyre, Cogniet, Isabey, and Signol.

ABOUT MARCH 23 Baudelaire, who has sent **Manet** his translation of Edgar Allan Poe's *Histoires grotesques et sérieuses* (*Tales of the Grotesque and Arabesque*), writes him to reassure him about the fate of his paintings *Jésus insulté par les soldats* (fig. 74) and *Olympia* (cat. 95, fig. 146), which are exhibited at the Salon. On the same day, Baudelaire writes to Théophile Gautier to introduce Manet. Baudelaire 1973, vol. 2, pp. 481–82.

MARCH 25 Death of Constant Troyon. Paul Mantz, "Troyon," *Gazette des Beaux-Arts*, May 1, 1865, pp. 393–407; Tabarant 1963 p. 351.

SPRING **Monet** goes to Chailly where he remains until the fall; he works on *Déjeuner sur l'herbe* (cats. 122, 123; fig. 169). Wildenstein 1974, p. 422.

SPRING **Manet**'s paintings are rejected at the Royal Academy in London. *Lettres à Baudelaire* (Neuchâtel, 1973), p. 237.

APRIL The painter Jules Le Coeur, a friend of **Renoir**'s, buys a house in Marlotte. Renoir visits him often and meets Clémence Tréhot, Le Coeur's mistress, and her sister Lise, who becomes Renoir's mistress and favorite model.

APRIL 19 Suicide of Jules Holtzapffel, a little-known painter rejected by the Salon, is announced in the newspapers; artists demonstrate on the boulevard.

APRIL 28 Production of Meyerbeer's *L'Africaine* at the Opéra. **Bazille** sees this piece several times and greatly admires it: "For me, this opera is a masterpiece as beautiful as all the previous works by Meyerbeer." Bazille 1992, no. 66, pp. 108–9.

MAY Ingres exhibits a new version of *Homère déifié* in his studio. It is a "drawing slightly tinted with India ink" (fig. 378): "He gave the composition a new grandeur. He has added a remarkable precision to endlessly multiplied details. The first design was idealistic. This one is more specifically historical." Léon Lagrange, "Bulletin mensuel, mai 1865," *Gazette des Beaux-Arts*, June 1, 1865, pp. 566–68.

MAY **Whistler** meets the painter Albert Moore. Later that same year, Moore will replace Legros as a member of the "Société des trois," which, since 1858, had consisted of **Fantin**, Whistler, and Legros. The new trinity wanted to promote the "continuation of the true traditions of nineteenth-century painting." Paris, Ottawa, San Francisco 1982–83, p. 98.

MAY **Manet** exhibits a few paintings at Cadart's. Charles Moffet, in Paris, New York 1983, p. 212.

MAY 1 Opening of the Salon.
Boudin exhibits two scenes of the Normandy coast, Courbet exhibits a portrait (fig. 379) and a landscape. **Fantin-Latour** shows *Le Toast!*, Jongkind a landscape of Normandy and a Dutch landscape, and Berthe **Morisot** one *Étude* and one

Nature morte. **Degas** is admitted for the first time (*Scène de guerre au Moyen Âge* [cat. 55, fig. 61]) but goes unnoticed. **Pissarro** sends two landscapes (*Chennevières au bord de la Marne* [cat. 155, fig. 115] and *Le Bord de l'eau*), **Renoir** sends the portrait of **Sisley**'s father (*Portrait de M. W[illiam] S[isley]*) and *Soirée d'été*, and **Whistler** sends *La Princesse du pays de la porcelaine* (fig. 380). **Manet** causes a scandal with *Jésus insulté par les soldats* (fig. 74) and, above all, with *Olympia* (cat. 95, fig. 146).

Monet, well placed, is congratulated for his two landscapes (*Embouchure de la Seine, à Honfleur*) and *La Pointe de la Hève a marée basse* [cat. 118, fig. 83]). "Monet was much more successful than he expected," writes **Bazille**, who has noticed "very few beautiful things, except for a *Saint-Sébastien* [fig. 38] by Ribot." **Manet**, heavily criticized, was supposedly upset by the success of this nearly homonymous artist. While looking at a canvas by his young rival, he is said to have exclaimed: "Who is this rascal who pastiches my painting so basely?" Thiébault-Sisson, "Claude Monet," *Le Temps*, December 7, 1926; Wildenstein 1974, p. 29; Bazille 1992, pp. 108–9.

See Giacomotti, *L'Enlèvement d'Amymoné* (fig. 129); Henner, *La Chaste Suzanne* (fig. 131); Lambron, *La Vierge et l'enfant Jésus* (fig. 36); and Ribot, *Saint Sébastien, martyr* (fig. 38). **Cézanne** is not admitted.

MAY 11 Baudelaire writes to **Manet** from Brussels to comfort him after the harsh criticism he received for his entries at the Salon: "*They make fun of you; these jokes irritate you; they do not do justice to you etc., etc. Do you think you are the first man in this situation? Do you have more genius than Chateaubriand and Wagner? Weren't*

they also ridiculed? They lived through it. I shall tell you, don't let it give you a swelled head, that these men are models, each in his own way, in a very rich world, and that *you are only the first in the decrepitude of your art.*" Baudelaire 1973, vol. 2, pp. 496–97.

MAY 15–17 Auction of a large part of Hippolyte Flandrin's studio (313 lots) at the Hôtel Drouot.

MAY 24 Baudelaire writes to Mme Paul Meurice; he asks her to offer moral support to **Manet**, then continues: "Manet possesses such brilliant and light qualities that it would be most unfortunate if he got discouraged. He will never overcome the gaps in his temperament. But he has *tempérament*, and it's what matters." Baudelaire 1973, vol. 2, p. 501.

MAY 25 Baudelaire writes to Champfleury from Brussels: "**Manet** has a strong and solid talent, but he has a weak personality. He seems to be upset and stunned by the shock. I am also struck by the joy of all the imbeciles who think he is finished." Baudelaire 1973, vol. 2, p. 502.

STARTING MAY 31 Auction of the collection of the duc de Morny. Several Japanese items are acquired by the empress (today in the Musée National du Château de Fontainebleau). Tabarant 1963, p. 362; Paris, Tokyo 1988, p. 76.

BEGINNING OF JUNE **Courbet** briefly visits Fontainebleau. He is in Paris on June 19.

SUMMER **Cézanne**, who lives in Paris all year round, comes back to Aix for the summer; he befriends Valabrègue, Marion, and the German musician Morstatt.

JULY **Monet** writes to **Bazille** to reproach him for not having come to pose for *Déjeuner sur l'herbe*: "I only think of my Painting, and if I happened to mess it up, I think I would go mad. Everybody knows that I am working on it and I receive a lot of encouragement." Wildenstein 1974, no. 20, p. 422. (See cats. 122, 123.)

JULY **Fantin-Latour** moves to 13, rue de Londres.

JULY 3 **Renoir** is staying with **Sisley** at 31, avenue de Neuilly. He invites **Bazille** to join them and a young model, "young Grange," to go boating on the Seine. He plans for them to be towed to Rouen by the *Paris et Londres* and then attend the regattas at Le Havre. Daulte 1952, p. 47.

JULY 16 **Bazille** wins a regatta at Bougival. Wildenstein 1974, p. 30.

JULY 17 **Bazille** writes to his father to inform him of his plans: he wants to finish the paintings he started for his uncle, particularly "a large life-size portrait," and then "spend five or six days in Chailly as a favor to **Monet**. After that, I will leave for Montpellier." Bazille also tells his father that he has begun to write a play with Édouard Blau, *Le Fils de don César*. Bazille, no. 69, 1992, pp. 112–13.

AUGUST 1865? **Degas** copies *Symphony in White, No. 3* by **Whistler** after a drawing sent by Whistler to **Fantin-Latour** (fig. 381). Reff 1985, notebook 20, p. 17.

AUGUST 16 Jongkind goes to Honfleur for the last time; he calls on Boudin. Hefting 1975, p. 357.

AUGUST 18 OR 25 **Bazille** finally finishes the paintings he promised his uncle (cat. 2): "I started

Fig. 378. J.-A. Dominique Ingres, *Homère déifié* (*Glorification of Homer*), 1865. Graphite and gray wash heightened with white, 29⅞ x 33⅝ in. (76 x 85.5 cm). Musée du Louvre, Paris, département des Arts Graphiques

Fig. 379. Gustave Courbet, *Portrait de Pierre-Joseph Proudhon en 1853*, 1865–67. Oil on canvas, 57⅞ x 78 in. (147 x 198 cm). Musée du Petit Palais, Paris

them afresh since my last letter; before, I had painted a mass of details, which had a very poor effect when seen from the distance they had to be viewed." Soon after, Bazille leaves for Chailly, where **Monet** is expecting him "as the Messiah." In Chailly, Bazille poses for *Déjeuner sur l'herbe* (cats. 121, 122, 123; fig. 169) and paints Monet, who accidentally wounded himself in the leg (fig. 382). Bazille 1992, no. 113, p. 113.

LATE AUGUST–EARLY SEPTEMBER On the advice of Zacharie Astruc, **Manet** takes a trip to Spain. He leaves about August 29 and reaches Madrid after stops in Burgos and Valladolid. As soon as he arrives in Madrid for a one-week stay, Manet meets Théodore Duret; both men visit the museums, go to a bullfight, and make an excursion to Toledo. Upon his return, Manet spends the month of September at Vassé (Sarthe); back in Paris in late September, he undertakes his *Courses de taureaux* and, in a manner inspired by Velázquez, paints *L'Acteur tragique* (fig. 384), a portrait of the actor Philibert Rouvière in *Hamlet*. On September 14, Manet gives Baudelaire the following account of his trip: "At last, my dear friend, I know Velázquez and I declare that he is the greatest painter that ever existed; I saw 30 to 40 works by him in Madrid, both portraits and paintings, and all are masterpieces. He is better than his reputation and he alone is worth the fatigue and the frustrations that are unavoidable when undertaking a trip to Spain. I saw very in-

teresting things by Goya, a few very beautiful works, and, among others, an extremely charming portrait of the duchess of Alba in maja costume. One of the most beautiful, strangest, and most terrible spectacles to be seen is a bullfight. Upon my return, I hope to fix on canvas the brilliant and dazzling aspect, dramatic at the same time, of the corrida that I attended." Paris, New York 1988, pp. 231–32.

SEPTEMBER 28 **Bazille** is staying at his parents' at Méric. Isaacson 1972, pp. 24, 101, note 26.

FALL **Courbet** and **Whistler** are staying in Trouville together. Courbet visits Boudin. On November 17, Courbet writes to his father to boast that he executed "thirty-five paintings" in a very short time, and that it "stunned everybody." Courbet's stay in Normandy was particularly profitable, since he executed seascapes, several portraits of the elegant society, and of "Jo, the beautiful Irish woman," Whistler's mistress and *La Fille aux mouettes* (cat. 43, fig. 279). Courbet concludes: "I went swimming in the ocean 80 times. Six days ago, I was still swimming with the painter Whistler, who is here with me; he is an Englishman who is my pupil." Riat 1906, p. 228.

FALL **Monet** returns to Paris to the rue de Fürstenberg. Wildenstein 1974, p. 422.

OCTOBER 27 New rules are established for the Salon of 1866: the members of the jury will increase in number (from twelve to twenty-four for painting and from eight to twelve for sculpture). The number of jurors elected by artists who have been awarded a medal or a decoration is reduced from three-quarters to two-thirds. Tabarant 1963, p. 374.

NOVEMBER **Bazille** tells his mother that he has begun a painting for the Salon: "It is a very sim-

ple subject that will attract very little attention if it is admitted. A young girl is playing the piano and a young man is listening to her." **Monet**, whose painting (*Le Déjeuner sur l'herbe*, cats. 122, 123, fig. 169) is "well under way," has sold "a thousand francs' worth of paintings over the last few days, and he still has one or two small commissions. His career has started." Bazille 1992, no. 72, p. 115.

DECEMBER Reopening of the museum of the "modern school of France" (école moderne de France) at the Luxembourg. The catalogue contains a preface by the marquis de Chennevières and includes 306 entries. Léon Lagrange, "Bulletin mensuel, décembre 1865," *Gazette des Beaux-Arts*, January 1, 1866, pp. 95–96. In the monthly bulletin for February 1866 (*Gazette des Beaux-Arts*, March 1, 1866, p. 292), Lagrange will lament the absence of several artists, particularly Ricard and Puvis, at the Musée du Luxembourg.

DECEMBER **Bazille** works on his entry for the Salon (November 1865); he writes to his brother: "Master **Courbet** complimented me on it. He paid us a visit to see **Monet**'s painting, and he was delighted by it. Besides, more than twenty painters came to see it and they all admired it greatly, although it is far from being complete (naturally, I am not speaking of my own work). This painting will get a lot of attention at the exhibition." Bazille announces that he must leave the rue Fürstenberg (he will leave with Monet on February 4, 1866) and that he has found a studio at 22, rue Godot de Mauroy. Bazille 1992, no. 74, pp. 116–17.

DECEMBER 5 Premiere of *Henriette Maréchal* by Edmond and Jules de Goncourt at the Comédie-Française.

DECEMBER 20 Boudin writes to his brother from Paris: "I have seen **Courbet** and others who

Fig. 380. James McNeill Whistler, *La Princesse du pays de la porcelaine*, 1863–64. Oil on canvas, 78¾ x 45⅝ in. (199.9 x 116 cm). Freer Gallery of Art, Washington

Fig. 381. Edgar Degas, copy of the *Symphony in White, No. 3* by Whistler, August 1865? Graphite, 4⅜ x 7⅛ in. (11 x 18 cm). Musée du Louvre, Paris, département des Arts Graphiques

dare to paint large canvases, the happy men. Young **Monet** has twenty feet to cover. As for me. I am less ambitious and would like to undertake something larger than my little canvases, but I must think of earning my living. There are so many small expenses that it never ends." Jean-Aubry 1922, p. 60.

DECEMBER 28 Gaston Bazille writes to his son: "I'm sorry for you that you and **Monet** are no longer together; I hear that he was a hardworking man, which must have made you ashamed of your laziness." Bazille 1992, no. 75, p. 118.

1866

Fantin-Latour makes the acquaintance of the painter Victoria Dubourg, whom he will marry in 1876.

Tissot purchases a town house at 64, avenue de l'Impératrice (now avenue Foch) with the Fr 70,000 income he received for the year 1865. **Degas**, Meissonier, Heilbuth...often visit him." Georges Bastard, James Tissot," *Revue de Bretagne*, November 1906, pp. 253–78.

Courbet is negotiating with the dealer Arthur Stevens—without success—for the purchase of *Un Enterrement à Ornans* (fig. 165) by the Belgium state. After being exhibited at the boulevard des Italiens in 1863, *La Curée* (Museum of Fine Arts, Boston) is bought by the Alston Club of Boston for Fr 25,000 by subscription. Riat 1906, pp. 153–54, 236.

Paul Baudry decorates the hôtel de la Païva on the avenue des Champs-Élysées.

Twenty-five etchings by Seymour Haden are published in London, with a preface by Philippe

Burty. J. Wilson, "Correspondance de Londres," *Gazette des Beaux-Arts*, June 1, 1866, pp. 571–72.

Pissarro moves to 1, rue du Fond-de-l'Ermitage in Pontoise.

1866–70 These are the great years of the Café Guerbois, a large establishment located on the avenue de Clichy; the presence of **Degas** and **Manet**, regulars, attracts others, namely: Duranty, Zola, **Fantin-Latour**, Antonin Proust, Nadar, Zacharie Astruc, Phillipe Burty, **Bazille**, **Whistler**, **Renoir**...Manet hosts frequent gatherings there, especially on Friday nights. Surrounded by his circle, he sits "at the second table on the left from the entrance." Tabarant 1947, p. 188; Loyrette 1991, pp. 230–33.

JANUARY **Courbet** writes to Bruyas describing to him the *marines* (seascapes) he executed in Trouville (cat. 44, fig. 293): there are "25 seascapes done in your style as well as in the style of those I painted at *Cabanes*, 25 autumn skies, one more extraordinary and free than the next; it is amusing." Riat 1906, p. 229.

JANUARY **Monet** leaves **Bazille** and settles into a small studio without frills on the third floor of an apartment building at 1, place (or rue) Pigalle at the beginning of the year. Wildenstein 1974, p. 31.

JANUARY Cadart takes his first trip to the United States (he will return in October); according to Castagnary, he lands in New York "with an enormous load of modern paintings, works by **Courbet**, Corot, Daubigny, Tassaert, Jongkind, Ribot, Vollon, Doré, which reflect all styles and all temperaments." Bailly-Herzberg 1972, pp. 211–16, 250ff.

JANUARY–MARCH **Renoir** exhibits three paintings at the Société des amis des Beaux-Arts at Pau. London, Paris, Boston 1985–86, p. 371.

JANUARY 1 Philippe Burty publishes an article entitled, "L'oeuvre de M. Meissonier et les photographies de M. Bingham," in *Gazette des Beaux-Arts* (pp. 78–79). This article is a supplement to an article written in May 1862 that describes the etchings and woodcuts by Meissonier.

JANUARY 15 Bazille has moved to 22, rue Godot de Mauroy. Shortly after, he writes to his mother: "My painting measures two meters by 1.50 meters, it is quite large as you can see, there is a lot to do, my two figures are half-size and give me a lot of trouble. One of my friends posed for the young man half lying on a sofa as he listens to the piano, it is almost finished. The women are terribly difficult to do, there is a green satin dress that I rented and a blond head that I fear will not come out as well as I would want, although **Courbet** paid me some compliments when it was begun. Besides, I believe I already told you that I repainted everything since then." Bazille 1992, no. 76, p. 120.

FEBRUARY **Sisley**, **Renoir**, and Le Coeur walk through the forest of Fontainebleau to go to Milly and Courances. According to Douglas Cooper, Renoir uses his friends Le Coeur, Sisley, and the waitress Nana as models for *Le Cabaret de la mère Antony* (cat. 170, fig. 225). Cooper 1959, p. 322.

FEBRUARY After playing host to Guillemet in Aix in January **Cézanne** goes back to Paris. He again lives at 22, rue Beautreillis.

FEBRUARY 1 In a short article, "D'une définition de l'art appliquée à l'art de peindre," Louis Viardot maintains that "art is like the result of an embrace between man and nature; it possesses a soul and a body, like man. No work of art can be found or conceived which is not somehow created half from idealism and half from realism." *Gazette des Beaux-Arts*, February 1, 1866, pp. 161–65.

MARCH Works by Théodore Rousseau, Dupré, Cabat, Troyon, Decamps, Delacroix, Ricard, Gérôme, Tissot, Fromentin, Meissonier, Alfred Stevens...are exhibited in a show of the Cercle de l'Union artistique. Léon Lagrange, "Bulletin mensuel, mars 1866," *Gazette des Beaux-Arts*, April 1, 1866, pp. 398–400.

MARCH 3 First delivery of the *Parnasse-contemporain* at Lemerre's; fifteen new *Fleurs du mal* by Bandelaire are published in it on March 31, and ten poems by Mallarmé on May 12.

MARCH 12 **Whistler** arrives in Valparaiso. He paints several seascapes and his first nocturnes (fig. 383). He returns to England in September.

MARCH 29 **Renoir** spends about ten days in Paris and then leaves with Jules Le Coeur to join **Sisley** in Marlotte. Cooper 1959, p. 164.

APRIL Manet meets **Cézanne**. Alfred Barr, "Cézanne d'après les lettres de Marion à Morstatt," *Gazette des Beaux-Arts* 17 (1937), pp. 51–52.

Fig. 382. Frédéric Bazille, *L'Ambulance improvisée* (*The Improvised Field Hospital*), 1865. Oil on canvas, 18½ x 25⅝ in. (47 x 65 cm). Musée d'Orsay, Paris

APRIL 2 Courbet writes to the comte de Nieuwerkerke asking to be allowed to retouch *Femme au perroquet* (cat. 45, fig. 148) in his studio, because he is ill. The work has already been sent to the Palais de l'Industrie. Nieuwerkerke refuses but authorizes Courbet to work at the Palais de l'Industrie. Paris, Archives du Louvre, X, Salon de 1866.

SECOND HALF OF APRIL Monet settles in Sèvres in a small rented house located on the chemin des Closeaux, near the railroad station of Ville-d'Avray. He writes Amand Gautier that he could not attend his wedding on April 12 because he was moving, and continues: "I would like to ask you to recommend me to Détrimont [Alexis Eugène Détrimont, Courbet and Daubigny's dealer and owner of a gallery at 33, rue Laffitte], to see if he would accept a few of my paintings so that I would have a place where I could send people to look at works I want to sell, as I have several finished ones at the moment...." Wildenstein 1974, no. 25, p. 423.

APRIL 16 Bazille writes to his parents: "I saw Courbet yesterday, he's rolling in money.... Although he is showing some very beautiful works this year, they are not as good as his *Baigneuses, Demoiselles de la Seine*, etc. The public has taken it upon itself to make him successful, and he has sold paintings for more than Fr 150,000 since the opening of the Salon. His drawers are so stuffed with banknotes that he does not know what to do with them, all the collectors rush to his studio, they look at a bunch of old, dusty canvases and they fight over them. The Galerie Bruyas has tripled in value." Daulte 1952, p. 52.

APRIL 19 Cézanne writes to comte de Nieuwerkerke after the rejection of his two paintings: "I will only say to you once more that I cannot accept the illegal judgment of colleagues whom I have not entrusted to evaluate my work. I am writing to you to second my request. I wish that the public have an opportunity to be the judge and that my work be exhibited in spite of all this... the Salon des Refusés should be reinstituted." Paris, Archives du Louvre, X, Salon de 1866.

APRIL–MAY Two studies on the Belgian painter Henri Leys are published in the *Gazette des Beaux-Arts*: Paul Mantz, "Henri Leys," April 1, 1866, pp. 297–317; Philippe Burty, "Les eaux-fortes de M. Henri Leys," May 1, 1866, p. 467–77.

MAY Manet meets Monet through Astruc. Wildenstein 1974, p. 32.

MAY 1 Opening of the Salon, accompanied by a demonstration of artists against the jury (Tabarant 1963, p. 382). Courbet exhibits two works: *Remise de Chevreuils, au Ruisseau de Plaisirs-Fontaine (Doubs)* and *La Femme au perroquet* (cat. 45, fig. 148), Gustave Moreau, *Orphée* (fig. 71). Boudin, Fantin-Latour, Jongkind, and Morisot are admitted with two paintings each. Bazille sends his *Poissons*; Degas, his *Scène de steeplechase* (fig. 350); Pissarro, *Bords de la Marne en hiver* (cat. 156, fig. 117); Sisley, *Femmes allant au bois; paysage* and *Une rue à Marlotte; environs de Fontainebleau* (cat. 185, fig. 103). Monet triumphs with his *Forêt de Fontainebleau* and above all with *Camille* (fig. 236). The superintendent's office of the Beaux-Arts acquires *L'Assassiné, souvenir de la campagne romaine* by Carolus-Duran (fig. 385) for the Musée de Lille. The work had been exhibited at the Salon and at the Exposition des Beaux-Arts in Lille. Philippe Burty, "L'Exposition des Beaux-Arts à Lille," *Gazette des Beaux-Arts*, October 1, 1866, p. 384. Manet's *Le Fifre* (cat. 102, fig. 261) and *L'Acteur tragique* (fig. 384) by Manet are rejected, as are Cézanne's entries (including *Portrait d'Antony Valabrègue*, Venturi 216, National Gallery of Art, Washington). The jury only accepts one hasty sketch done in Marlotte by Renoir but rejects a landscape with two figures, in spite of Corot and Daubigny's support; Renoir does not want to be represented by a mere sketch and decides not to exhibit (London, Paris, Boston 1985–86, p. 372).

MAY 7 Because he came to Manet's defense in a review of the Salon, Zola is asked to leave *L'Événement*; he is replaced by Théodore Pelloquet. On the same day, Manet writes to Zola as he wishes to meet him (see cat. 102, fig. 261).

MAY 22 Marie-Jeanne Lecadre expresses her satisfaction to Monet, her nephew, after reading of his success at the Salon in *L'Événement*. Monet writes Amand Gautier: "My success at the Salon resulted in the sale of several canvases; since your departure, I earned Fr 800." Wildenstein 1974, p. 423.

MAY–JUNE Manet exhibits "an excellent study of a young woman dressed in white muslin" (cat. 101, fig. 240) at the exhibition of the Société des amis des arts de Bordeaux. Works by Gérôme, Breton, Corot, Daubigny, Courbet, and Aicart are also on view. Philippe Burty, "Exposition de la Société des amis des arts de Bordeaux," *Gazette des Beaux-Arts*, June 1, 1866, p. 564.

JUNE 19 Monet writes to Courbet to ask if he can borrow money from him: "My large canvas [cats. 122, 123; fig. 169] only made me go deeply into debt. My family considered it a complete failure and refuses to help me to get out of this terrible mess. My things are about to be confiscated and sold: all my studies would be taken away." Wildenstein 1991, no. 2686, p. 188.

JULY Bazille moves into his new apartment at 20, rue Visconti (fig. 386); he will reside there until the end of 1867. Bazille 1922, p. 128.

JULY Cézanne stays at Père Dumont's inn at Bennecourt on the banks of the Seine with a group of friends, among them Zola and Valabrègue. While there, Cézanne paints *Vue de Bonnières* (cat. 23). Zola would memorialize this event some twenty years later in his novel *L'Oeuvre*.

AUGUST Sisley and Renoir are staying with the Le Coeur family in Berck. Cooper 1959, p. 322.

AUGUST–DECEMBER Cézanne is in Aix, where he is joined by Guillemet in October–November. In November, Cézanne undertakes a large *Soirée de famille* and subsequently drops it.

MID-AUGUST Bazille leaves for Méric, where he probably paints *Étude de fleurs* (cat. 4, fig. 221). He stays in the Languedoc until the end of November–early December.

AUGUST 19 Jongkind leaves Paris and goes to Holland. Hefting 1975, p. 358.

AUGUST 22 The rules of the 1867 Salon are published in *Le Moniteur*: one-third of the jury will consist of "members of the Académie des Beaux-Arts, nominated by that Académie and selected from each of the sections."

Fig. 383. James McNeill Whistler, *Crepuscule in Flesh Colour and Green: Valparaiso*, 1866. Oil on canvas, 22½ x 29¾ in. (57.2 x 75.5 cm). Tate Gallery, London

SEPTEMBER **Whistler** goes back to England and breaks with his mistress, Johanna Hiffernan (fig. 387).

SEPTEMBER–OCTOBER Courbet vacations at the home of comte Horace de Choiseul in Deauville (the comte's chalet is a "paradise on earth"). He meets Monet and his "lady" at the casino and at the comte's request invites the couple, along with Boudin, to dine "Wednesday at 6 pm." Riat 1906, pp. 243–44; Courbet 1992, no. 66–25, p. 300.

FALL 1866 **Courbet** is in Ornans where he will stay until May 1, 1867.

SEPTEMBER 29 A decree of the minister of state establishes the conditions under which works of art will be admitted to the Exposition Universelle of 1867: to avoid an excessive number of entries presented to the jury, artists must submit a preliminary list of works they intend to enter. At the end of November, many artists, including **Manet**, receive a letter stating that their works, because of a lack of space, cannot be submitted to the imperial commission and after that to the jury. In December Théodore Rousseau is elected president of the admitting jury for painting and drawing.

OCTOBER The **Manet**s leave their apartment at 34, boulevard des Batignolles and move to 49, rue de Saint-Pétersbourg with Manet's mother. Upon Zola's request, Manet plans to illustrate his *Contes à Ninon*. Letter from Manet to Zola, October 15, 1866, in Paris, New York 1983, p. 520.

OCTOBER–DECEMBER William Bürger [Théophile Thoré] publishes his articles on "Van der Meer de Delft" in the *Gazette des Beaux-Arts*: October 1, pp. 297–330; November 1, pp. 458–70; December 1, pp. 542–75. These articles appear at the time of an exhibition, "Tableaux anciens empruntés aux galeries particulières," that features several works by Vermeer. Francis S. Jowell, in Bouillon 1989, p. 37.

OCTOBER 19 **Cézanne** writes to Zola from Aix-en-Provence to extol the virtues of plein air painting. "You see, all the paintings done indoors will never equal those done out-of-doors. When depicting outdoor scenes, the contrast of figures against the background is startling and the countryside is magnificent. I see wonderful things and must resolve to paint only out-of-doors." Cézanne 1937, pp. 98–99.

OCTOBER 31 *La Vie Parisienne* by Offenbach (libretto by Meilhac and Halévy) is produced on the stage of the Bouffes-Parisiens.

NOVEMBER 12 The ballet *La Source* is performed at the Opéra (cat. 61, fig. 343).

NOVEMBER 17 Verlaine's *Poèmes saturniens* published by Lemerre.

DECEMBER 1 **Monet** writes to **Bazille**, who is in Paris, from Saint-Siméon to ask him to send a small-scale copy of *Camille* (Wildenstein 66) and *Femme blanche*. He states: "I will paint an important seascape on the latter and, as you can see, time is very short. Send me the small-scale copy of *Camille* that I could not finish in Paris and that I must complete since it is already paid for.... The small-scale copy of *Camille* commissioned by Luquet is going to America." Wildenstein 1974, no. 29, p. 423.

FIRST HALF OF DECEMBER **Bazille** writes to his mother to ask her for some money: "I must absolutely work on the nude figure throughout the winter, but I cannot do it without a little more money...do not condemn me to perpetual still lifes" (see p. 156). Bazille 1992, no. 86, pp. 131–32.

1867

Chabal-Dussurgey publishes his *Études et Compositions de fleurs et fruits: Cours gradué pour l'enseignement* (see p. 160).

Théodore Duret publishes *Les Peintres français en 1867* (Paris: E. Dentu, 1867).

Charles Blanc publishes *Grammaire des arts du dessin* (see pp. 102, 166).

Duranty publishes, "Sur la physionomie" (see p. 204) in the next to last issue of the *Revue libérale*, which will cease publication shortly thereafter.

Fantin-Latour introduces **Morisot** to **Manet**.

Degas meets Adolf Menzel at Alfred Stevens's (this event occurred in 1867 or 1868). Reff 1985, notebook 24, p. 116.

JANUARY 1 Zola publishes "Une nouvelle manière en peinture: M. Édouard Manet," in the *Revue du XIXᵉ siècle*. During **Manet**'s private exhibition, on the Pont de l'Alma, Zola's text is reprinted as a brochure under the title *Édouard Manet, étude biographique et critique*. Zola 1991, pp. 139–69.

JANUARY 2 **Manet** writes to Zola to tell him that he will not send anything to the Salon: "I

Fig. 384. Édouard Manet, *L'Acteur tragique (Portrait de Philbert Rouvière) (The Tragic Actor)*, 1865. Oil on canvas, 72⅞ x 43¼ in. (185 x 110 cm). National Gallery of Art, Washington

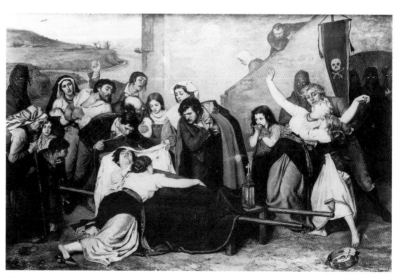

Fig. 385. Carolus-Duran, *L'Assassiné; souvenir de la campagne romaine (The Murdered: Souvenir of the Roman Campaign)*, 1865. Oil on canvas, 9 ft. 1¼ in. x 13 ft. 7¾ in. (280 x 420 cm). Musée des Beaux-Arts, Lille

have decided to organize my own private exhibition. I have at least forty paintings to show. I have already been offered very good locations, near the Champs-de-Mars. I am going to risk it, and with the support of men like you, I can count on success." Paris, New York 1983, p. 250.

JANUARY 14 Ingres dies on Sunday, January 14, shortly before midnight, at his home on the quai Voltaire (see p. 29, fig. 388). Between June 1867 and August 1868, Charles Blanc publishes a series of articles on the painter in the *Gazette des Beaux-Arts*.

JANUARY 18–JULY 10 *Manette Salomon* by Edmond and Jules de Goncourt is published serially in *Le Temps*. Goncourt 1956, vol. 7, p. 238.

JANUARY 31 **Courbet** writes to the dealer Bardenet that he has painted "a series of snow landscapes that will be similar to the seascapes." Among the works produced in Ornans over the past few months, the "snow landscapes" will be included in Courbet's private exhibition at the Rond-point du Pont de l'Alma in the spring (cat. 46). Courbet 1992, no. 67–2, p. 303.

FEBRUARY **Whistler** settles into 2 Lindsay Row in London. He will live there for the next eleven years. Younger et al., 1980, p. 61.

FEBRUARY **Fantin-Latour** works on the *Portrait d'Édouard Manet* that he will exhibit at the Salon. Douglas Druick, in Paris, Ottawa, San Francisco 1982–83, pp. 194–97.

FEBRUARY 2 From Honfleur, Dubourg writes to Boudin about **Monet**: "Monet is still working on enormous canvases which show remarkable qualities, but which I find inferior, or less successful, than the famous *Robe* [*Camille*, fig. 236] that brought him an understandable and well-deserved success. He had a work [cat. 130, fig. 175] of nearly three meters in height and proportionate width; the figures are somewhat smaller than lifesize and represent well-dressed women picking flowers in a garden. This canvas was started after nature and in the open air. It has good qualities, but the effect seems a bit weak, no doubt because of the lack of contrast, for the color is strong. He has also started a large seascape [*Le Port de Honfleur*; Wildenstein 1974, no. 77, rejected at the Salon and now destroyed], but it is not yet complete enough to be judged. He is also painting some rather pleasing effects of snow." Wildenstein 1974, p. 444.

END OF FEBRUARY **Bazille**, who lives with **Renoir** at 20, rue Visconti is visited by **Monet**. He writes to his mother that Monet has "a real lucky break as his collection of wonderful paintings will have the greatest success at the Exposition. He will stay here with me until the end of the month. With Renoir, I am now putting up two working but penniless painters. My home is becoming a veritable sickward." Bazille 1992, no. 88, p. 135.

MARCH **Bazille** writes to his mother: "My friend **Renoir** executed an excellent painting that amazed everyone. I hope it will be successful at the Exposition, because he really needs it." This work is *Diane chasseresse* (fig. 56), which will be rejected. Bazille 1992, no. 89, p. 136.

MARCH **Degas** writes to the superintendent of Beaux-Arts to request permission to retouch works already sent to the Salon (among them *Portrait de Famille* known as *La Famille Bellelli* [fig. 253]):

"I assure you, sir, that one cannot help suffer when one knows that one's work is not well done. Without the hope of being granted an extension that I cannot obtain because I am not *exempted*, I only want to be allowed to finish what I have started; otherwise, I would have not have sent any of my work, in spite of my desire to show it. I can assure you that if I were not motivated only by a true love of my being a painter, a real passion, I would not want to bother you, nor the kind M. de Chennevières...." Paris, Archives du Louvre, X, Salon of 1867; Henri Loyrette, in *Degas e l'Italia*, exhibition catalogue, Rome, 1984–85, pp. 171–72.

MARCH 29 The results of the jury deliberations for the next Salon are made public. Castagnary reacts immediately to their severity (in *La Liberté*, April 1, p. 2): "Never in the memory of a painter has a jury been so severe." Out of the three thousand artists who sent their works, two thousand were rejected. On March 30, at the instigation of **Bazille**, a petition is launched "to request a Salon des Refusés"; according to Bazille, "this petition is supported by all the Parisian painters who are worth something." **Pissarro, Monet, Renoir, Manet, Sisley**, Jongkind, Daubigny, and of course Bazille, sign it. Bazille, promising himself never to send anything else to the Salon, writes to his mother that he and "a dozen talented young men" have decided "to rent a large studio each year where we will show our works, as many as we please. We will invite painters we like to send their works. **Courbet**, Corot, Diaz, Daubigny, and many others whom you may not know promised to send us pictures and strongly approved of our idea. With these people and Monet, the strongest of all, we are certain to succeed." Bazille 1992, p. 137; Paris, Archives du Louvre, X, Salon of 1867.

Fig. 386. Frédéric Bazille, *Atelier de la rue Visconti* (*Studio on the rue Visconti*), 1867. Oil on canvas, 25¼ x 19¼ in. (64 x 49 cm). Virginia Museum of Fine Arts, Richmond, Collection of Mr. and Mrs. Paul Mellon

Fig. 387. Gustave Courbet, *Portrait de Jo* (*La Belle Irlandaise* (*Portrait of Jo [The Beautiful Irishwoman]*), 1866. Oil on canvas, 22 x 26 in. (55.9 x 66 cm). The Metropolitan Museum of Art, New York, H. O. Havemeyer Collection, Bequest of Mrs. H. O. Havemeyer, 1929

APRIL 1 Opening of the Exposition Universelle on the Champ-de-Mars (see cat. 107, fig. 360). In the French Beaux-Arts section, none of the artists of the New Painting are represented. In the first category (painting), the four medals of honor will be awarded to Meissonier, Cabanel, Gérôme, and Théodore Rousseau.

APRIL 10 Opening of Ingres's retrospective exhibition at the École des Beaux-Arts.

APRIL 11–13 Laperlier auction (Collection of M. Laperlier: *Tableaux et dessins de l'École française du XVIIIe siècle et de l'École moderne*, Paris, Hôtel Drouot). The Louvre buys three works by Chardin, *La Pourvoyeuse* (M.I. 720), *La Tabagie* (M.I. 721), and the *Panier de pêches* (M.I. 722) (see p. 161).

APRIL 27 After the death of Ingres, an auction of seventeen of his works is held at the Hôtel Drouot. Tabarant 1963, pp. 409–10.

APRIL 27 **Monet** asks the comte de Nieuwerkerke's authorization to "paint some views of Paris from the windows of the Louvre, and particularly the exterior colonnade, in order to do a view of *St.-Germain-l'Auxerrois*" (cat. 132, fig. 306). Nieuwerkerke immediately gives his permission. Wildenstein 1991, no. 2687, p. 188.

MAY–JUNE **Degas** visits the Exposition Universelle a few times, where he particularly admires the English paintings and the way they are hung. Disregarding works by Millais and Leighton, he writes down the names of Inchbold, so admired by Ruskin; James C. Hook, so highly spoken of by **Whistler** and Baudelaire; John Raven and his meticulous landscapes; the watercolorist Alfred William Hunt; and Charles J. Lewis and Alfred P. Newton. Reff 1985, notebook 21, pp. 31ff.; Loyrette 1991, pp. 223–24.

MAY **Bazille** describes for his parents various artistic events in Paris: "the Ingres exhibition is

very interesting...the Salon is the most mediocre I have ever seen...the Exposition Universell has about twenty beautiful paintings by Millet and Corot...Manet and Courbet are soon going to open their private exhibitions." Bazille 1992, no. 93, p. 140.

MAY 1 Opening of the Salon. Because of the competition with the Exposition Universelle, there will be few visitors and less comment than usual. The deficit of the Salon of 1867 is the largest one since the Salon of 1851 (Tabarant 1963, pp. 410–13). **Bazille** (*La Terrasse de Méric*, fig. 173), **Cézanne**, **Pissarro**, **Renoir** (*Diane chasseresse*, fig. 56), **Monet** (*Femmes au jardin*, cat. 130, fig. 175), and **Sisley** are rejected. Jongkind exhibits two landscapes from Belgium and Holland, **Morisot** sends *Vue prise en aval du pont d'Iéna*, and **Whistler** sends *At the Piano* and *Wapping on Thames*. **Fantin-Latour** sends two portraits, including that of his friend **Manet** (*Portrait de M. M...*, fig. 275) and **Degas**, two paintings entitled *Portrait de Famille*, one of which being *La Famille Bellelli* (fig. 253).

MAY 20 **Bazille** leaves Paris and will not return until November.

MAY 20 **Monet** thanks **Bazille**, who has just purchased *Femmes au jardin* (cat. 130, fig. 175), for his compliments on this canvas. Monet writes: "**Renoir** and I are still working on our views of Paris [cat. 132, fig. 306; cat. 133, fig. 309; cat. 134, fig. 308; fig. 307]...young Renoir is in Chailly." Poulain 1932, pp. 80–82; Daulte 1952, p. 59; Wildenstein 1974, no. 32, p. 423.

MAY 22 OR 24 Opening of **Manet**'s private exhibition at the Pont de l'Alma in a pavilion built at his own expense (Fr 15,000, according to Zola). He shows fifty pictures, three copies, and three etchings. **Manet** will have mixed feelings about the exhibit: "There are good things that I did know of. The *Femme rose* (cat. 103, fig. 243) is

bad; he has done better than he is doing now." *Catalogue des tableaux de M. Édouard Manet exposés avenue de l'Alma en 1867* (Paris: L. Poupart-Davyl, 1867); Tabarant 1963, pp. 415–18; Wildenstein 1974, no. 33, p. 424.

END OF MAY **Bazille** writes to his mother: "I have begun three or four landscapes of the area around Aïgues-Mortes. In my large canvas I am going to do the walls of the city reflected in a pond at sunset. This will be a very simple painting, which should not take long to do" (cats. 5, 6, 7). Bazille 1992, no. 94, p. 142.

MAY 26 Violent quarrel between Silvestre and Thoré in the press, the former criticizing the latter for his preface to a sales catalogue published in Germany. Tabarant 1963, p. 418.

MAY 30 Opening of **Courbet**'s private exhibition at the Rond-point du Pont de l'Alma (fig. 389). There are 115 entries grouped under different headings in the catalogue; later on, Courbet will add about twenty more works. On the eve of the opening, he tells Bruyas: "I have had a cathedral constructed on the most beautiful site in Europe, at the Pont de l'Alma, with its unlimited horizons, on the banks of the Seine, and in the heart of Paris. I will astonish the entire world." However, receiving little attention and poorly attended, the exhibition will not be successful. *Exposition des oeuvres de M. G. Courbet*, Rond-point du Pont de l'Alma, Paris, 1867. **Monet** judges the show with severity: "God, Courbet showed us some bad things." Paris, London 1977–78, p. 43; Wildenstein 1974, p. 424; Courbet 1992, no. 67–12, p. 313.

JUNE Several studies by Théodore Rousseau are exhibited at the Cercle des Arts. *Notice des études peintes par M. Théodore Rousseau exposées au Cercle des Arts*, Paris, June 1867.

JUNE 17 Birth of Pierre Sisley, the son of the painter **Sisley** and his companion Marie-Adélaïde Eugénie Lescouezec. London, Paris, Baltimore 1992–93, p. 269.

JUNE 19 Execution of Maximilian, emperor of Mexico, in Queretaro. **Manet** begins a series of canvases on the subject (fig. 63). London, National Gallery, *Manet: The Execution of Maximilian*, catalogue by Juliet Wilson Bareau, 1992.

JUNE 25 **Monet**, who arrived in Sainte-Adresse two weeks earlier (he gives chemin des phares [lighthouse road] as his address) works on "twenty or so canvases," "stunning seascapes and figures, gardens and a little bit of everything." He writes to **Bazille**, stating, "Among my seascapes, I am painting the Le Havre regattas with many figures on the beach and the harbor filled with small sails. For the Salon, I am painting a huge steamboat [figs. 416, 417]. This is very peculiar. You know that before leaving Paris, I sold a small seascape to Cadart and one of my Paris views [cat. 134, fig. 308] to Latouche." Wildenstein 1974, no. 33, pp. 423–24.

SUMMER **Cézanne** is in Aix; he returns to Paris in the fall.

Fig. 388. Charles Marville, *Ingres sur son lit de mort* (*Ingres on His Deathbed*), 1867. Photograph. Musée Ingres, Montauban

SUMMER **Sisley** is staying in Honfleur. Guillemet joins him there in mid-July. London, Paris, Baltimore 1992–93, p. 269; Wildenstein 1974, p. 424.

JUNE 30 Following a proposal made by Ferdinand Chaigneau, the "first free exhibition" is organized in Barbizon; among the participants are Brendel, Pils, Corot, Jongkind, Schreyer, Otto Weber, and Achard. Tabarant 1963, pp. 419–20.

JULY–AUGUST **Renoir** stays in Chantilly. Daulte 1971, p. 34.

BEGINNING OF JULY **Monet** is suffering from serious eye problems: "The doctor told me that I had to stop painting out-of-doors." About the middle of July, his ailment will subside "thanks to the sun that has not come out for several days." His letters include pressing requests for money for his companion, Camille, who gives birth to a son Jean, on August 8 in Paris. Wildenstein 1974, no. 36a, p. 424.

JULY 20 Duranty publishes his short story, "Le peintre Marsabiel" in *La Rue*. A revised and extended version of it will reprinted in *Le Siècle* in November 1872, under the title "La simple vie du peintre Louis Martin." Crouzet 1964, p. 160.

AUGUST **Manet** spends a few days in Trouville with Antonin Proust. Proust reports that "when the mail came, Manet would say: 'Here comes the muddy stream. The tide is coming in.' And he would add: 'This tide cannot stain me.' He had left Paris nearly discouraged. But in Trouville, he has regained his self-control." Proust 1897, p. 35.

AUGUST In a letter to **Fantin-Latour**, **Whistler** writes that he rejects **Courbet**'s realism and regrets not having studied with Ingres. Young et al. 1980, p. 54.

AUGUST 1 Last issue of journal published by the Société des Aquafortistes. Bailly-Herzberg 1972, vol. I, p. 231.

AUGUST 7 After many ups and downs, Théodore Rousseau is finally made officer of the Légion d'Honneur. Mainardi 1987, p. 184.

AFTER AUGUST 10 **Degas** writes in one of his notebooks: "Ah! Giotto, let me see Paris and you, Paris, let me *see* Giotto!" Reff 1985, notebook 22, p. 5.

AUGUST 12 **Monet**, who has gone to Paris for the birth of his son Jean on August 8, returns to Sainte-Adresse. Wildenstein 1974, no. 37, p. 424.

AUGUST 31 Death of Baudelaire. His funeral takes place on September 2 (see cat. 105, fig. 336). Notably present at Saint-Honoré in Passy are **Manet**, Champfleury, Arsène Houssaye, Alfred Stevens, **Fantin-Latour**, and Verlaine. Pichois and Ziegler 1987, pp. 593–97.

SEPTEMBER After a stay in Saint-Aubin-sur-Mer, **Courbet** leaves for Le Havre, where he exhibits eight paintings.

NOVEMBER **Fantin-Latour** finally finds a studio at 8, rue des Beaux-Arts. Paris 1982, p. 51.

END OF NOVEMBER OR DECEMBER **Manet** thanks Zola for having sent him his newly published *Thérèse Raquin*: "It is truly a well written and very interesting novel." The book will possibly influence Degas's *Intérieur* (cat. 63, fig. 344). Paris, New York 1983, p. 51.

DECEMBER Private exhibition of works belonging to Khalil-Bey, including *Le Bain turc* by Ingres and *Les Deux Amies* by **Courbet**. The paintings will be sold on January 16–18, 1868. Goncourt 1956, vol. 8, pp. 73–74.

DECEMBER Because of lack of space, **Bazille** leaves the studio in the rue Visconti and moves to an "immense studio on the Batignolles," located at 9, rue de la Paix (which becomes the rue La Condamine in December 1869) (cat. 12, fig. 355). **Renoir** will move in with him at the beginning of 1868. Bazille is working on "the painting of Méric" (fig. 174), and on the *Fleurs* (fig. 196). Bazille 1992, no. 98, pp. 148–49.

DECEMBER 15 **Manet** signs an acknowledgment of indebtedness to his mother: "December 15, 1867, I acknowledge that for the sums advanced to me by my mother Mme Manet for my exhibition. I owe her *eighteen thousand three hundred francs*. Édouard Manet" (private collection).

DECEMBER 22 Death of Théodore Rousseau, who had been tenderly looked after by the Millet couple, in Barbizon. He is buried in Chailly-en-Bière on December 24. The pallbearers are Millet, Sensier, Théophile Silvestre, and Charles Tillot.

1868

Duranty publishes a short article against plein air painting, "Que nous veut la campagne?" in the 1868 *Almanach parisien* (see p. 273). Crouzet 1964, p. 249.

Michel Lévy publishes *Curiosités ésthétiques* and *L'Art romantique* by Baudelaire.

Ernest Chesneau publishes *Peinture, Sculpture. Les nations rivales dans l'Art…De l'influence des expositions internationales sur l'avenir de l'art* (Paris: Didier, 1868). In this book dedicated to the princess Mathilde, Chesneau judges Ingres, Flandrin, and Gérôme with severity. Flaubert is of the same opinion. Chesneau highly praises Gustave Moreau and compares Henri Leys's art to that of Flaubert. Letter from Gustave Flaubert to Ernest Chesneau, September 27, 1868, in Gustave Flaubert, *Correspondance*, vol. 3 (Paris: Gallimard, 1991), pp. 806-8.

Antonin Proust writes: "During the years 1868, 1869, 1870, I sometimes brought **Manet** to the Café de Londres at the corner of the rue Duphot. There, he met Gambetta. He liked to attend the lectures organized by Lissagaray on the rue de la Paix." Proust 1897, p. 35.

Courbet, about whom Camille Lemonnier publishes *Gustave Courbet et son oeuvre* (Paris: Alphonse Lemerre, 1868), illustrates *Le Camp des bourgeois*, by Étienne Baudry (Paris: E. Dentu, 1868), with twelve drawings of bourgeois men and women and servants, engraved on wood by E. Bellot.

Founding of the *Société française de gravure*. Philippe Burty, "La gravure, le bois et la lithographie au Salon de 1868," *Gazette des Beaux-Arts*, August 1, 1868, p. 109.

JANUARY–FEBRUARY **Monet** is in Le Havre, where he works on *La Jetée du Havre* for the Salon. He is having terrible financial difficulties; **Bazille** has commandant Lejosne buy one of Monet's still lifes. Wildenstein 1974, pp. 38, no. 34, pp. 424–25.

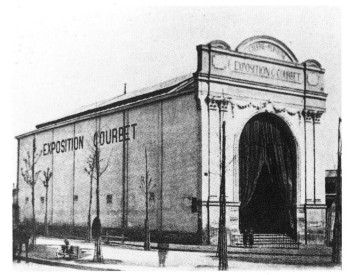

Fig. 389. Pavilion of the *Exposition Courbet*, 1867, at the Rond-point de l'Alma, Paris

JANUARY With Edmond Maître, **Bazille** discovers Schumann's music: "At this time, we are playing pieces by modern German composers almost unknown in France." Bazille 1992, no. 99, p. 152.

JANUARY 16–18 Auction of the Khalil-Bey's collection. Boudin attends the presale exhibition. "There," he writes, "it is Delacroix and Rousseau who are the front-runners." Laurent Manoeuvre, *Boudin et la Normandie* (Paris, 1991), pp. 187–88.

JANUARY 23 Under the pseudonym Ferragus (Louis Ulbach), a vehement criticism of *Thérèse Raquin* by Zola, "La littérature putride," is published in *Le Figaro:* "He [Zola] sees woman as M. Manet paints her, the color of mud with pink makeup."

FEBRUARY **Manet** paints a portrait of Zola, who sits for the artist in the afternoon in the studio on the rue Guyot (cat. 108, fig. 270).

MARCH 25 Auction sale at the Hôtel Drouot of forty paintings and about one hundred pastels and watercolors by Boudin. **Monet** attends the auction. Wildenstein 1974, p. 38.

AROUND MARCH Through the intervention of the architect Charles Le Coeur, the brother of his friend Jules le Coeur, **Renoir** secures a commission to decorate Prince George Bibesco's town house, located at 22, avenue de La-Tour-Maubourg. Cooper 1959, p. 326.

SPRING *La Source* by Ingres, belonging to the comtesse Duchâtel, is exhibited at the Société des Amis des Arts de Bordeaux, along with replicas by Puvis de Chavannes of his paintings in Amiens (cat. 167, fig. 60) and *La Mort de Chassériau* by Gustave Moreau. Philippe Burty, "Exposition de la Société des amis des arts de Bordeaux," *Gazette des Beaux-Arts*, May 1, 1868, pp. 464–500.

SPRING Probably following Zola's advice, **Monet** settles, with his wife and son, at the Auberge de Gloton in the hamlet of Bennecourt (cat. 141, fig. 181). Zola had been staying regularly at the inn, run by *mère* Dumont, since his first visit in 1866 with **Cézanne** (cat. 23, fig. 105) and Guillemet. Wildenstein 1974, p. 39.

SPRING *Le Cercle de la rue Royale* (fig. 390) by Tissot and *Le Réfectoire* by Legros are exhibited at the Royal Academy, London. Philippe Burty, "Exposition de la Royal Academy," *Gazette des Beaux-Arts*, July 1, 1868, p. 67.

MARCH 26 "Degas Edgar, 33 years old, 13, rue de Laval" registers as a copyist at the Louvre for the last time. Paris, Archives du Louvre, LL 11: 417; Theodore Reff, "New Light on Degas's Copies," *Burlington Magazine*, June 1964, p. 255.

APRIL–OCTOBER **Pissarro**, who is in financial straits, lives in Pontoise.

APRIL 1 Philippe Burty publishes a fine article in homage to his friend Théodore Rousseau (*Gazette des Beaux-Arts*, April 1, 1868, pp. 305–25): "Like a skillful musician, like an accomplished composer, he has always harmonized

the country, the site, the season, the feeling of the day and the hour. . . . Art, pushed as far as the way Théodore Rousseau felt it, is a communion with the very forces of the world. He understood the horror of the woods, the tender gaiety of dawn, the terrors of the night, the solemnity of the plain as the Ancients understood it. These qualities will enable his work will live on" (pp. 324–25).

APRIL 1 First issue (with a frontispiece by Bracquemond) of *L'Illustration nouvelle* published "by a society of painters and etchers." The periodical will stay in circulation until 1881.

MID-APRIL **Bazille** writes to his mother: "My two pictures are accepted at the Salon. Almost all my friends have been rejected; as for **Monet**, only one of the two pictures he sent was accepted." Bazille 1992, no. 105, p. 158.

MAY–DECEMBER **Cézanne** is in Aix-en-Provence. He makes friends with Paul Alexis (cat. 30, fig. 265).

MAY 1 Opening of the Salon.

Monet presents *Femme au jardin* (cat. 130) and *Navires sortant des jetées du Havre* (Wildenstein 89); only the latter is accepted. **Bazille** exhibits *Portrait de la famille* (fig. 174) and *Étude de fleurs* (cat. 4, fig. 221); Boudin, *Le Pardon de Sainte-Anne-Palud au fond de la baie de Douarnenez (Finistère)* and *La Jetée du Havre;* **Degas**, *Portrait de Mlle E[ugénie] F[iocre]: à propos du ballet de la "Source"* (cat. 61, fig. 343); Morisot, *Ros-Bras (Finistère);* **Pissarro**, *La Côte de Jallais* (cat. 158, fig. 119) and *L'Hermitage* (cat. 160, fig. 121); **Renoir**, *Lise* (fig. 176); **Sisley**, *Avenue de châtaigniers, près de la Celle-Saint-Cloud.* Daubigny, a member of the jury, had used his influence and energy to defend the "Salon des jeunes." Castagnary writes: "M. de Nieuwerkerke has it in for Daubigny. If this year's Salon is what it is, a Salon of newcomers; if its doors have opened to almost all who wanted to exhibit; if it exhibits 1,378 more works than last year's Salon; if amid this overflow of free painting state painting makes a poor showing, it is Daubigny's fault. Daubigny wanted to make himself popular, he is ambitious, a liberal and a free-thinker. . . ." Castagnary 1892, p. 254.

See **Courbet**, *L'Aumône d'un mendiant à Ornans* (fig. 391); Fromentin, *Centaures* (fig. 72); Gérôme, *7 décembre 1815 neuf heures du matin* (fig. 44); *Jérusalem* (fig. 45). Cézanne is rejected.

MAY 4 **Boudin** writes to F. Martin: "At the Salon, I met **Monet** who sets for us all the example of an artist faithful to his principles. One of his works has been accepted, to the great dismay of some people; they are wrong because this painting shows an always commendable search for true tonality that everybody is beginning to appreciate." Wildenstein 1974, p. 445.

MAY 15 Publication of Delacroix's notes on "L'idéal et le réalisme," in *L'Artiste.*

MAY 24 **Cézanne** writes to Morstatt: "I had the pleasure of listening to the overture of *Tannhäuser*, of *Lohengrin*, and of the *Flying Dutch-*

man" (cat. 28, fig. 345). Cézanne Letters 1937, p. 105.

MAY 26 In a serial published in *L'Éténdard*, "Le Japon chez nous," Zacharie Astruc draws a list of the collectors of Japanese art, including particularly Diaz, Tissot, Legros, Bracquemond, **Fantin-Latour**, **Manet**, Lambron, **Monet** ("faithful emulator of Oksai"), Frédéric Villot, Ernest Chesneau, Champfleury, Philippe Burty, and the Goncourts.

JUNE 1 Opening of the Exposition Maritime Internationale du Havre; it will close on November 15. **Monet** shows four paintings (*Camille*, fig. 236; *Le Port de Honfleur*, Wildenstein 77; *Cabane à Sainte-Adresse*, Wildenstein 94; and *La Jetée du Havre*, Wildenstein 109), **Manet**, *L'Homme mort* (Rouart-Wildenstein 72), **Courbet**, eight paintings including *L'Aumône d'un mendiant à Ornans* (fig. 391). Boudin and **Pissarro** are also represented.

SUMMER One day, **Courbet** invites **Monet** to visit Alexandre Dumas, then living in Le Havre. The very next day, they all go to the famous inn of the beautiful Ernestine Aubourg in Saint-Jouin. Wildenstein 1974, p. 40.

SUMMER **Renoir** is staying in Ville-d'Avray. Poulain 1932, pp. 153–54.

SUMMER **Bazille** is staying in Méric. During the summer he paints *La Vue du village* (cat. 9, fig. 182) and *Le Pêcheur à l'épervier* (cat. 10, fig. 153). He returns to Paris in November.

JUNE 20 **Monet** must leave Bennecourt in a hurry. He writes to **Bazille** that he was "kicked out of the inn where I lived, as naked as a jaybird." After finding a place for Camille and his son in the neighborhood, he leaves for Le Havre on June 29, to "arrange something with [his] art collector [Louis-Joachim Gaudibert (cat. 142, fig. 231)]." Wildenstein 1974, pp. 39–40, no. 40, p. 425.

JUNE 26 Castagnary gets indignant about the fate of **Renoir**'s *Lise* (fig. 176) at the Salon: "Then, because *Lise* was successful . . . , it was put aside, ceiling height, next to the *Famille* (fig. 174) by **Bazille**, not too far from the great *Navires* (Wildenstein 89) by **Monet**." Castagnary, "Le Salon, Les Naturalistes," *Le Siècle*, June 26, 1868.

JULY 29 From Boulogne-sur-Mer, **Manet** writes to **Degas** offering to accompany him to London: "I think I want to test the waters over there, there may be some outlets for our products." If Degas agrees, Manet will inform Legros, who lives in London; he asks Degas to try to convince **Fantin-Latour** to go with them (see p. 271). Loyrette 1991, p. 222.

AUGUST 1868–MARCH 1869 Monthly gathering of a group of republican friends and collectors of Japanese art, Zacharie Astruc, Alphonse Hirsch, Bracquemond, Philippe Burty, Jacquemart, and **Fantin-Latour** at the home of Marc-Louis Solon, director of the Manufacture de Sèvres. Jean-Paul Bouillon, "À gauche: note sur

la société du Jing-Lar et sa signification," *Gazette des Beaux-Arts*, March 1978, pp. 107–18.

AUGUST 15 Founding of *La Cloche* by Louis Ulbach (Ferragus); on December 19, 1869, the publication will become a daily newspaper.

AUGUST 26 **Manet** is bored in Boulogne-sur-Mer, where he spends the summer (cat. 110, fig. 305; cat. 111, fig. 358). He writes to **Fantin-Latour**: "I have nobody to talk to here, and I envy your being able to discuss with the great aesthete **Degas** the nonfeasibility of an art accessible to the lower classes and allowing the sale of paintings for thirteen sols. . . . Tell Degas to write to me. According to Duranty, Degas is becoming the painter of High-Life [English used in the original]. It is his business, and I further regret that he did not come to London. The motions of the well-kept horses would have inspired a few paintings." Moreau-Nélaton 1926, vol. I, p. 102.

SEPTEMBER **Morisot**, who along with her sister Edma, meets **Manet** at the Louvre through **Fantin-Latour**, poses for *Le Balcon* (fig. 266). *Pierre Prins et l'époque impressionniste, sa vie, son oeuvre, 1838–1913 par son fils* (Paris, 1949), p. 26.

SEPTEMBER 1 Zola dedicates his novel *Madeleine Férat* to **Manet**: "Some foolish people dared to say that we were working together to create scandal. Since our hands have been joined by fools, let them stay united forever."

SEPTEMBER 3 **Monet**, in Fécamp with Camille and their son Jean since the beginning of August, is called to Le Havre by Louis-Joachim Gaudibert: "I have just received a telegraph from my art collector in Le Havre asking me for next Monday to do a portrait of his wife." Monet arrives in Le Havre on September 7, where he paints the portrait of Louis-Joachim Gaudibert (Wildenstein 120; whereabouts unknown) and then that of his wife (cat. 142, fig. 231), at the château des Ardennes-Saint-Louis, village of Montvilliers. Wildenstein 1974, no. 42, p. 425.

BEGINNING OF OCTOBER At the Exposition Maritime Internationale in Le Havre, **Monet** is awarded a medal for two paintings, *Camille* (fig. 236) and *Bâteaux de pêche à Honfleur* (Wildenstein 77). *Camille* is bought for Fr 800 by Arsène Houssaye. Yet, Monet writes **Bazille** that his success and the commission of portraits by the Gaudiberts, who welcome him "delightfully," are not "enough to give me back that old fervor. Painting is not going well and, in truth, I no longer expect to be famous. I am feeling really low. . . . I see everything in black. . . . I did not sell a thing at the exhibition in Le Havre. I received a silver medal (worth Fr 15) and wonderful reviews in the local newspapers, that's all; it is not very nourishing. . . . I sold the *Femme verte* to Arsène Houssaye, who came to Le Havre. He is very enthusiastic, and he wants to help me make a name for myself, he says." Poulain 1932, pp. 148–50; Wildenstein 1974, no. 43, p. 425.

OCTOBER 17 The poster announcing the publication of Champfleury's book *Les Chats*, with the reproduction of one of **Manet**'s lithographs *Rendez-vous des chats* appears on the walls of Paris. Paris, New York 1983, pp. 299–301.

NOVEMBER 5 A subscription for a monument to Baudin, a deputy killed during the coup of December 1851, is opened. The promoters of the subscription will be prosecuted.

LATE NOVEMBER–EARLY DECEMBER **Bazille** writes to his father: "My friends were very enthusiastic regarding my studies, especially the male nude (cat. 10, fig. 153). I am really pleased because it was my favorite canvas also." Bazille 1992, no. 109, p. 162.

DECEMBER *Madeleine Férat* by Zola, already published as a serial in *L'Événement*, is available in bookstores.

DECEMBER 1 **Manet sends three paintings (including** *Le Chanteur espagnol*, fig. 368) to the exhibition of the Société Artistique des Bouches-du-Rhône in Marseille, in the hope that the society will buy them. However, its members decide to purchase a painting by Millet, *La Bouillie*. Paris, New York 1983, p. 522.

DECEMBER **Monet** is in Étretat with his family, financially secure thanks to Jean Gaudibert. He tells **Bazille** about his plans: "I am going to paint him [Jean] surrounded by other figures, as it is appropriate, for the Salon. This year, I will make two figure paintings, an interior with a baby and two women (fig. 239) and sailors out-of-doors, and I want to do it in a stunning fashion." Monet misses neither the life in Paris, where he now plans to spend only one month a year, nor the never-ending discussions in the cafés: "Despite one's personal strength, it is too easy to be influenced by what you see and hear in Paris, and the work I do here will at least have the merit of looking like no one else's. Or I believe so, because it will express only the impressions of what I, personally, have felt. The more time passes, the more I regret knowing so little; it is certainly what bothers me the most. The older I grow, the more I realize that we never dare to express directly what we feel." Wildenstein 1974, no. 44, pp. 425–26.

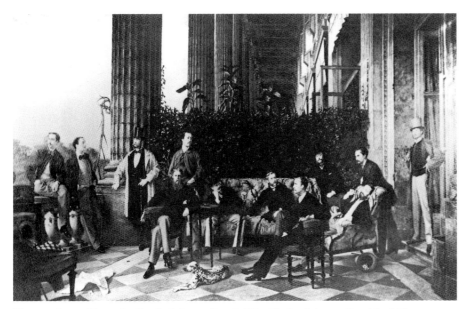

Fig. 390. James Tissot, *Le Cercle de la rue Royale* (*The Circle of the rue Royale*), 1868. Oil on canvas, 83⅞ in. x 128¾ in. (215.9 x 330.2 cm). Private collection, Paris

Fig. 391. Gustave Courbet, *L'Aumône d'un mendiant à Ornans* (*Charity of a Beggar in Ornans*), 1867–68. Oil on canvas, 82⅝ x 68⅞ in. (210 x 175 cm). Burrell Collection, City Art Gallery, Glasgow

LATE DECEMBER 1868–EARLY JANUARY 1869 **Monet** asks **Bazille** to send him the following paintings in Étretat: "the two large avenues of Fontainebleau that are the same size [cat. 119, figs. 99, 413]. The Chinese painting in which there are flags [cat. 137, fig. 310]; then the rosebush now at Guillemet's; the slightly smaller snowscape, all white with crows; the seascape with blue boats [cat. 136, fig. 88]; and finally the painting that shows Le Havre in the distance with little cabins and the sea with white waves." Poulain 1932, p. 70; Wildenstein 1974, no. 45, p. 426.

1869

Cézanne meets nineteen-year-old Hortense Fiquet, who will become his wife in 1886. In his new Paris studio at 31, rue Saint-Lazare, Boudin finishes painting the decorative panels for the dining room of the château de Bourdainville. This year he also meets Gauchez, a rich Belgian collector, who will provide funds so that he can live fairly comfortably over the next years. Schmit 1973, p. 29.

EARLY JANUARY Performance of *Ruy Blas* by Victor Hugo at the home of the Lejosnes: **Bazille**, François Coppée, and Alfred Stevens act in the play. Bazille 1992, p. 167.

JANUARY–FEBRUARY **Manet** learns that his painting *L'Exécution de Maximilien* (fig. 63) cannot be exhibited because the picture too bluntly exposes France's responsibility in the death of the emperor of Mexico. A lithograph of the picture that Manet wanted to have printed is also forbidden. In *La Tribune* of February 4, 1869, Zola comes to his defense: "You can understand the fear and the wrath of the censorship committee. What! An artist dared to put such a cruel irony before their eyes—France shooting Maximilian! If I were M. Manet, I would regret not having intended the bloody satirical piece for which the censors held me accountable." Juliet Wilson Bareau, in Paris, New York 1983, pp. 529–31 (Paris), pp. 531–34 (New York); London, National Gallery, *Manet: The Execution of Maximilian,* catalogue by Juliet Wilson Bareau, 1992.

JANUARY 9 Death of Paul Huet. Philippe Burty notes the loss of interest in this artist during the 1860s; only one of his paintings was exhibited in the Musée du Luxembourg; the state was no longer buying his works; he could not become an officer of the Légion d'Honneur; only half of the paintings requested by the Exposition Universelle of 1867 had been hung. Philippe Burty, "Paul Huet," *Gazette des Beaux-Arts,* April 1, 1869, pp. 297–315; Philippe Burty, *Paul Huet, notice biographique et critique* (Paris, 1869).

JANUARY 11 In a letter to **Bazille**, **Monet** reveals that his possessions have been impounded but that Louis-Joachim Gaudibert was able to buy back all his paintings at the auction. He goes on to say: "I am always going to stay around Le Havre, because I can make a living here. I think that one of these days I will even have a studio in Le Havre." Wildenstein 1974, no. 46, p. 426.

JANUARY 18 Boudin writes to F. Martin in regard to **Monet**'s paintings: "There is, in the shop of a dealer on the rue La Fayette, a *Vue de Paris* [probably cat. 134, fig. 308] that you may have seen and that would be a masterpiece worthy of the greatest if the details corresponded to the whole. There is good stuff in that boy. It is a pity that you have not seen the Gaudibert portraits, especially Madame's [cat. 142, fig. 231], which her husband told me is a marvelous burst of color." Wildenstein 1974, p. 445.

JANUARY 29 Birth of Jeanne-Adèle Sisley, second child of the painter. *Sisley* 1992, p. 270.

FEBRUARY Eva Gonzalès, introduced to **Manet** by Alfred Stevens, becomes his student (see p. 159 and fig. 199).

MID-FEBRUARY **Bazille** befriends the Stevenses, who "could hardly be more thoughtful." He writes to his mother: "Three or four days ago, the painter Stevens, whose work I am not really fond of, but who knows his trade, greatly complimented me." Sometime later, Bazille will remark that Stevens's friendship is mainly motivated by the fact that he sits on the admissions jury of the Salon. Bazille 1992, no. 115, p. 168; Daulte 1952, p. 75.

FEBRUARY 16 Achille De Gas, brother of the painter, writes to his family in New Orleans: "Edgar came with me to Brussels. He met M. Van Praet, minister of the king, who had bought one of his paintings, and he saw his work exhibited at the Gallery, one of the most famous places in Europe, it gave him some satisfaction, as you can well imagine, and it finally gave him confidence in his talent, which is real. During his stay in Brussels, he sold two more paintings, and a very well-known dealer, Stevens, offered him a contract for Fr 12,000 a year" (see p. 268). Lemoisne 1946–49, vol. 1, p. 63.

SPRING **Monet** returns to Paris, where he stays with **Bazille**. Wildenstein 1974, p. 42.

SPRING At the exhibition of the Cercle de l'Union Artistique, place Vendôme, works by Cabanel, Bonnat, Gérôme, Galland, Tissot, Heilbuth, and Penguilly are exhibited.

SPRING The art dealer Louis Latouche exhibits in his shop window, 34, rue La Fayette, a small study painted at Sainte-Adresse by **Monet**. It causes a scandal. On April 25, Boudin writes: "It draws the whole artistic world. There's been a mob in front of the window the entire time the exhibit lasted, and for the young, the unexpectedness of this violent painting has caused a *fanatical* reaction." Wildenstein 1974, pp. 42, 445.

SPRING **Pissarro** settles in Louveciennes, in the Retrou house, 22, route de Versailles, very near the Marly aqueduct (cat. 164, fig. 326). *Correspondance de Camille Pissarro,* ed. by Janine

Bailly-Herzberg (Paris: Presses Universitaires de France, 1980), vol. 1, p. 30.

MARCH 19 Louis-Joachim Gaudibert and then Arsène Houssaye petition the comte de Nieuwerkerke in an attempt to obtain an extension of time for **Monet** to send his work to the Salon; it will be refused. Paris, Archives du Louvre, X, Salon of 1869.

BEGINNING OF APRIL The jury of the Salon rejects two paintings by **Monet**, *La Pie* (cat. 144, fig. 315) and *Bateaux de pêche en mer* (Wildenstein 126).

APRIL 6 **Bazille** attends the first performance of *Rienzi* by Wagner, an "early work from a man of genius," at the Théâtre-Lyrique. Bazille 1992, no. 119, p. 172.

APRIL 9 **Bazille** has only one work admitted at the Salon, *La Vue du village* (cat. 9, fig. 182). In a letter to his father, he blames the numerous rejections of his friends on Gérôme's hostility (see p. 36); as for himself, he has been supported, to his "great astonishment," by Cabanel and Bonnat. He learns it from Alfred Stevens. Bazille 1992, no. 109, p. 173; Daulte 1952, p. 75.

APRIL 27 Asked to advise his cousin Louis wishing to assemble an art collection, **Bazille** describes his own taste: "I admire Delacroix, more than anything; I like very much Ingres, Corot, Rousseau, Millet, often **Courbet**; I do not trust men like Troyon; some of his early works are very good, but success spoiled him. . . . I never think one can pay too much for a Delacroix. . . . For me, Corot is the best of past and present landscapists, and one of the leading French painters. . . . There are two or three young painters, known only to the younger crowd, whose talent I really appreciate. . . . For God's sake, do not buy Cabanel's work, this man was not born a painter." Bazille 1992, no. 120, pp. 173–74.

APRIL 30 Death of Théophile Thoré (William Bürger).

MAY 1 Opening of the Salon.
Boudin and Jongkind exhibit two landscapes each; **Bazille,** *La Vue du village* (cat. 9, fig. 182); Degas, *Portrait de Mme G[aujelin]*; **Fantin-Latour,** *Le Lever*; **Manet,** *Le Balcon* (fig. 266) and *Le Déjeuner* (fig. 186); **Pissarro,** *L'Ermitage* (cat. 161, fig. 122); and **Renoir,** *En été; étude* (cat. 174, fig. 246).
Monet, Sisley, and **Cézanne** are rejected.

MAY 2 **Bazille,** in a letter to his father, judges the "whole Salon" extremely weak: "Only Millet's and Corot's works are truly beautiful. **Courbet**'s paintings, very poor by his standards, are like masterpieces among universal dullness. **Manet** is beginning to be more appreciated by the public." Bazille 1992, no. 121, p. 175.

MAY 3 **Pissarro** writes to the comte de Nieuwerkerke to complain that his works were poorly hung at the Salon. *Correspondance de Camille Pissarro,*

ed. by Janine Bailly-Herzberg (Paris: Presses Universitaires de France, 1980), vol. 1, p. 62.

MAY–JUNE Degas has become a regular at the Morisots' home, rue Franklin. He is "crazy" about the face of Yves Gobillard-Morisot, Morisot's sister, and paints her portrait (fig. 392). The sittings take place in their house, which many artists visit often (Manet, the Stevenses, Fantin-Latour, Puvis de Chavannes), and some rather caustic comments are exchanged about everyone's talent. On May 23, Morisot notes: "[Degas] made fun of his friend Fantin, telling us that Fantin should draw new strength in the arms of Love, because, at the moment, painting was not enough." The young artist herself does not have much in common with the sarcastic Degas. She writes to her sister: "As for your friend Degas, I really do not find him very engaging; he is clever, and nothing more. Manet was telling me yesterday, in a very funny way: 'He is not very natural; he is not capable of loving a woman, nor to tell her he does or do anything about it.'" Morisot 1950, pp. 27–32.

MAY–NOVEMBER Bazille is in Montpellier; he is working on *Scène d'été* (cat. 11).

JUNE 2 From Saint-Michel, Monet writes to the journalist Arsène Houssaye, who had bought his *Camille* (fig. 236), to ask him to come see his most recent works. After the rejection of his pictures at the Salon, Monet is experiencing great financial difficulties and he is in "nearly desperate" straits: "Despite my low prices, dealers and collectors ignore me.... The worst is that I am now unable to work." Wildenstein 1974, no. 49, p. 426.

JULY 1 Manet sends *Le Balcon* (fig. 266), *Le Déjeuner* (fig. 186), and *Clair de lune* (cat. 110, fig. 305) to the Exposition Générale des Beaux-Arts in Brussels.

JULY–AUGUST Degas stays in Étretat and Villers-sur-Mer. He visits Boulogne-sur-Mer, where Manet, according to Tabarant, is spending the summer with his family at the Hôtel Folkestone. On the way back, he visits his friends the Valpinçons in Ménil-Hubert (Orne), where he paints *Aux courses en province* (cat. 66, fig. 287). Reff 1985, notebook 23, pp. 58–60, 151–59.

AUGUST 9 Monet writes to Bazille: "Do you want to know my situation and how I have been living for the past eight days while waiting for your letter? Well, ask Renoir who brought us bread from his home so that we would not starve [Renoir is in Voisins, a hamlet near Louveciennes, staying at his parents' home]. For eight days, we had no bread, no wine, no fire for cooking, no light. It is terrible." On August 25, he will write: "I have to stop [working] for lack of paint." Wildenstein 1974, nos. 50, 52, pp. 426–27.

AUGUST 10 Courbet is in Étretat until mid-September; he paints "twenty seascapes" (cat. 47, fig. 294). Paris, London 1977–78, p. 45; Courbet 1922, no. 69–9, p. 354.

SEPTEMBER Morisot writes to her sister Edma: "I saw your friend Fantin, who inquired about you. He has become more ill-natured and unattractive than ever. While listening to his disparagements of everyone, I thought of what Degas says of him, and I concluded that he is not wrong in maintaining that Fantin is becoming a sour old maid." Morisot 1950, p. 35; English ed. 1957, p. 39.

FALL Renoir exhibits a few paintings at Carpentier's, 8, boulevard Montmartre. London, Paris, Boston 1985–86, p. 373; Distel 1989, p. 33.

SEPTEMBER 25 Monet finally sends Bazille some better news from Saint-Michel: "I sold a still life and I have worked a little. But, as always, I have to stop for lack of paint." Then, he confesses to "a dream, a painting, the baths of La Grenouillère [cat. 146, fig. 320; cat. 147, fig. 322], for which I have made some bad sketches, but it is only a dream. Renoir, who has just spent two months here, also wants to do this painting" (cat. 177, fig. 319; cat. 178, fig. 321). Poulain 1932, pp. 160–62; Wildenstein 1974, no. 53, p. 427.

SEPTEMBER 26 Death of the collector and patron of the Louvre, Louis La Caze (see p. 165).

OCTOBER Courbet stays in Munich, where he is very well received by the younger artists. Nearly 450 French paintings, including works by Courbet and Manet (*Le Philosophe*; *Le Chanteur espagnol*, fig. 368), are exhibited at the international exposition in Munich. Paris, London 1977–78, p. 45.

OCTOBER 13 Death of Sainte-Beuve. Goncourt 1956, vol. 8, p. 224; Philippe Burty, "Sainte-Beuve, critique d'art," *Gazette des Beaux-Arts*, November 1, 1869, pp. 458–65.

NOVEMBER 17 Opening of the Suez canal; several writers and artists have been invited, including Théophile Gautier, Charles Blanc, Fromentin, Berchère, Gérôme, and Tournemine. Thompson and Wright 1987, pp. 254–72.

DECEMBER Monet, in Saint-Michel, takes advantage of the snow "to make some studies, as he does when he" (fig. 316). Wildenstein 1974, p. 427. Monet spends a few days with Pissarro in nearby Louveciennes (cat. 149, fig. 316). Wildenstein 1974, no. 54, p. 427; Richard Bretell, in Los Angeles, Chicago, Paris 1984–85, p. 80.

DECEMBER Bazille goes twice to the Théâtre des Italiens to hear *Le Paradis et la Péri* by Schumann; a devotee of Schumann, he is brokenhearted by the lack of success of the piece. With Renoir and Edmond Maître, he hears *Fidelio* by Beethoven in the same theater. At the end of the year, he informs his father of his plan of action: "I began working, I am painting: 1, the interior of my studio [cat. 12, fig. 355]; 2, the portrait of Blau; and 3, a female nude for the Salon [cat. 13, fig. 154]. I shall be busy all winter long." Bazille 1992, no. 125, pp. 178–79.

DECEMBER 15 Death in Paris of Louis Lamothe, follower of Hippolyte Flandrin and teacher of Degas.

1870

Death of Louis-Joachim Gaudibert, Monet's patron from Le Havre (cat. 142, fig. 231). Wildenstein 1974, p. 41.

MID-JANUARY Bazille begins *La Toilette* (cat. 13, fig. 154); he is very happy to be leaving the rue La Condamine and to be moving soon to the rue des Beaux-Arts: "Renoir will not be able to live with me. I will therefore be alone, but one of my friends [Fantin] lives in the same house, and I will be two steps away from Maître." Bazille 1992, no. 130, pp. 184–85.

FEBRUARY 1 Henri Delaborde publishes, "Notes et pensées de J. A. D. Ingres sur les Beaux-Arts" in the *Gazette des Beaux Arts*, February 1, 1870, pp. 112–21.

FEBRUARY 2 Bazille attends the first performance of *Lucrèce Borgia* by Victor Hugo at the Théâtre de la Porte-Saint-Martin. Bazille 1992, no. 133, p. 187.

FEBRUARY 18 At the Cercle de l'Union Artistique, place Vendôme, Manet exhibits *Le Philosophe* (Rouart-Wildenstein 99; The Art Institute of Chicago) and the watercolor *Les Anges au tombeau du Christ* (Musée du Louvre, département des Art graphiques, Paris, fonds du musée d'Orsay).

FEBRUARY 20 Manet slaps Duranty in the face at the Café Guerbois. He had recently quarreled with the critic because of an article published by Duranty in *Paris-Journal*. They fight a duel: "A crossing of swords took place today February 23, 1870, in the forest of St. Germain, around 11 A.M. between MM. Manet and Duranty. Only one engagement took place; it was so violent that both swords were bent. M. Duranty was slightly wounded above the right breast when the sword of his opponent slid over his rib. In view of the wound, the witnesses declared that honor was satisfied and that there was no reason to continue the fight." Duranty claims that Fantin did not play a praiseworthy part in this entire matter. Crouzet 1964, pp. 290–93.

MARCH Manet joins a committee, organized by Jules de La Rochenoire, to change the composition of the jury for the Salon. Despite the great efforts of committee's members, only Millet is elected. Moreau-Nelaton 1926, vol. 1, pp. 119–20.

MARCH Monet is refused by the Salon; Millet and Daubigny resign from the jury. In a letter, Arsène Houssaye asserts that Monet and Renoir are the masters of "the school of nature for nature." Wildenstein 1974, p. 46.

MARCH **Manet** retouches the picture Berthe **Morisot** had sent to the Salon. Morisot 1950, pp. 36–38.

APRIL **Bazille** continues to look for paintings on behalf of his cousin Louis; he has just acquired a Jongkind for Fr 460 at an auction, "a truly good deal...." He writes to his cousin: "I am sure this painting will be appreciated for its liveliness and its subtlety. It represents boats sailing out of Honfleur harbor." Bazille 1992, pp. 189–90.

APRIL 1 Charles Blanc begins to publish his *Grammaire des arts décoratifs pour faire suite à la grammaire sur les arts du dessin* in several installments in the *Gazette des Beaux-Arts*.

APRIL 12 **Degas** publishes a letter to "Gentlemen Jurors of the 1870 Salon" in *Paris Journal*. In it, he strongly criticizes the installation of the paintings and provides some suggestions:

"1. Use only two rows of paintings, and leave a space of at least 20 or 30 centimeters between them, for without such a space, they harm their neighbors or they prejudice you.'

"2. Install the remaining works in a few of the galleries currently devoted to drawing.

"3. Arrange small and large screens, similar to those used by the English at the Exposition Universelle. Use the screens to display the displaced drawings and distribute them in the two large rooms, called the dumping ground, or somewhere else.... The drawings would no longer be isolated and would be mixed with the paintings, as they should be....

"4. After a few days, every exhibitor shall have the right to take back his work; because nothing must force him to show something that he would

have to be ashamed of, or which could harm his reputation....

"5. Using only two rows of paintings, the following will happen: the exhibitor will indicate on his label on which of the two rows he wishes to be displayed. The top row, the detestable top row, source of all our dissensions, will no longer be a favor, a mandated risk. It will be chosen for some works and will definitely not be chosen for others. Some paintings are made to be seen from above, others from below....

"6. The large marbles, whose weight and transportation are a difficult enterprise, can stay on the ground floor; but, I beg you, display them without symmetry. About the medallions, the busts, the small groups, etc., they need to be upstairs, on small tables or on screens...."

Degas concludes with this admonition: "In short, once you have satisfied your judges' pride, be good interior decorators."

APRIL 27 **Courbet** presides over a "literary and artistic evening" held in the Sorbonne gymnasium to benefit Rodolphe Bresdin. Paris, London 1977–78, p. 46.

MAY Ludovic Halévy publishes "Monsieur and Madame Cardinal" in *La Vie Parisienne*; in 1876–77, **Degas** will illustrate this story and its sequels with a series of monotypes.

MAY 1 Opening of the Salon.

Bazille presents two works: *Scène d'été* (cat. 11, fig. 337) and *La Toilette* (cat. 13, fig. 154); Boudin exhibits two views of Brittany and Jongkind two views of Holland; **Degas**, *Portrait de madame C[amus]* (fig. 259) and *Portrait de Mme G[obillard]*; pastel (fig. 394); **Fantin-Latour**, *La Lecture* and *Un atelier aux Batignolles* (cat. 74,

fig. 232); Gonzalès, *Enfant de troupe* (cat. 78, fig. 260) and *La Passante*; **Manet**, *La Leçon de musique* and *Portrait de Mlle Eva Gonzalès* (fig. 199); **Morisot**, *Portrait de Mmes**** and *Jeune femme à sa fenêtre*; **Pissarro**, *Automne* and *Paysage*; **Renoir**, *Baigneuse* (cat. 180, fig. 151) and *Femme d'Alger*; **Sisley**, *Péniches sur le canal Saint-Martin* and *Vue du canal Saint-Martin*. See Carolus-Duran, *Portrait de Mme X**** (cat. 21, fig. 230); **Courbet**, *La Falaise d'Étretat, après l'orage* (fig. 393); Puvis de Chavannes, *La Madeleine au désert* (fig. 395); Regnault, *Salomé, la danseuse, tenant le bassin et le couteau qui doivent servir à la décollation de saint Jean-Baptiste* ([fig. 40]).

Monet's two works are refused (Wildenstein 132 and possibly Wildenstein 136). **Cézanne**'s two paintings are refused, one being the *Portrait d'Achille Emperaire* (fig. 262).

MAY **Morisot** writes to her sister Edma: "M. Degas has sent a really pretty painting to the Salon [fig. 259], but his masterpiece is the portrait of Yves [Gobillard] in pastel [fig. 394]." She complains to her sister about Degas's "supreme contempt" for what she does. Morisot 1950, pp. 39–40; English ed. 1957, p. 43.

MAY 2 OR 3 **Bazille** writes to his brother that he is "very pleased with the exhibition. My painting [*Scène d'été*, cat. 11, fig. 337] is in a very good place, everyone can see it and talks about it; many people say more bad than good things about it, but I have made a name for myself, and from now on, they will look at whatever I do." Bazille 1992, p. 192.

MAY 5 **Bazille** leaves his studio on the rue La Condamine (cat. 12, fig. 355) and moves to 8, rue des Beaux-Arts. **Renoir** lives with Edmond Maître at 5, rue de Taranne. Bazille 1992, p. 182; Daulte 1971, p. 36.

MAY 17 Champfleury visits **Degas**. Paris, New York, Ottawa 1988–89, p. 58.

JUNE **Bazille** is in Montpellier. He writes to his father: "I have begun a large landscape which is beginning to take shape [cat. 15, fig. 100]." Bazille 1992, no. 140, p. 194.

JUNE 20 Death of Jules de Goncourt. Goncourt 1956, vol. 8, pp. 247–48.

SUMMER **Manet** stays with Giuseppe De Nittis at Saint-Germain-en-Laye (cat. 112, fig. 211): "On the eve of the war, Manet had retired to the country with De Nittis, often visiting the pianist Delaborde and Heilbuth. However, he went to Paris to get news and, as the war grew worse, he became more and more silent. Being very patriotic, he had grown gloomy and taciturn." Proust 1897, p. 36.

SUMMER *La Fortune des Rougon* by Émile Zola, the first volume of *Rougon-Macquart*, is serialized in *Le Siècle*.

JUNE 23 From l'Isle-Adam, where he went to visit Jules Dupré, **Courbet** writes Minister Maurice

Fig. 392. Edgar Degas, *Portrait de Mme Théodore Gobillard, née Yves Morisot*, 1869. Oil on canvas, 21⅜ x 25⅝ in. (54.3 x 65.1 cm). The Metropolitan Museum of Art, New York, H. O. Havemeyer Collection, Bequest of Mrs. H. O. Havemeyer, 1929

Richard refusing the Légion d'Honneur which was just awarded to him: "My beliefs as a citizen are against accepting an honor which is explicitly part of the monarchic order." *Courbet* 1977–78, p. 46.

JUNE 28 **Monet** marries Camille Doncieux at the town hall of the 8th arrondissement; **Courbet** and two patrons of Monet, the physician Paul Dubois and the journalist Antoine Lafont, serve as witnesses. Wildenstein 1974, p. 46.

END OF JUNE–FIRST TWO WEEKS OF SEPTEMBER **Monet** spends the summer in Trouville, living at the Hôtel Tivoli (cat. 150, fig. 327, cat. 151, fig. 329). On August 12, Boudin joins him and stays until September 13.

JULY 7 Marie-Jeanne Lecadre, eighty years old, **Monet**'s aunt and major supporter early in his career, dies in Sainte-Adresse. Wildenstein 1974, p. 51.

JULY 19 The Franco-Prussian War begins.

SEPTEMBER After the defeat at Sedan (September 2), the Third Republic is proclaimed (September 4). **Degas**, **Manet**, Bracquemond, and Alfred Stevens enlist in the National Guard as volunteers. **Cézanne** is in L'Estaque. **Pissarro** and his family seek refuge with Piette in Moutfoucault; they return to London in early September. **Monet** leaves for London on an unknown date.

NOVEMBER 28 **Bazille** is killed at Beaune-la-Rolande near Orléans. Général d'Armagnac will write Marc Bazille: "I can still hear your unfortunate brother claiming with the confidence of youth: 'As for me, I am sure I will not be killed. I have too many things to do with my life…'" Bazille Letters 1992, p. 207, n. 1.

Fig. 393. Gustave Courbet, *La Falaise d'Étretat, après l'orage* (*The Cliff at Étretat, after the Storm*), 1870. Oil on canvas, 52⅜ x 63¾ in. (133 x 162 cm). Musée d'Orsay, Paris

Fig. 394. Edgar Degas, *Portrait de Mme G[obillard]*, 1869. Pastel, 18⅞ x 11⅞ in. (48 x 30 cm). The Metropolitan Museum of Art, New York, Bequest of Joan Whitney Payson, 1975

Catalogue

The catalogue entries were written by Gary Tinterow (G.T.) and Henri Loyrette (H.L.).

The technical apparatus (provenance, exhibitions, selected references) were prepared by Anne M. P. Norton for the entries by Gary Tinterow and Marina Ferretti-Bocquillon for those by Henri Loyrette.

The lists of exhibitions and bibliographic references before 1870 are as complete as possible. After 1870 these are selective.

We have used titles of works that were used during the artists' lifetime. When a different title has come into common use, it is given in parentheses.

Short references are given in full in Abbreviated Bibliographic References.

Paul Baudry

La Roche-sur-Yon, 1828–Paris, 1886

Coming from a modest background, Paul Baudry received financial help from his native village which allowed him to pursue his art studies. Winning the Premier Grand Prix de Rome in 1850, he stayed at the Villa Medici from 1851 to 1856. His success at the Salon of 1857 launched his official career, and he gained considerable renown during the Second Empire: he was named a knight of the Légion d'Honneur in 1861 and an officer in 1869; in May 1870 he was elected to the Académie des Beaux-Arts without having applied. Throughout the 1870s he painted numerous portraits (fig. 229) as well as nudes (fig. 128) and historical subjects (fig. 51). His large-scale decorative works took more and more of his time; he did private commissions (Achille Fould, 1858; the duc de Galliéra at the Hôtel Matignon, 1861; the Païva, 1865) and public commissions (tapestry cartoons for the Gobelin works). In 1865, thanks to the support of his friend Charles Garnier, he was commissioned to do paintings for the grand foyer of the new Opéra; that would be his essential activity until 1874.

1

Fig. 8

Paul Baudry

La Madeleine pénitente
(*The Penitent Magdalen*)
1858
Oil on canvas
37 x 57⅞ in. (94 x 147 cm)
Signed lower right: Paul Baudry
Dated upper right: 1858
Musée des Beaux-Arts de Nantes 801

PROVENANCE: Acquired by the French government at the Salon of 1859; sent by the French government to the Musée des Beaux-Arts, Nantes, 1859

EXHIBITIONS: Paris, Salon of 1859, no. 165 (La Madeleine pénitente); Paris, Galerie Georges Petit, 1882, *Exposition internationale de Peinture*, no. 20 (Madeleine); Paris, École nationale des Beaux-Arts, 1886, *Paul Baudry*; no. 33 (La Madeleine pénitente); Paris, Exposition Universelle, 1900, *Exposition centennale*, no. 17 (La Madeleine pénitente); Paris, Petit Palais, 1968–69, *Baudelaire*, no. 455; La Roche-sur-Yon, Musée d'Art et d'Archéologie, 1986, *Baudry*; no. 13

SELECTED REFERENCES: Astruc 1859, pp. 159–60; Aubert 1859, p. 141; Louis Auvray, *Salon de 1859*, Paris, 1859, p. 22; Chaud-de-Ton, "Salon de 1859," *La Vérité*, May 4, 1859, p. 5; Émile Cantrel, "Salon de 1859. XIII," *L'Artiste*,

July 3, 1859, p. 145; Ernest Chesneau, "Libre étude sur l'art contemporain. Salon de 1859," *Revue des races latines* 14 (1859), p. 129; Delaborde 1859, p. 511; E.-J. Delécluze, "Exposition de 1859," *Journal des débats*, April 27, and June 3, 1859, p. 2; Du Camp 1859, pp. 51, 53; Dumas 1859, pp. 33–34; Dumesnil 1859, pp. 94–95; A.-J. Du Pays, "Salon de 1859," *L'Illustration*, June 18, 1859, p. 435, repr. p. 437; Ferdinand Gabrielis, "Salon de 1859," *Le Moniteur des arts*, April 23, 1859, p. 195; Théophile Gautier, "Exposition de 1859," *Le Moniteur universel*, April 30, 1859, pp. 489–90; Houssaye 1859, pp. 263–64; Louis Jourdan, *Salon de 1859* (Paris, 1859), p. 73; Mantz 1859, p. 204; Perrier 1859, pp. 304–5; Jean Rousseau, "Salon de 1859. IV. L'État-major," *Le Figaro*, May 17, 1859, p. 4; Paul de Saint-Victor, "Salon de 1859. II," *La Presse*, April 30, 1859, p. 2; Mathilde Stevens, *Impressions d'une femme au Salon de 1859* (Paris, 1859), pp. 23–24; Olivier Merson, *Exposition de 1859. La peinture en France* (Paris, 1861), p. 41; Armand Silvestre in E. Montrosier, *Les Chefs-d'oeuvre d'art au Luxembourg* (Paris, 1881), p. 94; Charles Ephrussi, *Paul Baudry: Sa vie et son oeuvre* (Paris, 1887), pp. 178–81; Jules Breton, *La Vie d'un artiste: Art et Nature* (Paris, n.d.), p. 233; Wolfgang Drost and Ulrike Henninges, *Théophile Gautier: Exposition de 1859* (Heidelberg, 1992), pp. 18–19

In 1859 Paul Baudry's friend Jules Breton described him as a quiet, "genuinely modest" young man astounded by the renown he had enjoyed since the Salon of 1857:[1] *Fortune et le jeune enfant* (*Fortune and the Young Child*; Musée d'Orsay, Paris), his third *envoi* from Rome, had fired the public's enthusiasm even though the critics accused him of pastiching Italian masters. His painting was acquired by the state and the painter was awarded a first-class medal. As a result, some people were hoping to trip him up in 1859; so Baudry cleverly offered a sampling of the genres he practiced successfully: portraits, religious scenes, and mythological episodes (*La toilette de Vénus* [*The Toilet of Venus*; Musée des Beaux-Arts, Bordeaux]). It was a waste of time, for the result was disappointing, and many observers regretted having rashly sung the praises of an artist who did not live up to his promise. The case of Baudry was cited by Maxime Du Camp, who felt it exemplified the lightning careers that, based on the lure of gain, were fueled by the excitement of the press and art lovers: "Seduced by qualities of freshness and distinction, fashion suddenly adopts a young artist overnight: he can barely keep up with his portrait commissions; he is hired to do decorations that will lead to further jobs—he is recommended, pushed, praised, his works are talked about before they are even completed, and when those same works, prematurely famous, are delivered to the public, people realize their mistake, they recognize that their hopes have been dashed; . . . none of this is Monsieur Baudry's fault; they intoxicated him, public opinion made too much of him and it is now unjustly turning against him after lavishing its accolades on him a bit too freely."[2]

Baudry's entry was judged harshly: he was reproached for just about everything—banal composition, mannered figures, lax craftsmanship, and so on. Only his portraits escaped this savage assault.[3] Many people ridiculed *La Madeleine pénitente*—the chubby saint was obviously on

the first day of what could only be a beneficial fast. A woman whose worldly graces were remarked by all was beginning a severe penitence after acquiring the panoply of her new state—the death's head "in ivory and the scourge in Russian leather."[4] In a more serious tone, Astruc underscored the ambiguity of this travesty: in depicting the "beloved of Christ," Baudry had painted a woman who could be seen every day on the boulevards: "This," Astruc concluded, "is an absolutely modern painting, modern in accent, sentiment, taste, and skill—I find an intensely pronounced impoverishment of nature and of soul here."[5] For this critic "modern" apparently meant that artistic tendency to pile on conventions with the hope of pleasing: the religious subject is merely a pretext for painting the nude, and everything, as Théophile Gautier noted, is "subordinated" to the description of that body.[6] The landscape, a slapdash job, is a backdrop, as flimsy as a stage set, and with no other function than to bring out the morbidezza of the bosom and the "satiny" flesh, which is "lit up by opaline reflections."[7] The studio model appears as Mary Magdalen today and will be Leda or Phryne tomorrow; she conceals the harsh accessories of contrition as much as possible, but with her unknotted hair and teary eyes, she looks more like a sinner than a penitent. The painting appealed to the duc de Morny, who considered buying it;[8] he would not have appreciated Cézanne's Magdalen (fig. 66) with her bewildered

Fig. 395. Pierre Puvis de Chavannes, *La Madeleine au désert* (*The Magdalen in the Desert*), ca. 1869–70. Oil on canvas, 61⅝ x 41½ in. (156.5 x 105.5 cm). Städelsches Kunstinstitut, Frankfurt

remorse or that of Puvis de Chavannes (fig. 395), looming straight and austere against a harsh desert landscape.

H.L.

1. "honnête modestie." Jules Breton, *La vie d'un artist: Art et Nature* (Paris, n.d.), 232–33.
2. "Séduite par des qualités de fraîcheur et de distinction, la mode adopte tout à coup, du jour au lendemain, le jeune artiste: il suffit à peine aux portraits qu'on lui commande; il est chargé d'exécuter des décorations qui en amèneront d'autres, ceci soit dit sans calembour, on le préconise, on le pousse, on crie ses louanges, on parle d'avance de ses travaux, et quand ces mêmes Travaux, si célébrés prématurément, sont livrés au public, on s'aperçoit qu'on s'est trompé, on reconnaît que les espérances avortent; ... M. Baudry n'est pas coupable de tout ceci; on l'a grisé; l'opinion l'a surfait, et elle est injuste en retournant aujourd'hui contre lui les éloges qu'elle lui a jadis prodigués un peu trop à l'aventure." Du Camp 1859, pp. 51–52.
3. For a summary of the criticism, see Wolfgang Drost and Ulrike Henninges in Gautier 1959, pp. 233–36.
4. "[la tête de mort] en ivoire et la discipline en cuir de Russie." Paul de Saint-Victor, "Salon de 1859, II," *La Presse*, April 30, 1859, p. 2.
5. "bien aimée du Christ"; "c'est une peinture absolument moderne, moderne par l'accent, le sentiment, le goût, l'art—j'y trouve un appauvrissement de nature et d'âme des plus marqués." Astruc 1859, p. 160.
6. "subordonné." Gautier 1859, pp. 18–19.
7. "morbidesse"; "satinée"; "opalins." Ibid.
8. Charles Ephrussi, *Paul Baudry; Sa vie et son oeuvre* (Paris, 1887), p. 178.

Frédéric Bazille

Montpellier, 1841–Beaune-la-Rolande, 1870

Bazille was the well-loved and loving son of a wealthy Protestant family in Montpellier. He was born in 1841 and graduated from lycée in 1859. He enrolled at the medical faculty in Montpellier but simultaneously took instruction from Baussans *père et fils*, sculptors in his native city. After completing his third year at the Montpellier medical school, he enlisted himself, in November 1862, at both the medical faculty in Paris and in the studio of Charles Gleyre. In his drawing classes at Gleyre's he met Claude Monet and Degas's friend vicomte Lepic. After he failed to pass the medical examinations in April 1864, he devoted himself to painting. Monet and Bazille became close companions, Monet giving Bazille encouragement and discipline, while Bazille was soon giving the indigent Monet money and lodging. The two went on painting expeditions: to Honfleur in 1864, to Chailly in 1865; once Bazille had a studio in Paris, Monet was a frequent inhabitant until his incessant demands for money and his growing family strained, around 1868, their friendship. Monet's place was soon occupied by Renoir, who, as Monet did, needed Bazille's financial support. Bazille alternated between his parents' properties around Montpellier and the studios he shared with his friends in Paris, preparing paintings that were accepted at the Salons of 1866, 1868, 1869, and 1870. Both of his *envois* were rejected in 1867, while one of each of his two *envois* was rejected in 1866, 1869, and 1870. By the end of the decade Bazille's painting style had shifted from a Monet-inspired painter of plein air landscapes to a Manet-and-Renoir-inspired figure painter with Orientalist tendencies. His conservative approach brought him greater acceptance by the Salon jury than Monet received, but as a result he was not championed by the advanced critics. He enlisted in the Third Regiment of the Zouaves in August 1870, within a month after France had declared war on Prussia. On November 28, 1870, he was killed in battle at Beaune-la-Rolande.

2

Fig. 80

Frédéric Bazille
Plage à Sainte-Adresse
(Beach at Sainte-Adresse)
1865
Oil on canvas
23 x 55⅛ in. (58.4 x 140 cm)
Signed and dated lower left: *F. Bazille, 1865*
High Museum of Art, Atlanta, Gift of the Forward Arts Foundation in honor of Frances Floyd Cocke 1980.62

CATALOGUE RAISONNÉ: Daulte 1992, no. 17

PROVENANCE: Commissioned by the artist's uncle and aunt, M. and Mme Georges-André Pomier-Layrargues, Montpellier, in 1865; Mme Brunel, Montpellier, by 1932; Pierre Fabre, Saint-Comes, before 1978; Wildenstein and Co., New York; acquired by the museum, 1980

EXHIBITIONS: Paris 1950, no. 15; Chicago 1978, no. 17, repr.; Los Angeles, Chicago, Paris 1985–86, no. 4, repr.; Manchester, New York, Dallas, Atlanta 1991–92, no. 1, repr.; Montpellier, Brooklyn, Memphis 1992–93, no. 9, repr.

SELECTED REFERENCES: Poulain 1932, pp. 52, 211, no. 3 ("Dessus de portes. 1864. Deux panneaux appartenant à Mme Brunel, Montpellier"); Daulte 1952, no. 15, repr.; Isaacson 1972, pp. 98–99, n. 13; Champa 1973, p. 85, fig. 115; Rewald 1973, repr. p. 110; Bazille 1992, nos. 66, 68, 69, 70

"I have begun one of the pictures of my uncle, which would be finished in the most, two weeks, if only I were able to go to Fontainebleau to do some needed studies. In any case neither will be finished before next August. I am taking great pains with them and I hope my uncle will be very pleased."[1] When Bazille wrote these lines from Paris to his mother in Montpellier, Monet was begging him to go to Chailly to pose for his *Déjeuner sur l'herbe* (cats. 122, 123). Hence it was not the "needed studies" that would take Bazille to Fontainebleau but his needy friend. Indeed, Bazille seems not to have made new studies for the two overdoor panels that his uncle Pomier-Layrargues had ordered; he referred instead to preexisting works. The subjects he chose were France of the north and France of the south, surf and turf, the cloudy Normandy coast at Sainte-Adresse and the sunny, broad plains of Saint-Sauveur, where his father had a farm. For the marine, he turned to a plein air sketch (cat. 116) that Monet had made in summer 1864, when both artists were working in the vicinity of Honfleur. Monet no doubt had left his painting in the Paris studio he shared with Bazille, and thus it was at hand.

In contrast to the solidly painted Monet, Bazille's picture is painted quite thinly. Only in the highlights does Bazille approach Monet's deft impasto. The figures and boats are summarily painted; yet the light effects, particularly the warm reflections on the lapping waves, are well conceived. Bazille's style is still immature in these works but not for lack of ability. The *Paysage à Chailly* (cat. 3), executed in the succeeding weeks, stands as a masterful reproach. Perhaps his heart was not in the paintings and he was straining to complete his obligation. He referred to his difficulties in another letter to his mother. "Finally, tomorrow morning, I will have finished the paintings for my uncle. I have completely reworked them since my last letter; originally I had included a mass of details, which, from the distance they were intended to be viewed, had a very bad effect. I have worked at breakneck speed for two weeks, and now I am rather pleased, at least with one of them."[2] The artist's ever-indulgent father asked him to bring back to Montpellier the first versions of the overdoors so that he might have them. "If you have not wiped out the first paintings for your uncle Pomier, please bring them with the new ones. I would not be sorry to see them and to keep them; I rather like the details."[3] However Bazille probably made his revisions on the same set of canvases; radiographs might reveal the "mass of details" that revolted him.

G.T.

1. "J'ai commencé un des tableaux de mon oncle, il serait fini dans une quinzaine de jours au plus si je pouvais partir pour faire les études nécessaires à Fontainebleau. Dans tous les cas, les deux ne seront faits qu'au mois d'août prochain. Je les soigne beaucoup et j'espère que mon oncle en sera content." Bazille to his mother, May 5, 1865, Bazille 1992, no. 66, p. 106. Translation by Paula Prokopoff-Giannini in Chicago 1978, p. 168.
2. "Enfin je vais avoir fini demain matin les tableaux de mon oncle, je les ai recommencés en entier depuis ma dernière lettre, j'avais fait auparavant une masse de détails qui à la distance où ils devaient être vus faisaient fort mauvais effet. J'ai travaillé d'arrache-pied depuis une quinzaine de jours et j'en suis maintenant assez content, du moins de l'un des deux." Bazille to his mother, August 18/25, 1865, Bazille 1992, no. 70, p. 113. Translation by Paula Prokopoff-Giannini in Chicago 1978, p. 169.
3. "Si tu n'as pas effacé les premiers tableaux pour ton oncle Pomier, porte-les je te prie avec les nouveaux; je ne serais pas fâché de les voir et de les garder; les détails ne me déplaisent pas." Letter from Gaston Bazille, August 28, 1865, Bazille 1992, no. 71, p. 114.

3 *Fig. 97*

Frédéric Bazille
Paysage à Chailly
(*Landscape at Chailly*)
1865
Oil on canvas
31⅞ x 39½ in. (81 x 100.3 cm)
Signed and dated lower left: *F. Bazille, 1865*
The Art Institute of Chicago, Charles H. and Mary F. S.
Worcester Collection 1973.64

CATALOGUE RAISONNÉ: Daulte 1992, no. 12

PROVENANCE: The artist's younger brother, Marc Bazille,
Montpellier, until 1923; by inheritance to his daughter
(the artist's niece), Mme Jules-François Meynier de
Salinelles, Montpellier; by descent to Marc Meynier de
Salinelles, Montpellier, 1942; sale, Palais Galliera, Paris,
"Tableaux modernes," March 17, 1971, no. A ("Paysage
à Chailly"); Sam Salz, Inc., New York, until 1973; pur-
chased by the museum, 1973

EXHIBITIONS: Paris 1910, no. 4; Montpellier 1927, no. 5
("Lisière de Forêt, Fontainebleau"); Montpellier 1941,
no. 14; Paris 1950, no. 18; Chicago 1978, no. 14, repr.;
Los Angeles, Chicago, Paris 1985–86, no. 7, repr.;
Edinburgh 1986, no. 61, repr.; Montpellier, Brooklyn,
Memphis 1992–93, no. 11, repr.

SELECTED REFERENCES: Poulain 1932, pp. 53–54, 212–13,
no. 10; Daulte 1952, pp. 110, 171, no. 12, repr.; Rewald
1973, repr. p. 98; Pitman 1989, pp. 81–82, fig. 32

After receiving a summer's worth of hounding
letters from Monet, Bazille finally tore himself
from Paris in order to go to Chailly and pose for
Monet's *Déjeuner sur l'herbe* (cats. 122, 123). Care-
ful reading of his correspondence with his par-
ents indicates that he arrived on either Saturday,
August 19 or August 26, 1865.[1] Bazille was at the
family house at Méric by September 28.[2] Although
some scholars have suggested that Bazille painted
this work in Chailly in early summer,[3] his corre-
spondence rules out the possibility.

Bazille did not describe this painting to his par-
ents, but it is unquestionably the most ambitious
of the several that he executed while staying at
Chailly. On an earlier trip to the forest, over Easter
1863, he wrote that he was struck by the differ-
ence between it and his native landscape. "Cer-
tain parts of the forest are truly wonderful. We
can't even imagine such oak trees in Montpellier.
In spite of their great fame, the rocks are not so
beautiful. One could easily find more imposing
ones around our city."[4] He must have been im-
pressed by the large and handsome landscapes
(cat. 119 and *Le Pavé de Chailly*, 1865, private
collection [Wildenstein 19]) that Monet had

painted in anticipation of the *Déjeuner sur l'herbe*,
for he adopted a format and palette similar to
that which Monet used in the *Chêne de Bodmer*
(cat. 120): brilliant blue sky, dark green foliage,
reddish brown undergrowth with orange high-
lights. Properly speaking, Bazille's painting is an
ébauche in that the brushstrokes and palette have
not been harmonized into a cohesive, carefully
balanced whole. But it is precisely the immedi-
acy conveyed by the sharp contrasts of color and
light, as well as by the palpable brushwork, that
is so appealing today. That Bazille worked long
and hard on the canvas, both out-of-doors and
back in the studio, is revealed by details such as
the use of the butt of the brush to bring out the
outline of the treetops, or by the delicate render-
ing of highlights on the small trees in the right
foreground.

During the month spent with Monet, Bazille
painted another forest view (Daulte 11) and the
charming *Ambulance improvisée* (fig. 382). "While
trying to protect some children from a bronze
discus with which some clumsy Englishmen were
playing, Monet injured his leg."[5] Bazille tenderly
painted the wounded Monet impatiently confined
to bed with a contraption that he had devised as
a knowledgeable medical student.

 G.T.

1. Bazille 1992, nos. 71, 72, pp. 114–15.
2. Isaacson 1972, pp. 24, 101, n. 26.
3. Pitman 1989, p. 222, gives a date of May 1865, which
 she contradicts in her catalogue entry in Montpellier,
 Brooklyn, Memphis 1992–93, p. 92; Schaefer, in Los
 Angeles, Chicago, Paris 1984–85, p. 66, gives a date of
 early summer.
4. "La forêt est vraiment admirable dans certains parties;
 nous n'avons pas d'idée à Montpellier des pareils chênes.
 Les rochers sont moins beaux malgré leur grande
 réputation, il n'est pas difficile d'en trouver de plus gran-
 dioses aux environs de notre ville." Bazille to his mother,
 April 8, 1863. Bazille 1992, no. 1, p. 51. Translation by
 Paula Prokopoff-Giannini in Chicago 1978, p. 156.
5. "En voulant protéger des enfants contre un disque de
 bronze avec lequel jouent des Anglais maladroits, Monet
 est blessé à la jambe." Poulain 1932, p. 56.

4 *Fig. 221*

Frédéric Bazille
Étude de fleurs
(*Study of Flowers*)
1866
Oil on canvas
38¼ x 34⅝ in. (97.2 x 87.9 cm)
Signed and dated lower left: *F. Bazille 66*
Mrs. John Hay Whitney

CATALOGUE RAISONNÉ: Daulte 1992, no. 20

PROVENANCE: A gift from the artist to his mother's first
cousins, Commandant and Madame Hippolyte Lejosne,
Paris, by 1868; by descent to M. Lejosne, Pau, by 1932;
purchased by Dr. F. Schoni, Zurich, until 1960; sold to
the Hon. John Hay Whitney, New York, 1960; Whitney
Collection, New York, 1960–82; to the present owner

EXHIBITIONS: Paris, Salon of 1868, no. 147 ("Étude de
fleurs"); Paris 1950, no. 21; London, Tate Gallery, De-
cember 16, 1960–January 29, 1961, *The John Hay
Whitney Collection*, no. 2, repr.; Washington, National
Gallery of Art, May 29–September 5, 1983, *The John
Hay Whitney Collection*, no. 1, repr.

SELECTED REFERENCES: J. Ixe, "Les Artistes Montpelliérains
au Salon de 1868: Lettres au Directeur du Journal de
Montpellier," *Journal de Montpellier*, no. 21 (May 23,
1868), p. 3 (reprinted in Montpellier 1992, pp. 16–17);
Poulain 1932, pp. 60, 213, no. 13; Daulte 1952, no. 18,
repr.; Rewald 1973, p. 112, repr. p. 113; François Daulte,
"Une grande amitié: Edmond Maître et Frédéric Bazille,"
L'OEil, no. 273 (April 1978), repr. p. 38; Guy Barral in
Montpellier 1992, p. 17, n. 19; Guy Barral in Montpellier,
Brooklyn, Memphis 1992–93, p. 31, n. 41; Bazille 1992,
nos. 103, 105

This splendid canvas is the earliest flower piece
by Bazille to survive. It is known, however, that
he began one in 1864. "In my studio, I have started
painting a study of flowers but I have abandoned
it and will start on it again only after my exam."[1]
In the same letter he mentioned in passing that
he went to view some works by Delacroix that
were going to be auctioned, and it is worth not-
ing that included in the sale[2] were some twenty-
two lots of flower pieces, and one of those lots,
number 625, comprised seventy-seven sheets of
studies. The sight of so many studies by Delacroix
may have inspired Bazille, but it is not known
what became of his canvas. That summer Monet
wrote a long letter encouraging Bazille to do a
flower piece: "Do one, then, because it is, I think,
an excellent subject to paint."[3]

By the time Bazille began to paint this work in 1866 he had had the opportunity to study Monet's *Fleurs de printemps* of 1864 (cat. 115) and Renoir's analogous *Fleurs de printemps* (cat. 168). He had also looked long and hard at Manet's still lifes in the 1865 exhibitions at the Galerie Martinet and at Cadart's—Bazille's first Salon acceptance, *Nature morte aux poissons* (*Still Life with Fish*, 1866; Detroit Institute of Arts), is an homage to Manet.[4] When Bazille sent the present painting as a safe bet to the Salon of 1868, it was Manet who was cited as Bazille's (decidedly negative) example, since Monet and Renoir were still virtually unknown. "Bazille resolutely follows Manet, with all the study and presently all the knowledge of the master's ignorance. He is also a realist, and this chivalry of the absurd leads to the reversal of all realities. M. Bazille has taken and placed in a very elegant setting, without unpotting or arranging them, some samples of those most charming creations of nature, the flowers: azaleas, hydrangeas, varieties of geraniums. In the dark glow of a gray atmosphere and the cold light of a prison courtyard, he has painted this study of flowers with a morbid brush, without grace or pity, . . . not without character and a harmony of color, I should add."[5]

Bazille had given the painting to his mother's cousins, the Lejosnes. "You know that I have sent [to the Salon] another one to please the Lejosnes, to whom I have given it. It is a flower painting, and I think it will be accepted."[6] The Lejosnes also owned a still life by Monet, *Poires et raisins* (Wildenstein 103), which they had acquired through Bazille.

G. T.

1. "J'ai commencé une étude de fleurs dans mon atelier, mais je l'ai abandonnée pour le moment, et ne la reprendrai qu'après mon examen." Bazille to his mother, February 24, 1864, Bazille 1992, no. 42, p. 80.
2. *Vente Eugène Delacroix [après déces]*, Hôtel Drouot, Paris, February 16–March 1, 1864, lots 1–249 (paintings), 250–679 (drawings), 680–858 (etchings, lithographic stones, and lithographs).
3. "Faites-en donc car c'est, je crois, une excellente chose à peindre." Monet to Bazille, August 26, 1864, Wildenstein 1974, letter 9, p. 421.
4. According to J. Patrice Marandel, "A Note on Bazille's *Still Life with Fish* of 1865," *Bulletin of the Detroit Institute of Arts* 65, no. 4 (1990), p. 7, a letter from Bazille to his parents of February 1865, "combien j'apprends en regardant ces tableaux" (how much I learn by looking at these pictures), quoted by Poulain 1932, p. 363, refers to his visits to Manet's exhibition at Martinet's. However, the letter that Poulain quotes does not appear to be in Bazille 1992, the date is not certain, and therefore the reference to Manet's still lifes is in doubt.
5. "Bazille emboîte décidément le pas à Manet, avec toute l'étude et bientôt toute la science de l'ignorance du maître. Réalisme aussi oblige, et cette chevalerie de l'absurde va jusqu'au renversement de toute réalité. M. Bazille a pris et placé, sans déporter ni arrangement aucun, dans un cadre de très beau style, lui, un coin d'étalage de ces plus charmants êtres de la création, des fleurs: azalées, hortensias, variétés de géraniums. Sous le jour noirâtre d'une atmosphère de houille et glacial d'un préau de prison, il a peinte cette étude de fleurs d'une brosse morbide, sans grâce ni pitié . . . , non sans caractère et harmonie de ton ajouterai-je vite." J. Ixe, "Les Artistes montpelliérains au Salon de 1868," *Journal de Mont-*

pellier, May 23, 1868, p. 3, reprinted in Montpellier 1992, pp. 16–17.
6. "Tu sais que j'en ai envoyé un autre pour faire plaisir aux Lejosne à qui je l'ai donné. Ce sont des fleurs, je pense qu'elles seront reçues." Bazille 1992, no. 103, p. 157.

5 *(New York only)* *Fig. 110*

Frédéric Bazille
Aigues-Mortes
1867
Oil on canvas
18⅛ x 21⅝ in. (46 x 55 cm)
Signed and dedicated lower right: *à M. Fioupou, son ami, F. Bazille*
Musée Fabre, Montpellier 56.13.1

CATALOGUE RAISONNÉ: Daulte 1992, no. 28

PROVENANCE: Acquired from the artist by his friend Joseph Fioupou, Paris and Toulon, by 1870; Léon Deshons, Montpellier, by 1947, until 1956; bought by the museum, 1956

EXHIBITIONS: Paris 1950, no. 33; Montpellier 1959, no. 22 ("Les Remparts d'Aiguesmortes du côté du midi"); Bordeaux 1974, no. 84, repr.; Chicago 1978, no. 22, repr.; Montpellier, Musée Fabre, November 5–December 29, 1985, *Courbet à Montpellier*, no. 37, repr.; Montpellier, Brooklyn, Memphis 1992–93, no. 16, repr.

SELECTED REFERENCES: Gaston Poulain, "Une oeuvre inconnue de Frédéric Bazille," *Arts de France*, no. 17–18 (1947), pp. 122–23, repr. p. 122; Daulte 1952, pp. 62, 176, no. 25, repr.; François Daulte, "Bazille: son oeuvre s'achève en 1870," *Connaissance des Arts* 226 (December 1970), p. 87; Champa 1973, pp. 86–87, fig. 122; Pitman 1989, pp. 83, 334, n. 184, fig. 35

6 *(New York only)* *Fig. 112*

Frédéric Bazille
Remparts d'Aigues-Mortes
(*The Ramparts at Aigues-Mortes*)
1867
Oil on canvas
24⅜ x 43¼ in. (62 x 110 cm)
Signed lower left: *F. Bazille*
National Gallery of Art, Washington, Collection of Mr. and Mrs. Paul Mellon 1985.64.1

CATALOGUE RAISONNÉ: Daulte 1992, no. 27

PROVENANCE: The artist's younger brother, Marc Bazille, Montpellier, until 1923; by inheritance to his daughter (the artist's niece), Mme Jules-François Meynier de Salinelles, Montpellier; by descent to M. Marc Meynier de Salinelles, Montpellier, 1942; by descent to Mme M. Meynier de Salinelles, Montpellier, by 1959; sale, Palais Galliera, Paris, "Important Paysage par Frédéric Bazille," June 19, 1963; purchased at this sale by Hector Brame, for Paul Mellon, 1963, until 1985; his gift to the museum, 1985

EXHIBITIONS: Paris 1910, no. 12; Montpellier 1927, no. 12; Montpellier 1941, no. 21; Paris 1950, no. 32 ("Les Remparts d'Aigues-Mortes du côté du Couchant"); Montpellier 1959, no. 21 ("Les Remparts d'Aiguesmortes du côté du couchant," lent by Mme M. Meynier de Salinelles, Montpellier); Washington, National Gallery of Art, March 17–May 1, 1966, *French Paintings from the Collections of Mr. and Mrs. Paul Mellon and Mrs. Mellon Bruce*, no. 112, repr.

SELECTED REFERENCES: Poulain 1932, pp. 86–88, 214–15, no. 21; Daulte 1952, pp. 62, 175–76, no. 24, repr.; François Daulte, "Bazille: son oeuvre s'achève en 1870," *Connaissance des Arts* 226 (December 1970), p. 87, repr. p. 86; Champa 1973, pp. 86–87, fig. 120; François Daulte, "Une grande amitié: Edmond Maître et Frédéric Bazille," *L'Oeil*, no. 273 (April 1978), repr. p. 42; Aleth Jourdan in Montpellier, Musée Fabre, November 5–December 29, 1985, *Courbet à Montpellier*, p. 67; Pitman 1989, pp. 83, 334, n. 184; Aleth Jourdan in Montpellier, Brooklyn, Memphis 1992–93, p. 102, fig. 46; Bazille 1992, no. 94

7 *(New York only)* *Fig. 113*

Frédéric Bazille
Porte de la Reine à Aigues-Mortes
(*Porte de la Reine at Aigues-Mortes*)
1867
Oil on canvas
31¾ x 39¼ in. (80.7 x 99.7 cm)
Signed and dated lower right: *F. Bazille, 1867*
The Metropolitan Museum of Art, New York. Purchase,
Gift of Raymonde Paul, in memory of her brother,
C. Michael Paul, by exchange, 1988 1988.21

CATALOGUE RAISONNÉ: Daulte 1992, no. 26

PROVENANCE: Mme Brunel, Montpellier, by 1932; Mme
Jules Castelnau; Henri Cazalis-Lehr, Montpellier, prob-
ably by 1950, until 1981; purchased by Wildenstein, Paris
and New York, 1981, until 1986; sold to Alan Clore, Paris,
1986, until 1988; his sale, Christie's, London, June 27,
1988, no. 75; acquired by the museum, 1988

EXHIBITIONS: Montpellier 1927, no. 13; Montpellier 1941,
no. 20 ("Porte d'Aiguesmortes," lent by Mme Castelnau);
Paris 1950, no. 31; Montpellier 1959, no. 20 ("Porte de
la Reine à Aiguesmortes," lent by M. H. Cazalis-Lehr,
Montpellier); Chicago 1978, no. 21, repr.; Edinburgh
1986, no. 75; Montpellier, Brooklyn, Memphis 1992–93,
no. 15, repr.

SELECTED REFERENCES: Poulain 1932, pp. 86–88, 214, no.
20; Daulte 1952, pp. 62, 175, no. 23, repr.; François Daulte,
"Bazille: son oeuvre s'achève en 1870," *Connaissance
des Arts* 226 (December 1970), p. 87; Champa 1973, pp.
86–87, fig. 121; François Daulte, "Une grande amitié:
Edmond Maître et Frédéric Bazille," *L'Œil*, no. 273
(April 1978), repr. p. 42; Aleth Jourdan in Montpellier,
Musée Fabre, November 5–December 29, 1985, *Courbet
à Montpellier*, p. 67; Pitman 1989, pp. 83–84, 334,
n. 185, fig. 36; Bazille 1992, no. 94

In a letter which exists only as a fragment, Bazille
informed his parents of his intention to travel for
"a few weeks or a month at Aigues-Mortes or at
the Saintes to paint some pine trees"; thinking
out loud, he observed, "It would be wise to choose
a season when there aren't fevers going around."[1]
By the end of May 1867, he was able to write,
"I am very well installed in the Hôtel St.-Louis.
Had the weather been fine, everything would have
been better. Unfortunately the sun allowed me
only four days of work. Today it is beautiful and
I am about to go out. I have begun three or four
landscapes of the area around Aigues-Mortes. In
my large canvas, I am going to do the walls of the
city reflected in a pond at sunset. This will be a
very simple painting, which should not take long
to do. Nevertheless I would need at least eight
beautiful days. I hope that everything will be fin-
ished by the 12th."[2]

True to his intentions, on his widest canvas
(cat. 6)[3] he painted the ramparts of Aigues-Mortes
as seen from the west, across the ship channel.
The air is still and, contrary to his first idea, the
sun is not setting but high in the sky. The sand-
stone walls act as a barrier between the turquoise
water and the blue sky: everything of interest in
the panorama hugs the horizon—boats, build-
ings, walls, clouds—leaving foreground and sky
virtually empty. The same is true of the canvas
now in Montpellier (cat. 5) which shows the east-
ern ramparts across the floodplain adjacent to
the Étang de la Ville. Quite to the contrary, the
canvas now in New York, *Porte de la Reine à
Aigues-Mortes* (cat. 7), presents an unexpected
composition and unusual lighting. The thirteenth-
century city gate looms ominously as the after-
noon sun falls behind it, casting the foreground
into a deep shadow, while tantalizingly illumi-
nating the rue Émile Jamais within. *Porte de la
Reine* is the most finished of the three works in
every sense. The brushwork is more labored,
reminiscent of both Manet's palpable paint and
Monet's constructive stroke, and there are figures
in the foreground, scattered in a manner that par-
adoxically makes it appear emptier than in the
other two landscapes. One of Bazille's notebooks
at the Louvre has many studies for these pic-
tures, including sheets devoted to the Camargue
horses and flying gulls.[4]

In choosing to paint three views of a famous
site in Languedoc, a site intimately associated
with the history of Protestantism in France, Bazille
found his response to the urban scenes that his
friends Monet and Renoir had painted the previ-
ous month (cats. 132–34, fig. 307). Unwilling to
attempt the difficult challenge of a complex
Parisian view, he wisely tried something "very
simple."

G. T.

1. "[une] quinzaine de jours ou un mois à Aigues-Mortes
ou aux Saintes, faire des pins, il vaudrait mieux choisir
la saison où il n'y a pas de fièvres." Bazille to his parents,
May 1867, Bazille 1992, no. 93, p. 140. Translation by
Paula Prokopoff-Giannini in Chicago 1978, p. 180.
2. "Je suis fort passablement installé à l'hôtel Saint-Louis.
S'il avait fait très beau temps tout serait pour le mieux.
Malheureusement le soleil ne m'a permis d'aller travailler
que quatre fois. Aujourd'hui il fait très beau temps et je
vais partir tout à l'heure. J'ai commencé trois ou quatre
paysages des environs d'Aigues-Mortes. Sur ma grande
toile, je vais faire les murs de la ville se reflétant dans
l'étang au couché du soleil. Ce tableau sera fort simple
et ne devrait pas être long à faire. Cependant il me faudrait
au moins huit belles journées. Je pense que vers le 12
tout pourrait être fini." Bazille to his mother, end of May
1867, Bazille 1992, no. 94, p. 142. Translation by Paula
Prokopoff-Giannini in Chicago 1978, p. 176.
3. In 1989 I mistakenly identified the Metropolitan Muse-
um's canvas as the largest of the three; *Recent Acquisi-
tions: A Selection 1988–1989*, in *Metropolitan Museum
of Art Bulletin* 47 (Fall 1989), p. 34.
4. The figures are close to those in Bazille's *Saint-Sauveur*
(Farm at Saint-Sauveur), dated by Daulte to 1863 and
by Pitman to 1865. Perhaps it dates to the same sum-
mer as the Aigues-Mortes landscapes.

8 *Fig. 217*

Frédéric Bazille
Le Héron
(*The Heron*)
1867
Oil on canvas
39⅜ x 27⅛ in. (100 x 70 cm)
Signed and dated lower left: *F. Bazille. 67*
Musée Fabre, Montpellier 898.5.2

CATALOGUE RAISONNÉ: Daulte 1992, no. 35

PROVENANCE: The artist's parents, Gaston and Camille
Vialars Bazille, Montpellier, from late December 1868,
until 1898; her gift to the museum, 1898

EXHIBITIONS: Montpellier 1927, no. 9; Montpellier 1941,
no. 24; Paris 1950, no. 38, repr.; Montpellier 1959, no.
25; Bordeaux 1974, no. 85, repr.; Chicago 1978, no. 24,
repr.; Bordeaux 1991, no. 46, repr.; Montpellier 1991–92,
fig. 17; Montpellier, Brooklyn, Memphis 1992–93, no.
14, repr.

SELECTED REFERENCES: Poulain 1932, pp. 102–4, 110, 216,
no. 26; Daulte 1952, p. 179, no. 32, repr.; Champa 1973,
pp. 46, 93; Rewald 1973, repr. p. 182; J. Patrice Marandel,
"A Note on Bazille's *Still Life with Fish* of 1865," *Bulle-
tin of the Detroit Institute of Arts* 65, no. 4 (1990), p. 9,
fig. 6; Bazille 1992, no. 113

Bazille painted this picture alongside Alfred Sisley,
who oriented his canvas, identical in size, hori-
zontally rather than vertically (cat. 187). Both
pictures were probably made in November or
December 1867, in Bazille's studio at 20, rue
Visconti. Renoir memorialized the event by por-
traying Bazille at work on this picture (cat. 172).
All three paintings can be interpreted as essays
in adopting the style of Édouard Manet, whose
still lifes, among other works, had recently been
shown in the exhibition the artist arranged to co-
incide with the 1867 Exposition Universelle. Al-
though Bazille was not in Paris from May until
November 1867, and therefore missed Manet's
—and Courbet's—exhibitions, he had seen, and
was very impressed by, Manet's 1865 exhibition
at Galerie Martinet. Bazille's *Poisson* (*Fish*) of 1866
(Detroit Institute of Arts) was closely related to
the Manet still lifes shown at Martinet's, and it
was this work that was accepted by the jury of
the 1866 Salon, even though Bazille's figure paint-
ing, a picture of a girl at the piano (now lost),
was not.

It seems likely that in painting the present work
Bazille was motivated by a similar strategy. Con-

cerned that his large figure painting, *La Réunion de famille* (fig. 174), might be rejected by the Salon of 1868, he conceived this canvas and *Fleurs* (*Flowers*; Musée de Grenoble) as conservative safe bets to ensure that he have at least one work that was likely to be accepted. In a letter of late 1867 to his parents, he wrote: "I finished entirely the painting of Méric [*Réunion de famille*]; I painted myself in the corner. It does not look at all like me, but that doesn't matter for the exhibition, especially if I am being rejected. I will paint myself again in Montpellier. I made two large still lifes in two days. I am not very happy with them; yet, the one with a great gray heron and jays is not bad, and I will send it to the Teulons if the one I am finishing right now [*Fleurs*] is no better."[1] In the end, he sent neither *Le Héron* nor the *Fleurs*, which he had given to his cousins Pauline and Émile Teulon, but rather a still life of 1866, *Étude de fleurs* (cat. 4), along with *Réunion de famille* to the jury of the 1868 Salon. He anxiously awaited their decision: "I have not heard anything from the Salon yet, but I expect that the Méric painting will be refused. You know that I have sent another one to please the Lejosnes, to whom I have given it. It is a flower painting and I think it will be accepted."[2] To his surprise, both were accepted.

Bazille's father, an avid hunter, coerced *Le Héron* from his son on a visit to Paris in December 1868. Writing to his mother on January 1, 1869, Bazille said, "Papa absolutely insisted on carrying off a still life of mine, which did not please me at all. I certainly hope that you will not hang it in a place where strangers may see it, and you would do me a service if you put it in the little anteroom with the female nude [Musée Fabre, Montpellier] and Thérèse seen from the rear [Musée d'Orsay, Paris]."[3] Father, however, had other plans. He wanted to hang it in his study between two windows.[4]

<div align="right">G.T.</div>

1. "J'ai tout à fait fini le tableau de Méric; je me suis fait moi-même dans le coin, je ne suis pas du tout ressemblant, mais cela ne fait rien pour l'exposition, surtout pour être refusé. Je me referai à Montpellier. J'ai fait depuis deux jours deux grandes natures mortes. Je n'en suis pas trop content; cependant il y en a une avec un grand héron gris et des geais, qui n'est pas mal, et que j'enverrai aux Teulon si celle que je finis en ce moment n'est pas meilleure." Poulain 1932, p. 110; Poulain does not indicate the date of the letter or to whom it was addressed, but Pitman 1989, p. 246, indicates that the excerpt is a fragment of a letter addressed to the artist's parents around February or March 1868. However, since in another letter (Bazille 1992, no. 98) Bazille says that the *Fleurs* will be completely dry by January 15, 1868, and since he was working on *Fleurs* when he wrote the excerpt mentioned above—"J'ai fait depuis deux jours deux grandes natures mortes"—this excerpt must in fact date from November or December 1867.
2. "Je n'ai encore aucune nouvelle du Salon, il faut s'attendre à ce que le tableau de Méric soit refusé, tu sais que j'en ai envoyé une autre pour faire plaisir aux Lejosne à qui je l'ai donné. Ce sont des fleurs, je pense qu'elles seront reçues." Bazille 1992, no. 103, p. 157.
3. "Papa a voulu à toute force emporter une nature morte de moi, ce qui m'a été fort désagréable. Je souhaite fort que tu ne l'accroches pas dans un lieu où les étrangers

puissent la voir, tu me ferais grand plaisir en la mettant dans la petite antichambre avec la femme nue et Thérèse de dos." Bazille 1992, no. 113, p. 166. Translation by Paula Prokopoff-Giannini in Chicago 1978, p. 179.
4. Montpellier, Brooklyn, Memphis 1992–93, p. 97.

9 *Fig. 182*

Frédéric Bazille
La Vue du village
(*View of the Village*)
1868
Oil on canvas
51⅛ x 35 in. (130 x 89 cm)
Signed and dated lower center: *F. Bazille 1868*.
Musée Fabre, Montpellier 898.5.1

CATALOGUE RAISONNÉ: Daulte 1992, no. 39

PROVENANCE: The artist's parents, Gaston (1819–1894) and Camille Vialars (1821–1908) Bazille, Montpellier; Mme Bazille's gift to the museum, 1898

EXHIBITIONS: Paris, Salon of 1869, no. 149 ("La vue du village"); Paris, Exposition Universelle of 1900, no. 22; Paris 1910, no. 14; Montpellier 1927, no. 17; Paris, Musée de l'Orangerie, March–April 1939, *Les Chefs-d'oeuvre du Musée de Montpellier*, no. 5; Montpellier 1941, no. 25, repr.; Paris 1950, no. 41, repr.; Montpellier 1959, no. 29; Bordeaux 1974, no. 86, repr.; Chicago 1978, no. 30, repr.; Montpellier, Musée Fabre, November 5–December 29, 1985, *Courbet à Montpellier*, no. 38, repr.; Montpellier, Brooklyn, Memphis 1992–93, no. 20, repr.

SELECTED REFERENCES: André Gill, "Le Salon de 1869," *La Parodie*, June 1869, p. 8 (reproduced in Montpellier, Brooklyn, Memphis 1992–93, p. 52, fig. 21); J. Ixe, "Les Artistes Montpelliérains au Salon de 1869," *Journal de Montpellier*, June 12, 1869, p. 2 (reprinted in Montpellier, Musée Fabre, 1992, *Bazille: Traces et lieux de la création*, p. 17); André Joubin, *Catalogue des peintures et sculptures exposées dans les Galeries du Musée Fabre de la ville de Montpellier* (Paris, 1926), no. 361; Poulain 1932, pp. 87, 91, 124–27, 146–48, 182, 216–17, no. 29; Daulte 1952, pp. 68, 75–76, 112, 117, 119–20, 134, 145, 147, 180–81, no. 36, repr.; Champa 1973, pp. 88–89, fig. 125; Rewald 1973, p. 218, repr. p. 223; Pitman 1989, pp. 60–91, 93, 101, 108, 131, 137, 150, 153, 154, 155, 156, 157, 180, 182, 183, 189, 196, 214, fig. 2; Aleth Jourdan and Didier Vatuone in Montpellier 1992, p. 22; Bazille 1992, nos. 119, 121

When *La Vue du village* was accepted for the 1869 Salon, Alfred Stevens, Bazille's only friend on the jury, was quick to write with the news. "My dear Bazille, your painting, *La Femme*, has been accepted; I am glad to give you this good news. You were defended (between us) by Bonnat, and guess who else? By Cabanel!"[1] (*Le Pêcheur à l'épervier* [cat. 10] had been rejected.) As soon as Berthe Morisot saw the painting she informed her sister, "The tall Bazille has painted something that I find very good. It is a little girl in a light dress seated in the shade of a tree, with a glimpse of a village in the background. There is much light and sun in it. He has tried to do what we have so often attempted—a figure in the outdoor light—and this time he seems to have been successful."[2] Puvis de Chavannes, now quite friendly with Morisot, also admired the painting. "I received some very flattering compliments, among them one from M. Puvis de Chavannes."[3]

For this admirable work Bazille took the composition of his first important figure painting, *La Robe rose* (The pink dress, 1864; Musée d'Orsay, Paris), reversed it, and turned the figure toward the viewer. Once again the village of Castelnau appears in all of its meridional beauty. The daughter of the family gardener posed for him in the summer of 1868. Although contemporaneous critics and modern ones too have found fault with the perspective,[4] Bazille quite clearly extended the visual field by looking down on his model and then looking up and out toward the far distance in order to make more of the landscape visible. In this respect he followed Monet's procedure in *Le Jardin de l'Infante* (cat. 133). As in the majority of his plein air scenes, he placed the foreground figure in shadow, but here there is sufficient light to model the young woman in the round.

Curiously, Bazille's picture was ignored by the Parisian press. Castagnary, for example, had cited *Portraits de la famille* (*Portraits of the Family*; Musée Fabre, Montpellier) as "a painting I would not call good, but interesting in all aspects."[5] But he did not mention *Vue du village* in 1869. Only J. Ixe, the disagreeable critic from Montpellier, felt obliged to consider the painting at length. "I like that very much. Certainly, it is original and new, very new… perhaps by dint of its reversion to the primitive painting of the Middle Ages as revived in the work of M. Puvis de Chavannes.

"A young lady dressed in white and hatless is seated in the shade on a knoll, at the very bottom of the painting. She looks at you with an expression all the more vacuous because it scarcely accounts for a nuance of shy uneasiness. Could she be afraid of having to show her hands, which, poor girl, are too small and so badly painted? Above her head, in dazzling sunlight, there rises almost to the top of the canvas the cavalier panorama of a landscape with river, village (Castelnau, I believe), vegetation and hills. One hesitates at first between qualifying the work as eccentric or as naive. In the end, one must recognize that all

the boldness of composition and color is absolutely true. The perspective, above all, particularly difficult, is as exact as seen through the lens of a camera lucida or in a photograph. The color and effect, except a few greens that would make Corot faint, equally impose themselves by their healthy sincerity. If M. Bazille can combine these instinctive qualities with a personal line of conduct, independent of the government . . . you will soon see Manet take good advantage of it."[6]

G.T.

1. "Mon cher Bazille, votre tableau, *La Femme*, est reçue; je suis heureux de vous annoncer cette bonne nouvelle. Vous avez été défendu (entre nous) par Bonnat, et devinez l'autre? par Cabanel!" Poulain 1932, p. 146.

2. "Le grand Bazille a fait une chose que je trouve fort bien: c'est une petite fille en robe très claire, assise à l'ombre d'un arbre derrière lequel on aperçoit un village; il y a beaucoup de lumière et de soleil. Il cherche ce que nous avons si souvent cherché: mettre une figure en plein air et cette fois-ci, il me paraît réussi." Berthe Morisot to Edna Pontillon, May 5, 1859, Morisot 1950, p. 28. Translation by Betty W. Hubbard, *The Correspondence of Berthe Morisot* (New York, 1957), p. 32.

3. "J'ai reçue quelques compliments qui m'ont beaucoup flatté, ceux de M. Puvis de Chavannes entre autres." Bazille 1992, no. 121, p. 175. Translation by Paula Prokopoff-Giannini in Chicago 1978, p. 180.

4. Champa 1973, p. 88; Pitman in Montpellier, Brooklyn, Memphis 1992–93, p. 112.

5. "un tableau, je ne dirai pas bon, mais intéressant à tous égards." "Salon de 1868," in Castagnary 1892, p. 313.

6. "Voilà qui me plaît beaucoup. C'est original à coup sûr, neuf, très-neuf . . . à force peut-être de remonter aux vieilleries de la peinture primitive du moyen âge, comme est jeune d'antiquité celle de M. Puvis de Chavannes.

"Une demoiselle vêtue de blanc, en cheveux, est assise à l'ombre sur un tertre, tout au bas du cadre. Elle vous regarde avec une expression d'autant plus insignifiante qu'on ne s'y explique guère une nuance d'inquiétude farouche. Pourrait-ce bien être par crainte d'avoir à montrer ses mains, dont elle n'a, la malheureuse, que trop peu et si mal? Audessus de sa tête, sous un soleil aveuglant, se dresse comme debout, presque jusqu'au sommet de la toile, la panorama *cavalier* d'un paysage avec rivière, village (Castelnau, je crois), végétations, collines. On hésite d'abord entre les qualifications d'excentrique et de naïf les plus opposés. En définitive, il faut reconnaître absolument vraies toutes les hardiesses de la composition et de la couleur. La perspective, surtout, singulièrement scabreuse, s'impose par une exactitude d'objectif de chambre claire ou de photographie, et le ton et l'effet, à quelques *verts* près dont s'évanouirait Corot, s'imposent non moins par leur saine franchise. Si à ses qualités d'instinct M. Bazille arrive à joindre une action de conduite personnelle, indépendante du gouvernement. . . . Manet, vous l'enverrez bientôt tirer excellent parti." J. Ixe, "Les Artistes Montpelliérains au Salon de 1869," *Journal de Montpellier*, June 12, 1869, reprinted in Montpellier 1992, p. 17.

10 *Fig. 153*

Frédéric Bazille
Le Pêcheur à l'épervier
(Fisherman with a Net)
1868
Oil on canvas
54¼ x 34⅛ in. (137.8 x 86.8 cm)
Signed and dated lower right: *F. Bazille, juillet 1868*
Fondation Rau pour le Tiers-Monde, Zurich GR 1.653

CATALOGUE RAISONNÉ: Daulte 1992, no. 38

PROVENANCE: The artist's younger brother, Marc Bazille (1845–1923), Montpellier, until 1923; by inheritance to his son André Bazille, Montpellier; by descent to Mme Rachou-Bazille, Montpellier, until at least 1959; Jean Davray, Paris, until 1961; sale, Palais Galliera, Paris, June 23, 1961; private collection

EXHIBITIONS: Refused at the Salon of 1869; Paris 1910, no. 15; Montpellier 1927, no. 19; Montpellier 1959, no. 28 (lent by Mme Rachou-Bazille, Montpellier); Chicago 1978, no. 32, repr.; Montpellier, Brooklyn, Memphis 1992–93, no. 19, repr.

SELECTED REFERENCES: Poulain 1932, pp. 122–24, 138, 146, 216, no. 28; Daulte 1952, pp. 68, 147, 180, no. 35, repr.; Cooper 1963, p. 255, repr. p. 261; Champa 1973, pp. 88–89, fig. 126; Pitman 1989, pp. 86–88, 182–83, 335, nn. 188–91, p. 385, n. 421, fig. 39; Bazille 1992, nos. 109, 115, 119, 120

Hoping to distinguish himself as a figure painter, Bazille looked for a pretext to depict a male nude out-of-doors, and he arrived at the unusual subject of a nude fisherman casting his net into a river.[1] Perhaps he sought to venture into Puvis de Chavannes's dreamy classical world, but Bazille's naturalist impulse kept him bound to a prosaic vision that still smacked of Gleyre's life-drawing class. (Bazille's nude remains academic in comparison to Renoir's *Jeune Garçon au chat* [cat. 175].) Heeding the program of his friend Monet, he understood that to be modern one had to show life in the broad light of day. But this work, while begun out-of-doors on the banks of the Lez near Montpellier, has the air of having been worked in his studio, regardless of where it was painted: he deliberately placed his figures in shadow in order to avoid rendering the fall of daylight on their skin. Rather in the manner of Courbet, Bazille circumscribed his figures with sharp contours so as to isolate them from the landscape.

Bazille's friends encouraged him in his effort. "My friends were very pleased with my studies, especially the one of the male nude. I feel good about this because it is the canvas I myself prefer."[2] He submitted it along with *La Vue du village* (cat. 9) to the Salon of 1869, but it was refused.

There are pencil sketches for the painting in one of the sketchbooks at the Louvre. Inspired by the sight of the painting at the 1910 Paris Salon, Suzanne Valadon executed a similar composition (1914; Musée National d'Art Moderne, Paris).[3]

G.T.

1. As Pitman has discovered, fishing with a net was a common practice on the Lez (Pitman 1989, p. 335, n. 190). "À Montferrier, curieusement, on pêchait plutôt à l'épervier qu'à la ligne" (At Montferrier, curiously, fishing was more often done with a net than with a line); Liliane Franck, *Une Rivière nommé Lez* (Montpellier, 1982), p. 129. Pitman also observed that a fishing scene by Corot in the Bruyas collection may have inspired Bazille, although the figures are clothed and work in a rowboat.

2. "Mes amis ont été fort contents de mes études, surtout de mon homme nu, j'en suis bien aise parce que c'est aussi la toile que je préférais." Letter from Bazille to his father, November/December 1868, Bazille 1992, no. 109, p. 162. Translation by Paula Prokopoff-Giannini in Chicago 1978, p. 177.

3. Marandel in Chicago 1978, no. 74.

11 *Fig. 337*

Frédéric Bazille
Scène d'été
(Summer Scene)
1869
Oil on canvas
62¼ x 62½ in. (158.1 x 158.9 cm)
Signed and dated lower left: *F. Bazille, 1869.*
Fogg Art Museum, Harvard University Art Museums, Cambridge, Massachusetts, Gift of Mr. and Mrs. F. Meynier de Salinelles 1937.78

CATALOGUE RAISONNÉ: Daulte 1992, no. 49

PROVENANCE: Family of the artist; the artist's niece Mme Jules-François Meynier de Salinelles, Montpellier; gift of M. et Mme Jules-François Meynier de Salinelles to the museum, 1937

EXHIBITIONS: Paris, Salon of 1870, no. 163; Paris 1910, no. 19; Montpellier 1927, no. 23; Paris 1950, no. 46, repr.; Chicago 1978, no. 43, repr.; Montpellier, Brooklyn, Memphis 1992–93, no. 25, repr.

SELECTED REFERENCES: Edmond Duranty, "Les irréguliers et les naïfs ou le clan des horreurs," *Paris-Journal*, May 19, 1870 (reprinted in Pitman 1989, p. 97); Bertall [Charles-Albert d'Arnoux], "Promenade au Salon de 1870," *Journal amusant*, May 28, 1870, p. 2; Zacharie Astruc, "Salon de 1870," *L'Écho des Beaux-Arts*, June 12, 1870, pp. 2–3 (reprinted in Pitman 1989, pp. 102–3); Cham [Amédée, comte de Noé], *Cham au Salon de 1870* (Paris: Arnauld de Vresse, 1870), p. 4; Poulain 1932, pp. 147, 152–53, 171, 176–78, 218, no. 36; "A Painting by Bazille," *Bulletin of the Fogg Museum of Art* 7 (November 1937), p. 15, repr.; Ernst Scheyer, "Jean Frédéric Bazille—The Beginnings of Impressionism, 1862–1870," *Art Quarterly* 5 (Spring 1942), pp. 127–28, repr. p. 124; Gabriel Sarraute, "Deux dessins de Frédéric Bazille au musée du Louvre," *Musées de France*, no. 4 (May 1949), pp. 91–93; Bernard Dorival, "'La scène d'été' de Bazille et Cézanne," *Musées de France*, no. 4 (May 1949), pp. 94–96; Daulte 1952, pp. 76–77, 80, 133–34, 154, 184, no. 44, repr.; Champa 1973, pp. 88–90, pl. 23; Rewald 1973, p. 232, repr. p. 234; Caroline A. Jones, *Modern Art at Harvard: The Formation of the 19th- and 20th-Century Collections of the Harvard University Art Museums* (New York and Cambridge, Mass., 1985), pp. 30, 32, 52, 53, fig. 15; Pitman 1989, pp. 89–90, 96–120, 130–31, 141, 149–53, 155–57, 160, 183, 188–90, fig. 3; Thérèse Dolan, "Frédéric Bazille and the Goncourt Brothers' *Manette Salomon*," *Gazette des Beaux-Arts* 115 (February 1990), p. 101, fig. 3; Bazille 1992, nos. 119, 121, 122, 123, 137, 138.

Undeterred by the refusal of *Le Pêcheur à l'épervier* (cat. 10) at the 1869 Salon, Bazille conceived a large canvas with not just two figures, but seven; in its final form there is an additional clothed figure in the background, to which he later added two more at the right. He envisioned a favorite site on the banks of the Lez, near Méric, and a large square canvas, a format he would return to for *La Toilette* (cat. 13). His letters show that he intended the painting as a picture of nudes, that it was conceived and begun in Paris in April 1869, and that it was elaborated out-of-doors once he had arrived in the south: "I am working [in Paris] on my Méric painting, and hope to continue during the first two weeks of May";[1] "I will not waste my time until then, I am drawing my figures in advance for the painting of the male nudes that I am proposing to do at Méric."[2] His preparatory drawings show the man standing at left wearing a bathing suit, but the rest of the figures are nude. The painting remained with his parents in Montpellier until November 1869, when he asked them to unstretch it, roll it, and send it to him in Paris, along with "the study of the child in the water."[3] Bazille did not originally include the two figures at the extreme right, which, as Colin Bailey recently underlined, are painted over the landscape.[4] But it is not known whether they were added at Méric or in Paris, out-of-doors or in the studio. He sent the canvas out to be reinforced in December 1869,[5] and as a result it does not appear in *L'Atelier de la rue La Condamine* (cat. 12).

Thérèse Dolan has proposed that the subject may have been prompted by a reading of *Manette Salomon*, published in 1867 by the Goncourts.[6] They wrote a passage in which one of the protagonists, Anatole, goes bathing at Asnières. The scene is set with "the open air free and vibrant, the reflection of the water, the sun glancing on the head, the shimmering blaze of all that is stunning and dazzling in these slippery walks.... In the water, mischievous children with small bodies, thin and graceful, move forward, smiling and shivering, creating in front of them a reflection of flesh on the ripples of the stream."[7] Yet the Goncourts were only describing something which Bazille himself had surely witnessed countless times, and they portrayed it in the manner in which the young painters were already depicting modern life. In some respects, *Scène d'été* is the masculine version of Monet's *Femmes au jardin* (cat. 130), but with an important difference. The conscious references to previous paintings—to Bassano's *Saint Sebastian* at Dijon, to de La Hire's *Paysage au joueur de flûte* (*Landscape with a Flute Player*) at the Musée Fabre, to Marcantonio Raimondi's river god, to Courbet's *Lutteurs* (*Wrestlers*)—seem to reflect an attempt by Bazille to emulate Manet's method. Manet, unlike Monet, often framed his portrayal of modern life within the context of the art of the great ancients. And it was just before this time that Manet replaced Monet as Bazille's mentor. After all, it is Manet, and not Monet, who appears at the center of *L'Atelier de la rue La Condamine*, and it was Manet who was given the privilege of painting the figure of Bazille in the picture of the studio (see cat. 12).

Zacharie Astruc addressed the quotations from the old masters in his extensive review of *Scène d'été* at the Salon. "Bazille sets up his easel in direct sunlight to paint under the magical effects of daylight. There is an abyss between old and new. Has the nude been abandoned? Is style less important?—not at all—but now painters seek it in real life, in close contemplation of all that is,

Fig. 396. Amédée, comte de Noé, called Cham, "163. M. Bazille. Se jetant à l'eau dans l'espoir de se débarrasser de la couleur que le peintre leur a mis dessus" (Jumping into the water in the hope of getting rid of the color with which the painter had colored them). Caricature from *Cham au Salon de 1870* (Paris: Arnauld de Vresse, 1870), p. 4

that shines forth, that strikes us and moves us. The true spirit of the past returns. Doesn't Corot follow the great tradition with his *Toilette*? He and Giorgione (think of the *Concert*) could go hand in hand. Thus, the old feeling that captivated us in the work of the masters—who associated dream with nature, the beautiful with the true—is here again: the figure lives in a breathable air, and all the charming, lovable, terrible or unexpected aspects of the exterior world impress the artist. That is the good tradition—as opposed to another expressing itself only with lies, memories or copies. Is not art a fixed, captured picture of all we see and all that moves us, a personal tracing (thus diverse and existing in the strength of our imagination)?

"In Bazille's *Baigneurs*, as in the painting he exhibited last year (a woman seated in a landscape), I find qualities of a first-rate hand. These qualities certainly announce one of the most original painters of our time. If he concentrates on form and finds its purity—at least the greatest truth which is the real style, in my opinion—if he changes his still somewhat rigid manner and gives nature the flexibility it always possesses, he will create very remarkable pages. Bazille has already mastered one element: an amazing comprehension of light—the particular impression of the open air, the power of daylight. Sun floods his canvases. In *Baigneurs*, the meadow is as though on fire. It is happy, it sings and plays. The eye feasts. We shall notice finesse in the shades of flesh, the two small wrestlers in the sun and the man dressing near the trees, in the comforting heat of a beautiful summer afternoon."[8]

Edmond Duranty appreciated that Bazille's picture was "full of greenery, of sunlight, and of simple strength," but he criticized him and other artists for not having "mastered their trade more rigorously, but I am grateful to them for their attempts to deliver us from the usual studio products."[9] Bertall published an amusing cartoon in which one of the bathers reaches outside of the painting to take a drink from a waitress in a painting by Chaplin. The legend reads, "Miss, be kind enough to pass us a little glass, which will give us some color. We really need it!"[10]

Another cartoon has recently come to light (fig. 396). In it Cham refers to the strong color of Bazille's palette.[11]

G.T.

1. "Je travaille à mon tableau de Méric, et j'espère bien le continuer dans la première quinzaine de mai." Bazille to his father, April 1869, Bazille 1992, no. 120, p. 173.
2. "je ne perdrai pas mon temps d'ici là, je dessine d'avance mes personnages pour le tableau d'hommes nues que je me propose de faire à Méric." Bazille 1992, no. 121, p. 174.
3. "l'étude de l'enfant dans l'eau." Bazille 1992, no. 123, p. 176.
4. Colin Bailey, "The Astonishing Fullness of Light," *Apollo* 137 (March 1993), p. 185.
5. "mon grand tableau qui est enfin arrivé de rentoilage" (my large canvas has finally arrived from being reinforced). January 1, 1870, Bazille 1992, no. 127, p. 182.
6. Thérèse Dolan, "Frédéric Bazille and the Goncourt Brothers' *Manette Salomon*," *Gazette des Beaux-Arts* 115 (February 1990), pp. 99–103.

7. "le plein air libre et vibrant, la réverbération de l'eau, le soleil dardant sur la tête, la flamme miroitante de tout ce qui étourdit et éblouit dans ces promenades coulantes.... Dans l'eau, des gamins d'enfants, de petits corps grêles et gracieux, avançaient, souriants et frissonnants, penchant devant eux un reflet de chair sur les rides de courant." Goncourt 1867, pp. 110–11.

8. "Bazille dresse son chevalet en plein soleil pour s'exercer aux magiques effets du jour. Il y a des abîmes entre les vocations anciennes et les nouvelles. A-t-on délaissé le nu? Se préoccuperait-on moins du style—pas du tout; —mais on le cherche dans la vérité de la vie, dans l'intime contemplation de ce qui est, qui brille à nos yeux, qui nous frappe et nous émeut. Le véritable esprit du passé revient. Corot n'est-il pas dans la grande tradition lorsqu'il nous peint sa *Toilette*? Lui et Giorgione (songer au *Concert*) peuvent se donner la main. Ainsi, nous retrouvons l'antique sentiment qui nous subjugue chez les maîtres—parce que chez eux le rêve s'associe à la nature, le beau au vraie—que la figure vit dans l'air respirable, que l'artiste est frappé par tout ce que le monde extérieur a de charmant, d'aimable ou de terrible, d'imprévu. Voilà la bonne tradition—et non l'autre qui ne s'exprime que par des mensonges, des souvenirs ou des copies. L'art, n'est-ce pas la vie fixée, retenue,—le calque personnel (par conséquent varié et dans la force de notre imagination) de ce que nous voyons, de ce qui nous émeut?

"Dans le *Baigneurs*, de Bazille, comme dans son tableau exposé l'année dernière (une femme assise dans un paysage), je trouve des qualités de première main. Elles nous promettent bien certainement un des peintres le plus particuliers de l'époque. S'il veut s'appliquer à la forme et la trouver dans sa pureté—au moins dans le mieux du vrai, qui est le véritable style, à mon avis—s'il s'observe dans son moyen encore un peu dur et donne à la nature la souplesse qu'elle a toujours, il créera des pages bien remarquables. Bazille est déjà maître d'un élément qu'il a conquis: la plénitude étonnante de la lumière—l'impression particulière du plein air, la puissance du jour. Le soleil inonde ses toiles. Dans les *Baigneurs*, la prairie en est comme incendiée. Cela est gai, cela chante et joue. L'oeil a bien vu. On remarquera la finesse des gammes dans les chairs, les deux petits lutteurs, au soleil, et l'homme en train de s'habiller, là-bas, contre les arbres, dans la réjouissante chaleur d'une belle après-midi d'été." Zacharie Astruc. "Le Salon de 1870," *L'Écho des Beaux-Arts*, June 12, 1870, pp. 2–3 (reprinted in Pitman 1989, pp. 102–3).

9. "pleins de verdure, de soleil et de carrure simple": "maîtriser plus rigoureusement leur métier, mais je leur suis reconnaissant de ce qu'ils tentent de nous délivrer des éternelles sauces d'atelier." Edmond Duranty. "Salon de 1870," *Paris-Journal*, May 19, 1870, p. 2 (reprinted in Pitman 1989, p. 97).

10. "Mademoiselle, soyez donc assez aimable pour nous passer un petit verre, ça nous donnera du ton. Nous en avons bien besoin!" Bertall. "Promenade au Salon de 1870," *Journal amusant*, May 28, 1870, p. 2 (reprinted in Pitman 1989, p. 99).

11. Thanks to Anne M. P. Norton for bringing this cartoon to my attention.

12 *Fig. 355*

Frédéric Bazille
L'Atelier de la rue La Condamine
(*The Studio in the rue La Condamine*)
1869–70
Oil on canvas
38⅝ x 50⅝ in. (98 x 128.5 cm)
Signed and dated lower right: *F. Bazille, 1870*
Musée d'Orsay, Paris RF 2449

CATALOGUE RAISONNÉ: Daulte 1992, no. 56

PROVENANCE: Family of the artist; the artist's brother, Marc Bazille (1845–1923), Montpellier; his bequest to the Musée du Luxembourg, in 1924; Louvre, 1931; Jeu de Paume, 1947; Musée d'Orsay, 1986

EXHIBITIONS: Paris 1910, no. 21; Montpellier 1927, no. 27; Montpellier 1941, no. 35, repr.; Paris, Musée du Louvre, 1976, *Technique de la peinture, l'atelier*, no. 163, repr.; Chicago 1978, no. 51, repr.

SELECTED REFERENCES: André Joubin, "Frédéric Bazille et ses tableaux légués aux Musées nationaux," *Les Beaux-Arts: Revue d'information artistique* 2 (April 15, 1924), p. 119, repr.; Georges Charensol, "Frédéric Bazille et les débuts de l'impressionnisme," *L'Amour de l'art* 8 (January 1927), pp. 27–28, repr. p. 27; Henri Focillon, *La peinture au XIXe et XXe siècles du réalisme à nos jours* (Paris: Renouard, 1928), p. 212, repr.; Poulain 1932, pp. 179–80, 219, no. 40; Daulte 1952, pp. 131–33, 144–45, 186–87, no. 48, repr.; Rewald 1973, p. 234, repr. p. 235; Pierre Georgel and Anne Marie Lecoq, in Musée des Beaux-Arts de Dijon, 1982–83, *La Peinture dans la peinture*, p. 148, fig. 266; Pitman 1989, pp. 141–54, 214, fig. 5; Bazille 1992, nos. 125, 127, 134; Pascal Bonafoux in Montpellier, Brooklyn, Memphis 1992–93, pp. 46–47, fig. 19

As Bazille announced in his letter of December 1869, he had begun "the interior of my studio."[1] On New Year's Day he wrote, "I have had to interrupt my letter because two painters just arrived to see my painting which finally returned from being relined [*Scène d'été*]. They are even now complimenting me highly for it. I have been amusing myself recently with painting the interior of my studio with my friends. Manet is helping me with it, and I may send it to the exhibition in Montpellier. This painting has delayed the one I am going to do for the Salon, but I am working hard and it won't take very long to complete."[2]

Thus Manet painted Bazille receiving compliments on his *Vue du village* (cat. 9), while Bazille painted Manet and Astruc looking at his painting *Vue du village* on the easel (some identify the figure next to Manet as Monet), Renoir on the stairs speaking to Sisley below, and Edmond

Maître at the piano. Bazille shared this studio at 9, rue La Condamine with Renoir, and the gilt-framed painting above the pink slipcovered couch is a Renoir which was probably the painting rejected by the Salon of 1866 and now survives only as a fragment of the dressed woman seated at left. High at the left is Bazille's *Pêcheur à l'épervier* (cat. 10), just above the couch is the incomplete *Toilette* (cat. 13), the *Tireuse de cartes* (*Fortune-Teller*) is under the window, and *La Terrasse de Méric* (fig. 173) is above the piano. Monet's *Fruits* (1867, Wildenstein 102) hangs under the Renoir, and Bazille's *Aigues-Mortes* (cat. 5) is just above *La Toilette*.

The amiable and gracious Bazille rendered his studio as it was: a place for his friends to gather and to work. Marandel sees a reference to Courbet's great *Atelier du peintre*,[3] but Georgel aptly saw the contrary. "The studio no longer is an imposing theater fit for the display of eternal truths, as it still was in Courbet's work; it is part of the rhythm of modern life as it was perceived in the second half of the nineteenth century, discontinued, incomplete, precarious. Yet, as it shares the fragility of that experience, it also shares its qualities: a joy of living irremediably linked with the pleasure of painting characteristic of early Impressionism."[4] Indeed the informality of this work acts as a realist antidote to the stiff formality of Fantin-Latour's *Atelier aux Batignolles* (cat. 74) for which Bazille was simultaneously posing.[5]

G.T.

1. "l'intérieur de mon atelier." Bazille 1992, no. 125, p. 178.
2. "Je viens d'interrompre ma lettre parce que deux peintres viennent arriver pour voir mon tableau qui est enfin arrivé de rentoilage. Ils me font en ce moment même de grands compliments. Je me suis amusé jusqu'ici à peindre l'intérieur de mon atelier avec mes amis. Manet m'y fait moi-même, je l'enverrai à l'exposition de Montpellier. Ce tableau a retardé celui que je vais faire pour le Salon, mais je m'y mets et il ne sera très long à faire." Bazille to his father, January 1, 1870. Bazille 1992, no. 127. Translation by Paula Prokopoff-Giannini in Chicago 1978, p. 182.
3. J. Patrice Marandel in Chicago 1978, p. 107.
4. "L'atelier n'est plus ce théâtre imposant, fait pour des vérités éternelles, qu'il était encore chez Courbet; il participe au rhythme de l'existence moderne tel que l'a ressentie cette seconde moitié du XIXe siècle discontinu, incomplet, précaire. Mais comme il partage la fragilité de cette expérience, il en partage aussi la saveur: la douceur de vivre, indissociable du plaisir de peindre, si caractéristique de l'impressionnisme à ses débuts." Pierre Georgel, in Paris, Musée du Louvre, 1976, *Technique de la peinture, l'atelier*, p. 48.
5. Bazille 1992, no. 130 (between January 13 and January 19, 1870), p. 84.

13 *Fig. 154*

Frédéric Bazille
La Toilette
(*The Toilette*)
1869–70
Oil on canvas
52 x 50 in. (132 x 127 cm)
Signed and dated lower left: *F. Bazille, 1870.*
Musée Fabre, Montpellier 18.1.2

Catalogue raisonné: Daulte 1992, no. 55

Provenance: Family of the artist; the artist's brother Marc Bazille, Montpellier; his gift to the museum, 1918

Exhibitions: Refused from the Salon of 1870; Paris, Exposition Universelle of 1900, no. 23; Paris 1910, no. 20; Paris, Musée de l'Orangerie, March–April 1939, *Les Chefs-d'oeuvre du Musée de Montpellier*, no. 7; Montpellier 1941, no. 36; Paris 1950, no. 53, repr.; Montpellier 1959, no. 35; Chicago 1978, no. 54, repr.; Montpellier, Brooklyn, Memphis 1992–93, no. 26, repr.

Selected references: André Joubin, *Catalogue des peintures et sculptures exposées dans les Galeries du Musée Fabre de la ville de Montpellier* (Paris, 1926), no. 364; Gaston Poulain, "Un Languedocien—Frédéric Bazille," *La Renaissance de l'art français et des industries de luxe* 10 (April 1927), p. 163; Henri Focillon, *La peinture au XIXe et XXe siècles du réalisme à nos jours* (Paris: Renouard, 1928), p. 212; Poulain 1932, pp. 102, 171–76, 179–80, 219, no. 41; Daulte 1952, pp. 80, 146, 150, 154, 187–88, no. 50, repr.; Champa 1973, p. 90, fig. 127; Rewald 1973, repr. p. 253; Hugh Honour, *The Image of the Black in Western Art*, vol. 4, pt. 1 of *From the American Revolution to World War I: Black Models and White Myths* (Cambridge, Mass., and London, 1989), p. 206, fig. 155; Pitman 1989, pp. 120–32, 135, 136, 137, 141, 142, 150, 151, 153, 155, 156, 201, fig. 49; Bazille 1992, nos. 125, 130, 133, 134, 137, 138

By December 1869, Bazille had prepared his strategy to gain acceptance at the 1870 Salon. He wrote his father, "I have begun to work on the following: 1st, the interior of my studio [cat. 12], 2nd, the portrait of Blau [disappeared?], and 3rd, a female nude for the Salon [*La Toilette*]. This will keep me busy all winter."[1] Shortly after January 10, 1870, he wrote his mother that he had begun working on *La Toilette*. "My friends have given me all sorts of compliments on my painting [presumably *Scène d'été* (cat. 11)]. Nevertheless it would not be surprising if it were rejected or at least badly placed. I am starting another which I think will be accepted; it is however very difficult to do. There are three women, one of whom

is entirely nude, another nearly so. I have found a ravishing model who is going to cost me an arm and a leg; 10 francs a day plus bus fare for her and for her mother who accompanies her."[2]

Bazille was then working in the studio that he depicted in *L'Atelier de la rue La Condamine* (cat. 12). *La Toilette* can be seen roughly sketched on a canvas hanging on the wall. It is not known whether the canvas depicted in that picture is an early state of the present picture or an ébauche that has not survived. Only two figures are visible in the sketch, but in Bazille's squared-up preparatory drawing (Musée du Louvre, Paris) for *La Toilette* there are only two figures. The third figure (on the right) appears as an idea in the margin of that drawing. What seems certain is that Bazille conceived *La Toilette* with only two figures, and that he had decided on including a third by the time he wrote his mother in January. Most scholars agree that the third figure was posed by Lise Tréhot, Renoir's companion and model. It is thought that the pose of the black servant was borrowed from Veronese's *Mystic Marriage of Saint Catherine* (Musée du Louvre), which Bazille copied.

Bazille's letters make clear that the painting was intended to please the jurors of the Salon. He hoped to ingratiate himself by appealing to the taste for Orientalism that had made Jean-Léon Gérôme president of the jury. As a strategy, it had much to recommend it. It enabled a painter to paint nudes, to depict elaborate decors and rich fabrics, to demonstrate his ability to render flesh, fur, silk, and satin. The strategy worked well for Bazille's friend Renoir, whose *Odalisque* (National Gallery of Art, Washington) was accepted, and for Henri Regnault, whose *Salome* (Metropolitan Museum of Art) was the sensation of the Salon. But oddly enough, Bazille's *Toilette* was rejected, while his more "modern" *Scène d'été* (cat. 11) was accepted. Bazille could not understand it. Indeed, when he first heard that the *Scène d'été* had been admitted, he assumed that *La Toilette* had been as well. He wrote his mother, "But in reality I had only one accepted: *The Bathers*. It seems that there was an error made and that I was given the wrong information. This is going to annoy you; as for me, you know what I've thought of the jury for a long time now."[3] Bazille explained further to his brother that "all the members of the jury who spoke to me about the bathers had not seen it. I strongly suspect that it was forgotten."[4]

Perhaps there was a procedural error. Yet Bazille did not realize that Renoir's overt appeal to Delacroix and Regnault's overt appeal to eroticism would gain favor, but that his frank reference to Manet would bring him problems. As Bazille himself observed in 1869, "Except for Manet whom they no longer dare reject...there is real animosity directed against us. The fault lies entirely with Mr. Gérôme,...saying that he felt it his duty to keep our paintings from being shown."[5] If Gérôme excused Bazille's Courbet-inspired bathers, he certainly would have con-

demned his dance with Manet's painterly style, particularly when it represented an excursion into his own Orientalist territory.

G.T.

1. "je me suis mis au travail, je fais 1. l'intérieur de mon atelier, 2. le Portrait de Blau et 3. Une femme nue pour le Salon. J'en ai pour tout l'hiver." Bazille to his father, end of 1869, Bazille 1992, no. 125, p. 178. Translation of this letter and the ones quoted in notes 2–5 are by Paula Prokopoff-Giannini in Chicago 1978, pp. 178–83.
2. "J'ai reçu toutes sortes de compliments pour mon tableau, de mes amis. Cependant, il ne faudrait pas s'étonner qu'il fût refusé ou du moins très mal placé. J'en commence une autre qui sera reçu, je pense quoique bien difficile à faire. Il y a trois femmes dont l'une entièrement nue et une autre presque. J'ai trouvé un modèle ravissant mais qui va me coûter les oreilles (dix francs pas jour plus l'omnibus pour elle et pour sa mère qui l'accompagne)." Bazille to his mother, January 13–19, 1870, Bazille 1992, no. 130, p. 185.
3. "Et voici que je n'en ai qu'un de reçu: *Les Baigneurs*. Il y a eu erreur à ce qu'il paraît et j'étais mal informé. Cela va vous ennuyer, pour moi tu sais ce que je pense du jury depuis longtemps." Bazille to his mother, April 27, 1870, Bazille 1992, no. 137, p. 191.
4. "Tous les membres du jury qui m'ont parlé des baigneurs ne l'avaient pas vu. Je crois très fort qu'il a été oublié." Bazille to his brother, May 2 or 3, 1870, Bazille 1992, p. 192.
5. "A part Manet qu'on n'ose plus refuser...il y a contre nous une vraie animosité. C'est M. Gérôme qui a fait tout le mal,...et déclaré qu'il croyait de son devoir de tout faire pour empêcher nos peintures de paraître." Bazille to his father, April 19, 1869, Bazille 1992, no. 119, p. 172.

14 *Fig. 282*

Frédéric Bazille
Négresse aux pivoines
(*African Woman with Peonies*)
1870
Oil on canvas
23⅝ x 29½ in. (60 x 75 cm)
Signed and dated lower left: *F. Bazille, 1870*
Musée Fabre, Montpellier 18-1-3

Catalogue raisonné: Daulte 1992, no. 59

Provenance: Family of the artist; the artist's brother, Marc Bazille, Montpellier; his gift to the museum, 1918

Exhibitions: Paris 1910, no. 22; Montpellier 1927, no. 29; Paris, Musée de l'Orangerie, March–April 1939, *Les Chefs-d'oeuvre du Musée de Montpellier*, no. 8; Montpellier 1941, no. 34; Paris 1950, no. 54, repr.; Montpellier 1959, no. 36; Bordeaux 1974, no. 87, repr.; Chicago 1978, no. 55, repr.; Philadelphia, Detroit, Paris 1978–79, no. VI-4, repr.; Montpellier, Brooklyn, Memphis 1992–93, no. 27, repr.

SELECTED REFERENCES: André Joubin, *Peintures et sculptures exposées dans les galeries du musée Fabre de la ville de Montpellier* (Paris, 1926), no. 365; Poulain 1932, pp. 176, 218–19, no. 39; Daulte 1952, pp. 78, 129, 188, no. 51, repr.; Hugh Honour, *The Image of the Black in Western Art*, vol. 4, pt. 1 of *From the American Revolution to World War I: Black Models and White Myths* (Cambridge, Mass., and London, 1989), p. 206, fig. 154; Pitman 1989, pp. 131, 135–41, 151, fig. 61

At some point in early 1870, Bazille, working in Paris, painted two versions of a composition depicting a black servant with flowers on identical canvases (see also fig. 397). In each the pretext was to demonstrate his real facility in painting flowers as well as to show off the handsome model he had found for his ambitious figure painting *La Toilette* (cat. 13). Courbet (cat. 41) and Degas (cat. 57) had recently developed genre paintings in which women and flowers were vying for pictorial supremacy, but here Bazille, without any apparent irony, refers directly to the famous flower-bearing servant in Manet's *Olympia* (cat. 95). The present painting is surely the second, improved version, for here the light strikes on the diagonal, allowing for a more convincing spatial recession and providing the opportunity to manipulate the highlights and shadows to provide greater relief.

Sarraute suggests that these pictures may be related to Bazille's mention of his desire to paint a flower picture for his sister-in-law Suzanne.[1] "I will certainly do the flowers I promised Suzanne, but I can't even think of starting before March 20th, when I will send off my new canvas to the Salon."[2]

G.T.

1. See Pitman in Montpellier, Brooklyn, Memphis 1992–93, p. 123.
2. "Je ferai certainement les *Fleurs* que j'ai promises à Suzanne mais je ne puis songer à m'y mettre avant le 20 mars, époque où j'enverrai ma toile nouvelle au Salon." Bazille to his mother, January 13–19, 1870, Bazille 1992, no. 130, p. 185. Translation by Paula Prokopoff-Giannini in Chicago 1978, p. 183.

15 *Fig. 100*

Frédéric Bazille
Paysage au bord du Lez
(*Landscape*)
1870
Oil on canvas
54½ x 79½ in. (138.4 x 201.9 cm)
Signed and dated lower left: *F. Bazille, 1870*
Lent by The Minneapolis Institute of Arts, Special Arts Reserve Fund 69.23

CATALOGUE RAISONNÉ: Daulte 1992, no. 64

PROVENANCE: Family of the artist; the artist's brother, Marc Bazille (1845–1923), Montpellier; by descent to his son Frédéric Bazille, Montpellier; Galerie Louis Carré, Paris; Wildenstein and Co., Paris; Walter P. Chrysler, Jr., New York, by 1960; Minneapolis Institute of Arts, 1969

EXHIBITIONS: Montpellier 1927, no. 31; Montpellier 1941, no. 38; Paris 1950, no. 66, repr.; Dayton Art Institute, March 25–May 22, 1960, *French Paintings 1789–1929 from the Collection of Walter P. Chrysler, Jr.*, no. 53, repr.; Minneapolis Institute of Arts, July 3–September 7, 1969, *The Past Rediscovered: French Paintings 1800–1900*, no. 1a, repr.; Chicago 1978, no. 59, repr.

SELECTED REFERENCES: Poulain 1932, pp. 181, 220, no. 43; Charles Descossy, *Montpellier, berceau de impressionnisme: Corot, Courbet, Bazille et la campagne montpelliéraine* (Montpellier, 1933), p. 27; Daulte 1952, p. 81, n. 1, pp. 113, 189, no. 55, repr.; Daulte 1970, p. 87, repr.; *Catalogue of European Paintings in the Minneapolis Institute of Arts* (New York, Washington, and London, 1971), pp. 193–94, no. 101, repr.; Pitman 1989, pp. 187–90, fig. 68; Bazille 1992, no. 140

This is Bazille's last work and largest known landscape. Whether he intended it for the Salon of 1871—as the scale would suggest—is unknown. He died in combat in the Franco-Prussian War on November 28, 1870.

Bazille began the painting in Montpellier sometime in June 1870 and finished it just before he left to join the Third Regiment of Zouaves, on August 16, 1870.[1] In a letter to his father in June 1870, he wrote: "I have started a large landscape which is beginning to take shape,"[2] and barely two months later, in a letter of August 2, 1870, to Edmond Maître, he declared, "I have almost finished a large landscape (eclogue)."[3] Away from the distractions of Paris Bazille was able to finish his landscape in record time. He told Maître that "I am completely alone in the country. My cousins and my brother are at the resort; my father and my mother are living in town. This solitude pleases me enormously; it makes me work a lot, and read a lot."[4]

Thanks to a letter annotated by the artist's brother Marc, the spot around Montpellier where Bazille painted his landscape can be pinpointed: "the banks of the Lez near the mill at Navitau on the road to Clapiers."[5] He successfully captured on canvas the appearance of the south, with its particular vegetation and its intense light, and with contrasts similar to those in paintings by Paul Guigou, the quintessential Provençal painter of the 1860s. Indeed, this work is a far cry from his first wooded landscapes done some five years earlier, *Lisière de forêt à Fontainebleau* (*Edge of the Forest at Fontainebleau*; Louvre, Paris; Daulte 11) and *Paysage à Chailly* (cat. 3).

Pitman speculates that Bazille may have intended to add figures to his unpopulated landscape, citing the compositional strategies of *Scène d'été* (cat. 11) and *Lauriers roses* (*Oleanders*, 1867; Cincinnati Art Museum; Daulte 29) as precedents.[6] Yet this seems unlikely. Bazille wrote that the painting was virtually finished on August 2, 1870, and two weeks later he enlisted in the army. This painting, among his most successful, can easily stand as a pure landscape.

G.T.

1. See *Registre matricule de la troupe, 3eme régiment de Zouaves*, vol. 26 (1870–71), no. 9465; a photocopy of this is in the Musée d'Orsay, documentation des peintures.
2. "J'ai commencé un grand paysage qui commence à prendre tournure." Bazille to his father, June 1870, Bazille 1992, no. 140.
3. "J'ai fini à peu près un grand paysage (églogue)." Daulte 1952, p. 81, n. 1.
4. "je suis absolument seul à la campagne. Mes cousines et mon frère sont aux eaux, mon père et ma mère habitent la ville. Cette solitude me plaît infiniment; elle me fait beaucoup travailler, et beaucoup lire." Daulte 1952, p. 81, n. 1.
5. "bords du Lez près le Moulin à Navitau route de Clapiers." Bazille 1992, p. 194, n. 2.
6. Pitman 1989, p. 189.

Fig. 397. Frédéric Bazille, *Négresse aux pivoines (African Woman with Peonies)*, 1870. Oil on canvas, 23⅝ x 29⅛ in. (60 x 74 cm). National Gallery of Art, Washington, Collection of Mr. and Mrs. Paul Mellon

François Bonvin
Vaugirard, 1817–Saint-Germain-en-Laye, 1887

Bonvin, born into very modest circumstances, had a harsh and unstable childhood—his father was a policeman, his mother a seamstress. His artistic vocation was thwarted early on by the need to earn his living, which he did with various insignificant jobs: clerk at the Vaugirard city hall, printer's apprentice, temporary civil servant for hospitals and prisons at the prefecture. During the 1840s he managed to establish himself as a painter. He enrolled at the Académie Suisse in 1843, met Courbet and Jules Champfleury as well as Théophile Gautier and François-Marius Granet, and frequented the Brasserie Andler. In 1847 he submitted a portrait to the Salon and was accepted for the first time; then in 1850, his *L'École des orphelins* (*The Orphans' School*; Musée du Breuil de Saint-Germain, Langres), a government commission, won a second-class medal, the highest distinction he ever received. During the Second Empire his still lifes and genre scenes, inspired by Chardin and the Dutch, gained him a succès d'estime but not fame or fortune. He was receptive to the young realist artists and in 1859 made his "Atelier flamand" available for an exhibition of some of the rejected artists: Fantin, Whistler, Legros (see p. 19). Ten years later, tired of the repeated unfairness of the Salon, he complained: "For twenty years now we have been humiliated, violated, decorated, awarded medals, and sometimes even somewhat dishonored by all sorts of directors, senators, art lovers, and inspectors of the fine arts; what use have they made of their power and influence?"[1] He demanded the elimination of the jury, the establishment of compensation, and a return to the "Free Exhibition of 1848."

1. "Voici bientôt vingt ans que nous sommes humiliés, molestés, médaillés, décorés et parfois même un peu déshonorés par toutes sortes de directeurs, de sénateurs, d'amateurs et d'inspecteurs des beaux-arts; quel emploi ont-ils faits de leur pouvoir et de leur influence?" François Bonvin, "Peinture, le prix annuel de quatre mille francs," *Le Figaro*, June 21, 1869, pp. 2–3.

16 *Fig. 189*

François Bonvin
Nature morte aux huîtres
(*Still Life with Lemon and Oysters*)
1858
Oil on canvas
29½ x 33 in. (75 x 83.8 cm)
Signed and dated lower right: F. Bonvin, 1858
Joey and Toby Tanenbaum, Toronto, Ontario, Canada

CATALOGUE RAISONNÉ: Weisberg 1979, no. 6

PROVENANCE: Galerie Huinck in Scherjoon, Amsterdam, no. 1019; sale, Sotheby's, London, April 13, 1972, no. 6; Galerie André Watteau, Paris; Shickman Gallery, New York; Mr. and Mrs. Joey Tanenbaum, Toronto, 1972

EXHIBITIONS: Ottawa, National Gallery of Canada, 1978, *Un autre xixe siècle: Peintures et sculptures de la collection de M. et Mme J. M. Tanenbaum*, no. 8; New York, Wheelock Whitney & Company, 1984, *François Bonvin*, no. 6

With Théodule-Augustin Ribot and Antoine Vollon as close seconds, Bonvin was the leader in the renewal of the still life during the 1860s. At the Salon during the preceding decade he had shown smooth, precise canvases, often marked by violent contrasts of light and shadow. Taking over Chardin's simple compositions, which were limited to a few everyday objects, Bonvin resisted, sometimes ostentatiously, any decorative temptation. His predilection for thick, sharply creased white tablecloths and glass objects that captured reflections of light had its roots in Dutch art. The lesson was not lost on Manet; taking in his turn from Chardin and the Dutch as well as the Spanish, he offered comparable arrangements, though freer, with the large flat color areas he was often reproached for and without Bonvin's overniceties or his labored gloom.

H.L.

Eugène Boudin
Honfleur, 1824–Deauville, 1898

Boudin was born on the Normandy coast and remained faithful to his native province throughout his long life. He was attracted to art at the age of twelve, when he began to work in a stationery shop. The shopkeeper, Lemasle, gave him instruction, and Boudin remained there until he was eighteen, when he set up a shop of his own to cater to artists including Troyon, Isabey, Cou-

ture, and Millet. In 1846 he bought himself a replacement so as to avoid military service. From 1847 to 1848 most of his time was spent in Paris. He was again in Paris from 1851 to 1854 for formal study, financed by a grant from the municipality of Le Havre. Although much of his early work is lost, it appears it was in Paris that he made still lifes of fish and game inspired by Dutch and Flemish painting of the seventeenth century and by French painting of the eighteenth century. In this effort he was encouraged by his friend Théodule Ribot. Back in Le Havre, he met Claude Monet in 1858 and began to act as his mentor. He befriended Courbet around 1859 and Jongkind in 1862. Boudin's first acceptance at the Paris Salon was in 1859: *Le Pardon de Sainte-Anne-Palud au fond de la baie de Douarnenez (Finistère)*, like much of his work in the late 1850s, was indebted to the style of the Barbizon school. Boudin exhibited at the Salon in 1863, 1864, 1865, 1866, 1867, 1868, 1869, and 1870. Based mostly along the Channel coast throughout the 1860s, he also traveled extensively in France.

17 *Fig. 219*

Eugène Boudin
Gerbe de fleurs
(*Hollyhocks*)
Ca. 1858–62
Oil on canvas
23½ x 18¼ in. (59.7 x 46.4 cm)
Signed lower left: *E. Boudin*
Mrs. John Hay Whitney

CATALOGUE RAISONNÉ: Schmit 1973–93, vol. 1, no. 210

PROVENANCE: Painted for Legris family of Fécamp, Normandy, ca. 1858–62, until 1957; bought by Wildenstein and Co., Paris, 1957, transferred to their New York branch by February 1958; sold to the Hon. John Hay Whitney, New York, March 28, 1958; Whitney Collection, New York, 1958–82; to the present owner

EXHIBITIONS: London, Tate Gallery, December 16, 1960–January 29, 1961, *The John Hay Whitney Collection*, no. 5, repr.; Washington, National Gallery of Art, May 29–September 5, 1983, *The John Hay Whitney Collection*, no. 2, repr.

SELECTED REFERENCES: Rewald 1973, p. 113, repr.

Still lifes are relatively uncommon in Boudin's oeuvre, and flower pieces are even more rare. Bergeret-Gourbin counts only sixty-five still lifes among the artist's fecund production, and Manoeuvre speculates that these still lifes more likely reflect the tastes and interests of Boudin's patrons—actual or perceived—than those of the artist.[1] Boudin thought of his still lifes as "dining-room paintings,"[2] and this attitude is reflected in his practice of sending landscapes, marines, and genre scenes to the Paris Salon, while sending still lifes to provincial exhibitions.

Rewald has reported that this painting and its pendant (Mrs. John Hay Whitney Collection) were, according to family tradition, given to friends named Legris. It is not known when the pictures were painted, but Rewald has pointed to the similarities with Monet's 1864 flower painting (cat. 115) and suggested that Boudin may have made his pair at the same time.[3] It is evident from Monet's letters that there was indeed great commonality of spirit at this time: "Jongkind and Boudin are here, we are all getting along very well, and we spend all our time together. Ribot will probably come."[4] In this same letter, Monet told of his pleasure in making flower paintings and urged Bazille to do the same.

Nevertheless, there are significant differences to note. Monet's painting has greater specificity and realism, whereas Boudin's retains old-masterish artifice, including glowing colors that seem by contrast to be artificial. The comparison is somewhat unfair because Monet's picture was destined for public exhibition, while Boudin's may only have been intended as decoration for a private house. But the similarities in handling and the rich colors set off by a neutral ground may be explained by common influences—Courbet and Ribot—rather than by a common date.

G.T.

1. Anne-Marie Bergeret-Gourbin in Honfleur, Musée Eugène-Boudin, 1992, *Eugène Boudin: 1824–1898*, p. 22; Laurent Manoeuvre, *Boudin et la Normandie* (Paris, 1991), p. 31.
2. "tableaux de salle-à-manger." G. Jean-Aubry and Robert Schmit, *Eugène Boudin: La vie et l'oeuvre d'après les lettres et les documents inédits* (Neuchâtel, 1987), p. 34.
3. Rewald 1973, p. 112.
4. "Jongkind et Boudin sont là, nous nous entendons à merveille et ne nous quittons plus. Ribot va probablement venir." Monet to Bazille, August 26, 1864, Wildenstein 1974, letter 9, p. 421.

18 *Fig. 78*

Eugène Boudin
La Plage de Trouville
(*Beach at Trouville*)
Ca. 1865
Oil on canvas
26½ x 41 in. (67.3 x 104.1 cm)
Signed and dated lower right: *E. Boudin 186?*
Lent by The Minneapolis Institute of Arts, The William Hood Dunwoody Fund 15.30

CATALOGUE RAISONNÉ: Schmit 1973–93, vol. 1, no. 254

PROVENANCE: Henry M. Johnston, New York, until 1898; sold to Durand-Ruel, Paris and New York, December 10, 1898 for Fr 1,350, until 1915; sold to the Minneapolis Institute of Arts, April 29, 1915

EXHIBITIONS: New York, Durand-Ruel Galleries, January 24–February 12, 1929, *Retrospective Exhibition of Paintings by Eugène Boudin*, no. 12; New York, Durand-Ruel Galleries, October 30–November 18, 1933, *Exhibition of Paintings by Eugène Boudin*, no. 10; Chicago, Art Institute, June 1–November 1, 1934, *A Century of Progress Exhibition*, no. 155; Chicago, Art Institute, December 19, 1935–January 19, 1936, *Loan Exhibition of Paintings by Eugène Boudin*, no. 3; Kansas City, Missouri, William Rockhill Nelson Gallery, November 29–December 30, 1936, *Exhibition of French Impressionist Paintings*, no. 6; Manchester, New Hampshire, Currier Gallery of Art, October 8–November 6, 1949, *Monet and the Beginnings of Impressionism*, no. 10, repr.; Los Angeles, Chicago, Paris 1984–85, no. 12, repr.

SELECTED REFERENCES: "An Initiator of Impressionism," *Minneapolis Institute of Arts Bulletin* 6, no. 8 (October 1917), pp. 57–58, repr.; Claude Roger-Marx, *E. Boudin* (Paris, 1935); Ruth L. Benjamin, *Eugène Boudin* (New York, 1937), p. 188; Jean-Aubry 1968, repr. p. 212; *European Paintings from The Minneapolis Institute of Arts* (New York and London, 1971), p. 197, no. 103, repr.

Boudin is remembered for his countless canvases of fashionable crowds on the beaches of Normandy, for his port scenes, and for recognizing the talent of young Claude Monet, taking him under his wing, and teaching him to paint outdoors. Conscientious, modest, patient, and plodding, Boudin achieved an early notoriety for being singled out by Baudelaire in his review of the 1859 Salon. What Baudelaire liked, however, was not Boudin's entry, *Le Pardon de Sainte-Anne-Palud au fond de la baie de Douarnenez (Finistère)*, but the cloud studies he saw in Boudin's studio. These subtly nuanced studies, attentive to minute atmospheric conditions, no doubt helped Monet to see. When Boudin conjoined these studies with rapidly notated society figures on the beach, he found his forte. Of the eleven paintings Boudin exhibited at the Salon between 1864 and 1869, nine depicted fashionable beach scenes.

Boudin may have been encouraged by Baudelaire's call for a painter of modern life, but he could also have sensed a reliable market for such pictures. Monet followed Boudin in adopting the imagery of fashionably dressed Parisians at leisure. But the more lasting importance of Boudin for the development of Impressionism was his emphasis on painting out-of-doors and the concomitant development of a light—or blond—palette. He was true to these tenets for the rest of his career.

This large and handsome work, organized in horizontal bands of sand, sea, and sky, is prototypical of the beach scenes with which Boudin made his reputation. As he wrote to a friend in 1868, "These gentlemen congratulate me precisely because I dared to represent in painting the things and people of our time, because I found the means to paint the gentleman in a top coat and the lady in a waterproof thanks to the mixture of paint and the composition. . . . I do not accept your opinion of my bad choices of subjects: on the contrary, I am becoming more and more fond of them, hoping to widen their still limited scope."[1] Yet at times he despaired and saw through the gaiety of beachfront society to the emptiness beneath. "Must I confess it? This beach in Trouville that I used to find delightful seems, since I have been back, to be only a terrible masquerade. You almost need genius to find this band of idle poseurs interesting."[2]

Boudin was conscious of his predecessors in Dutch seventeenth-century fishing scenes, wherein one finds wide skies looming over barren beaches. In the nineteenth century, Paul Huet and Eugène Isabey painted the very same beaches of the Normandy coast that Boudin favored, but, true to their romantic impulses, they emphasized the fearful waves and dangerously high cliffs and made the beaches the site of shipwrecks and drownings. Boudin was the first to attempt to legitimize as proper painting the depiction of what was a recent phenomenon, the taking of sea cures along the Channel coast. Just before mid-century, hotels and casinos sprang up in Trouville and neighboring Deauville to cater to the ever-expanding bourgeoisie who could conveniently reach the coast by the newly laid railroad. Soon the empress and high-ranking court officials began to patronize the resorts, thereby ensuring their success. Boudin recorded the visit of the empress and the presence of Princess Metternich in a number of canvases, a clear indication that he understood the importance of these celebrities to the tourism industry of which he was a direct beneficiary.

Although the date inscribed on this painting is often read as 1860, Boudin began to paint the Trouville beach only in 1862. There was little change in his beach scenes over the subsequent five years, and it is therefore difficult to assign a date to the works that lack an inscription, or as here, on which the date is illegible.[3] Canvases of 1865 seem to have a greater emphasis on the brushwork of the sky, and that, coupled with the large size of the canvas—something Boudin may

have tried in response to watching Monet develop large canvases—may point to a date of about 1865 for this work.

<div align="right">G.T.</div>

1. "Ces messieurs me félicitaient précisément d'avoir d'osé mettre en tableaux des choses et des gens de notre temps, d'avoir trouvé le moyen de faire accepter le monsieur en paletot et la dame en waterproof grâce à la sauce et l'accommodement. . . . Je n'accepte donc pas votre opinion sur le choix mauvais de mes sujets: au contraire, j'y prends goût de plus en plus, en espérant élargir ce genre encore très bornés." G. Jean-Aubry and Robert Schmit, *Eugène Boudin: La vie et l'oeuvre d'après les lettres et les documents inédits* (Neuchâtel, 1987), p. 101.
2. "Faut-il confesser? Cette plage de Trouville qui naguère faisait mes délices n'a plus l'air à mon retour que d'une affreuse mascarade. Il faut presque du génie pour tirer parti de cette bande de fainéants poseurs." Jean-Aubry and Schmit, *Eugène Boudin*, p. 90.
3. The woman in a white dress with a blue parasol seated next to the woman in gray is a grouping repeated by Boudin in *Scène de Plage*, Schmit 1973–93, vol. 1, no. 287, dated ca. 1863–6?.

William Bouguereau

La Rochelle, 1825–La Rochelle, 1905

After studying at Bordeaux's municipal school of painting and drawing, Bouguereau went to Paris in March 1846 and signed up for Picot's studio at the École des Beaux-Arts. Starting with the Salons of 1849 and 1850–51, he showed "harsh, strong" paintings (according to Théophile Gautier), which are among the best in his oeuvre (*Egalité* [*Equality*; private collection]; *Dante et Virgile aux enfers* [*Dante and Virgil in Hell*; private collection]).[1] In 1850, the year Baudry received the Premier Grand Prix de Rome, Bouguereau also got an exceptional Premier Grand Prix de Rome (the first prize had not been awarded in 1848). He resided at the Villa Medici from 1850 to 1854; his last *envoi*, *Triomphe du Martyr: Le corps de Sainte Cécile apporté dans les Catacombes* (*The Triumph of the Martyr: The Body of Saint Cecilia Brought to the Catacombs*; Musée de Lunéville). Promptly acquired by the government, it was a great hit at the Salon of 1855. This was the beginning of Bouguereau's official career, which was marked by the usual rewards (a first-class medal in 1857, the Légion d'Honneur in 1859). He was supported by private commissions (decorations of the two Bartholoni *hôtels*, 1854–56, and the Hôtel Pereire, 1858) as well as public commissions: *Napoléon III visitant les inondés de Tarascon* (*Napoléon III Visiting the Flood Victims of Tarascon*; Hôtel de Ville, Tarascon); decorations in the churches of Sainte-Clotilde, 1859, and of Saint-Augustin, 1865, both in Paris; the Grand Théâtre of Bordeaux, 1865–69.

In 1859 he launched a series of genre scenes, which were first sold by the dealer Paul Durand-Ruel and then by Adolphe Goupil. Bouguereau's exclusive contract with Goupil which he signed in 1866 reveals the definitive commercialization

of an artist who started out as singular and powerful. His output was, alas, fed by his legendary workaholism.

1. "âpres"; "fortes." Quoted by Louise d'Argencourt in *William Bouguereau*, exh. cat. (Petit Palais, Paris, 1984), p. 146. The best recent biography of this artist was written by Mark Steven Walker for that catalogue.

19 *Fig. 26*

William Bouguereau
Le Jour des morts
(*All Souls' Day*)
1859
Oil on canvas
57⅞ x 47¼ in. (147 x 120 cm)
Signed and dated lower right: W. Bouguereau 1859
Musée des Beaux-Arts, Bordeaux E.518 (old inventory), M.6262 (new inventory)

PROVENANCE: Bought by the city of Bordeaux at the exhibition of the Société des amis des arts, 1860

EXHIBITIONS: Paris, Salon of 1859, no. 335 (Le jour des morts); Bordeaux, Salon de la Société des amis des arts, 1860; Paris, Exposition Universelle, 1867, no. 69 (Le jour des Morts); New York Cultural Center, Detroit Institute of Arts, and San Francisco, M. H. de Young Memorial Museum, 1974–75, *William Adolphe Bouguereau*, no. 4; Philadelphia Museum of Art, Detroit Institute of Arts, and Paris, Grand Palais, *L'Art en France sous le second Empire*, 1979, no. VI–1

SELECTED REFERENCES: Astruc 1859, pp. 154–55; Émile Cantrel, "Salon de 1859. XIII," *L'Artiste*, July 3, 1859, p. 146; Ernest Chesneau, "Libre étude sur l'art contemporain," *La Revue des races latines* 14 (1859), pp. 73–74; Du Camp 1859, pp. 62–63; Dumesnil 1859, pp. 109–10; A. J. Du Pays, "Salon de 1859," *L'Illustration*, May 7, 1859, p. 302; Gautier, *Le Moniteur universel*, May 7, 1859; Houssaye 1859, p. 265; Albert de La Fizelière, "L'Exposition à vol d'oiseau," *L'Artiste*, April 10, 1859, p. 232; Lépinois 1859, pp. 138–39; Perrier 1859, p. 303; Paul de Saint-Victor, "Salon de 1859. II," *La Presse*, April 30, 1859, p. 2; Mathilde Stevens, *Impressions d'une femme au Salon de 1859* (Paris, 1859), pp. 20–21; Ludovic Baschand, *Catalogue illustré des oeuvres de William Bouguereau* (Paris, 1885), pp. 16–19, repr.; Marius Vachon, *Bouguereau* (Paris, 1900), pp. 95, 146; Th. Ricaud, "Le Musée de peinture et de sculpture de Bordeaux de 1830 à 1870," *Revue historique de Bordeaux*, October–December 1936 and July–September 1937, p. 126; Th. Ricaud, *Le Musée de peinture et de sculpture*

de Bordeaux de 1830 à 1870 (Bordeaux, 1938), pp. 118–20; C. Colin, "Du 'Jour des morts'. . . à 'La Fontaine de Jouvence,'" *Sud-Ouest*, Bordeaux, March 25, 1973, repr. p. 12; Wolfgang Drost and Ulrike Henninges, *Théophile Gautier: Exposition de 1859* (Heidelberg 1992), p. 29, repr.

Théophile Gautier tells the story of this picture: "A still-beautiful widow kneels at a tomb; she fixes a long, resigned gaze on the sky as if seeking the soul whose remains lie underground, while the girl buries a tear-stained face in the maternal breast. We cannot see her tears but we sense them. Her shoulders weep, her side sobs, and her pain convulsively lifts this young body in the somber livery of mourning: what a lovely group to place on a tomb—this sculpted painting could turn into marble!"[1]

While Gautier's commentary is not quite accurate since the widow is staring at the ground and her daughter is facing her, the stereotypes he piles up translate the narrow sentimentalism of the painting very precisely. Gautier was the sort of person who was tenderly moved, like Paul de Saint-Victor, who approved of this "Athenian elegy,"[2] or Lépinois, who was so enthralled by the "realism of this spectacle" that he felt his eyes growing moist.[3] Many other observers, however, managed to keep a dry eye: Arsène Houssaye derided the "studio tears,"[4] Du Pays sneered at this "utterly mundane elegy," this "boon-companion sadness,"[5] and Zacharie Astruc remained calm and cool in the face of this huge expression of grief.[6] Bouguereau was already staging—as he would so often—a work of "bourgeois sentimentality": the models pose with conventional gestures, gladly quoting ancient examples like brilliant schoolboys.[7] However, in 1859, Bouguereau was a competent painter: *Le Jour des morts* was not "without color," as Émile Lévy described it (see p. 24); it was a lovely harmony of green and black, expertly "bouguerautée"—that is, sacrificed to the delight in "the soft tones of a polished finish," the style that ultimately spelled his doom.[8]

<div align="right">H.L.</div>

1. "Une veuve, belle encore, est agenouillée devant une tombe; elle lève vers le ciel, comme pour y chercher l'âme dont la dépouille gît sous la terre, un long regard résigné, tandis que la jeune fille cache dans le sein maternel un visage noyé de larmes; on ne les voit pas, ces larmes, mais on les devine; les épaules pleurent, le flanc sanglote et la douleur soulève convulsivement ce jeune corps sous la sombre livrée du deuil: quel beau groupe à placer sur une tombe on ferait de ce tableau sculpté en marbre!" Gautier 1859, p. 29.
2. "élégie athénienne." Paul de Saint-Victor, "Salon de 1859," *La Presse*, April 30, 1859, p. 2.
3. Lépinois 1859.
4. "larmes d'atelier." Arsène Houssaye, "Salon de 1859," *Le Monde illustré*, April 23, 1859, p. 265.
5. "élégie toute mondaine"; "tristesse de bonne compagnie." A. J. Du Pays, "Salon de 1859," *L'Illustration*, May 7, 1859, p. 302.
6. Astruc 1859, p. 155.
7. "sentimentalité bourgeoise." Paul de Saint-Victor, "Salon de 1865," *La Presse*, May 21, 1865.
8. "les tons finis, doux, léchés." Émile Cantrel, "Salon de 1859," *L'Artiste* 3 (July 1859), p. 146.

Jules Breton

Courrières, 1826–Paris, 1906

Born in Artois, Jules Breton was the son of the steward of a large estate. He always remained attached to his native soil, which he celebrated in most of his paintings. In 1843, at the Royal Academy of Ghent, he began studying under Félix de Vigne, whose daughter he later married. In 1847 after a brief stint at the academy in Antwerp he arrived in Paris. He frequented Michel-Martin Drolling's studio, where he became friends with Paul Baudry (see cat. 1). Breton debuted at the Salon of 1849 with the realistic painting *Misère et désespoir* (*Poverty and Despair*); but, as of 1853, he devoted himself to depictions of peasant life. These works established his fame in the course of three Salons: 1855 (*Les Glaneuses* [*The Gleaners*]), 1857 (*La Bénédiction des blés* [*The Blessing of the Grain*]), and 1859 (*Le Rappel des glaneuses* [cat. 20]). In 1861 he was made a knight of the Légion d'Honneur and in 1867 an officer. At the Salon of 1864, *Les Vendanges* (*The Wine Harvest*), executed after a long trip through the Médoc and the Midi in 1862–63, marked his evolution toward a freer and more highly colored style. In his 1890 autobiography, *La Vie d'un artiste* (*An Artist's Life*), he voiced some sharp and jealous opinions about the Impressionists, especially Manet: "I can scarcely believe that posterity will recognize Manet as a forerunner; instead it will see him as a mediocre pupil of Goya, Velázquez, and, later on, the Japanese."[1]

1. "J'ai peine à croire que la postérité reconnaisse un précurseur en Manet, mais bien plutôt une élève médiocre de Goya, de Vélasquez, et, plus tard, des Japonais." Jules Breton, *La Vie d'un artiste* (Paris, [1890]), p. 332.

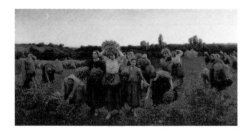

20 *Fig. 10*

Jules Breton
Le Rappel des glaneuses (Artois)
(*The Calling of the Gleaners*)
1859
Oil on canvas
35⅜ x 69¼ in. (90 x 176 cm)
Signed and dated lower right: Jules Breton, Courrières 1859
Musée d'Orsay, Paris MI 289

PROVENANCE: Bought from the emperor's civil list at the Salon of 1859 (Fr 8,000); his gift to the Musée du Luxembourg, 1862; Musée du Louvre, Paris, 1920; depos-

ited at the Musée d'Arras, 1926; Musée d'Orsay, Paris, 1986

EXHIBITIONS: Paris, Salon of 1859, no. 409 (Le rappel des glaneuses [Artois]); Paris, Exposition Universelle, 1867, no. 84 (Le Rappel des glaneuses [Artois]); Vienna, Universal Exposition, 1873, no. 84; Paris, Petit Palais, 1968–69, *Baudelaire*, no. 471; Paris, Grand Palais, 1974, *Le Musée du Luxembourg en 1974*, no. 34; Cleveland Museum of Art, 1980–81, *The Realist Tradition: French Paintings and Drawings, 1830–1900*, ed. by G. P. Weisberg, no. 52

SELECTED REFERENCES: Astruc 1859, pp. 228–29; Aubert 1859, pp. 179–80; Louis Auvray, *Salon de 1859* (Paris, 1859), p. 41; A. de Belloy, "Salon de 1859. IV," *L'Artiste*, May 1, 1859, p. 5; Émile Cantrel, "Voyage en zigzag à travers l'exposition," *L'Artiste*, June 26, 1859, p. 132; Chaud-de-Ton, "Salon de 1859. Lettres de Chaud-de-Ton, artiste," *La Vérité contemporaine*, May 25, 1859, p. 3; Ernest Chesneau, "Libre étude sur l'art contemporain. Salon de 1859," *Revue des races latines* 14 (1859), p. 42; Delaborde 1859, pp. 511–13; Delécluze, "Exposition de 1859," *Journal des débats*, April 27, 1859, p. 1, and May 18, 1859, p. 1; Du Camp 1859, p. 37; Dumas 1859, pp. 53–54; Dumesnil 1859, p. 32; A.-J. Du Pays, "Salon de 1859," *L'Illustration*, June 25, 1859, pp. 459, 462; Ferdinand Gabrielis, "Salon de 1859," *Le Moniteur des arts*, April 23, 1859, p. 195, and June 18, 1859, p. 250; Théophile Gautier, "Exposition de 1859," *Le Moniteur universel*, July 7, 1859; Houssaye 1859, p. 359; Jourdan 1859, pp. 26–27; Lépinois 1859, pp. 149–50; Mantz 1859, pp. 286–87, repr.; Anatole de Montaiglon, "La Peinture au Salon de 1859," *Revue universelle de l'art* 9 (1859), p. 459; Charles Perrier 1859, p. 311; Paul de Saint-Victor, "Salon de 1859. V," *La Presse*, May 28, 1859, p. 1; Mathilde Stevens, *Impressions d'une femme au Salon de 1859* (Paris, 1859), p. 88; M.V. [Mac Vernoll], "Salon de 1859," *Le Monde illustré*, August 20, 1859, repr. p. 117; Nettement 1862, p. 361; Marc de Montifaud, "Salon de 1867 et Exposition Universelle," *L'Artiste*, May 1, 1867, p. 246; R. Ménard, *Le Monde vu par les artistes: géographie artistique* (Paris, 1881), p. 979; Eugène Montrosier, "Le Musée du Luxembourg," in *Les Chefs-d'oeuvre d'art au Luxembourg* (Paris, 1881), p. 189; Marius Chaumelin, *Portraits d'artistes. E. Meissonier, J. Breton* (Paris, 1887), p. 91; Jules Breton, *La Vie d'un artiste* (Paris, n.d.), pp. 226–33; Jules Breton, *Un peintre paysan* (Paris, 1896), pp. 105–9; Marius Vachon, *Jules Breton* (Paris, 1899), p. 142, repr. p. 76; Baudelaire 1985–87, vol. 2, p. 1077; William Drost and Ulrike Henninges, *Théophile Gautier: Exposition de 1859* (1992), pp. 116, 317.

Zacharie Astruc described this scene: "It is evening, the sun is about to vanish on the horizon behind a dense curtain of trees. To the right the sun burns the sky with a red flame; to the left it casts a dying reflection on the hills and the herd of sheep which moves away. The timid disk of the moon is already peeping out. The gnats are massing in the background, billowing across the clear sky in black troops. The guard arrives; he leans his back against a boundary marker, cupping his hands around his mouth and shouting: 'Hey! Down there, you gleaners, leave, it's time.' At his feet his dog, turning its head toward a tardy gleaner, growls: 'C'mon! You heard the man!...' The gleaners arrive; their burdens are not heavy, but the poor need so little, and the ears are so lovely this year."[1]

Further on, Astruc praises the painting for its "felicity of color and light" and its "new, original...and highly agreeable effect."[1] These are

amiable words rather than a detailed encomium —Astruc's voice was just one more in the well-nigh unanimous chorus that hailed Jules Breton as one of the only hopes of the French school at the Salon of 1859. Among the few who didn't join in were the marquis de Belloy, who found a certain lack of unity in Breton, and Ernest Chesneau, more severe and pungent, who carped about the dryness of the material, the dull coloring, the "abuse of oblique light," and the lack of modeling in the figures, who were "positively cut out, illuminated, and pasted to the background without the slightest relief" (a reproach often flung at Courbet's figures).[2]

This painting was displayed in the Salon d'Honneur, where it was viewed by the empress. It was bought for eight thousand francs on the emperor's civil list and hung at the palace of Saint-Cloud.[3] It pleased both the friends and the foes of realism: the champions of realism gladly adopted the successful artist, and its opponents were happy to point out that the humbleness of the subject had not forced the painter to flaunt the hideousness of the world. Théophile Gautier contentedly remarked that *Le Rappel des glaneuses* "proves that truth is not always ugly." He went on: "The clothes of these gleaners may be threadbare, worn-out, and faded from years of use and inclement weather, but they have none of the sordid quality of rags; they are not dirty or gratuitously disgusting. Their garments are the humble liveries of work and not the tatters of beggary."[4]

We catch Gautier's drift—his statement is also an attack on Courbet and Millet. Indeed, by comparing the undeserved plaudits that rained on *Le Rappel des glaneuses* in 1859 and the jeers hurled at Millet's masterpiece *Les Glaneuses* (fig. 52) at the Salon of 1857, we can understand why so many critics felt relief at the sight of Breton's peasant women. These gleaners are proud, beautiful, hard at work, while Millet's faceless, shapeless figures look like "ragged scarecrows."[5] Breton's evoke Léopold Robert's charming Italian scenes, George Sand's eclogues, or a "real idyll, produced by our climate, our agriculture, and our peasant type" when their forebears sensed the Revolution.[6] Breton's gleaners achieve a delicate closeness to Ceres while their socialist sisters are "the three Fates of poverty."[7] Breton makes acceptable that which was sulfurous in Millet. Breton did not conceal his debt to Millet, but he weighed every word of the lukewarm obligatory tribute in his autobiography, *La Vie d'un artiste*. Although Millet "created some masterpieces," he was hampered by the poverty of his color and by an "awkward and woolly technique"; he was a "sublime and solitary genius," who did not found a school. Breton warned: "Stop right there, imitators! Millet created masterpieces, even when interpreting humans brought down by deprivation to the bottom of their being; you have no right to deny his great, his divine beauty!" Earlier in his memoir, Breton justifies their divergent visions of the rural world on the basis of the difference of the characters

they had studied: his own peasants, he says, resurrect "the age of the biblical patriarchs," while those of Millet arise from a "strange, almost prehistoric dream."[8]

H.L.

1. "C'est le soir; le soleil va disparaître à l'horizon derrière un rideau compact d'arbres. À droite, il embrasse le ciel d'un rouge flamme; à gauche, il jette un reflet mourant sur les collines et le troupeau de moutons qui s'éloigne. La lune montre déjà son disque craintif. Les moucherons s'agglomèrent au fond, et roulent sur le ciel clair par troupes noires. Le garde arrive; il s'appuie du dos contre une borne de séparation, se fait un porte-voix des deux mains et crie: 'Ho! là-bas, les glaneuses, partez, il est temps.' Son chien, à ses pieds, tournant la tête vers celle qui s'attarde, grogne à son tour: 'Eh bien! avez-vous entendu!...' Les glaneuses arrivent: la charge n'est pas lourde,—mais il faut si peu au pauvre,—et les épis sont si beaux cette année."; "heureuse de couleur, de lumière"; "effet nouveau et original . . . fort agréable." Astruc 1859, pp. 228–29.
2. Marquis de Belloy, "Salon de 1859, IV," L'Artiste, May 1, 1859, p. 5. "lumières frisantes"; "positivement découpés, enluminés et collés au fond de la toile sans le moindre relief." Ernest Chesneau, "Libre étude sur l'art contemporain, Salon de 1859," Revue des races latines 14 (1859), p. 42.
3. "Ouvrages désignés par M. le ministre pour l'Empereur et l'Impératrice" [the empress accepted only items marked with an x]: "x Breton 409 le Rappel des glaneuses (Artois) 8000." Paris, Archives du Louvre x, Salon de 1859.
4. "Le Rappel des glaneuses prouve que la vérité n'est pas toujours laide"; "Les vêtements de ces glaneuses, usés, élimés, rompus de ton par un long usage et les intempéries de l'air, n'ont pas cependant la sordidité du haillon; ils ne sont pas salis et rendus dégoûtants à plaisir. C'est l'humble livrée du travail et non le dépenaillement de la mendicité." Gautier 1859, pp. 116–17.
5. "épouvantaille en haillons." Paul de Saint-Victor, "Salon de 1857," quoted by Robert L. Herbert in Paris, London 1975–76, p. 101.
6. "idylle vraie, telle que la comportent notre climat, notre agriculture et le type de nos paysans." Gautier, 1859, p. 117. On the Revolution, see Robert L. Herbert in Paris, London 1975–76, p. 101.
7. "trois Parques du paupérisme." Paul de Saint-Victor, "Salon de 1859, v," La Presse, May 28, 1859, p. 1.
8. "a créé des chefs-d'oeuvre"; "facture maladroite et laineuse"; "Halte là, imitateurs! Parce que Millet a créé des chefs-d'oeuvre, même en interprétant l'homme déprimé par la misère jusqu'à l'affaissement de son être, vous n'avez pas le droit de nier la grande, la divine beauté!"; "le temps des patriarches bibliques"; "rêve étrange au caractère presque préhistorique." Jules Breton, La Vie d'un artiste: Art et nature (Paris, n.d.), pp. 217–18. On the critical reading of the works of Millet and Breton during the 1850s and 1860s, see Neil McWilliam, "Le Paysan au Salon: Critique d'art et construction d'une classe sous le Second Empire," in Bouillon 1989, pp. 81–94.

Charles-Émile Auguste Durand, called Carolus-Duran

Lille, 1838–Paris, 1917

The son of an innkeeper, Durand received his early artistic education in Lille at the municipal school of drawing and at François Souchon's studio. In 1853 Durand moved to Paris, but in 1858 a lack of money forced him to return to Lille, where he survived thanks to several portrait commissions.

The following year a prize from his hometown allowed him to return to Paris and take courses at the Académie Suisse. Through Zacharie Astruc, whom he had known in Lille, he made friends with Courbet and his realist disciples. During the Salon of 1861 Durand, together with Fantin-Latour and Legros, visited Manet's studio to congratulate him on his Espagnol jouant de la guitare (The Spanish Singer, 1860; Metropolitan Museum of Art). From 1862 to 1866, the Prix Wicar, awarded by the city of Lille, enabled Durand to live in Italy. He came back with his large painting L'Assassiné (The Murdered Man; Musée des Beaux-Arts, Lille), which won a medal at the Salon of 1866 and was bought by the French government for the Musée des Beaux-Arts in Lille. This prize allowed Durand to stay in Spain, where he copied works by Murillo and Velázquez. In 1868 he went back to Paris, and the following year he triumphed at the Salon with the Portrait de Mme *** (cat. 21). In 1876 in Les Coulisses artistiques Pierre Véron pinpoints "that very peculiar mark of the painter: Carolus loves Manet, almost to the point of worship. As a foil, no doubt. His admiration does not strike us as any less imprudent. For at times Manet's defects look as if they were aimed at parodying the qualities of his admirer."[1]

1. "signe très particulier du peintre: Carolus aime Manet, presque au point de l'admirer. Comme repoussoir sans doute. Cette admiration ne nous en paraît pas moins imprudente. Car les défauts de Manet ont parfois bien l'air de vouloir être la parodie des qualités de son admirateur." P. Véron, Les Coulisses artistiques (Paris, 1876), p. 158.

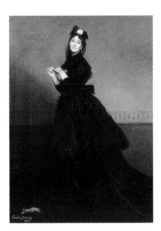

21 Fig. 230

Carolus-Duran
*Portrait de Mme *** (La Dame au gant)*
(*Portrait of Mme X*** [Woman with a Glove]*)
1869
Oil on canvas
89¾ x 64⅝ in. (228 x 164 cm)
Musée d'Orsay, Paris RF 152

PROVENANCE: Bought from the artist by the French government for the Musée du Luxembourg, Paris, 1875;

Musée du Louvre, Paris, 1929 (incorrectly reinventoried as RF 2756); Musée d'Orsay, Paris, 1986

EXHIBITIONS: Paris, Salon of 1869, no. 843 (Portrait de Mme ***); Vienna 1873, Universal Exposition, repr. (Mme X); Paris 1878, Exposition Universelle, no. 302 (La dame au gant); Paris, 1900, Exposition Universelle, p. 125, repr. (La Dame au gant)

SELECTED REFERENCES: Zacharie Astruc, "Salon de 1869," Le Dix Décembre, June 20, 1869, p. 10; Louis Auvray, Salon de 1869 (Paris, 1869), p. 50 ; Charles Blanc, "Salon de 1869," Le Temps, May 26, 1869, p. 1; Jules Castagnary, "Salon de 1869," Salons: 1857–1870 (Paris, 1892), p. 364; Marius Chaumelin, "Salon de 1869," La Presse, June 22, 1869, pp. 1–2; Ernest Chesneau, "Salon de 1869," Le Constitutionnel, May 4, 1869, p. 3, and June 17, 1869, p. 3; Louis Énault, "Salon de 1869," Le Nain jaune, May 13, 1869, p. 5; Jules Guillemot, "Salon de 1869," Le Français, June 10, 1869, p. 3; Louis Leroy, "Salon de 1869," Le Gaulois, May 24, 1869, p. 3; Paul Mantz, "Salon de 1869," Gazette des Beaux-Arts, June 1, 1869, p. 503; A. Ranc, "Le Salon de 1869: Le portrait," Revue internationale de l'art et de la curiosité, May 15, 1869, p. 412; M. de Thémines, "Salon de 1869," La Patrie, June 2, 1869, p. 34; Albert Wolff, "Le Salon de 1869," Le Figaro, May 14, 1869, p. 2; Jules Claretie, Peintres et sculpteurs contemporains (Paris, 1883), p. 163; Castagnary 1892, p. 364; Léonce Bénédite, Le Musée national du Luxembourg. Catalogue raisonné: . . . (Paris, 1896), no. 48; McCauley 1985, p. 145, repr. fig. 145

The Salon of 1869 established Carolus-Duran's reputation as well as his distance from the artists of the New Painting. Like Tissot several years earlier, Carolus-Duran had sold out as a painter, becoming a crowd-pleaser. Suddenly kowtowing to the Academy, he surprised and melted the hearts of the people who had once put him down. Paul Mantz was astonished: "Who would have imagined that this painter, who began so violently and who even sought reality à la Courbet, would eventually believe in the rustling of silk gowns, the mysterious poetry of a pearl-gray glove, the chimerical hats of a first-rate modiste?"[1]

The portrait of his wife, the painter Pauline Croizette, was to Monet's Camille (fig. 236) what L'Enfant de troupe (cat. 78) by Eva Gonzalès was, the following year, to Le Fifre (cat. 102) by her master Manet. Carolus-Duran made his former boldness acceptable and finally managed to paint what so many artists pursued in vain, "the modern woman, the women of our time, the Frenchwoman, the Parisienne."[2] In an almost unanimous concert of accolades (for Zacharie Astruc, the painting was the "masterpiece" of the Salon), one could nevertheless catch the discordant voice of Castagnary, who in 1872 rebuked Carolus-Duran for sacrificing the portrait to a flaunting of elegance (see pp. 190–91): "It is an entirely exterior portrait, a surface likeness as it were, a study of a woman's attire or rather of an elegant pose."[3]

H.L.

1. "Qui aurait jamais cru que ce peintre se violent à ses origines et qui a même cherché la réalité à la Courbet, ne viendrait à croire au frou-frou des robes de soie, aux mystérieuses poésies d'un gant gris perle, aux chapeaux chimériques de la bonne faiseuse?" Paul Mantz, "Salon de 1869," Gazette des Beaux-Arts, June 1, 1869, p. 503.

2. "la femme moderne"; "la femme de notre temps, la Française, la Parisienne." Marius Chaumelin, "Salon de 1869," *La Presse*, June 22, 1869, p. 1.

3. "chef-d'oeuvre." Zacharie Astruc, "Salon de 1869," *Le Dix Décembre*, June 20, 1869, p. 10. "C'est un portrait tout extérieur, de surface pour ainsi dire, l'étude d'une toilette, ou plutôt d'une pose élégante." Castagnary 1892, p. 364.

Paul Cézanne

Aix-en-Provence, 1839–Aix-en-Provence, 1906

Paul Cézanne, under pressure from his banker father, began law studies at the Université d'Aix in 1858, but at the same time he enrolled in the École Municipale Gratuite de Dessin in Aix, there receiving a traditional artistic training. Cézanne finally obtained parental permission to go to Paris in 1861 to continue his art studies. In Paris, he was able to enroll at the Académie Suisse and visit the Louvre, as well as rejoin his close friend from school, Émile Zola, who would later depict Cézanne as the painter Claude Lantier in *L'OEuvre* of 1886. However, in 1861, Cézanne was intimidated and overwhelmed by Paris and fled back to Aix after only a few months. After an unhappy stint at his father's bank in Aix, Cézanne again returned to Paris and the Académie Suisse in late 1862; this time he would stay until 1864. After this, he would spend part of each year at home in Aix, painting at the family residence, the Jas de Bouffan.

Cézanne soon became involved in avant-garde circles: through the Académie Suisse, he was able to meet Pissarro, Bazille, Monet, Renoir, and others. In line with the radical stance he fostered, Cézanne every year submitted his resolutely idiosyncratic works to the Salon, with the defiant goal of offending the Salon juries. Thus, he was regularly rejected from the Salon between 1863 and 1870, exhibiting only at the Salon des Refusés in 1863 (see Chronology). Cézanne's oeuvre from this period is indeed startling for his aggressively personal subjects, often violent or erotic in theme, and his original handling, most notable in his series of palette-knife or "manière couillarde" works.

22 *Fig. 206*

Paul Cézanne
Pain et OEufs
(*Still Life with Bread and Eggs*)
1865
Oil on canvas
23¼ x 30 in. (59.1 x 76.3 cm)
Signed and dated lower left: *P. Cezanne 1865*
Cincinnati Art Museum, Gift of Mary E. Johnston
1955.73

CATALOGUE RAISONNÉ: Venturi 1936, no. 59

PROVENANCE: Ambroise Vollard, Paris, and Bernheim-Jeune, Paris; Ambroise Vollard, Paris, until 1909; sold to Paul Cassirer, Berlin, in 1909; sold to Walter Levenstein, Berlin, in 1909; Fritz Gurlitt, Berlin; sold to Paul Cassirer, Berlin, in 1915; sold to his brother Hugo Cassirer, Berlin, in 1915, until his death in 1920; by inheritance to his wife, Lotte Fürstenberg-Cassirer, Berlin and Johannesburg (on deposit for several years at the Gemeentemuseum, The Hague, and during World War II at the Museo Nacional de Bellas Artes, Buenos Aires); J. K. Thannhauser, New York, after 1945; sold to the Cincinnati Art Museum, 1955

EXHIBITIONS: Prague, Pavillon Manes, 1907, *Tableaux Modernes*, no number; Berlin, Paul Cassirer, 1909, *Group Exhibition*, no. 19; Berlin, Galerie Paul Cassirer, November–December, 1921, *Cézanne—Ausstellung*, no. 4; Berlin, Paul Cassirer, 1925, *Herbstausstellung—Impressionisten*, no. 1; Buenos Aires, Museo Nacional de Bellas Artes, July–August 1939, *La pintura francesca* I: *De David a nuestros días*, no. 5; Milwaukee Art Institute, September 1956, Cincinnati Art Museum, October 1956, *Still Life Painting since 1470*, no. 9, repr.; New York, Wildenstein Galleries, November 5–December 5, 1959, *Loan Exhibition: Cézanne*, no. 2, repr.; Bordeaux, Musée des Beaux-Arts, May–September, 1966, *La peinture française—collections américaines*, no. 53, pl. 39; Baltimore Museum of Art, October 22–December 8, 1968, *From El Greco to Pollock*, no. 51, repr.; Washington, Phillips Collection, February 27–March 28, 1971, Chicago, Art Institute, April 17–May 16, 1971, Boston, Museum of Fine Arts, June 1–July 3, 1971, *Cézanne: An Exhibition in Honor of the Fiftieth Anniversary of the Phillips Collection*, no. 1, repr.; London, Paris, Washington 1988–89, no. 7, repr.; Munich, Bayerische Staatsgemäldesammlungen, Neue Pinakothek, January 25–March 18, 1990, *Französische Impressionisten und ihre Wegbereiter: aus der National Gallery of Art, Washington und dem Cincinnati Art Museum*, no. 59, repr.

SELECTED REFERENCES: Théodore Duret, "Paul Cézanne," *Kunst und Künstler* 5 (1907), p. 93, repr.; Ambroise Vollard, *Paul Cézanne* (Paris, 1914), pp. 19, 23; Meier-Graefe 1920, repr. p. 88; Rivière 1923, p. 197; Émile Bernard, *Souvenirs sur Paul Cézanne, une conversation avec Cézanne* (Paris, 1925), repr. facing p. 60; Nina Viktorovna Iavorskaia, *Cézanne* (Moscow, 1935), pl. 7; Gerstle Mack, *Paul Cézanne* (New York, 1935), p. 142; Dorival 1948, pp. 28, 31; Rainer Maria Rilke, *Briefe über Cézanne* (Wiesbaden, 1952), pp. 47–48 (letter to Clara

Rilke, Prague, November 4, 1907), repr.; Philip Adams, in *Cincinnati Art Museum Bulletin* 4 (March 1956), pp. 17–18, repr. p. 16; Lawrence Gowing, "Notes on the Development of Cézanne," *Burlington Magazine* 98 (June 1956), p. 186; Iris Elles, *Das Stilleben in der französischen Malerei des 19. Jahrhunderts* (Zurich, 1958), p. 99; Schapiro 1968, p. 14; Orienti 1970, no. 119, repr.; Anne d'Harnoncourt, "The Necessary Cézanne," *The Art Gallery* 14 (April 1971), p. 35; Gabriel P. Weisberg and William S. Talbot, *Chardin and the Still-Life Tradition in France* (Bloomington, Ind., 1979), pp. 44–45, repr.; M. Virginia Bettendorf, "Cézanne's Early Realism: *Still Life with Bread and Eggs* Reexamined," *Arts Magazine* (January 1982), pp. 138–41, repr.; Rewald 1986c, repr. p. 80

The dark background and meagerness of the proffered repast suggest the Spanish tradition of still-life painting, a tradition that was reinvestigated in France at mid-century, alongside the full-blown revival of interest in the work of Chardin. The elements—cloth, glass, knife, and comestibles—which can all be found in paintings by Chardin, such as *La Nappe blanche* (fig. 398), became de rigueur for the majority of Second Empire still lifes, whether by Ribot and Bonvin, or by Manet and Bazille.

Although Lawrence Gowing and others have suggested that Courbet was a source for this and other still lifes by Cézanne in the 1860s,[1] this painting has very little in common with Courbet's still lifes. The creamy application of paint and the broad planes of color in this work are much closer to Manet. Just as Cézanne grappled with Manet's achievements in his figure paintings, so too did he seek an equivalent for still life. Cézanne probably saw the exhibition of still lifes by Manet at Martinet's and Cadart's galleries in the course of 1865. It is also possible that Manet saw this painting. A letter written by Cézanne's friend Valabrègue on April 12, 1866, reads: "Cézanne has already written you about his visit with Manet; but he did not tell you that Manet had seen his still lifes at Guillemet's; he found them perfectly executed; Cézanne felt very happy, a feeling he does not cultivate and does not linger much upon, as usual. Manet should pay him a visit."[2]

Fig. 398. Jean-Baptiste Siméon Chardin, *La Nappe blanche* (*White Tablecloth*), ca. 1731–32. Oil on canvas, 38 x 48⅜ in. (96.6 x 123 cm). The Art Institute of Chicago, Mr. and Mrs. Lewis Larned Coburn Memorial Collection

In view of the large number of still lifes painted by Cézanne in the 1880s and 1890s, this work is one of a relatively small number executed in the 1860s. It stands out for being signed and dated by the artist, a fact which led Gowing to speculate that Cézanne may have thought to submit it to the Salon of 1866.[3]

G.T.

1. Gowing in London, Paris, Washington 1988–89, p. 82.
2. "Cézanne t'a déjà décrit sa visite chez Manet; mais il ne t'a pas dit que Manet avait vu ses natures mortes chez Guillemet; il les a trouvées parfaitement traitées; Cézanne en a une grande joie, une joie qu'il ne développe pas, et sur laquelle il n'insiste guère, selon son habitude. Manet doit lui faire une visite." Antony Valabrègue to Fortuné Marion, in Dorival 1948, p. 31.
3. Gowing in London, Paris, Washington, p. 82.

23 *Fig. 105*

Paul Cézanne
Vue de Bonnières
(*View of Bonnières*)
1866
Oil on canvas
15 x 23⅝ in. (38 x 60 cm)
Musée Faure, Aix-les-Bains

PROVENANCE: Possibly the Cézanne landscape owned by Émile Zola, Médan, until his death in 1902, that was included in his posthumous sale, Hôtel Drouot, Paris, March 9–13, 1903 ("Paysage"), not in catalogue, and bought for Fr 720 by Léon Orosdi, Paris;[1] André Schoeller, director of the Galeries Georges Petit, Paris; Dr. Faure, Aix-les-Bains; to his museum by 1962

EXHIBITION: London, Paris, Washington 1988–89, no. 17, repr.

SELECTED REFERENCES: Rodolphe Walter, "Un vrai Cézanne: La vue de Bonnières," *Gazette des Beaux-Arts* 61 (May–June 1963), pp. 359–66, repr.; Rodolphe Walter, "Aux sources de l'impressionisme: Bennecourt," *L'OEil*, no. 393 (April 1988), pp. 32–33, repr.; Denys Sutton, "The Early Cézanne," *Gazette des Beaux-Arts* 112 (October 1988), p. 151, fig. 2

In summer 1866, a small band of friends from Aix—Cézanne, Zola, Antony Valabrègue, Jean-Baptistin Baille, and Jean-Baptiste Chaillan—descended on the inn of Père Dumont at Bennecourt, northwest of Paris near Mantes. They were probably joined by other acquaintances, Philippe Solari, Marius Roux, and Antoine Guillemet. Twenty years later, Zola would memorialize the occasion in *L'OEuvre*, the novel in which the painter-protagonist is loosely modeled on both Cézanne and Monet.

While there, Cézanne painted this canvas. Although rejected by Venturi from his catalogue raisonné, it has been restored to the artist's oeuvre by John Rewald and Rodolphe Walter, who identified the precise site, on the island of La Lorionne, from which Cézanne painted.[2] Much of what Cézanne painted is still there: the Seine, of course, the thirteenth-century church, and the two presbyteries. The factory smokestack was taken down in the 1930s, and the trail ferry is long gone. The painting remains a durable legacy of Cézanne's new style in 1866: thickly impasted paint, applied with a knife, to create sheets of color less like Courbet's mottled effects and more like Manet's smooth planes.

Zola approved of this new direction, although he had no illusions about how difficult official acceptance would be. In a letter to Numa Coste of July 26, 1866, he wrote, "Cézanne is working; he is asserting himself more and more along the original path where his nature thrust him. I have great expectations of him. Besides, we think he will be rejected for another 10 years. At the moment, he is attempting to make works, large works, on canvas measuring 4 to 5 meters."[3]

G.T.

1. See provenance in London, Paris, Washington 1988–89, no. 17, and Adhémar 1960, p. 294, no. 134.
2. Rodolphe Walter, "Un vrai Cézanne: La Vue de Bonnières," *Gazette de Beaux Arts* 61 (May–June 1963), pp. 359–66.
3. "Cézanne travaille; il s'affirme de plus en plus dans la voie originale où sa nature l'a poussé. J'espère beaucoup en lui. D'ailleurs, nous comptons qu'il sera refusé pendant 10 ans. Il cherche en ce moment à faire des oeuvres, de grandes oeuvres, de toiles de 4 à 5 mètres." Zola 1978–82, vol. 1, letter 151, p. 453.

24 *(Paris only)* *Fig. 251*

Paul Cézanne
L'Oncle Dominique (L'Avocat)
(*Uncle Dominique [The Lawyer]*)
Ca. 1866
Oil on canvas
24⅜ x 20½ in. (62 x 52 cm)
Musée d'Orsay, Paris RF 1991.21

CATALOGUE RAISONNÉ: Venturi 1936, no. 74

PROVENANCE: Ambroise Vollard, Paris; Auguste Pellerin, Paris, by 1907, until his death in 1929; by descent to

Mme René Lecomte (née Pellerin), Paris; private collection; to Musée d'Orsay, 1991

EXHIBITIONS: Paris, Grand Palais, Salon d'Automne, October 1–22, 1907, *Exposition rétrospective d'oeuvres de Cézanne*, no. 1; Paris 1954, no. 5, pl. III; London, Paris, Washington 1988–89, no. 23, repr.

SELECTED REFERENCES: Elie Faure, "Toujours Cézanne," *L'Amour de l'art* 1 (December 1920), p. 270, repr.; Rivière 1923, p. 202; Roger Fry, "Le développement de Cézanne," *L'Amour de l'art* 12 (December 1926), p. 394, repr.; Roger Fry, *Cézanne: A Study of His Development* (New York, 1927), p. 21, fig. 7; Maurice Raynal, *Cézanne* (Paris, 1936), pl. LIX; Brion-Guerry 1950, p. 40; Orienti 1970, no. 59, repr.; Wells 1987, pp. 71–74, 77, pl. XIX; Sylvie Patin, "Deux 'Figures' de Cézanne au Musée d'Orsay," *Revue du Louvre* 42 (April 1992), p. 16, repr.

25 *(New York only)* *Fig. 252*

Paul Cézanne
L'Oncle Dominique
(*Uncle Dominique*)
Ca. 1866
Oil on canvas
31⅜ x 25¼ in. (79.7 x 64.1 cm)
The Metropolitan Museum of Art, New York, Wolfe Fund, 1951; from The Museum of Modern Art, Lillie P. Bliss Collection 53.140.1

CATALOGUE RAISONNÉ: Venturi 1936, no. 73

PROVENANCE: Ambroise Vollard, Paris, until 1898; sold to Alexandre Rosenberg, Paris, probably in 1898, until 1899; sold to Auguste Pellerin, Paris, probably in 1899, until 1916; sold to Jos Hessel, Paris, 1916, until 1920; sold to Marius de Zayas, New York, 1920, until ca. 1921; sold to Lillie P. Bliss, New York, ca. 1921 (by 1926), until her death in 1931; her bequest to the Museum of Modern Art, New York, 1931, until 1951; purchased by the Metropolitan Museum of Art, 1951

EXHIBITIONS: New York, Metropolitan Museum of Art, May 3–September 15, 1921, *Loan Exhibition of Impressionist and Post-Impressionist Paintings*, no. 4, repr.; New York, Brooklyn Museum, June 12–October 14, 1926, *Modern French and American Painters*, no catalogue; New York, Museum of Modern Art, November 8–December 7, 1929, *First Loan Exhibition: Cézanne, Gauguin, Seurat, van Gogh*, no. 1, repr.; New York, Museum of Modern Art, 1939, *Art in Our Time*, no. 56; Chicago, Art Institute, February 7–March 16, 1952; New York, Metropolitan Museum of Art, April 1–May 16, 1952, *Cézanne: Paintings, Watercolors & Drawings*, no. 5; London, Paris, Washington 1988–89, no. 22, repr.

SELECTED REFERENCES: Rivière 1923, p. 204, repr.; Roger Fry, "New Laurels for the Scorned Cézanne," *New York*

Times Magazine, May 1, 1927, repr. p. 6; Kurt Pfister, *Cézanne: Gestalt/Werk/Mythos* (Potsdam, 1927), fig. 33; Huyghe 1936, p. 32, fig. 11; Rewald 1948, p. 43, fig. 17; Dorival 1948, pp. 29, 133; Kurt Badt, *The Art of Cézanne*, trans. Sheila Ann Ogilvie (Berkeley, 1965), p. 300; Brion-Guerry 1966, p. 40; Orienti 1970, no. 56, repr.; Rewald 1973, repr. p. 117; Richard Shiff, "Seeing Cézanne," *Critical Inquiry* 4 (Summer 1978), fig. 10; Lionello Venturi, *Cézanne* (Geneva, 1978), p. 60, repr. p. 61; Richard Shiff, *Cézanne and the End of Impressionism* (Chicago, 1984), pp. 204, 266, fig. 45; Wells 1987, pp. 71–72, 76–77, pl. XVIII; John Rewald, *Cézanne and America: Dealers, Collectors, Artists and Critics, 1891–1921* (Princeton, 1989), p. 349, fig. 171

Cézanne's working habits were a constant source of amazement to his friends. Antony Valabrègue wrote to Zola in November 1866 to report: "Paul had me pose for the study of a head yesterday. The flesh is fiery red with scrapings of white flesh; it is a mason's painting. My face is so bright that it reminds me of the statue of the priest of Champfleury when it was covered with crushed blackberries. Fortunately, I only posed for one day. The uncle is asked to serve as a model more often. Each afternoon, a portrait of him appears, while Guillemet heaps scorn upon it."[1] The uncle was Dominique Aubert, the brother of Cézanne's mother, who sat for some ten portraits, each evidently executed with startling rapidity. Six are bust length, four are almost half-length. In three of the four half-lengths Aubert wears a costume or at least an accessory to define a role: lawyer in a toque; artist in a smock and tasseled cap; monk in a robe. Like Fragonard's "figures de fantaisie" or Daumier's caricatures, Cézanne's portraits of his uncle Dominique reveal little of the sitter's personality but a great deal of the artist's thoughts about social types. Gary Wells has suggested that in this particular series Cézanne depicted the various careers open to him: "The lawyer represents education, success and social status; the monk represents study, meditation and dedication, and the artisan represents training, talent and skill."[2]

The year 1866 was for Cézanne the year of the palette knife and his self-styled "manière couillarde."[3] "For Aix, Paul has been an epidemic germ—now all the painters and even the glassmakers, are using impasto!"[4] As several historians have remarked, Cézanne took Courbet's knife, coupled it with Manet's planes of color, and created an aggressive, individual style. Cézanne quite deliberately adopted a provocative stance. "The people of Aix continue to irritate him, they demand to be allowed to come and see his paintings only to scoff at them afterwards, and so he has discovered a good way of dealing with them: 'Be damned to you,' he says to them, and the people who have no temperament flee in horror."[5] And his posture was aimed not only at the despised bourgeoisie but also at Courbet and Manet, the leaders of the avant-garde. Guillemet was no doubt parroting Cézanne's words when he wrote, "Only Pissarro continues to create masterpieces ... Courbet is becoming classical. He has done superb things, but next to Manet he is traditional and Manet next to Cézanne will become traditional in turn.... The gods of today will not be

those of tomorrow: let's take up arms, let's seize with a febrile hand the knife of insurrection, let's demolish and reconstruct ... paint with heavy impasto and dance on the belly of the terrified bourgeois."[6]

Owing to the heavy application of paint and perhaps some early mistreatment, *L'Avocat* has lost some of its original paint surface.

<div style="text-align:right">G.T.</div>

1. "Paul m'a fait poser hier pour une étude de tête. Chairs d'un rouge d'incendie avec des raclures de chair blanche; c'est une peinture de maçon. J'y suis teint si vigoureusement qu'elle me rappelle la statue du curé du Champfleury, lorsqu'elle était enduite de mûres écrasées. Je n'ai posé, heureusement, qu'un jour. L'oncle sert plus souvent de modèle. Chaque après-midi, un portrait de lui apparaît, tandis que Guillemet l'accable d'atroce." Quoted in Denis Coutagne and Bruno Ely, *Cézanne au Musée d'Aix* (Aix-en-Provence, 1984), p. 120.
2. Wells 1987, p. 77.
3. See London, Paris, Washington 1988–89, p. 10.
4. "Paul a été pour Aix un germe d'épidémie—voilà que tous les peintres, vitriers même, se mettent à empâter!" Fortuné Marion to Émile Zola, November 27, 186?, in Rewald 1936, p. 71.
5. "Les Aixois agacent toujours les nerfs, ils demandent à aller voir sa peinture pour ensuite la débiner, aussi a-t-il pris avec eux un bon moyen: 'Je vous emmerde' leur dit-il, et les gens sans tempérament fuient épouvantés." Antoine Guillemet to Émile Zola, November 2, 1866, in Rewald 1937, pp. 300–302. The translation given here is from John Rewald, *Paul Cézanne, Letters*, trans. Marguerite Kay (London, 1941), p. 80.
6. "Seul Pissarro continue à faire des chefs d'oeuvre ... Courbet devient classique. Il a fait des choses superbes, à côté les Manet c'est de la tradition et Manet à côté de Cézanne le deviendra à son tour.... Les dieux d'aujourd'hui ne seront pas ceux du lendemain, aux armes, saisissons d'une main fébrile le couteau de l'insurrection, démolissons et construisons ... peindre en pleine pâte et danser sur le ventre des bourgeois terrifiés." Guillemet to Francisco Oller, March 12, 1866, in Puerto Rico, Museo de Arte de Ponce, 1983, *Francisco Oller*, p. 226.

26

Fig. 264

Paul Cézanne
Portrait de Louis-Auguste Cézanne
(Portrait of Louis-Auguste Cézanne)
1866
Oil on canvas
78¾ x 47¼ in. (200 x 120 cm)

National Gallery of Art, Washington, Collection of Mr. and Mrs. Paul Mellon 1970.5.1

CATALOGUE RAISONNÉ: Venturi 1936, no. 91

PROVENANCE: Auguste Pellerin, Paris, before 1913, until his death in 1929; by descent to Mme René Lecomte (née Pellerin), Paris, until 1970; sold to Paul Mellon, 1970; his gift to the museum, 1970

EXHIBITIONS: (?) Paris, Salon of 1882, no. 520; Paris 1936, no. 3; Paris 1954, no. 8, pl. 4; Washington, National Gallery of Art, July 20–October 19, 1986, *Gifts to the Nation: Selected Acquisitions from the Collections of Mr. and Mrs. Paul Mellon*, no number; London, Paris, Washington 1988–89, no. 21, repr.

SELECTED REFERENCES: (?) 1882 Salon review, reprinted in Rewald 1986c, p. 147; F. Lawton, "A Private Collection in Germany that Contains Fourteen Examples of the Art of Paul Cézanne ..." *New York Times*, July 6, 1913, section 5, p. 15; Gustave Coquiot, *Paul Cézanne* (Paris, 1919), pp. 40–41, 244; Meier-Graefe 1920, repr. p. 83; Gasquet 1921, repr. facing p. 12; Alan Burroughs, "Ambroise Vollard, Sensible Biographer," *The Arts* 4 (September 1923), p. 170, repr.; Rivière 1923, p. 198; Émile Bernard, *Souvenirs sur Paul Cézanne, une conversation avec Cézanne* (Paris, 1925), repr. facing p. 117; Fry 1927, pp. 18–19, fig. 4; Nina Viktorovna Iavorskaia, *Cézanne* (Moscow, 1935), pl. 2; Gerstle Mack, *Paul Cézanne* (New York, 1935), pp. 23, 142, pl. 1; René Huyghe, "Cézanne et son oeuvre," *L'Amour de l'art*, May 1936, fig. 37; Raynal 1936, pl. LVI; Rewald 1936, fig. 12; Novotny 1937, pl. 7; Alfred Barnes and Violette de Mazia, *The Art of Cézanne* (New York, 1939), pp. 13–14, 402, no. 7, repr. p. 151; Jean-Louis Vaudoyer, *Les peintres provençaux de Nicolas Froment à Paul Cézanne* (Paris, 1947), p. 83, repr.; Dorival 1948, pp. 29, 145, pl. 20; Rewald 1948, p. 45, fig. 26; Maurice Raynal, *Cézanne* (Geneva, Paris, and New York, 1954), pp. 28–29, repr.; Douglas Cooper, "Au Jas de Bouffan," *L'OEil* 2 (February 15, 1955), p. 16; Kurt Badt, *Die Kunst Cézannes* (Munich, 1956), pp. 117, 142, pl. 33; Iris Elles, *Das Stilleben in der französischen Malerei des 19. Jahrhunderts* (Zurich, 1958), p. 107; Peter H. Feist, *Paul Cézanne* (Leipzig, 1963), pp. 9, 21, pl. 3; Kurt Leonhard, *Paul Cézanne in Selbstzeugnissen und Bilddokumenten* (Reinbek near Hamburg, 1966), p. 119, repr.; Orienti 1970, no. 67, repr.; Wayne Andersen, *Cézanne's Portrait Drawings* (Cambridge, Mass., and London, 1970), fig. 4; Madeleine Hours, "Cézanne's Portrait of His Father," *Studies in the History of Art*, National Gallery of Art, Washington 4 (1971–72), pp. 63–80, figs. 1–11; Rewald 1971–72, pp. 38–62, fig. 2 (reprinted in John Rewald, *Studies in Impressionism* [New York, 1985], pp. 69–101, pl. VII); Rewald 1973, p. 146, repr. p. 147; Anna G. Barskaya, *Paul Cézanne* (Leningrad, 1975), p. 13, repr.; Sophie Monneret, *Cézanne, Zola: La fraternité du génie* (Paris, 1978), repr. p. 11; Lionello Venturi, *Cézanne* (Geneva, 1978), repr. p. 18; Theodore Reff, "The Pictures within Cézanne's Pictures," *Arts Magazine* 53 (June 1979), fig. 4; Denis Coutagne and Bruno Ely, *Cézanne au Musée d'Aix* (Aix-en-Provence, 1984), p. 213, repr.; Sylvie Gache-Patin, "Douze oeuvres de Cézanne de l'ancienne collection Pellerin," *Revue du Louvre* 34, no. 2 (1984), p. 130, no. 3; John Rewald, "Paintings by Paul Cézanne in the Mellon Collection," *Essays in Honor of Paul Mellon, Collector and Benefactor*, ed. by John Wilmerding (Washington, 1986), pp. 289, 294–97, fig. 4; Rewald 1986c, pp. 54, 67, 147, 157, repr. p. 23; Bob Kirsch, "Paul Cézanne: *Jeune fille au piano* and Some Portraits of His Wife: An Investigation of His Painting of the Late 1870's," *Gazette des Beaux-Arts* 60 (July–August 1987), p. 22; Wells 1987, pp. 42–58, 61, 62, 65, 67–69, pl. VIII; John Rewald, *Cézanne and America: Dealers, Collectors, Artists and Critics, 1891–1921* (Princeton, 1989), p. 219, fig. 105; Nina Athanassoglou-Kallmyer, "An Artistic and Political Manifesto for

Cézanne," *Art Bulletin* 72 (September 1990), pp. 482–84, 491–92, fig. 2

Thanks to a letter from Antoine Guillemet, who was visiting Cézanne in Aix, to Émile Zola, then in Paris, the precise date of this painting is known. On November 2, 1866, Guillemet reported that Cézanne was painting "a portrait of his father in an armchair which looks very good. The painting is 'blond' and the effect is splendid; the father looks like a pope on his throne were it not for *Le Siècle* that he is reading."[1] It was the second full-fledged portrait of this man that the artist had undertaken. The first (fig. 399) was painted for the salon of the Jas de Bouffan about 1865. Seated, wearing a cap (Louis-Auguste had been a hat maker before becoming a banker), Cézanne *père* adorned a niche flanked by two of four panels representing the four seasons. On the opposite wall Cézanne painted *Le Christ aux limbes et la Madeleine* (fig. 67, and see cat. 27) soon afterward.

The gestation of this painting began in summer 1866. According to Fortuné Marion, writing on August 28, 1866, the first version of *L'Ouverture de Tannhäuser* included "an old father in profile in an armchair."[2] Cézanne *père* was eliminated from that painting in subsequent revisions, but the high-backed chair with a chintz slipcover retained its identification with him, for when the painter decided to dedicate a large canvas to him he naturally posed him in the chair. Given his father's attitude toward Cézanne's rebellious na-

ture, it is somewhat surprising that stern Louis-Auguste gave his son the necessary time for sittings. Cézanne's letters from Aix clearly state his exasperation with his family, and Zola's notes clearly indicate Louis-Auguste's difficult personality. While anticipating his novel *La Conquête de Plassans*, Zola reminded himself to "take the type of C[ézanne]'s father, mocking, republican, bourgeois, cold, meticulous, stingy; depict his home life; he refuses his wife any luxury, etc. He is, moreover, garrulous and, sustained by his wealth, doesn't care a rap for anyone or anything."[3]

As Guillemet's letter reveals, Louis-Auguste was originally shown reading *Le Siècle*, a republican daily founded in 1836 that grew to have one of the largest circulations in France. At some point Cézanne changed the masthead to read *L'Événement*, a short-lived paper founded by the director of *Le Figaro* that published in the spring of 1866 Zola's provocative art criticism. The paper folded in November 1866. There can be no doubt that in substituting the paper in his father's hands, Cézanne sought to make reference to Zola and to the progressive ideas embodied by *L'Événement*. He may also have been playing a childish prank.

It is not known whether Cézanne intended to submit the portrait to the Salon in the 1860s. An analogous portrait of Achille Emperaire was submitted to, and rejected by, the 1870 Salon. As Cézanne knew very well, Manet, Monet, Renoir, and Degas were all creating large-scale portraits at this time. Yet none was as defiantly provocative as this one. By the 1880s the novelty of the work was less offensive, and Cézanne submitted the painting to the permissive 1882 Salon, where it was accepted.

Cézanne made several sketches for the picture in his notebook.

G.T.

1. Rewald 1971–72, p. 47.
2. Barr 1937, p. 54.
3. Quoted in Rewald 1971–72, p. 39.

Fig. 399. Paul Cézanne, *Portrait de Louis-Auguste Cézanne, père de l'artiste*, ca. 1862. Oil on plaster mounted on canvas, 66⅛ x 44⅞ in. (168 x 114 cm). The Trustees of The National Gallery, London

27 *Fig. 66*

Paul Cézanne
La Madeleine
(*Mary Magdalen*)
Ca. 1867
Oil on canvas
65 x 49⅜ in. (165 x 125.5 cm)
Musée d'Orsay, Paris RF 1952.10

Catalogue raisonné: Venturi 1936, no. 86

Provenance: The artist, as part of the decor of the *grand salon* of the Jas de Bouffan, near Aix-en-Provence, until 1899; the property, including the works in situ, purchased by Louis Granel, Aix-en-Provence, in 1899, until at least 1907; offered to the state for the Musée du Luxembourg, but rejected, 1907; sold to Jos Hessel, Paris; Marius de Zayas, New York, by 1921; Alphonse Kann, Saint-Germain-en-Laye, until his death in 1948; by descent to his niece Hélène Kann Bokanowski and her husband, Maurice Bokanowski, Paris, until 1952; acquired by the Louvre, with funds of an anonymous Canadian gift, May 5, 1952; transferred to the Jeu de Paume; transferred to the Musée d'Orsay, 1986

Exhibitions: Zurich, Kunsthaus, October 5–November 14, 1917, *Französische Kunst des XIX. und XX. Jahrhunderts*, no. 20; New York, Metropolitan Museum of Art, May 3–September 15, 1921, *Loan Exhibition of Impressionist and Post-Impressionist Paintings*, no. 2; New York, Modern Gallery (de Zayas), 1921, *Group Exhibition*, no number; Paris, Musée de l'Orangerie, June 19–September 15, 1953, *Monticelli et le Baroque provençal*, no. 2, pl. XXIV; Paris 1954, no. 12, pl. V; Paris, Musée de l'Orangerie, December 16, 1967–March 1968, *Vingt ans d'acquisitions au Musée du Louvre*, no. 401; Paris, Musée de l'Orangerie, July 20–October 14, 1974, *Cézanne dans les musées nationaux*, no. 1, repr.; London, Paris, Washington 1988–89, no. 33, repr.; Paris, Louvre, April 26–July 26, 1993, *Copier Créer, de Turner à Picasso: 300 oeuvres inspirées par les maîtres du Louvre*, no. 318, repr.

Selected references: Fritz Bürger, *Cézanne und Hodler* (Munich, 1913), pp. 222–23, pl. 171; Gustave Coquiot, *Paul Cézanne* (Paris, 1919), pp. 41, 214; Meier-Graefe 1922, repr. p. 97; Rivière 1923, p. 199, listed; Kurt Pfister, *Cézanne: Gestalt/Werk/Mythos* (Potsdam, 1927), fig. 15; Eugenio d'Ors, *Paul Cézanne* (Paris, 1930), p. 50, repr.; Orienti 1970, no. 18, repr.; Götz Adriani, *Paul Cézanne, "Der Liebeskampf": Aspekt zum Frühwerk Cézannes* (Munich and Zurich, 1980), p. 57, pl. 10; Mary Tompkins Lewis, "Cezanne's 'Harrowing of Hell and the Magdalen,'" *Gazette des Beaux-Arts* 97 (April 1981), pp. 175–78, fig. 1; Theodore Reff, "Cézanne: The Severed Head and the Skull," *Arts Magazine* 58 (October 1983), p. 92, fig. 9; Denis Coutagne and Bruno Ely, *Cézanne au Musée d'Aix* (Aix-en-Provence, 1984), p. 116; Carol Solomon Kiefer, "Cézanne's 'Magdalen': A New Source in the Musée Granet, Aix-en-Provence," *Gazette des Beaux-*

Arts 103 (February 1984), pp. 91–94, fig. 1; Mary Tompkins Lewis, *Cezanne's Early Imagery* (Berkeley and Los Angeles, 1989), pp. 25, 38, 47–62, 65, pl. 11

Cézanne's father bought the Jas de Bouffan outside Aix in 1859. Throughout the 1860s, Cézanne worked on various decorations, with a disconcerting variety of styles and subjects, for the salon of the house. About 1860–62, he created panels depicting *Les Quatre Saisons* (*The Four Seasons*), *Le Baigneur au rocher* (*Bather and Rocks*), *Paysage au pêcheur* (*Landscape with a Fisherman*), and the *Portrait de Louis-Auguste Cézanne*. Later in the decade he made *Jeu de cache-cache* (*Blindman's Bluff*) after Lancret, *Contrastes* (*Contrasts*), and *Le Christ aux limbes et la Madeleine* (*Christ in Limbo and the Magdalen*). The last was probably painted in 1867, on the wall opposite the copy after Lancret and adjacent to the portrait of his father.

The decorations were disassembled in 1907, after Cézanne's death, and the *Madeleine* was split off from *Christ aux limbes*. When placed side by side, it is difficult to reconcile the jarring juxtaposition of these two images, in scale, color, and style. Noting the differences in facture, Cuzin and Dupuy have recently suggested that the *Madeleine* may have been painted after *Christ aux limbes*.[1]

Most of the decorations are directly based on well-known old masters. (The *Quatre Saisons* are ironically signed Ingres, although they have nothing to do with his work.) *Christ aux limbes* is based on a painting by Sebastiano del Piombo in the Prado that was illustrated in Charles Blanc's *Histoire des peintres de toutes écoles* (*École Espagnole*), which was published periodically from 1867 on. The source for the *Madeleine* is less certain; the most likely contender is Domenico Feti's *Melancholy* in the Louvre.[2] However, another possibility is a small painting formerly attributed to Subleyras in the Musée Granet in Aix. Carol Kiefer has identified it as one of fourteen depictions of the Magdalen in the Galerie Jean-Baptiste de Bourguignon de Fabregoules (1746–1836), whose son gave his collection of six hundred works of art to the city of Aix in 1860. Although Cézanne wrote to Zola that he was not impressed when he saw the collection installed in a disaffected chapel in town, there could well be a connection.[3]

Gowing, following Mary Tompkins Lewis, sees the juxtaposition of Christ and the Magdalen as typical of Easter imagery.[4] They suggest, following Kiefer, that it may be part and parcel of a revival in the cult of the Magdalen in Provence at mid-century—she was the patroness of the province. The tearlike forms above the Magdalen's head are interpreted as her jewels transformed into burning tears and tongues of fire. To the contrary, Reff interprets the work as almost secular, a mourning figure grieving over a shrouded coffin from which the head has inexplicably appeared. He sees Tompkins's flaming jewels as embroidered tears symbolic of mourning, such as those on the cloth that covered the coffin of Emma Bovary or that of the unnamed *disparu* in Courbet's *En-*

terrement à Ornans. Reff sees the *Madeleine* as a representation of a surrender to death and the *Christ* as a divine triumph over mortality. As such, Cézanne's work may be related to contemporary deathbed scenes by Théodule Ribot or Alphonse Legros.[5] But in sum, the various interpretations ask more questions than they answer. As Cuzin and Dupuy note, "The painting remains difficult to interpret: is the large white shape at the right, which makes one think of the trunk of a birch tree, a table draped in white, seen from above? Is the woman in front of a skull or a corpse? Is it water at the bottom right?"[6] And was Cézanne, as he had done several times, trying to outdo Manet, in particular the *Christ mort aux anges* (cat. 96)?

<div align="right">G.T.</div>

1. Jean-Pierre Cuzin and Marie-Anne Dupuy in Paris, Musée du Louvre, 1993, *Copier Créer, de Turner à Picasso: 300 oeuvres inspirées par les maîtres du Louvre*, p. 444.
2. Suggested by A. Chatelet in Paris 1954.
3. Carol S. Kiefer, "Cézanne's 'Magdalen': A New Source in the Musée Granet, Aix-en-Provence," *Gazette des Beaux-Arts* 103 (February 1984), pp. 91–94.
4. Gowing in London, Paris, Washington 1988–89, p. 12; Mary Tompkins Lewis, "Cezanne's 'Harrowing of Hell and the Magdalen'," *Gazette des Beaux-Arts* 97 (April 1981), pp. 175–78.
5. Theodore Reff, "Cézanne: The Severed Head and the Skull," *Arts Magazine* 58 (October 1983), pp. 91–92.
6. "Le tableau reste difficile à interpréter: la grande forme blanche, à droite, qui fait penser au tronc d'un bouleau, est-elle celle d'une table drapée de blanc vue par en haut? La femme est-elle devant un crâne, ou un cadavre? Y a-t-il de l'eau, tout en bas à droite?" Cuzin and Dupuy in *Copier Créer*, p. 444.

28 *(New York only)* *Fig. 345*

Paul Cézanne
L'Ouverture de Tannhäuser
(*The Overture to "Tannhäuser"*)
Ca. 1869–70
Oil on canvas
22¾ x 36⅜ in. (57.8 x 92.5 cm)
Hermitage Museum, Saint Petersburg 9166

CATALOGUE RAISONNÉ: Venturi 1936, no. 90

PROVENANCE: Ambroise Vollard, Paris; sold to Ivan Morosov, Moscow, for Fr 20,000, by 1908, until 1918; his collection nationalized by a decree of the Council of People's Commissar and renamed the Second Museum of Modern Western Painting, 1918; State Museum of Modern Western Art, Moscow, 1923; transferred to the State Hermitage Museum, Saint Petersburg, 1948

EXHIBITIONS: Moscow, Museum of Modern Western Art, 1926, *Paul Cézanne/Vincent van Gogh*, no. 2; Paris

1936, no. 8; Leningrad, Hermitage, 1956, *Paul Cézanne*, no. 2; London, Paris, Washington 1988–89, no. 44, repr.

SELECTED REFERENCES: B. Ternovietz, "Le musée d'art moderne de Moscou," *L'Amour de l'art*, December 1925, pp. 465–66, repr.; Louis Réau, *Catalogue d'art français dans les musées russes* (Paris, 1929), p. 99, no. 736; Nina Viktorovna Iavorskaia, *Cézanne* (Moscow, 1935), pl. 4; Gerstle Mack, *Paul Cézanne* (New York, 1935), pp. 22–23; Huyghe 1936, p. 14; René Huyghe, "Cézanne et son oeuvre," *L'Amour de l'art*, May 1936, p. 168, repr.; Barr 1937, pp. 40, 52–58, repr.; Lionello Venturi, "The Early Style of Cézanne and the Post-Impressionists," *Parnassus* 9 (March 1937), p. 15, repr.; Fritz Novotny, *Cézanne* (Vienna, 1937; reprinted 1961, 1971), pl. 14; Alfred Barnes and Violette de Mazia, *The Art of Cézanne* (New York, 1939), pp. 309–10, 404, no. 19, repr. p. 157; Dorival 1948, pp. 30, 33, 177, pl. VII; Rewald 1948, fig. 23; Peter H. Feist, *Paul Cézanne* (Leipzig, 1963), pp. 12, 21, pl. 2; Brion-Guerry 1966, pp. 45–47, pl. 7; Orienti 1970, no. 40, repr.; Anna G. Barskaya, *Paul Cézanne* (Leningrad, 1975), pp. 15–16, 163, pl. 2; Lionello Venturi, *Cézanne* (Geneva, 1978), pp. 16, 23, 60, repr. p. 22; Rewald 1986c, pp. 55, 63, 67, 71, repr. p. 63; Wells 1987, pp. 81–123, pl. XXI; Bob Kirsch, "Paul Cézanne: *Jeune fille au piano* and Some Portraits of His Wife: An Investigation of His Painting of the Late 1870's," *Gazette des Beaux-Arts* 60 (July–August 1987), pp. 21–24, repr.; Mary Tompkins Lewis, *Cezanne's Early Imagery* (Berkeley and Los Angeles, 1989), pp. 139–48, 187, pl. IX

In 1937, Alfred Barr identified this painting with the composition described in letters from Cézanne's friend Fortuné Marion to a young German named Heinrich Morstatt. These letters are extraordinary documents, for they reveal not only the subject of the painting, which would otherwise remain obscure, but also something of the genesis of the composition, as well as insight into how Cézanne was regarded by his friends.

There were three versions of this composition and at least two canvases. It is not known whether the second version was painted over the first version, or if the third version, the present painting, was painted over the second version. The present painting is all that survives today, and examination of the painting has not revealed an earlier composition underneath the present surface.

The first version can be precisely dated to August 28, 1866. Marion wrote, "In a single morning, he executed a superb painting, as you will see. It will be called *Ouverture du Tanauhser* [*sic*],—it is as futuristic as Wagner's music. It shows: a young girl at the piano; white on blue; everything in the foreground. The piano is treated exceptionally well and fully, an old father in profile in an armchair;—a young child, with a stupid look, is listening in the background. The mass is very wild and overwhelmingly powerful; the painting must be looked at for a very long time."

A year later, in June or July 1867, Marion reported, "He [Paul] has already begun several large canvases and he is going to treat again in totally different tonalities and in blonder tones the *Ouverture du Tannhäuser* that you saw in an earlier canvas." On September 6, 1867, he wrote, "I would like you to see the canvas he is working on at the moment. He is reusing a subject that you already know, the *Ouverture du Tannhäuser*, but in very different tonalities and very clear colors,

with all the figures completely finished. There is a head of a young blond girl, surprisingly pretty and powerful, and my profile bears a great resemblance, although it is very finished, without those previously disturbing clashing colors and repulsive ferocious aspects. The piano is still very beautiful, as in the first canvas, and the draperies are depicted with an astonishing truth, as usual. This painting will probably be refused at the exposition, but it will always be shown some other place, such a painting is enough to make a reputation."[1] Whether or not Cézanne did submit the painting to the Salon is not known.

Antoine Guillemet mentioned having seen the first version in a letter to Zola of November 2, 1866, to which Cézanne appended a note saying, "and that having tried to paint a family evening, it did not come out at all, but yet, I will persevere and maybe it will come out right some other time."[2] If this indeed is the family portrait to which he referred, there may be some irony in his depiction, for his feelings toward his family were ambivalent at best. In a letter of October 23, 1866, to Pissarro, Cézanne complained, "Here I am with my family, with the nastiest beings in the world, those who make up my family, boring in the extreme."[3]

Most scholars agree that Cézanne represented one of his sisters at the piano, either Rose or Marie, and his mother sewing in the salon of the Jas de Bouffan outside of Aix. According to Lawrence Gowing, the room's wallpaper, here rendered in exaggerated arabesques, is visible in other pictures of the Jas de Bouffan.[4] The empty armchair may be a substitute for Cézanne's father, who was shown sitting in it in the first version of 1866. It is possible, as some scholars have suggested, that Degas's family portrait *La Famille Bellelli* may have inspired Cézanne in this work, although the only place Cézanne could likely have seen the Degas was at the Salon of 1867, and it is not certain that Degas's painting was actually exhibited.

Wagner's *Tannhäuser* was first performed at the Paris Opéra on March 13, 1861. It was too avant-garde for the clubs that controlled the Opéra, and it was retired after three performances. However, advanced critics such as Baudelaire championed Wagner as a kindred spirit, and most of the young painters, such as Fantin-Latour, Renoir, and Cézanne, admired his music. Cézanne could not have seen *Tannhäuser* in 1861 since he arrived in Paris one month after it closed; and although he was back in Paris when it was performed again in 1865, it is thought he did not attend. Nevertheless the music was widespread. In inviting Morstatt to Aix for Christmas 1865, Cézanne promised, "You will make our acoustic nerves vibrate to the noble tones of Richard Wagner."[5] In a letter to Morstatt of May 24, 1868, Cézanne reported, "I had the pleasure of listening to the overture of *Tannhäuser*, of *Lohengrin* and of the *Flying Dutchman*."[6] The theme of listening to music is one explored throughout the 1860s by Whistler, Fantin-Latour, Manet, and Degas.

G.T.

1. "En un matin il a à demi bâti un tableau superbe, tu verras. Cela s'appellera l'*Ouverture du Tanauhser*,—c'est aussi bien de l'avenir que la musique de Wagner. Voici: —Une jeune fille au piano; du blanc sur du bleu; tout au premier plan. Le piano supérieurement et largement traité, un vieux père dans un fauteuil de profil;—un jeune enfant, l'air idiot écoutant dans le fond. La masse toute sauvage et d'une puissance écrasante; il faut regarder bien longtemps." "Il a déjà plusieurs grandes toiles commencées et il va de nouveau traiter dans des tonalités tout à fait différentes avec des notes plus blondes l'*ouverture du Tannhäuser* dont tu avais vu une première toile." "Je voudrais que tu vis la toile qu'il est en train de faire à ce moment. Il a repris le sujet que tu connais déjà, l'*ouverture du Tannhäuser*, mais dans des tonalités tout à fait différentes dans des colorations très claires, et tous les personages très finis. Il y a une tête de jeune fille blonde, d'un joli et d'une puissance étonnante, et mon profil est d'une ressemblance très grande, tout en étant très fait, sans ces aspérités de couleurs qui gênaient et ces aspects féroces qui repoussaient. Le piano est toujours très beau, comme sur l'autre toile, et les draperies, comme d'ordinaire, d'une vérité étonnante. Il est probable que ça sera refusé à l'exposition, mais ce sera toujours exposé quelque part, une toile semblable suffit pour faire une réputation." The Marion letters are taken from Barr 1937, pp. 54–55.
2. "et que ayant tenté une soirée de famille, ça n'est point venu du tout, mais cependant je persévérerai et peut-être qu'un autre coup, ça viendra." Renée Baligand, "Lettres inédites d'Antoine Guillemet à Émile Zola (1866–1870)," *Les Cahiers naturalistes*, 1978, p. 183.
3. "me voici dans ma famille avec les plus sales êtres du monde, ceux qui composent ma famille, emmerdants par dessus tout." Cézanne 1937, p. 101.
4. Gowing in London, Paris, Washington 1988–89, no. 44, p. 158.
5. "vous ferez vibrer notre nerf acoustique aux nobles accents de Richard Wagner." Cézanne 1937, pp. 91–92.
6. "J'ai eu le bonheur d'entendre l'ouverture de *Tannhäuser*, de *Lohengrin* et du *Hollandais volant*." Barr 1937, p. 53.

29 *(Paris only)* *Fig. 118*

Paul Cézanne
Usines près du mont de Cengle
(Factories near Mont de Cengle)
Ca. 1869–70
Oil on canvas
16⅛ x 21⅝ in. (41 x 55 cm)
Private collection

CATALOGUE RAISONNÉ: Venturi 1936, no. 58

PROVENANCE: Ambroise Vollard, Paris; Cornelius Hoogendijk, The Hague, until his death in 1911; his posthumous sale, F. Muller et Cie., Amsterdam, May 22, 1912, no. 7 ("Ville dans une vallée"); Auguste Pellerin, Paris, until his death in 1929; by descent to his son, Jean-Victor Pellerin, Paris; H.J.M., by 1939; Paul Rosenberg, Paris and New York, by 1941; Sam Salz, New York, by

1946; consigned by him to M. Knoedler and Co., New York, from March to April 1946; sold to William F. C. Ewing, New York (Knoedler's stock no. CA 2634), in April 1946, until October 1946; sold to M. Knoedler and Co., New York, October 1946, until 1953; sold to Walter Feilchenfeldt, Zurich, in April 1953 (Knoedler stock no. CA 3559); sold to Emil G. Bührle, Zurich, by 1953; private collection

EXHIBITIONS: Paris, Paul Rosenberg, February 21–April 1, 1939; London, Rosenberg and Helft, April 19–May 20, 1939, *Exposition Cézanne (1839–1906)*, no. 2, repr.; Manchester, New Hampshire, Currier Gallery of Art, October 8–November 6, 1949, *Monet and the Beginnings of Impressionism*, no. 25; The Hague, Gemeentemuseum, June–July 1956, *Paul Cézanne, 1839–1906*, no. 4, repr.; Aix-en-Provence, Pavillon de Vendôme, July 21–August 15, 1956, *Exposition pour commémorer le cinquantenaire de la mort de Cézanne*, no. 2, repr.; Zurich, Kunsthaus, August 22–October 7, 1956, *Paul Cézanne, 1839–1906*, no. 7, repr.; Cologne, Wallraf-Richartz-Museum, December 1956–January 1957, *Cézanne, Austellung zum Gedenken an sein 50. Todesjahr*, no. 4, repr.; London, Paris, Washington 1988–89, no. 48, repr

SELECTED REFERENCES: Rivière 1923, p. 198; Lionello Venturi, "L'impressionismo," *L'Arte* 38 (March 1935), p. 147, repr.; Maurice Raynal, *Cézanne* (Paris, 1936; reprinted 1954), pl. XXXVI; John Rewald, "Paul Cézanne: New Documents for the Years 1870–1871," *Burlington Magazine* 74 (April 1939), p. 164, repr.; Rewald 1939, pl. 27; Dorival 1948, p. 33; Rewald 1948, fig. 33; Lawrence Gowing, "Notes on the Development of Cézanne," *Burlington Magazine* 98 (June 1956), p. 187; Brion-Guerry 1966, pp. 53–54; Orienti 1970, no. 114, repr.; Rewald 1986c, repr. p. 66

According to John Rewald,[1] there is no evidence of a factory at the site Cézanne depicts in this work. Because it is similar to an imaginary industrial scene that Cézanne executed in 1869, ironically, to decorate the lid of the sewing box of Mme Alexandrine Zola, most scholars give this work the same date. It belongs to a group of landscapes that are largely imaginary but are based on aspects of the Provençal countryside around Aix and L'Estaque, where Cézanne remained during the Franco-Prussian War. The paint in these works is thickly applied but more fluid than his work of the mid-1860s. The style of the landscapes is summary, and the mood is often apocalyptic, although this work does not convey the typical foreboding sensation characteristic of most of them. Bernard Dorival described the group well: "These are paintings whose composition is strange on purpose, where colors are sharply contrasted, where black and white are dominant, where a loose and purposely summary drawing, rather than color, defines tormented and wildly dynamic forms. Clearly, the painter only wanted to translate, and translate immediately, an overall sensation of such intensity that it becomes vehemence and can no longer be analyzed."[2]

Cézanne's friends Guillaumin and Pissarro both explored industrial landscapes at this time, and the subject was of course examined by Émile Zola in his novels.

G.T.

1. Cited by Lawrence Gowing in London, Paris, Washington 1988–89, p. 166.

2. "Ce sont là des tableaux d'une composition volontaire-
ment étrange, dont les couleurs contrastent brutalement,
où le noir et le blanc occupent une place prépondérante,
et où un dessin lâche, volontairement sommaire, définit,
moins que la couleur, des formes tourmentées, d'un
dynamisme plein d'agitation. Visiblement l'auteur n'a
voulu que traduire et traduire immédiatement une sen-
sation globale d'une telle intensité qu'elle en devient de
la véhémence et ne se peut analyser." Dorival 1948, p. 33.

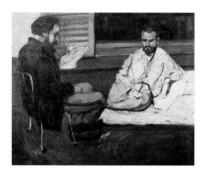

30 *Fig. 265*

Paul Cézanne
Paul Alexis lisant à Émile Zola
(*Paul Alexis Reading to Émile Zola*)
Ca. 1869–70
Oil on canvas
51⅛ x 63 in. (130 x 160 cm)
Museu de Arte de São Paulo Assis Chateaubriand 86

CATALOGUE RAISONNÉ: Venturi 1936, no. 117

PROVENANCE: Émile Zola, Médan, found in Zola's attic
several years after the death of his widow, Eléonore-
Alexandrine Meley Zola, in 1925; M. Helm, Le Vésinet,
probably purchased from Mme Zola's posthumous sale
of house furnishings; Paul Rosenberg, Paris, after 1927;
owned jointly with Wildenstein, Paris and New York,
by 1934, until 1951; sold to Museu de Arte, São Paulo,
October 29, 1951

EXHIBITIONS: Paris 1936, no. 178; Paris, Grand Palais,
50eme Exposition de la Société des Artistes Indépendants,
March 17–April 10, 1939, *Centenaire du peintre indépen-
dant Paul Cézanne*, no. 17; London, Paris, Washington
1988–89, no. 47, repr.; Tübingen, Kunsthalle, January
16–May 2, 1993, *Cézanne Gemälde*, 1993, no. 6, repr.

SELECTED REFERENCES: Nina Viktorovna Iavorskaia,
Cézanne (Moscow, 1935), pl. IV; Rewald 1936, fig. 21;
René Huyghe, "Cézanne et son oeuvre," *L'Amour de
l'art*, May 1936, fig. 43; Rewald 1939, fig. 24; Alfred
Barnes and Violette de Mazia, *The Art of Cézanne* (New
York, 1939), pp. 312, 403, no. 12, repr. p. 155; Raymond
Cogniat, *Cézanne* (Paris, 1939), pl. 20; Dorival 1948,
pp. 30, 146, pl. 26; Rewald 1948, fig. 31; Meyer Schapiro,
Cézanne (New York, 1952), p. 25, repr. p. 9; Maurice
Raynal, *Cézanne* (Geneva, Paris, New York, 1954), p. 28;
Lawrence Gowing, "Notes on the Development of
Cézanne," *Burlington Magazine* 98 (June 1956), pp.
186–87; Adhémar 1960, p. 288, fig. 5; Orienti 1970,
no. 32, repr.; Sophie Monneret, *Cézanne, Zola: La
fraternité du génie* (Paris, 1978), repr. p. 39; Lionello
Venturi, *Cézanne* (Geneva, 1978), repr. p. 23; Götz
Adriani, *Paul Cézanne, "Der Liebeskampf": Aspekt zum
Frühwerk Cézannes* (Munich and Zurich, 1980), p. 14,
pl. C

Zola and Cézanne were great, inseparable child-
hood friends. With Jean-Baptistin Baille they
dreamed of escaping the stifling provincialism of
Aix-en-Provence to make their mark in Paris.
They were nursed on the romantic literature of
Hugo, Musset, and Lamartine, and their child-
hoods were remarkable in their similarity, a sim-
ilarity that is all the more remarkable in view of
their very different subsequent careers. Zola shed
his romantic fervor early in the 1860s and re-
nounced it with the creation of a new, brutal style
of literary realism, while Cézanne continued to
pursue romantic and fantastical imagery through
the mid-1870s. Although he abandoned dream
imagery by the 1880s to focus exclusively on the
phenomenal world, Cézanne did continue to paint
imaginary scenes of women bathing until the end
of his life.

Zola's and Cézanne's differences rose to the sur-
face upon the publication of Zola's novel *L'OEuvre*
in 1886. The book, based on the fraternity of
avant-garde painters and writers in Paris in the
1860s, was essentially autobiographical, but in
the character of Claude Lantier, a painter par-
tially reminiscent of Manet and Monet, he cap-
tured something of Cézanne's obsessive character
and had him paint with the crude and primitive
quality of Cézanne's style of the 1860s. In the
novel, Zola contrasted the steady climb to suc-
cess of Pierre Sandoz, the young realist writer in
whom many saw Zola's portrait, with Claude
Lantier's critical misfortune, a failure to win rec-
ognition which ultimately led to artistic impo-
tence. When Zola sent him a copy of the book,
Cézanne acknowledged receipt and never spoke
to the author again.[1]

Paul Alexis (1847–1901) also grew up in Aix
and followed Zola to Paris. According to Adhémar,
he arrived in Paris in 1869, so they probably posed
for the picture in the garden of Zola's building at
14, rue La Condamine.[2] Since at this period
Cézanne was in Paris only from January 1869 to
summer 1870, the date of this picture can be as-
signed to these eighteen months. Alexis wrote
poetry, novels, and plays, and in 1882, he published
Émile Zola, notes d'un ami. There is another,
smaller picture of Alexis reading to Zola (fig. 400)
that may be similar in date, although it is very
different in style. Nina Athanassoglou-Kallmyer
has proposed, convincingly, that Cézanne simul-
taneously worked in two styles: "painting con-
ceived in a spirit of irony—as parodies of other
paintings—and paintings created as earnest state-
ments of the artist's own preferred manner."[3] The
present work is no doubt an earnest statement.
And by giving Zola an unusual pose—one more
typical of an odalisque than of a realist author
—and a passive activity—listening—he cleverly
alludes to some of the same aspects of Zola's char-
acter that were perceived by others. The Goncourts
described Zola in 1868 as having an "ambigu-
ous, almost hermaphroditic appearance; at once
burly and frail, he looked more youthful than he
was, with the delicate moulding of fine porcelain
in his features, in the arch of his eyebrows. Rather
like the weak-willed, easily dominated heroes of
some of his early novels, he seemed like an amal-
gam of male and female traits, with the latter
dominant."[4]

Zola's letters indicate that Cézanne worked on
several other portraits of him, beginning in the
early 1860s. Only one seems to have survived, of
about 1862–64 (whereabouts unknown).

 G.T.

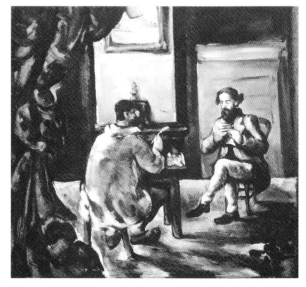

Fig. 400. Paul Cézanne, *La Lecture de Paul Alexis chez Zola*
(*Paul Alexis Reading at Zola's*), ca. 1867–69. Oil on canvas,
20½ x 22 in. (52 x 56 cm). Private collection, Switzerland

1. Roger Pearson, introduction to Émile Zola, *The Masterpiece*, trans. by Thomas Walton (Oxford, 1993), p. xix.
2. Adhémar 1960, p. 287.
3. Nina Athanassoglou-Kallmyer, review of London, Paris, Washington 1988–89, in *Art Journal* 49 (Spring 1990), p. 72.
4. Goncourt 1956, vol. 2, pp. 474–75; translation from E. W. J. Hemmings, *The Life and Times of Émile Zola* (London, 1977), pp. 87–88; quoted by Mary Louise Krumrine in London, Paris, Washington 1988–89, p. 23.

31 *Fig. 190*

Paul Cézanne

La Pendule noire
(*The Black Clock*)
Ca. 1870
Oil on canvas
21¾ x 29¼ in. (55.2 x 74.3 cm)
Private collection

CATALOGUE RAISONNÉ: Venturi 1936, no. 69

PROVENANCE: Émile Zola, Médan, until his death in 1902; his posthumous sale, Hôtel Drouot, Paris, March 9–13, 1903, no. 114; bought at this sale for Fr 3,000 by Auguste Pellerin, Paris, 1903,[1] until at least 1907; Ambroise Vollard, Paris, by 1909;[2] Baron Adolf Kohner, Budapest, by 1911, until at least 1929; Paul Rosenberg, Paris; Wildenstein and Co., New York, by October 1931; transferred to Wildenstein, London, in 1935; sold to Edward G. Robinson, Beverly Hills, November 19, 1936, until 1957; private collection

EXHIBITIONS: London, Grafton Galleries (organized by Durand-Ruel Gallery), January–February 1905, *Pictures by Boudin, Cézanne, Degas, Manet, Monet, Morisot, Pissarro, Renoir, Sisley*, no number; Paris, Grand Palais, Salon d'Automne, October 1–22, 1907, *Rétrospective de Cézanne*, no. 8; Paris 1936, no. 11, repr.; Chicago, Art Institute, February 7–March 16, 1952, New York, Metropolitan Museum of Art, April 1–May 16, 1952, *Cézanne Paintings, Watercolors and Drawings, Loan Exhibition*, no. 11; New York, Knoedler Galleries, December 3, 1957–January 10, 1958, Ottawa, National Gallery of Canada, February 1958, *A Loan Exhibition of Paintings and Sculpture from The Niarchos Collection*, no. 5, repr.; Vienna, Österreichische Galerie, Oberes Belvedere, April 14–June 18, 1961, *Paul Cézanne, 1839–1906*, no. 5, repr.; Washington, Phillips Collection, February 27–March 28, 1971, Chicago, Art Institute, April 17–May 16, 1971, Boston, Museum of Fine Arts, June 1–July 3, 1971, *Cézanne: An Exhibition in Honor of the Fiftieth Anniversary of the Phillips Collection*, no. 2, repr.; Paris, New York 1974–75, no. 5, repr.; London, Paris, Washington 1988–89, no. 49, repr.

SELECTED REFERENCES: Meier-Graefe 1910, repr. p. 77; Hugo Haberfeld, "Die Französischen Bilder der Sammlung Kohner," *Der Cicerone* 3 (1911), p. 588, pl. 7; Fritz Bürger, *Cézanne und Hodler* (Munich, 1913), p. 120, pl. 114; Maurice Denis, "Cézanne," *Kunst und Kunstler* 12 (1913), p. 208; Meier-Graefe 1920, repr.; Rivière 1923, p. 199; Julius Meier-Graefe, *Entwicklungsgeschichte der modernen Kunst* (Munich, 1925), p. 495, repr.; Julius Meier-Graefe, *Cézanne* (London and New York, 1927), pl. v; Kurt Pfister, *Cézanne: Gestalt/Werk/Mythos* (Potsdam, 1927), fig. 25; E. Petrovics, ("Collection of Baron A. von Kohner"), *Magyar Muveszet (Hungarian Art)*, 1929, p. 321, repr.; René Huyghe, "Cézanne et son oeuvre," *L'Amour de l'art*, May 1936, fig. 40; Huyghe 1936, p. 34, fig. 15; Rewald 1936, fig. 7; Novotny 1937, pl. 10; Rewald 1939, fig. 20; Alfred Barnes and Violette de Mazia, *The Art of Cézanne* (New York, 1939), pp. 66, 403, no. 14, repr. p. 162; Raymond Cogniat, *Cézanne* (Paris, 1939), pl. 14; Dorival 1948, pp. 28–29, 144, pl. 17; Rewald 1948, p. 81, fig. 32; Meyer Schapiro, *Cézanne* (New York, 1952), pp. 25, 36, repr. p. 37; Rainer Maria Rilke, *Briefe über Cézanne* (Wiesbaden, 1952), pp. 46–47 (letter to Clara Rilke, Paris, October 24, 1907), repr.; Charles Sterling, *La nature morte* (Paris, 1952), p. 92, pl. 92; Maurice Raynal, *Cézanne* (Geneva, Paris, and New York, 1954), pp. 32–33, repr.; Iris Elles, *Das Stilleben in der französischen Malerei des 19. Jahrhunderts* (Zurich, 1958), p. 100; Peter H. Feist, *Paul Cézanne* (Leipzig, 1963), p. 24, pl. 15; John McCoubrey, "The Revival of Chardin in French Still-Life, 1850–1870," *Art Bulletin* 46 (March 1964), p. 52, fig. 19; Brion-Guerry 1966, pp. 47, 49, 51–52, fig. 9; Orienti 1970, no. 126, repr.; Rewald 1973, repr. p. 248; Sidney Geist, "What Makes *The Black Clock* Run," *Art International* 22 (February 1978), pp. 8–14, repr.; Lionello Venturi, *Cézanne* (Geneva, 1978), p. 64, repr. p. 65; Rewald 1986c, pp. 82, 212

This work is usually dated 1870, and it is generally agreed that it was painted in Zola's house at 14, rue La Condamine before August 1870, when painter and poet quit the capital. Zola owned the black marble clock crowned by a small bust, visible in the background of *La Lecture de Paul Alexis chez Zola* (fig. 400), and Adhémar, for one, believes that the ceramic inkwell at right (Japanese? Provençal faience?) is visible in Manet's portrait of Zola.[3]

Modern writers see this work as a turning point for Cézanne, a work of supreme control in contrast to the emotional turmoil of much of the work of the 1860s. The structure is asserted with the strong play of horizontal and vertical lines, emphasized by the thick layer of paint, and contrasted with the organic forms of lemon, shell, cup, vase, and inkwell. Given the frequent recurrence of objects in Cézanne's still lifes, it is noteworthy that he never again painted these particular objects. Like the *Nature morte: crâne et chandelier* (*Still Life with Skull and Candlestick*, Venturi 61) painted for Heinrich Mörstatt, and the *Nature morte: bas-relief, parchemin, encrier* (*Still Life with Bas-Relief, Parchment, and Inkwell*, ca. 1870–72, Venturi 67) probably painted for Dr. Gachet, this work was probably painted for Zola and the objects may well have had private meanings.

One can find shells (here a *Strombus gigas*, a king conch of the Caribbean) in seventeenth-century *pronk* still lifes as well as in late eighteenth-century pictures devoted to curiosities of natural history. But the strongest reference here is to the still lifes of Manet, who, of course, was publicly defended by Zola. Cézanne may have seen his *Fruits* (cat. 104) and *Nature morte au poisson* (*Still Life with Fish*, 1864) in the 1867 exhibition at the Pont de l'Alma. (Although Cézanne stayed in Paris in order to see the Courbet and Manet pavilions, whether he did or not is unclear.)[4] Both paintings share the palette Cézanne adopted of black, gray, and white with a sharp note of lemon yellow. The motif of a sharply creased white linen tablecloth appears to have been ubiquitous in the 1860s.

Much ink has been spilled on the significance of the absent clock hands. Gowing asserts that they were too picayune to merit inclusion in such a magisterial work.[5] Geist sensibly suggests that "this clock does not suggest fleeting or destructive time. Rather, lacking hands, it implies timelessness and permanence, ideas which would have been routed by the indication of a specific hour."[6] It is worth noting that in two of three studies of a similar clock in his parents' house, Cézanne also omitted the hands.[7]

Meyer Schapiro observed that Cézanne's still life "is distinctive through its distance from every appetite but the aesthetic-contemplative. The fruit on the table, the dishes and bottles, are never chosen or set for a meal; they have nothing of the formality of a human purpose.... The world of proximate things, like the distant landscape, exists for Cézanne as something to be contemplated rather than used, and it exists in a kind of prehuman, natural disorder which has first to be mastered by the artist's method of construction."[8]

Cézanne gave this painting to Zola, who owned ten paintings by his fellow Aixois. Cézanne thought enough of it to request it in 1878 for a forthcoming Impressionist exhibition, which, in the end, did not occur. When it was exhibited posthumously at the 1907 Salon d'Automne, Rainer Maria Rilke wrote a highly detailed appreciation of it to his wife.[9]

G.T.

1. See Adhémar 1960, p. 294.
2. See Tübingen, Kunsthalle, 1993, *Cézanne Gemälde*, p. 310, n. 35, which indicates that this work was included in a 1909 group exhibition at Paul Cassirer, Berlin, as no. 21 ("Stilleben mit Uhr") and among the works that Vollard sent specifically for this show; it is listed as such in a letter from Vollard to Cassirer (November 11, 1909).
3. Adhémar 1960, pp. 287–88.
4. Barr 1937, p. 49.
5. London, Paris, Washington 1988–89, p. 168.
6. Sidney Geist, "What Makes *The Black Clock* Run," *Art International* 22 (February 1978), p. 13.
7. Chappuis 1973, nos. 348, 349, 411. I thank Roberta Wue for this observation.
8. Meyer Schapiro, *Cézanne* (New York, 1952), pp. 14–15.
9. Rainer Maria Rilke, *Briefe über Cézanne* (Wiesbaden, 1952), pp. 46–47.

32 *Fig. 162*

Paul Cézanne
Une moderne Olympia
(*A Modern Olympia*)
Ca. 1869–70
Oil on canvas
22½ x 21⅝ in. (57 x 55 cm)
Private collection

CATALOGUE RAISONNÉ: Venturi 1936, no. 106

PROVENANCE: Paul Cézanne *fils*, Paris; Ambroise Vollard, Paris, and Bernheim-Jeune, Paris; Auguste Pellerin, Paris, until his death in 1929; by descent to Mme René Lecomte (née Pellerin), Paris; private collection

EXHIBITIONS: Paris 1936, no. 16; Paris 1954, no. 19, pl. VIII; London, Paris, Washington 1988–89, no. 40, repr.; Basel 1989, pp. 39, 83, 85, no. 4, ill. 50

SELECTED REFERENCES: Meier-Graefe 1918, repr. p. 96; Gustave Coquiot, *Paul Cézanne* (Paris, 1919), p. 213, repr. facing p. 212; Meier-Graefe 1920, repr. p. 96; Rivière 1923, p. 202, repr.; Roger Fry, "Le développement de Cézanne," *L'Amour de l'art* 12 (December 1926), p. 391; Roger Fry, *Cézanne: A Study of His Development* (New York, 1927; reprinted 1989), pp. 16–17, fig. 3; Nina Viktorovna Iavorskaia, *Cézanne* (Moscow, 1935), pl. II; Ors 1936, p. 70, pl. 33; Maurice Raynal, *Cézanne* (Paris, 1936; reprinted 1954), pl. XVI; Alfred Barnes and Violette de Mazia, *The Art of Cézanne* (New York, 1939), pp. 314, 405, no. 33, repr. p. 178; Dorival 1948, pp. 26–27, 39, 40, 42–43, 177–78, pl. VIII; Kurt Badt, *Die Kunst Cézannes* (Munich, 1956), p. 76; Sven Lövgren, *The Genesis of Modernism: Seurat, Gauguin, Van Gogh, and French Symbolism in the 1880's* (Stockholm, 1959), p. 34, repr. p. 33; Theodore Reff, "Cézanne, Flaubert, St. Anthony, and the Queen of Sheba," *Art Bulletin* 44 (June 1962), p. 113; Sara Lichtenstein, "Cézanne & Delacroix," *Art Bulletin* 46 (March 1964), p. 59, fig. 9; Brion-Guerry 1966, pp. 33–34, 35, 37, 40, fig. 1; Schapiro 1968, pp. 9–10; Orienti 1970, no. 36, repr.; Lionello Venturi, *Cézanne* (Geneva, 1978), repr. p. 60; Wells 1987, pp. 117, 119, 149–64, 184, 194, 198, 200–206, pl. LXI; Mary Tompkins Lewis, *Cézanne's Early Imagery* (Berkeley and Los Angeles, 1989), p. 201, fig. 107; Hollis Clayson, *Painted Love: Prostitution in French Art of the Impressionist Era* (New Haven, 1991), pp. 16–21, 23; Robert Simon, "Cézanne and the Subject of Violence," *Art in America* 74 (May 1991), pp. 131–35

Like many of Cézanne's paintings of 1869 and 1870, this one engages a dialogue with the work of Manet, the acknowledged leader of the new school of painting. Here he redoes Manet's most scandalous painting to date, *Olympia* (cat. 95) and makes it more "modern." Yet it is not clear whether Cézanne's stance toward the elder Manet was reverential or critical. On a personal level,

Cézanne acted as if he were an unwashed provincial in the presence of Manet. When they met at the Café Guerbois, Cézanne reputedly said, "I do not shake your hand, M. Manet; I have not washed for a week."[1] But this statement, if it was indeed said, could be interpreted as the remark either of a respectful professional inferior or of a mocking equal. What is certain is that in his own day Cézanne was considered a provocateur who intended to out-scandalize Manet and Monet. When Cézanne's submissions to the 1870 Salon were refused, the cartoonist Stock made the following joke: "Courbet, Manet, Monet, and all of you who paint with a knife, a brush, a broom or any other instrument, you are out-distanced! I have the honour to introduce you to your master: M. Cézannes [*sic*].... He is a realist painter and, what is more, a convinced one. Listen to him rather, telling me with a pronounced Provençal accent: 'Yes, my dear Sir, I paint as I see, as I feel—and I have very strong sensations. The others, too, feel and see as I do, but they don't dare... they produce Salon pictures... I do dare, Sir, I do dare... I have the courage of my opinions—and he laughs best who laughs last!'"[2]

Manet's *Olympia* was shown twice in the 1860s: at the 1865 Salon and in Manet's independent exhibition of 1867. Although Cézanne was in and out of Paris both years, it appears that he missed both opportunities to see it.[3] Thus he must have relied on Manet's etching that was included in Zola's pamphlet of 1867. But Cézanne's picture is in no way faithful to Manet's composition. Instead he makes explicit much of the hidden or ambivalent messages of the Manet: that Olympia was a prostitute, that the setting is a brothel. The observer whom Manet only implies is actually included in Cézanne's picture, and many writers have found in him a likeness to Cézanne. So in one sense, one could say that Cézanne has not only borrowed Manet's famous painting, he has stepped into it.

Cézanne exhibited at the 1874 Impressionist exhibition a slightly smaller, and slightly later version of the present picture. As one might expect, the critics were derisive. Wrote one, "Why look for an indecent joke, a motif of scandal in Olympia? In reality, it is only one of the fantastic forms of hashish torn from the swarms of droll visions still hidden in the Hotel Pimodan."[4] Louis Leroy said disparagingly, "Do you remember the *Olympia* of M. Manet? Well, that was a masterpiece of drawing, accuracy, finish, compared with the one by M. Cézanne."[5]

G.T.

1. Rewald 1986c, p. 73.
2. Quoted in John Rewald, "Un article inédit sur Paul Cézanne," *Arts* (Paris), July 21–27, 1954, p. 8; the translation given here is from London, Paris, Washington 1988–89, p. 15.
3. See Barr 1937. The letters from Marion to Morstatt suggest that while Cézanne intended to see the 1867 exhibition, in the end he did not.
4. "Pourquoi chercher une plaisanterie indécente, un motif de scandale dans l'Olympia? Ce n'est en réalité qu'une des formes extravagantes du haschisch empruntée à l'essaim des songes drolatiques qui doivent encore se

cacher dans l'hôtel Pimodan." Marc de Montifaud, "Exposition du boulevard des Capucines," *L'Artiste*, May 1, 1874.
5. Louis Leroy, in *Le Charivari*, April 25, 1874, quoted in Rewald 1973, p. 324.

33 *Fig. 59*

Paul Cézanne
Le Festin
(*The Banquet*)
Ca. 1870
Oil on canvas
50¾ x 31½ in. (129 x 80 cm)
Private collection

CATALOGUE RAISONNÉ: Venturi 1936, no. 92

PROVENANCE: Ambroise Vollard, Paris; Auguste Pellerin, Paris, until his death in 1929; by descent to Mme René Lecomte (née Pellerin), Paris; private collection

EXHIBITIONS: Paris, Galerie Vollard, November–December 1895, *Paul Cézanne*, no number; Paris, Galerie Bernheim-Jeune, June 1–30, 1926, *Rétrospective Paul Cézanne*, no. 21; Paris 1954, no. 2, pl. I; London, Paris, Washington 1988–89, no. 39, repr.

SELECTED REFERENCES: Gustave Geffroy, *La vie artistique* (Paris, 1900), vol. 6, pp. 215–17; Ambroise Vollard, *Paul Cézanne* (Paris, 1914), p. 31; Gustave Coquiot, *Paul Cézanne* (Paris, 1919), pp. 211, 245; Gasquet 1921, repr. facing p. 2; Meier-Graefe 1922, repr. p. 95; Rivière 1923, pp. 46, 198; Roger Fry, *Cézanne: A Study of His Development* (New York, 1927; reprinted 1989), pp. 10–13; Eugenio d'Ors, *Paul Cézanne* (Paris, 1930), pl. 27; Huyghe 1936, pp. 28, 33; Maurice Raynal, *Cézanne* (Paris, 1936), pl. XXI; Alfred Barnes and Violette de Mazia, *The Art of Cézanne* (New York, 1939), p. 402, no. 4; Dorival 1948, pp. 16, 24, 27, 142, pl. 10; Maurice Raynal, *Cézanne* (Geneva, Paris, and New York, 1954), pp. 17–22, 25, repr.; Novotny 1961, pl. 2; Adrien Chappuis, *Les dessins de Paul Cézanne au Cabinet des Estampes du Musée des Beaux-Arts de Bâle* (Olten and Lausanne, 1962), fig. 2; Theodore Reff, "Cézanne's *Dream of Hannibal*," *Art Bulletin* 45 (June 1963), p. 151, fig. 1 (March 1964), p. 58, fig. 5; Sara Lichtenstein, "Cézanne & Delacroix," *Art Bulletin* 46 (March 1964), p. 58, fig. 5; Schapiro 1968, pp. 7–8, fig. 4; Orienti 1970, no. 20, repr.; Chappuis 1973, vol. 1, pp. 78–79; Lionello Venturi, *Cézanne* (Geneva, 1978), p. 60, repr. p. 62; John Rewald, *Paul Cézanne: The Watercolors* (Boston, 1983), pp. 87–88, repr.; Rewald 1986c, p. 79; Krumrine 1989, pp. 42, 48, 50, ill. 23; Mary Tompkins Lewis, *Cézanne's Early Imagery* (Berkeley and Los Angeles, 1989), pp. 75, 173–86, 195, fig. 98

This, the most extravagant of Cézanne's subject pictures around 1870, was probably inspired, as Mary Tompkins Lewis has demonstrated, by a passage in Flaubert's *La Tentation de saint Antoine*.[1] Thirty years ago Theodore Reff proposed that the subject was based on one of Cézanne's own poems, "Le Songe d'Annibal," written the day after he matriculated from school in 1858 and sent to Zola.[2] Reff observed that the tentative and searching quality of Cézanne's drawings for the picture indicate that he did not have a descriptive text to follow, but in 1978 a highly finished preparatory watercolor came to light (private collection, Stuttgart) that incorporated the preparatory drawings and looked forward to the finished painting. Cézanne's vision closely fits Flaubert's description of Nebuchadnezzar's feast in the second version of *La Tentation de saint Antoine*, published in 1856 and 1857 in *L'Artiste*, which Cézanne is known to have consulted often.[3] "Ranked columns half lost in the shadows, so great is their height, stand beside tables which stretch to the horizon, ... a luminous vapour.... Fellow diners crowned with violets rest their elbows on very low couches. Wine is dispensed from tilting amphorae.... Running slaves carry dishes. Women come around with drinks.... So fearful is the uproar that it might be a storm, and a cloud floats above the feast, what with all the meats and steamy breath."[4]

Searching for a stylistic vocabulary in which to render the mythological banquet, Cézanne turned naturally to the most famous orgy scene of the Second Empire, Couture's *Romains de la décadence* (*Romans of the Decadence*), exhibited in 1847 and again in 1855, and to its prototype, Veronese's *Marriage at Cana* (Louvre, Paris). The blatantly sexual subject of the Couture must have appealed to Cézanne; he kept a photograph of the painting.[5] And of course Veronese's masterpiece was held in great esteem at mid-century, especially by those painters interested in *la peinture blonde*. The Venetian held lessons for Delacroix, Manet, Fantin-Latour, and many other painters both advanced and conservative, for he supplemented a classical style of composition with vivid effects of color and light. In comparison to Veronese, however, Cézanne's orgy spins wildly out of control, with figures and objects lurching left and right, propelled by volcanic emotional surges. The sinful snake in the foreground may be a reference to the serpent in Manet's *Christ mort aux anges* (cat. 96).

It is not known precisely when Cézanne painted this work. The high-pitched palette points to the early 1870s, while the overt sexuality and baroque composition point to the late 1860s. During the 1870s Cézanne painted several related works: *La Tentation de saint Antoine* (*The Temptation of Saint Anthony*; Musée d'Orsay, Paris) and *Pastorale* (cat. 34).

G.T.

1. Mary Tompkins Lewis, "Literature, Music and Cézanne's Early Subjects," in London, Paris, Washington 1988–89, pp. 32–40, and Mary Tompkins Lewis, *Cezanne's Early Imagery* (Berkeley and Los Angeles, 1989), pp. 173ff.

2. Theodore Reff, "Cézanne's *Dream of Hannibal*," *Art Bulletin* 45 (June 1963), p. 151.

3. Guila Ballas, "Paul Cézanne et la revue *L'Artiste*," *Gazette des Beaux-Arts* 98 (December 1981), pp. 223–32.

4. "Des colonnes, à demi perdues dans l'ombre tant elles sont hautes, vont s'alignant à la file en dehors des tables qui se prolongent jusqu'à l'horizon, ... une vapeur lumineuse....Les convives, couronnés de violettes, s'appuient du coude contre des lits très bas. Le long de ces deux rangs, des amphores qu'on incline versent du vin.... Les esclaves courent portant des plats. Des femmes circulent offrant à boire....La clameur est si formidable qu'on dirait une tempête, et un nuage flotte sur le festin, tant il y a de viandes et d'haleines." Quoted in Lewis, *Cezanne's Early Imagery*, pp. 182, 256, n. 15; the translation is from Gustave Flaubert, *The Temptation of St. Anthony*, trans. by Kitty Mrosovsky (Ithaca, N.Y., 1981), pp. 81–82.

5. Wayne Andersen, "A Cézanne Drawing after Couture," *Master Drawings* 1 (Winter 1963), pp. 44–46.

34 *Fig. 161*

Paul Cézanne
Pastorale (Idylle)
(Pastoral [Idyll])
Ca. 1870
Oil on canvas
25⅝ x 31⅞ in. (65 x 81 cm)
Musée d'Orsay, Paris RF 1982.48

CATALOGUE RAISONNÉ: Venturi 1936, no. 104

PROVENANCE: Dr. Paul-Ferdinand Gachet, Auvers-sur-Oise, presumably from ca. 1872; Bernheim-Jeune, Paris (?); Auguste Pellerin, Paris, until his death in 1929; by descent to his son, Jean-Victor Pellerin, Paris; left to the state in lieu of death duties, 1982

EXHIBITIONS: Paris 1936, no. 12, pl. x; Paris, Musée de l'Orangerie, June 19–September 15, 1953, *Monticelli et le Baroque provençal*, no. 11; Aix-en-Provence, Pavillon de Vendôme, July 21–August 15, 1956, *Exposition pour commémorer le cinquantenaire de la mort de Cézanne*, no. 3; Paris, London, Tate Gallery, July 10–September 27, 1959, *The Romantic Movement*, no. 50; Brooklyn Museum, March 13–May 5, 1986, Dallas Museum of Art, June 1–August 3, 1986, *From Courbet to Cézanne: A New 19th Century* (*Preview of the Musée d'Orsay, Paris*), no. 2, repr.; London, Paris, Washington 1988–89, no. 52, repr.; Basel 1989, pp. 39, 65, 75, 77–78, ill. 40, no. 5

SELECTED REFERENCES: Meier-Graefe 1910, p. 8, repr. p. 19; Ambroise Vollard, *Paul Cézanne* (Paris, 1914), p. 34, pl. 7; Julius Meier-Graefe, *Entwicklungsgeschichte der modernen Kunst* (Munich, 1915; reprinted 1925), p. 490, repr.; Meier-Graefe 1920, repr. p. 93; Maurice Denis, "L'influence de Cézanne," *L'Amour de l'art* 1 (December 1920), p. 282, repr.; Rivière 1923, p. 202; Roger Fry, "Le développement de Cézanne," *L'Amour de l'art* 12 (December 1926), pp. 396, 398, repr.; Roger Fry, *Cézanne: A Study of His Development* (New York, 1927; reprinted 1989), p. 23, fig. 10; Eugenio d'Ors, *Paul Cézanne* (Paris, 1930), pl. 32; Huyghe 1936, pp. 28, 34, 53, 56, fig. 16; René Huyghe, "Cézanne et son oeuvre," *L'Amour de l'art*, May 1936, fig. 48; Maurice Raynal, *Cézanne* (Paris, 1936; reprinted 1954), pl. xv; Fritz Novotny, *Cézanne* (Vienna, 1937; reprinted 1961, 1971), pl. 15; Alfred Barnes and Violette de Mazia, *The Art of Cézanne* (New York, 1939), p. 404, no. 26, repr. p. 165; Dorival 1948, pp. 24, 33, 83–85, 134, 143–44, pl. 15; Meyer Schapiro, *Cézanne* (New York, 1952), pp. 21–22, repr.; Lawrence Gowing, "Notes on the Development of Cézanne," *Burlington Magazine* 98 (June 1956), p. 187; Kurt Badt, *Die Kunst Cézannes* (Munich, 1956), pp. 77, 197, 224, pl. 38; Brion-Guerry 1966, pp. 29, 31, 34, 61, fig. 2; Orienti 1970, no. 35, repr.; Schapiro 1978, p. 8, fig. 5; Lionello Venturi, *Cézanne* (Geneva, 1978), repr. p. 55; Sylvie Gache-Patin, "Douze oeuvres de Cézanne de l'ancienne collection Pellerin," *Revue du Louvre* 34 (1984), pp. 128, 130–33, no. 4, repr.; Wells 1987, pp. 122–33, pl. XXXII; Mary Tompkins Lewis, *Cezanne's Early Imagery* (Berkeley and Los Angeles, 1989), pp. 105, 185, 186, 190–91, 195, 200, 204, pl. XIV

The precise date of this work is not known. The number on the hull of the sailboat at right has been read as 1870, but it can also be read as 1270. Nevertheless, the handling and palette are typical of Cézanne's work around 1870, and he frequently explored the theme of picnics, promenades, and outdoor leisure at this time.

Here Cézanne takes Manet's *Déjeuner sur l'herbe* (cat. 93) as his point of departure, and, in an operation typical for him, inverts Manet's purportedly realistic scene of bohemian bathers, artists, and model into a dreamlike—or nightmarish—fantasy. Scholars have also suggested that there may be a literary source at play as well. Gowing wrote that the picture may represent the artist visiting Tannhäuser's Venusberg.[1] Mary Tompkins Lewis concurred, seeing Tannhäuser's conflict between carnal lust and higher love as a metaphor for Cézanne's emotional turmoil.[2] Sterling thought that Baudelaire was at the root: "In the midst of a tarlike impasto, the enamel of flesh, the ruby of blood, and the silver of the moon shine like a Baudelairean fire."[3] Florisoone saw a particular source in Baudelaire's *Femmes damnées*: "The works dating back to that time are...only works of damnation, rebellion, and remorse; they represent only gruesome, bloody, orgiastic, and sacrilegious subjects where white and black are opposed. Could we not see in *L'Idylle*, this somber and ironic canvas where a bearded man, perhaps Cézanne himself, the Poet in any case, rests on the bank of an estuary surrounded by nude women lying on the grass, an illustration of these two verses from the *Femmes damnées*: Like pensive cattle lying on the sand / They scan the far horizon of the ocean."[4]

Above all, the work is rife with sexual symbolism. As Schapiro wrote, "the desires implied in the paired figures of the naked and clothed reverberate in the eroticized thrust of the trees and clouds and their reflections in the river, and in the suggestive coupling of a bottle and a glass."[5] Elsewhere, Schapiro remarked that in this work the landscape carries as much meaning as the

figures. "The trees, with their projecting shapes, are more pronounced than the human beings and echo their forms; and near the center of the space, Cézanne has designed an exotic symmetrical pattern of a tall tree and its reflection in the water, which terminates below near an analogous bottle and wine glass, the counterparts of the paired men and women. Such activations of the landscape through vaguely human forms is rare in the painting of the time.... Cézanne approaches the pastoral theme in a more passionate spirit; where the Impressionist blurs the elements of the landscape, Cézanne overinterprets them, endowing them with the feelings or relationships insufficiently expressed in the human figures. The picture abounds in odd parallelisms and contrasts, independent of nature and probably issuing from unconscious impulses, as in psychotic art."[6]

Some three sheets of pencil studies for the painting survive.[7]

G.T.

1. Gowing in London, Paris, Washington 1988–89, p. 174.
2. Mary Tompkins Lewis, *Cezanne's Early Imagery* (Berkeley and Los Angeles, 1989), p. 188.
3. "Au milieu d'une pâte goudronneuse luisent d'un feu baudelairien l'émaile des chairs, le rubis du sang, l'argent de la lune." Charles Sterling, "Cézanne et les maîtres d'autrefois," *La Renaissance*, May–June 1936, p. 8.
4. "Les oeuvres de cette époque ne sont...qu'oeuvres de damnation, de révolte et de remords, n'offrent que sujets macabres, sanguinaires, orgiaques et sacrilèges où s'opposent les noirs et les blancs. *L'Idylle*, cette toile de sombre ironie, où un homme barbu, Cézanne lui-même peut-être, le Poète en tout cas, étendu sur la berge d'un estuaire est entouré de femmes nues allongées sur l'herbe, ne pourrait-elle illustrer ces deux vers des *Femmes damnées*: Comme un bétail pensif sur le sable couchées. / Elles tournent leurs yeux vers l'horizon des mers." Michel Florisoone, "Paul Cézanne, la secrète et dramatique montée vers le divin," *Le Correspondant*, August 10, 1936, p. 201; translation of the verses of *Femmes damnées* is from Charles Baudelaire, *The Flowers of Evil*, selected and edited by Marthiel and Jackson Mathews (New York, 1989).
5. Schapiro 1978, p. 8.
6. Meyer Schapiro, *Cézanne* (New York, 1952), pp. 21–22.
7. Chappuis 1973, nos. 248, 249, 250.

Jean-Baptiste Camille Corot

Paris, 1796–Paris, 1875

With the support of his parents, affluent merchants in Paris, Corot devoted himself to painting full time in 1822, studying with the landscape painters Achille-Etna Michallon and Jean-Victor Bertin. From 1825 until 1828 he traveled in Italy, making, as was the custom, outdoor sketches that were sometimes used to elaborate larger studio compositions, two of which he sent to the Salon of 1827. He returned to France in 1828 and continued to exhibit at the Salon regularly for the rest of his life. By 1845 critics recognized him, with Théodore Rousseau, as one of the *chefs d'école* of French landscape. He was awarded the Légion d'Honneur in 1846.

Corot visited Italy again in 1834 and in 1843, and traveled to the Netherlands in 1854 and to

England in 1862, but these were exceptions to a life otherwise spent primarily in a few locales: Barbizon, Paris, and his family property at Ville-d'Avray. He generally made plein air sketches at Barbizon over the summer and worked on his Salon paintings in Paris over the winter. He had been one of the first artists to paint extensively in the Fontainebleau forest, and in the 1850s and 1860s he counted Rousseau, Dupré, Diaz, Troyon as his friends. He was particularly close to Millet and Daubigny. Chintreuil and Français considered themselves students of Corot, and as he grew older he dispensed advice to younger painters such as Pissarro and Morisot. He was at heart a classicist, and most of his mature landscapes evoke a wistful arcadia that stood in marked contrast to the realism of Courbet or even Rousseau. Although he was encouraging to the young generation, he never embraced their art.

35 *(Paris only)* *Fig. 75*

Camille Corot

Souvenir de Marcoussis, près Montlhéry
(Memory of Marcoussis, near Montlhéry)
Ca. 1855
Oil on canvas
38¼ x 51⅛ in. (97 x 130 cm)
Signed lower right: *Corot*.
Musée d'Orsay, Paris RF 1778

CATALOGUE RAISONNÉ: Robaut 1905, no. 1101

PROVENANCE: Emperor Napoléon III, purchased from the artist at the Exposition Universelle of 1855; sold on behalf of Empress Eugénie by M. Rainbeaux, ca. 1879; Adolphe Tavernier, Paris, by 1889; Alfred Chauchard, Paris; his bequest to the Louvre, 1909

EXHIBITIONS: Paris, Exposition Universelle of 1855, no. 2792 ("Souvenir de Marcoussy, près Montlhéry"); Paris, Exposition Centennale of 1889, no. 164

SELECTED REFERENCES: Ernest Gebaüer, *Les Beaux-Arts à l'Exposition universelle de 1855* (Paris, 1855), p. 149; Philippe de Chennevières, *Souvenirs d'un Directeur des Beaux-Arts*, pt. 2 (Paris, 1885; reprinted 1971), p. 4; Étienne Moreau-Nélaton, *Corot* (Paris, 1913), pp. 47–51, pl. 11; Moreau-Nélaton 1924, vol. 1, p. 100, fig. 134, vol. 2, p. 111; Fosca 1958, p. 31; Leymarie 1992, p. 122, repr.

Corot exhibited six works, including this one, at the Exposition Universelle of 1855. Although he was of the same generation as Delacroix and Decamps, he was not offered, as they were, the

distinction of a large retrospective display, no doubt because the Surintendant des Beaux-Arts, the comte de Nieuwerkerke, did not like his work: "muddy color" and "cottonlike texture."[1] Nevertheless, the emperor, Napoléon III, who did not like Nieuwerkerke, purchased this painting for his personal collection, and Corot was awarded a first-class medal after much debate among the jurors.[2]

At the Exposition Universelle, almost all the critics, like the emperor, found much to admire in Corot's work. Setting the tone that would continue to be used for Corot, they called him "the poet of landscape,"[3] "a fine landscapist...[with] a truly idyllic grace, tenderness and poetry."[4] What they admired most was the universality of Corot's landscapes, or, to put it differently, their lack of specificity: "Even when he works after nature, he is inventing."[5] Above all, Corot was perceived as the painter of "idealized landscapes taken from imaginary vantage points."[6]

This painting, however, stands apart in that it represents a specific site, Marcoussis, although the fact that the scene is filtered through Corot's poetic sensibility is signaled by the title *Souvenir*. But the realist underpinnings of the painting may have been what attracted the emperor, even as it disappointed at least one critic, Ernest Gebaüer. "The only painting in which he wanted to depict more exactly a more ordinary view, the *Souvenir de Marcoussy* [sic] is far from being as good as his other works."[7]

According to Moreau-Nélaton, Corot made annual trips to Marcoussis, southwest of Paris, in the old department of Seine-et-Oise, to visit with a former pupil, the painter Ernest-Joachim Dumax. "The food was good, the conversation casual, and there was an abundance of pretty motifs."[8]

G.T.

1. "couleur boueuse"; "facture cotonneuse." Quoted in Étienne Moreau-Nélaton, *Corot* (Paris, 1913), p. 48.
2. See the entry in Delacroix's *Journal* for November 7, 1855. The relevant passage is quoted in Moreau-Nélaton 1924, vol. 1, p. 101.
3. "le poëte du paysage." About 1855, p. 218.
4. "un paysagiste de style...[avec] une grâce, une tendresse, une poésie vraiment idylliques." Théophile Gautier, *Les Beaux-Arts en Europe* (Paris, 1856), vol. 2, p. 129.
5. "Lors même qu'il travaille d'après nature, il invente." About 1855, p. 211.
6. "paysages idéalisés, des points de vue imaginaires." Ernest Gebaüer, *Les Beaux-Arts à l'Exposition universelle de 1855* (Paris, 1855), p. 148.
7. "Le seul tableau où il ait voulu rendre plus exactement une vue plus ordinaire, le *Souvenir de Marcoussy*, est loin de valoir ses autres toiles." Gebaüer, *Les Beaux-Arts*, p. 149.
8. "La table était bonne, la causerie familière, et les jolis motifs abondaient." Moreau-Nélaton, *Corot*, p. 48. See also Moreau-Nélaton 1924, vol. 1, p. 107.

36 *(Paris only)* *Fig. 11*

Camille Corot

Idylle
(*Idyll*)
1859
Oil on canvas
64 x 51⅛ in. (162.5 x 130 cm)
Signed lower right: *C. Corot* (signature reinforced)
Musée des Beaux-Arts, Lille, Gift of the artist, 1869

CATALOGUE RAISONNÉ: Robaut 1905, no. 1110

PROVENANCE: The artist until 1869; his gift to the museum

EXHIBITIONS: Paris, Salon of 1859, no. 690 ("Idylle");
Lille, Exhibition of the Société des Amis des Arts, 1866,
no. 373 ("Paysage, Cache-Cache"); Paris, École Nationale
des Beaux-Arts, *Exposition de l'oeuvre de Corot,* 1875,
no. 37 ("Fête antique"); Paris 1968–69, no. 473; Paris,
Rome 1975–76, no. 77 (Paris), no. 55 (Rome)

SELECTED REFERENCES: Astruc 1859, pp. 181–82; Émile
Cantrel, "Salon de 1859: Les paysagistes," *L'Artiste,* n.s.
7 (May 29, 1859), p. 70; Chalons d'Argé 1859, p. 51;
Charles Dollfus, "Salon de 1859," *Revue germanique* 6,
no. 4 (April–June 1859), pp. 249–50; Dumesnil 1859,
p. 19; A.-J. Du Pays, "Salon de 1859," *L'Illustration* 33
(May 21, 1859), p. 339; Georges Duplessis, "Salon de
1859," *Revue des beaux-arts* 10, no. 9 (1859), p. 177;
Victor Fournel, "Le Salon de 1859 (deuxième article),"
Le Correspondant 11 (June 1859), p. 268; Gautier 1859,
p. 187, ill. 156; Guyot de Fère, "Salon de 1859," *Journal
des arts, des sciences et des lettres,* July 8, 1859, p. 358;
Charles Habeneck, "Le Salon de 1859," *Le Causer* 1
(March–August 1859), p. 222; Jourdan 1859, p. 21;
Lépinois 1859, p. 195; Mantz 1859, p. 295; Nettement,
"Salon de 1859," reprinted in Nettement 1862, p. 355;
Edmond Renault, "Salon de 1859," *La Presse théâtrale,*
July 10, 1859; Paul de Saint-Victor, "Salon de 1859," *La
Presse,* July 2, 1859; Jules Thierray, "Salon de 1859,"
Le Paris élégant, no. 14 (July 1, 1859), p. 261; Jules
Claretie, *Peintres et sculpteurs contemporains* (Paris,
1873), p. 3, n. 1; Dumesnil 1875, p. 65, n. 1, pp. 70–71,
127, no. 77; Moreau-Nélaton 1924, vol. 1, pp. 115, 121, fig.
169; Baud-Bovy 1957, p. 235; Fosca 1958, p. 34; Leymarie
1992, p. 124, repr. p. 125

Corot's stature at the Salon of 1859 was indispu-
table: he along with Rousseau were the grand
masters of landscape painting. Every critic was
obliged to consider Corot's entries at length, and
no one dared challenge his genius. Yet paradoxi-
cally, Corot's paintings were little liked, and most
of the reviews were apologetic in tone. Aubert
said at the beginning of his review: "Let us say
at once that the public has not granted them the

attention they incontestably deserve."[1] Chesneau
listed the primary criticisms: "a clumsiness of
hand that is now proverbial, he is not endowed
with the gift of color, his palette varies in invari-
ably gray tonalities; from up close, it is scarcely
possible to see anything but a shapeless super-
imposition of confused and mixed tones, half
erased, pale and muddled."[2] But Corot's support-
ers were those who did not look for dazzling tech-
nique or realistic transcription; rather they were
those who sought poetry. "Take me with you, dear
master, into this beautiful landscape where your
imagination led you one day."[3] Gautier concurred:
"A landscape by Corot is always charming, even
when the execution is clumsy and the color is
gray."[4] The young Monet was very impressed with
Corot's exhibits and mentioned them twice:
"There are pretty works by Corot" and "Works
by Corot are pure wonders."[5]

Corot described the painting in a letter to E.
Brandon of November 27, 1858, as "a country
outing in an antique style, women playing, men
drinking, children, etc."[6] There is as well a little
sketch of the picture in the letter.

The imaginary landscape is similar to that in
a painting exhibited at the Salon of 1840, *Petit
Berger* (*Little Shepherd;* Musée de Metz).

 G.T.

1. "Disons-le tout de suite, le public ne leur a pas accordé
l'attention qu'ils méritent incontestablement." Aubert
1859, p. 25.
2. "inhabileté de main devenue proverbiale, il ne possède
pas le don de la couleur, sa palette varie dans les tons
invariablement gris; de près, il n'est guère possible de
voir autre chose qu'une informe superposition de tons
confus et confondus, à demi effacés, pâles et troublés."
Chesneau 1859, p. 163.
3. "Emmenez-moi, cher maître, avec vous dans ce beau
paysage où la fantaisie vous conduisit un jour." Astruc
1859, p. 181.
4. "Un paysage de Corot charme toujours, même quand la
touche est gauche, même quand la couleur est grise."
Gautier 1859, p. 185.
5. "Il y a de jolis Corot"; "Les Corot sont de simples
merveilles." Monet to Boudin, May 19 and June 3, 1859,
Wildenstein 1974, letters 1 and 2, p. 419.
6. "une partie de campagne style antique, des joueuses,
des buveurs, des enfants, etc." Moreau-Nélaton 1924,
vol. 1, p. 121.

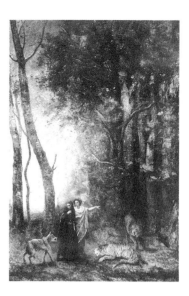

36A *(New York only)* *Fig. 11a*

Camille Corot

Dante et Virgile; paysage
(*Dante and Virgil, Landscape*)
1859
Oil on canvas
101½ x 66⅜ in. (258 x 168.5 cm)
Signed lower right: *C. Corot.*
Museum of Fine Arts, Boston, Gift of Quincy A. Shaw,
1876 75.2

CATALOGUE RAISONNÉ: Robaut 1905, no. 1099

PROVENANCE: Remained with the artist until his death;
his sale, Paris, Hôtel Drouot, May 26–28, 1875, no. 149;
purchased at this sale by M. Détrimont for Fr 15,000;
Quincy A. Shaw; presented by him to the Museum of
Fine Arts, Boston, 1876

EXHIBITIONS: Paris, Salon of 1859, no. 688; Paris 1968–69,
no. 472

SELECTED REFERENCES: Astruc 1859, pp. 176–80; Aubert
1859, p. 26; G. de Cadoudal, "A propos du Salon," *Jour-
nal des jeunes personnes,* no. 10 (August 1859), p. 307;
Émile Cantrel, "Salon de 1859: Les paysagistes," *L'Artiste,*
n.s. 7 (May 29, 1859), p. 70; Castagnary, "Salon de 1859,"
in Castagnary 1892, vol. 1, p. 89; Charles Dollfus, "Salon
de 1859," *Revue germanique* 6 (April–June 1859), p.
249; Du Camp 1859, p. 151; Dumesnil 1859, pp. 16–17;
A.-J. Du Pays, "Salon de 1859," *L'Illustration* 33 (May
21, 1859), p. 339; Georges Duplessis, "Salon de 1859,"
Revue des beaux-arts 10 (1859), no. 9, p. 177; Gautier
1859, pp. 185–86, fig. 154; Guyot de Fère, "Salon de
1859," *Journal des arts, des sciences et des lettres,* July
8, 1859, p. 358; Charles Habeneck, "Le Salon de 1859,"
Le Causer 1 (March–August 1859), p. 222; Lépinois 1859,
p. 195; Louis Leroy, "Le Charivari au Salon de 1859," *Le
Charivari,* May 4, 1859; "Salon de 1859," *Magasin
pittoresque* 27 (July 1859), pp. 209–10; Mantz 1859,
vol. 2, p. 295; Jean Rousseau, "Salon de 1859," *Le Figaro,*
May 8, 1859; Paul de Saint-Victor, "Salon de 1859," *La
Presse,* July 2, 1859; Jules Thierray, "Salon de 1859,"
Le Paris élégant, no. 14 (July 1, 1859), p. 261; Paul Mantz,
"Corot," *Gazette des Beaux-Arts* 11 (November 1, 1861),
p. 428; Philippe Burty, "Camille Corot," in Paris, École
Nationale des Beaux-Arts, 1875, *Exposition de l'oeuvre
de Corot,* p. 23; Dumesnil 1875, pp. 63–65; Jules Claretie,
L'Art et les artistes français (Paris, 1876), p. 393;
Germain Bazin, *Corot* (Paris, 1942), p. 52; Baud-Bovy
1957, pp. 235, 237, 280, n. 131; Fosca 1958, p. 34;
Madeleine Hours, *Corot* (New York, 1972), p. 34, fig.
29; Joseph C. Sloane, *French Painting Between the Past*

and the Present: Artists, Critics, and Traditions, from 1848 to 1870, 2nd ed. (Princeton, 1973), p. 126, fig. 47; Jean Leymarie, *Corot* (New York, 1979), p. 108, repr. p. 107; Fiona E. Wissman, "The Generation Gap," in Manchester, New York, Dallas, Atlanta 1991–92, p. 71, fig. 6

Corot chose his scene from the first canto of the *Inferno*, when Dante, lost in a dark and dense forest, encounters at dawn three frightening beasts—a leopard (lust), a lion (pride), and a wolf (cupidity):

And almost where the hillside starts to rise—
look there!—a leopard, very quick and lithe,
a leopard covered with a spotted hide.

. .

but hope was hardly able to prevent
the fear I felt when I beheld a lion.

His head held high and ravenous with hunger—

. .

And then a she-wolf showed herself; she seemed
to carry every craving in her leanness;
she had already brought despair to many.[1]

Just then Dante encounters Virgil who offers to serve as a guide through hell and purgatory. The macabre was a wholly new mood for Corot, but he clearly sought to achieve something of the sublime at this time, for he exhibited a scene from *Macbeth* the same year.

Corot was at work on this enormous canvas throughout 1858. In a letter to Constantin Dutilleux of January 4, 1858, he described and sketched the composition.[2] Sometime during the year he went to the Jardin des Plantes and drew sketches of a panther in his notebook.[3] And he was still at work on the painting on November 27, 1858, when he wrote Édouard Brandon to say that in his studio he had "first of all, the Dante and Virgil, at the beginning of the *Inferno*," which he did not then expect to have completed in time for the 1859 Salon.[4] Moreau-Nélaton recounted that Corot asked his friend Antoine-Louis Barye to paint the wild beasts and that he complied, but that Corot did not consider Barye's "impeccable anatomy" compatible with his fantastic vision so he repainted the animals completely.[5] Moreau-Nélaton offered no substantiation for this assertion, and since there is no mention of this by Corot's contemporaries, it is probably apocryphal.

The critical reaction to *Dante et Virgile* was predictable: the critics were unanimous in praising the artist's gifts while criticizing the drawing, the color, or the composition. Nevertheless almost everyone admired the emotion provoked by the painting. Castagnary was alone in thinking that "the physiognomy and attitude of Dante express a puerile fear, and not the mystical and intellectual horror which he should assume."[6] Gautier, to the contrary, called it "one of the greatest and most original of the artist's conceptions. . . . Never was Dante better understood than by the good and simple Corot."[7] Astruc was bowled over: "Nothing can compare to the effect of powerful simplicity."[8] For his part, Baudelaire did not specifically address this painting.

Bertall published a cartoon in which he de-

scribed the "two poets disguised as umbrellas—in order to maintain a serious incognito—visiting a landscape by Corot, populated with felt animals and painted with a combination of licorice and soot. They have been told that the landscape represents Hell; they are assured that it's not worth the devil!"[9]

<div style="text-align: right;">G.T.</div>

1. *The Divine Comedy of Dante Alighieri*, vol. 1, *Inferno*, translated by Allen Mandelbaum (Berkeley, 1980; reprint, New York, 1982), canto 1, lines 31–51.
2. Moreau-Nélaton 1924, vol. 1, p. 115 and fig. 157.
3. Moreau-Nélaton 1924, vol. 1, p. 121, fig. 160.
4. "J'ai entrepris plusieurs choses: d'abord le Dante et Virgile, tout le commencement de l'Enfer." Moreau-Nélaton 1924, vol. 1, p. 121.
5. "anatomie impeccable." Moreau-Nélaton 1924, vol. 1, p. 121.
6. "La physionomie et l'attitude du Dante expriment une peur puérile et non la mystique et tout intellectuelle horreur qui dût le prendre." "Salon de 1859," in Castagnary 1892, p. 89.
7. "une des plus hautes et des plus originales conceptions de l'artiste. . . . Jamais Dante n'a été mieux compris que par ce bon et simple Corot." Gautier 1859, pp. 185–86.
8. "Rien de comparable à cet effet d'une simplicité puissante." Astruc 1859, p. 178.
9. "Les deux poètes déguisés en parapluies—pour conserver un sévère incognito,—visitent un paysage de Corot, peuplé d'animaux en feutre, et peint avec du jus de réglisse et de la suie combinés. On leur avait dit que ce paysage représentait l'enfer; ils assurent que cela ne vaut pas le diable." Bertall, *Gazette de Paris*, July 7, 1859.

37 *Fig. 107*

Camille Corot
Cour d'une maison de paysans aux environs de Paris
(*Courtyard of a Farmhouse, in the Vicinity of Paris*)
Ca. 1865–70
Oil on canvas
18¼ x 22 in. (46.5 x 56 cm)
Signed lower left: *Corot*
Musée du Louvre, Paris, département de Peintures, on deposit at the Musée d'Orsay RF 2441

CATALOGUE RAISONNÉ: Robaut 1905, no. 1402

PROVENANCE: Jaquette, Lisieux; Galerie Boussod et Valadon, Paris, by 1895; Ernest May, Paris; his bequest to the Louvre, retaining life interest ("sous réserve d'usufruit"), 1923; deposited in the Louvre, 1925

EXHIBITIONS: Paris 1895, no. 22; Paris, Lyon 1936, no. 86 (Paris), no. 89 (Lyon)

SELECTED REFERENCES: Moreau-Nélaton 1924, vol. 2, p. 18, fig. 189; Fosca 1958, repr. p. 148

This intimate and presumably realistic depiction of a modest house stands in contrast to much of Corot's late work. Most of the landscapes in his exhibition pictures are dreamy evocations prompted by specific sites or experiences he had out in nature, which were nevertheless significantly transformed by Corot in the process of making a picture. In this work he made his picture by selecting his point of view and choosing his palette, but otherwise he allowed the inherently picturesque quality of this specific motif to speak for itself. In these respects, Corot's method here is similar to that often employed by the new young landscapists, such as Monet, Sisley, and Pissarro.

Despite the literalness of Corot's rendering, the specific site, paradoxically, has not been identified. Robaut suggested "aux environs de Paris"; Moreau-Nélaton implied that it is in Fontainebleau.[1]

<div style="text-align: right;">G.T.</div>

1. Moreau-Nélaton 1924, vol. 2, p. 18.

Gustave Courbet

Ornans, 1819–La Tour de Peilz, Switzerland, 1877

Born into a well-to-do farming family in Franche-Comté, Courbet moved to Paris in 1840 to become a painter. He studied at the Académie Suisse, copied pictures in the Louvre, and, very early on, tried different genres, focusing chiefly on landscapes and portraits. In 1844, after three rejections by the Salon, he was finally admitted with one of his first self-portraits, *Portrait de l'auteur dit Courbet au chien noir* (*Portrait of the Artist Known as Courbet with a Black Dog*; Petit Palais, Paris). Following an 1847 trip to Holland, where he was overwhelmed by Rembrandt's compositions involving several figures, Courbet painted *Un Après-dînée à Ornans* (*An Afternoon in Ornans*; Musée des Beaux-Arts, Lille); this huge canvas was bought by the French government at the Salon of 1849. In 1850 Courbet's Salon entry included three masterpieces: *Un enterrement à Ornans* (fig. 165; Musée d'Orsay, Paris); *Les Paysans de Flagey revenant de la foire (Doubs)* (*The Farmers of Flagey Returning from the Fair [Doubs]*; Musée des Beaux-Arts et Archéologie, Besançon); and *Les casseurs de pierre (Doubs)* (*The Stone Breakers [Doubs]*; destroyed). The scandal ignited by the *Enterrement*, which raised everyday life to the level of historical painting, established Courbet's scandalous reputation. Throughout the 1850s, his "realism" was a target of constant jibes, which did not really let up until the mid-1860s. He did, however, win over a small number of art lovers, notably Alfred Bruyas, and gained disciples—not only in France but also in Belgium (see cat. 38) and Germany. In 1855, in a shed called the Pavilion of Realism, he presented "Exhibition of Forty Paintings," on the

periphery of the Exposition Universelle. Courbet's "Manifesto of Realism" was the introduction to this show's catalogue. The most important inclusion was *L'Atelier du peintre. Allégorie réelle déterminant une phase de sept années de ma vie artistique et morale* (*The Artist's Studio: A Real Allegory Determining a Seven-Year Phase in My Artistic and Emotional Life*; Musée d'Orsay, Paris). He participated in the Salon of 1857 with, notably, *Les Demoiselles des bords de la Seine (été)* (fig. 150) but was absent in 1859. It was at this point that Zacharie Astruc, debuting as a critic, visited him and predicted that he would create a certain lack of understanding from which he would suffer: "One hundred years from now, the critics will doff their hats at the mention of his name and his paintings will sell at astronomical prices."[1]

For Courbet's life during the 1860s, see the chronology.

1. "Dans cent ans son nom prononcé fera lever les chapeaux de la critique; ses toiles se vendront à des prix fous." Astruc 1859, p. 398.

38 *(Paris only)* *Fig. 268*

Gustave Courbet
La Signora Adela Guerrero
1851
Oil on canvas
62¼ x 62¼ in. (158 x 158 cm)
Signed and inscribed lower left: G. Courbet/Bruxelles/1851
Inscribed lower right: LA SIGNORA /
ADELA GUERRERO
Musées royaux des Beaux-Arts de Belgique, Brussels
6416

CATALOGUES RAISONNÉS: Fernier 1977, vol. 1, no. 125; Courthion 1987, no. 118

PROVENANCE: Decorative painting made for the fête given for Leopold I by the Cercle artistique et littéraire, Brussels, September 24, 1851

EXHIBITIONS: Brussels, Cercle littéraire et artistique, 1851; Paris, Petit Palais, 1955, *Courbet*, no. 16; Paris, 1968–69, no. 225; Rome, Villa Medici, 1969–70, *Gustave Courbet*, no. 9; Brooklyn, Minneapolis 1988–89, no. 15; Tokyo, Bridgestone Museum of Art, *Gustave Courbet*, no. 10

SELECTED REFERENCES: Théophile Silvestre, *Histoire des artistes vivants français et étrangers: Études d'après nature* (Paris, 1856), p. 278; Alexandre Estignard, *Courbet, sa vie et ses oeuvres* (Besançon, 1897), p. 182

On September 2, 1851, Courbet left Paris for a short trip to Belgium and Germany. After stopping in Lille, where he went to the museum to see his *Après-dînée à Ornans* (*Afternoon in Ornans*), he arrived in Brussels on September 5 or 6. The Exposition Générale des Beaux-Arts—equivalent to the Paris Salon—included two of Courbet's paintings: *Les Casseurs de pierre* (*The Stone Breakers*; Fernier 101; destroyed) and *Joueur de basse*, his self-portrait as a cellist (Fernier 74; Nationalmuseum, Stockholm).[1] The success of these paintings (a success that was repeated throughout the 1850s in Belgium, where Courbet was greatly appreciated) is said to have inspired him to show his gratitude by doing this rapid portrait of Adela Guerrero, a Spanish dancer. Courbet presented it on September 24, at a celebration honoring Leopold I of Belgium.[2] It remained in Belgium, where it was probably never seen by Manet whose *Lola de Valence* (cat. 87) bears a striking resemblance to her fearsome compatriot. Aside from the overlapping subject matter, the similarities of the present painting and *Lola de Valence* are due to the tapping of common sources—popular imagery and particularly Spanish painting. Both Courbet and Manet may have been inspired by Goya's portrait of the duchess of Alba (Hispanic Society of America, New York), which was in the collection of Louis-Philippe of France. Like his sometime disciple Manet, Courbet sums up the scene in which the robust Spanish woman twists and turns, with a "prop": the iridescent drapery that falls to the left, removing the figure from a neutral background that can be read with difficulty as the landscape backdrop of a stage set.

H.L.

1. See Courbet's letter to his family, September 9, 1851, in Courbet 1992, p. 102 (no. 51–2).
2. The large portrait was based on a small bust sketch of the dancer; see the catalogue of the exhibition *Courbet dans les collections privées françaises* (Galerie Claude Aubry, Paris, 1966), no. 6.

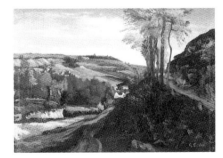

39 *Fig. 77*

Gustave Courbet
La Vallée d'Ornans
(*The Ornans Valley*)
1858

Oil on canvas
23¾ x 33½ in. (60.2 x 85.2 cm)
Signed lower right: G. Courbet
The Saint Louis Art Museum: Museum Purchase
74:1937

CATALOGUE RAISONNÉ: Fernier 1977, no. 240 (La Vallée d'Ornans?)

PROVENANCE: P. Hartwood, Montreal; Rhea Reid Topping, by 1925, until 1926; sold through M. Knoedler and Co., New York, to the T. Eaton Co., Toronto, 1926; sold back to M. Knoedler and Co., New York, 1926; sold to Joseph Stransky, New York, November 1926, until at least 1931; Wildenstein and Co., New York; acquired by the Saint Louis Art Museum, November 1937

EXHIBITIONS: New York, 1931, *Private Collection of Joseph Stransky*; Manchester, New York, Dallas, Atlanta, 1991–92, no. 41

SELECTED REFERENCES: Jessie B. Chamberlain, "The Valley of Ornans by Gustave Courbet (1819–1877)," *Bulletin of the City Art Museum of Saint Louis*, January 1938, pp. 5–7

While often stressing the influence of Courbet's figures on those of Manet, Renoir, and Bazille, critics have paid less heed to the effect that Courbet's landscapes had on Monet's early ones and, more lastingly, on Pissarro's. The present painting was probably done in 1858—however, the setting is autumnal and in the fall of 1858 Courbet was already in Germany. His painting prefigured the substantial pictures that Pissarro did almost ten years later in Pontoise. Thus, in *La Côte de Jallais* (cat. 158), Pissarro uses a similar composition, buries the geometric houses in a tangle of greenery, focuses equally on the different textures of the soils, and paints in a vast, thick, somber manner without using a knife. When Zacharie Astruc, talking about the Salon of 1859, deplored the dismal state of French painting, he saw Courbet as the sole hope for regeneration. He remarked that Courbet was the "paysagiste who with Corot dominates the contemporary school," noting that his "various small landscapes of Franche-Comté," which Astruc saw at his studio, are "remarkable . . . for their enchanting truthfulness and forcefulness."[1]

H.L.

1. "paysagiste, il domine l'école contemporaine avec Corot"; "divers petits paysages de Franche-Comté"; "remarkable . . . par un caractère de vérité et de force qui charme." Astruc 1859, pp. 394, 398.

40 *Fig. 220*

Gustave Courbet
Fleurs
(*Flowers in a Vase*)
1862
Oil on canvas
39½ x 28¾ in. (100.3 x 73 cm)
Signed and dated lower right: 62. / Gustave Courbet
Collection of the J. Paul Getty Museum, Malibu,
California 85.PA.168

CATALOGUES RAISONNÉS: Fernier 1977, vol. 1, no. 302;
Courthion 1987, no. 292

PROVENANCE: Sold for Fr 500 by the artist to Frédéric
Mestreau, Saintes, by 1863; by descent at the château
de Terrefort, near Saintes; Galerie Wildenstein; sold to
Florence J. Gould; her sale, Sotheby's, New York, April
24, 1985, lot. no. 11; J. Paul Getty Museum, Malibu, 1985

EXHIBITIONS: Saintes, Town Hall, 1863, *Explication des
ouvrages de peinture et de sculpture exposés dans les
salles de la mairie au profit des pauvres. 160 tableaux
signés Corot, Courbet, Auguin, Pradelles*, no. 77 (Fleurs
[property of M. Mestreau]); Brooklyn, Minneapolis
1988–89, no. 42

SELECTED REFERENCES: Unsigned, "L'Exposition de
peinture à Saintes, G. Courbet," *L'Indépendant de la
Charente-Inférieure*, Saintes, January 29, 1863, p. 3;
Pierre Conil, "Exposition de peinture, M. Courbet,"
Courrier des deux Charentes, Saintes, February 12, 1863,
p. 4; Castagnary, unpublished manuscript cited by
Courthion 1948, p. 168; Roger Bonniot, "Un tableau de
fleurs inédit de Gustave Courbet," *Bulletin de la Société
de l'histoire de l'art français*, March 2, 1957, pp. 77–87;
Bonniot 1986, pp. 88, 230, 231, 314

Through Castagnary, Courbet had met Étienne
Baudry, a young man of thirty-two who, like the
critic, came from Saintonge. The author of some
studies of social issues, Baudry was a rich land-
owner with a fine collection of paintings. In the
spring of 1862, Baudry invited Courbet to spend
some time at his château in Rochemont; and on
May 31, after traveling with Castagnary, Courbet
arrived at that beautiful estate near Saintes—a
house rather than a château, "in an immense,
wonderfully wooded park." He was supposed to
visit for two weeks but lingered on until Septem-
ber; he then settled not far from there, in Port-
Berteau, from October to December, and finally
in Saintes, from January to May 1863.[1]

In Rochemont Courbet did over twenty paint-
ings of flowers, a "fugitive passion" that he had

rarely indulged before (see pp. 150–51).[2] Excep-
tional in its size and vertical format, the present
still life shows a vase with marigolds, tiger lilies,
morning glories, peonies, cornflowers, poppies,
and hollyhocks.[3] Roger Bonniot, to whom we owe
everything we know about Courbet's year in
Saintonge, rightly emphasized this painter's way
of appropriating an ordinary subject that was usu-
ally the bailiwick of feminine talents (see pp.
158–59): "It may be in his flower paintings that
Courbet most profoundly became the force of na-
ture that he was before anything else, plunging
uninhibitedly into an art that gratified his earthy
love of beautiful material and unreservedly spend-
ing his enormous vitality."[4]

This vitality, this delight in profusion recur in
the compositions of Renoir (cat. 168), Monet (cat.
115), and Bazille (cat. 4), evoking an ephemeral
Eden through the mere juxtaposition of potted
flowers.

Under the simple title of *Fleurs*, this painting
was shown at the exhibition organized at the
Saintes town hall in January 1863 "for the benefit
of the poor," and it sparked "general admiration."[5]
It had already been purchased by Frédéric Mes-
treau, a banker and cognac wholesaler, who had
gotten it for five hundred francs from his new
friend Courbet.[6]

H.L.

1. "dans un immense parc magnifiquement boisé." Bonniot
 1986, pp. 44–49.
2. "une passion fugitive." Hélène Toussaint in Paris, Lon-
 don 1977–78, p. 161.
3. Roger Bonniot, "Un tableau de fleurs inédit de Gustave
 Courbet," *Bulletin de la Société de l'art français*, 1957,
 p. 80.
4. "c'est peut être dans la peinture de fleurs que Courbet
 redevient le plus profondément la force de la nature qu'il
 était avant tout, se plongeant sans contrainte dans un
 art qui comblait son amour terrien de la belle matière
 et, dépensant sans réserve son énorme vitalité." Ibid, p. 77.
5. "au profit des pauvres"; "l'admiration générale."
 L'Indépendant de la Charente-Inférieure, January 29,
 1863, p. 3, quoted in Bonniot 1986, p. 230.
6. Regarding Frédéric Mestreau, see Bonniot 1986, p. 52.

41 *Fig. 280*

Gustave Courbet
La Femme aux fleurs (Le Treillis)
(*Woman with Flowers [The Trellis]*)
1862

Oil on canvas
43¼ x 53¼ in. (109.8 x 135.2 cm)
Signed lower left: G. Courbet
The Toledo Museum of Art; Purchased with funds from
the Libbey Endowment, Gift of Edward Drummond
Libbey 1950.309

CATALOGUES RAISONNÉS: Fernier 1977, vol. 1, no. 357;
Courthion 1978, no. 340

PROVENANCE: Cotel, Paris 1878(?); Jules Paton, Paris, in
1882; his sale, Paris, Hôtel Drouot, April 24, 1883, no.
23, repr. (bought in for Fr 7,600); T. J. Blakeslee, New
York; sale, American Art Galleries, New York, April 10–11,
1902, no. 50; Durand-Ruel, New York and Paris,
1902–1906; Adrien Hébrard, Paris, 1906; prince de
Wagram, Paris, 1908; bought by Durand-Ruel, Paris,
May 2, 1908, and sold the same year to the baron
Cacamizy, London(?); Blanche Marchesi, London,
1909–1919/20; Mrs. R. A. Workman, London, 1919/20–
1929; Paul Rosenberg, Paris, 1929; Wildenstein, New
York, 1929–50; gift of Edward Drummond Libbey to
the Toledo Museum of Art, 1950

EXHIBITIONS: Saintes, Mairie, 1863, *Explication des
ouvrages de peinture et de sculpture exposés dans les
salles de la mairie au profit des pauvres. 160 tableaux
signés Corot, Courbet, Auguin, Pradelles*, no. 76 (*La
femme aux fleurs*), Rond-point du Pont de l'Alma,
1867, *Exposition des oeuvres de M. G. Courbet*, in
"*Études et esquisses*," no. 108 (Jeune fille arrangeant
des fleurs, Saintes 1863); Paris, École nationale des
Beaux-Arts, 1882, *Exposition des oeuvres de G. Courbet*,
no. 128 (Jeune fille arrangeant des fleurs. Signed at left:
G. Courbet. Private showing, 1867, with notation "Saintes
1863"; 42⅛ x 54⅜ in. [107 x 138 cm]; property of
M. Paton); Paris, Palais des Beaux-Arts, 1929, *Gustave
Courbet*, no. 41, pl. 8; Berlin, Galerie Wertheim, 1935,
Gustave Courbet, no. 70, pl. 23; Baltimore Museum of
Art, 1938, *Paintings by Courbet*, no. 10; New York,
Wildenstein and Co., N.Y., 1949, *Courbet*, no. 19, repr.;
Venice, Biennale, 1954, *Courbet*, no. 21; Lyon, Musée
des Beaux-Arts, 1954, *Courbet*, no. 26; Paris, Petit Palais,
1955, *Courbet*, no. 45, repr. on cover; New York, Paul
Rosenberg Gallery, 1956, *Gustave Courbet*, no. 8, repr.;
Philadelphia Museum of Art, 1959, *Gustave Courbet*,
no. 39, repr.; Paris, London 1977–78, nos. 70 (Paris),
no. 67 (London); Brooklyn, Minneapolis 1988–89, no.
41, repr. on cover

SELECTED REFERENCES: Unsigned, "Exposition de peinture,
M. Courbet," *L'Indépendant de la Charente-Inférieure*,
Saintes, January 29, 1863, p. 3; Pierre Conil, "L'Expo-
sition de peinture de Saintes, G. Courbet," *Courrier
des deux Charentes*, Saintes, February 19, 1863, p. 3;
Jean Bruno [Jean Vaucheret], *Les Misères des gueux*
(Paris, 1871–72), p. 136 repr. as engraving (Alise à la
serre); Paul Eudel, *L'Hôtel Drouot et la Curiosité en
1883* (Paris, 1883), p. 281; Riat 1906, pp. 200, 336;
Bonniot 1986, pp. 88–89, 91, 231; Jean-Jacques Fernier,
"À propos d'une exposition," *Bulletin des Amis de
Gustave Courbet*, no. 77 (1987), unpaginated

The few flower paintings shown by Courbet at
the Saintes town hall in January 1863 were warmly
received (cat. 40). Even the most reticent observ-
ers praised this happy anomaly in his controver-
sial oeuvre. In *Courrier des deux Charentes* Pierre
Conil wrote, "Appreciated today as a painter of
landscapes, portraits, and animals, Courbet had
omitted only one genre—flowers. It was given to
Saintes to witness this new and utterly graceful
aspect of Courbet.... And to think that it was the
painter of *Lutteurs* [*Wrestlers*, 1853; Szépmúvésti
Muzeum, Budapest] and *L'enterrement à Ornans*

[*The Burial at Ornans*, 1850; Musée du Louvre, Paris] who painted these two superb bouquets! Only a painter can tackle such extremes. That is what impelled me to tell you, dear readers, that Courbet is indeed a 'painter.'" Conil then qualifies his praise: *La Femme aux fleurs* "did not and could not appeal to anyone.... This whole tiny woman is antinatural; there is nothing seductive about her, neither the nonchalance of a true daughter of the fields nor that conventional simpering of the shepherdess of the Trianon. She combines the lady and the trollop in her manners."[1]

The reviewer for *L'Indépendant de la Charente-Inférieure* calmly discussed the girl's body, praising her head and shoulders but expressing reservations about the hands.[2]

Nevertheless the present painting is the most important of the floral pictures that Courbet painted during his stay in Saintonge.[3] As Hélène Toussaint noted, Courbet took up the arrangements used by Flemish and Netherlandish artists of the seventeenth century and by the Neapolitans.[4] With its sumptuous and improbable bouquet (see pp. 224–25), this painting resurrects Baroque pomp as well as purely decorative contemporary pictures which were meant for dining rooms and which aped the *grand siècle* (fig. 401). These older models must be cited in regard to this masterpiece of the realist Courbet; comparison to similar compositions of Degas (cat. 57) and Bazille (cat. 14) underscore the elements that already separate the Ornans painter from the artists of the New Painting.

H.L.

1. "Apprécié aujourd'hui comme paysagiste, comme peintre de portraits et d'animaux, il ne restait qu'un genre où

Fig. 401. Louis Dumont, *Jeanne Fille cueillant des fruits* (*Young Woman Picking Fruit*), 1861. Engraving after the painting by Émile Faivre, published in *Le Magasin pittoresque*, October 1861, p. 313

Courbet ne se fût pas essayé, les fleurs. Il était donné à Saintes de voir Courbet sous ce nouvel et tout gracieux aspect.... Et dire que c'est le peintre des 'Lutteurs' et de 'L'Enterrement à Ornans' qui a fait ces deux superbes bouquets! Un peintre seul peut aborder ces extrêmes. C'est ce qui m'engageait à vous dire, chers lecteurs, que Courbet est un 'peintre'"; "n'a pas plu et ne pouvait plaire"; "Toute cette petite personne est anti-naturelle; elle n'a rien qui séduise, ni le nonchaloir de la vraie fille des champs, ni cette afféterie convenue des bergères du Trianon. Il y a de la demoiselle et de la Margot dans ses manières." Pierre Conil, "L'Exposition de peinture de Saintes," *Le Courrier des deux Charentes*, February 12 and 19, 1863, quoted in Bonniot 1986, pp. 230–31.
2. Bonniot 1986, p. 231. The young girl was supposedly Courbet's Saintonge model, Mlle Viot or Viaud; Bonniot 1986, p. 91.
3. *La Femme aux fleurs* was reexhibited by Courbet at the Rond-point du Pont de l'Alma in 1867 under the title *Jeune fille arrangeant des fleurs* (*Girl Arranging Flowers*). It has sometimes been confused with a painting that was merely sketched (Fernier 306) and that could not be the one that Courbet chose to display twice during the 1860s; see Hélène Toussaint's discussion in Paris, London 1977–78, p. 161, and Jean-Jacques Fernier, "À propos d'une exposition—Maîtres français XIXᵉ et XXᵉ siècles, Galerie Schmit, Paris, May 7–July 19, 1986," *Les Amis de Gustave Courbet*, March 1987, unpaginated.
4. Hélène Toussaint in Paris, London 1977–78, p. 161. See also Charles Sterling, "Courbet's Still Lifes," in *Courbet in Perspective*, edited by Petra ten-Doesschate Chu (Englewood Cliffs, N.J.), 1977, p. 58.

42 *Fig. 93*

Gustave Courbet

Le Chêne de Flagey appelé chêne de Vercingétorix
(*Oak Tree in Flagey, Called the Oak of Vercingetorix*)
1864
Oil on canvas
35 x 44 in. (88.9 x 111.7 cm)
Signed and dated lower left: 64 / G. Courbet
Murauchi Art Museum, Tokyo

CATALOGUES RAISONNÉS: Fernier 1977, vol. 1, no. 417; Courthion 1987, no. 395

PROVENANCE: Juliette Courbet, the artist's sister, 1906; Durand-Ruel, Paris; Henry C. Gibson, Philadelphia; his gift to the Pennsylvania Museum of Fine Arts, Philadelphia, 1896; sale, Sotheby's, New York, October 29, 1987; Murauchi Art Museum, Tokyo

EXHIBITIONS: Paris, Rond-point du Pont de l'Alma, 1867, *Exposition des oeuvres de M. G. Courbet*, no. 25 (Le Chêne de Flagey, called *chêne de Vercingétorix*, Camp de César, near Alésia, Franche-Comté [1864]); Venice, Biennale, 1954, *Courbet*, no number; Paris, Petit Palais, 1955, *G. Courbet*, no. 53; New York, Rosenberg Gallery,

1956, *Paintings by Gustave Courbet*, no. 10, repr.; Providence, Rhode Island School of Design, 1956–57, *Courbet*; Philadelphia Museum of Art, and Boston, Museum of Fine Arts, 1959–60, *Courbet*, no. 44; Paris, London 1977–78, nos. 76 (Paris), 73 (London); Hamburg, Kunsthalle, and Frankfurt am Main, Städtische Galerie im Städelschen Kunstinstitut, 1978–79, *Courbet und Deutschland*, no. 271; Brooklyn, Minneapolis 1988–89, pp. 60–64, no. 44

SELECTED REFERENCES: Armand Silvestre (preface), *Galerie Durand-Ruel. Receuil d'estampes* (Paris and London, 1873), p. 3, repr. in first edition, no. VIII; Alexandre Estignard, *Courbet, sa vie et ses oeuvres* (Besançon, 1897), p. 55; Riat 1906, p. 253; Linda Nochlin, *Gustave Courbet: A Study of Style and Society* (New York and London), 1976; Linda Nochlin, "Le Chêne de Flagey de Courbet: Un motif de paysage et sa signification," *Quarante-huit/Quatorze* (Paris, 1989), no. 1, pp. 15–25

In 1867, when Courbet showed this three-year-old painting at the Rond-point du Pont de l'Alma, he gave it a title, seldom repeated afterwards, that was "a whole political platform": *Le Chêne de Flagey appelé Chêne de Vercingétorix, Camp de César près d'Alésia, Franche-Comté, 1864* (*The Oak of Flagey, Known as the Oak of Vercingetorix, Caesar's Camp near Alesia, Franche-Comté, 1864*). In his own way, the artist was placing himself in a then lively dispute between the residents of Burgundy and Franche-Comté, who were quarreling over the location of the site of Alesia. The painter of Ornans never doubted that the capital of the Gallic resistance had been situated on the soil of his forebears.[1] In executing this "portrait" of a tree, Courbet placed himself in a tradition that already included Corot (*Fôret de Fontainebleau: Le Rageur* [*Fontainebleau Forest: The Rager*], 1830–35; Robaut 266) and the Barbizon painters, especially Théodore Rousseau. Four paintings, the first going back to Courbet's earliest efforts (about 1840–41?), had already evinced what Hélène Toussaint aptly calls his "Druid love" of large trees.[2] In 1867 Théodore Duret declared Théodore Rousseau the uncontested "specialist" of the oak. "Obviously," writes Manet's friend, "all he ever saw in nature was the inanimate portion, and the only living beings that spoke to him were the trees, first and foremost the oak. I say 'living beings' deliberately, for the role played by oaks in Rousseau's oeuvre, their priority, elevates them to the rank of real people and lead actors. One may say that Rousseau is admirably familiar with the oak and its anatomy, that he has thoroughly studied the trunk, the manner in which the branches move away from it, displaying themselves or marking their silhouettes against the sky or the horizon."[3]

Rousseau studied the oak (cat. 183) and he was always "respectfully delighted" and astounded by these "severe and magnificent trees that were as old as the gods and as solemn as monuments."[4] In his Fontainebleau landscapes, especially *Le Chêne de Bodmer* (cat. 120), Monet showed what a loyal disciple he was, adopting a composition that Rousseau would not have disowned even if the coloring—the intense azure of the sky, the vivid yellow of the foliage, the orange of the

patches of sunlight on the ground—have nothing to do with the palette of the Barbizon painter.

Conceptually, *Le Chêne de Flagey* is altogether different; by trimming off the top of the tree, Courbet lends it a strength that breaks through the canvas's narrow confines and thus distinguishes it from Théodore Rousseau's calm portraits. The thickness of the pigments and the limited range of greens and blacks are a far cry from Monet's more spare canvases and subtle tonal investigations. As Linda Nochlin astutely points out, this painting is in fact a self-portrait of Courbet.[5] After being a wounded man, an art student, a cellist, he is now a deep-rooted oak in his native countryside; a centuries-old historic marker, robust and still unyielding, like the Gauls who once fought in this area; an isolated tree, occupying the terrain; a steadfast tree, which, unlike the tormented Barbizon trees, shows no moods; an oak tree "whose head was neighbor to the sky, / Whose feet touched the empire of the dead."[6]

H.L.

1. See Hélène Toussaint in Paris, London 1977, p. 166, and Linda Nochlin, *"Le Chêne de Flagey* de Courbet: un motif de paysage et sa signification," *Quarante-huit/ Quatorze* 1 (Paris, 1989), pp. 20–21.
2. "amour druidique." Hélène Toussaint in Paris, London 1977–78, p. 166.
3. "Évidemment il n'a jamais vu dans la nature que la partie inanimée, et les seuls êtres vivants qui lui aient parlé sont les arbres, le chêne entre tous. Je dis êtres vivants à dessein, car le rôle que jouent les chênes dans l'oeuvre de Rousseau, la place qu'ils y occupent au premier plan, les élèvent à la dignité de véritables personnages et d'acteurs principaux. On peut dire de Rousseau qu'il connaît admirablement le chêne et son anatomie, qu'il a étudié à fond le tronc, la manière dont les rameaux s'en détachent, dont ceux-là eux-mêmes s'étalent ou dessinent leur silhouette sur le ciel ou l'horizon." Théodore Duret, *Les Peintres français en 1867* (Paris, 1867), p. 35.
4. "ravissement respectueux"; "magnifiques et sévères, ayant un âge de dieux et une solemnité de monuments." Goncourt, 1867, p. 239.
5. Nochlin, *"Le Chêne de Flagey,"* pp. 15–25.
6. "Celui de qui la tête au ciel était voisine/Et dont les pieds touchaient à l'empire des morts." Jean de La Fontaine, "Le Chêne et le roseau," in *Fables*, book 1, fable 22.

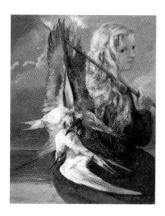

43 *Fig. 279*

Gustave Courbet
La Fille aux mouettes
(*Girl with Seagulls*)
1865
Oil on canvas
31⅞ x 25⅝ in. (81 x 65 cm)
Signed lower left: G. Courbet
Private collection, United States

CATALOGUES RAISONNÉS: Fernier 1977, vol. 1, no. 435; Courthion 1987, no. 421

PROVENANCE: Sold by the artist for Fr 1,000 to the Société artésienne des amis des arts for its annual charitable lottery, Arras, 1869; collection Binoche; Paul Rosenberg Gallery, New York; collection James Deely, New York, 1958–82; Paul Rosenberg & Co., New York, 1982

EXHIBITIONS: Paris, Rond-point du Pont de l'Alma, 1867, *Exposition des oeuvres de M. G. Courbet*, no. 101 (La Fille aux mouettes, Trouville, [1865]); Paris, Petit Palais, 1929, *Gustave Courbet*, no. 48; Venice, Biennale, 1954, *Courbet*, no. 29; Philadelphia Museum of Art and Boston, Museum of Fine Arts, 1959–60, *Courbet*, no. 48; Paris, London 1977–78, nos. 87 (Paris), 84 (London); New York, Brooklyn Museum, 1988, *Courbet Reconsidered,* no. 58

SELECTED REFERENCES: Jean Bruno [Jean Vaucheret], *Les Misères des gueux* (Paris, 1871–72), p. 216, repr. as engraving (Madame Ratapouf dans sa jeunesse); Alexandre Estignard, *Courbet: Sa vie et ses oeuvres* (Besançon, 1897), p. 185; Riat 1906, p. 230

In 1869 this painting was bought by the Société Artésienne des Amis des Arts. Emphasizing the modest price ("The painting is very cheap compared with the pictures being sold today"), Courbet explained the subject to the painter Charles-Paul Desavary, the chairman of the society: "It is an impression of the seashore at Trouville, [the girl] is the daughter of a sea hunter."[1] The painting was done on the Normandy coast during Courbet's prolific autumn of 1865, when he did seascapes as well as several portraits of members of high society. He painted Whistler's mistress, "Jo, the beautiful Irishwoman [Johanna Hiffernan]" (Whistler, "an Englishman who is my pupil," was in Trouville, staying with Courbet, whom he greatly admired).[2]

Whistler's proximity can be read from this "impression," which, to use his terminology, is a "symphony" of white, gray, and gold. The anonymous seagull girl—like the figure in Courbet's *Femme aux fleurs* (cat. 41) or Bazille's African

woman (cat. 14)—enhances a splendid still life. The birds with spreading wings may have influenced the herons seen in Bazille (cat. 8) and Sisley (cat. 187). In a Whistlerian range of hues, however, Courbet here takes up a personal theme— the alliance of women and animals, the disturbing association of hair and plumage (see cat. 45).

H.L.

1. "Le tableau est fort bon marché comparativement à la peinture qui se vend aujourd'hui"; "C'est une impression des bords de la mer à Trouville, la fille d'un chasseur de mer." Courbet's letter to Desavary, July 27, 1869, published in *Les Amis de Gustave Courbet* 31, (1964), p. 15.
2. "Jo, la belle Irlandaise"; "un anglais qui est mon élève." Riat 1906, p. 228.

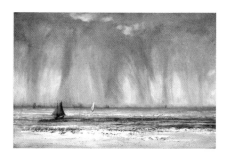

44 *Fig. 293*

Gustave Courbet
La Trombe (Marine)
(*The Waterspout* [*Marine*])
1865
Oil on canvas on cardboard
17 x 25⅞ in. (43.2 x 65.7 cm)
Signed and dated lower left: Gustave Courbet 66
The John G. Johnson Collection, Philadelphia Museum of Art, Philadelphia JC948

CATALOGUES RAISONNÉS: Fernier 1977, vol. 2, no. 595; Courthion 1987, no. 510

PROVENANCE: Sale, Paris, June 1, 1882, Mᵉ Chevalier, no. 14 (Fr 1,250); Erwin Davis, New York, 1883; John G. Johnson, after 1892; his bequest to the city of Philadelphia, 1917; his bequest to the city of Philadelphia, 1917

EXHIBITIONS: Paris, Cadart et Luquand, 1866 (see Jules Vallès, *L'Événement*, March 11, 1866, p. 1); Paris, Rond-point du Pont de l'Alma, 1867, *Exposition des oeuvres de M. G. Courbet*, no. 52 (La Trombe [Trouville 1865]); Philadelphia Museum of Art, and Boston, Museum of Fine Arts, 1959–60, *Courbet*, no. 58; Brooklyn, Minneapolis 1988–89, no. 52

SELECTED REFERENCES: Jules Vallès, "Paris," *L'Événement*, March 11, 1866, p. 1; G. Randon, "Exposition Courbet," *Le Journal amusant*, June 22, 1867, p. 7; *Catalogue of the Johnson Collection* (Philadelphia, 1914), vol. 3, and 1941, no. 948; Douglas Edelson, "Courbet's Reception in America before 1900," *Courbet Reconsidered*, New York, Brooklyn Museum and Minneapolis Institute of Arts, 1988–89, pp. 73–74

Discussing the Courbet seascapes exhibited at the Rond-point du Pont de l'Alma in 1867, the cartoonist Randon wrote: "Just as God drew heaven and earth from nothingness, M. Courbet draws his seascapes from nothing or next to nothing:

three tones on his palette, three brushstrokes—as he knows how to apply them—and we have an infinite sea and sky! Prodigious! Prodigious! Prodigious!"¹

To depict an unusual climatic phenomenon —the formation of a foggy twister linking a cloudy mass to the ocean—Courbet resorts to his usual small marine format and his customary viewpoint, facing a very low horizon from the very edge of the waves. The sea, painted with a palette knife, is heavy and choppy, fringed with white foam, spangled with maddened sails articulating human distress before unleashed nature. Some observers, citing Caspar David Friedrich's compositions, have called this a Romantic vision; more than anything, however, it is a strong and admirable study, solid, passionate, devoid of the alien elegance and Japanese elements of Courbet's disciple, Whistler. *La Trombe* was one of twenty-five "seascapes" which the painter boasted were "each more extraordinary and free than the next"—all of which he did when he and Whistler were together in Trouville in the fall of 1865.²

In March 1866, when this "gray waterspout," shown at the gallery of Cadart and Luquet, aroused "a feeling of melancholy," the young writer Jules Vallès crowed that one must salute the metamorphosis of Courbet, an "eccentric of bygone days," a habitual user of somber shades, into a painter employing "gay and tender colors" and producing "vistas filled with healthy fragrances and pure air."³

H.L.

1. "De même que Dieu a tiré le ciel et la terre du néant, de même M. Courbet tire ses marines de rien, ou à peu près rien: trois tons sur sa palette, trois coups de brosse—comme il les sait donner—et voilà une mer et un ciel infinis! Prodigieux! Prodigieux! Prodigieux!" Caricature by G. Randon in *Le Journal amusant*, 1867, reproduced in Charles Léger, *Courbet selon les caricatures et les images* (Paris, 1920), p. 72.
2. "paysages de mer"; "tous plus extraordinaires et libres l'un que l'autre." Courbet's letter to Alfred Bruyas, January 1866, in Courbet 1977, p. 41, and Courbet 1992, p. 273 (no. 66–3).
3. "trombe grise"; "une sensation de mélancolie"; "excentrique du temps passé"; "des spectacles tout plein d'odeurs saines, d'air pur!" Jules Vallès, "Paris," *L'Événement*, March 11, 1866, p. 1.

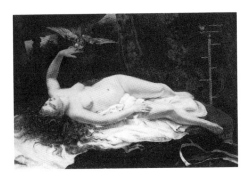

45 *Fig. 148*

Gustave Courbet
La Femme au perroquet
(*Woman with a Parrot*)
1866
Oil on canvas
51 x 77 in. (129.5 x 195.6 cm)
Signed and dated lower left: 66 Gustave. Courbet.
The Metropolitan Museum of Art, New York, H. O. Havemeyer Collection, Bequest of Mrs. H. O. Havemeyer, 1929 29.100.57

CATALOGUES RAISONNÉS: Fernier, 1978, vol. 2, no. 526; Courthion 1987, no. 518

PROVENANCE: The artist until 1870; sold to Jules Bordet, Dijon, for Fr 15,000, spring 1870, until at least 1889; possibly Haro, Paris; Durand-Ruel, Paris, received on deposit from Boudet (Bordet?), February 2, 1895 (deposit no. 8623); transferred to Durand-Ruel, New York, November 4, 1895 (deposit no. 5358); purchased by Durand-Ruel, New York, for Fr 20,000, April 30, 1898 (stock no. 1994); sold to Henry O. (1847–1907) and Louisine (1855–1929) Havemeyer, New York, for $12,000, April 30, 1898, until 1929; her bequest to the Metropolitan Museum, 1929

EXHIBITIONS: Paris, Salon of 1866, no. 463 (La femme au perroquet); Paris, Rond-point du Pont de l'Alma 1867, *Exposition des oeuvres de M. G. Courbet*, no. 10 (La femme au perroquet [Paris, 1866]); Munich, Glaspalatz, 1869, *International Kunst Austellung*; Anabout, 1870, Salon (La Courtisane); Dijon, 1870, *Exposition au profit des femmes des condamnés du Creusot*; Paris, École nationale des Beaux-Arts, 1882, *Exposition des oeuvres de G. Courbet*, no. 13 (La Femme au Perroquet. Salon de 1866. Private showing, 1867; 50 x 76 in. [127 x 193 cm]; property of M. Jules Bordet); Paris, Exposition Universelle, 1889, *Centennale de l'art français*, no. 210 (La Femme au perroquet [property of M. Jules Bordet, at M. Haro—s[igned] 1866]); New York, Metropolitan Museum, 1919, *Works of Gustave Courbet*, no. 24; Philadelphia Museum of Art, and Boston, Museum of Fine Arts, 1959–60, *Courbet*, no. 60; Paris, 1977–78, nos. 96 (Paris), 91 (London); Philadelphia Museum of Art, Detroit Institute of Arts, and Paris, Grand Palais, 1979, *L'Art en France au second Empire*, no. 198; New York, Metropolitan Museum of Art, 1993, *Splendid Legacy: The Havemeyer Collection*, no. 145

SELECTED REFERENCES: Louis Auvray, *Salon de 1866* (Paris, 1866), pp. 54–55; Arthur Baignières, "Journal du Salon de 1866," *La Revue contemporaine* 51 (May–June, 1866), pp. 347–48; Bertall, "Salon de 1866," *Le Journal amusant*, May 26, 1866, p. 1; Charles Blanc, "Salon de 1866," *Gazette des Beaux-Arts* 20 (June 1, 1866), p. 510; Hippolyte Briolland, *L'Artiste*, July 15, 1866, p. 239; Théophile Thoré, "Salon de 1866" in Thoré-Bürger 1870, vol. 2, pp. 277, 283–84; Jules Castagnary, *Salons: 1857–1870* (Paris, 1892), pp. 239–40; Hector de Callias,

"Les revenants de Mai," *L'Artiste*, May 30, 1866, p. 208; Jules Castagnary, "Le Salon," *La Liberté*, May 12, 1866, p. 1; Jules Castagnary, "Salon de 1866," *Le Nain jaune*, May 23, 1866, pp. 3–4, and June 6, 1866, pp. 3–4; P. Challemel-Lacour, "Le Salon de 1866," *La Revue moderne*, June 1, 1866, pp. 534–36; Cham, *Le Charivari*, May 13, 1866, p. 3; Gustave Courbet, "Lettre à M. Charles Yriarte, rédacteur du Monde illustré," *Le Nain jaune*, August 18, 1866, pp. 2–3; Gustave Courbet, "L'Affaire de la Femme au perroquet," *Le Nain jaune*, August 29, 1866, pp. 4–5; Maxime Du Camp "Le Salon de 1866," *La Revue des Deux Mondes*, May–June 1866, pp. 711–13; Théophile Gautier, "Salon de 1866. IV." *Le Moniteur universel*, July 4, 1866, p. 2; R. Martial, *Album du Salon de 1866*, repr. as etching; Marc de Montifaud, "Salon de 1866," *L'Artiste*, May 15, 1866, p. 173; Paul de Saint-Victor, "Salon de 1866," *La Presse*, June 10, 1866, p. 3; Jules Vallès, "Paris," *L'Événement*, March 11, 1866, p. 1; Pierre Véron, "À travers le Salon," *Le Journal amusant*, May 12, 1866, p. 2; Charles Yriarte, "Courrier de Paris," *Le Monde illustré*, August 11, 1866, p. 83; Émile Zola [Claude], "Mon Salon," *L'Événement*, March 11, 1866, pp. 1–2, April 30, 1866, p. 2, and May 15, 1866, p. 3; Edmond About, *Salon de 1866* (Paris, 1867), pp. 47–48; Edmond and Jules de Goncourt, *Journal*, September 18, 1867; Thoré-Bürger 1870, pp. 277, 283–84; Paul Mantz, "Gustave Courbet," *Gazette des Beaux-Arts*, September 1, 1878, pp. 375–78; Joris-Karl Huysmans, *L'Art moderne* (Paris, 1883; 1975 ed.), pp. 213–14; Georges Riat, *Gustave Courbet* (Paris, 1906), pp. 241–42, 276; Jules Castagnary, "Fragments d'un livre sur Courbet," *Gazette des Beaux-Arts*, January 1912, pp. 23–24; Étienne Moreau-Nélaton, *Bonvin* (Paris, 1927), p. 72; Louisine H. O. Havemeyer, *Sixteen to Sixty: Memoirs of a Collector* (New York, 1961; 1993 ed.), pp. 184–85, 195–97; Sterling and Salinger 1966, pp. 125–27; Lucie Chamson Mazauric, "Comment on perd un tableau," *Revue du Louvre*, 1968, no. 1, pp. 27–36; Philippe de Chennevières, *Souvenirs d'un directeur des Beaux-Arts* (Arthena, 1979), pp. 43–47; Douglas Edelson, "Courbet's Reception in America before 1900," in Brooklyn, Minneapolis 1988–89, pp. 74–75; Michael Fried, *Courbet's Realism* (Chicago and London, 1990), pp. 201–5

Courbet reexhibited *La Femme au perroquet* at his pavilion at the Rond-point du Pont de l'Alma in 1867, and in the catalogue he summed up "the scandal" it had provoked at the previous year's Salon: "[It] triggered an incident with which *Le Nain Jaune* of August 18 and 29, 1866, entertained the public. It had been executed for Count de Niewerkerek [sic], at his behest, at the same time as *Le Ruisseau couvert* [*The Covered Stream*], a landscape currently on view at the Champ de Mars Exhibition. The comte de Nieuwerkerke took *Le Ruisseau couvert*, for which he paid the artist two thousand francs and which now belongs to the French empress. As for *La Femme au perroquet*, since M. de Nieuwerkerke declared he had never acquired this painting, the artist turned down the six thousand francs offered to him by the administration of the Beaux-Arts."¹

The issue was murkier than the painter made it seem. The voluminous file in the Archives du Louvre, published by Lucie Chamson Mazauric, shows that the initial misunderstanding rapidly degenerated into a dispute, which was aggravated by Courbet's hostility toward the French government and by the financial secretary's breach of faith. Nevertheless at the very start the administration showed its "good will" toward an "unde-

niably talented" painter who was not in the government's bad books.[2] In 1865 Nieuwerkerke visited Courbet's studio and chose two paintings, *Le Ruisseau couvert*, which was already finished, and *La Femme au perroquet*, as yet incomplete. Courbet's unpublished letter to Nieuwerkerke (April 2, 1866) proves that even before its inclusion at the Salon, both parties regarded the nude as the property of "the administration."[3] The sale miscarried when the financial secretary, long after the Salon opening, made Courbet a niggardly offer of six thousand francs, which he rejected.

The wealth of critiques sparked by this masterpiece can be divided into those that praise unreservedly, those (the rarest) that condemn without appeal, and those that hail the artist for no longer terrifying "all the delicate sensibilities of the world" yet still deplore some incorrigible vulgarities and regret that Courbet is rallying the Baudrys and Cabanels.[4] In the front line of the fawners was the tireless Castagnary, who tried in vain to find anything greater in French painting: "When has anyone painted like this in France? To which art is this art not equal? And what would the great Renaissance say about such a piece?"[5] Arthur Baignières was less lyrical: "Overall the piece is beautiful, a few details are defective, but the whole is luminous and modeled with rare perfection."[6] Paul de Saint-Victor was exasperated by the woman's lack of "style, . . . substance, and life"; "This woman, frolicking with a macaw, has the look of a drowned woman exposed to a skylight in the morgue. And for a realist, what mannerism in the congealed contortion of her pose, in the Baroque arrangement of her hair, which is twisted into serpent coils!"[7]

The Goncourts noted in their journal: "The body of his *Femme au perroquet* is as remote, in its way, from the truthfulness of the nude as any eighteenth-century *académie*. Ugliness, ugliness forever! And ugliness with no great character, ugliness without the beauty of ugliness!"[8]

Théophile Gautier and Edmond About were the most illustrious of those who, before stating the usual objections, saluted Courbet's "praiseworthy return to healthy doctrines."[9] About conceded that "this is a very fine and very lovely creature. She has the same father as *Les Demoiselles d'Ornans* and so many other harlots, as confirmed by her birth certificate; but I swear she is actually their stepsister. She has all the breeding they lacked."[10]

In *Le Journal amusant* Pierre Véron summed up the relief felt by the right-thinking observers: "Had you asked for M. Courbet's address last year [when he had shown *Portrait de Pierre-Joseph Proudhon en 1853* (fig. 379)], you would have been told: 'Tarpeian rock, abyss to the left.' If you ask for his address this year, you will be told: 'Capitol, facing door.' *La Femme au perroquet*—which an enemy of the fair sex has subtitled: *Birds of a Feather Flock Together*—is a work that no one expected to come from a brush that had sacrificed grace without sacrificing to the Graces."[11]

However, earlier defenders of the painter admitted that they were stumped: "Courbet has ap-parently gone over to the enemy," groused Émile Zola before the opening of the Salon.[12] On May 15 he expressed his disappointment: "I do not deny that *La Femme au perroquet* is a solid painting, very clear and well-crafted; I do not deny that *La Remise des chevreuils [Covert of the Roe Deer]* is very charming, very airy, and very lively. But these paintings lack the *je ne sais quoi* of power and intention that fully makes up Courbet. We find sweetness and smiles; Courbet, to crush him with a word, has given us prettiness!"[13]

Bonvin was far terser: "Why, this is a Dubufe!"[14] Castagnary ended the long accolade to his friend Courbet with a pirouette of apology for leaving out his disciples: "I have devoted so much space to Courbet because pleading his cause constitutes pleading the cause of those who surround him, including all the young idealists and realists (naturalism involves both terms) coming after him: Millet, Bonvin, Ribot, Vollon, Roybet, Duran, Legros, Fantin, Monet, Manet, Brigot."[15]

But by 1866 this argument was no longer cogent. The artists of the New Painting gradually retreated from Courbet, and Courbet himself had moved on. In many respects *La Femme au perroquet* is a riposte to Manet's *Olympia* which was shown in the preceding Salon: the Ornans painter was showing his young rival how to paint a nude. *Jeune dame in 1866 (La Femme au perroquet)* (cat. 103), shown by Manet at the Pont de l'Alma in 1867, became the shepherd's reply to the shepherdess. Here Manet in his turn painted the woman with the parrot; *he* was now the modern—i.e., realist—painter. He swapped Courbet's improbable studio nude for a contemporary young woman and made the particolored macaw, which had been the Holy Spirit or a metamorphosed god, bent on a mythological coupling, a domestic pet.

H. L.

1. "Ce tableau a donné lieu à un incident dont le *Nain Jaune* des 18 et 29 août a entretenu le public. Il avait été exécuté pour M. le comte de Niewerkerek [*sic*], sur sa demande, en même temps que le *Ruisseau couvert*, paysage qui se trouve en ce moment à l'Exposition du Champ de Mars. M. le comte de Nieuwerkerke prit le *Ruisseau couvert* qu'il paya 2000 F à l'auteur et qui appartient actuellement à l'Impératrice des Français. Quant à la *Femme au perroquet*, M. de Nieuwerkerke ayant déclaré n'avoir jamais fait l'acquisition de cette toile, l'auteur refusa les six mille francs que l'administration des Beaux-Arts lui en avait fait offrir." Lucie Chamson Mazauric, "Comment on perd un tableau," *Revue du Louvre* 1 (1968), pp. 27–36.
2. "bonne volonté"; "incontestable talent." Ibid., p. 27.
3. "Paris 2 avril
 Monsieur le comte
 j'ai été très sensible à votre gentillesse—un jeune peintre dont le nom m'échappe qui est allé vous solliciter se servant de moi je ne sais pourquoi, est venu me dire de votre part, que vous étiez enchanté du tableau que je vous avais fait. Si ce fait est exact et qu'il ait pu vous plaire autant, je vous assure que j'en suis plus enchanté que vous-même.
 Je suis le plus grand ennemi des privilèges et des privilégiés, et pourtant dans le cas qui se présente, pourquoi laisser ce tableau inachevé puisqu'il peut être irréprochable, en quelques heures de travail de plus. Le règlement ne peut vous atteindre en aucune façon, le tableau vous appartenant peut être chez vous, comme au palais de l'industrie jusqu'au moment de l'exposition.

 Il reste quelques détails à terminer tel que des plumes au perroquet, la tenture qui fait le fond manque de quelques tons plus légers, le haut des cheveux sur la draperie noire ne sont qu'indiqués, en un mot il y a pour 5 ou 6 heures de travail.
 Si c'est possible je désirerais que vous m'envoyiez la toile, la raison est majeure, je suis malade à mourir depuis le 2 mars d'une inflammation d'intestin, qui me prend chaque soir lorsque je me suis trop poussé au travail, il me serait impossible de travailler hors de chez moi. Si cela ne peut se faire, il restera comme cela jusqu'à la fin de l'exposition; le soleil a bien des taches.
 Veuillez Mr le comte accepter mes salutations les plus distinguées.
 Gustave Courbet.
 j'ai fait mettre dans le livret que ce tableau vous appartenait.
 Si ce que je vous demande ne peut avoir lieu on pourrait mettre aussi qu'il est inachevé pour couper court aux criailleries des gens de parti pris."
 A note in pencil reads: "This painting, although belonging to the administration, cannot leave the exhibition. If it needs some retouching, I will have it placed in a separate room of the Palais de l'Industrie as I have done with other artists.
 7 April"
 Paris 2 April
 Dear Monsieur le comte,
 I was very grateful for your kindness—a young painter whose name slips my mind and who approached you using my name, I do not know why, came to tell me on your behalf that you were enchanted by the painting I had done for you. If this is so and if you did like the painting, I can assure you that I am even more enchanted than you.
 I am the greatest enemy of privilege and the privileged, and yet in this matter, why leave this painting incomplete since it can be flawless with a few more hours of work. The adjustment cannot affect you in any way since the painting may belong to you in your home as in the Palais de l'Industrie at the time of the exhibition.
 There are a few details left to attend to, such as some feathers in the parrot, the tapestry making up the background lacks a few lighter tones, the top of the hair on the black drapery is merely indicated—in a word, this would require some five or six hours of work.
 If at all possible, I would like you to send me the painting, there is a very good reason, since March 2 I have been mortally ill with an inflamed intestine, which attacks me every evening when I have pushed myself too hard. It would be impossible for me to work away from home. If this is out of the question, the painting will remain as it is until the end of the exhibit; the sun has many splotches.
 With my very best wishes, I remain
 Yours truly,
 Gustave Courbet.
 I have registered your ownership of the painting.
 If my request to you cannot be fulfilled, we could also indicate that the painting is incomplete, to cut short the hue and cry of biased people.
 A note in pencil reads: "This painting, although belonging to the administration, cannot leave the exhibition. If it needs some retouching, I will have it placed in a separate room of the Palais de l'Industrie as I have done with other artists.
 7 April"
 Paris, Archives du Louvre, x (Salon de 1866). Courbet finally retouched his painting at the Palais de l'Industrie during the second half of April; see Courbet 1992, p. 279.
4. "toutes les délicats du monde." Edmond About, *Salon de 1866* (Paris, 1867), p. 48.
5. "Quand a-t-on peint comme cela en France? À quel art, cet art n'est-il point égal? La grande Renaissance elle-même, que dirait-elle d'un pareil morceau?" Castagnary 1892, pp. 239–40.
6. "L'ensemble est beau; quelques détails défectueux, mais le tout est lumineux et modelé avec une rare perfection." Arthur Baignières, "Journal du Salon de 1866,"

La Revue contemporaine 51 (May–June 1866), pp. 347–48.

7. "style"; "la substance et la vie"; "Il y a des teintes de noyée, exposée contre une lucarne de la Morgue, sur cette femme qui folâtre avec un ara. Et, pour un réaliste, quel maniérisme dans la contorsion figée de sa pose, dans l'étalage baroque de ses cheveux tortillés en nœuds de serpents!" Paul de Saint-Victor, "Salon de 1866," *La Presse*, June 10, 1866, p. 3.

8. "Le corps de sa *Femme au perroquet* est aussi loin, dans son genre, du vrai du nu que n'importe quelle académie du XVIIIe siècle. Le laid, toujours le laid! Et le laid sans grand caractère, le laid sans la beauté du laid!" The Goncourt verdict came on September 18, 1867 after a visit to Courbet's pavilion at the Rond-point du Pont de l'Alma; Goncourt 1956, vol. 8, p. 55.

9. "retour louable aux saines doctrines." Théophile Gautier, "Salon de 1866," *Le Moniteur* 4 (July 1866), p. 2.

10. "C'est une bien jolie et bien fine créature. Elle est du même père que les *Demoiselles d'Ornans* et tant d'autres margots: l'état civil du livret en fait foi; mais elle n'est pas du même lit, je vous le jure. Elle a autant de race que les autres en avaient peu." About, "Salon de 1866," p. 47.

11. "Si vous aviez demandé l'adresse de M. Courbet l'année dernière, on vous aurait répondu:
—Roche tarpéienne, le gouffre à gauche.
Si vous le demandez cette année, on vous répondra:
—Capitole, la porte en face.
La Femme au perroquet—qu'un ennemi du beau sexe a sur-intitulée: *Qui se ressemble s'assemble*—est une œuvre qu'on ne s'attendait guère à trouver au bout du pinceau qui sacrifiait les grâces, bien plutôt qu'il ne sacrifiait aux grâces." Pierre Véron, "À travers le Salon," *Le Journal amusant*, May 12, 1866, p. 2.

12. "Courbet, paraît-il, a passé à l'ennemi." Émile Zola, "Mon Salon," *L'Évènement*, March 11, 1866, p. 2.

13. "Je ne nie point que la *Femme au perroquet* ne soit une solide peinture, très travaillée et très nette; je ne nie point que la *Remise des chevreuils* n'ait un grand charme, beaucoup d'air et beaucoup de vie; mais il manque à ces toiles le je ne sais quoi de puissant et de voulu qui est Courbet tout entier. Il y a douceur et sourire; Courbet, pour l'écraser d'un mot, a fait du joli!" Émile Zola, "Mon Salon," *L'Évènement*, March 15, 1866; Zola 1991, p. 128.

14. "Mais c'est un Dubufe!" Étienne Moreau-Nélaton, *Bonvin* (Paris, 1927), p. 72. Twenty years later Huysmans expressed an equally negative opinion: "La *Femme au perroquet* est aussi peu vraie, comme ordonnance et comme chair, que la *Femme couchée* de Lefebvre ou la *Vénus* à la crème de Cabanel. Le Courbet est durement peint avec un couteau du temps de Louis-Philippe, tandis que les charnures des autres plus modernes vacillent comme des plats entamés de tôt-faits; c'est au demeurant, la seule différence qui existe entre ces peintres. Courbet n'aurait pas placé, au pied du lit, une moderne crinoline, que sa femme aurait fort bien pu prendre le titre de naïade ou de nymphe; c'est par une simple supercherie de détail que cette femme a été considérée comme une femme moderne." (Joris-Karl Huysmans, *L'Art moderne* [Paris, 1975], pp. 213–14.)
[La *Femme au perroquet* is as inauthentic in its flesh and its arrangement as Lefebvre's *La Femme couchée* (fig. 134) or Cabanel's *Vénus* à la crème (fig. 127). The Courbet is harshly painted with a palette knife from the time of Louis-Philippe, while flesh from other, more modern painters jiggles like a pudding heaped on a plate; this, incidentally, is the only difference between these painters. Courbet would never have placed a modern crinoline at the foot of the bed, so his woman could have easily been called a nymph or naiad; only through the trickery of a detail could this woman have been considered modern.]

15. "J'ai tant donné à Courbet, parce que plaider la cause de Courbet, c'est plaider en même temps la cause de ceux qui l'entourent, et de toute la jeunesse idéaliste et réaliste (le Naturalisme comporte les deux termes), qui vient après lui: Millet, Bonvin, Ribot, Vollon, Roybet, Duran, Legros, Fantin, Monet, Manet, Brigot." Castagnary 1892, p. 240.

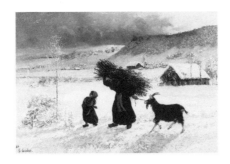

46

Fig. 313

Gustave Courbet
La Pauvresse de village
(*The Poor Woman of the Village*)
1867
Oil on canvas
34 x 50⅛ in. (86.3 x 127.4 cm)
Signed and dated lower left: 66, G. Courbet
Private collection, Switzerland, with the cooperation of the Galerie Schmit, Paris

CATALOGUES RAISONNÉS: Fernier 1977, no. 550; Courthion 1987, no. 533

PROVENANCE: Bought for Fr 4,000 by Laurent-Richard, 1867; his sale, Paris, Hôtel Drouot, May 1873; Jules Castagnary, Paris; Dreyfus, Paris; sale, Paris, Hôtel Drouot, April 7, 1876, no. 4 (*Effet de neige*); bought for Fr 2,550 by M. Goupil; private collection, Frankfurt, in 1935; collection L. M. Broomfield, Quebec; private collection, Canada; Galerie Schmit, Paris; private collection

EXHIBITIONS: Paris, Rond-point du Pont de l'Alma, 1867, *Exposition des œuvres de M. G. Courbet*, no. 38 (La Pauvresse de village [Ornans, 1867]); Paris, Galerie Bernheim-Jeune, 1920, *Paysages impressionnistes*, no. 3 (La Fagotière); Zurich, Kunsthaus, 1935, *Gustave Courbet*, no. 92; Paris, London, 1977–78, no. 103

SELECTED REFERENCES: Jean Bruno [Jan Vaucheret], *Les Misères des gueux* (Paris, 1871–72), p. 167, repr. p. 161 (La Veuve au fagot); Riat 1906, p. 257; Charles Léger, *Courbet* (Paris, 1929), pp. 122–26; Gerstle Mack, *Courbet* (New York, 1951), p. 216

Courbet spent the summer of 1866 in Normandy, and in October he settled in Franche-Comté. There he prepared for his participation in the Exposition Universelle of 1867 and for the one-man show that he was planning for the same time. This was a period of intense activity; he did numerous landscapes and an ambitious painting that was the last of his very large-scale works, *L'Hallali du cerf, épisode de chasse à courre sur un terrain de neige* (*Death of the Stag, a Hunting Episode on a Snowy Terrain*; 140 x 199 in. [355 x 505 cm]; Musée des Beaux-Arts et d'Archéologie, Besançon). On January 31, 1867, Courbet sent a letter to M. Bardenet, an art dealer who came from the same region and was now living in Paris. Courbet wrote that he was hard at work on "a series of snow landscapes that will be similar to the seascapes (see cat. 44)."[1] A bit later, a providential "meter of snow" enabled him to pursue his studies for *L'Hallali du cerf*.[2] Hence, although the painter dated *La Pauvresse* 1866, it must have been painted in early 1867.[3]

During this winter in the Jura Mountains, Courbet stocked up on landscapes for his one-man show and balanced his important series of seascapes with "snowscapes"—the rubric under which they were exhibited in 1867. They seduced a number of art lovers, including M. Laurent-Richard, a tailor, who bought *La Pauvresse de village* as well as one of Courbet's great masterpieces, *Les Casseurs de pierre* (*The Stone Breakers*; destroyed).[4] Claude Monet was also inspired

Fig. 402. Gustave Courbet, *L'Hallali du cerf, épisode de chasse à courre sur un terrain de neige* (*The Death of the Stag, Episode in the Hunt on Snowy Ground*), 1867. Oil on canvas, 11 ft. 6½ in. x 16 ft. 5 in. (355 x 505 cm). Musée des Beaux-Arts et d'Archéologie, Besançon

by the snowscapes, and he himself did such scenes during the next few winters.

The *Pauvresse* is a social painting or more precisely, as Courbet himself proclaimed, a "Socialist" painting. The woman carrying firewood, preceded by the little girl delighting in her loaf of bread, and followed by a restive goat, emphasizes the three basic peasant rights that were diminished during the course of the nineteenth century: the use of the communal oven for baking bread, the right to gather firewood on communal property, and the right to graze animals on the commons. Courbet takes up the exploitation of the underprivileged, a theme that is intrinsic to his art but that he somewhat neglected during the 1860s. In this deliberately archaic frieze the somber outline of the figures against a snowy background evokes the winter compositions of Pieter Brueghel the Elder.[5]

In 1872 this painting was reproduced in *Les Misères des gueux* (*The Beggars' Miseries*), a book by Courbet's friend Jean Bruno. The "widow with the kindling wood" illustrated a legend of Franche-Comté, the apparition of the White Lady to a "poor woman in Villeneuve, the widow of a roadman and mother of three children": "She fell to her knees, begging the White Lady to spare her.... The Lady hastened to help her up. She then slipped a few pieces of silver into her hand and promised to protect her. The next day the poor widow, preceded by her little girl, who held an enormous bread in her arms, joyfully came home to the isolated shack she lived in. She was carrying a huge bundle of kindling on her shoulder and dragging along a fine goat, which had been given to her. Henceforth the little family lacked neither bread nor wood.[6]

H.L.

1. Courbet 1992, p. 303 (67–2).
2. Ibid., p. 306 (67–6).
3. To complicate matters further, the painter dated this canvas 1867 in the register of his exhibition at the Rondpoint du Pont de l'Alma.
4. In 1873 Laurent-Richard got rid of his first collection (Courbet and the Barbizon School) in order to devote himself to the Impressionists—chiefly Pissarro and Sisley.
5. See Hélène Toussaint's remarks in Paris, London 1977–78, pp. 194–95.
6. "la veuve en fagot"; "pauvre femme de Villeneuve, veuve d'un cantonnier et mère de trois jeunes enfants"; "Elle tomba à genoux en priant la Dame blanche de l'épargner. ...Celle-ci s'empressa de la relever. Elle lui glissa ensuite quelques pièces d'argent dans la main et lui promit de la protéger. Le lendemain on vit la pauvre veuve, précédée de sa petite fille qui tenait un pain énorme dans ses bras, regagner joyeusement la cabane isolée qu'elle habitait. Elle portait un bon fagot de bois sec sur ses épaules, et trainait à sa suite une superbe chèvre qui lui avait été donnée. ...Depuis ce moment la petite famille ne manqua ni de pain ni de bois." Jean Bruno, *Les Misères des gueux, ouvrage entièrement illustré par G. Courbet* (Paris, 1872), p. 167, engraving p. 161.

47 *Fig. 294*

Gustave Courbet

Mer calme
(*The Calm Sea*)
1869
Oil on canvas
23½ x 28¾ in. (59.7 x 73 cm)
Signed and dated lower left: G. Courbet/69
The Metropolitan Museum of Art, New York, H. O. Havemeyer Collection, Bequest of Mrs. H. O. Havemeyer, 1929 29.100.566

CATALOGUES RAISONNÉS: Fernier 1978, vol. 2, no. 712; Courthion 1987, no. 684

PROVENANCE: James Stillman, Paris; Théodore Duret, Paris, until 1911; sold to Mrs. H. O. Havemeyer, New York, fall 1911, until 1929; bequest of her to the Metropolitan Museum, 1929

EXHIBITIONS: New York, Metropolitan Museum of Art, 1993. *Splendid Legacy: The Havemeyer Collection*, no. 151

SELECTED REFERENCES: Sterling and Salinger 1966, p. 131

In the summer of 1869 Courbet returned to the Normandy coast (see cat. 44), where he stayed at Etretat from the second week of August to the third week of September. During this month-long working vacation, he painted a great number of pieces—some twenty seascapes, including two large-format works, for the next Salon.[1] He was fired by the desire to bring some of these seascapes to his dealers, Durand-Ruel and Haro, who could sell them easily; the present painting is one of these.

This is no frail and fleeting atmospheric study like a Boudin watercolor; it is a full-fledged painting of an empty and almost desolate scene. Under the foamy mass of clouds, the painter arranged two beached boats on shimmering strips of sand, the narrow green ribbon of ocean, and the distant sailboats—three times nothing. This pareddown simplicity has caused observers to regard the seascapes as Courbet's most modern works.[2] In 1947 Lionello Venturi, tracking down every last precursory sign of modernism, focused on this marine, which he praised as "a great masterpiece": "The horizon is luminous. The sea and the sky are gigantic; if Courbet feels that he too is a giant, the boats can be meaningless specks—the man who sees in this way is a giant. No one in the nineteenth century, not even Delacroix, felt such great power, such heroic strength in the face of the sea."[3]

By 1869, however, the Courbet who painted this marine was already neglected by the artists of the New Painting. He had given them everything he could; they had taken what they needed and had then gone elsewhere. This was a time of lack of interest in Courbet, even denial of his worth: Whistler had spent the fall of 1865 with Courbet in Trouville (see cat. 192); after witnessing the creation of these first seascapes, he disavowed his earlier admiration for the French artist and voiced regret that he had not studied with Ingres.[4]

H.L.

1. Courbet 1992, pp. 352–54.
2. See Hélène Toussaint's remarks in Paris, London 1977–78, p. 178.
3. "un grand chef d'oeuvre"; "L'horizon est lumineux. La mer et le ciel sont géants, mais si Courbet se sent un géant comme eux, les barques peuvent être des points chétifs: celui qui voit de la sorte est un géant. Personne au XIXᵉ siècle, même Delacroix, n'avait senti en face de la mer une puissance aussi grandiose, une force à ce point héroïque." Lionello Venturi, *Peintres modernes* (Paris, 1947), p. 231.
4. Young et al. 1980, p. LVI.

Charles-François Daubigny

Paris, 1817–Paris, 1878

Born into a family of artists, Daubigny worked as a decorator of trinkets for a clockmaker and then as a restorer of paintings in the Louvre. His formal training began when he entered the studio of Pierre-Anasthasie-Théodore Sentiès in 1835. He also studied briefly with Paul Delaroche. Daubigny traveled independently to Italy in 1836, before competing unsuccessfully for the Prix de Rome in historical landscape in 1837 and 1841. He began exhibiting regularly at the Salon of 1838, making trips to the provinces each summer in search of landscape motifs. He met Corot on one such excursion to Crémieu in 1852. Although Daubigny achieved considerable success by the early 1850s, critics consistently complained about the rough execution and lack of finish in his landscapes. In the autumn of 1857 he purchased his famous studio-boat, the "Botin," which prompted him to turn increasingly to riverscapes. Daubigny's career reached its apogee in 1859, when he received his third first-class medal at the Salon, was awarded a major commission to decorate a government office in the Louvre, and was named Chevalier of the Légion d'Honneur. Shortly thereafter, however, his fortunes began to decline as complaints over his sketchy execution intensified. In 1865 Daubigny traveled to London, where he met Whistler, and to Trouville, where Monet, Courbet, and Boudin were also working. Daubigny was first elected to the Salon jury in 1866 and became notorious for his support of the younger generation, particularly Pissarro, Cézanne, and Renoir. He resigned from the jury of the 1870 Salon over the rejection of a painting by Monet.

48 Fig. 102

Charles-François Daubigny

Le Hameau d'Optevoz (?)
(*The Hamlet of Optevoz* [?])
Ca. 1857
Oil on canvas
22¾ x 36½ in. (57.8 x 92.7 cm)
Signed lower left: *C. Daubigny*
The Metropolitan Museum of Art, New York, Bequest
of Robert Graham Dun, 1911 11.45.3

CATALOGUE RAISONNÉ: Hellebranth 1976, no. 518

PROVENANCE: (?) B. Claudon, by 1867; Robert Graham
Dun, New York, bequeathed to the Metropolitan Mu-
seum, 1910, with his wife retaining life interest until her
death, 1911

EXHIBITIONS: (?) Paris, Exposition Universelle of 1867,
no. 192 ("Le hameau d'Optevoz"); Edinburgh 1986,
no. 53; Manchester, New York, Dallas, Atlanta 1991–92,
no. 51 (exhibited in New York only)

SELECTED REFERENCES: (?) Claretie 1873, p. 230, n. 1 ("le
Hameau d'Optevoz" [1867, Ex. un.]); San Francisco,
Toledo, Cleveland, Boston 1962–63, under no. 22 (not
in exhibition); Sterling and Salinger 1966, pp. 95–96,
repr.; Price 1967, pp. 96, 208, 236; Champa 1973, p. 93,
fig. 132; Rewald 1973, repr. p. 104; Fidell-Beaufort and
Bailly-Herzberg 1975, p. 113, fig. 27; Grad 1977, pp. 72–73,
118–19, no. 17, fig. 27; Bühler 1979, p. 64, fig. 60; Bühler
1984, p. 2929, fig. 2

This may be the picture called *Le Hameau
d'Optevoz* which Daubigny exhibited, along with
many others, at the 1867 Exposition Universelle.
If not, then it is unlikely that it was publicly ex-
hibited during the 1850s and 1860s. Neverthe-
less, it is precisely the kind of picturesque scene
of rural France for which Daubigny was known
and admired. The choice of an ordinary site, de-
picted without interpretation as if through a cam-
era's lens, in a subdued harmony of dark earth
colors, became Daubigny's signature. It contrib-
uted to his fame at the end of the 1850s and con-
tributed to his critical failure in the 1860s. By the
end of the 1860s, Daubigny had lightened his pal-
ette in response to the work of young artists such
as Monet.

Optevoz is a hamlet not far from Lyon. Daubigny
worked there in 1849, 1852, when he met Corot
there for the first time, 1854, and 1859. Daubigny
depicted the same scene in a painting dated 1857
that is now in the Philadelphia Museum of Art.
Like the present painting, the Philadelphia can-
vas was probably developed in his studio from
oil sketches and drawings that were made on the
site. One such drawing is at the Metropolitan
Museum of Art (acc. no. 12.100). Bonnie Grad
argues that the present picture was painted sev-

eral weeks later in 1857 than the Philadelphia can-
vas because of differences in vegetation,[1] but this
evidence is irrelevant since Daubigny was not in
Optevoz that year. The style of this painting is
sufficiently close to the Philadelphia canvas that
the date is probably the same.

G.T.

1. Grad 1977, p. 119, no. 17.

49 Fig. 18

Charles-François Daubigny

Les Bords de l'Oise
(*The Banks of the Oise*)
1859
Oil on canvas
35⅜ x 71⅝ in. (90 x 182 cm)
Signed and dated lower left: *Daubigny 1859*
Musée des Beaux-Arts, Bordeaux E624 (old inv. no.),
M6230 (new inv. no.)

CATALOGUE RAISONNÉ: Hellebranth 1976, no. 222

PROVENANCE: Félix Nadar, Paris, purchased from the
artist in 1859; sold by Nadar to the municipality of
Bordeaux on the occasion of the exhibition of the Société
des Amis des Arts, 1863

EXHIBITIONS: Paris, Salon of 1859, no. 767; Bordeaux,
Galeries de la Société des Amis des Arts, 1863, no. 170;

Paris, Exposition Universelle of 1867, no. 189; Paris
1968–69, no. 476; Bordeaux 1974, no. 52

SELECTED REFERENCES: Astruc 1859, p. 306; Aubert 1859,
pp. 30–32; Auvray 1859, p. 60; A. de Belloy, "Salon de
1859 IV," *L'Artiste*, n.s. 7 (May 7, 1859), p. 20; G. de
Cadoudal, "A propos du Salon," *Journal des jeunes
personnes*, no. 10 (August 1859), p. 307; Émile Cantrel,
"Salon de 1859: Les paysagistes," *L'Artiste*, n.s. 7 (May
29, 1859), p. 71; Castagnary, "Salon de 1859," reprinted
in Castagnary 1892, vol. 1, p. 79; Chalons d'Argé 1859,
p. 47; Charles Dollfus, "Salon de 1859," *Revue germa -
nique* 6, no. 4 (April–June 1859), p. 248; Du Camp 1859,
pp. 155–56; Dumas 1859, pp. 88–89; Dumesnil 1859,
p. 37; Georges Duplessis, "Salon de 1859," *Revue des
beaux-arts* 10, no. 9 (1859), p. 176; Victor Fournel, "Le
Salon de 1859 (deuxième article)," *Le Correspondant*
11 (June 1859), p. 268; Ferdinand Gabrielis, "Salon de
1859," *Moniteur des arts* 2 (May 28, 1859), p. 234;
Gautier 1859, pp. 192–93, fig. 161; Charles Habeneck,
"Le Salon de 1859," *Le Causer* 1 (March–August 1859),
p. 223; Arsène Houssaye, "Salon de 1859," *Le Monde
illustré* 4 (June 4, 1859); Lépinois 1859, pp. 85, 218;
Mantz 1859, p. 296; Nadar, "Nadar-Jury au Salon de
1859," *Journal amusant*, July 16, 1859, p. 2; Nettement,
"Salon de 1859," in Nettement 1862, p. 368; Émile
Perrin, "Salon de 1859," *Revue européenne* 3 (July 1,
1859), p. 654; Jean Rousseau, "Salon de 1859," *Le Figaro*,
May 17 1859; Paul de Saint-Victor, "Salon de 1859," *La
Presse*, July 2, 1859; Louis Vintimille, "Salon de 1859,"
Le Courrier de la mode, June 1859, p. 89; Charles
Clément, "Exposition universelle. Beaux-arts. Premier
article," *Journal des Débats*, March 28, 1867; W. Bürger,
"Exposition universelle de 1867," in Thoré-Bürger 1870,
vol. 2, p. 358; Henriet 1874, pp. 262–64; Frédéric Henriet,
"Daubigny," *L'Artiste*, ser. 9, 27 (June 1878), p. 400;
Henriet 1878, pp. 33–36, 172, no. 767; Claretie 1882,
p. 282; Laran 1912, pp. 59–60, no. 22, repr.; Moreau-
Nélaton 1925, vol. 1, p. 71, fig. 50; Price 1967, pp. 91–92,
116–18, 148–49; Fidell-Beaufort and Bailly-Herzberg
1975, pp. 49, 64, 133, fig. 54; Grad 1977, pp. 80, 90, 93,
95–97, 104–5, 123–24, no. 26, fig. 40

With this painting, Daubigny sealed his status as
one of France's most respected landscapists in the
naturalist style. It was purchased out of the art-

Fig. 403. Félix Nadar, "Effet produit sur un visiteur du salon par l'eau des
merveilleux tableaux de M. Daubigny" (Effect produced on a visitor to the
Salon by the water in the marvelous paintings of M. Daubigny), 1859.
Caricature published in *Journal amusant*, no. 185 (July 16, 1859), p. 2
(Nadar-Jury)

ist's studio, before it was exhibited at the Salon, by the famous photographer Nadar, an arbiter of taste who was an astute judge of new trends. Nadar then publicized the work in his *Journal amusant* with a cartoon (fig. 403) depicting a visitor to the Salon who took off his clothes to jump into the placid waters of Daubigny's painting.[1] The painting was well received by conservative and liberal critics alike. Paul Mantz, for example, missed the inspirational grandeur of classical landscapes but found it "pretty" and "charming."[2] Théophile Gautier considered Daubigny to be "the first among objective landscapists. He does not choose, he does not create, he neither adds or removes, he does not confuse the reproduction of the site with his own feelings, he paints the selected view with a charming naïveté, leaving the spectator free with his own impression; his paintings are like pieces of nature cut out and set into golden frames."[3] Many critics found an almost photographic quality in the painting, and there is an undeniable relationship between Daubigny's style at that time and contemporary landscape photography.[4] Gautier brought this point home when he wrote, "It seems as if the canvas exposed in front of the site had painted itself by some magic process and new invention."[5]

Other writers, however, criticized the lack of finish and painterliness of Daubigny's works, qualities that are precisely opposed to photographic realism. Baudelaire, for example, was disappointed with the finish of Daubigny's landscapes but found poetry and sentiment in them.[6] Maurice Aubert considered Daubigny's execution negligent but thought that *Les Bords de l'Oise* united all the conditions of beauty in landscape.[7] Zacharie Astruc reconciled most of the criticism by chalking it up to Daubigny's naïveté. He called him "the painter par excellence of simple impressions." Regarding this specific painting, he said, "This common nature charms you with a quiet sweetness like the kindness of a plain woman."[8]

The young Claude Monet was tremendously impressed by Daubigny's pictures at the Salon. He wrote to Boudin that "Daubigny's paintings are really beautiful in my opinion."[9] And again, "Daubigny, here is a fellow who paints well, who understands nature! The view of Villerville [fig. 30] that I mentioned to you is a true wonder. It would be very unfortunate if you did not see it. To describe it to you in detail is difficult for me and I am in a hurry."[10]

Daubigny earned, for the third time, a first-class medal at the Salon but was further rewarded that year with the Légion d'Honneur. According to Moreau-Nélaton,[11] this was largely due to the success of this picture. Daubigny made numerous copies, of which one, dated 1868 and now in Budapest (Hellebranth 229), may be the work to which Daubigny referred in a letter of 1868 to his daughter.[12] He explained that he had gone to Bordeaux specifically to make a copy of this picture, which was already in the collection of the municipal museum. Other versions are dated 1864

(Hellebranth 228), 1870 (Hellebranth 232), 1877 (Hellebranth 239), and 1878 (Hellebranth 240).

G.T.

1. "Nadar-Jury au Salon de 1859," *Journal amusant*, July 16, 1859, p. 2.
2. Mantz 1859, pp. 294–96.
3. "le premier des paysagistes objectifs. Il ne choisit pas, il ne compose pas, il n'ajoute ni n'élague, il ne mêle pas son sentiment personnel à la reproduction du site; il peint avec une naïveté charmante l'aspect choisi, laissant le spectateur libre de son impression; ses tableaux sont des morceaux de nature coupés et entourés d'un cadre d'or." Gautier 1859, p. 192.
4. For discussions of Daubigny and photography, see Grad 1977, and Price 1967.
5. "Il semble que la toile exposée devant le site se soit peinte toute seule par quelque procédé magique et d'invention nouvelle." Gautier 1859, p. 193.
6. "Salon de 1859: Le paysage," in Baudelaire 1975–76, vol. 2, p. 661.
7. Aubert 1859, p. 31.
8. "le peintre par excellence des simples impressions." "Cette nature commune vous charme par sa tranquille douceur, comme la bonté d'une femme laide." Astruc 1859, pp. 303, 306.
9. "Les Daubigny sont pour moi quelque chose de bien beau." Monet to Boudin, May 19, 1859, Wildenstein 1974, letter 1, p. 419.
10. "Daubigny, en voilà un gaillard qui fait bien, qui comprend la nature! Cette vue de Villerville dont je vous ai parlé, c'est quelque chose de merveilleux. Ce serait bien malheureux si vous ne voyiez pas ça. Vous peindre les détails est chose difficile pour moi, et le temps me presse." Monet to Boudin, June 3, 1859, Wildenstein 1974, letter 2, p. 419.
11. Moreau-Nélaton 1925, vol. 1, pp. 71–72.
12. Fidell-Beaufort and Bailly-Herzberg 1975, p. 64.

50 *Fig. 114*

Charles-François Daubigny
Un village près de Bonnières
(*A Village near Bonnières*)
1861
Oil on canvas
32½ x 57½ in. (82.5 x 146 cm)
Signed and dated lower right: *Daubigny 1861*
Private collection

CATALOGUE RAISONNÉ: Hellebranth 1976, no. 79

PROVENANCE: Th. Claudon, by 1867; his sale, Paris, Hôtel Drouot, March 9, 1896, no. 1; Alexander Young, London; Boussod-Valadon et Cie, Paris; sale of works from Boussod-Valadon et Cie, Galerie Georges Petit, Paris, March 3, 1919, no. 6; H. A. Robinson, Bexhill; sold by Robinson, Christie's, London, June 22, 1938, no. 109; R. C. Pritchard; Colnaghi, London; Tooth and Sons, London; sale, Christie's, London, June 28, 1968, no. 25; private collection

EXHIBITIONS: Paris, Salon of 1861, no. 793; London, International Exhibition of 1862, no. 130; Paris, Exposition Universelle of 1867, no. 190

SELECTED REFERENCES: W. Bürger, "Salon de 1861," in Thoré-Bürger 1870, vol. 1, p. 53; Alphonse de Calonne, "La peinture contemporaine à l'exposition," *Revue contemporaine*, ser. 2, 11 (May 31, 1861), p. 334; Gautier 1861, p. 121; Léon Lagrange, *La Peinture et la sculpture au Salon de 1861* (Paris, 1861), pp. 97–98; Olivier Merson, *La Peinture en France: Exposition de 1861* (Paris, 1861), pp. 321–23; Charles Clément, "Exposition universelle: Beaux-arts, premier article," *Journal des Débats*, March 28, 1867; Henriet 1874, p. 266; Henriet 1878, pp. 40, 174, no. 793; Claretie 1882, p. 282; Laran 1912, no. 24 (another version repr.); Moreau-Nélaton 1925, vol. 1, p. 80, fig. 62; Fiddell-Beaufort and Bailly-Herzberg 1975, p. 53; Rodolphe Walter, "Aux sources de l'Impressionnisme: Bennecourt," *L'Œil*, no. 393 (April 1988), pp. 30–32 (another version repr.)

Despite the praise Daubigny received at the Salon of 1859, or perhaps because of it, his paintings were sharply criticized at the Salon of 1861. His simplicity and honesty, virtues in 1859, became banality in 1861. And although he was accused of having no style, of being a dumb recorder of nature, it was in fact his style, his summary execution, that provoked objections.

"M. Aligny is nothing but style, M. Corot is largely style, and M. Daubigny comes immediately after M. Corot, because in wanting to paint nature without style, he has given it one, an ugliness that nature does not have as much as one might think."[1] So complained Hector de Callias. Théophile Thoré concurred. He considered the present painting Daubigny's best that year, "with houses reflecting in the water"; but, he asked, "is this village made of cardboard or of tin?"[2] Olivier Merson considered the painting no more than an ébauche, and he held such "ébauches, pochades, and esquisses" insulting to the public.[3] Gautier wrote, "The *Village près de Bonnières* is a good study and nothing more . . . a motif so vulgar, so unpicturesque in itself, needed to be enhanced by the execution to become interesting."[4] Delécluze voiced the common reproach of Daubigny's dark palette: "The sight of his landscapes exudes a distressing sadness. We could also say a good deal more about his monotonous execution and his lusterless color. M. Daubigny needs to wake up."[5] It goes without saying that it was Daubigny's independence from convention and his informal approach to execution that interested young painters such as Monet and Renoir, and Pissarro, too.

The village depicted is Gloton, a hamlet on the Seine just upstream from Bennecourt and across the river from Bonnières. Daubigny painted many views in this area (Hellebranth 76, 77, 78, 80), as did Monet and Cézanne.[6]

G.T.

1. "M. Aligny n'est que style. M. Corot est beaucoup style, et M. Daubigny vient immédiatement après M. Corot, en ce que, voulant peindre la nature sans style, il lui en a donné un, celui du laid, qu'elle n'a pas autant qu'on

pense." Hector de Callias, "Salon de 1861: Les lettres B.C.D.E.," *L'Artiste*, n.s. 11 (June 1, 1861), p. 247.
2. "avec des maisons qui se réfléchissent dans l'eau; encore ce village, est-il en carton ou en fer-blanc?" "Salon de 1861," in Thoré-Bürger 1870, vol. 1, p. 53.
3. "ébauches, les pochades et les esquisses." Olivier Merson, *La Peinture en France: Exposition de 1861* (Paris, 1861), pp. 322–23.
4. "Le *Village près de Bonnières* est une bonne étude, mais rien de plus... un motif si vulgaire, si peu pittoresque en lui-même, avait besoin d'être relevé par l'exécution pour être intéressant." Gautier 1861, p. 121.
5. "L'aspect de ses paysages est d'une tristesse désolante. Nous aurions bien à dire aussi sur son exécution monotone, sur son coloris sans éclat. Il faut que M. Daubigny se réveille." Étienne-Jean Delécluze, "Salon de 1861 (sixième article)," *Journal des Débats*, June 22, 1861.
6. See Rodolphe Walter, "Aux sources de l'Impressionnisme: Bennecourt," *L'OEil*, no. 393 (April 1988), pp. 30–37.

Edgar Degas

Paris, 1834–Paris, 1917

Born into a comfortable family with relatives in Naples and Louisiana, Edgar Degas had a solid classical education. After graduating from the lycée, he became a painter, working briefly under Félix Barrias and then, for a longer period, under Louis Lamothe (a disciple of and assistant to Hippolyte Flandrin). In 1855 Degas spent a few weeks at the École des Beaux-Arts and then dropped out. From 1856 to 1859, he lived in Italy: at his grandfather's home in Naples; in Rome, where he worked regularly at the Villa Medici; and with his Aunt Bellelli in Florence, where he began his first large painting (fig. 253). In Italy, during the winter of 1858, he met Gustave Moreau, who deeply influenced him for several years.

For a biography of Degas during the 1860s, see the chronology.

51 *Fig. 70*

Edgar Degas
Petites Filles spartiates provoquant des garçons
(*Young Spartan Girls Provoking Boys*)
1860

Oil on canvas
37¾ x 50⅜ in. (96 x 128 cm)
Signed lower right: Degas
The Art Institute of Chicago, Charles H. and Mary F. S. Worcester Collection 1961.334

CATALOGUES RAISONNÉS: Lemoisne 1946–49,vol. 2, no. 71; Minervino 1974, no. 89

PROVENANCE: Artist's studio; second sale of the "Atelier Edgar Degas," Paris, Galerie Georges Petit, December 13, 1918, no. 7, repr.; René De Gas, Paris; his estate sale, Hôtel Drouot, Paris, November 10, 1927, no. 76, repr.; Paul Durand-Ruel, Paris; Jean d'Alayer d'Arc, Paris, 1950; Sam Salz, New York; acquired by the Art Institute of Chicago with the funds of Charles H. and Mary F. S. Worcester, 1960

EXHIBITIONS: Berne, Kunstmuseum, 1951, *Degas*, no. 2; Amsterdam, Stedelijk Museum, 1952, *Edgar Degas*, no. 5; Paris, Gazette des Beaux-Arts, 1955, *Degas dans les collections françaises*, no. 9; Paris, Galerie Durand-Ruel, 1960, *Edgar Degas: 1834–1917*, no. 2, repr.; Tokyo, Seibu Museum of Art, 1976, *Edgar Degas*, no. 4, repr.; Chicago, Art Institute, 1984, *Degas in the Art Institute of Chicago* (text by Richard Brandell), no. 9.

SELECTED REFERENCES: Paul Lafond, *Degas* (Paris, 1918–19), vol. 2, p. 4, repr.; Richard Thomson, *The Private Degas* (Manchester, Witworth Art Gallery, and Cambridge, Fitzwilliam Museum, 1987), repr. fig. 36; Henri Loyrette in Paris, Ottawa, New York, 1988–89, pp. 99–100, repr.

For the fifth Impressionist Exhibition in 1880, Degas planned to show a revised version of a painting he had started twenty years earlier: *Petites filles spartiates provoquant des garçons*. Hung with his recent works—portraits and dance scenes—and with the works of Cassatt, Gauguin, Morisot, and Pissarro, this painting would have been both historical and historic in all senses of the terms, inevitably clashing with everything else and showing that the New Painting was concerned not only with landscapes, portraits, and genre scenes but also with historical material. For unknown reasons this work, listed as number 33 in the catalogue of the Impressionist Exhibition and dated 1860, was not displayed.

The subject depicted here has rarely been treated by painters. Douglas Cooper, in his discussion of the final work (National Gallery, London), mentions a fresco (1836) by Giovanni Demin at the Villa Patt near Sedico (Venetia). Phoebe Pool, Douglas Cooper, and, more recently, Carol Salus have pointed out the various immediate sources of the painting—one being Plutarch, who, in his *Life of Lycurgus*, reports that the education of the Spartan girls was similar to that of the boys. Daniel Halévy relates that Degas told him: "These are the Spartan girls challenging young men to a fight," adding, "I read it in Plutarch."[1]

Passages from Abbé Barthélemy's once-famous *Voyage du jeune Anacharsis en Grèce* (1787) may have struck the painter: "Girls in Sparta were not raised as in Athens: they were not ordered to stay locked up, spinning wool and abstaining from wine and overly rich food. Instead they were taught to dance, to sing, to wrestle with one another, to

run lightly on sand, to throw the discus and the javelin with force, and to perform all their exercises unveiled and half-nude, in the presence of kings, magistrates, and all the citizens, including even the young men, whom they incited to glory, either by their example, their flattering praise, or their piquant irony."[2]

Degas's choice of this rare subject may have been due to his assiduous perusal of classic authors. But the source may more likely be his stimulating conversations with Gustave Moreau, who had a formidable impact on him. In 1860, when Degas was working on *Petites filles*, Moreau was painting *Hésiode et les Muses* (cat. 152), which explored a similar Greece of pubescent bodies in an equally restrained and limited range. At the same time, in *Tyrtée chantant pendant le combat* (*Tyrtaeus Singing during Combat*), Moreau began his first studies for a large composition (163 x 83 in. [415 x 211 cm]) glorifying this Lacedaemonian poet who led Spartan youths to victory.[3] It is tempting to compare these two takes on Spartan themes, especially since their preparatory drawings reveal kinship. (Oddly enough, at the Palais Bourbon several years earlier, Delacroix had thought of linking these two subjects but eventually abandoned the idea.) Perhaps both Degas and Moreau wanted to do parallel research in this area of historical painting (whose imminent death was regularly announced) and to find an original solution by using comparable narratives.

In 1860 Degas buckled down to this composition, which, like the near-contemporary *Fille de Jephté* (fig. 64), would go through several avatars before reaching its definitive state. The point of departure may have been an offhand comment in one of the painter's notebooks: "Girls and boys wrestling in the plane tree grove in front of old Lycurgus next to the mothers." He then adds this note: "The sketches have a Pontormo-like red chalk depicting old crones sitting and arguing while pointing to something."[4] The sheet to which he refers is in the Louvre (inv. 949); now attributed to Polidoro Caldara, it was once credited to Rosso Fiorentino.

Degas's multiple studies for the present painting run from a rough drawing to an elaborate oil sketch. More and more is sloughed from the composition: the landscape is gradually reduced to its simplest expression, and the young people, having found their definitive positions, freeze into postures of calm rivalry. The monochrome canvas in Chicago is not an intermediary sketch but a version abandoned before completion; unlike the London version, it preserves obvious Hellenist features in the landscape (the grove survives as a few slender trunks), in the adolescents, and in the architecture. Degas then eliminated precise references to ancient Greece, dropping archaeological details and, as has often been observed,[5] giving his young men the "common mugs" of Parisian urchins.

H.L.

1. "Ce sont les jeunes filles spartiates provoquant au combat les jeunes gens. . . . J'ai lu cela dans Plutarque." Halévy 1960, p. 14.

2. "Les jeunes filles de Sparte ne sont point élevées comme celles d'Athènes: on ne leur prescrit point de se tenir enfermées, de filer la laine, de s'abstenir du vin et d'une nourriture trop forte; mais on leur apprend à danser, à chanter, à lutter entre elles, à courir légèrement sur le sable, à lancer avec force le palet et le javelot, à faire tous leurs exercices sans voile et à demi-nues, en présence des rois, des magistrats et de tous les citoyens, sans en excepter même les jeunes garçons, qu'elles excitent à la gloire, soit par leurs exemples, soit par des éloges flatteurs, ou des ironies piquantes." Abbé Jean-Jacques Barthélémy, *Le Voyage du jeune Anacharsis en Grèce* (*Travels of the Young Anacharsis in Greece*) (Paris, 1787; reprinted 1836), p. 293.

3. See Pierre-Louis Mathieu, *Gustave Moreau* (Paris, 1976), p. 88.

4. "Jeunes filles et jeunes garçons luttant dans le Plataniste sous les yeux de Lycurgue vieux à côté des mères"; "il y a dans les dessins une sanguine de Pontorme représentant des vieilles femmes assises et se disputant en montrant quelque chose." Reff 1985, notebook 18, p. 202.

5. See in particular Douglas Druick, "La petite danseuse et les criminels: Degas moraliste?" in *Degas inédit* (Paris, La Documentation française, 1989), pp. 225–50.

52 *Fig. 349*

Edgar Degas
Sur le champ de courses
(*At the Racetrack*)
1861
Oil on canvas
16⅞ x 25¾ in. (43 x 65.5 cm)
Signed lower right: Degas
Öffentliche Kunstsammlung Basel, Kunstmuseum
G 1977.36

CATALOGUES RAISONNÉS: Lemoisne 1946–49, vol. 2, no. 77; Minervino 1974, no. 162

PROVENANCE: Ambroise Vollard, Paris; Holzmann, Berlin; von Hirsch collection, Basel; gift of Robert and Martha von Hirsch to the Kunstmuseum, Basel, 1977

SELECTED REFERENCES: Christian Geelhaar, *Kunstmuseum Basel: L'histoire de la collection de peinture et une sélection de 250 chefs-d'oeuvre* (Basel, 1992), p. 164, no. 138; Richard Kendall, *Degas Landscapes* (New Haven and London, 1993), pp. 67–68

In 1861 Degas visited Orne for the first time; he stayed with the Valpinçons and afterward returned regularly. In Ménil-Hubert he enjoyed the agreeable company of art lovers from the haute bourgeoisie as well as a delightful, varied, and—as society put it—"inhabited" countryside. Degas also found large rooms, and since Paul Valpinçon

was a painter in his own right, a studio that allowed him to "slog away." Astonished at this Norman world, Degas felt that characters in Fielding's *Tom Jones*, which he was then reading, had come alive; he saw the squires and farmers of Somersetshire in the rich, mountainous environs of Gacé. He had never visited England, but he felt a true passion for that land which he thought to be beyond compare. When he and Paul Valpinçon went to Haras du Pin, Degas came upon a landscape on the road to Exmes that was utterly new to him and that he said was "absolutely England": "the small and large pastures completely hedged in, the paths kept moist by the ponds, the wind, and the earth in shadow." All he had known of the French countryside was the flat, bare area of Saint-Valéry-sur-Somme, where nature struck him as being "less rich and less dense than here." He recalled "English-type paintings" and Grégoire Soutzo, his master in landscape, as well as the tutelary figure of Corot: "They alone would add a little interest to this calm." For his elaborate drawings Degas, closer to a Claude Gellée than a Corot, used a pen and brown ink with white gouache highlights. Emphasizing the exuberance of a fertile nature, he depicted the classic château of Pin, a small structure at the end of leafy garden paths, and the village of Exmes, set against a hill and huddled around its church spire: "This is a typical tidy hamlet with its church and its brick houses."[1]

It is Exmes, or its memory, that we see at the end of a winding road in the present painting. It was done in Ménil-Hubert in early autumn 1861 or soon afterward in the artist's Paris studio. Contemporary with his first racetrack scenes, it is stylistically close to *Aux Courses, le départ* (*At the Races, the Start*; Lemoisne 76; Fogg Art Museum, Cambridge, Mass.). It presages *Aux Courses en province* (cat. 66) but without that painting's boldness. This work may recall "English-type paintings," but it also evokes Corot, the object of Degas's constant admiration. The overall tonality is gloomy, and the only bright spots, in a burst of sunshine on the emerald meadows, are the tiny, vivid touches of the white, pink, blue, and yellow silks worn by the jockeys.

H.L.

1. "piocher"; "exactement l'Angleterre"; "des herbages petits et grands, tous clos de haies, des sentiers humides des mares, du vent et de la terre d'ombre"; "semble être beaucoup moins grasse et touffue qu'ici"; "tableaux de genre anglais"; "Eux seuls donneraient un peu d'intérêt à ce calme"; "C'est bien le type d'un bourg propre avec son église et ses maisons en briques." Reff 1985, notebook 18, p. 161.

53 *(Paris only)* *Fig. 91*

Edgar Degas
Le Renard mort
(*The Dead Fox*)
Ca. 1861–64
Oil on canvas
36¼ x 28¾ in. (92 x 73 cm)
Degas atelier stamp lower left: Degas
Musée des Beaux-Arts, Rouen 990.5.1

CATALOGUES RAISONNÉS: Lemoisne 1946–49, vol. 2, no. 120; Minervino 1974, no. 170

PROVENANCE: Artist's studio; third sale of the "Atelier Edgar Degas," Paris, Galerie Georges Petit, April 7–9, 1919, no. 13, repr.; Ambroise Vollard, Paris; private collection; acquired by the Musée des Beaux-Arts, Rouen, 1990

SELECTED REFERENCES: François Bergot in *La Revue du Louvre* 4 (1990), p. 325; Richard Kendall, *Degas Landscapes* (New Haven and London, 1993), p. 77

This unfinished painting, so unusual in Degas's oeuvre, is difficult to date. It is probably based on studies done at the Normandy home of Degas's friends, the Valpinçons, whom he began to visit regularly in 1861 (see cat. 57). Lemoisne suggested 1864–68, Bergot 1861–64, and Kendall around 1867. Two circumstances favor an early date.[1] The first is the lovely drawing in pencil and red chalk of a dead fox (Sterling and Francine Clark Art Institute, Williamstown, Mass.). Degas seldom used red chalk and only, so far as we know, during the 1850s and the very early 1860s. The second is the closeness of this painting to *Le Sanglier* (*The Boar*; Lemoisne 123; Musée des Beaux-Arts, Rouen), a hunting scene inspired by a Frans Snyders that Degas copied at the Uffizi in 1858–59.[2] Kendall has likened the present painting to *Renard dans la neige* (*Fox in the Snow*; Dallas Museum of Art), which Courbet showed at the Salon of 1861.[3] Degas measured his own work against Courbet's landscapes; he admired that artist's fluency, swiftness, and painterly instinct while feeling that he himself "spent all his time refining his painting."[4] In the present painting Degas adopted a "close surface," identical to that of Courbet, employing a restrained harmony of browns, greens, and blacks and placing the animal's body in a severe, enveloping nature, on a heavy, grassy soil, at the foot of pillarlike tree trunks.

H.L.

1. See François Bergot's comments on the acquisition of this painting by the Musée des Beaux-Arts, Rouen in *La Revue du Louvre*, 4 (1990), p. 325.
2. Reff 1985, notebook 12, pp. 40–41.
3. Richard Kendall, *Degas' Landscapes* (New Haven and London, 1993), p. 77.
4. "passe sa vie à alambiquer sa peinture." Letter from Jacques-Émile Blanche to an unknown correspondent (Fantin-Latour?), reporting remarks Degas made while viewing Courbet's works, quoted in Paris, Ottawa, New York 1988–89, p. 42.

54 *(Paris only)* *Fig. 258*

Edgar Degas
Portrait de Thérèse De Gas
1863
Oil on canvas
35 x 26⅜ in. (89 x 67 cm)
Musée d'Orsay, Paris RF 2650

CATALOGUES RAISONNÉS: Lemoisne 1946–49, vol. 2, no. 109; Minervino 1974, no. 156

PROVENANCE: René de Gas, Paris; his estate sale, Paris, Hôtel Drouot, November 10, 1927, no. 70, repr.; acquired for Fr 181,000 by the Musée du Louvre, Paris; Musée du Jeu de Paume, Paris, 1947; Musée d'Orsay, Paris, 1986

EXHIBITIONS: Paris, Musée de l'Orangerie, 1931, *Degas: Portraitiste, sculpteur*, no. 28; Paris, Musée de l'Orangerie, 1969, *Degas: Oeuvres du Musée du Louvre*, no. 10; Rome, Villa Medici, 1984–85, *Degas e l'Italia*, no. 78.

SELECTED REFERENCES: Paul Jamot, "Acquisitions récentes du Louvre," *L'Art vivant*, March 1, 1928, pp. 175–76; Jean Sutherland Boggs, *Portraits by Degas* (Berkeley, Calif., 1962), pp. 17–18; Theodore Reff, *Degas: The Artist's Mind* (New York, 1976), pp. 111–12; Loyrette 1989, pp. 21–23.

"According to René De Gas's recollections," Paul-André Lemoisne has told us, "this portrait was painted during Thérèse's engagement—that is, at the start of 1863, in Paris."[1] Indeed, Thérèse De Gas, born in 1840, was scheduled to marry at La Madeleine on April 16, 1863; a papal dispensation had been granted since her fiancé was her first cousin, Edmondo Morbilli, the third son of the late Giuseppe Morbilli, duc di Sant-Angelo a Frosolone, and the duchesse, née Rose De Gas. Executed shortly before the wedding, this picture of a sister Degas drew frequently (see p. 203) is an engagement portrait, a fact that the painter

underscored in three elements: the hand emerging from the black shawl, the subject's posture, and the landscape within the window frame. Thérèse, dressed to go out or, more precisely, to depart, timidly reveals her left hand, which bears the engagement ring. The view of Naples, strange in a picture done in Paris, is taken partially from a watercolor in a notebook of 1860.[2] The landscape glimpsed through the window, as in numerous Renaissance works, has a premonitory rather than symbolic role, announcing Thérèse's future as a wife in Naples, a city that she loved and knew well and that is, it is tempting to say, painted in the tenderest hues. In this connection the differences between the present painting and the watercolor of 1860 are striking: here the ultramarine bar marking the farther shore of the gulf, with its line of very white houses, brings out the bluish flanks of Vesuvius, and the clouds have drifted away to reveal a very pure and serene sky.

H.L.

1. "D'après les souvenirs de René De Gas ce portrait aurait été exécuté durant les fiançailles de Thérèse, c'est-à-dire au début de 1863, à Paris." Lemoisne 1946–49, vol. 2, no. 109.
2. Reff 1985, notebook 19, p. 11.

55 *Fig. 61*

Edgar Degas
Scène de guerre au Moyen Âge
(War Scene in the Middle Ages)
1865
Essence on paper mounted on canvas
31⅞ x 57⅞ in. (81 x 147 cm)
Musée d'Orsay, Paris RF2208

CATALOGUES RAISONNÉS: Lemoisne 1946–49, vol. 2, no. 124; Minervino 1974, no. 107

PROVENANCE: Artist's studio; first sale of the "Atelier Edgar Degas," Paris, Galerie Georges Petit, May 6–8, 1918, no. 13, repr. (Les malheurs de la ville d'Orléans); acquired for Fr 60,000 by the Musée du Luxembourg

EXHIBITIONS: Paris, Salon of 1865, no. 2406 (Scène de guerre au moyen âge; pastel); Paris, Petit Palais, 1918, *Expositions exceptionnelles: Hommage de la "Nationale" à quatre de ses présidents décédés*, no. 10 (Les malheurs de la Ville d'Orléans); Paris, Galerie Georges Petit, 1924, *Degas*, no. 17; Paris, Musée du Jeu de Paume, 1967–68, *Autour de trois tableaux majeurs de Degas*, no catalogue; Paris, Musée de l'Orangerie, 1969, *Degas: Oeuvres du Musée du Louvre*, no. 12; Paris, Ottawa, New York, 1988–89, no. 45

SELECTED REFERENCES: Paul Lafond, *Degas* (Paris, 1918–19), vol. 1, p. 15, repr., vol. 2, p. 41; Léonce Bénédite, *Le Musée du Luxembourg* (Paris, 1924), no. 161, repr. p. 62; Paul Jamot, *Degas* (Paris, 1924), pp. 11, 23–24, 27, 29; John Walker, "Degas et les maîtres anciens," *Gazette des Beaux-Arts*, September 1933, p. 180, fig. 15; Hélène Adhémar, "Edgar Degas et la scène de guerre au Moyen Age," *Gazette des Beaux-Arts*, November 1967, pp. 295–98, repr.; Carlo Ludovico Ragghianti, "Un ricorso ferrarese di Degas," *Bollettino annuale dei Musei Ferraresi*, 1971, p. 23–29

A brief sentence in the 1947 Jeu de Paume catalogue gives a terse description of this painting; dry and definitive, the closing words articulate an almost universal opinion: "This work is the artist's final effort at historical painting."[1] For Paul Jamot, Degas's forays into this genre were simply "utterly curious documents . . . highly unexpected for those who think of Degas as enclosed in a virtually congenital realism."[2] Thus this "document" experienced the fate of other historical paintings, becoming the object of modest attention; in this case an attention due essentially to the painting's admirable preliminary drawings but heightened by its presence at the Salon of 1865 and especially by its strange subject.

Originally the title of what was identified as a "pastel" was indicated in the Salon catalogue as *Scène de guerre au Moyen Age*—unaccompanied by any reference or citation inviting research on its subject. But for decades after the picture was shown briefly at the Petit Palais in May 1918, it was called *Les Malheurs de la ville d'Orléans* (*The Miseries of the City of Orleans*), a title repeated in the catalogue of the posthumous sale of Degas's collection. The most ingenious explanation for this strange mistake was supplied by Hélène Adhémar, to whom we owe an interesting analysis of this difficult work. She regards it as an allegory of the cruelty displayed by Northern soldiers toward the women of New Orleans upon the taking of that city on May 1, 1862, during the American Civil War; after all, Degas's family on his mother's side came from Louisiana. Adhémar has attributed the incorrect title to a misreading: *Les Malheurs de la Nlle Orléans* was written on some list or document and *Nlle*, an abbreviation often used by the artist for *Nouvelle* (New), was mistaken for *Ville* (City).[3] Degas must have been impressed by family stories about Yankee atrocities, which he allegorically transposed to the Middle Ages, an era of extraordinary barbarism so far as the nineteenth century was concerned—and this was the source of *Scène de guerre*. Finally Degas, perhaps at the very moment he was formulating his theme, had bought an 1863 edition of Goya's *Disasters of War*, which is still owned by his family. There too he could find striking images, albeit in a completely different manner, of what war has always meant: rape, cruelty, and torture.

In 1865 Degas finally managed to participate in the Salon—by showing *Scène de guerre*. The reasons for his earlier absences from this exhibition are unknown, for all evidence would seem to indicate that after returning from Italy in 1859

he had worked on large compositions meant for the Salon. Perhaps he was rejected; perhaps he was never ready in time—tardiness would become a regrettable habit for him in subsequent exhibitions. But in 1865 Degas, who, unlike Manet, never succeeded in attracting attention through the Salon, went entirely unnoticed. There were several reasons for the total silence surrounding the presentation of this picture. First, the subject was very strange: an illustration both absurd and expressive of violence between the sexes. Furthermore, it was impossible to grasp the allegory. And finally, there was the artist's technique: essence on paper, which, to quote Gustave Moreau, produces "the matte tone and the softness of fresco."[4] Nevertheless, without supplying a reference, John Rewald mentions compliments supposedly voiced by Puvis de Chavannes,[5] who, four years earlier, had painted *La Guerre* (see cat. 167), one of the few works that can be compared to Degas's picture. There would be nothing surprising about praise from Puvis, for, aside from Moreau, he alone could truly appreciate this painting, lauding the allegorical ambition, admiring its dreary tones that so effectively translate desolation, envying the perfection of the draftsmanship, and grasping what would have to be called not an "effort" but a masterpiece, isolated in its century and still not understood today.

H.L.

1. "L'oeuvre est la dernière tentative de peinture d'histoire de l'artiste."
2. "des documents des plus curieux . . . forts inattendus pour ceux qui enfermaient Degas dans un réalisme en quelque sort congenital." Paul Jamot, *Degas* (Paris, 1924), p. 28.
3. Hélène Adhémar, "Edgar Degas et la scène de guerre au Moyen Age," *Gazette des Beaux-Arts*, November 1967, pp. 295–98.
4. Moreau's letter to his parents, February 5, 1858, quoted in Paris, Ottawa, New York 1988–89, p. 107.
5. Rewald 1986, p. 89.

56 *Fig. 276*

Edgar Degas
Portrait de l'artiste avec Évariste de Valernes
1865

Oil on canvas
45⅝ x 35 in. (116 x 89 cm)
Musée d'Orsay, Paris RF 3586

CATALOGUES RAISONNÉS: Lemoisne 1946–49, vol. 2, no. 116; Minervino 1974, no. 161

PROVENANCE: Artist's studio; Gabriel Fevre, the artist's nephew, Nice, 1918–31; his gift to the Musée du Louvre, 1931; Musée du Jeu de Paume, Paris, 1947; Musée d'Orsay, Paris, 1986

EXHIBITIONS: Paris, Galerie Georges Petit, 1924, *Exposition Degas*, no. 3 (Degas et son ami Fleury, ca. 1860); Paris, Musée de l'Orangerie, 1931, *Degas: Portraitiste, sculpteur*, no. 40; Paris, Musée de l'Orangerie, 1969, *Degas: Oeuvres du Musée du Louvre*, no. 11; Paris, Grand Palais, 1983, *Hommage à Raphaël: Raphaël et l'art français*, no. 65; Rome, Villa Medici, 1984, *Degas e l'Italia*, no. 80; Paris, Ottawa, New York, 1988–89, no. 58

SELECTED REFERENCES: Jeanne Fevre, *Mon oncle Degas* (Geneva, 1949), pp. 77–78; Henri Dubled, *De Valernes et Degas*, exh. cat. (Musée de Carpentras, 1963), unpaginated; *Bulletin du laboratoire des musées de France*, 1966, pp. 26–27; Eunice Lipton, "Deciphering a Friendship: Edgar Degas and Evariste de Valernes," *Arts Magazine*, June 1981, pp. 128–32, fig. 1; Theodore Reff, "Degas and Valernes in 1872," *Arts Magazine*, September 1981, pp. 126–27; Loyrette 1989, p. 24

In this self-portrait, the last he painted, Degas, who often modeled for himself during the 1850s, is accompanied by a painter twenty years his senior (Évariste de Valernes was born in 1816); Degas probably had met him about 1855 at the Louvre. An obscure artist, barely making ends meet by painting copies for state ministers, the older man was a close friend of the younger throughout his life. Their intimacy, no doubt, inspired this double portrait: Degas, whose friendships were seldom rooted in artistic affinities, preferred well-bred though mediocre people to great artists from lesser backgrounds; thus he was certain to appreciate this affable aristocrat with whom he shared a passion for Delacroix. However, Valernes was also the painter of realistic scenes praised by Zola[1] and a great admirer of Duranty, to whom he wrote a long letter expressing his enthusiasm and support when *La Nouvelle Peinture* appeared in 1876.[2]

X-rays of the painting have revealed that Degas, like Valernes, originally wore a top hat, that his frock coat was wide open over his white shirt, and that his hand was not on his chin. According to Georges Rivière, who knew Degas in later years, the gesture he chose to show, which was habitual for him, betrays hesitation or reflection:[3] sitting next to Valernes, who looks indifferent or, at this stage of his life, sure of himself, the young artist is manifestly perplexed. Years after he completed this picture, in the long and well-known letter of October 26, 1890, to Valernes, who had retired to Carpentras, Degas discussed his state of mind at that earlier time, writing: "You've always been the same, my old friend. You have always persisted in that delightful romanticism that garbs and colors truth." In contrast to Valernes's unchanging nature, Degas described himself as vacillating, hesitant, unintentionally brusque and hurtful: "I felt so poorly made, so poorly

equipped, so soft, while it seemed to me that my artistic *calculations* were so accurate. I rejected everyone, including myself."[4]

Painted in 1865, close to the time he executed two other double portraits (figs. 256, 274), this work conforms to the Renaissance tradition of the double portrait.[5] Although he uses an old formula, Degas nevertheless tries to create a new image, replacing the usual neutral backgrounds with a large studio window that reveals a hieroglyphic city in a magnificent range of grays, blacks, blues, and pinks, from which domes and columns emerge. Renouncing the traditional timeless costume, such as Ingres wears in his *Self-portrait*, Degas omits "artistic" clothes; as in most of his self-portraits and in the pictures of his painter friends (cat. 62), he adopts the black uniform of bourgeois life without affecting elegance or excessive rigor. Rarely has he chosen a more classical, more deliberate composition: the two artists are enclosed in a circle whose center is Valernes's heart and which coincides with the right and left edges, with the older man's thigh at the bottom and with Degas's head and his friend's hat at the top. Rather than hinting at the unlikely influence of the daguerreotype, this structure should be seen as echoing a principle that Degas proclaimed throughout his life: modern painting is based on a study of the masters.

H.L.

1. Zola 1991, p. 220. Regarding Degas and Valernes, see Henri Loyrette, "Degas pour son ami Valernes," *Revue de l'art* 86 (1989), pp. 82–83.
2. Crouzet 1964, pp. 270–71, 338.
3. Georges Rivière, *Mr. Degas, bourgeois de Paris* (Paris, 1935), p. 108.
4. "Vous avez toujours était le même mon vieil ami. Toujours il a persisté en vous de ce romantisme delicieux qui habille et colore la vérité. . . . Je me sentais si mal fait, si mal outillé, si mou, pendant qu'il me semblait que mes *calculs* d'art étaient si justes. Je boudais contre tout le monde et contre moi." Degas 1945, pp. 178–79.
5. See Loyrette, "Degas pour son ami," pp. 24–25.

57 *Fig. 281*

Edgar Degas
Femme accoudée près d'un vase de fleurs (Portrait de Mme Paul Valpinçon)
(A Woman seated beside a vase of flowers [Mme Paul Valpinçon?])
1865

Oil on canvas
29 x 36½ in. (73.7 x 92.7 cm)
Signed and dated twice, lower left: Degas 1865 [and partially illegible] 1865 Degas
The Metropolitan Museum of Art, New York, H. O. Havemeyer Collection, Bequest of Mrs. H. O. Havemeyer, 1929 29.100.128

CATALOGUES RAISONNÉS: Lemoisne 1946–49, vol. 2, no. 125; Minervino 1974, no. 210

PROVENANCE: Bought from the artist for Fr 4,000 by Theo Van Gogh, for Boussod, Valadon et Cie, Paris (as *Femme accoudée près d'un pot de fleurs*), July 22, 1887, until 1889; sold for Fr 5,500 to Jules-Émile Boivin, Paris, February 28, 1889, until 1909; by descent to his widow, Mme Jules-Émile Boivin, Paris, 1909–19; sold by her heirs to Durand-Ruel, Paris and New York, 1920, until 1921; sold for $30,000 to Mrs. H. O. Havemeyer, New York, January 28, 1921, until 1929; her bequest to the Metropolitan Museum, 1929

EXHIBITIONS: New York, no. 45, repr.; Philadelphia Museum of Art, 1936, *Degas 1834–1917*, no. 8, repr.; Paris, Musée de l'Orangerie, 1937, *Degas*, no. 6, pl. VI; Paris, New York 1974–75, no. 10, col. repr.; New York, Metropolitan Museum of Art, 1977, *Degas in the Metropolitan*, no. 3, repr.; Paris, Ottawa, New York, 1988–89, no. 60, col. repr.; New York, 1993, no. 196, repr.

SELECTED REFERENCES: Louis Hourticq, "E. Degas," *Art et Décoration*, supp. XXXII, October 1912, pp. 109–10; Paul-André Lemoisne, *Degas* (Paris, 1912), pp. 33–34, pl. IX; Paul Jamot, "Degas," *Gazette des Beaux-Arts*, April–June 1918, pp. 152, 156, repr., p. 153; Paul Lafond, *Degas* (Paris, 1918–19), vol. 2, p. 11; Louise Burroughs, "Degas in the Havemeyer Collection," *Metropolitan Museum of Art Bulletin* 27 (May 5, 1932), pp. 144–45, repr.; Jean Sutherland Boggs, *Portraits by Degas* (Berkeley, Calif., 1962), pp. 31ff., 37, 41, 59, 119, pl. 44; Sterling and Salinger 1967, pp. 57–60, col. repr. and on cover (detail); John Rewald, "Theo Van Gogh, Goupil and the Impressionists," *Gazette des Beaux-Arts*, January 1973, pp. 8, 11, fig. 5; Charles S. Moffett, *Degas: Paintings in The Metropolitan Museum of Art* (New York, 1979), p. 61, col. reprs. pls. 7, 8; Loyrette 1991, pp. 196–98

The setting is rustic. The window opens upon a mass of verdure, and the blossoms gathered in an enormous bouquet are freshly cut garden flowers. These are not chrysanthemums, as critics long have claimed,[1] but a mélange of late-summer blooms: china asters, gillyflowers, centauries, gaillardias, dahlias. Dressed casually, protecting her hands with gloves that she subsequently left on the table, the sitter went to cull her bouquet in the morning. After placing the flowers in a vase, the tired woman is now resting for a moment— and Degas has extracted a magnificent portrait from the final episode of this middle-class ritual. We have identified[2] the model by her features: the lively, elongated, black eyes, the large mouth in a wide, flat face belong to the wife of Degas's friend Paul Valpinçon, whom the painter regularly visited at his estate in Orne from 1861 (fig. 349). For some time before he executed this picture he had wanted to do a portrait of "Paul's wife," of whom he was very fond[3] and whom he would depict again in 1869, tenderly leaning over her newborn son in *Aux courses, en province* (cat. 66). In August or September 1865 he finally undertook this intimate portrait—its intimacy confirmed by the model's careless attire. Nevertheless, the canvas is ambitious, and Degas would

certainly have called it a "painting" instead of a "portrait" (see pp. 224–25). The composition does not stand halfway between a still life and a genre scene, like Courbet's *Le Treillis* (cat. 41) or Bazille's *Négresse aux pivoines* (cat. 14). Rather, it is a portrait in an interior, where the sitter is caught in a "familiar and typical" posture. The things that surround her— notably the enchanting bouquet with its mellow tones and a few dazzling yellows and raw whites—are not just accessories that enhance her importance but the very attributes of her condition.

H . L .

1. Until 1988 this famous painting was titled *La Femme aux chrysanthèmes* (*Woman with Chrysanthemums*); it has now been given a title resembling the one Theo van Gogh bestowed on it in 1887 when he acquired it from Degas for Goupil and Valadon: *Femme accoudée près d'un pot de fleurs* (*Woman Leaning near a Vase of Flowers*); Paris, Ottawa, New York 1988–89, pp. 114–16.
2. Ibid.
3. Reff 1985, notebook 18, p. 96, and notebook 19, p. 51.

58 *Fig. 283*

Edgar Degas
L'Amateur d'estampes
(*The Print Collector*)
1866
Oil on canvas
20⅞ x 15¾ in. (53 x 40 cm)
Signed and dated lower left: Degas 1866
The Metropolitan Museum of Art, New York, H. O. Havemeyer Collection, Bequest of Mrs. H. O. Havemeyer, 1929 29.100.44

CATALOGUES RAISONNÉS: Lemoisne 1946–49, vol. 2, no. 138; Minervino 1974, no. 219

PROVENANCE: Bought from the artist for Fr 3,000 or Fr 5,000 by Henry O. and Louisine Havemeyer, New York, probably spring 1891; sent to them by Durand-Ruel, Dec. 13, 1894, until 1929; her bequest to the Metropolitan Museum, 1929

EXHIBITIONS: New York, 1930, no. 47; New York, Metropolitan Museum of Art, 1977, *Degas in the Metropolitan*, no. 5, repr.; Paris, Ottawa, New York, 1988–89, no. 66; New York, 1993, no. 197

SELECTED REFERENCES: Louisine W. Havemeyer, *Sixteen to Sixty: Memoirs of a Collector* (New York, 1961), p. 252; Sterling and Salinger 1967, p. 61, repr.; Theodore Reff, *Degas: The Artist's Mind* (New York, 1976), pp. 90, 98–101, 106, 138, 144, 145, figs. 65, 66; Charles S. Moffett, *Degas: Paintings in The Metropolitan Museum of Art* (New York, 1979), p. 7, pl. 12; Frances Weitzenhoffer, *The Havemeyers: Impressionism Comes to America* (New York, 1986), p. 81, pl. 34

The sitter's anonymity has often led observers to consider this little canvas a genre scene rather than a portrait. However, like Degas's pictures of Tissot (cat. 62) and Mme Valpinçon (cat. 57), this is a portrait in an interior, and it is based on a formula that Degas developed during the 1860s. Although this formula is similar to the one that Manet chose for depicting his friend Zola encircled by objects and meaningful images (cat. 108), Degas prefers a small format and a smooth, precise treatment reminiscent of Dutch painting. The features of this print lover are perfectly decipherable and even idiosyncratic (note the importance of the nose); distracted from the pursuit in which he is absorbed, he assumes a fleeting pose and gazes at the painter. However obvious the reference, he is a far cry from Daumier's characters, who, grubbing through a box of drawings or peering at a canvas, are archetypal collectors with indistinct physiognomies.

The pictures in the box, scattered across the table, or affixed to the walls and the horse in the display case have been identified by Theodore Reff:[1] colored lithographs by Redouté, a T'ang dynasty horse, and samples of Japanese or Japanesey fabrics stuck up together pell-mell with photographs and calling cards—or are we dealing with one of those trompe-l'oeils that studded the nineteenth century? This art lover is apparently not a large-scale collector but just someone who enjoys rummaging through old, cheap pictures. Perhaps—and this might identify him—he is hunting for those engravings done by Redouté during the July Monarchy and later undervalued, prized only as models for fabrics and floral wallpaper. Reff summons up Degas's highly pertinent memories of childhood and adolescence, when he and his father visited Marcille and La Caze: Marcille, recalled Degas, "had a cape and a worn-out hat. Back then everyone had a worn-out hat."[2] *L'Amateur d'estampes* focuses on a type that the Second Empire believed was vanishing: the passionate collector, more eager to own than to show—and that was what the painter himself became thirty years later. Here he portrays a man who became a prototype for the entire literature of his century: "one of those bizarre maniacs who eventually go so far downhill that they end up dealing in second-hand goods, becoming shopkeepers without shops, messing around in knickknacks the way some people mess around in the stock market."[3] And he thumbs through his boxes

in the midst of so many things that proclaim his collecting passion: a negligently presented object of value, a disorderly throng of engravings, a lopsided gaggle of multicolored images.

H. L.

1. Theodore Reff. *Degas: The Artist's Mind* (New York. 1972). pp. 98–101.
2. "avait un paletot à pèlerine et un chapeau usagé. Les gens de ce temps-là avaient tous des chapeaux usagés." Étienne Moreau-Nélaton. "Deux heures avec Degas." *L'Amour de l'art* 12 (July 1931). p. 267.
3. "Un de ces maniaques bizarres qui finissent par dégringoler jusqu'à la brocante, par devenir de vrais marchands sans boutique qui tripotent dans le bibelot comme on tripote, là-bas, en bourse." René Maizeroy. *La Fin de Paris* (Paris, 1886). pp. 124–25.

59 *Fig. 351*

Edgar Degas
Le Défilé (Chevaux de course devant les tribunes)
(*The Parade [Horses before the Stands]*)
Ca. 1866–68
Essence on paper mounted on canvas
18⅛ x 24 in. (46 x 61 cm)
Musée d'Orsay, Paris RF 1981

CATALOGUES RAISONNÉS: Lemoisne 1946–49. vol. 2. no. 262; Minervino 1974. no. 194

PROVENANCE: Jean-Baptiste Faure, Paris 1873 or 1874. until 1893; bought for Fr 10.000 by Durand-Ruel, Paris, January 2. 1893; bought for Fr 30.000 by Comte Isaac de Camondo, Paris, 1893, until 1911; his bequest to the Musée du Louvre, 1911; first exhibited in 1914

EXHIBITIONS: Paris. Musée de l'Orangerie, 1969. *Degas: Oeuvres du musée du Louvre*, no. 18; Paris, Ottawa, New York. 1988–89. *Degas*, no. 68

SELECTED REFERENCES: Camille Mauclair. "Artistes contemporains: Edgar Degas." *Revue de l'art ancien et moderne*, November 1903. p. 384. repr.; George Moore. "Degas." *Kunst und Kunstler* 3 (1907–08). p. 105. repr.; Paul Jamot. "La Collection Camondo au Musée du Louvre: Les peintures et les dessins." *Gazette des Beaux-Arts*, June 1914. p. 29; Paris. Musée du Louvre. *Catalogue de la collection Isaac de Camondo* (Paris, 1914). no. 165; Paul Lafond. *Degas* (Paris, 1918–19). vol. 2. p. 42; Theodore Reff. "Further Thoughts on Degas's Copies." *Burlington Magazine*, July 1971. p. 538

For a long time this work was ascribed to the 1870s. but it was quite certainly done earlier. It is one of those "small racing pictures that are considered very fine" that Fantin-Latour mentioned

in a letter to Whistler in January 1869.[1] The preliminary drawings supply exact chronological data. Although it does not provide a study for the whole composition, a notebook that Degas kept between 1867 and 1869 (which contains, notably, sketches for the *Portrait de James Tissot* [cat. 62] and *Intérieur* [cat. 63]) does offer a few rough sketches of details. These are a group of women outdoors. the back view of a jockey, and, next to them, partial copies of Meissonier's famous *L'Empereur à la bataille de Solférino* (fig. 41). a painting that entered the Musée du Luxembourg in August 1864. immediately after it was shown at the Salon of that year.[2] For the horse at the center of his composition, Degas borrowed and reversed one of the mounts shown by Meissonier, an artist whom he lampooned as the "giant of dwarfs" but whose knowledge of horses he admired. Finally, a drawing at the Art Institute of Chicago, *Quatre études d'un jockey* (*Four Studies of a Jockey*; Lemoisne 158) has often been linked to the present painting; one of a series of mounted jockeys (Lemoisne 151–62), it was published by Manzi[3] in 1897 with the date 1866 indicated by Degas, who selected the plates and oversaw the publication. Therefore we should probably situate *Le Défilé* between 1866 and 1868. a bit earlier than Lemoisne, who suggests dating it between 1869 and 1872.

It is hard to pinpoint the exact location of the scene. Contrary to what has often been proposed, Degas did not set his races at Longchamp, whose stands, which were built in 1857 and expanded in 1863, appeared in César Daly's *La Revue générale d'architecture de 1868*. Although the stands at Degas's racetrack reveal a similar combination of wood and cast iron, his central pavilion is covered with a skylight roof, which is not found at Longchamp. Furthermore, if it were Longchamp, the vantage point chosen by Degas would reveal a glimpse of a mill and hills on the other side of the Seine, not the improbable factory chimneys depicted. So perhaps this is Saint-Ouen, a more popular venue, or some provincial racetrack, although this hypothesis is unlikely given elaborate nature of the facilities.

Degas's technique here, mounting paper on canvas—employed also in *Scène de guerre au Moyen Age* (cat. 55)—is highly personal; he leaves several areas of the support bare and in the darker parts of the composition he stains it. The preliminary drawing, much of which is visible, is almost everywhere traced over in pen and ink; thus the sharply inked-in construction lines of the stands are clearly visible. This procedure, like the originality of the composition, makes the work novel; it distinguishes this picture not only from Degas's earlier racing scenes (cat. 52) and those of Henri Delamarre and Olivier Pichat—painters of elegant equestrian subjects—but, above all, from those of Manet (cat. 106), whose modernity is profoundly different (see pp. 283–84).

H. L.

1. Fantin-Latour's letter to Whistler. January 4, 1869. University Library. Glasgow. mentioned in Reff 1985, notebook 22. p. 109.
2. Reff 1985, notebook 22. pp. 109–17, 123, 127, 129. notebook 23. p. 41.
3. *Degas: Vingt dessins, 1861–1896.* (Paris, 1896–98). no. 7.

60 *Fig. 286*

Edgar Degas
Jeune Femme debout près d'une table
(*Young Woman Standing near a Table*)
Ca. 1867–68
Oil on canvas
22½ x 19¼ in. (57 x 49 cm)
Signed lower right: Degas
Musée National des Beaux-Arts, Algiers

CATALOGUES RAISONNÉS: Lemoisne 1946–49. vol. 2. no. 90; Minervino 1974. no. 146

PROVENANCE: Artist's studio; second sale of the "Atelier Edgar Degas." Paris. Galerie Georges Petit, December 13. 1918. no. 2. repr.; Mouradian-Vallotton collection, Paris; acquired by the Musée National des Beaux-Arts, Algiers

This strange, unfinished portrait, which remained in the artist's studio until his death, was dated "about 1861" by Lemoisne. It has been regarded as a likeness of either Thérèse De Gas, the painter's sister (cat. 54), or Alphonsine Fournaise, the pretty daughter of a restaurant owner from the island of Chiard, between Chatou and Rueil. However, this waitress in a café or eatery, with a napkin in her hand and a white apron, comes from an entirely different station than that of the aristocratic Thérèse. Nor do her regular features, her large, dark, empty eyes, or her stubborn air have anything to do with the blondness, the maliciously sparkling look, and the full, slightly puffy face of Alphonsine as Renoir would paint her in 1879 (Musée d'Orsay, Paris). In addition, the date of 1861 seems too early and is more likely about 1867–68, in view of the stylistic evidence of the extant preparatory drawings for Degas's composition: two studies of the head of the young girl, looking more attentive and pleasant than the model in the final work,[1] and three three-quarter-length graphite sketches.[2] Following the practice of his New Painting colleagues, Degas tried to implant the figure in a landscape; his fleeting and

unsatisfied ambition (see pp. 229, 231) is indicated by his notes to one of the drawings: "the creases modeled for reflections/ + pale in the leaves."[3]

<div style="text-align: right">H.L.</div>

1. "Atelier Degas," third sale, Paris, Galeries Georges Petit, April 5–6, 1919, no. 156 (2); fourth sale, July 2–4, 1919, no. 72 (6).
2. "Atelier Degas," fourth sale, Paris, Galeries Georges Petit, nos. 72 (1, 2), 73 (a).
3. "les plis modelés pour des reflets/ + clair dans les feuilles." Ibid., no. 72 (1).

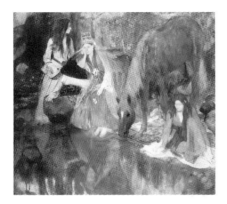

61 *Fig. 343*

Edgar Degas
Portrait de Mlle E[ugénie] F[iocre]; à propos du ballet de "La Source"
(*Mlle Fiocre in the Ballet "La Source"*)
1867–68
Oil on canvas
51⅛ x 57⅛ in. (130 x 145 cm)
The Brooklyn Museum, Gift of James H. Post, John T. Underwood, and A. Augustus Healy 21.111

CATALOGUES RAISONNÉS: Lemoisne 1946–49, vol. 2, no. 146; Minervino 1974, no. 282

PROVENANCE: Artist's studio; first sale of the "Atelier Edgar Degas," Paris, Galerie Georges Petit, May 6–8, 1918, no. 8A; bought for Fr 80,500 by Seligmann, Bernheim-Jeune, Durand-Ruel, and Vollard; Seligmann sale, New York, American Art Association/Anderson Galleries, January 27, 1921, no. 68; bought by Durand-Ruel for James H. Post, John T. Underwood, and A. Augustus Healy; their gift to the Brooklyn Museum, 1921

EXHIBITIONS: Paris, Salon of 1868, no. 686 (Portrait de Mlle E. F.; à propos du ballet de "la Source"); Paris, Petit Palais, 1918, *Expositions exceptionnelles: Hommage de la "Nationale" à quatre de ses présidents décédés*, no. 9; Northampton, Mass., Smith College Museum of Art, 1933, *Edgar Degas*, no. 9; Philadelphia Museum of Art, 1936, *Degas 1834–1917*, no. 9, repr.; Philadelphia Museum of Art, Detroit Institute of Arts, and Paris, Grand Palais, 1978, *L'Art en France sous le second Empire*, no. 211; Paris, Ottawa, New York, 1988–89, *Degas*, no. 77; New York, Brooklyn Museum, 1988, *Degas's "Mlle Fiocre" in Context* (cat. ed. by Ann Dumas)

SELECTED REFERENCES: Zacharie Astruc, *L'Étendard*, July 30, 1868, p. 1; Louis Leroy, "Session du Salon de 1868," *Le Charivari*, May 20, 1868, p. 2; Raoul de Navery, *Le Salon de 1868* (Paris, 1868), pp. 42–43, no. 686; M. de Themines, "Salon de 1868," *La Patrie*, May 19, 1868, p. 3; Émile Zola, "Mon Salon," *L'Événement*, June 9, 1868, pp. 2–3; Jules Castagnary, *Le Bilan de l'année 1868* (Paris, 1869), p. 354; Paul Jamot, *Degas* (Paris, 1924), pp. 25, 57, 58, 97, 135–36, pl. 18; Ernest Rouart, "Degas," *Le Point*, February 1, 1937, p. 21; Lilian Browse, *Degas Dancers* (London [1949]), pp. 21, 28, 51, 335, pl. 3; Loyrette 1991, pp. 209–12

Although the title of this painting is enigmatic and the phrase "à propos de" is hard to explain, the subject is easily read. This is a pause during the rehearsal of *La Source*, a ballet in three acts and four scenes; the story is by Charles Nuitter and Arthur Saint-Léon, the choreography by Saint-Léon, and the music by Ludwig Minkus and Léo Delibes. Premiering in Paris on November 12, 1866, and enjoying a great success, the ballet tells of Djémil, a hunter in love with the cruel and inaccessible Nouredda, a beautiful Georgian. As a pretext for orientalism and also for fantasy, it particularly highlighted the abilities of the two female leads: Fiocre as Nouredda and Salvioni as Naïla, a sacrificial nymph.

Starting in August 1867, Degas made many preliminary graphite drawings and oil sketches[1] before he began the final canvas, which, according to Ernest Rouart's later testimony, he continued to work on up to the very eve of the Salon opening. (He had done the same thing with *Sémiramis* [fig. 65] the previous year.) At the last moment a layer of varnish was applied to the still-fresh paint; but Degas did not like that final step and had the varnish removed—thereby wiping out "half the painting." Rouart goes on: "To avoid destroying everything, they were forced to interrupt the devarnishing. It was not until much later (between 1892 and 1895, I believe) that Degas rediscovered this painting and took it into his head to start reworking it. He sent for a restorer, who, for better or worse, removed the rest of the varnish and explained how to retouch the picture and repair the damage that Degas himself previously had inflicted upon his work. He was only half-satisfied with the results."[2]

Thanks to this portrait of Eugénie Fiocre, Degas, who had been exhibiting at the Salon for four consecutive years, was finally noticed —despite the wretched location of his painting, "which was placed so high, so high!"[3] The critic at *La Patrie* admitted about the canvas, "I am completely lost."[4] And Louis Leroy in *Le Charivari*, imagining a funny dialogue with the "beautiful ballerina," had her confess that she was totally at sea with this "riddle."[5] Indeed Zacharie Astruc and Émile Zola, the only ones who focused somewhat on the painting, understood it no better and did not even know whether their acquaintance with Degas obligated them to utter a few words of praise. Overjoyed that Degas "seems to have left reality for dreams" and that "black suits" are now inspiring his "judicious horror," Astruc regretted that the choice of subject forced the painter to "sacrifice a great deal to memories, approximations, and lighting effects that need their theatrical environment."[6]

At the same time the painting of Fiocre was shown, Manet presented *Jeune Dame en 1866* (cat. 103) and his *Portrait d'Émile Zola* (cat. 108), both of which were described as having "an astonishing reality...a straightforward and generous execution."[7] In contrast, people were surprised by Degas's "light touch" and "slightly morbid elegance." Nevertheless, Astruc conceded that the figures revealed "an indefinable charm in their singularly poetic and even more silent postures. The painting has those rare effects that attract us and hold us spellbound despite their faults. Only a poet could delight in this scene and render it." For Astruc, Degas's canvas is a "tentative effort," praiseworthy but abortive, at renewing the artist's creativity and shaking "monotonous traditions."[8] Zola voiced comparable reservations on June 9, 1868. In his previous reviews, he had discussed Manet, the naturalists (Pissarro), the actualists (Monet, Bazille, Renoir), the landscapists (Jongkind, Corot, the Morisot sisters). Now, under the heading "some good canvases," he grouped paintings that he had been unable to classify earlier, and he accorded Degas a few lines of ambiguous praise. After talking at length about Courbet, Bonvin, and his friend Valernes, Zola came to the "well-observed and very fine example" of the *Portrait de Mlle E[ugénie] F[iocre]*. The title did not convince him; significantly enough, he would have preferred a simple and realistic title, *Une halte au bord de l'eau (Halting at the Water's Edge)*: "Three women are gathered on a riverbank; a horse is drinking nearby. The horse's coat is magnificent, and the women's attire is treated with great delicacy. There are exquisite reflections in the water. When gazing at this painting, which is a bit thin and has a strange elegance, I thought about Japanese prints, which are so artistic in the simplicity of their tones."[9] Without knowing Degas's title, readers of this commentary could not imagine that this is a ballet scene; we would instead think of a "naturalist" or "actualist" scene, like those of Pissarro or Monet to which Zola had referred. Furthermore, "finesse," a word Zola used, and "delicacy," "exquisiteness," "strange elegance" (which recalls Astruc's "morbid elegance") conjure up anything but the solid, compact work that we are looking at. The well-meaning Raoul de Navery (pseudonym for Eugénie Caroline Chervet) agreed with Zola's views; calling Degas one of the many gentleman painters at the Salon (his name was always spelled "de Gas" in the catalogue), Navery praised the "very harmonious and very remarkable" portrait of "one of the great beauties of Paris."[10]

Painting the celebrated ballerina was bound to cause gossip, and Degas's friends at the Café Guerbois could not figure out why in the world he had painted her. Born in Paris on July 22, 1845 (she died on June 6, 1908), Eugénie Fiocre, along with her sister, had rapidly become one of the glories of the Opéra—albeit more for her charm, her verve, her fine figure, her thoroughly Parisian spirit, than for any real balletic talent."[11] As an old and ribald operagoer put it, "What a fine

figure for me to kneel before—and behind!"¹² In August 1867, when Degas began her portrait between two performances of *La Source*, he had an eye toward fashionable society, choosing a sitter who would subsequently be sculpted by Carpeaux (marble, private collection) and painted by Winterhalter (private collection). Thus, Degas had a chance to become a "painter of high life" (in the words of Duranty as reported by Manet).¹³ And yet Degas did not seize the opportunity; for he did not depict her as a dancer, any more than he highlighted her physical appeal, which he concealed under the billows of her oriental costume. One reason for the ambiguity and parsimony of the reviews was the awkwardness felt by a Zola, a Castagnary, a Duranty when viewing the likeness of someone who was not of their world but a glaring symbol of imperial display. Another was that the uncomprehending critics in high society, the lovers of celebrities, the stage-door johnnys failed to recognize Fiocre when brushing past her portrait.

That probably clarifies the "à propos" in Degas's title, which would otherwise be rather cryptic. He portrayed a celebrated ballerina, but not as a fashionable woman or a dancer, for nothing in the setting hints at the stage. The rocks, which constitute a real landscape and not a theatrical set, have the solidity of Courbet's rocks in Franche-Comté. Never, indeed, has the influence of the master of Ornans been more obvious in Degas than in this portrait, executed when Courbet was the subject of passionate debates. Whistler always dwelled on his debt to Courbet, and Theodore Reff cites Whistler's *Symphony in White, No. 3* (Barber Institute of Fine Arts, Birmingham, England), which Degas sketched at the same time he portrayed Fiocre, as a possible source for the present painting.¹⁴ Castagnary, in his "Salon de 1866," had defended the master of Ornans, taking up the cudgels for what he called "the entire idealist and realist youth that came after him." As Marcel Crouzet has pointed out, Castagnary extolled "a monstrous alliance of realism and idealism as the definition of the movement of contemporary painting."¹⁵

In the present portrait Degas seems to be following Castagnary to the letter, injecting fantastic elements into a realistic setting. For instead of the exotic landscape described in the libretto for *La Source*, we discover a severe and compact accumulation of rocks bathed in smooth, dark water. This somewhat oppressive mass contrasts with the calm and lassitude of the three characters shown and the tranquil posture of the horse about to drink. Standing out against the deep greens and browns of the rocks, which recall Degas's studies of rocks in Bagnoles-de-l'Orne (Lemoisne 191, 192), are the dresses of the two attendants and especially Fiocre's Nouredda costume: "Tartar cap of poppy-red satin. Embroidered with white jet, black pearls, red pearls, gold spangles.... gem-encrusted belt; gem necklace; outer jacket of sky blue Pekin silk with silver braiding."¹⁶

Had it been better understood, Degas's canvas could have functioned as a manifesto, breathing new life into a realist heritage. In time, it came to be recognized as one of the great masterpieces of painting, summing up Degas's investigations of historical painting during the 1860s (for *Fiocre* is also rooted in *Sémiramis*) and, despite all else, announcing the ballerinas to come with the strange and moving presence of the small pink ballet slippers between the two solid front legs of the horse.

H. L.

1. See Henri Loyrette in Paris, Ottawa, New York 1988–89, p. 134.
2. "la moitié de la peinture"; "Pour ne pas tout détruire on fut obligé de laisser le travail inachevé. Ce n'est que bien plus tard (entre 1892 et 1895 je crois) que Degas retrouvant ce tableau se mit en tête d'y travailler à nouveau. Il fit venir un restaurateur qui tant bien que mal enleva ce qui restait du vernis et donna les indications nécessaires pour exécuter les retouches et réparer les dommages autrefois causés par Degas lui-même à son oeuvre. Il ne fut qu'à demi satisfait du résultat." Ernest Rouart, "Degas," *Le Point*, February 1, 1937, p. 21.
3. "placé si haut, si haut!" M. de Thémines, "Salon de 1868, VIII," *La Patrie*, May 19, 1868, p. 3.
4. "Je ne comprends pas du tout." Ibid.
5. "la jolie danseuse"; "rébus." Louis Leroy, "La Session du Salon de 1868," *Le Charivari*, May 20, 1868, p. 2.
6. "semble avoir quitté la réalité pour le rêve"; "les habits noirs"; "judicieuse horreur"; "sacrifier beaucoup aux souvenirs, à la peu près, à des effects de lumière qui veulent leur milieu théatral." Zacharie Astruc, "Salon de 1868: Le Genre," *L'Étendard*, July 31, 1868, p. 1.
7. "d'une réalité étonnante"; "d'une exécution franche et généreuse." Thoré-Bürger 1870, vol. 2, p. 532.
8. "la touche légère"; "élégances un peu maladives"; "Un charme indéfinissable est dans leur attitude singulièrement poétique et encore plus silencieuse. La peinture a ces rares effets qui nous attachent et nous subjuguent malgré leurs défauts. Un poète pouvait seul se plaire à cette scène et la rendre"; "tentative"; "les traditions monotones." Astruc 1868, p. 1.
9. "page observée et très fine"; "Trois femmes sont groupées sur une rive; un cheval boit à côté d'elles. La robe du cheval est magnifique, et les toilettes des femmes sont traitées avec une grande délicatesse. Il y a des reflets exquis dans la rivière. En regardant cette peinture qui est un peu mince et qui a des élégances étranges, je songeais à ces gravures japonaises, si artistiques, dans la simplicité de leurs tons." Zola 1991, pp. 220–21.
10. "très harmonieuse et très remarquable"; "une des grandes beautés de Paris." Raoul de Navery, *Le Salon de 1868* (Paris, 1868), pp. 42–43.
11. Concerning Eugénie Fiocre's career, see Loyrette 1991, pp. 209–12.
12. "Quelle plastique à se mettre à genoux devant—et derrière!" Un viel abonné [an old subscriber], *Ces demoiselles de l'Opéra* (Paris, 1887), p. 196.
13. "Peintre du High-Life." Manet's letter to Fantin-Latour, August 26, 1868, quoted in Moreau-Nélaton, 1926a, vol. 1, p. 103.
14. Reff 1985, notebook 20, p. 17.
15. "toute la jeunesse idéaliste et réaliste qui vient après lui"; "comme définition du mouvement pictural contemporain, une alliance monstrueuse du réalisme et de l'idéalisme." Crouzet 1964, pp. 237–38.
16. "bonnet tartare en satin ponceau. Brodé de jais blanc, perles noires, perles rouges, paillettes or.... ceinture de pierreries; collier de pierreries; dolman de dessus en pékin de soie bleu ciel orné galon argent." Handwritten description, Paris, Bibliothèque de l'Opéra.

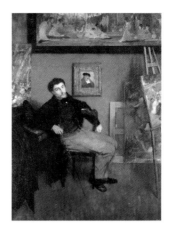

62 *Fig. 277*

Edgar Degas
Portrait de James Tissot
1867–68
Oil on canvas
59⅝ x 44 in. (151.4 x 112.1 cm)
Stamped lower right: Degas
The Metropolitan Museum of Art, New York, Rogers Fund, 1939 39.161

CATALOGUES RAISONNÉS: Lemoisne 1946–49, vol. 2, no. 175; Minervino 1974, no. 240

PROVENANCE: Artist's studio; first sale of the "Atelier Edgar Degas," Paris, Galerie Georges Petit, May 6–8, 1918, no. 37 (Portrait d'homme dans un atelier de peintre); bought for Fr 25,700 by Jos Hessel, Paris; deposited by him at Durand-Ruel, Paris, March 14, 1921; acquired by Durand-Ruel, New York, April 28, 1921; bought for $1,400 by Adolph Lewisohn, New York, April 6, 1922, until his death in 1938; Jacques Seligmann, New York, 1939; acquired by the Metropolitan Museum, 1939

EXHIBITIONS: Cambridge, Mass., Fogg Art Museum, *Degas*, 1931, no. 3; New York, Durand-Ruel Galleries, 1937, *Exhibition of Masterpieces by Degas*, no. 2, repr.; New York, Wildenstein and Co., 1960, *Degas*, no. 14; New York, Metropolitan Museum of Art, 1977, *Degas in the Metropolitan*, no. 6; Paris, Ottawa, New York, 1988–89, *Degas*, no. 75

SELECTED REFERENCES: *Renaissance de l'art français*, vol. 1 (Paris, 1918), p. 146; Paul Lafond, *Degas* (Paris, 1918–19), vol. 2, p. 15; Louise Burroughs, "A Portrait of James Tissot by Degas," *Metropolitan Museum Bulletin*, 36 (1941), pp. 35–38, repr. cov.; Jean Sutherland Boggs, *Portraits by Degas* (Berkeley, Calif., 1962), pp. 23, 32, 54, 57, 59, 106, 131, pl. 46; Sterling and Salinger 1967, pp. 62–64; Theodore Reff, *Degas: The Artist's Mind* (New York, 1976), pp. 28, 90, 101–10, 138, 144, 145, 223, 224, pl. 68; Charles S. Moffett, *Degas: Paintings in The Metropolitan Museum of Art* (New York, 1979), pp. 7–8, pl. 9; Michael Wentworth, *James Tissot* (Oxford, 1984), p. xv, 49, 59, pl. 37

Tissot was not always the "plagiarist painter" whom Edmond de Goncourt began denouncing in 1874.¹ Not only did he reveal a community of taste with Degas during the 1860s, but he also struck a new note in French painting with his portraits and his historical scenes. Moreover, Tissot introduced original solutions (despite the highly obtrusive influence of the Belgian Henri Leys), and he skillfully combined tradition and trendiness, although this brew may now seem a bit dubious. Degas's notebooks of the early 1860s attest

to an obvious interest in the oeuvre of the young artist from Nantes: they include partial copies, from memory, no doubt, of Tissot's *Promenade dans la neige* (*Stroll in the Snow*, 1858, Salon of 1859; whereabouts unknown) and *Voie des fleurs, Voie des pleurs* (*Path of Flowers, Path of Tears*, Salon of 1861; Museum of Art, Rhode Island School of Design, Providence)—compositional projects in the spirit of Tissot.[2]

When painting portraits, both artists often employed the same formula, that of a sitter placed in an interior—a legacy from Ingres. Tissot, however, added a finish, a detailing, a taste for anecdote, a chicness, a porcelained manner not found in Degas's work, which is stronger, more ample, more significant—in short, which has everything that separates an uninterrupted series of masterpieces from a sequence of amiable, fashionable canvases.

The present picture, which was preceded by numerous preparatory drawings,[3] is the largest portrait painted by Degas during the 1860s, except for the *Portrait de famille* (*La Famille Bellelli*) (fig. 253). It shows a weary, elegant, ever so slightly apathetic Tissot playing with his riding crop, seated momentarily while he visits (note the hat, the coat) a studio that is neither his nor, for that matter, any painter's. On the table are an upside-down black hat set against a vividly colored painting and a negligently tossed coat that play the role of the usual studio draperies. The deliberate nonchalance of the subject and the disposition of his accessories contrast with the rigidity of the frames and stretchers, which, as in Poussin's *Self-portrait* (Musée du Louvre, Paris), provide a setting for the sitter.

Theodore Reff has patiently identified the works that line this studio:[4] behind Tissot the only perfectly readable canvas, Cranach's portrait of Frederick III, the Wise; overhead a long composition with a Japanese subject; on the table a canvas in which women in contemporary garb under thick, bright trees seem discernible; finally, on the easel a fragment of a plein air scene that partially hides what appears to be a picture of Moses rescued from the waters. For the portrait of Frederick III, Degas surely must have chosen to quote, from among the many known examples of the subject, the one in the Louvre—which was part of Napoléon's booty. Nevertheless, Degas presents it not as a copy but as an original hanging in a large, old frame in the place of honor. The Louvre canvas measures 5⅛ by 5½ inches (13 x 14 cm), and in order to make it visible, Degas significantly increases its size. The painting of the Japanese subject may be the Western transcription of a makimono scroll or, more probably, a Japanesque invention à la Tissot or Stevens.

The biblical scene, according to Reff, may allude to Degas's and Tissot's shared delight in Venetian painting of the cinquecento and seicento, which frequently depicted the story of Moses. It is even more relevant to point out the connection between the silhouette of pharaoh's daughter and that of Mlle Fiocre in Degas's portrait (cat. 61); the two figures are shown in the same posture, sug-

gesting very close dates for the two paintings—in 1867–68. The portrait of Frederick III reminds us that Degas and his sitter were both attracted to sixteenth-century German painting and that Tissot's work during the 1860s frequently harked back to an older Germany. The Japanesque canvas refers to the sharp focus of Tissot on Japanese art, which he was one of the first Europeans to appreciate (fig. 132). The plein air scenes testify to his alertness to such artists as Manet or Monet. There is nothing contradictory about the five canvases that surround Tissot, since they present a sampling of the genres he practiced successfully: portraits (cat. 189), exotica, plein air scenes, historical motifs.

Tissot sits before us, perfectly at ease yet in an unstable position: enjoying a high income, living in a mansion on avenue de l'Impératrice, he is no longer an innovator but now has become a fashionable painter. By depicting Tissot at this stage in his career, Degas evinces curiosity, sympathy, and also a touch of envy and a little irony. Perhaps the Japanesque painting, a simple, picturesque variation on an oriental theme (which Degas hated) is supposed to remind us of the danger of yielding to a facile exoticism—something that remained Tissot's natural bent for the rest of his life. At this point Degas is amused by the indolence of the successful painter, but he is no dupe, and the severe face of the Lutheran prince—a Renaissance echo of the Parisian dandy—is not only a delicate reminder of Tissot's predilections, but also a warning.

H.L.

1. Goncourt 1956, vol. 10, p. 197.
2. Reff 1985, notebook 18, pp. 11, 133, 183.
3. There are three drawings detailing Tissot: two studies of the sitter's head on one sheet and, on separate sheets, two full-length studies of a position close to the one in the final painting. The drawings are followed by a quick sketch that outlines the overall composition. (Reff 1985, notebook 21, p. 6.) The drawings were included in the third sale of the "Atelier Degas," Paris, Galeries Georges Petit, April 7–9, 1919, no. 158.
4. Theodore Reff, *Degas, the Artist's Mind* (New York, 1976), pp. 101–10.

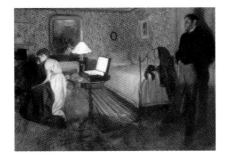

63

Fig. 344

Edgar Degas
Intérieur (Le Viol)
(Interior [The Rape])
Ca. 1868–69

Oil on canvas:
32 x 45 in. (81.29 x 114.3 cm)
Signed lower right: Degas
Philadelphia Museum of Art: The Henry P. McIlhenny Collection in memory of Frances P. McIlhenny
1986-026-010

CATALOGUES RAISONNÉS: Lemoisne 1946–49, vol. 2, no. 348; Minervino 1974, no. 374

PROVENANCE: The artist, deposited by him at Durand-Ruel, Paris, June 15, 1905, and at Durand-Ruel, New York, August 26, 1909; bought for Fr 100,000 by Durand-Ruel, Paris, August 30, 1909, and sold the same day for Fr 100,000 to M. Jaccaci, New York; A. A. Pope, Farmington, Conn.; Harris, Whittemore, Naugatuck, Conn., 1911; J. H. Whittemore Company; acquired by Henry P. McIlhenny, 1936; his bequest to the Philadelphia Museum of Art, 1986

EXHIBITIONS: Cambridge, Mass., Fogg Art Museum, 1911, *A Loan Exhibition of Paintings and Pastels by H. G. E. Degas*, no. 2; Philadelphia Museum of Art, 1936, *Degas 1834–1917*, no. 23; Paris, Musée de l'Orangerie, 1937, *Degas*, no. 20, repr.; Paris, Grand Palais, Ottawa, National Gallery of Canada, and New York, Metropolitan Museum of Art, 1988–89, *Degas*, no. 84

SELECTED REFERENCES: Paul-André Lemoisne, *Degas* (Paris, 1912), pp. 61–62, repr.; Georges Rivière, *Monsieur Degas, bourgeois de Paris* (Paris, 1935), pp. 49, 97, repr.; Ernest Rouart, "Degas," *Le Point*, February 1, 1937, p. 21; Degas 1945, pp. 255–56; Jean Adhémar, *Émile Zola*, exh. cat. (Paris, 1952), p. 20; Quentin Bell, "Degas: Le Viol," *Charlton Lectures on Art* (Newcastle-upon-Tyne, 1965), unpaginated; Theodore Reff, *Degas: The Artist's Mind* (New York, 1976), pp. 206–38, col. repr.

The difficulty begins with the very title of the painting. Paul-André Lemoisne called it *The Rape* in 1912; he was the first to refer to it by this appellation, which was frequently reiterated thereafter.[1] Ernest Rouart maintains that Degas himself—"God knows why"—called it that.[2] Nothing corroborates that hypothesis, however. When Degas dropped the canvas off at Durand-Ruel on June 15, 1905, it was baptized simply *Intérieur* (and it was *Scène d'intérieur* in 1909). Paul Poujaud, Degas's close friend, who first saw the painting in 1897, stated in a letter to Marcel Guérin: "He never called it *The Rape* in my presence. That title did not come from him. It must have been devised by a littérateur, a critic."[3]

The dating is likewise controversial. Lemoisne places it about 1874, Boggs about 1868–72, and Reff about 1868–69.[4] Reff's reasons are perfectly convincing. He has noted that the very summary compositional sketch, which is the only one we know of and which differs in many ways from the final canvas, was scrawled on back of a printed change-of-address announcement dated December 25, 1867 (Musée du Louvre, Paris, département des arts graphiques, fonds du Musée d'Orsay, RF 31779). Moreover, in a notebook he used between 1867 and 1872 (contrary to Reff, we do think that he worked in it after that date), Degas made two graphite sketches: the first of the empty room, without the bed but with the open casket on the table; the other, two pages further on, of the man leaning against the wall.[5]

Degas relied on several sketches of each figure when he worked out the canvas, which he revised at the turn of the century. While he painted

it, he benefited from a friend's advice, which was scrawled on an envelope addressed to the artist at his studio at 13 rue de Laval. The anonymous author, apologizes for missing an appointment with Degas and then pours out his ideas about the work in progress, which he had just seen at the studio: "I will express my compliments on the painting in person—watch out for the carpet next to the shocking bed, the room that is overly bright at the back, not enough mystery—the overly glaring or else not sufficiently vivid sewing box, the not shadowy enough fireplace (think of the vague background of Millais's green woman without letting it overwhelm your own ideas), the too red floor—the not proprietary enough legs of the man—but hurry, I won't be at Stevens's place for long tonight, here is the effect I believe you need for the mirror [rough sketch of the mirror over the mantel] the ceiling must be brighter in the very bright mirror if make the room dark." After repeating, "Hurry, hurry," he continued on the back of the envelope, "next to the lamp on the table something white to bring out the fireplace ball of yarn and the (necessary) string [rough sketch of the table with the open box, the lamp base, and a ball of yarn pierced with needles] darker under the bed. A chair in back where a table might be good and make up for the bedside rug [sketch of a chair in front of the table]."[6]

The correspondent had to be familiar with the painting, conversant with British art, and close enough to Degas to give him such advice. After considering the possible candidates, Reff decided that James Tissot was the anonymous adviser. In any case, Degas appears to have followed a few of the suggestions by stressing the penumbra, darkening the floor, adding a white touch to the table, and lightening the ceiling in the mirror.

Ever since its first showing at the beginning of the twentieth century, this painting, which Degas referred to as simply "my genre picture" (see pp. 278–79), has elicited multiple interpretations. Observers from Georges Rivière in 1935 to Theodore Reff in 1976 have suggested various literary sources, including stories and novels by Zola and Duranty. The most convincing idea was advanced by Reff, who compared the canvas to a section in Zola's novel *Thérèse Raquin*, which hit the Paris bookshops in December 1867 after it was serialized from August to October. In the Zola passage the two lovers, who married a year after they killed Thérèse's first husband, celebrate their wedding night. There is a striking kinship between the postures of the characters in the book and those of the figures in the painting; nevertheless, the differences between the written and the painted work are numerous, especially in the decor of the room. If Degas did not actually illustrate Zola, he was very likely inspired by this novel, which appeared just as he presumably began his painting and which caused a scandal. Certainly this "genre picture" also realizes strictly painterly goals such as those announced in Degas's notebook: "Greatly elaborate the effects of the evening—lamp, candle, etc. The intriguing thing

is to show not the source of the light but the effect of the light."[7]

However, Degas is scouting what for him was unfamiliar terrain, which, in literature, belongs precisely to Zola. The painter was, no doubt, responding to the writer's mixed review of his *Portrait de Mlle E[ugénie] F[iocre]* (cat. 61) at the Salon of 1868. Now Degas was foregoing the "strange elegance" Zola found to be inspired by a hypothetical Japan; instead he created a dark, dense, tight painting, with nothing "thin" or "exquisite" about it, and with a subject that had no connection to the fashionable set. Given the probable meddling of Tissot and his reference to Millais, Degas may have also intended to make a product for the British market, which both he and Manet saw as a possible outlet for their work.

H.L.

1. Paul-André Lemoisne. *Degas* (Paris, 1912). pp. 61–62.
2. "Dieu sait pourquoi." Ernest Rouart. "Degas." *Le Point*, February 1, 1937. p. 21.
3. "Il ne me l'a jamais appelé *Le Viol*. Ce titre n'est pas de sa langue. Il a dû être trouvé par un littérateur, un critique." Degas 1945. p. 255.
4. Theodore Reff. *Degas: The Artist's Mind* (New York, 1976). pp. 206–38.
5. Reff 1985. notebook 22. pp. 98, 100.
6. "Je ne vous ferai des compliments du tableau que de vive voix—prendre garde à la descente de lit choquant, la chambre trop clair dans les fonds, pas assez de mystère—la boîte à ouvrage trop voyante ou alors pas assez vivante, la cheminée pas assez dans l'ombre (pensez à l'indécision du fond de la femme verte de Millais sans vous commander) trop roux le parquet—pas assez propriétaire les jambes de l'homme—seulement dépêchez-vous, il n'est que temps serai ce soir chez Stevens, pour la glace l'effet je crois... la glace doit être plus clair dans la glace très clair en mettant la chambre dans l'ombre.... dépêchez-vous, dépêchez-vous... à côté de la lampe sur la table quelque chose de blanc pour enfoncer la cheminée pelote et fil (nécessaire) plus noir sous le lit. Une chaise là ou derrière la table ferait peut-être bien et ferait pardonner la descente de lit." Bibliothèque Nationale, Paris, département des Manuscrits, n.a. fr. 24838; see Reff. *Degas: The Artist's Mind*, pp. 225–26.
7. Reff 1985. notebook 23. p. 45.

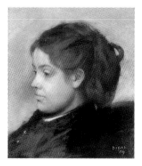

64

Fig. 272

Edgar Degas
Portrait d'Emma Dobigny
1869
Oil on panel
12 x 10⅜ in. (30.5 x 26.5 cm)
Signed and dated lower right: Degas 69
Private collection, Switzerland

CATALOGUES RAISONNÉS: Lemoisne 1946–49, vol. 2, no. 198; Minervino 1974, no. 254

PROVENANCE: Ludovic Lepic, Paris until 1897; his sale, Paris, Hôtel Drouot, March 30, 1897, no. 51 (Buste de femme); bought for Fr 700 in half shares by Durand-Ruel and Manzi; deposited with Mr. and Mrs. Erdwin Amsinck, Hamburg, November 16, 1897, who bought it for Fr 3,000, November 24, 1897 until 1921; their bequest to the Kunsthalle, Hamburg, 1921, until 1939; exchanged along with *A Vase of Flowers* by Renoir, for *Evening: The Artist's Mother and Sister* by Hans Thoma, with Karl Haberstock, a Berlin merchant, 1939; acquired on the Munich market by the present owner, 1952

EXHIBITIONS: Paris, Musée de l'Orangerie, 1937, *Degas*, no. 10, pl. VIII; Paris, Musée de l'Orangerie, 1967, *Chefs-d'oeuvre des collections suisses de Manet à Picasso*, no. 4; Paris, Grand Palais, Ottawa, National Gallery of Canada, and New York, Metropolitan Museum of Art, 1988–89, *Degas*, no. 86

SELECTED REFERENCES: Jean Sutherland Boggs, *Portraits by Degas* (Berkeley, Calif., 1962), p. 64

Little is known about Emma Dobigny, whose real name was Marie Emma Thuilleux and who was born in 1851 in Montmacq, Oise, and died in 1915 in Paris. Degas spelled her name like that of the painter Daubigny, and when he first met her, about 1868, she was a painter's model living on a poor back street, at 20 rue Tholozé in Montmartre.[1] She posed for Corot's *La Source (The Spring)* and Puvis de Chavannes's *Espérance (Hope)*; perhaps Tissot already had used her or was going to use her for *Le Goûter (Afternoon Tea)*.[2] Degas himself turned her into a plebian laundress (cat. 65) and the middle-class but less attractive companion of a businessman (cat. 67). She was one of Degas's favorite models, as is proved by a brief note (private collection) that he sent her during the period in which she sat for these pictures: "Little Dobigny, another session and one more if

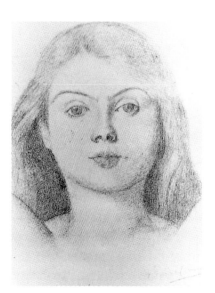

Fig. 404. Pierre Puvis de Chavannes, *L'Espérance (Hope)*, August 1, 1869. Graphite. Published in *L'Estampe moderne*, April 1896

possible."[3] The year that Degas painted this little portrait of her, Puvis made a lovely pencil drawing of Emma Dobigny, which is dated August 1, 1869 (fig. 404). The drawing shows the head and shoulders of the young woman with her hair down; Puvis's obvious stylization produces not a portrait but an allegorical figure with a beautiful face marked by regular features. This is the same round, firm face encountered in the paintings mentioned above: the nose is slightly snubbed, the mouth narrow with thick lips, the eyebrows are long, fine, and regular and frame a somber gaze. Degas does not paint Emma Dobigny as a professional model but rather pays homage to her; relying on the same small format that Manet had devoted to his portrait of Victorine Meurent (cat. 91), he depicts a young, pensive woman whose lovely profile stands out against a light background. In the sharp and searching half-length views he liked to use for people close to him, Degas alluded to the French Renaissance portraits that he loved. Louisine Havemeyer understood this when she hung Degas's profile portrait of Joseph-Henri Altès (1868, Lemoisne 176, Metropolitan Museum of Art), the artist's friend and a flutist at the Paris Opéra, in her New York house—for she placed it "between [a panel] by Clouet and one by Corneille de Lyon."[4]

H.L.

1. Reff 1985, notebook 21, p. 34.
2. See Wentworth, 1984, p. 66.
3. "Petite Dobigny, encore un séance et de suite si c'est possible."
4. Louisine W. Havemeyer, *Sixteen to Sixty: Memoirs of A Collector*, edited by Susan Alyson Stein (New York, 1993), p. 263.

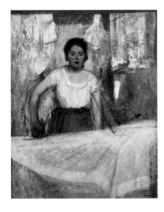

Edgar Degas
La Repasseuse
(A Woman Ironing)
1869
Oil on canvas
36¼ x 29⅛ in. (92 x 74 cm)
Neue Pinakothek, Munich inv. no. 14310

CATALOGUES RAISONNÉS: Lemoisne 1946–49, vol. 2, no. 216; Minervino 1974, no. 364

PROVENANCE: Artist's studio; first sale of the "Atelier Edgar Degas," Paris, Galerie Georges Petit, May 6–8, 1918, no. 104, repr.; Jos Hessel, Paris; Christian Mustad, Norway, 1929; acquired on the New York art market, 1972

SELECTED REFERENCES: Erich Steingräber, "La repasseuse," *Pantheon* 32 (January–March 1974), pp. 47–53, repr. p. 49

On February 13, 1874, "a bizarre painter named Degas," who "has fallen in love with modernism," was at his studio, showing an entire series of dancers and women ironing to Edmond de Goncourt. Goncourt noted that the painter accompanied his explanation with gestures: "Before our eyes he placed laundresses, laundresses, in their poses and their graceful foreshortenings . . . speaking their language and providing a technical clarification of their *emphatic* stroke, their *circular* stroke, etc." In an 1891 addition to his text, the writer would pride himself on being the first, in his novel *Manette Salomon*, to "have celebrated those two professions for supplying the most painterly female models of that time, for a modern artist." His remark was unfounded; there are no dancers whatsoever in his novel, and, unlike Degas's toilers, the laundresses carry their heavy baskets through the streets à la Daumier.[1]

We do not know when Degas captured this subject of modern life, which had already been treated by Amand Gautier and by Bonvin in 1858 (fig. 339); it was not an unusual motif, and painters and photographers treated it without harping on it. Because of the stifling heat in the laundries, the female employees, who had a reputation for being easy, wore nothing but light camisoles, which fed salacious suggestions. In December 1860 the Variétés presented some unbuttoned laundresses in a review, *Oh! Là Là! Que c'est bête tout ça!* (Oh La, La! How silly it all is!): "The censor allowed them to show *tableaux vivants* of all the little obscenities of photographs. Even photographs in which the laundresses bend forward while ironing, so that the spectators can see their bosoms as if they were holding them."[2] Degas's laundress is certainly closer to those "little obscenities" than are the dismal working women of his realist predecessors (see pp. 274–75, 277).

The present painting has been dated 1869 because the woman wielding the iron is Emma Dobigny, one of Degas's favorite models at that time (cats. 64, 67). This date is highly probable for the young woman—whose face so closely resembles the one in Degas's little profile portrait of Dobigny—and for the large sheet she is ironing. The background, however, must have been redone later, as is quite obvious around the head, where the white of the linen encroaches upon the woman's hair. Degas, no doubt, returned to it about 1873–76, when he painted numerous variations on this theme.

H.L.

1. "Un peintre bizarre, du nom de Degas"; "s'est énamouré du moderne"; "Il nous met sous les yeux, dans leurs poses et leurs raccourcis de grâce, des blanchisseuses, des blanchisseuses....parlant leur langue et nous expliquant techniquement le coup de fer *appuyé*, le coup

de fer *circulaire*, etc."; "chanté ces deux professions, comme fournissant les plus picturaux modèles de femmes de ce temps, pour un artiste moderne." Goncourt 1956, vol. 10, p. 164.
2. "La censure leur a permis de réaliser en tableaux vivants toutes les petites obscénités des photographies. Jusqu'à la photographie des blanchisseuses, où l'on peut voir, de celles qui repassent en se baissant, la gorge comme si on la tenait." Ibid., vol. 4, p. 141.

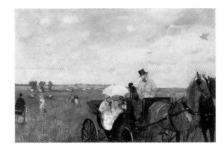

Edgar Degas
Aux courses en province
(At the Races in the Countryside)
1869
Oil on canvas
14⅜ x 22 in. (36.5 x 55.9 cm)
Signed lower left: Degas
Museum of Fine Arts, Boston, 1931 Purchase Fund
26.790

CATALOGUES RAISONNÉS: Lemoisne 1946–49, vol. 2, no. 281; Minervino 1974, no. 203

PROVENANCE: Bought from the artist for Fr 1,000 by Durand-Ruel, Paris, September 17, 1872 (La voiture sortant du champ de courses); sent to Durand-Ruel, London, October 12, 1872; bought for Fr 1,300 by the intermediary Charles Deschamps for Jean-Baptiste Faure, Paris, April 25, 1873, until 1893; bought for Fr 10,000 by Durand-Ruel, Paris, January 2, 1893 (Voiture aux courses); deposited with the Durand-Ruel family, Les Balans, March 29, 1918; acquired in New York by the Museum of Fine Arts, Boston, 1926

EXHIBITIONS: London, 168 New Bond Street, 1872, *Fifth Exhibition of the Society of French Artists*, no. 113; London, 168 New Bond Street, 1873, *Sixth Exhibition of the Society of French Artists*, no. 79; Paris, 35, boulevard des Capucines, Société anonyme des artistes peintres, sculpteurs, graveurs, etc., 1874, *Première Exposition*, no. 63 (Aux Courses en province); Saint Petersburg, 1899, *Mir Iskousstvo*, no. 81; Vienna, 1903–04, *Secession*; London, Grafton Galleries, 1905, *A Selection of Pictures by Boudin, Cézanne, Degas, etc.*, no. 57, repr.; Zurich, Kunsthaus, 1917, *Französische Kunst des 19 und 20 Jahrhunderts*, no. 88, repr.; Paris, Galerie Georges Petit, 1924, *Exposition Degas*, no. 40; Philadelphia Museum of Art, 1936, *Degas 1834–1917*, no. 21; Paris, Musée de l'Orangerie, 1937, *Degas*, no. 14, pl. x; Washington, San Franciso 1986, no. 4, col. repr.; Paris, Ottawa, New York, 1988–89, *Degas*, no. 95

SELECTED REFERENCES: Ernest Chesneau, "À côté du Salon, II. Le plein air: Exposition du boulevard des Capucines," *Paris-Journal*, May 7, 1874; Paul-André Lemoisne, *Degas* (Paris, 1912), pp. 53–54, repr.; Suzanne Barazetti, "Degas et ses amis Valpinçon," *Beaux-Arts*, August 21,

1936, p. 43; Jean Sutherland Boggs, *Portraits by Degas* (Berkeley, Calif., 1962), pp. 37, 46, 92, 93, n. 66, pl. 72; Loyrette 1991, pp. 196–98

In 1874 Degas chose to present this small canvas, which he had painted five years before, at the first Impressionist Exhibition. Both portrait and genre scene, it had entered the major collection of baritone Jean-Baptiste Faure several months earlier. The painting went more or less unnoticed, except by Ernest Chesneau, who lauded this "work marked by exquisite color, draftsmanship, precision in the bearing of its figures, and compositional subtlety."[1]

In the summer of 1869 Degas, returning from a lengthy stay on the Normandy coast (see p. 231), stopped off to pay his usual visit to his friends, the Valpinçons, at Ménil-Hubert in Orne (cat. 52). *Aux courses en province* is the memento of an outing to Argentan, which had the racetrack closest to the Valpinçons—some ten miles from their home. It was the only racetrack that they could reach by carriage, with an infant and without too much discomfort. The elegant victoria, in which the family bulldog has claimed a place, is driven by Paul Valpinçon, Degas's childhood friend and contemporary. They are accompanied by Paul's wife, Marguerite-Claire (née Brinquant), their eight-month-old baby, Henri (he was born on January 11, 1869), and the nurse.

Scholars have rather unconvincingly posited a Japanese influence and with more justification an English influence for the present painting. In the latter regard, they have argued that the Argentan region of Normandy brought England and its painters to Degas's mind (see p. 282). It would, no doubt, be more valid to make such a presumption for the wooded and hilly surroundings of Exmes than for the flat, dreary plain of Argentan, whose green stretches Degas shows to be punctuated only by a few low houses and the slender silhouettes of three trees. Granted, the three horses running in the background for an unseen audience do recall the colored English engravings that Degas particularly liked (cat. 67); but the equal division of the canvas into areas of sky and earth and the smooth, thick, precise technique—"flat as a pancake," according to Degas[2]—conjure up Dutch painting, whose finish and care, calm and fastidiousness the scene echoes.

H.L.

1. "Oeuvre exquise de coloration, de dessin, de justesse dans les attitudes et de finesse d'ensemble." Ernest Chesneau, "A côté du Salon," *Paris-Journal*, May 7, 1874.
2. "Plate comme une porte," Degas, *Bouderie (Sulking)*, ca. 1869–1870

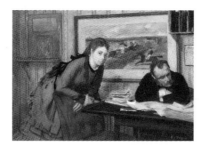

67 *Fig. 342*

Edgar Degas
Bouderie
(Sulking)
Ca. 1869–70
Oil on canvas
12¾ x 18¼ in. (32.4 x 46.4 cm)
Signed lower right: E. Degas
The Metropolitan Museum of Art, New York, H. O. Havemeyer Collection, Bequest of Mrs. H. O. Havemeyer, 1929 29.100.43

CATALOGUES RAISONNÉS: Lemoisne 1946–49, vol. 2, no. 335; Minervino 1974, no. 386

PROVENANCE: Deposited by the artist at Durand-Ruel, Paris, December 27, 1895 (Bouderie); bought for Fr 13,500 on April 28, 1897, by Durand-Ruel, which had already sold it on December 15, 1896, for $4,500 to Durand-Ruel, New York, for Mrs. H. O. Havemeyer; Mrs. H. O. Havemeyer, New York 1896–1929; her bequest to the Metropolitan Museum, 1929

EXHIBITIONS: New York, M. Knoedler and Co., 1915, *Loan Exhibition of Masterpieces by Old and Modern Painters*, no. 25; New York, 1930, no. 46, repr.; Philadelphia Museum of Art, 1936, *Degas 1834–1917*, no. 19, repr.; Paris, Musée de l'Orangerie, 1937, *Degas*, no. 11; New York, Metropolitan Museum of Art, 1977, no. 10; Richmond, Virginia Museum of Fine Arts, 1978, *Degas*, no. 6; Edinburgh, National Gallery of Scotland, for the Edinburgh International Festival, 1979, *Degas*, no. 38, repr.; Paris, Ottawa, New York, 1988–89, *Degas*, no. 85; New York, 1993, no. 201

SELECTED REFERENCES: *Revue encyclopédique*, 1896, p. 481; Georges Lecomte, "La Crise de la peinture française," *L'Art et les artistes* 12 (October 1910), repr. p. 27; Louise Burroughs, "Degas in the Havemeyer Collection," *Metropolitan Museum of Art Bulletin* 27 (May 5, 1932), p. 144, repr.; Sterling and Salinger 1967, pp. 71–73; Theodore Reff, *Degas: The Artist's Mind* (New York, 1976), pp. 116–20, 144, 162–64, fig. 83; Charles S. Moffett, *Degas: Paintings in The Metropolitan Museum of Art* (New York, 1979), p. 10, fig. 14

The date of *Bouderie* (the artist's own title)[1] was given as 1873–75 by Lemoisne and pushed back to 1869–71 by Theodore Reff, who wrote the most thorough study of the painting.[2] We would date it about 1869–70, when Emma Dobigny (cat. 64) modeled for Degas, who painted her as an impassive laundress (cat. 65) and then as an elegant, peevish girl. Three sketches in a notebook now at the Bibliothèque Nationale, Paris, show details of the window in the door, the ledger rack, and the table cluttered with papers.[3] These sketches, which appear in the notebook next to drawings for *L'Orchestre de l'Opéra*, along with particulars of the painting's provenance, constitute the only documentation we have about this

enigmatic scene; everything else that is said—concerning the site, the circumstances of the models, the interpretation of the subject—is mere conjecture. Two people—a man working, a woman visiting—have been interrupted in the midst of what looks like a passionate and strained discussion; they are in an office linked to the racing world (as indicated by the colored engraving on the wall) or, more probably, in a small bank like the one that belonged to the De Gas family, on rue de la Victoire, where the artist may have gone to draw his studies of the furniture. Degas's models for this ambiguous genre scene were Emma Dobigny, with her full, round face and pointed nose, and perhaps Duranty, who, according to Reff, posed as the surly man. On the wall behind them hangs a highly simplified rendition of the English engraving *Steeple-Chase Tracks* of 1847 by J. F. Herring. Its presence emphasizes the close bond between this canvas and British painting, which Degas knew well and appreciated, having studied the British section at the 1867 Exposition Universelle at length. Indeed, the taste for scenes of interrupted middle-class intimacy that Degas indulged in *Bouderie* is encountered in the work of the Victorians, and also that of the French artists they influenced—for example Tissot, Stevens, and Toulmouche.

H.L.

1. This title was given to the painting when Degas left it with Durand-Ruel on December 27, 1885 (Durand-Ruel Archives, Paris).
2. Theodore Reff, *Degas, the Artist's Mind* (New York, 1976), pp. 116–20, 144, 162–64.
3. Reff 1985, notebook 25, pp. 36, 27, 39.

68 *Fig. 284*

Edgar Degas
L'Orchestre de l'Opéra (Portrait de Désiré Dihau)
(The Opéra Orchestra [Portrait of Désiré Dihau])
Ca. 1870
Oil on canvas
22¼ x 18¼ in. (56.5 x 46.2 cm)
Musée d'Orsay, Paris RF2417

CATALOGUES RAISONNÉS: Lemoisne 1946–49, vol. 2, no. 186; Minervino 1974, no. 286

PROVENANCE: Désiré Dihau, Paris, 1870 or 1871, until 1909; his sister, Marie Dihau, Paris, from 1909, until she sold it to the Musée du Luxembourg (along with a portrait of her by Degas [RF2416]) in 1924, retaining life interest and receiving a life annuity from the museum; entered the museum in 1935

EXHIBITIONS: Exhibited at Lille during the War of 1870, according to Lemoisne 1946–49, vol. 2, no. 186; Paris, Galerie Durand-Ruel, 1871(?); Paris, Galerie Georges Petit, 1924, *Exposition Degas*, no. 30, repr.; Paris, Musée de l'Orangerie, 1931, *Degas: Portraitiste, sculpteur*, no. 44; Philadelphia Museum of Art, 1936, *Degas 1834–1917*, no. 12, repr.; Paris, Musée de l'Orangerie, 1937, *Degas*, no. 9; Paris, Musée de l'Orangerie, 1969, *Degas: Oeuvres du musée du Louvre*; Paris, New York 1974–75, no. 12, repr.; Washington, National Gallery of Art, 1985, *Degas: The Dancers*, no. 1, repr.; Paris, Ottawa, New York, 1988–89, *Degas*, no. 97

SELECTED REFERENCES: Marcel Guérin, "Deux tableaux de Degas acquis par le musée du Luxembourg," *Beaux-Arts*, January 15, 1923, pp. 311–13; Paul Jamot, "Deux tableaux de Degas acquis par les musées nationaux, l'Orchestre et le Portrait de mademoiselle Dihau," *Le Figaro artistique*, January 3, 1924, pp. 2–4, repr.; Paul Jamot, "La peinture au musée du Louvre, École française, XIXᵉ siècle (pt. 3)," *L'Illustration*, 1928, pp. 54–57; Lillian Browse, *Degas Dancers* (London, 1949), pp. 21, 22, 28, 335–36, pl. 4; Jean Sutherland Boggs, *Portraits by Degas* (Berkeley, Calif., 1962), pp. 28–30, 90, nos. 40–42, pl. 60; Loyrette 1991, pp. 241–45

Marie Dihau, the sister of the bassoonist depicted here, who was also portrayed by Degas (Lemoisne 263, Musée d'Orsay, Paris), has supplied almost everything we now know about this painting, including its dating and the identities of the figures. Done shortly before the Franco-Prussian War of 1870, it is the result of the painter's intensive ex-plorations in the domain of the portrait (see pp. 225–26). No sooner was the picture completed than Degas, who was still considering changes, handed it over to his model for an exhibition in Lille (see pp. 225–26). Peeping out of the stage box is the head of the composer Emmanuel Chabrier, who was friends with Manet and Tissot. Then, appearing successively from left to right, are the violist Louis-Marie Pilet, whom Degas would portray alone (Lemoisne 188; Musée d'Orsay, Paris); and behind him, the Spanish tenor Lorenzo Pagans; and, crowned with curly white hair, Gard, "ballet master of the Opéra," about whom the archives are mute. Next, pensively playing the violin, sits the painter Alexandre Piot-Normand, Picot's pupil. Gazing toward the auditorium is the composer Souquet, according to Lemoisne, possibly the obscure Louis Souquet, who wrote a capriccio waltz for the piano in 1884. Then, facing the stage, we see a man called Dr. Pillot by Lemoisne and variously identified as a "medical student" or "amateur musician"—perhaps the musician Adolphe Jean Désiré Pillot, born in 1832 and admitted to the elementary class at the Paris conservatory in 1846.[1] In front of him, smack in the middle, sits the bassoonist Désiré Dihau, one year older than Degas; next is the flutist Henry Altès, whom Degas also portrayed alone (Lemoisne, 176; The Metropolitan Museum of Art, New York). Farther to the right are Zéphirin-Joseph Lancien and Jean-Nicolas Joseph Gout, violinists at the Opéra, and, finally, Albert Achille August Gouffé, first contrabass at the Opéra. It should also be noted that a tracing preserved in the records of the Musée d'Orsay, Paris, that identifies the figures indicates that "Mlle Parent probably posed for the ballerinas."[2]

It is a somewhat eclectic orchestra, in which the musicians are certainly in the majority, although they are not all instrumentalists (Pagans, Souquet). However, it also brings together obscure friends of Degas's: the mysterious Gard, whom the artist amicably calls a "tyrant" in a letter of November 11, 1872, to Dihau,[3] and the painter Piot-Normand, who frequented Auguste De Gas's Mondays on the rue de Mondovi. Degas probably met them, as he did Désiré Dihau himself, at a little eatery run by Mère Lefebvre on rue de la Tour d'Auvergne.[4]

The genesis of the *Orchestre de l'Opéra*, which is chiefly a portrait of Dihau, is difficult to trace. Marcel Guérin maintains that Degas initially wanted to paint a portrait of the bassoonist alone, and that he subsequently had the idea of surrounding him with an entire orchestra. But nothing in the studies—which, granted, are incomplete—bears out that hypothesis. The only extant compositional study, an oil on canvas (fig. 403), is markedly different from the present painting. Although of comparable size, it is horizontal, whereas the final work is vertical, and it shows the orchestra in a rigorously frontal view instead of at an angle. It also omits the wooden balustrade separating the orchestra from the first row of spectators and hints at a strictly horizontal stage in the upper part of the composition. Only the relatively detailed figure of Dihau blowing his bassoon and Gouffé's massive back, which is treated more sketchily, emerge from the confused mass of the orchestra. An X ray of the Orsay canvas also reveals how Degas changed his mind. The composition was originally larger, but he trimmed the sides and the top, thereby altering the relationship of the scene to the frame. The edge of the stage, which now cuts off the feet of the dancers, was raised sharply, and the balustrade of the pit was subsequently inserted. Some of the legs of the ballerinas were removed and others were added. Most importantly, however, three essential elements, which are barely visible in the X ray, seem to have been added only after Degas made his initial sketch: the harp floating at the left above the scramble of musicians; the box in which Chabrier is sitting; and, above all, the contrabassist Gouffé on his chair. These changes were preceded by a few graphite sketches Degas executed in two of his notebooks.[5]

In order to emphasize Dihau, the painter does not balk at changing Habeneck's traditional disposition of the orchestra in the pit. This he accomplishes by placing the bassoon, which is usually hidden behind a wall of alternating cellos and contrabasses, in the front.[6] This does not matter, for there are more important things: the strangeness of these huddling faces that conceal one another, of these lively fragments surging from the uniform blackness of the suits and the whiteness of the shirts—an eye, a bald pate, a shiny forehead, a tuft of curly hair, beards, mustaches, clean-shaven faces, sliced by the bows, cut by the neck of a cello, alert only to the music, playing imperturbably while legs and tutus move through the fairyland of the stage overhead. H.L.

Fig. 405. Edgar Degas, *L'Orchestre de l'Opéra*, ca. 1870. Oil on canvas, 19¾ x 24 in. (50 x 61 cm). The Fine Arts Museums of San Francisco

1. Archives Nationales, Paris, AJ³⁷ 353 (2).
2. "Mlle Parent a probablement posé pour les danseuses." Regarding the identities of the people, see Henri Loyrette, Paris, New York 1988, pp. 161–62.
3. Degas 1945, p. 20.
4. Marcel Guérin, "Deux tableaux de Degas acquis par le musée du Luxembourg." *Gazette des Beaux-Arts*, January 15, 1923, pp. 311–13; Paul Jamot, "Deux tableaux de Degas acquis par les musées nationaux, l'Orchestre et le Portrait de mademoiselle Dihau." *Le Figaro artistique*, January 3, 1924, pp. 2–4.
5. Reff 1985, notebook 24, p. 1; notebook 25, pp. 29, 33, 35.
6. *Rapport sur l'Opéra par M[onsieur] Garnier architecte* (Paris, n.d.), pièce 143 bis.

Eugène Delacroix

Charenton, Saint-Maurice, 1798–Paris, 1863

Delacroix participated in his final salon in 1859. Public recognition had come to him only recently with two events: the retrospective exhibition of his works—which was on a par with that of Ingres—had been mounted at the Exposition Universelle of 1855, and he had been elected to the Institut in 1857 after seven abortive candidacies. From 1859 to 1861 he chiefly focused on decorating the Chapelle des Saints-Anges in Saint-Sulpice, producing only a few paintings from that time until his death. Delacroix was unanimously admired by the artists of the New Painting—by the colorists, of course, but also by Degas, who, after discovering him through Gustave Moreau, regularly copied his works. In 1863–64 Fantin-Latour painted his *Hommage à Delacroix* (fig. 233) as a requiem, in which the portrait of the deceased is surrounded by several artists and writers who revered him: Duranty, Whistler, Champfleury, Manet, Baudelaire, Cordier, Legros, Bracquemond, and Balleroy.

CATALOGUES RAISONNÉS: Robaut 1885, no. 1376; Luigina Rossi Bortolatto, 1984 ed., no. 760; Johnson 1989, vol. 3, no. 334, pl. 142

PROVENANCE: Commissioned by Benoît Fould in March 1856 for Fr 6,000; when he died in July 1858, the picture was not finished, and his widow affirmed the commission; Mme de Sourdeval, Fould's niece, from 1892; Mme Charles Demachy, her daughter; Baronne Ernest Seillière, her daughter; bought from the heirs of Baronne Seillière by César de Hauke who sold it to the National Gallery in 1956.

EXHIBITIONS: Paris, Salon of 1859, no. 822 (Ovide en exil chez les Scythes / Les uns l'examinent avec curiosité, les autres lui font accueil à leur manière et lui offrent des fruits sauvages, du lait de jument, etc., etc. [Ovid in exile among the Scythians / Some examine him with curiosity; others welcome him in their manner, offering him wild fruits, mare's milk, etc., etc.]); Paris, boulevard des Italiens, 1861 (hors catalogue; added between June 1 and June 15); Paris, Musée du Louvre, 1930, *Delacroix*, no. 183; Edinburgh and London, The Art Council, 1964, *Delacroix*, no. 69, repr. fig. 36; Paris, Petit Palais, 1968–69, *Baudelaire*, no. 479, repr.

SELECTED REFERENCES: Astruc 1859, pp. 255–61; Aubert 1859, p. 145; Louis Auvray, *Salon de 1859* (Paris, 1859), pp. 19–20; A. de Belloy, "Salon de 1859. I," *L'Artiste*, April 17, 1859, p. 243; A. de Belloy, "Salon de 1859. III," *L'Artiste*, May 1, 1859, p. 3; Chaud-de-Ton, "Salon de 1859," *La Vérité*, May 4, 1859, p. 6; E.-J. Delécluze, "Exposition de 1859," *Le Journal des débats*, April 15, 1859, p. 1; Du Camp 1859, pp. 33–34; Dumas 1859, pp. 9–13, 47–48; Dumesnil 1859, p. 82; A.-J. Du Pays, "Salon de 1859," *L'Illustration*, May 21, 1859, p. 339; Victor Fournel, "Salon de 1859," *Le Correspondant*, May 1859, p. 157; Théophile Gautier, "L'exposition de 1859," *Le Moniteur universel*, May 21, 1859; Houssaye 1859, p. 295; Arsène Houssaye, "Eugène Delacroix," *L'Artiste*, May 29, 1859, p. 68; Louis Jourdan, *Les Peintres français: Salon de 1859* (Paris, 1859), pp. 34–35; Albert de La Fizelière, "L'Exposition à vol d'oiseau," *L'Artiste*, April 10, 1859, p. 231; Lépinois 1859, p. 196; Louis Leroy, "Le Charivari au Salon de 1859. VII," May 10, 1859, p. 5; Mantz 1859, p. 137; A. de Montaiglon, "La Peinture au Salon de 1859," *Revue universelle de l'art*, 1859, p. 442; Perrier 1859, p. 296; Jean Rousseau, "Salon de 1859," *Le Figaro*, May 10, 1859, p. 3; Paul de Saint-Victor, "Salon de 1859," *La Presse*, April 23, 1859, p. 2; Mathilde Stevens, *Impressions d'une femme au Salon de 1859* (Paris, 1859), pp. 32–33; Étienne Moreau-Nélaton, *Delacroix raconté by lui-même* (Paris, 1916), vol. 1, pp. 167, 192, fig. 387; Raymond Escholier, *Delacroix* (Paris, 1929), vol. 3, pp. 228, 249; Maurice Sérullaz, *Delacroix* (Paris, 1981), p. 148, repr.; Wolfgang Drost and Ulrike Henninges, *Théophile Gautier: Exposition de 1859* (Heidelberg, 1992), p. 34, repr. fig. 26

Delacroix's entries at the Salon of 1859, the last the painter took part in, received a conventional welcome; people celebrated the great old artist more than they appreciated the disturbing innovations of his eight canvases in small and medium formats (see p. 10). The landscape in the *Ovide en exil chez les Scythes* was unanimously praised, perhaps to hide the embarrassment caused to many by the "fantastic mare"[1] in the foreground—which Théophile Gautier called "the female of the Trojan horse."[2] Du Camp, saddened by this "spectacle of unpardonable decadence," advised the painter "to return to the literary works that he loves and to the music for which he was certainly born."[3]

But Charles Baudelaire and Zacharie Astruc waxed enthusiastic. Astruc, penning his first review of a Salon, extolled all the details in the painting: Ovid, "What noble elegance!"; the mare, "what color and what an air about her"; the dog, which recalled "ancient sculptures"; even the water, which was "exquisitely beautiful"; and, above all, the landscape: "The mind will not surpass this even in its most magnificent aspirations."[4]

69 *Fig. 12*

Eugène Delacroix
Ovide en exil chez les Scythes
(*Ovid among the Scythians*)
1859
Oil on canvas
34½ x 51¼ in. (87.6 x 130.2 cm)
Signed and dated: Eug. Delacroix. 1859
The Trustees of the National Gallery, London
NG 6262

Fig. 406. Edgar Degas, copy after *Ovide en exil chez les Scythes* by Delacroix. Pen, brown ink, and gray wash, 10 x 7½ in. (25.4 x 19.2 cm). Bibliothèque Nationale, Paris

As for Baudelaire, who was obviously more sensitive to the theme of the exiled poet, he lauded the Ovid as "one of those astonishing works that Delacroix alone can conceive and paint."[5]

It was in March 1856 that the politician and great connoisseur Benoît Fould, whose brother was Achille Fould, minister to Napoleon III, commissioned this painting from Delacroix;[6] the artist had already treated this strange subject in the fifth bay of the library of the Palais-Bourbon, which he described as follows: "*Ovid in exile. The sad poet is sitting on the cold, bare ground in a barbaric land. A Scythian family is offering him simple gifts: mare's milk and wild fruit.*"[7] Yet Ovid does not mention Scythian hospitality either in the *Tristia* or the *Epistles from Pontus*; instead, he bewails the conjoined hostility of the populace, the soil, and the climate. But Delacroix, resurrecting the image of the banished poet and scanning Herodotus for details on the mores and morphology of those shores, transforms the ancient episode into an autobiographical meditation: "A framework for the account of the feelings of a heart and of a sick imagination—that of a man who, after living a sophisticated existence, suddenly finds himself a slave among the barbarians or stranded on a desert isle like Robinson Crusoe, compelled to use the strength of his body and the force of his industry."[8] At the end of his life, Delacroix carried his meditation on exile further by exploring new reflections on extreme barbarity and extreme refinement and expressing his regrets about the loss of untouched landscapes in the face of technological progress. Civilized man, destroying nature and reviling poets, had nothing to envy in the savages of Pontus.

After visiting the Salon, Degas copied the painting from memory in wash and ink (fig. 406); making use of a technique comparable to that of the master, he created an unfaithful but subtle copy that could have been a preparatory drawing from Delacroix's own hand.

H. L.

1. "cavale fantastique." Louis Jourdan, *Les Peintres français, Salon de 1859* (Paris, 1859), p. 35.
2. "la femelle du cheval de Troie." Gautier 1859, p. 35.
3. "spectacle d'une irrémissible décadence."; "retourner maintenant aux travaux littéraires qu'il aime et à la musique pour laquelle il était certainement né." Du Camp 1859, p. 34.
4. "quelle noble élégance!"; "quelle couleur et quel air autour d'elle"; "sculpteurs antiques"; "d'une exquise beauté"; "L'esprit dans ses plus magnifiques aspirations ne vas pas au-delà." Astruc 1859, pp. 260–61.
5. "une de ces étonnantes oeuvres comme Delacroix seul sait les concevoir et les peindre." Baudelaire 1975–76 (and 1985–87), vol. 2, p. 636.
6. "*Ovide en exil*. Il est assis tristement sur la terre nue et froide, dans une contrée barbare. Une famille scythe lui offre de simples présents, du lait de jument et des fruits sauvages." Delacroix 1980, p. 571.
7. Quoted in Maurice Sérullaz, *Mémorial de l'exposition Eugène Delacroix organisée au musée du Louvre à l'occasion du centenaire de la mort de l'artiste* (Paris 1963), p. 274.
8. "Cadre pour l'histoire du sentiment d'un coeur et d'une imagination malade celle d'un homme qui après avoir vécu de la vie du monde se trouve devenu esclave chez les barbares, ou jeté dans une île déserte comme Robinson, forcé d'user des forces de son corps et de son industrie." Delacroix 1980, p. 839.

Henri Fantin-Latour

Grenoble, 1836–Buré, 1904

The son of a painter and of a mother of Russian ancestry, Fantin-Latour received artistic training from his father starting at the age of ten. In 1850, despite his youth, he was allowed to take evening courses at the Petite École de Dessin on rue de l'École de Médecine in Paris. From 1851 to 1854, the year he studied briefly at the École des Beaux-Arts, he frequented the studio of Lecoq de Boisbaudran, who based his instruction on visual memory. As reported by Léonce Bénédite: "Lecoq had a very unusual teaching method, and its consequences are noticeable in all his pupils. He focused on the early development of their memory of images; to this end, he exercised their faculties of observation to the utmost by getting them into the habit of concentrating on the essentials of all things. He would often send his pupils out into nature and he would very frequently send them to the Louvre to do drawings, which they had to redo from memory once they were back at the school."[1] Starting in 1852, Fantin copied the masters at the Louvre—a practice he pursued throughout the 1860s. It was at the Louvre that he met Manet in 1857 and Whistler in 1858, rapidly becoming their friend and confidant.

For the biography of Fantin-Latour during the 1860s, see the chronology.

1. Léonce Bénédite, *Catalogue des oeuvres exposées d'Alphonse Legros*, exh. cat., Musée National du Luxembourg, Paris, 1920, p. 17.

70 *Fig. 234*

Henri Fantin-Latour

Les Deux Soeurs
(*The Two Sisters*)
1859
Oil on canvas
38⅝ x 51³⁄₁₆ in. (100.3 x 130 cm)
Signed and dated lower left: Fantin 59
The Saint Louis Art Museum, Museum Purchase
8:1937

CATALOGUE RAISONNÉ: Fantin-Latour 1911, no. 114 (Les deux Soeurs or les Brodeuses)

PROVENANCE: Mme Victor Klotz, Paris, by 1903; Tooth & Sons, London; Mme Gillou, Paris; Jacques Seligmann,

New York; acquired by the Saint Louis Art Museum, 1937

EXHIBITIONS: Refused at Salon of 1859 but exhibited during the Salon at the atelier of François Bonvin (see Denney 1993, p. 100–102); Paris, Musée du Luxembourg, 1903; Paris, École nationale des Beaux-Arts, 1906, *Exposition de l'oeuvre de Fantin-Latour*, no. 23 (Les deux soeurs); Northampton, Mass., Smith College Museum of Art, *Fantin-Latour*, 1966, no. 3, repr.; Cleveland Museum of Art, New York, Brooklyn Museum, Saint Louis Art Museum, Glasgow Art Gallery, 1980–82, *The Realist Tradition: French Painting and Drawing 1830–1900*, no. 71; Paris, Grand Palais, Ottawa, National Gallery of Canada, and San Francisco, California Palace of the Legion of Honor, 1982–83, *Fantin-Latour*, no. 20

SELECTED REFERENCES: Léonce Bénédite, "Un tableau de Fantin-Latour," *Revue de l'art ancien et moderne* 2 (1902), pp. 95–101, repr. as engraving; Meyric R. Rogers, "The Two Sisters," *Bulletin of the City Art Museum of Saint Louis* 12:2 (April 1937), pp. 14–16; Denney 1993, pp. 100, 102

In early 1859 Fantin-Latour completed this double portrait of his sisters, Marie, the blonde, and Nathalie, the brunette. This was the last time they would be together: in October Nathalie would be committed for dementia praecox in Charenton, where she vegetated until her death half a century later. According to Douglas Druick, one of the sources of this composition is Seymour Haden's etching *Woman Reading* of 1858. The engraver gave the only proof to his brother-in-law, Whistler, shortly after the American painter met Fantin.[1] However, it is even more important to note the relationship between *Two sisters* and Whistler's contemporary investigations: in *At the Piano* (fig. 3), the American uses a similar composition, presenting the musician in strict profile and punctuating the space with framed pictures, and relies on an equally reduced range of colors. These canvases were prototypes not only of the paintings on related themes that the two artists would reiterate throughout the decade but also of works by Manet (cat. 109), Degas (fig. 237), and Cézanne (cat. 28): calm, attentive pictures that are both portraits and family scenes, tenderly devoted to the domestic universe we find when we return home.

By 1859 a part of Fantin's universe was complete; until the end of his life, he would move back and forth among several areas, concerning himself with comfortable intimacy that was often touching and introspective, sometimes doleful and drowsy; the tranquil description of dear people and inanimate objects; and the highly colored, sweeping fantasies that aroused his imagination. Thus in *Les Deux Soeurs* he evokes the sober dresses of the two girls, the prim and proper atmosphere of this cozy interior, and the stridency of the blue, red, and green skeins of wool; in years to come such effects would no longer be in fashion.

Fantin's canvas, like his friend Whistler's *At the Piano*, was rejected by the Salon of 1859; however, Bonvin retrieved both paintings and showed them on the wall of his "Flemish studio" "among the expertly arranged pitchers and tin plates" (see p. 19).[2] Early in this century, Léonce Bénédite very astutely saw the start of the Impressionist

381

revolution in this modest display. Fantin's "simple, contemplative interior," rejecting the picturesque, renouncing the usual simperings of genre scenes, deliberately used a "familiar, ordinary subject." To Bénédite's mind, that modest presentation in a studio far from faubourg Saint-Jacques marked a step as important as that represented by *Déjeuner sur l'herbe* at the rowdy Salon des Refusés: "We who have grown up since 1859 have learned to prefer simple images of our own lives to all the grandiloquent lies of the false restorations of the past. And so this painting by a young man who was then shy and unknown, who signed a masterpiece without knowing he had done so, touches and delights us as much as yesterday's masterworks; and it does this with its candor and simplicity, its intense and restrained feeling of the intimacy of life, which it helps us to understand and love all the more."[3]

H.L.

1. Douglas Druick in Paris, Ottawa, New York 1982–83, p. 92.
2. "atelier flamand"; "parmi les pichets et les plats d'étain savamment rangés." Léonce Bénédite, "Un tableau de Fantin-Latour" *Revue de l'Art ancien et moderne* 12 (July-December 1902), p. 99.
3. "l'intérieur simple, recueilli"; "sujet médiocre et familier"; "Et c'est pourquoi nous qui avons grandi depuis 1859 et qui avons appris à préférer à tous les mensonges grandiloquents de fausses restitutions du passé la simple image de notre propre vie, ce tableau du jeune homme, alors timide et inconnu, qui signait, sans s'en douter, une oeuvre de maître, nous touche-t-il et nous ravit-il à l'égal des chefs-d'oeuvre d'autrefois, par son accent de candeur et de simplicité, son sentiment intense et contenu de l'intimité de la vie qu'il contribue à nous faire comprendre et aimer davantage." Ibid., p. 101.

71

Fig. 58

Henri Fantin-Latour
Scène du Tannhäuser
(*Tannhäuser on the Venusberg*)
1864
Oil on canvas
38 7/16 x 51 5/16 in. (97.5 x 130.2 cm)
Los Angeles County Museum of Art, Gift of Mr. and Mrs. Charles Boyer 59.62

CATALOGUE RAISONNÉ: Fantin-Latour 1911, no. 233

PROVENANCE: Bought for Fr 2,000 by Alexander Ionides, London, 1864; Rosenberg collection, Paris, by 1906, until 1911; F. Gérard, Paris, after 1911; Montague Napier col-

lection, London; Mrs. R. A. Workmann, London, until 1924; sold by her, Christie's, London, May 9, 1924, no. 47, repr.; bought for £1,260 by Paul E. Cremetti, London; Cyril Davis, London until 1951; his sale, Christie's, London, May 4, 1951, no. 25; bought by the Marlborough Gallery, London (£540 or £567); Mr. and Mrs. Charles Boyer, Los Angeles; their gift to the Los Angeles County Museum, 1959

EXHIBITIONS: Paris, Salon of 1864, no. 678 (Scène du Tannhäuser); Paris, École nationale des Beaux-Arts, 1906, *Exposition de l'oeuvre de Fantin-Latour*, no. 151 (Tannhäuser); London, Marlborough Gallery, 1951, *French Masters of the Nineteenth and Twentieth Centuries*, no. 23; Philadelphia, Detroit, Paris, 1978–79, no. 218; Paris, Ottawa, San Francisco, 1982–83, no. 50

SELECTED REFERENCES: Théophile Gautier, "Salon de 1864," *Le Moniteur universel*, June 25, 1864, p. 1; Charles Baudelaire, letter to Philippe de Chennevières, March 1864, and letter to Fantin-Latour, March 22, 1864, in Baudelaire 1973, vol. 2, pp. 350–51 and nn. pp. 844–45; Larry Curry, "Henri Fantin-Latour's Tannhäuser on Venusberg," *Los Angeles County Museum of Art Bulletin* 16:1 (1964), pp. 3–19, repr.; Andrea Heesemann-Wilson, "Henri Fantin-Latour Rheingold," *Jahrbuch der Hamburger Kunstsammlungen* 25 (Hamburg, 1980), pp. 103–15, fig. 3; Mary Tompkins Lewis, *Cézanne, 1988–1989*, p. 49 repr.

In March 1864 Baudelaire asked Philippe de Chennevières to find "good locations" for the canvases that were sent to the salon by Manet and Fantin. Manet had the advantage of being an old and close friend of the poet's, while Fantin was a recent acquaintance, who would never become an intimate. But that year Fantin had submitted paintings that touched Baudelaire directly: *Hommage à Delacroix* (fig. 233), which included the poet's portrait, and *Scène du Tannhäuser*. These works celebrated two artists whom Baudelaire had strongly defended—Delacroix, who inspired Fantin as much as the Venetians did, and Wagner, who supplied the Tannhäuser motif. Having seen them in Fantin's studio, Baudelaire praised their "marvelous qualities" to the Salon's "upholsterer."[1]

We do not know whether Baudelaire's recommendation had any effect. *Hommage à Delacroix* drew critical attention, while *Scène du Tannhäuser* attracted less notice. In discussing the canvases by "this gaggle of painters known as realists," whom he described as "fantasists of ugliness" rather than "exact imitators of nature," Théophile Gautier had a few mixed remarks about the Wagnerian picture: "This is nothing but an impetuously scrawled sketch, a hot debauch of the palette, a series of juxtaposed *splotches*; yet many patiently polished and rigorously tidy works cannot hold a candle to this mess of colors, in which one glimpses a born painter."[2] "Debauch of the palette" and "juxtaposed splotches" were some of the very terms that a good number of critics applied to Manet's oeuvre.

An imaginary subject, a brilliant, sonorous, and highly colored counterpoint to the patient and discreet "études" and still lifes that are the other side of Fantin's art, the *Scène du Tannhäuser* is one of many testimonies to the fervent Wagnerism of the 1860s. With more or less passion, most of the artists of the New Painting sacrificed to this

deity; Degas himself, so reticent in this area afterward, paid tribute to Wagner in his portrait, painted after a photograph, of Princess von Metternich, the instigator of the Paris performances of *Tannhäuser* (Lemoisne 89; National Gallery, London). Fantin polemically renders the Venusberg scene of the opera, which was created in Dresden in 1845 and revised for Paris in 1861. This scene was the chief reason for the opera's failure; against all advice, Wagner had decided to place the indispensable ballet, which the audience craved, in act 1, right after the long overture. He thereby infuriated the subscribers, who wished to applaud their protégées, the ballerinas, but were used to coming to the theater late in the evening, after the first act.[3] Not only was Fantin's *Scène du Tannhäuser* a fiery attack on the stupidity of the elegant public, it was also autobiographical: for the painter himself echoed Tannhäuser's wavering between Venus and Elisabeth, between "the ardent embrace, the blissful heat of Love" and a reclusive life of labor, between forgetfulness of self and of time and the patient, daily, measured building of his personality.[4]

The painter was not reconstructing Wagner's *Tannhäuser* in his canvas, for he had, in fact, missed the fourth performance, which he was supposed to attend, because it was canceled due to the opera's resounding failure. Fantin's Tannhäuser, a brother to Delacroix's Faust, is a dreamer in a landscape that, despite its many beauties, ignores the libretto's description: "A vast grotto curving toward the background, stage right.... A waterfall spurts and plunges across the entire top of the grotto.... To the left, the grotto opens at its top: a soft, rosy mist settles in from that orifice, under which, Venus, stage front, reclines on a richly decorated couch."[5] The setting does, however, recall the late, morphologically incomprehensible landscapes used by the painter of *Ovide en exil chez les Scythes*.

H.L.

1. "les merveilleuses qualités"; "tapissier." Baudelaire 1973, vol. 2, pp. 350–51.
2. "ce cénacle de peintres qu'on nomme réalistes"; "fantaisistes en laid"; "imitateurs exacts de la nature"; "Ce n'est guère qu'une esquisse fougueusement barbouillée, une chaude débauche de palette, une suite de *taches* juxtaposées; mais bien des oeuvres patiemment polies et d'une propreté rigoureuse ne valent pas ce gâchis de couleurs où se devine le peintre né." Théophile Gautier, "Salon de 1864," *Le Moniteur universel*, June 25, 1864, p. 1.
3. The fundamental study of the Paris version of Wagner's opera is Carolyn Abbate, "The Parisian 'Vénus' and the 'Paris' Tannhäuser," *Journal of the American Musicology Society* 36, no. 1 (1983), pp. 73–123.
4. Regarding this subject, see Douglas Druick's apt remarks in Paris 1982, p. 158, and Mary Tompkins Lewis, "La Littérature, la musique et les thèmes de l'oeuvre de jeunesse de Cézanne," in London, Paris, Washington, 1988–89, p. 48.
5. "Une vaste grotte s'incurvant dans le fond vers la droite.... une cascade jaillit et chute sur toute la hauteur de la grotte.... À gauche, la grotte s'ouvre vers le haut: une douce vapeur rosée tombe de cet orifice, sous lequel, à l'avant-plan, Vénus est étendue sur une couche richement parée."

72 *Fig. 212*

Henri Fantin-Latour
Fleurs de printemps, pommes et poires
(*Still Life with Flowers and Fruit*)
1866
Oil on canvas
28¾ x 23⅝ in. (73 x 60 cm)
Signed and dated upper left: Fantin. 1866
The Metropolitan Museum of Art, New York, Purchase,
Mr. and Mrs. Richard J. Bernhard Gift, by exchange,
1980 1980.3

CATALOGUE RAISONNÉ: Fantin-Latour 1911, no. 288 (Nature morte)

PROVENANCE: One of a series of four pictures commissioned by Michael Spartali, London, in 1866. He found them too much alike and only paid for two; the two others were bought by Stravros Dilberoglou in 1867. It is not known whether the present picture belonged to Spartali or to Dilberoglou from 1867; Tempelaere, Paris; L. H. Lefèvre. Ltd., London; sale, Paris, Galerie Georges Petit, May 22, 1919, no. 16, repr.; bought for Fr 34,000 by Graat et Madoulé for Calouste Gulbenkian; M. Cayrol, Paris, from 1948; Mme Joel Hardion, Paris, until 1979; Galeries Robert Schmidt, Paris, David Carritt Ltd., London, and Reid and Lefèvre, London, 1979–80; acquired by the Metropolitan Museum, 1980

EXHIBITIONS: Paris, Ottawa, San Francisco, 1982–83, no. 36

SELECTED REFERENCES: Charles S. Moffet and Anne Wagner, *Metropolitan Museum of Art, Notable Acquisitions: 1979–1980* (New York, 1980), pp. 43–44, repr.

Starting in the mid-1860s, Fantin-Latour's still lifes, sought after by an already loyal clientele in France and especially England (see p. 150), grew more ample and more decorative. At the Salon of 1865 he showed a composition comparable to the present painting except for its oblong format (Fantin-Latour 285; National Gallery of Art, Washington), which elicited a lukewarm response. A few painter friends apparently regretted his abandonment of simple, unaffected motifs in favor of an ornamental art. Edmond About reproached him for "the neutral background [that] undermines the fruits and flowers" and for the size of the canvas, which was too big for such a limited subject.[1] But none of this carping discouraged Fantin, and the following spring he presented this variation on the Salon painting of 1865, along with three other still lifes, to one of his collectors in London's Greek colony, who had requested them. However, the group of four pictures was

not well received by his client, Michaël Spartali, who found them too much alike and accepted only two. In 1867 another Greek collector in London, Stavros Dilberoglou, acquired the two rejected canvases after some hard bargaining. We do not know which lot included the present painting. This painful affair signaled the beginning of the gradual disenchantment of Fantin's British clientele: he would be berated—most vociferously by his friend Legros—for constantly rehashing his subject matter and forever reproducing "the same fruits, the same flowers, the same vases."[2]

H.L.

1. "le fond neutre [qui] fait tort aux fleurs, aux fruits." Quoted by Douglas Druick in Paris, Ottawa, New York 1982–83, p. 128.
2. "toujours les mêmes fruits, les même fleurs, les mêmes vases." Mme Legros, quoted by Douglas Druick, in ibid., p. 130.

73 *(New York only)* *Fig. 213*

Henri Fantin-Latour
Nature morte aux fiançailles
(*The Betrothal Still Life*)
1869
Oil on canvas
12⅝ x 11⅜ in. (32 x 29 cm)
Signed and dated upper right: Fantin 1869
Musée de Grenoble MG 2490

CATALOGUE RAISONNÉ: Fantin-Latour 1911, no. 325 (Nature morte)

PROVENANCE: Given by Henri Fantin-Latour to Victoria Dubourg, his fiancée; her bequest to the Musée de Peinture et de Sculpture, Grenoble, 1921

EXHIBITIONS: Grenoble, Musée-Bibliothèque, 1936. *Centenaire de Henri Fantin-Latour*, no. 120; Grenoble, Musée de Peinture et de Sculpture, 1977. *Fantin-Latour: Une famille de peintres au XIXᵉ siècle*, no. 39; Paris, Galeries nationales du Grand Palais, Ottawa, National Gallery of Canada, San Francisco, California Palace of the Legion of Honor, 1982–83. *Fantin-Latour*, no. 38

SELECTED REFERENCES: Paul Claudel, *Journal*, June 12, 1930 (Paris, 1962), vol. 1, p. 217

In the spring of 1869 the regulars who visited the small Morisot clan, noticing a change in Fantin-Latour's attitude, blamed it on the open secret of his new intimacy with Victoria Dubourg. Fantin,

like so many people, was rendered stupid by love.[1] To mark the start of his long engagement to the woman who did not become his wife until November 1876, he presented his fiancée with this still life: "spring flowers in a white and blue coneshaped vase and strawberries in a small, white compote; on the table, a white camellia, two cherries, and a strawberry, a wineglass containing wine.[2]

The artist's intention was obviously delicate and loving, but it was also an homage to his discreet and exclusive talent as a painter of still lifes. The picture was shown for the first time at the Salon in 1869, the same year he painted it. Returning to the simple compositions of his first works, Fantin relaxes his subtle but deliberately muted harmonies, calling upon all the colors in the prism to celebrate his beloved.

H.L.

1. Fantin-Latour 1911, no. 325.
2. "Dans un cornet blanc et bleu, des fleurs de printemps et des fraises dans un petit compotier blanc; sur la table, un camélia blanc, deux cerises et une fraise, un verre à pied contenant du vin." Morisot 1950, p. 29.

74 *Fig. 232*

Henri Fantin-Latour
Un atelier aux Batignolles
(*A Studio at Les Batignolles*)
1870
Oil on canvas
80⅜ x 107⅝ in. (204 x 273.5 cm)
Signed and dated lower left: Fantin. 70
Musée d'Orsay, Paris RF 729

CATALOGUE RAISONNÉ: Fantin-Latour 1911, no. 409 (L'Atelier aux Batignolles)

PROVENANCE: Purchase negotiations with French government interrupted by the War of 1870; acquired by Mme Edwin Edwards, 1871; acquired by the French government for the Musée du Luxembourg, Paris, 1892; Musée du Louvre, Paris, 1931; Musée du Jeu de Paume, Paris, 1946; Musée d'Orsay, Paris, 1986

EXHIBITIONS: Paris, Salon of 1870, no. 10,000 (Un atelier aux Batignolles), third class medal; Paris, École nationale des Beaux-Arts, 1906. *Exposition de l'oeuvre de Fantin-Latour*, no. 35; Paris, Musée du Louvre, 1976. *Technique de la peinture: L'Atelier*, Dossier du département des

peintures no. 12, no. 156, repr.: Paris, Ottawa, San Francisco, 1982–83, no. 73 and p. 200

SELECTED REFERENCES: Zacharie Astruc, "Le Salon," L'Écho des Beaux-Arts, June 5, 1870, p. 3; Frédéric Bazille, letter to his mother, between January 13 and 19, 1870, in Bazille 1992, no. 130, p. 184; Bertall, "Promenade au salon de 1870," Le Journal amusant, May 21, 1870, p. 4; Philippe Burty, "Le Salon, III," Le Rappel, May 11, 1870, pp. 2–3; Marius Chaumelin, "Salon de 1870," La Presse, June 21, 1870, p. 3; Edmond Duranty, "Le Salon de 1870," Paris-Journal, May 8, 1870, p. 2, and May 19, 1870, p. 2; Théodore Duret, "Le Salon," L'Électeur libre, June 2, 1870, p. 85; E. d'H. [Hervilly], "Salon de 1870. Croquis rimés," Paris-Caprice 1870, p. 759; Louis Leroy, Le Charivari, May 19, 1870, p. 3; René Ménard, "Salon de 1870," Gazette des Beaux-Arts, June 1, 1870, pp. 506–7; letters from Fantin to Edwards, 1870–71, in Adolphe Jullien, Fantin-Latour (Paris, 1909), pp. 36, 72–75; Léonce Bénédite, "Les artistes contemporains," Revue de l'art ancien et moderne, 1899, pp. 1–8, repr. p. 5; Léonce Bénédite, "À propos des Peintres-lithographes: Deux nouvelles oeuvres de Fantin-Latour," Revue de l'art ancien et moderne 14 (1903), p. 379; Jacques-Émile Blanche, Propos de peintre (Paris, 1919), pp. 29, 31–32; Raymond Bouyer, Fantin-Latour et ses modèles (Paris, 1928), pp. 282–83; Gabriel P. Weisberg, "Fantin-Latour and Still Life Symbolism in 'Un atelier aux Batignolles'," Gazette des Beaux-Arts, December 1977, pp. 205–15; Reff 1982, p. 29

This is the third of the great homages that Fantin-Latour painted during the 1860s; he had celebrated Delacroix in 1864 (fig. 233) and had exalted Truth in 1865. The failure of the latter canvas, shown as Le Toast! at the Salon, had a dreadful effect on the artist. Nevertheless, he immediately began musing and making countless compositional studies in an album,[1] on the theme that would become Un Atelier aux Batignolles five years later. In late August 1869 he took up his old idea and, by mid-October, he had a clear vision of the future composition: "I am going to muse about resuming an active life, I am thinking of the Salon. I am beginning to do pencil sketches of projects. I am giving a lot of thought to a large painting . . . showing Manet, at the center, painting at his easel, his model posing in front of him, the two of them surrounded by friends, acquaintances, a lot of people in the studio. This strikes me as a fine, picturesque motif."[2]

A few months later, at the Salon of 1870, the informal and "picturesque" throng around Manet became the very official Un Atelier aux Batignolles.

In a room that is more like a starchy middle-class parlor or an art gallery than an artist's studio, Zacharie Astruc is having his portrait painted by Manet, the "head of the Batignolles school"; also present are Otto Scholderer, Renoir, Émile Zola, Edmond Maître, Bazille, and Monet. Some of them are in the light and some in shadow (Maître, Monet partly concealed by Bazille's tall form). Some are following the painter's work and some are looking elsewhere (Zola, Maître, Monet). There is Renoir, attentive and discreet, enclosed in a large gilded picture frame, which transforms his modest likeness into the portrait of a master. There is the very tall Bazille, elegant in his checked trousers and with the white handkerchief in his jacket. There are painters and also two writers—

Zola and Astruc—who represent the new criticism of the New Painting. There is even a dilettante, Maître, an employee at city hall and an intimate friend of Bazille's, representing no one but himself—the cultivated art lover, agreeable companion, and talented musician who proclaims his passion for Schumann and Wagner. And then there are the absent ones—starting with Fantin himself, who appeared in the two earlier homages. A few certainly had good reasons for not posing; others were not asked. Thus, Degas is conspicuously missing; although a friend of Fantin's and Manet's, he despised the kind of solemnity shown here and probably did not wish to appear as the disciple of the latter painter.

At any rate, in 1870, this homage to Manet, which he deserved for his impact on the decade, was not a fair assessment of the contemporary artistic situation. Renoir and Bazille were flying on their own wings, while Monet, marginalized as if he were an afterthought added in the interest of having a complete family photograph, inspired Manet more than he was inspired by him. On a table, three objects pinpoint the ambitions and tastes of the sitters: Laurent Bouvier's Japanese lacquer and the Japanesque ceramic pot testify to an interest in Japan, while the plaster Minerva symbolizes both Truth, which Fantin sought, and Reason, which condemns all emotionality.[3]

Atelier aux Batignolles, characterized by Pierre Georgel as "clean, orderly, and nonpicturesque," appears "to confirm serious conceptions as well as a healthy simplicity of style."[4] It was favorably received at the Salon of 1870, even if many observers found it displayed the stiltedness of a "cluster of people posing for a photographer."[5] Marius Chaumelin praised "the breadth of execution, the harmony of color, the truth and precision of the attitudes, the sincerity of expression," and hoped that "all the young painters of the guild of Batignolles [would] produce this kind of realism."[6] Although he bewailed the "embarrassment" of all the men called up by Fantin "one after another to take their places in the painting," Philippe Burty nevertheless underscored the veracity of the postures: "All these young, intelligent men—artists, writers, or art lovers—have the exact gestures and bearing of their professions or characters. This is a very contemporary gathering, living a life of its own as well as the general life of its time."[7] There was only one discordant voice—that of Duranty, who took advantage of this opportunity to savage Fantin's entire oeuvre perfidiously: "He has nervously stuck a foot in a somewhat dull genre, which is traversed by overly brusque cool winds and blindingly bright lights. He executes his work in a manner that is both swift and complicated, and he still has not found what he really wants to do." Duranty's conclusion was murderous but not without substance: "He strikes me as being an artist locked up in a bourgeois, unable to break out of his shell, so that neither of his two natures wins and both thwart each other."[8]

H.L.

1. See Paris, Ottawa, New York 1982–83, pp. 191–94.
2. "Je vais songer à reprendre la vie active, je pense au Salon. Je commence à crayonner des projets. Je pense beaucoup à un grand tableau . . . représentant au centre Manet peignant à son chevalet, devant lui son modèle posant, à côté de lui et autour, des amis, des connaissances, du monde dans l'atelier. Cela me paraît un joli motif de pittoresque." Fantin-Latour's letter to Edwin Edwards, October 15, 1869, in Adolphe Jullien, Fantin-Latour (Paris, 1909), pp. 74–75.
3. Gabriel P. Weisberg, "Fantin-Latour and Still Life Symbolism in Un atelier aux Batignolles," Gazette des Beaux-Arts, December 1977, pp. 205–15.
4. Pierre Georgel in Technique de la peinture l'Atelier, exh. cat., Musée du Louvre, Paris, 1978, pp. 47–48.
5. "net, ordonné, sans pittoresque"; "Garantir le sérieux des conceptions, la simplicité du style"; "réunion de portraits posants devant un photographe." René Ménard, "Salon de 1870," Gazette des Beaux-Arts, June 1, 1870, p. 506.
6. "la largeur de l'exécution, l'harmonie de la couleur, la vérité et la justesse des attitudes, la sincérité de l'expression. . . . à tous les jeunes peintres de la gilde des Batignolles de faire du réalisme dans ce goût-là." Marius Chaumelin, "Salon de 1870," La Presse, June 22, 1870, p. 2; similar statements were made by Théodore Duret, "Le Salon, III. Les Portraitistes," L'Électeur libre, June 2, 1870, p. 85.
7. "embarras"; "l'un après l'autre, à venir prendre place dans le tableau"; "Tous ces hommes, jeunes et intelligents, artistes, gens de lettres ou amateurs d'art, ont bien l'attitude et le geste de leur profession ou de leur caractère. C'est une réunion bien contemporaine, vivante de la vie propre et de la vie générale de son temps." Philippe Burty, "Le Salon, III. Les Portraitistes," Le Rappel, May 11, 1870, pp. 2–3.
8. "Il a posé avec inquiétude le pied dans un genre un peu sourd, que traversent des fraîcheurs trop brusques, des vivacités de lumière aigres. Il exécute son travail d'une façon à la fois compliquée et rapide, et n'a pas encore trouvé ce qui lui plaisait réellement à faire."; "Il me fait l'effet d'un artiste enfermé dans un bourgeois, et ne pouvant percer son enveloppe, de sorte qu'aucune des deux natures ne l'emporte et que toutes deux se contrarient." Louis Duranty, "Le Salon de 1870," Paris-Journal, May 8, 1870, p. 2.

Hippolyte Flandrin

Lyons, 1809–Rome, 1864

The second in a trio of painter brothers, between Auguste (1804–1842) and Paul (1811–1902), Hippolyte Flandrin studied with Pierre Henri Révoil at the École des Beaux-Arts in Lyon. In 1829 he and his brother Paul moved to Paris, where Hippolyte entered the École des Beaux-Arts to study under Ingres, becoming his most loyal and most gifted disciple. Winning his first Prix de Rome in 1832, Flandrin lived at the Villa Medici from 1833 to 1838 under the successive directorships of Horace Vernet and Ingres. After returning to France, Flandrin essentially divided his time between portraits and church decoration. He worked in Paris at Saint-Séverin (1839–41), Saint-Germain-des-Prés (1839–63), and Saint-Vincent de Paul (1848–53); and also in Nîmes at Saint-Paul (1846–49) and in Lyon at Saint-Martin d'Ainay (1855).

During the summer of 1855 Degas, then a pupil of Louis Lamothe and Hippolyte Flandrin's assistant on the scaffold at Saint-Martin d'Ainay,

went to Lyon to visit his teacher. Scholars would like to confirm that Degas helped paint the decorations at Saint-Martin d'Ainay, but there is no evidence to this effect aside from a sketch of the church interior in a notebook he kept at that time.[1] Flandrin's official career in church decoration resulted in his election to the Académie des Beaux-Arts in 1853; yet he intensely pursued his parallel activity as a portraitist. His successes in this area, notably his triumph at the Salon of 1859 with his *Portrait of Mlle M[aison]* (cat. 75), led to commissions for two masterpieces depicting imperial France—his *Portrait de S.A.I. le prince Napoléon* (fig. 227) and the *Portrait de l'empereur Napoléon III* (Musée National du Château, Versailles), shown, respectively, at the Salon of 1861 and the Salon of 1863. In 1863 Flandrin, like Ingres, reacted very sharply against the plan to reform the École des Beaux-Arts (see chronology, p. 309). The following year he died in Rome—"a sudden stroke, completely unforeseen and affecting everyone."[2] Tributes were now paid to him: the École des Beaux-Arts mounted a major Flandrin retrospective exhibition from February 15 to April 1, 1865; and in 1866, at the initiative of a committee chaired by comte Walewski, a monument to the painter, designed by the sculptor Oudiné and the architect Baltar, was erected at Saint-Germain-des-Prés.

1. Reff 1985, notebook 3, p. 14; see Loyrette 1991, pp. 64–65.
2. "coup soudain, imprévu de tous et dont chacun s'est senti atteint." Émile Saglio, "Hippolyte Flandrin," *Gazette des Beaux-Arts*, August 1, 1864, p. 105.

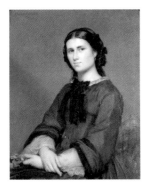

75 *Fig. 20*

Hippolyte Flandrin
Portrait de Mlle M[aison] (La Jeune Fille à l'oeillet)
(*Portrait of Mlle M[aison] [Young Girl with a Carnation]*)
1858
Oil on canvas
31⅛ x 25¼ in. (79 x 64 cm)
Signed and dated upper left: Hippolyte Flandrin 1858
Private collection

PROVENANCE: Mathilde Maison, baronne Armand de Mackau; comtesse Humbert de Guinsonas née Anne de Mackau, her daughter; vicomtesse de Bonneval, née Guinsonas, her daughter, who was a great benefactor of the Archives nationales (Mackau, Watier de Saint-Alphonse, and Maison funds); transferred by her to a collateral descendant, about 1957–58

EXHIBITIONS: Paris, Salon of 1859, no. 1070 (Portrait de Mlle M . . .); London, Exposition Universelle, 1862, no. 74 (La jeune fille à l'oeillet); Paris, École impériale des Beaux-Arts, *Exposition des oeuvres d'Hippolyte Flandrin*, 1865, no. 47 (Portrait de Mlle Maison [Mme la Baronne de Mackau]); Paris, École nationale des Beaux-Arts, 1885, *Deuxième exposition de portraits du siècle*, no. 79 (Mlle Maison [La jeune fille à l'oeillet]); Paris, Musée du Luxembourg, and Lyon, Musée des Beaux-Arts, 1984, *Hippolyte, Auguste et Paul Flandrin: Une fraternité picturale au XIXᵉ siècle*, no. 105, pp. 184–85, repr. p. 183 (text by Marie-Martine Dubreuil and Jacques Foucart)

SELECTED REFERENCES: Astruc 1859, pp. 212–15; Aubert 1859, pp. 218–20; Louis Auvray, *Salon de 1859* (Paris 1859), p. 49; A. de Belloy, "Salon de 1859. II," *L'Artiste*, April 21, 1859, p. 258; Ernest Chesneau, "Libre étude sur l'art contemporain. Salon de 1859," *Revue des races latines* 14 (1859), p. 40; Delaborde 1859, p. 520; E.-J. Delécluze, "Exposition de 1859," *Journal des Débats*, April 27, 1859, p. 2; Du Camp 1859, pp. 23–25; Dumesnil 1859, pp. 138–39; A. J. Du Pays, "Salon de 1859," *L'Illustration*, July 30, 1859, p. 94; Faucheux, "Aperçu sur l'exposition des arts à Paris," *La Revue universelle*, 1859, p. 268; Théophile Gautier, "Exposition de 1859," *Le Moniteur universel*, July 13, 1859; Houssaye 1859, pp. 377–78; Albert de La Fizelière, "L'exposition à vol d'oiseau," *L'Artiste*, April 10, 1859, p. 231; Jourdan 1859, pp. 40–41; Lépinois 1859, p. 184; Louis Leroy, "Le Charivari au Salon de 1859. III," *Le Charivari*, April 24, 1859, p. 4; Louis Leroy, "Le Charivari au Salon de 1859. VIII," *Le Charivari*, May 17, 1859, p. 2; Mantz, "Salon de 1859," *Gazette des Beaux-Arts*, June 1, 1859, pp. 275–76; Jean Rousseau, "Salon de 1859," *Le Figaro*, May 7, 1859, p. 4; Paul de Saint-Victor, "Salon de 1859. VIII," *La Presse*, June 18, 1859, p. 1; Henri Delaborde, "Le Salon de 1861," *La Revue des Deux Mondes* 3 (1861), p. 887; Marc de Montifaud, "Salon de 1865," *L'Artiste*, May 15, 1865, p. 225; Thoré-Bürger 1870, p. 328; Charles Blanc, *Les Artistes de mon temps* (Paris, 1876), p. 271; Louis Flandrin, *Hippolyte Flandrin: Sa vie et son oeuvre* (Paris, 1902), pp. 17, 258; Baudelaire 1985–87, vol. 2, p. 656; Wolfgang Drost and Ulrike Henninges, *Théophile Gautier: Exposition de 1859*, (Heidelberg, 1992), pp. 127–28, repr.

Along with Henriette Browne's *Les Soeurs de charité* (Sisters fig. 19), *Portrait de Mathilde Maison (La Jeune Fille à l'oeillet)* was the great success of the Salon of 1859: Hippolyte Flandrin's sober portrait was competing with a large-format genre scene of bourgeois sentimentality by Mme Jules Saux, née Sophie Bouteillier, a socialite, who disguised herself with a chic British pseudonym.

It was in 1858, shortly before her marriage to baron Armand de Mackau, that Flandrin painted Mathilde Maison (1837–1886). She was the daughter of the comtesse Joseph Maison, whose portrait he had painted six years earlier (Couvent des Dominicaines, Étrépagny), and the granddaughter of Marshal Maison, who had held several posts as minister and ambassador during the July Monarchy.[1] Hanging in the place of honor, "in the square exhibition salon between the two entrance doors,"[2] *La Jeune Fille à l'oeillet* aroused the enthusiasm of all the critics—Zacharie Astruc and Henri Delaborde, Arsène Houssaye and Théophile Gautier. Imagining a dialogue between David and his pupils, Louis Leroy had Prud'hon say, "Flandrin has wiped out everyone this year."[3] Indeed, even the most reluctant observers of Flandrin's art heaped praise on this painting. Paul Mantz was harsh about Flandrin's two other entries: the *Portrait de Mlle M[aison]*, whose subject was a cousin of our sitter,[4] was "thin, meager, formulaic, and lifeless," while *Madame de S[iéyès]* he judged to be dry and hard. On the other hand, he described the portrait of Mathilde Maison as "one of the masterpieces of the master," concealing "his faults and revealing his best qualities." Flandrin, said Mantz, had painted a particular girl but also a type, that of a young girl poised between adolescence and adulthood, one of those "big children who are turning into women and whom one loves in advance—charming but still a little green, fruits that will not ripen for another two or three springtimes."[5] And Astruc, the future defender of Manet and the New Painting, dwelt at length on this "admirable work": Flandrin had finally "smiled" and "promises an appreciable improvement of his unobtrusive bourgeois manner."[6] For this portrait gratified not only the champions of Ingrism—those who lauded the perfection of his draftsmanship, the sobriety of his approach, the restraint of his color—but also those who had previously rebuked the painter for sacrificing truth to the model and naturalness of pose to an exclusive quest for style. In regard to Mathilde Maison's enigmatic smile, Gautier, Paul de Saint-Victor, Houssaye, and Maurice Aubert inevitably cited Leonardo da Vinci: thus, with "the mysterious, singular, disquieting quality" of her beauty, the "malice" of her eyes, and the "acidity" of her flesh tones, Mathilde Maison has "one of the most immortally vivid faces ever produced by a brush."[7] The amazing success of this severe picture was triggered precisely by its austerity. In a Salon devoid of great ambitions and marked by the triumph of "the pretty, the elegant, the minor" (see p. 10), Flandrin's art resounded like a call to order. According to Maxime Du Camp, "In the sheer simplicity of this portrait there is a powerful, astonishing strength; amid works painted for effect, with shameful carelessness, and tending toward often dishonest surprises, this canvas is like a diamond inadvertently placed in a setting of false gems: it dazzles us with its candor and sincerity."[8]

Only Degas and Baudelaire dissented. Without dwelling on Flandrin's entry, the poet assailed "the Ingres school in general." For Baudelaire, Flandrin's nicely painted portraits were like those well-written books that are boring because of all the effort put into them, annoying because of their ostentatious quest for style, and irreproachable but thoroughly lacking imagination.[9] As for Degas, he disregarded the man whom he had once venerated. Louis Lamothe, Flandrin's assistant on all his major decoration projects, had been Degas's mentor before Degas departed for Italy in 1856. However, Degas's contact with Gustave

Moreau had definitively estranged him from Lamothe and now he turned to Delacroix (cat. 69), Ricard (cat. 182), and Fromentin (cat. 76). A few months later Degas's father was pleased to note that his son had "rid himself of that flaccid and banal draftsmanship à la Flandrin and Lamothe and that dull gray color."[10] In December of 1859 Degas broke off with Lamothe for good.[11]

H.L.

1. Regarding the Maison family, see the inventory by Chantal de Tourtier-Bonzassi at the Archives Mackau, Watier de Saint-Alphonse et Maison, Archives nationales, Paris, 1972. Regarding the portraits of the comtesse Maison and her daughter, see Jacques Foucart, *Les Frères Flandrin*, exh. cat., Musée du Luxembourg (Paris 1983), pp. 176, 184–85.
2. "dans le Salon carré de l'exposition entre les deux portes d'entrée." Jean Rousseau, "Salon de 1859," *Le Figaro*, May 7, 1859, p. 4.
3. "Flandrin tue tout cette année." Louis Leroy, *Le Charivari au Salon de 1859, VIII*, May 17, 1859, p. 2.
4. Identified by Louis Flandrin, *Hippolyte Flandrin. Sa vie et son oeuvre* (Paris, 1902), p. 331.
5. "peinture maigre, systématique et peu vivante"; "un des chefs-d'oeuvre du maître"; "ses défauts et laissant briller ses meilleurs qualités"; "grands enfants qui deviendront des femmes et qu'on aime par avance, fruits charmants mais un peu âpres encore, et que deux ou trois printemps mûriront." Paul Mantz, "Salon de 1859," *Gazette des Beaux-Arts*, June 1, 1859, p. 275.
6. "oeuvre admirable"; "sourire"; "fait espérer une amélioration sensible dans sa manière effacé et bourgeoise." Astruc 1859, pp. 212, 215.
7. "quelque chose de mystérieux, de singulier, d'inquiétant"; "malice"; "acidité"; "une des têtes les plus immortellement douées de vie qu'ait produites le pinceau." Gautier 1859, pp. 128–29.
8. "joli, l'élégant, le petit"; "Dans la simplicité même de ce portrait il y a une force qui saisit et qui étonne; au milieu des oeuvres brossées en parti pris d'effet, négligées jusqu'à l'impudence et tendant à des surprises souvent déloyales, cette toile ressemble à un diamant placé par mégarde dans une parure en pierres fausses: elle éblouit par sa bonne foi et par sa sincérité." Du Camp 1859, p. 24.
9. "l'école Ingres en général." Baudelaire 1985–87, vol. 2, p. 656.
10. "débarrassé de ce flasque et trivial dessin Flandrinien Lamothien, et de cette couleur terne grise." Paris, New York 1988, p. 52.
11. Ibid., p. 53.

Eugène Fromentin

La Rochelle, 1820–Saint Maurice, 1876

The son of a doctor and amateur painter, Fromentin spent his childhood in La Rochelle and then moved to Paris in order to study law. However, he rejected the law to devote himself to painting, which he studied sporadically under the landscape artist Louis Cabat. Fromentin began to participate in the Salon in 1847, obtaining a second-class medal in 1849. Thereafter, he pursued parallel careers as writer and painter, specializing in the landscapes of Algeria, where he visited three times. He wrote about his travels in *A Summer in the Sahara* (1854), *A Year in the Sahel* (1857), and in his novel *Dominique* (1862).

During the 1850s he became friends with Gustave Moreau, who developed a close relationship with him, George Sand, who greatly admired his writings, Delacroix, Théophile Gautier, and Alexandre Dumas. It was at the Salon of 1857 that he achieved his first success as a painter. Fromentin finally triumphed at the Salon of 1859, when he won the first-class medal and was made a knight of the Légion d'Honneur. He was now discovered by Degas, whom he influenced very briefly. Henceforth and until his death, Fromentin appeared in two guises simultaneously: he was both an unusual painter reinvigorating rather outmoded Orientalist subjects and a repetitious artist, rehashing from one Salon to the next, the "little blue sky, the little silvery ford, the little tree without a botanical name, and the little Arab with bare arms."[1]

After 1865 he attempted to renew his work, dramatizing his accustomed themes or making a hapless excursion into historical painting (*Centaures*, Centaurs, Salon of 1868, fig. 72). As a friend of the princess Mathilde, he was invited to Compiègne by the emperor in 1864. At the Salon of 1863 the government paid him ten thousand francs for *Chasse au faucon en Algérie; la curée* (*Falcon Hunt in Algeria; the Quarry*; Musée d'Orsay, Paris). Fromentin was a member of the jury at the Exposition Universelle of 1867, and, with Narcisse Berchère, Jean-Léon Gérôme, and Charles Emile de Tournemine, he was invited to the opening of the Suez Canal in 1869. However, the painter was never elected to the Académie des Beaux-Arts, and the writer was passed over for membership in the Académie Française in favor of Charles Blanc in 1876. In 1870, probably at the request of Alfred Arago, a division head at the Ministry of Fine Arts, Fromentin penned "Notes on Nominations for the Order of the Legion of Honor"; here, he reviewed some of his contemporaries, benevolently promoting mediocre artists in his camp but also emphasizing the importance of Courbet: "the most loudly celebrated of this period. Major weaknesses but also great gifts. Has exerted a profound influence on our young school—something to be taken advantage of. Ludicrous in his doctrines, excellent in some of his works. In sum, has at times displayed a recognized talent and has often been acclaimed by the very people who are the most offended by his errors and controversies. Head of a noisy faction that produces good paintings but often spouts a lot of tripe."[2]

By 1876, however, with the publication of his final literary masterpiece, *Past Masters*, this great writer was no longer so indulgent toward "our young school." For Fromentin was aiming at Manet, who had painted *Bon Bock* (1873, Rouart-Wildenstein, I, no. 186; Philadelphia Museum of Art), and his "young comrades" when he condemned a recent and—to his mind—outrageous admiration for Frans Hals: "Today the name of Hals is reappearing in our school at the very moment when the love of the natural has come back to it with some noise and no less excess. Hals's method serves as a program for certain doctrines

that compel us to mistake the most pedestrian exactitude for the truth and the most perfect carelessness for the last word in taste and knowledge."[3] Elsewhere, Fromentin attacked the widespread predilection for landscape, the new and undeserved importance of "plein air...diffused light...real sun," and "the love of absolute truth and fidelity to the subject": "At the present time, painting is never bright enough, sharp enough, formal enough, raw enough."[4] The installment of *Past Masters* in the *Revue des Deux Mondes* that included these remarks triggered an immediate retort from Duranty: his essay on the New Painting, which was chiefly inspired by Degas, who burned what he had venerated fifteen years earlier. The piece opens with a long quotation from Fromentin, "an eminent painter among those who do not like talent," and who, with Moreau, "is spreading the true, disturbed painting of an era of criticism, curio collecting, and pastiches."[5]

1. "petit ciel bleu, le petit gué argenté, le petit arbre sans nom dans la botanique, et le petit Arabe aux bras nus." Maxime Du Camp, *Souvenirs littéraires* (Paris, 1892), vol. 2, p. 202.
2. "La renommée la plus bruyante de ce temps-ci. De grandes infirmités mais de grands dons. A exercé sur notre jeune école une influence profonde, dont il y aurait à tirer parti. Ridicule par ses doctrines, excellent dans quelques-unes de ses oeuvres. Somme toute, a fait preuve par moments d'un talent reconnu et souvent acclamé par ceux-là mêmes qui sont le plus offensés de ses erreurs et de ses controverses. Chef d'une faction remuante où il se fait de bons tableaux, où il se dit beaucoup de folies." Fromentin 1984, p. 1118.
3. "jeunes camarades"; "Aujourd'hui, le nom de Hals reparaît dans notre école au moment où l'amour du naturel y rentre lui-même avec quelque bruit et non moins d'excès. Sa méthode sert de programme à certaines doctrines en vertu desquelles l'exactitude la plus terre à terre est prise à tort pour la vérité, et la plus parfaite insouciance pratique prise pour le dernier mot du savoir et du goût." Eugène Fromentin, *Les Maîtres d'autrefois*, edited and annotated by Jacques Foucart (Paris, 1965), p. 300.
4. "plein air...la lumière diffuse...vrai soleil...amour du vrai absolu et du textuel"; "A l'heure qu'il est, la peinture n'est jamais assez claire, assez nette, assez formelle, assez crue." Ibid., pp. 284–85.
5. "peintre éminent parmi ceux dont nous n'aimons pas le talent"; "la vraie peinture trouble d'une époque de critique, de bibelotage, et de pasticheries." Washington, San Francisco 1986, p. 477.

76

Fig. 21

Eugène Fromentin
Une rue a El-Aghouat
(A Street in El-Aghouat)
1859
Oil on canvas
56 x 40½ in. (142 x 103 cm)
Signed at bottom right: Eug. Fromentin
Musee de la Chartreuse, Douai 148

PROVENANCE: Acquired by the French state at the Salon of 1859; sent to the Musee de Douai, 1959

EXHIBITIONS: Paris, Salon de 1859, no. 1173 (Une rue à El-Aghouat/ [M. d'État]); Paris, 1968–69, no. 486

SELECTED REFERENCES: Astruc 1859, pp. 297–98; Aubert 1859, p. 51; Baudelaire, "Salon de 1859," reprinted in Baudelaire 1985–87, vol. 2, pp. 649–51; Émile Cantrel, "Salon de 1859, XII," *L'Artiste*, July 3, 1859, p. 147; Delaborde 1859, p. 516; Du Camp 1859, pp. 119–22; Dumas 1859, p. 128; Dumesnil 1859, p. 59; A.-J. Du Pays, "Salon de 1859," *L'Illustration*, July 30, 1859, p. 93; Théophile Gautier, "L'Esposition de 1859," *Le Moniteur universel*, May 28, 1859, p. 613, Louis Jourdan, *Salon de 1859* (Paris, 1859), pp. 18–19; Lepinois 1859, p. 198; Mantz 1859, pp. 292–93, repr.; Jean Rousseau, "Salon de 1859. IV. L'Etat-major," *Le Figaro*, May 17, 1859, p. 3; Paul de Saint-Victor, "Salon de 1859. IX," *La Presse*, June 25, 1859, pp. 1–2; Louis Gonse, "Eugène Fromentin," *Gazette des Beaux-Arts*, 1879, pp. 292–94, repr.; Jules Breton, *Nos peintres du siècle* (Paris, 1899), p. 142; Prosper Dorbec, *Eugène Fromentin* (Paris, 1926), pp. 66–69; Anne-Marie Christin, *Fromentin, conteur d'espace* (Paris, 1982), pp. 28–29; Thompson and Wright 1987, pp. 172–74; Wolfgang Drost and Ulrike Hennings, *Théophile Gautier* (Heidelberg, 1992), pp. 43–44

To a skeptical inquirer who asked him what he had seen "over there," Fromentin replied, "Summer."[1] And that is the dominant impression made by *A Summer in the Sahara* and a *Year in Sahel*, his two accounts of the three trips he made to Algeria from March to April 1846, September 1847 to May 1848, and November 1852 to October 1853. Nothing but sun, dazzling whiteness, shade, torpor, and extreme heat. In June 1853 the painter-writer was sojourning in El-Aghouat (Laghouat), a newly conquered city in the Sahara that still bore the visible and heartrending traces of recent combat.

However, this "arid and burned place, where providence has, exceptionally, put water, where human industry has created shade" is primarily a "digest" of the entire Orient, with its fountain "where the women linger, and the shadowy street where the men sleep.... Bab-el-Gharbi Street is one of my boulevards. While I wait for the heat to force me out of the city and into the gardens, it is rare for me not to be seen there at some point during the day. Toward one in the afternoon, the shadow begins to feebly mark the ground. If you are sitting, it has not yet reached your feet. If you are standing, the sun is still grazing your head. You have to hug the wall and keep straight. The reflections from the ground and the walls are horrible. The dogs let out soft whimpers when they happen to walk across the metallic roadway. All the shops that are exposed to the sun are shut. The far end of the street, toward the west, undulates in white flames. You can feel the air quiver with weak noises that sound as if the earth were gasping as it breathed. Little by little, however, you can see the half-open porches releasing tall, pale, dreary figures in white, looking more exhausted than pensive. They arrive, blinking their eyes, lowering their heads, creating shade with their veils, which shelter their entire bodies from that perpendicular sun. One after another, they arrange themselves against the wall, sitting or lying down when they find a place. These are the husbands, the brothers, the young men who come here to spend their day. They start the day on the left side of the street, and they continue it on the right side; that is the sole difference between their morning and evening habits."

Fromentin follows these lines with a "painter's remark": "Contrary to what we see in Europe, a painting here is composed in shadow with a dark center and corners of light. This in a way is Rembrandt transposed. Nothing could be more mysterious."[2] During his visit to Laghouat, Fromentin, obviously seduced by the grandeur of the town, not only wrote his observations but also drew and painted numerous studies. These often remarkable studies detail the rocky desert countryside, the "gray, almost black walls," pierced with very few apertures, and the inhabitants: "tall women with virile shapes" and the always somnolent men, who "even though dazed ...maintain the beauty of a sculpture and, even though uncouth...are as interesting as a strong sketch.[3]

Fromentin's notes on Laghouat were serialized in *Revue de Paris* from June to December 1854 and issued as a book in 1857. Together with them, the various studies and sketches he executed in the town constitute the direct source for *Une rue à El-Aghouat*, which was executed in Gustave Moreau's studio during his absence and shown at the Salon of 1859. In this canvas, on a large scale and in a vertical format that was unusual for him, Fromentin reproduces the features that had struck him six years earlier: the impeccably blue sky, the "white roadway sparkling like steel," the "silence as heavy as the heat," and the brutishness of the natives. Above all, however—and this explains the surprising reference to Rembrandt—Fromentin wanted to render the "shadow of the land of light," the way the Dutchman had painted the shadows of the closed interiors of the North: "This is something dark and transparent, something limpid and colored; it looks like deep water. It seems black, and when your eyes plunge in, you are always surprised at how clearly you can see. Get rid of the sun, and this shade itself will become the daylight." Arranged against a background that appears dark only in comparison with the other, violently illuminated side of the alley, the flabby shapes "float in some kind of blonde atmosphere that blurs the outlines.... The whitish clothing merges into the walls; the bare feet are almost indistinguishable from the terrain, and aside from the faces, which appear as brown splotches in the midst of this vague totality, the figures look like petrified mud statues and, like the houses, are baked by the sun."[4]

At the Salon of 1859 the few discordant notes on Fromentin's entry showed a lack of understanding for his initial intention. Thus Jean Rousseau lauded the "quality of the light and the sunburned tone of the buildings," but he questioned the "restrained modeling" of the figures.[5] Zacharie Astruc faulted the painter for his weak point here, as in his other canvases—the rendering of the figures: "The human being strikes me as having been sacrificed to some degree; he is often badly defined in his principal lines. The tone is accurate, even audaciously so, in the vigor of the effect, but the modeling does not always endow the bodies with true relief."[6] Du Pays, more critical, attacked the "free-and-easy brush," whose pretext was the reflections of the ground and the walls.[7]

However, Baudelaire and Alexandre Dumas, Paul de Saint-Victor and Théophile Gautier were lavish with their praise. For Fromentin had undeniably introduced a new tone, reviving the legacy of Decamps and Marilhat and borrowing Delacroix's "knowledgeable and natural intelligence regarding color."[8] Furthermore, Fromentin was offering new subjects in the Orientalist manner and, as Baudelaire commented, challenging the overly narrow categories of landscape and genre.[9] Degas's sudden admiration for this friend of Gustave Moreau's (see p. 120) sprang from all this. Perhaps, as James Thompson and Barbara Wright have noted, Degas would remember Fromentin's inventions, especially in *Bateleurs nègres dans les Tribus* (fig. 24), when he undertook his *Petites Filles spartiates provoquant des garçons*.[10] More surprising than Degas's appreciation was the indifference of Monet, whom one would have expected to be struck by the "dreadful truth" of this "illuminated, or rather sunroasted" canvas.[11] However, in 1859 Monet's Orient was that of the mediocre Théodore Frère: conventional, tiresome, commercial in its multiplicity of camels, palm groves, and harem scenes.[12]

H.L.

1. "là-bas"; "L'été." Eugène Fromentin, *Une année dans le Sahel* in Fromentin 1984, p. 308.
2. "lieu aride et brûlé, où la providence a, par exception, mis de l'eau, où l'industrie de l'homme a créé de l'ombre"... "résumé"... "où sont les femmes, l'ombre d'une rue où dorment les hommes...La rue Bab-el-Gharbi est un de mes boulevards. En attendant que la

chaleur me force à abandonner la ville pour les jardins, il est rare qu'on ne m'y voie pas à quelque moment que ce soit de la journée. Vers l'heure, l'ombre commence à se dessiner faiblement sur le pavé; assis, on n'en a pas encore sur les pieds; debout, le soleil vous affleure encore la tête; il faut se coller contre la muraille et se faire étroit. La réverbération du sol et des murs est épouvantable; les chiens poussent de petits cris quand il leur arrive de passer sur ce pavé métallique; toutes les boutiques exposées au soleil sont fermées; l'extrémité de la rue, vers le couchant, ondoie dans des flammes blanches; on sent vibrer dans l'air de faibles bruits qu'on prendrait pour la respiration de la terre haletante. Peu à peu cependant, tu vois sortir des porches entrebâillés de grandes figures pâles, mornes, vêtues de blanc, avec l'air plutôt exténué que pensif; elles arrivent les yeux clignotants, la tête basse, et se faisant de l'ombre de leur voile, un abri pour tout le corps, sous ce soleil perpendiculaire. L'une après l'autre, elles se rangent au mur, assises ou couchées quand elles en trouvent la place. Ce sont les maris, les frères, les jeunes gens qui viennent achever leur journée. Ils l'ont commencée du côté gauche du pavé, ils la continuent du côté droit; c'est la seule différence qu'il y ait dans leurs habitudes entre le matin et le soir"; "une remarque du peintre"; "À l'inverse de ce qu'on voit en Europe, ici les tableaux se composent dans l'ombre avec un centre obscur et des coins de lumière. C'est en quelque sorte du Rembrandt transposé; rien n'est plus mystérieux." Fromentin 1984, pp. 105–6.

3. "murs gris, presque noirs"; "grandes femmes aux formes viriles"; "même hébétés … conservent la beauté d'une sculpture, même incorrects … offrent l'intérêt d'une forte ébauche." Ibid., pp. 79, 101, 108.

4. "pavé blanc etincelant comme de l'acier"; "silence aussi pesant que la chaleur"; "l'ombre du pays de lumière"; "C'est quelque chose d'obscur et de transparent, de limpide et de coloré; on dirait une eau profonde. Elle parait noire, et, quand l'oeil y plonge, on est tout surpris d'y voir clair. Supprimez le soleil, et cette ombre elle-même deviendra du jour"; "flottent dans je ne sais quelle blonde atmosphère qui fait évanouir les contours.… les vêtements blanchâtres se confondent presque avec les murailles; le pieds nus masquent à peine le terrain, et sauf le visage qui fait tache en brun au milieu de ce vague ensemble, c'est à croire à des statues pétries de boue et, comme les maisons, cuites au soleil." Ibid., pp. 79, 106. On the genesis of this painting, see Anne-Marie Christin's remarks in *Fromentin conteur d'espace* (Paris, 1982), pp. 28–29.

5. "qualité de la lumière et le ton rissolé des bâtisses"; "modelé effacé." Jean Rousseau, "Salon de 1859, iv, L'État-major," *Le Figaro*, May 17, 1859, p. 3.

6. "L'homme me semble un peu sacrifié: il est souvent mal défini dans ses lignes principales; le ton est juste jusqu'à l'audace par la vigueur de l'effet, mais le modelé ne donne pas toujours le véritable relief des corps." Astruc 1859, p. 298.

7. "laisser-aller du pinceau." N. J. Du Pays, "Salon de 1859," *L'Illustration*, July 30, 1859, p. 93.

8. "Savante et naturelle intelligence de la couleur." Baudelaire 1985–87, vol. 2, pp. 650.

9. Ibid., p. 649.

10. Thompson and Wright 1987, p. 185.

11. "effrayante vérité"; "eclairée, ou plutôt torréfiée." Aubert 1859, p. 51.

12. See the negative critique of Frère's entry voiced by the *salonniers* in Gautier 1859, p. 260.

Jean-Léon Gérôme
Vesoul, 1824–Paris, 1904

The son of a well-to-do goldsmith in Vesoul, Gérôme moved to Paris in 1841 after completing solid classical studies in his hometown. He entered the studio of Paul Delaroche, with whom he spent 1844 in Rome. He would remember this year as "one of the happiest and most fulfilling of my life."[1] Upon returning to Paris, he studied under Charles Gleyre; he failed to win a Prix de Rome but had a great success at the Salon of 1847 with *Jeunes grecs faisant battre des coqs* (*Cockfight*, Musée d'Orsay, Paris). The Second Empire brought him artistic and social triumphs. In 1855 his gigantic *Siècle d'Auguste* (*Augustan Period*, Musée d'Orsay, Paris) won him a second-class medal and a knighthood in the Légion d'Honneur and his fame was consolidated at the Salon of 1859. He was invited to the royal palace at Compiègne, frequented the princess Mathilde's home, and traveled widely in Africa and the Near East. From 1860 to 1862 he directed his own studio. In 1863 he married the daughter of the merchant Adolphe Goupil; that same year he began teaching at the Institut, and in 1864 he was named professor at the École des Beaux-Arts. The apotheosis of this fierce enemy of the artists of the New Painting (see p. 36) was marked in 1867, when he obtained the grand médaille d'honneur at the Exposition Universelle and was made an officer of the Légion d'Honneur.

1. "une des plus heureuses et des mieux remplies de ma vie." Jean-Léon Gérôme, *Notes autobiographiques*, edited and annotated by Gerald M. Ackerman (Vesoul, 1981), pp. 7–8.

77 *Fig. 13*

Jean Léon Gérôme
Le Roi Candaule
(*King Candaules*)
1859
Oil on canvas
26¼ x 39½ in. (66 x 100.3 cm)
Signed and dated lower left on the pedestal: J. L. Gérome
MDCCCLIX
Museo de Arte de Ponce, Puerto Rico 63.0353

CATALOGUE RAISONNÉ: G. M. Ackerman 1986, no. 111

PROVENANCE: Wilson, Paris; Wilson sale, Paris, March 1882; Mayer collection; Mayer sale, Paris, April 27–28,

1886; Captain J. L. De Lamar, New York; his sale, New York, Plaza Hotel, January 29, 1920, no. 30; William Randolph Hearst; Hearst Corporation sale, Parke-Bernet Galleries, New York, March 21, 1963, no. 82; acquired by the Museo de Arte de Ponce

EXHIBITIONS: Paris Salon of 1859, no. 1239 (Le Roi Candaule); "Et Candaules, quand il fut l'heure de dormir, conduisit Gygès dans la chambre, et tantôt vint après la femme, laquelle, près de l'huis, quittant ses vêtements, Gygès la vit, et comme elle lui tourner le dos pour aller au lit, s'échappa; mais elle l'aperçoit sortir. [And Candaules, when it was time to sleep, led Gyges into his chamber; soon after them, his wife came in, taking off her clothes by the door. Gyges saw her, and when she turned her back to get into bed, Gyges fled, but his wife had seen him leave. Herodotus]); Dayton Art Institute, Ohio, 1972, *Jean-Léon Gérôme*, no. 8; Atlanta, High Museum of Art, 1993, *French Salon Paintings from Southern Collections*, no. 33

SELECTED REFERENCES: Théophile Gautier, "À travers les ateliers," *L'Artiste*, 1858, no. 62, p. 18; Astruc 1859, p. 187; Aubert 1859, pp. 108–11; Louis Auvray, *Salon de 1859* (Paris, 1859), p. 19; A. de Belloy, "Salon de 1859. II," *L'Artiste*, April 21, 1859, p. 258; Émile Cantrel, "Menus propos," *L'Artiste*, May 8, 1859, p. 30; Chaud-de-Ton, "Salon de 1859," *La Vérité*, May 4, 1859, p. 5, and May 25, 1859, p. 2; Ernest Chesneau, "Libre étude sur l'art contemporain. Salon de 1859," *Revue des races latines* 14 (1859), pp. 46–47; Delaborde 1859, pp. 504–5; E.-J. Delécluze, "Exposition de 1859," *Le Journal des débats*, April 27, 1859, p. 1; Du Camp 1859, p. 64; Dumesnil 1859, p. 93; A.-J. Du Pays, "Salon de 1859," *L'Illustration*, April 23, 1859, pp. 269–70; J.-H. Duvivier, *Salon de 1859: Indiscrétions* (Paris, 1859), p. 7; Emmanuel des Essarts, "Poésies: Trois tableaux du Salon," *L'Artiste*, June 12, 1859, p. 109; Albert de La Fizelière, "L'Exposition à vol d'oiseau," *L'Artiste*, April 10, 1859, p. 231; Ferdinand Gabrielis, "Salon de 1859," *Le Moniteur des arts*, April 23, 1859, p. 195, and June 25, 1859, p. 254; Théophile Gautier, "L'Exposition de 1859," *Le Moniteur universel*, April 23, 1859; Houssaye, April 30, 1859, p. 282; Louis Jourdan, *Les Peintres français: Salon de 1859* (Paris, 1859), p. 38; Lépinois 1859, pp. 129–30; Mantz 1859, pp. 196–98; Anatole de Montaiglon, "La Peinture au Salon de 1859," *La Revue universelle de l'art* 9, (1859), p. 445; Perrier 1859, pp. 298–99; Jean Rousseau, "Salon de 1859. IV. L'État-major," *Le Figaro*, May 17, 1859, p. 4; Paul de Saint-Victor, "Salon de 1859. II," *La Presse*, April 30, 1859, p. 1; Mathilde Stevens, *Impressions d'une femme au Salon de 1859* (Paris, 1859), pp. 17–18; A. Cantaloube, *Lettre sur les expositions et le Salon de 1861* (Paris, 1861), p. 69; Théodore Duret, *Les Peintres français en 1867* (Paris, 1867), p. 73; Edward Strahan, *Gérôme* (New York, 1881), p. 1, repr.; Claretie, *Peintres* 1884, p. 67; Castagnary 1892, p. 93–97; Musée de Vesoul, *Gérôme, ses oeuvres conservées dans les collections françaises*, 1981, p. 110; Baudelaire 1985–87, vol. 2, pp. 639–41; Wolfgang Drost and Ulrike Henninges, *Théophile Gautier: Exposition de 1859* (Heidelberg, 1992), p. 14

At the Salon of 1859 Gérôme showed *Le Roi Candaule*, a subject from Herodotus, as well as two scenes drawn from Roman history—*Cesar* (lost) and *Ave, Cesar, i imperator, morituri te salutant* (Walters Art Gallery, Baltimore). *Le Roi Candaule* elicited a lukewarm reception (see pp. 13–14). For his detractors it crystallized attacks against the temptations of the archaeological approach focused solely on restoring an era and pinpointing exact details, which was gradually suffocating historical painting. Curiously enough, Gérôme's canvas, a Second Empire variation on Ingres's *Antiochus et Stratonice* (1840, Musée

Condé, Chantilly), resembles a composition that Degas was pondering before he went to Italy: *La Femme de Candaule (The Wife of Candaules)*, for which he drew several studies in the spring of 1856. His sketches, recorded in a notebook, insistently show the female nude from the back and surrounded by the indispensable signs of Hellenism.[1]

H.L.

1. Reff 1985, Notebook 6, pp. 35, 36, 40, 50–54, 62.

Eva Gonzalès

Paris, 1849–Paris, 1883

Born into a solid, literate bourgeois family, Eva Gonzalès was the daughter of Emmanuel Gonzalès, a well-received writer, who became chairman of the Société des gens de lettres in 1864. Her mother, a musician, had a salon, which was visited by Théodore de Banville, the Stevenses, and Alexandre Dumas among others. In 1865 Eva, then sixteen years old, entered the studio of the elegant Charles Chaplin, who specialized in Pompadour mythology and vaporous portraiture. She left him in May 1867 and in February 1869 began studying with Manet, whom her parents had met through Alfred Stevens. Manet's affection for the girl was translated into a large portrait (fig. 199), which he exhibited at the Salon of 1870, the year that she first showed there (cat. 78). A jealous Berthe Morisot, who felt that Manet was over-attentive to his new disciple, wrote on August 13, 1869: "Manet lectures me and holds up that eternal Mlle Gonzalès as an example; she has poise, perseverance; she is able to carry an undertaking to a successful issue, whereas I am not capable of anything."[1]

1. "Manet me fait de la morale à sa soeur Edma, et m'offre cette éternelle Mlle Gonzalès comme modèle; elle a de la tenue, de la persévérance, elle sait mener une chose à bien, tandis que moi, je ne suis capable de rien." Berthe Morisot to Edma Pontillon, August 13, 1869, in Morisot 1950, p. 33; translation by Betty W. Hubbard, *The Correspondence of Berthe Morisot*, New York, 1957.

78 *Fig. 260*

Eva Gonzalès
Enfant de troupe
(Soldier Boy)
1870
Oil on canvas
51⅛ x 38⅜ in. (130 x 97.5 cm)
Signed lower right: Eva Gonzales
Musée Gaston Rapin, Villeneuve-sur-Lot

CATALOGUE RAISONNÉ: Sainsaulieu and de Mons 1990, no. 18

PROVENANCE: Purchased by the state for Fr 2,000; deposited at Villeneuve-sur-Lot, 1874

EXHIBITIONS: Paris, Salon of 1870, no. 1219 (Enfant de troupe); Paris, salons of *La Vie moderne* 1885, *Eva Gonzalès*, no. 7; Paris, Galerie Daber, 1959, *Eva Gonzalès*, no. 2; Philadelphia Museum of Art, Detroit Institute of Arts, and Paris, Grand Palais, 1978–79, no. 231, repr.; London, National Gallery, 1992, no. 30; *Manet: The Execution of Maximilian*

SELECTED REFERENCES: Karl Bertrand, "Salon de 1870," *L'Artiste*, May 1870, p. 316; Philippe Burty, "Le Musée de L'État," *La Chronique politique des arts et de la curiosité*, July 31, 1870, p. 1; Jules Castagnary, "Salon de 1870," *Le Siècle*, June 3, 1870, p. 1, reprinted in Castagnary 1892, p. 428; Philippe Burty, "Eva Gonzalès," *La République française*, January 8, 1885, p. 3; Philippe Burty, preface to the exh. cat., *Eva Gonzalès* (Paris, 1885), pp. 11–12

At the Salon of 1870 Eva Gonzalès prudently described herself as a "pupil of M. Chaplin." Her precaution was useless, for in writing about *Enfant de troupe*, Castagnary instantly pinpointed what he considered Manet's pernicious influence: "The army child, standing, holding a trumpet and wearing a police cap, is a more important piece, evincing great promise for the future. The face is very well modeled, the pose and the expression are appropriate. What can we reproach this little fellow for? He is inadequately constructed. His left arm is poorly attached to his shoulder, his hands are not indicated distinctly enough. But these are faults in the draftsmanship, which will be corrected by work and age. Mlle Gonzalès's more urgent goal is to leave M. Manet's defects to him. She tends toward favoring black a bit and, like that artist, toward omitting the half-tones. This is a perilous slope, at the bottom of which there is no sincere practice of art, but just a manner. In short, she ought to get rid of the backgrounds

and paint in the open air, under the true and beautiful light of the sky."[1]

In bringing this little twelve-year-old foot soldier from the nearby barracks and posing him in Manet's studio,[2] Gonzalès quite obviously was alluding to her teacher's *Fifre* (cat. 102). But, contrary to Castagnary's opinion, instead of exaggerating Manet's lessons, she dilutes them. Using a dark background into which the figure merges rather than allowing it to stand out against a light color as Manet did, she gives him solidity, while her teacher made his sharply outlined fifer flat. And she abandons Manet's audacity for the sober good form of a Bonnat or a Carolus-Duran.

H.L.

1. "L'Enfant de troupe debout, trompette en main et bonnet de police en tête, est un morceau plus important, qui présage on ne peut mieux pour l'avenir. Le visage est fort bien modelé, la pose et l'expression sont celles qui conviennent. Que reprocherai-je à ce petit homme? d'être insuffisamment construit. Son bras gauche est mal attaché à l'épaule, ses mains ne sont pas assez fermement indiquées. Mais ce sont là des insuffisances de dessin que le travail et l'âge corrigent. Pour y couper court, la première recette ce serait de supprimer les fonds et de peindre au grand air, sous la belle et vraie lumière du ciel." Castagnary 1892, pp. 428–29.

2. Paule Bayle, "Eva Gonzalès," *La Renaissance*, June 1932, p. 113.

Ernest Hébert

Grenoble, 1817–La Tronche (Isère), 1908

After learning the rudiments of drawing in Grenoble, Hébert moved to Paris in 1834, entering the École des Beaux-Arts and passing through the studios of Monvoisin, David d'Angers, and Delaroche. He was awarded the first Prix de Rome in 1839 and lived in Italy from 1840 to 1847. In 1844 in Florence he met, and became close to, Princess Mathilde, first cousin of the future Napoléon III. At the Salon of 1850–51, his *La Malaria (Malaria)* won a first-class medal, inaugurating his official career. Throughout the Second Empire he alternated between society portraits and scenes of Italian life. Between 1853 and 1858 he took two long trips to Italy, preparing his entries for the Salons of 1857 and 1859 (cat. 79). In 1866 he was named director of the Académie Française in Rome.

79 *Fig. 9*

Ernest Hébert

Les Cervarolles (États romains)
1858
Oil on canvas
113⅜ x 69¼ in. (288 x 176 cm)
Signed monogram, lower right on step: H
Musée d'Orsay, Paris M.I. 225

PROVENANCE: Bought for Fr 15,000 on August 6, 1859, by the Musées impériaux for the Musée du Luxembourg, using the proceeds of the Salon entry fees; listed in the inventory of paintings as a gift of the emperor; transferred to the Musée du Louvre, Paris, 1920; Musée Hébert, Paris, 1979; Musée d'Orsay, Paris, 1986

EXHIBITIONS: Paris, Salon of 1859, no. 1420 (Les Cervarolles [États-Romains]); London, Universal Exposition, 1862, no. 217 (Les Cervarolles [États Romains]); Paris, Exposition Universelle, 1867, no. 337 (Les Cervarolles [États Romains]); Vienna, Exposition Universelle, 1873, no. 323; Paris, 1968–69, Petit Palais, *Baudelaire*, no. 488; Paris, Grand Palais, 1974, *Le Musée du Luxembourg en 1874*, no. 118

SELECTED REFERENCES: Astruc 1859, p. 193–95; Aubert, *Souvenirs du Salon de 1859* (Paris, 1859), pp. 187–88; Louis Auvray, *Salon de 1859*, (Paris, 1859), p. 40; A. de Belloy, "Salon de 1859. I," *L'Artiste*, April 17, 1859, p. 243, and "Salon de 1859. II," April 21, 1859, p. 257; Émile Cantrel, "Salon de 1859. XIV," *L'Artiste*, July 10, 1859, p. 162; Chaud-de-Ton, "Salon de 1859," *La Vérité*, May 25, 1859, p. 3; Ernest Chesneau, "Libre étude sur l'art contemporain," *Revue des races latines* 14 (1859), pp. 27–28; Delaborde 1859, pp. 506–7; E.-J. Delécluze, "Exposition de 1859," *Journal des Débats*, April 15, 1859, pp. 1–2; Du Camp 1859, pp. 45–47; Dumas 1859, pp. 13–15; Dumesnil 1859, pp. 100–101; A.-J. Du Pays, "Salon de 1859," *L'Illustration*, April 30, 1859, p. 275; J.-H. Duvivier, *Salon de 1859: Indiscrétions* (Paris, 1859), p. 10; Ferdinand Gabrielis, "Salon de 1859: Histoire et genre," *Le Moniteur des arts*, July 2, 1859, p. 258; Théophile Gautier, "Exposition de 1859," *Le Moniteur universel*, April 18, 1859; Houssaye 1859, p. 311; Jourdan 1859, p. 40; Albert de La Fizelière, "L'Exposition à vol d'oiseau," *L'Artiste*, April 10, 1859, p. 231; Lépinois 1859, pp. 124–26; Mantz 1859, p. 280; Nadar, "Nadar jury au salon de 1859," *Journal amusant*, June 4, 1859, p. 2; Charles Perrier, "Le Salon de 1859," *Revue contemporaine*, May–June 1859, pp. 302–3; Jean Rousseau, "Salon de 1859: Les étoiles fixes," *Le Figaro*, July 2, 1859, p. 3; Paul de Saint-Victor, "Salon de 1859. II," *La Presse*, April 30, 1859, pp. 1–2; Mathilde Stevens, *Impressions d'une femme au Salon de 1859* (Paris, 1859), p. 51; E. Saglio, "Exposition de tableaux modernes dans la Galerie Goupil," *Gazette des Beaux-Arts*, 1859, p. 49; Louis Auvray, *Salon de 1861* (Paris, 1861), p. 23; Castagnary

1892, pp. 116–17; Georges Lafenestre, "M. Ernest Hébert," *Gazette des Beaux-Arts*, November 1897, pp. 353–60; Sâr Joséphin Péladan, *E. Hébert* (Paris, 1910), p. 125, repr. p. 56; Henry Roujon, *Artistes et amis des arts* (Paris, 1912), p. 180; René Patris d'Uckermann, *Ernest Hébert 1817–1908* (Paris, 1982), p. 104, repr. p. 108; Baudelaire 1985–87, vol. 2, p. 647; Wolfgang Drost and Ulrike Henninges, *Théophile Gautier: Exposition de 1859* (Heidelberg, 1992), pp. 5–8

Sâr Joséphin Péladan tells us that Hébert, trying to renew the banal stock-in-trade of Italianisms, capitalized on his "qualities as an explorer and adventurer" to unearth some "fierce beauties" in Cervara, a village perched high in the mountains of the Roman countryside. They were so difficult to tame that it took him six months to get those "naive mountain women" to pose: "In that sinister landscape, where people weep and shriek with hunger the way they sing elsewhere, the artist was snowbound for eighteen months in dreadful conditions! He had to break a window in a wall to have daylight and cobble together an easel with pieces of wood; and the days were like nights."[1]

At the Salon of 1859 Hébert showed *Portrait de Mme la marquise de l['Aigle]* (*Portrait of the Marquise de l'[Aigle]*) but also two paintings inspired by his Italian sojourn of 1857–59: *Rosa Nera à la fontaine* (*Rosa Nera at the Fountain*, Musée Hébert, La Tronche) and *Les Cervarolles*. The last two canvases were described as a small, sentimental anecdote and "a genre painting of large proportions"[2] limited to three monumental figures who might symbolize the ages of life.[3] *Les Cervarolles* was a success. Well placed in the salon d'honneur, it was sold for fifteen thousand francs; the price, indicated on the list of receipts for the Salon entries, which were sent to the Luxembourg, was one of the highest sums ever paid by the imperial museums.[4] However, the painting was not unanimously hailed by the critics. Many of them faulted the artist for mining the same lode that had brought him triumph at the Salon of 1851 with *La Malaria*: that of an exhausted Italy haunted by famine and death, yet a land in which the girls nevertheless flaunt their morbid beauty and precarious charms. The large, dark, ringed eyes of these consumptive paupers were so characteristic of the master that they adorned his portraits of princesses in court attire and well-fed middle-class women. Hébert's early efforts had led observers to expect greater diversity in his work; for example, *Le Baiser de Judas* (*The Kiss of Judas*, Salon of 1853, Musée Hébert, La Tronche) hinted at possibilities that were never fully realized.[5] Essentially a one-note artist, he became boring. *Les Cervarolles* of 1859 was a rehash of *Les Filles d'Alvito* of 1857 (*The Girls of Alvito*, Musée Hébert, La Tronche), which, in turn, was the nth reprise in a minor key of the Italian scenes painted by Jean Victor Schnetz and Léopold Robert. Baudelaire summed up the many criticisms when he reproached this distinguished painter for yielding to "the charms of morbidity," for lacking "authority and energy," and trying to satisfy his "social ambitions" and pan-

der to public taste by serving up the same old literary subjects with subtle doses of the picturesque and the sentimental.[6]

Nevertheless, Hébert's "poetic realism"[7] allowed certain critics to hope that he would offer an alternative to the sordid realism of Courbet: "The distance between M. Hébert and M. Courbet is beyond measure. However, although the master painter of Ornans did not exhibit [in the Salon of 1859], we cannot help indicating the following commonality: M. Hébert likes to paint rags; M. Courbet, for his part, does not skimp on them. Why is it, then, that despite this rough similarity one painter is poetic, the other simply crude? . . . Could it be that M. Hébert paints better than M. Courbet? This is certainly debatable, and indeed, to our mind, the slightly muddy brush of the apostle of realism has usually revealed qualities of firmness and precision that the painter of *Les Cervarolles* has never had. The answer is quite simply that poetry is a subjective thing. . . . M. Hébert . . . applies his singular mental illness almost indiscriminately [to his figures] There are a thousand and one kinds of mental illnesses, and all poetry is one variety of the species. In all ages robust temperaments have produced positive men and realists; but never a poet."[8]

Ultimately Hébert disappointed those who in the 1850s had seen him as having the qualities of the leader of a school. He immersed himself in the "picturesque," envisaging only a commercial triumph when he could have claimed a place in French painting "between the coldness of M. Ingres and the excesses of M. Eugène Delacroix": "There was a very serious school to be founded," Maxime Du Camp grumbled bitterly in 1859, "a school that would not have excluded movement and where light would fuse with color."[9] Things grew worse and worse for Hébert; the protégé of Princess Mathilde floundered more and more in the inexact belaboring of his successful formulas. Yet in the 1850s he had offered something new. Thus the acerbic harangues against Manet's "pantheism" (see p. 216) were prefigured when Zacharie Astruc, Jean Rousseau, and Henri Delaborde berated Hébert for paying as much heed to decor as to figures—for painting "every vein" of "every stone"[10] in *Les Cervarolles* with "loving fastidiousness," giving those very veins and stones "almost the definitional value of the figures," so that "the detail virtually ate up the totality."[11] Indeed, Hébert was one of the first painters to realize the importance of the surroundings in the characterization of figures: the flat countryside of *La Malaria*, the sticky, "verdigris" steps[12] climbed in *Les Cervarolles* bear the signs of the inexorable languor that afflicts Hébert's human beings. This is an obvious allegory of the Italian influence on the painting of the time—a once strong and lively art that was wasting away like the rustic women of the Pontine Marshes. New sources—Spain and Japan—were replacing that academic terrain. The change was mourned by some, including Hébert and also his friend Théophile Gautier, who hailed the vanish-

ing of a world in the painter's morbid scenes: "I love this Italy with its wonderful pallor / A sweet reflection of your heart, melancholy Hébert!"[13]

H.L.

1. "qualités d'explorateur et d'aventurier"; "farouche beautés"; "naïves montagnardes"; "Dans ce pays sinistre où l'on pleurait, où l'on criait la faim comme ailleurs on chante, l'artiste se trouva bloqué dans la neige et passa dix-huit mois dans quelles conditions! Il dut percer une fenêtre dans un mur pour avoir du jour, fabriquer un chevalet avec des morceaux de bois; et les jours ressemblaient à des nuits." Sâr Joséphin Péladan, E. Hébert (Paris, 1910), p. 125.

2. "un tableau de genre dans de grandes proportions." A. J. Du Pays, "Salon de 1859," L'Illustration, April 30, 1859, p. 275.

3. Georges Lafenestre, "M. Ernest Hébert," Gazette des Beaux-Arts, November 1897, p. 353.

4. See Le Musée du Luxembourg en 1974, edited by Geneviève Lacambre, exh. cat., Grand Palais (Paris, 1974), p. 98.

5. Regarding this subject, see Maxime Du Camp's remarks in ibid., p. 98.

6. "aux charmes de la morbidesse"; "autorité et d'énergie"; "ambition mondaines." Baudelaire 1985–87, vol. 2, p. 647.

7. "réalisme poetique." Émile Cantrel, "Salon de 1859, XIV," L'Artiste, July 10, 1859, p. 162.

8. "De M. Hébert à M. Courbet, la distance ne se mesure pas. Cependant, bien que le maître peintre d'Ornans n'ait pas exposé, nous ne pouvons nous empêcher de faire le rapprochement que voici: M. Hébert peint volontiers les haillons; M. Courbet, de son côté, ne les épargne pas. Comment se fait-il que sur des données à peu près semblables, l'un soit poétique, l'autre simplement grossier? ... Serait-ce que M. Hébert peint mieux que M. Courbet? Cela est fort discutable, et même, à notre sens, le pinceau un peu boueux de l'apôtre réaliste a presque toujours des qualités de fermeté et de précision que l'auteur des Cervarolles n'a jamais eues. C'est tout simplement que la poésie est chose subjective.... M. Hébert ... applique presque indistinctement [à ses figures] sa singulière maladie mentale.... Il y a mille et une sortes de maladies mentales, et toute poésie est une des variétés de l'espèce. Les températures robustes ont de tout temps fait des hommes positifs et des réalistes; de poètes pas un." Charles Perrier 1859, pp. 302–3.

9. "pittoresque"; "entre les froideurs de M. Ingres et les excès de M. Eugène Delacroix"; "Il y avait une école très sérieuse à fonder, école où le style n'eût pas exclu le mouvement et où la ligne se fût alliée à la couleur." Du Camp 1859, p. 47.

10. "chaque veine"; "chaque pierre." Jean Rousseau, "Salon de 1859," Le Figaro, July 2, 1859, p. 3.

11. "avec une amoureuse minitie"; "presque la valeur de définition des figures"; "le détail absorbait un peu l'ensemble." Astruc 1859, p. 194.

12. "verdigrisées." Rousseau, "Salon," p. 3.

13. "J'aime cette Italie adorablement pâle/Doux reflet de ton coeur, mélancolique Hébert!" Théophile Gautier, "À Ernest Hébert sur son tableau La Mal'Aria," quoted in Drost and Henninges 1992, p. 228.

Johan Barthold Jongkind

Latrop, The Netherlands, 1819–Grenoble, 1891

After working for a short time in a notary's office, Jongkind decided to become a painter, and he went to The Hague in 1837 to study under the leading Dutch landscape artist Andreas Schelfhout. In 1846 Jongkind left for Paris, where he became a pupil of Eugène Isabey, the marine painter who introduced him to the Normandy coast in 1847; Jongkind also studied the figure with François Picot. In 1848 he made his debut at the Salon, where in 1852 he won a third-class medal. In 1853 the royal stipend, which had funded his study in Paris to date, was withdrawn. Financial debt and ill health occasioned his return to the Netherlands in 1855. In 1860 he went back to Paris, thanks to the proceeds raised by a sale that fellow artists organized on his behalf. That year he met his lifelong companion, a watercolorist, Mme Joséphine Fesser. In 1861 and 1863 Jongkind's works were rejected by Salon juries, but they were included annually in the Salons of 1864 through 1870. In 1862 Jongkind produced his first etchings, Six vues de Hollande, their success leading to his membership in the Société des Aquafortistes. The same year marks his return to the Normandy coast, where he visited Le Havre and Sainte-Adresse for the first time; he reestablished contact with Boudin, who would become a constant companion, and he met Monet, whom he saw again in 1864. Jongkind spent the summers of 1863, 1864, 1865 in Honfleur, making regular visits to the favored artists' gathering place Ferme Saint-Siméon; from 1866 to 1869, he departed Paris at the end of each summer for Belgium and the Netherlands. In 1870 Jongkind and Mme Fesser fled besieged Paris for Nantes and then Nevers.

By the end of the 1860s, Jongkind's luminous and fluidly painted harbor views had won the support of a number of patrons, from dealers Martin, Beugniet, and Brame to collectors Théophile Bascle and Poulet-Malassis; he also had the admiration of critics (among them Baudelaire, Castagnary, Champfleury) and a wide circle of artists that bridged two generations.

80 Fig. 82

Johan Barthold Jongkind
Sur la plage de Sainte-Adresse
(On the Beach at Sainte-Adresse)
1862
Oil on canvas
10¹¹⁄₁₆ x 16³⁄₁₆ in. (27 x 41 cm)
Signed and dated lower right: *Jongkind 1862*
Phoenix Art Museum, Mrs. Oliver B. James Bequest
70.37

CATALOGUE RAISONNÉ: Hefting 1975, no. 236

PROVENANCE: Earliest whereabouts unknown; with Carroll Carstairs, New York, until 1939; sold to Mrs. Oliver B. James, May 1939, until her death in 1970; her bequest to the museum, 1970

Jongkind first visited the Normandy coast with his teacher Eugène Isabey in 1847, and again in the early 1850s. He returned in 1862, spending the successive summers of 1863–65 in Honfleur. This period was not only a turning point for Jongkind's art, but for those younger painters—in particular Boudin, five years his junior, and Monet, nearly half his age—with whom he came into contact. From 1862 on, Jongkind and Boudin were constant companions, and in September of that year Monet met Jongkind for the first time. As Monet later recalled: "His painting was too new and too artistic in tone to be rightly appreciated in 1862. Also, no one knew less than he how to show one's qualities. He was a good man, very simple, speaking very bad French, and very shy. He was quite outspoken on that day. He asked to see my sketches, invited me to go work with him, explained to me the how and why of his manner and completed the teachings I had received from Boudin. From this moment on, he was my true master, and it is to him that I owe the final education of my eye."[1]

Perhaps the real "eye-opener" for Monet was his introduction to Jongkind's oil sketches, such as this example, one of three closely related beach scenes executed in 1862 at Sainte-Adresse. Distinctive from the finished studio compositions that had already established Jongkind's reputation for Monet as "the only good painter of marines that we have,"[2] the oil sketches were both "new" and instructive. Here Monet found subtle color harmonies of prussian blue and gray, a fluid and textural manner, and an insistent asymmetry of strong compositional patterns with triangular shapes that, by 1864 when the two artists spent entire days together, even sketching side by side, had an indelible impact on the younger artist's approach to the same subject.

G.T.

1. "Sa peinture était trop nouvelle et d'une note bien trop artistique pour qu'on l'appréciât, en 1862, à son prix. Nul, aussi, ne savait moins se faire valoir. C'était un brave homme tout simple, écorchant abominablement le français, très timide. Il fut très expansif ce jour-là. Il se fit montrer mes esquisses, m'invita à venir travailler avec lui, m'expliqua le comment et le pourquoi de sa manière et compléta par là l'enseignement que j'avais déjà reçu de Boudin. Il fut à partir de ce moment mon vrai maître, et c'est à lui que je dois l'éducation définitive de mon oeil." Thiébault-Sisson 1900, p. 3.
2. "le seul bon peintre de marines que ayons." Monet to Boudin, February 20, 1860, Wildenstein 1974, letter 3, p. 421.

81 *Fig. 84*

Johan Barthold Jongkind
Le Port de Honfleur
(*Honfleur*)
1865
Oil on canvas
20½ x 32⅛ in. (52.1 x 81.6 cm)
Signed and dated lower right: *Jongkind 1865*
The Metropolitan Museum of Art, New York, Catharine Lorillard Wolfe Collection, Wolfe Fund, 1916 16.39

CATALOGUE RAISONNÉ: Hefting 1975, no. 344

PROVENANCE: Durand-Ruel, Paris and New York, until 1916; purchased by the Metropolitan Museum, 1916

EXHIBITION: Northampton, Smith College Museum of Art; Williamstown, Sterling and Francine Clark Art Institute, 1976–77, *Jongkind and the Pre-Impressionists*, no. 9

SELECTED REFERENCE: Sterling and Salinger 1966, p. 133, repr.

This harbor view was painted in August or September 1865, during Jongkind's third and last visit to Honfleur, the town on the Normandy coast where he had established himself for consecutive summers beginning in 1863. It belongs to the category of studio works—distinct from oil sketches such as *Sur la plage de Sainte-Adresse* (cat. 80)—that already a decade earlier were thought to rival those of his mentor, or at least, in the words of Nadar, "do not fade at all next to Isabey's."[1] Despite Jongkind's method or the fact that he "seems condemned never to progress,"[2] he was able to retain a freshness and "persistent vitality"[2] in marines, like the present work, that were composed in the studio on the basis of sketches done in watercolor and pencil.[3] His example proved instructive. Witness the ambitious seascapes that Monet sent to the Salon of 1865, pursuant to his working side by side with Jongkind the previous summer.

Monet, who had met Jongkind in 1862, enjoyed the benefit of renewed and more substantive contact with the older artist in September 1864; their association came at a point when the younger artist was struggling to make of his "études," not merely "something complete," but "marvelous things."[4] The success of Monet's large seascapes submitted to the Salon of 1865 was, in some measure, indebted to Jongkind. They were admired for "the taste for harmonious tonalities" and "the sense of values,"[5] qualities he had learned from Jongkind.

G.T.

1. "ne pâlissent point à côté des Isabey." Nadar in *Journal pour rire*, April 23, 1852, quoted in Hefting 1975, p. 330.
2. "semble condamné à ne progresser jamais"; "vitalité persistante." Edmond About, *Salon de 1866* (Paris, 1867), pp. 179–80, commenting on the views of Honfleur that Jongkind exhibited in the Salon of 1866: "Les paysages de M. Jongkind sont toujours un peu froids, un peu noirs, un peu brouillés, jamais insignifiants ni vulgaires. Il y a une vitalité persistante dans cet art tout personnel qui semble condamné à ne progresser jamais" (M. Jongkind's landscapes are always a little cold, a little black, a little blurred, but they are never insignificant or vulgar. There is a persistent vitality in this very personal art that seems condemned never to make any progress).
3. There is related to the present painting a view in watercolor, inscribed *Honfleur, 12 Sept. 1864* (Hefting 314; Fogg Art Museum, Cambridge, Mass.).
4. "études"; "une chose compléte"; "des choses épatantes." Letter from Monet to Bazille, July 15, 1864, Wildenstein 1974, letter 8, p. 420.
5. "le goût des colorations harmonieuses"; "le sentiment des valeurs." Paul Mantz, "Salon de 1865," *Gazette des Beaux-Arts* 18 (1865), p. 26.

Alphonse Legros
Dijon, 1837–Watford, near London, 1911

Legros came from a modest background, with a father who was a "clerk" and then a grain dealer, before going into "business." He arrived in Paris during the early 1860s: here he attended the Petite École de Dessin, on rue de l'École de Médecine, while earning his livelihood by working for Charles-Antoine Cambon, the theater decorator. It was at the drawing school that Legros met Fantin. In 1857 Legros's portrait of his father (Musée des Beaux-Arts, Tours), which the artist sent to the Salon, was noticed by Champfleury, and his *L'Angélus* piqued Baudelaire's interest at the Salon of 1859. In 1861 he produced his first etchings, showed *L'Ex-voto* (fig. 73) at the Salon, and visited London at the invitation of Whistler's brother-in-law, Seymour Haden. In 1863 Legros, weary of the financial difficulties he experienced in France, settled in England. London was a delight: his colleagues welcomed him with open arms, Whistler introduced him to his devotees, he married, and he showed regularly at the Royal Academy. In 1863 Whistler wrote to Fantin: "Legros is, first of all, so handsome that you wouldn't recognize him. His greatest preoccupation is the exact shade of the gloves he wears!

I'm going to have him photographed so that you can see the great extent of his splendor! Moreover he is the darling of high society here, all the young British girls are mad about him."[1] Why, given all that, would he have wanted to remain in Paris? His English career developed brilliantly, and he became a British subject in 1880. Nevertheless, he had several discreet triumphs in France. At the Salon of 1867 *La Lapidation de saint Étienne* (*The Stoning of Saint Stephen*, destroyed) was acquired by the Maison de l'Empereur. The following year *L'Amende honorable* (*Due Apology*; Musée d'Orsay, Paris) brought him a medal and was purchased by the government. Though he drifted away from Fantin and Whistler, he stayed in touch with Manet, whom he informed of possible outlets for his work in England. During the Franco-Prussian War and the Commune, he was extremely hospitable to the French artists who fled to his adopted country.

1. "Legros est d'abord d'un beau à ne plus le reconnaître, écrit Whistler à Fantin en 1863. Sa grande préoccupation est la nuance des gants qu'il porte! Je vais le faire photographier pour que tu le voies dans la fine fleur de sa splendeur! Du reste, il est le chéri du beau monde ici, toutes les demoiselles anglaises se font une passion pour lui." Whistler's letter to Fantin-Latour, 1863, copy at the Archives du Louvre.

82 *Fig. 166*

Alphonse Legros
Femme dans un paysage
(*Woman and Dog in a Landscape*)
1860
Oil on canvas
51⅝ x 64⅛ in. (131 x 163 cm)
Signed and dated lower left: A. Legros 1860
Musée des Beaux-Arts et de la Dentelle, Alençon

PROVENANCE: Gift of the artist to the Musée d'Alençon, 1861

EXHIBITIONS: Paris, Exposition Universelle, 1900, *Exposition centennale de l'art français*, no. 416 (Femme dans un paysage [Musée d'Alençon]); Dijon, Musée des Beaux-Arts, 1957, *Alphonse Legros: Peintre et graveur*, no. 3; Dijon, Musée des Beaux-Arts, 1987–88, *Alphonse Legros 1837–1911*, no. 12, pp. 46–48, repr.

SELECTED REFERENCES: Catalogue, Musée d'Alençon, 1862, no. 61, p. 18; Two articles, which appeared in *Le Nouvelliste alençonnais* when the painting was given to the musée, are quoted by Timothy Wilcox in *Alphonse Legros* (Dijon, 1987–88), pp. 47–48

In 1861 Legros presented this canvas to the Musée d'Alençon. He had painted it the preceding year at the behest of Poulet-Malassis, a publisher, who had helped to establish the museum in 1857. The gift, if we are to believe the local critics, was not appreciated; they spoke of a children's illustration and saw the young woman as "a common Latin Quarter grisette who is afraid of being devoured by some old lecher."[1] The painting has scarcely been noticed since then, except by Henri Focillon, who devoted a few admiring pages to Legros in his *La Peinture au XIXe siècle*. Among the artists in the Group of 1863 around Manet, Legros struck Focillon as an essential figure, who transmitted the teachings of Lecoq de Boisbaudran and Courbet, demonstrating "a power of vision that made his work consistent, eloquent, and simple and that spontaneously created style. . . . [Granted,] he was not fully expressed in painting, [but] a few remarkable islets occurred here and there in his oeuvre: *L'Ex-voto* (1861, Dijon) [fig. 73] and *La Dame au chien [Woman with a Dog]* (Alençon) represent, if you will, his Courbet manner."[2]

Femme dans un paysage does follow in Courbet's narrow wake, as is emphasized by the dark colors; the thick pigments; the way the figure stands out against a rich, green, rocky landscape that recalls the environs of Ornans; and the hand holding a few flowers, like the one in *La Mère Grégoire (Mother Gregory*; The Art Institute of Chicago). It is difficult to find any trace of Lecoq de Boisbaudran's abstract lessons in this composition, which is heavily reworked (the woman was originally accompanied by a man who was leaning toward her). Nevertheless, it is a significant leg of the journey leading from Courbet to Manet, a pioneering if abortive attempt to integrate the figure in a landscape, which would be one of the great goals of the artists of the New Painting.

H.L.

1. See Timothy Wilcox, *Alphonse Legros 1837–1911*, exh. cat., Musée des Beaux-Arts, Dijon (1987), p. 47.
2. Henri Focillon, *La Peinture au XIXe siècle* (Paris, 1991), vol. 2, pp. 164–65.

Édouard Manet

Paris, 1832–Paris, 1883

The son of a senior official in the Ministry of Justice, Manet was a product of the old, established Paris bourgeoisie. He had a sound classical education at the Institut Poiloup de Vaugirard and then at the Collège Rollin, where he met Antonin Proust. His schooldays over, he decided to go to sea but failed the entrance examination to the École Navale. From December 1848 to June 1849, however, he sailed on a long voyage aboard a training ship bound for Rio de Janeiro. After he had failed a second time to get into the École Navale, Manet's family agreed to his becoming a painter, and in 1850 he entered the atelier of Couture, whose teaching he was later to criticize severely. During the 1850s Manet made copies in the Louvre and traveled in Holland (1852) and Italy (1853 and 1857). In February 1856 he left Couture's studio and set himself up with the animal painter Albert de Balleroy in the rue Lavoisier, in a quarter of Paris that he would stay in for the rest of his life. It was there that he worked on *Le Buveur d'absinthe* (fig. 4) his first submission —rejected—to the Salon of 1859 (see pp. 19–20).

For Manet's biography in the 1860s, see the chronology.

83 *Fig. 85*

Édouard Manet
Le Pont d'un bateau
(*The Deck of a Ship*)
Ca. 1860
Oil on canvas mounted on panel
22¼ x 18½ in. (56.4 x 47 cm)
Signed (not in the artist's hand) lower right: Manet
National Gallery of Victoria, Melbourne, Australia, Felton Bequest, 1926 2046/3

CATALOGUE RAISONNÉ: Rouart-Wildenstein 1975, no. 64

PROVENANCE: Quentin collection, Paris; John James Cowan, Edinburgh, until 1926; his sale, Christie's, London, July 27, 1926, no. 13; purchased at this sale by Rinder for 950 guineas for the museum; Felton bequest to the National Gallery of Victoria, 1926

EXHIBITIONS: Philadelphia, Philadelphia Museum of Art, and Chicago, Art Institute, 1966–67, *Manet*, no. 61

SELECTED REFERENCES: Edmond Bazire, *Manet* (Paris, 1884), p. 3; Louis Gonse, "Manet," *Gazette des Beaux-Arts*, February 1884, p. 135, repr.; Julius Meier-Graefe, *Édouard Manet* (Munich, 1912), pp. 11–12; Tabarant 1947, p. 23, no. 11; Rouart-Orienti 1970, no. 13; Moreau-Nélaton, cat. ms., no. 58; Tabarant 1931, no. 10; Jamot-Wildenstein 1932, no. 90; Wilson Bareau 1991, p. 19

No other work by Manet has been given such widely divergent dates, from 1849 for Meier-Graefe, to about 1868 for Juliet Wilson Bareau.[1] Tabarant, in a brief fit of anger, took exception to the proposal made in the Jamot-Wildenstein catalogue, which "dates it to 1864, which is altogether unacceptable"; and in the second edition of his book, published in 1947, he maintained: "*Le Pont d'un bateau* is one of the rare works of Manet's youth and was executed between his twentieth and his twenty-sixth year."[2] But if one compares it with several surviving paintings, all clumsy and labored—Manet's beginnings were not as easy as those of Degas—it is impossible to agree with Tabarant. The present picture indeed shows a grasp of coloring, a subtle harmony of black and brown, and a free, full brushstroke that bar its classification among the artist's earliest efforts. On the other hand, certain awkwardnesses, such as the painful drawing of the parapet and the composition itself—a realistic, faithful rendering of the motif, without any adjustment, contrary to Manet's normal practice in the marine pictures he painted after 1864 (cat. 110)—coupled with the distorted perspective, flat tints, and "strange elegances" of *Japonisme* make a date late in the decade unlikely. I incline, therefore, like Hanson and Reff, to an intermediate dating, at the beginning of the 1860s.[3]

H.L.

1. Julius Meier-Graefe, *Édouard Manet* (Munich, 1912), pp. 11–12. According to Tabarant, Meier-Graefe retracted this error (Tabarant 1947, p. 29). Wilson Bareau 1991, p. 19.
2. "la date de 1864, ce qui est tout à fait inacceptable." "*Le Pont d'un bateau* est une des rares oeuvres de jeunesse de Manet et a été exécutée entre sa vingtième et sa vingt-sixième année." Tabarant 1947.
3. See Theodore Reff's review of the Rouart and Wildenstein catalogue in *Art Bulletin* December 1976.

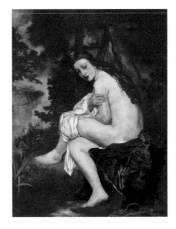

84 *Fig. 123*

Édouard Manet
Nymphe surprise
(*The Surprised Nymph*)
1861
Oil on canvas
56⅞ x 44¼ in. (144.5 x 112.5 cm)
Signed lower left: ed. Manet 1861
Museo Nacional de Bellas Artes, Buenos Aires 2712

CATALOGUE RAISONNÉ: Rouart-Wildenstein 1975, no. 40

PROVENANCE: The artist, until his death in 1883 (recorded in Manet's 1872 inventory with an estimated value of Fr 8,000 and in the posthumous inventory of 1882, no. 11); Manet estate sale, Paris, Hôtel Drouot, February 4–5, 1884, no. 14; bought for Fr 1 250 by M. Le Meilleur, Paris; Michel Manzi, Paris; Galerie Bernheim-Jeune, Paris; bought by the Museo Nacional de Bellas Artes, Buenos Aires, 1914

EXHIBITIONS: Saint Petersburg, Imperial Academy, 1860–61, Exposition annuelle, no. 71 (Nymphe et Satyre. Price: 1,000 ruble); Paris, Pont de l'Alma, 1867, *Tableaux de M. Édouard Manet*, no. 30 (Nymphe surprise); Paris, École des Beaux-Arts, 1884, *Exposition de Édouard Manet*, no. 13 (La Nymphe surprise); Paris, New York, 1983, no. 19

SELECTED REFERENCES: Bibliography in Russian is given in the article by D. G. Barskaya (Bucharest, 1961): *Vremya*, October 1861; Pandrov, *Illiustratsiia* 187 (1861); Ryanov, *Russkii invalid* 204 (1861); caricature by N. A. Stepanov, *Iskra* 40 (1861), pp. 566–67; Vinaev, *Russkoye Slovo*, October 1861; Edmond Bazire, *Manet* (1884), p. 12; Louis Gonse, "Manet," *Gazette des Beaux-Arts*, February 1884, p. 138; Proust 1897, p. 168; Duret 1902, no. 24; Jacques-Émile Blanche, *Manet* (Paris, 1924), p. 22; Moreau-Nélaton 1926, vol. 1, p. 33, repr. fig. 24; Tabarant 1931, no. 39; Germain Bazin, "Manet et la tradition," *L'Amour de l'art*, May 1932, p. 155, repr. fig. 26; Charles Sterling, "Manet et Rubens," *L'amour de l'art*, September–October 1932, p. 290; Tabarant 1947, pp. 43–44, no. 42; Sandblad 1954, p. 95; Giovanni Corradini, "La Nymphe surprise de Manet et les rayons X," *Gazette des Beaux-Arts*, September 1959, pp. 149–54, repr. fig. 1; D. G. Barskaya, "Édouard Manet's Painting "Nymph and satyr" on Exhibition in Russia in 1861," *Omagiu lui George Oprescu . . .* (Bucharest, 1961), pp. 5–8; Beatrice Farwell, "A Manet Masterpiece Reconsidered," *Apollo*, July 1963, p. 46; Rosalind E. Krauss, "Manet's Nymph Surprised," *Burlington Magazine*, November 1967, pp. 622–27, fig. 16; Merete Bodelsen, "Early Impressionist Sales: 1874–94," *Burlington Magazine*, June 1968, p. 344, no. 14; Michael Fried, "Manet's Sources: Aspects of His Art—1859–65," *Art Forum*, March 1969, repr.; Rouart-Orienti 1970, no. 38a; Farwell 1973, pp. 54, 67–79; Beatrice Farwell, "Manet's Nymphe Surprise," *Burlington Magazine*, April 1975, pp. 225–29; Mauner 1975, pp. 22–23, fig. 12; Hanson 1977, part 2, p. 92; Juan Corradini, *Édouard Manet: La Ninfa Sorprendida* (Buenos Aires, 1983); Armbrust-Seibert 1986, vol. 1, pp. 81–88; Juliet Wilson Bareau, *The Hidden Face of Manet*, exhibition at the Courtauld Institute, London, 1986, pp. 30–36

This large painting, clearly undertaken with the Salon in view, was exhibited by Manet twice in his lifetime: in 1861 at Saint Petersburg and again in 1867 as part of his Pont de l'Alma retrospective, where it caused no comment. Zola omitted it from his "biographical and critical study." Later considered as an "able mixture of styles" and as "a fine piece of nude painting but one that still gives the impression of a man toiling in search of himself," the work attracted only moderate attention.[1] During the last thirty years, however, there have been multiple studies investigating its difficult elaboration: Corradini, Krauss, Farwell, and Wilson Bareau have analyzed old photographs, deciphered X rays, and enumerated sketches in order to retrace its history.

Shortly before leaving his studio in the rue Lavoisier—that is, in the course of 1859—Manet began, according to Antonin Proust, "a large picture, *Moïse sauvé des eaux* [*The Finding of Moses*], which he never finished and of which there remains only one figure that he cut out of the canvas and called *La Nymphe surprise*."[2] Surviving from this first project is a brightly colored sketch (fig. 407), which shows Pharaoh's daughter in the position of the present nymph; she is attended by a maidservant bending toward her, while in the background a woman in her retinue points to the cradle floating on the Nile. Dissatisfied with this large composition—it must have measured about 62 by 90 inches (160 x 230 cm) —Manet cut it down, keeping only the Egyptian princess and doing away with the figure of the maidservant (she appears in the X rays), who was not needed once the artist had abandoned his biblical subject. Signed and dated 1861, this work was shown under the title *Nymphe et satyre* (*Nymph and Satyr*) in the annual exhibition of the Imperial Academy of the Arts at Saint Petersburg. There, according to Barskaya, it was roundly criticized by the adherents of academic art, who judged its coloring to be unpleasant and who found something "Bulgarian" about the portrait of the nymph.[3] The new title was accounted for by the presence of a satyr in the upper right corner, no doubt hastily painted in for the Russian exhibition; it was still visible in the photographs taken first by Godet and then by Lochard in 1883 or 1884 and was erased after Manet's death.

Today the nymph is no longer surprised by anyone but the onlooker. Despite the fact that Manet himself did not eliminate the satyr, its removal has given rise to inevitable speculations about the painter's suppression of his subject and the new role of the spectator-voyeur.[4] Beatrice Farwell has rightly pointed out that Manet's sole ambition throughout the difficult process of realizing *Nymphe surprise* was to paint the nude. In its final version this "truly . . . experimental work," to use Françoise Cachin's phrase,[5] belongs to the category of *Le Déjeuner sur l'herbe* (cat. 93), which it prefigures: a nude planted in a conventional landscape and stamped with the example of the old masters, in a pose and with the attributes that make her at will a nymph, Susannah, or Bathsheba. For Manet, as has been observed, was here inspired by many sources: the *Bathsheba* of Giulio Romano or that of Rembrandt, the *Diana at the Bath* of Boucher or of a print by Marcantonio Raimondi, a Rubens reproduction in Charles Blanc's *Histoire des peintres*, an engraving after van Dyck, and so forth.[6] These references can be exhaustively rehearsed; they were not twisted and exposed as in *Le Déjeuner sur l'herbe* or *Olympia*, but quoted calmly in order to arrive at this beautiful variation on an ancient theme. We are still—though not for long—in "olden times," the days when, according to Degas's formula, to paint the nude one chose goddesses, biblical heroines, or princesses of antiquity, all soon to be supplanted by the *grisette* and the courtesan.

H. L.

1. "habile mixture d'école." Louis Gonse, "Manet," *Gazette des Beaux-Arts*, February 1884, p. 138. "un beau morceau de nu mais où l'on sent encore le travail de l'homme qui se cherche." Duret 1926, p. 17.
2. Proust 1897, p. 25.
3. D. G. Barskaya, "A Picture of Édouard Manet, 'The Nymph and the Satyr,' on Exhibition in Russia in 1861," *Omagiu lui George Oprescu cu prilejul împlinirii a 80 de ani*, Academia Republicii Populare Romine, [1961], pp. 61–68.
4. See especially Rosalind E. Krauss, "Manet's Nymph Surprised," *Burlington Magazine*, November 1967, pp. 622–27, and Michael Fried, "Manet's Sources: Aspects of His Art, 1859–1865," *Artforum*, March 1969, p. 72.
5. Françoise Cachin, in Paris, New York 1983, p. 83.
6. Ibid., pp. 83–84.

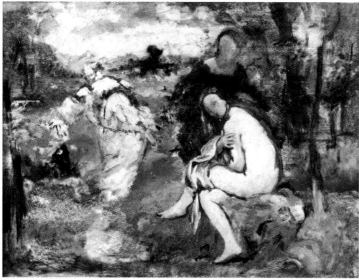

Fig. 407. Édouard Manet, study for *Nymphe surprise*, 1860–61. Oil on wood, 14 x 17¾ in. (35.5 x 45 cm). Nasjonalgalleriet, Oslo

85 *Fig. 191*

Édouard Manet
Guitare et Chapeau
(*Guitar and Hat*)
1862
Oil on canvas
30⅜ x 47⅝ in. (77 x 121 cm)
Musée Calvet, Avignon 22.273

CATALOGUE RAISONNÉ: Rouart-Wildenstein 1975, no. 60

PROVENANCE: The artist, until his death in 1883; Manet estate sale, Hôtel Drouot, Paris, February 4–5, 1884, no. 93; acquired by Léon Leenhoff for Raoul Fournier, Manet's cousin; Paris, sale D . . . , May 1923; bought by Joseph Rignault, Saint-Cirq Lapopie (Lot); his gift to the Musée d'Avignon, 1947

EXHIBITIONS: Paris, École nationale des Beaux-Arts, 1884, *Exposition des oeuvres de Édouard Manet*, no. 17 (Guitare et chapeau, dessus-de-porte)

SELECTED REFERENCES: Duret 1902, no. 39; Moreau-Nélaton, cat. ms., no. 44; Tabarant 1931, no. 49; Jamot-Wildenstein 1932, no. 58; Tabarant 1947, p. 56, no. 58; Theodore Reff, "The Symbolism of Manet's Frontispice Etchings," *Burlington Magazine*, June 1968, pp. 182–87; Rouart-Orienti 1970, no. 54; Juliet Wilson Bareau in Paris, New York 1983, pp. 136–41

Little known and rarely exhibited, this still life is one of the earliest that Manet painted. He executed it as a an overdoor painting for his studio in the rue Guyot, which explains its large size. Piled up in a basket are a black bolero, a white shirt, a guitar, and a hat. These elements of Spanish costume appear in two contemporary canvases: all of them in *Espagnol jouant de la guitare*, and the bolero and hat in *Mlle V . . . en costume d'espada* (cat. 90). Manet backs these objects against a painted and carved ledge with a cartouche that confirms the function of the painting —a trompe l'oeil designed to feature a number of studio props, arranged on a shelf above a door.

It is true that *Guitare et chapeau* was, as Tabarant noted, the "last sacrifice" to that "Spanishism" that was so strong in 1862,[1] for everything here refers to Spanish painting—the thickness of the impasto, the somber hues, the play of black and white, the deliberate austerity that recalls the severity of Spanish still lifes. Above all, however, Manet was proclaiming, at the outset of his career, both his tastes and his ancestry. Thanks to this overdoor painting, his studio became in 1862 "the Spanish studio," as Bonvin's was the Flemish (see p. 19). So well did this simple subject express Manet's loyalties and ambitions that he used it as a print on the cover of a

volume of his etchings, seeing in it no mere decoration but an eloquent coat of arms.

 H.L.

1. "dernier sacrifice"; "espagnolisme." Tabarant 1947, p. 56.

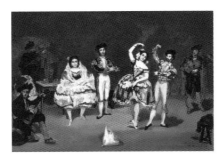

86 *Fig. 346*

Édouard Manet
Le Ballet espagnol
(*The Spanish Ballet*)
1862
Oil on canvas
24 x 35⅝ in. (60.9 x 90.5 cm)
Signed and dated lower right: ed. Manet 62
The Phillips Collection, Washington acc. no. 1250

CATALOGUE RAISONNÉ: Rouart-Wildenstein 1975, no. 55

PROVENANCE: The artist, until 1872; bought by Paul Durand-Ruel, Paris, for his person collection, 1872; sold by Durand-Ruel, New York, to Duncan Phillips, Washington, D.C.

EXHIBITIONS: Paris, Galerie Martinet, February 1863; Paris, Pont de l'Alma, 1867, *Tableaux de M. Édouard Manet*, no. 28 (Le ballet espagnol, 62 x 91 cm); London, Dowdeswell and Dowdeswell, 1883, *Paintings, Drawings and Pastels by Members of La Société des impressionnistes*, no. 41; Paris, École nationale des Beaux-Arts, 1884, *Tableaux de M. Édouard Manet*, no. 12, (Le Ballet espagnol. Property of M. Durand-Ruel); New York, Durand-Ruel Galeries, 1895, *Paintings by Édouard Manet*, no. 18; Paris, Musée de l'Orangerie, 1932, *Manet*, no. 8; Washington, National Gallery of Art, 1982, *Manet and Modern Paris*, no. 32

SELECTED REFERENCES: Paul Mantz, "Exposition du boulevard des Italiens," *Gazette des Beaux-Arts*, April 1, 1863, p. 383; Émile Zola, "Une nouvelle manière en peinture, Édouard Manet," *Revue du xixᵉ siècle*, January 1, 1867, p. 56; Paul Alexis, "Marbres et plâtres, Manet," *Le Voltaire*, July 25, 1879; Louis Gonse, "Manet," *Gazette des Beaux-Arts*, February 1884, p. 138; Sâr Joséphin Péladan, "Le Procédé de Manet d'après l'exposition faite à l'école des Beaux-Arts," *L'Artiste*, February 1884, p. 108; Georges Lecomte, *L'Art impressionniste d'après la Collection privée de M. Durand-Ruel* (Paris, 1892), pp. 41, 43–45; Duret 1902, no. 29; Moreau-Nélaton, cat. ms., no. 41; Moreau-Nélaton 1926, vol. 1, p. 35; Tabarant 1931, no. 50; Jamot-Wildenstein 1932, no. 48; Tabarant 1947, pp. 51–52, no. 52; Rouart-Orienti 1970, no. 46; McCauley 1985, pp. 173–79; Herbert 1988, pp. 94–95

In 1862 the troupe of Spanish dancers led by Mariano Camprubi appeared in Paris, first at the Odéon, opening there on April 27, and then at

the Hippodrome at the rond-point de Saint-Cloud, from August 12 to August 17.[1] Their ballet *La Flor di Sevilla* (*The Flower of Seville*) attracted only moderate attention in the press but had, according to Tabarant, a "lively" public success; at the Hippodrome it added spice to that of the military spectacle *La Prise de Malakoff* (*The Capture of Malakoff*), while at the Odéon it was inserted into the first act of *The Barber of Seville*. Manet, obsessed with Spain, arranged with Mariano Camprubi "a deal whereby part of the troupe would go as often as was necessary to Alfred Stevens's studio at 18 rue Taitbout, the rue Guyot studio being too far away and not big enough."[2] At intervals after April 1862 Manet painted three pictures of the Spanish dancers: *Lola de Valence* (cat. 87); a small portrait of the leading male dancer, Mariano Camprubi (Rouart-Wildenstein 54; private collection); and this *Ballet espagnol*. A preparatory watercolor (Szépmüvészeti Múzeum, Budapest) shows only minor differences from the finished painting, which juxtaposes the principal dancers in the group—Lola Meléa, known as Lola de Valence, seated on a stool; a male dancer identified by Manet in a drawing as "Alemay"; and Anita Montès and Camprubi, who look like porcelain figures, dancing. Two guitarists flank them, while in the background on the left, barely visible against the unified ground, lurk two men with the air of conspirators, straight out of an engraving by Goya; these four supernumeraries are dressed in black and brown, while the dancers wear bright stage costumes in which a dazzling white predominates. Perhaps because they did not pose as a group, they appear arbitrarily lined up on the picture plane, a feature that has caused certain commentators to question Manet's compositional ability at this date.[3] Robert L. Herbert has, however, noted that the picture "speaks more of studio than of stage,"[4] and it is true that there is nothing to indicate the theater apart from the incongruous bouquet, wrapped in white paper, the tribute of an admirer of the women; it plays exactly the same role as the pink shoes between the horse's hooves in Degas's *Portrait of Mlle E[ugénie] F[iocre]; à propos du ballet de "La Source"* (cat. 61). For these two pictures, both of them ambiguous, are essentially portraits. Manet painted the four protagonists of *La Flor di Sevilla* in the studio, subtly blending the conventions of the theater and those of art. These individuals are all in stage costume, the guitarists play, two dancers try out a movement; but Lola de Valence, calmly seated, at once infanta and toad, looks out at the painter, and the occasional accessories, benches, or stools, the table with its bottle and glasses, are the ordinary furnishings of a studio. For this group portrait, which he might have called in a pastiche of Degas, "Portrait of Spanish Dancers: Apropos the Ballet of *La Flor di Sevilla*," Manet arranged a simple setting, that of the interlude performed at the Odéon during the first act of the *Barber of Seville*, an impromptu Spanish dance to enliven—as was the custom

—the Beaumarchais play: the dancers occupy the front of the stage, while in the shadows Figaro, in black, and the count, "in a large brown cloak and slouch hat," await a sign from the charming Rosina.[5]

H.L.

1. Ivor Guest, *The Ballet of the Second Empire* (London, 1953–55), vol. 2, p. 147; Sauzeau, "Causeries," *L'Entracte*, August 12, 1862, p. 3 ("À l'Hippodrome, aujourd'hui, début de la troupe d'Espagnols dans le ballet de *La Flor di Sevilla*, et représentation extraordinaire tous les jours jusqu'à dimanche prochain [At the Hippodrome today the opening of the troupe of Spaniards in the ballet *La Flor di Sevilla* and extraordinary performance every day until next Sunday]"); and McCauley 1985, p. 173. The Hippodrome was no longer the one on what is today the avenue des Portugais, near the Étoile, where Courbet had placed his *Lutteurs* (fig. 152) and which had burned down in 1856, but a new establishment built by Davioud in 1857 at the rond-point de Saint-Cloud (now place Victor Hugo); it was destroyed by fire on the night of September 29–30, 1869.

2. "très vif"; "un marché au terme duquel une partie de la troupe se transporterait autant de fois qu'il faudrait dans l'atelier d'Alfred Stevens, 18, rue Taitbout, celui de la rue Guyot étant trop éloigné, et d'ailleurs de dimensions trop restreintes." Tabarant 1947, p. 52. The Hippodrome was, however, nearer to the rue Guyot than to the rue Taitbout. According to Moreau-Nélaton, the sittings took place in the rue Guyot studio: "L'ensorcelant personnel défile à l'atelier de la rue Guyot [Personal bewitchment slips away at the rue Guyot studio]" (Moreau-Nélaton 1926, vol. 1, p. 35).

3. Duret 1926, p. 18; and Germain Bazin, *Manet* (Paris, 1974), p. 19.

4. Herbert 1988, p. 96.

5. "en grande manteau brun et chapeau rabattu." Beaumarchais, *The Barber of Seville*, act 1, scene 1.

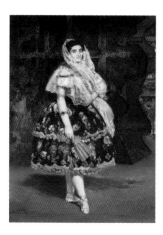

87 *(Paris only)* *Fig. 269*

Édouard Manet
Lola de Valence
1862
Oil on canvas
Signed lower left: Ed. Manet
48⅜ x 36¼ in. (123 x 92 cm)
Musée d'Orsay, Paris RF 1991

CATALOGUE RAISONNÉ: Rouart-Wildenstein 1975, no. 53

PROVENANCE: The artist, until 1873; bought for Fr 2,500 by Jean-Baptiste Faure, Paris, 1873, until at least 1889; Camentron and Martin, Paris, until 1893; bought for Fr

15,000 by Comte Isaac de Camondo, Paris, July 1893, until his death in 1908; his bequest to the Musée du Louvre, 1911; exhibited at the Musée du Louvre, Paris, 1914; Musée du Jeu de Paume, Paris, 1947; Musée d'Orsay, Paris, 1986

EXHIBITIONS: Paris, Galerie Martinet, 1863, private exhibition; Paris, 1867, Pont de l'Alma, *Tableaux de M. Édouard Manet*, no. 17 (Lola de Valence); Paris, École nationale des Beaux-Arts, 1884, *Exposition des oeuvres de Édouard Manet*, no. 14 (Lola de Valence. Property of M. Faure); Paris, Exposition Universelle, 1889, *Centennale des artistes français*, no. 497 bis (Lola de Valence. Property of M. Faure); Paris, Musée de l'Orangerie, 1932, *Manet*, no. 7; Philadelphia Museum of Arts, and Chicago, Art Institute, 1966–67, *Manet*, no. 44; Paris, 1968–69, no. 652; Paris, New York, 1983, no. 50

SELECTED REFERENCES: Henry de La Madelène, *Salon des refusés* (Paris, 1863), p. 41; Paul Mantz, "Exposition du boulevard des Italiens," *Gazette des Beaux-Arts*, April 1, 1863, p. 383; Pigalle [Jean Rousseau], "L'Autographe au Salon de 1865," *L'Autographe au Salon de 1865 et dans les ateliers* (Paris, 1865); Hippolyte Babou, "Les dissidents de l'exposition," *La Revue libérale* 2 (1867), p. 288; Émile Zola, "Une nouvelle manière en peinture, Édouard Manet," *La Revue du xixᵉ siècle*, January 1, 1867, p. 55; G. Randon, "L'Exposition d'Édouard Manet," *Le Journal amusant*, June 29, 1867, p. 6; E. Spuller, "M. Édouard Manet et sa peinture," *Le Nain jaune*, June 9, 1867, p. 5; Barbey d'Aurevilly, "Un ignorant au Salon," *Le Gaulois*, July 3, 1872; Paul Alexis, "Marbres et plâtres, Manet," *Le Voltaire*, July 25, 1879; Paul Alexis, "Manet," *La Revue moderne et naturaliste*, 1880, pp. 289–95; Émile Zola, "Édouard Manet," preface to catalogue of posthumous exhibition, Paris, École des Beaux-Arts, 1884, p. 13; Bazire 1884, p. 86; Sâr Joséphin Péladan, "Le procédé de Manet," *L'Artiste*, February 1884; Louis Gonse, "Manet," *Gazette des Beaux-Arts*, February 1884, p. 138; Duret 1902, no. 36; Paul Jamot, "La Collection Camondo au Musée du Louvre," *Gazette des Beaux-Arts*, June 1914, pp. 442–44; Moreau-Nélaton, cat. ms., no. 43; Moreau-Nélaton 1926, vol. 1, p. 35; Tabarant 1931, no. 51; Jamot-Wildenstein 1932, no. 46; Tabarant 1947, no. 52; Rouart-Orienti 1970, no. 47; Reff 1982, pp. 112–13; Herbert 1988, pp. 94–95; Darragon 1989, pp. 77–79

It was probably after he had had the group pose for him in *Le Ballet espagnol* (cat. 86) that Manet turned his attention to the star of Mariano Camprubi's dance troupe—Lola Meléa, known as Lola de Valence, "so often feted, embraced, and made much of in Paris."[1] She was celebrated by Baudelaire and Astruc, surprising in light of her stocky build, heavy features, and the mannish air that casts doubt on her sex.[2] When this medium-size full-length portrait was exhibited at the Galerie Martinet in March 1863, it bore a cartouche fastened to the frame with the lines written by Baudelaire on discovering the painting in his friend Manet's studio:

"Entre tant de beautés que partout on peut voir
Je comprends bien, amis, que le Désir balance;
Mais on voit scintiller dans Lola de Valence
Le charme inattendu d'un bijou rose et noir."
(Among so many beauties to be seen all around
I can well understand, my friends, that Desire hesitates;
But seen sparkling in Lola de Valence
Is the unexpected charm of a rose and black jewel.)[3]

The quatrain, wrote Zola in 1867, "was hissed and abused as much as the picture itself."[4] Indeed, it needed Jacques-Émile Blanche's good nature to discern in this "harmony" of black, white, and red a "picture in two shades, black and pale pink."[5] Evidently, the Baudelairean "unexpected charm" suggested to contemporaries jewels more indiscreet than the study in two colors; catcalls were unleashed by the erotic allusion, just as they would be later by the redheaded Olympia's black cat. They were reinforced by the striking coloring of the picture, the "gaudiness" denounced by Paul Mantz, which certainly bore witness to the painter's "abundant energy" and "honesty," but which seemed unhealthy, "a caricature of color and not color itself."[6]

When the painting reappeared four years later in the Pont de l'Alma exhibition, it had lost nothing of its éclat and was "so charming in its oddness," "possibly the jewel of the show."[7] Zola, who was then in some sort "inventing" Manet (see pp. 216–17), ventured a hazardous and highly personal interpretation ("I do not know," he cautioned prudently, "if I am straining the sense of Baudelaire's verse"): "It is perfectly true that *Lola de Valence* is a rose and black jewel; the artist was already working only in patches of color, and his Spanish woman was painted broadly, in vivid contrasts; the whole canvas is covered in two hues."[8] These vivid contrasts must have been even more striking when the sturdy ballerina appeared against a neutral background, a feature confirmed by the dependent works that Manet executed in 1862—a watercolor done in preparation for an etching (of which eight states are known) and a lithograph illustrating the sheet-music cover of a serenade by Zacharie Astruc—and by the caricatures published at the time of the 1867 exhibition.[9] It was probably soon after this date—Tabarant, without specifying exactly when the reworking took place, states only that it was undertaken "on the advice of his friends"[10]—that Manet added the scenery scaffolding to the background, allowing a narrow glimpse on the right of the auditorium, balconies, and boxes of an ordinary theater rather than the tiers of the Hippodrome. The "friends" mentioned by Tabarant would surely have included Degas, who at this very moment, in his portrayal of Eugénie Fiocre (cat. 61), was painting the first dancer of his career. But *Lola de Valence* comes from quite a different lineage: the aristocratic one of Goya and his *Duchess of Alba* (Hispanic Society of America, New York) and another, unacknowledged and more obscure, of popular images and photographic cartes de visite.[11] Both artists, however, betray the continuing influence of Courbet. It shows up in the rocky decor of the ballet *La Source*, and is even clearer in the composition of *Lola de Valence*: like Adela Guerrero (cat. 38) before her, the ballerina strikes a pose; like Guerrero she is short and dark, like her "weighed down with a heavy, rich basquine"; like her she stands waiting "proudly in the wings for the cue to launch herself into the verve, the beat, and the breathless delirium of her performance."[12]

H.L.

1. "si souvent fêtée, embrassée, caressée à Paris." Zacharie Astruc, *Le Généralife*, quoted in Paris, New York 1983, p. 146.

2. Caricature by Randon in *Le Journal amusant*, June 29, 1867, repr. in Paris, New York 1983, p. 148.

3. Baudelaire 1985–87, vol. 1, p. 168.

4. "fut sifflé et maltraité autant que le tableau lui-même." Zola 1991, p. 157.

5. "tableau en deux tons, noir et rose pâle." Jacques-Émile Blanche, *Manet* (Paris, 1928), p. 23.

6. "bariolage"; "sève abondante"; "loyauté"; "caricature de la couleur et non la couleur elle-même." Paul Mantz, "Exposition du boulevard des Italiens," *Gazette des Beaux-Arts* (April 1, 1863), p. 383.

7. "si charmante dans son étrangeté"; "le bijou de la salle peut-être." Émile Zola, "Préface," *Exposition des oeuvres de Édouard Manet*, exh. cat. (Paris: École des Beaux-Arts, 1884), p. 13.

8. "je ne sais si je force le texte"; "Il est parfaitement vrai que *Lola de Valence* est un bijou rose et noir; le peintre ne procède déjà plus que par taches, et son Espagnole est peinte largement, par vives oppositions; la toile entière est couverte de deux teintes." Zola 1991, p. 157.

9. See Françoise Cachin in Paris, New York 1983, pp. 150–56, repr. p. 146.

10. "sur les conseils de ses amis." Tabarant 1947, p. 53.

11. On Goya, see Françoise Cachin in Paris, New York 1983, p. 146. On popular images and cartes de visite, see Hanson 1972 and McCauley 1985, p. 182.

12. "chargée d'une lourde et riche basquine"; "superbement à l'abri d'un décor, le signal de l'élan, du rythme et du délire saccadé de ses actes." Paul Valéry, "Triomphe de Manet," *Oeuvres* (Paris, 1960), vol. 2, p. 1329.

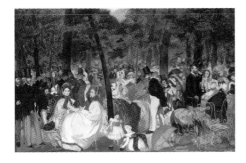

88 *Fig. 332*

Édouard Manet

La Musique aux Tuileries
(*Music in the Tuileries*)
1862
Oil on canvas
30 x 46½ in. (76.2 x 118.1 cm)
Signed and dated: éd. Manet 1862
The Trustees of the National Gallery, London
NG 3260

CATALOGUE RAISONNÉ: Rouart-Wildenstein 1975, no. 51

PROVENANCE: The artist, until 1883; sold to Jean-Baptiste Faure, Paris 1883, until 1898; bought by Durand-Ruel 1898, until 1906; bought by Sir Hugh Lane, Dublin, 1906, until his death in 1915; his bequest to the National Gallery, London, 1915; exhibited at the Tate Gallery, London, from 1917; transferred to the National Gallery, 1950

EXHIBITIONS: Paris, Galerie Martinet, 1863; Paris, Pont de l'Alma, 1867, *Tableaux de M. Édouard Manet*, no. 24 (La Musique aux Tuileries); Paris, École nationale des Beaux-Arts, 1884, *Exposition des oeuvres de Édouard Manet*, no. 9 (La Musique aux Tuileries. Property of M.

Faure); Paris, Galerie Durand-Ruel, 1894, *Manet*, and New York 1895, *Paintings by Manet*, no. 14; Duret 1902, no. 16; London, Grafton Galleries, 1905, no. 87; Paris, Grand Palais, 1905, salon d'Automne, no. 2; Moreau-Nélaton, cat. ms., no. 33; Tabarant 1931, no. 28; Jamot-Wildenstein 1932, no. 36; London, Tate Gallery, 1954, *Manet and His Circle*, no. 2; Rouart-Orienti 1970, no. 31; Paris, New York, 1983, no. 38; London, National Gallery, 1983, *Manet at Work*, no. 1; London, 1991, no. 1

SELECTED REFERENCES: Paul Mantz, "Exposition du boulevard des Italiens," *Gazette des Beaux-Arts*, April 1, 1863, p. 383; Paul de Saint-Victor, *La Presse*, April 27, 1863; Hippolyte Babou, "Les dissidents de l'exposition," *La Revue libérale* 2 (1867), p. 289; Émile Zola, "Édouard Manet," preface to the catalogue of the posthumous exhibition, Paris, École des Beaux-Arts, 1884, p. 12; Edmond Bazire, *Manet* (Paris, 1884), cited *in* P. Courthion, *Manet raconté by lui-même et ses amis* (Paris, 1953), p. 107; Paul Signac, December 14, 1894, *Journal*, published by John Rewald, "Journal inédit de Paul Signac," *Gazette des Beaux-Arts* 2 (1949), p. 112; Antonin Proust, "Édouard Manet inédit," *La Revue blanche*, February 15, 1897, p. 174; Moreau-Nélaton 1926, vol. 1, p. 34; Jacques-Émile Blanche, *Manet* (Paris, 1928), p. 26; Tabarant 1947, no. 33; Sandblad 1954, pp. 17–64; Michael Fried, "Manet's Sources," *Art Forum*, March 1969; Hanson 1977, pp. 21–23, 36–38, 67, 161–62; Reff 1982, pp. 14–17, 24–25; Herbert 1988, pp. 36–38

Sometimes wrongly dated to 1860 or 1861,[1] this picture was painted in the course of that fertile year 1862, in the rue Guyot studio, after Manet had dashed off several drawings in a sketchbook: *Coin de jardin aux Tuileries* (*Corner of the Tuileries Gardens*), *Deux Fillettes de profil* (*Two Little Girls in Profile*), and the vague outline of Offenbach.[2] Beneath the regularly planted trees of the Tuileries, he groups a series of Parisian characters, more select than the mixed society that normally attended the concerts given there on fine spring and summer afternoons. As identified by Meier-Graefe, Tabarant, and Sandblad.[3] Manet stands at the extreme left, behind his friend the animal painter Albert de Balleroy, with whom he shared a studio from 1856 to 1859. Then comes Astruc, plump and lolling in a chair, with the journalist Aurélien Scholl, terribly dandified and mustachioed, standing behind him. The two fashionable women in the foreground, each identically clad in a cream-colored dress and a bonnet tied with a blue bow, seem to be the counterparts of the Manet-Balleroy duo; they are Mme Lejosne, whose guest list included Manet, Baudelaire, and Bazille, and another "art lady," the formidable Mme Loubens, a friend of the Morisots', whose sheeplike countenance was to be portrayed by Degas (Lemoisne 265; Art Institute of Chicago). Behind them is an unexpected trinity made up of Baudelaire, Gautier, and Baron Taylor, who introduced Spanish art into France; and at yet another remove, Fantin-Latour, an isolated figure looking out "at the camera." At the center right, with his hands behind his back, Eugène Manet, the painter's brother, leans forward slightly toward a seated woman with whom he is in conversation; just behind him is Offenbach, the celebrated author of *Orphée aux enfers* (*Orpheus in the Underworld*). We might add Charles Monginot, who is probably the ramrod figure at the

right raising his top hat, and perhaps, between the heads of Manet and Balleroy, the unobtrusive Champfleury.

Manet was not painting a "slice of life" here in the manner of Hédouin (*Une Allée des Tuileries* [*An Allée in the Tuileries*], Salon of 1865),[4] or of Menzel (*Après-midi au jardin des Tuileries* [*Afternoon in the Tuileries Gardens*], 1867, Gemäldegalerie Neue Meister, Dresden); his guests were carefully selected, and their gathering smacks of a society reception and an artistic turnout. Intended for exhibition, the picture must have prompted remarks of the gossip-column type—"Among the many present were to be seen in particular. . . ." Manet was mixing colleagues who were fashionable but mediocre (Balleroy) or talented but retiring (Fantin-Latour) with habitués of the boulevards (Scholl, Offenbach) and critics of every persuasion, whom he hoped in this way to win over.

The work addressed the concerns of Baudelaire, who did not understand it (see pp. 266–68); and it was also designed to acknowledge the kind words that Théophile Gautier, who was to show an increasing hostility to Manet's art, had had for *Espagnol jouant de la guitare* (*Spaniard Playing the Guitar*; Metropolitan Museum of Art) in 1861. When the picture was exhibited at Martinet's in 1863, "an exasperated art lover went so far as to threaten violence if [it] was left on display any longer."[5] Thirty years later it appeared to Huysmans, who was usually more perceptive, "detestable," "uninspired," inflated with "pretensions of novelty," awkward and academic in its handling of the crowd.[6]

It was, however, as Zola observed in 1879, "one of the artist's characteristic works, the one in which he has followed most closely the dictates of his eyes and his temperament"; in juxtaposing patches of color in a cluster that may seem shapeless at close quarters, in inventing an alphabet of "lines and black dots," he was writing the first page of modernity.[7] Since then, as so often with Manet, there has been emphasis on the debt this modernity owed to old sources—engravings and watercolors by the minor masters of the eighteenth century so highly praised by the Goncourt brothers, as well as the *Réunion de treize personages* (*Gathering of Thirteen Persons of Rank*; Musée du Louvre, Paris), then attributed to Velázquez, and popular images such as newspaper illustrations or prints in *Les Français peints par eux-mêmes*.[8]

In 1862 Manet's modernity exploded in this canvas, which is the prototype for all those that Monet and Renoir were to paint of gatherings in the open air, the urban masses, and popular dance halls, vibrant with splashes of color, contrasting masculine black with feminine light and the severe geometry of top hats with the graceful rococo of dresses and chairs, mixing the blare of the brass band with memories of Velázquez.

H.L.

1. Tabarant 1947, p. 38 (1860), and Duret 1926, p. 22 (1861).
2. Bibliothèque Nationale, Paris. See Françoise Cachin in Paris, New York 1983, p. 127.

3. Julius Meier-Graefe, *Édouard Manet* (Munich, 1912), pp. 107–9; Tabarant 1947, p. 38; and Sandblad 1954, pp. 17–68.

4. See Paul Mantz, "Salon de 1865," *Gazette des Beaux-Arts*, July 1, 1865, p. 10.

5. "amateur exaspéré alla jusqu'à menacer de se porter à des voies de fait si on [la] laissait plus longtemps dans la salle d'exposition." Zola 1991, p. 157.

6. "détestable"; "pompier"; "prétentions au neuf." J. K. Huysmans, unpublished notes in the margin of his catalogue of the Manet exhibition at the École des Beaux-Arts in 1884, quoted in Pierre Courthion, *Manet raconté par lui-même et par ses amis* (Geneva, 1953), vol. 2. p. 183.

7. "une des oeuvres caractéristiques de l'artiste, celle où il a le plus obéi à ses yeux et à son tempérament"; "lignes et de points noirs." Zola 1991, pp. 157–58.

8. Sandblad 1954, pp. 37–38, 49, and Hanson 1972, p. 148.

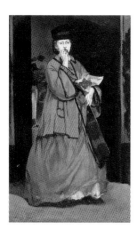

89

Fig. 242

Édouard Manet

La Chanteuse des rues
(*Street singer*)
1862
Oil on canvas
67½ x 41⅝ in. (171.3 x 105.8 cm)
Signed lower left: éd. Manet
Museum of Fine Arts, Boston, Bequest of Sarah Choate Sears in Memory of her Husband Joshua Montgomery Sears 66.304

CATALOGUE RAISONNÉ: Rouart-Wildenstein 1975, no. 50

PROVENANCE: The artist, until 1872; sold for Fr 2,000 to Durand-Ruel, Paris, 1872, until 1878; sold for Fr 4,000 to Ernest Hoschédé, Paris, 1877, until 1878; his sale, Paris, Hôtel Drouot, June 5–6, 1878, no. 42 (*Femme aux cerises*); bought for Fr 450 by Jean-Baptiste Faure, Paris; sold to Durand-Ruel, Paris, by 1899; bought for Fr 70,000 by Sarah Choate Sears, Boston, before 1902; her bequest to the Museum of Fine Arts, Boston, retaining a life interest in her daughter, Mrs. J. Cameron Bradley until the later's death in 1966

EXHIBITIONS: Paris, Galerie Martinet, 1863, private exhibition; Paris, Pont de l'Alma, 1867, *Tableaux de M. Édouard Manet*, no. 19 (La Chanteuse des rues); Paris, École nationale des Beaux-Arts, 1884, *Exposition des oeuvres de M. Édouard Manet*, no. 10 (La Chanteuse des rues. Property of M. Faure); Paris, New York, 1983, no. 32

SELECTED REFERENCES: Paul Mantz, "Exposition du boulevard des Italiens," *Gazette des Beaux-Arts*, April 1, 1863, p. 383; Hippolyte Babou, "Les dissidents de

l'exposition," *La Revue libérale* 2 (1867), p. 289; Émile Zola, "Une nouvelle manière en peinture, Édouard Manet," *La Revue du xixᵉ siècle*, January 1, 1867, p. 56; E. Spuller, "Édouard Manet et sa peinture," *Le Nain jaune*, June 9, 1867, p. 5; Émile Zola, "Édouard Manet," preface to the catalogue of the posthumous exhibition, Paris, École des Beaux-Arts 1884, p. 13; Louis Gonse, "Manet," *Gazette des Beaux-Arts*, February 1884, p. 138; Sâr Joséphin Péladan, "Le Procédé de Manet d'après l'exposition faite à l'école des Beaux-Arts," *L'Artiste*, February 1884, p. 106; Antonin Proust, "Édouard Manet, souvenirs," *La Revue blanche*, February 15, 1897, p. 169; Duret 1902, no. 31; Moreau-Nélaton, cat. ms., no. 37; Moreau-Nélaton 1926, vol. 1, pp. 44–45; Tabarant 1931, no. 44; Jamot-Wildenstein 1932, no. 45; Tabarant 1947, p. 46; Rouart-Orienti 1970, no. 44; Reff 1982, pp. 16, 20, repr. p. 172; Herbert 1988, pp. 35–36; Darragon 1989, pp. 69–72

Antonin Proust's unreliable memory failed him when he recalled *La Chanteuse des rues* in his *Souvenirs* of Manet. He dated the genesis of this painting to 1865, on Manet's return from Spain. In crossing the work site of the boulevard Malesherbes on his way to the studio, the artist encountered "at the entrance to the rue Guyot, a woman" who was leaving "a sleazy café, picking up her skirt and holding on to her guitar. He went straight up to her." Proust continued, "and asked her to come and pose for him. She burst out laughing. 'I'll nab her again,' cried Manet, 'and then if she's not willing, I've got Victorine.'"[1]

She was not willing and Victorine posed, not in 1865 but probably in 1862, since her image in *La Chanteuse des rues* was exhibited at Martinet's in March 1863. It is difficult to be more precise about the date. Théodore Duret, allowing Manet a laudable desire to alternate scenes of fashionable life with popular subjects, places it after *La Musique aux Tuileries* (cat. 88), which he dates to 1861.[2] According to Tabarant, the picture was executed sometime after *Le Vieux Musicien* (fig. 333) and marks the entry of Victorine Meurent into Manet's life.[3] But the painter's statement quoted by Proust—"I've got Victorine"—negates this hypothesis. When he embarked on *La Chanteuse des rues*, Manet had perhaps already painted *Mlle V... en costume d'espada* (cat. 90) and even begun *Le Déjeuner sur l'herbe* (cat. 93).

Shown on the boulevard des Italiens, in a well-stocked exhibition where Courbet, Théodore Rousseau, Corot, Amaury-Duval, Baudry, and Stevens hung side by side, Manet's submission disconcerted Paul Mantz, although the latter retained an excellent impression of *Espagnol jouant de la guitare* (*Spaniard Playing the Guitar*; Metropolitan Museum of Art) at the Salon of 1861. He pointed to *La Chanteuse des rues*, however, as an exact example of what should not be done: "All form is lost in his large portraits of women, especially in that of the *Chanteuse*, where, in an odd fashion that we find extremely disconcerting, the eyebrows abandon their horizontal position in favor of a vertical alignment alongside the nose, like two commas of shadow; there is nothing there but the blatant strife between shades of plaster and shades of black."[4] Four years later Zola, reviewing Manet's oeuvre, singled out this picture and took a stand that was diametrically

opposed to that of the *Gazette des Beaux-Arts* critic; where the latter had deplored the disappearance of the contours and the dreadful clash of colors, the writer praised "the conscientious labor of a man who wants above all to express frankly what he sees" and the subtle harmony "of a soft, light gray."[5]

Zola also speaks of "simplicity," "precision," and "austerity," appropriate words to describe this painting, in which Manet, after *Le Buveur d'absinthe* (fig. 4) and *Le Vieux Musicien*, enlarged to the size of the aristocratic full-length portrait what normally fell to the vignette or small-scale genre scene. For *La Chanteuse des rues*, "as bizarre and stylized as an Ingres," was a prototype of those "figures" that many sought to consider one of the distinguishing features of the New Painting (see p. 210).[6] Jacques-Émile Blanche has rightly qualified the distance between this "majestic and weighty" image and the small pictures of similar subjects by such painters as Stevens.[7] Beatrice Farwell and Anne Coffin Hanson have shown how Manet was inspired by—and perverted—popular sources; and Theodore Reff has convincingly demonstrated that in focusing on these individuals—products of the old Paris given short shrift by Haussmannization—Manet was expressing his distaste for the urban policies of the Second Empire.[8]

H. L.

1. "à l'entrée de la rue Guyot, une femme [qui] sortait d'un cabaret louche, relevant sa robe, retenant sa guitare. Il alla droit à elle et lui demanda de venir poser chez lui. Elle se prit à rire: 'Je la repincerai,' s'écria Manet, 'et puis si elle ne veut pas j'ai Victorine.'" Proust 1897, p. 28.

2. Duret 1926, p. 22.

3. Tabarant 1947, p. 47.

4. "Toute forme se perd dans ses grands portraits de femmes, et notamment dans celui de la *Chanteuse*, où par une singularité qui nous trouble profondément, les sourcils renoncent à leur position horizontale pour venir se placer verticalement le long du nez, comme deux virgules d'ombre; il n'y a plus là que la lutte criarde de tons plâtreux avec des tons noirs." Paul Mantz, "Exposition du boulevard des Italiens," *Gazette des Beaux-Arts*, April 1, 1863, p. 383.

5. "la labeur consciencieux d'un homme qui veut, avant tout, dire franchement ce qu'il voit"; "d'un gris doux et blond." Émile Zola, *Édouard Manet, étude biographique et critique*, in Zola 1991, p. 157.

6. "simplicité"; "exactitude"; "austérité." Zola 1991, p. 157; "bizarre et stylisée comme un Ingres"; "figures." Jacques-Émile Blanche, *Manet* (Paris, 1924), p. 26.

7. "majesteuse et pesante." Blanche, *Manet*.

8. Farwell 1973, pp. 110–18; Hanson 1972; and Reff 1983, p. 20.

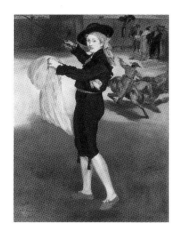

90 *Fig. 244*

Édouard Manet

Mlle V. . . en costume d'espada
(*Mlle V. . . in the Costume of an Espada*)
1862
Oil on canvas
65 x 50¼ in. (165.1 x 127.6 cm)
Signed and dated lower left: éd Manet. 1862
The Metropolitan Museum of Art, New York, H. O.
Havemeyer Collection, Bequest of Mrs. H. O. Havemeyer,
1929 29.100.53

CATALOGUE RAISONNÉ: Rouart-Wildenstein 1975, no. 58

PROVENANCE: The artist, until 1872; bought for Fr 3,000
by Durand-Ruel, Paris, until 1874; bought for Fr 5,000
by Jean-Baptiste Faure, Paris, February 16, 1874, until
1898; bought for Fr 45,000 by Durand-Ruel, Paris, December 22, 1898; sold for $15,000 by Durand-Ruel, New
York, to Henry O. and Louisine Havemeyer, New York,
December 30, 1898, until 1929; her bequest to the
Metroropolitan Museum, 1929

EXHIBITIONS: Paris, palais des Champs-Élysées, 1863, *Catalogue des ouvrages de peinture, sculpture, gravure . . .
refusés par le Jury de 1863 et exposés par décision de
S.M. l'Empereur au Salon annexe*, no. 365 (Melle V. en
costume d'Espada); Paris, Pont de l'Alma, 1867, *Tableaux de M. Édouard Manet*, no. 12 (Melle V. . . en costume d'espada); Paris, École nationale des Beaux-Arts,
1884, *Exposition des oeuvres de Édouard Manet*, no. 15
(Melle V . . . en costume d'espada. Property of M. Faure);
Philadelphia Museum of Art, and Chicago, Art Institute, 1966–67, *Manet*, no. 50; Paris, New York, 1983,
no. 33; New York, 1993, no. 344

SELECTED REFERENCES: Zacharie Astruc, *Le Salon*, May
20, 1863, p. 16; Ernest Chesneau, "Salon de 1863," *Le
Constitutionnel*, May 19, 1863, p. 1; Monsieur de Cupidon
[Charles Monseland], "Les Refusés," *Le Figaro*, May
24, 1863, p. 6; Fernand Desnoyers, *Salon des refusés:
La peinture en 1863* (Paris, 1863), p. 41; J. Graham
[Arthur Stevens], "Un étranger au salon," *Le Figaro*,
July 16, 1863, p. 3; Henry de La Madelène, *Le Salon des
refusés* (Paris, 1863), p. 41; Louis Leroy, "Les Refusés,"
Le Charivari, May 20, 1863, p. 3; Adrien Paul, "Le Salon
de 1863: Les Refusés," *Le Siècle*, July 19, 1863, p. 2;
Arthur Stevens, *Salon de 1863* (Paris, 1866), pp. 196–97;
Émile Zola, "Une nouvelle manière en peinture, Édouard
Manet," *La Revue du xixᵉ siècle*, January 1, 1867, reprinted in *Éd. Manet: Étude biographique et critique*
(Paris, 1867), and in Zola, 1991, p. 158; Jules Claretie,
"Le Salon de 1872," *Le Soir*, May 25, 1872; Émile Zola,
"Édouard Manet," preface to the catalogue of the posthumous exhibition, Paris, École des Beaux-Arts, 1884,
p. 12; Louis Gonse, "Manet," *Gazette des Beaux-Arts*,
February 1884, p. 140; Sâr Joséphin Péladan, "Le Procédé
de Manet d'après l'exposition faite à l'école des Beaux-

Arts," *L'Artiste*, February 1884, p. 140; Castagnary 1892,
pp. 173–74; Duret 1902, no. 37; Moreau-Nélaton, cat.
ms., no. 48; Moreau-Nélaton 1926, vol. 1, p. 48; Paul
Jamot, "Manet, 'Le Fifre' et Victorine Meurend," *Revue
de l'art ancien et moderne*, 1927, p. 10; A. Tabarant,
"Les Manet de la collection Havemeyer," *La Renaissance de l'art français*, February 1930, pp. 58–61;
Tabarant 1931, no. 54; Jamot-Wildenstein 1932, no. 51;
Tabarant 1947, pp. 54–55; Sterling and Salinger 1967,
pp. 33–35; Michael Fried, "Manet's Sources: Aspects of
His Art," *Art Forum*, March 1969, pp. 52–53; Theodore
Reff, "Manet's Sources: A Critical Evaluation," *Art
Forum*, September 1969, p. 40; Farwell 1969, vol. 2, pp.
197–98, 200, 202–4, 206–7; Rouart-Orienti 1970, no.
50; Champa 1973, pp. 4, 52; Hanson 1977, pp. 79–82,
188; Leiris 1978, pp. 112–17; McCauley 1985, pp. 181–90;
Mauner 1988, pp. 313–48

At the Salon des Refusés in 1863 Manet's paintings
were shown as a triptych: *Jeune Homme en costume de majo* (fig. 375) and *Mlle V . . . en costume
d'espada* hung to the left and right respectively
of *Le Bain* (cat. 93), which in 1867 was to become *Le Déjeuner sur l'herbe*.[1] For Ferdinand
Desnoyers, defender of the Refusés, these three
pictures and the three prints that completed Manet's contribution (*Les Petits Cavaliers* [*The Little
Cavaliers*] and *Philippe IV*, both after Velázquez,
and *Lola de Valence*) had been deliberately chosen by the painter in order to emphasize his Spanish affiliation.[2] The succès de scandale of the
partie carrée somewhat overshadowed the two
figures; they served those with the greatest reservations merely to demonstrate the limitations of
Manet's art, his ignorance of the laws of perspective, the awkwardness of his drawing, his inability to deliver anything but "good sketches." Manet
was certainly a colorist, declared Castagnary and
Arthur Stevens (the latter signed a column in *Le
Figaro* as "J. Graham"), and undeniably he had
a "temperament," but he was without the means
to realize his ambitions: "a painter always has
the design for his color. With Manet, there is a
lack of knowledge, and there is perhaps contempt
for form, design, and modeling. These canvases
remain charming patches of color, but, being without skill, they are without substance."[3] His method
of abruptly juxtaposing patches of color on the
canvas while ignoring intermediate passages and
of demarcating them with a hard, dry outline—
everything that four years later would signify for
Zola "a new style in painting"—condemned
Manet despite undeniable predispositions in his
favor. Adrien Paul, who was more perceptive in
his disparagement, noted that, in *Mlle V . . . en
costume d'espada* apart from the handling "by
slabs," Manet painted "people and things in an
even-handed manner," the first echo of the "pantheism" that Thoré was to denounce (see p. 216).
"Painting is an art of illusion," Manet rightly emphasized, though only to regret the absence of
"nuances" and the lack of logic in the establishment of the "range of shades."[4] Yet no other work
by Manet declares as forcefully that art is made
up of accumulated conventions, as if the better
to emphasize that its sole subject is the painting
itself. The very title declares the fiction: a model
assuming an unsteady pose under studio lighting; a woman dressed up in male costume while

continuing to wear completely unsuitable shoes;
a monumental figure, painted with precision,
standing out in a deliberately skewed perspective
against a rapidly executed background.[5] It is a
picture that takes the attitude of the matador from
Marcantonio Raimondi and the bull and picador
from a print by Goya, while measuring itself without hesitation against the Japanese print and the
photographic carte de visite.[6]

H.L.

1. Thoré-Bürger 1870, vol. 1, p. 424.
2. Desnoyers 1863, p. 41.
3. "Un peintre a toujours le dessin de sa couleur. Chez
 M. Manet, la science manque, et il y a peut-être mépris
 de la forme, du dessin, du modelé. Ces toiles restent
 d'adorables taches de couleur, mais elles sont dépourvues
 de solidité étant dépourvues de savoir." J. Graham, "Un
 Étranger au Salon," *Le Figaro*, July 16, 1863, p. 3.
4. "par plaques"; "les êtres et les choses"; "panthéisme";
 "La Peinture est un art d'illusion"; "nuances"; "gamme
 de tons." Adrien Paul, "Salon de 1863: Les Refusés," *Le
 Siècle*, July 19, 1863, p. 2.
5. For an excellent analysis of this subject, see Farwell 1969.
6. See ibid., especially p. 200; Leiris 1978; McCauley
 1985, pp. 181, 185, 190; and Mauner 1988 (interesting
 comparisons).

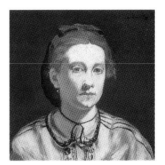

91 *Fig. 271*

Édouard Manet

Portrait de Victorine Meurent
1862
Oil on canvas
16⅞ x 17¼ in. (42.9 x 43.7 cm)
Signed upper right: Manet
Museum of Fine Arts, Boston, Gift of Richard C. Paine
in Memory of his father, Robert Treat Paine, 2nd
46.846

CATALOGUE RAISONNÉ: Rouart-Wildenstein 1975, no. 57

PROVENANCE: Probably given by the artist to Victorine
Meurent; Sir William Burrell, Glasgow, by 1900; Bernheim-Jeune, Paris, 1905; Alphonse Kann, Saint-Germain-en-Laye; Paul Rosenberg, New York; Robert Treat Paine,
2nd, Boston, before 1931, until his death in 1943; gift of
Richard C. Paine to the Museum of Fine Arts, Boston,
in memory of his father, 1946

EXHIBITIONS: Paris, Musée de l'Orangerie, 1932, *Manet*,
no. 12; Paris, New York, 1983, no. 31

SELECTED REFERENCES: Durand 1902, no. 30; Moreau-Nélaton, cat. ms., no. 77; Moreau-Nélaton 1926, vol. 1,
p. 48; Tabarant 1931, no. 56; Jamot-Wildenstein 1932,
no. 50; Tabarant 1947, p. 58, no. 62; Rouart-Orienti
1970, no. 57; Armbrust-Seibert 1986, vol. 1, pp. 88–92

It was in the spring of 1862, according to Théodore Duret, who probably had it from the artist himself, that Manet met Victorine Meurent in the Palais de Justice.[1] Born on February 18, 1844, she had just turned eighteen and impressed him with "her singular appearance and her decided air."[2] With long red hair that she tied back with a ribbon, and with regular if unremarkable features, she had "a face alive with beautiful eyes and animated by a fresh, smiling mouth"; she also had, as he was soon to discover, "the responsive body of the Parisienne, delicate in every detail, notable for the harmonious line of the hips and the graceful suppleness of the bust."[3] Victorine Meurent might have been as ordinary as her first name or as her appearance in the present portrait if she had not had the verve of the Paris urchin, a sort of calm effrontery that would suit Olympia, a talent for metamorphosis that would enable her to adopt the most disparate disguises, and an undeniable gift for catching the light.[4]

Tabarant casts doubt on Duret's account of this legendary meeting. He points out that a notebook kept by Manet at the time contains the name of the young woman—"Louise Meuran"—followed by the address "rue Maître Albert, 17," which was near the printshop that the artist patronized. In addition, Meurent had been drawing pay from Couture's studio since December 1861,[5] and she may have already met Alfred Stevens, with whom she was to have an affair. Good models were too rare for her to have escaped Manet's curiosity for long.

It is difficult to date this portrait exactly. The year 1862, adopted unanimously and retained here as the accepted usage, is based on the universal assumption that the artist was thus embarking on his long collaboration with the young woman, making the painting something of a trial run. In my view the portrait was done rather to please Meurent and to give her an immediate token of friendship after she had already posed for Manet in *Mlle V... en costume d'espada* (cat. 90) or in *La Chanteuse des rues* (cat. 89). For here, once in her life, Meurent appeared as her real self, wearing her own clothes and not dressed up. Degas was to do the same thing in 1869 with Emma Dobigny (cat. 64), also using the small format reserved for close friends, those whose memory one wished to preserve without going to the lengths of an ambitious "picture."

Jacques-Émile Blanche was the first to refer to Corot's figures apropos Meurent—"a more violent, white-hot Corot," as Françoise Cachin has rightly added.[6] Also referred to in this connection are the bust-length portraits by Clouet and Corneille de Lyon, of which Degas was probably more aware than Manet. But whereas Degas in his small portraits, so numerous during the 1850s and 1860s, uses a smooth, precise technique in a limited range of colors, Manet here paints with broad strokes and lights the face harshly from one side. The portrait of Emma Dobigny, *profil perdu*, remote and distant, was to be entirely in subtle intermediate hues; that of Victorine Meurent, blunt and contrasted, is—perhaps

symbolically—nothing but light and shade. As was her wont, she imposed her presence on the canvas, stubborn and insistent, with no soulful depths, simply a beautiful object to paint.

H.L.

1. Duret, quoted in Tabarant 1947, p. 47.
2. See Jacques Goedorp, "La Fin d'une légende: L'*Olympia* n'était pas montmartroise," *Journal de l'amateur d'art*, February 23, 1967, p. 7. "son aspect original, et sa manière d'être tranchée." Duret, quoted in Tabarant 1947, p. 47.
3. "une face où vivaient des beaux yeux et qu'animait une bouche fraîche et souriante"; "le corps nerveux de la Parisienne, délicat en chacun de ses détails, remarquable par la ligne harmonieuse des hanches et la souplesse gracieuse du buste." Duret, quoted in Tabarant 1947, p. 47.
4. See Françoise Cachin in Paris, New York 1983, p. 105.
5. Ambrust-Seibert 1986, vol. 1, p. 51.
6. Jacques-Émile Blanche, *Manet* (Paris, 1924), p. 24, and Françoise Cachin in Paris, New York 1983, p. 105.

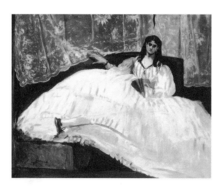

92 *(Paris only)* *Fig. 267*

ÉDOUARD MANET
La Maîtresse de Baudelaire couchée
(Baudelaire's Mistress Reclining)
Ca. 1862–1863
Oil on canvas
35 x 44½ in. (90 x 113 cm)
Signed lower left: Manet
Szépművészeti Múzeum, Budapest 368-B

CATALOGUE RAISONNÉ: Rouart-Wildenstein 1975, no. 48

PROVENANCE: Though possibly owned by Charles Baudelaire, Paris, in 1866–67, this work was part of the contents of Manet's studio at the time of his death in 1883; his widow, Suzanne Manet, Paris, 1883–93; sold to Hermann Paechter (according to Tabarant) or to Boussod & Valadon (according to Rouart-Wildenstein), 1893; Professor Heilbut, Hamburg; Bachstitz, Berlin, until 1916; sold to the Szépművészeti Múzeum, 1916.

EXHIBITIONS: Paris, Galerie Martinet, 1865(?); Paris, *La Revue indépendante*, 1888(?); Paris, 1968–69, no. 115; Paris, New York 1983, no. 27; Copenhagen, Ordrupgaard, 1989, *Manet*, no. 5, repr.

SELECTED REFERENCES: Philippe Burty, "Exposition de la Société des amis des arts de Bordeaux," *Gazette des Beaux-Arts*, June 1, 1866, p. 564; Duret 1902, no. 33; Moreau-Nélaton, cat. ms., no. 71; Moreau-Nélaton 1926, vol. 1, p. 65; Jamot-Wildenstein 1932, no. 110; Tabarant 1947, no. 59; Rouart-Orienti 1970, no. 37; Jean Adhémar, "A propos de la maîtresse de Baudelaire par Manet (1862), un problème," *Gazette des Beaux-Arts*, November 1983, p. 178; Heather McPherson, "Manet: Reclining Women of Virtue and Vice," *Gazette des Beaux-Arts*, January 1990, pp. 34–44

The posthumous inventory drawn up in December 1883 by the notaries Cotelle and Tansard with Suzanne Manet's help listed this picture among the "painted studies" and titled it "Maîtresse de Baudelaire couchée."[1] Since then the title has always been repeated, and the poet's "mistress" inevitably identified as Jeanne Duval. This has enabled the painting to be dated to 1862, at the height of the friendship between Manet and Baudelaire, when the former included Baudelaire among the Parisian characters in *La Musique aux Tuileries* (cat. 88) and engraved his portrait and when Baudelaire wrote the verse that served as a caption for *Lola de Valence* (cat. 87). Moreau-Nélaton accepted the attribution with some reserve—"a figure that passes rightly or wrongly as that of *Baudelaire's mistress*."[2] Only Jean Adhémar, following the Manet retrospective of 1983, has rejected it.[3] One is bound to agree with him that the identification poses a certain number of problems. Baudelaire began living with Jeanne Duval (Jeanne Lemer) in 1842. She was, according to Théodore de Banville, "a very tall, colored prostitute, with a frank, proud head that she carried well, crowned with a mass of tightly crimped hair."[4] Their affair was long and stormy, marked by abrupt ruptures and hasty reconciliations, always barely endured and yet desired by Baudelaire, who complained of "LIVING WITH A PERSON who acknowledges none of your efforts... a creature who *refuses to learn anything*...WHO DOES NOT ADMIRE ME, and who does not even take an interest in my writing, who would throw my manuscripts on the fire if that brought her more money than letting them be published."[5] In 1859 she suffered an attack of paralysis from which she never fully recovered, making her movements difficult and turning the poet "into a guardian and a Sister of Charity."[6] The appearance of a "brother" of Jeanne's, installed in the house, provoked a new rupture in 1861, although Baudelaire continued to take care of this "woman always ill," who had to be "supported and comforted" and constantly helped "with some money."[7] He mentioned her, however, more and more rarely and multiplied his fleeting affairs with prostitutes, whom he listed in a small notebook (in use from July 1861 to November 1863): Adèle, Adrienne, Bathilde, Blanche, Émilie, Fanny, Gabrielle, and so on—*Brédas* (low-life prostitutes, so called from the quartier Bréda, then a red-light district in the ninth arrondissement of Paris), "five-franc tarts."[8] One might well ask if Baudelaire, who had known Manet since 1859 but was never an intimate friend of his, would have wanted a portrait of his "old mistress" about 1862—she was then between forty and fifty years of age—and would have dragged the invalid to the studio in the rue Guyot, whose large window can be seen behind the sofa. Certainly, the "strange, exotic, and fatal" mask of this "mistress of Baudelaire" might be that of Jeanne Duval, withered and worn by her "senseless escapades," but it could equally be that of one of Baudelaire's passing fancies, for he evidently liked dark beauties.[9] In 1863–64 his "last mistress" was Berthe, like Jeanne a small-

time actress, like Jeanne having "features so strongly marked as to appear slightly masculine" and a "helmet of brown-black hair."[10] But Manet's model could just as well have been the Adèle that he mentioned three times in the notebook already referred to,[11] and of whom he made a "sketch," as Adhémar points out. In a letter to Baudelaire of February 14, 1865, Manet wrote in connection with a future exhibition at Martinet's: "I have not erased *the sketch of Adèle*."[12] This "sketch," generally considered lost, would be the present broadly painted picture.

If Adèle was indeed the model, the painting must definitely be dated to 1863 or 1864. For *La Maîtresse de Baudelaire couchée* is a work akin to *Olympia* (cat. 95), a bichrome black-and-white picture, both hard (the facial features, the stiffness of the hand and foot, the solid, dark mass of the sofa) and fluid (the enormous white crinoline and the fluttering muslin curtain that create, as Georges Bataille puts it, "a delicate fugue of linen and lace").[13] This is a picture evidently in the spirit of Baudelaire and conceived as such by Manet, who made a large oil painting of what Constantin Guys reserved for wash and watercolor—the faded courtesan decked out in her finery, with eyes like shadowy pools.

H.L.

1. "études peintes." Tabarant 1947, p. 57.
2. "une figure qui passe à tort ou à raison, pour celle d'une *maîtresse de Baudelaire*." Moreau-Nélaton 1926, vol. 1, p. 65.
3. Jean Adhémar, "À propos de la maîtresse de Baudelaire par Manet (1862), un problème," *Gazette des Beaux-Arts*, November 1983, p. 178.
4. "une fille de couleur, d'une très haute taille, qui portait bien sa tête ingénue et superbe, couronnée d'une chevelure violemment crespelée." Quoted in Pichois and Ziegler 1987, p. 183.
5. "VIVRE AVEC UNE ÊTRE qui ne vous sait aucun gré de vos efforts ... une créature qui *ne veut rien apprendre* ... QUI NE M'ADMIRE PAS, et qui ne s'interesse même pas à mes études, qui jetterait mes manuscrits au feu si cela lui rapportait plus d'argent que de les laisser publier." Letter from Baudelaire to his mother, March 27, 1852, in Baudelaire 1973, vol. 1, p. 193.
6. "en tuteur et en soeur de charité." Ibid., p. 624.
7. "femme toujours malade"; "soutenir et consoler"; "de quelque argent." Ibid., December 25, 1861, vol. 2, p. 205.
8. "putains à cinq francs." Pichois and Ziegler 1987, pp. 424–26.
9. "étrange, exotique et fatal"; "maîtresse de Baudelaire"; "caravanes insensées." Jacques-Émile Blanche, *Manet* (Paris, 1924), p. 36.
10. "dernière maîtresse"; "traits accusés jusqu'à paraître un peu masculins"; "casque de cheveux brun noir." Pichois and Ziegler 1987, p. 428.
11. Baudelaire 1985–87, vol. 1, pp. 711–79.
12. "Je n'est pas effacé *l'esquisse d'Adèle*." *Lettres à Baudelaire* (Neuchâtel, 1973), p. 230.
13. "une fugue légère de linge et de dentelle." Bataille 1983, p. 30.

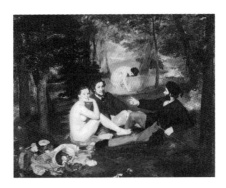

93 *(Paris only)* *Fig. 143*

Édouard Manet
Le Déjeuner sur l'herbe (Le Bain)
1863
Oil on canvas
81⅞ x 104⅛ in. (208 x 264.5 cm)
Signed and dated lower right: éd. Manet 1863
Musée d'Orsay, Paris RF1668

CATALOGUE RAISONNÉ: Rouart-Wildenstein 1975, no. 67

PROVENANCE: The artist, until 1878; bought for Fr 2,600 by Jean-Baptiste Faure, Paris, 1878, until 1898; bought for Fr 20,000 by Durand-Ruel, Paris, 1898; bought for Fr 55,000 by Étienne Moreau-Nélaton, Paris, before 1900, until 1906; his gift to the Musée du Louvre, 1906; Musée des Arts Décoratifs, Paris, 1907; Musée du Louvre, Paris, 1934; Musée du Jeu de Paume, Paris, 1947; Musée d'Orsay, Paris, 1986

EXHIBITIONS: Paris, palais des Champs-Elysées, 1863, *Catalogue des ouvrages de peinture, sculpture, gravure ... refusés par le Jury de 1863 et exposés par décision de S.M. L'Empereur au Salon annexe*, no. 363 (Le bain); Paris, avenue de l'Alma, 1867, *Tableaux de M. Édouard Manet*, no. 1 (Le Déjeuner sur l'herbe); Paris, École nationale des Beaux-Arts, 1884, *Exposition des oeuvres de Édouard Manet*, no. 19 (Le Déjeuner sur l'herbe. Property of M. Faure); Paris, Exposition Universelle, 1900, *Centennale*, no. 440; Paris, New York, 1983, no. 62

SELECTED REFERENCES: Zacharie Astruc "Le salon des Refusés," *Salon de 1863*, May 20, 1863; Monsieur de Cupidon [Charles de Monseland], "Les Refusés," *Le Figaro*, May 24, 1863, p. 6; L. Étienne, *Le Jury et les exposants* (Paris, 1863), p. 30; Ferdinand Desnoyers, *Salon des refusés: La peinture en 1863* (Paris, 1863), pp. 41–42; J. Graham [Arthur Stevens], "Un étranger au Salon," *Le Figaro*, July 16, 1863, p. 3; Louis Leroy, "Les Refusés," *Le Charivari*, May 20, 1863, p. 3; Édouard Lockroy, "L'Exposition des refusés," *Le Courrier artistique*, May 16, 1863, p. 1; Paul Mantz, "Le Salon de 1863," *Gazette des Beaux-Arts*, July 1, 1863, p. 59; Adrien Paul, "Les Refusés," *Le Siècle*, July 19, 1863, p. 2; Ernest Chesneau, *L'Art et les artistes modernes en France et en Angleterre* (Paris, 1864), pp. 188–89; le capitaine Pompilius, "Letters sur le Salon," *Le Petit Journal*, June 11, 1865, p. 2; Claude [Émile Zola], "Mon Salon. M. Manet," *L'Événement*, May 7, 1866, p. 2; Arthur Stevens, *Le Salon de 1863* (Paris, 1866), pp. 196–97; Louis Auvray, *Salon de 1866* (Paris, 1866), p. 32; G. Randon, "L'Exposition d'Édouard Manet," *Le Journal amusant*, June 29, 1867, p. 7; E. Spuller, "Manet et sa peinture," *Le Nain jaune*, June 9, 1867, p. 5; Émile Zola, "Une nouvelle manière en peinture, Édouard Manet," *La Revue du xixe siècle*, January 1, 1867, pp. 32–34 (reprinted by Dentu, Paris, [May] 1867); Thoré-Bürger 1870, pp. 424–25; Louis Gonse, "Manet," *Gazette des Beaux-Arts*, February 1884; Paul Mantz, "Les Oeuvres de Manet," *Le Temps*, January 16, 1884; Castagnary 1892, p. 76; Duret 1902, no. 43; Duret 1926, pp. 25–33; Moreau-

Nélaton, cat. ms., no. 50; Moreau-Nélaton 1926, vol. 1, p. 49; Tabarant 1931, no. 62; Jamot-Wildenstein 1932, no. 79; Tabarant 1947, no. 66; Rouart-Wildenstein 1970, no. 58A; Judith Wechsler, "An Apéritif to Manet's Déjeuner sur l'herbe," *Gazette des Beaux-Arts*, January 1978, pp. 32–34; Mary G. Wilson, "Édouard Manet's Déjeuner sur l'herbe. An Allegory of Choice: Some Further Conclusions," *Arts Magazine*, January 1980, no. 5, pp. 52–56; Alain Krell, "Manet's Déjeuner sur l'herbe: A Reappraisal," *Art Bulletin*, June 1983; Ambrust-Seibert 1986, pp. 121–58; Juliet Wilson Bareau, *The Hidden Face of Manet*, (London, Courtauld Institute, 1986), pp. 37–40; Francis Haskell, *De l'art et du goût: Jadis et naguère* (Paris, 1989), pp. 314–15

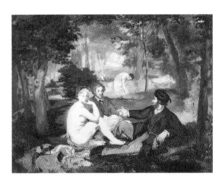

94 *(New York only)* *Fig. 145*

Édouard Manet
Le Déjeuner sur l'herbe
Ca. 1863–67
Oil on canvas
35¼ x 45⅝ in. (89.5 x 116.5 cm)
Courtauld Institute Galleries, London, Courtauld Gift, 1932 232

CATALOGUE RAISONNÉ: Rouart-Wildenstein 1975, no. 66

PROVENANCE: Given by the artist to Commandant Lejosne, Paris; Lejosne family, Paris, from 1884; Galerie Druet, Paris, 1924; acquired through Percy Moore Turner, London, by Samuel Courtauld, London, 1928

EXHIBITIONS: London, Tate Gallery, 1948, *Samuel Courtauld Memorial Exhibition*, no. 36; London, Tate Gallery, 1954, *Manet and His Circle*, no. 3; Paris, Musée de l'Orangerie, 1955, *Les Impressionnistes de la collection Courtauld*, no. 27; London, National Gallery, 1983, *Manet at Work*, no. 10

SELECTED REFERENCES: Jamot-Wildenstein 1932, no. 78; J. B. Manson, "Déjeuner sur l'herbe," *Apollo*, May 1928, p. 205; Paul Jamot, "The First Version of Manet's Déjeuner sur l'herbe," *Burlington Magazine*, June 1931, p. 299; Tabarant 1947, pp. 61, 73–74, no. 65; Rouart-Orienti 1970, no. 58B

Tabarant dates the first studies for *Le Déjeuner sur l'herbe* to the summer of 1862; taking advantage of his Sundays at Gennevilliers, "a real family enclave where for two hundred years the Manets had owned some 150 acres and several houses," Manet sought "the decorative ambience" of his great painting.[1] From these Sunday labors Tabarant singles out a small canvas, *La Pêche* (Fishing, Rouart-Wildenstein 65; Von der Heydt Museum, Wuppertal), as a rapidly executed land-

scape sketch for *Le Déjeuner sur l'herbe*. The connections between the two works, however, are rather loose, as are those that link *La Pêche* in the Metropolitan Museum (fig. 157; Rouart-Wildenstein 36) to the Refusés picture, although the landscape is handled in the same way, with the boat on a stretch of water and the fisherman leaning forward in an attitude that would be repeated by the woman bathing in the background of *Le Déjeuner*.

In the studio Manet made Victorine Meurent, whom he had met a few months or perhaps even a few weeks before (see cat. 91), pose for the nude, seated and calmly available; the model for her immediate neighbor was Ferdinand Leenhoff, a young Dutch sculptor who was the brother of Suzanne, Manet's companion and soon to be his wife. The identity of the man seen in profile, wearing a student's cap, has been the subject of discussion: Moreau-Nélaton maintains that he was Eugène Manet, Tabarant that he was the artist's other brother, Gustave.[2] Antonin Proust combines both versions, claiming that "the two brothers" posed, and it is indeed feasible that these two similar-looking young men took turns sitting. By contrast, the identity of the woman paddling in shallow water is unknown; Proust says only that she was a "little Jewish woman *de passage*."[3]

The X ray taken by the laboratory of the Musées de France and published by Juliet Wilson Bareau shows that originally Manet was still thinking of a composition in the tradition of Renaissance Arcadian scenes and that only later did he add the pile of clothes in one corner, turning the timeless nude into a modern woman in a state of undress. At the same time the wooded landscape, initially more sparse and open, was reworked, and several thick tree trunks were added. It is also possible, since Meurent's face was considerably revised, that Manet had used another model to begin with. These important changes, which were made as the work progressed, were perhaps tried out in the Courtauld picture (cat. 94). This shows only minor differences from the Refusés painting—Meurent's red hair, the position of the right hand of the student facing her, the glove he holds in his left hand, for example. But it could also be a later version, executed between 1863 and 1867, for it succeeds where the original painting fails, or to be more precise, where it ignores the integration of the figures in the landscape (see p. 95).

The Orsay painting is known to have appeared under the title *Le Bain* at the Salon des Refusés of 1863, where it created a lively scandal (for the reception and analysis of the work, see chapter IV. It was hung "in the farthest room,"[4] between two others submitted by the artist: *Jeune Homme en costume de Majo* (fig. 375) to the left and *Mlle V... en costume d'espada* (cat. 90) to the right.

H.L.

1. "véritable fief familial où depuis deux siècles les Manet possédaient soixante hectares de terre et plusieurs maisons"; "l'ambiance décorative." Tabarant 1947, p. 60.

2. Moreau-Nélaton 1926, vol. 1, p. 49; Tabarant 1947, p. 61.
3. "petite juive de passage." Proust 1897, p. 31.
4. "la plus reculée des salles." Adolphe Tabarant, *Manet: Histoire catalographique* (Paris, 1931), p. 95.

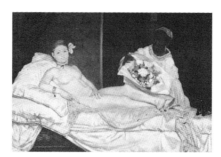

95 *(Paris only)*　　　　　　　　　*Fig. 146*

Édouard Manet
Olympia
1863
Oil on canvas
51³⁄₈ x 73¾ in. (130.5 x 290 cm)
Signed and dated lower left: éd. Manet 1863
Musée d'Orsay, Paris　　RF644

CATALOGUE RAISONNÉ: Rouart-Wildenstein 1975, no. 69

PROVENANCE: The artist, until his death in 1883; Manet estate sale, Paris Hôtel Drouot, February 2, 1884, no. 1 (bought in by the Manet family); Suzanne Manet, Paris, until 1890; acquired from her and offered to the French State with funds raised (Fr 19,415) by public subscription initiated by Claude Monet, 1890; accepted for the Musée du Luxembourg, Paris, 1890; entered the Musée du Louvre, Paris, 1907; Musée du Jeu de Paume, Paris, 1947; Musée d'Orsay, Paris, 1986

EXHIBITIONS: Paris 1865, Salon, no. 1428 (Olympia [poem by Zacherie Astruc]. "Quand, lasse de songer, Olympia s'éveille, /Le printemps entre au bras du doux messager noir; /C'est l'esclave à la nuit amoureuse pareille, /Qui vient fleurir le jour délicieux à voir; /L'auguste jeune fille en qui la flamme veille" (When, tired of dreams, Olympia will arise, /Spring enters on the kind black envoy's arm; /For in the dark of the amorous night, the slave /Would celebrate the day so fair to see— /The august maiden, keeper of the flame); Paris, Pont de l'Alma 1867, *Tableaux de M. Édouard Manet*, no. 2 (Olympia); Paris, École nationale des Beaux-Arts, 1884, *Exposition des oeuvres de M. Édouard Manet*, no. 23 (Olympia. Salon de 1865); Paris, Exposition Universelle, 1889, *Centennale des artistes français*, no. 487 (Olympia. Property of Mme Manet, s.1865); Paris, Musée de l'Orangerie, 1932, *Manet*, no. 15; Paris, Musée de l'Orangerie, 1952, unnumbered; Paris 1968–69, no. 714; Paris, New York 1983, no. 64

SELECTED REFERENCES: Edmond About, "Salon de 1865," *Le Petit Journal*, May 13, 1865, p. 3, and May 27, 1865, p. 3; C. S. P. d'Arpentigny, "Le Salon de 1865," *Le Courrier artistique*, May 21, 1865, p. 201; Ch. Bataille, *L'Univers illustré*, May 11, 1865; Bertall, "Promenade au Salon de 1865," *Le Journal amusant*, May 27, 1865; Bertall, *L'Illustration*, June 3, 1865, p. 341, and June 17, 1865, p. 389; A. Berthand, *Le Tintamarre*, May 7, 1865; Amédée Cantaloube, "Le salon de 1865," *Le Grand Journal*, May 21, 1865, p. 2; Cham, "Le Salon comique," *Le Musée des familles*, June 1865, p. 288; Cham, *Le Charivari*, May 14, 1865; Ernest Chesneau, "Salon de

1865: Les excentriques," *Le Constitutionnel*, May 16, 1865, pp. 1–2; Jules Claretie, "Salon de 1865," *L'Artiste*, May 15, 1865, pp. 225–26; Jules Claretie, "Échos de Paris," *Le Figaro*, June 25, 1865, p. 6; Ch. Clément, "Exposition de 1865," *Journal des débats*, May 21, 1865; Félix Deriège, "Salon de 1865," *Le Siècle*, June 2, 1865, p. 1; Dubosc de Pesquidoux, *L'Union*, May 24, 1865; A. J. Du Pays, "Salon de 1865," *L'Illustration*, May 13, 1865, p. 299; Ernest Filloneau, *Le Moniteur des arts*, May 5, 1865, p. 2; Théophile Gautier, "Salon de 1865," *Le Moniteur*, June 24, 1865, pp. 1–2; Grimm, "Courrier de Paris," *L'Illustration*, May 13, 1865, p. 290; Félix Jahyer, *Supplément au Journal pour toutes*, May 10, 1865, p. 25; Louis Leroy, "Salon de 1865," *Le Charivari*, May 5, 1865, pp. 2–3; M. de Lescure, *La Revue contemporaine*, July 1, 1865; Paul Mantz, "Le Salon de 1865," *Gazette des Beaux-Arts*, July 1, 1865, pp. 6–7; Olivier Merson, "Salon de 1865," *L'Opinion*, May 29, 1865, p. 3; Marc de Montifaud, "Salon de 1865," *L'Artiste*, May 15, 1865, pp. 225–26; G. Privat, *Place aux jeunes: Causeries critiques sur le Salon de 1865*, pp. 63–64; Jean Ravenel, *L'Époque*, May 4, 1865; Paul de Saint-Victor, "Salon de 1865," *La Presse*, May 28, 1865, p. 3; Judith Walter [Judith Gautier], *L'Entracte*, May 17, 1865, p. 2; Claude [Émile Zola], "Mon Salon. M. Manet," *L'Événement*, May 7, 1866, p. 2; G. Randon, "L'Exposition d'Édouard Manet," *Le Journal amusant*, June 29, 1867, p. 7; E. Spuller, "M. Édouard Manet et sa peinture," *Le Nain jaune*, June 9, 1867, p. 5; Émile Zola, "Une nouvelle manière en peinture, Édouard Manet," *La Revue du xix^e siècle*, January 1, 1867, p. 58 (reprinted by Dentu, Paris [May 1867]); Zacharie Astruc "Salon de 1868," *L'Étendard*, June 27, 1868, p. 2; Louis Leroy, "La session du Salon de 1868," *Le Charivari*, May 23, 1868, p. 3; Edmond Bazire, *Manet* (Paris, 1884), pp. 118–23; Émile Zola, "Édouard Manet," preface to the catalogue of the posthumous exhibition, Paris, École des Beaux-Arts, 1884, p. 12; Sâr Joséphin Péladan, "Le Procédé de Manet," *L'Artiste*, February 1884; Louis Gonse, *Gazette des Beaux-Arts*, February 1884, pp. 140–41; Proust 1897, pp. 80–81; Duret 1902, no. 44; Moreau-Nélaton, cat. ms., no. 75; Duret 1926, pp. 35–49; Jacques-Émile Blanche, *Manet* (1928), pp. 33–35; Tabarant 1931, no. 66; Jamot-Wildenstein 1932, no. 82; Tabarant 1947, pp. 76–78, 104–13, no. 68; Theodore Reff, "The Meaning of Manet's Olympia," *Gazette des Beaux-Arts*, February 1964, pp. 111–22; Rouart-Orienti 1970, no. 61; Reff 1976; Hanson 1977, pp. 96–102; David Alston, "What's in a name? 'Olympia' and a Minor Parnassian," *Gazette des Beaux-Arts*, April 1978, pp. 148–54; T. J. Clark, "Un réalisme du corps: 'Olympia' et ses critiques en 1865," *Histoire et critique des arts* 4–5 (May 1978), pp. 139–55; T. J. Clark, *The Painting of Modern Life* (New York, 1985), pp. 79–146; Juliet Wilson Bareau, *The Hidden Face of Manet* (London, Courtauld Institute, 1986), pp. 42–47; Ambrust-Seibert 1986, vol. 1, pp. 159–203

Little is known about the development of *Olympia*. Théodore Duret sees it as a companion work of *Le Déjeuner sur l'herbe* (see p. 115), and it is indeed very possible that Manet undertook it at the same time as the other painting, beginning in 1862. Two red-chalk drawings of a reclining nude with her right leg bent (Musée du Louvre, Département des Arts Graphiques, Fonds du Musée Orsay, Paris, and Bibliothèque Nationale, Paris) have generally been considered as studies for the Orsay picture.[1] In 1947, however, Tabarant rejected this notion: "life-class studies both of them, these red-chalk drawings, and probably earlier than 1860. They have nothing to do with *Olympia*."[2] Juliet Wilson Bareau has recently confirmed Tabarant's view and pro-

posed the date of 1858 for the two life studies.[3] There is in fact nothing to indicate that they were drawn from Victorine Meurent, "invented" by Manet in 1862; moreover, the model assumes a conventional pose that is only distantly related to that of *Olympia*, so distinctive, aggressive, and tense.

The X ray published by Wilson Bareau shows that the canvas evolved in much the same way as *Le Déjeuner sur l'herbe* (cat. 94). At the outset Manet painted a nude similar to Titian's *Venus of Urbino*; Meurent may not even have been on the scene yet as his model. At a later stage, when he filled out the bouquet of flowers and wrapped it in white paper, he added all the signs of modernity, the ribbon, the equivocal cat, and the courtesan's slippers.[4] It is very likely that he intended the picture for the Salon of 1864 but that, rendered uneasy by the reactions at the Refusés to *Le Déjeuner sur l'herbe*, he preferred to wait, proposing a less controversial submission (cat. 96), although that turned out to be a miscalculation.[5] For an analysis of *Olympia* and its reception at the Salon of 1865, see chapter IV.

H.L.

1. Reff 1976, pp. 74–76; and Françoise Cachin in Paris, New York 1983, pp. 183–85.
2. "Académies l'une et l'autre, ces deux sanguines, et probablement antérieures à 1860. Elles ne se rapportent en rien à l'*Olympia*." Tabarant 1947, p. 76.
3. Wilson Bareau 1986, pp. 42–43.
4. Ibid., pp. 44–46.
5. Edmond Bazire, *Manet* (Paris, 1884), p. 26.

96 *Fig. 68*

Édouard Manet
Les Anges au tombeau du Christ (Le Christ mort aux anges)
(*The Dead Christ and the Angels*)
1864
Oil on canvas
Signed lower left and inscribed lower right: Manet / évang[ile]. sel[on]. St. Jean chap[itre] XXV.XII
The Metropolitan Museum of Art, New York, H. O. Havemeyer Collection, Bequest of Mrs. H. O. Havemeyer, 1929 29.100.51

CATALOGUES RAISONNÉS: Rouart-Wildenstein 1975, vol. 1, no. 74

PROVENANCE: Sold by the artist to Durand-Ruel, Paris, January 1872, (for Fr 4,000 according to Manet, Fr 3,000 according to Durand-Ruel); unidentified private collection; bought by Durand-Ruel, 1881, until 1903; sold for $17,000 to Henry O. and Louisine Havemeyer, New York, February 7, 1903; her bequest to the Metropolitan Museum, 1929

EXHIBITIONS: Paris, Salon of 1864, no. 1281 (Les anges au tombeau du Christ); Paris, Pont de l'Alma, 1867, *Tableaux de M. Édouard Manet*, no. 7 (Le Christ mort et les Anges); London, Durand-Ruel, 1872, *Fourth Exhibition of the Society of French Artists*, no. 91 (Christ in the Sepulchre); Boston, Mechanic's Building, 1883, *American Exhibition of Foreign Arts*, no. 1 (Entombment of Christ); New York, Durand-Ruel, 1895, *Paintings by Édouard Manet*, no. 8; New York 1930, no. 75; Paris, Musée de l'Orangerie, 1932, *Manet*, no. 20; Paris, 1968–69, no. 581; Paris, New York 1983, *Manet*, no. 74; New York 1993, no. 346

SELECTED REFERENCES: Edmond About, "Salon de 1864" (Paris, 1864), pp. 156–57; Georges Barral, *Salon de 1864. Vingt-sept pages d'arrêt!!!* (Paris, Dubuisson, 1864), p. 13; Hector de Callias, "Salon de 1864," *L'Artiste*, June 1, 1864, p. 242; A.-J. Du Pays, "Salon de 1864," *L'Illustration*, July 16, 1864, p. 38; Théophile Gautier, "Salon de 1864," *Le Moniteur universel*, June 25, 1864, p. 1; Leon Lagrange, "Le Salon de 1864," *Gazette des Beaux-Arts*, June 1864, p. 515; Raoul de Navery [Eugénie Caroline Saffray Chervand], "Salon de 1864," *Gazette des étrangers*, June 7, 1864; Paul de Saint-Victor, "Salon de 1864," *La Presse*, June 19, 1864, p. 3; Émile Zola, "Une nouvelle manière en peinture, Édouard Manet," *La Revue du xixe siècle*, January 1, 1867, p. 37 (reprinted by Dentu Paris, 1867) and Zola, 1991; Thoré-Bürger 1870, vol. 2, pp. 99–100; Philippe de Chennevières, *Souvenirs d'un Directeur des Beaux-Arts* (Paris, 1883; 1979 edition), p. 40; Sâr Joséphin Peladan, "Le Procédé de Manet d'après l'exposition faite à l'école des Beaux-Arts," *L'Artiste*, February 1884, p. 108; Duret 1902, no. 50; Adolphe Tabarant, "Manet peintre religieux," *Bulletin de la Vie artistique*, June 15, 1923, p. 247, repr.; Moreau-Nélaton, cat. ms., no. 51; Moreau-Nélaton 1926, vol. 1, pp. 56–58; Jacques-Émile Blanche, *Manet* (Paris, 1928), pp. 32–33; Tabarant 1931, no. 72; Jamot-Wildenstein 1932, no. 85; Michel Florisoone, "Manet inspiré par Venise," *L'Amour de l'art*, January 1937, p. 27; Tabarant 1947, pp. 80–84; Adolphe Tabarant, *La Vie artistique au temps de Baudelaire* (Paris, 1942; 1963 edition), pp. 335–36, 345, 415; Tabarant 1947, pp. 81–87, no. 71; Alain de Leiris, "Manet's Christ Scourged and the Problem of His Religious Paintings," *Art Bulletin*, 1959, pp. 198–201; Sterling and Salinger 1967, pp. 36–40; Michael Fried, "Manet's Sources: Aspects of His Art," *Art Forum*, March 1969, unpaginated, repr.; Theodore Reff, "Manet's Sources: A Critical Evaluation," *Art Forum*, September 1969, pp. 40–48; Rouart-Orienti 1970, no. 63; Baudelaire 1973, vol. 2, pp. 352, 386; Dorival 1975, p. 320, repr.; Hanson 1977, pp. 105–8; Richard R. Brandell, *French Salon Artists: 1800–1900* (Chicago, 1987), pp. 55–59; Darragon 1989, p. 96–98

Manet undertook this large religious painting, intended for the Salon, at the end of 1863. It must have been then that he announced to the abbé Hurel: "I am going to do a dead Christ, with the angels, a variant of the scene of Mary Magdalen at the tomb according to Saint John."[1] Tabarant, however, maintains that if Manet "had not known the abbé Hurel, he would probably not have painted a religious subject," a doubtful point. Hurel, "a young man of distinguished appear-

ance and discriminating culture," was a school friend of Manet's;[2] he took an interest in painting and in 1868 published a weighty volume, *L'Art religieux contemporain* (Contemporary religious art), in which he analyzed the "causes of the decadence of Christian art" (see p. 30) and tried to promulgate some formulas for its redemption.[3] He was surely pleased to see his friend tackle religious subjects, although he knew the difficulty of exhibiting them at the Salon. In fact, throughout his life Manet was haunted by the figure of Christ and later contemplated painting a Crucifixion.

The picture had already left for the Palais de l'Industrie when Manet realized that he had placed the lance wound on the wrong side. He told Baudelaire, who confirmed that "the lance wound was made on the right side," adding: "So you must go and change the location of the wound before the opening," and concluding with the sensible advice: "take care not to give the malicious something to laugh at."[4] Manet had no time to make the alteration—it was done in the watercolor copy of the painting in reverse (Musée du Louvre, Département des Arts Graphiques, Fonds du Musée d'Orsay, Paris)—and if the picture did indeed give the malicious something to laugh at, it was for solely pictorial reasons. In its detractors' eyes, the artist abused black, wielding a brush dipped in ink that he clumsily dropped from time to time, splattering the canvas.[5] As with *Olympia* (cat. 95) the following year, there was no dearth of facile observations, ranging from the artist's excessive use of blacks to pointed witticisms about the dirtiness of the divine body. Saint-Victor commented ironically on "Christ in the cellar, supported by two winged chimney sweeps."[6] Gautier, although he recognized Manet's "true qualities as a painter," was not happy in front of this picture by a "terrible realist": "If the Christ of M. Lazerges is too white, too clean, too well scrubbed, that of M. Manet, by contrast, seems never to have known the use of soap and water. With him the lividity of death is combined with filthy hues, dark, dirty shadows that the Resurrection will never clean up—that is, if a corpse in such an advanced state of decay could ever rise again."[7] Hector de Callias and, to a lesser degree, Gautier emphasized one of the characteristics of the work that they found shocking: the sudden clash, in an ensemble of whites and blacks, of the angel's "azure" wings; over time this blue has darkened and the angel no longer "awakens," as in 1864, the dead Christ and the sepulchral bichromy.[8] Théophile Thoré, for his part, made polite fun of those wings, "colored a more intense blue than the depths of the sky," but his by and large indulgent criticism also claimed that the painter had "pastiched" El Greco—"no doubt," he commented, "as a sarcastic measure directed against the lovers of discreet and tidy painting."[9] The term "pastiche" displeased Manet, who asked Baudelaire to correct it; the poet did so in a long letter in which he declared that Manet had never seen El Greco and attributed any pos-

sible similarity to the "astonishing geometric parallels" that existed "in nature."[10]

The oddness of Manet's subject has only recently come under scrutiny. Indeed, from Zola in 1867 on, so little attention was paid to this question (see pp. 51–52) that all the historians confined their observations to Manet's sources among the old masters (see p. 46). In 1967, however, Sterling and Salinger pointed out for the first time that the reference to the Gospel of John inscribed by Manet on the rock that crushes the serpent did not correspond with what was to be seen in the picture;[11] ten years later Anne Coffin Hanson published a remarkable interpretation of the painting. The Evangelist's verse (20:12) refers to Mary Magdalen's surprise and sorrow when she arrives at the tomb on the first day of the week and finds it empty: "And she saw two angels in white, sitting where the body of Jesus had lain, one at the head and one at the feet." Mary Magdalen, thinking that her lord has been "taken away," questions the angels, but immediately Christ appears to her as a gardener. Manet, however, shows us not what Mary Magdalen witnesses—two angels keeping vigil over an absent, already risen lord—but Jesus well and truly dead, holy to be sure, as witness the halo, but hopelessly a corpse. This is Renan's Jesus—*La Vie de Jésus* had appeared the year before, in 1863—a fact, moreover, underlined by one critic when he referred to the "poor miner, dragged out from the coal underground, painted for M. Renan,"[12] that is to say, an "incomparable man" made God by the naive and loving credulity of his disciples. The artist, rather than reproducing the vision created by Mary Magdalen's "vivid imagination," those "sacred moments when the passion of a hallucinating woman gives the world a risen God," displays the reality of a martyred body to which nothing, it seems, will restore life.[13]

The image of Christ, Man of Sorrow, was a continuing obsession of Manet's; at the Salon of 1865 he showed him "mocked by the soldiers" (fig. 74). Later he confessed: "There is one thing that I have always wanted to do. I would like to paint a Christ on the cross.... What a symbol! One could rummage till the end of time without ever finding anything like it. Minerva, that's fine; Venus, that's fine. But the image of heroism and the image of love will never equal the image of sorrow. It is at the heart of humanity. It is its poem."[14] Apropos his portrait of Antonin Proust (1880, Rouart-Wildenstein 331; Toledo Museum of Art, Toledo, Ohio), he told the sitter: "I've made you a Christ wearing a hat, with a frock coat and a rose in your buttonhole. That's Christ on his way to Mary Magdalen's."[15] Twice during the 1860s Manet, using the symbol of the Man of Sorrow, made himself a Christ "despised and rejected by men," "I gave my back to the smiters" (Isaiah 53:3, 50:6); lamenting his unhappiness, he was consoled with difficulty by Baudelaire, who conjured up a band of notable examples such as Chateau-

briand and Wagner, who had, however, forgotten the very "image of sorrow."[16]

H.L.

1. "Je vais faire un Christ mort, avec les anges, une variante de la scène de Madeleine au sépulcre selon saint Jean." Adolphe Tabarant, *Manet: Histoire catalographique* (Paris, 1931), pp. 188–89. In the reissue of this work in 1947 Tabarant omitted the second part of the sentence: "une variante de la scène de Madeleine au sépulcre selon Saint Jean" (Tabarant 1947, p. 80). He dates Manet's disclosure to the abbé Hurel as taking place in November 1863, but at that time the artist was in Holland, where he spent a month after marrying Suzanne Leenhoff at Zalt-Bommel on October 28 (Paris, New York 1983, p. 508).

2. "s'il n'avait pas connu l'abbé Hurel n'aurait probablement pas peint de sujet religieux"; "garçon d'allures distinguées et de culture fine." Adolphe Tabarant, "Manet peintre religieux," *Bulletin de la vie artistique*, June 15, 1923, p. 247.

3. "causes de la décadence de l'art chrétien." See Abbé Hurel, *L'Art religieux contemporain* (Paris, 1868), pp. 407ff.

4. "le coup de lance a été porté à droite"; "Il faudra donc que vous alliez changer la blessure de place, avant l'ouverture"; "prenez garde de prêter à rire aux malveillants." Baudelaire 1973, vol. 2, p. 352. At the end of February Manet had written to the comte de Nieuwerkerke (unpublished letter; Archives du Louvre, vol. 10, Salon de 1864, Paris): "Monsieur le comte / J'ai l'honneur de solliciter de votre bienveillance une prolongation de huit à dix jours. Veuillez agréer Monsieur le comte, l'assurance de ma considération et de mon dévouement / Édouard Manet / 34 Bd des Batignolles." But the request, already linked perhaps with uncertainties over the placement of the lance wound, was turned down: "impossible / rép. le 1ᵉʳ mars." (See translation on p. 18.)

5. A. J. Du Pays, "Salon de 1864," *L'Illustration*, July 16, 1864, p. 38; Edmond About, *Salon de 1864* (Paris, 1864), pp. 156–57.

6. "Christ à la cave, soutenu par les deux ramoneurs ailés." Paul de Saint-Victor, "Salon de 1864," *La Presse*, June 19, 1864, p. 3.

7. "les vraies qualités de peintre"; "terrible réaliste"; "Si le Christ de M. Lazerges est trop blanc, trop propre, trop savonné, en revanche, celui de M. Manet ne semble pas avoir connu jamais l'usage des ablutions. La lividité de la mort se mêle chez lui à des teintes crasseuses, à des ombres sales et noires dont jamais la résurrection ne le débarbouillera, si un cadavre tellement avancé peut ressusciter toutefois." Théophile Gautier, "Salon de 1864," *Le Moniteur universel*, June 25, 1864, p. 1.

8. "azur"; "réveille." Hector de Callias, "Salon de 1864," *L'Artiste*, June 1, 1864, p. 242.

9. "coloriées d'un azur plus intense que le fin fond du ciel"; "pastiché"; "sans doute en manière de sarcasme contre les amoureux transis de la peinture discrète et proprette." Thoré-Bürger 1870, vol. 2, p. 99.

10. "étonnants parallélismes géométriques"; "dans la nature." Baudelaire 1973, vol. 2, pp. 386–87. Thoré echoed Baudelaire's protest in his column in *L'Indépendance belge* of June 25 (ibid., p. 867).

11. C. Sterling and M. M. Salinger, *A Catalogue of the Collection of the Metropolitan Museum of Art: French Paintings*, vol. 3, *19th–20th Centuries* (New York, 1967), pp. 36–40.

12. "pauvre mineur qu'on retire du charbon de terre, exécuté pour M. Renan." "Salon de 1864," *La Vie parisienne*, May 1, 1864, p. 266.

13. "forte imagination"; "moments sacrés où la passion d'une hallucinée donne au monde un Dieu ressuscité." Ernest Renan, *Vie de Jésus* (Paris, 1974), p. 410.

14. "Il est une chose que j'ai toujours eu l'ambition de faire. Je voudrais peindre un Christ en croix.... Quel symbole! On pourra se fouiller jusqu'à la fin des siècles on ne

trouvera rien de semblable. La Minerve, c'est bien, la Vénus, c'est bien. Mais l'image héroïque, l'image amoureuse ne vaudront jamais l'image de la douleur. Elle est le fond de l'humanité. Elle en est le poème." Proust 1897, p. 64.

15. "Je t'ai fait en Christ coiffé d'un chapeau, avec une redingote et une rose à la boutonnière. Cela c'est le Christ allant chez Madeleine." Ibid.

16. "image [même] de la douleur." Baudelaire 1973, vol. 2, p. 496.

97 *(Paris only)* *Fig. 198*

Édouard Manet
Un vase de fleurs (Pivoines dans un vase)
(Vase of Flowers [Vase of Peonies on Small Pedestal])
1864
Oil on canvas
36⅝ x 27½ in. (93 x 70 cm)
Musée d'Orsay, Paris, donation Moreau-Nélaton
RF1669

CATALOGUE RAISONNÉ: Rouart-Wildenstein 1975, no. 86

PROVENANCE: Sold by the artist to Durand-Ruel, Paris, 1872; John Saulnier, Bordeaux, until 1886; his sale, Paris, Hôtel Drouot, June 5, 1886, no. 62; bought at this sale by Durand-Ruel, Paris; Beugniand et Boujean, Paris; Durand-Ruel, Paris, 1900; bought by Étienne Moreau-Nélaton, Paris, until 1906; his gift to the Musée du Louvre, 1906; Musée des Arts Décoratifs, Paris, 1907; Musée du Louvre, Paris, 1934; Musée du Jeu de Paume, Paris, 1947; Musée d'Orsay, Paris, 1986

EXHIBITIONS: Paris, Galerie Martinet, 1865(?); Paris, Galerie Cadart, 1865(?); Paris, avenue de l'Alma, 1867, *Tableaux de M. Édouard Manet*, no. 33 (Un vase de fleurs); Bordeaux, Société des amis des arts, Salon of 1869, no. 411 (Pivoines dans un vase)(?); Paris, Exposition Universelle, 1900, *Centennale*, no. 452; Paris, Musée de l'Orangerie, 1932, *Manet*, no. 21; Paris, New York 1983, no. 77

SELECTED REFERENCES: Duret 1902, no. 84; Moreau-Nélaton, cat. ms., no. 65; Moreau-Nélaton 1926, vol. 1, pp. 62–64; Tabarant 1931, no. 75; Jamot-Wildenstein 1932, no. 101; Tabarant 1947, p. 93, no. 79; Rouard-Orienti 1970, no. 70

98 *(New York only)* *Fig. 200*

Édouard Manet
Bouquet de pivoines
(Peonies)
1864
Oil on canvas
23⅜ x 13⅞ in. (59.4 x 35.2 cm)
The Metropolitan Museum of Art, New York, Bequest
of Joan Whitney Payson, 1975 1976.201.16

CATALOGUE RAISONNÉ: Rouart-Wildenstein 1975, vol. 1,
no. 87

PROVENANCE: The artist, until his death in 1883; Manet
estate sale, Paris, Hôtel Drouot, February 5, 1884, no.
76; bought for Fr 130 by Emmanuel Chabrier, Paris;
Mme Eugène Moullé, Paris, before 1896; Albert Moullé,
her son, by 1902–23; L. C. Hodebert, Paris, 1923; Galerie
Étienne Bignou, Paris; Mrs. R. A. Workman, London;
Reid and Lefèvre Gallery, London; David W. T. Cargill,
Lanark, Scotland, by 1931; Bignou Gallery, New York,
1940; Mrs. Millicent Rogers, Taos, N.M., until 1952; Joan
Whitney, wife of Charles S. Payson, New York and
Manhasset, 1952–75; her bequest to the Metropolitan
Museum, 1975

EXHIBITIONS: Detroit Institute of Arts, 1940, *The Age of
Impressionism and Objective Realism*, no. 27 (Vase of
Flowers, lent by the Bignou Gallery, New York); New
York, Metropolitan Museum of Art, 1960, *Paintings from
Private Collections: Summer Loan Exhibition*, no. 64;
Amsterdam, Rijksmuseum Vincent Van Gogh, 1987,
*Franse meesters uit hand Metropolitan Museum of Art:
Realisten en Impressionisten*, no. 13

SELECTED REFERENCES: Duret 1902, no. 85; Moreau-
Nélaton, cat. ms., no. 66; Tabarant 1931, no. 76; Jamot-
Wildenstein 1932, vol. 1, no. 104; Tabarant 1947, pp. 94,
604, no. 83; Rouart-Orienti 1970, no. 73

In the spring of 1864 Manet painted his first flower
pictures, six canvases depicting peonies that range
from the simple, rapidly executed sketch (*Branche
de pivoines blanches et sécateur* [*Branch of White
Peonies and Secateurs*], Musée d'Orsay, Paris) to
the more ambitious still life, such as the wonder-
ful bouquet from the Moreau-Nélaton collection
seen here.[1] If the time of year is dictated by the
subject itself—peonies are spring flowers—the
year in question can be inferred from a note by
Manet to Louis Martinet in which the artist lists
some recent works that he intends to exhibit at
the Galerie Martinet in February 1865. Apart from
"La mer: le navire fédéral Kerseage [*sic*] en rade
de Boulogne-sur-mer" (cat. 100), painted in July

1864, and *L'Espada mort* (*The Dead Toreador*), a
fragment cut from *Episode d'une course de
taureaux* (*Episode in the Course of a Bullfight*)
shown at the Salon of 1864, he mentions a picture
of flowers, without giving any further details; this
is very likely to have been the Moreau-Nélaton
example, the largest and most impressive work
in the series.[2]

Manet loved peonies, which "swarmed" on his
Gennevilliers property.[3] Grown in France since
the early nineteenth century, the moutan peony
(*Paeonia suffruticosa*), a native of distant China,
was then a fashionable flower.[4] With its blossoms
opening out in countless undisciplined petals,
making large splashes of white, pink, and red
among its dense green foliage, it was also the
flower for colorists (see p. 160 and fig. 202). Placed
in a vase, peonies form a bouquet that is not stiff
and crackling, like the one that Degas put beside
his dear Mme Valpinçon (cat. 57), but heavy and
sumptuous, very Second Empire. Manet's vase of
peonies has none of the touching, popular ap-
peal of the flowers painted by Renoir (cat. 168)
and Monet (cat. 115). To the poet André Fraigneau
it even suggested the lavish but swiftly faded
charms of Marguerite Gautier; for it is also, be-
neath its appearance of luxury, calm, and sensu-
ous pleasure, a *vanitas* (see p. 179).

The Metropolitan Museum picture, which is
smaller, is not a sketch but an unfinished first
version; possibly Manet was dissatisfied with its
overly vertical format, the bouquet too tightly
bunched, the vase too prominent, the lack of a
sense of abandon and ease. In the 1860s he did
not return to bouquets of flowers except to show
his fashionable pupil Eva Gonzalès how to re-
peat feebly the task that had occupied him in the
spring of 1864 (see pp. 159–60 and fig. 199).

 H.L.

1. The Metropolitan Museum has recently acquired one of
these works (*Still Life with Flowers, Fans, and Pears*;
Rouart-Wildenstein 89) and has dated it about 1860.
2. Moreau-Nélaton 1926, vol. 1, pp. 62–63.
3. "foisonnaient." Tabarant 1947, p. 93.
4. See "Peonies," in Pierre Larousse, *Grand Dictionnaire
universel du XIXe siècle*, vol. 12 (Paris, 1874).

99 *Fig. 62*

Édouard Manet
*Le Combat des navires américains
"Kearsarge" et "Alabama"*
*(Battle of the "Kearsarge" and the
"Alabama")*
1864
Oil on canvas
54¼ x 50¾ in. (137.8 x 128.9 cm)
Signed lower right: Manet
The John G. Johnson Collection; Philadelphia Museum
of Art cat. no. 1027

CATALOGUE RAISONNÉ: Rouart-Wildenstein 1975, no. 76

PROVENANCE: Sold by Manet for Fr 3,000 by Manet to
Durand-Ruel, Paris, 1872; L.*** et al., sale, Paris, Hôtel
Drouot, March 23, 1878, no. 32; acquired by the pub-
lisher Georges Charpentier who left it on deposit at
Durand-Ruel from October 24, 1884, to October 27, 1887;
Théodore Duret, Paris; deposited by him at Durand-
Ruel, Paris, March 21, 1888; bought for Fr 3,000 by
Durand-Ruel, Paris, October 16, 1888, and resold the
same day for Fr 4,000 to its New York branch; sold on
the following day for $1,500 to John G. Johnson, Phila-
delphia, until his death in 1917; his bequest to the city
of Philadelphia, 1917

EXHIBITIONS: Paris, in vitrine at Cadart, 79, rue de
Richelieu, July 1864 (see Philippe Burty, *La Presse*, July
18, 1864, p. 3); Paris, avenue de l'Alma, 1867, *Tableaux
de M. Édouard Manet*, no. 22 (Le Combat des navires
américains *Kerseage* [*sic*] et *Alabama*); Paris, Salon of
1872, no. 1059 (Combat du *Kearsage* et de l'*Alabama*);
Brussels, salon des Beaux-Arts, summer 1872, no. 489;
Paris, École nationale des Beaux-Arts, January 1884,
Exposition posthume, no. 35 (Le Combat du *Kearsage*
et de l'*Alabama*); Philadelphia, Pennsylvania Museum
of Art, 1933–34, *Manet et Renoir*; New York, Paul Ro-
senberg, 1946–47, *Masterpieces by Manet*, no. 4; Phila-
delphia Museum of Art and Chicago, Art Institute,
1966–67, *Manet*, no. 62; Philadelphia, Detroit, Paris,
1978–79, VI–80; Paris, New York, 1983, no. 83

SELECTED REFERENCES: Philippe Burty, "La Quinzaine
artistique," *La Presse*, July 18, 1864, p. 3; G. Randon,
"L'Exposition d'Édouard Manet," *Le Journal amusant*,
June 29, 1867, p. 8; Émile Zola, "Une nouvelle manière
en peinture, Édouard Manet," *La Revue du xixᵉ siècle*,
January 1, 1867, p. 59 (reprinted by Dentu, Paris [May
1867]); Jean Aicard, "Salon de 1872," *La Renaissance
littéraire et artistique*, June 29, 1872, p. 75; Jules Barbey
d'Aurevilly, "Un ignorant au Salon," *Le Gaulois*, July
3, 1872, p. 2; Castagnary, "Salon de 1872," *Le Siècle*,
May 25, 1872, p. 2; Cham, *Le Salon pour rire* (Paris,
1872); Jules Claretie, "Salon de 1872," *Le Soir*, May 25,

1872, p. 3; Edmond Duranty, "Le Salon de 1872," *Paris-Journal*, May 30, 1872, p. 2; Frou-Frou, "Les premières," *Le Figaro*, May 12, 1872, p. 1; Jules Guillemot, "Le Salon de 1872," *Le Journal de Paris*, June 18, 1872, p. 1; Gaston Jollivand, "Salon de 1872," *Paris-Journal*, May 21, 1872, p. 1; Louis Leroy, "Le Salon," *Le Charivari*, May 16, 1872, p. 3; Camille Pellandan, "Le Salon," *Le Rappel*, May 11, 1872, p. 2; G. Puissant, "Salon de 1872," *L'Avenir national*, May 19, 1872; Armand Silvestre, "L'École de peinture contemporaine," *La Renaissance littéraire et artistique*, September 28, 1872; Stop, *Journal amusant*, May 25, 1872, caricature p. 4; Stop, *Paris-Magazine*, May 24, 1872; Pierre Véron, "Voyage en zigzag à travers le Salon," *Le Journal amusant*, May 25, 1872, p. 2; Stéphane Mallarmé, "Impressionists and Édouard Manet," *Art Monthly Review*, 1 (1876), p. 119; Louis Gonse, "Manet," *Gazette des Beaux-Arts*, February 1884, pp. 142–43; Paul Mantz, "Les oeuvres de Manet," *Le Temps*, January 16, 1884, quoted in Pierre Courthion, *Manet et ses amis* (1953), vol. 2, pp. 135–36; Sâr Joséphin Péladan, "Le Procédé de Manet," *L'Artiste*, February 1884, pp. 110–11; Émile Zola, "Édouard Manet," preface to the catalogue of the posthumous exhibition, Paris, École des Beaux-Arts, 1884, p. 13; Proust 1897, pp. 34, 100; Duret 1902, no. 81; Louis Hourticq, *Manet*, 1911, pp. 63–64; Duret 1926, pp. 99–100; Moreau-Nélaton, cat. ms., no. 54; Moreau-Nélaton 1926, vol. 1, pp. 60–61; Paul Jamot, "Manet peintre de marine et le 'Combat du Kearsage [*sic*] et de l'Alabama,'" *Gazette des Beaux-Arts*, June 1927, pp. 381–90, repr. p. 387; Jacques Émile Blanche, *Manet* (Paris, 1928), pp. 11–12; Tabarant 1930, no. 69; Jamot-Wildenstein 1932, no. 87; Tabarant 1947, p. 88, no. 74; G. H. Hamilton, *Manet and His Critics*, (New Haven, 1954), pp. 155–60; Anne Coffin Hanson, "A Group of Marine Paintings by Manet," *Art Bulletin*, 44 (1962), pp. 332–36; Léonce Peillard, "La Mer rouge de sang," *Les Nouvelles littéraires*, May 27, 1965; Rouart-Orienti 1970, no. 66; Hanson 1977, p. 52, 54, 98, 104, 105, 121–25, 188–89, repr. pl. 85; Darragon 1989, pp. 103–6

100 *Fig. 289*

Édouard Manet

Bateau de pêche arrivant vent arrière (Le "Kearsarge" à Boulogne)
(*Fishing Boat Coming in before the Wind* [*The "Kearsarge" at Boulogne*])
1864
Oil on canvas
31⅞ x 39⅛ in. (81 x 99.4 cm)
Private collection

CATALOGUE RAISONNÉ: Tabarant 1931, no. 70; Jamot-Wildenstein 1932, no. 88; Tabarant 1947, no. 75; Rouart-Orienti 1970, no. 67; Rouart-Wildenstein 1975, no. 75

PROVENANCE: Bought for Fr 2,000 from a collector named Gotti, by Boussod, Valadon et Cie, Paris, March 10, 1890, and sold the same day for Fr 4,000 to Gustave Goupy, Paris, until 1898; his sale, Hôtel Drouot, Paris, March 30, 1898, no. 20; bought at this sale for Fr 4,000 by Durand-Ruel for Henry O. and Louisine Havemeyer, New York, until 1929; by descent to her daughter, Adaline Havemeyer Frelinghuysen, Morristown, N.J., 1929–63; private collection

EXHIBITIONS: Paris, Galerie Martinet 1865 (La mer, le navire fédéral Kerseage en rade de Boulogne sur mer [?]); Paris, Pont de l'Alma, 1867, *Tableaux de M. Édouard Manet*, no. 45 (Bateau de pêche arrivant vent arrière); Philadelphia Museum of Art and Chicago, Art Institute, 1966–67, *Manet*, no. 63; Paris, New York 1983, no. 84

SELECTED REFERENCES: G. Randon, "L'Exposition d'Édouard Manet," *Le Journal amusant*, June 29, 1867, p. 6; Émile Zola 1867, p. 38; Duraet 1902, no. 83; Moreau-Nélaton, cat. ms., no. 55; Moreau-Nélaton 1926, vol. 1, p. 62; Tabarant 1931, no. 70; Jamot-Wildenstein 1932, no. 88; Tabarant 1947, no. 75; Anne Coffin Hanson, "A Group of Marine Paintings by Manet," *Art Bulletin* 44 (1962), p. 332–36; Rouart-Orienti 1970, no. 67

In the evening of June 11, 1864, the *Alabama* entered the roads of Cherbourg. It was a steam-driven corvette, built two years earlier by the Confederate government in Richmond, Virginia, "a vessel with elegant lines, made for speed, riding low in the water, and painted black." Since its launching, it had been on the high seas under the command of Captain Semmes; "in two years, thanks to its turn of speed, he had boarded and captured fifty-six federal vessels. With no harbor open to receive his prizes, he sank or burnt them at sea, keeping only the chronometers as trophies." In the morning of June 14, the *Kearsarge*, a "federal steam sloop," which had already had an encounter with the *Alabama* in 1862, "appeared outside the seawall"; the next day its captain sent a challenge to his opposite number on the *Alabama*. The battle took place on June 19, after a vain attempt at mediation by "some Cherbourg dignitaries." The *Alabama* left French waters in the morning and at ten minutes past eleven fired its first shot at the Union vessel. By midafternoon the battle was over, and the victorious *Kearsarge* entered Cherbourg "at five o'clock in the evening, without major losses, despite having been hit by twenty-five cannonballs." Since the duel had been anticipated for several days, "thousands of spectators had taken up positions on the montagne du Roule and neighboring heights, on the masts of ships in the roadstead or docks, on the terraces of the Casino des Bains de Mer, and on the houses along the seawall. Visitors traveling down from Paris on an excursion train swelled this population of sightseers."[1]

By the first half of July Manet was exhibiting his *Combat des navires américains "Kearsarge" et "Alabama"* in the window of Cadart, 79, rue de Richelieu, where it swiftly elicited a favorable response from Philippe Burty in *La Presse* of July 18, 1864: "As early as the day after the battle between the *Kearsarge* [Burty, unlike Manet, was one of the few to spell this name correctly] and the *Alabama*, it was announced that all the marine painters had left Paris for Cherbourg. We shall

see more than one record of this naval event at the next Salon. In the meantime this battle rendered by M. Manet with uncommon powers of realization, or at least of verisimilitude, can already be viewed in the windows of Cadart's shop, that permanent Salon of the young school."[2] There has been much speculation since then as to whether Manet went to Cherbourg and captured the event live. Later Antonin Proust (whose well-meaning testimony has to be treated with some caution) confirmed that Manet had made the trip to Normandy with the many other "sightseers" and that he "had embarked on a pilot boat and had recorded the encounter between the two American vessels at first hand."[3] But Burty's few lines were ambiguous, since his use of the word *verisimilitude* might indicate that the painter was inspired solely by the reports given in the press. Manet's note to Burty thanking him for his brief commendation is equally equivocal; mentioning the picture that he had just painted at Boulogne and that he was to call *Bateau de pêche arrivant vent arrière* (cat. 100), he wrote: "Last Sunday the Kearsage [*sic*] was lying off Boulogne. I went to visit it. I had guessed it about right. Besides, I painted what it looked like at sea. You will be the judge."[4] "I had guessed it about right" could mean that Manet was pleased to have done an accurate picture of a ship that he had not seen, or one that he was unable to see clearly because of the clouds of smoke that enveloped it.[5] Although it is now impossible to decide one way or the other, no one has ever contested the truthfulness of the scene painted by Manet, who was a sailor in his youth; the pilot boat coming to the aid of the *Alabama* flies the regulation blue-edged white flag, while in the distance, under British colors, is the steamship that rescued a large number of Confederate seamen; contrary to the draftsman for the *Journal illustré*, who showed the *Alabama* sinking by the bow,[6] Manet renders it going down by the stern, as in fact it did.

This was the first time that Manet turned his attention to a contemporary event, something he was to repeat on a more ambitious scale with *L'Exécution de Maximilien* (fig. 63) and later with *L'Évasion de Rochefort* (*The Escape of Rochefort*). For *Le Combat des navires américains "Kearsarge" et "Alabama"* is a history painting and not a simple "marine," as Zola, who despised the subject, saw it (see p. 45).[7] Moved by the fate of this vessel mortally wounded in single combat, as he was to be affected in 1867 by the destiny of the "blond emperor who was shot over there," Manet painted it sinking in an "invading, deep green sea," whose "magnificent waves" Zola rightly praised.[8] As has often been pointed out, he borrowed the composition from Japanese art, placing the line of the horizon high up and creating the impression, a few cable lengths from the shore, of being on the open sea.[9] Japan was also the influence behind his watercolor *Le "Kearsarge" à Boulogne* (*The "Kearsarge" at Boulogne*; Musée des Beaux-Arts, Dijon). This was done from life when Manet went to Boulogne at the beginning of July; he spent the summer there and

worked on a painting that he was to exhibit in 1867 under the title *Bateau de pêche arrivant vent arrière*. Executed in the same green-and-black harmony as the Philadelphia canvas, *Courses à Longchamp* (cat. 106), and *L'Enterrement* (cat. 105), this is the second episode in the narrative begun a few days earlier; everything appears, as Françoise Cachin points out, "much as though the *Alabama*, in sinking, had left its conqueror in plain sight but a few moments later."[10] Making use of a similar composition, Manet, like the demiurge of a theatrical spectacle, calms the waves, clears the smoke, and places the victorious ship—dark, metallic, opaque, and terrifying—high up while inquisitive small craft frisk around it.

H.L.

1. "bâtiment de formes élégantes, taillé pour la course, peu élevé sur l'eau et peint en noir"; "Grâce à la rapidité de ses mouvements, en deux ans il accosta et captura cinquante-six navires fédéraux. Comme il n'avait point de port ouvert pour y conduire ses prises, il les coulait ou les incendiait en mer. Il en conservait seulement les chronomètres comme trophées"; "sloop à vapeur fédéral"; "parut au large de la digue"; "quelques notables de Cherbourg"; "à cinq heures du soir, sans avaries majeures bien qu'il eût été atteint de vingt-cinq boulets"; "des milliers de spectateurs avaient pris place sur la montagne du Roule et les hauteurs voisines, sur les mâts des navires en rade ou dans les bassins, sur les terrasses du casino des bains de mer, sur les maisons de la digue. Les voyageurs amenés de Paris par un train de plaisir grossissaient cette population de curieux." Émile de la Bédollière, "L'Alabama et le Kearseage [sic]," *Le Journal illustré*, July 10–17, 1864, p. 1.
2. "Dès le lendemain du combat du *Kearsarge* et de l'*Alabama*, on annonçait que tous les peintres de marine étaient partis de Paris pour Cherbourg. Le prochain salon nous révélera plus d'une réplique de cet épisode naval. En attendant, on a déjà pu voir, aux vitrines de ce salon permanent de la jeune école que forme le magasin de Cadart, ce combat peint par M. Manet avec une rare puissance de réalisation, ou tout au moins de vraisemblance." Philippe Burty, "La Quinzaine artistique," *La Presse*, July 18, 1864, p. 3.
3. "curieux"; "s'était embarqué à bord d'un bateau pilote et avait saisi sur nature la collision des deux navires américains." Proust 1897, p. 34.
4. "Le Kearsage [sic] se trouvait dimanche dernier en rade de Boulogne. Je suis allé le visiter. Je l'avais assez bien deviné. J'en ai peint du reste l'aspect en mer. Vous en jugerez." Letter from Manet to Philippe Burty, n.d., quoted in Moreau-Nélaton 1926, vol. 1, p. 61.
5. This was notably the opinion argued by Paul Jamot, "Manet peintre de marine et le combat du Kearsage [sic] et de l'Alabama," *Gazette des Beaux-Arts* (June 1927), pp. 386–88.
6. Drawing by M. de Bérard published in *Le Journal illustré*, July 10–17, 1864, p. 1.
7. Zola 1991, p. 162. In his article in *La Revue du XIXe siècle* ("Une Nouvelle Manière en peinture, Édouard Manet," January 1, 1867, p. 59) Zola mentioned "deux très remarquables marines [two very remarkable marines]" without naming them. Some months later, in his brochure *Édouard Manet: Étude biographique et critique*, he referred to "quatre très remarquables marines [four very remarkable marines]" and cited *Le Steam-boat*; *Le Combat du Kearsage et de l'Alabama*; *Vue de mer, Temps calme*; and *Bateau de pêche arrivant vent arrière*.
8. "blond empereur qu'on fusilla là-bas"; "mer envahissante, lourdement verte." Jean Aicard, "Salon de 1872," *La Renaissance littéraire et artistique*, June 29, 1872, p. 75. "vagues magnifiques." Zola 1991, p. 162.
9. In 1872, when this picture was exhibited at the Salon, Jules Claretie criticized it for its lack of realism, due to

the perspective having been "traitée un peu trop à la façon japonaise" (handled a little too much in the Japanese style); Jules Claretie, "Salon de 1872," *Le Soir*, May 25, 1872, p. 3.
10. "tout se passe comme si l'*Alabama*,' coulé, avait laissé apparaître son vainqueur, quelques instants plus tard." Françoise Cachin, in Paris, New York 1983, pp. 221–22.

101 *(Paris only)* *Fig. 240*

Édouard Manet
La Lecture
(Reading)
1865, retouched ca. 1873–75
Oil on canvas
23⅞ x 29 in. (60.5 x 73.5 cm
Musée d'Orsay, Paris RF1944–17

CATALOGUE RAISONNÉ: Tabarant 1947, no. 143; Rouart-Orienti 1970, no. 123; Rouart-Wildenstein 1975, no. 136

PROVENANCE: The artist, until his death in 1883; to his widow, Suzanne Manet, Paris from 1883 until about 1890; bought for Fr 3,500 by Winnaretta Singer, through the offices of the painter Ernest Duez and the dealer Alphonse Portier, Paris, about 1890; bequest of princesse Edmond de Polignac (née Winnaretta Singer) to the Musée du Louvre, Paris, 1944; Musée du Jeu de Paume, Paris, 1947; Musée d'Orsay, Paris, 1986

EXHIBITIONS: Bordeaux, Société des amis des arts de Bordeaux, 1866, no. 97(?); Paris, La Vie moderne, 1880, *Oeuvres nouvelles d'Édouard Manet*, no. 10 (La Lecture); Paris, École nationale des Beaux-Arts, 1884, *Exposition des oeuvres de Édouard Manet*, no. 46 (La lecture); Paris, Musée de l'Orangerie, 1932, *Manet*, no. 34; London, Tate Gallery, 1954, *Manet and His Circle*, no. 9; Marseille, Musée Cantini, 1961, *Manet*, no. 12; Paris, New York 1983, no. 97

SELECTED REFERENCES: Philippe Burty, "Exposition de la Société des amis des arts de Bordeaux," *Gazette des Beaux-Arts*, June 1, 1866, p. 564; Duret 1902, no. 97; Moreau-Nélaton, cat. ms., no. 108; Moreau-Nélaton 1926, vol. 1, p. 109; Tabarant 1931, no. 138; Jamot-Wildenstein 1932, no. 167; Tabarant 1947, pp. 155–56, no. 143; Rouart-Orienti 1970, no. 123

It was about 1890 when the painter Ernest Duez, who was seeking works by Manet for the wealthy Winnareta Singer, discovered at Gennevilliers, where the artist's widow was living in retirement in straitened circumstances, "a portrait of her dressed all in white in a white drawing room." "It is exquisite. It is one of Manet's nicest paintings," he added for the benefit of the American, herself an amateur painter, who bought it immediately.[1]

Identified in the posthumous inventory as a

"portrait of Mme Manet and Léon Koëlla," this picture was dated about 1868 until Françoise Cachin reviewed the problem. Noting the impossible age difference between the two sitters, she wrote: "There are many stylistic indications that the painting was originally done in 1865 and portrayed Suzanne Manet alone."[2] At a later date,[3] either to fill the dark rectangle above the sofa or with a view to turning the initial portrait into a scene of modern life, Manet added the figure of Léon Koëlla, by then a tall young man (he was born in 1852), holding a book (see p. 194).

It is very likely that the portrait of Mme Manet, painted during the fine spring or summer weather of 1865 in the apartment at 34, boulevard des Batignolles, was exhibited in the spring of 1866 at the Exposition de la Société des Amis des Arts de Bordeaux. For Philippe Burty was no doubt referring to this picture when, among the works by Chabry, Chaigneau, Auguin, and Faxon, he praised a Manet as "an excellent study of a young woman dressed in white muslin."[4]

Manet did indeed execute, in Whistler's manner, a "harmony in white," rendering the hue as light, transparent, and iridescent and adding two other colors that were fetishes of his—black, a discrete note around the neck and waist of his wife, and dark green. In the 1860s a dazzling white was an obsession among artists of the New Painting, as witness portraits and figures by Whistler and Manet, as well as Monet's "snows," Renoir's *Lise* (fig. 176), and a still life by Cézanne (cat. 31).

Seated in front of a window, Mme Manet must have been posed *à contre-jour*; but if the light is filtering through the muslin curtains, it is also coming from invisible and unpredictable sources that vividly illuminate the dress, the hand, and the slipcover on the sofa. Preoccupied solely with his tone-on-tone effect, Manet left it to Degas to work out. Beginning at the end of the 1860s, Degas used the violent effects of contrapposto, making the dark shapes of his sitters, with their indistinct features, stand out against brightly colored backgrounds (fig. 259).

H.L.

1. "un portrait d'elle habillée tout en blanc dans un salon blanc"; "C'est adorable. C'est une des plus jolies manifestations de Manet." Françoise Cachin in Paris, New York 1983, p. 260.
2. "Il y a de fortes raisons stylistiques de penser que le tableau original a été peint en 1865 et représentait seulement Suzanne Manet." Ibid., p. 258.
3. According to Françoise Cachin, about 1873 (ibid.); according to Juliet Wilson Bareau, about 1875 (Wilson Bareau 1991, p. 154).
4. "une excellente étude de jeune femme vêtue de mousseline blanche." Philippe Burty, "Exposition de la Société des Amis des Arts de Bordeaux," *Gazette des Beaux-Arts*, June 1, 1866, p. 564.

102 *Fig. 261*

Édouard Manet
Le Fifre
(The Fifer)
1866
Oil on canvas
63³⁄₈ x 38¼ in. (161 x 97 cm)
Musée d'Orsay, Paris RF1992

CATALOGUE RAISONNÉ: Rouart-Wildenstein 1975, no. 113

PROVENANCE: The artist, until 1872; bought for Fr 1,500 by Durand-Ruel, Paris, 1872, until 1873; bought for Fr 2,000 by Jean-Baptiste Faure, Paris, 1873, until 1893; bought by Durand-Ruel, Paris, 1893, until 1894; bought for Fr 30,000 by comte Isaac de Camondo, Paris, 1894; his bequest to the Musée du Louvre, 1911; exhibited at the Musée du Louvre, Paris, 1914; Musée du Jeu de Paume, Paris, 1947; Musée d'Orsay, Paris, 1986

EXHIBITIONS: Private exhibition in Manet's studio, rue Guyot, spring 1866 (Tabarant 1947, p. 124); Paris, pont de l'Alma, 1867, *Tableaux de M. Édouard Manet*, no. 11 (Le Fifre); Paris, École nationale des Beaux-Arts, 1884, *Exposition des oeuvres de Édouard Manet*, no. 33 (Le Fifre. Property of M. Faure); New York, National Academy of Design, 1886, *Works in Oil and Pastel by the Impressionists of Paris*, no. 22; Paris, Exposition Universelle, 1889, *L'Exposition centennale de l'art français*, no. 485 (Le Fifre. Property of M. Faure); Paris, Musée de l'Orangerie, 1932, *Manet*, no. 23; Paris, New York, 1983, no. 93; Paris, Tokyo 1988, no. 179

SELECTED REFERENCES: Claude [Émile Zola], "Mon Salon," *L'Événement*, April 27, p. 2, April 30, pp. 1–2, May 4, p. 2, May 7, 1866, p. 2; Émile Zola, "Une nouvelle manière en peinture: Édouard Manet," *La Revue du xix siècle*, January 1, 1867, reissued by Dentu, Paris, May 1867, p. 37; Jules Claretie, "Courrier de Paris," *L'Indépendance belge*, June 15, 1867, p. 2; Louis Gonse, "Manet," *Gazette des Beaux-Arts*, February 1884, p. 142; Paul Mantz, "Les Oeuvres de Manet," *Le Temps*, January 16, 1884; Antonin Proust, "Édouard Manet inédit," *La Revue blanche*, February 15, 1884, p. 174; Émile Zola, *Exposition des oeuvres de Édouard Manet*, preface to exh. cat., Paris, École nationale des Beaux-Arts, 1884, p. 13; Duret 1902, no. 76; Paul Jamot, "La Collection Camondo au Musée du Louvre," *Gazette des Beaux-Arts*, June 1914, p. 444; Duret 1926, pp. 79–80; Moreau-Nélaton cat. ms., no. 88; Moreau-Nélaton 1926, vol. 1, pp. 79–80; Paul Jamot, "Manet, Le Fifre et Victorine Meurend," *Revue de l'art ancien et moderne*, 1927, pp. 3–14; Tabarant 1931, no. 117; Jamot-Wildenstein 1932, no. 126; Tabarant 1947, p. 124, no. 117; Rouart-Orienti 1970, no. 104; Hanson 1977, pp. 183–192; London, National Gallery of Art, 1992, *The Execution of Maximilian*, pp. 71–73

Manet wanted to exhibit two large full-length figures at the Salon of 1866: the portrait of the actor Rouvière in the role of Hamlet, which he called *L'Acteur tragique* (fig. 384); and the image of a little soldier (the present picture). No doubt he thought, after the uproar caused by *Olympia* (cat. 95) the year before, that what was needed was a respectable submission, unlikely to arouse the bitter criticism that had so greatly distressed him. As in 1864 (see cat. 96), though for different reasons, this was a miscalculation. Manet's two paintings were turned down by a particularly severe jury, which nonetheless accepted *Camille* (fig. 236) by his young colleague Claude Monet; according to Tabarant, the small band of academics, although it included Fromentin, Corot, and Daubigny, took exception not to the works submitted but to the very name of the scandalous Manet.[1] Voices, rendered all the more indignant by news of the suicide of the obscure Jules Holtzapffel, who had been rejected by the jury, were once more raised to demand a Salon des Refusés. One voice was that of Charles Yriarte, who chanted, "Dubufe the assassin! Cabanel the assassin!"[2] Another was that of Zola, amused and mocking: "Let a jury be created, it does not matter which. The more they make mistakes, the more they spoil things, the more I shall laugh.... But then what is known as the Salon des Refusés must be set up again."[3] The voices went unheeded and Manet had to be satisfied with exhibiting for a period of two months in his rue Guyot studio *Le Fifre*, *L'Acteur tragique*, and "some recent, as yet unexhibited works" (see cat. 103).[4]

The model for *Le Fifre* was a boy trooper from the Imperial Guard, stationed at the barracks near La Pépinière (place Saint-Augustin), who had been "supplied" by the artist's friend and patron Commandant Lejosne.[5] Out of this blotchy-skinned adolescent, with eyes like marbles and a cabbage leaf of an ear, Manet made an imposing portrait: "The figure is in fact a latter-day icon," Françoise Cachin rightly observes, "erect, unassuming, impressive, meeting the viewer's eye like a stained-glass saint, a Poulbot urchin painted like a Spanish grandee, and carrying the artist's colors and principles like a banner."[6] As he had done previously (cat. 93), Manet—soon to be followed by Renoir (cat. 173), Cézanne (cat. 26), and Eva Gonzalès (cat. 78)—painted in the size of an official full-length portrait one of those subjects hitherto confined to the small format of a genre scene. In *Le Fifre*, before enlarging the *images d'Épinal* or having recourse to Japanese sources, Manet drew on the lessons of his Spanish trip the year before. This is known to have been prompted by the desire to see Velázquez, the painter of painters, in all his glory. "The most astonishing example in this splendid oeuvre," Manet wrote to Fantin-Latour after a visit to the Prado, "and perhaps the most astonishing piece of painting ever done, is the paining listed in the catalogue as *Portrait of a Famous Actor in the Time of Philip IV* [Pablillos de Valladolid]. The background vanishes, and atmosphere envelops

the good man, a vital presence dressed in black."[7] *L'Acteur tragique* and also *Le Fifre* were inspired by the desire to imitate the unsurpassable model. Against a neutral light gray background Manet uses a limited palette of black, white, and red. Black surrounds the whole figure—forage cap, velvety shadow on the cheeks, short tunic, braid on the trousers, leather of the boots—and outlines it like the leading of a stained-glass window, a treatment that occurs often in Degas's work of the same period. Only the artificial shadows that extend the two parted feet give a semblance of depth to this deliberately flat image.

The jury's rejection of Manet's two works prompted an enthusiastic article from Émile Zola, which marked the beginning of the close relations between the two men. In his column in *L'Événement* of May 7, 1866, under the pseudonym "Claude," Zola praised *Le Fifre*—"the work I prefer"—lauding its "rightness" and "simplicity," and concluding: "I do not think it would be possible to obtain a stronger effect with less complicated means. M. Manet's temperament is a lean temperament that strikes home. He captures his figures briskly, he does not shrink before the abruptnesses of nature, he renders different objects in all their vigor, distinct from one another. His whole being leads him to see in patches, in simple, energetic pieces. It can be said of him that he is content to seek the right hues and then to juxtapose them on the canvas. Thus in the end the canvas is covered with strong, solid painting. I find in this picture a man who is curious for the true and who draws from it a vital world with a powerful life of its own."[8] If this new "confession by Claude" is so easy and convincing, it is because Zola, in a few lines, was speaking of his own art and ambitions as much as Manet's. Some months later he would emphasize the benign influence of Japanese prints, which spread "their strange elegance and their magnificent patches of color," and would modify the comparisons already made with Épinal; those images too were "simplified," colored "in slabs," but they differed in that "the Épinal workers employ pure tones, with no regard for values," while Manet "multiplies tones and puts the right relations between them."[9] In 1866 *Le Fifre* sealed a friendship and signed a program in common, drawing from the fife some shrill, tenacious notes, playing—like the painter, like the writer—its stubborn little air, always the same.

H.L.

1. Tabarant 1947, p. 122.
2. "Dubufe assassin! Cabanel assassin!" Ibid., p. 123.
3. "Qu'on crée donc un jury, il n'importe lequel. Plus il commettra d'erreurs et plus il manquera sa sauce, plus je rirai.... Mais qu'on retablisse alors ce qu'on a appelé le Salon des Refusés." Zola 1991, pp. 98–99.
4. Tabarant 1947, p. 124.
5. Moreau-Nélaton 1926, vol. 1, p. 72.
6. Françoise Cachin, in Paris, New York 1983, p. 246.
7. "Le morceau le plus étonnant de cet oeuvre splendide et peut-être le plus étonnant morceau de peinture que l'on ait jamais fait est le tableau indiqué au catalogue, portrait d'un acteur célèbre au temps de Philippe IV: le

fond disparaît, c'est de l'air qui entoure ce bonhomme tout habillé de noir et vivant." Letter from Manet to Fantin-Latour, written from Madrid, September 3, 1865, quoted in Manet 1988, p. 44.

8. "l'oeuvre que je préfère"; "justesse"; "simplicité"; "Je ne crois pas qu'il soit possible d'obtenir un effet plus puissant avec des moyens moins compliqués. Le tempérament de M. Manet est un tempérament sec, emportant le morceau. Il arrête vivement ses figures, il ne recule pas devant les brusqueries de la nature, il rend dans leur vigueur les différents objets se détachant les uns sur les autres. Tout son être le porte à voir par taches, par morceaux simples et énergiques. On peut dire de lui qu'il se contente de chercher des tons justes et de les juxtaposer ensuite sur une toile. Il arrive que la toile se couvre aussi d'une peinture solide et forte. Je retrouve dans le tableau un homme qui a la curiosité du vrai et qui tire de lui un monde vivant d'une vie particulière et puissante." Zola 1991, p. 117.

9. "leur élégance étrange et leurs taches magnifiques"; "simplifiées"; "par plaques"; "les ouvriers d'Épinal emploient les tons purs, sans ce soucier des valeurs"; "multiplie les tons et met entre eux les rapports justes." Émile Zola, *Édouard Manet: Étude biographique et critique*, 1867, in ibid., p. 152.

103 *Fig. 243*

Édouard Manet
Jeune Dame en 1866 (La Femme au perroquet)
(*Young Woman in 1866 [Woman with a Parrot]*)
1866
Oil on canvas
72⅞ x 50⅝ in. (185.1 x 128.6 cm)
Signed lower left:
Manet
The Metropolitan Museum of Art, New York, Gift of Erwin Davis, 1889 89.12.3

CATALOGUE RAISONNÉ: Rouart-Wildenstein 1975, no. 115

PROVENANCE: The artist, until 1872; bought for Fr 1,500 by Durand-Ruel, Paris, 1872, until 1877; bought for Fr 2,000 or Fr 2,500 by Ernest Hoschedé, Paris, 1877, until 1878; his sale, Paris, Hôtel Drouot, June 6, 1878, no. 44; bought at this sale for Fr 700 by Henri Hecht, Paris; sold to Durand-Ruel, Paris, until 1881; bought by Erwin Davis, New York, 1881, until 1889; his sale, New York, Ortgies and Co., March 19–20, 1889, no. 99; bought in for $1,350 by Erwin Davis, who gave it to the Metropolitan Museum the same year

EXHIBITIONS: Artist's studio, spring 1866, private exhibition (Tabarant 1947, p. 124); Paris, pont de l'Alma, 1867, *Tableaux de M. Édouard Manet*, no. 15 (Jeune dame en 1866); Paris, Salon of 1868, no. 1659 (Une jeune femme); London, Durand-Ruel 1872, *Society of French Artists, 3rd exhibition*, no. 49 (Lady in Pink); New York, National Academy of Design, 1883, *Pedestal Fund Art Loan Exhibition*, no. 182 (Portrait of a lady, lent by Erwin Davis); Paris, École nationale des Beaux-Arts, 1884, *Exposition des oeuvres de Édouard Manet*, no. 39 (Une jeune femme(?). Salon of 1868. Property of M. Gérard); Paris, New York, 1974–75, no. 19; Paris, New York, 1983, no. 96

SELECTED REFERENCES: Hippolyte Babou, "Les Dissidents de l'exposition," *La Revue libérale* 2 (1867), p. 288; G. Randon, "L'Exposition d'Édouard Manet," *Le Journal amusant*, June 29, 1867; E. Spuller, "M. Édouard Manet et sa peinture," *Le Nain jaune*, June 9, 1867, p. 5; Émile Zola, "Une nouvelle manière en peinture: Edouard Manet," *La Revue du xixᵉ siècle*, January 1, 1867, p. 59; Louis Auvray, *Salon de 1868* (Paris, 1868), p. 73–74; Durand-Brager, "Le Salon de 1868," *Le Pays*, June 4, 1868; Henri Fouquier, "Salon de 1868," *L'Avenir national*, May 20, 1868; Théophile Gautier, "Salon de 1868," *Le Moniteur*, May 11, 1868, p. 2; André Gill, *Le Salon pour rire* (Paris, 1868), p. 11; S. Grangedor, "Le Salon de 1868," *Gazette des Beaux-Arts*, June 1, 1868, p. 520; Louis Leroy, "La session de Salon de 1868," *Le Charivari*, June 4, 1868, p. 3; Paul Mantz, "Le Salon de 1868," *L'Illustration*, June 6, 1868, p. 362; Marc de Montifaud, "Le Salon de 1868," *L'Artiste*, May 1868; B. de Renjarde, "Salon de 1868. VII. L'École du laid," *Le Petit Journal*, May 28, 1868; E. Roger de Tranois, "Salon de 1868," *Le Figaro-Programme*, June 12, 1868; G. de Varennes, "Salon de 1868," *La Gazette de France* May 18, 1868; Pierre Véron, *Le Monde illustré*, August 1, 1868, p. 67; Émile Zola, "Mon Salon," *L'Événement illustré*, May 10, 1868, p. 3; Thoré-Bürger 1870, p. 318; Marius Chaumelin, "Le Salon de 1868," *L'Art contemporain* (Paris, 1873), pp. 136–37; Edmond Bazire, *Manet* (Paris, 1884), p. 60; Duret 1902, no. 88; Moreau-Nélaton, cat. ms., no. 89; Moreau-Nélaton 1926, vol. 1, p. 88; Paul Jamot, "Manet as Portrait Painter," *Burlington Magazine*, December 1926, pp. 302–09; Paul Jamot, "Manet, Le Fifre et Victorine Meurend," *Revue de l'art ancien et moderne*, January 1927, pp. 39–40; Tabarant 1931, no. 111; Jamot Wildenstein 1932, no. 132; Tabarant 1947, pp. 119, 146–47, 150, no. 115; Sterling and Salinger 1967, pp. 40–43; Merete Bodelsen, "Early Impressionist Sales, 1874–1894," *Burlington Magazine*, June 1968, pp. 339–40; Margareta Salinger, "Windows Open to Nature," *Metropolitan Museum of Art Bulletin*, summer 1968, pp. 8–9; Michael Fried, "Manet's Sources," *Art Forum*, March 1969, p. 57; Rouart-Orienti 1970, no. 102; Hanson 1972, p. 158; Mona Hadler, "Manet's Woman with a Parrot of 1866," *Metropolitan Museum Journal*, 1973, pp. 115–22; Theodore Reff, "Courbet and Manet," *Arts Magazine* 54 (March 1980); Frances Weitzenhoffer, "First Manet Paintings to Enter an American Museum," *Gazette des Beaux-Arts*, March 1981, pp. 125–29; Anne Distel, "Albert Hecht collectionneur," *Bulletin de la Société de l'histoire de l'art français* (1981), pp. 271–73, n. 21

Two of Manet's major works, *Le Fifre* (cat. 102) and *L'Acteur tragique* (fig. 384), were rejected by the Salon of 1866. Following an old practice (see p. 19), he then organized a private exhibition in his studio that lasted two months; apart from the two rejected paintings, it featured "his female guitar player, his woman in a long pink peignoir, his bullfighting scenes, his Matador saluting."[1] Théophile Thoré saw it and in *L'Indépendance belge* of July 5 wrote a column in which he ran

down the works accepted by the Salon—"when those contraptions are sold at the hôtel Drouot for 60 francs, I shall not be the one to buy them!"—and declared his preference for "the wild sketches of M. Manet." In the artist's studio he made particular note of this "woman in a long pink peignoir," which had not yet been given a title: "Those pink tones against the gray background would challenge the subtlest colorists. It is true that it is a sketch, but so is Watteau's *Isle of Cythera* in the Louvre. Watteau would have perfected his sketch, but Manet is still struggling with this great pictorial problem: finishing certain parts of a painting in order to give greater strength to the whole. But one can see that Manet will eventually win the day, as have all the others who have been the victims of the Salon."[2] Taking Thoré's observations into account, Manet probably went back to the canvas in the second half of 1866 and, with an eye to the Salon of 1867, turned the "sketch" into a finished work, giving all the parts an equal weight. It was then, no doubt, that he added to the figure of Victorine Meurent—as he did with the accessories in the portrait of Théodore Duret (fig. 235)—the parrot on its perch, an essential element in the composition and one not mentioned by Thoré. At any rate Zola, in the article he devoted to Manet on January 1, 1867, referred to this figure among the "barely dry" canvases that he had seen in the studio. He used this *Femme en rose* (*Woman in Pink*) as evidence of Édouard Manet's "native elegance" as a "man of the world": "The peignoir is infinitely graceful, attractive to look at, very full and very opulent; the young woman's gesture has an indescribable charm. The whole thing would even be too pretty if the painter's temperament had not imposed on it the hallmark of his austerity."[3]

Manet, as we know, refused to participate in the Salon of 1867, and *Jeune Dame en 1866* figured in the exhibition at the Pont de l'Alma, where it attracted no particular attention. That was one of the reasons that caused Manet to send it to the Salon of 1868, where it formed a nice counterpoint to the severe portrait of Émile Zola (cat. 108); Tabarant tells us that Manet made the choice "on the advice of Zola himself,"[4] proving that the "terrible realist" was capable of graceful touches. The two works were accepted easily, but they were poorly received by the critics.

The usual reproaches were leveled against *Jeune Dame en 1866*, now called *Une Jeune Femme*: lack of flesh and consistency in the person, dirt on the peignoir, "a sleazy, gaudy tonality" overall, the absurd desire to give accessories the same importance as the figure.[5] Théophile Gautier, who had kind words for the portrait of his colleague Zola, criticized this picture in which Manet had so clearly failed in "his duty as a realist," making "ugly" a "model whose head is fine, pretty, and intelligent, and adorned with the richest Venetian tresses that a colorist could wish for." "Over features that are ordinary and badly drawn," he continued, "there spreads a sickly color that does

not represent the complexion of a woman young and blond. The light that should glitter in gold sparks on her hair is sadly dimmed. In a false, sleazy pink, the robe reveals nothing of the body underneath it. The folds are poorly suggested and carelessly scooped out with a brushstroke; the rods of the perch lack perspective, and the parrot can hardly keep its balance."[6] It was also "in the name of realism perverted" that Marie-Émilie Chartroule, who signed herself "Marc de Montifaud," contributed some words of disappointment: certainly the painter had talent but he lacked "the hand," that is to say, "the exact nuance in intense coloring that he dreams of and renders only ponderously." Manet, she declared, was the opposite of Bouguereau, but both were to be condemned; the second lost himself in exquisite subtleties, while the first, exaggerating the lessons of realism, exceeded and aggravated it, rejecting the "broken tone," content to juxtapose on the canvas areas of color of equal importance.[7]

Despite the carping, critics understood very well that Manet in 1866 had forever freed himself from Courbet as a model. The presence of the parrot forced a comparison between the two painters; for Marius Chaumelin, the bird seemed to have been lent by Manet to "his friend Courbet." In adding, as I believe, the perch and the bird at a second stage in the development of the painting, Manet was in fact responding to Courbet's *Femme au perroquet* (cat. 45), exhibited at the Salon of 1866, which was itself a response to *Olympia* (see p. 210). Courbet's lascivious nude has become a young woman amiable enough but fully clad, and the parrot that with the master of Ornans evoked mythological couplings is now a nice domestic companion. But the "sketched" figure that Thoré saw in June 1866 was also Manet's rapidly executed reaction to the success that his near homonym Monet was then having at the Salon with *Camille* (fig. 236). Like *Camille*, *Jeune Dame en 1866* is a lifesize figure that stands out against a neutral background, a personification of the modern woman that many of the Salon critics hoped for in vain (see cat. 21). The very title that Manet wanted for his woman in a pink dress made her the exact contemporary of her rival in a green one; once again, there was no question of allowing the young Monet to seem the pioneer. And if, as Zola and Astruc noted, Renoir's *Lise* appeared to be a younger sister of *Camille* at the Salon of 1868, the subject was also among those entitled simply *Une Jeune Femme.*[8] Chaumelin stated it with pleasure and some anxiety: "M. Manet is already apparently a master, since he has imitators; among them is M. Renoir, who has painted under the title of *Lise* a lifesize woman strolling in a park."[9] Degas himself was not insensible to *La Femme au perroquet* of his friend Manet; in a sketchbook of the period he drew in his turn the portrait of a woman in a peignoir, holding the inquisitive bird by one hand.[10] In 1868 there were many who discerned —and deplored—in these large figures the emergence of a school, instigated by Courbet and especially by Manet. *Lise*, declared Ferdinand de

Lasteyrie, "is evidently inspired, no longer by the great examples of M. Courbet, but by the strange models of M. Manet. And that is how, from imitation to imitation, the realist school threatens to go definitively... over the edge. So be it!"[11]

H.L.

1. "sa joueuse de guitare, sa femme en long peignoir rose, ses scènes tauromachiques, son Matador saluant." Tabarant 1947, p. 124.
2. "Quand on vendra ces machines-là 60 francs à l'hôtel Drouot, ce n'est pas moi qui les achèterai!"; "les folles ébauches de M. Manet"; "femme en long peignoir rose"; "Les tons roses sur fond gris déferaient les plus fins coloristes. Ébauche, c'est vrai, comme est au Louvre l'*Île de Cythère* par Watteau. Watteau aurait pu pousser son ébauche à la perfection. Manet se débat encore contre cette difficulté extrême de la peinture, qui est de finir certaines parties d'un tableau pour donner à l'ensemble sa valeur effective. Mais on peut prédire qu'il aura tous les succès, comme tous les persécutés du Salon." Théophile Thoré [William Bürger], quoted in Tabarant 1947, p. 124.
3. "à peine sèches"; "élégance native"; "homme du monde"; "le peignoir est d'une grâce infinie, doux à l'oeil, très ample et très riche; le mouvement de la jeune femme a un charme indicible. Cela serait même trop joli, si le tempérament du peintre ne venait mettre sur cet ensemble l'empreinte de son austérité." Émile Zola, "Une Nouvelle Manière en peinture, Édouard Manet," *La Revue du XIXe siècle*, January 1, 1867, p. 59, and Zola 1991, p. 162.
4. "sur le conseil même de Zola." Tabarant 1947, p. 146.
5. "tonalité louche et criarde." See especially Louis Auvray, *Salon de 1868* (Paris, 1868), pp. 73–74.
6. "en laid"; "modèle dont la tête est fine, jolie et spirituelle et ornée de la plus riche chevelure vénitienne qu'un coloriste puisse souhaiter"; "Sur les traits communs et mal dessinés s'étend une couleur terreuse qui ne représente pas la carnation d'une femme jeune et blonde. La lumière qui devrait pétiller en étincelles d'or dans les cheveux s'éteint tristement. D'un rose faux et louche, la robe ne laisse pas deviner le corps qu'elle recouvre. Les plis s'y déduisent mal et sont négligemment creusés d'un coup de brosse; les bâtons du perchoir manquent de perspective, et le perroquet s'y soutient à peine." Théophile Gautier, "Salon de 1868," *Le Moniteur*, May 11, 1868, p. 2.
7. "nom du réalisme faussé"; "la main"; "la nuance précise dans la coloration intense qu'il rêve et qu'il ne rend que massivement"; "ton rompu." Marius Chaumelin, "Salon de 1868," *L'Art contemporain* (Paris, 1873), pp. 136–37.
8. Zola 1991, p. 211; Zacharie Astruc, "Salon de 1868," *L'Étendard*, June 27, 1868, p. 2.
9. "M. Manet est déjà un maître apparemment, puisqu'il a des imitateurs; de ce nombre est M. Renoir, qui a peint, sous le titre de *Lise* une femme de grandeur naturelle se promenant dans un parc." Marius Chaumelin, "Salon de 1868," p. 137.
10. Reff 1985, sketchbook 22, p. 27. See Jean Sutherland Boggs, *Portraits by Degas* (Berkeley and Los Angeles, 1962), p. 33.
11. "*Lise* s'est évidemment inspiré, non plus même des grands exemples de Monsieur Courbet, mais des curieux modèles de M. Manet. Et voilà comme, d'imitation en imitation, l'école réaliste menace de s'en aller définitivement... en cascade. Ainsi soit-il." Ferdinand de Lasteyrie, "Salon de 1868," *L'Opinion nationale*, June 20, 1868.

104 *Fig. 188*

Édouard Manet
Fruits (Nature morte avec melon et pêches)
(Still Life with Melon and Peaches)
1866(?)
Oil on canvas
27⅛ x 34¼ in. (69 x 92.2 cm)
National Gallery of Art, Washington, Gift of Eugene and Agnes E. Meyer 1960.1.1

CATALOGUE RAISONNÉ: Rouart-Wildenstein, 1975, no. 121

PROVENANCE: Léopole Baugnée, Brussels; his estate sale, Brussels, March 22, 1875, no. 44; Pérouse, Paris, by 1910 when placed on deposit with Durand-Ruel, Paris; Eugene Meyer, Washington and Mount Kisco, New York, by 1913; gift of Agnes and Eugene Meyer to the National Gallery, Washington, 1960

EXHIBITIONS: Paris, pont de l'Alma 1867, *Tableaux de M. Édouard Manet*, no. 37 (Fruits); New York, Galerie Durand-Ruel, 1913, *Loan Exhibition of Paintings by Édouard Manet*, no. 17; Moreau-Nélaton, cat. ms., no. 94; Tabarant 1931, no. 124; Jamot-Wildenstein, 1932, no. 131; Tabarant 1947, no. 127; Philadelphia Museum of Art, and Chicago, Art Institute, *Manet*, 1966–67, no. 99; Rouart-Orienti 1970, no. 110; Philadelphia, Detroit, Paris, 1978–79, no. 249; Paris, New York, 1983, no. 82; Copenhagen, Ordrupgaard, 1989, *Manet*, no. 16, repr.

SELECTED REFERENCES: G. Randon, "L'Exposition d'Édouard Manet," *Le Journal amusant*, June 29, 1867, p. 8; Hourticq 1911, pp. 59–60; Moreau-Nélaton 1926, vol. 1, p. 89; Tabarant 1947, pp. 130–31; Rouart-Orienti 1970, no. 110; Hanson 1979, p. 70

Manet's most confirmed enemies acknowledged that he painted still life well (see p. 152), even if they deplored the excessive presence of inanimate objects in his portraits or scenes of modern life. In 1870, before the portrait of Eva Gonzalès struggling with her peonies, Albert Wolff was still incensed: "As long as M. Manet paints lemons or oranges, as long as he does still lifes, he can still be granted extenuating circumstances; but when he dares to make such a monster out of a human being... I must be allowed to shrug my shoulders in passing."[1] Yet with the still lifes that he produced regularly during the 1860s, Manet never had the success that the partial indulgence of the critics let him hope for.

This still life, painted no doubt at the end of the summer in 1866, was shown at Manet's independent exhibition at the Pont de l'Alma in 1867, probably listed as no. 37 under the title *Fruits* (the dimensions were not given). Charles S. Moffett has plausibly suggested that it might have been the pendant to no. 36, *Un Déjeuner (nature morte) (A Luncheon [Still Life])*, which he identifies as *Le Saumon (The Salmon)*, now in the

Shelburne Museum, Vermont, with almost identical measurements.[2] In 1867 the picture was remarked on only by the caricaturist Randon, who in his take off reduced it to the melon, the bottle, and the bunch of grapes; his caption, "I don't know much about melons, but that one doesn't look like prime quality to me," transferred to the unfortunate fruit those complaints about rottenness and damaged goods that had only recently been directed at *Olympia*.[3]

The quietude of Dutch still lifes has rightly been evoked in connection with this painting. Above all, however, with its tranquil, unspectacular arrangement and its thick, starched, crisply folded linen tablecloth, this still life was to influence those executed by Monet the following year (Wildenstein 102–4; fig. 187) and the Cézanne, more geometric and abrupt, of *La Pendule noire* (cat. 31).

H.L.

1. "Tant que M. Manet peint des citrons ou des oranges, tant qu'il brosse les natures mortes, on peut encore lui accorder les circonstances atténuantes; mais quand il ose faire un tel monstre d'une créature humaine... il me permettra de hausser les épaules en passant." Albert Wolff, "Le Salon de 1870," *Le Figaro*, May 13, 1870, p. 2.
2. Charles S. Moffett in Paris, New York 1983, pp. 216–17.
3. "Je ne me connais guère en melons, mais il me semble que celui-ci n'est pas de première qualité." G. Randon, "L'Exposition d'Édouard Manet," *Le Journal amusant*, June 29, 1867, p. 9.

105 *Fig. 336*

Édouard Manet
L'Enterrement
(*The Burial*)
Ca. 1867
Oil on canvas
28⅝ x 35⅝ in. (72.7 x 90.5 cm)
Inscribed lower right: Certifié d'Ed. Manet Vve. Manet
The Metropolitan Museum of Art, New York, Catharine Lorillard Wolfe Collection, Wolfe Fund, 1909 10.36

CATALOGUE RAISONNÉ: Rouart-Wildenstein 1975, no. 162

PROVENANCE: The artist, until his death in 1883; to his widow, Suzanne Manet, Paris, 1883, until 1894; sold for Fr 300 to Alphone Portier, Paris, August 1894; acquired by Camille Pissarro, Eragny and Paris, before 1902; Ambroise Vollard, Paris, until 1909; bought for $2,319 by the Metropolitan Museum, 1909

EXHIBITIONS: Washington, National Gallery, 1982–83, *Manet and Modern Paris*, no. 4; Paris, New York, 1983, no. 98

SELECTED REFERENCES: Duret 1902, no. 126; Moreau-Nélaton, cat. ms., no. 139; Tabarant 1931, no. 153; Jamot-Wildenstein 1932, no. 184; Tabarant 1947, no. 158; Sterling and Salinger, 1967; Rouart-Orienti 1970, no. 135; Mauner 1975, p. 120; Reff 1982, pp. 40–41

Dated by Tabarant to "January or February 1870,"[1] this painting, which for some years at the turn of the century belonged to Camille Pissarro, has recently been moved back to about 1867 for stylistic as much as iconographic reasons. Emphasis has rightly been placed on its close relationship with *Courses à Longchamp* (cat. 106) and *L'Exposition universelle de 1867* (cat. 107), both pictures vigorously sketched and striking in their black-and-green harmonies and in the new simplification of the figures, rendered in a few strokes. The identification of the scene with the burial of Baudelaire, September 2, 1867, corroborated what the style had suggested. This hypothesis, proposed by Mauner and taken up by Reff and Moffett,[2] is clearly an attractive one—Manet erecting a tomb, even if unfinished, to his friend and first defender. The account of the funeral that Asselineau sent to Poulet-Malassis a few days after the event shows striking resemblances with Manet's picture: "There were about a hundred people in the church and fewer at the cemetery. The heat prevented many from following to the end. A clap of thunder, which burst as we entered the cemetery, all but drove away the rest.... The orations were read before sixty people. The reading suffered from this disappointment. Théodore was very upset, I was even more so and angry too. We rushed like people in a hurry to finish. Among those present I noticed: Houssaye and his son, Nadar, Champfleury, Monselet, Wallon, Vitu, Manet, Alfred Stevens, Bracquemond, Fantin, Pothey, Verlaine, Calmann Lévy, Alph. Lemerre the publisher, Ducessois the printer, Silvestre, Veuillot, etc."[3] Apart from certifying Manet's presence, this description indicates stormy

weather, which corresponds to the painting, and a sparse attendance. Nonetheless, the "sixty people" mentioned by Asselineau are reduced in the picture to a small group that numbers no more than a dozen. The principal objection, however, is topographic. After a service at Saint-Honoré d'Eylau, the burial took place at the Montparnasse cemetery. Now although it was no doubt possible then to see the panorama of Paris that Manet sets forth—the dome of the Observatory, the cupola of the Val de Grâce and that of the Panthéon, the spire of Saint-Étienne-du-Mont, and the tower of Clovis—the viewpoint adopted by the artist shows that he was placed farther to the east. The posthumous inventory listed this canvas under the title "Burial at La Glacière," and La Glacière is certainly where we are.[4] A *Vue de Paris prise de Gentilly* (fig. 408) shows, from the same angle though farther away, the monuments captured by Manet, who was positioned lower down and quite near the rue de la Glacière, formerly the chemin de Gentilly. Perhaps he sketched a "tomb of Baudelaire" that had little to do with the real funeral, giving nature all the colors of mourning and accentuating the sparse attendance, overlooking this patch of green in which it is difficult to make out a cemetery already encumbered with vaults, edifices symbolic of "his" Paris. Perhaps, too, we have been following for more than a century a sad, anonymous funeral procession.

Manet's *Enterrement* is the opposite of the Parisian views by Monet (cats. 133, 134). Here we are looking from the other side of the hill at the monuments that Monet depicted from a window in the Louvre; we are among the dead, in the suburban Champs Elysées, while he painted the hectic, vernal, joyful life at the heart of Paris. Here we are reunited with the tragic panoramas of El Greco as Manet made his way along the path of Impressionism.

H.L.

Fig. 408. Jean-Jacques Champin, *Vue de Paris prise de Gentilly* (*View of Paris from Gentilly*). Oil on canvas, 8¼ x 13 in. (21 x 33 cm). Musée de l'Ile-de-France, Sceaux

1. Tabarant 1947, p. 171.
2. Mauner 1975, p. 120; Reff 1982, pp. 40–41; and Moffett, in Paris, New York 1983, pp. 260–61.
3. "Il y avait environ cent personnes à l'église et moins au cimetière. La chaleur a empêché beaucoup de gens de suivre jusqu'au bout. Un coup de tonnerre, qui a éclaté comme on entrait au cimetière, a failli faire sauver le reste.... Les discours ont été lus devant soixante personnes. La lecture s'est ressentie de ce désappointement. Théodore était très ému, moi encore plus et en colère. Nous nous sommes précipités en gens pressés de finir. J'ai remarqué comme présents: Houssaye et son fils, Nadar, Champfleury, Monselet, Wallon, Vitu, Manet, Alfred Stevens, Bracquemond, Fantin, Pothey, Verlaine, Calmann Lévy, Alph. Lemerre. éditeur, Ducessois, imprimeur, Silvestre, Veuillot, etc." Quoted in Pichois and Ziegler 1987, pp. 595–96.
4. "Enterrement à la Glacière." Rouart and Wildenstein 1975, vol. 1, p. 27.

106 *Fig. 353*

Édouard Manet
*Courses à Longchamp
(Races at Longchamp)*
1867(?)
Oil on canvas
17¼ x 33¼ in. (43.9 x 84.5 cm)

Signed and dated lower right: Manet 1864
The Art Institute of Chicago, Potter Palmer Collection
1922.424

CATALOGUE RAISONNÉ: Rouart-Wildenstein 1975, no. 98

PROVENANCE: Probably bought from the artist for Fr 1,000 by the English composer Frederick Delius in 1877 as noted in Manet's 1877 account book (Courses), until at least 1884, when he lent it to the Manet retrospective in Paris; however, the 1880 account book mentions a painting "Courses" sold for Fr 1,000 to Charles Éphrussi; Durand-Ruel, New York, by 1895 until 1896; sold to Potter Palmer, Chicago, 1896; bequest of Mrs. Potter Palmer to the Art Institute, 1918

EXHIBITIONS: Artist's studio, 1876(?); Paris, École nationale des Beaux-Arts 1884, *Exposition des oeuvres de Édouard Manet*, no. 61 (Courses à Longchamp. Property of M. Delius); New York, Galerie Durand-Ruel 1895, no. 27; New York, Wildenstein and Co., 1937, *Édouard Manet*, no. 18; Philadelphia Museum of Art, and Chicago, Art Institute, 1966–67, *Manet*, no. 68; Washington, National Gallery, 1982–83, *Manet and Modern Paris*, no. 43; Paris, New York, 1983, no. 99

SELECTED REFERENCES: Sâr Joséphin Péladan, "Le Procédé de Manet," *L'Artiste*, February 1884, p. 114; Duret 1902, no. 142; Moreau-Nélaton, cat. ms., no. 145; Moreau-Nélaton 1926, vol. 1, pp. 138–39; Tabarant 1931, no. 96; Jamot-Wildenstein 1932, no. 202; Tabarant 1947, p. 101, no. 101; J. C. Harris, "Manet's Racetrack Paintings," *Art Bulletin* 48 (1966), pp. 78–82; Rouart-Orienti 1970, no. 86A; Herbert 1988, pp. 154–59

The genesis and composition of this picture, and its relationship with Degas's works on the same theme, are discussed elsewhere (see pp. 283–84). Its dating to 1867, sanctioned by custom and maintained here, was prompted by the comparison with *L'Enterrement* (cat. 105) and, more convincingly, with *L'Exposition universelle de 1867* (cat. 107).[1] Theodore Reff has offered the most plausible account, according to which the present painting

is a vigorous sketch for the larger picture (25 x 51 in. [64 x 130 cm]) exhibited by Manet at the Pont de l'Alma in 1867 under the title *Les Courses au bois de Boulogne (The Races in the Bois de Boulogne)*, the final version of an 1864 composition (see p. 282 and fig. 348). It is very possible that Manet's work, which has often been praised for its novel organization, inspired the anonymous draftsman of *L'Événement*: in June 1868, when the latter caricatured the society event that was the Grand Prix de Paris, he used a composition similar to Manet's to show the public invading the track and pursuing the already distant group of racehorses (fig. 409).

H.L.

1. Reff 1982, p. 134, and Charles S. Moffett, in Paris, New York 1983, pp. 263–64.

107 *Fig. 360*

Édouard Manet
L'Exposition universelle de 1867
1867
Oil on canvas
42½ x 77⅜ in. (108 x 196.5 cm)
Signed, by Mme Manet, lower right: E. Manet
Nasjonalgalleriet, Oslo NG.M.1293

CATALOGUE RAISONNÉ: Rouart-Wildenstein 1975, no. 123

PROVENANCE: The artist, until his death in 1883; Manet estate sale, Paris, Hôtel Drouot, Paris, February 4–5, 1884, no. 67; bought at this sale for Fr 655 by Mme Besnard, Paris; Auguste Pellerin, Paris, by 1902; Galerie Bernheim-Jeune, Paris, 1907; Mme Angelot, Paris, by 1912, until at least 1919; Tryggve Sagen, Oslo; Klaveness Bank, Oslo, until 1923; gift of the Friends of the Nasjonalgalleriet, 1923

EXHIBITIONS: Paris, École nationale des Beaux-Arts, 1884, *Exposition des oeuvres de Édouard Manet*, no. 41 (Vue de l'Exposition Universelle, esquisse); Paris, Musée de l'Orangerie, 1932, *Manet*, no. 25; Philadelphia, Detroit, Paris, 1978–79, no. 250; Washington, National Gallery of Art, 1982, *Manet and Modern Paris*, no. 2; Copenhagen, Ordupgaard, 1989, *Manet*, no. 17, repr.

SELECTED REFERENCES: Duret 1902, no. 92; Moreau-Nélaton, cat. ms., no. 139; Moreau-Nélaton 1926, vol. 1, p. 92; Paul Jamot, "Études sur Manet," *Gazette des Beaux-Arts*, January 1927, pp. 3–4; Tabarant 1931, no. 153; Jamot-Wildenstein 1932, no. 137; Tabarant 1947, p. 140, no. 131; Rouart-Orienti 1970, no. 114; Werner Hofmann, "Poesie und Prosa. Rangfragen in der neueren kunst," *Jahrbuch der Hamburger Kunstsammlungen*, 18 (1973), pp. 173–74; Sigurd Willoch, "Édouard Manets "Fra Verdensutstillingen i Paris"," *Konsthistorisk tidskrift* (Stockholm, 1976), pp. 101–08; Hanson 1977,

Fig. 409. *Grand Prix de Paris (Bois de Boulogne)*, June 7. Caricature published in *L'Événement*, June 9, 1868, p. 1

pp. 68, 201–02; Patricia Mainardi, "Édouard Manet's View of the Univers Exposition of 1867," *Arts Magazine*, January 1980, pp. 108–15; Clark 1985, pp. 60–66; Mainardi 1987, pp. 141–50; Herbert 1988, pp. 4–5

According to Tabarant,[1] Manet painted this sweeping panorama of the Exposition Universelle in June 1867, working "in the morning before 10 o'clock," as a note by Léon Koëlla specifies.[2] There is no reason to doubt the biographer's statement; the Exposition Universelle opened on April 1, but until May 22 or 24 Manet was very taken up with the preparations for his own exhibition at the Pont de l'Alma. Not until June could he have found a period of calm in which to paint. The canvas, which is unfinished, was no doubt interrupted when news of the execution of Maximilian, emperor of Mexico, reached Paris on July 5, immediately impelling Manet to undertake a vast composition on this subject (fig. 63).

Manet adopted the vantage point recommended by all the guidebooks from which to contemplate the entire installation, placing himself on the heights of the Trocadéro in the early morning, at the time when dogs come out, the gardener waters the flower beds, and the spectators are still thinly scattered and are not getting in the painter's way. The slightly skewed perspective, which is that of most of the contemporary illustrations to which it is indebted, enabled him to have in the background a few Paris monuments that help to situate this ephemeral and universal town. Built on the Champ-de-Mars, which was then a neglected area, the Exposition of 1867, unlike that of 1855, which had been confined to a few exhibition halls, was for the first time a real city. It was laid out in "quarters," whose boundaries were fixed by the huge circular palace of Le Play and Krantz, and along winding streets was a whole assortment of different buildings, pavilions erected by foreign countries and commercial enterprises, and various reconstructions. On the terrace overlooking the site Manet depicts a few sightseers, who have come—as if to the theater—to see this "entertainment with colossal boxes, installed by the city of Paris for the world's amusement."[3] There are some who eye it attentively, others gazing absentmindedly, and others strolling about; in the foreground is the gardener, to remind us that, despite this universal display, the important thing is, in the words of Voltaire's *Candide*, "to cultivate one's own garden." This gathering of people, the primary object of which was to supply the painter with a foreground, has been seen as a sampling of French society—bourgeois and working class, civilian and military, respectable womanhood and cocotte, Parisian and provincial.[4] Such an interpretation, however, entails a very specific reading of figures that are far off and sketchily rendered: the two working women, for instance, who have been the subject of emotional digressions on the laboring classes, could be a couple of Chinese; the cocotte, a little girl in an orange dress escorted by her mother. What is certain is that the artist was depicting a more mixed society than that in *La Musique aux Tuileries*

(cat. 88), less Parisian, one that had come to gawk peacefully at the temporary city.

Manet made a New World Symphony out of this panorama of an exhibition that marked the apogee of the Second Empire and that he—hostile to Napoléon III and excluded, like all his painter friends, from official representation in the Beaux-Arts section—had no reason to celebrate. His touch has become quick and flickering, his contours less precise beneath the vast sky that alone seems to be made of a unified material; throughout the canvas there is a nerviness, a new electricity. The painter's world, once limited to some friends gathered to listen to music under the quincunxes of the Tuileries, has expanded to the whole universe.

H.L.

1. Tabarant 1947, p. 140.
2. "le matin avant 10 heures." Bibliothèque Nationale, Paris; see the exhibition catalogue *Manet* (Copenhagen: Ordrupgaard, 1989), p. 94.
3. "fête des loges de dimensions colossales, installée par la Ville de Paris pour l'amusement de l'univers." Victor Fournel, "Voyage à travers l'exposition," *Le Correspondant*, quoted in *Le Livre des expositions universelles, 1851–1889* (Paris, 1983), p. 44.
4. Mainardi 1987, p. 147.

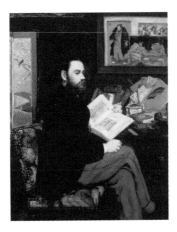

108 *Fig. 270*

Édouard Manet
Portrait d'Émile Zola
1868
Oil on canvas
57⅝ x 44⅞ in. (146.5 x 114 cm)
Musée d'Orsay, Paris RF2205

CATALOGUE RAISONNÉ: Rouart-Wildenstein 1975, no. 128

PROVENANCE: Gift of the artist to Émile Zola, Paris, in 1868, until his death in 1902; by inheritance to his widow, Mme Émile Zola; her gift to the Musée du Louvre, reserving life interest, 1918; the Musée du Louvre, 1925; Musée du Jeu de Paume, Paris, 1947; Musée d'Orsay, Paris, 1986

EXHIBITIONS: Paris, Salon of 1868, no. 1660 (Portrait de M. Émile Zola); Paris, École nationale des Beaux-Arts, 1883, *Portraits du siècle*, no. 304 (M. Zola); Paris, École nationale des Beaux-Arts, 1884, *Exposition des œuvres de Édouard Manet*, no. 42 (Portrait de M. Émile Zola.

Salon of 1868. Property of M. Émile Zola); Paris, Salon d'Automne, 1905, no. 7; Paris, Musée de l'Orangerie, 1932, *Manet*, no. 30; Paris, Grand Palais, 1974, *Impressionnisme*, no. 20; Philadelphia, Detroit, Paris, 1978–79, no. 251; Paris, New York, 1983, no. 106; Paris, Tokyo, 1988, no. 180

SELECTED REFERENCES: Zacharie Astruc "Salon de 1868 aux Champs-Élysées," *L'Étendard*, May 19, 1868, p. 1, and July 29, 1868, p. 2; Louis Auvray, *Le Salon de 1868* (Paris, 1868), pp. 73–75; Théophile Gautier, "Salon de 1868. IV," *Le Moniteur*, May 11, 1868, p. 2; Louis Leroy, "La Session du Salon de 1868," *Le Charivari*, May 9, 14, 20, 23, and 29, 1868, pp. 2–3, and June 4, 6, 16 18, 23, 24, and 26, 1868, pp. 2–3; Paul Mantz, "Salon de 1868," *L'Illustration*, June 6, 1868, p. 362; Marc de Montifaud, "Salon de 1868," *L'Artiste*, June 1, 1868, p. 212; Émile Zola, "Mon Salon," *L'Événement illustré*, May 10, 1868, p. 3; Théodore Duret, "Le Salon IV: Édouard Manet," *L'Électeur libre*, June 9, 1870, p. 92; Thoré-Bürger 1870, vol. 2, p. 531; Marius Chaumelin, "Salon de 1868," in *L'Art contemporain* (Paris, 1873), p. 137; Castagnary 1892, pp. 313–14, 316; Duret 1902, no. 93; Paul Jamot, "Manet as Portrait Painter," *Burlington Magazine*, December 1926, pp. 302–9; Moreau-Nélaton 1926, vol. 1, p. 99; Tabarant 1931, no. 132; Jamot-Wildenstein 1932, no. 146; Tabarant 1947, no. 137; Jean Adhémar, "Le Cabinet de travail de Zola," *Gazette des Beaux-Arts*, November 1960, pp. 279–98; Rouart-Orienti 1970, no. 118; Theodore Reff, "Manet's Portrait of Zola," *Burlington Magazine*, July 1975, pp. 34–44

Until it entered the Louvre in 1925, the portrait of Émile Zola was always badly hung: badly hung in the Salon of 1868, "very high, between two doors"; and badly hung by Zola, to whom Manet had given it, "relegated to the vestibule" in the house at Médan.[1] In spite of this, it had a precocious fame, due as much to the sitter as to the artist and to the fact—instantly perceived—that the two of them were putting their hands there to a program in common, to be posted on the walls of the official exhibition. The circumstances of its execution are well known. In 1866 Zola reviewed his first Salon; in his column in *L'Événement* of May 7 he was the first to utter a eulogy of Manet "without reservations." Although Manet was absent from the Salon that year—*Le Fifre* (cat. 102) and *L'Acteur tragique* (fig. 384) were not accepted—Zola had admired his works since the Refusés of 1863 and had recently met him in his studio, thanks no doubt to Guillemet. Zola's dithyramb—"Manet will be one of tomorrow's masters," "M. Manet's place is marked out for him in the Louvre like that of Courbet"—aroused such a wave of protests that the new critic had to abandon his column, which was then entrusted to the harmless Théodore Pelloquet.[2] The same day on which this article appeared Manet wrote to Zola to thank him and suggest a meeting: "If it suits you, I am at the Café de Bade every day from 5:30 to 7."[3] From this beginning as a business connection, their friendship became close, especially during the 1870s. Zola returned swiftly to the attack and on January 1, 1867, published a "biographical and critical study" of the artist in *La Revue du XIXe siècle*; he issued this as a pamphlet on the occasion of Manet's independent exhibition at the Pont de l'Alma some months later. In February 1868, as a thank-you but above all

with a view to the Salon, Manet embarked on Zola's portrait; the author went to pose every afternoon in the studio on the rue Guyot.[4] "I recall," he wrote later, "the long hours of sitting.... The nonsense abroad in the streets, the lies of some and the platitudes of others, all that human noise that flows to no avail like dirty water was far, far away.... Sometimes, in the half sleep induced by the sitting, I would look at the artist, standing in front of his canvas, his face set, his eye clear, totally immersed in his work. He had forgotten me, he no longer knew I was there, he was copying me as he would have done any human animal, with an attentiveness, an artistic conscience that I have never seen anywhere else.... Around me, on the walls of the studio, were hung those powerful and characteristic paintings that the public has been unwilling to understand.... Often, when he was dealing with a secondary detail, I would abandon the pose and give him bad advice, telling him to invent it. 'No,' he would answer me, 'I can do nothing without nature. I don't know how to invent. As long as I wanted to paint according to the lessons I had learned, I produced nothing that counted. If I am worth anything today, it is to precise interpretation and accurate analysis that I owe it.'"[5]

Manet portrays Zola not in the real setting of his study but surrounded by objects brought together for the occasion, with a significant purpose. On the table, among a mass of books and pamphlets, is the brochure recently devoted by Zola to the painter; its title in capital letters is also the signature on the painting. Above is a jumble consisting of a black-and-white image of *Olympia*, who, protective and grateful, turns her eyes toward her defender; a print representing a wrestler by Kuniaki II, a Japanese contemporary of Manet's; and half hidden, an engraving, no doubt by Nanteuil, after Velázquez's *Borrachos*. To the left is the end leaf of a Japanese screen. Soberly seated, Zola is holding in full view a large book that could well be a volume of Charles Blanc's *Histoire des peintres* (History of painters), a work that Manet often consulted.[6] It has always been thought that these different allusions expressed the painter's tastes rather than those of the writer and that Manet was in some sense portraying himself in terms of his defender. I see in them, rather, the painter's desire to illustrate the reading of his work that Zola had just given and by this homage to seal the new alliance (see pp. 216–17).

The Salon critics frequently noted that this homage was also a manifesto. The most hostile, inflamed by the name of Manet and the image of the author of *Madeleine Férat*, peevishly repeated criticisms that were already passé, reproving the methods of the painter and those of the novelist in the same breath. The most observant remarked that the surrounding objects were represented as accurately and as effectively as the features of the sitter; thus Thoré talked of "pantheism" (see p. 216) and the young Odilon Redon considered the portrait to be a still life (see pp. 152–54). There were many who, either in praise or mockery, dwelt

on the large, flat tints that were spread over the canvas, now somber, now sonorous. Thoré regretted this juxtaposition of colored areas, all equal in value, and in his columns in *Le Charivari* Louis Leroy waxed ironic over a Zola who endlessly repeated the word "patches" and who, when he went beyond the two syllables, spread himself in devastating aphorisms: "Patch, always patch, never draw."[7] Théophile Gautier, however, understood better than anyone else that *Portrait d'Émile Zola* marked the coming of a new era: Courbet had been dispossessed and from then on, Manet was "the leader, the hero of realism." For the first time Gautier, disabused and in spite of his "repugnance," admitted that victory had been won. Without bitterness, then, and because it was in the order of things, he resigned himself to being relegated to the old fogeys, recognizing that the portrait of Zola "belongs to the sphere of art from which the artist's other productions emerge so violently" and finding some tight-lipped words to praise this image of his young and formidable colleague, watched over by the "triple agency of realism": Japan, Velázquez, and *Olympia*.[8]

H.L.

1. "très haut entre deux portes." Tabarant 1947, p. 147. "relégué dans l'antichambre." Goncourt 1956, vol. 17, p. 124.
2. "Manet sera un des maîtres de demain"; "La place de M. Manet est marqué au Louvre comme celle de Courbet." Zola 1991, pp. 112–19.
3. "Si cela vous allait, je suis tous les jours au Café de Bade de 5½ à 7h." Paris, New York 1983, p. 519.
4. Ibid., p. 282.
5. "Je me rappelle les longues heures de pose.... Les sottises qui courent les rues, les mensonges des uns et les platitudes des autres, tout ce bruit humain qui coule inutile comme une eau sale, était loin, bien loin.... Par moments, au milieu du demi-sommeil de la pose, je regardais l'artiste, debout devant sa toile, le visage tendu, l'oeil clair, tout à son oeuvre. Il m'avait oublié, il ne savait plus que j'étais là, il me copiait comme une bête humaine quelconque, avec une attention, une conscience artistique que je n'ai jamais vue ailleurs.... Autour de moi, sur les murs de l'atelier, étaient pendues ces toiles puissantes et caractéristiques que le public n'a pas voulu comprendre.... Souvent, quand il traitait un détail secondaire, je voulais quitter la pose, je lui donnais le mauvais conseil d'inventer. Non, me répondait-il, je ne puis rien faire sans la nature. Je ne sais pas inventer. Tant que j'ai voulu peindre d'après les leçons apprises, je n'ai produit rien qui vaille. Si je vaux quelque chose aujourd'hui, c'est à l'interprétation exacte, à l'analyse fidèle que je le dois." Zola 1991, pp. 198–99.
6. On the identification of these objects, see Theodore Reff, "Manet's 'Portrait of Zola,'" *Burlington Magazine* 117 (1975), pp. 34–44; Françoise Cachin, in Paris, New York 1983, pp. 282–84; and Geneviève Lacambre, in Paris 1988, p. 177.
7. "Tachez, tachez toujours, ne dessinez jamais." Louis Leroy, "La Session du Salon de 1868. 8," *Le Charivari*, June 16, 1868, p. 2. Leroy was here making fun of what was for Zola one of Manet's great virtues, his method of "voir par taches, par morceaux simples et énergetiques" (seeing in patches, in simple, energetic pieces; Zola 1991, p. 117).
8. "le chef, le héros du réalisme"; "repugnance"; "ancienne chevelure romantique"; "rentre dans la sphère de l'art d'où les autres productions de l'artiste sortent violemment"; "triplicité phénoménale du réalisme." Théophile Gautier, "Salon de 1868. 4," *Le Moniteur*, May 11, 1868, pp. 1–2.

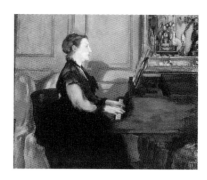

109

Fig. 241

Édouard Manet
Madame Manet au Piano
(*Mme Manet at the Piano*)
1868
Oil on canvas
15 x 18¼ in. (38 x 46.5 cm)
Musée d'Orsay, Paris RF1944

CATALOGUE RAISONNÉ: Rouart-Wildenstein 1975, no. 131

PROVENANCE: The artist, until his death in 1883; to his widow, Suzanne Manet, Paris, 1883, until 1894; bought for Fr 5,000 by Maurice Joyant, Paris, November 23, 1894, until 1895; bought for Fr 10,000 by comte Isaac de Camondo, Paris, March 1895; his bequest to the Musée du Louvre, 1908; Musée du Louvre, Paris, 1911; Musée du Jeu de Paume, Paris, 1947; Musée d'Orsay, Paris, 1986

EXHIBITIONS: Paris, École nationale des Beaux-Arts, 1884, *Exposition des oeuvres de Édouard Manet*, no. 47 (Au piano); Paris, Musée de l'Orangerie, 1932, *Manet*, no. 26; Marseille, Musée Cantini, 1961, no. 10; Paris, New York, 1983, no. 107

SELECTED REFERENCES: Duret 1902, no. 98; Moreau-Nélaton, cat. ms., no. 105; Moreau-Nélaton 1926, vol. 1, p. 95; Tabarant 1931, no. 134; Jamot-Wildenstein 1932, no. 142; Tabarant 1947, p. 155, no. 142; Rouart-Orienti 1970, no. 122; Darragon 1989, pp. 183–84

Suzanne Manet was an excellent pianist. The daughter of an organist, she enjoyed playing German music—Beethoven as well as Schumann and Wagner, who were being discovered in France at this time—and contemporary French composers such as her friend Chabrier, who dedicated his *Impromptu* for piano to her in 1873. At home in the boulevard des Batignolles and then, after October 1866, in the rue de Saint-Pétersbourg the Manets hosted musical evenings, which Fantin-Latour and Degas attended with pleasure. About 1867–68 Degas portrayed the Manets (fig. 237), she at the piano, he sprawled on a sofa protected by a white slipcover, looking more bored than "intoxicated with the heady perfume of the melody."[1] Degas presented this portrait to the Manets and received in exchange a still life of "plums," only to learn sometime later that Manet, finding an unacceptable "distortion in the features of his dear Suzanne," had cut up the canvas and done away with the figure of his wife.[2]

Contrary to an earlier opinion of mine,[3] the portrait of Mme Manet at the piano is likely to have followed soon after this celebrated incident. The setting is the drawing room of the elder Mme Manet on the fourth floor at 49, rue de Saint-Pétersbourg; as in Degas's damaged picture, there

are the light-colored paneling with gilt moldings and the armchairs protected by white slipcovers; there is also, reflected in the looking-glass over the marble chimneypiece, the clock given by Bernadotte to his goddaughter Eugénie-Désirée Fournier when she married Auguste Manet.[4]

As always when he painted his wife, Manet linked her with Dutch art because of her native country; in this small portrait, so simple and loving, he borrowed a composition by Metsu, *Dutchwoman Playing the Clavichord*, engraved by Charles Blanc in his *Histoire des peintres* (History of painters).[5] With this intimate scene, comparable to those already painted by Fantin-Latour and Whistler (fig. 3), Manet wished first to blot out the offense and then to show his young rival how the features of "his dear Suzanne" ought to be rendered.

H.L.

1. "grisé par le parfum enveloppant de la mélodie." Moreau-Nélaton 1926, vol. 2, p. 40.
2. "prunes"; "déformation des traits de sa chère Suzanne." Ibid., vol. 1, p. 36.
3. Paris, New York 1988, pp. 140–42. Antonin Proust (Proust 1897, p. 35) dates this portrait to 1868.
4. Moreau-Nélaton 1926, vol. 1, p. 95, and Tabarant 1947, p. 155.
5. See Françoise Cachin, in Paris, New York 1983, p. 287.

110 Fig. 305

Édouard Manet
Clair de lune
(Moonlight)
1868
Oil on canvas
32¼ x 39¾ in. (82 x 101 cm)
Musée d'Orsay, Paris RF 1993

CATALOGUE RAISONNÉ: Rouart-Wildenstein 1975, no. 143

PROVENANCE: The artist, until 1872; sold for Fr 800, while on deposit at the studio of Alfred Stevens, Paris, to Paul Durand-Ruel, Paris, January 1872, until 1873; bought for Fr 7,000 by Jean-Baptiste Faure, Paris, January 3, 1873, until late 1889; bought for Fr 33,000 by the dealer Camentron, Paris, 1889; bought for Fr 65,000 by comte Isaac de Camondo, Paris, 1899; his bequest to the Musée du Louvre, 1908; entered the Musée du Louvre, Paris, 1911 (exhibited 1914); Musée du Jeu de Paume, Paris, 1947; Musée d'Orsay, Paris, 1986

EXHIBITIONS: Brussels 1869, July 1–September 28, *Exposition générale des Beaux-Arts*, no. 756 (Clair de lune); Paris, École nationale des Beaux-Arts, 1884, *Exposition des oeuvres de Édouard Manet*, no. 49 (Le Clair de lune. Property of M. Faure); Paris, Exposition Universelle 1889, *Exposition centennale de l'art français*, no. 496 (Le Port de Boulogne;—effet de nuit. Property of M. Faure); Paris, Musée de l'Orangerie, 1932, *Manet*, no. 39; Los Angeles, Chicago, Paris, 1984–85, no. 3; Paris, New York, 1983, *Manet*, no. 118

SELECTED REFERENCES: Castor and Pollux, "Salon de Bruxelles," *Revue illustrée*, 1869, p. 29, repr. p. 30; *Galerie Durand-Ruel. Recueil d'estampes* (Paris and London, 1873, 3rd ed.); Louis Gonse, "Manet," *Gazette des Beaux-Arts*, February 1884, p. 146; Sâr Joséphin Péladan, "Le procédé de Manet," *L'Artiste*, February 1884, p. 112; Paul Jamot, "La Collection Camondo au Musée du Louvre," *Gazette des Beaux-Arts*, June 1914, pp. 445–46; Duret 1902, no. 112; Moreau-Nélaton, cat. ms., no. 118; Moreau-Nélaton 1926, vol. 1, p. 111; Tabarant 1931, no. 144; Jamot-Wildenstein 1932, no. 159; Tabarant 1947, pp. 165, 194, no. 150; Rouart-Wildenstein 1975, no. 143; Herbert 1988, pp. 274–75

In 1869, according to Tabarant, Manet spent the summer at Boulogne-sur-Mer, as he had done the previous year; he stayed at the Hôtel Folkestone, overlooking the harbor, where he had a room on the second floor. Arriving in July, he "seized his brushes with a frenzy of determination that Mme Édouard Manet still liked to recall toward the end of her life."[1] One result of this "frenzy," noted the biographer, was this nocturne, which shows sails and masts in silhouette under the bright light of the moon, while on the jetty some men in shadow and a huddled group of seven women wearing the local headdress await the fishing boats' return. It is, however, difficult to place this canvas in 1869, for after July 1 that year it was featured in the Exposition Générale des Beaux-Arts of Brussels, where Manet sent it with two recent works, *Le Balcon* (fig. 266) and *Le Déjeuner* (fig. 186), which had just been shown in the Paris Salon. *Clair de lune*, as it was titled in the Brussels catalogue, was thus certainly executed during the summer of 1868.[2]

The decision to send this work to Brussels was a judicious one. The picture refers, in fact, to the Northern schools of painting, and in particular to Aert van der Neer, who had made a specialty of nocturnal scenes; Manet himself owned a *clair de lune* by van der Neer.[3] His style, however, had nothing to do with the Dutchman's, which was smooth and precise. Here it is bold and full, close to the "Spanish" pictures whose starkly opposed blacks and whites he recaptures, yet without the disturbing quality of Monet's night effects (cat. 128).

Among the fifteen hundred canvases at Brussels, arranged in a "series of wooden huts," the painting was "very favorably placed, right next to Courbet's two submissions, *La Baigneuse* [The Woman Bather] and *La Dormeuse* [The Sleeping Woman].["4] According to Tabarant, "it was much liked."[5] One critic, however, without naming it, gave this "advice to the followers of the Batignolles school: stay at home in future. Spurned without hesitation in London," he concluded, "they have fallen back on Brussels, where we have had the

weakness and good manners to receive them; but one swallow does not make a summer."[6]

H.L.

1. "il empoigna ses pinceaux avec une frénésie de volonté que Mme Édouard Manet, sur la fin de sa vie, aimait à rappeler encore." Tabarant 1947, p. 163.
2. In Paris the Salon closed on June 20 (see *Chroniques des arts et de la curiosité*, no. 23, June 6, 1869, p. 3); the two pictures that Manet had shown there, *Le Balcon* and *Le Déjeuner*, left at once for Brussels with *Clair de lune*. Antonin Proust (Proust 1897, p. 35), often inaccurate in his datings, maintained that Manet had painted this canvas in 1868, "très peu de temps après avoir peint le portrait de sa femme au piano (very soon after he had painted the portrait of his wife at the piano [cat. 109])."
3. See Françoise Cachin, in Paris, New York 1983, p. 311.
4. "série de baraques en planches." Wallenstein, "Salon de Bruxelles," *Gazette des Beaux-Arts*, November 1, 1869, p. 466. "très favorablement placé, tout auprès des deux envois de Courbet, *La Baigneuse* et *La Dormeuse*." Tabarant 1947, p. 165.
5. "il plut beaucoup." Tabarant 1947, p. 165.
6. "conseil aux adeptes de l'école batignollaise: qu'ils restent chez eux à l'avenir. Repoussés sans hésitation à Londres, ils se sont rabattus sur Bruxelles, où on a eu la courtoise faiblesse de les accueillir; mais une fois n'est pas coutume." Wallenstein, "Salon de Bruxelles," pp. 471–72.

111 Fig. 358

Édouard Manet
Sur la plage de Boulogne
(On the Beach at Boulogne)
1868
Oil on canvas
12¾ x 26 in. (32.4 x 66 cm)
Signed lower right: Manet
Virginia Museum of Fine Arts, Richmond, Collection of Mr. and Mrs. Paul Mellon 85.498

CATALOGUE RAISONNÉ: Rouart-Wildenstein 1975, no. 148

PROVENANCE: The artist, until 1872; bought for Fr 500 by Durand-Ruel, Paris, January 1872, until 1873; bought for Fr 1,000 by Jean-Baptiste Faure, Paris, March 17, 1873, until 1907; bought for Fr 25,000 by Durand-Ruel, Paris, March 13, 1897; transferred to Durand-Ruel, New York, November 24, 1909; with Durand-Ruel, until at least 1912; O. Nielsen, Oslo, by 1922; Jean Laroche, Paris; Alphonse Morhange, Paris, until at least 1935; Mrs. A. E. Pleydell-Bouverie, London, until at least 1954; Galerie des Arts Anciens et Modernes, Lichtenstein, until 1960; sold to Mr. and Mrs. Paul Mellon, 1960, until 1985; their gift to the Virginia Museum of Fine Arts, 1985

EXHIBITIONS: Paris, Galerie Durand-Ruel, 1906, *Exposition de 24 tableaux et aquarelles par Manet formant la collection Faure*, no. 11; Paris, Musée de l'Orangerie, 1932, *Retrospective Manet*, no. 38; Washington, National Gallery of Art, 1982, *Manet and Modern Paris*, no. 51

SELECTED REFERENCES: Duret 1902, no. 117; Moreau-Nélaton, cat. ms., no. 123; Moreau-Nélaton 1926, vol. I, p. III; Tabarant 1931, no. 147; Jamot-Wildenstein 1932, no. 166; Tabarant 1947, pp. 165–66, no. 166; Alain de Leiris, "Manet: sur la plage de Boulogne," *Gazette des Beaux-Arts*, January 1961, pp. 53–61; Alain de Leiris, *The Drawings of Édouard Manet* (Berkeley and Los Angeles, 1969), p. 70, no. 259; Rouart-Orienti 1970, no. 130; Callen 1971, no. 377; Hanson 1977, pp. 199–202; Herbert 1988, pp. 275–76

Of all the scenes that Manet painted at Boulogne, this is the only one in which he depicted the beach and the leisure activities of the summer visitors. A subject à la Boudin, à la Monet, it inaugurated the artist's "Impressionist" phase, according to Alain de Leiris, the author of the fullest study of this masterpiece, a phase in which he allowed himself to be influenced by his young rival Monet while knowing how to impose "his difference." Almost unanimously dated 1869,[1] the picture is likely to have been executed the year before, at the same time as *Clair de lune* (cat. 110). Painted in the studio, it was in fact preceded by a whole series of very free drafts in a sketchbook, rough drawings of the people scattered on the beach (Musée du Louvre, Paris, Département des Arts Graphiques, Fonds du Musée d'Orsay); in the same sketchbook is a fine watercolor study for *Clair de lune*.[2]

H.L.

1. Only Juliet Wilson Bareau (Wilson Bareau 1991, p. 141) dates it 1868.
2. The drawings have been studied by Alain de Leiris, "Manet: *Sur la plage de Boulogne*," *Gazette des Beaux-Arts*, January 1961, pp. 53–62.

112 *(New York only)* *Fig. 211*

Édouard Manet
La Brioche
(*The Brioche*)
1870
Oil on Canvas
25⅝ x 31⅞ in. (65 x 81 cm)
Signed and dated lower right: Manet 1870
The Metropolitan Museum of Art, New York, Partial and Promised Gift of Mr. and Mrs. David Rockefeller, 1991 1991.287

CATALOGUE RAISONNÉ: Rouart-Wildentstein, 1975, no. 157

PROVENANCE: The artist, until 1880; bought for Fr 500 by Evans, 1880; Jean-Baptiste Faure, Paris, by 1884, until 1907; bought for Fr 25,000 by Durand-Ruel, Paris, March 13, 1907; transferred to Durand-Ruel, New York, October 22, 1909, until at least 1912 (see Callen 1971, no. 380, for early history of ownership.); Carl O. Nielson, Oslo, by 1918, until at least 1922; Étienne Bignou, Paris; Alex Reid, Glasgow, 1923; Leonard Gow, Glasgow and Craigendoren, by 1932, until at least 1935; The Lefevre Gallery, London; Mrs. Chester Beatty, London, by 1936, until at least 1947; Mr. and Mrs. David Rockefeller, New York, by 1955

EXHIBITIONS: Paris, École nationale des Beaux-Arts, 1884, *Oeuvres de Édouard Manet*, no. 85 (La brioche. Property of M. Faure); Paris, Galerie Durand-Ruel, 1906, *Exposition de 24 tableaux et aquarelles par Manet formant la collection Faure*, no. 12, and London, Sulley, no. 10; Paris, Musée de l'Orangerie, 1932, *Manet*, no. 43

SELECTED REFERENCES: Louis Gonse, "Manet," *Gazette des Beaux-Arts*, February 1884, pp. 143–44; Duret 1902, no. 223; Moreau-Nélaton, cat. ms., no. 219; Moreau-Nélaton 1926, p. 227; Tabarant 1931, no. 154; Jamot-Wildenstein 1932, no. 181; Tabarant 1947, pp. 178–79, no. 161; Rouart-Orienti 1970, no. 137; Callen 1971, no. 380; Charles F. Stuckey, "What's Wrong with the Picture?" *Art in America*, September 1981, pp. 104, 106

Dated 1870, this is perhaps the last canvas that Manet painted before closing his studio on September 16, a few days after the rout of the French troops by the Germans. Tabarant states that it was executed at "that junction between June and July" when Manet was working on two portraits that he left as rough drafts.[1] The fruits surrounding the brioche, however, suggest a date a little later, in July or August. In that case, Manet would have painted *La Brioche* while staying with Giuseppe de Nittis at Saint-Germain-en-Laye,[2] where in his concern over the war he had decided to remain so as not to be too far from Paris.

In the 1860s Manet had placed his still lifes under Spanish or Dutch auspices (cats. 85 and 104); here he turns to France in the eighteenth century. For this picture—which lays out on a "Louis XV table in rosewood, with ormolu mounts a brioche stuck with a white rose, a bunch of grapes, peaches, plums, a knife with a vermeil blade and a mother-of-pearl handle," and "a red lacquer sweetmeat box"[3]—is an overt reference to *La Brioche* by Chardin (fig. 210), which had entered the Louvre the previous year as part of the legacy of Dr. La Caze (see p. 165). But it is not a direct quotation, as *Olympia*, for instance, quoted Giorgione, creating a dazzling and aggressive display of modernity out of a variation on an ancient theme. Here Manet is painting an homage to Chardin, and to make the reference even clearer, he gives it a historical context, placing on a piece of rococo furniture the inanimate objects that his predecessor had lined up on a simple stone slab.

H.L.

1. Tabarant 1947, p. 178.
2. "table Louis XV en bois de rose, orné de bronzes dorés, une brioche piquée d'une rose blanche, une grappe de raisin, des pêches, des prunes, un couteau à lame de vermeil, au manche en nacre"; "une rouge bonbonnière en vernis Martin." Proust 1897, p. 36.
3. Tabarant 1947, pp. 178–79.

Jean-François Millet

Gruchy, 1814–Barbizon, 1875

Millet was born into a relatively wealthy and pious family of Norman peasants. After a rigorous classical education from the Gruchy clergy, Millet received his first artistic training in nearby Cherbourg. In January 1837 he arrived in Paris on a municipal scholarship from Cherbourg. The following March Millet entered the studio of the popular *juste-milieu* artist Paul Delaroche and enrolled at the École des Beaux-Arts. He left the École after unsuccessfully competing for the Prix de Rome in April 1839, and his municipal scholarship was subsequently suspended. Millet debuted at the Salon of 1840 with a portrait. Lack of funds forced him to spend much of the early 1840s in the provinces. After his first wife died of consumption, Millet moved back to the capital in 1845 with his new mistress, Catherine Lemaire, a former servant girl. Millet experienced his first critical success at the Salon of 1847 with the mythological painting *OEdipe détaché de l'arbre* (*OEdipus Unbound from the Tree*; National Gallery of Canada, Ottawa), followed in 1848 by his *Vanneur* (*Winnower*; National Gallery, London). In 1849 Millet moved definitively to Barbizon. His paintings of toiling peasants created a sensation at the Salons throughout the 1850s and early 1860s, with such works as *Les Glaneuses* of 1857 (fig. 52) and *L'Homme à la houe* of 1863 (fig. 55) being overtly politicized in the press. Millet's more bucolic, sentimentalized images of country life were widely admired, however, and the artist received a first-class medal in 1864 for his *Bergère gardant ses moutons* (*Shepherd Tending His Sheep*; Musée d'Orsay, Paris). Millet's reputation as a modern master was secured with a large retrospective showing at the Exposition Universelle of 1867.

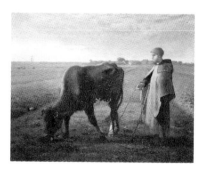

113 *(not in exhibition)* *Fig. 6*

Jean-François Millet
Femme faisant paître sa vache
(*Woman Pasturing Her Cow*)
1858
Oil on canvas
28¾ x 36⅝ in. (73 x 93 cm)
Signed lower right: *J.F. Millet.*
Musée de Brou, Bourg-en-Bresse 859.1

PROVENANCE: Commissioned by the state in 1852, accepted in 1859, and sent directly to the museum in Bourg-en-Bresse

EXHIBITIONS: Paris, Salon of 1859, no. 2183; Marseille, *Exposition de la société artistique des Bouches-du-Rhône* (not in cat.); Paris, École des Beaux-Arts, 1877, *J. F. Millet*, no. 53; Cherbourg, Musée Thomas Henry, 1964, *Jean-François Millet*, no. 53; Paris 1968–69, no. 498; Seoul, Musée du Palais Duksoo, 1972, *Jean-François Millet et les peintres de la vie rurale en France au XIXe siècle*, no. 1; Paris, London 1975–76, no. 67 (Paris), no. 43 (London); Bremen 1977–78, no. 80

SELECTED REFERENCES: Astruc 1859, pp. 293–95; Aubert 1859, pp. 69–70; A. de Belloy, "Salon de 1859 III," *L'Artiste*, n.s. 7 (May 1, 1859), p. 5; Émile Cantrel, "Salon de 1859: Les paysagistes," *L'Artiste*, n.s. 7 (May 22, 1859), p. 53; Castagnary, "Salon de 1859," reprinted in Castagnary 1892, vol. 1, pp. 72–76; Chalons d'Argé 1859, p. 49; Chaud-de-Thon, "Salon de 1859: Lettres de Chaud-de-ton, artiste," *La Vérité contemporaine*, May 25, 1859; Ernest Chesneau, *Libre étude sur l'art contemporain* (Paris, 1859); Du Camp 1859, pp. 98–100; Dumas 1859, pp. 27–31; Dumesnil 1859, pp. 34–36; A.-J. Du Pays, "Salon de 1859," *L'Illustration* 33 (May 21, 1859), p. 341; Georges Duplessis, "Salon de 1859," *Revue des beaux-arts* 10, no. 9 (1859), p. 179; J.-H. Duvivier, *Salon de 1859, indiscrétions* (Paris, 1859), p. 11; Victor Fournel, "Le Salon de 1859 (deuxième article)," *Le Correspondant* 11 (June 1859), pp. 267–68; Gautier 1859, pp. 125–26, fig. 96; Charles Habeneck, "Le Salon de 1859," *Le Causer* 1 (August 1859), pp. 255–56; Houssaye 1859, p. 359; Lépinois 1859, p. 147; Louis Leroy, "Le Charivari au Salon de 1859," *Le Charivari*, April 21, 1859, p. 5; Mantz 1859, pp. 361–63; Nadar, "Nadar-Jury au Salon de 1859," *Journal amusant*, no. 179 (June 4, 1859), p. 5; Perrier 1859, p. 311; Émile Perrin, "Salon de 1859," *Revue européenne* 3 (July 1, 1859), pp. 655–56; Paul de Saint-Victor, "Salon de 1859, V," *La Presse*, May 25, 1859; Mathilde Stevens, *Impressions d'une femme au Salon de 1859* (Paris, 1859), p. 75; Claretie 1873,

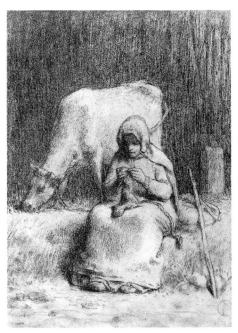

Fig. 410. Jean-François Millet, *Paysanne gardant sa vache* (*Woman Guarding Her Cow*), 1852. Graphite, 16⅜ x 12¼ in. (41.5 x 31.2 cm). Musée Boymans-van-Beuningen, Rotterdam

p. 28, n. 2; A. Piedagnel, *J.-F. Millet* (Paris, 1876), p. 60; Alfred Sensier, *La Vie et l'oeuvre de J.-F. Millet* (Paris, 1881), pp. 186–88, 191, 196, 199–200; [Bénézit-Constant], *Le livre d'or de J.-F. Millet par un ancien ami* (Paris, 1891), pp. 61, 100–105; Julia Cartwright, *Jean François Millet: His Life and Letters* (London, 1902), pp. 193–94, 198–99; J. Cain, *Millet* (Paris, [1913]), pp. 59–60, fig. 22; Étienne Moreau-Nélaton, *Millet raconté par lui-même* (Paris, 1921), vol. 2, pp. 53–54, 63–64, 66–67, 122, fig. 142, vol. 3, p. 134; H. Marcel, *J.-F. Millet* (Paris, 1927), pp. 44–45; André Fermigier, *Jean-François Millet* (New York, 1977), pp. 56–58, repr. p. 61; Clark 1982, p. 80; Neil McWilliam, "Le Paysan au Salon: Critique d'art et construction d'une classe sous le Second Empire," in Bouillon 1989, pp. 84–85, 87, 89–90, repr.

Thanks to Alfred Sensier, the artist's close friend and future biographer, Millet was awarded a state commission for this painting, probably on the basis of a drawing now in Rotterdam (fig. 410). Because of his proletarian subject matter, Millet was thought (wrongly) to be a radical, so the director of fine arts, M. Romieu, who was not "sympathetic toward political painters," had the police check his record, only to discover that "Millet had never caused any trouble in any way, he seemed to be quite satisfied with simply painting, staying very quietly at home, or walking around gazing at the sky, the fields, and the trees."[1] Moreau-Nélaton suggested that Millet altered his original idea for the composition and suppressed the woman's knitting because an "old woolen stocking" was susceptible to "odors too common."[2] The painting was completed in September 1858, and the state accepted and paid for it in early 1859. It was hung in a prominent position at the Salon, at the handrail, and discussed at length by every prominent critic. Millet's other entry, *Le Mort et le Bûcheron* (fig. 2), was rejected for reasons that are not clear.

The critical response was neatly divided. Left-wing or antiestablishment writers who approved of Millet's moralizing subject found the painting admirable; conservative critics who sought only beauty or "style" found the painting abhorrent. In the first camp, one finds Astruc, "a sweet poem which the painter has told with deep emotion";[3] Castagnary, "a new step taken by M. Millet in the interpretation of rustic life, of its silent and desolate aspects, of the ruthless pastoral poems and terrible idylls that compose its formidable thread";[4] Chesneau, "He avoids all dramatic effect because it would be false. Indeed, if these women are unhappy, it is for us to conclude; they themselves do not know it";[5] and Du Camp, "truer than reality, because they [Millet's paintings] sum up in a single huge misery all the woes we so often painfully witness."[6] In the second camp, one finds Cantrel, "Why did he take the trouble to paint the woman, the cow, the field—and the rope that binds these three miseries, these three wrecks, these three barren things?...What good is it to show us this yet again?"[7] Dumesnil, "*Vache* is neither pleasant nor attractive";[8] and Du Pays, "It is always the same woman."[9]

Baudelaire also dissented. He found Millet's paintings pretentious and his execution maladroit; he also profoundly distrusted the artist's pious

sentiments.[10] Alexandre Dumas summed up the response well when he said that in 1859 Millet had the same effect as Courbet did six or seven years before: indignation on the part of some, admiration on the part of others. Mediocre men cannot make such an impact.[11]

G.T.

1. "porté pour les peintres politiques"; "Millet n'avait jamais fait parler de lui en quoi que ce soit, qu'il semblait se borner à peindre, rester fort calme en sa maison ou à se promener en regardant le ciel, les champs et les arbres." Alfred Sensier, *La Vie et l'oeuvre de J.-F. Millet* (Paris, 1881), p. 187.

2. "vieux bas de laine"; "d'exhalaisons trop populaires." Étienne Moreau-Nélaton, *Millet raconté par lui-même* (Paris, 1921), vol. 2, p. 54.

3. "un doux poëme que le peintre a raconté avec une profonde émotion." Astruc 1859, p. 293.

4. "un nouveau pas fait par M. Millet dans l'interprétation de la vie rustique, de ses aspects silencieux et navrés, des impitoyables églogues et des terribles idylles qui en constituent la formidable trame." "Salon de 1859," in Castagnary 1892, vol. 1, p. 75.

5. "Il évite tout effet dramatique parce qu'il serait faux. Et si ces femmes sont malheureuses, c'est nous qui devons tirer cette conclusion; elle l'ignorent elles-mêmes." Ernest Chesneau, *Libre étude sur l'art contemporain* (Paris, 1859).

6. "plus vrais que la réalité, car ils résument en une seule et immense misère toutes les misères dont le spectacle nous a souvent douloureusement frappés." Du Camp 1859, p. 98.

7. "Pourquoi s'est-il donné la peine de peindre la femme, la vache, le champ,—et la corde qui relie ces trois misères, ces trois lambeaux, ces trois nudités?...A quoi bon, encore une fois, nous montrer cela?" Émile Cantrel, "Salon de 1859: Les paysagistes," *L'Artiste*, n.s. 7 (May 22, 1859), p. 53.

8. "*Vache* n'a rien d'agréable ni de séduisant." Dumesnil 1859, p. 34.

9. "C'est toujours la même femme." A.-J. Du Pays, "Salon de 1859," *L'Illustration* 33 (May 21, 1859), p. 341.

10. Baudelaire, "Salon de 1859: Le paysage," in Baudelaire 1975–76, vol. 2, pp. 661–62.

11. Dumas 1859, p. 27.

Claude Oscar Monet

Paris, 1840–Giverny, 1926

Monet's father was a wholesale merchant. His parents moved to Le Havre when he was about five years old. He had an early talent for drawing, and when still quite young he became known about town for his caricatures. Boudin took note of him sometime around 1858 and encouraged him to paint *en plein air*. He saw the 1859 Salon on his first significant trip to Paris, and he was

introduced to Troyon. From 1861 to 1862 Monet served in the French military in Algeria. On his return to the Normandy coast he met Jongkind, who replaced Boudin as his mentor. He enrolled in the Gleyre studio at the end of 1862 and as a result befriended Bazille, Renoir, and Sisley. He painted with Bazille in the Fontainebleau forest in 1863 and in Honfleur in 1864. His first Salon submissions, two marines (see cat. 118), were accepted in 1865. That summer he undertook at Chailly the enormous *Déjeuner sur l'herbe* (see cats. 122, 123), which he did not complete. To the 1866 Salon he sent instead a landscape and the quickly painted *Camille* (fig. 236), which created a sensation. For the rest of the decade, all of his Salon submissions were rejected, save one marine (see figs. 418, 419), accepted in 1868. His pictures were considered even more audacious than those of Manet, and he was discouraged at all official levels. He took up with his model Camille Doncieux in 1865, but his liaison cost him family support. Their son Jean was born on August 8, 1867. Bazille, and perhaps Courbet, contributed to his allowance, but creditors constantly pursued him from Paris to Ville-d'Avray to Bennecourt, Étretat, and Trouville. Nevertheless he persevered. He was a formative influence on Bazille and Sisley, and later Renoir and Pissarro learned from his example. He left France in autumn 1870 to avoid the war. Although in the 1860s he had ambitions to be a figure painter, his true love was landscape. His interest in reflections and the depiction of light, later the "envelope" of atmosphere, nascent in the late 1860s, carried through to the end of his life.

CATALOGUE RAISONNÉ: Wildenstein 1974, no. 10

PROVENANCE: M. and Mme Jean Bayeux, Quincampoix (Seine-Maritime), by 1937; Raphaël Gérard, Paris; assigned to the Musée du Louvre, Paris, in 1950 by the Office des Biens Privés; transferred to the Jeu de Paume, Paris, 1958; transferred to the Musée d'Orsay, 1986

EXHIBITIONS: Paris, Palais National des Arts, 1937, *Chefs-d'oeuvre de l'Art Français*, no. 370 (lent by "M. et Mme. Bayeux, Quincampoix [S.-I.]"); Saint-Etienne, Musée d'Art et d'Industrie, 1954, *Natures mortes de Géricault*

à nos jours, no. 19, fig. 8; Edinburgh, London 1957, no. 4, pl. 1; Bordeaux, Galerie des Beaux-Arts, May 5–September 1, 1978, *La Nature Morte de Breughel à Soutine*, no. 168, repr.; Paris 1980, no. 1, repr.; Bordeaux 1991, no. 49, repr.

SELECTED REFERENCES: Reuterswärd 1948, p. 280; Charles Sterling and Hélène Adhémar, *Musée National du Louvre: Peintures. École Française, XIXe siècle* (Paris, 1960), vol. 3, p. 25, no. 1343, pl. 498; Isaacson 1967, p. 56

As a young artist, Monet was not in the least adverse to still-life painting. Perhaps because he never aspired to join the ranks of grand history painters, he was sensitive to the achievements of contemporary painters of the genre such as Constant Troyon and Théodule Ribot. In his report of the Salon of 1859 to his mentor Boudin, Monet recorded his impressions of quite a few hunting still lifes: "I will tell you what I think about some of the paintings....There are many by him [Troyon], and he has been the most successful artist this year. There are some of his works I find a little too dark in the shadows....I was forgetting a very beautiful painting by him [fig. 411] showing a dog with a partridge in his mouth. It is magnificent; one can feel the hair. The head, above all, is very well done." Monet went on to mention three other paintings of dogs: by Joseph Stevens, "he skips the fine details"; by Rousseau "too big. He is a little confused. It looks better in the details than in the whole"; and by Godefroy Jadin, "after Troyon, it is overdone."[1]

Monet certainly did not forget Troyon's painting when he composed this one. He used a similar hunting dog, and he attempted to inscribe himself in the same grand tradition—that of Desportes, Chardin, and Oudry—to which Troyon subscribed. Monet met Troyon in 1859, thanks to a letter of introduction, and on that occasion the younger artist brought along two still lifes, which

Fig. 411. Henry Linton, after Constant Troyon, *Étude de chien*, 1859. Wood engraving published in *Le Monde illustré*, April 16, 1859

114 *Fig. 184*

Claude Monet
Trophée de chasse
(*Trophy of the Hunt*)
1862
Oil on canvas
41 x 29½ in. (104 x 75 cm)
Signed and dated lower right: *O.C. Monet 62*
Musée d'Orsay, Paris MNR 213

Fig. 412. Eugène Boudin, *Nature morte sur une console* (*Still Life on a Console Table*), ca. 1854–57. Oil on canvas, 22 x 32¼ in. (56 x 82 cm). Private collection

Troyon complimented.[2] However, the present painting seems to contain a more specific reference to the work of Boudin, for the marble console and the paneled wall appear in two still lifes by him (figs. 412, 413). While the illusionism in Boudin's pictures is more convincing, Monet's picture is nevertheless more striking—perhaps because of the unusual blond light and carefully drawn elements as well as the large format and greater number of depicted objects.

G.T.

1. "Je vous dirai ce que je pense de quelques tableaux.... Il y en a beaucoup de lui, et c'est lui qui a remporté cette année le plus de succès. Il y en a de lui que je trouve un peu trop noirs dans les ombres.... Un bien beau tableau de lui que j'oubliais, c'est un chien qui a à la gueule une perdrix. C'est magnifique; on sent le poil. La tête est surtout très soignée"; "il escamote les finesses"; "trop grand. Il est un peu confus. Il est mieux en détail qu'en ensemble"; "après Troyon c'est de la charge." Monet to Boudin, June 3, 1859, Wildenstein 1974, letter 2, p. 419.
2. Monet to Boudin, May 19, 1859, Wildenstein 1974, letter 1, p. 419.

Fig. 413. Eugène Boudin, *Nature morte au gibier, aux fruits et aux fleurs* (*Still Life with Game, Fruit, and Flowers*), 1854–57. Oil on canvas, 22½ x 31⅞ in. (57 x 81 cm). Private collection

115 *Fig. 222*

Claude Monet
Fleurs de printemps
(*Spring Flowers*)
1864
Oil on canvas
46 x 35⅞ in. (116.8 x 91.1 cm)
Signed and dated upper right: *Claude Monet 64*
The Cleveland Museum of Art, Gift of the Hanna Fund
53.165

CATALOGUE RAISONNÉ: Wildenstein 1974, no. 20

PROVENANCE: The artist's elder brother, Léon Pascale Monet, Rouen; Wildenstein and Co., New York, until 1953; sold to the Cleveland Museum, 1953

EXHIBITIONS: (?) Rouen, Musée de Rouen, October 1, 1864, *2ceme exposition municipale des beaux-arts* (not in catalogue); Saint Louis, Minneapolis 1957, no. 1, repr.; Chicago 1975, no. 3, repr.; Philadelphia, Detroit, Paris 1978–79, no. VI-88 (Philadelphia, Detroit), no. 256 (Paris), repr.

SELECTED REFERENCES: Poulain 1932, p. 44; Rewald 1973, pp. 111–12, repr.

"I wish to report that I am sending my flower painting to the Exposition in Rouen; there are many beautiful flowers now, but unfortunately I have to work so much on my out-of-door studies that I do not dare begin doing any flowers."[1] The painting Monet describes may well be the present sumptuous still life: it is the most important flower painting of this date to survive.

Monet's point of departure was no doubt the informal still lifes Boudin painted about the same time such as the *Gerbe de fleurs* (cat. 17): flowers culled from the garden and casually arranged against a neutral dark background. But the operative influence, as Joseph Rishel has stressed, was Courbet.[2] The opulence of the flowers and the rich use of paint may derive from Courbet's still lifes such as *Fleurs* (cat. 40), although these were usually achieved with a palette knife. Yet the only flower picture of this date that equals Monet's in freshness of vision and sheer painterly effect is the contemporaneous canvas by Renoir *Fleurs de printemps* (cat. 168). Already at this early date Renoir and Monet shared a common aesthetic, one that sought a new kind of beauty derived from conventional subjects.

419

According to a later letter to Bazille, Monet was disappointed in the other works exhibited in Rouen as well as in the placement his picture was given. "I have never seen a collection of such bad works...disgraceful works....As for me, I have had no luck, I have been assigned a terrible spot in bad light, and it is completely impossible to make out anything."[3]

G.T.

1. "Je vous annoncerai que j'envoie mon tableau de fleurs à l'Exposition de Rouen; il y en a de bien belles en ce moment, malheureusement j'ai tellement à travailler à mes études de dehors que je n'ose pas me mettre à faire des fleurs." Monet to Bazille, August 26, 1864, Wildenstein 1974, letter 9, p. 421.
2. Joseph Rishel in Philadelphia, Detroit, Paris 1978–79, p. 336 (English ed.).
3. "Je n'ai jamais vu un assemblage d'aussi mauvaises choses...des choses honteuses....Quant à moi je n'ai pas eu de chance, je suis affreusement mal placé dans un faux jour, et il est complètement impossible que l'on y distingue rien." Monet to Bazille, Wildenstein 1974, letter 12, p. 421.

116 *Fig. 81*

Claude Monet
Bord de la mer à Sainte-Adresse
(*Seaside at Sainte-Adresse*)
1864
Oil on canvas
15¾ x 28¾ in. (40.1 x 73.3 cm)
Signed lower right: *C. Monet*
Lent by The Minneapolis Institute of Arts, Gift of Mr. and Mrs. Theodore W. Bennett 53.13

CATALOGUE RAISONNÉ: Wildenstein 1974, no. 22

PROVENANCE: Possibly purchased from Monet by Durand-Ruel in February 1873; Faulque de Jonquières; Marlborough Fine Art Ltd., London, until 1953; Mr. and Mrs. Theodore W. Bennett, Minneapolis; their gift to the museum, 1953

EXHIBITION: Saint Louis, Minneapolis 1957, no. 2, repr.

SELECTED REFERENCES: Catlin 1954, pp. 10–15; Rewald 1973, repr. p. 110; Scott Schaefer in Los Angeles, Chicago, Paris 1984–85, pp. 58, 60, fig. 13; Daulte 1992, pp. 28–30, repr. p. 28

Monet, in the company of Bazille, arrived in Honfleur in the last week of May 1864. "Ever since we arrived in Honfleur we have been looking for our landscape motifs. They have been easy to find because the countryside is a paradise."[1] They painted out-of-doors in the rural environs of the Ferme Saint-Siméon, but they were also attracted to the stretches of the Seine near the harbor, which afforded picturesque motifs of land and sea, sun

and clouds, and boats large and small. Monet painted several pictures of the mouth of the Seine, such as this one, which he did not consider completed works but rather studies which he would copy in the studio in order to make larger and more finished works. But the broad and seemingly palpable brushstrokes of the outdoor studies were carried over to the larger paintings for public exhibition and contributed to the novelty of Monet's style.

It is thought that this work was painted in June 1864. Bazille used this study as the basis for an overdoor that he painted a year later for his uncle's house (see cat. 2).

G.T.

1. "Dès notre arrivée à Honfleur nous avons cherché nos motifs de paysages. Ils ont été faciles à trouver car le pays est le paradis." Bazille to his mother, Honfleur, June 1, 1864, Bazille 1992, no. 52, p. 91.

117 *Fig. 79*

Claude Monet
Le Phare de l'hospice, 1864
(*The Lighthouse*)
1864
Oil on canvas
21¼ x 31⅞ in. (54 x 81 cm)
Signed lower left: *C. Monet*
Kunsthaus Zurich, Gift of the heirs of Dr. Adolf Jöhr 1968/4

CATALOGUE RAISONNÉ: Wildenstein 1974, no. 38

PROVENANCE: Depeaux, Rouen, until 1901; his sale, "Catalogue de Tableaux Modernes...Provenant de la Collection d'un Amateur [Depeaux]," Hôtel Drouot, Paris, April 25, 1901, no. 33 ("Le Phare de l'Hospice et la Côte-de-Grâce à Honfleur"); purchased at this sale by Bernheim-Jeune, Paris; Lord Grimthorpe, London, until 1906; his sale, Christie's, London, May 12, 1906, no. 7; purchased at this sale by Rosenberg for £204 15s.;[1] Bernheim-Jeune, Paris, 1906; Hugo Nathan, Frankfurt, by 1917; by descent to Mrs. Nathan, Basel, ca. 1938; Bottenwieser, New York; Dr. Adolf Jöhr; by descent to Prof. Walter A. Jöhr, Saint Gall, until 1975; the family's gift to the museum, 1975

EXHIBITIONS: Frankfurt am Main, Kunstverein, July 20–September 30, 1913, *Frankfurter Kunstschatz*, no. 60; Berlin, Galerien Thannhauser, mid-February–March 1928, *Claude Monet (1840–1926)*, no. 13 ("Leuchtturm von Honfleur"); Zurich, Kunsthaus, May 10–June 15, 1952, *Claude Monet: 1840–1926*, no. 1

SELECTED REFERENCES: Georg Swarzenski, "Die Sammlung Hugo Nathan in Frankfurt A.M.," *Kunst und*

Kunstler 15 (December 1917), p. 114, repr. p. 111; Reuterswärd 1948, p. 21, fig. 4, p. 28; Skeggs 1987, pp. 22–24, repr.

Like *Bord de la mer à Sainte-Adresse* (cat. 116), this work is one of several marine studies intended for use as a model for a larger exhibition picture. The closely wrapped jackets of the men in the four-oared whaler in the foreground suggest that the weather is cool, so it is possible that Monet executed this sometime in the autumn of 1864; he left Honfleur for Paris in November. The sea is cloudy and filled with sand, and stripped of its color by the leaden clouds which encroach upon a patch of blue at center, but otherwise there is no anecdote or incident depicted. Monet seems to wish only to record the phenomenon he observed. He made, presumably about the same time, on a canvas of the same dimensions, a much more dramatic version of the identical view seen at sunset (*Halage d'un bateau, Honfleur*, Memorial Art Gallery, University of Rochester; Wildenstein 37). In that, the sun sets as fishermen, their day's work done, haul their boat in the waning light. Clearly, Monet conceived the two pictures as complementary.

Back in Paris in the winter of 1864–65, Monet worked up the present composition on a canvas almost twice as large (*L'Embouchure de la Seine*, Norton Simon Museum of Art, Pasadena; Wildenstein 51). Recognizing the problem posed by the empty foreground at lower left, he invented for the larger picture a fishing boat listing at anchor. He made the sea more agitated and thus gave the boats at the right, increased in number, a decided diagonal tilt as the wind strained their sails. The sky, however, remained true to the artist's original study. Monet submitted the larger canvas to the Salon, along with *La Pointe de la Hève à marée basse* (cat. 118), where it was not only accepted but well received by critics Paul Mantz and Pigalle (presumed to be Zacharie Astruc).[2]

G.T.

1. Douglas Cooper, *Courtauld Collection* (London, 1954), p. 66.
2. Rewald 1973, p. 123.

118 *Fig. 83*

Claude Monet
La Pointe de la Hève à marée basse
(*Pointe de la Hève at Low Tide*)
1865

Oil on canvas
35½ x 59¼ in. (90.2 x 150.5 cm)
Signed and dated lower right: *Claude Monet 1865*
Kimbell Art Museum, Fort Worth AP 1968.07

CATALOGUE RAISONNÉ: Wildenstein 1974, no. 52

PROVENANCE: The artist's elder brother, Léon Pascale Monet, Rouen; Galerie Bernheim-Jeune, Paris; Georges Bernheim, Paris, by 1923;[1] M. Y. de Saint-Albin, Paris; Rémond Collection, Geneva; Wildenstein and Co., New York, until 1968

EXHIBITION: Paris, Salon of 1865, no. 1525 ("La pointe de la Hève à marée basse")

SELECTED REFERENCES: Mantz 1865, p. 26; Louis de Gonzague Privat, *Place aux jeunes! Causeries critiques sur le Salon de 1865* (Paris, 1865), p. 190; Pigalle, *L'Autographe au Salon et dans les ateliers* (Paris, 1865), p. 76 (partial transcription in Geffroy 1922, pp. 27–28); Philippe Burty, "Les paysages de M. Claude Monet," *La République française*, March 27, 1883, p. 3; Hugues Le Roux, "Silhouettes parisiennes, l'exposition de Claude Monet," *Gil Blas*, March 3, 1889, p. 2; Cahen 1900, p. 106; Thiébault-Sisson 1900, p. 3; Théodore Duret, *Histoire d'Édouard Manet et son oeuvre* (Paris, 1902), p. 61; Wynford Dewhurst, *Impressionist Painting: Its Genesis and Development* (London, 1904), p. 39; Georges Lanöe, *Histoire de l'école française de paysage depuis Chintreuil jusqu'à 1900* (Nantes, 1905), p. 280; Théodore Duret, *Histoire des peintres impressionnistes: Pissarro, Claude Monet, Sisley, Renoir, Berthe Morisot, Cézanne, Guillaumin* (Paris, 1906), p. 95; Alexandre 1921, p. 36, pl. 7; René Chavange, "Claude Monet," *Le Figaro artistique*, December 16, 1926, p. 147; Régamey 1927, p. 76; René Gimpel, "At Giverny with Claude Monet," *Art in America* 15 (1927), p. 173; Mauclair 1927, pp. 8, 18; Fels 1929, p. 73; Reuterswärd 1948, pp. 28, 30, 31; Malingue 1943, p. 15; Rewald 1973, pp. 122–23, 137, nn. 41–43; Isaacson 1978, pp. 12, 13, 14, 59, 193, 195, 196, 199, no. 11, pl. 11; Emmanuel Bondeville, "Claude Monet —Claude Debussy," in *Aspects of Monet: A Symposium on the Artist's Life and Times*, ed. John Rewald and Frances Weitzenhoffer 1984, pp. 182–87; House 1986, pp. 15, 75, 147, 148, 205, pl. 181; Skeggs 1987, pp. 25–28, 32–33, 37, 45, 48, repr. p. 30; Spate 1992, pp. 28–29, 49, pl. 23

Monet returned to Paris from Honfleur in the winter of 1864–65 and moved into Bazille's studio at 6, rue de Furstenberg, the same building in which Delacroix had kept his studio. Monet's goal was, for the first time, to prepare pictures that would be accepted at the Salon, thereby placing himself squarely in the public arena. His strategy was to create two large marines of the Channel coast. For models he turned to the studies he had painted out-of-doors in Honfleur over the previous summer, *Le Phare de l'hospice* (cat. 117) and *Chevaux à la Pointe de la Hève* (fig. 414), which Monet used to make the present picture.

Although Monet made a number of changes in developing *Le Phare de l'hospice* into a Salon painting, in enlarging *La Pointe de la Hève* from study to finished picture he remained true to his original composition. For the large work Monet deleted the horse and cart at the right of the study, brought the man walking with a cane closer to the center of the composition, and added the boats beached at right and a boat sailing on the horizon at left, but there were no other substantive changes.

This Salon painting, like the study, owed a great deal to his two mentors, Boudin and Jongkind. One could say that Monet took the anecdotal scene—figures on a beach—from Jongkind (see cat. 80) and placed it beneath one of Boudin's famous gray skies. The gambit worked: the painting was accepted for exhibition. But the enthusiastic response it elicited from the pens of the critics was probably as much a surprise for Monet as for his teachers. Pigalle, presumed to be Zacharie Astruc, wrote: "Monet. The author of the most original and supple, firmly and harmoniously painted seascape exhibited in a long time. It has the same dull tonalities as the work of Courbet; but it is so rich and it looks so simple! M. Monet, unknown yesterday, has immediately made a name for himself with this single painting."[2] The highly influential and rather conservative critic Paul Mantz devoted an entire paragraph to Monet's two exhibits: "Here, it is necessary to mention a new name. We did not know M. Claude Monet, the author of the *Pointe de la Hève* and the *Embouchure de la Seine à Honfleur*. These are, we think, works of a beginner, and they lack the finesse only achieved after years of study; yet the taste for harmonious tonalities within the play of similar tones, the sense of values, the astonishing look of the whole work, a daring way of seeing things and of grabbing the viewer's attention, these are qualities that M. Monet already possesses to a large degree. His *Embouchure de la Seine* made us stop short and we will never forget it. Now we are interested in following the future endeavors of this sincere seascape painter."[3]

Bazille recorded in a letter to his mother that "Monet was a lot more successful than he had hoped to be. Several very talented painters whom he does not even know have written him letters of congratulation."[4]

G.T.

1. See Gimpel 1963, p. 253.
2. "Monet. L'auteur de la marine la plus originale et la plus souple, la plus solidement et la plus harmonieusement peinte qu'on ait exposée depuis longtemps. Une tonalité un peu sourde, comme dans les Courbet; mais quelle richesse et quelle simplicité d'aspect! M. Monet, inconnu hier, s'est fait d'emblée une réputation par ce seul tableau." Pigalle, *L'Autographe au Salon et dans les ateliers* (Paris, 1865), quoted in Geffroy 1922, p. 28.
3. "Il nous faut ici écrire un nom nouveau. Nous ne connaissions pas M. Claude Monet, l'auteur de la *Pointe de la Hève* et de l'*Embouchure de la Seine à Honfleur*. Ce sont là, croyons-nous, des oeuvres de début, et il y manque cette finesse qu'on n'obtient qu'au prix d'une longue étude; mais le goût des colorations harmonieuses dans le jeu des tons analogues, le sentiment des valeurs, l'aspect saisissant de l'ensemble, une manière hardie de voir les choses et de s'imposer à l'attention du spectateur, ce sont là des qualités que M. Monet possède déjà à un haut degré. Son *Embouchure de la Seine* nous a brusquement arrêté au passage, et nous ne l'oublierons plus. Nous voilà intéressé désormais à suivre dans ses futures tentatives ce mariniste sincère." Paul Mantz, "Salon de 1865," *Gazette des Beaux-Arts* 18 (1865), p. 26.
4. "Monet a eu un succès beaucoup plus grand qu'il ne l'espérait. Plusieurs peintres de beaucoup de talent qu'il ne connaît pas, lui ont écrit des letters de compliments." Bazille to his mother, May 5, 1865. Bazille 1992, no. 66, p. 108.

Fig. 414. Claude Monet, *Chevaux à la Pointe de la Hève* (*Horses at the Pointe de la Hève*), 1864. Oil on canvas, 20¼ x 29 in. (51.5 x 73.7 cm). Private collection (photograph courtesy Wildenstein and Co.)

119 *Fig. 99*

Claude Monet
*Le Pavé de Chailly dans la forêt de
Fontainebleau*
(*Pavé de Chailly in the Fontainebleau Forest*)
1865
Oil on canvas
38¼ x 51⅜ in. (97 x 130.5 cm)
Signed lower left: *Claude Monet*
Ordrupgaardsamlingen, Copenhagen

Catalogue raisonné: Wildenstein 1974, no. 57

Provenance: The artist¹ until 1873; sold to Durand-Ruel,
Paris, March 1, 1873, for Fr 700; purchased by Jean-
Baptiste Faure, Paris, March 13, 1873; bought back by
Durand-Ruel, Paris, by 1877;² Henri Rouart, Paris, by
1891, until 1912;³ his sale, Galerie Manzi-Joyant, Paris,
December 9–11, 1912, no. 255 ("Le Pavé de Chailly dans
la forêt de Fontainebleau"); purchased at this sale by
Durand-Ruel, Paris, 1912, until 1918; sold to Duval-Fleury,
Paris, for Wilhelm Hansen, Ordrupgaard, 1918; gift of
Mrs. Wilhelm Hansen to the country, 1951

Exhibitions: Copenhagen, Statens Museum for Kunst,
1957, *Fransk Kunst*, no. 101; Tokyo, Yokohama, Toyohashi,
Kyoto, 1989–90, *French Masterpieces from the Ordrup-
gaard Collection in Copenhagen*, no. 51

Selected references: Armand Dayot, "A travers les col-
lections parisiennes," *L'Art dans les deux mondes*, no.
22 (April 18, 1891), p. 260; A. Dalligny, "Collection H.
Rouart," *Journal des arts*, November 30, 1912; Arsène
Alexandre, "La collection Henri Rouart," *Les Arts*, no.
132 (December 1912), pp. 12, 28, repr. p. 31; Vittorio
Pica, "Artisti contemporaner: Jacques Émile Blanche,"
Emporium 37 (January 1913), p. 52, repr.; Geffroy 1920,
p. 53, repr.; Alexandre 1921, p. 51, repr.; Ernest Dumon-
thier, "Une grande collection d'oeuvres françaises
modernes au Danemark, la collection Wilhelm Hansen,"
La Revue de l'art ancien et moderne, no. 241 (1922),
p. 338; Poulain 1932, p. 70; Haavard Rostrup, *Claude
Monet et ses tableaux dans les collections danoises*
(Copenhagen, 1941), pp. 13–14, pl. 1; Leo Swane, *Katalog
over Kustvaerkerne pa Ordrupgaard* (Copenhagen, 1954),
pp. 86–87, no. 80, repr. p. 84; Isaacson 1972, p. 110,
n. 81, fig. 7; Champa 1973, p. 5, fig. 8; Distel in Paris 1980,
p. 58; Marianne Wirenfeldt Asmussem, *Wilhelm Han-
sen's Original French Collection at Ordrupgaard* (Co-
penhagen, 1993), pp. 296–97, no. 95, repr.

Monet arrived at Chailly from Paris in early April
1865. He stayed there until October, and through-
out the entire period he had only one objective:
to paint a picnic scene, peopled with many figures,
on a vast scale. The present work is one of three
independent landscapes that he painted in order
to develop the landscape background of his large
figure painting. The other two landscapes are *Forêt
de Fontainebleau* (private collection; Wildenstein
19) and *Le Chêne de Bodmer* (cat. 120), and both
are the same size as the present canvas. When he
failed to complete *Le Déjeuner sur l'herbe* (cats.
122, 123) in time for the Salon of 1866, he sent
Forêt de Fontainebleau, in addition to *Camille*
(fig. 236), to represent his accomplishment over
the preceding year. One can therefore infer that
the artist considered these landscapes significant
works in themselves.

On a previous visit to Chailly, perhaps in 1863
or 1864, Monet painted from precisely the same
spot. The earlier work is on a canvas approxi-
mately half the size (fig. 415) of the present work,
and the style, while pleasingly atmospheric, has
none of the bold articulation of the landscapes of
1865. As in *Le Déjeuner sur l'herbe*, the light here
comes from behind, glancing across the tops of
the trees, which cast the shadows Monet uses to
such great effect.

 G.T.

1. Monet to Bazille, 1868–69, Wildenstein 1974, letters 45,
 48, p. 426.
2. Letter from Douglas Cooper to Margaretta Salinger, Feb-
 ruary 17, 1970, Metropolitan Museum of Art, Depart-
 ment of European Paintings Archives, no. 64.210.
3. Armand Dayot, "À travers les collections parisiennes, col-
 lection H. Rouart," *L'Art dans les deux mondes*, no. 22
 (April 18, 1891), p. 260.

120 *Fig. 96*

Claude Monet
Le Chêne de Bodmer. La Route de Chailly
(*The Bodmer Oak, Fontainebleau Forest,
the Chailly Road*)
1865
Oil on canvas
37⅞ x 50⅞ in. (96.2 x 129.2 cm)
Signed lower right: *Claude Monet.*
The Metropolitan Museum of Art, New York, Gift of
Sam Salz and Bequest of Julia W. Emmons, by exchange,
1964 64.210

Catalogue raisonné: Wildenstein 1974, no. 60

Provenance: Among the canvases in the artist's studio
at Ville-d'Avray that, owing to his nonpayment of debt,
were impounded and sold by the local authorities in
1866 or 1867; thus purchased by Martin (nephew of the
dealer Pierre Firmin Martin) for "une dizaine de francs";¹
reacquired by the artist; sold to Durand-Ruel, Paris,
March 1, 1873, for Fr 600 ("Le Bodmer, Arbre de la Forêt
de Fontainebleau"), transferred to Durand-Ruel, New
York, August 26, 1891, until 1900; sold to Chauncey J.
Blair, Chicago, July 30, 1900; purchased back by Durand-
Ruel, New York, December 20, 1900, until 1962 (stock
nos. 2362, 2392);² Sam Salz, New York, by 1962, until
1964; his gift and bequest of Julia W. Emmons, by ex-
change, to the Metropolitan Museum, 1964

Exhibitions: New York, Durand-Ruel, January 26–
February 14, 1907, *Exhibition of Paintings by Claude
Monet*, no. 23 ("Le Pavé à Chailly, 1867"); Boston,
Museum of Fine Arts, January 1927, *Claude Monet:
Memorial Exhibition*, no. 43 ("Le Pavé à Chailly" [1867],

Fig. 415. Claude Monet, *Le Pavé de Chailly*, ca. 1864. Oil on canvas, 16½ x 23¼ in.
(42 x 59 cm). Musée d'Orsay, Paris

lent by Durand-Ruel galleries); Paris, Durand-Ruel, May 22–September 30, 1959, *Exposition Claude Monet: 1840–1926*, no. 4; San Francisco, Toledo, Cleveland, Boston 1962–63, no. 109 ("Le Pavé de Chailly," lent by Mr. Sam Salz); Cologne, Wallraf-Richartz-Museum, April 6–July 1, 1990, Zurich, Kunsthaus, August 3–October 21, 1990, *Landschaft im Licht: Impressionistische Malerei in Europa und Nordamerika, 1860–1910*, no. 18, repr.

SELECTED REFERENCES: Alexandre 1921, pp. 51–52; Sterling and Salinger 1967, pp. 124–25, repr.; Cooper 1970, pp. 281–84, 302, 305, fig. 3; Isaacson 1972, pp. 99–100, n. 16; Champa 1973, p. 5, fig. 9; Rewald 1973, repr. p. 95; Elizabeth H. Jones in Boston 1977–78, p. 12; Moffett 1985, pp. 106–7, 251, repr.; Broude 1991, pp. 43, 45, fig. 21

Monet returned to Paris from Chailly by October 14, 1865, when he wrote to Bazille to say, "I have had a lot of trouble leaving Chailly; I still do not have all my things. However, I hope to go and get them in a few days and I am going to start working hard on my canvas."[3] Here, the carpet of russet leaves on the forest floor indicates that Monet painted this canvas either just before he left Chailly in early October or during his return later in the month. It is thus probably the last of the several landscape studies that were executed in connection with his monumental *Déjeuner sur l'herbe* (see cats. 122, 123). For although the site Monet depicted in the *Déjeuner* was probably based on an area at the edge of the Chailly road (see cat. 119), rather than under the majestic oak in this work, the *sous-bois* setting of the *Déjeuner* is similar in effect to that here. As in the *Déjeuner*, the light here streams in from behind the screen of trees at the left, and the sky in both pictures is represented as patches of deep ultramarine blue punctuating the veil of branches and leaves.

The Bodmer Oak, named after the Swiss artist Karl Bodmer, who exhibited his portrait of the tree in the 1850 Salon, was one of several great trees in the Fontainebleau forest that had earned a name. The Bodmer Oak was a favorite of photographers and painters alike. Gustave Le Gray's

calotype of about 1850 (fig. 416) is perhaps the best-known photograph, one that Monet may have seen. According to Elizabeth Jones, a tree similar in appearance to the Bodmer Oak once was visible at the left of Monet's 1863 canvas *Porteuses de bois, forêt de Fontainebleau* (*Road in the Forest with Woodgathers*, Museum of Fine Arts, Boston). It is now visible only through X rays.[4]

Also visible through X rays is a cut in the upper right quarter of the present canvas. According to Arsène Alexandre,[5] Monet slashed a number of canvases that he left behind in his studio at Ville-d'Avray in 1866 before leaving for Honfleur. The canvases were seized by his landlord because the artist had not paid his rent, and this work was reputedly bought by a nephew of an art dealer, Martin, who knew Monet through Boudin and who thus recognized the author of the damaged canvas.

A fine study (formerly in the collection of Léon Monet) of an individual oak tree has recently come to light. It is very close in style to the Metropolitan Museum picture.

G.T.

1. Alexandre 1921, pp. 51–52; Gimpel 1966, pp. 72–73.
2. Letter from Charles Durand-Ruel to Theodore Rousseau, March 31, 1965, and letter from Douglas Cooper to Margaretta Salinger, February 17, 1970, Metropolitan Museum of Art, Department of European Paintings Archives, no. 64.210.
3. "j'ai eu bien des ennuis pour partir de Chailly; je n'ai même pas encore toutes mes affaires. Cependant j'espère aller les chercher dans quelques jours et je vais me mettre à piocher à ma toile." Wildenstein 1974, letter 22, p. 422.
4. Boston 1977–78, p. 12.
5. Alexandre 1921, pp. 51–52.

Fig. 416. Gustave Le Gray, *Bas-Bréau, forêt de Fontainebleau*, 1849. Albumen print from dry waxed-paper negative, 10⅛ x 14 in. (25.6 x 35.7 cm). Victoria and Albert Museum, London

121 *Fig. 172*

Claude Monet
*Étude pour le Déjeuner sur l'herbe
(Les Promeneurs)
(Study for the "Déjeuner sur l'herbe"
[The Strollers])*
1865
Oil on canvas
36⅝ x 27⅛ in. (93 x 69 cm)
Signed lower right: *Claude Monet*
National Gallery of Art, Washington, Ailsa Mellon Bruce Collection 1970.17.41

CATALOGUE RAISONNÉ: Wildenstein 1974, no. 61

PROVENANCE: The artist, until his death in 1926; by descent to his son Michel Monet (1878–1966), Giverny, 1926, until 1931; Edward Molyneux, Paris, 1931, until 1955; acquired from his collection by Mrs. Ailsa Mellon Bruce, New York, 1955, until 1970; her gift to the museum, 1970

EXHIBITIONS: Paris 1931, no. 8, repr.; Paris 1940, no. 1; New York, Museum of Modern Art, June 24–September 7, 1952, *French Paintings from the Molyneux Collection*, no number, repr.; San Francisco, California Palace of the Legion of Honor, June 15–July 30, 1961, *French Paintings of the Nineteenth Century from the Collection of Mrs. Mellon Bruce*, no. 27, repr.; New York, Wildenstein and Co., October 28–November 27, 1965, *Olympia's Progeny: French Impressionist and Post-Impressionist Painting (1865–1905)*, no. 1, repr.; Washington, National Gallery of Art, March 17–May 1, 1966, *French Paintings from the Collection of Mr. and Mrs. Paul Mellon and Mrs. Mellon Bruce, Twenty-fifth Anniversary Exhibition 1941–1966*, no. 80, repr.; Paris 1980, no. 7, repr.

SELECTED REFERENCES: A. M. F[rankfurter], "The Molyneux Collection Travels," *Art News* 51, no. 2 (April 1952), p. 35, repr.; Adhémar 1958, pp. 37, 40, fig. 2; Sarraute 1962, p. 92; Mark Roskill, "Early Impressionism and the Fashion Print," *Burlington Magazine* 112 (June 1970), p. 392, n. 8, p. 395, n. 22; Isaacson 1972, pp. 26, 57–59, figs. 11, 31; Champa 1973, p. 6, fig. 11; Rewald 1973, pp. 118–19, repr.

This is the only painted figure study that survives of the many that evidently were made by Monet in preparation for the large *Déjeuner sur l'herbe* (see cats. 122, 123). Since Monet wrote Bazille, in the letter imploring him to come to Chailly, "all that is missing are the men,"[1] it is assumed that he began with studies of his female model, presumed to be his new companion, Camille Doncieux. Thus it seems likely that Monet had already begun this study of the female figure

in summer 1865, and when Bazille arrived in mid-August, he added the courteously attentive male companion. Although there are slight changes in the inclination of Bazille's torso and in the color of the highlights, what is more noteworthy is how remarkably similar this study is to the same group in the sketch in the Pushkin State Museum, Moscow (fig. 170), and how close the Pushkin sketch is to the final painting. Indeed hesitation and revision are more conspicuous in the remnants of the large painting than in the studies, and that may be due to the last-minute advice of Monet's colleagues.

G.T.

1. "il ne manque plus que les hommes." Monet to Bazille, Chailly, July or beginning of August 1865, Wildenstein 1974, letter 20, p. 422.

122 *(Paris only)* *Fig. 169*

Claude Monet

Le Déjeuner sur l'herbe (partie gauche)
(Left part of *Le Déjeuner sur l'herbe*)
1865–66
Oil on canvas
164⅝ x 59 in. (418 x 150 cm)
Musée d'Orsay, Paris RF1957.7

CATALOGUE RAISONNÉ: Wildenstein 1974, no. 63a

PROVENANCE: The artist, until January 1878; to his landlord Alexandre Flament, Argenteuil, in lieu of rent, 1878, until 1884; bought back by Monet in 1884 (at this date Monet cut the canvas into several pieces [see cat. 123]), until his death in 1926; by descent to his son Michel Monet (1878–1966), Giverny, 1926, until at least 1931; Georges Wildenstein, Paris, until 1957; his gift to the museum, 1957

EXHIBITIONS: Paris, Musée de l'Orangerie, December 7, 1940–March 18, 1941, *Centenaire Monet-Rodin*, no. 4; Paris 1980, no. 5, repr.

SELECTED REFERENCES: Hélène Adhémar, "Un don au musée du Louvre, la partie gauche du *Déjeuner sur l'herbe* de Monet," *Arts*, no. 633 (August 28, 1957), p.

7; Adhémar 1958, pp. 37–45, repr. p. 38, figs. 3–8; Hélène Adhémar and M. Dreyfus-Bruhl, *Musée du Louvre. Catalogue des peintures impressionnistes* (Paris, 1958), no. 226; Sarraute 1958, p. 48; Charles Sterling and Hélène Adhémar, *Musée du Louvre. Peintures école française XIXeme siècle* (Paris, 1960), vol. 3, no. 1348, pl. 500; Gimpel 1963, p. 179; Nochlin 1971, pp. 139–47; Isaacson 1972, pp. 66–77, figs. 4, 23, 24, 25, 36, 40, 41; Champa 1973, pp. 6–8, 27, pl. 1; Rewald 1973, pp. 118–19, repr.; House 1977, no. 2, repr.; Isaacson 1978, pp. 14, 195–96, no. 10, pl. 10; Herbert 1988, pp. 174–77; Isabelle Compin, Geneviève Lacambre, and Anne Roquebert, *Musée d'Orsay: Catalogue sommaire illustré des peintures, M–Z* (Paris, 1990), p. 335; Spate 1992, pp. 31–34, 35, 37, 38, 39, 40, 42, 269, pl. 28

123 *(Paris only)* *Fig. 169*

Claude Monet

Le Déjeuner sur l'herbe (partie centrale)
(Center part of *Le Déjeuner sur l'herbe*)
1865–66
Oil on canvas
97⅝ x 85⅜ in. (248 x 217 cm)
Stamped lower right: Claude Monet
Musée d'Orsay, Paris RF 1987.12

CATALOGUE RAISONNÉ: Wildenstein 1974, no. 63b

PROVENANCE: The artist, until January 1878; to his landlord Alexandre Flament, Argenteuil, in lieu of rent, 1878, until 1884; bought back by Monet in 1884 (at this date Monet cut the canvas into several pieces [see cat. 122]), until his death in 1926; by descent to his son Michel Monet (1878–1966), Giverny, 1926, until at least 1931; private collection, Paris; acquired in lieu of state taxes by the Musée d'Orsay, 1987

EXHIBITIONS: Paris, Musée de l'Orangerie, December 7, 1940–March 18, 1941, *Centenaire Monet-Rodin*, no. 2; Paris 1980, no. 6, repr.

SELECTED REFERENCES: Maurice Guillemot, "Claude Monet," *Revue illustrée*, no. 7 (March 15, 1898); G. Jean-Aubry, "Une visite à Giverny: Eugène Boudin et Claude Monet," *Le Havre-Éclaire*, August 1, 1911, p. 1; Alexandre 1921, p. 43; Geffroy 1922, p. 29; Trévise 1927, p. 121, repr. p. 45; Reuterswärd 1948, p. 280; Sarraute 1958, p. 48, repr. p. 47; Seitz 1960, pp. 17, 21, 67, repr. pp. 20, 66; Gimpel 1963, p. 179; Linda Nochlin, *Realism* (London, 1971), pp. 139–47, 261, no. 77, fig. 77; Isaacson 1972, pp. 66–77, figs. 2, 35, 38; Champa 1973, pp. 6–8, 27, fig. 12; Isaacson 1978, pp. 14, 195–96, no. 9, pl. 9; Herbert 1988, pp. 174–77, pl. 139; Isabelle Compin,

Geneviève Lacambre, and Anne Roquebert, *Musée d'Orsay: Catalogue sommaire illustré des peintures, M–Z* (Paris, 1990), p. 337; Spate 1992, pp. 31–34, 35, 37, 38, 39, 40, 42, 269, pl. 29

These two fragments are all that remain from Monet's enormous canvas of over four by six meters, *Le Déjeuner sur l'herbe*, the studies for which he began at Chailly-en-Bière in summer 1865. He abandoned the large canvas, incomplete, just before the opening of the Salon of 1866, when he turned his attention to *Camille (La Femme à la robe verte)* (fig. 236). He kept the rolled canvas with him until 1878, when he gave it up.[1] In an interview with the duc de Trévise in 1920, Monet explained what had happened. "Since I had to pay my rent, I gave it as a pledge to the landlord, who rolled it up in his basement. When, at last, I had the means to get it back, you can imagine that it had had time to mildew."[2] He retrieved the canvas in 1884,[3] cut out these two sections as well as a third—the group at the base of the tree —and disposed of the rest. The third section has been lost, and the central section has been trimmed at the right, probably after Monet's death. A photograph taken during the duc de Trévise's visit in 1920 shows that the central section included the head and shoulders of the woman in the striped muslin dress trimmed in green seated at far right, as well as a ghostly pentimento of her bust and head in a more upright position. This passage has since been cut away.

All indications seem to suggest that Monet transferred every element from the Pushkin sketch (fig. 170) quite literally onto his large canvas. As he told Trévise, "I proceeded, as everyone did then, with small studies after nature and I composed the whole in my studio."[4] He attempted as well to transfer the spontaneous touch of the studies to the big picture, producing blotches of color so large that the final appearance must have resembled scenic painting for the stage.

The fawn-colored dress of the figure in the vertical remnant and the striped muslin dress at the right of the square remnant remain unfinished, for Monet continued to revise the hem lengths and change other details, but the rest of the canvas seems complete and thus accurately reflects Monet's intention. He began to alter the color and design of the dress on the first female figure at the left, now gray and red, which in the original studies was gray with black trim. X rays reveal that he changed the hat as well from that seen in the Pushkin sketch to the one visible now.

The most significant change was the replacement of the slender man at the left edge of the tablecloth in the Pushkin sketch with the burly, bearded figure in the Orsay canvas. Observers long ago noticed that the bearded man resembled Courbet, and it seems likely that Monet intended the resemblance to be noticed. Courbet visited the studio Monet and Bazille shared in the winter of 1865–66 and commented approvingly on the *Déjeuner*. "Master Courbet . . . paid us a visit to see Monet's painting, and he was delighted by it," wrote Bazille to his brother.[5] Gustave Geffroy,

a writer well acquainted with Monet, wrote that Courbet suggested some changes to the *Déjeuner* that Monet obligingly made, only to regret them later.[6] Disappointed that he was unable to complete the huge canvas in time for the Salon, Monet wrote Amand Gautier in April 1866 from his newly rented quarters in Sèvres that he had decided "to leave aside, for the time being, all my large works in progress that would only make me eat up money and put me in a tight spot."[7]

G.T.

1. Joel Isaacson has made it clear that Monet kept the canvas until 1878, when it was ceded to his landlord in Argenteuil, Alexandre Flament. Monet asked Durand-Ruel to negotiate the return of the canvas in March 1884. See Isaacson 1972, p. 95, n. 2.
2. "Je devais payer mon loyer, je l'ai donné en gage au propriétaire qui l'a roulé dans sa cave, et quand, enfin, j'ai eu de quoi le retirer, vous voyez s'il avait eu le temps de moisir." Quoted in Trévise 1927, p. 122.
3. Venturi 1939, vol. 1, p. 274.
4. "je procédais, comme chacun alors, par des petites études sur nature et je composais l'ensemble dans mon atelier." Trévise 1927, p. 122.
5. "Maître Courbet... est venu nous faire une visite pour voir le tableau de Monet, dont il a été enchanté." Bazille 1992, no. 74, p. 116. Courbet returned to Paris from Trouville on November 20, 1865, the terminus post quem for this letter.
6. Geffroy 1922, p. 30.
7. "laisser de côté pour le moment toutes mes grandes choses en train qui ne feraient que me manger de l'argent et me mettraient dans l'embarras." Wildenstein 1974, letter 25, p. 423.

124 *Fig. 108*

Claude Monet
Rue de la Bavolle, Honfleur
1866
Oil on canvas
22 x 24 in. (55.9 x 61 cm)
Signed lower left: *Claude Monet*
Museum of Fine Arts, Boston, Bequest of John T. Spaulding 48.580

CATALOGUE RAISONNÉ: Wildenstein 1974, no. 33

PROVENANCE: Possibly Frédéric Bazille, Paris, by 1867;[1] M. Diot, Paris; his posthumous sale, Hôtel Drouot, Paris, March 8–9, 1897, no. 102 ("Une rue"); Arthur Tooth, London, until 1902; sold to Durand-Ruel, Paris, November 21, 1902, until 1912; sold to Thannhauser, Munich, August 12, 1912; Oskar Schmitz, Dresden, by 1921; John T. Spaulding, Boston, ca. 1946; his gift to the museum, 1948

EXHIBITIONS: Weimar, Grossherzögliches Museum, 1905, *Monet*, no. 12; Berlin, Galerien Thannhauser, mid-February–March 1928, *Claude Monet (1840–1926)*, no. 7, repr.; Manchester, New Hampshire, Currier Gallery of Art, October 8–November 6, 1949, *Monet and the Beginnings of Impressionism*, no. 34, repr.; Zurich, Kunsthaus, May 10–June 15, 1952, *Claude Monet: 1840–1926*, no. 3, repr.; The Hague, Gemeentemuseum, July 24–September 22, 1952, *Claude Monet*, no. 2; Edinburgh, London 1957, no. 8, pl. 16d; Chicago 1975, no. 5, pl. 11; Boston 1977–78, no. 2, repr.; Paris 1980, no. 13, repr.

SELECTED REFERENCES: Georg Biermann, "Die Kunst auf dem Internationalen Markt. 1. Gemälde aus dem Besitz der modernen Galerie Thannhauser, München," *Der Cicerone* 5 (1913), p. 325, fig. 21; Karl Scheffler, "Die Sammlung Oscar Schmitz in Dresden," *Kunst und Künstler* 19 (1921), p. 186, repr. p. 178; Marie Dormoy, "La collection Schmitz à Dresde," *L'Amour de l'art* 7 (1926), p. 342; Malingue 1943, pp. 22, 145, no. 33, repr. p. 33; Seitz 1960, pp. 19, 22, figs. 15, 16; Champa 1973, p. 60, n. 5; Rewald 1973, repr. p. 128; Isaacson 1978, pp. 194–95, no. 7, repr.; Distel in Paris 1980, pp. 76–77, no. 13, repr.; Paul Hayes Tucker, *Monet at Argenteuil* (New Haven and London, 1982), pp. 27, 29, fig. 12; Isaacson 1984, pp. 19, 20–22, fig. 2

As Douglas Cooper suggested in 1957,[2] this work may well have been painted during Monet's stay in Honfleur in late 1866 instead of 1864, the date it is more commonly given. Many factors argue for 1866: the confident execution, the great contrast between light and shade, the heavy paint and somewhat blocky brushstrokes all point to the accomplished painter of 1866 rather than the more timid and searching painter of 1864. Nevertheless the clear sky and light tonality is more typical of Monet's earlier work. Further support for a date in 1864 can be found in the fact that this picture and the nearly identical canvas in Mannheim (cat. 125) constitute a pair, and in 1864 Monet painted two other pairs of pictures— *Chantier des petits navires* (*Yard of the Small Boats*, Wildenstein 26, 27) and *Pointe de la Hève* (Wildenstein 39, 40). It is at present impossible to be conclusive about the date.

There is an inherent affinity between this work (and its cognate in Mannheim) and the early work of Corot and his associates, such as Théodore Caruelle d'Aligny. Monet seems to evoke the bright light, deep shadows, clarity of depiction, and fidelity to topography found in the small studies that Corot and d'Aligny made in Italy and France in the late 1820s and early 1830s. Monet suggested to Bazille in a letter of 1864 that Bazille might see a resemblance to Corot's work in one of the paintings Monet was sending to him (we do not know which canvas this was): "You may find in it a certain relationship to Corot, but without imitating him in any way. The motif and above all the quiet and vaporous effect are the reasons for this."[3] Monet's adjectives, "quiet and vaporous," point to late rather than early Corot, and it was not certain at this time that Monet had ever seen early works by Corot. It is true, however, that Monet's method at this point was similar to that of the young French artists who made outdoor sketches in the 1830s, and the similarity may be more a result of common purpose and method than self-conscious emulation.

The newly assertive structure of the composition may reveal the effect of Jongkind's advice, for Monet and Jongkind worked together closely in Honfleur in 1864.

G.T.

1. Either this work or cat. 125 below figures in Bazille's *L'Atelier de la rue La Condamine* (cat. 12).
2. Cooper in London 1957, no. 8, p. 41. Anne Distel concurred with this date in Paris 1980, no. 13, p. 76.
3. "Vous y trouverez peut-être un certain rapport avec Corot, mais c'est bien sans imitation aucune qu'il en est ainsi. Le motif et surtout l'effet calme et vaporeux en est seul la cause." Monet to Bazille, October 14, 1864. Wildenstein 1974, letter 11, p. 421.

125 *(not in exhibition)* *Fig. 109*

Claude Monet
Rue de la Bavolle, Honfleur
1866
Oil on canvas
22⅞ x 24¾ in. (58 x 63 cm)
Signed lower right: *Claude Monet*
Städtische Kunsthalle, Mannheim 299

CATALOGUE RAISONNÉ: Wildenstein 1974, no. 34

PROVENANCE: Possibly Frédéric Bazille, Paris, by 1867;[1] Bernheim-Jeune, Paris, 1900, until 1910; sold to Paul Cassirer, Berlin, February 14, 1910; acquired by the museum, 1911

SELECTED REFERENCES: Julius Meier-Graefe, *Entwicklungsgeschichte der modernen Kunst* (Berlin, 1914–15), vol. 2, pl. 372; Marie Dormoy, "La collection Schmitz à Dresde," *L'Amour de l'art* 7 (1926), p. 342; Reuterswärd 1948, p. 281; Champa 1973, p. 60, n. 5; Isaacson 1978, pp. 194–95, no. 6, repr.; Distel in Paris 1980, p. 76; Isaacson 1984, pp. 20–22, fig. 3

With the exception of the figures, this painting is virtually identical to the canvas in Boston (cat. 124). Both are painted in the same style and thus were probably made at the same time. Anne Distel has remarked that in the 1860s Monet often made a study before nature which he followed with a studio copy of the same composition,[2] but in this instance both paintings are equally finished. Thus this work and the Boston painting conform instead to a practice, described in detail by Joel Isaacson,[3] unique to Monet's early years: the artist made two very similar pictures of the same scene for reasons that are not immediately identifiable. In other examples, such as the two paintings of the *Pointe de la Hève* (Wildenstein

39, 40), Monet conveyed a sense of changing time—low tide versus high tide. But in the two paintings of the *Lieutenance à Honfleur* (Wildenstein 31, 32), there is little difference apart from the orientation of Monet's canvas. And in the paintings of the *Rue de la Bavolle*, there is no implied narrative. The citizens come and go without doing much, and apart from the shift in the midday shadows, which Joel Isaacson believes represents about a fifteen-minute difference between the Boston painting and this one, there is no substantive change between the two pictures. One cannot be called an improvement over the other.

<div style="text-align:right">G.T.</div>

1. Either this work or cat. 124 figures in Bazille's *L'Atelier de la rue La Condamine* (cat. 12).
2. Distel in Paris 1980, no. 13, p. 76.
3. Isaacson 1984, pp. 16–35.

126 *Fig. 86*

Claude Monet
Le Port de Honfleur
1866
Oil on canvas
19¼ x 25⅝ in. (48.8 x 65.1 cm)
Signed lower right: *Claude Monet*
Private collection

CATALOGUE RAISONNÉ: Wildenstein 1991, no. 2044-77 bis

PROVENANCE: Possibly the dealer Alphonse Portier (1841–1902), Paris; Alexander J. Cassatt (1839–1906), Philadelphia (possibly the "Marine" purchased for him by his sister Mary Cassatt for Fr 800), by April 18, 1881;[1] by inheritance to his daughter Mrs. William Plunket Stewart, Unionville, Pennsylvania; by descent to Mr. and Mrs. William Potter Wear, Penllyn, Pennsylvania; by descent to Elsie Cassatt Stewart Simmons, Philadelphia; sold at Christie's, New York, November 5, 1991, no. 26 ("Property from the Estate of Elsie Cassatt Stewart Simmons, Philadelphia")

EXHIBITION: Philadelphia, Pennsylvania Academy of the Fine Arts, April–May 1920, *Paintings and Drawings by Representative Modern Masters*, no. 173

In the winter of 1866–67, Monet made several studies of fishing boats in the harbor of Honfleur in preparation for a very large picture (148 x 226 cm), *Port de Honfleur* (destroyed? Wildenstein 77), intended for the 1867 Salon. The painting was rejected, but Monet submitted it to the Exposition Maritime Internationale du Havre the next year and received a silver medal. It subsequently belonged to his patron Louis Gaudibert

and the great collector Jean-Baptiste Faure, but it disappeared from the Arnhold collection in Berlin during the Second World War. For this reason the painting has not been seen for several generations, but it probably shared the exquisite tan, gray, and pale blue palette of the present picture, a bold and free rendering of a subject favored by Jongkind (see cat. 81). Zola was probably thinking of the large painting when he wrote, "There is a first rank seascape painter in him. But he interprets the genre in his own way, and I see this as further proof of his intense love for the reality of the present. One can always see in his seascapes some part of a pier, the corner of a wharf, something that indicates a date and a place.... Besides, he loves the water as a mistress, he knows each piece of a ship's hull and could name any rope of the masting."[2]

The present painting may be the work bought by Mary Cassatt for her brother Alexander Cassatt, president of the Pennsylvania Railroad. When their father wrote Alexander on April 18, 1881, to report the acquisition, he said, "Well you must know that in addition to the Pissaro [*sic*], of which she wrote you she has bought you a marine by Monet for 800 fcs—It is a beauty, and you will see the day when you will have an offer of 8000 for it."[3]

<div style="text-align:right">G.T.</div>

1. Letter from Robert Cassatt to Alexander Cassatt, April 18, 1881, in Nancy Mowll Mathews, *Cassatt and Her Circle: Selected Letters* (New York, 1984), p. 161.
2. "Il y a en lui un peintre de marines de premier ordre. Mais il entend le genre à sa façon, et là encore je trouve son profond amour pour les réalités présentes. On aperçoit toujours dans ses marines un bout de jetée, un coin de quai, quelque chose qui indique une date et un lieu.... D'ailleurs il aime l'eau comme une amante, il connaît chaque pièce de la coque d'une navire, il nommerait les moindres cordages de la mâture." Zola, "Mon Salon: Les actualistes," 1868, in Zola 1991, p. 208.
3. Mathews, *Cassatt and Her Circle*, p. 161.

127 *Fig. 303*

Claude Monet
La Vague verte
(*The Green Wave*)
1866–67
Oil on canvas
19⅛ x 25½ in. (48.6 x 64.8 cm)
Signed and dated, at a later date, lower right: *Cl. Monet 65*.

The Metropolitan Museum of Art, New York, H. O. Havemeyer Collection, Bequest of Mrs. H. O. Havemeyer, 1929 29.100.111

CATALOGUE RAISONNÉ: Wildenstein 1974, no. 73

PROVENANCE: Possibly Théodore Duret, Paris, in 1879; M. Oudard, until 1882; purchased by Durand-Ruel, Paris, for Fr 150, July 19, 1882, until 1883 (stock no. 2512, "Marine"); sold to Mary Cassatt, Paris, for Fr 800, for her brother Joseph Gardner Cassatt (1849–1911), October 8, 1883; J. Gardner Cassatt, Philadelphia, from 1883, until 1898; Durand-Ruel, New York, received on deposit from Cassatt on February 2, 1898 (dep. no. 5658, as Marine), purchased from Cassatt on July 1, 1898, for $1,000 (stock no. 2012, as Marine); sold to Henry O. and Louisine Havemeyer, New York, for $1,000, July 1, 1898, until 1929; her bequest to the museum, 1929

EXHIBITIONS: (?) Paris, 28, avenue de l'Opéra, April 10–May 11, 1879, *4me exposition de peinture*, no. 140 ("Marine" [1875], lent by M. Duret; New York 1930, no. 81, repr.; New York, Metropolitan Museum of Art, May 14–September 30, 1934, *Landscape Paintings*, no. 49; Manchester, New Hampshire, Currier Gallery of Art, October 8–November 6, 1949, *Monet and the Beginnings of Impressionism*, no. 32; New York 1993, no. A387, repr.

SELECTED REFERENCES: (?) Armand Silvestre, in *L'Estafette*, April 16, 1879, p. 3; (?) Armand Silvestre, in *La Vie moderne*, April 24, 1879, p. 38; Frank Jewett Mather, Jr., "The Havemeyer Pictures," *The Arts* 16 (March 1930), repr. p. 459; Harry B. Wehle, "The Exhibition of the H. O. Havemeyer Collection," *Bulletin of the Metropolitan Museum of Art* 25 (March 1930), p. 56; Stephen Gwynn, *Claude Monet and His Garden* (London, 1934), p. 168; Isaacson 1967, pp. 81–82, 169, 296–97, n. 47, p. 301, n. 25, p. 323, n. 4; Sterling and Salinger 1967, p. 124, repr.; Cooper 1970, pp. 282–83, 304–5, fig. 2; Grace Seiberling, *Monet's Series*, Ph.D. diss., Yale University, New Haven, 1976 (New York and London, 1981), p. 305, n. 31; Moffett 1985, pp. 104–5, 251, repr.; House 1986, p. 238, n. 7; Pickvance in Washington, San Francisco 1986, pp. 259, 265, nn. 94, 95, p. 268, n. 140, p. 269, no. 140, repr.; Frances Weitzenhoffer, *The Havemeyers: Impressionism Comes to America* (New York, 1986), pp. 135, 257, pl. 97

This may well be the *Marine* that Monet exhibited as number 140 in the 1879 Impressionist exhibition. Although the exhibition catalogue gives a date of 1875 for the painting, this was probably a typographical error. As Ronald Pickvance has recognized, the description of the painting in Armand Silvestre's contemporary reviews appears to identify this work: "his *Barque de pêcheurs sur une grosse mer* [*Fishing Boat on a Rough Sea*], and there, he was directly influenced by Manet";[1] and "his *Barque de pêcheurs* (no. 141) [*sic*], a very beautiful seascape summarily executed."[2]

Silvestre's remarks point to the most salient feature of this painting: its broad brushwork and its resemblance to Manet's work of this date. The closest analogue, Manet's 1864 *Combat des navires américains "Kearsarge" et "Alabama"* (cat. 99), was not shown at the Salon until 1872, and Monet was not in Paris when Cadart exhibited it in 1864. It is often thought that he saw it, or the related painting *Le "Kearsarge" à Boulogne* (cat. 100), at the Martinet exhibition in Paris in February 1865.[3] However, while it is known from Manet's draft exhibition list for Martinet's that he intended to display the marines, contemporary reviews suggest that he sent only a still life.[4] It seems likely,

then, that Monet saw Manet's marines at his special exhibition of 1867, the same year in which there was a large exhibition of Japanese art mounted in Paris. If this is true, then the present picture probably dates to 1867, and not 1865. Monet frequently misdated pictures when he retrospectively inscribed them.

It is difficult to imagine Monet inventing *La Vague verte* without having seen the dense green sea painted with thick brushstrokes in Manet's *Combat*. It would be natural for the young Monet to measure his skill against that of Manet, and here he comes very close. Even the dark gray of the wet sails and the manner in which the sky is painted is common to both. And both seem equally to refer to Japanese color woodblock prints. The high horizon line and disproportionate scale of sea to ship is frequently encountered in early nineteenth-century prints. Katsushika Hokusai's *Under the Wave off Kanagawa*, about 1829 (Musée Claude Monet, Giverny), is especially close to Monet's composition, and he may have been consciously quoting from it. In his remarks to Marc Elder in 1924, Monet recalled that he had begun to collect Japanese prints when he was quite young: "The purchase of my first prints dates to 1856. I was sixteen years old!"[5]

G.T.

1. "sa *Barque de pêcheurs sur une grosse mer*, et là, procède-t-il directement de Manet." Armand Silvestre, in *La Vie moderne*, April 14, 1879, quoted by Pickvance in Washington, San Francisco 1986, p. 265.
2. "sa *Barque de pêcheurs* (no. 141), une très belle marine exécutée sommairement." Armand Silvestre, in *L'Estafette*, April 16, 1879, quoted by Pickvance in Washington, San Francisco 1986, p. 265.
3. Isaacson 1967, p. 296, n. 46.
4. See Tabarant 1931, p. 123.
5. "L'achat de mes premières estampes datent de 1856. J'avais seize ans!" Elder 1924, p. 64.

CATALOGUE RAISONNÉ: Wildenstein 1974, no. 71

PROVENANCE: Possibly included among the series of "Marines" sold by the artist to Durand-Ruel, Paris, between 1872 and 1877; D. McCorkindale, Carfin Hall, Lanarkshire, until 1903; his sale, Morrison, Dick and McCulloch, Glasgow, November 6–7, 1903, no. 62 ("Sea-piece with Shipping—Moonlight"); William Robertson, Paisley, by ca. 1903, until it was sold as "The property of The William Robertson Charitable Trust, Glasgow," 1980; sold, Christies, London, June 30, 1980, no. 8 ("Marine, Effet de Nuit"); purchased at this sale by Lefevre Gallery, London, for the National Galleries of Scotland, Edinburgh

EXHIBITION: Edinburgh 1986, no. 73, repr.

SELECTED REFERENCE: House 1986, p. 238, n. 7

Like *La Vague verte* (cat. 127) and *Marine: orage* (cat. 129), this painting was executed with a palette knife. But because the execution is so much more summary, the work seems more daring and thus more dramatic. The dark gray-blue sky, for example, appears much less finished than the sky in the other two daytime marines. Monet exploited the effects that can be obtained with thickly applied paint by creating sharp contrasts of value: the bright moonlight is visible only in narrow ribbons at the edges of the dark clouds or reflected in the sea. Although it is somewhat larger, this canvas may have been conceived as a nocturnal pendant to *L'Entrée du port de Honfleur* (fig. 417). Both of these works, in turn, share motifs with the large *Navires Sortant des jetées du Havre* (see figs. 418, 419), which Monet exhibited at the 1868 Salon and then later destroyed.

Jongkind had executed several nocturnal marines, but it seems more likely that Japanese color woodblock prints and the nocturnes of Whistler, which were themselves influenced by Japanese art, provided Monet with inspiration. About nocturnes, Monet said to an American in 1899, "I greatly admire moonlights and from time to time have made studies of them; but I have never finished any of these studies because I found it so difficult to paint nature at night. Some day, however, I may finish such a picture."[1]

Because it could not have been painted out-of-doors at night, this work, like the other two palette-knife pictures, may have been executed in the studio. Only one other nocturnal marine by Monet is known, a view of the port of Le Havre of 1873 now in a New York collection (Wildenstein 264).

X rays have revealed that this work was painted over a still life with a jug.

G.T.

1. Fuller 1899, p. 24.

128

Fig. 304

Claude Monet

Marine: effet de nuit
(*Seascape, Shipping by Moonlight*)
1866–67
Oil on canvas
23⅝ x 29 in. (60 x 73.8 cm)
Inscribed and dated on stretcher in a later hand: *Claude Monet 1864 / "Marine, temps . . . , Port du Havre"*
National Galleries of Scotland, Edinburgh NG 2399

Fig. 417. Claude Monet, *L'Entrée du port de Honfleur* (*The Entrance to the Port of Honfleur*), ca. 1868. Oil on canvas, 19¾ x 24 in. (50 x 61 cm). The Norton Simon Foundation, Pasadena

129 *Fig. 302*

Claude Monet
Marine: orage
(*Seascape: Storm*)
1866–67
Oil on canvas
19³/₁₆ x 25½ in. (48.9 x 64.8 cm)
Signed lower right: *Claude Monet*
Sterling and Francine Clark Art Institute, Williamstown,
Massachusetts 561

CATALOGUE RAISONNÉ: Wildenstein 1974, no. 86

PROVENANCE: Andrew Bain, Glasgow, by 1901 (possibly
purchased from Alexandre Reid, Glasgow); Étienne
Moreau-Nélaton, Paris; Durand-Ruel, Paris, 1906; Frank-
furter Kunstverein, by 1912; possibly D. S. MacColl, Glas-
gow; Fine Arts Associates, New York, until 1950; sold to
M. Knoedler and Co., New York, October 1950, until
January 1951 (stock no. A 4449); sold to Robert Sterling
Clark, New York, January 1951; Sterling and Francine
Clark Art Institute, 1955

EXHIBITIONS: Glasgow, International Exhibition, 1901, *19th
Century Art*, no. 1311 ("The Freshening Breeze"); Saint
Petersburg, Institut français, 1912, *Exposition centennale
de l'art français*, no. 440; Williamstown, Sterling and
Francine Clark Art Institute, May 8, 1956, *Exhibit 5:
French Paintings of the 19th Century*, no. 117, pl. 34

SELECTED REFERENCES: D. S. MacColl, *Nineteenth Century
Art* (Glasgow, 1902), p. 162, repr.; René Jean, *L'Art
français à Saint-Pétersbourg: Exposition Centennale
sous les auspices de S.A.I. le grand-duc Nicolas
Mikhaïlovitch* (Paris, 1912), pp. 69, 83; Douglas Cooper,
Courtauld Collection (London, 1954), p. 65; John H.
Brooks, *List of Paintings in the Sterling and Francine
Clark Art Institute* (Williamstown, Mass., 1984), p. 26,
fig. 225; House 1986, pp. 75, 238, n. 7, fig. 113

Marine: orage, La Vague verte (cat. 127), and
Marine: effet de nuit (cat. 128) are not only sim-
ilar in size and subject, they are similar in tech-
nique. They may be the only surviving works by
Monet that were executed with a palette knife.[1]
Palette-knife technique was, in the mid-1860s,
inextricably linked with Courbet, whose exam-
ple began to affect Monet significantly in early
1866, while he was attempting to complete the
Déjeuner sur l'herbe (cats. 122, 123). One can cite
other important influences, however, that are
evident in these pictures: Manet and Japanese
prints. It seems likely that all three of Monet's
palette-knife pictures were made after the artist
had the opportunity to see the exhibitions Courbet
and Manet independently set up in 1867, and after
he had viewed the large display of Japanese art
created for the 1867 Exposition Universelle, which
opened on the first of April. Monet wrote Bazille
that he was looking forward to the Manet and
Courbet exhibitions, and described them in a sec-
ond letter. "When I left [Paris], Manet's box office
was becoming more successful, which will have
done him the world of good, and also there are
good things I did not know...."[2] Monet stayed in
Paris from late 1866 until June 1867, when he
returned to the Channel coast. These paintings
were thus probably executed sometime between
June 1867 and early 1868.

The three palette-knife pictures also relate to
the painting Monet sent to the Salon of 1868,
Navires sortant des jetées du Havre. The sail-
boat in the present painting was depicted by
Monet in *L'Entrée du port de Honfleur* (fig. 417),
which in turn served as a study for *Navires sortant*.
The large Salon picture was destroyed by Monet
and is known only through caricatures and con-
temporary descriptions (see figs. 418, 419).

G.T.

1. House 1986, p. 238, n. 7.
2. "Quand je suis parti, les recettes de Manet commençait
à devenir plus serieuses, à lui cela aura fait grand bien,
et puis il y a des choses bien que je ne connaissais pas...."
Monet to Bazille, Sainte-Adresse, June 25, 1867, Wilden-
stein 1974, letter 33, p. 424.

130 *Fig. 175*

Claude Monet
Femmes au jardin
(*Women in the Garden*)
1866–67
Oil on canvas
100³/₈ x 80³/₄ in. (255 x 205 cm)
Signed lower right: *Claude Monet*
Musée d'Orsay, Paris RF 2773

CATALOGUE RAISONNÉ: Wildenstein 1974, no. 67

PROVENANCE: The artist, until May 1867; sold to Frédéric
Bazille for Fr 2,500, May 1867, until his death in 1870;[1]
by inheritance to his parents, M. and Mme Gaston Bazille,
Méric, 1870–76; exchanged with Édouard Manet, for
Renoir's *Frédéric Bazille peignant Le Héron* (cat. 172),
in 1876; returned to Monet in exchange for Manet's
Camille au Jardin d'Argenteuil in 1876, until 1881; put
on deposit with Durand-Ruel, 1882–87; purchased from
Monet by the state for the Musée du Luxembourg, Paris,
1921; transferred to the Musée du Louvre, Paris, 1929;
transferred to the Jeu de Paume, Paris, 1947; trans-
ferred to the Musée d'Orsay, 1986

EXHIBITIONS: Refused at the Salon of 1867; (?) Paris,
Latouche, 34, rue Lafayette, Spring 1867;[2] (?) Paris,
"Un tout petit marchand," rue Auber, Spring 1867;[3]
Paris, Galerie Georges Petit, January 4–18, 1924, *Claude
Monet*, no. 1; Paris 1931, no. 9, repr.; Chicago 1975,
no. 7, repr.; Paris 1980, no. 9, repr.

Fig. 418. Bertall, *Le Navire de l'estaminet
hollandais (Palais Royal) par M. Monet* (*The
Dutch Tavern Ship [Royal Palace] by M. Monet*),
1868. Caricature published in *Journal amusant*,
no. 649 (June 6, 1868), p. 2

Fig. 419. *Monet—La sortie du port*
(*Monet—Leaving the Port*), 1868.
Caricature published in *Le Tintamarre*,
June 18, 1868, p. 4

SELECTED REFERENCES: Zola, "Mon Salon: Les actualistes," 1868, in Zola 1991, p. 209; Fuller 1899, p. 11; Thiébault-Sisson 1900, p. 3; Louis Vauxcelles, "Chez les peintres; Un après-midi chez Claude Monet," *L'Art et les artistes* 2 (December 1905), p. 86, repr. facing p. 88 ("L'Été"); W. Pach, "At the Studio of Claude Monet," *Scribner's Magazine*, June 1908, p. 766; G. Jean-Aubry, "Une visite à Giverny: Eugène Boudin et Claude Monet," *Le Havre-Éclaire*, August 1, 1911, p. 1; Geffroy 1920, repr. p. 54; Alexandre 1921, pp. 47, 48, 54, pl. 14; Jean-Aubry 1922, p. 64; Geffroy 1922, pp. 36–37, 105, 263, 329, repr. facing p. 48; Elder 1924, p. 71, pl. 4; Fels 1925, p. 2; Gustave Geffroy, "Claude Monet et l'impressionnisme," *L'Art vivant*, January 1, 1925, p. 2; René Chavange, "Claude Monet," *Le Figaro artistique*, December 16, 1926, pp. 147, 148; Louis Gillet, *Trois variations sur Claude Monet* (Paris, 1927), pp. 48–54; Raymond Koechlin, "Claude Monet 1840–1926," *Art et décoration* 51 (February 1927), pp. 36–38; Trévise 1927, pp. 122–24, repr. facing p. 124; Gaston Poulain, "L'Origine des *Femmes au jardin* de Claude Monet," *L'Amour de l'art*, no. 3 (March 1937), pp. 89–92, repr.; Charles Sterling and Hélène Adhémar, *Musée du Louvre: Peintures école française, XIXeme siècle*, 4 vols. (Paris, 1960), no. 1351, pl. 502; Mark Roskill, "Early Impressionism and the Fashion Print," *Burlington Magazine* 112 (June 1970), p. 391; Isaacson 1972, pp. 24, 50, 52, 57, 80–88, 91, 111–13, 115, fig. 45; Champa 1973, pp. 4, 10–14, 22, 25, 30, 46–50, 86–88, pl. 2; Rewald 1973, pp. 150, 165–69, 193, n. 20, repr. p. 160; Isaacson 1978, pp. 14–15, 16, 17, 19, 21, 194, 195, 196, 198, 200, nos. 12, 13, pls. 12, 13; Distel in Paris 1980, pp. 68–70, no. 9, repr.; House 1986, pp. 34, 47, 111, 114, 135–36, 147, 178, 205, pl. 64; Herbert 1988, pp. 177–80, 182, 186, 292, pl. 181; Spate 1992, pp. 39–40, 42, 43, 46, 56, 77, 275, 280, 314, pl. 36

Monet's disappointment in finding himself unable to complete the *Déjeuner sur l'herbe* (see cats. 122, 123) was more than compensated for by the success of *Camille* (fig. 236) at the Salon of 1866. He wrote Amand Gautier from Ville-d'Avray, near Sèvres, on May 22, 1866: "I am increasingly happy; I have decided to retreat to the country; I work a lot with more resolution than ever."[4] Hoping to realize the ambitions he had held for the *Déjeuner sur l'herbe*, he threw himself into work on the present canvas, another scene of fashionably dressed people enjoying themselves at leisure, painted this time near lifesize, out-of-doors.

Late in life, Monet explained the method he devised to work on this huge canvas. "This work I actually painted on the spot and after nature, which had not been done before. I had dug a hole in the ground, a sort of ditch, to lower my canvas gradually when I came to paint the top. I was working at Ville-d'Avray, where from time to time I had advice from Courbet, who came to visit me."[5] Working out-of-doors on a figure painting was Monet's innovation, and many of the older artists of his acquaintance were skeptical. Once when Courbet stopped to visit and saw that Monet was not working, he cynically suggested that Monet work on the landscape even though the day was overcast. Dubourg wrote Boudin: "Monet is still here working on enormous canvases which show remarkable qualities, but which I find inferior, or less successful than the famous *Robe* [*Camille (La Femme à la robe verte)*, fig. 236] that brought him an understandable and well-deserved success. He has a work of nearly three meters in height and proportionate width; the figures are somewhat smaller than lifesize and represent well-dressed women picking flowers in a garden. This canvas was begun after nature and in the open air. It has good qualities, but the effect seems a bit weak, no doubt because of the lack of contrast, for the color is strong."[6]

Needless to say, the Salon jury refused the painting. Monet later recalled, "After being so favorable at first, the jury turned against me, and I was ignominiously blackballed when I presented this new painting at the Salon."[7] Zola reviewed the work the following year, even though it was not exhibited. "Last year, a figurative painting by him was rejected, representing women in light summer dresses picking flowers in the allées of a garden; the sun was aiming directly at the strikingly white skirts; the lukewarm shadow of a tree created a large area of gray on the allées and sunlit dresses. A very strange effect was thus produced. One must love his epoch very dearly to dare such a tour de force, fabrics divided in two by shade and sun, well-dressed women in a bed of flowers carefully groomed by a gardener's rake."[8]

In 1937 Gaston Poulain published photographs (fig. 420) of three of Bazille's cousins in the garden at Méric which may have inspired the present composition.[9] But far more influential, as Mark Roskill has shown, were the contemporary fashion magazines that Monet doubtlessly consulted.[10] Roskill has identified plates in *Le Monde élégant* and *Petit Courier des dames* that are similar to the poses or costumes of the women in *Camille*,

Fig. 420. Pauline, Thérèse, and Camille des Hours on the terrace at Méric, ca. 1866. Photograph published in Gaston Poulain, "L'Origine des *Femmes au jardin* de Claude Monet," *L'Amour de l'art*, no. 3 (March 1937), p. 91

Déjeuner sur l'herbe (cats. 122, 123), and the present painting, *Femmes au jardin*. In addition, as Roskill states, the general flatness of the style of depiction as well as the psychological disconnection of one figure from another seem to derive from the popular illustrations. Evidently Monet's companion, Camille, posed for the figures on the left, while an unidentified redhead, also recognizable in *Le Déjeuner sur l'herbe*, posed for the figure at right.

After the painting was refused by the Salon, Bazille bought it from Monet for Fr 2,500, paying in monthly installments. It later passed to Manet before Monet received it back in an exchange.

G.T.

1. Purchased by Bazille for Fr 2,500 to be paid in monthly installments of Fr 50. Wildenstein 1974, letter 39, p. 425, pièce justificative 15, p. 444.
2. G. Jean-Aubry, "Une visite à Giverny: Eugène Boudin et Claude Monet," *Le Havre-Éclaire*, August 1, 1911, p. 1.
3. See Trévise 1927, pp. 122–24.
4. "Je suis de plus en plus heureux; j'avais pris le parti de me retirer à la campagne; je travaille beaucoup avec plus de courage que jamais…." Wildenstein 1974, letter 26, p. 423.
5. "Ce tableau, je l'ai vraiment peint sur place et d'après nature, ce qui ne se faisait pas alors. J'avais creusé un trou dans la terre, une sorte de fossé, pour enfouir progressivement ma toile, lorsque j'en peignais le haut. Je travaillais à Ville-d'Avray, où j'avais de temps en temps les conseils de Courbet, qui venait me voir." Trévise 1927, p. 122.
6. "Monet est toujours ici travaillant à d'énormes toiles où il y a des qualités remarquables, mais que je trouve cependant inférieures, ou moins heureuses que la fameuse *Robe* qui lui a valu un succès que je comprends et qui est mérité. Il a une toile de près de trois mètres de haut sur une largeur à proportion; les figures sont un peu plus petites que nature, ce sont des femmes en grande toilette cueillant des fleurs dans un jardin, toile commencée sur nature et en plein air. Il y a des qualités, mais l'effet me semble un peu effacé à cause sans doute du manque d'opposition, car la couleur en est vigoureuse." Dubourg to Boudin, February 2, 1867. Wildenstein 1974, pièce justificative 13, p. 444.
7. "Le jury, qui m'avait si bien accueilli tout d'abord, se retourna contre moi, et je fus ignominieusement blackboulé quand je présentai cette peinture nouvelle au Salon." Thiébault-Sisson 1900, p. 3.
8. "L'année dernière, on lui a refusé un tableau de figures, des femmes en toilettes claires d'été cueillant des fleurs dans les allées d'un jardin; le soleil tombait droit sur les jupes d'une blancheur éclatante; l'ombre tiède d'un arbre découpait sur les allées, sur les robes ensoleillées, une grande nappe grise. Rien de plus étrange comme effet. Il faut aimer singulièrement son temps pour oser un pareil tour de force, des étoffes coupées en deux par l'ombre et le soleil, des dames bien mises dans un parterre que le râteau d'un jardinier a soigneusement peigné." Zola, "Mon Salon: Les actualistes," 1868, in Zola 1991, p. 209.
9. Gaston Poulain, "L'Origine des *Femmes au jardin* de Claude Monet," *L'Amour de l'art*, no. 3 (March 1937), pp. 89–92.
10. Mark Roskill, "Early Impressionism and the Fashion Print," *Burlington Magazine* 112 (June 1970), pp. 391–95.

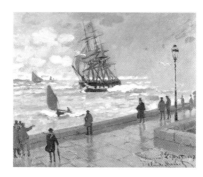

131 (not in exhibition) Fig. 89

Claude Monet

La Jetée du Havre par mauvais temps
(*The Jetty of Le Havre in Bad Weather*)
1867–68
Oil on canvas
20¼ x 24 in. (50 x 61 cm)
Signed, dated, and dedicated at a later date: *à son ami
Lafont 1870 / Claude Monet*
Commendatore Gabriel B. Sabet, Geneva

CATALOGUE RAISONNÉ: Wildenstein 1974, no. 88

PROVENANCE: Gift of the artist to Antoine or Antonin
Lafont (journalist friend of Monet) in 1870;[1] in the fam-
ily until 1969; Lafont sale, Christie's, London, Decem-
ber 12, 1969, no. 50

EXHIBITION: Paris 1980, no. 17, repr.

SELECTED REFERENCES: Isaacson 1978, pp. 16, 198, no. 17,
pl. 17; House 1986, pp. 17, 147, pl. 17

As Anne Distel has proposed,[2] Monet may well
have made this work while he was in Le Havre
from January to early March 1868. The heavily
clothed sightseers and the rough sea they have
come to watch certainly suggest a winter scene.
A journalist named Billot found Monet out paint-

ing in the winter of 1868 on a day that was "cold
enough to split rocks. We perceived a foot warmer,
then an easel, then a gentleman bundled up in
three overcoats, gloves on his hands, his face half
frozen; it was Monet studying an effect of snow....
Art has some courageous soldiers."[3]

This canvas seems to be a study, painted on
the site, that Monet referred to while making a
huge painting with a somewhat different compo-
sition (fig. 421) destined for the Salon of 1868. It
was rejected. Nevertheless, Zola preferred it to
the other marine that was accepted (and later
destroyed; *Navires sortant des jetées du Havre*,
Wildenstein 89). "The other painting by Claude
Monet, the one rejected by the jury and repre-
senting the jetty at Le Havre is perhaps more char-
acteristic. The jetty juts out, long and narrow in
the turbulent sea, and lifts against the pale hori-
zon the thin black silhouettes of a row of lamp-
posts. A few strollers are on the jetty. The wind
blows in from the sea, sharp, bitter, whipping
the women's skirts, scooping out the sea to its
bed, the muddy waves yellowed with sludge from
the bottom breaking against the concrete blocks.
It is these dirty waves, these surges of muddy
water that must have scared the jury accustomed
to the little babbling and sparkling waves of sugar-
candy seascapes."[4]

G.T.

1. Antoine or Antonin Lafont was a witness to Monet and
Camille's wedding, June 28, 1870. Monet most probably
gave this work, as well as *L'Entrée du port de Honfleur*
(fig. 417), to Lafont about the same date as his wedding.
2. Distel in Paris 1980, no. 17, p. 83.
3. "il faisait un froid à fendre les cailloux. Nous apercevons
une chaufferette, puis un chevalet, puis un monsieur
emmailloté dans trois paletots, les mains gantées, la figure
à moitié gelée: c'était M. Monet, étudiant un effet de

neige.... L'art à quelques courageux soldats." Léon Billot,
"Exposition des Beaux-Art," *Journal du Havre*, October 9,
1968. The translation given here is from Stuckey 1985,
p. 40.
4. "L'autre tableau de Claude Monet, celui que le jury a
refusé et qui représentait la jetée du Havre, est peut-être
plus caractéristique. La jetée s'avance, longue et étroite
dans la mer grondeuse, élevant sur l'horizon blafard les
maigres silhouettes noires d'une file de becs de gaz. Quel-
ques promeneurs se trouvent sur la jetée. Le vent souffle
du large, âpre, rude, fouettant les jupes, creusant la mer
jusqu'à son lit, brisant contre les blocs de béton des vagues
boueuses, jaunies par la vase du fond. Ce sont ces vagues
sales, ces poussées d'eau terreuses qui ont dû épouvanter
le jury habitué aux petits flots bavards et miroitants des
marines en sucre candi." Zola, "Mon Salon: Les actua-
listes," 1868, in Zola 1991, p. 209, quoted by Distel in
Paris 1980, p. 84.

132 Fig. 306

Claude Monet

Saint-Germain-l'Auxerrois
1867
Oil on canvas
31⅛ x 38⅝ in. (79 x 98 cm)
Signed and dated, at a later date, lower right: *66 Claude
Monet*
Staatliche Museen zu Berlin, Nationalgalerie NG998

CATALOGUE RAISONNÉ: Wildenstein 1974, no. 84

PROVENANCE: Zacharie Astruc, Paris, before 1872; sold to
Durand-Ruel, Paris, for Fr 400, May 4 or June 4, 1872
(stock no. 1690), until at least 1877;[1] Ernest Hoschedé,
Paris, until 1878; his sale, Hôtel Drouot, Paris, June 5–6,
1878, no. 50 ("Saint-Germain l'Auxerrois"); purchased
by Luq/Luqun (?) for Fr 505;[2] Jean-Baptiste Faure,
Paris, by 1889, until 1906; sold to Durand-Ruel, Paris,
for Fr 12,500, September 22, 1906 (stock no. 2879);[3]
sold to Dr. Hugo von Tschudi, Berlin, for the museum
(with funds provided by Karl Hagen), September 22,
1906, for Fr 33,000

EXHIBITIONS: London, 168 New Bond Street, Durand-
Ruel, Winter 1872, *Fifth Exhibition . . . of the Society of
French Artists*, no. 9 ("St. Germain l'Auxerrois");[4] Paris,
Galerie Georges Petit, June 21–August 1889, *Claude
Monet, Auguste Rodin*, p. 27, no. 2 ("Saint-Germain-
l'Auxerrois, 1866. Appartient à M. Faure"); Paris,
Durand-Ruel, March 19–31, 1906, *Dix-sept tableaux de
Claude Monet de la collection Faure*, no. 2; Paris, Musée
de l'Orangerie, December 7, 1940–March 18, 1941,
Centenaire Monet-Rodin, no. 3; Paris 1980, no. 12, repr.

SELECTED REFERENCES: Pierre Dax, "Chronique," *L'Artiste*,
July 1878, p. 68; J. A. "Beaux-Arts: Exposition de la
Galerie Georges Petit," *Art et Critique*, June 29, 1889,
p. 76; Arsène Alexandre, "Claude Monet et Auguste
Renoir," *Paris*, June 21, 1889; Octave Mirbeau, "Claude
Monet," *L'Art des deux mondes*, March 7, 1891, p. 185;

Fig. 421. Claude Monet, *La Jetée du Havre* (*The Jetty of Le Havre*), 1867–68. Oil on
canvas, 57⅞ x 89 in. (147 x 226 cm). Private collection (© Christie's, New York)

Notice sur la collection Jean-Baptiste Faure, suivie du catalogue des tableaux formant cette collection (Paris, 1902), p. 30, no. 52; W. Weisbach, *Impressionismus* (Berlin, 1910–11), vol. 2, pp. 134, 135, 258, repr. p. 133; Julius Meier-Graefe, *Entwicklungsgeschichte der modernen Kunst* (Berlin, 1914–15), pp. 404, 405, 409, 411, 413, pl. 373; Georges Lecomte, "Claude Monet ou Le vieux Chêne de Giverny," *La Renaissance de l'art français et des industries de luxe* 3 (October 1920), repr. p. 404; Alexandre 1921, p. 34, pl. 3; Geffroy 1922, pp. 117, 261–62, repr. p. 32; Blanche 1927, pp. 562, 570; Raymond Koechlin, "Claude Monet (1840–1926)," *Art et décoration* 51 (February 1927), p. 36; Mauclair 1927, pp. 35, 40, 60, pl. 1; Hans Tietz, "Les peintres français du XIXeme siècle dans les Musées Allemands," *Gazette des Beaux-Arts* 1 (1928), p. 113; Venturi 1939, vol. 1, p. 21, vol. 2, p. 207; Malingue 1943, pp. 23, 145, repr. p. 39; Isaacson 1966, pp. 4–22, fig. 3; Champa 1973, pp. 16–17, fig. 23; Rewald 1973, p. 413, repr. p. 152; Barbara Dieterich, Peter Krieger, Elisabeth Krimmel-Decker, *Nationalgalerie Berlin, Staatliche Museen, Preussischer Kulturbesitz: Verzeichnis der Gemälde und Skulpturen des 19. Jahrundrets* (Berlin, 1976), pp. 289–91, repr. p. 290; Skeggs 1987, pp. 42–45; Herbert 1988, p. 10, fig. 12; Spate 1992, pp. 46–47, pl. 39

In an act that could be viewed as symbolic of the relationship of the young landscape painters to their predecessors, Claude Monet requested permission of Nieuwerkerke, surintendant des Beaux-Arts on April 27, 1867, to paint *outside* the Louvre, in the eastern colonnade, rather than inside the Louvre, for which he already had permission. "Sir...I have the honor of asking you to grant me special authorization to paint some views of Paris from the windows of the Louvre, and particularly the exterior colonnade, in order to do a view of *St-Germain-l'Auxerrois*."[5] Authorization was granted three days later. On May 20, Monet mentioned in a letter to Bazille that he and Renoir were still at work on their city views.[6] With these two documents as evidence, it can be assumed that Monet's three urban views (see also cats. 133, 134) were all made in spring 1867, as was Renoir's analogous painting, *Le Pont des Arts* (fig. 307), rather than 1866, the date Monet later, and erroneously, inscribed on this canvas.[7]

Standing in the colonnade of Claude Perrault's principal facade of Louis XIV's new palace, Monet looked east and painted a view that, with the exception of the large department store, La Samaritaine, lurking behind the church, is little changed today. The point of view is quite normal and unexaggerated, similar to that produced by a camera. Since such street scenes were commonly made by contemporary photographers and were widely distributed, Monet could not have composed this picture without being conscious of photographic effects. On the other hand, the plunging, bird's-eye view of Japanese prints is often thought to have inspired Monet in these urban scenes, and that is the key influence operative here.

The square Monet depicts had recently been made on the site of old buildings razed by Napoléon III as part of his vast plan for urban renewal, and a new *mairie* had been built adjacent to the recently restored Saint-Germain-l'Auxerrois. But to the frustration of modern social historians, Monet eschewed any political commentary and focused instead on the young chestnut

trees with their festive spring candles and the splendid, flamboyant rose window which remains a marvel of medieval art and technology.

G.T.

1. See Callen 1971, p. 319, no. 433, and Distel in Paris 1980, no. 12.
2. See Merete Bodelsen, "Early Impressionist Sales 1874–94 in the Light of Some Unpublished Procès-verbaux," *Burlington Magazine* 110 (June 1968), p. 340.
3. See Callen 1971, p. 319, no. 433.
4. Reprinted in Kate Flint, *Impressionists in England: The Critical Reception* (London, Boston, Melbourne, and Henley, 1984), appendix, p. 358.
5. "Monsieur...J'ai l'honneur de venir vous demander de vouloir bien me faire accorder une autorisation spéciale pour faire des vues de Paris des fenêtres du Louvre, et notamment de la colonnade extérieure, ayant à faire une vue de *St-Germain-l'Auxerrois*." Wildenstein 1991, letter 2687, p. 188.
6. Wildenstein 1974, letter 32, p. 423.
7. See the discussion in Isaacson 1966, pp. 5–22.

133 *Fig. 309*

Claude Monet

Le Jardin de l'Infante
(*Garden of the Princess, Louvre*)
1867
Oil on canvas
36⅛ x 24⅜ in. (91.8 x 61.9 cm)
Signed lower right: *Claude Monet*
Collection of the Allen Memorial Art Museum, Oberlin College, Ohio, R. T. Miller, Jr., Fund, 1948 48.296

CATALOGUE RAISONNÉ: Wildenstein 1974, no. 85

PROVENANCE: Purchased from the artist by Charles de Bériot, 1873, until 1901; his sale, Hôtel Drouot, Paris, March 11, 1901, no. 76; purchased by Bernheim-Jeune, Paris, 1901; Durand-Ruel and Rosenberg, Paris, in 1908; Frédéric Bonner, until 1912; sold from his estate, Plaza Hotel, New York, January 24, 1912, no. 36; purchased by Durand-Ruel for $4,100, for Louisine Havemeyer, until her death in 1929; by descent to her son, Horace Havemeyer, 1929, until 1948; consigned to M. Knoedler and Co., New York, by Horace Havemeyer, September 1948 (stock no. CA3142); bought by the museum from Horace Havemeyer through Knoedler, December 1948

EXHIBITIONS: Strasbourg, Château des Rohan, March 2–April 2, 1907, *Art français contemporain*, no. 186; Stuttgart, Museum der Bildenden Künste, May 1–31, 1907, *Französische Kunstwerke*, no. 169; Saint Louis,

Minneapolis 1957, no. 3, repr.; New York, Wildenstein, April 2–May 9, 1970, *One Hundred Years of Impressionism*, no. 6

SELECTED REFERENCES: Alexandre 1921, p. 34; Geffroy 1922, pp. 261–62, repr. p. 25; Elder 1924, pp. 55–56; Mauclair 1927, pp. 35, 40; *H. O. Havemeyer Collection* (New York, 1931), pp. 420–21, repr.; Reuterswärd 1948, p. 35; Isaacson 1966, pp. 4–22, fig. 1; Champa 1973, pp. 16–19, fig. 24; Rewald 1973, pp. 150, 152, 193, n. 20, repr. p. 151; Isaacson 1978, pp. 15, 16, 21, 23, 194, 198, 199, 203, 209, 213, 217, no. 5, pl. 5, fig. 10; Distel in Paris 1980, p. 74; Isaacson 1984, pp. 22–31, pl. 14; Skeggs 1987, pp. 42–45, repr. p. 44; Herbert 1988, pp. 10–12, 17, 143, 149, 177, 178, 210, 296, 303, fig. 14; Spate 1992, pp. 47, 49, pl. 40; Gretchen Wold in New York 1993, pp. 361–62, no. 388 repr.

This may be the handsomest of Monet's three views from the colonnade of the Louvre. Abandoning the horizontal format and visual congestion of the other two views (cats. 132, 134), Monet chose to orient this canvas vertically, thereby organizing the composition into strong shapes stacked one above the other. Arsène Alexandre, writing in 1921, thought that it was the oblique axis of the composition that gave the picture its strength: "Another *Vue de Paris*, perhaps even more beautiful, shows the Pantheon and, in the foreground, the trees and the houses crowded along the quays. A throng circulates between these masses and the corner of the garden of the Louvre that the viewer is supposedly overlooking from the height of the colonnade. A slightly oblique median line is, so to speak, the axis of the entire view. This line is the course of the river itself, more inferred than shown, because the incidental details of the buildings continuously intervene. One feels it and one cannot see it.... It is at once extremely precise, very remarkable in its colors, and observed with great spirit."[1]

Late in life, Monet told the interviewer Marc Elder that this painting was the work which he had sold to a dealer named Latouche, in whose window it was seen by the great Honoré Daumier. He despised it. "'Latouche,' he shouted loudly, 'are you not going to remove this horror from your window?' I turned pale and I choked as if struck by a blow to the heart. Daumier! the great Daumier! A god of mine! ... I had been awaiting his verdict with trembling."[2] According to Wildenstein, however, this painting was not owned by Latouche; rather it was sold by Monet to Bériot in 1873. Wildenstein suggests that it was *Le Quai du Louvre* (cat. 134) that may have been purchased by Latouche and shown in his window in the late 1860s. In a letter of January 18, 1869, to the dealer Martin, Boudin mentioned, "There is, in the shop of a dealer on the rue Lafayette, a *Vue de Paris* that you may have seen and that would be a masterpiece worthy of the greatest if the details corresponded to the whole."[3] It is not clear which of Monet's three views Boudin saw.

G.T.

1. "Une autre *Vue de Paris*, peut-être plus belle encore découvre le Panthéon et, en avant, les arbres et les maisons qui se pressent le long des quais. Une foule circule entre ces masses et le coin du jardin du Louvre que le spectateur est censé surplomber du haut de la colonnade. Une ligne médiane d'un oblique peu prononcé est pour ainsi dire

l'axe de toute la vue. Cette ligne, c'est le courant même du fleuve plus deviné que montré, parce que les détails accidentels des édifices s'interposent de façon continue. On le sent et on ne le voit pas.... C'est à la fois extrêmement exact, très remarquable de valeurs, et vu avec beaucoup d'esprit." Alexandre 1921, p. 34.

2. "'Latouche, cria-t-il d'une voix forte, vous n'allez pas retirer cette horreur de votre montre?' Je pâlis, j'étouffai comme sous un coup de poing appliqué au coeur. Daumier! le grand Daumier! Un dieu pour moi!...J'avais attendu son verdict en tremblant." Elder 1924, pp. 55–56.

3. "Il y a ici, chez un marchand de la rue Lafayette, une *Vue de Paris* que vous avez peut-être vue et qui serait un chef-d'oeuvre digne des maîtres, si les détails répondaient à l'ensemble." Wildenstein 1974, pièce justificative 23, p. 445.

134 *Fig. 308*

Claude Monet
Le Quai du Louvre
1867
Oil on canvas
25⅝ x 36⅝ in. (65 x 93 cm)
Signed lower right: *Claude Monet*
Collection Haags Gemeentemuseum, The Hague

CATALOGUE RAISONNÉ: Wildenstein 1974, no. 83

PROVENANCE: Possibly purchased from the artist by Latouche, Paris, May or June 1867;[1] Jaquette, Lisieux; Boussod, Valadon et Cie., Paris, 1893; Jean-Baptiste Faure, Paris, by 1894, until 1906; sold to Durand-Ruel, Paris, for Fr 12,500, December 13, 1906, until 1909 (stock no. 8408); sold to Hirsch, Paris, for Fr 30,000, April 13, 1909; Rosenberg, Paris, ca. 1911; the Dutch artist Léonardus Nardus, Paris (possibly acquired in partnership with Stephan Bourgeois), by 1917; his sale (anonymously), Frederik Muller et Cie., Amsterdam, June 19, 1917, no. 44; Dr. G. L. F. Philips and Mme J. P. Philipsvan der Willigen, Netherlands; their gift to the museum, 1942

EXHIBITIONS: Paris, Durand-Ruel, March 19–31, 1906, *Dix-sept tableaux de Claude Monet de la collection Faure*, no. 3; Berlin, September–October 1906, and Stuttgart, December 1906, Cassirer, *Monet, Manet, collection Faure*, no. 21; Edinburgh, London 1957, no. 9; Chicago 1975, no. 8, repr.

SELECTED REFERENCES: *Notice sur la collection J.-B. Faure, suivi du catalogue des tableaux formant cette collection* (Paris, 1902), p. 31, no. 53; Geffroy 1920, repr. p. 59; Alexandre 1921, pp. 34–35, pl. 2; Geffroy 1922, pp. 261–62, repr. p. 20; Gustave Geffroy, "Claude Monet et l'impressionnisme," *L'Art vivant*, January 1, 1925, repr. p. 2; Poulain 1932, p. 92; Malingue 1943, pp. 23, 145, repr. p. 38; Reuterswärd 1948, p. 35; Daulte 1952, p. 55; Isaacson 1966, pp. 4–22, fig. 2; Linda Nochlin, *Realism* (London, 1971), pp. 175, 265, no. 108; Champa 1973, pp. 16, 18–19, fig. 22; Isaacson 1978, pp. 15, 16, 21, 23, 194,

198, 199, 203, 213, 217, no. 4, pl. 4; Distel in Paris 1980, p. 74; Isaacson 1984, pp. 22–31, fig. 6; House 1986, pp. 15, 47, 51, 81, 115, pl. 68; Skeggs 1987, pp. 42–45, repr. p. 43; Herbert 1988, p. 10, fig. 13; Spate 1992, p. 47

To make this painting, Monet placed himself at the same position he would occupy while painting *Le Jardin de l'Infante* (cat. 133). He lifted his head slightly to look past the iron fence of the Louvre's garden, directing his vision to the Pont Neuf and the quays on both banks of the Seine, which extends through the middle of this composition. Naturally, the horizontal canvas accommodates a larger panorama than does the vertical canvas of *Le Jardin de l'Infante*, but the scale is otherwise the same. As Joel Isaacson has observed, the gray silhouette of the Pantheon is identical in size in both paintings.[2]

It seems inevitable that Monet would paint a view of the quays at the heart of Paris in 1867. His mentor Jongkind had been doing so for almost twenty years, although never from the elevated position that Monet obviously preferred. And, from the contemporary perspective, Paris never looked better. A great deal of money and effort were spent to clean the city for the influx of visitors to the Exposition Universelle, which opened while Monet was setting up his easel at the Louvre.

G.T.

1. See Wildenstein 1974, letter 33, p. 424; and pièce justificative 23, p. 445.
2. Isaacson 1966, pp. 16–18. Isaacson sees between the two paintings a slight shift in position, which I do not see. He also interprets the leaves of the trees in the *Quai du Louvre* as being less mature than those on the trees in the *Jardin de l'Infante*.

135 *Fig. 87*

Claude Monet
Les Régates à Sainte-Adresse
(*Regatta at Sainte-Adresse*)
1867
Oil on canvas
29⅝ x 40 in. (75.2 x 101.6 cm)
Signed lower left: *Claude Monet*
The Metropolitan Museum of Art, New York, Bequest of William Church Osborn, 1951 51.30.4

CATALOGUE RAISONNÉ: Wildenstein 1974, no. 91

PROVENANCE: Possibly purchased from the artist as "Baie de Saint-Adresse" for Fr 500 by Henri Hecht, Paris, Jan-

uary 1873, until June 25, 1876, when it was returned to Monet in exchange for "Figures dans les fleurs" plus Fr 150;[1] sale, Hôtel Drouot, Paris, April 5, 1884, no. 25 ("Sainte-Adresse," 0.75 x 1.00); acquired by Durand-Ruel, Paris, between August and December 1888, until 1891 (stock no. 105); sold to P. A. B. Widener, Ashbourne, near Philadelphia, August 20, 1891, until 1907; bought back by Durand-Ruel, New York, February 27, 1907 (stock no. 3153); sold to William Church Osborn, New York, March 25, 1907, until 1951; his gift to the museum, 1951

EXHIBITIONS: (?) London, Durand-Ruel, 168 New Bond Street, Spring 1874, *Eighth Exhibition of the Society of French Artists*, no. 142 ("Ste Adresse near Havre") (reprinted in Kate Flint, *Impressionists in England: The Critical Reception* [London, Boston, Melbourne, and Henley, 1984], p. 359); New York, The Metropolitan Museum of Art, May 3–September 15, 1921, *Loan Exhibition of Impressionist and Post-Impressionist Paintings*, no. 76 ("Plage de Sainte Adresse," lent by William Church Osborne); Paris 1980, no. 16, repr.

SELECTED REFERENCES: (?) "Notice of the exhibition of the Society of French Artists, New Bond Street," *The Times*, April 27, 1874 (reprinted in Kate Flint, *Impressionists in England: The Critical Reception* [London, Boston, Melbourne, and Henley, 1984], p. 35); Théodore Duret, "Monet und der Impressionismus," *Kunst und Künstler*, March 1904, p. 243, repr.; Emil Waldmann, "Französische Bilder in Amerikanischem Privatbesitz," *Kunst und Künstler* 9 (1911), repr. p. 140; Geffroy 1920, repr. p. 61; André Fontainas and Louis Vauxcelles, *Histoire générale de l'art français de la Révolution à nos jours* (1922), vol. 1, repr. p. 132; Mauclair 1924, p. 36, pl. 8; Fels 1929, p. 237; Isaacson 1967, pp. xii, 183–85, 203, 243, pl. 63; Champa 1973, pp. 19–20, fig. 25; Rewald 1973, pp. 179–80; Distel in Paris 1980, pp. 80–82, no. 16, repr.; Skeggs 1987, p. 37, repr. p. 38; Herbert 1988, pp. 284, 290, 292, 296, fig. 294; Spate 1992, 28, 48, 115, 117, 154, fig. 43

136 *Fig. 88*

Claude Monet
La Plage de Sainte-Adresse
(*The Beach at Sainte-Adresse*)
1867
Oil on canvas
29½ x 39¾ in. (75 x 101 cm)
Signed and dated lower right: *Claude Monet 67*
The Art Institute of Chicago, Mr. and Mrs. Lewis L. Coburn Memorial Collection 1933.439

CATALOGUE RAISONNÉ: Wildenstein 1974, no. 92

PROVENANCE: Purchased from the artist by Durand-Ruel, Paris, February 28, 1873; sold to Jean-Baptiste Faure, by 1876, until 1893; sold back to Durand-Ruel, Paris, January 9, 1893, for Fr 7,000 (stock no. 2585);[2] sold to

the jeweler Henri Véver, Paris, January 17, 1893; his sale, "Collection H. V.," Galerie Georges Petit, Paris, February 1–2, 1897, no. 79 ("Sainte-Adresse"); purchased at this sale by Boulley, for Fr 9,000, for Gustave Kahn; Gustave Kahn, Paris, 1897; Durand-Ruel, 1920; Annie Swan Coburn (Mrs. Lewis L. Coburn), Chicago, 1923, until 1933; her gift to the museum, 1933

EXHIBITIONS: (?) London, Durand-Ruel, 168 New Bond Street, Spring 1874, *Eighth Exhibition of the Society of French Artists*, no. 142 ("Ste Adresse near Havre") (reprinted in Kate Flint, *Impressionists in England: The Critical Reception* [London, Boston, Melbourne, and Henley, 1984], p. 359); Paris, 11, rue Le Peletier, April 1876, *2eme exposition de peinture*, no. 151 ("La Plage à Sainte-Adresse appartient à M. Fauré"); Paris, Galerie Georges Petit, June 21–August, 1889, *Claude Monet, Auguste Rodin*, p. 27, no. 5 ("Sainte-Adresse. 1867, Appartient à M. Faure."); Chicago 1975, no. 10, repr.; Paris 1980, no. 16 bis; Los Angeles, Chicago, Paris 1984–85, no. 6, repr.; Washington, San Francisco 1986, no. 31, repr.

SELECTED REFERENCES: (?) "Notice of the exhibition of the Society of French Artists, New Bond Street," *The Times*, April 27, 1874 (reprinted in Kate Flint, *Impressionists in England: The Critical Reception* [London, Boston, Melbourne, and Henley, 1984], p. 35); Émile Blémont [Émile Petitdidier], "Les impressionnistes," *Le Rappel*, April 9, 1876, p. 3 (reprinted in Geffroy 1922, pp. 60–62); Arthur Baignères, "Exposition de peinture par un groupe d'artistes, rue Le Peletier, 11," *L'Écho universel*, April 13, 1876, p. 3; Georges Rivière, "Les intransigeants de la peinture," *L'Esprit moderne*, April 13, 1876, pp. 7–8; Pierre Dax, "Chronique," *L'Artiste*, May 1, 1876 (reprint of the article by Rivière; see Washington, San Francisco 1986, p. 180); Philippe Burty, "Les paysages de M. Claude Monet," *La République française*, March 27, 1883, p. 3 ("Marée basse à Sainte-Adresse"); Geffroy 1920, repr. p. 64; Geffroy 1922, pp. 59, 62, 71, 118, 262, repr. facing p. 40; Mauclair 1927, pp. 36, 60, pl. 6; Champa 1973, pp. 19–20, fig. 26; Rewald 1973, p. 154, repr.; Skeggs 1987, p. 37, repr. p. 39; Herbert 1988, pp. 284, 290, 292, 296, figs. 267, 295; Broude 1991, pl. 13; Spate 1992, pp. 28, 48, 115, 117, 154, fig. 43

These two pictures were undoubtedly conceived as a pair. They are identical in size, and the point of view differs only by a few meters: they both show the beach at Sainte-Adresse, the well-to-do suburb of Le Havre where Monet's father lived. Destitute, Monet spent the summer of 1867 with his father and his aunt Sophie Lecadre at the cost of abandoning his companion, Camille Doncieux, and their newborn infant, Jean. Monet attended his birth in Paris on August 8 and returned to Sainte-Adresse on August 12.

In the pair of paintings the artist juxtaposed a sunny regatta watched at high tide by well-dressed bourgeois, with an overcast scene at low tide, showing fishing boats hauled onto the beach now peopled with sailors and workers. Since Monet never exhibited the paintings side by side, the contrast between them was not intended as a social manifesto but provided instead differing conditions by which the same scene, convenient to his father's house, could be observed.

Both paintings were painted out-of-doors, a practice which led to severe eye strain for Monet. In a letter he wrote to Bazille on July 3, 1867, he complained, "I am losing my sight, I can barely see after working for half an hour; the doctor

told me that I had to stop painting out-of-doors."[3] But ten days later he reported, "I am working constantly. My eyes are better thanks to the sun that has not come out for several days."[4] Although the paintings lack the programmatic quality of *Jardin à Sainte-Adresse* (cat. 137), they nevertheless embody Monet's latest technical advances. Sea and sky are rendered as broad sheets of color, enlivened by fleecy white clouds or azure waves, while figures are ciphers of light and shadow, with little modeling in between.

G.T.

1. See Distel in Paris 1980, p. 80; and Anne Distel, "Albert Hecht collectionneur (1842–1889)," *Bulletin de la Société de l'histoire de l'art français*, 1981 (1983), p. 279.
2. For Durand-Ruel stock number, see Callen 1971, pp. 325–26, no. 437.
3. "je perds la vue, je n'y vois à peine au bout d'une demi-heure de travail; le médecin dit qu'il faut renoncer à peindre dehors." Wildenstein 1974, letter 34, p. 424.
4. "je travaille sans cesse. Mes yeux vont mieux grâce au soleil qui s'est caché depuis quelques jours." Wildenstein 1974, letter 36a, p. 424.

137 *Fig. 310*

Claude Monet
Jardin à Sainte-Adresse
(Garden at Sainte-Adresse)
1867
Oil on canvas
38⅝ x 51⅛ in. (98.1 x 129.9 cm)
Signed lower right: *Claude Monet*
The Metropolitan Museum of Art, New York, Purchase, special contributions and funds given or bequeathed by friends of the Museum, 1967 67.241

CATALOGUE RAISONNÉ: Wildenstein 1974, no. 95

PROVENANCE: Purchased from Monet by Victor Frat (Bazille's friend), Montpellier, purportedly for Fr 400 in 1866,[1] until his death; by inheritance to his widow, Mme Victor Frat, Montpellier, until 1913; sold to Durand-Ruel, Paris, April 16, 1913, for Fr 27,000; transferred to Durand-Ruel, New York, May 12, 1913 (stock no. 3653), until 1926;[2] sold to the Reverend Theodore Pitcairn, Bryn Athyn, Pennsylvania, for $11,500, June 4, 1926, until 1967; his sale, *The Reverend Theodore Pitcairn and the Beneficia Foundation, Bryn Athyn, Pennsylvania*, Christie's, London, December 1, 1967, no. 26; purchased from the sale by the museum

EXHIBITIONS: Paris, 28, avenue de l'Opéra, April 10–May 11, 1879, *4me exposition de peinture*, no. 157 ("Jardin à

Sainte-Adresse" [1867], lent by M. Frat); Chicago 1975, no. 6, repr.; Washington, San Francisco 1986, no. 81

SELECTED REFERENCES: Geffroy 1920, repr. p. 57; Alexandre 1921, p. 35, repr. facing p. 26 ("Terrasse du Havre"); Geffroy 1922, pp. 98, 261, repr. facing p. 16; André Fontainas and Louis Vauxcelles, *Histoire générale de l'art français de la Révolution à nos jours* (1922), vol. 1, repr. p. 137 ("Terrasse du Havre"); Blanche 1927, p. 570; Albert Dreyfus, "Claude Monet," *Der Cicerone* 19 (1927), p. 60, repr. p. 61; François Fosca, *Claude Monet* (1927), p. 97 ("Terrasse au bord de la mer"); Koechlin 1927, p. 36 ("Terrasse au Havre au bord de la mer"); C. Kunstler, in *L'Art vivant* 3 (September 1927), pp. 676–77, repr. ("Terrasse au Havre"); Régamey 1927, pp. 70, 78–79 ("Terrasse au bord de la mer"); Robert Rey, "Claude Monet et l'impressionnisme," *L'Art vivant* 3 (January 1, 1927), 1927, p. 13, repr.; Isaacson 1967, pp. xi, 144, 158–65, 168–74, 188, 195, 204, 231, 235, 239, 313, n. 21, p. 314, n. 28, p. 315, n. 29, p. 320, n. 31, pl. 50; Margaretta M. Salinger, "Windows Open to Nature," *Metropolitan Museum of Art Bulletin* 27 (Summer 1968), repr. facing p. 1; Cooper 1970, pp. 281, 284–85, 300, 302, 305, fig. 4; Champa 1973, pp. 13–15, 17–18, 20, 30, pl. 5; Isaacson 1978, pp. 16, 69, 199–200, pl. 21; House 1986, pp. 15–16, 47, 51, 114–15, 136, 188, 235, n. 6, p. 237, n. 22, pl. 67; Skeggs 1987, pp. 34–37, repr.; Herbert 1988, pp. 177, 210, 291–93, 296, fig. 297; Broude 1991, p. 20, pl. 9; Spate 1992, pp. 14, 48–49, 59, 83, 87, 144, fig. 45

Were it not for Monet's extraordinary ambitiousness, one would assume that this large canvas was prepared for Salon exhibition. For many other artists a canvas of 130 centimeters would automatically be considered large scale, yet in fact the canvases that Monet did prepare for the Salon were considerably larger: six meters for the *Déjeuner sur l'herbe* (see cats. 122, 123), two and one-half meters for *Femmes au jardin* (cat. 130), etc. There is no evidence to indicate that Monet intended this work for the next Salon, held in 1868, when he exhibited the huge *Navires sortant des jetées du Havre* (see figs. 418, 419). (*La Jetée du Havre* [fig. 421] was rejected.) On the other hand, the sizable format and the emphatic composition do suggest that he was making a demonstration piece.

Monet called his painting "the Chinese painting in which there are flags."[3] The epithet "tableau chinois" reveals his fundamental intention to make a painting in an orientalizing style. A reference by Renoir to this painting as "the Japanese painting with little flags"[4] confirms that *Japonisme* was perceived as the essential characteristic of this work (in the 1860s the adjectives Chinese and Japanese were interchangeable in common parlance). Today it is more difficult to see the Japanese qualities, but in the 1860s the flat bands of color that divide the composition in a manner much like the flat panels of flags that wave, implying spatial recession through vertical stacking, as well as the strong diagonal slant of the shadows would have reminded sophisticated viewers of Japanese color woodblock prints. Later, Monet recalled that "at the time this composition was considered daring."[5] John House has identified a particular print, which Monet owned and which still hangs in his house at Giverny, that may have served as a model (fig. 311).[6] Monet probably exaggerated when he said he made his first pur-

chases of Japanese prints in 1856,[7] but it seems possible that he already owned this Hokusai when he painted *Jardin à Sainte-Adresse*. However, by the mid-1860s it was not just Japanese art itself that was suggesting new possibilities to Monet; he was undoubtedly affected by the Japanese-influenced paintings by Manet, Millet, and others. John House has also written that a Millet exhibited at the Salon of 1866 may have provided a point of departure for Monet.[8]

Monet painted the canvas in summer 1867 in a Sainte-Adresse garden with a view of Honfleur at the horizon. It is thought that Monet's father, Adolphe, sits in the foreground, and that Jeanne Marguerite Lecadre stands at the garden fence with a man sometimes identified as her father, Dr. Adolphe Lecadre. It has been suggested that the woman seated next to Monet's father was Sophie Lecadre, but of course all of these figures are merely actors, punctuating the scene with their presence, providing the necessary contrasts with their costumes.

It is thought that this is the painting that Monet exhibited at the 1879 Impressionist exhibition under the title *Jardin à Sainte-Adresse*, but no contemporary reviews of the exhibition are sufficiently descriptive to identify particular works.

G.T.

1. For the purchase price, see Gimpel 1966, p. 152; for the acquisition date, see Bazille 1992, p. 29, n. 5.
2. According to the Archives of the Department of European Paintings, Metropolitan Museum; an undocumented price of Fr 40,000 is given in Gimpel 1966, p. 152.
3. "le tableau chinois où il y a des drapeaux." Monet to Bazille, December 1868, Wildenstein 1974, letter 45, p. 426.
4. "le Japonais aux petits drapeaux." Renoir to Bazille, August 1869, Wildenstein 1974, pièce justificative 26, p. 445.
5. Gimpel 1966, p. 152. "à l'époque cette composition fut considerée comme très osée." Gimpel 1963, p. 178.
6. House 1986, pp. 49, 51.
7. Elder 1924, p. 64.
8. *Un Bout du village de Greville* (*End of the Village of Greville*), Museum of Fine Arts, Boston. House 1986, p. 51.

138 *(New York only)* *Fig. 180*

Claude Monet
Jeanne Marguerite Lecadre au jardin
(*Jeanne Marguerite Lecadre in the Garden*)
1867

Oil on canvas
32¼ x 39¾ in. (82 x 101 cm)
Signed lower left: *Claude Monet*
The Hermitage, Saint Petersburg N 6505

CATALOGUE RAISONNÉ: Wildenstein 1974, no. 68

PROVENANCE: Possibly with Guillemet, Paris, late 1868 or early 1869;[1] M. and Mme Eugène Lecadre, Le Havre, by 1879; acquired by M. Meunier, according to M. Thieullent (Jeanne Marguerite Lecadre's grandson), in exchange for two Chinese vases;[2] Lebas (gilder, looking-glass maker, picture dealer), Le Havre, until 1893; sold to Durand-Ruel, June 14, 1893, until 1899; sold to Pytor Shchukin, April 20, 1899, until 1912; his gift to his younger brother Sergei Shchukin, Moscow, 1912, until 1918; his collection nationalized by a decree of the Council of People's Commissar and renamed the First Museum of Modern Western Painting, Moscow, 1918; Museum of Modern Western Art, Moscow, 1923; transferred to the State Hermitage Museum, Saint Petersburg, 1948

EXHIBITIONS: Paris, 28, avenue de l'Opéra, April 10–May 11, 1879, *4me exposition de peinture*, no. 155 ("Un jardin [1867], appartient à M. Lecadre"); Leningrad, Hermitage, 1955, *French Art of the 15th–early 20th Centuries* (catalogue in Russian), pp. 92–93, repr.; Leningrad, Hermitage, 1956, *L'Art français du XIIe au XXe siècle* (*Exhibition of French Art 12th–20th Centuries*) (catalogue in Russian), p. 41, pl. 13; Tokyo, April 10–May 30, 1971, Kyoto, June 8–July 25, 1971, *One Hundred Masterpieces from USSR Museums*, no. 49; Washington, National Gallery of Art, March 31–April 29, 1973, New York, M. Knoedler and Co., May 3–June 3, 1973, Los Angeles County Museum of Art, June 15–July 8, 1973, Chicago, Art Institute, Fort Worth, Kimbell Art Museum, Detroit Institute of Arts, *Impressionist and Post-Impressionist Paintings from the USSR*, no. 27; Leningrad, Hermitage, Moscow, Pushkin Museum, 1974, *The Centenary of the First Exhibition of the Impressionists: 1874–1974* (catalogue in Russian), no. 19 (Leningrad), no. 10 (Moscow); Le Havre, Musée des Beaux-Arts André Malraux, May 23–July 3, 1978, *La peinture impressioniste et post-impressioniste du musée de l'Ermitage*, no catalogue; Paris 1980, no. 14, repr.

SELECTED REFERENCES: Otto Grautoff, "Die Sammlung Serge Stschoukine in Moskau," *Kunst und Künstler*, December 1918, p. 94; Geffroy 1922, p. 182; Boris Ternovietz, "Le Musée d'art moderne de Moscou: Anciennes collections Stchoukine et Morosoff," *L'Amour de l'art*, December 1925, p. 457; Louis Réau, *Catalogue de l'art français dans les musées russes* (Paris, 1929), p. 120, no. 975; F.P., "Sainte-Adresse: Histoire d'un 'Monet' perdu et peut-être retrouvé," *Le Havre libre*, April 16, 1959, p. 7; Anna Barskaya, "Les nouvelles données sur la dame dans le jardin de Claude Monet," *Bulletin de l'Ermitage* 28 (1967), pp. 25–27; Rewald 1973, repr. p. 180; Paul Hayes Tucker, *Monet at Argenteuil* (New Haven and London, 1982), p. 128, fig. 98; Nina Kalitina, Anna Barskaya, and Eugenia Goergievskaya, *Claude Monet: Paintings in Soviet Museums* (Leningrad: Aurora, 1984), pp. 124–25, repr.; House 1986, p. 75, fig. 114

Most writers have dated this painting and the related view of the same garden, *Jardin en fleurs* (*Flowering Garden*, Musée d'Orsay, Paris; Wildenstein 69), to 1866, but, as Anne Distel has suggested, it is more likely to have been executed in 1867.[3] When Monet exhibited the work in the fourth Impressionist exhibition in 1879, he indicated in the catalogue that the date was 1867. But since Monet often misremembered the actual dates of his paintings, the more important fact is that the flat planes of color—bright green grass, deep blue sky—punctuated by touches of

brilliant red, orange, and white flowers relate the painting to *Jardin à Sainte-Adresse* (cat. 137), which was certainly executed in 1867. This work was probably one of those mentioned by Monet in a letter to Bazille: "Canvases...with astonishing seascapes and with figures and with gardens."[4]

In its day, this work was seen as one of a group of pictures of gardens populated with strollers. The theme was an important part of the *Déjeuner sur l'herbe* (see cats. 122, 123), and Monet isolated and intensified it in *Femmes au jardin* (cat. 130) and *Jardin à Sainte-Adresse*. Zola described the series in 1868: "I have said it before: Claude Monet has a special affection for nature that the human hand has dressed in a modern style. He has painted a series of canvases, executed in gardens. I know of no paintings that have a more personal accent, a more characteristic look. The flower beds, dotted with bright reds of geraniums and the flat whites of chrysanthemums, stand out against the yellow sand of the path. Basket after basket is laden with flowers, surrounded by strollers dressed in elegant informality. I would love to see one of these paintings at the Salon, but it seems that the jury is there to scrupulously prohibit their admittance. But so what? They will endure as one of the great curiosities of our art, as one of the marks of our era's tendencies."[5]

The woman in the white dress is Jeanne Marguerite Lecadre (1842–1917), the great-niece of Monet's aunt.

G.T.

1. See Wildenstein 1974, letter 45, p. 426 ("le rosier").
2. F.P., "Sainte-Adresse: Histoire d'un 'Monet' perdu et peut-être retrouvé," *Le Havre libre*, April 16, 1959, p. 7.
3. Paris 1980, no. 14, p. 77.
4. "toiles...marines étourdissantes et des figures et des jardins." Wildenstein 1974, letter 33, p. 424.
5. "Je l'ai déjà dit, Claude Monet aime d'un amour particulier la nature, que la main des hommes habille à la moderne. Il a peint une série de toiles prises dans des jardins. Je ne connais pas de tableaux qui aient un accent plus personnel, un aspect plus caractéristique. Sur le sable jaune des allées les plates-bandes se détachent, piquées par le rouge vif des géraniums, par le blanc mat des chrysanthèmes. Les corbeilles se succèdent, toutes fleuries, entourées de promeneurs qui vont et viennent en déshabillé élégant. Je voudrais voir une de ces toiles au Salon; mais il paraît que le jury est là pour leur en défendre soigneusement l'entrée. Qu'importe d'ailleurs! elles resteront comme une des grandes curiosités de notre art, comme une des marques de tendances de l'époque." Zola, "Mon Salon: Les actualistes," 1868, in Zola 1991, pp. 209–10. The translation given here is from Stuckey 1985, p. 39.

139 *Fig. 314*

Claude Monet

La Route de la ferme Saint-Siméon, l'hiver
(*The Road from the Ferme Saint-Siméon,*
Winter)
1867
Oil on canvas
19 x 25 in. (48.3 x 63.2 cm)
Signed lower left: *Claude Monet*
Mrs. Alex Lewyt

CATALOGUE RAISONNÉ: Wildenstein 1974, no. 81

PROVENANCE: With the artist until at least 1869;[1] Jean-Baptiste Faure, Paris; Paul Rosenberg, Paris, 1903; Jean Dollfus-Zygomalas, Paris, by ca. 1911; Paul Rosenberg, Paris, by 1926, until at least 1932; Georges Martin, Paris; Sam Salz, New York, by ca. 1951, until 1952; to the present owner

EXHIBITIONS: London, Grafton Galleries, 1906, *Impressionists*, no. 91; Amsterdam, Musée d'État [Rijksmuseum], July 3–October 3, 1926, *Exposition rétrospective d'art français*, no. 73 ("La Route de Saint-Siméon en hiver, A M. P. Rosenberg"); Paris, Durand-Ruel, January 16–19, 1928, *Claude Monet*, no. 2; Paris 1931, no. 3, repr. ("La route de Saint-Siméon, effet de neige, vers 1866, collection de M. Paul Rosenberg"); London, Royal Academy of Arts, Burlington House, January 1932, *French Art 1200–1900*, no. 465, repr. (lent by Paul Rosenberg, Paris); Saint Louis, Minneapolis 1957, no. 12, repr.; Chicago 1975, no. 21, repr.

SELECTED REFERENCES: Mauclair 1927, p. 61, pl. 11; Poulain 1932, p. 70; Champa 1973, pp. 14–15, 46, fig. 18; Rewald 1973, repr. p. 179

There are some five undated landscapes by Monet that depict the environs of Honfleur in snow.[2] They were probably all made in early 1867, while Monet was painting in the vicinity of the Ferme Saint-Siméon, the legendary hospice of painters just outside Honfleur. In a letter of February 2, 1867, a friend wrote Boudin that Monet was in Honfleur, working on, among other things, his large marine, *Femmes au jardin* (cat. 130), and some snowscapes: "He is also painting some very successful impressions of snow."[3] These works all appear to have been begun *en plein air*, and they seem to represent various stages in a snowfall, from a fresh blanket of white powder in this painting to melting, sullied snow in *La Route sous la neige* (*The Road under Snow*, Wildenstein 82).

It may be no coincidence that almost simultaneously Courbet was preparing a large number of snow scenes, "paysages de neige," for his spring exhibition. He hung at least eleven snow scenes in a special section of his pavilion at the Pont de l'Alma. Monet saw Courbet in late 1866, and he

may have viewed some of Courbet's works in progress. Nevertheless, there are important differences of approach between the two artists. Courbet was interested in spectacular effects of turquoise skies and shadows played against brilliant white snow, often on huge canvases. Monet, on the other hand, worked his "paysages de neige" on small canvases, with correspondingly small nuances of differentiation between the gray skies and the gray reflections on the snow. Even in comparison to Monet's recent work, such as the *Femmes au jardin*, these snowy landscapes seem to be exercises in a restricted palette.

G.T.

1. See Wildenstein 1974, letters 45, 48, p. 426.
2. In addition to the present work, the others are *La Route de la ferme Saint-Siméon, effet de neige* (Wildenstein 80), *La Route de la ferme Saint-Siméon* (Wildenstein 79), *La Route sous la neige à Honfleur* (Wildenstein 82), and *La Charette* (Wildenstein 50).
3. "Il fait aussi des effets de neige assez heureux." Wildenstein 1974, pièce justificative 13, p. 444.

140 *Fig. 179*

Claude Monet

Portrait de Victor Jacquemont
Ca. 1868
Oil on canvas
39 x 24 in. (99 x 61 cm)
Signed lower right: *Claude Monet*
Kunsthaus Zurich 2334

CATALOGUE RAISONNÉ: Wildenstein 1974, no. 54

PROVENANCE: Lair-Dubreuil, Paris; Bernheim-Jeune, Paris, until 1907;[1] sold to Paul Cassirer, Berlin, February 2, 1907, until 1908; sold to Franz Hancke, Breslau, May 6, 1908;[2] Carl Sachs, Zurich, by 1934; acquired by the museum, 1939

EXHIBITIONS: Berlin, Galerien Thannhauser, mid-February–March, 1928, *Claude Monet (1840–1926)*, no. 6; Zurich, Kunsthaus, May 10–June 15, 1952, *Claude Monet: 1840–1926*, no. 10; Paris, Galerie Wildenstein, June 19–July 17, 1952, *Claude Monet*, no. 9; The Hague, Gemeentemuseum, July 24–September 22, 1952, *Claude Monet*, no. 10, repr.; Edinburgh, London 1957, no. 12, pl. 16c; Chicago 1975, no. 13, repr.; Paris 1980, no. 21, repr.

SELECTED REFERENCES: "Kunstausstellungen," *Kunst und Künstler* 6 (1908), p. 441, repr. p. 439; Karl Scheffler, "Breslauer Kunstleben," *Kunst und Künstler* 11 (1923),

p. 131, repr.; *Dr. Fritz Nathan und Dr. Peter Nathan: 1922–1972* (Zurich, 1972), no. 74, repr.; Champa 1973, pp. 3–4, fig. 3

"It is the portrait of a friend from my youth, M. Victor Jacquemont; I painted it in 1868 or '69, which does not make it better although I was very happy to see it again because of the memories."[3] So declared Monet in a letter of 1907 to the art dealers MM. Bernheim Jeune. Until 1980 however, this portrait was presumed by historians to represent Jules-Ferdinand Jacquemart (1837–1880), an engraver. In preparation for the 1980 Monet exhibition at the Grand Palais, Anne Distel questioned the identity of the sitter and brought to light the previously unpublished letter that conclusively identified the man with the parasol. Little is known of Jacquemont, except that he seems to have been a patron of the artist, at least in the 1870s. An entry in Monet's notebooks at the Musée Marmottan indicates that Jacquemont bought a canvas of a Vétheuil scene and an ébauche for Fr 200.[4]

In its simple composition and broad planes of color, this painting elicits comparison to Manet's contemporaneous portraits, but there are nonetheless important distinctions to be made. The pose Monet has given his sitter is without rhetorical or dramatic gesture, qualities that often are present in most of Manet's portraiture. A more significant difference, perhaps, is that Monet has pushed Manet's notorious tonal contrast—the absence of a middle tone and the exaggeration of light and shadow—to a new extreme. The summary execution of the landscape, where the brushstrokes barely coalesce into recognizable shapes, is also noteworthy.

G.T.

1. See Daniel Wildenstein, *Claude Monet*, vol. 4, *1899–1926* (Lausanne and Paris, 1985), letter 1821a, p. 371.
2. See Karl Scheffler, "Breslauer Kunstleben," *Kunst und Künstler* 11 (1923), p. 131, repr.
3. "C'est le portrait d'un ami de jeunesse M. Victor Jacquemont; je l'ai fait en 1868 ou 69, et il n'est pas meilleur pour cela, bien que j'ai eu du plaisir à le revoir à cause des souvenirs." Wildenstein, vol. 4, 1985, letter 1821a, p. 371. Quoted in Paris 1980, no. 21, p. 90.
4. Paris 1980, no. 21, p. 90.

141 *Fig. 181*

Claude Monet
Au bord de l'eau, Bennecourt
(*The River at Bennecourt*)
1868
Oil on canvas
31⅞ x 39½ in. (81 x 100.3 cm)
Signed and dated lower left: *Cl. Monet / 1868*
The Art Institute of Chicago, Potter Palmer Collection
1922.427

CATALOGUE RAISONNÉ: Wildenstein 1974, no. 110

PROVENANCE: Léon-Marie Clapisson, Paris (stockbroker and son of the famous conductor), by 1889, until 1892; sold to Durand-Ruel, Paris, April 21, 1892 (stock no. 2127); sold to Mr. Potter Palmer, Chicago, May 18, 1892, until his death in 1902; by inheritance to his wife, Mrs. Potter Palmer, Chicago; her gift to the museum, 1922

EXHIBITIONS: Paris, Galerie Georges Petit, June 21–August 1889, *Claude Monet, Auguste Rodin*, p. 28, no. 7 ("Au bord de l'eau; Bennecourt, 1868, Appartient à M. Clapisson."); Boston, Copley Hall, 1905, *Monet*, no. 78; Chicago, Art Institute, 1910, *Potter Palmer Collection*, no. 40; Edinburgh, London 1957, no. 13, pl. 16e; Chicago 1975, no. 17, repr.; Paris 1980, no. 18, repr.; Los Angeles, Chicago, Paris 1984–85, no. 47, repr.; Edinburgh 1986, no. 86, repr.

SELECTED REFERENCES: *Bulletin of The Art Institute of Chicago* 15 (1921), repr. p. 160; M.C., "Monets in the Art Institute," *Bulletin of The Art Institute of Chicago* 19 (February 1925), p. 19, repr. p. 18 ("Argenteuil, Palmer Collection"); Venturi 1939, vol. 2, p. 257; Ernst Scheyer, "Jean Frederic Bazille—The Beginnings of Impressionism," *Art Quarterly* 5 (1942), pp. 123, 125, fig. 2; Reuterswärd 1948, p. 283; Seitz 1960, pp. 78–79, repr.; Frederick A. Sweet, "Great Chicago Collectors," *Apollo* 84 (September 1966), p. 194, fig. 9; Isaacson 1966, pp. 186–88, pl. 64; Rodolphe Walter, "Critique d'art et vérité: Émile Zola en 1868," *Gazette des Beaux-Arts* 73 (April 1969), pp. 227–29, fig. 2; John Maxon, *The Art Institute of Chicago* (New York, 1970), p. 81, repr. p. 284; Champa 1973, pp. 25, 27, 28, 59, 63, fig. 30; Rewald 1973, repr. p. 228; Isaacson 1978, pp. 17, 18, 19, 197, 200, nos. 24, 25, p. 211; Stuckey 1984, pp. 114–17, fig. 51; Skeggs 1987, pp. 51–54, repr. p. 50; Rodolphe Walter, "Aux Sources de l'Impressionnisme: Bennecourt," *L'OEil*, no. 393 (April 1988), pp. 33–36, fig. 7; David Bomford et al., in London 1991, pp. 122–23, pl. 82; Spate 1992, pp. 52–53, 54, 59, 83, 88, 138, 186–87, 191, fig. 64

The calm, passive figure of Camille, the mother of the artist's son Jean, contemplating the Seine and the hills of Gloton beyond, belies the personal anxiety that Monet was experiencing while he painted this picture. Against his family's advice, in May 1868 he brought Camille and Jean to live with him at an inn at Bennecourt, a spot

visited by Zola and Cézanne, and before that, Corot. Monet's recognition of his mistress and son cost him the modest allowance his family afforded him, and he was desperate for money. In a letter to Bazille posted in Paris on June 20, 1868, he explained his situation: "I was just kicked out of the inn where I lived, as naked as a worm. I found a place in the area where Camille and my poor little Jean can stay for a few days. As for me, I came here [Paris] this morning and I am leaving tonight, in a moment, for Le Havre, to see if I can arrange something with my art collector.... Write me at Le Havre, general delivery, because my family refuses to do anything more for me; and I still do not know where I will spend the night tomorrow.... I was so upset yesterday that I did a very stupid thing and threw myself into the water; fortunately no harm came of it."[1]

The broad flat areas of color, arranged in horizontal bands, carry forward the compositional device of *Jardin à Sainte-Adresse* (cat. 137), but unlike that work, the present canvas may have been left incomplete. As Charles Stuckey has observed, the white clouds reflected in the Seine do not appear where they should above the houses on the horizon, and the face of Camille is without features. Stuckey has also noted that the figures on the opposite riverbank appear to be sketching or painting.[2] X rays show that Monet originally painted a child on the lap of the woman, where he later painted the little white dog.

G.T.

1. "Je viens d'être mis à la porte de l'auberge où j'étais, et cela nu comme un ver, j'ai casé Camille et mon pauvre petit Jean à l'abri pour quelques jours dans le pays. Quant à moi, je suis venu ici ce matin et je pars ce soir, dans un instant, pour le Havre, voir à tenter quelque chose auprès de mon amateur.... Ecrivez-moi au Havre, poste restante, car ma famille ne veut plus rien faire pour moi, je ne sais donc pas encore où je coucherai demain.... J'étais si bouleversé hier que j'ai fait la boulette de me jeter à l'eau, heureusement il n'en est rien résulté de mal." Wildenstein 1974, letter 40, p. 425.
2. Stuckey 1984, p. 116.

142 *Fig. 231*

Claude Monet
Portrait de madame Louis-Joachim Gaudibert
1868
Oil on canvas
85⅜ x 54½ in. (217 x 138.5 cm)
Signed and dated lower right: *Claude Monet 1868*
Musée d'Orsay, Paris RF1951.20

CATALOGUE RAISONNÉ: Wildenstein 1974, no. 121

PROVENANCE: Commissioned from the artist by the sitter's husband, M. Louis-Joachim Gaudibert, for Fr 130, on September 3, 1868, for his mother, Mme Louis Gaudibert, Le Havre; by inheritance to her niece Mme Edgar Lamotte, Le Havre; by descent to M. Maurice Lamotte, Le Havre; acquired from him for the Jeu de Paume with interest from an anonymous Canadian gift, 1951; transferred to the Musée d'Orsay, 1986

EXHIBITIONS: Paris, Musée des Arts Décoratifs, May 28–July 12, 1925, *Cinquante ans de peinture française 1875–1925*, no. 46, repr. ("Portrait de Mme G. Collection M. Maurice Lamotte"); Paris 1931, no. 11 ("Portrait de Mme G. Collection de M. Maurice Lamotte"); Saint Louis, Minneapolis 1957, no. 6, repr.; Chicago 1975, no. 16, repr.; Philadelphia, Detroit, Paris 1978–79, no. VI-91, repr.; Paris 1980, no. 19, repr.

SELECTED REFERENCES: Alexandre 1921, pl. 9; Jean-Aubry 1922, p. 72; Raymond Régamey, "La Formation de Claude Monet," *Gazette des Beaux-Arts* 15 (February 1927), pp. 70, 78, 82; Poulain 1932, pp. 129, 149; Malingue 1943, p. 23; Reuterswärd 1948, p. 279; Hélène Adhémar and M. Dreyfus-Bruhl, *Musée du Louvre: Catalogue des peintures impressionnistes* (Paris, 1958), no. 229; Champa 1973, pp. 23, 26, 27, pl. 9; Levine 1978, pp. 92–93, repr.; House 1986, p. 34

Although *Navires sortant des jetées du Havre* (destroyed) had been accepted by the 1868 Salon, Monet's situation had become increasingly desperate. He was so despondent that in a letter of June 20 he mentioned suicide,[1] yet he had managed to place four paintings at the Exposition Maritime Internationale du Havre. Things began to brighten over the summer, however. By September 3 he was able to write Bazille from Fécamp to say, "I have just received a telegram from my art collector in Le Havre asking for me for next Monday to do a portrait of his wife."[2] Just as this commission materialized, there was word that Monet would receive a silver medal from the exhibition at Le Havre. According to Boudin's friend

Martin, Arsène Houssaye pushed that through, and extended his patronage to purchasing *Camille* (fig. 236). Martin reported on October 6 that Monet "is painting at the moment a full-length portrait of Mme Gaudibert, in the same fashion as that picture [*Camille*], after having painted the one of her husband which I recently saw in the home of M. Gaudibert. One cannot deny that this young man is destined by his boldness to paint an original work because he is commanded by a search for truth, but in execution it is very vulgar and neither the tenderness of the flesh nor the subtlety of the character is spared. It is a painting; it is not a portrait. Mme Gaudibert and the father are furious to see such a similar reproduction of their beloved progeny and would give all [illegible] the art students of the world."[3] Evidently the portrait of M. Gaudibert was heartily disliked, and Monet painted another version (both portraits of M. Gaudibert were lost sometime before 1900[4]). While working on the portrait of Madame, Monet wrote Bazille to say that "I am in a country house near Le Havre where I am received delightfully in a charming region. Yet, all of that is not enough to give me back that old fervor. Painting is not going well and, in truth, I no longer expect to be famous."[5] But the splendid portrait of Mme Gaudibert did hit the mark. M. Gaudibert told Boudin that it was "a marvelous burst of color."[6]

The commission must have been to recreate the allure of *Camille*, which had been shown in Le Havre over the summer. But Mme Gaudibert does not proffer her face, as Camille did, and her fawn-colored silk dress is not as spectacular as the (no doubt rented) costume that Camille wore. Instead Monet relied on the setting, completely absent in *Camille*, to convey to the observer that Mme Gaudibert was a proper, well-to-do Havraise, with an upholsterer who furnished curtains in as rich and understated a fabric as that used by her dressmaker. There is prosperity, but no ostentation. And for this portrait of the quintessential bourgeoise of the provinces, Monet called upon his memory of the Salon portraits of Alfred Stevens, which he elaborated with fluid brushwork and stark modeling to rival Manet. One could easily agree with Martin and say that this too is "un tableau," but not a "portrait," except that it is indeed a portrait of a type, just as *Camille* was.

Evidently Monet also painted a portrait of the Gaudibert's son Louis, but it too is now lost.[7] On the back of this canvas is a sketch for an interior with two women and a child, a composition ultimately expressed as *Le Déjeuner* (fig. 239), rejected by the Salon of 1870, and now in the Städelsches Kunstinstitut in Frankfurt.

G.T.

1. Wildenstein 1974, letter 40, p. 425.
2. "Je viens de recevoir à l'instant une dépêche télégraphique de mon amateur du Havre, qui me demande pour lundi prochain pour faire le portrait de sa femme." Wildenstein 1974, letter 42, p. 425.
3. "fait en ce moment le portrait en pied de Mme Gaudibert dans le genre de ce tableau, après avoir fait celui du mari que je viens de voir chez M. Gaudibert. On ne peut

nier que ce garçon est appelé pour son audace à faire une peinture originale, que la recherche du vrai domine quand même, mais comme exécution c'est vulgaire en diable et ni la délicatesse des chairs, ni la finesse du type sont respectées. C'est un tableau, ce n'est pas un portrait. Mme Gaudibert et le papa sont furieux d'une pareille reproduction de leur adorée progéniture et donneraient leur [illisible] tous les rapins du monde." F. Martin to Boudin, Le Havre, October 6, 1868, Wildenstein 1974, pièce justificative 22, p. 445.
4. Wildenstein 1974, p. 172, nos. 120, 122.
5. "Je suis dans un château aux environs du Havre, où je suis reçue à ravir dans un pays charmant. Mais tout cela ne suffit pas à me redonner cette ancienne ardeur. La peinture ne va pas, et décidément je ne compte plus sur la gloire." Wildenstein 1974, letter 43, p. 425.
6. "très remarquable comme éclat de couleur." Wildenstein 1974, pièce justificative 23, p. 445.
7. Wildenstein 1974, p. 174, no. 123.

143 *(New York only)* *Fig. 323*

Claude Monet

La Porte d'Amont, Étretat
1868–69
Oil on canvas
32 x 39½ in. (81.3 x 100.3 cm)
Signed lower left: *Claude Monet*
Fogg Art Museum, Harvard University Art Museums, Cambridge, Massachusetts, Gift of Mr. and Mrs. Joseph Pulitzer, Jr. 1957-163

CATALOGUE RAISONNÉ: Wildenstein 1974, no. 258

PROVENANCE: Purchased from the artist by Durand-Ruel, Paris; Louis-Alexandre Berthier, Prince de Wagram, Paris, until 1914; sold to Durand-Ruel, Paris, April 1914; acquired by comte and comtesse Jean d'Alayer (née Marie-Louise Durand-Ruel), Paris; 19th and 20th Century French Art, Inc., New York (Sam Salz), until 1955; sold to Louise and Joseph Pulitzer, Saint Louis, May 2, 1955; their gift to the museum, 1957

EXHIBITIONS: Paris, Durand-Ruel, 1902, *Chefs d'oeuvre de l'art français*; New York, M. Knoedler and Co., Cambridge, Fogg Art Museum, April 9–May 4, May 16–September 16, 1957, *Modern Painting, Drawing & Sculpture Collected by Louise and Joseph Pulitzer, Jr.*, no. 47; Chicago 1975, no. 15, repr.

SELECTED REFERENCES: Mauclair 1927, p. 62, pl. 32; Werth 1928, pl. 30; Charles Scott Chetham, *Modern Painting, Drawing & Sculpture Collected by Louise and Joseph Pulitzer, Jr.* (New York and Cambridge, Mass., 1957), pp. 65–66, no. 47, pl. 1; Nina Kasanof, "Monet and Étretat," *North Carolina Museum of Art Bulletin* 7 (May 1968), pp. 3–11, fig. 2; Rewald 1973, repr. p. 233; Robert Gordon and Andrew Forge, *Monet* (New York, 1983), p. 108, repr.; House 1986, p. 141, fig. 175

Although the Wildenstein catalogue raisonné assigned this painting a date of 1873, John Rewald, John House, Robert Gordon, and others have all placed this picture around 1868–69. According to Gustave Geffroy, Monet visited Étretat in the company of Courbet and Alexandre Dumas *père* in 1868.[1] Courbet was on the north coast by September 11, 1868, and he had returned to Ornans by October 6, 1868. Monet moved to Fécamp, adjacent to Étretat, at the beginning of August 1868 and remained in the area until he returned to Paris in spring 1869. The subject is one that Courbet certainly favored, but his paintings of the cliffs (see fig. 393), despite their extraordinary realism, have none of the power of Monet's audacious composition. Standing out on a shoal reachable only at low tide,[2] Monet viewed the cliff from close-up, centering the famous needle through the eye of the limestone formation. Waiting until sunset so that the striations of the sky resembled those of the cliffs, he contrasted the grays and browns of the stone, rendered in great horizontal brushstrokes, with the pink, orange, and blue of the sky. Monet painted the cliffs again in 1885, but by then his use of divided color and small, commalike brushstrokes mitigated the powerful form of the subject. Since Monet had begun to use divided color extensively by 1873, the broad use of uniform hues in this work points decidedly to 1868–69, but in the absence of documentary evidence it is difficult to assign this magnificent canvas to a specific campaign at Étretat.

G.T.

1. Geffroy 1922, p. 41, cited by Gerstle Mack, *Gustave Courbet* (New York, 1951), p. 227, who is cited by Charles Scott Chetham, *Modern Painting, Drawing & Sculpture Collected by Louise and Joseph Pulitzer, Jr.* (New York and Cambridge, Mass., 1957), p. 66.
2. As John House, who visited the site, has observed. House 1986, p. 141.

144 *Fig. 315*

Claude Monet

La Pie
(*The Magpie*)
1869
Oil on canvas
35 x 51⅛ in. (89 x 130 cm)
Signed lower right: *Claude Monet*
Musée d'Orsay, Paris RF1984.164

CATALOGUE RAISONNÉ: Wildenstein 1974, no. 133

PROVENANCE: Thor Carlander; Durand-Ruel, Paris, by 1941; Jacques Guerlain, Paris, by 1955; Société Guerlain, by 1957; acquired by the museum, 1984

EXHIBITIONS: Zurich, Kunsthaus, May 10–June 15, 1952, *Claude Monet: 1840–1926*, p. 20, no. 19 ("Le merle [Effet de neige, environs de Honfleur]," 1870); Paris, Galerie Wildenstein, June 19–July 17, 1952, *Claude Monet*, p. 59, no. 14 ("Le Merle, 1869, Collection particulier"); The Hague, Gemeentemuseum, July 24–September 22, 1952, *Claude Monet*, no. 16 ("Honfleur in de winter," 1869); Rome, Florence, 1955, *Chefs-d'oeuvre du XIXe siècle français*, no. 74, fig. 68; ("Effet de Neige, Environs de Honfleur, coll. Jacques Guerlain, Paris"); Edinburgh, London 1957, no. 18, pl. 4 ("The Magpie," lent by the Société Guerlain, Paris); Paris 1980, no. 22, repr.; Paris, Grand Palais, November 5, 1985–February 3, 1986, *Anciens et nouveaux: Choix d'oeuvres acquises par l'État ou avec sa participation de 1981 à 1985*, p. 207, no. 131, repr.; Paris, Musée d'Orsay, November 12, 1990–March 10, 1991, *De Manet à Matisse: Sept ans d'enrichissement*, p. 71, repr.

SELECTED REFERENCES: Isaacson 1978, pp. 17, 200, no. 22, pl. 22; House 1986, pp. 136, 245, no. 3, pl. 168 (detail p. 134); Spate 1992, pp. 56, 59, 67, 213, fig. 62

This work is not dated and its early provenance is uncertain, but most scholars agree that Monet painted it at Étretat in winter 1868–69 and submitted it to the 1869 Salon, where it was refused. There is no documentation for this last assertion, but the large size of *La Pie* makes it a likely candidate for a Salon submission. Thanks to a letter of April 25, 1869, by Boudin, we know that "ultimately, his two paintings were *rejected*."[1] Given the undeniable appeal of this painting today—a pure, clear vision of the peace of rural life—it is difficult to imagine grounds for its rejection. Yet no doubt the fact that so grand a canvas was executed in such a summary manner, with no attempt at polish, made acceptance difficult.

In a letter of January 11, 1869, Monet wrote Bazille from Étretat asking for oil paints, "given that the Salon is approaching." It may be only a coincidence, but the principal colors he requested are those that predominate in this work: "Here are the colors I need: silver white...a lot / ivory black...a lot / cobalt blue...a lot / fine lacquer / yellow ocher / brown red / bright yellow / Naples yellow / burnt sienna / I have a sufficient quantity of the other colors. Send the first four colors in large quantities, as they are the ones I need most."[2] It is possible, as Daniel Wildenstein has suggested, that this work was painted over an unfinished painting—either a portrait of Bazille or a still life of flowers, since Monet mentioned both in a letter to him of December 1868: "If you want to do me a favor, look in every corner of your house for [blank] canvases of mine that are still there, and also for canvases whose subject was left unfinished, such as your full-length portrait and another canvas of 60 where I have done bad flowers."[3] *La Pie* is painted on a size 60 canvas. The Laboratoire du Louvre has made an X ray of it and, owing to the extensive use of lead-white paint, finds it impossible to discern what might be under the visible surface.

G.T.

1. "enfin on lui a *refusé* ses deux toiles." Boudin to F. Martin, April 25, 1869, Wildenstein 1974, pièce justificative 25, p. 445.
2. "vu le Salon qui s'approche." "Voici les couleurs qu'il me faut: blanc d'argent...beaucoup / noir d'ivoire... beaucoup / bleu de cobalt...beaucoup / lacque fine / ocre jaune / brun rouge / jaune brillant / jaune de Naples / terre de Sienne brûlée / les autres couleurs j'en ai une quantité suffisante. Forcez surtout la quantité des quatres premières couleurs, ce sont celles dont j'ai le plus besoin." Monet to Bazille, January 11, 1869, Wildenstein 1974, letter 46, p. 426.
3. "Si vous voulez me faire un plaisir cherchez dans tous vos recoins les toiles [blanches] que j'ai encore chez vous et aussi les toiles où il y a des choses abandonnées tel que votre portrait en pied et une autre toile de 60 où j'avais fait des mauvaises fleurs." Monet to Bazille, December 1868, Wildenstein 1974, letter 44, p. 426; also p. 178, no. 133.

145 *Fig. 215*

Claude Monet

Fleurs et fruits
(Flowers and Fruit)
1869
Oil on canvas
39⅜ x 31¾ in. (100 x 80.7 cm)
Signed upper right: *Claude Monet*
Collection of the J. Paul Getty Museum, Malibu, California 83.PA.215

CATALOGUE RAISONNÉ: Wildenstein 1974, no. 139

PROVENANCE: Possibly Henri Rouart, Paris, by 1878; Rosenberg, Paris, ca. 1904; Louis-Alexandre Berthier, Prince de Wagram, Paris; Ernst, Berlin; Wildenstein and Co., New York, until 1980; sold to Mrs. Seward Johnson, Princeton, November 1980, until 1981; sold to Wildenstein and Co., New York, July 1981, until 1983; purchased by the museum, 1983

EXHIBITIONS: Paris, 28, avenue de l'Opéra, April 10–May 11, 1879, *4me exposition de peinture*, no. 142 ("Fleurs, Appartient à M.R."); Tokyo, National Museum of Western Art, October 9–November 28, 1982, Kyoto, National Museum of Modern Art, December 8, 1982–January 30, 1983, *Monet*, no. 4; Washington, San Francisco 1986, no. 78, repr.

SELECTED REFERENCES: Geffroy 1922, p. 98; Elder 1924, pl. 21; Rewald 1973, p. 230, repr. p. 232; "Acquisitions/1983," *J. Paul Getty Museum Journal* 12 (1984), p. 314, no. 16, repr.; Burton B. Fredericksen, "Recent Acquisitions of Paintings: The J. Paul Getty Museum," *Burlington Magazine* 127 (April 1985), p. 268, fig. 106; House and Distel, in London, Paris, Boston 1985–86, p. 193, no. 14 (English ed.), p. 92, no. 13 (French ed.); House

1986, p. 40; Burton B. Fredericksen, *Masterpieces of Painting in the J. Paul Getty Museum*, rev. ed. (Malibu, 1988), no. 40, repr.

In the 1860s, Monet did not dwell in the genre of still life. There are only fourteen proper still lifes known from the years 1861–70, although he did include marvelous passages of still life in other compositions, such as *Déjeuner sur l'herbe* and *Portrait de madame Gaudibert* (cats. 122, 123, 142). He began with ambitious works, such as the *Trophée de chasse* of 1862 (cat. 114) and the *Fleurs de printemps* of 1864 (cat. 115), but he did not pursue the subject vigorously. After executing some five works of food and game in the years 1861–63 and the *Fleurs de printemps* in 1864, he did not return to the genre until 1866–67, when he executed four canvases of fruit, three of them arranged in the manner of Manet on a white linen cloth. Then, quite exceptionally, he composed the present work, a resplendent composition that combines the dense floral display of the 1864 *Fleurs* with the more modest still lifes of autumn fruit on a cloth-covered table that he executed in 1867. There was no restraint here, for in effect he packed three still lifes onto this single canvas—a bouquet of flowers, a basket of pears, a cluster of apples, pears, and grapes—as if he were competing with Renoir, who simultaneously depicted the same bouquet in a much more conventional composition (cat. 176). Although the still lifes of Fantin-Latour are sometimes invoked in connection with Monet's picture, there is little comparison to be made, for while Fantin did construct similar compositions, his photographic perfectionism has nothing to do with Monet's bravura brushwork.

Because Monet and Renoir worked together closely in the summer of 1869, it is thought that they must have painted the two canvases during the same campaign. Monet's picture has little of the strident brushstrokes and strong tonal contrasts of the outdoor paintings at La Grenouillère, but still life seemed inherently to demand a more conservative treatment. Nevertheless, Monet here achieved a chromatic and compositional tour de force that he would not surpass until his great flower pieces of 1880.

G.T.

146 *Fig. 320*

Claude Monet

Les Bains de la Grenouillère
(*La Grenouillère*)
1869
Oil on canvas
28¾ x 36¼ in. (73 x 92 cm)
Signed and dated lower right: *Claude Monet / 1869*
The Trustees of the National Gallery, London NG6456

CATALOGUE RAISONNÉ: Wildenstein 1974, no. 135

PROVENANCE: Probably Charles Éphrussi, Paris, by 1882, until at least 1889;[1] Collardeau; Bernheim-Jeune, Paris, 1899; Durand-Ruel, Paris, until 1901; sold to Bruno Cassirer, Berlin, in 1901; by descent to Mr. and Mrs. (née Sophie Cassirer) Richard Walzer, Oxford; their bequest to the museum, 1979

EXHIBITIONS: Probably Paris, Galerie Georges Petit, June 21–August 1889, *Claude Monet, Auguste Rodin*, p. 28, no. 9 ("La Grenouillère; Bougival, 1869, Appartient à M. Charles Éphrussi"); London 1991, no. 2, repr.

SELECTED REFERENCES: Reuterswärd 1948, pp. 45–48, repr.; Champa 1973, pp. 56–66; Isaacson 1978, pp. 17–18; House 1986, pp. 115, 136, 147, 161, 205, pl. 145; Croissy-sur-Seine, Château Chanorier, June 11–September 27, 1992, *Croissy-sur-Seine: Les Impressionnistes à la Grenouillère*, catalogue by Christian Lasalle, n.p.; Spate 1992, pp. 57–59, fig. 58

The Metropolitan Museum of Art, New York, H. O. Havemeyer Collection, Bequest of Mrs. H. O. Havemeyer, 1929 29.100.112

CATALOGUE RAISONNÉ: Wildenstein 1974, no. 134

PROVENANCE: Probably the Grenouillère painting owned by Édouard Manet, until his death in 1883, that was listed as "La Grenouillère à Croissy" in the inventory of Manet's estate of June 18, 1883, among the pictures at his mother's, Mme Eugénie-Désirée Manet;[2] possibly purchased from Mme Manet by Durand-Ruel, Paris, in 1886, and definitely by 1891 (stock no. 1586), until 1897; sold to Henry O. and Louisine Havemeyer, New York, on September 27, 1897, for Fr 12,500, until 1929; her bequest to the museum, 1929

EXHIBITIONS: (?) Paris, 11, rue Le Peletier, *2e Exposition de Peinture* (2nd Impressionist exhibition), April 1876, no. 164 ("Les Bains de la Grenouillère"); Manchester, New Hampshire, Currier Gallery of Art, October 8–November 6, 1949, *Monet and the Beginnings of Impressionism*, no. 38; Edinburgh, London 1957, no. 16; Chicago 1975, no. 19

SELECTED REFERENCES: Wynford Dewhurst, *Impressionist Painting: Its Genesis and Development* (London and New York, 1904), repr. facing p. 40; Rudolf Adelbert Meyer, "Manet und Monet," *Die Kunst unserer Zeit* 19 (1908), repr. p. 63; Georges Grappe, *Claude Monet* (Paris, [1909]), p. 28, repr. facing p. 54; Geffroy 1922, p. 262, repr. facing p. 52; Mauclair 1924, p. 41, pl. 17; Malingue 1943, pp. 6, 23, 146, pl. 51; Reuterswärd 1948, pp. 45–48, 280, pl. 14; M. Catinat, *Les Bords de la Seine avec Renoir et Maupassant, l'école de Chatou* (Chatou, 1952), pp. 95–98, repr.; Seitz 1960, pp. 23, 84–85, repr.; Isaacson 1967, pp. xiii, 224–37, 326–27, n. 32, pl. 79; Cooper 1970, pp. 281–82, 286–87, 302–5, fig. 6; Champa 1973, pp. 63–66, pl. 11; Rewald 1973, pp. 227–32, repr.; House 1977, p. 6, pl. 8; Isaacson 1978, pp. 17–19, 22, 77–78, 201–2, pls. 29, 30; Jacques Dufwa, *Winds from the East: A Study in the Art of Manet, Degas, Monet and Whistler 1856–86* (Stockholm, 1981), pp. 135–36, 207, n. 28, fig. 112; Joel Isaacson, "Impressionism and Journalistic Illustration," *Arts Magazine* 56 (June 1982), pp. 97, 100, 102, 114, n. 38, p. 115, n. 93; Ronald Pickvance, "La Grenouillère," in *Aspects of Monet: A Symposium on the Artist's Life and Times*, ed. John Rewald and Frances Weitzenhoffer (New York,

1984), pp. 36–51, repr.; Brettell, in Los Angeles, Chicago, Paris 1984–85, p. 88; John House, *Claude Monet: Painter of Light*, exh. cat. (Auckland, 1985), p. 10; Distel, in London, Paris, Boston 1985–86, p. 88 (French ed.), p. 192 (English ed.), repr.; Clayson, in Washington, San Francisco 1986, pp. 145, 147, 157, 163, 254, repr.; House 1986, pp. 51, 53, 59, 77, 136, 147, 161, 205, 235, n. 5, p. 242, n. 38; Skeggs 1987, pp. 57–60, repr.; Bomford et al., in London 1991, pp. 120–25, pl. 81; Croissy-sur-Seine, Château Chanorier, June 11–September 27, 1992, *Croissy-sur-Seine: Les Impressionnistes à la Grenouillère*, catalogue by Christian Lasalle, n.p.; Spate 1992, pp. 57–59

It is not certain precisely when Monet moved to Saint-Michel, a small village neighboring Louveciennes and thus not far from Bougival. A letter of June 2, 1869, was postmarked Saint-Michel,[3] and it is known from other letters that he was still there in September. From all appearances it was his primary address until the summer of 1870, when he moved to Trouville. He was, as usual, desperately poor. His money from the Gaudiberts had evidently run out, and by August the tenor of his letters to Bazille had become shrill. "Do you want to know my situation and how I have been living for the past eight days while waiting for your letter? Well, ask Renoir who brought us bread from his home so that we would not starve. For eight days, we had no bread, no wine, no fire for cooking, no light. It is terrible."[4] "I hope you will never know such moments of misery!"[5] "As always, I have to stop for lack of paint. Happy you, who will take back a lot of canvases! I alone will have done nothing this year. This makes me furious with everybody, I feel jealous, mean, angry; if I could work, everything would be fine."[6]

This last letter, written on September 25, 1869, mentioned his work at La Grenouillère. "I do have a dream, a painting, the baths of La Grenouillère, for which I have made some bad sketches, but it is only a dream. Renoir, who has just spent two

147 *Fig. 322*

Claude Monet

La Grenouillère
1869
Oil on canvas
29⅜ x 39¼ in. (74.6 x 99.7 cm)
Signed and inscribed lower right: *Claude Monet*
LOCATI[ON] CANO

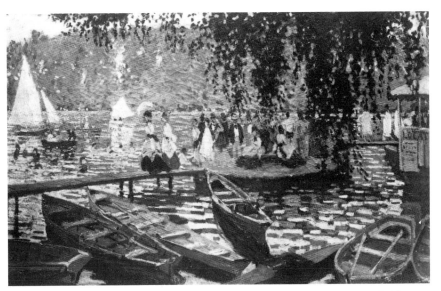

Fig. 422. Claude Monet, *La Grenouillère*, 1869. Oil on canvas. Formerly in the Arnhold Collection, Berlin; work destroyed?

439

months here, also wants to do this painting." The paintings now in New York and London are probably the "pochades" he mentions, and a painting (fig. 422), now lost but formerly in the Arnhold collection, Berlin, may well have been the "tableau." By comparing the Arnhold painting to other known paintings visible in photographs of the Arnhold house, it appears that the lost picture measured 66 by 118 centimeters, a proper size for a Salon "tableau." In addition, Monet also painted a small study of two of the rowboats (Kunsthalle Bremen; Wildenstein 137). Renoir, for his part, painted three medium-sized canvases that were made from a vantage point very close to that of Monet (see cats. 177, 178). It was about this time that Monet and Renoir also painted the same still lifes of flowers (cats. 145, 176), and in 1873 they would paint similar views of the Pont Neuf in Paris. But in 1884, perhaps remembering his frustration at La Grenouillère, Monet wrote, "As pleasant as it has been to travel as a tourist with Renoir, I would find it awkward to travel with someone if I wanted to work. I have always worked better alone and from my own impressions."[7]

In choosing the bathing spa La Grenouillère as a subject, Monet and Renoir had in front of them a working-class resort, optimistically promoted as "Trouville-sur-Seine,"[8] that had just been favored with a visit by the emperor, his wife, and their son.

G.T.

1. For the 1882 date, see Wildenstein 1974, pièce justificatif 50, p. 445; for the 1889 date, see Paris, Galerie Georges Petit, 1889, *Claude Monet, Auguste Rodin*, p. 28, no. 9 ("La Grenouillère; Bougival, 1869, Appartient à M. Charles Éphrussi").
2. See Rouart and Wildenstein 1975, pp. 25–26.
3. Wildenstein 1974, letter 49, p. 426.
4. "Voulez-vous savoir dans quelle situation je suis et comment je vis depuis huit jours que j'attends votre lettre? Eh bien, demandez-le à Renoir qui nous a apporté du pain de chez lui pour que nous ne crevions pas. Depuis huit jours pas de pain, pas de vin, pas de feu pour la cuisine, pas de lumière. C'est atroce." Monet to Bazille, August 9, 1869, Wildenstein 1974, letter 50, p. 426.
5. "Puissiez-vous ne jamais connaître ces moments de misère!" Monet to Bazille, August 17, 1869, Wildenstein 1974, letter 51, p. 426.
6. "comme toujours, me voilà arrêté, faute de couleurs. Heureux mortel, vous allez, vous rapporter des quantités de toiles! Moi seul cette année n'aurai rien fait. Cela me rend furieux contre tous, je suis jaloux méchant, j'enrage; si je pouvais travailler, tout irait bien." "J'ai bien un rêve, un tableau, les bains de la Grenouillère, pour lequel j'ai fait quelques mauvaises pochades, mais c'est un rêve. Renoir, qui vient de passer deux mois ici, veut faire aussi ce tableau." Monet to Bazille, September 25, 1869, Wildenstein 1974, letter 53, p. 427.
7. "Autant il m'a été agréable de faire le voyage en touriste avec Renoir, autant il me serait gênant de le faire à deux pour y travailler. J'ai toujours mieux travaillé dans la solitude et d'après mes seules impressions." Monet to Durand-Ruel, January 12, 1884, Daniel Wildenstein, *Claude Monet*, vol. 2, 1882–1886 (Lausanne and Paris, 1979), letter 388, p. 232.
8. Raoul de Presles in *L'Événement illustré*, June 20, 1868, reprinted in London, Paris, Boston 1985–86, p. 86 (French ed.) and p. 191 (translated, English ed.).

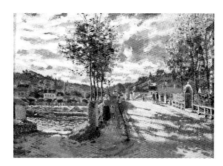

148 *Fig. 324*

Claude Monet
La Seine à Bougival
(*The Seine at Bougival*)
1869
Oil on canvas
25 x 36 in. (63.5 x 91.4 cm)
Signed lower left: *Claude Monet*
The Currier Gallery of Art, Manchester, New Hampshire, Currier Funds 1949.1

CATALOGUE RAISONNÉ: Wildenstein 1974, no. 152

PROVENANCE: The artist, until ca. 1870; sold, in exchange for a painting by Cézanne plus Fr 50, to dealer Pierre Firmin Martin, Paris, ca. 1870;[1] Hadengue-Sandras, until 1880; his sale, Hôtel Drouot, Paris, February 2–3, 1880, no. 58; Gaucheron; Galerie Bernheim-Jeune, Paris, by 1910; private collection, Paris; Rosenberg and Stiebel, New York; acquired by the museum, 1949

EXHIBITIONS: Saint Louis, Minneapolis 1957, no. 9, repr.; Chicago 1975, no. 20, repr.; Los Angeles, Chicago, Paris 1984–85, no. 13, repr.; Manchester, New York, Dallas, Atlanta 1991–92, no. 95, repr.

SELECTED REFERENCES: Alexandre 1921, pl. 17; Elder 1924, p. 69; "Paroles," *Bulletin de la vie artistique* (MM. Bernheim-Jeune, Paris), July 15, 1925, p. 294; Fels 1929, p. 107; Champa 1973, pp. 59–61, 63, pl. 6; Isaacson 1978, pp. 17, 200, no. 23, p. 202, pl. 46; Skeggs 1987, pp. 68–69, repr. p. 71; Herbert 1988, pp. 206–10, 217, figs. 207, 209; Spate 1992, p. 59, fig. 65

Although this painting has been dated to 1870, it seems likely that Monet painted it, as Skeggs has suggested, in autumn 1869.[2] That Monet depicted an autumn day is unmistakable. The brown leaves still cling to the trees, and the sun, tracking closer to the horizon, casts long, oblique shadows. By autumn 1870, Monet was in London, so this work was probably made while he was stationed in Saint-Michel, a village on the hill just outside of Bougival. For this painting, Monet placed his easel on the Ile de Croissy, a small island in the middle of the Seine, and looked toward the embankment of Bougival. He used the same abbreviated brushstrokes for the reflections on the water as those he had developed in his paintings of La Grenouillère, and large cottony strokes to render the blustery sky. The palette has a blonde and silver harmony that one associates with Pissarro at this date.

G.T.

1. The following citations mention the purchaser and purchase price: Elder 1924, p. 69; Fels 1929, p. 107; and Gimpel 1963, pp. 69, 155 (English ed., Gimpel 1966, pp. 61, 128). According to Monet, speaking in 1925, he

sold the painting in 1868; see "Paroles," *Bulletin de la vie artistique* (MM. Bernheim-Jeune, Paris), July 15, 1925, p. 294. Monet probably misremembered the date since stylistic evidence suggests that he painted the work in the fall of 1869.
2. Skeggs 1992, p. 69.

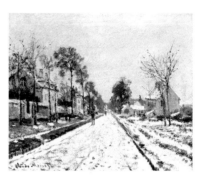

149 (*New York only*) *Fig. 316*

Claude Monet
Route à Louveciennes, effet de neige
(*Road to Louveciennes, Effect of Snow*)
1869–70
Oil on canvas
22 x 25¾ in. (55.9 x 65.4 cm)
Signed lower left: *Claude Monet*
Private collection, Chicago

CATALOGUE RAISONNÉ: Wildenstein 1974, no. 147

PROVENANCE: Possibly purchased from the artist by Michel Lévy in 1873 ("Effet de neige, Louveciennes"); Mme Berend, Paris; Durand-Ruel, Paris and New York, 1912, until 1930; sold to M. Knoedler and Co., New York, January 1930, until 1941 (stock no. A 1055); sold to Mrs. Richard N. Ryan, New York, September 1941, until 1968; sold, Parke-Bernet Galleries, New York, October 9, 1968, no. 2 ("The Property of a New York Private Collector"); purchased at this sale by E. V. Thaw and Co., New York, until May 1971; sold to present owner

EXHIBITIONS: New York, Durand-Ruel, 1914, *Monet*, no. 6; Saint Louis, Minneapolis 1957, no. 23, repr.; Chicago 1975, no. 23, repr.; Los Angeles, Chicago, Paris 1984–85, no. 15, repr.

SELECTED REFERENCES: Geffroy 1920, repr. p. 67; Alexandre 1921, pl. 21; Werth 1928, pl. 16; Rewald 1973, p. 212, repr.; Isaacson 1978, p. 201, no. 28, pl. 28

This picture may well have been begun just a few days after Pissarro's painting of the same scene (cat. 162). Pissarro showed fresh snow, whereas the snow in this work has begun to melt. Monet was staying with Pissarro at Louveciennes when the Paris region was hit with a record snowfall in December 1869. Having already executed a number of snow scenes in 1867, Monet profited from this new occasion and made some six small paintings, including this one, of sites in the area around Louveciennes and Bougival (Wildenstein 143, 144, 145, 148, 149).

The house on the left has been identified as the Maison Retrou, 22, route de Versailles, where Pissarro and Monet stayed,[1] although the identi-

fication does not seem certain. Monet positioned himself farther away from the houses than Pissarro, but Pissarro showed a street coming in from the right, which Monet evidently omitted. Monet's palette is here more varied than Pissarro's, but the facture is quite close.

G.T.

1. Wildenstein 1974, p. 184, no. 147.

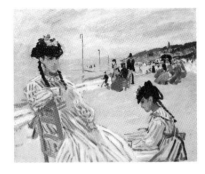

150
Fig. 327

Claude Monet
La Plage de Trouville
(Beach at Trouville)
1870
Oil on canvas
21⅛ x 25⅝ in. (53.5 x 65 cm)
Signed lower right: *Claude Monet*
Wadsworth Atheneum, Hartford, The Ella Gallup Sumner and Mary Catlin Sumner Collection Fund 1948.116

CATALOGUE RAISONNÉ: Wildenstein 1974, no. 156

PROVENANCE: Possibly purchased from the artist by Durand-Ruel, June 1871; Mrs. Otis Kimball, Boston, by 1927, until 1929; by inheritance to her daughter Mrs. Henry L. (Estelle) Mason, Boston, from 1929; her estate until 1948; acquired by the museum, 1948

EXHIBITIONS: Chicago 1975, no. 22; Kanazawa, Ishikawa Prefectural Museum of Art, September 14–October 6, 1991, Tokyo, Isetan Museum of Art, October 31–November 26, 1991, Takamatsu City Museum of Art, December 6, 1991–January 26, 1992, Nagoya, Matsuzakaya Art Museum, January 30–February 23, 1992, *Goya to Matisse: Paintings, Sculpture and Drawings from the Wadsworth Atheneum of Hartford, Connecticut*, no. 37

SELECTED REFERENCE: Herbert 1988, p. 295, pl. 301

151 *(Paris only)*
Fig. 329

Claude Monet
Sur la plage à Trouville
(On the Beach at Trouville)
1870
Oil on canvas
15 x 18⅛ in. (38 x 46 cm)
Signed lower left: *Claude Monet*
Musée Marmottan, Paris 5016

CATALOGUE RAISONNÉ: Wildenstein 1974, no. 162

PROVENANCE: The artist's son Michel Monet, Sorel-Moussel, until his death in 1966; his bequest to the museum, 1966

EXHIBITIONS: Zurich, Kunsthaus, May 10–June 15, 1952, *Claude Monet: 1840–1926*, no. 13; Paris, Galerie Wildenstein, June 19–July 17, 1952, *Claude Monet*, no. 17; The Hague, Gemeentemuseum, July 24–September 22, 1952, *Claude Monet*, no. 18; Edinburgh, London 1957, no. 21, repr.

SELECTED REFERENCES: *Monet et ses amis: le legs de Michel Monet, la donation Donop de Monchy*, Musée Marmottan (Paris, 1977), p. 15, no. 1; Herbert 1988, pp. 296–99; Bomford et al., in London 1991, pp. 126–31, pl. 90

Despite his rejections at the Salon of 1870, despite his catastrophic financial condition, despite the rumblings of war on the horizon, on June 28, 1870, Monet married Camille Doncieux, his companion since 1865 and the mother of his son Jean. There were four witnesses to the ceremony in Paris: Gustave Courbet, Gustave Monet (a relation?), Paul Dubois (doctor), and Antoine or Antonin Lafont (journalist). Fearing seizure because of his debts, Monet left some paintings with Pissarro in Louveciennes[1] and took his family to Trouville for the summer. They stayed at the Hôtel Tivoli, which became the new site of their recurring nightmare: by September 9 Monet found himself unable to leave because he could not pay his bill.[2]

Nevertheless Monet somehow refused to despair and painted four good-sized canvases and five smaller works over the summer. He was quite consciously in Boudin country, and all of his pictures at Trouville adopted Boudin's characteristic imagery: fashionable life as played out on the beach of the resort, under the changing skies of the Channel coast. True to his nature, he found new and unexpected ways of depicting the very scenes that Boudin had so patiently explored. The four larger canvases, such as *La Plage de Trouville*

(cat. 150), all show the beach seen laterally from its narrow width: the boardwalk or a hotel terrace directs the observer's attention in toward the horizon. The smaller pictures, including *Sur la plage à Trouville* (cat. 151), all show Camille on the beach with a parasol, seen from up close. Sometimes she is accompanied by another figure, but the ancillary figures have not been satisfactorily identified. It seems possible, as some scholars have suggested, that Monet may have had a large composition in mind for which the nine known paintings would serve as studies, but there is no evidence to confirm the suggestion.

Late in life, Boudin wrote Monet to say, "I can still see you with that poor Camille at the Hôtel Tivoli. I have even kept a drawing of you on the beach.... Little Jean is playing in the sand and his papa is sitting on the ground holding a drawing board."[3] As experts at the National Gallery, London, have demonstrated, Monet was indeed working on the beach. They have found sand embedded in the surface of their painting of Camille on the beach.[4] Each of the paintings done at Trouville has the hallmark of plein air painting, not only in the subject and in the spontaneity of the touch, but also in the sharp contrast between light and shade and in the summary description of the forms. Monet may not have been aware of Manet's contemporaneous beach scene (cat. 111) or that by Degas (fig. 359), but all three artists seized a similar informal approach to their analogous pictures—even if Degas brought the figures in the foreground of his picture to a higher degree of finish than Manet or Monet. Monet seemed to revel in the *non fini*. He allowed the warm ground of his picture to show through and to act as a midtone.

G.T.

1. Wildenstein 1974, p. 51, and Pissarro 1988, vol. 3, p. 70, n. 7.
2. Manet to Boudin, September 9, 1870, Wildenstein 1974, letter 55, p. 427.
3. "Je vous vois encore avec cette pauvre Camille dans l'Hôtel Tivoli. J'ai même conservé un dessin qui vous représente sur la plage.... Le petit Jean joue dans le sable et son papa est assis par terre un carton à la main." Jean-Aubry 1922, pp. 76–77.
4. London 1991, pp. 126–31.

Gustave Moreau

Paris, 1826–Paris, 1898

A middle-class childhood and education, spent with a freethinking architect father and a doting mother, gave Gustave Moreau a cultural background and social manner lacking in most artists of his day. After two years at the Collège Rollin, he pursued his studies at home; with his lycée diploma at last in his pocket, Moreau launched into his artistic career. Encouraged by Pierre-Joseph Dedreux-Dorcy, a pupil of Picot's, that glorious painter of the July Monarchy, Moreau entered the École des Beaux-Arts, which he left after twice failing to obtain a Prix de Rome. It was at this time that he met Chassériau, young but already famous, who was the first to aspire to a reconciliation of what was then judged to be irreconcilable: the lessons of Ingres and those of Delacroix. Deeply upset by Chassériau's untimely death in 1856, Moreau soon felt, despite his distant contacts with Delacroix and his new friendship with Fromentin, a need to resume his training. It was thus as a student, a rather belated student, that he left for Italy, residing there from October 1857 to September 1859, first in Rome, then throughout the peninsula. In Rome, during the winter of 1858, he met Degas, who was considerably influenced by him. Their bond persisted for some time after the two artists returned to Paris (see figs. 69, 70) but became strained after 1862–63. Moreau's triumphs at the Salons of 1864 and 1865 (fig. 71), with works that Degas could not appreciate, drove them apart. Their final break came in 1876, when Moreau and Fromentin were attacked by Duranty in his essay *La Nouvelle Peinture*, which was largely inspired by Degas (see pp. 50–51).

PROVENANCE: Bequeathed by the artist to the French state, 1898; bequest accepted in 1902

EXHIBITIONS: Yamanashi, Kamakura, and Mie (Japan), 1984–85, *Gustave Moreau and Symbolism*, no. 52; Zurich, Kunsthaus, 1986, *Gustave Moreau symboliste*, no. 12; Florence, Palazzo Vecchio, and Ferrara, Palazzo dei Diamanti, 1989, *Gustave Moreau*, no. 9; Heerlen, Stadsgalerij, 1991, *Gustave Moreau*, no. 6; Spoleto, Palazzo Racani Arroni, 1992, *Gustave Moreau, l'Elogio del poeta*, no. 16

SELECTED REFERENCE: Gustave Moreau, in *L'Assembleur de rêves: Écrits complets de Gustave Moreau* (Paris, 1984), p. 59

In November 1897, shortly before his death, Gustave Moreau evoked, in a few lines, a subject that had haunted him throughout his career: "Surrounded by virgin sisters lightly fluttering about him, murmuring mysterious words, revealing to him the sacred arcana of nature, the young shepherd, an astonished, delighted child, smiles in wonderment, opening up to the whole of life. A holy neophyte, he listens to the teachings from on high, blended as they are with caresses and enchantment, while Nature in all her springtime likewise awakens and smiles at her future singer. The swans lovingly frolic about, the flowers open and grow animated, everything seems to be beginning, everything awakens to divine love at this contact with youth, joy, and love."[1] The Muses, to put it simply, unveil to the poet the divine mysteries and crown him in the presence of the sacred swan of Apollo; as Geneviève Lacambre has remarked, the artist's description applies more to this precocious canvas, most likely executed in 1860, just after Moreau's return from Italy, than to later variations on the same theme.[2] The kinship to contemporary works by Degas, particularly the first version of *Petites Filles spartiates provoquant des garçons* (fig. 70), is evident. From his mentor the young Degas took the morphology of these long bodies, gracile and androgynous, as well as a taste for uncommon subjects, in a somber, spare coloring.

H.L.

1. "Entouré de soeurs vierges voletant légères autour de lui, murmurant les mots mystérieux, lui révélant les arcanes sacrés de la nature, le jeune pâtre, le pâtre enfant étonné, ravi, sourit émerveillé, s'ouvrant à la vie toute entière. Néophyte sacré, il écoute ces leçons d'en haut mêlées de caresses et d'enchantements. Tandis que la Nature, toute dans son printemps s'éveille aussi et sourit à son chantre futur. Les cygnes s'ébattent amoureusement, les fleurs s'ouvrent et s'animent, tout semble naître, tout s'éveille à l'amour divin à ce contact de jeunesse, d'allégresse et d'amour." Gustave Moreau, *L'Assembleur de rêves* (Fontfroide, 1984), p. 59.
2. Geneviève Lacambre, in the exhibition catalogue *Gustave Moreau, l'Elogio del poeta* (Spoleto 1992), no. 16.

152 *Fig. 69*

Gustave Moreau
Hésiode et les Muses
(Hesiod and the Muses)
Ca. 1860
Oil on canvas
52⅜ x 52⅜ in. (133 x 133 cm)
Musée Gustave Moreau, Paris cat. 872

CATALOGUE RAISONNÉ: Mathieu 1976, p. 104

Berthe Morisot

Bourges, 1841–Paris, 1895

In 1864, upon being named chief counselor at the state accounting office, Tiburce Morisot, together with his wife, his three daughters, Yves, Edma, and Berthe, and his son, Tiburce, moved into a house on the rue Franklin, Paris. Painting was the family's great preoccupation: M. Morisot built a garden studio for his daughters, who devoted themselves to their work more or less happily; their home on the rue Franklin was frequented by Fantin-Latour, Puvis de Chavannes, the Stevenses, and, before long, Manet. The Manets and the Morisots quickly became close friends, and it was probably at Mme Auguste Manet's Thursday-evening salons that the Morisots met Degas, who, despite his initial aloofness toward Berthe, was not indifferent to the bohemian charm of this solidly bourgeois family. In 1869, after long and tumultuous posing sessions, he produced a lovely portrait of Yves Gobillard-Morisot (Metropolitan Museum of Art, New York).

Berthe Morisot received her very first drawing lessons in 1857 from the painter Chocarne, whom she soon left for Joseph Guichard, an artist from Lyons and a friend of Corot's. A short time later she met Corot, who advised her patiently and to whom she owed her taste for landscapes and painting in the open air. First admitted to the Salon in 1864, she continued to show there regularly, eliciting rare but laudatory comments. In 1869, together with the musician Fanny Claus and the painter Antoine Guillemet, Morisot posed for Manet's *Balcon* (fig. 266).

153 *(Paris only)* *Fig. 328*

Berthe Morisot
Marine (Le Port de Lorient)
(Seascape [The Harbor at Lorient])
1869
Oil on canvas
17⅛ x 28¾ in. (43.5 x 73 cm)
National Gallery of Art, Washington, Ailsa Mellon Bruce Collection 1970.17.48

CATALOGUE RAISONNÉ: Bataille-Wildenstein 1961, no. 17

PROVENANCE: Gift of the artist to Édouard Manet, 1869; Gabriel Thomas, Paris, in 1896; Mme Gabriel Thomas, Bellevue; Edward Molyneux, Paris, after 1936; Ailsa Mellon Bruce, New York; her bequest to the National Gallery of Art, 1955

In June and July 1869, Berthe Morisot went to Lorient to visit her sister Edma, who early that year had gotten married to Adolphe Pontillon, a naval officer. Disheartened for the past few months and not touching her brushes, Morisot was counting on her trip to Brittany to produce "something worthwhile." She wrote to Edma on May 11, "My painting has never seemed to me as bad as it has in recent days. I sit on my sofa, and the sight of all these daubs nauseates me."[1] Her stay in Lorient did, in fact, prove beneficial, for she went home with both a full-length sketch of Edma for a portrait that was shown at the Salon of 1870 and the present seascape. Here she demonstrates her loyalty to the lessons of Corot and Boudin, whom she venerated, painting brightly and with a lightness suggesting watercolor over a rigorous preliminary drawing. The canvas pleased the attentive family and Manet, who at the time was mindful only of Eva Gonzalès. Morisot offered him the seascape, no doubt retaining a fond memory of it since she decided to show it, in 1874, at the first Impressionist exhibition.

H.L.

1. "quelque chose de passable"; "jamais ma peinture ne m'a paru aussi mauvaise que depuis quelques jours. Je m'assieds sur mon canapé et la vue de toutes ces croûtes me donne des nausées." Morisot 1950, p. 29 (translation by Betty W. Hubbard, Morisot 1950, p. 33).

Camille Pissarro

Charlotte Amalie, 1830–Paris, 1903

Pissarro was born in Charlotte Amalie, the capital of Saint Thomas in the Virgin Islands. His father was a Jewish businessman who had migrated from Bordeaux in 1824. In 1842 Pissarro was sent to boarding school in Passy, a suburb of Paris. He returned to Charlotte Amalie in 1847 to enter the family business. After two years in Venezuela with the Danish painter Fritz Melbye, Pissarro decided to renounce his business career and return to France to become an artist. He arrived in Paris around mid-October 1855, in time to visit the Exposition Universelle, where he ad-

mired the works of Corot and Delacroix. In 1859 Pissarro's first painting was accepted at the Salon (*Paysage à Montmorency*; unidentified). This same year he met Monet at the Académie Suisse, where, sometime later, he also befriended Cézanne. In 1866, after years of eliciting little critical comment at the Salon, Pissarro attracted the attention of Castagnary and Zola, critics whom he had met through Cézanne in 1863, with his *Bords de la Marne en hiver* (cat. 156). In 1866 Pissarro settled in Pontoise, though he continued to spend a considerable amount of time in Paris, where he entered the circle of Manet and the future Impressionists at the Café Guerbois. Early in 1869, Pissarro moved from Pontoise to Louveciennes. The artist and his family took refuge from the siege of Paris in London. They returned to Louveciennes at the end of June 1871 to find that their house had been occupied and pillaged by the Germans.

154 *Fig. 116*

Camille Pissarro
Bords de la Marne (?)
(*The Banks of the Marne* [?])
1864

Oil on canvas
32¼ x 42½ in. (81.9 x 107.9 cm)
Signed and dated lower right: *C. Pissarro. 1864.*
Glasgow Museums, Art Gallery and Museum, Kelvingrove 2934

Two paintings by Pissarro were accepted by the jury of the Salon of 1864. The artist entitled them *La Route de Cachalas à La Roche-Guyon* and *Bords de la Marne*. The first has not been identified; the second is probably this painting: the large size announces that it was destined for public exhibition, and the inscription of a date announces which one. This picture is commonly called *The Towpath*, but the road Pissarro depicts is too far from the waterway to act as a towpath.[1] Thus *Bords de la Marne* is indeed a plausible identification, although Christopher Lloyd has suggested, without further explanation, that the site may be the banks of the Seine at Bougival.[2]

Although Pissarro described himself in the Salon *livret* as a student of Melbye and Corot, in this work he proclaims his allegiance to Daubigny's vision. The subject matter, a riverscape, was inevitably linked to Daubigny's numerous paintings of France's waterways, and the specific site, a nondescript section of river that was at once nowhere and everywhere, reflects Daubigny's

Fig. 423. Camille Pissarro, *Les Bords de la Seine à Bougival* (*The Banks of the Seine at Bougival*), 1864. Oil on canvas, 9⅝ x 12¾ in. (24.4 x 32.4 cm). Fitzwilliam Museum, Cambridge

typical choice. Even the homely poplar punctuating the sky at the right seems characteristic of Daubigny. But in fact, the composition, with the dark repoussoir at the left carefully balanced by the sky reflected in the river at the right, is far more conservative and classical than Daubigny's relentlessly ordinary views that almost always defied conventional good taste. The careful and consistent brushstroke is also more conservative than Daubigny's varied and sometimes flickering brushwork of this date. All in all, Pissarro conventionalized in this large canvas the fresh scene he captured in his first sketch (fig. 423), which was less panoramic than the final work and more direct. As much as we might today prefer the sketch, Pissarro understood what was necessary to win acceptance at the Salon, and he succeeded.

G. T.

1. As Michael Clarke has observed, in Edinburgh 1986, p. 33, the Marne did not have towpaths.
2. Lloyd 1979, p. 4. Lloyd later reverts to the traditional title, *The Towpath*. Lloyd 1981, p. 28.

155 *Fig. 115*

Camille Pissarro
Chennevières au bord de la Marne
(*Chennevières on the Bank of the Marne*)
Ca. 1864–65
Oil on canvas
36 x 57¼ in. (91.5 x 145.5 cm)
Signed lower right: *C. Pissarro*
National Galleries of Scotland, Edinburgh NG 2098

CATALOGUE RAISONNÉ: Pissarro and Venturi 1939, no. 46

PROVENANCE: Ambroise Vollard, Paris, by 1904; purchased by Reid and Lefevre, London, January 1937; purchased by A. J. McNeill Reid, May 8, 1939; Reid and Lefevre, London; T. J. Honeyman, Glasgow, by June 1939; sold to the National Galleries of Scotland, 1947

EXHIBITIONS: Paris, Salon of 1865, no. 1723 ("Chennevières au bord de la Marne"); Paris, Galeries Durand-Ruel, April 7–30, 1904, *Exposition de l'oeuvre de Camille Pissarro*, no. 1 ("Paysage à la Varenne-Saint-Hilaire"); Paris 1930, no. 7; Paris, Galerie Marcel Bernheim, May 22–June 11, 1936, *Les premières époques de Camille Pissarro, de 1858 à 1884*, no. 8; London, Reid and Lefevre, January 1937, *Pissarro and Sisley*, no. 1; London, Paris, Boston 1980–81, no. 4 (exhibited in Paris only); Edinburgh 1986, no. 12

SELECTED REFERENCES: J. Ravenal [Alfred Sensier], "Salon de 1865," *L'Époque*, June 15, 1865; Champa 1973, pp. 71–74, pl. 19; Rewald 1973, p. 106, repr.; Lloyd 1979, p. 4, pl. 3; Shikes and Harper 1980, p. 63; Lloyd 1981,

pp. 28–29, repr.; Brettell 1990, p. 62, fig. 56; Broude 1991, p. 55, pl. 26; Pissarro 1993, pp. 45–50, 65, fig. 39

For the Salon of 1865, Pissarro once again prepared a large, handsome river landscape in the manner of Daubigny. Although recent commentators have suggested that Daubigny himself secured entry for Pissarro's canvas,[1] in fact the elder landscapist was not elected to the Salon jury until 1866. Nevertheless, Pissarro was not foolish to practice Daubigny's style, for while his stature was debated in France, an outside observer, P. G. Hamerton, had already proclaimed Daubigny the chief of the modern French landscape school.[2] And Pissarro's essay in Daubigny's style was indeed accepted by the Salon jury.

This work, however, is not a slavish copy. The brushwork, in particular, is very different from that of Daubigny, and the occasional use of a palette knife was, of course, an effect Pissarro could have observed in Courbet's work. But, as Kermit Champa observed, the "fresh and ingratiating" color scheme was ultimately derived from Daubigny, as was the use of bright accents of salmon red and yellow.[3]

Chennevières lies southeast of Paris, across the Marne from La Varenne-Saint-Hilaire, where Pissarro lived from 1863 to 1865. No painted studies for this work, executed in the studio, survive. There is a distantly related drawing in the Ashmolean Museum, Oxford.[4]

G. T.

1. Shikes and Harper 1980, p. 63.
2. P. G. Hamerton, "The Salon of 1863," *Fine Arts Quarterly Review*, October 1863, cited in Rewald 1973, p. 102.
3. Champa 1973, p. 72.
4. Richard Brettell and Christopher Lloyd, *A Catalogue of the Drawings by Camille Pissarro in the Ashmolean Museum, Oxford* (Oxford, 1980), no. 64 recto.

156 *Fig. 117*

Camille Pissarro
Bords de la Marne en hiver
(*The Banks of the Marne in Winter*)
1866
Oil on canvas
36⅛ x 59⅛ in. (91.8 x 150.2 cm)
Signed and dated lower right: *C. Pissarro. 1866*
The Art Institute of Chicago, Mr. and Mrs. Lewis L. Coburn Fund, 1957 1957.306

CATALOGUE RAISONNÉ: Pissarro and Venturi 1939, no. 47

PROVENANCE: The artist until his death; Mme Pissarro, Paris; her sale, Paris, Galerie Georges Petit, December

3, 1928, no. 27 ("Paysage à La Varenne-Saint-Hilaire"); purchased at this sale by the art dealer Jacques Dubourg, Paris; S. G. Archibald, by 1930; Reid and Lefevre, London, by 1952; purchased by the Art Institute of Chicago, 1957

EXHIBITIONS: Paris, Salon of 1866, no. 1564 ("Bords de la Marne en hiver"); Paris 1930, no. 3 ("Paysage à La Varenne-Saint-Hilaire"); New York 1965, no. 2; Philadelphia, Detroit, Paris 1978–79, no. VI-96; London, Paris, Boston 1980–81, no. 6; Los Angeles, Chicago, Paris 1984–85, no. 9

SELECTED REFERENCES: Zola, "Mon Salon: Adieux d'un critique d'art," 1866, in Zola 1991, p. 133; Castagnary, "Salon de 1866," in Castagnary 1892, vol. 1, p. 235; Rousseau 1866, p. 447; Linda Nochlin, "Camille Pissarro: The Unassuming Eye," *Art News* 64 (April 1965), p. 60 (revised and expanded in Christopher Lloyd, ed., *Studies on Camille Pissarro* [London and New York, 1986], p. 5, pl. 2); Champa 1973, pp. 72–73, pl. 27 (incorrect caption); Shikes and Harper 1980, pp. 70–71, repr. p. 65; Lloyd 1981, p. 31, repr. p. 30; Pissarro 1993, pp. 48–52, 65, fig. 41

When he was not rejected outright, as in 1861 and 1863, Pissarro's earliest appearances at the Salon were received with silence. He seems to have been little noticed by critics until he sent this austere painting, one of his most daring to date, to the Salon of 1866. This time Daubigny, as a new member of the jury, did speak up on Pissarro's behalf; such intervention was now necessary because the composition and the coloring of this work were not nearly as ingratiating or conventional as Pissarro's previous entries (cats. 154, 155). According to Moreau-Nélaton, Corot, whom Pissarro had previously listed as one of his masters, did not approve of the direction the young artist's work was taking. As a result, Pissarro no longer listed himself as a pupil of Corot.[1]

Zola, however, listed Pissarro along with Daubigny and Corot as one of the three landscapists whom he wished to discuss more fully in what he called his "farewell as an art critic." He immediately seized the novel aspects of Pissarro's picture and praised him for them. "M. Pissarro is an unknown artist, whom no one will likely mention. I consider it my duty to give him a vigorous handshake before I leave. Thank you, sir, your landscape allowed me to rest for a good half an hour during my trip across the great desert of the Salon. I know that you were admitted with great difficulties, and I sincerely congratulate you for it. Besides, you must know that no one appreciates your work, and that your painting is deemed too bare and too black. Then, why in the devil's name are you so very clumsy as to study nature and paint it in a plain and forthright manner!

"See here: you selected a winter scene; you put in it a mere portion of an avenue, then a small hill at the back, and empty fields extending to the horizon. This is no feast for the eyes. It is an austere and serious painting, showing an extreme concern for the truth and for correctness, a bleak and strong will. What a clumsy fellow you are, sir—you are one artist I like."[2]

The critic Jean Rousseau was equally impressed. "Surely, nothing is more vulgar than this site,

and yet I challenge you to walk in front of it without noticing it. It becomes original by the brusque energy of the execution, in some way underlining ugliness rather than attempting to conceal it. One can see that M. Pissarro is not banal because he is lacking in the picturesque. On the contrary, he uses his strong and exuberant talent to emphasize the vulgar aspects of the contemporary world, in the manner of a satirical poet, all the more eloquent as he is telling the raw and unaltered truth."[3]

Pissarro kept this painting, his first critical success, all of his life.

G.T.

1. Moreau-Nélaton 1924, vol. 2, p. 22, cited in Rewald 1973, p. 134.
2. "M. Pissarro est un inconnu, dont personne ne parlera sans doute. Je me fais un devoir de lui serrer vigoureusement la main, avant de partir. Merci, monsieur, votre paysage m'a reposé une bonne demi-heure, lors de mon voyage dans le grand désert du Salon. Je sais que vous avez été admis à grand-peine, et je vous en fais mon sincère compliment. D'ailleurs, vous devez savoir que vous ne plaisez à personne, et qu'on trouve votre tableau trop nu, trop noir. Aussi pourquoi diable avez-vous l'insigne maladresse de peindre solidement et d'étudier franchement la nature!

"Voyez-donc: vous choisissez un temps d'hiver; vous avez là un simple bout d'avenue, puis un coteau au fond, des champs vides jusqu'à l'horizon. Pas le moindre régal pour les yeux. Une peinture austère et grave, un souci extrême de la vérité et de la justesse, une volonté âpre et forte. Vous êtes un grand maladroit, monsieur—vous êtes un artiste que j'aime." "Mon Salon: Adieux d'un critique d'art," 1866, in Zola 1991, p. 133.
3. "Rien de plus vulgaire assurément que ce site, et pourtant je vous défie de passer devant sans le remarquer. C'est qu'il devient original par l'énergie abrupte de l'exécution qui souligne, en quelque sorte, ces laideurs, au lieu de chercher à les dissimuler. On voit que M. Pissarro n'est pas banal par impuissance d'être pittoresque. Il emploie au contraire un talent robuste et exubérant à faire ressortir les vulgarités du monde contemporain, à la façon du poète satirique, d'autant plus éloquent qu'il est d'une vérité plus brutale et moins arrangée." Rousseau 1866, p. 447.

157 Fig. 205

Camille Pissarro
Nature morte
(*Still Life*)
1867
Oil on canvas

31⅞ x 39¼ in. (81 x 99.6 cm)
Signed and dated upper right: *C. Pissarro. 1867*
The Toledo Museum of Art, Purchased with funds from the Libbey Endowment, Gift of Edward Drummond Libbey, 1949 1949.6

CATALOGUE RAISONNÉ: Pissarro and Venturi 1939, no. 50

PROVENANCE: The artist until his death; Mme Pissarro, Paris; her sale, Galerie Georges Petit, Paris, December 3, 1928, no. 33; purchased at this sale by Georges Viau, Paris; his first sale, Hôtel Drouot, Paris, December 11, 1942, no. 108; his second sale, Galerie Charpentier, Paris, June 22, 1948, no. 5; Wildenstein and Co., New York; sold to the Toledo Museum of Art, 1949

EXHIBITIONS: Paris 1930, no. 6; New York, Wildenstein and Co., October 24–November 24, 1945, *Camille Pissarro: His Place in Art*, no. 1; New York 1965, no. 3; London, Paris, Boston 1980–81, no. 8 (exhibited in Boston only); Cleveland, Brooklyn, Saint Louis, Glasgow 1980–82, no. 121

SELECTED REFERENCES: Rewald 1963, pp. 16, 68, repr. p. 69; Champa 1973, pp. 74–75, pl. 18; Rewald 1973, pp. 157–58, repr. p. 156; Lloyd 1979, p. 4, pl. 5; Shikes and Harper 1980, p. 73, repr. p. 72; Lloyd 1981, p. 64, repr. p. 63; Brettell 1990, p. 168; Christopher B. Campbell, "Pissarro and the Palette Knife: Two Pictures from 1867," *Apollo* 136 (November 1992), pp. 311–14, pl. 1

John Rewald has suggested that Pissarro painted this still life in the fall of 1867, at La Roche-Guyon, where Antoine Guillemet and possibly Paul Cézanne were also staying.[1] Since the only other Pissarro of the 1860s that was entirely executed with a knife was certainly painted in La Roche-Guyon (*Une place à La Roche-Guyon* [*A Square at La Roche-Guyon*], Nationalgalerie, Berlin), it is reasonable to surmise that this work was made there as well.

Whether or not Cézanne was present at its creation, Pissarro unmistakably addressed Cézanne with this work. For while so conspicuous a use of a palette knife might be thought to derive from Courbet, in fact, as Christopher Campbell has shown, it more closely resembles some of Cézanne's recent work.[2] Courbet used the palette knife to blend paint and to create multilayered and craggy effects, whereas Cézanne and, here, Pissarro used the knife—properly speaking a paint, not a palette, knife—to load slabs of pigment, often unmodulated in hue, onto the canvas. Once applied, these broad planes of creamy paint had more to do with effects observed in Manet's paintings than in those of Courbet.

Still lifes are rare throughout Pissarro's oeuvre, although it is possible that more were painted in the 1860s than the very few that survived the German occupation of his house during the Franco-Prussian War. Given their frequency in the 1880s and 1890s, still lifes were also rare in Cézanne's oeuvre in the 1860s. His *Pain et Œufs*, signed and dated 1865 (cat. 22), stands out as an important precedent for the present work, not only in Cézanne's rich use of impasted paint, but also in the choice of humble objects. Other artists, such as Bonvin or even Manet, also depicted simple objects, but their compositions were more sophisticated, worldly, and elegant, evoking seventeenth-century Spanish painting or the eighteenth-century still lifes of Chardin. Cézanne

and Pissarro stand alone with their forceful and awkward compositions.

G.T.

1. Rewald 1963, p. 19.
2. Christopher B. Campbell, "Pissarro and the Palette Knife: Two Pictures from 1867," *Apollo* 136 (November 1992), pp. 311–14.

158 Fig. 119

Camille Pissarro
La Côte de Jallais
(*Jallais Hill*)
1867
Oil on canvas
34¼ x 45¼ in. (87 x 114.9 cm)
Signed and dated lower right: *C. Pissarro / 1867.*
The Metropolitan Museum of Art, New York, Bequest of William Church Osborn, 1951 51.30.2

CATALOGUE RAISONNÉ: Pissarro and Venturi 1939, no. 55

PROVENANCE: Durand-Ruel, Paris; Heinemann Gallery, New York, 1927; William H. Holston, New York, 1929; William Church Osborn, New York, 1929; his bequest to the museum, 1951

EXHIBITIONS: Paris, Salon of 1868, no. 2015 ("La Côte de Jallais"); Paris 1914, no. 5; New York, Wildenstein and Co., October 24–November 24, 1945, *Camille Pissarro: His Place in Art*, no. 2; Paris, New York 1974–75, no. 33; London, Paris, Boston 1980–81, no. 9

SELECTED REFERENCES: Castagnary, "Salon de 1868," in Castagnary 1892, vol. 1, p. 278; Redon, "Le Salon de 1868," in Redon 1987, p. 57; Zola, "Mon Salon: Les naturalistes," 1868, in Zola 1991, p. 205; Rewald 1963, p. 70, repr.; Sterling and Salinger 1967, pp. 15–16, repr.; Champa 1973, pp. 75–76, fig. 107; Rewald 1973, repr. p. 186; Lloyd 1979, p. 5; Shikes and Harper 1980, pp. 73–75, repr. p. 66; Lloyd 1981, pp. 31–33, repr. p. 34; Christopher Lloyd, "Reflection on La Roche-Guyon and the Impressionists," *Gazette des Beaux-Arts*, ser. 6, 15 (January 1985), pp. 39–40, fig. 8; Thomson in Birmingham, Glasgow 1990, p. 26, fig. 24 (not in exhibition); Brettell 1990, pp. 105, 122, 126, 137–38, 213, n. 32, figs. 95, 116; Broude 1991, p. 56, fig. 34; Lloyd 1992, pp. 285–86, fig. 6; Pissarro 1993, pp. 51–56, fig. 44

This large canvas is one of several similar landscapes of the environs of Pontoise, where Pissarro lived from autumn 1866 until spring 1869. (After stays in Louveciennes and London, he and his family returned to Pontoise in 1872.) Most of these large views depict the hamlet of l'Hermitage, adjacent to Pontoise, which nestles beneath the broad

Jallais hill. The cultivated fields on the hill serve as a beautifully striped foil to the picturesque jumble of houses and walled gardens. Although he changed houses frequently, Pissarro lived primarily in l'Hermitage, an attractive quarter of eighteenth- and nineteenth-century farmhouses.

At the Salon of 1868 Pissarro exhibited this painting along with another, entitled *L'Hermitage* (perhaps cat. 159 or 160). It is generally assumed that Daubigny encouraged the Salon jury to accept Pissarro's pictures, and he did send Pissarro a note informing him of the jury's decision.[1]

Although the works were badly hung, they were noticed by the progressive critics. Castagnary gave them a favorable mention: "The *Côte de Jallais* and the *Ermitage* [*sic*] by Pissarro, still hung too high this year, but not high enough to prevent the public from making out the solid qualities that characterize it, etc., etc."[2] The young Odilon Redon paused to consider Pissarro's entries seriously: "*L'Hermitage* and the *Côte du Jallais* are very strong subjects and do not lack in character. The color is a bit dull, but it is simple and very true. His peculiar talent seems to brutalize nature. He paints it in an apparently very rudimentary manner, but this indicates above all sincerity. M. Pissarro's vision is simple; the sacrifices he makes in his coloring only express the general impression more vividly, and this expression is always strong because it is simple."[3]

Émile Zola was most enthusiastic of all. He found in Pissarro the ideal exponent of "naturalist" landscape painting, an artist who provided an analogy to the "naturalist" writing he had begun to develop. Reminding his readers that Pissarro was ignored by the public and pedestrian critics, Zola considered the artist to be "one of the most profound and serious talents of our time."[4] After extolling Pissarro's temperament and vision, he went on to characterize the two landscapes of Pontoise on view. "This is the modern country. One feels that man has been here, digging the ground, dividing it, creating a dejected landscape. This small valley, this little hill possess a heroic simplicity and candor. If it were not so great, nothing would be more banal. The temperament of the painter has drawn a precious poem of life and force out of ordinary truth."[5]

G.T.

1. Rewald 1973, p. 185.
2. "La *Côte de Jallais* et l'*Ermitage* de Pissarro, qu'on a encore placé trop haut cette année, mais pas assez haut cependant pour empêcher les amateurs de suivre les solides qualités qui le distinguent, etc., etc." Castagnary, "Salon de 1868. V," in Castagnary 1892, vol. 1, p. 278.
3. "*L'Hermitage* et la *Côte du Jallais* sont des choses fortement vues et qui ne manquent pas de caractère. La couleur est un peu sourde, mais elle est simple, large et bien sentie. Singulier talent qui semble brutaliser la nature. Il la traite dans une facture en apparence très rudimentaire, mais cela dénote surtout de la sincérité. M. Pissarro voit simplement; il a, dans la couleur, ces sacrifices qui n'expriment que plus vivement l'impression générale, toujours forte parce qu'elle est simple." "Le Salon de 1868," in Redon 1987, p. 57.
4. "un des talents les plus profonds et les plus graves de l'époque." "Mon Salon: Les naturalistes," 1868, in Zola 1991, p. 201.

5. "C'est là la campagne moderne. On sent que l'homme a passé, fouillant le sol, le découpant, attristant les horizons. Et ce vallon, ce coteau sont d'une simplicité, d'une franchise héroïque. Rien ne serait plus banal si rien n'était plus grand. Le tempérament du peintre a tiré de la vérité ordinaire un rare poème de vie et de force." "Mon Salon: Les naturalistes," 1868, in Zola 1991, p. 205.

159 *(Paris only)* *Fig. 120*

Camille Pissarro

L'Hermitage à Pontoise
(*L'Hermitage at Pontoise*)
1867
Oil on canvas
35⅞ x 59¼ in. (91 x 150.5 cm)
Signed and dated lower right: *C. Pissarro. 1867.*
Wallraf-Richartz-Museum, Cologne WRM 3119

CATALOGUE RAISONNÉ: Pissarro and Venturi 1939, no. 56

PROVENANCE: Ambroise Vollard, Paris, by 1930; Alfred Chester Beatty, London; Fritz and Peter Nathan, Zurich; sold to the Wallraf-Richartz-Museum, 1961

EXHIBITIONS: (?) Paris, Salon of 1868, no. 2016 ("L'hermitage"); Paris 1930, no. 6 bis; London, Paris, Boston 1980–81, no. 10 (exhibited in London only)

SELECTED REFERENCES: (?) Castagnary, "Salon de 1868," in Castagnary 1892, vol. 1, p. 278; (?) Redon, "Salon de 1868," in Redon 1987, p. 57; (?) Zola, "Mon Salon: Les naturalistes," 1868, in Zola 1991, pp. 204–5; Rewald 1963, repr. p. 17; *Dr. Fritz Nathan und Dr. Peter Nathan 1922–1972* (Zurich, 1972), no. 67, repr.; Champa 1973, pp. 75–77, pl. 21; Lloyd 1979, p. 5, pl. 6; Lloyd 1981, pp. 31–33, repr.; Anthea Callen, *Techniques of the Impressionists* (London, 1982), pp. 46–49, repr.; Brettell 1990, p. 147, pl. 131; Lloyd 1992, pp. 285–86, fig. 7; Pissarro 1993, pp. 51–53, fig. 47

Although this painting is sometimes identified as the work Pissarro exhibited at the Salon of 1868 alongside the Metropolitan Museum's *Côte de Jallais* (cat. 158), Zola's description of the exhibited work more closely fits the painting now in Prague (cat. 160). Nevertheless, this canvas shares with the painting at the Metropolitan a rigid geometrical composition worked out in dense paint applied with palpable brushstrokes, which, as Anthea Callen recently noted, imitate natural textures.[1] Callen has found a resemblance in this populated composition to Corot's work, but the specificity of the depicted labor seems closer to Millet, and the emphasis on architecture, a product of man's work rather than nature's, is far removed from the spirit of Corot.

G.T.

1. Anthea Callen, *Techniques of the Impressionists* (London, 1982), p. 46.

160 *(Paris only)* *Fig. 121*

Camille Pissarro

L'Hermitage
Ca. 1868
Oil on canvas
32⅛ x 39⅜ in. (81.5 x 100 cm)
Signed lower left: *C. Pissarro.*
Národni Galeri, Prague 0.3197

CATALOGUE RAISONNÉ: Pissarro and Venturi 1939, no. 52

PROVENANCE: Miss A. Isaacson, London; acquired by the Národni Galeri, 1923

EXHIBITIONS: (?) Paris, Salon of 1868, no. 2016 ("L'hermitage"); Paris, Galeries Durand-Ruel, April 7–30, 1904, *Exposition de l'oeuvre de Camille Pissarro*, no. 4; Paris 1914, no. 8; Bordeaux 1974, no. 113

SELECTED REFERENCES: (?) Castagnary, "Salon de 1868," in Castagnary 1892, vol. 1, p. 278; (?) Redon, "Salon de 1868," in Redon 1987, p. 57; (?) Zola, "Mon Salon: Les naturalistes," 1868, in Zola 1991, pp. 204–5; Brettell 1990, p. 149; Pissarro 1993, p. 51, fig. 46

Pissarro exhibited paintings entitled *L'Hermitage* at both the Salon of 1868 and the Salon of 1869. One view of the hamlet of l'Hermitage is now at the Solomon R. Guggenheim Museum, New York (cat. 161), another is now in Cologne (cat. 159). Although there is some debate among scholars as to which painting was exhibited in which Salon, it seems unlikely that the Guggenheim picture was exhibited in 1868 because its bright palette and varied brushwork is typical of Pissarro's work in late 1868 to early 1869, not early 1868. The Cologne painting was executed in a manner very similar to that of *La Côte de Jallais* (cat. 158), which was dated 1867 and certainly exhibited in 1868. Thus while it is possible that the Cologne picture was the one exhibited in 1868, more likely it was the present painting, now in Prague, because it more closely fits the description written in a review by Émile Zola:[1]

"The foreground of the *Hermitage* represents an extending and receding piece of ground; beyond it, there is a main building surrounded by a cluster of tall trees. Nothing more. But what a living earth, what a plant life saturated with sap, what a vast horizon! After examining the painting for a few minutes, I thought I saw the country opening in front of me." Zola went on to extol (and to exaggerate) Pissarro as an isolated, unappreciated searcher for pictorial truth. "The artist is alone, full of conviction, following his own path, without ever being discouraged. Around him, makers are celebrated and their paintings bought. If he was willing to lie as they do, he

would partake of their good fortune. But he persists in the face of public indifference, he remains the proud and lone lover of truth."[2]

There remains an obstacle to the identification of this painting as the work exhibited in 1868. Richard Brettell has argued that this composition depicts an area called Le Chou rather than l'Hermitage.[3] If this is true, then another candidate must be sought for the 1868 Salon painting.

G.T.

1. I thank Anne M. P. Norton for relating this identification to me.
2. "Dans l'*Hermitage*, au premier plan, est un terrain qui s'élargit et s'enfonce; au bout de ce terrain, se trouve un corps de bâtiment dans un bouquet de grands arbres. Rien de plus. Mais quelle terre vivante, quelle verdure pleine de sève, quel horizon vaste! Après quelques minutes d'examen, j'ai cru voir la campagne s'ouvrir devant moi." "L'artiste est seul, convaincu, suivant sa voie, sans jamais se laisser abattre. Autour de lui, on décore les faiseurs, on achète leurs toiles. S'il consentait à mentir comme eux, il partagerait leur bonne fortune. Et il persiste dans l'indifférence publique, il reste l'amant fier et solitaire de la vérité." "Mon Salon: Les naturalistes," 1868, in Zola 1991, pp. 204–5.
3. Brettell 1990, p. 149.

161 *(New York only)* *Fig. 122*

Camille Pissarro

L'Hermitage
Ca. 1868
Oil on canvas
59⅞ x 79 in. (151.4 x 200.6 cm)
Signed lower left: *C. Pissarro.*
The Solomon R. Guggenheim Museum, New York, Justin K. Thannhauser Collection

CATALOGUE RAISONNÉ: Pissarro and Venturi 1939, no. 58

PROVENANCE: Jean-Baptiste Faure, Paris, purchased directly from the artist or through Durand-Ruel, by 1876;[1] Durand-Ruel, Paris, placed on deposit by Faure on June 14, 1899, and purchased on June 6, 1901; sold to Cassirer, Berlin, June 1901; Moderne Galerie (Heinrich Thannhauser), Berlin, by 1918; bequest of Justin K. Thannhauser to the Guggenheim Museum, 1976

EXHIBITIONS: (?) Paris, Salon of 1869, no. 1950 ("L'ermitage" [sic]); Paris 1930, no. 10; London, Paris, Boston 1980–81, no. 11 (exhibited in Boston only)

SELECTED REFERENCES: Champa 1973, pp. 75–77, fig. 109; Rewald 1973, repr. p. 159; Vivian Endicott Barnett, *The Guggenheim Museum: Justin K. Thannhauser Collection* (New York, 1978), pp. 181–83, no. 67, repr.; Shikes and Harper 1980, pp. 73–75, 84, 130, repr. p. 74; Lloyd 1981,

pp. 31–32, repr. p. 30; Lloyd 1992, pp. 285–86, 290, n. 28, fig. 8; Pissarro 1993, pp. 51–56, fig. 45

This magnificent work is the largest and probably last of the big canvases of the 1860s devoted to the environs of Pontoise. There is considerable debate about the date of the work, but the bright palette and varied brushwork point firmly in the direction that Pissarro's work took in late 1868 and early 1869, when he moved to Louveciennes. This is probably the work listed as *L'Hermitage* in the *livret* of the 1869 Salon. But it is not known whether Pissarro's picture was actually exhibited. Castagnary, who normally mentioned Pissarro's pictures, wrote nothing about him in his article for that year, and Pissarro's other major supporter, Zola, did not review the 1869 Salon. In any event this painting is not likely to be the work exhibited at the Salon of 1868, which was most probably the view of l'Hermitage now in Prague (cat. 160).

With its brilliant blue sky, picturesque group of buildings, and informal conversation occurring on a village road, this painting could be seen as Pissarro's response to Courbet's *Demoiselles de village* (fig. 164). The huge canvas, by far the largest of his entire career, is atypical of Pissarro, and it shows him reaching out to the dimensions that Courbet and, more recently, Monet used to attract attention. It lacks the interchange between classes that is an important part of Courbet's message, but this absence of anecdote is to be expected with Pissarro.

G.T.

1. See Vivian Endicott Barnett, *The Guggenheim Museum: Justin K. Thannhauser Collection* (New York, 1978), p. 181, n. 1.

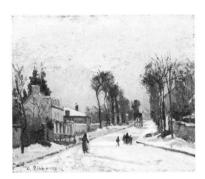

162 *Fig. 317*

Camille Pissarro

La Route de Versailles à Louveciennes (effet de neige)
(*The Versailles Road at Louveciennes [Snow]*)
1869
Oil on canvas
15⅛ x 18¼ in. (38.4 x 46.3 cm)
Signed lower left: *C. Pissarro*
Courtesy of the Walters Art Gallery, Baltimore, lent by the George A. Lucas Collection of the Maryland Institute, College of Art 37.1989

PROVENANCE: Probably purchased from the artist by Pierre Firmin "Père" Martin, Paris; purchased from Martin by George A. Lucas, Paris, January 7, 1870; his bequest to the Maryland Institute, 1910

EXHIBITIONS: London, Paris, Boston 1980–81, no. 13; Tokyo et al. 1984, no. 11

SELECTED REFERENCES: *The Diary of George A. Lucas: An American Art Agent in Paris, 1857–1909*, transcribed and edited by Lilian M. C. Randall (Princeton, 1979), vol. 1, fig. 102, vol. 2, p. 313; Lloyd 1981, p. 43; Richard R. Brettell, "The Cradle of Impressionism," in Los Angeles, Chicago, Paris 1984–85, p. 80, fig. 14, p. 90, under no. 15 (not in exhibition); Brettell 1990, p. 215, n. 25

In early 1869, Pissarro moved from Pontoise to rented quarters in a large house called the Maison Retrou at 22, route de Versailles in Louveciennes. Over the course of the year he was joined by Monet, Sisley, and Renoir. Monet and Renoir worked in nearby Bougival, for example, in the summer of 1869, and Renoir often visited his mother and grandmother in Louveciennes even while he was living at Ville-d'Avray. Sisley moved to Voisins de Louveciennes in autumn 1870, but it is thought that he visited Monet and Pissarro over the previous winter. Monet actually came to stay with Pissarro in December 1869, when a very heavy snow fell over the entire Ile-de-France. Both artists set out to paint Louveciennes in the snow. Although Monet had executed a number of snow scenes in 1867, this painting is the first snow scene Pissarro ever painted.[1]

Following his pictorial instincts, Pissarro did not portray any of the vestiges of royal habitation in nearby Marly-le-Roi but focused instead on the modest street where he lived. A number of writers have identified the house on the left of this painting as the Maison Retrou, but the identification remains uncertain. In all of Pissarro's pictures of the route de Versailles he emphasized the unusual silhouettes of the slender chestnuts that line the road in contrast to the blocky houses. Monet also depicted the route de Versailles but from different vantage points (see cat. 149).

The loose and broken brushstrokes here, the close attention to subtle changes in value, the pale palette, and the absence of a strong shape dominating the middle ground, all are indications that Pissarro was bringing his style away from the architectonic paintings of his work in Pontoise toward a new aesthetic similar to that concurrently being developed by Monet.

An American art agent, George A. Lucas, purchased this painting from the dealer Martin on January 7, 1870, just weeks after it was painted.[2] It was one of the first by Pissarro to be bought by an American.

G.T.

1. See Richard R. Brettell in London, Paris, Boston 1980–81, p. 20.
2. *The Diary of George A. Lucas: An American Art Agent in Paris, 1857–1909*, transcribed and edited by Lilian M. C. Randall (Princeton, 1979), vol. 1, fig. 102, vol. 2, p. 313.

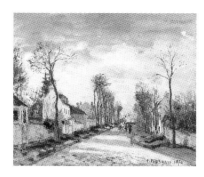

163 *Fig. 318*

Camille Pissarro
La Route de Versailles à Louveciennes
(*The Versailles Road at Louveciennes*)
1870
Oil on canvas
12⅞ x 16³⁄₁₆ in. (32.8 x 41.1 cm)
Signed and dated lower right: *C. Pissarro. 1870*
Sterling and Francine Clark Art Institute, Williamstown,
Massachusetts 828

CATALOGUE RAISONNÉ: Pissarro and Venturi 1939, no. 77

PROVENANCE: Lucien Pissarro, London, son of the artist;
sold to the art dealer Sam Salz, New York; sold to
Durand-Ruel, New York, July 15, 1941; sold to Robert
Sterling Clark, February 26, 1942; their gift to the mu-
seum, 1955

EXHIBITION: London 1931, no. 38

SELECTED REFERENCES: Shikes and Harper 1980, p. 83,
repr. p. 82; London, Paris, Boston 1980–81, under
no. 14 (not in exhibition); Lloyd 1981, repr. p. 42; Pissarro
1993, p. 61, fig. 54

Presumably this painting was executed in early
1870, soon after the previous work (cat. 162). The
trees are still bare, but snow has melted and the
pale green of new grass is beginning to emerge.
Pissarro carefully selected a view that ignored
the great aqueduct of Marly, which ran behind
the houses on this street, and sought instead to
capture the fragile and fugitive coloration of a
fine day with a hint of spring. The blond palette,
a dramatic departure from the paintings of
1867–68, announces the harmonies that Pissarro
would explore throughout the 1870s. The casual
and varied brushwork is evidence that the aes-
thetic of the sketch has been fully accepted as
appropriate for finished paintings.

G.T.

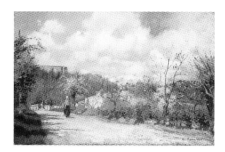

164 *Fig. 326*

Camille Pissarro
Printemps à Louveciennes
(*Springtime in Louveciennes*)
Ca. 1869–70
Oil on canvas
20¾ x 32¼ in. (52.7 x 81.9 cm)
Signed lower right: *C Pissarro*
The Trustees of the National Gallery, London.
3265

CATALOGUE RAISONNÉ: Pissarro and Venturi 1939, no. 85

PROVENANCE: Purchased from the artist by Durand-Ruel,
Paris, 1897; sold to Sir Hugh Lane, Dublin, 1905; his
bequest to the Tate Gallery, 1917; transferred to the
National Gallery, 1952

EXHIBITIONS: London 1931, no. 2; Tokyo et al. 1984, no.
12; Edinburgh 1986, no. 88

SELECTED REFERENCES: Martin Davies, *National Gallery
Catalogues: French School*, revised by Cecil Gould
(London, 1970), pp. 111–12; Lloyd 1981, repr. p. 42;
Bernard Dunstan, *Painting Methods of the Impressionists*
(New York, 1983), p. 68, repr. p. 71; Michael Wilson,
*The National Gallery Schools of Painting: French Paint-
ings after 1800* (London, 1983), p. 56, pl. 20; Herbert
1988, p. 204, pl. 206; Richard Thomson in Birmingham,
Glasgow 1990, p. 21, fig. 8 (not in exhibition); Pissarro
1993, pp. 60–61, 65, fig. 50

Martin Davies identified the cluster of houses in
the middle of this painting as the village of Voisins
near Louveciennes.[1] The road in the foreground
was called the route de la Princesse and ran from
the train station at Bougival to Pissarro's house
in Louveciennes.[2] The aqueduct of Marly is plainly
visible at the horizon on the left.

There are no paintings dated 1869 in the Pis-
sarro catalogue raisonné, and scholars have until
now explained that those that existed were de-
stroyed during the Prussian occupation of Pis-
sarro's house during the siege of Paris. However,
as Joachim Pissarro has recently pointed out, a
large number of works have survived that are
dated 1870, works that would also have been in
Pissarro's house at Louveciennes and thus should
have been destroyed.[3] It seems likely, therefore,
that several pictures usually dated after the war
in fact date from before the war—1869–70—and
this work could be one of them. It has the light
touch and variety of brushstrokes that one asso-
ciates with Pissarro after he began to work with
Monet in December 1869. It may therefore re-
cord the fruit trees flowering in spring 1870, but
it is also possible that it was painted soon after
Pissarro moved to Louveciennes in spring 1869,
as Brettell, Thomson, and Joachim Pissarro have
suggested.[4]

What appears to be the same stretch of this
road was painted by Renoir about 1870 (cat. 179).
Renoir's scene is more lush and probably was
made in summer, but, more significantly, his
brushstrokes are much more fluid and flickering,
creating a canvas that shimmers.

G.T.

1. Martin Davies, *National Gallery Catalogues: French
 School*, revised by Cecil Gould (London, 1970), p. 111.
2. According to Richard R. Brettell in Tokyo et al. 1984,
 p. 17.
3. Pissarro 1993, p. 60.
4. Brettell in Tokyo et al. 1984, p. 17; Thomson in Birming-
 ham, Glasgow 1990, p. 21; Pissarro 1993, pp. 60–61.

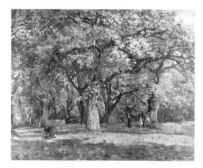

165 *(New York only)* *Fig. 101*

Camille Pissarro
La Forêt
(*The Forest*)
1870
Oil on canvas
31 x 38½ in. (78.8 x 97.9 cm)
Signed and dated lower left: *C. Pissarro 1870*
Johannesburg Art Gallery 322

CATALOGUE RAISONNÉ: Pissarro and Venturi 1939, no. 91

PROVENANCE: (?) Pierre Firmin "Père" Martin (1817–1891),
Paris; Durand-Ruel, Paris; acquired, probably from
Durand-Ruel, by Sir Hugh Lane for Sir Otto Beit; pre-
sented by Beit to the Johannesburg Art Gallery, 1910

EXHIBITIONS: Paris, Galeries Durand-Ruel, *Tableaux et
gouaches par Camille Pissarro*, 1910, no. 41; Tokyo et
al. 1984, no. 13

SELECTED REFERENCE: London, Paris, Boston 1980–81,
under no. 18 (not in exhibition)

These trees appear to be the grove of chestnut
trees at Louveciennes that perennially attracted
Pissarro both before and after the war. Other pic-
tures of the trees (Pissarro and Venturi 88, 144,
148) show them at spring and winter when the
gnarled branches and crooked trunks could cast
strong shadows on the ground. Here of course
they are in full leaf, so their dense foliage and
massive forms inscribe them in the tradition of
Barbizon painting as exemplified by Théodore
Rousseau. The palette, however, is brighter and
the brushwork looser than those ever used by
Rousseau, who before his death in 1867 was act-
ing against the emerging Impressionist painters
in his role as a member of the Salon jury. And

paintings such as this demonstrate how far removed Pissarro's work was by the end of the decade from the cool, silvery landscapes of his master Corot, who had also denounced the direction Pissarro had taken.

G.T.

Pierre Puvis de Chavannes

Lyons, 1824–Paris, 1898

Born to a middle-class family in Lyons, Puvis received his first art lessons from Henri Scheffer. In 1849, after a few weeks at Delacroix's short-lived studio, he began studying with Couture. He produced his first decorative paintings in 1854–55 at the family estate in Brouchy. Admitted to the Salon in 1850, he was subsequently rejected until the Salon of 1859, when he exhibited *Un Retour de chasse* (fig. 23). Puvis's fame was established at the Salons of 1861 and 1863 with the large canvases that would eventually decorate the Musée de Picardie in Amiens. After that he received a number of major commissions: in 1866 Claude Vignon, a sculptor and writer, requested four panels for the vestibule of his town house in Passy; and in 1867–69 he was asked for two wall canvases, *Marseille, colonie grecque* (*Marseille as a Greek Colony*) and *Marseille, porte de l'Orient* (*Marseille, Gateway to the East*), for the stairway of the Musée des Beaux-Arts in Marseille.

166 *Fig. 23*

Pierre Puvis de Chavannes
Un retour de chasse
(*Return from the Hunt*)
1859
Oil on canvas
155½ x 116⅛ in. (395 x 295 cm)
Signed and dated lower left: P.Puvis de Chavannes 1859
Musée des Beaux-Arts, Marseille inv. 214

PROVENANCE: Gift from the artist to the Musée des Beaux-Arts, Marseille, 1859

EXHIBITIONS: Paris, Salon of 1859, no. 2526 (Un retour de chasse. Fragment of painted mural); Lyon, Musée des Beaux-Arts, 1937, *Puvis de Chavannes et la peinture lyonnaise du xixe siècle*, no. 11; Paris, Grand Palais, and Ottawa, National Gallery of Canada, 1976–77, *Puvis de Chavannes*, no. 32; Marseille, Musée des Beaux-Arts, 1984–85, *Puvis de Chavannes et le musée des Beaux-Arts de Marseille*, no. 1

SELECTED REFERENCES: Delaborde 1859, pp. 501–2; A.-J. Du Pays, "Salon de 1859," *L'Illustration*, July 16, 1859, p. 60; Théophile Gautier, "L'Exposition de 1859," *Le Moniteur universel*, June 23, 1859, pp. 721–22; Louis Leroy, "Le Charivari au Salon de 1859. IV," *Le Charivari*, April 27, 1859, p. 3; Jean Rousseau, "Salon de 1859. V. Les hommes nouveaux," *Le Figaro*, May 31, 1859, p. 4; Paul de Saint-Victor, "Salon de 1859. III," *La Presse*, May 7, 1859, p. 2; Théophile Gautier, *Abécédaire du Salon de 1861* (Paris, 1861), p. 102; Marius Vachon, *Puvis de Chavannes* (Paris, 1895), p. 77; Léon Riotor, *Essai sur Puvis de Chavannes* (Paris, 1896), pp. 36, 38–39; René Jean, *Puvis de Chavannes* (Paris, 1913), pp. 16–17; Wolfgang Drost and Ulrike Henninges, *Théophile Gautier: L'exposition de 1859* (Heidelberg, 1992), pp. 77–78

At the Salon of 1859 the only painting by Puvis de Chavannes was badly placed, "relegated to a distant room among those religious pictures of which one can praise only the intention and over which the indifferent glances of the public glide," noted Théophile Gautier, who was one of the first to discover the painter and was, in 1859, his most pertinent critic.[1] Ten years later, however, Edmond About remembered the impact of the painting and the "quasi-religious awe manifested by the public...the revelation, the promise."[2] But if we compare it with works by Flandrin (fig. 20), Bouguereau (fig. 26), Baudry (fig. 8), or Fromentin (fig. 21), Puvis's painting garnered only the skimpiest reviews. Few of the *salonniers* mentioned it, and, except in the cases of Gautier and Saint-Victor, the praise was never sincere. Still, Puvis was credited with qualities that even the most reluctant would eventually have to admit (see p. 32): "a certain instinct for grandeur" (Delaborde), "a certain aspiration to style" (du Pays), and, less subdued, "a horror of vulgarity and a passion for grand style" (Saint-Victor). Critics clearly reproached him for elements essential to his originality: the deliberate archaism, which seemed awkward or affected; the soft matte coloring, intended to recall that of frescoes but viewed by some as dull and washed out; the simplified structure; the use of large expanses of flat tints that some declared lacking in "bite" and "depth."

In his *Retour de chasse* of 1859 Puvis returned to one of the subjects in the mural series he had painted in the dining room of his brother's home at Brouchey, Saône-et-Loire, during 1854–55; the earlier *Retour d'une chasse d'Esaü* (Esau returning from the hunt) was accompanied there by *Pêche miraculeuse* (The miraculous draft of fishes), the *Retour de l'enfant prodigue* (Return of the Prodigal Son), *Ruth et Booz* (Ruth and Boaz), and the *Invention du vin* (Invention of Wine). Reworked almost "verbatim" yet stripped of its biblical reference, the new *Retour de chasse* looked like a scene culled from ancient history or from a primitive tale, something immemorial and naive—indeed, Nadar's caricature (fig. 424) re-

called the wooden pieces of a children's game, and Gautier spoke of "medieval naïveté."[3] Puvis turned his back on the fashionable hunts painted by society artists and the restorations of archaeological experts and, after vacillating so long between Couture and Chassériau, found himself at last; *Un Retour de chasse* became the prototype for his large compositions to come.[4] The exhibition listing for the work indicated a "fragment of mural painting" and specified the purpose of this huge canvas, which was to advertise the painter's interest in taking on large-scale decorating projects. His call was heard, and Puvis himself later reminisced that this painting had launched his career, "changing my luck for the better" and showing him "that there was something to do along these lines."[5] At the Salon of 1861 *Concordia* and *Bellum* would establish his reputation. Without doubt Degas, alerted by Gustave Moreau, was aware of Puvis's originality as early as 1859—even though he did not mention him in the report on the Salon he prepared for Moreau (see pp. 20–21).[6] The central group in Degas's *Fille de Jephté* (fig. 64), which he began right after the Salon of 1859, borrows from Delacroix's *Attila* (Palais Bourbon) as well as from *Le Retour de chasse*, although in reverse: the position of the horse is the same, Jephtha's movement resembles that of the hunter holding the quarry's head, and even the dog trotting alongside the horse is similar. Furthermore, both landscapes are extremely simplified; Degas noted that he meant to "treat a lot of the landscape as patches."[7] And, finally, we have the parallels of the deliberate references to the old masters: to the Bolognese, and especially to Guido Reni, for Puvis; to Veronese,

Fig. 424. Félix Nadar, caricature of *Un retour de chasse* by Puvis de Chavannes, published in *Journal amusant*, July 16, 1859, p. 5

for Degas; and, for both, Mantegna and the *Triumphs* at Hampton Court.[8]

H.L.

1. "relégué dans une salle lointaine parmi ces toiles reli-gieuses dont on ne peut louer que l'intention et sur lesquelles glissent les regards indifférents du public." Gautier 1859, p. 78.

2. "respect quasi religieux qui se manifestèrent dans le public... cette révélation, cette promesse." About, quoted by Jacques Foucart-Borville in Paris, Ottawa 1976–77, p. 55.

3. "Naïveté moyen âge." Gautier 1859, p. 78.

4. See Jacques Foucart-Borville's analysis in Paris, Ottawa 1976–77, p. 55.

5. "désenguignonn[ant] définitivement"; "qu'il y a quel-que chose à faire dans cette voie." Marius Vachon, *Puvis de Chavannes* (Paris, 1895), p. 77.

6. Gustave Moreau's friends did not always perceive Puvis's originality. Thus, after meeting the painter, who had just completed a self-portrait, and visiting his studio, Eugène Lacheurié wrote: "J'ai fait connaissance avec sa peinture qui m'a semblée bien étrange; il a du talent, je crois; mais qu'il se donne de mal pour imaginer des sujets détestables." (I got to know his paintings, which struck me as quite strange; I believe that he has talent, but that he trips himself up by imagining detestable subjects). Eugène Lacheurié's unpublished letter to Gustave Mo-reau, January 1858, Musée Gustave Moreau, Paris.

7. Reff 1985, notebook 15, p. 6.

8. For Puvis, see Jacques Foucart-Borville, in Paris-Borville 1976, p. 55. Both Saint-Victor and Gautier 1859 link *Un Retour de chasse* to the Mantegna at Hampton Court.

167

Fig. 60

Pierre Puvis de Chavannes
La Guerre
(War)
1867
Oil on canvas
43⅛ x 58¾ in. (109.5 x 149.2 cm)
Signed lower left: P. PUVIS DE CHAVANNES
The John G. Johnson Collection; Philadelphia Museum of Art JC1063

PROVENANCE: Sold by the artist to Durand-Ruel, Paris, about 1872; Hiltbrunner collection, 1887; Galerie Durand-Ruel, 1888; John G. Johnson, Philadelphia, 1888, until his death in 1917; his bequest to the city of Phila-delphia, 1917

EXHIBITIONS: Paris, Exposition Universelle, 1867, no. 526 (La Guerre, la Paix, le Travail, le Repos / Reduced ver-sions of the paintings executed for the Musée Napoléon III, Amiens, and exhibited at the Salons of 1861 and 1863); Paris, Musée des Arts Décoratifs, Palais de l'Industrie, 1881, *Exposition de peinture et de sculpture moderne de décoration et d'ornement*, no. 144 (La Paix, la Guerre, le Travail, le Repos / Four painted reductions

of decorative panels for a monument); Paris, Galerie Durand-Ruel, 1887, *Exposition de tableaux, pastels, dessins, par M. Puvis de Chavannes*, no. 21 (La Guerre / reduction of painted murals at the Musée Napoléon III, Amiens / Property of M. H.); New York, National Academy of Design, 1888, exhibition organized by Durand-Ruel; New York, Durand-Ruel Galleries, 1894, *Decorations and Pastels by M. Puvis de Chavannes*, no. 17; Toronto, Art Gallery of Ontario, 1975, *P. Puvis de Chavannes and the Modern Tradition*, no. 6; Paris, Grand Palais, and Ottawa, National Gallery of Canada, 1976–77, *Puvis de Chavannes*, no. 37; Philadelphia Museum of Art, Detroit Institute of Arts, and Paris, Grand Palais, 1979, *L'Art en France sous le second Empire*, no. 266

SELECTED REFERENCES: Edmond About, "Salon de 1861," *L'Opinion nationale*, May 17, 1861, p. 3; Louis Auvray, *Salon de 1861* (Paris, 1861), p. 38; Louis Brès, "Salon de 1861. IX," *Le Moniteur des arts*, July 13, 1861, p. 3; Hector de Callias, "Salon de 1861," *L'Artiste*, June 15, 1861, p. 11; Alphonse de Calonne, "La Peinture contemporaine à l'exposition de 1861," *La Revue contemporaine* (1861), pp. 354–56; A. Cantaloube, *Lettre sur les expositions et le salon de 1861* (Paris, 1861), pp. 52–54; Jules Castagnary, *Les artistes au xixᵉ siècle: Salon de 1861* (Paris, 1861), p. 11; Cham, "Le Salon de 1861," *Le Charivari*, May 26, 1861, p. 3; Henri Delaborde, "Le Salon de 1861," *La Revue des Deux Mondes* 3 (1861), pp. 885–86; E.-J. Delécluze, "Exposition de 1861," *Le Journal des débats*, May 8, 1861, p. 2; Alfred Delvau, "Salon de 1861. Deuxième journée," *Revue des Beaux-Arts*, May 6, 1861, pp. 191–92; Maxime Du Camp, *Salon de 1861* (Paris, 1861), pp. 74–80; A.-J. Du Pays, "Salon de 1861. I," *L'Illustration*, May 25, 1861, p. 330; Théophile Gautier, *Abécédaire de Salon de 1861* (Paris, 1861), pp. 102–6; Albert de La Fizelière, *A-Z ou le Salon en miniature* (Paris, 1861), pp. 41–42; Anatole de La Forge, "Salon de 1861: Rêveurs et réalistes," *Le Siècle*, May 17, 1861, p. 1; Léon Lagrange, "Salon de 1861," *Gazette des Beaux-Arts*, May 15, 1861, pp. 207–10, repr.; Louis Leroy, "Salon III," *Le Charivari*, May 12, 1861, p. 2; Olivier Merson, *Exposition de 1861: La Peinture en France* (Paris, 1861), pp. 172–82; Jean Rousseau, "Salon de 1861," *Le Figaro*, May 9, 1861, p. 5; Paul de Saint-Victor, "Salon de 1861," *La Presse*, May 12, 1861, pp. 1–2; Frédéric Des Granges, "Train de plaisir à travers l'exposition de Limoges," *L'Artiste*, June 30, 1864, p. 19; Thoré-Bürger 1870, vol. 1, pp. 41–42; Castagnary 1892, p. 129; Olivier Merson, *L'Exposition Universelle de 1867 illustrée* (Paris, 1867); Armand Silvestre, *Galerie Durand-Ruel: Recueil d'estampes* (Paris, London, 1873), no. 17; Marius Vachon, *Puvis de Chavannes* (Paris, 1895), pp. 67, 78, 80, 82, 84; Léon Riotor, *Essai sur Puvis de Chavannes* (Paris, 1896), pp. 31, 56; Jules Brandon, *Nos peintres du siècle* (Paris, 1899), pp. 173–74; Gustave Scheid, *L'Oeuvre de Puvis de Chavannes à Amiens* (Paris, 1907), pp. 10–16, repr.; René Jean, *Puvis de Chavannes* (Paris, 1913), pp. 20–24, repr.; Léonce Bénédite, *Notre art—nos maîtres* (Paris, 1922), pp. 22–24; Jacques Foucart-Borville, *La Genèse des peintures murales de Puvis de Chavannes au Musée de Picardie* (Paris, 1976), pp. 28–30, 49–54; Dominique Viéville, *Les Peintures murales de Puvis de Chavannes à Amiens*, Musée d'Amiens, May 1989, pp. 12–13

With *Un Retour de chasse* (fig. 23) Puvis de Chavannes distinguished himself. At the Salon of 1861 he showed two "mural paintings," as the exhibition listing once again put it, of very large dimensions (134 x 218 in. [340 x 555 cm]), *Con-cordia* and *Bellum*, which were "a universal success" (Théophile Thoré), "one of the biggest and most deserved hits" (Louis Brès). The two canvases instantly forged the artist's reputation. The French government bought *Concordia* for

seven thousand francs, and Puvis, anxious to keep the two paintings together, offered to add *Bellum*.[1] At the Salon of 1863, Puvis exhibited two even larger works (177 x 254 in. [450 x 645 cm]), *Le Travail (Labor)* and *Le Repos (Rest)*, which were meant to complete the cycle he had begun two years earlier. They were less successful; whereas previously critics had stigmatized the excessively schematic figures and the dreary colors, they now also attacked the weak draftsmanship and the lax execution. More justifiably, Castagnary stressed that *Le Travail* and *Le Repos* could not pretend to be a "complement" to the canvases of 1861: "Do not *Peace* and *War* form the two terms of an antinomy whose solution is justice? Thus if he wanted to complement his idea, such a comple-ment could only be a painting of *Justice*.... When one wishes to philosophize in painting, one must do so correctly."[2]

Of the two pictures of 1863, according to Puvis, "neither one was bought," and he had to "roll them up in the corner of [his] studio." He was vis-ited, in the meantime, by A. S. Diet, the architect of the Musée de Picardie in Amiens, who told him that they "might have a location where they could fit the two canvases [*Concordia* and *Bellum*], owned by the government.... At his request, they were delivered and the adaptation to the wall worked perfectly. Chance did it all," concluded Puvis, "and then it did even more, for M. Diet, wondering about two empty spaces in the stair-well, asked me what had become of the paint-ings [*Le Travail* and *Le Repos*] that I had been forced to keep; again, their measurements cor-responded exactly to the areas to be filled [and] I made a gift of them to the museum."[3] It was in 1867 that Puvis, hoping to participate in the Exposition Universelle, produced smaller versions of the canvases of 1861 and 1863. These two ear-lier sets of works, having been permanently at-tached to the walls of the Musée de Picardie, could not be moved, and the artist wished to present a memento of his most important creations. He de-manded of his dealer, Durand-Ruel, that the four reductions not be separated; indeed, they did not part company until 1899, when their owner, John G. Johnson, who would leave *La Paix* and *La Guerre* to the Philadelphia Museum of Art in 1917, sold *Le Travail* and *Le Repos* (now in the Na-tional Gallery of Art, Washington) to Peter A. B. Widener.

In 1861 the *salonniers* (Delécluze and Edmond About, as well as Delaborde, Du Camp, and Castagnary) were unanimous in hailing the paint-er's ambition and praising his "qualities of ar-rangement, style, and taste, which are becoming more and more rare."[4] They all applauded his reaction to "the industrialization of modern life," his refusal to concede to the petty taste of the era, his absence of facile effects, and his disdain for vulgarity.[5] For among the big hollow contrap-tions and the commercial products (see fig. 32), *Concordia* and *Bellum*, the works of a "mind mov-ing in the highest sphere of art,... intrigue the eyes." "Are these cartoons, tapestries," wondered Théophile Gautier, "or rather frescoes removed

from an unknown Fontainebleau, by some mysterious procedure, these luminous paintings framed in flowers and attributes like the paintings in the Farnesina? In what medium were they painted? Distemper, wax, oil? We simply cannot tell, for the range of hues is so strange, beyond the usual colorations." Once the happy surprise wore off, however, many observers, according to Gautier, admitted that "the painter's ambition still surpasses his talent."[6] They emphasized his originality but then criticized the means he used to achieve it. Rare were those who, like Alphonse de Calonne, found nothing to fault. The rest lambasted *Bellum* for the lack "of shapeliness and style" in the female nudes, the ridiculous draperies ("little dishcloths in the most wretched arrangements"), the unrelatedness of the different groups, and the "sketchiness" of the composition, which was generally deemed inferior to that of *Concordia*.[7] The most frequent reproach was aimed at the coloring, which the severest reviewers found "pale and chalky" and the more favorable ones, dull or nonexistent: "Truth to tell," Louis Auvray opined, "these are nothing but lightly tinted cartoons."[8]

Degas was sympathetic to Puvis's efforts, to his "slow, majestic figures"; to his taste for allegory, which distanced him from the restorations of Gérôme; to his deliberately restrained colors, which recall those of frescoes.[9] While devoid of monumental ambitions, Degas's *Scène de guerre au Moyen Âge* (fig. 61), shown at the Salon of 1865, was an echo of the *Bellum* of 1861. Despite the medieval reference, Degas's war belongs to no specific period, it is timeless, a succession of killings, rapings, and lootings in a spare palette redolent of mourning. Like Puvis, he paints "war in its most synthetic expression; stripped of any character of time or place, of costume, weapons, or tribe; cleared, finally, of any elements that could localize its idea or diminish its universality. This is war minus era and nation, abstract war."[10]

H.L.

1. Nevertheless, Jacques Foucart-Borville points out that in a letter of August 5, 1861, the minister of the emperor's house and of fine arts speaks of acquiring the two paintings, including the frames, for seven thousand francs, although the painter believed that this relatively modest sum applied only to *Concordia*. Jacques Foucart-Borville, *La Génèse des peintures murales de Puvis de Chavannes au musée de Picardie* (Amiens, 1976), p. 29.
2. "Est-ce que la *Paix* et la *Guerre* ne forment pas les deux termes d'une antinomie dont la solution est la justice? Si donc il voulait donner un complément à son idée, ce complément ne pouvait être autre que le tableau de la *Justice*...Quand on veut faire de la philosophie en peinture, il faut le faire correctement." Castagnary 1892, p. 129.
3. "ne furent achetés ni l'un ni l'autre...[il dut] les rouler dans un coin de [s]on atelier"; "entrevoir dans ce monument des emplacements où pourraient s'adapter les deux toiles que l'État possédait...Sur sa demande elles lui furent livrées et l'adaptation à la muraille se trouva absolument parfaite. Le hasard avait tout fait, mais il fit encore plus, car M. Diet pensant à deux places vides dans l'escalier me demanda ce qu'étaient devenues les toiles qu'il m'avait fallu garder; leur mesure correspondant encore cette fois exactement aux places à remplir, j'en fis don au musée." Puvis de Chavannes's

letter, April 25, 1890, quoted by Louis d'Argencourt in Paris, Ottawa 1976–77, p. 60.
4. "qualités d'ordonnance, de style, de goût qui se font de plus en plus rares." Jean Rousseau, "Salon de 1861," *Le Figaro*, May 9, 1861, p. 5.
5. "l'industrialisation de l'art moderne." Alphonse de Calonne, "La Peinture contemporaine à l'exposition de 1861," *Revue contemporaine*, 1861, p. 354.
6. "esprit [qui] se meut dans la plus haute sphère de l'art...intriguent le regard"; "Sont-ce des cartons, des tapisseries, ou plutôt des fresques enlevées d'un Fontainebleau inconnu, par un procédé mystérieux, que ces lumineuses toiles entourées d'un cadre de fleurs et d'attributs comme les peintures de la Farnésine? Quel procédé a-t-on employé pour les peindre? la détrempe, la cire, l'huile? On ne sait trop, tant la gamme est étrange, en dehors des colorations habituelles"; "l'ambition dépasse encore le talent du peintre." Théophile Gautier, *Abécédaire du Salon de 1861* (Paris, 1861), p. 102.
7. "de tournure et de style"; "de petits torchons du plus piètre arrangement." Jean Rousseau, "Salon de 1816," p. 4. Olivier Merson, *Exposition de 1861. La Peinture en France* (Paris, 1861), p. 175.
8. "blafard et plâtreux." Louis Brès, "Salon de 1861, 9, *Le Moniteur des arts*, July 13, 1861, p. 3. "Ce ne sont à vrai dire que des cartons légèrement teintés." Louis Auvrey, *Salon de 1861*, Paris, 1861, p. 38.
9. "figures lentes et majestueuses." Degas 1945, p. 108.
10. "la guerre dans son expression la plus synthétique; dépouillée de tout caractère de temps et de lieu, de costume, d'armes et de race; dégagée enfin des éléments qui pourraient en localiser l'idée et en amoindrir la généralité. C'est la guerre moins l'époque et la nation, la guerre abstraite." Jules-Antoine Castagnary, *Les Artistes au XIXe siècle. Salon de 1861* (Paris, 1861), p. 11.

Pierre-Auguste Renoir
Limoges, 1841–Cagnes, 1919

The son of a Limoges tailor and a dressmaker, Renoir was the sixth of seven children. The family moved to Paris when he was three years old. At thirteen he was apprenticed to a porcelain painter while taking free courses at the drawing school on the rue des Petits-Carreaux. In 1858, after completing his apprenticeship, he went to work for a window-blind manufacturer on the rue du Bac. Two years later he received permission to copy works at the Louvre, thereby beginning his career as a painter.

For Renoir's biography during the 1860s, see the chronology.

168 *Fig. 223*

Auguste Renoir
Fleurs de printemps
(*Spring Flowers/Still Life*)
1864
Oil on canvas
51⅛ x 38⅝ in. (130 x 98 cm)
Signed lower right: A. Renoir
Kunsthalle, Hamburg

CATALOGUE RAISONNÉ: Fezzi-Henry 1985, no. 8a

PROVENANCE: Sale, Hôtel Drouot, Paris, May 29, 1900, no. 17(?); the painter Max Liebermann (1847–1935), Berlin; by descent to Mrs. Kurt Riezler (neé Liebermann), New York; acquired by the Hamburg Kunsthalle, 1958

EXHIBITION: London, Paris, Boston 1985–86, no. 2

SELECTED REFERENCE: Champa 1973, p. 41

The year 1864 marked the debut of Renoir, who was twenty-three at the time. That spring he participated in the Salon for the first time, showing *La Esméralda*, a canvas he destroyed a short time later. He most likely painted this work around the same period, given the spring flowers: arums, white lilac, daisies, hyacinth, cineraria. It is the sketch for, or rather the abandoned first version of, a more precise and more resolved painting with identical measurements (Stiftung Oskar Reinhart, Winterthur), which has a slightly dif-

ferent viewpoint (the long arum stalk is shifted toward the center, and the left part of the composition is filled out). Instead of arranging a sumptuous bouquet in an elegant interior, Renoir here organizes a familiar rustic layout on the ground, against a neutral and vibrant background. In this painting, where whites and dark greens dominate, where blank space plays an important role, Renoir appears less lyrical and decorative than Monet, who at that time covered his entire canvas with heavy blossoms, colorful and in full bloom (fig. 222).

H.L.

169 *Fig. 226*

Auguste Renoir
Portrait de Romaine Lacaux
1864
Oil on canvas
31⅞ x 25½ in. (81 x 64.8 cm)
Signed and dated lower right: A. Renoir, 1864
The Cleveland Museum of Art, Gift of the Hanna Fund
42.1065

CATALOGUES RAISONNÉS: Daulte 1971, vol. 1, no. 12; Fezzi-Henry 1985, no. 7

PROVENANCE: Lacaux family, Paris; Edmond Decap, Paris; by descent to Mme Maurice Barret-Decap, Biarritz, until at least 1933; M. Decap, Paris; M. and Mme Maurice Barrand-Decap, Biarritz; sale, Hôtel Drouot, Paris, December 12, 1929, no. 12, repr.; bought for Fr 330,000 by Roger Bernheim, Paris; Jacques Seligmann, and Co., Inc., New York, by 1941; gift of the Hanna Fund to the Cleveland Museum, 1942

EXHIBITIONS: Paris, Musée de l'Orangerie, 1933, *Renoir*, no. 1; Chicago, 1973, no. 2; Philadelphia Museum of Art, Detroit Institute of Art, Paris, Grand Palais, 1978–79, *L'Art en France au second Empire*, no. 268; London, Paris, Boston 1985–86, no. 1

SELECTED REFERENCES: H. S. Francis, "Mlle Romaine Lacaux by Renoir," *Bulletin of the Cleveland Museum of Art*, 1943, pp. 92–98; Champa 1973, pp. 35–37; McCauley 1985, pp. 200–201

The portrait of Romaine Lacaux, one of Renoir's earliest commissions, was executed at the request of the girl's father, a Parisian porcelain manufacturer, during the artist's stay in Barbizon, where the Lacaux family was vacationing.[1] Renoir, at the beginning of his career, applied himself not only to large compositions for the Salon intended

to establish his reputation but also to portraits and still lifes, which allowed him to make ends meet. Diverse influences have been enumerated for this likeness of a nine-year-old girl; among those mentioned are Corot, Ingres, Whistler (it is true that Renoir produced a "symphony" in white and gray), and Fantin-Latour, but these suggestions seem so contrary that they cannot be relevant. Anne Distel's comparison to Velázquez's *Portrait of the Infanta Margarita*, which Renoir could have seen at the Louvre, seems to us the most legitimate; it is certainly a "bourgeois infanta" that Renoir has painted, rejecting the Spaniard's somber manner and playing instead on the delicacy of the flesh tones, the transparency and lightness of the fabrics.[2] The arrangement is simple, the background decorative; there is nothing of Degas's more elaborate compositions, in which the elements surrounding the sitter do as much to define the subject as do his or her physiognomy and posture (see pp. 205–6). Renoir would repeat a similar formula throughout the 1860s without ever again achieving, despite (or because of) the obvious awkward elements (the chair, the bust), the freshness and ingenuousness of this little girl playing the grownup.

H.L.

1. See Anne Distel, in London, Paris, Boston, 1985–86, p. 182.
2. Distel 1993, p. 17.

170 *Fig. 225*

Auguste Renoir
Le Cabaret de la mère Antony
(The Inn of Mère Antony)
1866
Oil on canvas
76 x 51⅝ in. (193 x 131 cm)
Signed and dated lower right: RE 1866
Nationalmuseum, Stockholm NM 2544

CATALOGUES RAISONNÉS: Daulte 1971, vol. 1, no. 20; Fezzi-Henry 1985, no. 14

PROVENANCE: Bought for Fr 45,000 by Adrien Hébrard, Paris, 1905, until 1911; bought for 55,000 florins by Klas

Fåhreus, Stockholm, 1912; gift of a group of friends of the Nationalmuseum, 1926

EXHIBITIONS: Chicago 1973, no. 4; London, Paris, Boston 1985, no. 3

SELECTED REFERENCES: Meier-Graefe 1912, p. 4; Ambroise Vollard, "La jeunesse de Renoir," *La Renaissance des arts français et des industries de luxe*, May 1918, p. 23; Ambroise Vollard, *Auguste Renoir* (Paris, 1920), pp. 40–41; Cooper 1959, p. 325; Champa 1973, pp. 41–44

In 1865 Jules le Coeur (fig. 90) bought a house in Marlotte, a village of barely five hundred inhabitants in the forest of Fontainebleau, "frequented," according to the Joanne guidebook, "primarily by landscape painters, who installed themselves at the inns."[1] Renoir began visiting Marlotte regularly. For the Goncourts, who in 1863 were assembling their notes for their novel *Manette Salomon*, the inn of *mère* Antony at Marlotte was a squalid hovel, a refuge for "low-life painters": "The whole place is smeared with paint, the windowsills are palettes; the plaster looks as if house painters had wiped their hands on it. From the pool room we can stick our noses into the dining room, daubed all over with guardhouse cartoons and Murger caricatures. There you'll find three or four men, among the boatman, the barber, and the art student, a view of sorry workers in peacoats, lunching at three o'clock with some indeterminate females who came there bareheaded and in slippers from the Latin Quarter and will return to it the same way."[2]

Renoir's painting has little to do with that assemblage of wonders that so shocked the refined Goncourts. While we may find caricatures on the wall, the waitress is not some "indeterminate female," and the atmosphere is relaxed, a conference of young people preoccupied with art. Later Renoir would delight in recalling the circumstances surrounding this large composition: "*Le Cabaret de la mère Anthony* [sic] is one of my paintings of which I have kept a most pleasant memory. It's not that I find this canvas particularly exciting, but it reminds me so strongly of the good *mère* Anthony [sic] and her inn in Marlotte, a real village inn! I took as the subject of my study the common room, which also served as the dining room. The old woman in a head scarf is *mère* Anthony [sic] in the flesh; the superb girl serving drinks is the waitress Nana. The white poodle is Toto, who had a wooden leg. I had a few of my friends, including Sisley and Le Coeur, pose around the table. As for the motifs that form the background of my painting, I borrowed them from the subjects painted right on the walls; they were the unpretentious, but often very successful, handiwork of the regular customers. I myself drew the Mürger silhouette, which I reproduced in my canvas, at the top left."[3]

Since then the various figures have been painstakingly identified; although no one has debated the naming of the women and the dog, the portraits of the men have been more problematic. Critics usually recognize Sisley in the man with beard and hat in the foreground, and Jules Le Coeur in the man, standing, who is about to roll

a cigarette; however, the man leaning on his elbow, listening carefully to Sisley, has never been clearly designated.[4] *L'Événement*, spread across the table, indicates that in the spring of 1866 our young artists were without doubt talking about painting; it was, in fact, in the columns of this newspaper from April 19 to May 20 that "Mon Salon" by Émile Zola, under the pen name Claude, was published. The writer, who for a long time vaunted Manet's talent, saluted Monet's *Camille*, and marveled at Courbet's new orientation, was, we know, forced to terminate his series prematurely. The very legible title of this daily paper allows Renoir to situate his painting in time, to discreetly support Zola, and to specify the artistic inclination of his sitters.

Le Cabaret de la mère Antony, as has often been remarked, falls into the tradition of Courbet and the realists' "meetings" (fig. 354); yet it is also the prototype of Renoir's later achievements, *Le Déjeuner des canotiers* (The boatmen's lunch) and *Le Moulin de la Galette*, a large-format canvas that is both a group portrait and a scene of modern life, and, in those terms, a notable work.

H.L.

1. "fréquenté principalement par les peintres paysagistes, qui s'y établissent dans les auberges." Adolphe Joanne, *Les environs de Paris illustrés* (Paris, 1868), p. 536.
2. "bas peintres"; "La maison est salie de peinture, les appuis des fenêtres sont des palettes; sur le plâtre, il y a comme des mains de peintres de bâtiments qui se seraient eessuyées. De la salle de billard, nous mettons le nez dans la salle à manger, toute peinturlurée de caricatures de corps de garde et de charges de Mürger. Là il y a trois ou quatre hommes, entre le canotier, le coiffeur et le rapin, l'aspect de mauvais ouvriers en vareuses, déjeunant à trois heures avec des femelles vagues de la maison, qui viennent là en cheveux et en pantoufles du Quartier Latin et s'en retournent de même." Goncourt 1956, vol. 6, p. 101.
3. "*Le Cabaret de la mère Anthony* est un de mes tableaux dont j'ai gardé le souvenir le plus agréable. Ce n'est pas que je trouve cette toile particulièrement excitante, mais elle me rappelle tellement l'excellente mère Anthony et son auberge de Marlotte, la vraie auberge de village! J'ai pris comme sujet de mon étude la salle commune, qui servait également de salle à manger. La vieille femme coiffée d'une marmotte, c'est la mère Anthony en personne; la superbe fille qui sert à boire était la servante Nana. Le caniche blanc, c'est Toto, qui avait une patte de bois. Je fis poser autour de la table quelques-uns de mes amis dont Sisley et Le Coeur. Quant aux motifs qui constituent le fond de mon tableau, je les avais empruntés à des sujets peints à même le mur, qui étaient l'oeuvre sans prétention, mais souvent très réussie, des habitués de l'endroit. Moi-même j'y avais dessiné la silhouette de Mürger, que je reproduis dans ma toile, en haut à gauche." Ambroise Vollard, *Auguste Renoir* (Paris, 1920), pp. 40–41.
4. For a summary of these questions, see Anne Distel in London, Paris, Boston 1985–86, p. 66.

171 *Fig. 90*

Auguste Renoir
Jules Le Coeur et ses chiens se promenant en forêt de Fontainebleau
(*Jules Le Coeur and His Dogs Walking in the Forest of Fontainebleau*)
1866
Oil on canvas
41¾ x 31½ in. (106 x 80 cm)
Signed and dated lower right: Renoir 1866
Museu de Arte de São Paulo Assis Chateaubriand 94

CATALOGUES RAISONNÉS: Daulte 1971, vol. 1, no. 27; Fezzi-Henry 1985, no. 11

PROVENANCE: Jules Le Coeur, Paris; Paul Cassirer, Berlin; M. Kuthe, Berlin; his sale, Berlin, December 2, 1911, no. 47; bought for DM 6,800 by Dr. Georg Hirth, Munich; sale, Düsseldorf, November 12, 1932, no. 142; M. Knoedler & Co., New York; acquired by the Museu de Arte de São Paulo, 1958

EXHIBITIONS: London, Paris, Boston, 1985–86, no. 4; Manchester, New York, Dallas, and Atlanta, 1991–92, no. 101, pp. 206–7, repr. p. 209

SELECTED REFERENCES: Cooper, May 1959, p. 163, and September–October 1959, p. 325; Champa 1973, pp. 40–41, 44

One day while painting in the Forest of Fontainebleau, Renoir was accosted by walkers who made fun of the porcelain-painter's blouse that he was in the habit of wearing. The joke was taking a turn for the worse when the young man was rescued by the artist Narcisse Diaz, who skillfully wielded his cane. Thanks were expressed, greetings extended, then, in front of the canvas, the master questioned Renoir: "Why the devil do you paint so black?" "For some time," Renoir replied, "I had had more than enough of bitumen. Diaz's reproach decidedly got me to search for something else, and I painted a study of nature in which I tried to give the trees and the shadows on the ground the light that I saw in them. 'You're crazy,' Sisley told me, seeing my canvas. 'Why in the world are you painting the trees blue and the ground lilac?'"[1] Although the trees are not yet blue nor the ground lilac, Diaz's impact is clearly apparent in this painting, in which Renoir uses the Barbizon style to depict his friend, the painter Jules Le Coeur; we find the same taste for a thick, colorful, quivering impasto to translate the exu-

berance of nature, a similar technique of minuscule, densely clustered strokes applied with the palette knife. For this first "figure in a landscape," Renoir is closer to the painters of 1840 working at Fontainebleau than to Monet's contemporary canvases. Renoir's nature, however, has an amiable touch that the large trees of Rousseau and Dupré never had; and Le Coeur, as a "mountaineer," infuses it with a modern sentiment, unlike the hunters and lumberjacks of the past who seemed timeless.

H.L.

1. "Pourquoi diable peignez-vous donc si noir?" "Depuis quelques temps déjà, j'en avais plus qu'assez du bitume: le reproche de Diaz m'amena décidément à chercher autre chose, et je peignis une étude sur nature en m'efforçant à donner aux arbres et aux ombres sur le terrain la lumière que je leur voyais. Tu es fou, me dit Sisley, apercevant ma toile. Quelle idée de faire des arbres bleus et des terrains lilas?" Ambroise Vollard, "La Jeunesse de Renoir," in *La Renaissance de l'art français et des industries de luxe*, May 1918, p. 22.

172 *Fig. 218*

Auguste Renoir
Frédéric Bazille peignant "Le Héron"
(*Frédéric Bazille Painting "The Heron"*)
1867
Oil on canvas
41⅜ x 29 in. (105 x 73.5 cm)
Musée d'Orsay, Paris RF2448

CATALOGUES RAISONNÉS: Daulte 1971, vol. 1, no. 28; Fezzi-Henry 1985, no. 18

PROVENANCE: Édouard Manet, Paris, until 1876; given to Frédéric Bazille's father, Léon Bazille, Montpellier, in exchange for Monet's *Femmes au jardin* (cat. 130), 1876; his son Marc Bazille; his bequest to the Musée du Luxembourg, 1924; Musée du Louvre, Paris, 1929; Musée du Jeu de Paume, Paris, 1947; Musée d'Orsay, Paris, 1986

EXHIBITIONS: Paris, 11 rue Le Pellandier, 1876, *2ᵉ exposition de peinture*, no. 224 (Frédéric Bazille, painter killed at Beaune-la-Rolande. Property of M. Manet); Marseille, Musée Cantini, 1963, *Renoir: Peintre et sculpteur*, no. 29

SELECTED REFERENCES: Meier-Graefe 1912, p. 32, repr. p. 55; Ambroise Vollard, *La Vie et l'oeuvre de Pierre-Auguste Renoir* (Paris, 1919), p. 52; Rewald 1986, p. 121

It was in the late winter or spring of 1867 that Renoir executed this magnificent variation in gray. The artist Bazille, in his studio on the rue Visconti, is painting *Le Héron* (fig. 217), a motif on which Sisley was hard at work at the same time (fig. 216). On the wall we see a canvas of comparable harmony, one of those "rather felicitous snow effects" that Dubourg discusses and that Monet had just completed in Normandy.[1] In late February, in fact, Monet had spent some time in Bazille's studio; he had "dropped in out of the blue" with, according to his host, "a collection of magnificent paintings." If we add to the already cited names of Renoir, Bazille, Sisley, and Monet that of Manet, who was the first owner of this portrait, we must regard it as an essential testimony to the bonds uniting all these artists and as tangible proof of the birth of a movement.

H.L.

1. "Effets de neige assez heureux." Letter from Dubourg to Boudin, February 2, 1867, reproduced in Wildenstein 1974, p. 444. Anne Distel, in London, Paris, Boston 1985–86, p. 72, identifies the painting on the wall as *La Route sous la neige, Honfleur* (*The Road under the Snow, Honfleur* [Wildenstein 82; private collection, United States]).

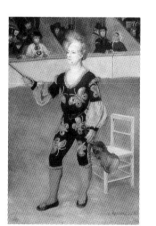

173 *Fig. 245*

Auguste Renoir
Clown au cirque
(*Clown at the Circus*)
1868
Oil on canvas
76⅛ x 51⅛ in. (193.5 x 130 cm)
Signed and dated lower right: A.Renoir 68
Rijksmuseum Kröller-Müller, Otterlo 666–19

CATALOGUES RAISONNÉS: Daulte 1971, vol. 1, no. 38; Fezzi-Henry 1985, no. 26

PROVENANCE: Ambroise Vollard, Paris; Louis-Alexandre Berthier, prince de Wagram, Paris, November 1905; recovered by Ambroise Vollard who had not been paid; Karl Sternheim, Munich; Mrs. Théa Sternheim, La Hulpe (near Brussels), until 1919; her sale, Amsterdam, February 11, 1919, no. 12; Hélène Kröller-Müller, The Hague

EXHIBITION: Chicago 1973, no. 5

SELECTED REFERENCES: Meier-Graefe 1912, pp. 12–13; Champa 1973, pp. 50–52; Anne Distel, "Les Amateurs de Renoir: Le Prince, le prêtre et le pâtissier" in London, Paris, Boston 1985–86, p. 42

Before detailing the comical circumstances of its execution, Julius Meier-Graefe cautions the reader: "The picture should not be regarded as a valid specimen of the master's talent during that period, for Renoir did not really apply himself when he painted it for the Café du Cirque d'Hiver on the boulevard des Filles du Calvaire. The price agreed on was 100 francs. But the café owner went bankrupt, and the canvas remained with the artist."[1] Although we do indeed observe some awkwardness in the hastily painted spectators in the background, the full-length portrait of the clown, James Bollinger Mazurtreek, handling his bow and his small fiddle the way a captain wields his sword and dagger, is impressive.[2] Meier-Graefe recalls the example of Courbet and his *Lutteurs* (fig. 152); yet a more recent model must be cited, the large figures of Manet, most notably *Mlle V... en costume d'espada* (fig. 244), who like Renoir's clown is part of a spectacle, and, like him, substantial against a vividly sketched background.

H.L.

1. "Le tableau ne doit pas être regardé comme un spécimen valable du talent du maître à cette époque, car Renoir le peignit sans beaucop s'appliquer pour le café du Cirque d'Hiver, boulevard des Filles du Calvaire. Le prix convenu était de 100 francs. Le cafetier fit banqueroute et la toile resta pour compte à l'artiste." Meier-Graefe 1912, p. 12.
2. Many have frequently believed that the clown was named John Price. He was recently identified by Barbara Ehrlich White (White 1985, p. 30); the name of James Bollinger Mazurtreek appears under the painter's signature.

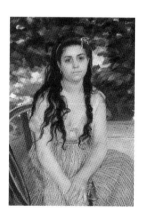

174 *Fig. 246*

Auguste Renoir
En été; étude
(*Summertime; Study*)
1868
Oil on canvas
33½ x 23¼ in. (85 x 59 cm)
Signed lower left: A. Renoir
Staatliche Museen zu Berlin, Nationalgalerie, Berlin
AI 1019

CATALOGUES RAISONNÉS: Daulte 1971, vol. 1, no. 33; Fezzi-Henry 1985, no. 32

PROVENANCE: Unknown dealer, Paris; bought by Théodore Duret, March 1873; Félix-François Depeaux, Rouen; his sale, Paris, Galerie Georges Petit, May 31 and June 1, 1906, no. 40; bought for Fr 4,500 by Durand-Ruel, Bernheim-Jeune, and Rosenberg(?); sold for Fr 2,166 to Paul Rosenberg, October 25, 1906; Paul Rosenberg & Co., Paris; Mathilde Kappel, Berlin; her gift to the Nationalgalerie, 1907

EXHIBITIONS: Paris, Salon of 1869, no. 2021 (En été; étude); London, Paris, Boston 1985–86, no. 7

SELECTED REFERENCES: Meier-Graefe 1912, pp. 30–32; Robert Rey, *La Renaissance du sentiment classique* (Paris, 1921), p. 48; Théodore Duret, *Renoir* (Paris, 1924), p. 13; Cooper 1959, p. 168; Champa 1973, pp. 53–55

Renoir, who had finally drawn attention at the Salon of 1868 with *Lise* (fig. 176), went completely unnoticed the following year with this medium-sized figure; the broadly painted foliage, more of a backdrop than a true depiction of nature, in front of which the young girl is superimposed, justifies without doubt the term "study." The painting lacks the integration of the figure in the landscape, achieved two years later in *La Promenade* (fig. 178), that was so sought after throughout the decade. Nevertheless, this is a wonderful "study" of Lise Tréhot, Renoir's companion and favorite model from 1866, whom he transformed, in turn, into an elegant lady with a parasol (fig. 176), Sisley's attentive fiancée (fig. 247), and this well-fed wild creature, amorphous and determined.

H.L.

175 *Fig. 155*

Auguste Renoir
Le Jeune Garçon au chat
(*Young Boy with a Cat*)
1868–1869
Oil on canvas
48¾ x 26⅜ in. (124 x 67 cm)
Signed lower right: Renoir
Musée d'Orsay, Paris RF1992.409

CATALOGUES RAISONNÉS: Daulte 1971, vol. 1, no. 42; Fezzi-Henry 1985, no. 30

PROVENANCE: Edmond Maître (1849–98), Paris; Éduard Arnhold, Berlin; by descent to his family; private collection; sale, Christie's, New York, March 30, 1981, lot 35; sale, Sotheby's, New York, November 10, 1992, no. 6; acquired by the Musée d'Orsay, 1992

SELECTED REFERENCES: Hugo von Tschudi, "Die sammlung Arnhold," *Kunst und Kunstler* (1908–09), repr. p. 20; Meier-Graefe 1912, p. 32, repr. p. 31; Albert C. Barnes and Violette de Mazia, *The Art of Renoir* (Merion, Pennsylvania, 1935), p. 376, repr. p. 227; Cooper 1959, no. 678, pp. 322–29; Champa 1973, pp. 52–53; Barbara Paul, "Drei sammlungen französischer impressionistischer Kunst im kaiserlichen Berlin: Bernstein, Liebermann, Arnhold," *Zeitschrift des Deutscher vereins für kunstwissenschaft* (Berlin, 1988), p. 22, repr. fig. 9; Anne Distel, "Acquisitions," *Revue du Louvre*, April 1993, p. 82, repr.

Douglas Cooper recognized Joseph Le Coeur, the nephew of Renoir's friend Jules Le Coeur (fig. 90), as the young boy tranquilly showing off here; it is unlikely, however, that the respectable Charles Le Coeur, architect and father of the boy, would have permitted such a portrait.[1] In another era, Renoir, like Parmigianino, who may have inspired him, would have painted a *Cupid Cutting His Bow* (Kunsthistorisches Museum, Vienna) or some prepubescent god; but from this impossible subject Renoir has made a modern painting by the simple addition of the cuddly, lazy cat and the sumptuous white silk with blue flowers. The boy's body is painted smoothly and fluidly; the richer and oilier impasto is reserved for the fur and the fabrics. This painting, executed in Bazille's studio, where that artist was also trying to paint "nude men" (fig. 153), remains a distant descendant of Courbet's oeuvre, although the manner is close to that of Manet, and the cold, reduced palette, dominated by white, green, and black, approaches that of *Le Balcon* (fig. 266).

H.L.

1. Cooper 1959, p. 327.

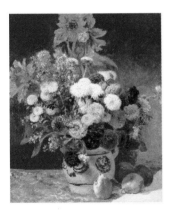

176 *(New York only)* *Fig. 214*

Auguste Renoir
Fleurs dans un vase
(Mixed Flowers in a Vase)
1869

Oil on paperboard mounted on canvas
25½ x 21⅜ in. (64.9 x 54.2 cm)
Museum of Fine Arts, Boston, Bequest of John T. Spaulding 48.592

CATALOGUE RAISONNÉ: Fezzi-Henry 1985, no. 37

PROVENANCE: Duze collection, until 1891; bought by Durand-Ruel, 1891, until 1925; sold to John T. Spaulding, Boston, January 1925, until 1948; his bequest to the Museum of Fine Arts, Boston, 1948

EXHIBITIONS: London, Paris, and Boston 1985–86, no. 13

Long dated, significantly, to the 1870s, this bouquet has been redated to 1869 by Daniel Wildenstein, who compared it to a similar bouquet, in the same vase, painted by Monet (fig. 215).[1] Wildenstein rightfully saw it as evidence of the close rapport between the two artists during the summer and early autumn of 1869, when Renoir was in Ville-d'Avray and Monet in Bougival. Despite the shared motif, the two canvases are profoundly different. Monet "stages" a composition, decentralizes the bouquet, adds a basket, and spreads fruits over a white napkin; Renoir creates a simple "portrait" of a few flowers. Monet is ampler, his format larger, suggesting a real depth, whereas Renoir is content to place his vase on the quickly painted patterning of a marble entablature.

H.L.

1. Wildenstein 1974, vol. 1, no. 139.

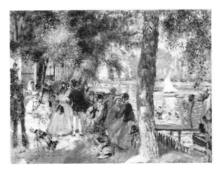

177 *Fig. 319*

Auguste Renoir
La Grenouillère
1869
Oil on canvas
23¼ x 31½ in. (59 x 80 cm)
Signed lower left: A. Renoir
Pushkin State Museum of Fine Arts, Moscow 3407

CATALOGUE RAISONNÉ: Fezzi-Henry 1985, no. 29

PROVENANCE: The artist's brother, Edmond Renoir, Paris, who sold it before 1903; Ambroise Vollard, Paris, until 1908; bought by Ivan Morosov, Moscow, 1908, until 1918; his collection nationalized by a decree of the Council of People's Commissar and renamed the Second Museum of Western Painting, Moscow, 1919; Museum of Modern Western Art, Moscow, 1923; Pushkin State Museum, 1948

EXHIBITIONS: London, and Paris, Boston 1985–86, no. 11

SELECTED REFERENCES: Ambroise Vollard, *Auguste Renoir* (Paris, 1920), pp. 48–49, reprinted in *En écoutant Cézanne, Degas, Renoir* (Paris, 1938); Jean Renoir, *Pierre-Auguste Renoir, mon père* (Paris, 1962; 1981 ed.), pp. 222–24; Champa 1973, pp. 61, 64–65, repr. fig. 84; White 1985, pp. 32–33; Anne Distel in London, Paris, Boston 1985–86, p. 61; Sophie Monneret, *Renoir* (Paris, 1989), pp. 8, 38; Christian Lassalle, *Les Impressionnistes à la Grenouillère*, exh. cat., Château Chanorier, Croissy-sur-Seine, 1992

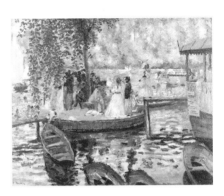

178 *Fig. 321*

Auguste Renoir
La Grenouillère
1869
Oil on canvas
26⅛ x 31⅞ in. (66.5 x 81 cm)
Signed lower left: A. Renoir
Nationalmuseum, Stockholm NM2425

CATALOGUE RAISONNÉ: Fezzi-Henry 1985, no. 34

PROVENANCE: The artist's brother, Edmond Renoir, Paris, who sold it before 1903; private collection; anonymous gift to the Nationalmuseum, Stockholm, through the Association of Friends of the Museum, 1923

EXHIBITIONS: Paris, New York 1974–75, no. 35; London, Paris, Boston, 1985–86, no. 12

SELECTED REFERENCES: Ambroise Vollard, *Auguste Renoir* (Paris, 1920), pp. 48–49, reprinted in *En écoutant Cézanne, Degas, Renoir* (Paris, 1938); Jean Renoir, *Pierre-Auguste Renoir, mon père* (Paris, 1962; 1981 ed.), pp. 222–24; Champa 1973, pp. 61, 64–65, repr. fig. 84; White 1985, pp. 32–33; Anne Distel in London, Paris, Boston 1985–86, p. 61; Sophie Monneret, *Renoir* (Paris, 1989), pp. 8, 38; Christian Lassalle, *Les Impressionnistes à la Grenouillère*, exh. cat., Château Chanorier, Croissy-sur-Seine, 1992

La Grenouillère was a bathing spa with an outdoor café on the Île de la Loge, on the Seine near Bougival, opposite the secularized church of the priory of Croissy. On the riverbank there was a large hall, extended by a pontoon moored on the Seine that adjoined, by way of a gangplank, the *"pot-à-fleurs"* (flowerpot) or "camembert," a small, round isle boasting a single tree.[1] In the mid-1860s, La Grenouillère became fashionable, and contemporaneous descriptions of it (written and illustrated) were numerous. In June 1868 Raoul de Presles went on at length about this "Trouville on the shores of the Seine," describ-

ing "the old, well-tarred barge" on which "they built a hut of wood painted green and white," "the studio of the shipbuilder," the changing rooms, and "the very picturesque but utterly primitive bridges" linking the "camembert" to the pontoon and the riverbank.[2] In 1869 La Grenouillère was at the peak of its fame; at the Salon that year, the obscure Antony Morlon, who specialized in wine-washed picnics and boating parties, exhibited *La Grenouillère de l'île de Croissy, près Bougival* (*La Grenouillère Seen from the Isle of Croissy, near Bougival*).[3] In July of that year the spa was visited, quite "covertly," by the empress. When, in the summer and early fall, Monet and Renoir focused on this motif, they did not discover an "Impressionist" site but joined the throng of those who had already celebrated it.

From July to the beginning of October 1869, Monet and Renoir were neighbors; Monet was in Saint-Michel near Bougival, Renoir was at his parents' home in Voisins-Louveciennes. Both artists experienced the same material difficulties, never eating their fill and not always having the wherewithal to buy pigments. They frequently worked together, and, on September 25, Monet told Bazille their common "dream," to make a "painting, the baths of La Grenouillère," that he himself had already prepared for with a "few poor sketches." All we have left today are those "poor sketches" —the first truly "Impressionist" masterpieces— deemed preliminaries for a "tableau" of large dimensions, destined, no doubt, for the Salon.

Renoir realized, in three canvases, a panorama of the establishment; he starts with the riverbank, showing the gangplank linking it to the "camembert" (Stiftung Oskar Reinhart, Winterthur), and, finally, the islet with its skinny tree and, at the right, an edge of the pontoon. To these three different views one must add the beautiful painting in a private American collection (fig. 425), recently published as depicting the same site at the same time.[4] However, with its dazzling colors, its orange boats, and its violet shadows, we would propose a later date, about 1875. Furthermore, nothing specifically ties it solely to La Grenouillère.

Although strongly influenced by Monet—who taught him at last how to integrate a figure in the landscape, a lesson that Renoir would remember in *La Promenade* (fig. 178)—Renoir's canvases diverge sharply from his. Renoir's range of colors is subtle, opposed to harshness; Monet accentuates the loud red of a skirt, the yellow of sun-drenched trees, or the black reflections of water at twilight. Renoir's touch is always light and dancing, whereas Monet's is broad, emphasizing the structures of the boats and the wooden constructions. Renoir seizes whatever is before him, even as Monet, always dissatisfied with an ordinary viewpoint, pursues unusual compositions.

H. L.

1. See Georges Poisson, "L'île de Chatou et ses peintres," *La Revue française*, May 1967, pp. 13–18; Christian Lassalle, exh. cat., *Croissy-sur-Seine: les impressionistes à la Grenouillère* (Château Chanorier, Croissy-sur-Seine, 1992); Jacques and Monique Laÿ, "Rediscovering La Grenouillère: Ars longa, vita brevis," *Apollo*, May 1993, pp. 281–86.
2. "Trouville des bords de Seine"; "la vieille péniche bien goudronnée"; "on a construit un baraquement en bois peint de couleur verte et blanche"; "l'atelier de constructeur de bateaux"; "les ponts fort pittoresques mais tout à fait primitifs." Raoul de Presles in *L'Événement illustré*, June 20, 1868, quoted by Anne Distel in London, Paris, Boston, 1985–86, p. 86.
3. See Louis Leroy, "Salon de 1869," *Le Gaulois*, June 17, 1869, p. 3.
4. London, Paris, Boston, 1985–86, p. 86.

179

Fig. 325

Auguste Renoir
Chemin à Louveciennes
(*A Road in Louveciennes*)
1869?
Oil on canvas
15 x 18¼ in. (38.1 x 46.4 cm)
Signed lower right: Renoir
The Metropolitan Museum of Art, New York, The Lesley and Emma Sheafer Collection, Bequest of Emma A. Sheafer, 1973 1974.356.32

PROVENANCE: Ambroise Vollard, Paris; A. R. Ball, New York, until 1948; Lesley and Emma Sheafer, New York, 1948–74; Emma A. Sheafer's bequest to the Metropolitan Museum, 1973; entered the Metropolitan Museum in 1974

EXHIBITIONS: New York, Metropolitan Museum of Art, 1975, *The Lesley and Emma Sheafer Collection*, no. 33; Amsterdam, Rijksmuseum Vincent Van Gogh, 1987, *Franse meesters uit hand Metropolitan Museum of Art: Realisten en impressionisten*, no. 19

This lovely small painting, little known, was probably executed by Renoir in the summer of 1869, when he was staying with his parents in Voisins-Louveciennes. In fact, we recognize in the painting—heading up the road that connects Louveciennes to Bougival, passing through Saint-Michel, where Monet lived at the time—a small fragment of the aqueduct of Louveciennes. The following spring, Pissarro would paint the same motif but on a larger scale (fig. 326), giving the elevated silhouette of the aqueduct an ancient feel and stressing the geometry of the roofs scattered among the slender trees. For Renoir the aqueduct is merely a reference point; all that counts is the summer exuberance of the vegetation— approaching that in *La Promenade* (fig. 178)— which overruns the architecture, transforming an ordinary suburban spot into a Mediterranean Eden.

H. L.

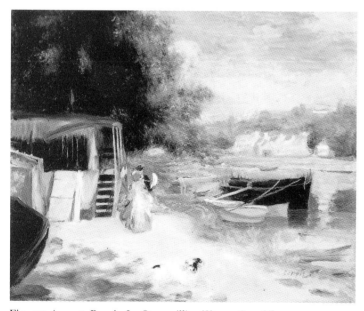

Fig. 425. Auguste Renoir, *La Grenouillère* (?), ca. 1875. Oil on canvas, 18⅞ x 22 in. (48 x 56 cm). Private collection

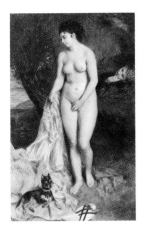

180 *Fig. 151*

Auguste Renoir
Baigneuse (La Baigneuse au griffon)
(Bather with a Terrier)
1870
Oil on canvas
72½ x 45¼ in. (184 x 115 cm)
Signed and dated lower right: A. Renoir. 70
Museu de Arte de São Paulo Assis Chateaubriand 95

CATALOGUES RAISONNÉS: Daulte 1971, vol. 1, no. 54; Fezzi-Henry 1985, no. 52

PROVENANCE: Cornelis Hoogendijk (1866–1911), The Hague; his estate sale, Amsterdam, Fredrik Muller & Cie., May 22, 1912, no. 56; bought for 18,100 florins by Bernheim-Jeune, Paris; sold to Auguste Pellerin, Paris; Paul Cassirer, Berlin; Alfred Cassirer, Berlin, in 1931; his estate, Berlin, 1933–35; deposited at the Kunstmuseum Basel; Wildenstein and Co., New York; acquired by the Museu de Arte de São Paulo, 1954

EXHIBITIONS: Paris, Salon of 1870, no. 2405 (Baigneuse); Paris, Galerie Bernheim-Jeune, 1913, *Renoir*, no. 4 (La Baigneuse au griffon), preface by Octave Mirbeau; Paris, Musée de l'Orangerie, 1933, *Renoir*, no. 7; London, Paris, Boston 1985–86, no. 14; Martigny, Fondation Pierre Gianadda, 1988, *Trésors du Musée d'art de São Paulo: De Manet à Picasso*, pp. 121–28

SELECTED REFERENCES: Bertall, "5ᵉ promenade au Salon de 1870," *Le Journal amusant*, June 18, 1870, p. 4; Marius Chaumelin, "Le Salon de 1870," *La Presse*, June 17, 1870, in *L'Art contemporain*, 1873, p. 417; Duranty, "Le Salon de 1870, XII. Erratum," *Paris-Journal*, May 19, 1870, p. 2; L. Goujon, *Salon de 1870: Propos en l'air* (Paris, 1870), pp. 94–95; B. de Mézin, *Promenade en long et en large au salon de 1870* (Paris, 1870), p. 37; Salomon Reinach, "L'Aphrodite de Cnide et la Baigneuse au griffon," *La Revue archéologique*, May–June 1913, pp. 371–75

After his failure at the Salon of 1869 with the discreet *En été; étude* (fig. 246), Renoir decided to make himself more conspicuous in 1870 and presented *Femme d'Alger* (*Algerian Woman*; National Gallery of Art, Washington) and *Baigneuse*. The first painting quoted Delacroix, the second Courbet. These references were perceived immediately; no longer scandalous, they were merely well worn. Renoir's entries aroused little interest.[1] There were the traditional jokes (see p. 109) about the dirt on the body of the bather, for whom, they maintained, a good bath would not be superfluous; there was Duranty's swift putdown—

Renoir "has adopted for his flesh tones a rather unpleasant bit of yellow plague"; and that was more or less all.[2]

Although Renoir, as Salomon Reinach has noted, may have given his *Baigneuse* the pose of the Aphrodite of Cnidus, he has in essence undressed *Les Demoiselles des bords de la Seine* (fig. 150).[3] Courbet's powerful influence is obvious throughout the painting: in the morphology of the young woman's body and the treatment of the flesh; in the way this studio nude stands out against a conventional landscape; in the clothes lying on the ground; and in the small griffon terrier that recalls the numerous paintings in which the master of Ornans associated woman and beast.

H.L.

1. See Marius Chaumelin, *L'Art contemporain* (Paris, 1873), p. 417.
2. Concerning the jokes about dirt, see Bertall's cartoon, "5e promenade au Salon de 1870," *Le Journal amusant*, June 18, 1870. Renoir "a adopté pour ses chairs une espèce de peste jaune bien désagréable." Duranty, "Le Salon de 1870, XII. Erratum," *Paris-Journal*, May 19, 1870, p. 2.
3. Salomon Reinach, "L'Aphrodite de Cnide et la Baigneuse au griffon," *La Revue archéologique*, May–June 1913, pp. 371–75.

181 *Fig. 178*

Auguste Renoir
La Promenade
(The Walk)
1870
Oil on canvas
32 x 25½ in. (81.3 x 65 cm)
Signed and dated lower left: A Renoir . 70
Collection of the J. Paul Getty Museum, Malibu
89.PA.41

CATALOGUES RAISONNÉS: Daulte 1971, vol. 1, no. 55; Fezzi-Henry 1985, no. 53

PROVENANCE: Gustave Goupy, Paris, until 1898; his sale, Paris, Hôtel Drouot, March 30, 1898, no. 33; bought for Fr 1,050 by Durand-Ruel, Paris, until 1908; bought for Fr 12,000 by Paul Cassirer, Berlin, September 11, 1908; Bernhard Köhler, Berlin, by 1929; Paul Rosenberg, Paris and New York, 1933–40; Nate B. and Frances Spingold, New York, by 1956, until her death in 1976; sale, Sotheby's, London, November 29, 1976, no. 22; bought at this sale by Seito collection, Tokyo; British Rail Pension Fund collection, London, by 1984, until 1989; its

sale Sotheby's, London, April 4, 1989, no. 6; acquired at this sale by the J. Paul Getty Museum

EXHIBITIONS: Paris, Durand-Ruel, *Tableaux, pastels, dessins par Renoir*, 1920, no. 44; Paris, Musée de l'Orangerie, 1933, *Renoir*, no. 18; New York, Metropolitan Museum of Art, 1960, *The Nate and Frances Spingold Collection*, p. 5; London, Paris, Boston 1985–86, no. 15

SELECTED REFERENCES: Meier-Graefe 1912, p. 37; White 1985, p. 35; Wadley 1987, p. 65; Herbert 1988, pp. 190, 192; "Acquisitions: 1989," *The J. Paul Getty Journal* 18 (1990), pp. 176–77, no. 14

La Promenade, as has often been remarked, succeeds at last in what Renoir had for so long and so vainly sought: the integration of the figure in a landscape. If we compare this canvas with *Les Fiancés* (fig. 247), executed two years earlier, the change in style, due largely to the artist's repeated contacts with Monet (figs. 320, 322), is evident. Renoir is enjoying his new freedom, multiplying the difficulties in a virtually tour-de-force composition. The sun, penetrating all the leaves of this suburban jungle, bounces off the dazzling white dress of the stroller; the light is never even, falling in shafts or broad pools, forming splotches of brightness and leaving pockets of shadow. The day is beautiful and warm; Renoir escorts his *Lise* (fig. 176) along the sunny but uneasy path of Impressionism.

H.L.

Gustave Ricard

Marseilles, 1823–Paris 1873

The son of a well-to-do businessman, Gustave Ricard attended the École de Dessin in Marseille and frequented the studio of the brothers Pierre and Jean Bronzen, who specialized in portraits and religious subjects. In 1842 he left for Paris and spent one year as Léon Cogniet's pupil at the École des Beaux-Arts. After failing to obtain the Prix de Rome, he decided to go to Italy; he stayed there from 1845 to 1847, then visited, successively, Marseille, London, and Venice, where he remained more than a year. It was upon his return to Paris in late 1849 that he really began his career as a painter. At his first Salon, in 1851, his eight portraits garnered a first-class medal; the following year, his success increased, and he won a first-place medal. He became close to the publicist Alphonse de Calonne, editor of *La Revue contemporaine*, and to the artistic circle that socialized at Calonne's home, which included painters (Chenavard, Jules Dupré, Hébert, Heilbuth) and especially writers (Arsène Houssaye, Théophile Gautier, Ernest Feydeau, Renan, and Baudelaire).

Although he was a sought-after portraitist, Ricard never seemed to satisfy completely some of the critics, who reproached him for sacrificing the sitter's true appearance in his desire to imitate the old masters. His subjects included government officials and the society people and the upper middle class of Paris and Marseille as well

as his close friends, Puvis de Chavannes, Gustave Moreau, Fromentin, and Chenavard. The Salon of 1859, where his ten portraits drew the usual compliments and criticisms, was his last Salon showing for quite some time; he did not reappear there until 1872, with just one portrait. During the 1860s he pursued his primary activity as a portraitist and continued to delve into the secrets of the painters he venerated, as demonstrated by his copies after Correggio, Van Dyck, Titian, Giorgione, Rubens, Rembrandt and others.

In 1865–66 the decoration of the Hôtel Demidoff allowed him for the first time to work extensively with large surfaces and to measure himself against the compositions of the Renaissance frescoists. In this so-called Palazzo Russo, the salon, the dining room, and the grand staircase are attributed to Ricard; here he painted *Apollon chassant les nues* (*Apollo Chasing the Clouds*), *Le Jugement de Paris* (*The Judgment of Paris*), *Vénus marine couchée sur un dauphin* (*Venus of the Sea Reclining on a Dolphin*), *Triton couché sur une vaste conque* (*Triton Reclining on a Large Seashell*), and several renderings of Cupid Triumphant and Cupid Vanquished. Three years after its installation, this set of paintings was dispersed, fueling the artist's bitterness.

In 1863, "disdainful, a bit haughty, nurturing a secret hostility because he had been kept waiting too long," Ricard refused the Légion d'Honneur.[1] In 1870, during the Franco-Prussian War, Ricard left for England; on his return to France, he took up his regular production of portraits for another two years. The day after his death, J. J. Weiss, in *Paris-Journal*, summed up the career of a man who had never become famous, who had always remained rather private, secretive and reclusive, like his paintings: "Gustave Ricard never obtained, in his lifetime, the portion of success and glory that was his due. He soon grew weary of pursuing it. His nature was too proud and too delicate ever to resort to that array of innocent, yet singularly petty measures that are no less necessary for the advancement of our reputations than for the advancement of our fortunes."[2]

1. "dédaigneux, un peu hautain, gardant le froissement secret d'une attente trop longue." Paul Leprieur, quoted by Stanislaw Giraud, *Gustave Ricard, sa vie et son oeuvre* (Paris, 1932), p. 207.
2. "Gustave Ricard n'a jamais obtenu, de son vivant, la part de succès et de gloire à laquelle il avait droit. Il se fatigua vite de la poursuivre. La nature l'avait fait trop fier et trop délicat pourqu'il eût voulu jamais recourir à cet ensemble de procédés innocents, mais singulièrement mesquins, qui ne son pas moins nécessaires pour l'avancement de notre réputation que pour celui de notre fortune." Quoted by Stanislaw Giraud in ibid., p. 340.

182 *Fig. 22*

Gustave Ricard

Portrait de M. Paul de D . . . (Portrait du prince Paul Demidoff)
(*Portrait of Prince Paul Demidoff*)
1859
Oil on canvas
82⅝ x 50⅜ in. (210 x 128 cm)
Signed and dated lower right: 1859 / G. Ricard f.
H.R.H. Prince Alexander of Yugoslavia

PROVENANCE: Prince Paul Demidoff, in Paris and then in San Donato near Florence; his son, Prince Elius Demidoff; the latter's sister, Princesse Aurora Demidoff, wife of Paul Karageorgevitch; Prince Alexander of Yugoslavia

EXHIBITIONS: Paris, Salon of 1859, no. 2562 (Portrait de M. Paul de D . . .); Paris, Salle du Jeu de Paume, 1912, *Exposition d'oeuvres de Carpeaux et de Ricard*, no. 24 (Le Prince Paul Demidoff [20 ans])

SELECTED REFERENCES: Astruc 1859, p. 301; Aubert 1859, p. 228; Delaborde 1859, p. 522; Du Camp 1859, p. 92; Dumas 1859, p. 105; Théophile Gautier, "L'Exposition de 1859," *Le Moniteur universel*, July 13, 1859; Jourdan 1859, p. 89; Lépinois 1859, p. 182; Mantz 1859, p. 277; Paul de Saint-Victor, "Salon de 1859. VIII," *La Presse*, June 18, 1859, p. 1; Mathilde Stevens, *Impressions d'une femme au Salon de 1859* (Paris, 1859), p. 104; Camille Mauclair, "Gustave Ricard," *Revue de l'art ancien et moderne* November 10, 1902, p. 247, repr.; Paul Drouot, "Gustave Ricard," *L'Art décoratif*, June 5, 1912, p. 327, repr.; Stanislas Giraud, *Gustave Ricard: Sa vie et son oeuvre* (Paris, 1932), p. 166, repr. p. 167; Baudelaire 1985–87, vol. 2, p. 658; Wolfgang Drost and Ulrike Henninges, *Théophile Gautier: L'Exposition de 1859* (Heidelberg 1992), pp. 130–31, repr. p. 132

At the Salon of 1859 Ricard showed ten portraits, mingling the highly official and surly President Troplong, head of France's Supreme Court, president of the Senate, member of the Institute, and recipient of the *grand-croix* of the Légion d'Honneur, with the affable Madame Antoine Chevrier, in a dress of black velvet and holding a red fan; a Capucine monk; and the Parisian physiognomy of Ernest Feydeau. There was also a full-length portrait of a twenty-year-old man, "dressed as a hunter in a Russian costume, his body proudly poised, his left fist on his hip, his right hand holding a rifle, his legs in high leggings," posed in an ambiguous landscape without doubt intended to evoke his distant Russia: "Monsieur Paul de D . . . ," as the Salon catalogue named him, Prince Paul Demidoff.[1] He was the nephew of Anatole, Count Demidoff and prince of San Donato, the

occasional husband of Princess Mathilde, first cousin of Napoléon III; unlike the count, the prince was neither brutal nor eccentric, but, like him, he was a lover of the arts. This love was proved in 1865, when he built, in honor of his marriage to the princess Marie Metscherska, a beautiful mansion on the rue Jean-Goujon, designed by Alfred Delvau and decorated by Fromentin, Ricard, Corot, and Chaplin, where he housed his important painting collection.[2]

The portraits that Ricard showed in 1859 were attacked for their excessive servitude to the old masters. This was a common reproach, which Chennevières had stated at Ricard's first Salon, in 1851; however, new voices now arose with the same rebukes.[3] Thus Zacharie Astruc maintained that Ricard "does pastiches and not paintings," that instead of portraying a sitter, he "paints his memory in terms of such and such painting by a master."[4] But for Théophile Gautier, for Baudelaire —both of whom, granted, were friendly with the artist—his love of the old masters and the "tricks of their trade" were what set him apart. "Imitation," Baudelaire paradoxically emphasized, "is the vertigo of supple and brilliant minds, and often even proof of their superiority."[5] Gautier, more interestingly, focused on the artist's spirit of "caprice, independence, and adventure" and pointed out that, for Ricard, a portrait was "usually just a pretext." "Depending on the nature of the type that he is interpreting, blond, brunette, delicate or robust, rough or smooth, Monsieur Ricard tries out various systems of coloration: he impastes or glazes, uses bright or dark hues, hazy or with sharp contrasts. Sometimes he thinks of Van Dyck, sometimes Calcar or even Lawrence, and whomever he happens to be admiring casts a reflection on his palette, which does not mean that he himself does not have a highly recognizable personality."[6] This uninterrupted surge of portraits, many of which today are dark and dull, having lost their original transparency and sfumato, reveals, despite the monotony of his arrangements as well as his "extreme preoccupation with the old masters," a painter "full of intelligent procedures."[7] Anticipating Whistler's "harmonies," the *Portrait du Prince Paul Demidoff* is characterized by its "effect of bright on bright, very bizarre, very audacious, very successful," particularly appreciated by Gautier, who recalled his own "Symphony in White Major."[8]

Degas's passing interest in Ricard (see p. 22), encouraged by the affection Gustave Moreau had for this artist, derived as much from his bright and fluid style, his "system of preparation in white," denounced by Maxime Du Camp, as from his search for picturesque compositions.[9] Within the domain of portraiture, Ricard seemed to Degas, in 1859, as anti-Flandrin, one of those who could liberate him from the strict tutelage of Flandrin and Lamothe. Without doubt Degas equally appreciated in Ricard's "young man in the white burnoose" the reference to Van Dyck's *Portrait of Charles I* (Musée du Louvre, Paris), revealed by Gautier and Saint-Victor.[10] Still impressed by his recent visit to the Palazzo Rosso in

Genoa, thinking about a Vandyckian pose for the figure of his aunt Bellelli in the *Portrait de famille* (fig. 253), the Flemish painter was at the center of Degas's concerns. Like the portraits of Genoese nobles, "completely in bright values," the *Portrait du Prince Demidoff*, which Camille Mauclair, in 1902, judged the most beautiful full-length portrait "of all our school," blended, according to the words of Degas, "distinction" with "elegance and chivalry."[11]

H.L.

1. "Vêtu d'un costume russe, en chasseur, le corps fièrement campé, le poing gauche sur la hanche, la main droite tenant le fusil, les jambes haut guêtrées." Stanislas Giraud, *Gustave Ricard, sa vie et son oeuvre* (Paris, 1932), p. 166.
2. This highly diverse collection, which included Flemish and Dutch artists, a few Spaniards and Italians, a good representation of the French School of the eighteenth century (Fragonard, Watteau, Greuze, and so on), and some contemporaries (among them Millet, Decamps, Meissonier, Delacroix, Delaroche, Jules Dupré, Français, Fromentin, Théodore Rousseau), was sold on February 3, 1869. After his wife's premature death upon giving birth to their son Elim, Paul Demidoff decided to give up his Paris residence.
3. Giraud, *Gustave Ricard*, p. 96.
4. "fait des pastiches, point de tableaux"; "peint son souvenir à propos de tel ou tel tableau de maître." Astruc 1859, p. 301.
5. "l'imitation est le vertige des esprits souples et brillants, et souvent même une preuve de supériorité." Baudelaire 1985–87, vol. 2, p. 658.
6. "caprice, d'indépendance et d'aventure"; "n'est, la plupart du temps qu'un prétexte"; "Selon la nature blonde, brune, délicate ou robuste, hérisée ou lisse du type qu'il interprète, M. Ricard essaye divers systèmes de coloration: il empâte ou glace, fait clair ou rembruni, flou ou heurté. Tantôt il pense à Van Dyck, tantôt à Calcar ou même à Lawrence, et les admirations qui lui passent par l'esprit jettent un reflet sur sa palette, ce qui ne veut pas dire qu'il n'ait lui-même une personnalité très reconnaissable." Gautier 1859, pp. 130–31.
7. "trop grande préoccupation des maîtres anciens"; "pleine de procédés intelligents." Alexandre Dumas, *L'Art et les artistes contemporains au Salon de 1859* (Paris, 1859), p. 105.
8. "effet de clair sur clair, très bizarre, très-audacieux, très-réussi"; "Symphonie en blanc majeur." Gautier 1859, p. 151. Gautier quotes himself, explaining the reasons for his predilection for Ricard's color investigations. "Symphony in White Major" was first published in 1849 and then included in the collection *Émaux et camées*, 1852.
9. "système de préparation en blanc." Du Camp 1859, p. 92.
10. "jeune homme en burnous blanc." Astruc 1859, p. 301.
11. "tout en valeurs claires"; "de toute notre école." Camille Mauclair, "Gustave Ricard," *Revue de l'art ancien et moderne*, November 10, 1902, p. 247. "Distinction"; "l'élégance et la chevalerie." Degas's letter to Gustave Moreau, April 26, 1859, published by Theodore Reff, "More Unpublished Letters of Degas," *Art Bulletin*, September 1969, p. 284.

Pierre-Étienne-Théodore Rousseau

Paris, 1812–Barbizon, 1867

Son of a successful Parisian draper, Rousseau counted a number of artists in his extended family. His first studies were with a cousin, Alexandre Pau de Saint-Martin. By the time he was fifteen he was studying with the well-known landscapist Jean-Charles-Joseph Rémond. He frequented the Fontainebleau forest in the second half of the 1820s and, after a long painting trip to the Auvergne, began to show in the Salon, exhibiting from 1831 to 1835. His republican sympathies became manifest in this decade, and he was excluded from the Salon in 1836 and from 1838 to 1840. He did not submit again until 1849, when he exhibited three pictures and won a first-class medal. Although his absence from the Salon deprived him of a conventional career, he cultivated the position of outsider and was championed by Baudelaire, George Sand, and above all Thoré. That Rousseau inculcated his essentially realistic paintings with a romantic sensibility endeared him to his supporters. From 1836 on, he summered in Fontainebleau regularly; Millet was his closest friend. Winters were spent in Paris. In the 1850s and 1860s, he became an irascible proponent of realist landscape and a vocal critic of the despolation and commercialization of the Fontainebleau forest. He was elected a member of the Salon jury for the first time in 1850. The regime of Napoléon III viewed him with suspicion, but Rousseau was finally feted at the 1867 Exposition Universelle and made president of its jury. He died with Millet at his bedside.

183 *(Paris only)* *Fig. 92*

Théodore Rousseau
Groupe de chênes dans les gorges d'Apremont
(Oak Trees in the Gorge of Apremont)
Ca. 1850–52
Oil on canvas
25 x 39⅛ in. (63.5 x 99.5 cm)
Signed lower right: *TH.Rousseau.*
Musée du Louvre, Paris, département de Peintures
RF 1447

PROVENANCE: Purchased from the artist by Charles Auguste Louis Joseph duc de Morny, ca. 1853; his sale, Paris, 1865, no. 31; Van Praet, Brussels; Édouard André

(1833–1894), Paris; George Thomy Thiéry (1823–1902); his bequest to the Louvre in 1902

EXHIBITIONS: Paris, Exposition Universelle of 1855, no. 3935 ("Groupe de chênes dans les gorges d'Aprmont" [*sic*]); Paris, Exhibition of the Cercle de l'Union Artistique, 1866; Vienna, International Exhibition of 1873; Paris, Musée du Louvre, November 29, 1967–February 12, 1968, *Théodore Rousseau*, no. 46; Bremen 1977–78, no. 111; Ghent, Museum of Fine Arts, The Hague, Haags Gemeentemuseum, Paris, Institut Néerlandais, 1985–86, *The Barbizon School*, no. 93

SELECTED REFERENCES: Maxime Du Camp, *Les beaux-arts à l'Exposition universelle de 1855* (Paris, 1855), p. 248; Ernest Gebaüer, *Les Beaux-Arts à l'Exposition universelle de 1855* (Paris, 1855), p. 147; Ch.-L. Duval, *Exposition universelle de 1855, l'école française* (Paris, 1856), p. 112; Théophile Gautier, *Les Beaux-Arts en Europe* (Paris, 1856), vol. 2, p. 132; Léon Lagrange, "Exposition du Cercle de l'Union artistique," *Gazette des Beaux-Arts* 20 (April 1, 1866), p. 398; Sensier 1872, pp. 213, 224; Réné Ménard, "Exposition de Vienne: France," *Gazette des Beaux-Arts*, ser. 2, 8 (November 1, 1873), p. 418 ("Bouquet de chênes au milieu d'une plaine"); Prosper Dorbec, *Théodore Rousseau* (Paris, 1910), p. 119, repr. p. 77; Dorbec 1913, p. 117; Prosper Dorbec, *L'Art du paysage en France* (Paris, 1925), p. 123, pl. 22; Bühler 1979, fig. 79; Mainardi 1987, fig. 56

Rousseau, systematically excluded from the Salon in the late 1830s, stopped submitting from 1841 to 1848. After that he regularly exhibited, winning medals and awards, considered with dignity and respect by a state which ultimately showered him with honor, perhaps in compensation for his previous neglect. Nevertheless, Rousseau relished the role of outsider, which he paradoxically maintained even after gaining critical and financial success. Yet while the journalists who favored him tended to be left wing, the collectors who bought his pictures tended to be rich, well connected, and conservative, such as the duc de Morny and Baron Nathan de Rothschild. A similar paradox may be detected in Rousseau's position around 1855, when *Groupe de chênes dans les gorges d'Apremont* was exhibited at the Exposition Universelle. He owned a house in nearby Barbizon, and the very oaks he depicted were threatened by a plan to introduce huge pine plantations, about which he had written in 1853 an extensive official complaint to his patron Morny, who was then a Membre du Conseil Supérieur du Commerce, de l'Agriculture et de l'Industrie.[1] Yet, as Nicholas Green has shown,[2] Rousseau's protest was one that was lodged by a highly cultivated man who maintained a studio in one of Paris's richest new quarters, who attended the opera regularly, and who collected rare coins and medals. He thus was a partisan of unspoiled nature without identifying with the simple peasants who figure in his paintings. There was a dramatic dichotomy between the life Rousseau led and the vision he promoted.

At the 1855 Exposition Universelle, landscape painting was perceived as the great school of French painting, and Rousseau was at the helm of the "naturalist" branch. Rousseau's biographer, Alfred Sensier, attributed the success of this painting to its "very careful, delicate and patient execution; Rousseau put into it all his virtuoso spirit."[3]

Assessing Rousseau's critical reception in 1855, Sensier said, "There was no longer in the press or among the collectors an actively hostile current, as there had been before; Rousseau always had his enemies or those who did not understand his art, but his victory was complete, considerable and conclusive."[4]

G.T.

1. See Sensier 1872, p. 212.
2. Nicholas Green, introduction, in Norwich, Sainsbury Center for Visual Arts, University of East Anglia; London, Hazlitt, Gooden and Fox, 1982, *Théodore Rousseau 1812–1867: Loan Exhibition of Paintings, Drawings and Prints from English and Scottish Collections*.
3. "exécution très soignée, délicate et patiente; Rousseau y a déployé tout son brio de virtuose." Sensier 1872, p. 213.
4. "Il n'y eut plus dans la presse ou dans les amateurs, comme autrefois, un courant activement hostile; Rousseau eut toujours ses ennemis ou ceux qui ne comprenaient rien à son art, mais la victoire fut complète, considérable et décisive." Sensier 1872, p. 224.

184 *(New York only)* *Fig. 76*

Théodore Rousseau
Lisière des Monts-Girard, forêt de Fontainebleau
(*The Edge of the Woods at Monts-Girard, Fontainebleau Forest*)
1854
Oil on panel
31½ x 48 in. (80 x 121.9 cm)
Signed and dated lower left: *TH.Rousseau 1854*
The Metropolitan Museum of Art, New York, Catharine Lorillard Wolfe Collection, Wolfe Fund, 1896 96.27

PROVENANCE: Papeleu, Paris; General Goethals, Brussels, by 1872; (?) Prosper Crabbe, Brussels; Defoer, Paris, by 1883; William Shaus, New York; his sale, American Art Association, New York, February 28, 1896, no. 16; purchased at this sale by the Metropolitan Museum

EXHIBITION: Paris, Exposition Universelle of 1855, no. 3934 ("Lisière des Monts-Gérard [*sic*], forêt de Fontainebleau")

SELECTED REFERENCES: J. de La Rochenoir, *Le Salon de 1855* (Paris, 1855), p. 65; Eugène Loudun, *Le Salon de 1855* (Paris, 1855), p. 161; Charles Perrier, "Exposition universelle des beaux-arts IX. La peinture française, paysage," *L'Artiste*, ser. 5, 15 (July 15, 1855), p. 142; Sensier 1872, pp. 213–14, 224; Dorbec 1913, p. 117; Sterling and Salinger 1966, pp. 82–83, repr.

This splendid, highly finished work is one of the rare paintings dated by the artist. Like the *Groupe de chênes* (cat. 183), it represents a partially cleared corner of the Fontainebleau forest and

thus stands as a kind of reproach to those who sought to destroy it. Sensier, the artist's biographer, interpreted the picture in anthropomorphic terms: "a road in the forest by the side of which stands an old oak tree, grim as though irritated to see a young tree daring to grow again after the slaughter of its contemporaries."[1]

Lisière des Monts-Girard was shown at the 1855 Exposition Universelle, and like Rousseau's other pictures on view, it received a great deal of attention. What seems curious to our eyes today is that the painting was then seen as unfinished. Although in composition and execution it is similar to the great seventeenth-century landscapes produced by Dutch naturalists such as Ruysdael, nineteenth-century critics such as Charles Perrier saw it as a mere sketch: "The *Lisière des monts Gérard* is not, strictly speaking, a finished painting. It is a brilliant sketch executed in bold and strong tones, indicative of the level of success the painter can attain, but not representative of his full talent."[2]

A reduction of this painting was sold at Christie's, New York, May 24, 1989, number 291.

G.T.

1. "une route de forêt au bord de laquelle se dresse un vieux chêne tout farouche et comme irrité de voir devant lui un jeune bois qui ose reverdir après le massacre de ses contemporains." Sensier 1872, pp. 213–14.
2. "La *Lisière des monts Gérard* n'est pas, à proprement parler, un tableau complet. C'est une esquisse très-brillante dans un ton vigoureux et accentué, qui indique à quelle puissance le peintre peut s'elever, mais qui ne donne pas toute la mesure de son talent." Charles Perrier, "Exposition universelle des beaux-arts IX: La peinture française, paysage," *L'Artiste*, ser. 5, 15 (July 15, 1855), p. 142.

Alfred Sisley
Paris, 1839–Moret-sur-Loing, 1899

Alfred Sisley, the son of English parents, was born in Paris, on October 30, 1839. Between 1857 and 1860 he studied commerce in London and there he saw and admired the work of Constable and Turner. Back in Paris 1860, living with his parents at 43, rue des Martyrs, Sisley studied at Gleyre's studio for a year or two and there met fellow students Monet, Bazille, and Renoir. Sisley was in Barbizon in 1861. By 1865, Sisley and Renoir were frequent companions: they were in Marlotte together in the spring; in July, Renoir stayed at Sisley's Paris apartment at 31, avenue de Neuilly. In February 1866, Sisley, Renoir, and Jules LeCoeur walked through the forest of Fontainebleau, stopping in Milly and Courances; in March they were in Marlotte, and that August they were in Berck on the Normandy coast. Sisley was in Honfleur in June 1867, back in the forest of Fontainebleau that October and again, in late summer 1868, when he also painted in the park of Courances. Sisley often worked in Bazille's studio in Paris at the end of the 1860s.

In 1866 Sisley debuted at the Salon with two pictures; his work was refused in 1867 and 1869 but was accepted for the Salons of 1868 and 1870. In June 1867, while Sisley was in Honfleur, Eugénie Lescouezec gave birth to their son, Pierre, in Paris, 27, cité des Fleurs; their second child, Jeanne Adèle, was born at the same address in January 1869. At the outbreak of the Franco-Prussian War in autumn 1870, Sisley was living in Bougival and all his possessions were destroyed or lost, which accounts for the meager record of Sisley's development as an artist in the 1860s.

185 *Fig. 103*

Alfred Sisley
Une rue à Marlotte; environs de Fontainebleau
(*A Street in Marlotte, Vicinity of Fontainebleau*)
1866
Oil on canvas
25½ x 36 in. (64.8 x 91.4 cm)
Signed and dated lower left: *A. Sisley 1866*
Albright-Knox Art Gallery, Buffalo, New York, General Purchase Funds, 1956 56.1

CATALOGUE RAISONNÉ: Daulte 1959, no. 3

PROVENANCE: Earliest whereabouts unknown; M. Renier, 3, place des États-Unis, Paris, until 1951; sold to M. Knoedler and Co., New York, 1951, until 1956 (stock no. A–4587); sold to the Albright-Knox Art Gallery, February 1956

EXHIBITIONS: Paris, Salon of 1866, (?) no. 1786 ("Une Rue de Marlotte; environs de Fontainebleau"); New York, Paul Rosenberg and Co., October 30–November 25, 1961, *Loan Exhibition of Paintings by Alfred Sisley*, no. 1; San Francisco, Toledo, Cleveland, Boston 1962–63, no. 112; Iowa City, University of Iowa Gallery of Art, 1964, *Impressionism and Its Roots*, no. 22; New York, Wildenstein and Co., October 27–December 3, 1966, *Sisley*, no. 1; Chicago 1978, no. 76; Los Angeles, Chicago, Paris 1984–85, no. 11; Manchester, New York, Dallas, Atlanta, 1991–92, no. 110; London, Paris, Baltimore 1992–93, no. 4

SELECTED REFERENCES: Champa 1973, pp. 92–93, pl. 26; Rewald 1973, pp. 132–34, repr. p. 133; Alice Bellony-Rewald, *The Lost World of the Impressionists* (London, 1976), p. 50, repr. p. 51; Cogniat 1978, pp. 34–35, repr. p. 16; Steven A. Nash, *Albright-Knox Art Gallery: Painting and Sculpture from Antiquity to 1942* (Buffalo, 1979), p. 260, repr. p. 261; Shone 1992, p. 34, repr. pp. 30–31

This may have been the work Sisley exhibited at the 1866 Salon as number 1786, *Une Rue de*

Marlotte; environs de Fontainebleau. If it is not, then number 1786 may have been a painting now at the Bridgestone Museum in Tokyo. Sisley also exhibited another work, number 1785, called *Femmes allant au bois; paysage* (*Women Going to the Woods, Landscape*), which is often identified as the painting at the Bridgestone Museum, but the title and the image do not match precisely. Since no other painting corresponds to the title of number 1785, it may be that it is now lost.

It is no surprise that none of the important critics—Edmond About, Charles Beaurin, Charles Blanc, Jules-Antoine Castagnary, Charles Clément, Théophile Thoré [William Bürger] Félix Jahyer, F. del Tal, or Émile Zola—mentioned Sisley's paintings in their reviews of the 1866 Salon. For a newcomer, it took large or startling paintings to attract attention. But late in life Sisley remembered that his entries were indeed noticed. In a letter of 1892 he reminisced, "It was only in 1866 that I submitted to the Salon two canvases which were accepted. Since I had put several women in one of my canvases, a witty critic called me an animal painter!"[1] This "witty critic" has unfortunately not been found.

The painting is a souvenir of Sisley's frequent visits to Marlotte, a village on the edge of the Fontainebleau forest. Renoir and Sisley stayed in Marlotte at the auberge of *mère* Antony in 1865, and that same year Jules Le Coeur, the great friend of Renoir, bought a house there. Sisley's movements are not well recorded in autumn and winter 1865–66, but it is known that Renoir, Sisley's constant companion, was frequently in Marlotte.[2] Renoir depicted Sisley, for example, in his painting *Le Cabaret de la mère Antony*, which is dated 1866 (cat. 170). Sisley, Renoir, and Le Coeur crossed the Fontainebleau forest on foot in February 1866, reaching Marlotte by March,[3] but the present painting is not a winter scene. Although it is possibly based on sketches that Sisley might have made in April 1865, more likely it is based on autumnal sketches. Most scholars agree that Sisley painted it in the studio, and thus it could have been made at any time, from any number of preparatory studies.

Sisley's somber palette resembles that of Pissarro, and like Pissarro, Sisley may have been thinking of Daubigny and Courbet when he made this work. It is not known when Sisley met Courbet, but Renoir met him in Marlotte in 1865,[4] and Sisley could have been present. In any event, with this work Sisley renounced the atmospheric style, inspired by Corot,[5] of his first landscapes for a new, self-consciously constructed style.

G.T.

1. "Ce n'est qu'en 1866 que j'envoyais au Salon 2 toiles qui furent reçues. Comme j'avait mis quelques femmes dans une de mes toiles, un critique spirituel me traita d'animalier!" Translation given here is from Shone 1992, p. 216.
2. There is no proof for the assertion in Los Angeles, Chicago, Paris 1984–85, p. 74, that Sisley remained with Renoir in Marlotte through 1865 and 1866.
3. Letter from Jules Le Coeur, February 17, 1866, cited in Cooper 1959, p. 322, n. 5.

4. Daulte 1971, p. 33.
5. Contrary to the statement in London, Paris, Baltimore 1992–93, p. 84, Sisley did not list himself in the catalogue of the 1866 Salon as an "élève de Corot," but rather as an "élève de Gleyre."

186 *Fig. 98*

Alfred Sisley
Allée des châtaigniers à La Celle-Saint-Cloud
(*Avenue of Chestnut Trees in La Celle-Saint-Cloud*)
Ca. 1866–67 (?)
Oil on canvas
51 x 81⅞ in. (129.5 x 208 cm)
Signed and dated lower left: *Sisley. 65.*
Musée du Petit Palais, Paris PPP693

CATALOGUE RAISONNÉ: Daulte 1959, no. 1

PROVENANCE: Purportedly sold by the artist to Jean-Baptiste Faure, Paris, in 1877;[1] collection of Jean-Baptiste Faure by 1899, until his death in 1914; placed on deposit with Durand-Ruel, Paris, June 14, 1899 (with an asking price of Fr 20,000), until November 14, 1902 (deposit no. L.9570), and again, from March 13, 1907, until February 1, 1919 (deposit no. L.11158); Mme Maurice Faure, 1914–19; sold to Durand-Ruel and Georges Petit, Paris, February 1, 1919;[2] sold to Sir Joseph Duveen, London, 1919, until 1921; his gift to the museum, 1921

EXHIBITIONS: Paris, Gazette des Beaux-Arts, May 1937, *Naissance de l'Impressionnisme*, no. 76; Berne 1958, no. 1; Chicago 1978, no. 75; London, Paris, Baltimore 1992–93, no. 2

SELECTED REFERENCES: Champa 1973, pp. 92–93, fig. 130; Rewald 1973, p. 99; Cogniat 1978, pp. 32, 35, repr. p. 11; Lassaigne and Gache-Patin 1983, pp. 8–9, repr.; Shone 1992, pp. 34–35, repr. p. 37, pl. 16

According to Daulte, Sisley was in La Celle-Saint-Cloud in May 1865.[3] It is documented that he had been with Renoir in Marlotte in April, and by July 3 they were in Paris, at 31, avenue de Neuilly; however there is no published documentation for a trip to La Celle-Saint-Cloud. Yet there are many reasons for Sisley to have been attracted to the region, and La Celle-Saint-Cloud was considered one of the most interesting of the forests that surround La Celle, a village just a few kilometers from Saint-Cloud, between Bougival and Vaucresson. Paul Huet and François Daubigny had also visited the area.[4]

There is a grandeur to this forest scene that is similar in effect to the landscapes that Monet and Bazille made during the same summer, on the other side of Paris in the Barbizon forest. Here

the monumentality is heightened by the lack of repoussoirs at the left and right: the barren foreground sweeps the eye to the great stand of trees in the middle distance, a device sometimes used by Rousseau. However here there is none of Rousseau's finicky drawing and brushwork. Instead Sisley relied on a well-conceived tonal structure, very much in the manner of Corot, but the touch is the bold stroke of the ébauche rather than the feathery brushwork typical of the elder landscapist. As with the contemporary work of Monet and Bazille, the tonal relationships are similar to those of contemporary landscape photography.

The date on this canvas is the earliest recorded on a painting by Sisley. However, since the 1959 publication of Daulte's catalogue raisonné, some previously unpublished works that may have preceded this painting have surfaced. *Forest Road* (location unknown),[5] is described by Kermit Champa as a road near Marlotte and datable to 1864–65. *Allée près d'une petite ville* (*Avenue near a Small Town*, Kunsthalle Bremen) is commonly given to 1864, but John Leighton recently suggested a date of the late 1860s.[6] *Country Road Near Marlotte* (art market, Paris) is also commonly given to 1865, and it is very close to a painting by Renoir (private collection)[7] which, like the Sisley, Renoir gave to his companion, Lise Tréhaut, whom he first met in 1865. However all three paintings bear a stylistic similarity, a Corot-like appearance, that would seem to antedate the present painting, which is more confidently executed and solidly constructed. Thus it seems possible that *La Celle-Saint-Cloud* was painted later than its 1865 date. The large scale could be an indication of a work intended for the Salon, and it is thought that Sisley submitted a painting to the 1867 Salon that was rejected. This work might be it, especially since stylistically it is close to the views of Marlotte that Sisley painted in 1866. If not, it could be related to the painting intended for the 1868 Salon, the large canvas of the same forest now in the Southampton City Art Gallery. Since, according to Daulte, Sisley first sold the painting in 1877, to the great patron Jean-Baptiste Faure, he could have signed and misdated the painting at the time of the sale, misremembering the precise date. The chronology of Sisley's oeuvre in the mid-1860s still requires significant research.

The small sketch now in the Ordrupgaardsamlingen, Copenhagen, may have served as the model for this painting.[8]

G.T.

1. According to the provenance entry in Daulte 1959, no. 1, albeit without supporting documentation. In the context of Faure's acquisition of this work in 1877, it is worth noting that included among the Sisleys sold in the 1877 Impressionist sale (*45 Tableaux par MM. Caillebotte Pissarro Renoir Sisley*; Hôtel Drouot, Paris, Salle 9, May 28, 1877) was a *Paysage près Saint-Cloud* (no. 43). It is possible that lot 43 was this landscape, and that Faure was the purchaser. (Faure, for example, did buy two Sisleys at the Hoschedé sale in 1878.) The 1877 Impressionist sale is not recorded in any of Daulte's provenance entries for Sisley landscapes in or near Saint-Cloud. We do know that in 1883 Faure lent six works by Sisley to a one-man show at Durand-Ruel, and this landscape was

not among the works lent. On the basis of Durand-Ruel deposit records (see Callen 1971) we can only be certain that he owned it by 1899.

2. According to Callen 1971, p. 415, no. 567. Callen also notes that an apparent sale to Cassirer, on December 20, 1901, seems not to have been consummated, since the work was returned to Faure in November 1902.
3. Daulte 1959, p. 27.
4. London, Paris, Baltimore 1992–93, p. 86.
5. Illustrated in Champa 1973, fig. 129.
6. John Leighton, "Adroit, Delicate, but...," *Apollo*, 136 (November 1992), p. 334.
7. Illustrated in Rewald 1973, pp. 99 and 132, respectively.
8. Daulte 1959, no. 2.

187 *Fig. 216*

Alfred Sisley
Le Héron
(*The Heron*)
1867
Oil on canvas
31⅛ x 38⅛ in. (79 x 97 cm)
Signed lower right: *Sisley*
Musée Fabre, Montpellier

CATALOGUE RAISONNÉ: Daulte 1959, no. 5

PROVENANCE: Sale, *Tableaux, pastels, dessins par Guillaumin, Luce, Renoir, Sisley*; Hôtel Drouot, Paris, November 24, 1903, no. 31; Georges Viau, Paris, until 1907; his sale, Galeries Durand-Ruel, Paris, March 4, 1907, no. 68; Joseph Reinach, Paris, until his death in 1921; by descent to his daughter, Mme Pierre Goujon (née Julie Reinach), Paris, until her death in 1971; her bequest to the Louvre, 1971 (inv. no. RF 1971.15); on deposit at the Musée Fabre, Montpellier, from the Musée d'Orsay, Paris, since 1979

EXHIBITIONS: Berne 1958, no. 3; Paris, Durand-Ruel, February 10–March 30, 1971, *Alfred Sisley*; no. 1; Bordeaux 1974, no. 126; Bordeaux 1991, no. 53; London, Paris, Baltimore 1992–93, no. 7

SELECTED REFERENCES: Champa 1973, pp. 46, 93, fig. 133; Rewald 1973, repr. p. 182; Lassaigne and Gache-Patin 1983, pp. 9, 57, pl. 68; Shone 1992, p. 38, repr. p. 29, fig. 12

This work is part of the result of an unusual séance in which Sisley and Bazille both painted a still life of dead game that had been set up in Bazille's studio, while Renoir painted a portrait of Bazille at work on his painting. The three paintings (see also cats. 8, 172) testify not only to the mutual friendship that existed among the three young artists but also to their mutual admiration of the work of Manet, for both still lifes and the por-

trait of Bazille constitute essays in Manet's style—whether it is in the choice of subject for still life was a genre in which Manet excelled, or in the fluid handling of paint which was one of Manet's virtuosities, or in the harmony of the palette since soft grays punctuated by creamy white was a signature combination for Manet.

A blue heron, a jay, and a magpie were arranged on a table in Bazille's studio at 20, rue Visconti. This occurred in November or December 1867, when Bazille, Sisley, and Renoir were all in Paris. Bazille had been absent from Paris from May 20 until November 3, 1867, and he moved to his new studio in the rue de la Paix (renamed the rue La Condamine in 1868) at the end of December 1867. Sisley had spent summer 1867 in Honfleur and was in Fontainebleau in mid-October; by spring 1868 he was giving Bazille's address in the rue de la Paix for his studio, as was Renoir, who had moved into Bazille's rue Visconti studio in late February 1867 and then moved on to the rue de la Paix. Since Bazille's and Renoir's canvases are dated 1867, and since Sisley's canvas was manifestly painted at the same time, the three related works were made in November or December 1867.[1]

Still life is exceedingly rare in Sisley's oeuvre. Only nine are known, and this work is one of only four that date before 1870; the other three are *Poisson sur un plat* (*Fish on a Platter*, Kunstmuseum Basel; Daulte 6), *Nature morte aux pommes* (*Still Life with Apples*, private collection; Daulte 7), and *Le Faisan* (*The Pheasant*, private collection; Daulte 8). Daulte dates the first to 1865–67 and the latter two to 1867–69. *Le Faisan* is close in motif to the present picture, although it lacks the quality of rendering of the present painting. Both depend from the eighteenth-century school of still-life painters, of which Oudry and Chardin were the prime exponents. Interest in their works was strong in the 1860s, witness the 1860 exhibition of painting of the ancien régime at the Galerie Martinet, or the publication of the Goncourts' study of Chardin in 1863–64, or the acquisition by the Louvre of celebrated works by Chardin in 1867 and 1869.

G.T.

1. The location of Bazille's studio in the rue Visconti from mid-July 1866 until the end of December 1867 is well documented in the Bazille correspondence and literature; in London, Paris, Baltimore 1992–93, p. 96, it is erroneously stated that the three pictures were painted at Bazille's subsequent address in the rue de la Paix.

188 *Fig. 104*

Alfred Sisley
Vue de Montmartre prise de la cité des Fleurs aux Batignolles
(*View of Montmartre from the Cité des Fleurs, Les Batignolles*)
1869
Oil on canvas
27½ x 46⅛ in. (70 x 117 cm)
Signed and dated lower left: *Sisley. 1869*
Musée de Grenoble MG1317

CATALOGUE RAISONNÉ: Daulte 1959, no. 12

PROVENANCE: M. Rousselin (almost certainly Joseph-Auguste Rousselin), Grenoble, until 1901; his gift to the museum, 1901

EXHIBITIONS: London, Royal Academy of Arts, December 10, 1949–March 5, 1950, *Landscape in French Art, 1550–1900*, no. 253; Berne 1958, no. 5; London, Paris, Baltimore 1992–93, no. 8

SELECTED REFERENCES: Champa 1973, p. 94, fig. 137; Rewald 1973, repr. p. 204; Cogniat 1978, p. 37, repr. p. 5; Lassaigne and Gache-Patin 1983, p. 62, repr. p. 76; Shone 1992, pp. 35, 47, repr. pp. 32–34, pl. 14.

It is difficult to dissociate this view from subsequent scenes of Montmartre, executed much later by Jean-François Rafaëlli, Vincent van Gogh, Paul Signac, and Maurice Utrillo, all of whom seemed to imbue the quarter with the same marginal, raw, and incomplete quality perceptible here. Sisley's association with the neighborhood was direct: he lived there, at 27, cité des Fleurs, with his companion and their son. Bazille's studio was just a few streets south, as was the Café Guerbois, meeting place of Manet, Degas, and the younger painters Monet and Renoir. In contrast to the density of central Paris, Montmartre was spacious and open, but with a haphazard appearance, an atmosphere aptly described by the brothers Goncourt in *Germinie Lacerteux*: "They went up the Chausée Clignancourt and, with the stream of Parisians from the suburbs all in a hurry to drink in some fresh air, they walked towards the open stretch of sky which awaited them at the top of the rise, at the end of the long row of houses. The heat was diminishing, the houses had no sun on them now except on their roofs and chimneys. A breath of space and liberty came from the end of the road as if from a great doorway open to the country."[1]

Although Georges Michel, Daubigny, and Jongkind each made views of the Butte Montmartre, they were all sweeping, essentially romantic landscapes, quite different from the stark realism of-

fered by Sisley. The closest parallel can be found in the work of Pissarro. In the early 1860s he had made several tentative and timid views of the quarter; but more important, his panoramic paintings of Pontoise of the late 1860s, with their rich, green foregrounds, middle grounds filled with blocky buildings, and blue-gray skies mottled with clouds, seem to underlie Sisley's picture. No doubt Sisley saw Pissarro's Pontoise landscapes at the 1868 and 1869 Salons (see cats. 158, 160), and he may have been shown others in Pissarro's studio. Behind Pissarro's contemporaneous work there lay prototypes by Daubigny, Rousseau, and Corot, artists who also interested and inspired Sisley. In a letter in 1892 Sisley wrote, "Which painters do I like? To confine myself to contemporaries: Delacroix, Corot, Millet, Rousseau, Courbet, our masters. All those who loved nature and felt it deeply."[2] Most modern writers find the influence of Corot paramount in this work. Richard Shone detects the presence of Courbet in addition to Corot,[3] and Kermit Champa sees in the light tonality and the crispness of the brushwork the effect of Monet's 1867 views of Paris.[4]

This painting was almost certainly acquired by Joseph-Auguste Rousselin, an animal painter who had attended Gleyre's studio, where he became friends with Bazille. He was also a cousin of Renoir's patron Jules Le Coeur and a resident of Grenoble in 1901, the date of M. Rousselin's gift.[5]

G.T.

1. "Ils montaient la chaussée Clignancourt et, avec le flot des Parisiens de faubourg se pressant à aller boire un peu d'air, ils marchaient vers ce grand morceau de ciel se levant tout droit des pavés, au haut de la montée, entre les deux lignes de maisons, et tout vide quand un omnibus n'en débouchait pas."Edmond and Jules de Goncourt, *Germinie Lacerteux* (1864; Paris: E. Flammerion, E. Fasquelle, 1921), p. 83. Translation from *Germinie* (New York: Grove Press, 1955), p. 51.
2. "Quels sont les peintres que j'aime? Pour ne parler que des contemporains: Delacroix, Corot, Millet, Rousseau, Courbet, nos maitres. Tous ceux enfin qui ont aimé la nature et qui ont senti fortement." Sisley to Adolphe Tavernier, 1892, reprinted in Paris, Bernheim-Jeune, December 2–14, 1907, *L'Atelier de Sisley*; cited and translated in Shone 1992, p. 220, French text, p. 218.
3. Shone 1992, pp. 34–35, 47.
4. Champa 1973, pp. 94–95.
5. I thank Susan Alyson Stein for the identification of the Monsieur Rousselin who donated this painting to the Musée de Grenoble with Sisley's contemporary, Joseph-Auguste Rousselin. See also Cooper 1959, p. 322, n. 3.

Jacques-Joseph, known as James Tissot

Nantes, 1836–Buillon, 1902

A pupil of Louis Lamothe, who was also Degas's teacher, Tissot enrolled at the École des Beaux-Arts in April 1857. In 1859 he began showing regularly at the Salon; these paintings, which had a "primitive flavor," were inspired by the Flemish

and German painters of the fifteenth and sixteenth centuries and by the more recent example of the Belgian painter Henri Leys. But, in 1864, Tissot changed his style (fig. 278), thereafter devoting himself to modern life. Within a brief time he became a fashionable and wealthy painter. His ties to Degas remained close (fig. 277); both artists had no doubt met during the early 1860s through Elie Delaunay, like Tissot a native of Nantes and a friend of Degas's in Rome. Tissot's fine upbringing, the charm of his manners, and the taste he shared with Degas for the Italian painters of the fifteenth century sealed a friendship that would be terminated fifteen years later.

189 *Fig. 278*

James Tissot
Portrait de Mlle L. L... (Jeune Femme en veste rouge)
(Portrait of Mlle L. L... [Young Woman in a Red Jacket])
1864
Oil on canvas
48⅞ x 39⅛ in. (124 x 99.5 cm)
Musée d'Orsay, Paris RF2698

PROVENANCE: Thiébaut-Sisson, Paris; his sale, Paris, Hôtel Drouot, November 23, 1907, no. 101 (Jeune Femme dans un intérieur); acquired by the French state for the Musée du Luxembourg; transferred to the Musée du Louvre, Paris, 1929; Musée d'Orsay, Paris, 1986

EXHIBITIONS: Paris, Salon of 1864, no. 1861 (Portrait de Mlle L. L...); Berlin, Nationalgalerie, and Prague, 1982, *Von Courbet bis Cézanne*, no. 82; Paris, Petit Palais, 1985, *James Tissot*, no. 14

SELECTED REFERENCES: Edmond About, "Salon de 1864," *Le Petit Journal*, July 6, 1864, p. 3; Jules Castagnary, "Salon de 1864," *Le Grand Journal*, June 12, 1864, p. 3; Ernest Chesneau, "Salon de 1864," *Le Constitutionnel*, June 14, 1864, p. 3; Théophile Gautier, "Salon de 1864," *Le Moniteur universel*, June 17, 1864, p. 1; Léon Lagrange, "Le Salon de 1864," *Gazette des Beaux-Arts*, June 1, 1864, pp. 525–26; Paul de Saint-Victor, *La Presse*, May 26, 1864, p. 2; Willard Erwin Misfeldt, *James Jacques-Joseph Tissot: A Bio-Critical Study* (Seattle, Wash., 1971), pp. 58–62, 78–79, 85; Michael Wentworth, *James Tissot* (Oxford, U.K., 1984), pp. 46–49

At the Salon of 1864, Tissot renounced definitively his existence as Jacobus Tissot, who, since 1859, had been submitting historical paintings with a primitive flavor, imitations of the compositions by the Belgian artist Henri Leys. Now Tissot became the very British James Tissot, partaker of modern and fashionable subjects; "this year M. Tissot left the Middle Ages to enter our century," commented Théophile Gautier.[1] Two canvases marked this change: *Les deux soeurs; portrait* (The Two Sisters: Portrait, Musée d'Orsay, Paris) and the *Portrait de Mademoiselle L. L....* These entries were well received, garnering abundant and flattering remarks. Thoré, in particular, lauded the double portrait for the "color, strange but perfectly true for the painter," and for the beauty of the girls: "Here we can spare M. Tissot the reproach, often fair enough, that we address to the realists, of painting common subjects or ugly types, for the young woman is a model of elegance, nobility, and simplicity."[2] Similar compliments were voiced about the *Portrait de Mademoiselle L. L...*, whose "primary merit is the sincerity of the modern sentiment." The prudish Léon Lagrange, however, remarked that the elegant clothing, "those so carefully treated accessories, those fantasy furnishings, that elegant interior do not exhale the healthy fragrance of a family."[3] Tissot had, in fact, painted a studio model, whom we find again in *Les deux soeurs* and, a bit later, in *Le Printemps* (Spring; private collection, New York), dressed in the bright red "Zouave" bolero that makes the painting. "The mistakes are glaring and obvious; the body is unmodeled under the fabric; the hair squashed against the mirror, breaking it rather than being reflected in it; the dress cuts awkwardly into the contour of the dangling hand; the foot that appears from under the folds [of fabric] should never have come out. But the head, stamped with remarkable individuality, stops you in your footsteps. She intrigues you like the mask of a mysterious character. A portrait that speaks to the imagination is never a bad portrait."[4]

The meticulously depicted accessories and the mirror above the head indicate a discovery of the Ingres prototype, and Tissot certainly remembered the *Portrait of Madame de Senonnes*, which he once copied in Nantes. Critics have frequently stressed the resemblance of this canvas to Degas's portraits. But we must add that in 1864 Degas had not yet adopted Tissot's picturesque arrangements; instead, he usually placed his models against a simplified background (figs. 258, 276). It was not until 1866 (fig. 283) that Degas would faithfully portray the setting and objects around the figure; it is thus quite possible that Tissot was influenced by the highly successful example of his friend from Nantes, Ingres.

H.L.

1. "cette année M. Tissot est sorti du moyen âge pour entrer dans notre siècle." Théophile Gautier, "Salon de 1864," *Le Moniteur universel*, June 17, 1864, p. 1.
2. "couleur étrange mais parfaitement vraie du peintre"; "Ici l'on ne saurait appliquer à M. Tissot le reproche,

assez juste souvent, qu'on adresse aux réalistes, de peindre des sujets grossiers ou des vilains types, car la jeune femme est un modèle d'élegance, de noblesse et de simplicité." Thoré-Bürger, 1870, vol. 1, pp. 100–102.

3. "ces accessoires si bien traités, ces meubles de fantaisie, cet intérieur élégant, n'exhalent plus le parfum sain de la famille." Léon Lagrange, "Le Salon de 1864," *Gazette des Beaux-Arts*, June 1, 1864, p. 525.

4. "Les défauts crient et vous sautent aux yeux: le corps ne se modèle pas sous l'étoffe; les cheveux plaqués contre une glace la crèvent au lieu de s'y refléter; la robe entame gauchement le contour de la main pendante; le pied qui passe sous les plis ne devrait jamais en sortir. Mais la tête empreinte d'une individualité singulière arrête au passage. Elle vous intrigue comme le masque d'un caractère mystérieux. Un portrait qui parle à l'imagination n'est jamais un mauvais portrait." Paul de Saint-Victor, "Salon de 1864," *La Presse*, May 26, 1864, p. 2.

Constant Troyon

Sèvres, 1810–Paris, 1865

Constant Troyon was the son of a decorator at the Sèvres porcelain factory, where he received his artistic education and worked for several years. He was more attracted to landscape than porcelain, however, and exhibited his first paintings in this genre at the Salon in 1833. In 1838 he received a third-class medal. In 1843 he met Rousseau and Jules Dupré and began frequenting the Fontainebleau region. Troyon, whose works were never really controversial, won a first-class medal at the 1846 Salon. The following year he traveled to Holland, a trip which proved to be a turning point in his career. There he became enamored with Dutch animal painting and became a specialist in this genre for the rest of his career. Troyon was named to the Légion d'Honneur in 1849, becoming the first Barbizon artist to win such acclaim. He died after a brief period of insanity.

190 *(Paris only)* *Fig. 29*

Constant Troyon
*Vue prise des hauteurs de Suresnes
(Seine-et-Oise)*
(*View from the Heights of Suresnes
[Seine-et-Oise]*)
1856
Oil on canvas
71⅞ x 104½ in. (182.5 x 265.5 cm)

Signed and dated lower left: *C. Troyon. 1856.*
Musée du Louvre, Paris, Bequest of Thomy Thiéry, 1902 RF1454

PROVENANCE: George Thomy Thiéry (1823–1902), Paris; his bequest to the Musée du Louvre, 1902

EXHIBITIONS: Paris, Salon of 1859, no. 2903; Paris 1968–69, no. 503

SELECTED REFERENCES: Astruc 1859, p. 252; Aubert 1859, pp. 20–21; Émile Cantrel, "Salon de 1859: Les paysagistes," *L'Artiste*, n.s. 7 (May 15, 1859), p. 34; Castagnary, "Salon de 1859," reprinted in Castagnary, 1892, vol. 1, p. 90–91; Chesneau 1859, p. 126; A.-J. Du Pays, "Salon de 1859," *L'Illustration* 34 (July 30, 1859), p. 94; Gautier 1859, p. 177; Miette de Villars, "Salon de 1859," *La Revue de la semaine*, no. 35 (June 4, 1859), p. 487; Nettement, "Salon de 1859," reprinted in Nettement 1862, p. 368; Perrier 1859, p. 319; Jean Rousseau, "Salon de 1859," *Le Figaro*, May 17, 1859; Jules Thierray, "Salon de 1859," *Le Paris élégant*, no. 14 (July 1, 1859), p. 261

Troyon was at his apogee in 1859. At the Salon he exhibited six works which were almost universally acclaimed. Part of this success can be traced to the fact that he was classified as an *animalier* while he painted like a landscapist. Critics expecting only a cow were continually surprised to find a beautiful landscape lit by subtly modulated light.

Maurice Aubert designated the *Vue prise de Suresnes* as one of the most popular works of Troyon's entries: visitors could find "more grandeur, truer beauty, a higher and more poetic understanding of nature, greater depth and air, in the *Vue prise des hauteurs de Suresnes*, which they [the visitors] may have seen a hundred times without grasping its beauty, but which the great landscapist has known how to see and understand."[1] Nevertheless, Aubert warned of exaggeration and complained that one unnamed critic (Maxime Du Camp) rashly preferred him to Paulus Potter. Gautier thought that "the public infatuation, possibly more than a little exaggerated, is not mistaken this time," although he remained condescending of public taste: "The range of silver gray made fashionable by Couture;—in France we like cows and gray very much." But he deplored the ever-enlarging canvas. "The air and the light play freely in the *Vue prise des hauteurs de Suresnes*, the planes recede very nicely; the meadows, separated by lines of trees and spotted with cattle, are nicely spread out under the sky. The grass is thick and delicious, but the whole is painted with too much facility. The site, though pleasant, is not beautiful enough to fill such a large canvas."[2]

Even those who admired Troyon, however, thought that his facility was a trap. Castagnary listed all the qualities of the *Vue de Suresnes* and then asked what was missing from Troyon's talent. "Almost nothing; but in art, this almost nothing is everything: a bit of poetry."[3] Baudelaire was more dismissive. "M. Troyon offers the best example of skill without soul. Thus what popularity! He earned it from a public without soul."[4]

Young Claude Monet was dazzled by the Troyons at the Salon. He wrote Eugène Boudin that they were "superbe." Thanks to a letter of introduc-

tion he was able to visit Troyon in his studio. "It would be impossible to describe to you the beautiful things I saw there; admirable cows and dogs.... I showed him two of my still lifes; right there, he said to me: 'Well, my dear friend, you will have a lot of color; the effect is right; but you need to study seriously, for this is very nice but you do it very easily; you will never lose it.'" Troyon advised him to follow traditional training, to draw from the figure, to copy at the Louvre. He ended by saying that if he, Troyon, could begin all over again, he would study with Thomas Couture.[5]

G.T.

1. "plus de grandeur, plus de véritable beauté, une intelligence plus élevée et plus poétique de la nature, plus de profondeur et d'air, dans la *Vue prise des hauteurs de Suresnes*, qu'ils ont pu apercevoir cent fois, sans se douter de ses beautés, mais que le grand paysagiste a su voir et comprendre." Aubert 1859, p. 21.

2. "l'engouement public, bien qu'un peu exagéré peut-être, ne se trompe pas cette fois." "La gamme de gris argentés mise à la mode par Couture;—en France on aime beaucoup les vaches et le gris." "L'air et la lumière jouent librement dans *la Vue prise des hauteurs de Suresnes*, les plans fuient bien; les prairies, coupées de lignes d'arbres, s'étalent bien sous le ciel, tachetées de bestiaux. L'herbe y est drue et savoureuse, mais le tout est brossé avec une facilité trop grande. Le site, d'ailleurs, quoique agréable, n'a pas la beauté qu'il faudrait pour se déployer dans une si vaste toile." Gautier 1859, pp. 175–77.

3. "Presque rien; mais en matière d'art, ce presque rien est tout: un peu de poésie." "Salon de 1859," in Castagnary 1892, vol. 1, p. 91.

4. "M. Troyon est le plus bel exemple de l'habilité sans âme. Aussi quelle popularité! Chez un public sans âme, il la méritait." "Salon de 1859," in Baudelaire 1975–76, vol. 2, p. 662.

5. "Vous dire les belles choses que j'y ai vues serait chose impossible à dire; des boeufs et des chiens admirables.... Je lui ai montré deux de mes natures mortes; là-dessus, il m'a dit: 'Eh bien, mon cher ami, vous aurez de la couleur; c'est juste d'effet; mais il faut que vous fassiez des études sérieuses, car ceci c'est très gentil, mais vous faites ça très facilement; vous ne perdrez jamais ça." Monet to Boudin, May 19, 1859, Wildenstein 1974, letter 1, p. 419.

190A *(New York only)*

Constant Troyon
Vache qui se gratte
(*Cow Scratching Itself*)
1859
Oil on canvas

44½ x 57⅛ in. (113 x 145 cm)
Signed lower left: *C. Troyon.*
Musée d'Osay, Paris, Bequest of Alfred Chauchard, 1909
RF1907

PROVENANCE: Alfred Chauchard (1821–1909), Paris; his bequest to the state, 1909

EXHIBITION: Paris, Salon of 1859, no. 2904

SELECTED REFERENCES: Astruc 1859, pp. 252–53; Aubert 1859, p. 23; Édouard Cadol, "Revue du Salon," *L'Univers illustré*, May 21, 1859, p. 198; Castagnary, "Salon de 1859," reprinted in Castagnary, 1892, vol. 1, p. 91; Chesneau 1859, p. 126; Charles Dollfus, "Salon de 1859," *Revue germanique* 6 (April–June 1859), p. 248; A.-J. Du Pays, "Salon de 1859," *L'Illustration* 34 (July 30, 1859), p. 94; Gautier 1859, p. 177, fig. 144; Guyot de Fère, "Salon de 1859," *Journal des arts, des sciences et des lettres*, July 8, 1859, p. 359; Houssaye 1859, vol. 4, p. 313, with an engraving after the painting by H. Linton; Miette de Villars, "Salon de 1859," *Revue de la semaine*, June 4, 1859, p. 487; Nettement, "Salon de 1859," reprinted in Nettement 1862, p. 368; Perrier 1859, p. 319; Jean Rousseau, "Salon de 1859," *Le Figaro*, May 17, 1859

Troyon knew what his admirers liked. If the *Vue prise des hauteurs de Suresnes* surprised, the *Vache qui se gratte* reassured. "The cow is beautiful," Astruc observed, "the tree takes up too much space, but it is well painted, very fine in color, quite correct in the modeling of the bark. The sky is a cold blue, without air; the light exists only in a phenomenal state. M. Troyon has made an otherworldly sun shine on his landscape."[1] Here Astruc touched on the one complaint uniformly leveled at this picture: the light was deemed too cool and artificial. Castagnary summed it up: "For all the powerful modeling, . . . the tones of the light are totally dull."[2]

G.T.

1. "La vache est belle; l'arbre tient trop de place, mais il est bien peint, très-beau de couleur,—très-juste comme modelé d'écorce. Le ciel est d'un bleu froid, sans air; la lumière n'existe qu'à l'état de phénomène. M. Troyon a fait luire sur son paysage un soleil de l'autre monde." Astruc 1859, pp. 252–53.
2. "Si puissamment modelée pourant, mais dont les tons de lumière sont totalement embus." "Salon de 1859," in Castagnary 1892, vol. 1, p. 91.

James Abbott (McNeill) Whistler

Lowell, Massachusetts, 1834–London, 1903

Whistler was born to a railroad engineer and his wife. His father helped design the Moscow–Saint Petersburg railroad, and during that time Whistler attended drawing classes at the Imperial Academy of Fine Arts in Saint Petersburg. After a stint at West Point and working as a topographical artist, Whistler left America for France and enrolled in Gleyre's studio in 1856. With Fantin-Latour and Legros he formed the "société des trois" in 1858. His first important composition, *At the Piano* (fig. 3), was rejected by the Salon of 1859, but it was shown in Bonvin's studio, where Courbet

admired it. Manet probably met Whistler in 1861. Whistler alternated between London and Paris in the early 1860s, visiting Madrid and Biarritz as well. He had better luck with his submissions to the Royal Academy in London than he did with the Paris Salon. In London he exhibited each year from 1859 through 1865, then in 1867 and 1870. In Paris his *White Girl* (fig. 249) earned him notoriety in the 1863 Salon des Réfusés; *Princesse du pays de la porcelaine* (fig. 380), shown in 1865, was his only work accepted by a Salon in the 1860s. At about this time he began to collect Japanese and Chinese works of art and became instrumental in the early development of *Japonisme* in Paris and London. He painted with Courbet at Trouville in autumn 1865 and then embarked on a mysterious voyage to Chile. In 1867 he took up residence in London, which remained his base for the rest of his life. In poor health from 1900, he died in London in 1903.

191 *(Paris only)* Fig. 250

James McNeill Whistler

The Little White Girl: Symphony in White, No. 2
1864
Oil on canvas
30⅛ x 20⅛ in. (76.5 x 51.1 cm)
Signed upper right: *Whistler.*
Tate Gallery, London, Bequeathed by Arthur Studd, 1919
N03418

CATALOGUE RAISONNÉ: Young et al. 1980, no. 52

PROVENANCE: Purchased from the artist by Gerald Potter, London, 1865; sold to Arthur H. Studd, London, 1893; his bequest to the National Gallery, London, 1919; transferred to the Tate Gallery, 1951

EXHIBITIONS: London, Royal Academy of Arts, 1865, *97th Exhibition of the Royal Academy of Arts*, no. 530 ("The Little White Girl"); London, Fine Art Department, South Kensington Museum, 1872, *International Exhibition*, no. 260 ("The White Girl"); London, Boussod, Valadon et Cie., Goupil Gallery, March–April 1892, *Nocturnes, Marines and Chevalet Pieces*, no. 33 ("Symphony in White No. II. The Little White Girl"); Munich, June 1–end of October 1892, *VI Internationale Kunst-Austellung*, no. 1950a; Glasgow, Wellington Studios, November 1893; Antwerp, Universal Exposition, U.S. Section, July 1894 (withdrawn); Venice, 1895, *I Esposizione Internazionale d'Arte*

della Città di Venezia, no. 363; Paris, Exposition Universelle, May 1900, *Fine Arts Exhibit of the United States of America*, no. 76; Edinburgh, Royal Scottish Academy, 1902, *76th Exhibition of the Royal Scottish Academy of Painting, Sculpture and Architecture*, no. 240; Boston, Copley Society, February 1904, *Oil Paintings, Water Colors, Pastels and Drawings: Memorial Exhibition of the Works of Mr. J. McNeill Whistler*, no. 28; Paris, Palais de l'École des Beaux-Arts, May 1905, *OEuvres de James McNeill Whistler*, no. 5; New York, Metropolitan Museum of Art, March 13–May 31, 1910, *Paintings in Oil and Pastel by James A. McNeill Whistler*, no. 6; London, Arts Council Gallery, New York, Knoedler Galleries, 1960, *James McNeill Whistler*, no. 12; Chicago, Art Institute, Utica, Munson-Williams-Proctor Institute, 1968, *James McNeill Whistler*, no. 5 (exhibited in Chicago only)

SELECTED REFERENCES: Philippe Burty, "Exposition de la Royal Academy," *Gazette des Beaux-Arts* 18 (June 1, 1865), p. 561; Algernon C. Swinburne, *Poems and Ballads* (London, 1866), pp. 149–52; William M. Rossetti, *Fine Art, Chiefly Contemporary* (London, 1867), pp. 274–75; *Times*, May 14, 1872; *Glasgow Herald*, November 9, 1893; Richard Muther, *Geschichte der Malerei im XIX Jahrhundert* (Munich, 1893–94), repr. p. 529; "Art and Mr. Whistler," *Art Journal*, December 1894, p. 359; *Morning Post*, September 1, 1895; George Moore, *Modern Painting*, new ed. (London, 1898), pp. 19–21; *Art Journal*, October 1900, p. 166, frontispiece; James McNeill Whistler, Letter, in *Standard*, November 21, 1902; "Dzh. Uistler," *Mir Iskusstva* 9 (1903), repr. p. 62; Arsène Alexandre, "J. McNeill Whistler," *Les Arts*, no. 21 (September 1903), p. 28; Théodore Duret, *Histoire de J. McN. Whistler et de son oeuvre* (Paris, 1904), pp. 28, 30–31, 205; Léonce Bénédite, "Artistes Contemporains: Whistler," *Gazette des Beaux-Arts*, ser. 3, 34 (August 1, 1905), pp. 152–53; Cary 1907, pp. 48, 65, 159, no. 28, repr. facing p. 46; Pennell 1908, vol. 1, pp. 89, 127–30, 144, 146–48, 178, vol. 2, pp. 127, 251, 261–62, 280, repr. facing p. 252; Elizabeth Robins and Joseph Pennell, *The Whistler Journal* (Philadelphia, 1921), pp. 48–49, 78, 126, 161, 191, 200, 300, 325; Martin Davies, *National Gallery Catalogues: British School* (London, 1946), p. 171; Eugene Matthew Becker, *Whistler and the Aesthetic Movement*, Ph.D. diss., Princeton University, 1959 (photocopy, University Microfilms), pp. 25–26, 85–86, 88, 100, 183, pl. 10; C. Y. Lang, ed., *The Swinburne Letters* (New Haven, 1959), vol. 1, p. 120; A. McLaren Young, *James McNeill Whistler* (Milan, 1963), pp. 5, 7; Denys Sutton, *Nocturne: The Art of James McNeill Whistler* (Philadelphia and New York, 1964), pp. 39–41, fig. 12; Gorder 1973, pp. 96, 103–11, 116–17, fig. 30; Gordon Fleming, *The Young Whistler* (London, 1978), pp. 206, 218, 220–22; Jeffrey Howe, "Mirror Symbolism in the Work of Fernand Khnopff," *Arts Magazine* 53 (September 1978), p. 116, fig. 11; Ira M. Horowitz, "Whistler's Frames," *Art Journal* 34 (Winter 1979–80), pp. 124–25; Jacques Dufwa, *Winds from the East: A Study in the Art of Manet, Degas, Monet and Whistler (1856–86)* (Stockholm, 1981), pp. 160–62, fig. 136; Ron Johnson, "Whistler's Musical Modes: Symbolist Symphonies," *Arts Magazine* 55 (April 1981), pp. 164–68, fig. 2; Cabanne 1985, pp. 38–39, repr. p. 22; John Walker, *James McNeill Whistler* (New York, 1987), pp. 46, 145–46, frontispiece; Elizabeth Broun, "Thoughts that Began with the Gods: The Content of Whistler's Art," *Arts Magazine* 62 (October 1987), pp. 38–39, fig. 8; Robin Spencer, ed., *Whistler: A Retrospective* (New York, 1989), pp. 63–64, 76–78, 276–79, 291–92, pl. 17

This painting, which originally bore the date 1864 in its upper right-hand corner,[1] was first exhibited at the Royal Academy Exhibition in London in 1865. It is to a certain extent the reprieve of an earlier picture, the famous *The White Girl: Sym-*

phony in White No. 1 of 1862 (fig. 249), which competed with Manet's *Déjeuner sur l'herbe* (cat. 93) for the honor of being the picture most commented upon at the 1863 Salon des Refusés. *Symphony in White, No. 3* of 1865–67 (Barber Institute of Fine Arts, University of Birmingham) closes this series of paintings featuring women in white. It was only with the completion of this work that Whistler rechristened the previous two paintings "Symphonies." The idea for such a title may go back, however, to Paul Mantz's characterization of *The White Girl* as a "symphonie du blanc" in his review of the 1863 Salon des Refusés.[2] Whatever the inspiration behind this appellation, Whistler commonly used musical titles (symphonies, harmonies, nocturnes, and arrangements) for his paintings after 1867.[3]

Whistler's mistress, the beautiful red-haired Irishwoman Joanna Hiffernan, posed for all three *Symphonies in White*.[4] "Jo" also became a favorite model of Gustave Courbet—and probably his mistress for a brief period.[5] In a painting that might have been inspired by *The Little White Girl*, Courbet portrayed Hiffernan looking into a handheld mirror and running her fingers through her flowing auburn hair. As Denys Sutton and others have pointed out, the earthy sensuality—the sheer physicality—of Courbet's depiction of Jo contrasts markedly with her ethereal, almost waiflike appearance in Whistler's representations.[6] Courbet's portrait of Jo, which exists in four nearly identical versions, was probably first essayed in autumn 1865 when Courbet, Whistler, and Hiffernan spent several months together in Trouville.[7]

When *The Little White Girl* was first exhibited in 1865, it had attached to its original, Orientalizing frame[8] a fourteen-verse poem entitled "Before the Mirror: Verses under a Picture" by Algernon Swinburne (1837–1909), a close friend of the artist. It might well be that Whistler requested Swinburne to compose the poem for this very purpose.[9] It was then quite common for English artists, especially the Pre-Raphaelites, to attach verses of poetry to the frames of their pictures.

Gordon Fleming has argued that the critical reception of *Little White Girl* at the 1865 Royal Academy exhibition was not as negative as is commonly thought.[10] Despite inevitable criticisms of its sketchiness and lack of finish, and denouncements of its "freakishness" and "impertinence,"[11] many critics were able to appreciate the delicate tonal harmonies of the painting and considered it Whistler's best creation to date. The painting's empty formalism—its apparent lack of meaning—was profoundly troubling to other critics, however. The French writer Philippe Burty, reviewing the English exhibition for the prestigious *Gazette des Beaux-Arts*, observed: "If one decides to put aside the observation of the passions, if one wants to forget momentarily that painting is the most eloquent form of poetry, then one must frankly proceed with only the investigation of external appearances, as does M. Whistler, an American already well known in Paris. The viewer looking at his *Little White Girl*, a weak repetition

of the *White Woman* of the 1863 Salon, knows perfectly well that he is supposed to enjoy the view only and does not have to use his mind. The fourteen verses of the poet on the border itself are only there as a label such as those used in the storeroom of a theater to identify costumes. In this piece, M. Whistler has reached his goal marvelously: it is white muslin, it is a pink hand, it is red hair, it is azaleas, but all of it is still only a variation on the white theme!"[12]

The meaning of the painting—or the lack thereof—continues to exercise modern scholars, who, not surprisingly, have concentrated on its sense of pent-up, languishing sexuality. Sutton, for instance, has interpreted the painting as representative of Whistler's "pre-occupation with adolescence and with the ideal of a pure, unspotted young girl."[13] More recently, Elizabeth Broun has argued that the work is rather an allegory of feminine fertility.[14]

In addition to the *japonisant* props and the compressed spatial configuration of the painting (the setting is supposedly Whistler's own house),[15] scholars have noted an affinity between *The Little White Girl* and the works of the Pre-Raphaelite Dante Gabriel Rossetti (1828–1882) and of Ingres. As George Moore noted as early as 1893, the "dreaming eyes and abundant hair"[16] of Jo in this picture are consistent with the melancholic feminine ideal celebrated with monotonous regularity by Rossetti in such works as *Lady Lilith* (1868; Delaware Art Museum, Wilmington). Scholars have also noted the possible inspiration of Ingres's portrait of the Comtesse d'Haussonville (1845; Frick Collection, New York), a picture Whistler could have admired at the 1855 Exposition Universelle, which similarly features a beautiful young woman leaning against a mantlepiece backed by a mirror. With regard to the venerable old artist, whose works Whistler copied as a student, the young American wrote in 1867: "Ah! how I wish I had been a pupil of Ingres! I don't go into raptures in front of his pictures—I only have a moderate liking for them—I find several of his canvases we've seen together to be in a very questionable style—not at all Greek in the way you would think—but they're really aggressively French! You feel there's much further to go! much more beautiful things to do—But I repea would I had been his pupil!"[17]

G.T.

1. See Young et al. 1980, fig. 371 (an old photograph with the date still present). According to Pennell 1908, vol. 1, p. 127, Whistler painted out the date around 1900 as he "did not see the use of those great figures sprawling there."
2. Paul Mantz, "Salon de 1863. Peinture et Sculpture," *Gazette des Beaux-Arts* 15 (July 1, 1863), p. 61.
3. See Gorder 1973, pp. 116–20.
4. In the final composition she is accompanied by Milly Jones, the wife of an actor. See Young et al. 1980, no. 61.
5. See Brooklyn, Minneapolis 1988–89, pp. 162–63.
6. Denys Sutton, *Nocturne: The Art of James McNeill Whistler* (Philadelphia and New York, 1964), p. 40.
7. Courbet's four portraits of Hiffernan are in the Nationalmuseum, Stockholm; Metropolitan Museum of Art, New York; Rolf and Margit Weinberg collection, Zurich;

8. See Ira M. Horowitz, "Whistler's Frames," *Art Journal* 34 (Winter 1979–80), pp. 124–25. A photograph of the picture in its original frame appears in Robin Spencer, ed., *Whistler: A Retrospective* (New York, 1989), p. 77.
9. See Swinburne's letter to Whistler announcing the completion of the poem, reprinted in Spencer, *Whistler*, p. 76. In addition to the entire text of the poem attached to the frame—and not several lines or verses as is sometimes maintained—Whistler also had verses four and six reproduced in the exhibition catalogue.
10. Gordon Fleming, *The Young Whistler* (London, 1978), p. 220. For the opposing view, see Pennell 1908, vol. 1, pp. 129–30.
11. For a broad sample of the criticism, see Fleming, *Young Whistler*, pp. 220–22.
12. "Si l'on délaisse l'observation des passions, si l'on veut oublier pour un instant que la peinture est la plus éloquente des poésies, il faut entrer franchement dans la seule recherche du rendu extérieur, comme le fait un Américain déjà connu à Paris, M. Whistler. Le spectateur, en face de sa *Petite jeune femme blanche*, répétition sans force de la *Femme blanche* du Salon de 1863, sait fort bien qu'il n'a qu'à se rassasier la vue et qu'aucun appel n'est fait à son esprit. Les quatorze vers du poète, écrits sur la bordure même, ne sont là que comme l'étiquette collée sur les costumes dans le magasin d'un théâtre. M. Whistler a du reste, dans ce morceau, merveilleusement atteint son but: c'est bien là de la mousseline blanche, c'est une main rose, ce sont des cheveux roux, ce sont des fleurs d'azalées, mais ce n'est là encore qu'une variation sur le thème blanc!" Philippe Burty, "L'exposition de la Royal Academy," *Gazette des Beaux-Arts* 18 (June 1, 1865), p. 561.
13. Sutton, *Nocturne* (see note 6 above), p. 41.
14. Elizabeth Broun, "Thoughts that Began with the Gods: The Content of Whistler's Art," *Arts Magazine* 62 (October 1987), p. 39.
15. Pennell 1908, vol. 1, p. 128.
16. George Moore, *Modern Painting* (1863; new ed., London, 1898), p. 20.
17. "Ah! que n'ai-je été un élève de Ingres! Je ne dis point cela par rhapsodie devant ses tableaux. Je ne les aime que médiocrement. Je trouve plusieurs de ses toiles, que nous avons vues ensemble, d'un style bien questionnable, pas du tout grec, comme on veut le dire, mais très vicieusement français. Je sens qu'il y a bien plus loin à aller, de choses bien plus belles à faire. Mais, je répète, que n'ai-je été son élève!" Whistler to Henri Fantin-Latour, 1867, quoted in Léonce Bénédite, "Artistes contemporains: Whistler," *Gazette des Beaux-Arts*, ser. 3, 34 (September 1, 1905), p. 233; translation in Spencer, *Whistler* (see note 8 above), pp. 82–83.

Nelson-Atkins Museum of Art, Kansas City. See Brooklyn, Minneapolis 1988–89, nos. 53–56.

192

Fig. 290

James McNeill Whistler
Trouville (Grey and Green, the Silver Sea)
1865
Oil on canvas
20¼ x 30⅜ in. (51.5 x 76.9 cm)

Signed lower right: *Whistler*
The Art Institute of Chicago, Potter Palmer Collection,
1922 1922.448

CATALOGUE RAISONNÉ: Young et al. 1980, no. 70

PROVENANCE: Mrs. W. Charles Deschamps, London, by
1873; sold to the artist, April 1891; probably purchased
from the artist by Théodore Duret (1838–1927), Paris;
purchased by Agnew of London for Mrs. Potter Palmer
(1849–1918), Chicago, July 1901; presented by Mrs.
Palmer's sons, Honoré and Potter Palmer, Jr., to the Art
Institute of Chicago, 1922

EXHIBITIONS: London, Society of French Artists, 1873,
7th Exhibition, no. 110 ("The Yacht Race—A Symphony
in B Sharp"); Boston, Copley Society, February 1904,
Oil Paintings, Water Colors, Pastels and Drawings: Memorial Exhibition of the Works of Mr. J. McNeill Whistler,
no. 12; Paris, Palais de l'École des Beaux-Arts, May 1905,
OEuvres de James McNeill Whistler, no. 63 ("Gris et
vert. Marine"); Chicago, Art Institute, Utica, Munson-
Williams-Proctor Institute, 1968, *James McNeill Whistler*,
no. 12 ("Grey and Green: The Silver Sea"); New York,
Wildenstein, Philadelphia Museum of Art, 1971, *From
Realism to Symbolism: Whistler and His World*, by A.
Staley and T. Reff, no. 19

SELECTED REFERENCES: *Athenaeum*, November 8, 1873,
p. 601; *Athenaeum*, November 22, 1873, p. 666; J. K.
Huysmans, "Uistler," *Mir Iskusstva* 2 (1899), repr.
p. 66; Cary 1907, no. 12; Denys Sutton, *Nocturne: The
Art of James McNeill Whistler* (Philadelphia and New
York, 1964), 1964, p. 51; Gorder 1973, pp. 127–29

It is not certain when Whistler arrived at Trouville
with his companion, Jo Hiffernan. Correspondence
suggests that he was still in London on August
16,[1] while Courbet reported that they were still
together at Trouville on November 17, having been
there for some time.[2] While there Whistler painted
at least five seascapes, including this work; they
are notable for their evanescent palettes, their
thinly applied veils of paint, and their lack of
dramatic subject. Whistler was grappling simultaneously with the example of Japanese prints
and the presence of Courbet, who made at
Trouville some of his most abstract seascapes,
which, nevertheless, were muscular in comparison to Whistler's new work. Whistler may also
have seen Manet's Japanese-inspired marines of
1864 (see cats. 99, 100), but this cannot be
documented.

This painting was exhibited in London in 1873
at the Society of French Artists. The *Athenaeum*
called it "a vigorous and beautiful study of colour, and bright, yet soft tone, the subject being a
contest of sailing vessels near the shore. Among
the finer, if not the finest portion of this interesting picture, is the sky, which is excellent."[3] Evidently, the work was given a false title when it
was exhibited, for Whistler wrote the following
letter to the *Athenaeum*. "I wish . . . to correct an
error now current about the title of a picture of
mine. . . . I am supposed to have named it 'The
Yacht Race, A Symphony in B sharp'; and it is
suggested that in doing so I have perpetrated a
senseless pun. M. Deschamps did not purchase
the painting from me, and I hear from him that
he found the silly title in question written on the
back of the canvas. The titles I have hitherto given
to my pictures have been intended by me as a key

to my work simply; but I cannot expect others,
who do not understand them, to refuse themselves any witticism, like the above brilliant parody, on the subject."[4]

G.T.

1. Young et al. 1980, pp. 37–38.
2. Courbet 1992, letter 65–16, pp. 268–69.
3. *Athenaeum*, November 8, 1873, p. 601, quoted in Young et al. 1980, p. 40.
4. *Athenaeum*, November 22, 1873, p. 666, quoted in Young et al. 1980, p. 40.

193 *Fig. 292*

James McNeill Whistler
Sea and Rain
1865
Oil on canvas, with wood backing
20 x 28⅝ in. (50.8 x 72.7 cm)
Signed and dated lower right: *Whistler. 65.*
The University of Michigan Museum of Art, Ann Arbor,
Margaret Watson Parker Bequest, 1955 1955/1.89

CATALOGUE RAISONNÉ: Young et al. 1980, no. 65

PROVENANCE: Purchased from the artist by Alexander
Ionides, by 1895; Alexander Young, London, probably
purchased from the Goupil Gallery at the time of the
1895 exhibition of the Ionides collection; Agnew, London; sold to Knoedler, London and New York; purchased
by Scott and Fowles, New York, August 1906; sold to
Miss Margaret Watson (Mrs. W. R. Parker), November
15, 1906; her bequest to the University of Michigan
Museum of Art, 1936, with life interest retained by Dr.
Walter R. Parker, Grosse Point, Michigan; deposited in
the University of Michigan Museum of Art, 1955

EXHIBITIONS: London, Royal Academy of Arts, 1867, *99th
Exhibition of the Royal Academy of Arts*, no. 670 ("Sea
and Rain"); (?) Paris, Galerie Georges Petit, May 11–June
10, 1883, *Exposition Internationale de Peinture*, no. 4
("Harmonie en bleu et argent"); London, Goupil Gallery, May 1895, *A Connoisseur's Treasures* (Alexander
Ionides Collection), no. 12; Glasgow, Royal Glasgow Institute of the Fine Arts, February 8–May 10, 1897, *36th
Exhibition of Works of Modern Artists*, no. 107; London, International Society of Sculptors, Painters and
Gravers, February 22–April 15, 1905, *Memorial Exhibition of the Works of the late James McNeill Whistler*, no.
3; Ann Arbor, University of Michigan Museum of Art,
August 27–October 8, 1978, *Whistler: The Later Years*,
no. 39.

SELECTED REFERENCES: *Daily Telegraph*, May 31, 1867;
George Moore, "The End of the Season," *Speaker*, July
27, 1895, p. 98; William M. Rossetti, ed., *Rossetti Papers,
1862–1870* (London, 1903), pp. 222, 228; Cary 1907,

p. 211, no. 367; Pennell 1908, vol. 1, pp. 133, 137, 144, vol.
2, p. 127; Herbert Barrows, "Four Works by Whistler,"
Bulletin of the University of Michigan Museum of Art,
no. 7 (April 1956), pp. 27–38, fig. 17; Cabanne 1985,
p. 40, repr. p. 6.

Like *Trouville* (cat. 192) this work was executed
in autumn 1865 when Whistler painted at the Normandy resort with Courbet. And like *Harmony
in Blue and Silver* (Isabella Stewart Gardner
Museum, Boston) it depicts a figure on the beach
looking out to sea; as such, it seems to refer to
Courbet's well-known *Bords de la mer à Palavas*,
1854 (fig. 295), then in Alfred Bruyas's collection
in Montpellier and now in the Musée Fabre. Courbet's picture was not publicly exhibited until 1867,
so it is not known whether or when Whistler saw
it, although he could easily have been shown a
photograph, perhaps by Courbet himself. Nevertheless, Whistler asserted in 1895 that the heavyset figure in the present painting does not represent
Courbet: "the only painting by me of Courbet"
is *Harmony in Blue and Silver*.[1] Whistler's friend
and biographer Pennell went further. In 1908 he
wrote, "In *Sea and Rain*, done then at Trouville,
there is not a suggestion of Courbet."[2] Pennell of
course exaggerates. It was indeed Courbet who
established the type of marine painting in which
there is little or nothing other than bands of sand,
sea, and sky. But Whistler took Courbet's suggestion and, emboldened by the Japanese color
woodblock prints that he collected, simplified the
composition even further and restrained the palette to a new minimalism. Nesta Spink has shown
that Whistler used only four pigments to make
this picture: cobalt blue, iron-oxide yellow, vermilion, and bone black on a white ground.[3] The
limited palette anticipates Whistler's nocturnes
of nearly a decade later.

The painting was exhibited and highly regarded
during Whistler's life. When it was shown in London in 1867, the *Daily Telegraph* remarked,
"Earth, air, and sea repeated by three splashes
on the canvas, a splash to an element. . . . The
object . . . is to show how the sea looks under a
steady, unbroken shower. The streaming pour of
rain slides down upon the water, smoothing out
all form, washing all keenness from the wave—
almost all substance away from everything. Thin
grey veils of vapour, damp streams of mist, fill the
air and blind the sight, and the result is a pervading liquid, dense transparency—an aerial effect for which, in truth, we can appeal to no surer
witness than Whistler's canvas."[4] Rossetti commented favorably on it, and George Moore hailed
it in 1895 as "an incomparable work of art."[5]

G.T.

1. Letter from Whistler to D. C. Thomson, April 26, 1895, quoted in Young et al. 1980, p. 37.
2. Pennell 1908, vol. 1, p. 133.
3. Nesta Spink, in *Eighty Works in the Collection of the University of Michigan Museum of Art: A Handbook* (Ann Arbor, 1979), no. 62.
4. *Daily Telegraph*, May 31, 1867, quoted in Young et al. 1980, p. 38.
5. George Moore, "The End of the Season," *Speaker*, July 27, 1895, p. 98, quoted in Young et al. 1980, p. 38.

Abbreviated Bibliographic References

About 1855
About, Edmond. *Voyage à travers l'Exposition des beaux-arts.* Paris, 1855.

Ackerman 1986
Ackerman, Gerald M. *La Vie et l'OEuvre de Jean-Léon Gérôme.* Paris: ACR Édition, 1986. Translated from *The Life and Work of Jean-Léon Gérôme, with a Catalogue Raisonné* (New York and London, 1986).

Adhémar 1958
Adhémar, Hélène. "Modifications apportées par Monet à son Déjeuner sur l'herbe de 1865 à 1866." *Bulletin du laboratoire du musée du Louvre,* June 1958, pp. 37–41.

Adhémar 1960
Adhémar, Jean. "Le cabinet de travail de Zola." *Gazette des Beaux-Arts,* ser. 6, 56 (November 1960), pp. 285–98.

Adriani 1980
Adriani, Götz. *Paul Cézanne. Der Liebeskampf: Aspekt zum Frühwerk Cézannes.* Munich and Zurich, 1980.

Alexandre 1921
Alexandre, Arsène. *Claude Monet.* Paris: Bernheim-Jeune, 1921.

Armbrust-Seibert 1986
Armbrust-Seibert, Margaret. *A Biography of Victorine-Louise Meurent and Her Role in the Art of Edouard Manet.* 2 vols. Ohio State University, Columbus, 1986.

L'Art du XIXe siecle 1990
See Cachin 1990.

Astruc 1859
Astruc, Zacharie. *Les 14 stations du Salon—1859—suivi d'un récit douloureux.* Preface by George Sand. Paris: Poulet-Malassis et de Broise, 1859.

Aubert 1859
Aubert, Maurice. *Souvenirs du Salon de 1859.* Paris, 1859.

Auvray 1859
Auvray, Louis. *Exposition des beaux-arts: Salon de 1859.* Paris, 1859.

Bailly-Herzberg 1972
Bailly-Herzberg, Janine. *L'Eau-forte de peintre au XIXe siècle: La Société des Aquafortistes (1862–1867).* 2 vols. Paris: Léonce Laget, 1972.

Barr 1937
Barr, Jr., Alfred H. "Cézanne d'après les lettres de Marion à Morstatt, 1865–1868." *Gazette des Beaux-Arts,* ser. 6, 17 (January 1937), pp. 37–58.

Basel 1989
Basel, Kunstmuseum, September 10–December 10, 1989. *Paul Cézanne: The Bathers.* See Krumrine 1989.

Bataille 1983
Bataille, Georges. *Manet.* 1955. Reprinted with an introduction by Françoise Cachin. Geneva: Skira, 1983.

Baud-Bovy 1957
Baud-Bovy, Daniel. *Corot.* Geneva, 1957.

Baudelaire 1973
Baudelaire, Charles. *Correspondance.* Selected and edited by Claude Pichois with Jean Ziegler. 2 vols. Paris: Gallimard, La Pléiade, 1973.

Baudelaire 1975–76 (and 1985–87)
Baudelaire, Charles. *OEuvres complètes.* 2 vols. Paris: Gallimard, La Pléiade, 1975–76. Reprint, 1985–87.

Bazille 1992
Bazille, Frédéric. *Correspondance.* Selected by Didier Vatuone; edited by Guy Barral and Didier Vatuone. Montpellier: Les Presses du Languedoc, 1992.

Bazin 1942
Bazin, Germain. *Corot.* Paris, 1942.

Bernard 1925
Bernard, Émile. *Souvenirs sur Paul Cézanne, une conversation avec Cézanne.* Paris, 1925.

Berne 1958
Berne, Kunstmuseum, February 16–April 13, 1958. *Alfred Sisley.*

Birmingham, Glasgow 1990
Birmingham, City Museum and Art Gallery; Glasgow, The Burrell Collection, 1990. *Camille Pissarro: Impressionism, Landscape and Rural Labour.* Catalogue by Richard Thomson.

Blanc 1867
Blanc, Charles. *Grammaire des arts du dessin.* Paris: H. Laurens, n.d. Originally published as a series of articles in *Gazette des Beaux-Arts* in 1867.

Blanche 1927
Blanche, Jacques-Émile. "Claude Monet." *Revue de Paris,* February 1, 1927, pp. 557–75.

Bonniot 1986
Bonniot, Roger. *Gustave Courbet en Saintonge.* 2nd ed., rev. and enl. Limoges: La Saintonge littéraire, 1986.

Bordeaux 1974
Bordeaux, Galerie des Beaux-Arts, May 3–September 1, 1974. *Naissance de l'impressionnisme.*

Bordeaux 1991
Bordeaux, Musée des Beaux-Arts, 1991. *Trophées de chasse.* Catalogue by Bernadette de Boysson and Olivier Le Bihan.

Boston 1977
Boston, Museum of Fine Arts, November 22, 1977–January 29, 1978. *Monet Unveiled: A New Look at Boston's Paintings.* Catalogue by Alexandra Murphy, Lucretia H. Giese, and Elizabeth H. Jones.

Bouillon 1989
Bouillon, Jean-Paul, ed. *La Critique d'art en France, 1850–1900: Actes du colloque de Clermont-Ferrand, 25, 26 et 27 mai 1987.* Saint-Étienne: CIEREC, 1989.

Bouillon et al. 1990
Bouillon, Jean-Paul, Nicole Dubreuil-Blondin, Antoinette Ehrard, and Constance Naubert-Pisier, eds. *La Promenade du critique influent: Anthologie de la critique d'art en France, 1850–1900.* Paris: Hazan, 1990.

Bremen 1977–78
Bremen, Kunsthalle, 1977–78. *Zurück zur Natur: Die Künstlerkolonie von Barbizon.*

Brettell 1990
Brettell, Richard R. *Pissarro and Pontoise: The Painter in a Landscape.* New Haven and London: Yale University Press, 1990.

Brion-Guerry 1950 (and 1966)
Brion-Guerry, Liliane. *Cézanne et l'expression de l'espace.* Paris: Flammarion, 1950; 2nd ed., Paris: Albin Michel, 1966.

Brooklyn, Minneapolis 1988–89
Brooklyn Museum, November 4, 1988–January 16, 1989; Minneapolis Institute of Arts, February 13–April 30, 1989. *Courbet Reconsidered.* Catalogue by Sarah Faunce and Linda Nochlin.

Broude 1991
Broude, Norma. *Impressionism: A Feminist Reading.* New York, 1991.

Bühler 1979
Bühler, Hans-Peter. *Die Schule von Barbizon: Französische Landschaftsmalerei im 19. Jahrhundert.* Munich, 1979.

Bühler 1984
Bühler, Hans-Peter. "Charles-François Daubigny: Poet der Flusslandschaften." *Weltkunst* 54 (October 15, 1984), pp. 2929–33.

Cabanne 1985
Cabanne, Pierre. *Whistler.* New York, 1985.

Cachin 1990
Cachin, Françoise, ed. *L'Art du XIXe siècle, seconde moitié.* With contributions by Geneviève Lacambre, Rodolphe Rapetti, Antoinette Le Normand-Romain, Anne Pingeot, Philippe Néagu, Françoise Heilbrun, Marc Bascou, Philippe Thiébaut, Caroline Mathieu, and Georges Vigne. Paris: Citadelles, 1990.

Cahen 1900
Cahen, Gustave. *Eugène Boudin, sa vie, son oeuvre.* Paris: H. Floury, 1900.

Callen 1971
Callen, Anthea. "Jean-Baptiste Faure, 1830–1914: A Study of a Patron and Collector of the Impressionists and Their Contemporaries." M.A. thesis, University of Leicester, 1971.

Cary 1907
Cary, Elisabeth Luther. *The Works of James McNeill Whistler.* New York, 1907.

Castagnary 1892
Castagnary, Jules-Antoine. *Salons (1857–1870).* 2 vols. Paris: Charpentier-Fasquelle, 1892.

Cézanne 1937 (and 1978)
Paul Cézanne, Correspondance. Edited by John Rewald. Paris: Grasset, 1937. Rev. ed., Paris: Grasset, 1978. Translated by Marguerite Kay, *Paul Cézanne: Letters* (London: B. Cassirer, 1941; 4th ed., rev. and enl., Oxford: B. Cassirer, 1976).

Chalons d'Argé 1859
Chalons d'Argé, Auguste-Philibert. *Notice sur les principaux tableaux de l'exposition de 1859.* Paris, 1859.

Champa 1973
Champa, Kermit S. *Studies in Early Impressionism.* New Haven and London: Yale University Press, 1973.

Chappuis 1966
Chappuis, Adrien. *Album de Paul Cézanne.* 2 vols. Paris: Berggruen, 1966.

Chappuis 1973
Chappuis, Adrien. *The Drawings of Paul Cézanne: A Catalogue Raisonné.* Translated from the French. 2 vols. Greenwich, Conn: New York Graphic Society; London: Thames and Hudson, 1973.

Chesneau 1859
Chesneau, Ernest. "Libre étude sur l'art contemporain: Salon de 1859." *Revue des races latines* 14 (May–June 1859), pp. 11–168.

Chicago 1973
Chicago, Art Institute, 1973. *Paintings by Renoir.* Catalogue by J. Maxon et al.

Chicago 1975
Chicago, Art Institute, March 15–May 11, 1975. *Paintings by Monet.* Essays by André Masson, Grace Seiberling, J. Patrice Marandel.

Chicago 1978
Chicago, Art Institute, March 4–April 30, 1978. *Frédéric Bazille and Early Impressionism.* Essays by J. Patrice Marandel and François Daulte; catalogue

entries by J. Patrice Marandel; letters of Bazille translated by Paula Prokopoff-Giannini.

Chu 1974
Chu, Petra ten-Doesschate. *French Realism and the Dutch Masters*. Utrecht: Haentjens Dekker and Gumbert, 1974.

Claretie 1873 (and 1882)
Claretie, Jules. *Peintres et sculpteurs contemporains*. Paris, 1873. Reprint, 1882.

Clark 1982
Clark, T. J. *The Absolute Bourgeois: Artists and Politics in France 1848–1851*. 1973. 2nd ed., Princeton: Princeton University Press, 1982.

Clark 1985
Clark, T. J. *The Painting of Modern Life—Paris in the Art of Manet and His Followers*. New York: Alfred A. Knopf, 1985.

Clemenceau 1965 (and 1928)
Clemenceau, Georges. *Claude Monet, cinquante années d'amitié*. Paris, 1928. Reprint, Paris and Geneva, 1965.

Cleveland 1979
Cleveland Museum of Art, June 8–August 12, 1979. *Chardin and the Still-life Tradition in France*. Catalogue by Gabriel P. Weisberg with William S. Talbot.

Cleveland, Brooklyn, Saint Louis, Glasgow 1980–82
Cleveland Museum of Art, November 12, 1980–January 18, 1981; Brooklyn Museum, March 7–May 10, 1981; Saint Louis Art Museum, July 23–September 20, 1981; Glasgow Art Gallery and Museum, Kelvingrove, November 5, 1981–January 11, 1982. *The Realist Tradition: French Painting and Drawing 1830–1900*. Catalogue by Gabriel P. Weisberg and Petra ten-Doesschate Chu.

Cogniat 1978
Cogniat, Raymond. *Sisley*. Paris: Flammarion; New York: Crown Publishers, 1978.

Cooper 1959
Cooper, Douglas. "Renoir, Lise and the Le Coeur Family: A Study of Renoir's Early Development." *Burlington Magazine* 101 (May, September/October 1959), pp. 163–71, 322–28.

Cooper 1970
Cooper, Douglas. "The Monets in the Metropolitan Museum." *Metropolitan Museum Journal* 3 (1970), pp. 281–305.

Courbet 1992
Letters of Gustave Courbet. Edited and translated by Petra ten-Doesschate Chu. Chicago and London: University of Chicago Press, 1992.

Courthion 1948
Courthion, Pierre. *Courbet raconté par lui-même et par ses amis*. 2 vols. Geneva: Pierre Cailler, 1948.

Critique 1990
See Bouillon et al. 1990.

Crouzet 1964
Crouzet, Marcel. *Un méconnu du réalisme: Duranty (1833–1880), l'homme, le critique, le romancier*. Paris: Nizet, 1964.

Darragon 1989
Darragon, Eric. *Manet*. Paris: Fayard, 1989.

Darragon 1991
Darragon, Eric. *Manet*. Paris: Citadelles, 1991.

Daulte 1952
Daulte, François. *Frédéric Bazille et son temps*. Geneva: Pierre Cailler, 1952.

Daulte 1959
Daulte, François. *Alfred Sisley: Catalogue raisonné de l'oeuvre peint*. Lausanne: Éditions Durand-Ruel, 1959.

Daulte 1971
Daulte, François. *Auguste Renoir: Catalogue raisonné de l'oeuvre peint*. Vol. 1, *Figures, 1860–1890*. Lausanne: Éditions Durand-Ruel, 1971.

Daulte 1992
Daulte, François. *Frédéric Bazille et les débuts de l'impressionnisme: Catalogue raisonné de l'oeuvre peint*. Paris: La Bibliothèque des Arts, 1992.

Degas 1945
Lettres de Degas. Edited by Marcel Guérin. Rev. ed. Paris: Grasset, 1945. Translated by Marguerite Kay, *Degas Letters* (Oxford: Cassirer, 1947).

Delaborde 1859
Delaborde, Henri. "L'Art français au salon de 1859." *La Revue des Deux Mondes* 21 (June 1, 1859), pp. 497–532.

Delacroix 1868
Delacroix, Eugène. "L'idéal et le réalisme." *L'Artiste*, May 15, 1868, pp. 333–40.

Delacroix 1980
Delacroix, Eugène. *Journal 1822–1863*. Preface by Hubert Damisch, introduction and notes by André Joubin. Paris: Plon, 1980.

Denney 1993
Denney, Colleen. "Exhibitions in Artists' Studios: François Bonvin's 1859 Salon des Refusés." *Gazette des Beaux-Arts*, September 1993, pp. 97–108.

Desnoyers 1863
Desnoyers, Ferdinand. *Salon des Refusés: La peinture en 1863*. Paris: Azur Dutil, 1863.

Distel 1989
Distel, Anne. *Les Collectionneurs des impressionnistes, amateurs et marchands*. Düdingen: La Bibliothèque des Arts, 1989.

Distel 1993
Distel, Anne. *Renoir, "il faut embellir."* Paris: Gallimard, collection Découvertes, 1993.

Dorbec 1913
Dorbec, Prosper. "L'oeuvre de Théodore Rousseau aux Salons de 1849 à 1867." *Gazette des Beaux-Arts*, ser. 4, 9 (February 1913), pp. 107–27.

Dorival 1948
Dorival, Bernard. *Cézanne*. Paris: Pierre Tisné, 1948.

Dorival 1975
Dorival, Bernard. "Quelques sources méconnues de divers ouvrages de Manet." *Bulletin de la Société de l'histoire de l'art français*, 1975, pp. 315–40.

Du Camp 1859
Du Camp, Maxime. *Le Salon de 1859*. Paris: Librairie nouvelle, 1859.

Dumas 1859
Dumas, Alexandre. *L'Art et les artistes contemporains au Salon de 1859*. Paris, 1859.

Dumesnil 1859
Dumesnil, Henri. *Salon de 1859*. Paris, 1859.

Dumesnil 1875
Dumesnil, Henri. *Corot, souvenirs intimes*. Paris, 1875.

Duranty 1867
Edmond Duranty. "Sur la Physionomie." *Revue libérale* 2 (July 25, 1867), pp. 494–523.

Duret 1924
Duret, Théodore. *Renoir*. Paris: Bernheim-Jeune, 1924.

Duret 1926
Duret, Théodore. *Manet*. Paris: Bernheim-Jeune, 1926.

Edinburgh 1986
Edinburgh, National Gallery of Scotland, August 1–October 19, 1986. *Lighting Up the Landscape: French Impressionism and Its Origins*. Catalogue by Michael Clarke.

Edinburgh, London 1957
Edinburgh, Royal Scottish Academy, August 17–September 15, 1957; London, Tate Gallery, September 26–November 3, 1957. *Claude Monet: An Exhibition of Paintings*. Catalogue by Douglas Cooper.

Elder 1924
Elder, Marc. *À Giverny, chez Claude Monet*. Paris: Bernheim-Jeune, 1924.

Fantin-Latour 1911
Catalogue de l'oeuvre complet (1849–1904) de Fantin-Latour, établi et rédigé par madame Fantin-Latour. Paris: H. Floury, 1911.

Farwell 1969
Farwell, Beatrice. "Manet's 'Espada' and Marcantonio." *Metropolitan Museum Journal* 2 (1969), pp. 197–207.

Farwell 1973
Farwell, Beatrice. *Manet and the Nude: A Study in Iconography in the Second Empire*. Ph.D. diss., University of California, Los Angeles, 1973. New York: Garland, 1981.

Fels 1925
Fels, Florent. *Claude Monet*. Paris, 1925.

Fels 1929
Fels, Marthe de. *La Vie de Claude Monet*. Paris, 1929.

Fermigier 1977
Fermigier, André. *Millet*. Geneva: Skira, 1977. Reprint, 1991.

Fernier 1977–78
Fernier, Robert. *La Vie et l'oeuvre de Gustave Courbet*. 2 vols. Lausanne: Fondation Wildenstein; Paris: La Bibliothèque des Arts, 1977–78.

Fidell-Beaufort and Bailly-Herzberg 1975
Fidell-Beaufort, Madeleine, and Janine Bailly-Herzberg. *Daubigny*. English text by Judith Schub. Paris, 1975.

Flescher 1978
Flescher, Sharon. *Zacharie Astruc—Critic, Artist and Japoniste (1833–1907)*. Ph.D. diss., Columbia University, 1977. New York: Garland, 1978.

Fosca 1958
Fosca, François. *Corot, sa vie et son oeuvre*. Brussels, 1958.

Foucart 1991
Foucart, Bruno. "Impressionnisme et peinture d'histoire." *Quarante-huit/Quatorze, Conférences du Musée d'Orsay*, no. 3 (1991), pp. 13–16.

Frankfurt 1913
Frankfurt, Kunstverein, 1913. *Frankfurter Kunstchatz*.

Fromentin 1984
Fromentin, Eugène. *OEuvres complètes*. Selected and edited by Guy Sagnes. Paris: Gallimard. La Pléiade, 1984.

Fuller 1899
Fuller, William H. *Claude Monet and His Paintings*. New York, 1899.

Gasquet 1926 (and 1921)
Gasquet, Joachim. *Cézanne*. Paris: Bernheim-Jeune, 1921. Reprint, 1926. Translated by Christopher Pemberton, *Joachim Gasquet's Cézanne: A Memoir with Conversations* (London, 1991).

Gautier 1859
Gautier, Théophile. *Exposition de 1859*. Text based on the articles published in the *Moniteur universel* and annotated by Wolfgang Drost and Ulrike Henninges. Heidelberg: Carl Winter Universitätsverlag, 1992.

Gautier 1861
Gautier, Théophile. *Abécédaire du Salon de 1861*. Paris, 1861.

Geffroy 1920
Geffroy, Gustave. "Claude Monet." *L'Art et les artistes* 11 (November 1920).

Geffroy 1922
Geffroy, Gustave. *Claude Monet, sa vie, son temps, son oeuvre*. Paris, 1922.

Georgel 1973
Georgel, Pierre. "Le Romantisme des années 1860." *Revue de l'art*, no. 20 (1973), pp. 8–64.

Georgel 1975
Georgel, Pierre. "Les transformations de la peinture vers 1848, 1855, 1863." *Revue de l'art*, no. 27 (1975), pp. 62–77.

Gimpel 1963 (and 1966)
Gimpel, René. *Journal d'un collectionneur: mar-

chand de tableaux. Paris: Calmann-Lévy, 1963. Translated by John Rosenberg, *Diary of an Art Dealer* (London, 1966).

Goncourt 1863–64
Goncourt, Edmond and Jules de. "Chardin." *Gazette des Beaux-Arts*, December 1, 1863, pp. 514–33; February 1, 1864, pp. 144–67.

Goncourt 1867
Goncourt, Edmond and Jules de. *Manette Salomon*. Paris, 1867. Reprinted in the series Fin de siècles, 10/18, 1979.

Goncourt 1956
Goncourt, Edmond and Jules de. *Journal, mémoires de la vie littéraire*. Edited by Robert Ricatte. 2 vols. Paris: Fasquelle and Flammarion, 1956. The edition used by Henri Loyrette was published in 22 vols. Monaco: Les Éditions de l'imprimerie nationale de Monaco, 1956.

Gorder 1973
Gorder, Judith Elaine. *James McNeill Whistler: A Study of the Oil Paintings 1855–1869*. Ph.D. diss., University of Iowa, Iowa City, 1973. Photocopy, Ann Arbor: University Microfilms International, 1984.

Grad 1977
Grad, Bonnie Lee. *An Analysis of the Development of Daubigny's Naturalism Culminating in the Riverscape Period (1857–1870)*. Ph.D. diss., University of Virginia, Charlottesville, 1977. Photocopy, Ann Arbor: University Microfilms International, 1988.

Halévy 1960 (and 1964)
Halévy, Daniel. *Degas parle....* Paris: La Palatine, 1960. Translated by Mina Curtiss, *My Friend Degas* (Middletown, Conn.: Wesleyan University Press, 1964).

Hamilton 1986
Hamilton, George Heard. *Manet and His Critics*. 1954. 2nd ed., New Haven, 1986.

Hanson 1972
Hanson, Anne Coffin. "Popular Imagery and the Work of Édouard Manet." In *French 19th Century Painting and Literature*, edited by Ulrich Finke, pp. 133–63. Manchester, 1972.

Hanson 1977
Hanson, Anne Coffin. *Manet and the Modern Tradition*. New Haven, 1977.

Hardouin-Fugier and Grafe 1992
Hardouin-Fugier, Élisabeth, and Étienne Grafe. *Les Peintres de fleurs en France de Redouté à Redon*. Paris: Les Éditions de l'Amateur, 1992.

Harris 1966
Harris, Jean C. "Manet's Race-Track Paintings." *Art Bulletin* 48 (1966), pp. 78–82.

Haskell 1976
Haskell, Francis. *Rediscoveries in Art: Some Aspects of Taste, Fashion and Collecting in England and France*. London: Phaidon, 1976.

Haskell 1989
Haskell, Francis. *De l'art et du goût—Jadis et naguère*. Paris: Gallimard, 1989. Translated from *Past and Present in Art and Taste: Selected Essays* (New Haven, 1987).

Hefting 1975
Hefting, Victorine. *Jongkind, sa vie, son oeuvre, son époque*. Paris: Arts et métiers graphiques, 1975.

Hellebranth 1976
Hellebranth, Robert, et al. *Charles-François Daubigny, 1817–1878*. Morges, 1976.

Henriet 1874
Henriet, Frédéric. "Les paysagistes contemporains: Daubigny." *Gazette des Beaux-Arts*, ser. 2, 9 (March 1, 1874), pp. 255–70.

Henriet 1878
Henriet, Frédéric. *Charles Daubigny et son oeuvre*. Paris, 1878.

Herbert 1988
Herbert, Robert L. *Impressionism: Art, Leisure and Parisian Society*. New Haven and London: Yale University Press, 1988. French translation, *L'Impressionnisme: Les plaisirs et les jours* (Paris: Flammarion, 1988).

Hoog 1982
Hoog, Michel. *La Thématique de Manet*. Paris, 1982.

Hourticq 1911
Hourticq, Louis. *Manet*. Paris: Librairie centrale des Beaux-Arts, [1911].

House 1977
House, John. *Claude Monet*. New York, 1977.

House 1986
House, John. *Monet: Nature into Art*. New Haven and London: Yale University Press, 1986.

Houssaye 1859
Houssaye, Arsène. "Salon de 1859." *Le Monde illustré*, 1859: vol. 4, pp. 246–47, 263–65, 279–82, 294–95, 311–14, 327–30, 343–46, 359–62, 375–78, 389, 391–94, 406–10; vol. 5, pp. 54–58, 384.

Huyghe 1936
Huyghe, René. *Cézanne*. Paris: Plon, 1936.

Isaacson 1966
Isaacson, Joel. "Monet's Views of Paris." *Allen Memorial Art Museum Bulletin* 24 (Fall 1966), pp. 4–22.

Isaacson 1967
Isaacson, Joel. *The Early Paintings of Claude Monet*. Ph.D. diss., University of California, Berkeley, 1967. Photocopy, Ann Arbor: University Microfilms International, 1990.

Isaacson 1972
Isaacson, Joel. *Monet: Le Déjeuner sur l'herbe*. New York: Viking, 1972.

Isaacson 1978
Isaacson, Joel. *Observation and Reflection: Claude Monet*. Oxford, 1978. French translation, *Claude Monet, observation et réflexion* (Neuchâtel, 1978).

Isaacson 1984
Isaacson, Joel. "Observation and Experiment in the Early Work of Monet." In *Aspects of Monet: A Symposium on the Artist's Life and Times*, edited by John Rewald and Frances Weitzenhoffer, pp. 16–35. New York: Abrams, 1984.

Jean-Aubry 1922
Jean-Aubry, G. *Eugène Boudin d'après des documents inédits*. Paris: Bernheim-Jeune, 1922.

Jean-Aubry 1968
Jean-Aubry, G. *Eugène Boudin d'après des lettres et documents inédits*. Neuchâtel: Ides et Calendes, 1968.

Jourdan 1859
Jourdan, Louis. *Les Peintres français: Salon de 1859*. Paris, 1859.

Koechlin 1927
Koechlin, Raymond. "Claude Monet." *Art et Décoration* 51 (February 1927), pp. 5–47.

Krumrine 1989
Krumrine, Mary Louise, with contributions by Gottfried Boehm and Christian Geelhaar. *Paul Cézanne: The Bathers*. Basel: Öffentliche Kunstsammlung Basel and Eidolon AG (Einsiedeln), 1989. French translation, *Cézanne: Les Baigneuses* (Paris: Albin Michel, 1990). See Basel 1989.

Laran 1912
Laran, Jean. *Daubigny*. Paris, [1912].

Lassaigne and Gache-Patin 1983
Lassaigne, Jacques, and Sylvie Gache-Patin. *Sisley*. Paris: Nouvelles Éditions Françaises, 1983.

Leiris 1978
Leiris, Alain de. "Édouard Manet's 'Mlle V. in the Costume of an Espada': Form, Ideas in Manet's Stylistic Repertory; Their Sources in Early Drawing Copies." *Arts Magazine*, January 1978, pp. 112–17.

Lemoisne 1946–49
Lemoisne, Paul-André. *Degas et son oeuvre*. 4 vols.

Paris: Paul Brame and C. M. de Hauke, and Arts et métiers graphiques, [1946–49].

Lépinois 1859
Lépinois, Eugène de Buchère de. *L'Art dans la rue et l'art au Salon*. Paris, 1859.

Leymarie 1992 (and 1979)
Leymarie, Jean. *Corot*. 1979. Rev. ed., Geneva: Skira, 1992.

Lloyd 1979
Lloyd, Christopher. *Pissarro*. Oxford and New York, 1979.

Lloyd 1981
Lloyd, Christopher. *Camille Pissarro*. New York, 1981.

Lloyd 1992
Lloyd, Christopher. "Paul Cézanne, Pupil of Pissarro: An Artistic Friendship." *Apollo* 136 (November 1992), pp. 284–90.

London 1931
London, Tate Gallery, June 27–October 10, 1931. *Exhibition of Oil Paintings by Camille Pissarro*. Catalogue foreword by J. B. M[anson].

London 1949–50
London, Royal Academy of Arts, 1949–50. *Landscape in French Art, 1550–1900*.

London 1986
London, Courtauld Institute Galleries, 1986. *The Hidden Face of Manet*. Catalogue by Juliet Wilson Bareau.

London 1991
London, National Gallery, 1991. *Art in the Making: Impressionism*. Catalogue by David Bomford, Jo Kirby, John Leighton, and Ashok Roy.

London, Paris, Baltimore 1992–93
London, Royal Academy of Arts, July 3–October 18, 1992; Paris, Musée d'Orsay, October 28, 1992–January 31, 1993; Baltimore, Walters Art Gallery, March 14–June 13, 1993. *Alfred Sisley*. Catalogue edited by MaryAnne Stevens, with contributions by Isabelle Cahn, Caroline Durand-Ruel Godfroy, William R. Johnston, Christopher Lloyd, Sylvie Patin, and MaryAnne Stevens. English and French editions.

London, Paris, Boston 1980–81
London, Hayward Gallery, October 30, 1980–January 11, 1981; Paris, Grand Palais, January 30–April 27, 1981; Boston, Museum of Fine Arts, May 19–August 9, 1981. *Pissarro*. Catalogue by John Rewald, Richard Brettell, Françoise Cachin, Janine Bailly-Herzberg, Christopher Lloyd, Anne Distel, Barbara Stern Shapiro, and Martha Ward. English and French editions.

London, Paris, Boston 1985–86
London, Hayward Gallery, January 30–April 21, 1985; Paris, Grand Palais, May 14–September 2, 1985; Boston, Museum of Fine Arts, October 9, 1985–January 5, 1986. *Renoir*. Catalogue by Anne Distel and John House. English and French editions.

London, Paris, Washington 1988–89
London, Royal Academy of Arts, April 22–August 21, 1988; Paris, Musée d'Orsay, September 20–December 31, 1988; Washington, National Gallery of Art, January 29–April 3, 1989. *Cézanne: The Early Years 1859–1872*. French edition, *Cézanne, les années de jeunesse 1859–1872*. Catalogue by Lawrence Gowing, with contributions by Götz Adriani, Mary Louise Krumrine, Mary Tompkins Lewis, Sylvie Patin, and John Rewald.

Los Angeles, Chicago, Paris 1984–85
Los Angeles County Museum of Art, June 28–September 16, 1984; Chicago, Art Institute, October 23, 1984–January 6, 1985; Paris, Grand Palais, February 8–April 22, 1985. *A Day in the Country: Impressionism and the French Landscape*. French edition, *L'Impressionnisme et le paysage français*. Catalogue by Richard Brettell, Sylvie Gache-Patin, Françoise Heilbrun, and Scott Schaefer.

Loyrette 1989
Loyrette, Henri. "Degas entre Gustave Moreau et Duranty: Notes sur les portraits, 1859–1876." *Revue de l'art*, no. 86 (1989), pp. 16–27.

Loyrette 1991
Loyrette, Henri. *Degas*. Paris: Fayard, 1991.

Lyon 1993
Lyon, Musée des Beaux-Arts, 1993. *Ernest Meissonier*. Catalogue by Constance Cain Hungerford.

Mainardi 1979
Mainardi, Patricia. "Gustave Courbet's Second Scandal: Les Demoiselles de Village." *Arts Magazine* 53 (January 1979), pp. 95–103.

Mainardi 1987
Mainardi, Patricia. *Art and Politics of the Second Empire: The Universal Expositions of 1855 and 1867*. New Haven: Yale University Press, 1987.

Malingue 1943
Malingue, Maurice. *Claude Monet*. Monaco, 1943.

Manchester, New York, Dallas, Atlanta 1991–92
Manchester, Currier Gallery of Art; New York, IBM Gallery of Science and Art; Dallas, Museum of Art; Atlanta, High Museum of Art, 1991–92. *The Rise of Landscape Painting in France: Corot to Monet*. Introduction by Richard R. Brettell, catalogue by Kermit S. Champa, with contributions by Fiona E. Wissman and Deborah Johnson.

Manet 1988
Manet, Édouard. *Voyage en Espagne*. Edited by Juliet Wilson Bareau. Caen: l'Échoppe, 1988.

Mantz 1859
Mantz, Paul. "Salon de 1859." *Gazette des Beaux-Arts*, 1859: vol. 1, pp. 129–41, 193–208, 271–99, 350–71; vol. 2, pp. 21–39.

Mauclair 1924 (and 1927)
Mauclair, Camille [Camille Faust]. *Claude Monet*. Paris: F. Rieder, 1924. Translated by J. Lewis May (London, New York, 1927).

Mauner 1975
Mauner, George. *Manet, Peintre-Philosophe: A Study of the Painter's Themes*. University Park and London: Pennsylvania University Press, 1975.

Mauner 1988
Mauner, George. "The Eternal and the Transitory in Manet's Emblematic Imagery." *Emblematica* 3, no. 2 (1988), pp. 313–48.

McCauley 1985
McCauley, Elizabeth Anne. *A. A. E. Disdéri and the Carte de Visite Portrait Photograph*. New Haven and London: Yale University Press, 1985.

McCoubrey 1964
McCoubrey, John W. "The Revival of Chardin in French Still-Life Painting, 1850–1870." *Art Bulletin*, March 1964, pp. 39–53.

Meier-Graefe 1910 (and 1918)
Meier-Graefe, Julius. *Paul Cézanne*. Munich: R. Piper, 1910. Reprint, 1918.

Meier-Graefe 1912
Meier-Graefe, Julius. *Renoir*. Paris: H. Floury, 1912.

Meier-Graefe 1920 (and 1922)
Meier-Graefe, Julius. *Cézanne und sein Kreis*. 2nd ed. Munich: R. Piper, 1920, reprint, 1922.

Millet 1975
See Paris, London 1975–76.

Moffett 1985
Moffett, Charles S. *Impressionist and Post-Impressionist Paintings in the Metropolitan Museum of Art*. New York: Metropolitan Museum of Art, 1985.

Montpellier 1927
Montpellier, Exposition Internationale, May–June, 1927. *Rétrospective Bazille*.

Montpellier 1941
Montpellier, Musée Fabre, May–June, 1941. *Centenaire de Frédéric Bazille*.

Montpellier 1959
Montpellier, Musée Fabre, October 13–31, 1959. *Frédéric Bazille*.

Montpellier 1970–71
Montpellier, Musée Fabre, November 28, 1970–January 31, 1971. *Hommage à Frédéric Bazille*.

Montpellier 1991–92
Montpellier, Musée Fabre, December 6, 1991–February 9, 1992. *Frédéric Bazille, 150e anniversaire*. Catalogue by Didier Vatuone, Mireille Lacave, Aleth Jourdan, and Jacques de Grasset.

Montpellier 1992
Montpellier, Musée Fabre, March 24–May 31, 1992. *Bazille: Traces et lieux de la création*. Essays by Aleth Jourdan, Didier Vatuone, Jean Rouaud, and Guy Barral.

Montpellier, Brooklyn, Memphis 1992–93
Montpellier, Pavillon du Musée Fabre, July 9–October 4, 1992; Brooklyn Museum, November 13, 1992–January 24, 1993; Memphis, Dixon Gallery and Gardens, February 14–April 25, 1993. *Bazille et ses amis impressionnistes*. English edition, *Frédéric Bazille: Prophet of Impressionism*. Catalogue by Aleth Jourdan, Dianne W. Pitman, and Didier Vatuone.

Moreau-Nélaton 1924
Moreau-Nélaton, Étienne. *Corot raconté par lui-même*. 2 vols. Paris: H. Laurens, 1924.

Moreau-Nélaton 1925
Moreau-Nélaton, Étienne. *Daubigny raconté par lui-même*. 2 vols. Paris: H. Laurens, 1925.

Moreau-Nélaton 1926 (or 1926a)
Moreau-Nélaton, Étienne. *Manet raconté par lui-même*. 2 vols. Paris: H. Laurens, 1926.

Morisot 1950 (and 1957)
Correspondance de Berthe Morisot. Edited by Denis Rouart. Paris: Quatre Chemins-Éditart, 1950. Translated by Betty W. Hubbard, *The Correspondence of Berthe Morisot* (New York, 1957).

Nettement 1862
Nettement, Alfred. *Poètes et artistes contemporains*. Paris, 1862.

New York 1930
New York, Metropolitan Museum of Art, 1930. *The H. O. Havemeyer Collection*.

New York 1965
New York, Wildenstein and Co., 1965. *Loan Exhibition C. Pissarro*. Catalogue introduction by John Rewald.

New York 1993
New York, Metropolitan Museum of Art, March 27–June 20, 1993. *Splendid Legacy: The Havemeyer Collection*. Catalogue by Alice Cooney Frelinghuysen, Gary Tinterow, Susan Alyson Stein, Gretchen Wold, and Julia Meech.

Nochlin 1966
Nochlin, Linda. *Realism and Tradition in Art 1848–1900*. Englewood Cliffs, N.J., 1966.

Novotny 1937 (and 1961)
Novotny, Fritz. *Cézanne*. Vienna, 1937. Reprint, 1961.

Orienti 1970
Orienti, Sandra. *L'opera completa di Cézanne*. Milan: Rizzoli, 1970. English edition, *The Complete Paintings of Cézanne* (New York: Abrams, 1972). French edition, *Tout l'oeuvre peint de Cézanne*, with an introduction by Gaëtan Picon (Paris: Flammarion, 1975).

Paris 1895
Paris, Palais Galliéra, May–June, 1895. *Exposition organisée au profit du monument du centenaire de Corot*.

Paris 1910
Paris, Grand Palais, Salon d'Automne, October 1–November 8, 1910. *Exposition rétrospective Bazille*.

Paris 1914
Paris, Galerie Manzi et Joyant, January–February 1914. *Rétrospective Camille Pissarro*.

Paris 1930
Paris, Musée de l'Orangerie, 1930. *Exposition Camille Pissarro organisée à l'occasion du centenaire de la naissance de l'artiste*. Catalogue introductions by Adolphe Tabarant and H. Rey.

Paris 1931
Paris, Musée de l'Orangerie, 1931. *Claude Monet*.

Paris 1933
Paris, Musée de l'Orangerie, 1933. *Renoir*. Catalogue preface by Paul Jamot.

Paris 1936
Paris, Musée de l'Orangerie, 1936. *Cézanne*.

Paris 1940
Paris, André Weil, 1940. *Centenaire de Claude Monet*.

Paris 1950
Paris, Galerie Wildenstein, 1950. *Rétrospective Frédéric Bazille*.

Paris 1954
Paris, Musée de l'Orangerie, 1954. *Hommage à Cézanne*.

Paris 1968–69
Paris, Petit Palais, November 23, 1968–March 17, 1969. *Baudelaire*. Catalogue by Arlette Calvet, Claudine Ganeval, Geneviève Lacambre, Jean Lacambre, Monique Pelletier, François Perot, Maurice Sérullaz, and Jacques Suffel, with essays by Claude Pichois and Maurice Sérullaz.

Paris 1976
See Paris, Ottawa 1976–77.

Paris 1979
See Paris, Cleveland, Boston 1979.

Paris 1980
Paris, Grand Palais, 1980. *Hommage à Claude Monet, 1840–1926*. Catalogue by Hélène Adhémar, Anne Distel, and Sylvie Gache, with contributions by André Masson, Gaston Bachelard, and Michel Hoog.

Paris, 1982
See Paris, Ottawa, San Francisco 1982–83.

Paris 1989
Paris, Musée Rodin, 1989. *Claude Monet-Auguste Rodin, centenaire de l'exposition de 1889*.

Paris-Guide 1867
Paris-Guide par les principaux écrivains et artistes de la France, 2 vols. Paris: Librairie internationale, 1867.

Paris, Cleveland, Boston 1979
Paris, Grand Palais, January 29–April 30, 1979; Cleveland Museum of Art, June 6–August 12, 1979; Boston, Museum of Fine Arts, September 18–November 19, 1979. *Chardin*. Catalogue by Pierre Rosenberg. French and English editions.

Paris, London 1975–76
Paris, Grand Palais; London, Hayward Gallery, 1975–76. *Jean-François Millet*. Catalogue by Robert L. Herbert. French and English editions.

Paris, London 1977–78
Paris, Grand Palais; London, Royal Academy of Arts, 1977–78. *Courbet*. Catalogue by Alan Bowness, Marie-Thérèse de Forges, and Hélène Toussaint. French and English editions.

Paris, Lyon 1936
Paris, Musée de l'Orangerie; Lyon, Musée de Lyon, 1936. *Corot*. Catalogue by Marie Delaroche Vernet, with a preface by Paul Jamot.

Paris, New York 1974–75
Paris, Grand Palais; New York, Metropolitan Museum of Art, 1974–75. *Centenaire de l'impressionnisme*. English edition, *Impressionism: A Centenary Exhibition*.

Paris, New York 1983
Paris, Grand Palais; New York, Metropolitan Museum of Art, 1983. *Manet*. Catalogue by Françoise Cachin, Anne Coffin Hanson, Charles S. Moffett, Michel Melot, and Juliet Wilson Bareau. French and English editions.

Paris, Ottawa 1976–77
Paris, Grand Palais, November 26, 1976–February

14, 1977; Ottawa, National Gallery of Canada, March 25–May 8, 1977. *Puvis de Chavannes*. Catalogue by Louise Argencourt, Marie-Christine Boucher, Douglas Druick, and Jacques Foucart. French and English editions.

Paris, Ottawa, New York 1988–89
Paris, Grand Palais; Ottawa, National Gallery of Canada; New York, Metropolitan Museum of Art, 1988–89. *Degas*. Catalogue by Jean Sutherland Boggs, Henri Loyrette, Michael Pantazzi, and Gary Tinterow with Douglas Druick. French and English editions.

Paris, Ottawa, San Francisco 1982–83
Paris, Grand Palais; Ottawa, National Gallery of Canada; San Francisco, California Palace of the Legion of Honor, 1982–83. *Fantin-Latour*. Catalogue by Douglas Druick and Michael Hoog.

Paris, Rome 1975–76
Paris, Musée de l'Orangerie, June 6–September 29, 1975; Paris, Académie de France à Rome, Villa Medici, October 25, 1975–January 11, 1976. *Hommage à Corot, peintures et dessins des collections françaises*. Italian edition, *Corot 1796–1875*. Catalogue by Hélène Toussaint, Geneviève Monnier, and Martine Servot.

Paris, Tokyo 1988
Paris, Galeries Nationales du Grand Palais, May 17–August 15, 1988; Tokyo, National Museum of Western Art, September 23–December 11, 1988. *Le Japonisme*. Catalogue with essays by Shûji Takashina, Geneviève Lacambre, Aiko Mahuchi, and Caroline Mathieu. French and Japanese editions.

Pennell 1908 (and 1909)
Pennell, Elizabeth Robins, and Joseph Pennell. *The Life of James McNeill Whistler*. 2 vols. London: W. Heinemann; Philadelphia: J. B. Lippincott, 1908. 3rd ed., 1909.

Perrier 1859
Perrier, Charles. "Le Salon de 1859." *La Revue contemporaine*, ser. 2, 9 (May–June 1859), pp. 287–324.

Philadelphia, Detroit, Paris 1978–79
Philadelphia Museum of Art, October–November 26, 1978; Detroit Institute of Arts, January 15–March 18, 1979; Paris, Grand Palais, April 24–July 2, 1979. *The Second Empire: Art in France under Napoleon III*. French edition, *L'Art en France sous le second Empire*. Catalogue by Jean-Marie Mourin, Kathryn B. Hiesinger, and Joseph Rishel.

Pichois and Ziegler 1987
Pichois, Claude, and Jean Ziegler. *Baudelaire*. Paris: Julliard, 1987.

Pissarro 1988
Correspondance de Camille Pissarro. Vol. 3, *1891–1894*. Edited by Janine Bailly-Herzberg. Paris: Éditions du Valhermeil, 1988.

Pissarro 1993
Pissarro, Joachim. *Camille Pissarro*. New York: Abrams, 1993.

Pissarro and Venturi 1939
Pissarro, Ludovic Rodo, and Lionello Venturi. *Camille Pissarro, son art, son oeuvre*. 2 vols. Paris, 1939.

Pitman 1989
Pitman, Dianne Williams. *The Art of Frédéric Bazille (1841–1870)*. Ph.D. diss., Johns Hopkins University, Baltimore, 1989. Photocopy, Ann Arbor: University Microfilms International, 1992.

Poulain 1932
Poulain, Gaston. *Bazille et ses amis*. Paris: La Renaissance du Livre, 1932.

Price 1967
Price, Charles Theodore. *Naturalism and Convention in the Painting of Charles-François Daubigny*. Ph.D. diss., Yale University, New Haven, 1967. Photocopy, Ann Arbor: University Microfilms International, 1988.

Proudhon 1939
Proudhon, Pierre-Joseph. *OEuvres complètes: Du principe de l'art et de sa destination sociale. La pornocratie*. Paris: Marcel Rivière et Cie, 1939.

Proust 1897 (and 1913)
Proust, Antonin. *Édouard Manet, souvenirs*. 1913. Caen: l'Échoppe, 1988. Reprint of articles originally published in *La Revue blanche*, February–May 1897.

Redon 1987
Redon, Odilon. *Critiques d'art*. Edited by Robert Coustet. Bordeaux, 1987.

Reff 1976
Reff, Theodore. *Manet: Olympia*. London: Allen Lane, 1976.

Reff 1980
Reff, Theodore. "Courbet and Manet." *Arts Magazine* 54, no. 7 (1980), pp. 9–22.

Reff 1982
Reff, Theodore. *Manet and Modern Paris*. Exh. cat. Washington: National Gallery of Art, 1982.

Reff 1985
Reff, Theodore. *The Notebooks of Edgar Degas*. 2 vols. London: Clarendon Press, 1976. Rev. ed., New York: Hacker Art Books, 1985.

Regamey 1927
Regamey, Raymond. "La formation de Claude Monet." *Gazette des Beaux-Arts*, ser. 5, 15 (February 1927), pp. 65–84.

Reuterswärd 1948
Reuterswärd, Oscar. *Monet*. Stockholm, 1948.

Revel 1963
Revel, Jean-François. "Delacroix entre les anciens et les modernes." *L'OEil*, no. 101 (May 1963), pp. 10–19, 67.

Rewald 1936
Rewald, John. *Cézanne et Zola*. Paris: Éditions A. Sedrowski, 1936.

Rewald 1939
Rewald, John. *Cézanne, sa vie, son oeuvre, son amitié pour Zola*. Paris: A. Michel, 1939. Rev. and exp., Paris: Flammarion, 1986.

Rewald 1948
Rewald, John. *Paul Cézanne: A Biography*. Translation by Margaret H. Liebman. New York: Simon and Schuster, 1948. Rev. and exp. ed., 1986.

Rewald 1961
See Rewald 1973.

Rewald 1963
Rewald, John. *Camille Pissarro*. New York: Abrams, 1963.

Rewald 1971–72
Rewald, John. "Cézanne and His Father." *Studies in the History of Art* (National Gallery of Art, Washington), 1971–72, pp. 38–62.

Rewald 1973
Rewald, John. *The History of Impressionism*. 1946, 1955, 1961. 4th rev. ed., New York, 1973. Translated by Nancy Goldet-Bouwens, *Histoire de l'impressionnisme* (Paris: A. Michel, 1955; rev. ed., Paris: A. Michel, 1986).

Rewald 1986a
Rewald, John. *Cézanne, sa vie, son oeuvre, son amitié pour Zola*. Paris: A. Michel, 1939. Rev. and exp., Paris: Flammarion, 1986.

Rewald 1986b
Rewald, John. *Histoire de l'impressionnisme*. Translation by Nancy Goldet-Bouwens. 1955. Rev. ed., Paris: A. Michel, 1986.

Rewald 1986c
Rewald, John. *Paul Cézanne: A Biography*. Translation by Margaret H. Liebman. New York: Simon and Schuster, 1948. Rev. and exp. ed., 1986.

Riat 1906
Riat, Georges. *Gustave Courbet peintre*. Paris: H. Floury, 1906.

Rivière 1923
Rivière, Georges. *Le maître Paul Cézanne*. Paris: H. Floury, 1923.

Robaut 1905
L'OEuvre de Corot, par Alfred Robaut, catalogue raisonné et illustré, précédé de l'histoire de Corot et de ses oeuvres par Étienne Moreau-Nélaton. 4 vols. Paris: H. Floury, 1905.

Rosen and Zerner 1984
Rosen, Charles, and Henri Zerner. *Romanticism and Realism*. New York, 1984. French edition, *Romantisme et réalisme, mythes de l'art du XIXe siècle* (Paris: Albin Michel, 1986).

Rosenthal 1914
Rosenthal, Léon. *Du romantisme au réalisme: Essai sur l'évolution de la peinture en France de 1830 à 1848*. Paris: H. Laurens, 1914.

Rouart and Wildenstein 1975
Rouart, Denis, and Daniel Wildenstein. *Édouard Manet: Catalogue raisonné*. 2 vols. Lausanne and Paris: La Bibliothèque des Arts, 1975.

Rousseau 1866
Rousseau, Jean. "Le Salon de 1866. IV." *L'Univers illustré* 9 (July 14, 1866), pp. 447–48.

Sainsaulieu and de Mons 1990
Sainsaulieu, Marie-Caroline, and Jacques de Mons. *Eva Gonzalès, 1849–1883: Étude critique et catalogue raisonné*. Paris: Bibliothèque des Arts, 1990.

Saint Louis, Minneapolis 1957
Saint Louis, City Art Museum; Minneapolis Institute of Arts, 1957. *Monet*.

Sandblad 1954
Sandblad, N. G. *Manet: Three Studies in Artistic Conception*. Lund: C. W. K. Gleerup Lund, 1954.

San Francisco, Toledo, Cleveland, Boston 1962–63
San Francisco, California Palace of the Legion of Honor; Toledo Museum of Art; Cleveland Museum of Art; Boston, Museum of Fine Arts, 1962–63. *Barbizon Revisited*. Catalogue by Robert Herbert.

Sarraute 1958
Sarraute, Gabriel. "Contribution à l'étude du Déjeuner sur l'herbe de Monet." *Bulletin du laboratoire du musée du Louvre*, June 1958, pp. 46–51.

Sarraute 1962
Sarraute, Gabriel. "Deux dessins inédits de Claude Monet." *Revue du Louvre*, 1962, no. 2, pp. 91–92.

Schapiro 1968 (and 1978)
Schapiro, Meyer. "The Apples of Cézanne: An Essay on the Meaning of Still-Life." *Art News Annual*, 1968, pp. 34–53. Reprinted in *Modern Art: 19th and 20th Centuries*, pp. 1–38. New York, 1978. French translation, "Les pommes de Cézanne, un essai sur la signification de la nature morte." *Revue de l'art*, nos. 1–2 (1968); reprinted in *Style, Artiste et Société* (Paris: Gallimard, 1982).

Schmit 1973–93
Schmit, Robert. *Eugène Boudin*. 5 vols. Paris: Robert Schmit, 1973–93.

Schneider 1978
Schneider, Pierre. *Manet et son temps*. New York: Time-Life International, 1978. Translated from *The World of Manet, 1832–1883* (New York, 1968).

Seigel 1991
Seigel, Jerrold. *Paris bohème, 1830–1930*. Paris: Gallimard, 1991.

Seitz 1960
Seitz, William. *Claude Monet*. New York, 1960.

Sensier 1872
Sensier, Alfred. *Souvenirs sur Théodore Rousseau*. Paris, 1872.

Sharf 1986
Sharf, Aaron. *Art and Photography*. 1968. Reprint, New York: Penguin Books, 1986.

Shikes and Harper 1980
Shikes, Ralph E., and Paula Harper. *Pissarro: His Life and Work*. New York: Horizon; London, 1980.

Shone 1992
Shone, Richard. *Sisley*. New York, 1992.

Skeggs 1987
 Skeggs, Douglas. *River of Light: Monet's Impressions of the Seine.* New York, 1987.
Spate 1992
 Spate, Virginia. *Claude Monet: Life and Work.* New York, 1992.
Spencer 1989
 Spencer, Robin, ed. *Whistler: A Retrospective.* New York, 1989.
Sterling 1985
 Sterling, Charles. *La Nature morte de l'antiquité au XXe siècle.* 1952. Paris: Macula, 1985.
Sterling and Salinger 1966
 Sterling, Charles, and Margaretta M. Salinger. *French Paintings: A Catalogue of the Collection of The Metropolitan Museum of Art.* Vol. 2, *XIX Century.* New York, 1966.
Sterling and Salinger 1967
 Sterling, Charles, and Margaretta M. Salinger. *French Paintings: A Catalogue of the Collection of The Metropolitan Museum of Art.* Vol. 3, *XIX–XX Centuries.* New York, 1967.
Stuckey 1984
 Stuckey, Charles. "Monet's Art and the Act of Vision." In *Aspects of Monet: A Symposium on the Artist's Life and Times,* edited by John Rewald and Frances Weitzenhoffer, pp. 106–21. New York: Abrams, 1984.
Stuckey 1985
 Stuckey, Charles F., ed. *Monet: A Retrospective.* New York, 1985.
Tabarant 1924
 Tabarant, Adolphe. *Pissarro.* Paris: Rieder, 1924.
Tabarant 1931
 Tabarant, Adolphe. *Manet, histoire catalographique.* Paris: Aubier, 1931.
Tabarant 1947
 Tabarant, Adolphe. *Manet et ses oeuvres.* Paris: Gallimard, 1947.
Tabarant 1963
 Tabarant, Adolphe. *La Vie artistique au temps de Baudelaire.* 1942. Paris: Mercure de France, 1963.

Thiébault-Sisson 1900
 Thiébault-Sisson, François. "Claude Monet, les années d'épreuves." *Le Temps,* November 26, 1900, p. 3.
Thompson and Wright 1987
 Thompson, James, and Barbara Wright. *Eugène Fromentin.* Paris: ACR Édition, 1987.
Thoré-Bürger 1870
 Thoré, Théophile [William Bürger]. *Salons de William Bürger, 1861–1868.* 2 vols. Paris: Renouard, 1870.
Tokyo et al. 1984
 Tokyo, Isetan Museum of Art, March 9–April 9, 1984; Fukuoka Art Museum, April 25–May 20, 1984; Kyoto, Municipal Museum of Art, May 26–July 1, 1984. *Retrospective Camille Pissarro.* Catalogue by Christopher Lloyd, Barbara Stern Shapiro, and Richard R. Brettell.
Trévise 1927
 Trévise, [duc Édouard de]. "Le pèlerinage de Giverny." *Revue de l'art* 51 (February 1927), pp. 42–50, 121–34.
Venturi 1936
 Venturi, Lionello. *Cézanne, son art, son oeuvre.* 2 vols. Paris: Paul Rosenberg, 1936.
Venturi 1939
 Venturi, Lionello. *Les Archives de l'impressionnisme.* 2 vols., Paris and New York: Durand-Ruel, 1939.
Washington, San Francisco 1986
 Washington, National Gallery of Art, January 17–April 6, 1986; San Francisco, M. H. de Young Memorial Museum, April 19–July 6, 1986. *The New Painting: Impressionism 1874–1886.* Catalogue by Charles S. Moffett, Stephen F. Eisenman, Richard Shiff, Paul Tucker, Hollis Clayson, Richard R. Brettell, Ronald Pickvance, Fiona Wissman, Joel Isaacson, and Martha Ward. Includes as an appendix a reprint of Edmond Duranty, *La Nouvelle Peinture, à propos du groupe d'artistes qui expose dans les galeries Durand-Ruel* (Paris, 1876).
Weisberg 1979
 Weisberg, Gabriel P. *Bonvin.* French translation by

André Watteau. Paris: Geoffroy-Dechaume, 1979.
Wells 1987
 Wells, Gary Neil. *Metaphysical Relevance and Thematic Continuity in the Early Paintings of Paul Cézanne 1865–1877.* Ph.D. diss., Ohio State University, Columbus, 1987. Microfiche, Ann Arbor: University Microfilms International, 1987.
Wentworth 1984
 Wentworth, Michael. *James Tissot.* Oxford: Clarendon Press, 1984.
Werth 1928
 Werth, Léon. *Claude Monet.* Paris, 1928.
White 1985
 White, Barbara Ehrlich. *Renoir.* Paris: Flammarion, 1985. Translated from *Renoir: His Life, Art, and Letters* (New York: Abrams, 1984).
Wildenstein 1974
 Wildenstein, Daniel. *Claude Monet: Biographie et catalogue raisonné.* Vol. 1, *1840–1881, Peintures.* Lausanne and Paris: La Bibliothèque des Arts, 1974. (Vol. 2, *1882–1886* [1979]; Vol. 3, *1887–1898* [1979]; Vol 4, *1899–1926* [1985].)
Wildenstein 1991
 Wildenstein, Daniel. *Monet: Catalogue des oeuvres.* Vol. 5. Lausanne: Wildenstein Institute, 1991.
Wilson Bareau 1991
 Wilson Bareau, Juliet. *Manet par lui-même.* Paris: Éditions Atlas, 1991.
Young et al. 1980
 Young, Andrew McLaren, Margaret MacDonald, Robin Spencer, with the assistance of Hamish Miles. *The Paintings of James McNeill Whistler.* 2 vols. New Haven and London: Yale University Press, 1980.
Zola 1978–82
 Zola, Émile. *Correspondance.* Edited by B. H. Bakker. 9 vols. Montreal and Paris: Presses de Montréal et du CNRS, 1978–.
Zola 1991
 Zola, Émile. *Écrits sur l'art.* Edited by Jean-Pierre Leduc-Adine. Paris: Gallimard, collection Tel, 1991.

Index

Photograph Credits

Photographs were supplied by the owners of works of art listed in the captions. All rights reserved.

Additional photography credits are as follows: Jörg P. Anders, cats. 132, 174; Joachim Blanel Artothek, cat. 65; Art Resource, fig. 236; Jean Bernard, cat. 166; E. Irving Blomstrann, fig. 203; Michael Bodycomb, cat. 118; Martin Bühler, cat. 52; Agence Bulloz, figs. 127, 379; courtesy of A. C. Cooper Ltd., Scott Bowron, cat. 31; Agence Giraudon, figs. 63, 71, 192, 385; Tom Haartsen, cat. 173; David Heald, cat. 161; Luis Hossaka, cat. 30; Photo-vidéo Japan Diffusion, G. Beaugrand, cat. 75; Cliché Fréderic Jaulmes, cats. 5, 8, 9, 13, 14, 187; Studio J. C., cat. 23; Patrick Jean, cat. 1; Ron Jennings, cat. 111, fig. 386; Dénes Jozsa, cat. 92; J. Lathion, cat. 107; Françoise Lechevalier, cat. 82; Studio Lourmel, cat. 46; Photograph Studio, The Metropolitan Museum of Art, cats. 7, 25, 45, 47, 48, 57, 58, 62, 67, 72, 81, 98, 103, 105, 120, 127, 137, 147, 158, figs. 40, 157, 164, 299, 300, 301, 352, 366, 375, 387, 392, 394; Antonia Reeve, cat. 128; Réunion des Musées Nationaux (Daniel Arnaudet, Michèle Bellot, Gérard Blot, Hervé Lewandowski, René-Gabriel Ojeda), cats. 12, 20, 21, 24, 27, 34, 35, 37, 54, 55, 56, 59, 68, 74, 76, 79, 87, 93, 95, 97, 101, 102, 108, 109, 110, 114, 122, 123, 130, 142, 144, 152, 172, 175, 177, 182, 183, 189, 190, 190A, figs. 27, 43, 47, 50, 51, 52, 65, 73, 131, 132, 133, 135, 136, 156, 160, 165, 168, 171, 174, 185, 201, 204, 207, 208, 210, 227, 228, 229, 233, 253, 256, 262, 266, 273, 331, 347, 356, 357, 362, 367, 378, 381, 382, 393, 415; Rheinisches Bildarchiv, cat. 159, figs. 167, 247; RKM S.A., cat. 131; Lynn Rosenthal, cat. 167; Roumagnac, fig. 388; Peter Schälchli, cat. 10; Craig Smith, cat. 80; Stickelmann, fig. 193; Jim Strong Inc., cat. 4; Varga, fig. 372; Malcolm Varon, cats. 90, 96, 112, 135; Elke Walford, figs. 19, 49; Werkstatt, cat. 168; Ole Woldbye, cat. 119; courtesy of Yale University Press, cat. 43